Previous volumes

Illustration Index, by Lucile E. Vance. New York: Scarecrow, 1957. Covers 1950 through June 1956.

Illustration Index, First Supplement, by Lucile E. Vance. New York: Scarecrow, 1961. Covers July 1956 through 1959.

Illustration Index, Second Edition, by Lucile E. Vance and Esther M. Tracey. New York and London: Scarecrow, 1966. Covers 1950 through June 1963.

Illustration Index, Third Edition, by Roger C. Greer. Metuchen, N.J.: Scarecrow, 1973. Covers July 1963 through December 1971.

Illustration Index IV, by Marsha C. Appel. Metuchen, N.J., & London: Scarecrow, 1980. Covers 1972 through 1976.

Illustration Index V, by Marsha C. Appel. Metuchen, N.J., & London: Scarecrow, 1984. Covers 1977 through 1981.

Illustration Index VI, by Marsha C. Appel. Metuchen, N.J., & London: Scarecrow, 1988. Covers 1982 through 1986.

Illustration Index VII, by Marsha C. Appel. Metuchen, N.J., & London: Scarecrow, 1993. Covers 1987 through 1991.

Illustration
Index
VIII

1992–1996

Marsha C. Appel

The Scarecrow Press, Inc.
Lanham, Md., & London
1998

SCARECROW PRESS, INC.

Published in the United States of America
by Scarecrow Press, Inc.
4720 Boston Way
Lanham, Maryland 20706

4 Pleydell Gardens, Folkestone
Kent CT20 2DN, England

British Cataloguing-in-Publication Information Available

Library of Congress Cataloging-in-Publication Data

Appel, Marsha C., 1953–
 Illustration index VIII, 1992–1996 / Marsha C. Appel.
 p. cm.
 Includes bibliographical references and index.
 ISBN 0-8108-3484-7 (cloth : alk. paper)
 1. Pictures—Indexes. I. Title.
 N7525.A66 1998
 011′ .37—dc21
 98-15585
 CIP

Printed in the United States of America

The paper used in this publication meets the minimum requirements of American National Standard for Information Sciences—Permanence of Paper for Printed Library Materials, ANSI Z39.48-1984.

Dedicated to Al, with love.

PREFACE

This eighth volume of the *Illustration Index* is entirely new and covers the years 1992–1996. It follows the patterns of scope, style, and arrangement set in volumes four through seven. The depth of indexing is attested to by the existence of more than 19,000 individual subject headings, encompassing about 28,000 entries.

Though the volume does not claim to be totally comprehensive, the only illustrations methodically excluded are ads. Individual personalities are included, provided that the personality is considered of sufficient historical significance to warrant a separate article in the *World Book Encyclopedia*. The rationale for this criterion is the fact that photos of people enjoying ephemeral fame abound and can easily be located through the periodical indexes.

Each illustration within each journal article is treated separately, rather than indexing a few illustrations from an article to represent its major theme. This system of handling each picture individually allows better access to more obscure subject matter.

There is an extensive system of cross-references. It should be easy for a user unfamiliar with the volume to be steered to the proper entry by following related-term "see also" and primary "see" references. In the interest of easy access to each citation, there are frequently multiple entries for one illustration or several cross-references. Entries tend toward the specific. The Hudson, Mississippi, and Danube Rivers can be found under their respective states or countries in which they are located.

Several main listings operate as key locators to identify every example of a given category to be found alphabetically throughout the book. Following are some of the key listings:

Amusements	Minerals
Animals	Mountains
Architectural structures	National parks
Art forms	Occupations

Art works (for artists with separate listings)
Arts & crafts
Athletes
Birds
Blacks in American history
Boats
Fish
Flowers
Geological phenomena
Housing
Industries
Military leaders
People & civilizations
Plants
Religions
Rivers
Rulers and monarchs
Scientists
Sports
Transportation
Trees
Water formations
Weather phenomena
Women in history
Writers

Publications were selected for their richness of illustration and for the availability of back issues in libraries.

A user desiring anything and everything on a specific country or city will go to the geographical entry. Here will be found general citations to illustrations of the country, perhaps some photographs of doctors or policemen, maybe a farm or food market. But suppose the user wants pictures of policemen of various nationalities, or would like to see how farmers do their plowing in different parts of the world. The subject breakdowns are geared to yield just this sort of cross-cultural information. There is a major emphasis on historical and sociocultural phenomena, and a quick glance at the entries and cross-references under FESTIVALS or OCCUPATIONS will show just how extensive their coverage is. MILITARY COSTUME, for example, is indexed hot only by different societies but also by different centuries as well, introducing a valuable historical perspective.

Marsha C. Appel
Port Washington, New York

USER'S GUIDE

The following is an example of a typical citation under a subject entry:

Nat Geog 190:124-5 (drawing,c,1) Jl '96

Most journal titles are abbreviated; "Nat Geog" refers to *National Geographic*. A complete list of journal abbreviations used follows below in the list of periodicals indexed. The journal designation is followed by the volume number of the publication. After the colon comes inclusive pagination.

Most illustrations in the book are photographs. If the text has identified an illustration as a painting, drawing, lithograph, etc., this additional information will appear as the first item inside the parentheses. If the illustrations are all photographs or a combination of photographs and other pictorial forms, no special notation will be made. There is one exception: if a map accompanies a set of photographs, "map" will appear in the parentheses.

The next item in the same citation above is a "c," which indicates that the illustration is in color. Lack of a "c" denotes black and white.

Size of illustration is the last item indicated within the parentheses. There will always be a number from 1 to 4 present:

1 Full page or larger
2 1/2 page or larger, but less than full page
3 Larger than 1/4 page, but less than 1/2 page
4 1/4 page or smaller

In the case of numerous illustrations in a single citation, the size of the largest one is indicated.

The date is the final item in the entry, with months in abbreviated form:

Ja January
F February
Mr March

Jl July
Ag August
S September

Ap April	O October
My May	N November
Je June	D December

PERIODICALS INDEXED

Am Heritage — *American Heritage.* vol. 43–47, February 1992–December 1996.

Gourmet — *Gourmet.* vol. 52–56, January 1992–December 1996.

Life — *Life.* vol. 15–19, January 1992–December 1996.

Nat Geog — *National Geographic.* vol. 181–190, January 1992–December 1996.

Nat Wildlife — *National Wildlife.* vol. 31–36, February 1992–December 1996.

Natur Hist — *Natural History.* vol. 101–105, January 1992–December 1996.

Smithsonian — *Smithsonian.* vol. 23–28, January 1992–December 1996.

Sports Illus — *Sports Illustrated.* vol. 76–85, January 1992—December 1996.

Trav&Leisure — *Travel & Leisure.* vol. 22–26, January 1992–December 1996.

Trav/Holiday — *Travel/Holiday.* vol. 177–186, January 1992—December 1996.

Here are the addresses for each publication for the user who wishes to order or inquire about reproduction rights to illustrations cited in this volume. Please note: Most of the publications do not own the illustrations and cannot, therefore, assign rights to them. They will, however, provide referrals to the artist or photographers who do own the rights.

American Heritage
Library
60 Fifth Avenue
New York, N.Y. 10011

Gourmet
Permissions Dept., 36th floor
Conde Nast Publications
140 East 45th Street
New York, N.Y. 10017

Life
Time-Life Syndication
28th floor
1271 Avenue of the Americas
New York, N.Y. 10020

National Geographic
1145 N.W. 17th Street
Washington, D.C. 20036

National Wildlife
National Wildlife Federation
8925 Leesburg Pike
Vienna, Virginia 22184

Natural History
Picture Editor
American Museum of Natural History
Central Park West at 79th St.
New York, N.Y. 10024

Smithsonian
Picture Editor
900 Jefferson Drive, S.W.
Washington, D.C. 20568

Sports Illustrated
Picture Sales
19th floor
1271 Avenue of the Americas
New York, N.Y. 10020

Travel & Leisure
Reader Service, 10th floor
1120 Avenue of the Americas
New York, N.Y. 10036

Travel/Holiday
Photo Dept.
1633 Broadway
New York, N.Y. 10019

ILLUSTRATION INDEX

AARON, HENRY
—Hitting home run #715 (1974)
 Sports Illus 77:82–3 (c,2) D 7 '92
 Sports Illus 80:86–102 (c,1) Ap 11 '94
Abolitionists. See
 BROWN, JOHN
 DOUGLASS, FREDERICK
ABORIGINES (AUSTRALIA)
 Trav&Leisure 22:130–1 (c,1) F '92
 Nat Geog 189:cov.,3–33 (c,1) Je '96
—Aborigines spearing sting rays
 Nat Geog 190:46–7 (c,3) N '96
—Boy
 Smithsonian 24:82 (c,2) N '93
ABORIGINES (MALAYSIA)
 Trav/Holiday 176:51 (c,4) S '93
ABORIGINES (TASMANIA)
 Natur Hist 104:30–5 (c,1) Ag '95
ABORIGINES—ART
—Bark painting (Australia)
 Gourmet 52:104 (c,4) Ap '92
ABORTION
—Anti abortion demonstrations
 Life 15:cov.,32–42 (c,1) Jl '92
—Pro choice activists
 Life 15:70 (c,3) Ja '92
 Life 15:41 (c,4) Je '92
—Pro choice demonstrations
 Life 15:cov.,32–42 (c,1) Jl '92
—Woman undergoing abortion (New York)
 Life 15:32–3 (c,1) Jl '92
ABRAHAM
—Tomb (Hebron, Israel)
 Nat Geog 181:93 (c,4) Je '92
ACACIAS
 Natur Hist 101:28–33 (c,1) Ag '92
 Trav/Holiday 175:60–1 (c,1) N '92
 Smithsonian 27:106–7 (c,3) My '96
ACADIA NATIONAL PARK, MAINE
 Trav&Leisure 25:96,102 (c,1) My '95
 Trav/Holiday 178:69–77 (map,c,1) Je '95

ACCIDENTS
—1848 skull pierced by iron bar
 Natur Hist 104:70 (3) F '95
—Boater swept into ocean to drown
 (Australia)
 Life 19:18–19 (c,1) Jl '96
—Crowded van tipping over (Indonesia)
 Life 19:14–15 (c,1) My '96
—Gorilla rescuing boy at zoo (Illinois)
 Life 19:78–84 (c,1) N '96
—History of volunteer rescue squads
 Am Heritage 47:90–8 (c,1) My '96
—Hockey rink accident
 Sports Illus 83:66–7 (c,2) N 20 '95
—Man about to drown (China)
 Life 19:14–15 (c,1) N '96
—Rescuing boy from cliff (California)
 Life 18:18 (c,2) S '95
—Staged automobile-bicycle accident
 Life 18:16 (c,2) Ag '95
—See also
 CRASHES
 DISASTERS
ACCORDION PLAYING
 Sports Illus 84:55 (c,4) Je 10 '96
—Argentina
 Smithsonian 24:161 (c,1) N '93
 Trav&Leisure 25:87 (c,1) Ja '95
—At Franklin Roosevelt's funeral (1945)
 Life 19:82–3 (1) O '96
—Czechoslovakia
 Nat Geog 184:12—13 (c,1) S '93
—Lawrence Welk
 Life 19:33 (c,4) Mr '96
—Zydeco music (Louisiana)
 Trav/Holiday 177:59 (c,4) N '94
ACONCAGUA, CHILE
 Nat Geog 181:92–3 (c,1) Mr '92
ACROBATIC STUNTS
—Acrobat on unicycle (Quebec)
 Trav/Holiday 176:37 (c,4) Jl '93
—Human pyramid (Spain)

Trav/Holiday 175:64 (c,1) Mr '92
Sports Illus 77:181 (c,2) Jl 22 '92
Sports Illus 77:19 (c,4) Ag 3 '92
— Ripley's "Believe it or Not" subjects
Smithsonian 25:90–6 (1) Ja '95
— See also
ATHLETIC STUNTS

ACROBATS
Life 18:84 (c,3) S '95
— 1920 child acrobat in balancing act (China)
Nat Geog 190:55 (1) Jl '96
— Ancient Greek figures
Nat Geog 186:7 (c,4) N '94

ACTORS
—1919 Actors' Equity Strike (New York)
Am Heritage 47:92–9 (1) S '96
— 1930s movie stars
Am Heritage 43:75 (4) S '92
— 1943 MGM stars
Life 19:82–3 (c,1) Mr '96
Life 19:22 (c,4) S '96
— 1950s movie stars
Sport Illus 78:60–73 (c,1) Je 21 '93
— 1987 Paramount stars
Life 19:22 (c,4) S '96
— Broadway stars
Life 19:64-5 (c,1) Je '96
— Jane Fonda
Life 19:78 (2) Mr '96
— Gertrude Lawrence
Smithsonian 27:53 (4) N '96
— Ida Lupino
Life 19:94 (4) Ja '96
— Shirley MacLaine
Life 18:35 (4) Mr '95
Life 19:26 (4) Mr '96
— Mary Martin
Smithsonian 27:cov.,54–5 (3) N '96
— Ethel Merman
Smithsonian 27:54 (c,4) N '96
— Zero Mostel
Smithsonian 23:140 (3) Je '92
— Mural of movie stars (Hollywood,
California)
Life 16:52 (c,2) Mr '93
— Lana Turner
Life 19:82–3 (1) Ja '96
— Woman trying to become movie star
Life 16:cov.,46–52 (c,1) Mr '93
— Anna May Wong
Smithsonian 26:32 (4) Je '95
— See also
ANDERSON, DAME JUDITH
ASTAIRE, FRED
AUTRY, GENE

BACALL, LAUREN
BALL, LUCILLE
BERGMAN, INGRID
BERNHARDT, SARAH
BOGART, HUMPHREY
BOW, CLARA
BRANDO, MARLON
COHAN, GEORGE M.
COOPER, GARY
CRAWFORD, JOAN
DEAN, JAMES
DIETRICH, MARLENE
FLYNN, ERROL
GABLE, CLARK
GARBO, GRETA
GISH, LILLIAN
GRABLE, BETTY
GRANT, CARY
HARLOW, JEAN
HAYWORTH, RITA
HEPBURN, AUDREY
HEPBURN, KATHARINE
LEIGH, VIVIAN
MIX, TOM
MONROE, MARILYN
OLIVIER, LAWRENCE
PECK, GREGORY
PICKFORD, MARY
ROBESON, PAUL
ROGERS, GINGER
STEWART, JAMES
TAYLOR, ELIZABETH
TEMPLE, SHIRLEY
TRACY, SPENCER
WEST, MAE

ADAM AND EVE
Natur Hist 105:25 (painting,c,1) My '96
— diPaolo painting
Natur Hist 101:70 (4) Ja '92

ADAMS, ANSEL
— "Aspens, Northern New Mexico, 1958"
Natur Hist 101:86 (4) D '92
— "Moonrise, Hernandez, N.M., 1911"
Trav&Leisure 22:NY6 (2) Ja '92

ADAMS, HENRY BROOKS
Am Heritage 46:88–9 (painting,c,1) Jl '95

ADAMS, JOHN
Am Heritage 44:86,93,99 (painting,c,1)
My '93

ADAMS, JOHN QUINCY
— Wife Louisa
Smithsonian 22:24 (painting,c,4) Mr '92

ADDERS
— Sidewinder buried in sand
Natur Hist 102:29 (c,4) Ag '93

ADDIS ABABA, ETHIOPIA
Sports Illus 83:81–90 (2) D 4 '95
ADELAIDE, AUSTRALIA
Trav/Holiday 175:65–75 (c,3) F '92
Trav&Leisure 24:98–114 (map,c,1) Jl '94
ADIRONDACK MOUNTAINS, NEW YORK
Natur Hist 101:cov.,24–63 (map,c,1) My '92
Gourmet 53:44–9 (c,1) Ag '93
Nat Geog 189:86–7 (c,1) Mr '96
Trav/Holiday 179:72–9 (c,1) Je '96
Trav&Leisure 26:84,142 (c,1) Je '96
— Rainbow Falls
Life 16:33 (c,4) O '93
ADVERTISING
— 1880s ad for opium teething pain remedy
Am Heritage 44:44 (c,4) F '93
— 1880s cracker ad featuring Miss Liberty
Smithsonian 27:83 (c,2) Jl '96
— Early 20th cent. cigarette ads
Am Heritage 43:72–8 (c,1) D '92
— Early 20th cent. stockings ads
Am Heritage 47:56 (4) My '96
— 1900 ad for Bayer drugs with heroin
Am Heritage 44:45 (4) F '93
— Early 20th cent. razor ads
Smithsonian 25:48 (c,4) F '95
— 1910 men's wear catalog
Am Heritage 44:40 (4) N '93
— 1920s transatlantic steamship ad
Am Heritage 47:96–7 (c,1) Ap '96
— 1930s billboard ad for night club (New York)
Am Heritage 43:88–9 (1) N '92
— 1930s Coca-Cola poster (Germany)
Am Heritage 46:69 (c,4) My '95
— 1937 billboard touting "The American Way"
Am Heritage 43:112 (3) F '92
— 1940s cigarette ad featuring baseball players
Sports Illus 78:16 (c,3) My 3 '93
— 1944 silverware ad
Am Heritage 46:114 (c,4) My '95
— 1953 ad for suburban homes (Levittown, New York)
Am Heritage 44:63 (4) Jl '93
—1967 perfume ad
Gourmet 56:82 (c,3) Mr '96
— 1980 margarine ad with Mickey Mantle and Willie Mays
Sports Illus 83:28 (c,4) Ag 21 '95
— Atlantic City "Monopoly" billboard
Trav/Holiday 176:30 (c,4) Mr '93

— Aunt Jemima (1902–1993)
Am Heritage 44:80–2 (c,4) S '93
— Billboards (Los Angeles, California)
Nat Geog 181:50–1 (c,1) Je '92
— Cigarette billboard (Shanghai, China)
Trav/Holiday 176:74 (c,1) O '93
— Cola billboard (Peru)
Trav&Leisure 25:112 (c,1) Mr '95
— Depictions of black "Mammy" as American icon
Am Heritage 44:78–86 (c,1) S '93
— Early ads for movie theaters
Am Heritage 44:78–92,114 (c,1) N '93
— Huge fashion billboard (Milan, Italy)
Nat Geog 182:90–1,111–12 (c,1) D '92
— Mock-up of sandwich for an ad
Life 17:107–8 (c,2) D '94
— Pickup truck ads (1933–1968)
Am Heritage 47:106–10 (c,1) N '96
— Print ads starring athletes
Sports Illus 78:16–19 (c,3) My 3 '93
— See also
POSTERS
AFGHANISTAN
Nat Geog 184:58–89 (map,c,1) O '93
— Herat
Nat Geog 190:32–3 (c,2) D '96
— Qandahar
Nat Geog 184:68–9,80–1 (c,1) O '93
— See also
KABUL
AFGHANISTAN—COSTUME
Life 15:35–8 (c,1) Ag '92
Nat Geog 184:58–89 (c,1) O '93
— Chadri
Nat Geog 184:60–1 (c,1) O '93
— Women in traditional dress
Life 19:70–1 (c,1) S '96
AFGHANISTAN—POLITICS AND GOVERNMENT
— Afghan guerrilla war
Life 15:35–8 (c,1) Ag '92
Nat Geog 184:58–89 (c,1) O '93
— Tanks preparing to fight extremist group
Life 18:14 (c,2) Je '95
AFRICA
— African Olympic basketball trials (Egypt)
Sports Illus 76:80–95 (c,2) F 17 '92
— See also
NILE RIVER
SAHARA DESERT
VICTORIA FALLS
AFRICA—ART
— 15th cent.
Nat Geog 182:68–9 (c,2) N '92

— 19th cent. Kongo minkisi figures
 Smithsonian 24:24 (c,4) D '93
— African crafts
 Smithsonian 23:140 (c,4) Ap '92
— Bead works
 Smithsonian 25:31 (c,4) S '94
— Ceremonial masks (Zaire)
 Smithsonian 25:32 (c,4) Ap '94
— Maternity sculpture
 Natur Hist 104:35 (c,2) D '95

AFRICA—COSTUME
— Headgear varieties
 Smithsonian 27:28 (c,4) Je '96

AFRICA—HISTORY
— History of African slave trade
 Nat Geog 182:62–91 (c,1) S '92
— See also
 RHODES, CECIL

AFRICA—HOUSING
— Painted huts
 Life 15:46 (c,2) Jl '92

AFRICA—MAPS
— 16th cent. slave trade
 Nat Geog 182:70–1 (c,1) S '92
— Safari locations
 Trav&Leisure 23:97 (c,2) F '93
— Africa's Skeleton Coast seen from space
 Nat Geog 186:63–5 (1) Ag '94

AFRICA—RITES AND FESTIVALS
— Female circumcision ritual
 Natur Hist 105:42–53 (c,1) Ag '96

AFRICA—SOCIAL LIFE AND CUSTOMS
— Dancing (Burkina Faso)
 Sports Illus 85:106–7 (c,1) Ag 5 '96

AFRICA, ANCIENT—ARTIFACTS
— Nubian artifacts
 Smithsonian 24:cov.,90–100 (c,1) Je '93
— Royal Nubian tombs (Sudan)
 Smithsonian 24:90–100 (c,1) Je '93

AFRICAN TRIBES
— Amhara people fording river (Ethiopia)
 Trav&Leisure 23:109 (c,2) O '93
— Asante people (Ghana)
 Nat Geog 190:36–46 (c,1) O '96
— Borana man (Kenya)
 Trav&Leisure 26:212 (c,4) N '96
— Dogon people (Mali)
 Trav&Leisure 25:141,144 (c,1) F '95
— Gabbra people (Kenya)
 Natur Hist 102:50–7 (c,1) S '93
— Himba people (Namibia)
 Smithsonian 24:81 (c,2) N '93
— Masai people (Kenya)
 Smithsonian 24:78 (c,3) N '93

— Masai shepherd boy (Tanzania)
 Natur Hist 104:12 (c,3) Jl '95
— Masai women (Tanzania)
 Trav&Leisure 26:67 (c,1) Ja '96
 Natur Hist 105:44–5,48–9 (c,1) Ag '96
— Nuba tribesmen wrestling (Sudan)
 Nat Geog 190:64–5 (c,1) Jl '96
— Samburu herdsmen (Kenya)
 Smithsonian 27:112–13 (c,1) My '96
— San tribesmen (South Africa)
 Nat Geog 190:34–41 (c,1) Jl '96
— See also
 BERBER PEOPLE
 PYGMIES
 TUAREG PEOPLE
 YORUBA PEOPLE
 ZULUS

AFRICAN TRIBES—ARTIFACTS
— 18th cent. ceremonial bird gong (Benin)
 Smithsonian 23:30 (c,4) F '93
— Asante golden pieces (Ghana)
 Nat Geog 190:36–46 (c,1) O '96
— Ibo mask (Nigeria)
 Smithsonian 25:96 (c,4) D '94
— Luba memory board (Zaire)
 Smithsonian 23:116 (c,4) F '93

AFRICAN TRIBES—COSTUME
— Ndebele women (South Africa)
 Trav&Leisure 24:98–9 (c,1) S '94

AFRICAN TRIBES—RITES AND FESTIVALS
— 1685 Akan birth ceremony (Ghana)
 Nat Geog 182:69 (painting,c,2) S '92
— 1925 Xhosa coming of age dance (South Africa)
 Nat Geog 190:132 (3) Jl '96
— Tuareg infant's naming ceremony (Niger)
 Natur Hist 101:54–62 (c,1) N '92
— Xhosa manhood ritual (South Africa)
 Nat Geog 183:66–7 (c,1) F '93

Agave plants. See
 CENTURY PLANTS

AGASSIZ, LOUIS
 Am Heritage 45:108 (4) N '94

AGED
— Caring for aging mother (California)
 Life 16:cov.,28–36 (1) Ag '93
— Elderly dancer doing headstand (Arizona)
 Nat Geog 186:38–9 (c,1) S '94
— Elderly woman (Utah)
 Life 16:18 (c,4) O '93
— Georgia, U.S.S.R.
 Nat Geog 181:84–5,90–1 (c,1) My '92
— Hermit (Idaho)
 Nat Geog 182:59 (c,3) D '92

— Mongolia
 Nat Geog 183:130–1 (c,1) My '93
— New York
 Nat Geog 186:114–15 (c,1) D '94
— Old man on bench (China)
 Nat Geog 185:21 (c,3) Mr '94
— Portugal
 Trav&Leisure 23:88 (c,1) Ag '93
— Research on the aging process
 Life 15:cov.,32–42 (c,1) O '92
— Retirees playing lawn bowling (Florida)
 Nat Geog 182:34–5 (c,1) Jl '92
— Senior Olympics
 Life 19:26–30 (c,3) Ag '96
— Sisters over 100 years old (New York)
 Smithsonian 24:145,164 (2) O '93
— Spain
 Nat Geog 181:9,15 (c,3) Ap '92
— Sweden
 Nat Geog 184:12 (c,4) Ag '93
— Women at community center (Miami,
 Florida)
 Nat Geog 181:90–1 (c,1) Ja '92

AIDS
— AIDS patient (Thailand)
 Nat Geog 189:95 (c,3) F '96
— AIDS patient dying
 Life 16:16 (2) Je '93
 Life 19:79 (3) O '96
— AIDS patient receiving last rites
 Nat Geog 181:63 (c,4) Je '92
— AIDS quilt
 Life 19:22 (c,2) D '96
— Baby with AIDS
 Life 15:49–56 (1) My '92
— Child with AIDS (New York)
 Life 16:38–46 (c,1) S '93
— People with AIDS
 Life 17:41–6 (1) F '94
 Nat Geog 186:80–91 (c,1) Jl '94

AIR POLLUTION
— El Salvador
 Nat Geog 188:118–19 (c,2) S '95
— Fibrous waste from factory (Siberia)
 Life 18:60–1 (1) Jl '95
— Oil refinery smoke (Pennsylvania)
 Nat Wildlife 34:26 (c,1) Ap '96
— Smokestacks spewing smoke (China)
 Trav/Holiday 175:37 (painting,c,4) N '92
— Soot-covered snow (Siberia)
 Nat Geog 186:92–3 (c,2) Ag '94
— Taiwan
 Nat Geog 184:6–7,21,33 (c,3) N '93
— U.S.S.R.
 Nat Geog 186:70–99 (map,c,1) Ag '94

— See also
 SMOG
AIREDALE TERRIERS
 Smithsonian 23:62–4,70-1 (c,3) Ap '92
AIRPLANE FLYING
— 1960s inflight meal
 Trav/Holiday 179:15 (c,4) N '96
— Flying F-14 jet
 Sports Illus 84:70–6 (c,1) Ap 15 '96
— Flying para plane (Pennsylvania)
 Sports Illus 78:9–11 (c,1) My 31 '93
— Russian MiG-29 crash
 Life 17:22 (c,2) F '94
— 12-year-old girl at controls
 Sports Illus 80:56–7 (c,1) Je 6 '94
— See also
 AVIATION
AIRPLANE PILOTS
— Early 20th cent. women pilots
 Smithsonian 25:72–6 (2) Ag '94
— U.S. World War I pilot
 Am Heritage 44:51 (1) N '93
— See also
 DOOLITTLE, JAMES
 EARHART, AMELIA
 LINDBERGH, CHARLES A.
 WRIGHT, WILBUR AND ORVILLE
 YEAGER, CHARLES
AIRPLANES
— 1903 Wright Brothers plane (Washington,
 D.C.)
 Smithsonian 27:44 (c,4) My '96
— 1918 Curtiss JN-4 airmail plane
 Smithsonian 27:24–5 (4) Jl '96
— 1931 plane crane wreckage (Kansas)
 Smithsonian 24:175 (4) N '93
— 1932 National Air Race plane "Gee Bee"
 Am Heritage 44:93 (painting,c,4) D '93
 Am Heritage 45:18 (4) Ap '94
— 1937 DC-2
 Am Heritage 45:138 (painting,c,3) Ap '94
— 1937 H-1 racer
 Smithsonian 25:20 (4) F '95
— 1937 Soviet patrol plane after transpolar
 flight
 Am Heritage 47:48 (3) Ap '96
— 1940s B-17 bomber
 Nat Geog 185:90–1,105–6 (c,1) Mr '94
— 1940s B-17 on display at Oregon gas
 station
 Am Heritage 46:90–1 (c,1) My '95
— 1940s B-25s
 Smithsonian 23:112,114 (3) Je '92
— 1940s B-29 bomber
 Smithsonian 26:24–33 (c,1) S '95

— 1940s B-38s
 Life 15:60–8 (c,1) D '92
— 1940s C-54
 Am Heritage 46:47,58 (4) O '95
— 1940s P-51 Mustangs
 Am Heritage 46:98 (c,4) My '95
 Am Heritage 46:34 (c,4) Jl '95
— 1969 plane crash wreckage (Iowa)
 Sports Illus 79:54–5 (2) Ag 23 '93
— 1972 Andes plane crash survivors
 Life 16:48–57 (c,1) F '93
— Cockpit
 Nat Geog 181:125–7 (c,1) F '92
— Crop duster plane (Belize)
 Nat Geog 184:126 (c,4) S '93
— Crop duster plane (Venezuela)
 Natur Hist 104:46 (c,4) S '95
— Early airmail planes
 Smithsonian 24:77,79 (c,4) Ag '93
— Floatplanes
 Trav&Leisure 22:86–7 (c,1) My '92
 Trav&Leisure 24:cov.,108–11 (c,1) Mr '94
 Trav&Leisure 24:36 (c,4) O '94
 Trav&Leisure 26:84 (c,1) Je '96
— Jet fighters
 Nat Geog 183:24–5 (c,1) Je '93
— Jets at airport
 Smithsonian 24:34,47 (c,1) Ap '93
— Lightweight private plane
 Nat Geog 181:74–7 (c,1) Ja '92
— Old U.S. military planes
 Am Heritage 44:35,46 (c,4) D '93
 Life 17:72–4 (c,1) Jl '94
 Nat Geog 186:47 (c,3) S '94
— Remains of small plane after crash
 Sports Illus 84:47 (c,4) Ap 29 '96
 Sports Illus 85:94 (c,3) D 30 '96
— Replica of 1919 Vimy open-cockpit biplane
 Nat Geog 187:cov.,2–43 (c,1) My '95
— Shoes of 1983 Korean airline disaster
 victims
 Life 16:22 (c,2) S '93
— Showering rice seeds on field (California)
 Nat Geog 185:67 (c,3) My '94
— Sky-writing plane (Florida)
 Life 18:104 (c,2) Ap '95
— Small aerial photography plane
 Nat Geog 188:44–5 (c,1) Jl '95
— Small planes destroyed by hurricane
 (Florida)
 Nat Geog 183:8–9 (c,1) Ap '93
— Snowplane (Wyoming)
 Nat Geog 187:137 (c,4) F '95
— Soviet bomber cemetery
 Life 16:25 (c,4) F '93

— Ultralight planes
 Life 19:22 (c,4) Ag '96
— Underside of jet in flight
 Nat Geog 187:122–3 (c,2) F '95
— See also
 AIRSHIPS
 GLIDERS
 HELICOPTERS
 AVIATION

AIRPORTS
— Dallas/Fort Worth Airport, Texas
 Smithsonian 24:34–47 (c,1) Ap '93
 Sports Illus 81:64–6 (c,1) D 12 '94
— Denver, Colorado
 Trav&Leisure 24:32 (c,4) Mr '94
 Nat Geog 190:94–5 (c,1) N '96
— Dulles Airport, Virginia
 Smithsonian 24:30–1 (c,2) Ja '94
— Kansai Intl Airport, Osaka, Japan
 Trav&Leisure 24:37 (c,4) S '94
— Las Vegas, Nevada
 Nat Geog 190:58–9 (c,1) D '96

AIRSHIPS
— 1932 airship construction (Ohio)
 Nat Geog 181:116 (1) Ja '92
— 1937 crash of the Hindenburg (New Jersey)
 Am Heritage 43:36 (4) S '92
— U.S.S. Macon (1930s)
 Nat Geog 181:114–27 (c,1) Ja '92
— See also
 ZEPPELIN, FERDINAND VON

AKITAS (DOGS)
 Sports Illus 82:82–3 (c,1) Ap 10 '95

ALABAMA
— Conecuh Bogs
 Natur Hist 101:60–2 (map,c,1) D '92
— Selma's Edmund Pettus Bridge
 Am Heritage 43:91 (c,4) Ap '92
— Sprott church
 Am Heritage 45:75 (c,4) Jl '94
— Tuskegee University (1902)
 Am Heritage 46:34 (c,3) F '95 supp.
— See also
 MOBILE
 MONTGOMERY
 WALLACE, GEORGE

ALABAMA—MAPS
 Trav&Leisure 25:64 (c,4) Mr '95
 Trav/Holiday 179:81 (c,4) Ap '96

ALAMO, SAN ANTONIO, TEXAS
 Gourmet 52:76 (c,4) Je '92
 Trav/Holiday 175:56–61 (c,1) Jl '92
 Life 16:96–8 (c,1) N '93
 Am Heritage 46:104–7 (c,2) Ap '95
 Trav/Holiday 179:92 (c,4) My '96

— 1836 battle
 Sports Illus 78:9 (painting,c,4) Ap 19 '93
ALASKA
 Gourmet 54:150–3,220 (map,c,1) My '94
 Trav/Holiday 179:42–4 (c,1) D '96
— 1908 dogsled race team
 Natur Hist 105:41 (4) Mr '96
— 1989 Prince William Sound cleanup
 Trav&Leisure 22:58 (c,4) Mr '92
— Admiralty Island
 Trav/Holiday 178:35 (c,4) Ap '95
 Natur Hist 104:A2 (c,3) N '95
— Aerial view of meandering rivers
 Trav&Leisure 24:109 (c,1) Mr '94
— Alaska wildlife
 Nat Wildlife 34:38–41 (c,1) Ap '96
— Arctic National Wildlife Refuge
 Smithsonian 26:32–41 (c,1) Mr '96
— Autumn countryside
 Nat Wildlife 31:2–3 (c,2) O '93
— Brooks Range
 Nat Geog 183:74–5,80–1 (c,1) Ap '93
 Smithsonian 26:60–71 (c,1) Je '95
 Smithsonian 26:32–3 (c,1) Mr '96
— Countryside
 Trav&Leisure 22:86–97 (c,1) My '92
 Trav&Leisure 23:72 (c,4) My '93
 Trav/Holiday 176:15 (c,3) S '93
 Trav&Leisure 24:cov.,105–11,143–4
 (map,c,1) Mr '94
— Glacier Bay
 Sports Illus 78:107–18 (c,1) F 22 '93
— Heart Lake
 Trav&Leisure 24:111 (c,1) Mr '94
— Iditarod
 Natur Hist 105:37–40 (c,1) Mr '96
— Kodiak Island
 Nat Geog 184:34–59 (map,c,1) N '93
— Little Diomede Island
 Natur Hist 101:40 (c,1) O '92
— Luxury lodges
 Trav&Leisure 22:92–7,140 (c,1) My '92
— Noatak River
 Natur Hist 104:34–5 (c,1) Jl '95
— Prince William Sound (1992)
 Trav&Leisure 22:55,61 (c,3) Mr '92
— Prince William Sound area
 Trav&Leisure 22:60–6 (map,c,4) Jl '92
— Redoubt Volcano erupting
 Nat Geog 182:32–3 (c,1) D '92
— St. Lawrence Island
 Nat Geog 182:82–3 (c,2) O '92
— Scenes along the Alaska Highway
 Trav/Holiday 176:56–63 (map,c,1) My '93
— Skagway

 Trav/Holiday 175:21 (c,4) My '92
— Sunset over Frederick Sound
 Nat Wildlife 31:58–9 (c,1) D '92
— Tatshenshini River
 Trav/Holiday 176:33 (c,4) Je '93
— Togiak National Wildlife Refuge
 Nat Geog 190:2–3,26–7 (c,1) O '96
— Tongass National Forest
 Nat Wildlife 34:40–1 (c,2) Ap '96
— Trek across Brooks Range (1989)
 Nat Geog 183:70–93 (map,c,1) Ap '93
— Tundra
 Nat Geog 190:24–5 (c,1) O '96
— Yukon Delta National Wildlife Refuge
 Nat Wildlife 33:40 (c,1) Je '95
— See also
 ALASKA HIGHWAY
 ALASKA RANGE
 ALEUTIAN ISLANDS
 ANCHORAGE
 BERING SEA
 DENALI NATIONAL PARK
 FAIRBANKS
 GATES OF THE ARCTIC NATIONAL
 PARK
 GLACIER BAY NATIONAL PARK
 KENAI FJORDS NATIONAL PARK
 MOUNT McKINLEY
 PRIBILOF ISLANDS
 ST. ELIAS RANGE
 WRANGELL-ST. ELIAS NATIONAL
 PARK
ALASKA HIGHWAY
 Smithsonian 23:102–11 (c,1) Jl '92
 Trav/Holiday 176:56–7 (c,1) My '93
— Construction (1942)
 Smithsonian 23:103–7 (3) Jl '92
ALASKA RANGE, ALASKA
 Nat Geog 182:62–9 (c,1) Ag '92
— See also
 MOUNT McKINLEY
ALBANIA
 Nat Geog 182:66–93 (map,c,1) Jl '92
ALBANIA—ARCHITECTURE
— Modern museum building
 Life 15:8–9 (1) Ap '92
ALBANIA—COSTUME
 Nat Geog 182:66–93 (c,1) Jl '92
— See also
 HOXHA, ENVER
**ALBANIA—POLITICS AND GOV-
 ERNMENT**
— Political demonstration
 Nat Geog 182:68 (c,4) Jl '92

ALBATROSSES
　　Trav/Holiday 175:90 (c,4) Mr '92
　　Nat Wildlife 33:30–1 (c,1) Je '95
　　Nat Wildlife 34:36 (c,4) F '96
　　Trav/Holiday 179:84 (c,4) F '96
　　Natur Hist 105:78–9 (c,1) S '96
— Chicks
　　Nat Wildlife 30:2–3 (c,2) Je '92
ALBEE, EDWARD
　　Life 15:24 (4) S '92
ALBERTA
— Carseland
　　Nat Geog 186:51 (c,3) D '94
— Columbia Icefield
　　Nat Geog 182:67 (c,3) D '92
— Countryside
　　Trav&Leisure 22:108–9 (c,1) S '92
— Dinosaur Provincial Park
　　Nat Geog 183:6–7,12 (c,1) Ja '93
— Red Deer church
　　Smithsonian 27:79 (c,3) My '96
— See also
　　BANFF NATIONAL PARK
　　EDMONTON
　　JASPER NATIONAL PARK
　　ROCKY MOUNTAINS
　　WATERTON LAKES NATIONAL
　　　PARK
ALBUQUERQUE, NEW MEXICO
— 1969
　　Life 19:14–15 (c,1) Winter '96
— Albuquerque decorated with Christmas
　　lights
　　Trav/Holiday 178:18 (c,4) N '95
ALCATRAZ, CALIFORNIA
— 1864 Alcatraz fortress
　　Am Heritage 43:98–103 (1) N '92
— History of Alcatraz prison
　　Smithsonian 26:84–95 (c,1) S '95
ALCOHOLISM
— Alcoholics Anonymous meeting (Moscow,
　　U.S.S.R.)
　　Nat Geog 181:8 (c,4) F '92
— Children with Fetal Alcohol Syndrome
　　Nat Geog 181:36–9 (c,2) F '92
— Detox center (Moscow, U.S.S.R.)
　　Nat Geog 181:8–9 (c,1) F '92
— Effect of alcohol on the body
　　Nat Geog 181:12–14 (drawing,c,1) F '92
— International problem of alcoholism
　　Nat Geog 181:2–36 (c,1) F '92
ALEUTIAN ISLANDS
— Wreckage from 1943 Japanese attack

　　Natur Hist 101:54–61 (c,1) Je '92
ALEXANDRIA, EGYPT
　　Trav&Leisure 25:166–7,178,182–6
　　　(map,c,1) S '95
ALEXANDRIA, VIRGINIA
　　Trav&Leisure 22:E17–E20 (map,c,1) N
　　　'92
**ALFALFA INDUSTRY—HARVEST-
ING**
— Kansas
　　Nat Geog 183:92 (c,1) Mr '93
**ALFRED THE GREAT (GREAT
BRITAIN)**
　　Trav/Holiday 179:60,67 (engraving,4) My
　　　'96
— Sites associated with Alfred the Great
　　Smithsonian 27:60–7 (1) My '96
ALGAE
　　Nat Geog 185:135 (c,1) Je '94
— Algae fossil
　　Smithsonian 27:25 (c,4) Ag '96
— Covering Channel Islands coast, California
　　Natur Hist 105:26 (c,4) Jl '96
ALGER, HORATIO
— 1868 Horatio Alger hero
　　Am Heritage 44:104 (drawing,4) My '93
ALGERIA
— Desert
　　Natur Hist 104:43 (c,3) Ja '95
ALHAMBRA, GRANADA, SPAIN
　　Nat Geog 181:36–7 (c,1) Ja '92
　　Gourmet 52:80–4 (c,1) Je '92
　　Smithsonian 23:42–53 (c,1) Ag '92
　　Trav/Holiday 177:44–6,51 (c,1) Jl '94
ALI, MUHAMMAD
　　Sports Illus 76:cov.,71–80 (1) Ja 13 '92
　　Sports Illus 76:49 (4) My 11 '92
　　Sports Illus 77:68–9,80–1 (c,1) Fall '92
　　Life 16:31 (4) Je '93
　　Sports Illus 80:107 (4) Mr 21 '94
　　Sports Illus 81:2–3,48–51 (c,1) S 19 '94
　　Sports Illus 81:30–4 (c,1) O 3 '94
　　Sports Illus 81:66–7 (c,1) N 14 '94
　　Sports Illus 83:65 (3) Ag 21 '95
　　Life 19:16 (c,2) S '96
　　Sports Illus 85:cov.,52–62 (c,1) S 30 '96
　　Sports Illus 85:65 (c,2) D 30 '96
— At 12 years old
　　Am Heritage 44:36 (4) Ap '93
— Caricature
　　Sports Illus 85:92–3 (c,1) Jl 15 '96
ALLAHABAD, INDIA
　　Life 15:76–7 (c,1) Mr '92

**ALLEGHENY MOUNTAINS, EAST-
ERN U.S.**
Nat Geog 185:41–3 (map,c,1) Je '94
ALLEN, ETHAN
— Home (Vermont)
Am Heritage 43:52 (c,4) Ap '92
ALLIGATORS
Nat Geog 181:69,86–9 (c,1) F '92
Nat Geog 181:35–6 (c,1) Ap '92
Nat Wildlife 30:2–3,52 (c,1) Ap '92
Trav&Leisure 23:E1 (c,4) Mr '93
Nat Wildlife 31:22–3 (c,1) Ag '93
Nat Geog 185:28–31 (c,1) Ap '94
Trav&Leisure 24:107 (c,4) Ap '94
Life 18:60–1 (c,1) S '95
— Albino alligator
Life 18:22 (c,3) Ap '95
— Eyes shining at night
Life 15:6–7 (c,1) F '92
Natur Hist 102:92–3 (c,1) N '93
— Gatorland, Florida
Nat Geog 181:88 (c,1) F '92
— Newborn alligators
Nat Geog 185:cov.,30–1 (c,1) Ap '94
Nat Wildlife 33:38–9 (c,1) Ap '95
Natur Hist 104:78–9 (c,1) Jl '95
— White alligator
Nat Geog 184:22–3 (c,2) Jl '93
ALMOND TREES
Nat Geog 183:92–3 (c,1) My '93
ALOE PLANTS
Nat Geog 189:56 (c,4) F '96
ALPACAS
Smithsonian 25:60 (c,4) Ag '94
Nat Geog 189:30–1 (c,1) My '96
ALPHABETS
— Engraving Chinese characters in stone
Natur Hist 105:cov. (c,1) Jl '96
— Letter photos done in unusual graphics
Life 19:89 (c,4) Ap '96
ALPS, EUROPE
— Conservation activities of Alps Action
group
Smithsonian 24:46–58 (map,c,1) N '93
ALPS, AUSTRIA
— Arlberg ski areas
Trav&Leisure 24:102–7,156–8 (map,c,1)
N '94
ALPS, FRANCE
Gourmet 52:60–1 (c,1) Ja '92
Sports Illus 76:88–98,108 (c,1) Ja 27 '92
— Albertville area
Sports Illus 76:72–3 (c,1) Mr 2 '92
— Savoy Alps

Trav&Leisure 25:E1–E2 (c,4) F '95
ALPS, ITALY
Trav/Holiday 176:72 (c,2) Ap '93
ALPS, SWITZERLAND
Trav&Leisure 22:120–3,127,176 (c,1) Mr
'92
Trav&Leisure 23:110–11,120–1 (c,1) Ap
'93
Gourmet 53:48–9 (c,1) Jl '93
Trav/Holiday 176:70–9 (map,c,1) N '93
— Schilthorn Mountain
Life 19:16–17 (c,1) My '96
— Simplon Pass (19th cent.)
Trav/Holiday 178:51 (4) Ap '95
— See also
JUNGFRAU
MATTERHORN
ALTOONA, PENNSYLVANIA
Nat Geog 185:38–9,53 (c,1) Je '94
AMAZON RIVER, SOUTH AMERICA
Nat Geog 187:2–39 (map,c,1) F '95
AMAZON RIVER, BRAZIL
Life 15:64–73 (c,1) Jl '92
— Seen from space
Nat Geog 190:22–3 (c,1) N '96
AMAZON RIVER, PERU
— Source
Nat Geog 187:38–9 (c,1) F '95
AMBER
Natur Hist 105:96–100 (c,1) F '96
— Amber Room in Catherine the Great's pal-
ace, Pushkin, Russia
Smithsonian 23:34–5 (c,3) Ja '93
Natur Hist 105:98–9 (c,1) F '96
— Ancient insects preserved in amber
Smithsonian 23:cov.,30–41 (c,1) Ja '93
Natur Hist 102:58–61 (c,1) Je '93
Life 16:111–12 (c,2) O '93
Natur Hist 105:97 (c,4) F '96
**AMERICA—DISCOVERY AND EX-
PLORATION**
— 1493 Columbus settlement La Isabela,
Hispaniola
Nat Geog 181:40–53 (map,c,1) Ja '92
— 16th cent. sites of Pizarro expeditions
Nat Geog 181:92–121 (map,c,1) F '92
— 1519 conquest of Aztecs by Cortes
(Mexico)
Smithsonian 23:56–69 (painting,c,1) O '92
— Pocahontas saving Captain John Smith
(1607)
Life 18:66 (painting,c,4) Jl '95
—See also
EXPLORERS

AMERICAN MUSEUM OF NATURAL HISTORY

Gourmet 56:46 (drawing,c,3) S '96
— 1890
Natur Hist 101:61 (4) Ag '92
— Exhibit on prehistoric man
Life 16:48–52 (c,1) My '93
— Animal murals by Charles Knight
Natur Hist 102:20–5 (c,3) O '93
— Hall of Vertebrate Origins
Natur Hist 105:cov.,30–45 (c,1) Je '96
— Renovating dinosaur exhibit
Natur Hist 104:7–10,82 (c,1) My '95

AMISH PEOPLE

— Amish country auction (Indiana)
Trav/Holiday 179:34–7 (c,4) S '96
— Amish farms (Pennsylvania)
Nat Geog 183:20 (c,3) Je '93
Trav&Leisure 24:E19 (c,4) Mr '94
Nat Geog 185:34–5 (c,1) Je '94
— Ohio
Trav/Holiday 179:54–9 (c,1) O '96
— Pennsylvania
Life 15:84–92 (c,1) Je '92
Am Heritage 47:126–7 (c,2) Ap '96

AMISH PEOPLE—COSTUME

— Indiana
Smithsonian 25:44,47 (c,2) Ag '94

AMISH PEOPLE—SOCIAL LIFE AND CUSTOMS

— Amish barn-raising (Pennsylvania)
Life 15:84–92 (c,1) Je '92
Life 18:96–7 (c,1) O '95
Ammunition. See
ARMS
Amphibians. See
FROGS
SALAMANDERS
TOADS
TORTOISES
TURTLES

AMSTERDAM, NETHERLANDS

Gourmet 54:100–3 (c,1) Je '94
Trav/Holiday 177:117 (painting,c,4) S '94
Trav/Holiday 178:25 (c,4) Mr '95
Trav&Leisure 26:82–91,23–5 (map,c,1) F '96
Trav/Holiday 179:30–3 (c,3) S '96
— 1940
Life 16:70 (4) Je '93
— Apartment building damaged in plane crash
Life 16:50–1 (c,1) Ja '93
— Impressionistic view of Amsterdam
Trav&Leisure 26:74 (painting,c,2) D '96
— Small shops

Trav&Leisure 24:72–8 (c,4) O '94

AMUSEMENT PARKS

— Alaskaland Park, Alaska
Trav/Holiday 176:58–9,62 (c,2) My '93
— Bumper cars
Life 16:56–7 (c,1) Je '93
— Carnival ride (Virginia)
Trav/Holiday 179:39 (4) Ap '96
— Cypress Gardens, Florida
Trav&Leisure 26:33 (c,4) Jl '96
— Euro Disney, Paris, France
Trav&Leisure 22:80–5,114–15 (c,1) Ag '92
Natur Hist 103:26 (c,3) D '94
— Gatorland, Florida
Nat Geog 181:88 (c,1) F '92
— Michael Jackson's Neverland,California
Life 16:52–64 (c,1) Je '93
— Japanese theme parks
Trav/Holiday 178:78–85 (c,1) O '95
— Kiddie car ride (Pennsylvania)
Trav&Leisure 26:33 (c,4) Jl '96
— Lakeside amusement park, Denver, Colorado
Am Heritage 43:74–9,106 (c,1) Jl '92
— Luna Park, Berlin, Germany (1930s)
Am Heritage 46:62–3 (1) My '95
— Mall of America, Minnesota
Life 17:94 (c,4) Ap '94
Trav&Leisure 24:59 (c,4) Jl '94
— Mermaids at Weeki Wachee Spring, Florida
Nat Geog 182:2–4 (c,1) Jl '92
Life 16:101 (c,2) Jl '93
— Myrtle Beach attractions, South Carolina
Trav/Holiday 179:90–5 (c,1) N '96
— Prater, Vienna, Austria
Trav/Holiday 177:71 (3) Mr '94
— Rooftop rides (Taiwan)
Nat Geog 184:27 (c,1) N '93
— Simulated earthquake ride at Universal Studios, California
Nat Geog 187:6–7 (c,1) Ap '95
— State fair midway rides (Iowa)
Trav/Holiday 178:48–9,54 (c,1) Je '95
— Tivoli Gardens, Copenhagen, Denmark
Trav/Holiday 176:18 (c,4) Mr '93
— Water park (Tucson, Arizona)
Nat Geog 184:80–1 (c,2) Jl '93
— See also
CONEY ISLAND
DISNEY WORLD
DISNEYLAND
FERRIS WHEELS
MERRY-GO-ROUNDS

ROLLER COASTERS
Amusements. See
 ACROBATIC STUNTS
 AMUSEMENT PARKS
 AQUARIUMS
 AUCTIONS
 AUDIENCES
 BALLOONING
 BEAUTY CONTESTS
 BILLIARDS
 BIRD WATCHING
 BOAT RACES
 CARD PLAYING
 CAVE EXPLORATION
 CIGARETTE SMOKING
 CIRCUS ACTS
 CONTESTS
 COOKING
 DANCES
 DOG SHOWS
 FAIRS
 FASHION SHOWS
 FIREWORKS
 FISHING
 GAME PLAYING
 GARDENING
 GUM CHEWING
 HEALTH CLUBS
 HUNTING
 KITE FLYING
 MAGIC ACTS
 MEDITATION
 MOTION PICTURES
 MUSEUMS
 NATIONAL PARKS
 NIGHT CLUBS
 PARADES
 PARKS
 PARTIES
 PHOTOGRAPHY
 PICNICS
 PINBALL MACHINES
 READING
 RODEOS
 ROLLER COASTERS
 ROPE JUMPING
 SHOPPING
 SLEEPING
 SUNBATHING
 SWIMMING
 TATTOOS
 TELEVISION WATCHING
 THEATER
 TOYS
 VIDEO GAMES

 ZOOS
ANACONDAS
 Life 17:78–9 (1) Mr '94
 Smithsonian 27:42–50 (c,1) S '96
ANATOMY
— Fat and thin abdomens
 Life 18:cov.,59 (c,1) F '95
— Male vs. female knee structure
 Sports Illus 82:47 (diagram,c,4) F 13 '95
— Reptiles' forked tongues
 Natur Hist 104:52–4 (c,2) Ap '95
— Whimsical view of how enzymes work
 Smithsonian 26:42–9 (painting,c,1) D '95
—See also
 ANTLERS
 ARMS
 BRAINS
 CELLS
 EARS
 EYES
 FEET
 HANDS
 HEARTS
 SKELETONS
 SKULLS
 TEETH
ANCHORAGE, ALASKA
 Trav&Leisure 26:60–4 (c,4) Ap '96
ANCIENT CIVILIZATIONS
— Carthage
 Smithsonian 25:124–41 (map,c,1) Ap '94
— Eastern Mediterranean sports events
 Natur Hist 101:cov.,50–61 (c,1) Jl '92
— See also
 AZTEC CIVILIZATION
 BABYLONIAN CIVILIZATION
 CELTIC CIVILIZATION
 ETRUSCAN CIVILIZATION
 GREECE, ANCIENT
 PHOENICIAN CIVILIZATION
 ROMAN EMPIRE
**ANCIENT CIVILIZATIONS—
 ARTIFACTS**
— 9th cent. B.C. Hittite chariot
 Nat Geog 190:46 (c,4) Jl '96
— Ancient Moche artifacts (Peru)
 Natur Hist 103:38 (c,2) F '94
 Natur Hist 103:26–35 (c,1) My '94
— Ancient Scythian artifacts
 Nat Geog 190:54–79 (c,1) S '96
ANDERSEN, HANS CHRISTIAN
— Home (Odense, Denmark)
 Trav/Holiday 176:78 (c,4) S '93
ANDERSON, DAME JUDITH
 Life 16:78 (1) Ja '93

ANDERSON, MARIAN
Smithsonian 24:15 (4) Je '93
Life 17:92 (2) Ja '94
Life 18:92 (4) O '95
Smithsonian 26:111 (painting,c,4) Mr '96
Life 19:124 (4) O '96
ANDES MOUNTAINS, SOUTH AMER-ICA
Nat Geog 181:84–111 (map,c,1) Mr '92
Natur Hist 104:cov.,52–9 (map,c,1) F '95
— See also
ACONCAGUA
ANDES MOUNTAINS, ARGENTINA
— Aiguille Saint Exupery
Natur Hist 104:cov. (c,1) F '95
ANDES MOUNTAINS, BOLIVIA
— Cars driving through mountains (1927)
Am Heritage 47:83 (1) N '96
ANDES MOUNTAINS, CHILE
Gourmet 54:102–3 (c,1) F '94
Trav&Leisure 24:50 (c,4) N '94
ANDES MOUNTAINS, ECUADOR
Natur Hist 101:72–3 (c,1) Jl '92
ANDES MOUNTAINS, PERU
Nat Geog 183:125 (c,1) Ja '93
Nat Geog 189:18–19 (c,1) My '96
ANEMONES
Natur Hist 103:56,58 (c,4) My '94
ANGELFISH
Natur Hist 101:34 (painting,c,4) O '92
Gourmet 52:115 (c,4) D '92
Trav/Holiday 175:69 (c,4) D '92
Nat Geog 184:cov.,78–9 (c,1) N '93
Nat Wildlife 34:60 (c,1) D '95
Natur Hist 105:59 (c,4) N '96
ANGELS
Life 18:cov.,62–79 (c,1) D '95
— Children in Christmas mass (France)
Trav&Leisure 24:103 (c,3) D '94
ANGKOR, CAMBODIA
— Angkor Wat
Trav&Leisure 22:88–99,139 (map,1) O '92
Trav/Holiday 178:76–7 (2) O '95
ANIMAL SACRIFICE
— Mummified Inca sacrifice victim (Peru)
Nat Geog 189:62–81 (c,1) Je '96
— Ritual turtle sacrifice (Bali, Indonesia)
Natur Hist 105:48–51 (c,1) Ja '96
— Skeletons of ancient human sacrifice
victims (Mexico)
Nat Geog 188:16–17 (c,1) D '95
ANIMAL SKINS
— Brazil

Natur Hist 102:20 (c,4) Ag '93
ANIMAL TRACKS
— Dinosaur footprints
Nat Geog 183:16–17,26–7 (c,1) Ja '93
Natur Hist 104:50–1 (c,1) Je '95
— Fossil footprints from Permian period
(New Mexico)
Smithsonian 23:70–6 (c,1) Jl '92
— River otter tracks in snow
Nat Wildlife 31:36 (c,4) Je '93
— Tiger footprints
Nat Geog 181:15 (c,3) My '92
ANIMAL TRAINERS
— Lion tamer
Am Heritage 47:87 (painting,c,4) S '96
— Training dolphins (Florida)
Smithsonian 23:62–3 (c,3) Ja '93
— Training elephants (Thailand)
Trav/Holiday 179:49 (c,2) Ap '96
ANIMALS
— 1830 depiction of prehistoric animals
Natur Hist 101:14 (painting,c,3) D '92
— Africa
Nat Geog 181:54–85 (c,1) Ja '92
Trav&Leisure 22:126–39 (c,1) Je '92
Trav/Holiday 175:cov.,60–9 (c,1) N '92
Trav&Leisure 23:94–101,136 (c,1) F '93
Life 16:62–72 (c,1) Jl '93
Trav/Holiday 177:88–95 (c,1) Mr '94
— Alaskan wildlife
Nat Wildlife 34:32–41 (c,1) Ap '96
— Albino animals
Life 18:22–4 (c,3) Ap '95
— Animal classification chart
Natur Hist 103:43 (c,3) Ap '94
— Animals defense strategies
Smithsonian 23:74–82 (c,2) Ap '92
— Anti-poaching sign (Siberia)
Nat Geog 184:43 (c,4) Jl '93
— Baby animals
Nat Wildlife 30:17–20 (c,2) F '92
Life 18:cov.,60–76 (c,1) My '95
— Baseball mascot
Sports Illus 81:82–3 (c,1) N 14 '94
— Belize
Sports Illus 76:170–8 (c,1) Mr 9 '92
— Burning confiscated elephant tusks (Kenya)
Natur Hist 104:8 (c,4) N '95
— Cambrian period animals
Smithsonian 23:109,114–15 (c,1) Ja '93
Nat Geog 184:120–36 (c,1) O '93
— College football mascots
Sports Illus 77:2–3,50–1 (c,1) Ag 31 '92
— Costa Rica
Trav/Holiday 179:74–81 (c,1) O '96

— Dinoflagellates
 Natur Hist 105:16 (1) Mr '96
— Eastern U.S.
 Nat Geog 181:cov.,66–89 (c,1) F '92
— Elephant-shrews
 Natur Hist 101:54–61 (c,1) S '92
— Farm animals
 Trav&Leisure 22:80–1 (c,1) S '92
 Life 17:30–40 (c,3) N '94
— Galapagos Islands wildlife, Ecuador
 Trav/Holiday 179:78–87 (c,1) F '96
— Game wardens (Wyoming)
 Nat Wildlife 30:20–1 (c,1) Je '92
— Genets
 Nat Geog 188:25 (c,4) Jl '95
— India
 Nat Geog 181:2–29 (c,1) My '92
—Inhumane puppy mills (South Dakota)
 Life 15:36–40 (c,1) S '92
— Left-handed animals
 Natur Hist 102:cov.,32–9 (c,1) Jl '93
— Paternal animal behavior
 Nat Wildlife 34:42–9 (c,1) Je '96
— Pets of U.S. presidents
 Life 15:44–5 (3) O 30 '92
— Playful animal behavior
 Nat Geog 186:cov.,2–35 (c,1) D '94
— Poached rhinoceros horns
 Nat Geog 181:27 (c,4) My '92
— Poachers snaring animals (Congo)
 Nat Geog 188:28–9 (c,1) Jl '95
— Prairie animals
 Nat Geog 184:94–119 (c,1) O '93
— Predatory behavior
 Smithsonian 23:74–82 (c,2) Ap '92
— Saving rhino from poachers (South Africa)
 Nat Geog 190:36–7 (c,1) Jl '96
— South Africa
 Gourmet 55:72–9 (c,1) Ja '95
 Nat Geog 190:cov.,5–37 (c,1) Jl '96
 Trav/Holiday 179:40–3 (c,1) Jl '96
— Taxidermists stuffing hippo (1930s)
 Smithsonian 27:160 (4) My '96
— Tracking animal poachers
 Nat Wildlife 30:26–8 (c,2) Ap '92
— See also
 ALLIGATORS
 ALPACAS
 ANIMAL TRACKS
 ANTELOPES
 ANTLERS
 ARMADILLOS
 BABOONS
 BADGERS
 BATS

BEARS
BEAVERS
BISON
BOBCATS
BUFFALOES
CAMELS
CARIBOU
CATS
CATTLE
CHEETAHS
CHIMPANZEES
COYOTES
DEER
DOLPHINS
DONKEYS
DUGONGS
ECHIDNAS
ELEPHANTS
ELKS
FERRETS
FOXES
GIRAFFES
GOATS
HEDGEHOGS
HIPPOPOTAMI
HORSESHOE CRABS
HORSES
HYENAS
IBEXES
IMPALAS
JACKALS
JAGUARS
JAGUARUNDIS
KANGAROOS
KOALAS
LEOPARDS
LIONS
LLAMAS
LYNXES
MANATEES
MARMOTS
MARTENS
MEERKATS
MOLES
MONGOOSES
MONKEYS
MOOSE
MOUNTAIN GOATS
MOUNTAIN LIONS
MULES
MUSK OXEN
OCELOTS
OKAPIS
OPOSSUMS
OTTERS

OXEN
PANDAS
PANGOLINS
PANTHERS
PETS
PIGS
PLATYPUSES
PORCUPINES
POSSUMS
POTTOS
PRAIRIE DOGS
PRONGHORNS
RACCOONS
REINDEER
RHINOCERI
SEA LIONS
SEALS
SHEEP
SKUNKS
SLOTHS
SPONGES
TASMANIAN DEVILS
TIGERS
VETERINARIANS
VICUNAS
WALRUSES
WART HOGS
WATER BUFFALOES
WEASELS
WHALES
WILDEBEESTS
WILDLIFE REFUGES
WOLVERINES
WOLVES
WOMBATS
WOODCHUCKS
YAKS
ZEBRAS
ZOOS

ANIMALS—TYPES
— Animal classification chart
 Natur Hist 103:43 (c,3) Ap '94
— See also
 AMPHIBIANS
 ARACHNIDS
 APES
 ARTHROPODS
 BIRDS
 COELENTERATES
 CRUSTACEANS
 ECHINODERMS
 FISH
 INSECTS
 MARINE LIFE
 MARSUPIALS
 MOLLUSKS
 PROTOZOA
 REPTILES
 RODENTS
 WORMS

ANIMALS, ENDANGERED
 Nat Wildlife 30:entire issue (c,1) Ap '92
 Life 17:cov.,50–63 (c,1) S '94
 Nat Geog 187:cov.,2–41 (c,1) Mr '95
 Nat Wildlife 34:11–17 (1) D '95
— Black rhinos
 Natur Hist 101:62–3 (c,1) Mr '92
 Trav&Leisure 22:129 (c,3) Je '92
— Black-footed ferrets
 Nat Wildlife 30:11 (painting,c,1) Ap '92
 Life 17:52 (1) S '94
— Chart of endangered species
 Nat Geog 187:16–21 (c,1) Mr '95
— Efforts to rescue loggerhead turtles
 Nat Wildlife 30:18–25 (c,1) Ap '92
— Florida panthers
 Nat Geog 181:51 (c,4) Ap '92
 Nat Wildlife 30:60 (c,1) Ap '92
 Life 15:68 (c,4) Je '92
 Nat Geog 182:62–3 (c,1) Jl '92
 Trav&Leisure 24:106 (drawing,c,1) Ap '94
 Nat Wildlife 32:30 (c,4) Ag '94
 Smithsonian 25:40 (c,4) S '94
 Life 17:cov.,51 (c,1) S '94
 Nat Wildlife 33:26–7 (painting,c,1) D '94
 Nat Wildlife 33:14–15 (c,1) Je '95
 Nat Geog 190:4–5 (c,1) O '96
— Grant's zebras
 Smithsonian 23:18 (c,4) Ag '92
— Gray wolves
 Nat Wildlife 30:6–7 (c,1) Ap '92
 Life 15:3,76–85 (c,1) Jl '92
 Nat Wildlife 33:10–11 (c,1) Je '95
— Lab researching deaths of endangered
 animals (Oregon)
 Smithsonian 22:40–9 (c,1) Mr '92
— Red squirrels
 Nat Wildlife 30:34–5 (c,1) Ap '92
— Red wolves
 Nat Wildlife 30:56–7 (c,1) Ap '92
— Siberian tigers
 Nat Geog 184:33,38–47 (c,1) Jl '93
— Snow leopards
 Life 16:4 (c,4) Mr '93
— Spotted owls
 Nat Wildlife 30:4–5 (c,1) Ap '92
— Vanishing domestic livestock breeds
 Smithsonian 25:cov.,60–5 (c,1) S '94
— White rhinos

Smithsonian 23:16 (c,4) Ag '92
Nat Geog 184:36–7 (c,2) Jl '93
Gourmet 55:76 (c,4) Ja '95
— See also
 BIRDS, ENDANGERED
ANIMALS, EXTINCT
— Ancient scene at La Brea Tar Pits,
 California
 Natur Hist 103:84–5 (painting,c,1) Ap '94
— Archaeotherium
 Natur Hist 105:38 (painting,c,4) Ap '96
— Blaauwbock antelope
 Natur Hist 102:16,18 (c,3) My '93
— Dicynodonts
 Natur Hist 105:50–2 (painting,c,1) Mr '96
— Ichthyosaurs
 Natur Hist 101:48–53 (painting,c,1) S '92
— Irish elk
 Natur Hist 103:68–9 (painting,c,1) Ap '94
 Natur Hist 105:16–22 (painting,c,1) Ag
 '96
— Lemur notharctus
 Natur Hist 101:54–8 (painting,c,1) Ag '92
— Permian period animals
 Smithsonian 23:72–3 (painting,c,2) Jl '92
— Prehistoric Australian animals
 Natur Hist 102:40–5 (painting,c,1) Je '93
— Prehistoric mammals
 Natur Hist 103:entire issue (painting,c,1)
 Ap '94
— Uintatherium
 Natur Hist 101:70–1 (painting,c,3) Jl '92
— See also
 DINOSAURS
 MAMMOTHS
 SABER-TOOTHED CATS
ANKARA, TURKEY
 Nat Geog 185:11 (c,3) My '94
ANNAPOLIS, MARYLAND
 Nat Geog 183:6–7 (c,2) Je '93
ANTARCTIC EXPEDITIONS
— 1911 Scott expedition
 Trav/Holiday 176:57–9 (3) Je '93
— 1928 Antarctic expedition ship
 Sports Illus 79:104 (3) O 18 '93
— 1940s
 Nat Geog 183:110–26 (c,1) Mr '93
— Foodstuffs left over from 1911 expedition
 Life 16:82–3 (c,1) Mr '93
ANTARCTICA
 Trav&Leisure 22:52 (c,4) Ja '92
 Trav/Holiday 175:88–96 (map,c,1) Mr '92
 Life 16:78–85 (c,1) Mr '93
 Trav&Leisure 24:cov.,126–40 (map,c,1)
 D '94

Natur Hist 105:56–7 (c,2) N '96
— Mt. Erebus, Ross Island
 Trav/Holiday 176:59 (3) Je '93
— Researching Antarctic ice
 Nat Geog 189:36–53 (c,1) My '96
— Site of U.S. base
 Nat Geog 183:110–26 (map,c,1) Mr '93
ANTELOPES
 Nat Geog 184:65–7,80–1 (c,1) Ag '93
 Trav&Leisure 25:E10 (c,4) My '95
— Bongos
 Nat Geog 188:25 (c,3) Jl '95
— Chiru antelope
 Natur Hist 105:48–53 (c,1) My '96
— Extinct blaauwbock
 Natur Hist 102:16,18 (c,3) My '93
— Nyala giving birth
 Life 19:14 (c,2) Mr '96
— Sable antelope
 Trav/Holiday 177:29 (c,4) S '94
— See also
 BLACKBUCKS
 GAZELLES
 GEMSBOKS
 IMPALAS
 MOUNTAIN GOATS
ANTENNAS
— Arecibo dish, Puerto Rico
 Life 15:67 (c,3) S '92
Anthropologists. See
 MEAD, MARGARET
Antigua. See
 LEEWARD ISLANDS
ANTIGUA, GUATEMALA
 Trav&Leisure 23:90–1,94 (c,2) Mr '93
 Trav/Holiday 178:84–91 (map,c,1) Mr '95
ANTIQUES
— Antique store (California)
 Trav&Leisure 22:102–3 (c,1) Ja '92
ANTLERS
 Natur Hist 103:66–9 (painting,c,1) Ap '94
— Caribou
 Nat Wildlife 32:16 (c,4) F '94
— Deer
 Natur Hist 102:30–1 (c,1) F '93
 Nat Wildlife 32:36–41 (c,1) O '94
— Elks
 Nat Wildlife 31:54–5 (c,1) O '93
 Nat Wildlife 32:52–3 (c,1) F '94
 Nat Wildlife 32:6–7 (c,1) O '94
ANTS
 Nat Geog 181:81 (c,4) Ja '92
 Smithsonian 23:50 (c,4) D '92
 Natur Hist 102:43 (c,2) Ag '93
 Natur Hist 102:4–6 (c,4) O '93

Natur Hist 103:40–7 (c,1) Ag '94
Natur Hist 103:86–7 (c,1) N '94
— Leafcutter ants
Nat Geog 188:98–111 (c,1) Jl '95
— Weaver ants
Natur Hist 105:16 (c,4) My '96
ANTWERP, BELGIUM
Trav/Holiday 175:39,41 (c,4) O '92
Trav&Leisure 24:74,76 (4) My '94
APACHE INDIANS (SOUTHWEST)
Nat Geog 182:47–71 (c,1) O '92
— Sites related to Geronimo's life
Nat Geog 182:47–71 (map,c,1) O '92
— See also
GERONIMO
APACHE INDIANS—RITES AND FESTIVALS
— Apache puberty ceremony
Nat Geog 182:56–7 (c,1) O '92
— Dance to honor fire (New Mexico)
Nat Geog 190:116–17 (c,1) S '96
APACHE INDIANS—SOCIAL LIFE AND CUSTOMS
— Dance of the Mountain Spirits
Nat Geog 182:48–9 (c,1) O '92
APARTMENT BUILDINGS
— London, England
Trav&Leisure 24:97 (c,4) Mr '94
— Swimming pool on roof (Illinois)
Sports Illus 80:56 (c,3) F 14 '94
— Tokyo, Japan
Trav&Leisure 26:146 (c,1) Mr '96
— U.S.S.R.
Nat Geog 182:128–9 (c,1) O '92
Nat Geog 185:132–3 (c,1) Je '94
APES
Nat Geog 181:cov.,2–45 (c,1) Mr '92
— Biological differences and evolution of apes
Nat Geog 181:16–18,51 (painting,c,3) Mr '92
— Bush babies
Natur Hist 104:48–57 (c,1) Ag '95
— King Kong sculpture
Life 18:32 (c,3) D '95
— World map of ape habitats
Nat Geog 181:12–13 (c,1) Mr '92
— See also
BABOONS
CHIMPANZEES
GIBBONS
GORILLAS
ORANGUTANS
APHIDS
Natur Hist 101:34–9 (c,1) Ap '92

Nat Wildlife 32:32 (c,4) Je '94
Appalachia. See
SOUTHERN U.S.
APPALACHIAN MOUNTAINS, NORTH CAROLINA
Trav&Leisure 22:108–9 (c,1) Mr '92
APPALACHIAN MOUNTAINS, VIRGINIA
Nat Geog 183:114–15 (c,1) F '93
APPALACHIAN TRAIL, EASTERN U.S.
Trav&Leisure 26:87–94 (map,c,1) Jl '96
APPLE INDUSTRY—HARVESTING
— Germany
Trav&Leisure 24:115 (1) F '94
— New York
Life 16:74–5 (c,1) N '93
APPLE TREES
Trav&Leisure 25:160–1 (c,1) S '95
APPLES
— Applefest (Bayfield, Wisconsin)
Trav&Leisure 25:158–9 (c,1) S '95
APPLIANCES
— 1945 refrigerator plant
Life 18:85 (2) Je 5 '95
— See also
LAUNDRY
SEWING MACHINES
STOVES
APRICOT INDUSTRY
— Apricots drying in sun (Pakistan)
Nat Geog 185:114–15 (c,1) Mr '94
APRICOT TREES
Nat Geog 185:128–9 (c,1) Mr '94
AQUARIUMS
Smithsonian 25:50–62 (c,1) D '94
— Baltimore, Maryland
Gourmet 54:140 (c,4) N '94
— Boston, Massachusetts
Smithsonian 25:53 (c,4) D '94
— In restaurant (New York)
Gourmet 52:64 (c,3) S '92
— Miami Seaquarium, Florida
Smithsonian 23:58–9 (c,1) Ja '93
— Monterey Bay Aquarium, California
Trav/Holiday 176:58–63 (c,1) N '93
— UnderWater World, San Francisco, California
Trav&Leisure 26:30 (c,4) Jl '96
AQUEDUCTS
— Ancient Roman aqueducts (Rome, Italy)
Smithsonian 23:88–91 (c,2) S '92
— Arizona
Nat Geog 184:18–19 (c,1) N 15 '93

Natur Hist 105:30–1 (c,1) S '96
— California
Nat Geog 184:46–7 (c,2) N 15 '93
— Nimes, France
Nat Geog 188:67 (c,3) S '95
AQUEDUCTS—CONSTRUCTION
— 1905 (California)
Nat Geog 184:57 (3) N 15 '93
ARAB COUNTRIES—COSTUME
Nat Geog 183:cov.,38–71 (c,1) My '93
— 1900 (Palestine)
Trav/Holiday 178:56 (4) Ap '95
— Bahrain
Nat Geog 187:22–3 (c,1) My '95
— Druze elder (Israel)
Nat Geog 187:52–3 (c,1) Je '95
— Men in burnooses (Dubai)
Sports Illus 82:2–3 (c,1) Ja 30 '95
— Oman
Nat Geog 187:112–38 (c,1) My '95
— See also
MUSLIMS—COSTUME
PALESTINIANS
ARABIAN DESERT, DUBAI
Sports Illus 82:2–3,42–3 (c,1) Ja 30 '95
Arachnids. See
DADDY LONGLEGS
SPIDERS
TARANTULAS
ARAFAT, YASIR
Life 17:14,50–1 (c,1) Ja '94
Nat Geog 190:44–5 (c,1) S '96
ARAL SEA, U.S.S.R.
— Dry site of Aral Sea
Nat Geog 186:97 (c,3) Ag '94
ARAPAHO INDIANS
— Chief Little Powder
Am Heritage 43:109 (1) N '92
ARAPAHO INDIANS—ARTIFACTS
— Cradleboards
Smithsonian 25:40 (c,4) O '94
ARC DE TRIOMPHE, PARIS, FRANCE
Gourmet 54:66 (painting,c,4) Ap '94
Trav&Leisure 24:cov. (c,1) Ap '94
Trav&Leisure 25:99 (c,4) Je '95
Gourmet 56:88 (c,3) D '96
— 19th cent.
Trav/Holiday 178:55 (4) Ap '95
ARCHAEOLOGICAL SITES
— Anasazi Indian sites (Southwest)
Smithsonian 24:28–39 (c,1) D '93
— Andes Mountains, Chile
Nat Geog 181:91 (c,4) Mr '92
— Cacaxtla, Mexico
Nat Geog 182:120–36 (map,c,1) S '92

— Carthage, Tunisia
Smithsonian 25:124–41 (map,c,1) Ap '94
— Casa Malpais, Arizona
Smithsonian 22:28–37 (c,1) Mr '92
— Cuneiform library, ancient Sippar, Iraq
Natur Hist 105:16 (4) S '96
— Dinosaur dig (Sahara, Africa)
Nat Geog 189:106–16 (c,1) Je '96
— Dos Pilas, Guatemala
Nat Geog 183:94–111 (map,c,1) F '93
— Hadar, Ethiopia
Nat Geog 189:98–115 (map,c,1) Mr '96
— Han Dynasty tombs, Xian, China
Nat Geog 182:114–30 (map,c,1) Ag '92
Nat Geog 190:68–85 (c,1) O '96
— Map of early human sites (China)
Natur Hist 102:56 (c,3) My '93
— Maya ruins (Bonampak, Mexico)
Nat Geog 187:50–69 (c,1) F '95
— Mogollon sites (Mexico)
Smithsonian 27:60–73 (c,1) N '96
— National Geographic Society research
projects
Nat Geog 189:112–17 (c,1) Ap '96
— Olmec sites (Mexico)
Nat Geog 184:90–1,106–9 (c,1) N '93
— Prehistoric Khok Phanom Di, Thai-
land
Natur Hist 103:60–5 (painting,c,1) D '94
— St. Mary's City tomb, Maryland
Smithsonian 27:84 (c,3) My '96
— Santorini, Greece
Trav/Holiday 178:50–1 (c,2) My '95
— Teotihuacan, Mexico
Nat Geog 188:2–35 (map,c,1) D '95
— Tikal, Guatemala
Trav&Leisure 23:88–9 (c,1) Mr '93
— Underwater dig (Alexandria, Egypt)
Life 19:70–4 (c,1) Ap '96
— Xinjiang, China
Nat Geog 189:44–51 (c,1) Mr '96
— See also
MACHU PICCHU
POMPEII
TROY
Archaeologists. See
SCHLIEMANN, HEINRICH
ARCHERY
— 1926 Hopi Indian archers
Nat Geog 190:62 (c,3) Jl '96
— Brazil Indian
Natur Hist 101:38 (c,4) Mr '92
— Copper Age bow and arrow
Nat Geog 183:54–5 (c,2) Je '93
— Mongolia

Nat Geog 190:25 (c,4) D '96
— Mounted archery (Japan)
Nat Geog 190:44–5 (c,1) Jl '96
ARCHES NATIONAL PARK, UTAH
Nat Geog 186:46–7 (c,2) O '94
— Delicate arch
Nat Geog 189:52–3 (c,1) Ja '96
ARCHITECTS
— Arata Isozaki
Smithsonian 23:59 (c,4) Jl '92
— Albert Kahn
Smithsonian 25:50 (4) S '94
— Maya Lin
Smithsonian 27:24 (c,4) Ag '96
— Sir John Saone's home (London, England)
Trav/Holiday 179:78 (c,4) Jl '96
— See also
BRUNELLESCHI, FILIPPO
GAUDI, ANTONIO
LE CORBUSIER
RICHARDSON, HENRY HOBSON
WHITE, STANFORD
WRIGHT, FRANK LLOYD
Architectural features. See
BATHROOMS
BEDROOMS
CLOCKS
CHIMNEYS
DINING ROOMS
FENCES
FIREPLACES
GARAGES
KITCHENS
LIBRARIES
PARLORS
PORCHES
STAIRCASES
WINDOWS
Architectural structures. See
APARTMENT BUILDINGS
AQUEDUCTS
BARNS
BOATHOUSES
CANALS
CAPITOL BUILDING
CAPITOL BUILDINGS—STATE
CASTLES
CHURCHES
CITY HALLS
COURTHOUSES
DAMS
FACTORIES
FORTRESSES
FORTS
GARAGES

GASOLINE STATIONS
GATES
GAZEBOS
GREENHOUSES
GYMNASIUMS
HEALTH CLUBS
HOTELS
HOUSING
JUNKYARDS
LIBRARIES
LIGHTHOUSES
MILLS
MINES
MISSIONS
MONASTERIES
MUSEUMS
OBSERVATORIES
OFFICE BUILDINGS
PAGODAS
PALACES
PLAYGROUNDS
POST OFFICES
PRISONS
PYRAMIDS
RAILROAD STATIONS
SCHOOLS
STABLES
STORES
TAVERNS
TEMPLES
THEATERS
TREE HOUSES
TUNNELS
WHITE HOUSE
ARCHITECTURE
— Modern Richard Meier office building
(Paris, France)
Trav&Leisure 23:111 (c,3) Ja '93
— Works by Santiago Calatrava
Smithsonian 27:76–86 (c,1) N '96
— Works by Arata Isozaki
Smithsonian 23:cov.,58–67 (c,1) Jl '92
ARCHITECTURE, AMERICAN
— Gargoyles on New York City buildings
Smithsonian 24:86–92 (c,2) Ag '93
— Landmarks remaining from Spanish
presence in the U.S.
Am Heritage 44:52–63,130 (c,1) Ap '93
**ARCHITECTURE, AMERICAN—
18TH CENT.**
— 1740s Georgian-style Drayton Hall,
Charleston, South Carolina
Trav/Holiday 179:61 (c,1) F '96
— Georgian-style house (Odessa, Delaware)
Trav/Holiday 178:41 (c,4) S '95

ARCHITECTURE, AMERICAN—
19TH CENT.
— 1853 wooden house (New York City, New
 York)
 Trav&Leisure 24:58 (2) N '94
— 1868 Sprague House, Red Wing,
 Minnesota
 Trav&Leisure 24:113 (c,4) Je '94
— 1862 Gothic Revival house (Geneva, New
 York)
 Smithsonian 24:126 (c,1) Ap '93
— 1870s Italianate row house (Brooklyn,
 New York)
 Trav&Leisure 24:60 (4) N '94
— Antebellum houses (Beaufort, South
 Carolina)
 Trav&Leisure 24:124–7 (c,1) My '94
— Buildings designed by Henry Hobson
 Richardson
 Am Heritage 43:4,108–15 (c,1) D '92
— Martinez hacienda, Taos, New Mexico
 Am Heritage 45:92–9 (c,1) F '94
— Victorian house (Georgetown, Colorado)
 Am Heritage 46:32 (c,4) N '95
— Victorian house (Saratoga Springs, New
 York)
 Trav&Leisure 23:144 (c,4) S '93
ARCHITECTURE, AMERICAN—
20TH CENT.
— Early 20th cent. works by Albert Kahn
 Smithsonian 25:48–59 (c,1) S '94
— Colonial Revival style
 Am Heritage 43:82–9 (c,1) My '92
— Cutler's native-sensitive homes
 (Washington)
 Smithsonian 27:46–57 (c,1) Je '96
— Postmodern style structures
 Am Heritage 47:96–7 (c,4) Jl '96
— Robert Venturi's 1963 "Mother's House"
 (Philadelphia, Pennsylvania)
 Am Heritage 47:94–101 (c,1) Jl '96
ARCHITECTURE, ITALIAN—
15TH CENT.
— Brunelleschi's Foundling Hospital,
 Florence, Italy
 Trav/Holiday 176:65–7 (painting,c,1) S
 '93
ARCTIC
 Nat Geog 187:120–38 (map,c,1) Ja '95
— Snow scene (Sweden)
 Nat Geog 184:4–5 (c,1) Ag '93
ARCTIC EXPEDITIONS
 Nat Geog 187:120–38 (map,c,1) Ja '95
 Nat Geog 189:78–89 (c,1) Ja '96

— Late 16th cent. Frobisher expeditions to
 Baffin Island area
 Smithsonian 23:119–30 (map,c,3) Ja '93
— 1989 trek across Brooks Range, Alaska
 Nat Geog 183:70–93 (map,c,1) Ap '93
— Crossing Baffin Island, Canada
 Nat Geog 190:126–39 (map,c,1) O '96
ARGENTINA
— Countryside
 Trav&Leisure 25:82–95 (map,c,1) Ja '95
— Ischigualasto Valley
 Natur Hist 104:32 (c,4) Je '95
— Lake Parmiento, Patagonia
 Natur Hist 101:29 (c,4) Ap '92
— Patagonia
 Trav/Holiday 175:28 (c,4) S '92
 Trav/Holiday 179:56–63 (map,c,1) Je '96
 Trav&Leisure 26:64-6,96–8 (map,c,2) Jl
 '96
— Peninsula Valdes
 Natur Hist 103:40,43 (map,c,4) Ja '94
— Seen from space shuttle
 Natur Hist 104:52–3 (c,1) F '95
— Towers of Paine, Patagonia
 Smithsonian 25:44 (c,4) N '94
— See also
 ANDES MOUNTAINS
 BUENOS AIRES
 IGUACU FALLS
ARGENTINA—COSTUME
— Buenos Aires
 Nat Geog 186:87–105 (c,1) D '94
 Trav&Leisure 26:151–61 (c,1) D '96
— Gauchos
 Trav&Leisure 25:81 (c,1) Ja '95
— Singer Carlos Gardel
 Trav/Holiday 179:62–3,67 (c,1) O '96
— See also
 PERON, JUAN
ARGENTINA—RITES AND
 FESTIVALS
— Body painted for initiation rite (Tierra del
 Fuego)
 Natur Hist 104:62 (4) Mr '95
ARGENTINA—SOCIAL LIFE
 AND CUSTOMS
— Tango dancing
 Smithsonian 24:cov.,152–61 (c,1) N '93
 Trav/Holiday 179:60–7 (c,1) O '96
ARIKARA INDIANS
— 1870s Arikara scout
 Natur Hist 101:38,43 (1) Je '92
ARIZONA
— Aqueduct
 Nat Geog 184:18–19 (c,1) N 15 '93

Natur Hist 105:30–1 (c,1) S '96
— Arizona Canal
 Natur Hist 105:38 (c,4) S '96
— Asteroid crater
 Smithsonian 25:68 (c,4) Je '94
— Bisbee
 Am Heritage 44:28 (c,4) N '93
— Boat gridlock on Lake Havasu
 Life 15:20–1 (c,3) S '92
— The Boulders resort
 Trav/Holiday 179:50–1 (c,4) S '96
— Canyon Ranch Spa, Tucson, Arizona
 Trav/Holiday 179:30–2 (c,1) N '96
— Cathedral Rock, Sedona
 Natur Hist 103:A1 (c,1) Ap '94
— Chitty Canyon
 Natur Hist 103:19–20 (map,c,1) Ag '94
— Corkscrew Canyon
 Trav/Holiday 178:cov. (c,1) Jl '95
— Countryside
 Nat Wildlife 32:54–7 (c,1) D '93
 Am Heritage 46:28 (c,4) S '95
— Diamond Point
 Natur Hist 104:70–2 (map,c,1) S '95
— Dragoon Mountains
 Nat Geog 182:68–9 (c,1) O '92
— Echo Cliffs
 Nat Geog 190:92 (c,4) S '96
— Four Corners countryside
 Trav&Leisure 24:68–75,106–7 (map,c,1)
 Ag '94
 Nat Geog 190:cov.,80–97 (map,c,1) S '96
— Gila River
 Nat Geog 182:53 (c,4) O '92
— Glen Canyon Dam
 Nat Geog 184:54–5 (c,1) N 15 '93
— Glendale housing development
 Nat Geog 184:34–5 (c,1) N 15 '93
— Havasu Canyon
 Trav&Leisure 24:E21–E24 (map,c,4) My
 '94
— Lake Havasu
 Sports Illus 84:47 (c,3) Ap 1 '96
— Lake Powell
 Natur Hist 102:cov.,40–5 (c,1) N '93
 Trav/Holiday 178:34–43 (map,c,1) Jl '95
— Monument Valley
 Life 16:96–8 (c,1) Jl '93
 Nat Geog 190:cov. (c,1) S '96
— Mount Baldy
 Natur Hist 102:62–3 (c,1) Jl '93
— Mount Lemmon
 Natur Hist 101:68 (c,4) S '92
— Native American sites

Trav&Leisure 23:cov.,134–45 (map,c,1)
 Ap '93
— Phelps Cabin
 Natur Hist 102:62–4 (map,c,1) Jl '93
— Prehistoric site Casa Malpais
 Smithsonian 22:28–37 (c,1) Mr '92
— Ranches
 Trav&Leisure 22:114–24 (c,1) O '92
— Red Rock countryside
 Gourmet 53:138–41 (c,1) Ap '93
— Resort hotels
 Trav&Leisure 23:96–7 (c,1) Jl '93
 Trav&Leisure 26:72–81,141 (map,c,1) F
 '96
— Route 66
 Trav&Leisure 26:84 (c,4) S '96
— San Pedro River
 Life 16:38–9 (c,1) O '93
— Santa Catalina Mountains
 Natur Hist 101:cov.68 (c,1) S '92
— Scenes along 1860 route of explorer John
 Wesley Powell
 Nat Geog 185:86–115 (map,c,1) Ap '94
— Scottsdale
 Trav&Leisure 24:1–5 (c,1) O '94 supp.
— Sedona
 Trav/Holiday 178:25 (c,4) F '95
 Gourmet 55:106 (c,4) My '95
 Am Heritage 47:30 (c,3) F '96
— Seligman (1947)
 Life 19:72 (1) Winter '96
— Sites related to Wyatt Earp and the Old
 West (Tombstone)
 Trav&Leisure 24:92–7,143–5 (c,3) F '94
— Sonoran Desert
 Nat Geog 184:18–19 (c,1) N 15 '93
 Nat Geog 186:36–51 (map,c,1) S '94
 Trav/Holiday 179:97 (map,c,4) F '96
 Natur Hist 105:58–61 (map,c,2) Ap '96
— Tombstones (Tombstone)
 Am Heritage 47:30 (c,4) F '96
— Water problems
 Nat Geog 184:2–36 (c,1) N 15 '93
— West Mitten Butte
 Nat Geog 190:83–5 (c,1) S '96
— See also
 CANYON DE CHELLY NATIONAL
 MONUMENT
 COLORADO RIVER
 GRAND CANYON
 HOOVER DAM
 NAVAJO NATIONAL MONUMENT
 PHOENIX
 SAGUARO NATIONAL PARK
 TUCSON

ARKANSAS
— Blanchard Springs Caverns
Trav/Holiday 177:86 (c,3) My '94
— Buffalo River
Gourmet 52:80,83 (c,1) F '92
Am Heritage 43:24 (c,4) Ap '92
Trav&Leisure 22:164 (c,4) My '92
— Countryside
Gourmet 52:78–83 (c,1) F '92
Trav&Leisure 22:161–6 (map,c,3) My '92
— Eureka Springs
Trav/Holiday 177:88–9 (c,1) My '94
— Helena park boardwalk
Am Heritage 47:22 (c,4) F '96
— Ouachita National Forest
Natur Hist 102:22–4 (map,c,1) S '93
— Ozark region
Gourmet 52:78–83,142 (map,c,1) F '92
Trav/Holiday 177:84–91 (map,c,1) My '94
— Thorncrown Chapel, Eureka Springs
Trav&Leisure 22:162 (c,4) My '92
— See also
FULBRIGHT, J. WILLIAM
LITTLE ROCK
HOT SPRINGS
ARMADILLOS
Nat Wildlife 30:18 (c,4) F '92
Nat Wildlife 31:9 (c,4) D '92
Smithsonian 26:148–51 (c,2) O '95
ARMOR
— 16th cent.
Smithsonian 23:22,25 (c,4) D '92
— Crow Indian shield
Life 17:129 (c,4) N '94
— Henry VIII's armor (Great Britain)
Nat Geog 184:51 (c,4) O '93
— Knight costumes for medieval-style warfare (Pennsylvania)
Life 18:28–32 (c,1) N '95
— Medieval battle gear (Great Britain)
Nat Geog 184:50 (c,1) O '93
Sports Illus 84:70–1 (c,1) Mr 18 '96
— Reproduction of ancient Scythian armor
Nat Geog 190:59 (c,3) S '96
ARMS
— Late 15th cent. Spanish weapons
Nat Geog 181:50–1 (c,2) Ja '92
— Late 16th cent. lead shot (Spain)
Nat Geog 186:54 (c,4) Jl '94
— 1930s anti-aircraft listening devices (Japan)
Life 19:29 (4) O '96
— Bullet cases (Tibet)
Nat Geog 184:82 (c,4) Ag '93
— Civil War shell
Nat Geog 186:73 (c,4) D '94

— Lead shot
Nat Wildlife 33:13 (c,4) Ap '95
— Making blowgun (Colombia)
Nat Geog 187:104–5 (c,1) My '95
— Remains of World War II military hardware
Am Heritage 46:90–3 (c,1) My '95
— See also
ARCHERY
ARMOR
ARROWS
ATOMIC BOMBS
AXES
BOMBS
CANNONS
DAGGERS
DUELS
GUNS
HARPOONS
KNIVES
MINES, EXPLODING
MISSILES
SWORDS
TANKS, ARMORED
ARMS (ANATOMY)
— Arms positioned in classic Greek column styles
Life 18:104 (4) Je '95
— Preserved arm of boxer Dan Donnelly (Ireland)
Sports Illus 82:164–5,172 (c,1) F 20 '95
ARMSTRONG, LOUIS
Smithsonian 24:66 (4) My '93
Smithsonian 25:28 (c,4) F '95
Life 18:37 (4) Jl '95
Am Heritage 46:80 (painting,c,3) O '95
Am Heritage 47:36 (4) My '96
— Armstrong's scarred lips
Life 19:116–17 (1) My '96
ARNICA (FLOWER)
Nat Wildlife 32:35 (c,2) Ag '94
ARNO, PETER
— 1936 cartoon about society hatred of Franklin Roosevelt
Smithsonian 26:90 (4) Je '95
ARNOLD, BENEDICT
Am Heritage 45:14 (painting,4) My '94
ARROWS
— 13th cent. Mongolian arrows
Nat Geog 190:16 (c,4) D '96
— Indian arrowhead (Wyoming)
Nat Geog 184:55 (c,4) D '93
Art forms. See
ARTS AND CRAFTS
CAVE PAINTINGS

CERAMICS
COLLAGES
FRESCOES
GRAFFITI
METALWORK
MOSAICS
MURALS
PAINTINGS
QUILTS
ROCK CARVINGS
ROCK PAINTINGS
SCULPTURE
SILHOUETTES
STAINED GLASS
TOTEM POLES
Art galleries. See
MUSEUMS

ART WORKS
— 2nd cent. "Cerne Giant" carved into Dorset
 landscape, England
 Trav&Leisure 25:88 (c,4) D '95
— 17th cent. prints by Wenceslaus Hollar
 (Czechoslovakia)
 Smithsonian 25:20 (4) Ja '95
— 19th cent. prints by women graphic artists
 Smithsonian 26:36 (c,4) My '95
— 20th cent. Mexican art
 Smithsonian 23:86–93 (c,2) Ap '92
 Trav&Leisure 23:106–18 (c,1) Je '93
— Early 20th cent. Goyo woodblock prints
 (Japan)
 Smithsonian 26:20 (c,4) S '95
— 1918 men assembled into living patriotic
 symbols
 Smithsonian 26:58–63 (1) Ja '96
— Aerial views of land sculptures (Kansas)
 Smithsonian 25:70–7 (c,1) Jl '94
— Artistic redesign of old cars
 Smithsonian 26:34–6 (c,2) Ag '95
 Smithsonian 26:20 (c,4) O '95
— Art glass
 Smithsonian 22:cov.,90–101 (c,1) F '92
 Nat Geog 184:62–9 (c,1) D '93
— Chinese art treasures
 Smithsonian 26:44–52 (c,1) Mr '96
— Classic James Montgomery Flagg World
 War I Uncle Sam poster
 Smithsonian 26:70 (c,4) Jl '95
— Computer art
 Smithsonian 25:cov.,56–64 (c,1) F '95
— Corn Palace, Mitchell, South Dakota
 Nat Geog 183:114–15 (c,1) Je '93
— Deem paintings done in the styles of
 famous artists
 Smithsonian 24:98–101 (c,1) Jl '93
— Folded paper art works by illegal Chinese
 immigrants in prison (Pennsylvania)
 Life 19:68–72 (c,1) Jl '96
— Glass flower bouquet (New Jersey)
 Nat Geog 184:49 (c,2) D '93
— Goldsworthy sculptures in landscape
 Natur Hist 105:8–9 (c,2) O '96
— "The Lightning Field" (New Mexico)
 Trav&Leisure 23:E25 (c,4) My '93
— Lilies of the valley Faberge egg
 Am Heritage 47:8 (c,2) F '96
— Outdoor art works (San Francisco,
 California)
 Smithsonian 26:60–9 (c,1) Jl '95
— Portraits by Cecilia Beaux
 Smithsonian 26:40 (painting,c,4) N '95
— Recovering stolen masterpieces from the
 Nazis (1945)
 Life 18:78–9 (1) Je 5 '95
— Reichstag wrapped in silver fabric by
 Christo, Berlin, Germany
 Life 18:20 (c,2) S '95
 Life 19:30–1 (c,1) Ja '96
 Nat Geog 190:102–3 (c,1) D '96
— Susan Rothenberg's images of horses
 Smithsonian 23:40 (c,4) Mr '93
— Sculpture of half-buried Cadillacs
 (Nebraska)
 Life 19:116 (c,2) Winter '96
— Soda can replica of church (Padua, Italy)
 Life 16:22 (c,4) Ap '93
— Stolen masterpieces
 Smithsonian 26:34–43 (painting,c,3) S '95
— Tools as art
 Smithsonian 27:112–15 (c,1) Ap '96
— Works by 16th cent. woman Sofonisba
 Anguissola (Italy)
 Smithsonian 26:106–9 (painting,c,1) My
 '95
— Works by 20th cent. black artists
 Smithsonian 24:137–48 (c,2) N '93
 Smithsonian 26:26 (c,4) Jl '95
— Works by Walter Anderson
 Smithsonian 25:108–18 (painting,c,1) O
 '94
— Works by black Americans in France
 Smithsonian 26:106–13 (c,1) Mr '96
— Works by Georges de la Tour
 Smithsonian 27:75–83 (painting,c,1) D '96
— Works by Ralph Fasanella
 Smithsonian 24:59–69 (c,1) Ag '93
— Works by Edward James
 Smithsonian 25:60–70 (c,1) Ap '94
— Works by Jacob Kainen
 Smithsonian 24:42 (painting,c,4) N '93

— Works by Archibold Motley, Jr.
Am Heritage 46:18–24 (painting,c,1) F
'95 supp.
— Works by Horace Pippin
Smithsonian 25:48–59 (c,1) Je '94
— Works by Jesse Trevino
Smithsonian 25:32,34 (painting,c,2) D '94
— Works by Beatrice Wood
Smithsonian 24:90–4 (c,2) Mr '94
— See also
ADAMS, ANSEL
AUDUBON, JOHN JAMES
BELLOWS, GEORGE WESLEY
BENTON, THOMAS HART
BERNINI, GIOVANNI LORENZO
BIERSTADT, ALBERT
BORGLUM, GUTZON
BOSCH, HIERONYMUS
BOTTICELLI, SANDRO
BOURKE-WHITE, MARGARET
BRAQUES, GEORGES
BREUGHEL, PIETER THE ELDER
BRUNELLESCHI, FILIPPO
CALDER, ALEXANDER
CARAVAGGIO
CATLIN, GEORGE
CEZANNE, PAUL
COCTEAU, JEAN
COLE, THOMAS
CORREGGIO
CURRY, JOHN STEUART
DALI, SALVADOR
DEGAS, EDGAR
DE KOONING, WILLEM
DELACROIX, EUGENE
DORE, GUSTAVE
DUBUFFET, JEAN
DURER, ALBRECHT
EAKINS, THOMAS
EISENSTAEDT, ALFRED
EL GRECO
EVANS, WALKER
GAINSBOROUGH, THOMAS
GAUDI, ANTONIO
GAUGUIN, PAUL
GHIRLANDAIO, DOMENICO
GIORGIONE
GIOTTO
GLACKENS, WILLIAM JAMES
GOYA, FRANCISCO
GRIS, JUAN
GROSZ, GEORGE
HARNETT, WILLIAM MICHAEL
HASSAM, CHILDE
HENRI, ROBERT
HOLBEIN, HANS THE YOUNGER
HOMER, WINSLOW
HOPPER, EDWARD
JACKSON, WILLIAM HENRY
KAHLO, FRIDA
KANDINSKY, WASSILY
LEGER, FERNAND
LEONARDO DA VINCI
LIPPI, FILIPPINO
MAGRITTE, RENE
MANET, EDOUARD
MATISSE, HENRI
MICHELANGELO
MIRO, JOAN
MODIGLIANI, AMEDEO
MONDRIAN, PIET
MONET, CLAUDE
MUNCH, EDVARD
O'KEEFFE, GEORGIA
OLDENBURG, CLAES
OROZCO, JOSE CLEMENTE
PARRISH, MAXFIELD
PEALE, CHARLES WILLSON
PICASSO, PABLO
PIERO DELLA FRANCESCA
PYLE, HOWARD
REMBRANDT
REMINGTON, FREDERIC
RENOIR, AUGUSTE
RESTORATION OF ART WORKS
RIVERA, DIEGO
ROCKWELL, NORMAN
RODIN, AUGUSTE
ROSSETTI, DANTE GABRIEL
ROTHKO, MARK
ROUSSEAU, HENRI
RUBENS, PETER PAUL
SARGENT, JOHN SINGER
SEURAT, GEORGES
SLOAN, JOHN
STUART, GILBERT
THORVALDSEN, BERTEL
TIEPOLO, GIAMBATTISTA
TIFFANY, LOUIS COMFORT
TINTORETTO
TITIAN
TOULOUSE-LAUTREC, HENRI DE
TRUMBULL, JOHN
TURNER, J.M.W.
VAN DYCK, ANTHONY
VAN GOGH, VINCENT
VELASQUEZ, DIEGO
VERMEER, JAN
VUILLARD, EDOUARD
WATTEAU, ANTOINE

WHISTLER, JAMES McNEILL
WOOD, GRANT
ART—EDUCATION
— Nursing home art workshops (Vermont)
 Smithsonian 23:78–87 (c,2) N '92
ARTHROPODS
— Fossil arthropods
 Natur Hist 102:46–51 (c,1) Mr '93
— See also
 CENTIPEDES
 CRUSTACEANS
 HORSESHOE CRABS
 INSECTS
 SCORPIONS
 TRILOBITES
ARTHUR, KING (GREAT BRITAIN)
— 15th cent. illustration of Round Table
 Smithsonian 27:18 (painting,c,4) Ap '96
— Sites associated with King Arthur
 (England)
 Smithsonian 26:32–41 (c,1) F '96
ARTISTS
— Late 19th cent. studio (Connecticut)
 Smithsonian 26:111 (c,2) F '96
— 20th cent. black artists
 Smithsonian 24:136–48 (4) N '93
— 1917 artists (France)
 Smithsonian 27:46–7 (drawing,2) Jl '96
— 1940s abstract expressionists (New York)
 Am Heritage 46:52 (4) S '95
— Walter Anderson
 Smithsonian 25:110 (4) O '94
— Artist sketching outdoors (France)
 Trav/Holiday 175:67 (4) Je '92
— Artist with Parkinson's disease
 Life 16:76–80 (c,1) Je '93
— Bazille's painting of French impressionists
 (1869)
 Smithsonian 25:88 (painting,c,3) N '94
— Caricaturist Miguel Covarrubias
 Am Heritage 46:92 (4) D '95
— George Deem
 Smithsonian 24:94 (c,4) Jl '93
— Ralph Fasanella
 Smithsonian 24:58 (c,4) Ag '93
— Hands of artists
 Life 19:86–7 (4) F '96
— Maya Lin
 Smithsonian 27:24 (c,4) Ag '96
— Mock palettes of famous artists (New
 Jersey)
 Smithsonian 24:106–9 (c,1) D '93
— Felix Nadar
 Smithsonian 26:76 (4) My '95
— Rembrandt Peale self-portrait

Smithsonian 23:26 (painting,c,4) Ja '93
— Horace Pippin self-portrait
 Smithsonian 25:52 (painting,c,4) Je '94
— Prehistoric cave painters
 Natur Hist 105:16–17 (painting,c,1) Ag
 '96
— Ad Reinhardt
 Am Heritage 46:63 (2) S '95
— Sculptor Vadim Sidur
 Smithsonian 25:119,127 (1) D '94
— Self-portrait of Archibold Motley, Jr.
 Am Heritage 46:18 (painting,c,4) F '95
 supp.
— Self-portraits by contemporary artists
 Smithsonian 24:30 (painting,c,4) S '93
— Studio (France)
 Smithsonian 26:113 (1) Mr '96
— Julian Weir
 Smithsonian 26:108 (4) F '96
— See also
 AUDUBON, JOHN JAMES
 BELLOWS, GEORGE WESLEY
 BENTON, THOMAS HART
 BOURKE-WHITE, MARGARET
 BRAQUE, GEORGES
 CARTIER-BRESSON, HENRI
 CEZANNE, PAUL
 COLE, THOMAS
 DALI, SALVADOR
 DE KOONING, WILLEM
 DEGAS, EDGAR
 DELACROIX, EUGENE
 DUBUFFET, JEAN
 DUCHAMP, MARCEL
 EISENSTAEDT, ALFRED
 FRENCH, DANIEL CHESTER
 HARNETT, WILLIAM MICHAEL
 HASSAM, CHILDE
 HIRSCHFELD, AL
 HOMER, WINSLOW
 KAHLO, FRIDA
 LAFARGE, JOHN
 LIPCHITZ, JACQUES
 MAGRITTE, RENE
 MATISSE, HENRI
 MIRO, JOAN
 MODIGLIANI, AMEDEO
 MONDRIAN, PIET
 MORRIS, WILLIAM
 O'KEEFFE, GEORGIA
 PICASSO, PABLO
 POLLOCK, JACKSON
 PYLE, HOWARD
 RIVERA, DIEGO
 ROCKWELL, NORMAN

ROTHKO, MARK
RUBENS, PETER PAUL
SAINT-GAUDENS, AUGUSTUS
SEGAL, GEORGE
TOULOUSE-LAUTREC, HENRI DE
WARHOL, ANDY
WHISTLER, JAMES McNEILL
WYETH, ANDREW
ARTS AND CRAFTS
— Early 20th cent. craft items
 Smithsonian 24:38 (c,4) O '93
— Early 20th cent. Utopian community
 (Delaware)
 Smithsonian 23:130 (4) My '92
— American craft treasures of the Renwick
 Gallery, Washington, D.C.
 Smithsonian 23:30,32 (c,4) O '92
— Batiks based on maps
 Smithsonian 25:143–5 (c,3) N '94
— Bead works (Africa)
 Smithsonian 25:31 (c,4) S '94
— Contemporary American crafts
 Smithsonian 24:30 (c,4) Ap '93
 Smithsonian 25:18 (c,4) Mr '95
 Smithsonian 27:34 (c,4) Ap '96
— Contemporary crafts shown at the White
 House, Washington, D.C.
 Smithsonian 26:cov.,52–6 (c,1) Je '95
— Creating creche figures (Naples, Italy)
 Trav/Holiday 179:78–85 (c,1) D '96
— Indian crafts
 Smithsonian 23:42,124–33 (c,2) N '92
— Mexico
 Gourmet 55:80–3 (c,1) Ja '95
— Peru
 Trav&Leisure 25:109 (c,4) Mr '95
— Scrapbooks
 Smithsonian 22:78–87 (c,1) F '92
— Thailand
 Trav&Leisure 25:88–90 (c,3) N '95
— Tie-dyeing cotton (India)
 Nat Geog 185:82 (c,4) Je '94
— See also
 BASKET WEAVING
 GLASS MAKING
 GLASSBLOWING
 METALWORK
 METALWORKING
 NEEDLEWORK
 PAINTING
 POTTERY
 QUILTING
 QUILTS
 ROCK CARVINGS
 SCULPTING

TATTOOING
WEAVING
WOOD WORKING
ARUBA
 Trav/Holiday 175:18 (c,3) Je '92
 Trav/Holiday 178:70–5 (map,c,2) F '95
 Trav/Holiday 179:11 (c,4) O '96
ASH TREES
— Golden ash
 Trav&Leisure 24:102 (c,1) Jl '94
ASHE, ARTHUR
 Sports Illus 76:25 (c,3) Ap 20 '92
 Sports Illus 77:cov.,16–27 (c,1) D 21 '92
 Sports Illus 78:cov.,13–15 (c,1) F 15 '93
 Life 16:61–6 (2) N '93
 Life 17:70–1 (c,1) Ja '94
 Sports Illus 81:116–17 (c,1) S 19 '94
— Family
 Life 16:cov.,61–9 (c,1) N '93
ASHEVILLE, NORTH CAROLINA
 Trav&Leisure 25:82–9,107–12 (map,c,1)
 Jl '95
— Biltmore estate
 Am Heritage 43:26 (c,4) My '92
 Smithsonian 23:58–71 (c,1) S '92
 Trav&Leisure 25:82–3,87-9 (c,1) Jl '95
ASHTRAYS
— 1908 Taft campaign ashtray
 Am Heritage 43:52 (c,4) S '92
ASIA
— Kingdom of Lo Monthang
 Life 16:78–85 (c,1) F '93
— See also
 HIMALAYA MOUNTAINS
 KURDISTAN
 MEKONG RIVER
 MONGOL EMPIRE
ASIA—MAPS
 Gourmet 56:207 (4) O '96
— Early maps of Asia
 Natur Hist 103:26–31 (c,1) Jl '94
ASIAN TRIBES
— Ainu people (Japan)
 Smithsonian 24:84 (c,4) N '93
— Bahinemo people (Papua New Guinea)
 Nat Geog 185:40–63 (c,1) F '94
— Dolpo people (Nepal)
 Nat Geog 184:9–23 (c,1) D '93
— Kazaks (China)
 Nat Geog 189:5–9,25–7 (c,1) Mr '96
— Koryak people (U.S.S.R.)
 Nat Geog 185:62–7 (c,1) Ap '94
— Padaung women with brass neck rings
 (Burma)
 Nat Geog 188:96 (c,1) Jl '95

Nat Geog 189:98–9 (c,1) F '96
— Penan tribesmen (Malaysia)
 Smithsonian 24:80 (c,3) N '93
— Rabari people (India)
 Nat Geog 184:cov.,64–93 (c,1) S '93
— Rong-pa people (Nepal)
 Nat Geog 184:5, 24–35 (c,1) D '93
— Sherpa people (Nepal)
 Nat Geog 182:70–89 (c,1) D '92
— Tadjik people (China)
 Smithsonian 24:83 (c,2) N '93
— Tatars (U.S.S.R.)
 Nat Geog 186:114–17 (c,1) S '94
— Uygur people (China)
 Natur Hist 101:36–9 (c,1) S '92

ASIAN TRIBES—ARTIFACTS
— Anga mummies (Papua New Guinea)
 Trav/Holiday 176:64 (c,4) Ap '93

ASIMOV, ISAAC
 Life 16:92–3 (c,1) Ja '93

ASPEN, COLORADO
 Trav&Leisure 22:55–6 (c,4) N '92
 Trav&Leisure 26:132–41,174–80
 (map,c,1) D '96
— Pyramid Peak
 Trav&Leisure 24:52 (c,4) D '94

ASPEN TREES
 Natur Hist 101:86 (4) D '92
 Nat Wildlife 33:59 (c,1) F '95
 Smithsonian 26:48–9 (c,3) Jl '95
 Nat Wildlife 34:28–35 (c,1) O '96

ASTAIRE, FRED
 Life 16:46 (4) Ap '93
 Life 18:138 (2) Je 5 '95
 Life 18:32–9 (4) D '95
 Life 19:91 (1) Ja '96
 Life 19:32 (4) O '96
 Smithsonian 27:cov.,53 (2) N '96
— Caricature
 Am Heritage 44:88–9 (c,1) O '93

ASTEROIDS
 Smithsonian 23:22 (4) Mr '93
— Asteroid crater (Arizona)
 Smithsonian 25:68 (c,4) Je '94

ASTROLABES
— 15th cent.
 Nat Geog 182:67 (c,2) N '92
— 1641 (Spain)
 Nat Geog 190:90 (c,4) Jl '96

ASTRONAUTS
 Am Heritage 45:6,41,50 (c,1) Jl '94
— 1959 Mercury 7 astronauts
 Life 19:112–13 (c,1) O '96
— 1962
 Am Heritage 43:64 (c,4) N '92

— Astronaut demonstrating launch position
 for school children (South Carolina)
 Nat Geog 186:68–9 (c,1) Ag '94
— Astronauts free-floating in space
 Life 17:17 (c,2) D '94
— Chimpanzee astronaut
 Life 19:69 (c,4) Ap '96
— Family posing in astronaut costumes
 (Japan)
 Nat Geog 185:92–3 (c,1) Ja '94
 Trav/Holiday 178:82 (c,3) O '95
— Jim Lovell
 Life 19:52–3 (c,1) Ja '96
— Christa McAuliffe
 Life 19:cov.,38–41 (c,1) F '96
— Russia
 Life 15:17 (c,4) Ap '92
— Training underwater
 Nat Geog 185:20–1 (c,1) Ja '94
— See also
 SHEPARD, ALAN BARTLETT, JR.

ASTRONOMY
— Comet hunting
 Smithsonian 23:74–83 (c,1) Je '92
— Henry Draper
 Nat Geog 188:94 (4) D '95
— Carl Sagan
 Life 19:24 (4) Mr '96
— See also
 ANTENNAS
 BARNARD, EDWARD E.
 HERSCHEL, CAROLINE L.
 HUBBLE, EDWIN POWELL
 LOWELL, PERCIVAL
 MESSIER, CHARLES
 OBSERVATORIES
 TELESCOPES
 UNIVERSE

ASUNCION, PARAGUAY
 Nat Geog 182:96,112–13 (c,1) Ag '92

ATATURK, KEMAL
 Smithsonian 26:117–27 (1) Mr '96

ATHENS, GREECE
— 17th cent.
 Trav/Holiday 178:100 (drawing,4) S '95
— Hephaisteion
 Smithsonian 24:47 (c,2) Jl '93
— Map
 Trav/Holiday 178:36 (c,4) O '95
— Stoa of Attalos
 Smithsonian 24:44 (c,3) Jl '93
— See also
 PARTHENON

ATHLETES
— 1992 Olympic athletes

Sports Illus 77:entire issue (c,1) Jl 22 '92
Sports Illus 77:entire issue (c,1) Ag 10 '92
— 1996 Olympic athletes
Sports Illus 85:entire issue (c,1) Jl 22 '96
— All-time "dream team" members
Sports Illus 77:22–31 (painting,c,1) Fall
'92
— Athletes in training (China)
Sports Illus 83:84–94 (c,1) O 16 '95
— Baseball players' life on the road
Sports Illus 77:40–6 (c,2) Ag 24 '92
— Chinese female athletes
Sports Illus 85:152–8 (c,1) Jl 22 '96
— Famous baseball players
Smithsonian 25:40–1,44 (4) Jl '94
— Famous women golfers
Sports Illus 76:47 (c,4) F 3 '92
— Female basketball player with amputated
leg
Sports Illus 80:72–3 (c,1) F 21 '94
— Legless track runner
Life 19:10–11 (c,1) N '96
— Suzanne Lenglen
Nat Geog 190:58 (4) Jl '96
— Nude Olympians
Life 19:cov.,2,65,50–66 (1) Jl '96
— Nude rugby players streaking across field
(France)
Life 17:26–7 (c,1) D '94
— Print advertisements starring athletes
Sports Illus 78:16–19 (c,3) My 3 '93
— *Sports Illustrated*'s "Sportsperson of the
Year" covers (1954–1993)
Sports Illus 81:102–24 (c,4) D 19 '94
— Top disabled athletes
Sports Illus 83:64–76 (c,1) Ag 14 '95
— Top mid-20th cent. sports figures
Sports Illus 81:48–147 (c,1) S 19 '94
— Track mile record holders
Sports Illus 80:70–86 (c,1) Je 27 '94
— See also
AARON, HENRY
ALI, MUHAMMAD
ASHE, ARTHUR
BANNISTER, ROGER
BASEBALL PLAYERS
BASKETBALL PLAYERS
BERRA, YOGI
BODYBUILDERS
BROWN, JIM
BUDGE, DON
CAMPANELLA, ROY
CHAMBERLAIN, WILT
CLEMENTE, ROBERTO
COBB, TY

CORBETT, "GENTLEMAN JIM"
DEAN, DIZZY
DEMPSEY, JACK
DIDRIKSON, BABE
DIMAGGIO, JOE
DUROCHER, LEO
EDERLE, GERTRUDE
ERVING, JULIUS
FENCERS
FOOTBALL PLAYERS
FOXX, JIMMIE
GEHRIG, LOU
GIPP, GEORGE
GOLFERS
GONZALES, PANCHO
GRANGE, "RED" HAROLD
HENIE, SONJA
HILLARY, EDMUND
HOCKEY PLAYERS
HOGAN, BEN
JACKSON, "SHOELESS JOE"
JONES, BOBBY
LOMBARDI, VINCE
LOUIS, JOE
KING, BILLIE JEAN
KOUFAX, SANDY
MACK, CONNIE
MANTLE, MICKEY
MARCIANO, ROCKY
MARIS, ROGER
MAYS, WILLIE
MUSIAL, STAN
NAMATH, JOE
NICKLAUS, JACK
ORR, BOBBY
OWENS, JESSE
PALMER, ARNOLD
PELE
ROBINSON, JACKIE
ROCKNE, KNUTE
RUDOLPH, WILMA
RUGBY PLAYERS
RUTH, GEORGE HERMAN (BABE)
SKIERS
SNEAD, SAM
STENGEL, CASEY
TENNIS PLAYERS
THORPE, JIM
TITTLE, Y.A.
TUNNEY, GENE
UNITAS, JOHNNY
WILLIAMS, ESTHER
WILLIAMS, TED
ATHLETIC STUNTS
— Climbing church tower (Paris, France)

Life 19:20 (c,2) Jl '96
— Cracking bricks with head (California)
 Life 19:88 (c,2) F '96
— History of English Channel swimming
 Smithsonian 27:118–29 (c,1) Ap '96
— Evel Knievel's stunts
 Sports Illus 85:80–1 (c,2) O 7 '96
— Man pulling truck (U.S.S.R.)
 Nat Geog 190:70 (c,4) S '96
— Santa Claus bungee jumping (California)
 Sports Illus 81:106 (c,2) D 26 '94
— Sitting on chair perched on cliff edge
 (Norway)
 Life 16:88 (c,2) Ap '93
— Sitting on tower of tires at California gas
 station (1920s)
 Smithsonian 24:100 (3) O '93
— Stuntmen performing stunts for movies
 Sports Illus 77:76–86 (c,1) O 5 '92

ATLANTA, GEORGIA
Trav/Holiday 177:48,50 (map,c,1) Ap '94
Am Heritage 47:82–92 (c,1) Ap '96
Gourmet 56:72–6 (c,4) Jl '96
— 1865 Civil War damage
 Am Heritage 47:85 (4) Ap '96
— 1903
 Am Heritage 47:86 (4) Ap '96
— Bombing at 1996 Olympics
 Sports Illus 85:22–8 (c,1) Ag 5 '96
 Sports Illus 85:88–94 (c,1) Ag 12 '96
— High Museum
 Gourmet 56:75 (c,4) Jl '96
— Martin Luther King, Jr. memorial
 Am Heritage 47:88–9 (c,2) Ap '96
— Sites related to Martin Luther King, Jr.
 Am Heritage 43:98–9 (c,2) Ap '92
— Stone Mountain carvings
 Am Heritage 47:83 (c,1) Ap '96

ATLANTIC CITY, NEW JERSEY
Trav&Leisure 22:E1–E2 (c,4) Mr '92
Am Heritage 47:30–2 (c,4) Ap '96
— Atlantic City "Monopoly" billboard
 Trav/Holiday 176:30 (c,4) Mr '93

ATLANTIC OCEAN
— Deep-sea geysers
 Nat Geog 182:104–9 (map,c,1) O '92
— Namibian coast
 Nat Geog 181:54–5,65 (c,1) Ja '92

ATLANTIC OCEAN—MAPS
— North Atlantic currents and winds
 Natur Hist 101:28 (c,3) Ja '92

ATOMIC BOMBS
— 1945 bombing of Hiroshima
 Life 18:80 (2) Je 5 '95
 Nat Geog 188:81–7 (1) Ag '95

— 1945 bombing of Nagasaki
 Am Heritage 46:10 (4) N '95
— 1945 U.S. directive to drop bomb on Japan
 Am Heritage 46:70 (1) My '95
— 1946 atomic testing (Bikini)
 Nat Geog 181:70–6 (c,1) Je '92
 Life 19:21 (3) Ag '96
— 1946 cake shaped like mushroom cloud
 Smithsonian 25:54 (4) Ap '94
 Natur Hist 104:1 (4) Jl '95
— 1949 first Soviet atomic explosion
 Natur Hist 104:50 (4) Jl '95
— 1952 hydrogen bomb test (Eniwetok Atoll)
 Am Heritage 46:106 (4) D '95
— 1953 test on mock house (Nevada)
 Life 19:66–7 (1) Ap '96
— 1955 atomic test (Nevada)
 Smithsonian 25:55 (4) Ap '94
 Life 18:108 (4) Je 5 '95
 Am Heritage 47:32 (4) N '96
— 1960s fallout shelters
 Smithsonian 25:46–58 (1) Ap '94
— First atomic bomb test explosion (1945)
 Natur Hist 104:42–3 (1) Jl '95
— Hiroshima after 1945 bombing
 Nat Geog 188:81–7 (1) Ag '95
— Memorial service for 1945 Nagasaki bomb
 Life 18:20–1 (c,1) O '95
— Nagasaki after 1945 bombing
 Life 18:81 (1) Je 5 '95
— Trinity site of first atomic explosions, New
 Mexico
 Natur Hist 104:42–51 (1) Jl '95
— See also
 OPPENHEIMER, ROBERT

AUCKLAND, NEW ZEALAND
Gourmet 55:104 (c,2) Ap '95

AUCTIONS
— Amish country auction (Indiana)
 Trav/Holiday 179:34–7 (c,4) S '96
— Auction school (Missouri)
 Smithsonian 25:40–2 (c,3) Ag '94
— Auctioning 1950s denim outfit (France)
 Nat Geog 185:64–5 (c,1) Je '94
— Farm auction (Indiana)
 Smithsonian 25:44–7 (c,2) Ag '94
— Farm auction (New York)
 Nat Geog 182:128–9 (c,1) N '92
— Fish auction (Japan)
 Nat Geog 188:46–7 (c,1) N '95
— Items auctioned by U.S. Government
 Smithsonian 27:82–93 (c,1) O '96
— Livestock auction (Great Britain)
 Nat Geog 186:22 (c,3) Ag '94
— Livestock auction (Texas)

Smithsonian 25:38–9 (c,1) Ag '94
— London auction house, England
 Gourmet 52:70 (drawing,c,2) N '92
— Race horse sale
 Sports Illus 79:88 (c,4) N 1 '93
— Wild pony auction (Virginia)
 Trav/Holiday 179:40–1 (2) Ap '96
AUDIENCES
— 1912 movie theater (Missouri)
 Am Heritage 44:85 (4) N '93
— 1950s sidewalk audience for the "Today"
 show (New York City)
 Trav&Leisure 24:38 (4) Je '94
— 1955 movie audience in 3-D glasses
 (California)
 Life 18:28 (3) F '95
— Baseball fans acting like dogs
 Sports Illus 83:2–3 (c,1) O 2 '95
— Children at 1963 puppet show (Paris,
 France)
 Life 18:102–3 (1) O '95
— IMAX movie audience in 3-D goggles
 (New York)
 Life 18:28 (c,3) F '95
 Nat Geog 188:18–19 (c,1) O '95
— Outdoor concert (Turkey)
 Nat Geog 185:22–3 (c,1) My '94
— Rock concert (Ireland)
 Nat Geog 186:7 (c,2) S '94
— Theatergoers entering theater (Great
 Britain)
 Trav&Leisure 22:99 (2) Ap '92
AUDUBON, JOHN JAMES
 Trav/Holiday 176:78 (painting,c,4) O '93
— Bird paintings
 Trav/Holiday 176:79–83 (c,1) O '93
 Smithsonian 25:96 (c,1) Jl '94
— Home (New York City, New York)
 Trav/Holiday 176:81 (4) O '93
— Painting of curlews
 Nat Wildlife 34:57 (c,4) Je '96
— Painting of swan
 Nat Wildlife 32:52–3 (c,1) O '94
AUKS
— Auklets
 Nat Wildlife 32:46 (c,4) Ag '94
— Auklets in flight
 Nat Geog 182:90 (c,1) O '92
— Extinct great auk
 Natur Hist 103:6 (painting,c,4) Ag '94
AURORA BOREALIS
 Nat Wildlife 31:58 (c,4) F '93
 Life 17:87–90 (c,1) D '94
 Natur Hist 105:33 (painting,c,4) F '96
 Nat Geog 189:124–5 (c,1) My '96

Trav/Holiday 179:96–100 (c,1) D '96
— Southern aurora
 Nat Geog 190:7–9 (c,1) N '96
AUSTIN, TEXAS
 Trav/Holiday 175:64–75 (c,3) F '92
 Trav&Leisure 25:82–6 (c,4) F '95
— Bats under Congress Avenue Bridge
 Nat Geog 188:57 (c,2) Ag '95
— Capitol building
 Trav&Leisure 25:82 (c,4) F '95
— Threadgill's roadhouse
 Gourmet 54:74 (painting,c,2) Mr '94
AUSTRALIA
 Trav/Holiday 179:38–40 (c,1) D '96
— Ayers Rock
 Trav&Leisure 26:30 (c,4) O '96
— Cape Leveque
 Trav&Leisure 22:118–21 (c,1) F '92
— Cape York Peninsula
 Nat Geog 189:3–37 (map,c,1) Je '96
— Hamersley Basin
 Natur Hist 101:52–3 (c,1) Ag '92
— "Kangaroo Crossing" sign
 Trav&Leisure 26:30 (c,4) O '96
— Kangaroo Island
 Trav&Leisure 24:98–109 (map,c,1) Jl '94
— Kata Tjuta rocks
 Trav/Holiday 176:38 (c,4) D '93
— Kimberley Plateau
 Trav&Leisure 22:118–31,134 (map,c,1) F
 '92
 Trav&Leisure 26:106 (c,4) D '96
— Lake Torrens, South Australia
 Natur Hist 101:42–9 (c,1) Ap '92
— Menindee Lakes, Kinchega
 Trav/Holiday 178:64–5 (c,1) O '95
— Ningaloo Reef
 Nat Geog 182:128–9 (c,1) D '92
— Outback
 Trav/Holiday 178:62–7 (map,c,1) O '95
— Pinnacle Rocks
 Natur Hist 104:A2 (c,4) N '95
— Plant life
 Nat Geog 187:66–89 (c,1) Ja '95
— Queensland
 Nat Geog 187:42–3 (map,c,3) Ap '95
— Queensland rivers
 Nat Geog 186:120 (c,4) Ag '94
— Simpson outback
 Nat Geog 181:64–93 (map,c,1) Ap '92
— Uluru National Park
 Trav/Holiday 175:18 (c,4) S '92
— See also
 ABORIGINES
 ADELAIDE

GREAT BARRIER REEF
MELBOURNE
SYDNEY
TASMANIA
AUSTRALIA—COSTUME
— Cape York Peninsula
Nat Geog 189:cov.,3–33 (c,1) Je '96
— Outback
Nat Geog 181:64–93 (c,1) Ap '92
AUSTRALIA—MAPS
— Northern Territory
Trav/Holiday 176:40 (c,4) D '93
AUSTRALIA—RITES AND FESTIVALS
— Chocolate Easter bilby
Natur Hist 105:16 (c,4) Ap '96
AUSTRALIA—SOCIAL LIFE AND CUSTOMS
— Competitive swimming
Sports Illus 85:190–8 (c,1) Jl 22 '96
AUSTRIA
— Arlberg ski areas
Trav&Leisure 24:102–7,156–8 (map,c,1) N '94
— Matrei
Trav/Holiday 176:50 (c,4) D '93
— St. Anton
Trav&Leisure 24:103 (c,1) N '94
— Sites related to famous composers
Trav&Leisure 25:133–6 (map,c,4) O '95
— Stylized depiction of Austrian village
Gourmet 54:102 (painting,c,2) N '94
— Vorarlberg province
Gourmet 55:96–9,152 (map,c,1) Je '95
— Zurs
Trav&Leisure 24:102–7 (c,1) N '94
— See also
DANUBE RIVER
GRAZ
SALZBURG
VIENNA
AUSTRIA—MAPS
Trav/Holiday 176:48 (c,4) D '93
Trav&Leisure 25:133 (c,4) O '95
AUSTRIA—SOCIAL LIFE AND CUSTOMS
— 1945 rescue of Lipizzan horses by Americans
Sports Illus 83:6–7 (4) O 16 '95
— Vienna Opera Ball
Life 16:12–13 (c,1) Mr '93
AUTOGRAPH SIGNING
— Author signing books
Sports Illus 80:80 (c,3) Mr 7 '94
— Baseball player (1950)

Am Heritage 43:35 (4) O '92
— Baseball players
Sports Illus 78:14–15,20–1 (c,1) My 3 '93
Sports Illus 81:48 (c,4) Jl 4 '94
Smithsonian 25:73 (c,3) O '94
Sports Illus 82:46 (c,2) Ja 16 '95
Sports Illus 82:58 (c,4) My 22 '95
Sports Illus 83:24–5 (c,1) Ag 7 '95
— Football player
Sports Illus 79:23 (c,4) Ag 2 '93
— Golfers
Sports Illus 77:2–3 (c,1) Ag 24 '92
AUTOMOBILE INDUSTRY
— 1895 Selden engine patent
Am Heritage 47:18 (c,4) N '96
— Early 20th cent. plants designed by Kahn
Smithsonian 25:48–59 (c,1) S '94
— 1930 automobile factory (Indiana)
Am Heritage 45:92 (3) Jl '94
— 1948 Tuckers
Life 19:80–1 (1) Winter '96
— Car factory (China)
Nat Geog 185:13 (c,4) Mr '94
— Car factory (Japan)
Nat Geog 185:110–11 (c,2) Ja '94
— Crash test dummies
Smithsonian 26:cov.,30–41 (c,1) Jl '95
— Designing electric cars (Michigan)
Smithsonian 23:38–41 (c,3) Ap '92
— Designing car on computer (Michigan)
Nat Geog 188:24–5 (c,1) O '95
— August and Fred Duesenberg
Am Heritage 45:91 (4) Jl '94
— See also
CHRYSLER, WALTER P.
DURANT, WILLIAM
DURYEA BROTHERS
FORD, HENRY
KAISER, HENRY
SLOAN, ALFRED P., JR.
AUTOMOBILE MECHANICS
— Mechanic working on racing car
Sports Illus 78:54 (c,3) My 31 '93
Sports Illus 83:44 (c,3) Jl 17 '95
— Restoring classic cars to hot rods
Smithsonian 24:54–5 (c,2) Jl '93
AUTOMOBILE RACING
— 1895 first auto race (Chicago, Illinois)
Am Heritage 43:69 (2) My '92
— Early 20th cent. Vanderbilt Cup trophy
Am Heritage 43:114 (c,4) My '92
— 1904 Vanderbilt Cup race (Long Island, New York)
Sports Illus 83:76 (4) D 25 '95
— 1905 (Long Island, New York)

Am Heritage 43:104 (3) Ap '92
— 1906 auto race crash
Am Heritage 43:70 (4) My '92
— 1908 "Great Car Race" from New York to
Paris
Am Heritage 47:64–77 (c,1) N '96
— 1909 (Indianapolis, Indiana)
Am Heritage 43:66–7 (1) My '92
— 1910 (Long Island, New York)
Am Heritage 43:70 (2) My '92
— 1912 French Grand Prix
Life 19:36–7 (1) Winter '96
— 1921 French Grand Prix
Am Heritage 45:91 (2) Jl '94
— 1930 (Long Island, New York)
Am Heritage 43:76 (4) My '92
— 1987 Safari Rally car off the ground
(Kenya)
Sports Illus 81:2–3 (c,1) N 14 '94
— 1991 highlights
Sports Illus 76:47–58 (c,1) F 17 '92
— Andretti family history
Sports Illus 76:78–93 (c,1) My 11 '92
— Automobile race crashes
Am Heritage 43:70–1 (c,4) My '92
Sports Illus 76:18–23 (c,1) My 18 '92
Sports Illus 76:9 (c,4) My 25 '92
Sports Illus 76:2–3,16–19 (c,1) Je 1 '92
Sports Illus 79:38–9 (c,2) Ag 2 '93
Sports Illus 80:79 (c,2) Mr 21 '94
Sports Illus 80:60–2 (c,1) My 9 '94
Sports Illus 80:2–3 (c,1) Je 6 '94
Sports Illus 82:26–9 (c,1) Je 5 '95
— Daytona 500 (1970)
Sports Illus 76:82 (c,3) My 11 '92
— Daytona 500 (1988)
Sports Illus 77:68 (c,2) O 19 '92
— Daytona 500 (1993)
Sports Illus 78:24–7 (c,1) F 22 '93
Sport Illus 78:60 (c,3) Je 7 '93
— Daytona 500 (1994)
Sports Illus 80:56–8 (c,2) F 28 '94
Sports Illus 84:12 (c,4) F 19 '96
— Daytona 500 (1995)
Sports Illus 82:62–4 (c,3) F 27 '95
— Daytona 500 (1996)
Sports Illus 84:36–41 (c,1) F 26 '96
— First Indianapolis 500 (1911)
Am Heritage 43:74 (2) My '92
Sports Illus 76:12 (3) My 18 '92
Life 19:26 (4) Winter '96
— Flipped over race car (1987)
Sports Illus 81:57 (c,1) N 14 '94
— Formula One race (Argentina)
Sports Illus 83:38–9 (c,1) Jl 17 '95
— History of American auto racing
Am Heritage 43:cov.,66–81 (c,1) My '92
— Indianapolis 500 history
Sports Illus 76:8–12 (c,2) My 18 '92
Sports Illus 80:41–60 (c,1) My 30 '94
— Indianapolis 500 (1956)
Am Heritage 43:80 (c,4) My '92
— Indianapolis 500 (1969)
Sports Illus 76:81 (4) My 11 '92
— Indianapolis 500 (1970)
Sports Illus 82:47–8 (c,1) My 29 '95
— Indianapolis 500 (1977)
Sports Illus 78:48–9 (c,1) My 31 '93
— Indianapolis 500 (1978)
Sports Illus 82:53 (c,4) My 29 '95
— Indianapolis 500 (1985)
Sports Illus 82:54 (c,3) My 29 '95
— Indianapolis 500 (1987)
Sports Illus 82:46,56 (c,4) My 29 '95
— Indianapolis 500 (1990)
Am Heritage 43:81 (c,2) My '92
Life 19:104–5 (c,1) Winter '96
— Indianapolis 500 (1991)
Sports Illus 76:54 (c,4) F 17 '92
— Indianapolis 500 (1992)
Sports Illus 76:2–3,14–19 (c,1) Je 1 '92
— Indianapolis 500 (1993)
Sports Illus 78:22–7 (c,1) Je 7 '93
— Indianapolis 500 (1994)
Sports Illus 80:2–3,32–3 (c,1) Je 6 '94
— Indianapolis 500 (1995)
Sports Illus 82:26–31 (c,1) Je 5 '95
— Indianapolis 500 (1996)
Sports Illus 84:22–5 (c,1) Je 3 '96
— Indianapolis 500 car on fire (1964)
Sports Illus 80:44–5 (1) My 30 '94
— Monaco
Nat Geog 189:88–9 (c,1) My '96
— NASCAR racing
Sports Illus 78:33–8 (c,2) F 15 '93
Sports Illus 81:24–8 (c,1) Ag 15 '94
Sports Illus 82:68–71 (c,1) F 6 '95
Sports Illus 82:47–9 (c,1) Ap 24 '95
Sports Illus 83:cov.,18–24 (1) Jl 24 '95
Sports Illus 83:12–13 (c,2) Ag 7 '95
Sports Illus 84:42–7 (c,1) Ap 22 '96
— Reenactment of 1895 race (Illinois)
Life 19:106–7 (c,1) Winter '96
— Soap box derby
Life 15:24 (c,4) Ag '92
Smithsonian 26:26–8 (c,4) My '95
— Stock car race (North Carolina)
Nat Geog 187:132–3 (c,2) Mr '95
— Sunrayce 95 for sun-powered cars
(Indianapolis)

Sports Illus 83:70–2 (c,4) Ag 21 '95
— 24 hours of Le Mans, France
Sports Illus 82:50–4 (c,1) Je 26 '95
— U.S. 500 1996 (Michigan)
Sports Illus 84:20–1 (c,1) Je 3 '96
AUTOMOBILE RACING—HUMOR
— 1968
Sports Illus 81:44–5 (painting,c,1) Ag 8 '94
AUTOMOBILE RACING CARS
Sports Illus 78:52–3 (c,2) My 3 '93
Sports Illus 82:7–16 (c,1) Ap 10 '95
— 1906 Stanley Steamer
Life 19:20 (4) Winter '96
— 1911 Marmon winner of first Indianapolis 500
Am Heritage 43:74 (2) My '92
Life 19:26 (4) Winter '96
— 1935 Aston Martin
Sports Illus 85:24 (c,4) O 7 '96
— 1947 Offy midget
Am Heritage 43:78 (2) My '92
— 1955 D.A. Lubricants Indy roadster
Sports Illus 85:24 (c,4) O 7 '96
— 1956 Traylor Special
Am Heritage 43:80 (c,4) My '92
— Car at pit stop
Life 17:112 (c,2) Je '94
— Hooked rug depiction of 1950 Indy 500 winner
Am Heritage 44:93 (c,4) D '93
— Jet car designed to break sound barrier
Sports Illus 85:20 (c,4) O 14 '96
AUTOMOBILES
Am Heritage 47:entire issue (c,1) N '96
— 1895 Duryea car
Smithsonian 25:105 (4) S '94
Life 19:18–19 (1) Winter '96
— Early 20th cent. electric car
Smithsonian 23:37 (4) Ap '92
— 1901 Winton
Am Heritage 43:93 (4) F '92
— 1904
Am Heritage 46:88–9 (painting,c,1) Jl '95
— 1908
Am Heritage 47:64–77 (c,1) N '96
— 1908 Peerless
Life 19:22–3 (1) Winter '96
— 1909 Maxwell
Life 19:29 (4) Winter '96
— 1910
Life 16:24–5 (1) Ap 5 '93
— 1910s Templar runabout
Am Heritage 47:78–9 (1) N '96
— 1912 Studebakers

Am Heritage 44:112 (3) F '93
— 1919 auto collision
Life 19:38 (2) Winter '96
— 1920 Model T Ford
Life 19:44 (2) Winter '96
— 1925
Am Heritage 44:94 (2) Jl '93
Am Heritage 45:69 (4) O '94
— 1928 Model A Ford
Am Heritage 43:32 (4) S '92
— 1929 Duesenberg
Am Heritage 45:88–9 (c,1) Jl '94
— 1930s Duesenbergs
Am Heritage 45:94–9,114 (c,1) Jl '94
Life 19:48–9 (1) Winter '96
— 1933 Ford
Smithsonian 24:cov.,59 (c,1) Jl '93
— 1935 Cord
Am Heritage 47:6 (c,3) N '96
— 1937
Am Heritage 46:104 (2) S '95
— 1938 Cadillac
Am Heritage 47:84–5,88 (c,1) N '96
— 1939 La Salle
Life 19:64–5 (c,1) Winter '96
— 1940s
Trav/Holiday 179:107 (c,1) D '96
— 1946 Ford convertible
Smithsonian 24:50–1 (c,2) Jl '93
— 1948 Chevrolet
Trav/Holiday 176:78–9 (c,3) Mr '93
— 1948 Tuckers
Life 19:80–1 (1) Winter '96
Smithsonian 27:52 (c,4) My '96
— 1950 pink Cadillac
Life 19:82–3 (c,1) Winter '96
— 1950s Edsels
Life 18:26 (c,4) Ag '95
Life 19:95 (c,4) Winter '96
— 1950s foreign sports cars
Am Heritage 47:93–100 (c,4) N '96
— 1953 Corvette
Life 19:95 (c,4) Winter '96
— 1954 Ferrari
Sports Illus 85:24 (c,4) O 7 '96
— 1957 Chevrolet turned into hot rod
Smithsonian 24:52–3 (c,2) Jl '93
— 1959 Chevrolet Bel Air
Nat Geog 184:31 (c,3) Ag '93
— 1960s muscle cars
Life 19:89–93 (c,1) Winter '96
— 1960s Sting Rays
Am Heritage 47:90–1 (4) N '96
— 1963 Cadillac
Life 16:34 (c,4) Je '93

— 1963 Corvette
Life 16:33 (c,4) Je '93
— 1963 Riviera
Am Heritage 47:90 (4) N '96
— 1963 woody station wagon
Life 16:31 (c,4) Je '93
— 1966 Cadillac
Trav&Leisure 25:158 (c,1) S '95
— 1966 Toronado
Am Heritage 47:91 (4) N '96
— American cars in use around the world
(1920s)
Am Heritage 47:78–83 (1) N '96
— Art cars
Smithsonian 26:34–6 (c,2) Ag '95
Smithsonian 26:20 (c,4) O '95
— Car dented by meteorite (New York)
Natur Hist 102:61 (c,2) Jl '93
— Classic auto dashboards
Life 19:52–7 (c,1) Winter '96
— Classic cars turned into hot rods
Smithsonian 24:cov.,50–9 (c,1) Jl '93
— Driver reading road map
Smithsonian 25:56 (c,4) O '94
— Driving a convertible
Sports Illus 81:38–9 (c,1) D 12 '94
— Driving car
Sports Illus 84:38 (c,2) F 12 '96
— Durant "Star"
Am Heritage 47:18 (4) F '96
— Electric cars
Smithsonian 23:34–43 (c,2) Ap '92
Life 19:111–15 (c,1) Winter '96
— Family driving on vacation
Trav/Holiday 176:cov.,33 (c,1) Jl '93
Life 17:cov.,71 (c,1) Ap '94
— History of automobiles in America
Life 19:entire issue (c,1) Winter '96
— History of the 1915 transcontinental
Lincoln Highway
Am Heritage 46:48–60 (c,1) Ap '95
— History of the Duesenberg
Am Heritage 45:88–99,114 (c,1) Jl '94
— Kids piled into 1958 Volkswagen Beetle
Life 19:96 (1) Winter '96
— Old pickup truck
Trav&Leisure 24:143 (c,4) F '94
— Replica of 1893 Duryea car
Smithsonian 25:104–8 (c,1) S '94
— Sculpture of half-buried Cadillacs
(Nebraska)
Life 19:116 (c,2) Winter '96
— Toddlers driving toy cars
Life 15:25 (c,4) D '92
— Washing the car (1958)

Life 19:95 (3) Winter '96
— See also
AUTOMOBILE RACING CARS
AUTOMOBILES—TRAFFIC
JEEPS
LICENSE PLATES
PARKING METERS
TIRES
AUTOMOBILES—TRAFFIC
— Bangkok, Thailand
Nat Geog 189:92 (c,3) F '96
— Crowded vacation town (Great Britain)
Nat Geog 186:10 (c,3) Ag '94
— India's Grand Trunk Road
Smithsonian 23:115–16 (c,2) My '92
— New York cat holding up traffic (1925)
Am Heritage 45:69 (4) O '94
— Selling coffee to commuters (Boston)
Nat Geog 186:28 (c,3) Jl '94
— Switzerland highway
Smithsonian 24:47 (c,4) N '93
— Unsnarling gridlock (El Salvador)
Nat Geog 188:123 (c,3) S '95
— See also
TRAFFIC LIGHTS
AUTRY, GENE
Sports Illus 76:60–1,67 (c,1) Ap 13 '92
AUTUMN
— Alaska
Nat Wildlife 31:2–3 (c,2) O '93
— Autumn vegetables
Nat Geog 181:62–3 (c,1) My '92
— Birch trees
Nat Wildlife 30:57 (c,1) O '92
— Catskill Mountains, New York
Nat Geog 182:110–11,120–1,125 (c,1) N
'92
— Delaware
Trav/Holiday 178:38–42 (c,1) S '95
— Forest in autumn (France)
Natur Hist 103:54–5 (c,1) N '94
— Grand Teton National Park, Wyoming
Nat Wildlife 34:28–9 (c,1) O '96
— New England
Trav/Holiday 175:79–86 (c,1) S '92
Gourmet 52:112 (c,4) N '92
Gourmet 53:78 (c,4) S '93
Nat Geog 185:64–6 (c,1) F '94
Nat Wildlife 33:2,30–5 (c,1) O '95
— Tennessee countryside
Nat Geog 184:130–1 (c,1) Ag '93
— Trees in autumn
Natur Hist 102:58–9,62–3 (c,1) S '93
— Wisconsin countryside
Trav&Leisure 22:50 (c,3) S '92

Am Heritage 45:52–3 (c,1) S '94
AVIATION
— 1903 Wright Brothers plane (Washington, D.C.)
 Smithsonian 27:44 (c,4) My '96
— 1910 glider take-off (France)
 Smithsonian 26:26 (4) F '96
— 1920s helicopter plant (New York)
 Am Heritage 43:44 (4) Ap '92
— 1932 airship construction (Ohio)
 Nat Geog 181:116 (1) Ja '92
— 1950s flight attendants
 Trav/Holiday 179:15 (4) S '96
— 1971 stewardesses
 Trav&Leisure 26:76 (c,4) S '96
— Air traffic controllers (Texas)
 Smithsonian 24:36 (c,4) Ap '93
— Flight attendant training
 Smithsonian 24:88–97 (c,2) F '94
— Flight attendants
 Trav/Holiday 177:64–7 (painting,c,1) F '94
— Museum of Naval Aviation, Pensacola, Florida
 Trav&Leisure 22:140 (c,4) Mr '92
— Retracing 1919 flight across Asia
 Nat Geog 187:cov.,2–43 (map,c,1) My '95
— See also
 AIRPLANE FLYING
 AIRPLANE PILOTS
 AIRPLANES
 AIRPORTS
 AIRSHIPS
 EARHART, AMELIA
 HANG GLIDING
 HELICOPTERS
 LINDBERGH, CHARLES A.
 SIKORSKY, IGOR
 WRIGHT, WILBUR AND ORVILLE
 ZEPPELIN, FERDINAND VON
AVIGNON, FRANCE
 Gourmet 53:92–7,132 (c,1) F '93
AVOCETS
 Sports Illus 76:8 (c,4) Je 15 '92
AWARDS
— Blue ribbon at fair (Maine)
 Smithsonian 24:93 (c,2) S '93
— See also
 NOBEL PRIZE
AXES
— Copper Age ax (Italy)
 Nat Geog 183:51 (c,3) Je '93
— Neolithic amber axes
 Natur Hist 105:97 (c,4) F '96
— Sharpening ax (Brazil)

Natur Hist 101:40–1 (c,2) Mr '92
AZORES
— Pico Island
 Nat Geog 182:64–5 (c,2) N '92
AZTEC CIVILIZATION
— Tenochtitlan
 Smithsonian 23:63 (painting,c,4) O '92
AZTEC CIVILIZATION—ART
— 14th cent. Aztec skull sculpture
 Natur Hist 105:34 (c,4) O '96
AZTEC CIVILIZATION—ARTIFACTS
— 1576 genealogical chart and map
 Smithsonian 23:114 (c,4) F '93
— Aztec ceremonial masks
 Natur Hist 105:36–7 (c,2) O '96
— Mosaic-covered skull
 Smithsonian 25:97 (c,4) D '94
AZTEC CIVILIZATION—COSTUME
— Aztec healer with medicinal plants
 Natur Hist 105:7 (painting,c,3) Jl '96
— Quetzal dancers
 Life 15:52 (c,3) Jl '92
AZTEC CIVILIZATION—HISTORY
— 1519 conquest by Hernan Cortes
 Smithsonian 23:56–69 (painting,c,1) O '92
— See also
 MONTEZUMA

–B–

BABIES
 Smithsonian 24:123 (c,4) Je '93
 Life 16:cov.,46–60 (c,1) Jl '93
 Life 18:cov. (c,1) Ap '95
— Late 17th cent. baby cradle
 Am Heritage 43:102 (c,4) S '92
— 19th cent. Indian amulets holding umbilical cords
 Smithsonian 23:129 (c,4) N '92
 Sports Illus 85:68–9 (c,1) O 14 '96
— Adding to "Old Pacifier" tree (Denmark)
 Life 15:26 (c,4) Je '92
— America woman adopting Chinese infant
 Life 19:27–34 (c,2) My '96
— Babies nursing (Brazil)
 Natur Hist 101:42 (c,4) Mr '92
 Nat Geog 186:74–5 (c,2) Jl '94
— Bathing infant
 Nat Wildlife 33:44 (c,4) Ap '95
— Bundled up against cold (Alaska)
 Nat Geog 182:102–3 (c,1) O '92
— Changing diaper
 Sports Illus 81:52 (c,1) D 12 '94
— Child in suspended cradle (Iraq)

Nat Geog 182:38 (c,1) Ag '92
— Child napping (Sao Tome and Principe)
Nat Geog 182:73 (c,2) N '92
— Children with Fetal Alcohol Syndrome
Nat Geog 181:36–9 (c,2) F '92
— Communal toilet training (Russia)
Nat Geog 190:60–1 (c,2) O '96
— Doing back float in pool
Life 18:14–15 (c,1) Ag '95
— Face pushed up against baseball fence
Sports Illus 84:2–3 (c,1) Mr 11 '96
— Father feeding baby
Sports Illus 77:40–1 (c,1) Ag 3 '92
— Father kissing baby son
Sports Illus 85:48–9 (c,1) S 30 '96
— Fetus
Life 19:68 (c,1) Ap '96
Life 19:50–1 (c,1) O '96
Life 19:cov.,38–56 (c,1) N '96
— In mother's front pack
Nat Geog 188:78–9 (c,1) D '95
— Indian cradleboards
Nat Geog 185:99 (c,1) Je '94
Smithsonian 25:40 (c,4) O '94
— Infant nursing
Life 16:cov. (c,1) D '93
— Infants in flower pots (New Zealand)
Life 15:86 (2) N '92
— Medical care for premature infants
Life 19:60–8 (c,1) Mr '96
Life 19:18 (c,2) Je '96
— Mother holding newborn
Life 15:84–5 (1) Ap '92
— Newborns in hospital (China)
Nat Geog 185:32–3 (c,2) Mr '94
— Packed in basket for journey (Nepal)
Nat Geog 184:33 (c,3) D '93
— Sick infant hooked up to medical
equipment
Life 16:88 (c,4) D '93
— Starving babies (Somalia)
Life 15:6–9 (c,1) N '92
— Supertwins (multiple birth babies)
Smithsonian 27:cov.,30–41 (c,1) S '96
— Toddler in backpack (China)
Trav/Holiday 176:61 (c,4) F '93
— Toddlers playing in paint (France)
Life 16:26 (c,4) My '93
— Triplets
Life 16:75–6 (c,4) D '93
Smithsonian 27:22 (c,4) N '96
— Tuareg infant's naming ceremony (Niger)
Natur Hist 101:54–62 (c,1) N '92
— Woman caring for sick babies
Life 15:49–56 (1) My '92

— See also
BABY CARRIAGES
BABY STROLLERS
BAPTISMS
CHILDBIRTH
CHILDREN
FAMILIES
FAMILY LIFE
PREGNANCY
BABOONS
Natur Hist 101:48–9 (c,1) F '92
Trav&Leisure 22:134–5 (c,1) Je '92
Smithsonian 24:122 (c,4) Je '93
Nat Geog 186:33 (c,3) D '94
Smithsonian 27:110 (c,2) My '96
Life 19:70–1 (c,1) O '96
— Impressionistic paintings of baboons
Natur Hist 105:16–20 (c,3) D '96
BABY CARRIAGES
— 1961
Trav&Leisure 22:80–1 (1) O 30 '92
BABY STROLLERS
— Iraq
Nat Geog 183:50–1 (c,1) My '93
— Quintmobile
Smithsonian 27:32 (c,4) S '96
BABYLONIAN CIVILIZATION—
ARTIFACTS
— 1500 B.C. clay tablet map
Smithsonian 23:113 (c,4) F '93
— Glazed brick depiction of dragon
Natur Hist 105:12 (c,3) F '96
BACALL, LAUREN
Am Heritage 45:39 (4) Ap '94
Smithsonian 25:102 (4) O '94
Life 18:80 (4) O '95
— 1945 wedding to Humphrey Bogart
Life 18:66–7 (1) Je 5 '95
BACHELOR'S-BUTTONS
Natur Hist 103:82 (c,4) N '94
BACTERIA
Nat Geog 184:36–61 (c,1) Ag '93
Natur Hist 103:39–41 (c,1) Je '94
— Cyanobacteria
Natur Hist 103:cov.,14 (c,1) Je '94
— Ocean bacteria
Nat Geog 186:121 (c,4) N '94
BADEN-BADEN, GERMANY
Gourmet 55:134–5,196 (map,c,1) N '95
BADGERS
Nat Wildlife 34:18–23 (c,1) D '95
BADLANDS NATIONAL PARK,
SOUTH DAKOTA
Am Heritage 44:26 (c,4) My '93
Gourmet 55:48–51 (c,1) Ag '95

Natur Hist 105:cov.,34–41 (map,c,1) Ap
'96
BADMINTON PLAYING
— High school
Sports Illus 84:97 (c,4) My 13 '96
— Indonesia
Sports Illus 85:200–6 (c,1) Jl 22 '96
— Sewing shuttlecocks (Indonesia)
Sports Illus 85:206 (c,3) Jl 22 '96
BAFFIN ISLAND, CANADA
Nat Geog 190:126–39 (map,c,1) O '96
BAGPIPE PLAYING
— In snow (New York)
Trav&Leisure 25:E8 (c,4) Ja '95
BAHAMAS
Gourmet 52:54–7, 88 (map,c,1) Ja '92
— Andros Island
Trav&Leisure 26:70–6 (map,c,4) O '96
— Exuma Islands
Trav/Holiday 177:58–67 (map,c,1) S '94
— Markers at Columbus landing sites (San
Salvador)
Natur Hist 105:24 (c,4) O '96
— See also
NASSAU
BAHAMAS—MAPS
Trav&Leisure 23:172 (c,4) N '93
BAHRAIN—COSTUME
Nat Geog 187:22–3 (c,1) My '95
BAKER, JOSEPHINE
Life 17:41 (4) Je '94
BAKERIES
— Baking bread (Italy)
Gourmet 55:48 (c,4) Jl '95
— Bread racks (Massachusetts)
Gourmet 54:116 (c,4) My '94
— Paris, France
Gourmet 53:120–3 (c,1) D '93
Trav/Holiday 177:64 (c,4) D '94
Smithsonian 25:50–8 (c,1) Ja '95
— Pittsburgh baking plant, Pennsylvania
Smithsonian 24:118–28 (1) O '93
— Scotland
Nat Geog 190:18 (c,1) S '96
BAKING
— Ancient Egyptian method of baking bread
Nat Geog 187:32–5 (c,1) Ja '95
— Bread (France)
Smithsonian 25:52–8 (c,4) Ja '95
— Making bread in outdoor stone oven
(Macedonia)
Nat Geog 189:130–1 (c,3) Mr '96
— Making focaccia (Italy)
Trav&Leisure 26:70 (4) Jl '96
— Pittsburgh plant, Pennsylvania

Smithsonian 24:118–28 (1) O '93
— Viennese pastries (Austria)
Trav/Holiday 179:68–73 (c,1) O '96
Gourmet 56:94 (c,4) D '96
BALL, LUCILLE
Smithsonian 25:28 (c,4) F '95
Life 19:77 (c,2) Mr '96
BALLET DANCERS
— Ballerina
Life 16:16–17 (c,1) F '93
— Dancer's bruised feet
Life 19:60–1 (c,4) Ap '96
— Degas ballerinas
Smithsonian 27:cov.,96–105 (painting,c,1)
O '96
— See also
NUREYEV, RUDOLF
BALLET DANCING
Life 18:24–30 (3) Mr '95
Life 19:58–65 (c,1) Ap '96
— Chimpanzee in tutu
Nat Geog 181:37 (c,1) Mr '92
— Israel
Nat Geog 181:63 (c,1) F '92
— Minnesota
Nat Geog 184:83 (c,4) D '93
— "The Nutcracker" movie (1993)
Life 16:34–44 (c,1) D '93
— Wheelchair ballet
Life 16:22 (4) Ap '93
BALLET DANCING—EDUCATION
— 1930 practice (France)
Life 18:100–1 (1) O '95
— Ballet class (Cuba)
Life 17:16 (c,2) D '94
— Children's ballet class (Massachusetts)
Life 15:65 (c,2) Ap '92
— Vermont
Smithsonian 26:60–9 (c,1) My '95
BALLOONING
— 1793 (Pennsylvania)
Am Heritage 44:36 (drawing,4) F '93
— Albuquerque festival, New Mexico
Trav&Leisure 24:66–8 (c,4) S '94
— California
Gourmet 54:86–7 (c,1) Mr '94
Trav&Leisure 25:74 (c,4) F '95
— Colorado
Gourmet 52:40 (c,4) Jl '92
Sports Illus 78:82–4 (c,3) Je 14 '93
— Minnesota
Trav&Leisure 24:172 (c,4) My '94
— Painting hot air balloons (Minnesota)
Trav&Leisure 24:172 (c,4) My '94
— Utah

Gourmet 55:88 (c,4) Je '95
BALLOONS
Gourmet 56:141 (c,2) Ap '96
— Champagne company launching balloon
(Russia)
Life 15:14–15 (c,1) My '92
— Huge motorcycle-shaped balloon
Smithsonian 24:95 (c,3) N '93
— Liberty Bell balloon for parade
(Pennsylvania)
Trav/Holiday 178:63 (c,4) N '95
— Ozone-measuring balloon (Antarctica)
Life 16:81 (c,3) Mr '93
— Preparing balloons for Macy's Thanks-
giving Day parade (Hoboken, New
Jersey)
Life 16:15–18 (c,1) N '93
— Tyrannosaurus rex balloon
Nat Geog 183:6 (c,1) Ja '93
BALLOONS, TOY
— Balloon bursting contest (Minnesota)
Nat Geog 182:102–3 (c,1) S '92
BALTIMORE, MARYLAND
Gourmet 54:138–43,220 (map,c,1) N '94
Trav&Leisure 25:E1–E2 (map,c,4) Ap '95
Trav/Holiday 179:54–9 (c,1) Jl '96
— American Visionary Art Museum treasures
Trav&Leisure 26:65–8 (c,4) Ap '96
— Baltimore Arts tower
Trav/Holiday 179:56 (c,4) Jl '96
— Camden Yards
Sports Illus 76:34–6,41 (c,1) Ap 13 '92
Trav&Leisure 22:17 (c,4) Ag '92
Sports Illus 77:44–5 (c,1) D 28 '92
— Fell's Point
Am Heritage 44:83 (c,1) Ap '93
— George Peabody Library
Trav/Holiday 179:57 (c,1) Jl '96
— Inner-city neighborhood
Life 16:70–6 (1) F '93
BAMBOO PLANTS
Trav/Holiday 176:68 (c,4) My '93
Trav/Holiday 177:68 (c,4) Jl '94
— Wildlife inside bamboo stalks
Smithsonian 25:120–9 (c,1) O '94
BANANA INDUSTRY
— California banana grove
Gourmet 54:114 (c,4) My '94
— Sorting bananas (Costa Rica)
Nat Wildlife 31:25 (c,2) Ap '93
BANANA TREES
Trav/Holiday 175:50 (c,4) F '92
**BANDELIER NATIONAL MONU-
MENT, NEW MEXICO**
Gourmet 53:132 (C,4) N '93

BANDICOOTS
Nat Geog 190:42 (drawing,4) N '96
BANDS
— Original Dixieland Jazz Band (1917)
Am Heritage 43:100–1 (1) F '92
— Pakistan
Trav&Leisure 24:122 (c,1) S '94
BANDS, MARCHING
— Band playing in ocean (California)
Nat Geog 184:62 (c,4) Jl '93
— Bermuda
Trav/Holiday 177:71 (c,3) My '94
— College band
Sports Illus 83:2–3 (c,1) D 18 '95
— Euro Disney, Paris, France
Trav&Leisure 22:80–1 (c,1) Ag '92
— High school band (Georgia)
Life 16:8–9 (c,1) F '93
— Mexico
Nat Geog 186:48–9 (c,2) N '94
— Practicing in lake (Indiana)
Life 16:18 (c,4) O '93
— U.S. Navy band
Life 15:18–19 (c,2) O 30 '92
— Wisconsin
Trav&Leisure 25:163 (c,1) S '95
BANFF NATIONAL PARK, ALBERTA
Nat Geog 186:56–7 (c,1) D '94
Nat Geog 188:46–69 (map,c,1) Jl '95
— Banff Springs Hotel
Nat Geog 188:60–1 (c,1) Jl '95
BANGKOK, THAILAND
Nat Geog 189:92–3 (c,2) F '96
Trav&Leisure 26:166,233–4 (c,4) S '96
— Resort hotel
Trav&Leisure 24:78–83 (c,1) Ag '94
— Wat Po temple
Trav&Leisure 24:81 (c,4) Ag '94
BANGLADESH
Nat Geog 183:118–34 (map,c,1) Je '93
— See also
BRAHMAPUTRA RIVER
BANGLADESH—COSTUME
Nat Geog 183:118–34 (c,1) Je '93
BANJO PLAYING
— Jerry Garcia
Life 18:17 (2) O '95
— Tennessee
Nat Geog 183:126–7 (c,1) F '93
— Wyoming
Trav/Holiday 177:46 (2) S '94
BANJOS
Smithsonian 27:56 (c,4) Jl '96
— 1895 Fairbanks banjo
Am Heritage 44:30–1 (c,1) Jl '93

BANKING
— Currency exchange kiosk (Afghanistan)
 Nat Geog 184:82–3 (c,1) O '93
— International ATM symbol
 Trav/Holiday 176:28 (4) S '93
— See also
 CREDIT CARDS
BANNISTER, ROGER
 Sports Illus 80:70–3,82,86 (c,1) Je 27 '94
 Sports Illus 81:30–3 (1) Ag 15 '94
— Bannister breaking four-minute mile
 (1954)
 Sports Illus 80:72–3 (1) Je 27 '94
BANYAN TREES
 Trav/Holiday 176:66–7 (c,3) My '93
 Trav&Leisure 25:114 (c,4) My '95
— Roots
 Nat Wildlife 31:59 (c,4) O '93
BAOBAB TREES
 Nat Wildlife 31:59 (c,4) O '93
BAPTISMS
— Adult baptism (Israel)
 Nat Geog 187:66–7 (c,2) Je '95
— Adult baptism (Jamaica)
 Trav/Holiday 179:70–1 (c,1) N '96
— Adult baptism (Tobago)
 Nat Geog 185:82–3 (c,1) Mr '94
— Australia
 Nat Geog 189:29 (c,4) Je '96
— Los Angeles, California
 Nat Geog 181:44–5 (c,1) Je '92
— Moscow, U.S.S.R.
 Life 19:80 (c,3) Jl '96
BARBADOS
 Trav/Holiday 177:60–7 (map,c,1) Mr '94
— Resort hotel
 Trav&Leisure 22:146–51 (c,2) Je '92
— Turner's Hall Woods
 Natur Hist 104:72–4 (map,c,2) O '95
**BARBADOS—SOCIAL LIFE AND
CUSTOMS**
— Boys playing cricket
 Natur Hist 104:58 (c,3) My '95
BARBARY APES
 Nat Geog 190:71 (c,4) N '96
BARBER SHOPS
— Florida
 Trav/Holiday 178:53 (c,4) Mr '95
— Mojave Desert, California
 Trav&Leisure 23:110 (4) D '93
— Rome, Italy
 Trav/Holiday 177:58 (c,3) My '94
BARCELONA, SPAIN
 Trav&Leisure 22:86–8 (c,2) Ja '92

Trav/Holiday 175:cov.,54–65 (map,c,1)
 Mr '92
— Cathedral
 Trav/Holiday 175:61 (c,1) Mr '92
— Gaudi architecture
 Gourmet 52:104–9 (c,1) My '92
— Museu d'Art Contemporani
 Trav&Leisure 26:39 (c,4) Mr '96
— Olympics Stadium
 Trav&Leisure 22:87 (c,4) Ja '92
— Outdoor sculpture "Match Cover"
 Smithsonian 26:81 (c,2) Ag '95
— Palau de la Musica Catalana interior
 Trav&Leisure 24:74 (c,4) Mr '94
— Palau Nacional
 Sports Illus 77:60–1 (c,1) Ag 10 '92
— Sagrada Familia Church
 Gourmet 52:104–5,109 (c,1) My '92
— Sant Jordi Stadium
 Trav/Holiday 175:55 (c,1) Mr '92
 Smithsonian 23:58–60 (c,2) Jl '92
BARGES
— Canal sightseeing barge (Burgundy,
 France)
 Trav/Holiday 179:60–6 (c,1) Jl '96
— Coal barge on canal (Germany)
 Nat Geog 182:20–3 (c,1) Ag '92
— Concert hall on barge (Brooklyn, New
 York)
 Smithsonian 24:48–54 (c,1) Ja '94
BARLEY INDUSTRY
— Barley fields (Ecuador)
 Natur Hist 101:72–5 (c,1) Jl '92
**BARLEY INDUSTRY—TRANSPORTA-
TION**
— Loading barley onto cargo ship (British
 Columbia)
 Nat Geog 181:120–1 (c,1) Ap '92
BARNACLES
 Natur Hist 103:36–7 (c,2) Jl '94
 Natur Hist 105:82 (c,4) N '96
BARNARD, EDWARD E.
 Smithsonian 23:78 (4) Je '92
BARNS
— Bank barns (Pennsylvania)
 Nat Geog 188:84–5 (c,1) D '95
— Delaware
 Trav/Holiday 178:40–1 (c,2) S '95
— Tilted barn (Colorado)
 Life 17:87 (c,4) Jl '94
— Vermont
 Am Heritage 43:48 (c,3) Ap '92
 Gourmet 54:136 (c,2) D '94
— Wisconsin
 Gourmet 54:144 (c,4) My '94

BARNS—CONSTRUCTION
— Amish barn-raising (Pennsylvania)
 Life 15:84–92 (c,1) Je '92
 Life 18:96–7 (c,1) O '95
BARRACUDAS
 Sports Illus 83:84 (c,4) S 18 '95
BARRELS
— Chemical drums (Mexico)
 Smithsonian 25:30–1,34 (3) My '94
— Half-made barrel
 Gourmet 53:68 (drawing,4) My '93
— Madeira barrels (Madeira)
 Gourmet 53:116 (c,3) D '93
— Nuclear waste storage barrels
 Smithsonian 26:44–5,47 (c,3) My '95
— Wine barrels (Spain)
 Gourmet 54:52–4 (painting,c,2) O '94
BASEBALL
— 1912 Olympics (Stockholm)
 Sports Illus 84:8 (3) My 13 '96
— 1996 Olympics (Atlanta)
 Sports Illus 85:82–4 (c,1) Ag 5 '96
— Baseball trading cards
 Sports Illus 85:104–8 (c,1) Jl 29 '96
— "Field of Dreams" farm (Iowa)
 Sports Illus 84:118 (c,4) Ap 1 '96
— Olympic baseball moments
 Sports Illus 84:7–18 (c,1) My 13 '96
BASEBALL—AMATEUR
— Civil War prisoners playing baseball
 (North Carolina)
 Sports Illus 80:90 (painting,c,3) Je 27 '94
— Little League
 Life 17:26–34 (c,1) My '94
— Little League World Series 1992 (William-
 sport, Pennsylvania)
 Sports Illus 77:14–15 (c,2) S 7 '92
— Little League World Series 1992 scandal
 Sports Illus 78:58–67 (c,1) Ja 18 '93
— Little League World Series 1993
 Sports Illus 79:30 (c,3) S 6 '93
— Many boys going after one ball
 Life 16:88 (2) S '93
— Sandlot game (Cuba)
 Sports Illus 82:60–1,70–1 (c,1) My 15 '95
— Seniors playing baseball (Florida)
 Life 16:50–1 (c,1) Je '93
— Small town baseball
 Life 16:3,44–51 (c,1) Je '93
— Venezuela
 Life 16:46–7 (c,1) Je '93
BASEBALL—COLLEGE
— 1882 college game (New Hampshire)
 Am Heritage 45:86–7 (1) O '94
— College World Series 1992

Sports Illus 76:2–3,22–3 (c,1) Je 15 '92
BASEBALL—HUMOR
— France
 Smithsonian 25:94–104 (painting,c,1) Ap
 '94
— Spring training (1981)
 Sports Illus 81:40–1 (painting,c,1) Ag 8
 '94
BASEBALL—PROFESSIONAL
 Sports Illus 76:2–3,32–124 (c,1) Ap 6 '92
 Sports Illus 76:cov.,2–3,14–19 (c,1) Ap
 27 '92
 Sports Illus 76:cov.,20–3 (c,1) My 4 '92
 Sports Illus 77:cov.,2–3,14–21 (c,1) O 19
 '92
 Sports Illus 77:cov.,16–41 (c,1) O 26 '92
 Sports Illus 78:cov.,2–3,34–98 (c,1) Ap 5
 '93
 Sports Illus 79:14–19 (c,1) Ag 2 '93
 Sports Illus 79:2–3,12–19 (c,1) Ag 9 '93
 Sports Illus 79:cov.,22–9 (c,1) S 27 '93
 Sports Illus 80:cov.,50–131 (c,1) Ap 4 '94
 Sports Illus 81:16–32 (c,1) Ag 8 '94
 Sports Illus 82:64–83 (c,1) My 1 '95
 Sports Illus 83:54–71 (c,1) O 9 '95
 Sports Illus 83:22–35 (c,1) O 16 '95
 Sports Illus 84:52–118 (c,1) Ap 1 '96
 Sports Illus 85:38–43 (c,1) Ag 19 '96
— 20th cent. history
 Sports Illus 79:21–104 (c,1) Jl 19 '93
— 1929
 Sports Illus 85:cov.,74–84 (1) Ag 19 '96
— 1930s
 Sports Illus 76:76–81 (1) Mr 23 '92
 Smithsonian 25:74–5 (2) F '95
— 1940s women players
 Life 18:82 (4) Je 5 '95
 Life 19:34 (4) Mr '96
— 1950s
 Sports Illus 79:90–2 (4) Jl 19 '93
 Sports Illus 81:cov. (c,1) Ag 15 '94
 Life 19:80 (3) F '96
 Sports Illus 84:45–7 (2) My 6 '96
— 1950s Pacific Coast minor league activities
 (California)
 Sports Illus 78:60–73 (c,1) Je 21 '93
— 1956 fight
 Sports Illus 79:3 (4) Ag 16 '93
— 1957 final game in the Polo Grounds
 Sports Illus 77:17–19 (4) Fall '92
— 1961 record-breaking hit by Roger Maris
 Sports Illus 82:35 (4) Je 5 '95
— 1962 Mets
 Sports Illus 76:82–95 (1) My 25 '92
 Sports Illus 80:66–74 (1) My 30 '94

— 1968
 Sports Illus 79:cov.,30–7 (c,1) Jl 19 '93
— 1994 baseball strike cartoons
 Sports Illus 81:20–3 (4) S 26 '94
— 1995 replacement players
 Sports Illus 82:28–31,66 (c,2) Mr 13 '95
— Hank Aaron hitting home run #715 (1974)
 Sports Illus 77:82–3 (c,2) D 7 '92
 Sports Illus 80:86–102 (c,1) Ap 11 '94
— Aerial view
 Sports Illus 76:2–3,48–57 (c,1) Ap 6 '92
— All-time "dream team" members
 Sports Illus 77:26–7 (painting,c,1) Fall '92
— Baseball Hall of Fame, Tokyo, Japan
 Sports Illus 78:98–9 (c,4) My 31 '93
— Baseball memorabilia collection (New Jersey)
 Sports Illus 82:66–76 (c,1) My 22 '95
— Batting practice
 Sports Illus 78:49 (c,3) Mr 29 '93
 Sports Illus 83:36 (c,3) Jl 17 '95
— Bunting
 Sports Illus 78:32–3 (c,1) Je 21 '93
 Sports Illus 82:68–9 (c,2) My 1 '95
— Catchers
 Sports Illus 76:2–3 (c,1) Mr 2 '92
 Sports Illus 79:cov.,12–15 (c,1) Jl 5 '93
 Sports Illus 84:48 (c,3) Mr 4 '96
— Celebrating win
 Life 17:60–1 (c,1) Ja '94
 Sports Illus 84:33 (c,1) My 27 '96
 Sports Illus 85:cov.,32 (c,1) N 4 '96
 Sports Illus 85:92–3 (c,1) D 30 '96
— Diving for ball
 Sports Illus 78:2–3 (c,1) Ap 26 '93
— Errors
 Sports Illus 76:2–3,46–53 (c,1) My 18 '92
 Sports Illus 84:24–9 (c,1) Ap 29 '96
— Fielder missing home run ball
 Sports Illus 84:74–5 (c,1) My 6 '96
— Fielding
 Sports Illus 77:20–1 (c,2) O 19 '92
 Sports Illus 77:21–1,25 (c,1) N 2 '92
 Sports Illus 78:68–9 (c,2) Ap 5 '93
 Sports Illus 78:29 (c,4) Ap 19 '93
 Sports Illus 78:22–3 (c,1) My 10 '93
 Sports Illus 78:19 (c,3) My 24 '93
 Sports Illus 79:44–5 (c,2) O 18 '93
 Sports Illus 79:18–20 (c,2) O 25 '93
 Sports Illus 80:92–3 (c,1) Ap 4 '94
 Sports Illus 82:66–7 (c,2) My 1 '95
 Sports Illus 82:56–7 (c,1) Je 19 '95
 Sports Illus 84:52–87 (c,1) Ap 1 '96
 Sports Illus 85:30 (c,2) O 21 '96
— Fielding fly balls

 Sports Illus 84:74–85 (c,1) Ap 1 '96
— Fight
 Sports Illus 78:22–3 (c,1) Je 14 '93
 Sports Illus 79:12–14 (c,2) Ag 9 '93
 Sports Illus 79:12–17 (c,1) Ag 16 '93
 Sports Illus 80:cov.,26–8 (c,1) My 23 '94
 Sports Illus 81:68–9 (1) N 14 '94
— Hitting
 Sports Illus 76:cov. (c,1) Mr 16 '92
 Sports Illus 77:48,58–9 (c,2) S 21 '92
 Sports Illus 77:25,39,41 (c,1) O 5 '92
 Sports Illus 77:18,22 (c,1) N 2 '92
 Sports Illus 78:44–5 (1) Ap 5 '93
 Sports Illus 78:18–19 (c,1) Ap 26 '93
 Sports Illus 78:44–5 (c,1) My 10 '93
 Sports Illus 78:18–23 (c,1) My 31 '93
 Sports Illus 78:22–3 (c,2) Je 28 '93
 Sports Illus 79:44–5 (c,1) Jl 26 '93
 Sports Illus 79:cov.,22 (c,1) S 27 '93
 Sports Illus 79:60 (c,2) O 4 '93
 Sports Illus 82:16 (c,1) F 27 '95
 Sports Illus 82:64–5 (c,1) My 1 '95
 Sports Illus 82:56–7 (c,1) My 22 '95
 Sports Illus 82:38–9 (c,1) My 29 '95
 Sports Illus 83:50–1,56–7 (c,1) Jl 3 '95
 Sports Illus 83:20–1,30 (c,2) Jl 10 '95
 Sports Illus 83:30 (c,4) Jl 17 '95
 Sports Illus 85:26–39 (c,1) Jl 1 '96
 Sports Illus 85:cov.,25 (c,1) O 14 '96
 Sports Illus 85:28–9,36 (c,1) O 21 '96
— Hitting home run
 Sports Illus 77:24–5 (c,1) O 26 '92
 Sports Illus 77:66 (c,2) D 28 '92
 Sports Illus 78:64 (c,3) Ap 5 '93
 Sports Illus 79:19–22,49 (c,1) Jl 26 '93
 Sports Illus 79:43 (c,1) O 4 '93
 Sports Illus 79:43 (c,3) O 18 '93
 Sports Illus 82:cov.,66 (c,1) Je 5 '95
 Sports Illus 83:28–9,33 (c,1) Jl 31 '95
 Sports Illus 83:54–5 (c,1) O 9 '95
 Sports Illus 83:cov. (c,1) O 16 '95
 Sports Illus 85:24–5 (c,1) Jl 8 '96
 Sports Illus 85:38–9 (c,1) S 30 '96
 Sports Illus 85:38–9 (c,1) O 28 '96
— Home run ball going over fence
 Sports Illus 79:2–3,16–17 (c,1) O 11 '93
 Sports Illus 85:28–9 (c,1) N 4 '96
— Indoor batting cage
 Sports Illus 82:70–1 (c,1) Ja 23 '95
— Japan
 Sports Illus 81:cov.,30–7 (c,1) O 31 '94
— Japanese World Series 1994
 Sports Illus 81:2–3,70–2 (c,1) N 7 '94
— Japanese World Series tickets
 Sports Illus 81:2–3 (c,1) O 31 '94

— Life on the road
Sports Illus 77:40–6 (c,2) Ag 24 '92
— Lineup card in Japanese
Sports Illus 77:2–3 (c,1) N 16 '92
— Mascot
Sports Illus 81:82–3 (c,1) N 14 '94
— Mexico
Sports Illus 85:2–3,18–22 (c,1) Ag 26 '96
— Minor leaguers doing stretches
Trav/Holiday 176:57 (c,3) D '93
— Minor leagues
Sports Illus 81:2–3,68–9 (c,1) Ag 22 '94
Sports Illus 81:48–53 (c,2) S 12 '94
— Negro League history
Sports Illus 80:65–8 (3) Je 20 '94
Smithsonian 25:40,50 (2) Jl '94
Sports Illus 81:148–50 (1) S 19 '94
— Pitch shown in slow motion
Sports Illus 80:36–7 (c,1) Ap 18 '94
— Pitching
Sports Illus 77:62–3 (c,1) Ag 24 '92
Sports Illus 77:54–5 (c,1) O 5 '92
Sports Illus 77:26 (c,2) N 2 '92
Sports Illus 78:36–41,87 (c,2) Ap 5 '93
Sports Illus 78:63 (c,3) My 17 '93
Natur Hist 102:34 (c,4) Jl '93
Sports Illus 79:18–19,30–1 (c,1) Ag 2 '93
Sports Illus 81:16–17 (c,1) Jl 18 '94
Sports Illus 82:60 (c,2) Je 26 '95
Sports Illus 83:cov.,19 (c,1) Jl 10 '95
Sports Illus 83:82 (c,2) Ag 7 '95
Sports Illus 83:cov.,22–3 (c,1) Ag 14 '95
Sports Illus 84:34,64–5 (c,1) My 27 '96
Sports Illus 85:34–6 (c,1) O 7 '96
Sports Illus 85:26–7 (c,1) N 4 '96
— Players colliding
Sports Illus 76:40 (c,4) Ap 27 '92
— Presidents throwing out first balls of the
season
Sports Illus 78:2–3,84–7 (c,1) Ap 12 '93
— Cal Ripken's record-breaking 2131st
consecutive game
Sports Illus 83:2–3,98 (c,1) S 18 '95
Life 19:22–3 (1) Ja '96
— Running
Sports Illus 82:74–7 (c,1) My 1 '95
— Scoring run
Sports Illus 83:2–3 (c,1) Jl 17 '95
Sports Illus 85:66–7 (c,1) Jl 15 '96
— Sliding
Sports Illus 77:30–1,60 (c,2) S 21 '92
Sports Illus 77:cov.,19 (c,1) O 19 '92
Sports Illus 80:33 (c,1) My 23 '94
Sports Illus 82:28–9 (c,1) Ap 24 '95
Sports Illus 82:2–3,22 (c,1) My 8 '95

Sports Illus 82:65 (c,3) Je 5 '95
Sports Illus 83:54–5 (c,2) Jl 17 '95
Sports Illus 85:22–30 (c,1) O 14 '96
— Sliding home
Sports Illus 76:2–3 (c,1) Ap 27 '92
Sports Illus 85:40–1 (c,1) S 23 '96
— Spring training
Sports Illus 76:2–3 (c,1) Mr 2 '92
Trav&Leisure 26:101–3,137–8 (c,4) F '96
— Stealing base
Sports Illus 76:50–1 (c,1) Ap 6 '92
Sports Illus 76:38 (c,4) Je 15 '92
Sports Illus 77:11 (c,4) S 7 '92
— Tagging runner out
Sports Illus 76:2–3 (c,1) Ap 6 '92
Sports Illus 79:36–8 (c,1) O 18 '93
Sports Illus 85:34 (c,3) S 30 '96
— Third base
Sports Illus 76:60–72,94 (c,2) Ap 6 '92
— Umpire calling runner out
Sports Illus 77:32–3 (c,2) O 26 '92
— Winter baseball (Puerto Rico)
Sports Illus 82:42–7 (c,2) Ja 16 '95
— World Series 1912 (Boston vs. N.Y.
Giants)
Sports Illus 77:44 (4) O 5 '92
— World Series 1929 (Philadelphia vs.
Chicago Cubs)
Sports Illus 85:76–84 (1) Ag 19 '96
— World Series 1934 (St. Louis vs. Detroit)
Sports Illus 77:44 (4) O 5 '92
— World Series 1947 (N.Y. Yankees vs.
Brooklyn Dodgers)
Sports Illus 77:48 (4) O 5 '92
— World Series 1953 (N.Y. Yankees vs.
Brooklyn Dodgers)
Sports Illus 79:52–3 (1) O 11 '93
— World Series 1954 (New York Giants vs.
Cleveland)
Sports Illus 81:54–5 (1) N 14 '94
— World Series 1955 (Brooklyn Dodgers vs.
N.Y. Yankees)
Sports Illus 77:50 (4) O 5 '92
— World Series 1956 (N.Y. Yankees vs.
Brooklyn Dodgers)
Sports Illus 79:58 (4) O 11 '93
— World Series 1959 (Los Angeles vs.
Chicago White Sox)
Sports Illus 85:22 (4) D 2 '96
— World Series 1960 (New York vs.
Pittsburgh)
Sports Illus 81:138–9 (1) N 14 '94
— World Series 1964 (St. Louis vs. N.Y.
Yankees)
Sports Illus 79:68 (3) O 11 '93

— World Series 1966 (Baltimore vs. Los
 Angeles)
 Sports Illus 83:51–5 (c,1) O 23 '95
— World Series 1968 (Detroit vs. St. Louis)
 Sports Illus 79:15 (4) S 6 '93
— World Series 1970 (Baltimore vs.
 Cincinnati)
 Sports Illus 83:58,69 (c,4) O 23 '95
— World Series 1975 (Cincinnati vs. Boston)
 Sports Illus 79:38–9 (c,1) Jl 19 '93
 Sports Illus 81:48–55 (c,1) O 10 '94
— World Series 1991 (Minnesota vs. Atlanta)
 Life 15:116 (c,2) Ja '92
 Sports Illus 77:39,42,52 (c,1) O 5 '92
 Sports Illus 81:60–1 (c,1) N 14 '94
— World Series 1992 (Toronto vs. Atlanta)
 Sports Illus 77:cov.,24–41 (c,1) O 26 '92
 Sports Illus 77:cov.,18–31 (c,1) N 2 '92
 Sports Illus 77:102–3 (c,1) D 28 '92
— World Series 1993 (Toronto vs. Philadel-
 phia)
 Sports Illus 79:16–25 (c,1) O 25 '93
 Sports Illus 79:cov.,18–31 (c,1) N 1 '93
 Life 17:60–1 (c,1) Ja '94
— World Series 1995 (Atlanta vs. Cleveland)
 Sports Illus 83:34–9 (c,1) O 30 '95
 Sports Illus 83:cov.,2–3,26–37 (c,1) N 6
 '95
— World Series 1996 (New York Yankees vs.
 Atlanta)
 Sports Illus 85:36–9 (c,1) O 28 '96
 Sports Illus 85:cov.,24–35 (c,1) N 4 '96
 Sports Illus 85:92–3 (c,1) D 30 '96

BASEBALL BATS
— Balancing bat on chin (1920s)
 Sports Illus 76:79 (4) Mr 23 '92
— Corked bat
 Life 18:82 (2) Mr '95
— Hand-making bats (Kansas)
 Sports Illus 83:9 (c,4) Ag 21 '95
— Louisville Slugger Museum, Louisville,
 Kentucky
 Sports Illus 85:6 (c,4) S 16 '96

BASEBALL GLOVES
— 1930s catcher's mitt
 Sports Illus 76:77 (c,2) Mr 23 '92

BASEBALL PLAYERS
 Sports Illus 78:28–9 (c,1) Mr 8 '93
 Sports Illus 78:cov.,12 (c,1) My 24 '93
— Early 20th cent. player Jake Beckley
 Sports Illus 82:7 (4) Je 12 '95
— 1920s
 Sports Illus 79:78 (4) Jl 19 '93
 Sports Illus 80:19 (4) Je 6 '94
 Sports Illus 83:5 (4) O 16 '95

— 1920s team of 12 brothers
 Sports Illus 81:4 (4) Jl 11 '94
— 1930s
 Sports Illus 80:20,22 (4) Je 6 '94
— Early 1960s
 Sports Illus 79:46–54 (1) Jl 19 '93
— Moe Berg
 Sports Illus 76:76–86 (1) Mr 23 '92
— Famous baseball players
 Smithsonian 25:40–1,44 (4) Jl '94
— Whitey Ford
 Sports Illus 83:25 (c,2) Ag 21 '95
— Rube Foster
 Life 17:42 (4) S '94
— Hank Greenberg
 Sports Illus 81:18 (4) S 12 '94
— Player kissing bat
 Sports Illus 81:16–17 (c,1) Ag 8 '94
— Retired Negro League players
 Sports Illus 76:80–92 (1) Jl 6 '92
— See also
 AARON, HENRY
 BERRA, YOGI
 CAMPANELLA, ROY
 CLEMENTE, ROBERTO
 COBB, TY
 DEAN, DIZZY
 DIMAGGIO, JOE
 DUROCHER, LEO
 FOXX, JIMMIE
 GEHRIG, LOU
 JACKSON, "SHOELESS JOE"
 KOUFAX, SANDY
 MACK, CONNIE
 MARIS, ROGER
 MANTLE, MICKEY
 MAYS, WILLIE
 MUSIAL, STAN
 ROBINSON, JACKIE
 RUTH, GEORGE HERMAN (BABE)
 STENGEL, CASEY
 WILLIAMS, TED
BASEBALL TEAMS
— 1866 college women's baseball team
 Am Heritage 45:111 (2) Jl '94
— 1884 Providence team
 Sports Illus 83:20 (4) O 23 '95
— 1891 college team
 Smithsonian 25:110 (4) Ja '95
— 1916 Red Sox
 Smithsonian 25:66 (4) O '94
— 1920s
 Sports Illus 78:90 (4) Ap '93
— 1922 Yankees
 Life 18:11–14 (1) My '95

— 1962 Mets
 Sports Illus 81:9 (4) Jl 4 '94
— Informal company team
 Smithsonian 24:73 (c,3) O '93
BASEBALLS
 Sports Illus 82:2–3 (c,1) Mr 6 '95
— Ancient rubber ball (Mexico)
 Nat Geog 184:100–1 (c,4) N '93
— Autographed by Ruth and Gehrig
 Smithsonian 27:24 (c,4) Ag '96
— Softball
 Life 16:49 (c,2) Je '93
BASIE, COUNT
 Am Heritage 46:72–3 (painting,c,2) O '95
BASKET MAKING
— Making metal fishing basket (Greece)
 Trav/Holiday 178:52 (c,2) My '95
BASKET WEAVING
— Japan
 Smithsonian 25:102 (c,4) Ja '95
— Pandanus-leaf baskets (Western Samoa)
 Trav/Holiday 179:46–7 (c,1) My '96
— Puerto Rico
 Trav/Holiday 177:76 (3) D '94
— Sweet-grass baskets (South Carolina)
 Trav/Holiday 179:63 (c,4) F '96
BASKETBALL
— 1936 Olympics (Berlin)
 Sports Illus 84:15 (2) Ja 15 '96
 Sports Illus 85:15 (4) Jl 22 '96
— 1956 Olympics (Melbourne)
 Sports Illus 84:16 (2) Ja 15 '96
— 1972 Olympics (Munich)
 Sports Illus 76:64–78 (c,1) Je 15 '92
 Sports Illus 84:18 (c,2) Ja 15 '96
— 1976 Olympics (Montreal)
 Sports Illus 84:20 (2) Ja 15 '96
— 1988 Olympics (Seoul)
 Sports Illus 84:24–8 (c,2) Ja 15 '96
— 1992 Olympics (Barcelona)
 Sports Illus 77:14–19 (c,1) Ag 17 '92
 Sports Illus 77:70–1 (c,1) D 28 '92
 Sports Illus 84:22,26,28 (c,2) Ja 15 '96
— 1996 Olympics (Atlanta)
 Sports Illus 85:48–61 (c,1) Ag 12 '96
— African Olympic basketball trials (Egypt)
 Sports Illus 76:80–95 (c,2) F 17 '92
— Basketball inventor James Naismith
 Sports Illus 83:118 (4) N 27 '95
 Nat Geog 190:59 (4) Jl '96
— Child playing in garage
 Sports Illus 85:88–9 (c,1) D 23 '96
— History of Olympic basketball
 Sports Illus 76:39–62 (c,2) Jl 6 '92
 Sports Illus 84:13–28 (c,1) Ja 15 '96

— Played on snow (Alaska)
 Sports Illus 80:70–5 (c,1) Ja 31 '94
— Playground games
 Nat Geog 187:114–15 (c,1) Mr '95
 Life 18:64 (3) Ag '95
— Wheelchair basketball
 Sports Illus 76:126 (c,4) Ap 6 '92
BASKETBALL—AMATEUR
— Women
 Sports Illus 76:40–2 (c,1) Je 8 '92
BASKETBALL—COLLEGE
 Sports Illus 76:cov.,12–19 (c,1) Mr 30 '92
 Sports Illus 77:34–106 (c,1) N 23 '92
 Sports Illus 78:cov.,2–3,14–17 (c,1) Mr 8
 '93
 Sports Illus 78:cov.,12–20 (c,1) Mr 29 '93
 Sports Illus 79:34–78 (c,1) N 29 '93
 Sports Illus 79:22–6 (c,1) D 27 '93
 Sports Illus 81:50–120 (c,1) N 28 '94
 Sports Illus 82:cov.,66–84 (c,1) Mr 6 '95
 Sports Illus 83:cov.,2–3,62–151 (c,1) N
 27 '95
 Sports Illus 85:54–118 (c,1) D 2 '96
— Aerial view
 Sports Illus 82:20–1 (c,1) F 20 '95
— Aerial view of ball in net
 Sports Illus 80:17 (c,1) Mr 21 '94
— Atlantic Coast Conference history
 Sports Illus 76:37–54 (c,1) Mr 23 '92
— Blocking
 Sports Illus 76:54 (c,1) Mr 2 '92
 Sports Illus 76:14,19 (c,4) Ap 6 '92
 Sports Illus 78:19 (c,1) Ap 5 '93
— Coaches
 Sports Illus 79:64 (c,4) D 6 '93
 Sports Illus 82:46–9 (c,1) Mr 13 '95
 Sports Illus 84:cov. (c,1) F 26 '96
— Cutting net after game
 Sports Illus 78:31 (c,4) Ap 12 '93
— Dribbling
 Sports Illus 79:cov. (c,1) D 13 '93
— Dunking
 Sports Illus 76:cov. (c,1) Mr 30 '92
 Sports Illus 76:12 (c,1) Ap 6 '92
 Sports Illus 77:52–3 (c,1) N 23 '92
 Sports Illus 77:14–15 (c,1) D 14 '92
 Sports Illus 82:31 (c,2) Ap 10 '95
— History of Final Four
 Sports Illus 84:39–66 (c,1) Mr 18 '96
— NCAA Championships 1974 (North
 Carolina State vs. Marquette)
 Sports Illus 80:43–72 (c,1) Mr 21 '94
— NCAA Championships 1984 (North
 Carolina vs. Georgetown)
 Sports Illus 84:39,58–60 (c,1) Mr 18 '96

— NCAA Championships 1992 (Duke vs. Michigan)
Sports Illus 76:22–7 (c,1) Mr 9 '92
Sports Illus 76:12–21 (c,1) Ap 6 '92
Sports Illus 76:cov.,18–29 (c,1) Ap 13 '92
— NCAA Championships 1993 (North Carolina vs. Michigan)
Sports Illus 78:14–26 (c,1) Ap 5 '93
Sports Illus 78:cov.,20–31 (c,1) Ap 12 '93
— NCAA Championships 1994 (Arkansas vs. Duke)
Sports Illus 80:cov.,2–3,14-22 (c,1) Mr 28 '94
Sports Illus 80:24–41 (c,1) Ap 4 '94
Sports Illus 80:cov.,20–9 (c,1) Ap 11 '94
— NCAA Championships 1995 (UCLA vs. Arkansas)
Sports Illus 82:32–9 (c,1) Mr 27 '95
Sports Illus 82:cov.,28–43 (c,1) Ap 3 '95
Sports Illus 82:cov.,28–34 (c,1) Ap 10 '95
— NCAA Championships 1996 (Kentucky vs. Syracuse)
Sports Illus 84:36–48 (c,1) Mr 25 '96
Sports Illus 84:20–7 (c,1) Ap 1 '96
Sports Illus 84:cov.,26–38 (c,1) Ap 8 '96
— NCAA Women's Championships 1992 (Stanford vs. Western Kentucky)
Sports Illus 76:30–1 (c,1) Ap 13 '92
— NCAA Women's Championships 1993 (Texas Tech vs. Ohio State)
Sports Illus 78:42–3 (c,2) Ap 12 '93
— NCAA Women's Championships 1994 (North Carolina vs. Louisiana Tech)
Sports Illus 80:30–1 (c,2) Ap 11 '94
— NCAA Women's Championships 1996 (Tennessee vs. Georgia)
Sports Illus 84:40–1 (c,1) Ap 8 '96
— NIT 1946
Sports Illus 84:12–13 (4) Mr 18 '96
— Passing
Sports Illus 80:68–9 (c,1) F 28 '94
— Rebounding
Sports Illus 76:14–15 (c,1) Mr 23 '92
— Shooting
Sports Illus 82:cov.,40 (c,1) Ap 3 '95
— Woman coach
Sports Illus 84:3 (c,4) Je 10 '96
— Women
Sports Illus 82:98–101 (c,1) Mr 20 '95
Sports Illus 82:28–40,43 (c,1) Ap 10 '95
Sports Illus 85:58–9 (c,1) N 25 '96
BASKETBALL—HIGH SCHOOL
Sports Illus 78:44–5 (c,2) Ap '93
Sports Illus 81:46–8 (c,1) Jl 25 '94

BASKETBALL—HUMOR
— 1983
Sports Illus 81:42–3 (painting,c,1) Ag 8 '94
BASKETBALL—PROFESSIONAL
Sports Illus 76:cov.,16–21 (c,1) F 10 '92
Sports Illus 77:cov.,58–104 (c,1) N 9 '92
Sports Illus 78:26–32 (c,1) Ja 25 '93
Sports Illus 79:76–130 (c,1) N 8 '93
Sports Illus 79:28–32 (c,1) D 13 '93
Sports Illus 80:28–31 (c,1) Ja 10 '94
Sports Illus 81:86–162 (c,1) N 7 '94
Sports Illus 82:18–177 (c,1) My 1 '95
Sports Illus 83:2–3,50–122 (c,1) N 13 '95
Life 18:90–2 (c,1) D '95
Sports Illus 84:26–35 (c,1) Ja 29 '96
Sports Illus 84:24–9 (c,1) Ap 15 '96
Sports Illus 85:64–126 (c,1) N 11 '96
— 1956
Sports Illus 81:114–15 (c,1) N 14 '94
— Aerial view of court
Sports Illus 80:34–40 (c,1) My 2 '94
Sports Illus 82:34–5 (c,1) Ja 9 '95
Sports Illus 83:2–3 (c,1) N 13 '95
— All-time "dream team" members
Sports Illus 77:28–9 (painting,c,1) Fall '92
— Ball missing net
Sports Illus 85:64–5 (c,1) D 16 '96
— Larry Bird playing against Magic Johnson
Sports Illus 77:cov.,44–55 (c,1) D 14 '92
— Blocking
Sports Illus 76:29 (c,3) Ja 20 '92
Sports Illus 82:20 (c,3) My 1 '95
Sports Illus 82:40 (c,2) Je 19 '95
— Coaches
Sports Illus 76:17 (c,4) F 10 '92
Sports Illus 76:62 (c,4) Mr 2 '92
Sports Illus 77:72–4 (c,3) N 9 '92
Sports Illus 81:33 (c,1) Jl 4 '94
Sports Illus 84:76–86 (1) My 27 '96
— Dunking
Sports Illus 78:2–3 (c,1) Mr 1 '93
Sports Illus 78:24–5,29 (c,1) Mr 15 '93
Sports Illus 78:2–3 (c,1) Je 21 '93
Sports Illus 82:43,51 (c,2) Je 5 '95
Sports Illus 82:36–7,40–1 (c,1) Je 19 '95
Sports Illus 83:35 (c,2) Jl 10 '95
Sports Illus 85:40–1 (c,1) D 2 '96
— Foul
Sports Illus 76:58 (c,4) Mr 16 '92
— Hoop and clock falling on player
Sports Illus 78:9 (c,4) My 3 '93
— NBA Playoffs 1992 (Bulls vs. Trail Blazers)

Sports Illus 76:cov.,16–21 (c,1) Je 15 '92
Sports Illus 76:cov.,12–20 (c,1) Je 22 '92
Sports Illus 77:60 (c,2) D 28 '92
— NBA Playoffs 1993 (Bulls vs. Suns)
Sports Illus 78:cov.,2–3,18–25 (c,1) Je 21
'93
Sports Illus 78:cov.,14–21 (c,1) Je 28 '93
— NBA Playoffs 1994 (Houston vs. New
York)
Sports Illus 80:42–9 (c,1) Je 20 '94
Sports Illus 80:50–4 (c,1) Je 27 '94
— NBA Playoffs 1995 (Houston vs. Orlando)
Sports Illus 82:32–40 (c,1) My 8 '95
Sports Illus 82:26–31 (c,1) My 15 '95
Sports Illus 82:cov.,22–37 (c,1) My 22 '95
Sports Illus 82:44–8 (c,1) Je 26 '95
— NBA Playoffs 1996 (Chicago vs. Seattle)
Sports Illus 84:34–43 (c,1) My 6 '96
Sports Illus 84:36–43 (c,1) My 13 '96
Sports Illus 84:36–47 (c,1) My 20 '96
Sports Illus 84:40–3 (c,1) My 27 '96
Sports Illus 84:cov.,28–32,37 (c,1) Je 3 '96
Sports Illus 84:cov.,32–8,43 (c,1) Je 10 '96
Sports Illus 84:cov.,40–6 (c,1) Je 17 '96
Sports Illus 84:28–33 (c,1) Je 24 '96
— Passing
Sports Illus 80:2–3 (c,1) My 9 '94
— Rebounding
Sports Illus 76:28 (c,1) My 18 '92
Sports Illus 82:36–7 (c,1) Je 5 '95
Sports Illus 84:cov.,30–9 (c,1) Mr 4 '96
— Shooting
Sports Illus 76:64 (c,1) Ap 27 '92
Sports Illus 81:96–105 (c,1) N 14 '94
Sports Illus 81:47–9 (c,1) D 26 '94
Sports Illus 84:2–3 (c,1) F 19 '96
— Slam-dunk contest
Sports Illus 81:118–19 (c,1) N 14 '94
Sports Illus 84:16 (4) F 5 '96
— Slow motion dribbling
Sports Illus 85:58–9 (c,1) D 9 '96
— Slow motion shot of player preparing to
shoot
Sports Illus 81:142 (c,3) N 7 '94
— Women
Sports Illus 82:64–9 (c,1) My 29 '95
Sports Illus 85:21 (c,2) O 28 '96
Sports Illus 85:78 (c,2) D 30 '96
BASKETBALL PLAYERS
— 7'5" basketball player
Sports Illus 81:120–9 (c,1) N 7 '94
— Female player with amputated leg
Sports Illus 80:72–3 (c,1) F 21 '94
— Life of college basketball player (Kansas)
Sports Illus 82:70–4 (c,1) F 13 '95

— Russian nesting dolls painted like NBA
stars
Sports Illus 80:61 (c,4) Ja 10 '94
— Short pro basketball player
Sports Illus 78:53–4 (c,1) Ap 12 '93
— Very tall and very short basketball players
Life 17:19–22 (c,1) Ap '94
— See also
CHAMBERLAIN, WILT
ERVING, JULIUS
BASKETBALL TEAMS
— 1893 women's college team
Sports Illus 78:8 (4) Mr 22 '93
— 1987 Yugoslavian team
Sports Illus 84:80–1 (1) Je 3 '96
— Harlem Globetrotters (1962)
Sports Illus 83:7 (4) N 13 '95
BASKETBALLS
— Twirling basketball on finger
Life 15:48 (c,1) Mr '92
BASKETS
— 19th cent. klickitat basket (Northwest)
Gourmet 53:143 (c,4) Ap '93
— Handwoven sweetgrass baskets (South
Carolina)
Nat Wildlife 31:38 (c,4) Ap '93
— Indonesia
Trav&Leisure 25:92 (c,4) Ap '95
— Japan
Smithsonian 25:102–5 (c,1) Ja '95
— Native American baskets
Smithsonian 25:42,44 (c,2) O '94
— Poultry basket (Bangladesh)
Nat Geog 183:130 (c,1) Je '93
— Varieties of baskets
Gourmet 55:120,183 (c,4) Ap '95
— Woven baskets (Chile)
Gourmet 54:104 (c,4) F '94
BASS
Trav/Holiday 179:83 (c,4) F '96
— Striped bass
Smithsonian 24:27–8 (4) Jl '93
BATH, ENGLAND
Trav&Leisure 24:108–15,145–50
(map,c,1) N '94
BATHING
— 1942 man bathing in barrel (Alaska)
Smithsonian 23:106 (4) Jl '92
— Baseball player hosing down fans
Sports Illus 83:2–3 (c,1) Jl 24 '95
— Bathing in campsite tub (California)
Nat Geog 186:54–5 (c,1) O '94
— Bathing in waterfall (Brazil)
Life 15:70 (c,4) Jl '92
— Bathing in waterfall (Japan)

Nat Geog 186:94–5 (c,2) S '94
— Bathing infant in washtub (Jordan)
Nat Geog 183:61 (c,1) My '93
— Bathing the dog (Connecticut)
Smithsonian 23:68 (c,4) Ap '92
— Blue jay wet from bath
Nat Wildlife 33:2–3 (c,2) Je '95
— Children in farm pond (Pennsylvania)
Nat Geog 185:56–7 (c,1) Je '94
— Children in mud flats (Alaska)
Nat Geog 185:92 (c,4) My '94
— Children jumping into creek (Minnesota)
Life 15:76 (c,2) S '92
— Children under sprinkler (Brazil)
Nat Geog 182:82–3 (c,1) S '92
— Collecting shower water in buckets
(California)
Nat Geog 184:8 (c,4) N 15 '93
— Enzyme bath at spa (Japan)
Nat Geog 184:61 (c,1) Ag '93
— Family bathing in country river (New
York)
Nat Geog 182:126–7 (c,1) N '92
— Father and son in bubble bath
Life 17:44 (c,4) Ja '94
— Ganges River, India
Life 15:74–9 (c,1) Mr '92
— Iceland spa
Life 15:26 (c,4) O '92
— In hot spring (Alaska)
Smithsonian 26:71 (c,1) Je '95
— In hot tub (El Salvador)
Nat Geog 188:120–1 (c,2) S '95
— In hot tub at ski lodge (Utah)
Nat Geog 189:72 (c,3) Ja '96
— Jumping off rocks into river (Tennessee)
Smithsonian 24:27 (c,4) Ag '93
— Man in bubble bath
Sports Illus 76:68–9 (c,2) Jl 6 '92
Sports Illus 77:72–3 (c,1) Ag 31 '92
— Migrant worker showering (South Africa)
Nat Geog 183:72 (c,3) F '93
— Mother soaping up small child (Senegal)
Life 15:14 (c,2) Jl '92
— Muslims washing at midday prayer (Syria)
Nat Geog 183:54–5 (c,1) My '93
— New Year's bathing ritual (Yunnan, China)
Life 16:19 (c,2) D '93
— Old men in shower (Massachusetts)
Nat Geog 186:30–1 (c,1) Jl '94
— Quadruplets in tub
Smithsonian 27:30–1 (c,1) S '96
— Tent shower at refugee camp (Croatia)
Nat Geog 183:118–19 (c,1) My '93
— Thermal pool (Russia)

Nat Geog 190:54 (c,3) O '96
— Woman in cave pool (British Virgin
Islands)
Trav/Holiday 177:54–5 (1) Jl '94
— Women in mud pool (Aeolian Islands,
Italy)
Nat Geog 186:20–1 (c,2) N '94

BATHING SUITS
Sports Illus 76:cov.,2–3,82–119 (c,1) Mr
9 '92
Sports Illus 78:cov.,2–3,65–140 (c,1) F 22
'93
Sports Illus 80:cov.,2–3,66–117 (c,1) F 14
'94
Sports Illus 82:cov.,2–3,70–129 (c,1) F 20
'95
Sports Illus 82:11–13 (c,1) Mr 6 '95
Sports Illus 84:cov.,58–119 (c,1) Ja 29 '96
— 1900-1990
Life 15:56–7 (c,4) Ag '92
— 1930s
Smithsonian 23:128 (4) F '93
Life 18:120 (2) N '95
Life 19:44 (4) O '96
— 1946
Life 15:6 (c,4) Je '92
— 1950s
Life 19:7 (4) D '96
— 1960s sexy suit
Life 18:118 (c,4) N '95
— Brazil
Trav&Leisure 23:137 (c,1) N '93
— Mauritius
Trav&Leisure 26:135 (1) O '96
— William Howard Taft in bathing suit (1895)
Trav&Leisure 25:71 (2) Jl '95

BATHROOMS
— 1860s ship toilets
Nat Geog 186:80 (c,2) D '94
— Communal toilet training (Russia)
Nat Geog 190:60–1 (c,2) O '96
— Elaborate theater ladies' room (Branson,
Missouri)
Trav/Holiday 177:59 (c,2) F '94
— Gilded toilets (Taiwan)
Life 16:24 (c,4) F '93
— Portable toilets in park (New Jersey)
Life 17:30 (c,2) D '94
— Street toilet (Paris, France)
Life 16:83 (c,4) O '93
— Water-guzzling toilets turned in for rebates
(California)
Nat Geog 184:53 (c,1) N 15 '93

BATHS
— Georgia, U.S.S.R.

Nat Geog 181:105 (c,4) My '92
— Hot springs resort Goryachinsk, Siberia
 Nat Geog 181:32–3 (c,2) Je '92
— Jacuzzi (West Indies)
 Trav&Leisure 26:111 (c,1) Mr '96
— Moroccan hammam
 Nat Geog 190:122 (c,3) O '96
— Thermal spring (Budapest, Hungary)
 Trav/Holiday 175:57 (3) My '92
 Trav&Leisure 24:86–7 (c,1) O '94
— Turkish bath (Istanbul, Turkey)
 Trav&Leisure 26:82 (c,1) Ag '96

BATHTUBS
— 19th cent. footed bathtub (Great Britain)
 Trav&Leisure 26:73 (c,4) Ag '96
— William Howard Taft's bathtub
 Trav/Holiday 175:73 (4) N '92

BATON ROUGE, LOUISIANA
 Nat Geog 184:102–3 (c,1) N 15 '93

BATS
 Smithsonian 23:78–9 (c,4) Ap '92
 Nat Wildlife 31:42–5 (c,1) F '93
 Natur Hist 103:48–55 (c,1) Ja '94
 Nat Geog 188:36–57 (c,1) Ag '95
 Natur Hist 105:72–6 (c,3) F '96
— Bat consuming praying mantis
 Natur Hist 102:32 (c,4) Ja '93
— Bat embryo
 Natur Hist 103:51 (c,2) Ja '94
— Big-eared bat
 Life 17:55 (1) S '94
 Nat Geog 188:54–5 (c,1) Ag '95
 Natur Hist 105:73 (c,4) F '96
— Fishing bats
 Natur Hist 101:cov.,60–3 (c,1) O '92
 Nat Wildlife 32:50–1 (c,1) O '94
— Free-tailed bats
 Natur Hist 103:48–9 (c,1) Ja '94
 Life 17:132 (c,2) N '94
 Nat Geog 188:52 (c,1) Ag '95
— Frog-eating bat
 Sports Illus 76:54 (c,3) My 25 '92
 Life 15:48–9 (c,1) S '92
— Fruit bats
 Trav&Leisure 22:126 (c,4) F '92
 Nat Wildlife 32:47–9 (c,1) Ap '94
— Leaf-nosed bat
 Nat Wildlife 30:20 (c,4) F '92
 Nat Geog 188:36–7,43 (c,1) Ag '95
— Lesser long-nosed bats
 Natur Hist 103:60–1,64–5 (c,1) O '94
— Little brown bats
 Natur Hist 103:50–2 (c,1) Ja '94
 Nat Wildlife 34:40 (c,4) F '96
— Red bats

 Nat Wildlife 32:58–9 (c,1) Ap '94
— Short-tailed fruit bats
 Natur Hist 101:34–5 (c,1) F '92
— See also
 FLYING FOXES
 VAMPIRE BATS
Battles. See
 BUNKER HILL, BATTLE OF
 WARFARE
 WARS

BATTLESHIPS
— 1920s U.S. destroyer "Noa"
 Am Heritage 47:86 (4) Jl '96
— Dismantling the "Michigan" (1924)
 Am Heritage 44:35 (4) D '93
— War of 1812 brigs
 Smithsonian 25:24–8,35 (painting,c,1) Ja
 '95
— World War II battleships
 Nat Geog 181:72–8 (3) Je '92

BAUDELAIRE, CHARLES
 Smithsonian 26:75 (4) My '95

BAY OF FUNDY, CANADA
— Bay of Fundy's extreme tides
 Life 17:80 (c,3) Jl '94

BAYS
— Glacier Bay, Alaska
 Sports Illus 78:107–18 (c,1) F 22 '93
— See also
 BAY OF FUNDY
 CHESAPEAKE BAY

BEACHES
 Trav/Holiday 175:37–50 (c,1) Jl '92
— Baja California, Mexico
 Trav&Leisure 23:96 (c,2) My '93
— Beach umbrella on deserted beach (Florida)
 Trav/Holiday 178:cov. (c,1) Mr '95
— Block Island, Rhode Island
 Trav/Holiday 176:59 (2) D '93
— Cabanas (Martha's Vineyard,
 Massachusetts)
 Trav&Leisure 26:148 (c,4) Ap '96
— California coast
 Trav&Leisure 23:E1–E2 (c,2) F '93
 Nat Geog 186:50–1 (c,1) O '94
 Trav/Holiday 178:61 (c,2) S '95
— Cape Cod, Massachusetts
 Trav/Holiday 178:31,33 (map,c,4) O '95
— Caribbean Islands
 Trav&Leisure 22:92–3 (c,1) D '92
 Trav&Leisure 23:15,78–9 (c,1) F '93
 Trav&Leisure 24:120–1 (c,1) N '94
 Trav/Holiday 179:44–6 (c,1) F '96
 Trav&Leisure 26:159 (c,1) O '96
— Coastal homes threatened by beach erosion

Smithsonian 23:74–86 (c,1) O '92
— Connecticut
Smithsonian 22:87 (c,2) Mr '92
— Costa Rica
Trav/Holiday 176:42 (c,4) F '93
Trav/Holiday 177:88–9 (c,2) O '94
— Delaware
Trav/Holiday 178:44 (c,2) S '95
— Dorset shore, England
Trav&Leisure 23:62 (c,1) Ag '93
— Grayton Beach, Florida
Life 18:84–5 (c,1) Ap '95
— Hawaii
Trav/Holiday 177:cov.,62–3,72–3 (c,1)
Ap '94
Trav&Leisure 26:44–5 (c,4) Ja '96
Trav/Holiday 179:91 (c,1) S '96
— Jamaica
Trav/Holiday 178:80–1 (c,1) D '95
— Keweenaw Peninsula, Michigan
Nat Geog 184:94–5 (c,1) D '93
— Leeward Islands
Gourmet 54:128–31 (c,1) D '94
Trav/Holiday 179:44–5 (c,1) Jl '96
— Long Island, New York
Gourmet 53:76 (c,4) Je '93
Nat Geog 186:122–3 (c,1) D '94
— Maine
Trav/Holiday 178:70 (c,1) Je '95
— Mexico
Trav&Leisure 24:109 (c,1) Ja '94
Nat Geog 190:18–19,92–3 (c,1) Ag '96
— Myrtle Beach, South Carolina
Trav/Holiday 179:94 (c,4) N '96
— New Jersey
Natur Hist 102:12 (c,3) My '93
— Nikumaroro, Pacific
Life 15:71 (c,2) Ap '92
— Normandy, France
Trav/Holiday 177:80–3 (c,1) Je '94
— North Carolina
Gourmet 55:98–103 (c,1) Ap '95
— Padre Island, Texas
Trav/Holiday 177:84–6 (c,1) D '94
— Sardinia, Italy
Trav/Holiday 176:40–3 (c,2) Je '93
— South Africa
Trav/Holiday 177:61 (c,1) O '94
— Spain's south Atlantic coast
Trav/Holiday 175:73 (c,3) Ap '92
— Thailand
Trav/Holiday 177:56,59 (c,1) D '94
— U.S. beach erosion problems
Smithsonian 23:73–86 (c,1) O '92
— Venice, California

Trav/Holiday 179:90,94–5 (c,1) D '96
— Yorkshire, England
Trav&Leisure 25:88 (c,2) Je '95
BEACHES, BATHING
Trav/Holiday 175:37–50 (c,1) Jl '92
— 1940 (Coney Island, Brooklyn, New York)
Smithsonian 27:100 (1) D '96
— 1963 teens dancing on beach
Life 16:28–9 (1) Je '93
— Australia
Nat Wildlife 30:30–1 (c,1) Ag '92
— Bahia, Brazil
Trav/Holiday 175:56–63 (c,1) Je '92
— Bermuda
Trav/Holiday 177:74 (c,3) My '94
— Biarritz, France
Nat Geog 188:91 (c,3) N '95
— Cape Cod, Massachusetts
Gourmet 53:124 (c,3) Ap '93
— Children playing with pail and shovel
Trav&Leisure 22:102–3 (c,1) Mr '92
— Covered chaise lounges (Hawaii)
Trav&Leisure 26:38 (c,4) Je '96
— Georgia, U.S.S.R.
Nat Geog 181:104–5 (c,1) My '92
— Ipanema, Rio de Janeiro, Brazil
Trav&Leisure 23:cov.,137,142–3 (c,1) N
'93
— Ixtapa, Mexico
Trav&Leisure 23:E1 (c,4) O '93
— Japan
Nat Geog 186:76–7 (c,2) S '94
— Java, Indonesia
Trav&Leisure 22:68–9 (c,1) Ja '92
— Key West, Florida
Gourmet 52:111 (c,1) D '92
— Lake Tahoe, California
Nat Geog 181:122 (c,4) Mr '92
— Martha's Vineyard, Massachusetts
Trav&Leisure 26:95,148 (c,1) Ap '96
— Miami Beach, Florida
Smithsonian 23:78 (c,3) O '92
— Monterosso al Mare, Italy
Gourmet 52:88 (c,3) S '92
— Negril, Jamaica
Trav&Leisure 23:62 (c,3) Ja '93
— Nude beach (Vancouver, B.C.)
Nat Geog 181:113 (c,3) Ap '92
— Pile of beachgoer's paraphernalia (1948)
Trav/Holiday 177:112 (painting,c,1) Je '94
— St. Tropez, France
Trav&Leisure 22:118–19 (c,1) Je '92
— Sarasota, Florida
Gourmet 53:86,89 (c,2) F '93
— Seaside, Florida

Trav/Holiday 176:15 (c,4) O '93
— South Africa
 Nat Geog 190:22 (c,3) Jl '96
— South Padre Island, Texas
 Nat Geog 182:7 (c,3) Jl '92
— Thatched beach umbrellas (Sardinia, Italy)
 Trav/Holiday 176:40–1 (c,2) Je '93
— Tobago
 Trav&Leisure 22:80 (c,3) Ja '92
— Trinidad
 Nat Geog 185:74–5 (c,1) Mr '94
— Waikiki, Honolulu, Hawaii
 Trav&Leisure 22:110–11 (c,1) F '92
— Woman burying boyfriend in sand (New
 York)
 Life 15:80–1 (1) Ap '92
BEARDS
— Frenchman with 11-foot beard (1904)
 Smithsonian 25:46 (3) F '95
— See also
 MUSTACHES
BEARS
— Black bear catching salmon
 Nat Wildlife 32:45 (c,1) O '94
— Black bear cubs
 Nat Wildlife 30:cov.,30,34 (c,1) Je '92
— Black bears
 Nat Geog 181:69,78–81 (c,1) F '92
 Nat Wildlife 30:cov.,30–6 (c,1) Je '92
 Smithsonian 24:23 (c,4) Ag '93
 Trav/Holiday 177:55 (c,4) Mr '94
 Nat Wildlife 33:35 (c,4) O '95
 Nat Wildlife 35:71 (c,2) D '96
— Brown bears
 Trav&Leisure 22:91 (c,2) My '92
 Natur Hist 102:66–7 (c,3) Je '93
 Nat Geog 185:52–3 (c,2) Ap '94
 Natur Hist 103:76–7 (c,1) Jl '94
 Trav&Leisure 24:59 (c,3) O '94
 Nat Wildlife 34:cov.,20–9 (c,1) Ag '96
— History of Smoky Bear
 Smithsonian 24:59–61 (c,2) Ja '94
— Kodiak brown bears
 Nat Geog 184:48–9 (c,1) N '93
 Nat Geog 189:74–5 (c,1) Ja '96
— Original "Teddy" bear
 Smithsonian 27:44 (c,4) My '96
— See also
 GRIZZLY BEARS
 POLAR BEARS
BEATLES
 Life 15:cov.,10–11,61 (1) D 1 '92
 Life 16:20–4 (2) O '93
 Life 19:cov.,9 (c,4) Ja '96
 Life 19:84–5 (1) O '96

— Paul McCartney
 Life 17:22 (c,4) Ag '94
— "Sgt. Pepper" cover
 Life 19:25 (c,4) Ag '96
— See also
 LENNON, JOHN
BEAUFORT, SOUTH CAROLINA
 Trav&Leisure 24:124–30 (map,c,1) My
 '94
BEAUTY CONTESTS
— 1921 first Miss America
 Life 19:28 (4) S '96
— 1942 Miss America pageant
 Am Heritage 43:40 (4) S '92
— 1945 Miss America
 Life 18:148 (2) Je 5 '95
— 1959 Miss America pageant
 Trav/Holiday 175:126 (c,4) S '92
— 1994 Miss America pageant
 Life 18:46 (c,4) Ja '95
— America's Cover Miss pageant
 Life 18:15–16 (c,1) My '95
— College homecoming queen
 Sports Illus 79:68–9 (c,1) N 29 '93
— Daffodil Queen contenders (Washington)
 Life 15:10–11 (c,1) Jl '92
— Life of child pageant contestant
 Life 17:56–68 (c,1) Ap '94
— Miss Culturama (Nevis)
 Natur Hist 102:57 (c,4) Mr '93
BEAUTY PARLORS
— Intimate salons (Los Angeles, California)
 Trav&Leisure 26:94,99–100 (c,3) O '96
BEAVERS
 Nat Wildlife 32:25–7 (c,1) Ap '94
— Ancient beavers
 Natur Hist 103:52–3,60 (painting,c,1) Ap
 '94
— Beaver dams
 Natur Hist 101:52–3 (c,2) My '92
 Natur Hist 103:38–9,43 (c,1) N '94
BED BUGS
 Life 17:64 (c,3) My '94
BEDOUINS—COSTUME
— Oman
 Nat Geog 187:116–17,125,134–5 (c,2)
 My '95
 Trav&Leisure 25:124 (c,4) D '95
— Syria
 Nat Geog 190:119 (c,3) Jl '96
BEDROOMS
— Bedroom-office (Connecticut)
 Smithsonian 23:61 (c,2) Ap '92
— Children's toy-strewn messy bedroom
 (Pennsylvania)

Life 15:12–13 (1) Jl '92
— Child's bedroom (California)
Life 18:48 (c,3) O '95
— President's bedroom, White House,
Washington, D.C.
Life 16:10–11,38–9 (c,1) Mr '93
— Frank Lloyd Wright's bedroom, Oak Park,
Illinois
Trav/Holiday 179:17 (c,4) My '96
BEDS
— 19th cent. canopied four-posters
Life 15:64 (c,3) O 30 '92
Am Heritage 44:96 (drawing,4) D '93
Trav&Leisure 25:E12 (c,4) D '95
— 1850s sleigh bed (Louisiana)
Trav&Leisure 26:114 (c,1) Ap '96
— Bed reinforced against earthquakes
(California)
Nat Geog 187:35 (c,1) Ap '95
— Canopied bed (France)
Trav&Leisure 24:26 (c,3) Ap '94
— Canopied bed at London hotel, England
Trav&Leisure 26:73 (c,4) Ag '96
— Children's bunk beds (California)
Life 17:62–3 (c,1) Mr '94
— Futons (Thailand)
Trav&Leisure 24:79 (c,4) Ag '94
— Insect net over bed (Costa Rica)
Trav&Leisure 25:167 (c,1) N '95
— Iron religious figure headboard by Yellin
Am Heritage 46:96–7 (1) O '95
— See also
HAMMOCKS
BEECH TREES
Natur Hist 105:46–7 (c,1) Je '96
BEEKEEPING
Nat Geog 183:72–93 (c,1) My '93
BEER INDUSTRY
— Beer bottles
Gourmet 53:121 (c,1) O '93
— Brewery (Czechoslovakia)
Trav/Holiday 179:58 (c,3) Mr '96
— Brewing vat at abbey (Belgium)
Gourmet 56:30 (c,2) Ag '96
BEES
Natur Hist 101:76–7 (c,1) Ag '92
Smithsonian 24:114 (c,4) Je '93
Natur Hist 102:22–9 (c,1) Jl '93
— Covered with pollen
Trav/Holiday 179:18 (c,4) N '96
— Dead honeybees caught in flowers
Natur Hist 103:74–5 (c,1) Ag '94
— Honeybees
Natur Hist 101:40–1 (c,1) F '92
Natur Hist 102:52–5 (c,1) Ag '93

— Honeybees color-coded for research
Life 17:100–1 (c,1) O '94
— Trigona bees on man's hand (Congo)
Nat Geog 188:6 (c,4) Jl '95
— Wearing tracking tags
Nat Wildlife 31:24–5 (c,1) F '93
— See also
BUMBLEBEES
BEETLES
Natur Hist 102:45 (c,2) Ag '93
Natur Hist 103:36–43 (c,1) Mr '94
Natur Hist 103:18–20 (c,4) N '94
Nat Geog 187:33 (c,1) Mr '95
Smithsonian 25:86 (c,4) Mr '95
Nat Wildlife 34:8 (c,4) Je '96
— American burying beetles
Nat Wildlife 30:57 (c,4) Ap '92
Nat Wildlife 34:12 (1) D '95
— Beetle varieties
Natur Hist 105:38 (drawing,c,4) Ja '96
Nat Geog 190:30–1 (c,1) N '96
— Diagram of beetle's burrow
Natur Hist 102:8 (4) Jl '93
— Dung beetle
Natur Hist 102:32–3 (c,1) S '93
— Larvae
Natur Hist 102:8 (c,4) O '93
— See also
LADYBUGS
BEGGARS
— India
Nat Geog 187:42–3 (c,1) Mr '95
— Legless child beggar (Cairo, Egypt)
Nat Geog 183:54–5 (c,2) Ap '93
BEGIN, MENACHEM
Life 16:83 (1) Ja '93
BEIJING, CHINA
Trav/Holiday 177:77–83 (c,1) My '94
Trav/Holiday 179:10 (c,3) N '96
— Forbidden City
Trav&Leisure 25:64–71 (map,c,1) Ja '95
BEIRUT, LEBANON
— 1956
Trav/Holiday 175:34 (4) My '92
— War-torn street
Life 15:50–1 (c,1) Jl '92
BELEM, BRAZIL
Nat Geog 187:4–5,10–15 (c,1) F '95
BELFAST, NORTHERN IRELAND
Trav&Leisure 25:61 (c,4) N '95
BELGIUM
— French fries
Trav/Holiday 179:76–81 (c,1) N '96
— See also
BRUSSELS

ANTWERP
GHENT
BELIZE
Trav&Leisure 24:108–15,148 (map,c,1)
My '94
Gourmet 55:144–7,218 (map,c,1) D '95
— Belize zoo
Sports Illus 76:170–7 (c,1) Mr 9 '92
— Ferry boat
Trav&Leisure 26:50 (c,4) F '96
— Rain forests
Nat Geog 184:118–30 (c,1) S '93
— See also
BELIZE CITY
BELIZE—COSTUME
Smithsonian 25:84–92 (c,2) My '94
BELIZE CITY, BELIZE
Sports Illus 76:180 (c,3) Mr 9 '92
BELL, ALEXANDER GRAHAM
— Home (Nova Scotia)
Trav&Leisure 26:50 (c,4) Ag '96
BELL INDUSTRY
— Bell foundry (Netherlands)
Smithsonian 25:116–18 (c,4) N '94
BELLOW, SAUL
Trav&Leisure 26:102 (c,4) N '96
BELLOWS, GEORGE WESLEY
Smithsonian 23:70 (4) Je '92
— "Cliff Dwellers"
Trav&Leisure 24:56 (painting,c,4) My '94
— Paintings by him
Smithsonian 23:58–71 (c,1) Je '92
BELLS
— History of carillons
Smithsonian 25:112–25 (c,1) N '94
— Making bell for clock tower (Great Britain)
Smithsonian 27:14 (c,4) Ag '96
— Mission bell tower (Lompoc, California)
Gourmet 55:123 (c,1) F '95
— Replica of sunken ship's bell (1975)
Nat Geog 189:47 (c,4) Ja '96
— Wabash school bell, Indiana
Sports Illus 79:22–3 (c,1) N 22 '93
— See also
LIBERTY BELL
BELUGAS
Nat Geog 181:98–100 (c,1) Ap '92
Sports Illus 77:5 (c,4) N 16 '92
Life 16:18–19 (c,1) Ja '93
Nat Wildlife 31:7 (c,1) F '93
Nat Geog 185:2–31 (c,1) Je '94
Life 18:12–13 (c,1) D '95
— Beluga giving birth
Life 18:12–13 (c,1) D '95

BENCHES
— Early 19th cent. Spanish-style banco (New Mexico)
Am Heritage 44:27 (c,1) S '93
— Central Park, New York City
Nat Geog 183:7 (c,3) My '93
BENIN—COSTUME
Natur Hist 104:42–9 (c,1) O '95
BENIN—MAPS
Natur Hist 104:79 (c,4) O '95
BENIN—RITES AND FESTIVALS
— Vodun rites
Natur Hist 104:cov.,40–9 (c,1) O '95
BENNY, JACK
Life 16:30 (3) N '93
Life 19:38 (4) O '96
BENTON, THOMAS HART
— "Self-portrait with Rita" (1922)
Smithsonian 24:37 (painting,c,4) N '93
BERBER PEOPLE
— Morocco
Nat Geog 190:110–11,120–1 (c,1) O '96
BERGEN, NORWAY
Trav&Leisure 22:110–11 (c,4) Jl '92
Nat Geog 186:66 (c,1) O '94
Trav/Holiday 178:46–7 (c,1) Jl '95
BERGMAN, INGRID
Life 18:130 (1) Je 5 '95
BERING SEA
Nat Geog 182:72–85 (map,c,1) O '92
BERKELEY, CALIFORNIA
— Chez Panisse restaurant
Gourmet 52:52,54 (c,3) Je '92
— University of California carillon
Smithsonian 25:112–13 (c,1) N '94
BERLIN, IRVING
— Caricature
Am Heritage 44:82–4 (c,1) O '93
BERLIN, GERMANY
Trav&Leisure 22:B1–B4 (c,1) My '92
Trav&Leisure 25:148–57,177 (map,c,1) S '95
Nat Geog 190:96–117 (map,c,1) D '96
— Early 20th cent. scenes of Jewish life in Berlin
Life 18:126–30 (c,1) N '95
— Brandenburg Gate
Trav&Leisure 22:B1 (c,1) My '92
— Cafes and night life
Trav&Leisure 23:101,106 (c,2) Mr '93
— Charlottenburg Palace
Trav&Leisure 25:177 (c,4) S '95
— Luna Park (1930s)
Am Heritage 46:62–3 (1) My '95
— Map

Trav&Leisure 23:105 (c,1) Mr '93
— Pergamon Museum
Trav&Leisure 22:B3 (c,4) My '92
Trav/Holiday 176:18 (c,4) N '93
— Reichstag wrapped in silver fabric by
Christo
Life 18:20 (c,2) S '95
Life 19:30–1 (c,1) Ja '96
Nat Geog 190:102–3 (c,1) D '96
— Russian flag atop the Reichstag (1945)
Life 18:52 (2) Je 5 '95
— Upended painted tanks decorating East
Berlin border
Life 16:24–5 (c,4) My '93
BERLIN WALL, GERMANY
Smithsonian 25:54–5 (3) Ap '94
Trav/Holiday 178:73 (c,3) S '95
Nat Geog 190:98–9,108–9 (c,1) D '96
— 1965
Am Heritage 46:cov.,66–7 (c,2) D '95
— 1989 destruction of the Wall
Life 17:46 (c,4) N '94
Life 18:114 (c,2) Je 5 '95
BERMUDA
Trav/Holiday 177:66–75 (map,c,1) My '94
— Resort hotels
Trav&Leisure 26:42–8 (c,3) O '96
BERMUDA—COSTUME
Trav/Holiday 177:70–4 (c,1) My '94
BERMUDA—MAPS
Sports Illus 82:98 (c,3) F 20 '95
BERN, SWITZERLAND
Trav/Holiday 176:78–9 (c,2) N '93
BERNESE MOUNTAIN DOGS
Trav&Leisure 26:92 (c,1) Ag '96
BERNHARDT, SARAH
Smithsonian 26:74 (4) My '95
BERNINI, GIOVANNI LORENZO
— Four Rivers fountain, Rome, Italy
Smithsonian 23:94–5 (c,2) S '92
Trav/Holiday 177:60–1 (c,1) My '94
BERNSTEIN, LEONARD
Life 18:142 (1) Je 5 '95
Smithsonian 27:55 (4) N '96
BERRA, YOGI
Sports Illus 83:8 (4) S 18 '95
Life 19:80 (3) F '96
BERRIES
Gourmet 53:58–9 (c,1) Jl '93
— Elderberries
Natur Hist 102:34 (c,4) Ap '93
— Lingonberries
Trav&Leisure 26:94 (c,4) My '96
— See also
BLACKBERRIES

BLUEBERRIES
CRANBERRIES
RASPBERRIES
STRAWBERRIES
BERRY, CHUCK
Life 15:44,81 (c,4) D 1 '92
Am Heritage 47:74 (c,4) Ap '96
BEVERLY HILLS, CALIFORNIA
— 1950s scene
Trav&Leisure 25:76 (3) S '95
— Luxury hotels
Trav&Leisure 25:76–81 (c,3) S '95
BHUTAN
Trav/Holiday 177:78–83 (map,c,1) O '94
Trav&Leisure 26:122–32 (map,c,1) Je '96
— Jhomolhari peak
Trav&Leisure 26:125 (c,4) Je '96
— Tigers Nest flame
Trav/Holiday 177:82 (c,4) O '94
BHUTAN—HOUSING
Trav/Holiday 177:81 (c,4) O '94
BIBLE
— 15th cent. painting of Moses dowsing for
water
Smithsonian 26:70 (c,3) Ja '96
— 1663 Algonquin language bible
Smithsonian 23:111 (c,4) Ap '92
— Shaped like a cross (Israel)
Trav&Leisure 24:89 (c,1) Ag '94
— See also
ABRAHAM
ADAM AND EVE
CHRISTIANITY
DAVID
DEAD SEA SCROLLS
JESUS CHRIST
JUDAISM
MOSES
BICYCLE RACES
Sports Illus 85:17 (c,2) O 21 '96
— Mountain biking competition
Sports Illus 83:46–7 (c,1) Jl 3 '95
— New York City, New York
Nat Geog 183:20–1 (c,2) My '93
BICYCLE TOURS
— Alaska
Smithsonian 25:87 (c,1) Je '94
— Annual Ride across Iowa
Sports Illus 83:6 (c,4) O 30 '95
— Tour de France 1992
Sports Illus 77:2–3,13 (c,1) Jl 27 '92
Sports Illus 77:64–5 (c,2) Ag 3 '92
— Tour de France 1993
Sports Illus 79:2–3,52–3 (c,1) Ag 2 '93
Sports Illus 81:54 (c,4) Jl 4 '94

— Tour de France 1994
Sports Illus 81:2-3,40-2 (c,1) Jl 18 '94
Sports Illus 81:38-40,43 (c,1) Ag 1 '94
— Tour de France 1995
Sports Illus 83:34-8 (c,1) Jl 31 '95
— Tour de France 1996
Sports Illus 85:84-8 (c,1) Jl 29 '96
— Tour du Pont 1992
Sports Illus 76:20-1 (c,2) My 25 '92
— Tour du Pont 1993
Sports Illus 78:50-1 (c,1) My 24 '93
— Tour du Pont 1995
Sports Illus 82:32-3 (c,2) My 15 '95
— Tour du Pont 1996
Sports Illus 84:2-3,48-50 (c,1) My 20 '96
BICYCLES
— 1881 Ottodicycle
Sports Illus 81:68 (c,4) Ag 22 '94
— 1960 Bowden Spacelander
Sports Illus 81:68 (c,4) Ag 22 '94
— Fixing child's bicycle
Sports Illus 79:55 (c,2) Jl 5 '93
— Innovative bicycles
Smithsonian 27:98-103 (c,1) S '96
— Mountain bikes
Smithsonian 25:cov.,74-87 (c,1) Je '94
— Repairing moving bicycle during race
(France)
Sports Illus 79:2-3 (c,1) Ag 2 '93
BICYCLING
— 1895 (New York)
Nat Geog 183:33 (4) My '93
— 1953 children riding tricycles (Washington, D.C.)
Life 15:36 (1) O 30 '92
— Acrobat on unicycle (Quebec)
Trav/Holiday 176:37 (c,4) Jl '93
— Bangladesh
Nat Geog 183:130 (c,1) Je '93
— Bora Bora
Trav&Leisure 22:116 (c,1) N '92
— California
Sports Illus 76:49 (c,4) Je 1 '92
— Canada
Natur Hist 102:50,54 (c,3) Ap '93
— China
Trav&Leisure 25:71 (c,1) Ja '95
— Colorado
Sports Illus 85:112-13 (c,2) Jl 22 '96
— Commuters bicycling in the rain
(Shanghai, China)
Nat Geog 185:cov.,8-9 (c,1) Mr '94
— Germany
Nat Geog 182:6-7 (c,1) Ag '92
— Hotel room service by bicycle (Arizona)

Trav&Leisure 26:75 (c,4) F '96
— Ice cycling with studded tires (Vermont)
Sports Illus 80:13 (c,4) F 21 '94
— Man on tricycle
Sports Illus 84:102-3 (c,1) Ap 1 '96
— Mountain biking
Trav&Leisure 22:E25 (c,4) Ap '92
Smithsonian 25:74-87 (c,1) Je '94
— Nebraska
Sports Illus 77:90 (c,3) D 21 '92
— Netherlands
Trav/Holiday 176:62-7 (c,1) Jl '93
Trav&Leisure 26:85-6 (1) F '96
— Police on mountain bikes (Los Angeles, California)
Nat Geog 181:59 (c,3) Je '92
— Polish forest
Trav&Leisure 24:48 (c,4) Ap '94
— Utah
Trav&Leisure 24:98-105 (c,1) My '94
— Vietnam
Trav&Leisure 24:60 (c,4) D '94
— Virginia
Trav/Holiday 177:123,127 (c,3) Ap '94
— Virtual reality exercise bike
Sports Illus 81:6 (c,4) S 19 '94
BIERCE, AMBROSE
Smithsonian 22:103,105,114 (c,3) Mr '92
— Family
Smithsonian 22:106,109 (4) Mr '92
BIERSTADT, ALBERT
— 1859 painting of bears
Am Heritage 44:90 (c,2) D '93
BIG BEND NATIONAL PARK, TEXAS
Trav/Holiday 175:44-53 (map,c,1) My '92
Trav&Leisure 23:104,110-11 (c,1) F '93
Trav&Leisure 23:95,101 (c,1) Je '93
Natur Hist 104:A10 (c,4) Ap '95
Nat Geog 189:58-9 (c,1) F '96
BIG SOUTH FORK NATIONAL RIVER AND RECREATION AREA
Nat Geog 184:122-36 (map,c,1) Ag '93
BIKINI ATOLL, MARSHALL ISLANDS
Nat Geog 181:70-83 (map,c,1) Je '92
Nat Geog 187:63 (map,c,3) Ja '95
— 1946 atomic testing
Nat Geog 181:70-6 (c,1) Je '92
BILLIARDS
Sports Illus 78:72 (c,3) My 17 '93
Trav&Leisure 23:NY1 (c,4) S '93
Sports Illus 80:62-3 (c,1) Ap 4 '94
Life 17:108 (c,2) Ap '94
Sports Illus 82:73 (c,1) Ja 23 '95
Sports Illus 82:58-9 (c,1) Ja 30 '95

Sports Illus 85:8 (c,3) Jl 8 '96
— Early 20th cent. pool (Colorado)
Am Heritage 47:120 (3) My '96
— Caricature of Minnesota Fats
Sports Illus 84:19 (c,3) Ja 29 '96
— Female pool champion
Sports Illus 76:75–8 (c,3) Ap 20 '92
— Hustler with portable pool table (China)
Nat Geog 189:20–1 (c,1) Mr '96
— Willie Mosconi
Life 17:82 (4) Ja '94
— One-armed man playing pool
Life 17:70 (c,4) Jl '94
— Playing pool (China)
Trav/Holiday 178:73 (c,4) O '95
— Playing pool (Nevada)
Life 16:47 (c,4) Ap 5 '93
— Playing pool in bar (Florida)
Trav&Leisure 22:137 (c,3) Mr '92
— Playing pool in rundown hall (Newfoundland)
Nat Geog 184:28–9 (c,1) O '93
— Pocket billiards
Sports Illus 79:45 (c,1) S 27 '93
— Pool hall (Texas)
Trav&Leisure 23:108–9 (c,1) F '93
— World Championship 1996 (Santa Rosa, California)
Sports Illus 84:2–3 (c,1) Ja 22 '96
Biology. See
ANATOMY
EVOLUTION
GENETICS
REPRODUCTION
BIRCH TREES
Natur Hist 101:26–7,36–9,58–9 (c,1) My '92
Nat Wildlife 30:54–60 (c,1) O '92
— Birch tree reflected in pool of water (New Hampshire)
Nat Wildlife 34:31 (c,1) D '95
BIRD FEEDERS
Nat Wildlife 30:10 (c,4) O '92
Nat Wildlife 31:21–2 (c,2) D '92
Nat Wildlife 31:12–13 (c,1) Ag '93
BIRD HOUSES
— Tree swallow homes (Quebec)
Nat Geog 186:122–3 (c,1) O '94
BIRD NESTS
Nat Geog 183:78–9,86-7 (c,1) Je '93
— Bird nests made from silk
Natur Hist 102:40–6 (c,1) My '93
— Eagles
Natur Hist 102:44–5 (c,1) Ap '93
— Hummingbirds

Trav&Leisure 24:46 (c,4) Ag '94
— Orioles
Nat Wildlife 30:10–11 (c,1) Ag '92
Nat Wildlife 32:18–19 (c,1) Ap '94
— Owl nest in hollow of oak tree
Natur Hist 102:76–7 (c,1) F '93
— Redstarts
Nat Wildlife 32:20 (c,1) Ap '94
— Stork nest
Trav/Holiday 175:80 (c,4) My '92
— Swallows
Nat Wildlife 31:22–3 (c,1) F '93
— Vireos
Nat Wildlife 33:42–3 (c,1) Ag '95
— Warblers
Nat Wildlife 30:4–5 (c,1) Ag '92
Natur Hist 103:40 (c,4) My '94
BIRD WATCHING
Trav/Holiday 178:87 (c,4) N '95
— 1868 chart of poultry breeds
Am Heritage 47:55 (c,1) S '96
— Arizona
Sports Illus 76:7 (c,4) Je 15 '92
— Bhutan
Trav/Holiday 177:80 (c,3) O '94
— Ecuador
Trav&Leisure 23:119 (c,3) Ja '93
— Fiji
Nat Geog 188:123 (c,2) O '95
— Maryland
Nat Geog 183:90 (c,4) Je '93
— New England
Trav/Holiday 176:82 (c,4) O '93
— New Jersey
Trav&Leisure 24:46 (c,4) Ag '94
— New York
Nat Geog 183:29 (c,3) My '93
BIRD WATCHING—HUMOR
Sports Illus 83:10 (drawing,c,4) O 2 '95
BIRDS
— Anhingas
Trav&Leisure 26:E20 (c,4) Mr '96
— Apapane
Natur Hist 104:58 (c,4) D '95
— Audubon paintings
Trav/Holiday 176:79–83 (c,1) O '93
— Banaquits
Natur Hist 105:36 (c,4) D '96
— Bird paintings
Nat Wildlife 32:22–7 (c,1) D '93
Nat Wildlife 33:40–7 (c,1) O '95
— Bird paintings by Ray Harris-Ching
Nat Wildlife 33:44–51 (c,1) Je '95
— Birds of prey migration map
Natur Hist 105:42–3 (c,1) O '96

— Choughs
 Natur Hist 104:44–51 (c,1) F '95
— Cormorant deformed from dioxin poisoning
 Nat Wildlife 32:9 (c,3) Ag '94
— Dickcissels
 Natur Hist 104:1,40–7,74 (c,1) S '95
— Dunnocks
 Natur Hist 104:70,73 (c,3) Ap '95
— Flock of dowitchers
 Nat Geog 182:26–7 (c,1) O '92
— Flocks of birds
 Life 15:24–5 (c,4) My '92
 Natur Hist 102:cov.,10 (c,1) My '93
— Fodies
 Trav&Leisure 26:146 (c,1) D '96
— Hawk-eagles
 Natur Hist 101:48 (c,4) Jl '92
— Honeycreepers
 Nat Wildlife 30:8–9 (painting,c,1) Ap '92
 Nat Wildlife 31:20–7 (c,1) O '93
— 'I'iwi bird
 Nat Geog 188:cov.,11 (c,1) S '95
— Jacamar
 Nat Geog 184:134 (c,4) D '93
— Lesser noddy
 Gourmet 56:116 (c,4) Ap '96
— Limpkins
 Natur Hist 101:68 (c,4) N '92
— Lory
 Natur Hist 104:78 (painting,c,4) Je '95
 Nat Geog 188:123 (c,4) O '95
— Mockingbird attacking car mirror
 Nat Wildlife 30:16 (c,4) Je '92
— Monarchs
 Natur Hist 102:44–5 (c,2) My '93
— Murrelets
 Smithsonian 24:70–81 (c,1) D '93
— Oxpeckers
 Natur Hist 101:56–63 (c,1) Mr '92
 Trav/Holiday 177:29 (c,4) S '94
— Roger Tory Peterson
 Am Heritage 47:18 (4) D '96
— Razorbills
 Nat Wildlife 31:45 (c,2) Je '93
— Red-tailed topics
 Natur Hist 103:52–3 (c,1) F '94
— Rusty pitohui
 Natur Hist 103:6 (c,4) F '94
— Scythebills
 Smithsonian 25:122 (c,4) O '94
— Takahe
 Natur Hist 104:71 (c,4) Je '95
— Tussock bird
 Natur Hist 105:71 (c,2) My '96
— See also

ALBATROSSES
AUKS
AVOCETS
BIRD FEEDERS
BIRD HOUSES
BIRD NESTS
BIRDS OF PARADISE
BITTERNS
BLACKBIRDS
BLUE JAYS
BLUEBIRDS
BOOBY BIRDS
BRANTS
BULLFINCHES
BUNTINGS
BUZZARDS
CANADA GEESE
CARACARAS
CARDINALS
CHICKADEES
CHICKENS
CHICKS
COCKATOOS
CONDORS
COOTS
CORMORANTS
COWBIRDS
CRANES
CROSSBILLS
CROWS
CUCKOOS
CURLEWS
DOVES
DUCKS
EAGLES
EGRETS
EMUS
FALCONS
FINCHES
FLAMINGOS
FLYCATCHERS
FRIGATE BIRDS
FULMARS
GALLINULES
GANNETS
GEESE
GOLDFINCHES
GOSHAWKS
GRACKLES
GROSBEAKS
GROUSE
GUILLEMOTS
GUINEA FOWL
GULLS
HARRIERS

HAWKS
HERONS
HORNBILLS
HUMMINGBIRDS
IBISES
JAYS
KESTRELS
KINGFISHERS
KINGLETS
KITES
KIWI BIRDS
LARKS
LOONS
MACAWS
MAGPIES
MALLARDS
MARTINS
MERGANSERS
MOCKINGBIRDS
MOTMOTS
NUTCRACKERS
NUTHATCHES
ORIOLES
OSTRICHES
OVENBIRDS
OWLS
PARAKEETS
PARROTS
PARTRIDGES
PEACOCKS
PELICANS
PENGUINS
PEWEES
PHALAROPES
PHEASANTS
PIGEONS
PLOVERS
PRAIRIE CHICKENS
PUFFINS
QUAIL
RAILS
RAVENS
REDPOLLS
REDSTARTS
REDWINGED BLACKBIRDS
ROADRUNNERS
ROBINS
ROOSTERS
SANDPIPERS
SHEARWATERS
SKIMMERS
SKUAS
SPARROWS
SPOONBILLS
STARLINGS

STILTS
STORKS
SUNBIRDS
SWALLOWS
SWANS
TANAGERS
TERNS
THRUSHES
TITMICE
TOUCANS
TOURACOS
TURKEYS
VIREOS
VULTURES
WARBLERS
WAXWINGS
WHIPPOORWILLS
WHOOPING CRANES
WOODPECKERS
WRENS

BIRDS, ENDANGERED
 Nat Wildlife 30:8–9,16,36–8,58–9 (c,1)
 Ap '92
 Life 17:50–63 (c,1) S '94
 — California condors
 Nat Wildlife 34:11 (1) D '95
 Nat Geog 190:28–9 (c,2) O '96
 — Chart of endangered species
 Nat Geog 187:16–21 (c,1) Mr '95
 — Dickcissels
 Natur Hist 104:1,40–7,74 (c,1) S '95
 — Efforts to save endangered songbirds
 Nat Geog 183:68–91 (c,2) Je '93
 — Falcon
 Nat Wildlife 34:17 (4) D '95
 — Painted bunting
 Nat Geog 183:91 (c,1) Je '93
 — Pueo owl
 Life 15:36–7 (c,1) My '92
 — Scrub jay
 Nat Wildlife 33:9 (c,4) Je '95
 — Warblers
 Nat Geog 183:68–89 (c,1) Je '93
 Nat Wildlife 33:13 (c,4) Je '95
 — Wood storks
 Nat Geog 190:32–3 (c,1) O '96
 — See also
 CONDORS
 WHOOPING CRANES

BIRDS, EXTINCT
 — Ancient birds
 Natur Hist 104:53–5,68–71 (c,1) Je '95
 — Archaeopteryx skeleton
 Natur Hist 102:41,43 (c,1) S '93
 — Carolina parakeets

Trav/Holiday 176:79 (painting,c,1) O '93
Smithsonian 25:126 (painting,c,4) O '94
— Great auk
Natur Hist 103:6 (painting,c,4) Ag '94
— Mononykus
Natur Hist 102:38–42 (painting,c,1) S '93
— Passenger pigeons
Am Heritage 44:42 (painting,c,3) O '93
— See also
DODO BIRDS
BIRDS OF PARADISE (BIRDS)
Natur Hist 103:10 (c,2) F '94
Natur Hist 105:8–9 (painting,c,2) S '96
BIRDS-OF-PARADISE (FLOWERS)
Gourmet 55:163 (c,4) My '95
BIRTH CONTROL
— 1950s birth control pills
Am Heritage 44:45 (4) My '93
BIRTHDAY PARTIES
— Baby's first birthday (1945)
Life 18:141 (2) Je 5 '95
— 15 year old Cuban girl (Florida)
Nat Geog 181:98–9 (c,1) Ja '92
— First birthday (Bosnia)
Nat Geog 189:60 (4) Je '96
BISON
Trav/Holiday 175:48 (c,4) Je '92
Nat Wildlife 31:10,18 (c,4) O '93
Nat Geog 184:94–5,118–19 (c,1) O '93
Life 16:40–1 (c,1) O '93
Life 17:18 (c,4) Ja '94
Trav&Leisure 24:62 (c,4) S '94
Nat Wildlife 32:56–7 (painting,c,1) O '94
Nat Geog 186:cov.,64–89 (c,1) N '94
Life 18:92 (c,4) Ap '95
Nat Wildlife 34:64 (c,1) F '96
Nat Geog 190:18–19 (c,2) O '96
Nat Wildlife 35:40–1 (c,1) D '96
— Covered by snow
Nat Wildlife 32:2–3 (c,1) F '94
— Huge bison statue (North Dakota)
Nat Geog 186:82–3 (c,1) N '94
— Indian hunting buffalo (1845)
Smithsonian 27:43 (painting,c,3) Ap '96
— Land sculpture of bison (Wyoming)
Nat Geog 186:76–7 (c,1) N '94
BITTER ROOT PLANTS
Natur Hist 103:68–9 (c,1) F '94
BITTERNS
Smithsonian 23:56 (c,4) F '93
Smithsonian 26:cov.,99–103 (c,1) My '95
— Least bittern
Nat Wildlife 31:6-7 (c,4) Ag '93
BLACK AMERICANS
— 1840s black nanny

Smithsonian 27:120 (4) My '96
— 1850 fashionably dressed black man
(Virginia)
Life 18:35 (4) F '95
— 1877 Homer painting of black life
(Virginia)
Smithsonian 26:120 (c,2) O '95
— 1890s affluent black family
Am Heritage 46:cov. (1) F '95 supp.
— 20th cent. black artists
Smithsonian 24:136–48 (4) N '93
— Early 20th cent. (South Carolina)
Am Heritage 43:49 (4) F '92
Natur Hist 105:78–9 (1) Ag '96
— 1924 women (Harlem, New York)
Smithsonian 24:20 (4) Ja '94
— 1928 women (Oklahoma)
Smithsonian 25:24 (4) F '95
— 1930s portraits (Harlem, New York)
Smithsonian 24:20 (4) Ja '94
— 1930–1950 scenes of black life (Cleveland,
Ohio)
Am Heritage 46:40–5 (1) F '95 supp.
— 1940s family at home (New York)
Smithsonian 27:28 (2) Jl '96
— Art works done by black Americans in
France
Smithsonian 26:106–13 (c,1) Mr '96
— Artist Horace Pippin self-portrait
Smithsonian 25:52 (painting,c,4) Je '94
— *Black Like Me* author John Howard Griffin
Life 19:32 (4) Je '96
— Family reunion (Pennsylvania)
Life 17:78–9 (1) N '94
— Harlem block party, New York City, New
York
Life 15:43 (3) S '92
— History of prominent Delany family
Smithsonian 24:145–64 (2) O '93
Am Heritage 44:68–79 (1) O '93
— Huddie "Leadbelly" Ledbetter
Am Heritage 44:10 (drawing,c,4) O '93
— Paintings by black Americans
Smithsonian 26:26 (c,4) Jl '95
— Scenes of African-American life
Smithsonian 22:60–7 (1) F '92
— See also
HARLEM
BLACK HISTORY
— 1899 "Little Black Sambo" illustration
Life 19:26 (c,4) S '96
— 1903 black show "In Dahomey"
Smithsonian 27:48 (3) N '96
— 1940s black Tuskegee airmen
Am Heritage 46:110 (4) My '95

— 1949 crowded classroom of black children
 (Arkansas)
 Life 19:62 (2) O '96
— 1995 Million Man March
 (Washington,D.C.)
 Life 18:24–30 (1) D '95
 Life 19:18–19 (1) Ja '96
 Am Heritage 47:cov.,103 (c,2) F '96
— "Aunt Jemima" (1902-1993)
 Am Heritage 44:80–2 (c,4) S '93
— Black Power salute at 1968 Olympics
 (Mexico City)
 Sports Illus 79:14 (c,4) O 25 '93
— Blacks voting in 1860s election (Louisiana)
 Smithsonian 24:106 (woodcut,4) F '94
— Buffalo Soldier monument to black
 soldiers (Leavenworth, Kansas)
 Am Heritage 44:8 (c,3) F '93
— Depictions of "Mammy" as American icon
 Am Heritage 44:78–86 (c,1) S '93
— First black congressman (1872)
 Smithsonian 24:108 (painting,c,4) F '94
— First Kansas Colored Infantry in Civil War
 Am Heritage 43:78–9,87–91 (paint-
 ing,c,1) F '92
— Retracing Underground Railroad escape
 route
 Smithsonian 27:48–61 (c,1) O '96
— Southern landmarks of black history
 Am Heritage 43:89–99 (c,2) Ap '92
— U.S. sites related to black history
 Am Heritage 46:27–38 (c,2) F '95 supp.
— See also
 BLACKS IN AMERICAN HISTORY
 CIVIL RIGHTS
 CIVIL RIGHTS MARCHES
 CIVIL WAR
 KU KLUX KLAN
 SLAVERY
BLACKBERRIES
 Natur Hist 101:24 (c,2) Ag '92
BLACKBIRDS
 Nat Wildlife 33:44–9 (c,1) D '94
— See also
 REDWINGED BLACKBIRDS
BLACKBUCKS (ANTELOPES)
 Nat Geog 181:6–7 (c,1) My '92
BLACK-EYED SUSANS
 Nat Wildlife 33:52 (c,1) Je '95
 Nat Wildlife 34:50 (c,4) Ap '96
BLACKFEET INDIANS (MONTANA)
— Chief Mad Wolf
 Natur Hist 101:67 (4) Ap '92
— Medicine man (1938)
 Trav&Leisure 25:161 (painting,c,2) O '95

BLACKS IN AMERICAN HISTORY
— 1920s black cowboy Bill Pickett
 Am Heritage 46:2 (c,4) F '95 supp.
— 1960s Motown recording artists
 Smithsonian 25:82–95 (c,1) O '94
— Artist Gordon Parks
 Life 17:26 (c,4) O '94
— Boxer Harry Wills
 Am Heritage 45:132 (4) Ap '94
— Early jazz greats
 Am Heritage 46:70–85 (painting,c,2) O
 '95
— Mother Hale
 Smithsonian 22:65 (4) F '92
— Jelly Roll Morton
 Am Heritage 46:70 (drawing,4) O '95
— Negro baseball league history
 Sports Illus 80:65–8 (3) Je 20 '94
 Smithsonian 25:40,50 (2) Jl '94
 Sports Illus 81:148–50 (1) S 19 '94
— Retired Negro League baseball players
 Sports Illus 76:80–92 (1) Jl 6 '92
— Sun Ra
 Life 17:86 (c,2) Ja '94
— Rock and roll stars (1952-1992)
 Life 15:entire issue (c,1) D 1 '92
— Sculptor Edmonia Lewis
 Smithsonian 27:18 (4) S '96
— See also
 AARON, HENRY
 ALI, MUHAMMAD
 ANDERSON, MARIAN
 ARMSTRONG, LOUIS
 ASHE, ARTHUR
 BAKER, JOSEPHINE
 BASIE, COUNT
 BERRY, CHUCK
 BLAKE, EUBIE
 BROWN, JIM
 CAMPANELLA, ROY
 CHAMBERLAIN, WILT
 CHARLES, RAY
 CLEMENTE, ROBERTO
 DAVIS, MILES
 DOUGLASS, FREDERICK
 DU BOIS, W.E.B.
 ELLINGTON, DUKE
 ELLISON, RALPH
 ERVING, JULIUS
 EVERS, MEDGAR
 GILLESPIE, JOHN BIRKS (DIZZY)
 HALEY, ALEX
 HANDY, W.C.
 HENDRIX, JIMI
 HOLIDAY, BILLIE

HORNE, LENA
HUGHES, LANGSTON
JACKSON, MICHAEL
JOHNSON, ROBERT
JOPLIN, SCOTT
KING, MARTIN LUTHER, JR.
LAWRENCE, JACOB
LOUIS, JOE
MALCOLM X
MARSHALL, THURGOOD
MAYS, WILLIE
MORRISON, TONI
OWENS, JESSE
PARKER, CHARLIE
POWELL, ADAM CLAYTON, JR.
PRICE, LEONTYNE
ROBESON, PAUL
ROBINSON, BILL "BOJANGLES"
ROBINSON, JACKIE
ROBINSON, SUGAR RAY
RUDOLPH, WILMA
SMITH, BESSIE
TUBMAN, HARRIET
WATERS, ETHEL
WILSON, AUGUST
WONDER, STEVIE
WOODSON, CARTER
WRIGHT, RICHARD
BLACKSMITHS
Smithsonian 24:46–54 (c,1) My '93
— Mongolia
Nat Geog 190:31 (c,1) D '96
BLAKE, EUBIE
Smithsonian 27:51 (4) N '96
BLINDNESS
— Blind child playing flute (Colombia)
Life 16:10–11 (c,1) O '93
— Blind girl feeling sculpture (New York)
Life 15:20 (1) Mr '92
— Blind musicians (Egypt)
Natur Hist 104:cov.,34–43 (1) N '95
— Blind people
Nat Geog 182:22–3,31–3 (c,1) N '92
— Computerized navigation aids for the blind
(California)
Nat Geog 188:28–9 (c,1) O '95
— Niger
Life 17:60–5 (1) Ag '94
— River blindness (Mali)
Nat Geog 184:59 (c,4) Ag '93
— Seeing eye dog
Nat Geog 182:10–11 (c,1) N '92
—Street scene viewed through eye disorders
Nat Geog 182:12–13 (c,4) N '92
— See also

KELLER, HELEN
BLIZZARDS
— Traveling in blizzard (Japan)
Nat Geog 186:82–3 (c,1) S '94
BLUE CRABS
Nat Geog 182:96,114–15 (c,1) Jl '92
Nat Wildlife 33:24–8 (c,1) O '95
Nat Wildlife 34:50 (painting,c,4) D '95
BLUE JAYS
Nat Geog 183:86–7 (c,1) Je '93
Nat Wildlife 31:60 (c,1) O '93
Nat Wildlife 32:24 (painting,c,4) D '93
— Wet from bathing
Nat Wildlife 33:2–3 (c,2) Je '95
**BLUE RIDGE MOUNTAINS,
 VIRGINIA**
Trav&Leisure 23:193 (c,4) Ap '93
BLUEBERRIES
Gourmet 55:56–7 (c,2) Jl '95
BLUEBIRDS
Trav/Holiday 175:40 (c,4) Je '92
Nat Wildlife 31:18–23 (c,1) F '93
Nat Wildlife 32:21 (c,4) Ap '94
Nat Wildlife 32:32 (c,4) Ag '94
Nat Wildlife 34:19 (c,1) Ap '96
Nat Wildlife 34:34 (c,4) O '96
Natur Hist 105:82–3 (c,1) D '96
Nat Wildlife 35:42–3 (c,1) D '96
BOA CONSTRICTORS
Sports Illus 76:170–1 (c,1) Mr 9 '92
Nat Wildlife 32:46,49 (c,4) Ap '94
Sports Illus 84:174–5 (c,1) Ja 29 '96
— Eating bird
Natur Hist 104:55 (c,1) Ap '95
— See also
ANACONDAS
PYTHONS
BOAT RACES
— Canoe race (Indonesia)
Nat Geog 189:32–3 (c,2) F '96
— Gig races (Great Britain)
Trav/Holiday 175:55 (c,4) Ap '92
— Hydroplane race (Michigan)
Sports Illus 78:54–5 (c,1) Je 14 '93
— Kayak race (Northwest)
Sports Illus 83:9–10 (c,4) O 16 '95
— Kinetic challenge race of human-powered
amphibious craft (Colorado)
Life 19:24–7 (c,2) Jl '96
— Outrigger canoe race (Hawaii)
Sports Illus 78:142–52 (c,1) F 22 '93
— Powerboat race
Sports Illus 78:82 (c,4) Ap 19 '93
— Regattas (Venice, Italy)
Nat Geog 187:70–2,96–7 (c,1) F '95

— See also
 SAILBOAT RACES
BOATHOUSES
— Iowa
 Smithsonian 25:69 (c,3) D '94
BOATING
— Personal watercraft
 Sports Illus 85:6 (c,4) S 2 '96
— Shooting Colorado River rapids, Southwest
 Nat Geog 185:90–1 (c,1) Ap '94
— Solo rowing trip across the Pacific
 Life 15:40–6 (c,1) F '92
— Tourists on "Maid of the Mist" at Niagara
 Falls
 Trav/Holiday 176:46–7 (c,1) Jl '93
— Young couple in small boat (Great Britain)
 Life 16:16 (c,2) S '93
— See also
 CANOEING
 KAYAKING
 RAFTING
 ROWING
 SAILING
 YACHTING
BOATS
— 1940s PT boat
 Nat Geog 181:64 (4) Mr '92
— Boat gridlock on Lake Havasu,
 Arizona/California
 Life 15:20–1 (c,3) S '92
— Canal boats (Suzhou, China)
 Trav&Leisure 23:70–1 (c,1) S '93
— Christmas harbor festival (Vancouver,
 British Columbia)
 Nat Geog 181:108–9 (c,1) Ap '92
— Civil War "tinclad" ships
 Am Heritage 46:86–7,90-3 (1) O '95
— Crowded wooden boat (Bangladesh)
 Nat Geog 183:134 (c,4) Je '93
— Destroyed by 1992 Hurricane Andrew
 (Florida)
 Nat Geog 183:16–17 (c,1) Ap '93
— Fireboat (California)
 Smithsonian 23:36 (c,4) My '92
— Fireboat (Venice, Italy)
 Nat Geog 187:86–7 (c,1) F '95
— Floating restaurant (Hong Kong)
 Gourmet 52:cov. (c,1) Mr '92
— Longtail boats (Thailand)
 Trav&Leisure 24:81 (c,4) Ag '94
— Mali
 Trav&Leisure 25:136,143 (c,1) F '95
— Malta
 Trav/Holiday 177:48–9,52 (c,1) D '94
— Reed boat (Peru)
 Trav&Leisure 25:110 (c,1) Mr '95
— Replica of 16th cent. birlinn galley ship
 (Ireland)
 Trav/Holiday 175:74–9 (c,1) Jl '92
— Sightseeing boat (New York City, New
 York)
 Trav/Holiday 176:52 (c,4) O '93
— Straw boat (Bolivia)
 Trav&Leisure 26:108 (c,1) F '96
— Tour boat (Egypt)
 Nat Geog 183:39–40 (c,1) My '93
— Toy boats in the Tuileries, Paris, France
 Trav&Leisure 24:88 (1) Ap '94
— Vietnam
 Nat Geog 183:2–3,26–7,35 (c,1) F '93
 Trav&Leisure 23:101 (c,1) Ap '93
— Whalewatch boat (New Zealand)
 Nat Geog 188:70–1 (c,1) N '95
— See also
 BARGES
 BATTLESHIPS
 CANOES
 CLIPPER SHIPS
 CRUISE SHIPS
 FERRY BOATS
 FIGUREHEADS
 FISHING BOATS
 FRIGATES
 GONDOLAS
 HOUSEBOATS
 JUNKS
 KAYAKS
 MARINAS
 MOTORBOATS
 OCEAN CRAFT
 PIERS
 RIVERBOATS
 ROWBOATS
 SAILBOATS
 SAMPANS
 SHIPS
 STEAMBOATS
 SUBMARINES
 TRAWLERS
 UMIAKS
 YACHTS
BOATS—CONSTRUCTION
— American Queen steamboat
 Am Heritage 46:6 (c,3) Ap '95
— Sculpting dugout canoe (Papua New
 Guinea)
 Nat Geog 185:52 (c,1) F '94
— Vietnam
 Trav&Leisure 25:201 (c,3) O '95

BOBCATS
Nat Wildlife 33:cov. (c,1) Ag '95
BOBSLEDDING
Trav&Leisure 22:NY1 (painting,c,3) D '92
Life 17:28 (c,4) F '94
— 1916 women on bobsled (New York)
Trav/Holiday 178:46 (3) Mr '95
— 1948 U.S. heavyset Olympic bobsled team
Life 17:28 (4) F '94
— 1980 Olympics (Lake Placid)
Sports Illus 76:50 (c,3) Ja 13 '92
— 1988 Olympics (Calgary)
Sports Illus 76:52 (c,2) Ja 13 '92
Sports Illus 81:126–7 (c,1) N 14 '94
— 1992 Olympics (Albertville)
Sports Illus 76:32–3 (c,2) F 24 '92
Sports Illus 76:76 (c,4) Mr 2 '92
Sports Illus 77:22–3 (c,1) D 28 '92
Sports Illus 80:46 (c,4) Ja 10 '94
— 1994 Olympics (Lillehammer)
Sports Illus 80:36 (c,3) Mr 7 '94
— Bobsled run (France)
Smithsonian 24:52 (c,4) N '93
— Monaco
Nat Geog 189:93 (c,4) My '96
Bobwhites. See
QUAIL
BODYBUILDERS
— India
Life 16:88 (c,2) My '93
BODYBUILDING
— Using makeshift equipment (Ukraine)
Nat Geog 183:52–3 (c,1) Mr '93
BOER WAR
— Monument to Australian soldiers
(Adelaide, Australia)
Trav/Holiday 175:72 (c,3) F '92
BOGART, HUMPHREY
— 1945 wedding to Lauren Bacall
Life 18:66–7 (1) Je 5 '95
BOLEYN, ANNE (GREAT BRITAIN)
— Tomb at Tower of London, England
Nat Geog 184:44 (c,4) O '93
BOLIVAR, SIMON
Nat Geog 185:38,42–3,58–9,64 (draw-
ing,c,4) Mr '94
— Bolivar's sword
Nat Geog 185:39 (c,4) Mr '94
— Home (Colombia)
Nat Geog 185:65 (c,3) Mr '94
BOLIVIA
Trav&Leisure 26:104–22 (map,c,1) F '96
— See also
ANDES MOUNTAINS
LAKE TITICACA

POTOSI
BOLIVIA—COSTUME
Nat Geog 181:90–1 (c,1) F '92
Nat Geog 185:62–3 (c,1) Mr '94
Trav&Leisure 26:104–18 (c,1) F '96
— Chipaya woman
Natur Hist 101:73 (c,1) Je '92
— Miners (Potosi)
Natur Hist 105:36–43 (c,1) N '96
— Potosi
Natur Hist 105:36–43 (c,1) N '96
— Street vendor
Natur Hist 102:79 (4) My '93
Bolivia—History. See
BOLIVAR, SIMON
BOLIVIA—RITES AND FESTIVALS
— Carnival dancers (Potosi)
Natur Hist 105:42 (c,4) N '96
BOLOGNA, ITALY
Trav&Leisure 22:121 (c,4) Ja '92
Trav/Holiday 177:48–59 (map,c,1) O '94
Gourmet 55:92,96 (c,4) O '95
BOMBAY, INDIA
Nat Geog 187:42–67 (map,c,1) Mr '95
— Outdoor hand laundries
Nat Geog 185:78–9 (c,1) Je '94
BOMBS
— Confiscated bomb device (Israel)
Life 19:42 (3) Jl '96
— Current efforts to dispose of live World
War I bombs (Verdun, France)
Smithsonian 24:26–33 (1) F '94
— See also
ATOMIC BOMBS
BOMBS—DAMAGE
— 1920 Wall Street bomb damage, NewYork
City
Am Heritage 45:40 (4) Ap '94
— 1960s bomb craters (Laos)
Natur Hist 104:50 (c,1) S '95
— 1993 damage to World Trade Center, New
York City, New York
Life 16:14–15 (c,1) Je '93
— 1995 Oklahoma City bombing
Life 18:10–11 (1) Je '95
Life 19:28–9,42–8 (c,1) Ja '96
— Afghanistan
Nat Geog 184:58–9 (c,1) O '93
— Child disfigured by phosphorous bomb
(Iraq)
Nat Geog 182:43 (c,1) Ag '92
— London office buildings damaged by IRA
bomb, England
Life 15:24 (c,4) Je '92
Life 17:22–3 (c,1) Ja '94

BOOBY BIRDS
 Natur Hist 103:56 (c,1) F '94
 Trav/Holiday 179:82 (c,4) F '96
 Natur Hist 105:62–5 (c,4) D '96
BOOKS
— 1430s copy of *Canterbury Tales*
 Smithsonian 23:110 (c,4) Ap '92
— 1868 Horatio Alger hero
 Am Heritage 44:104 (drawing,4) My '93
— 1899 *Little Black Sambo* illustration
 Life 19:26 (c,4) S '96
— *Alice in Wonderland* illustrations
 Smithsonian 23:104 (painting,c,4) O '92
 Natur Hist 105:31 (drawing,4)) N '96
— *Black Like Me* author John Howard Griffin
 Life 19:32 (4) Je '96
— Books by David Macaulay
 Smithsonian 23:70–81 (c,1) My '92
— *The Cat in the Hat* (1957)
 Life 17:50 (c,4) N '94
— *A Christmas Carol* manuscript by
 Dickens (1843)
 Gourmet 53:146 (c,2) D '93
— *Classics Illustrated* comics
 Am Heritage 44:78–85 (c,4) My '93
— *The Count of Monte Cristo* poster
 Smithsonian 27:111 (c,2) Jl '96
— Dickens' written-in copy of *A Christmas
 Carol*
 Life 16:112 (c,2) D '93
— Green Gables house, Cavendish, Prince
 Edward Island
 Trav&Leisure 23:E4 (c,4) My '93
— *Hunchback of Notre Dame* films
 (1923-1996)
 Life 19:35 (c,4) Je '96
— Illustrations from du Maurier's *Trilby*
 (1894)
 Smithsonian 24:118–25 (drawing,4) D '93
— Illustrations from *Kidnapped*
 Smithsonian 26:59 (painting,c,1) Ag '95
— Illustrations from Herman Melville's books
 Smithsonian 26:108–12 (c,3) Jl '95
— Illustrations from *U.S.A.* by Dos Passos
 Am Heritage 47:64–72 (drawing,4) Jl '96
— Manuscript of Joyce's *Ulysses*
 Smithsonian 23:113 (c,4) Ap '92
— Mystery novel covers
 Am Heritage 44:40,45,48 (c,4) Jl '93
— *Old Farmer's Almanac* history
 Smithsonian 23:90–102 (c,1) N '92
— Rosenbach's rare book collection
 Smithsonian 23:106–13 (c,1) Ap '92
— *Sister Carrie* cover (1900)

 Am Heritage 44:72 (c,4) F '93
— Sites associated with *Midnight in the
 Garden of Good and Evil* (Savannah,
 Georgia)
 Trav/Holiday 179:cov.,68-77 (map,c,1)
 My '96
— *Tom Sawyer* inspired events (Hannibal,
 Missouri)
 Life 18:86–7 (c,2) Ap '95
— Unusually shaped science books
 Smithsonian 26:108–11 (c,1) Je '95
— Wildlife guides
 Nat Wildlife 33:46–53 (c,1) Ap '95
— *A Wind in the Willows* illustration
 Smithsonian 24:62 (painting,c,4) Mr '94
— Works by H.P. Lovecraft
 Am Heritage 46:83–90 (c,2) D '95
— See also
 BIBLE
 ROBIN HOOD
 SHERLOCK HOLMES
BOOTH, JOHN WILKES
 Am Heritage 43:cov.,104 (1) S '92
— Sites related to Booth's flight
 Am Heritage 43:104–19 (c,1) S '92
BORDERS
— 1926 immigration officers at Texas/
 Mexico border
 Am Heritage 45:84–5 (2) F '94
— Albania/Greece border
 Nat Geog 182:71 (c,3) Jl '92
— Austrian border guards
 Nat Geog 183:100–1 (c,1) My '93
— Border guards on camels (India)
 Natur Hist 104:58 (c,4) Mr '95
— California/Mexico border at Tijuana/San
 Ysidro
 Nat Geog 190:94–5 (c,1) Ag '96
— German border guards with illegal
 immigrant
 Nat Geog 183:122–3 (c,1) My '93
— Illegal Mexican immigrants crossing into
 Texas
 Nat Geog 182:22–3 (c,4) Jl '92
— India/Pakistan border guards
 Smithsonian 23:120–1 (c,2) My '92
— Mexico/Guatemala border
 Nat Geog 182:100–1 (c,1) N '92
— See also
 BERLIN WALL
BORGLUM, GUTZON
 Smithsonian 23:68 (4) Ag '92
— See also
 MOUNT RUSHMORE

BORNEO
— Rain forest
Nat Geog 189:115 (c,2) Ap '96
BOSCH, HIERONYMUS
— "The Ascent into the Empyrean"
Life 15:66–7 (painting,c,1) Mr '92
— "Garden of Earthly Delights"
Trav&Leisure 23:74–5 (painting,c,1) Jl '93
— "Judgment Day"
Trav/Holiday 178:83 (painting,c,4) Mr '95
Bosnia. See
YUGOSLAVIA
BOSPORUS STRAIT, TURKEY
Nat Geog 185:4–5 (c,1) My '94
— Istanbul
Trav&Leisure 26:84–5,112 (c,3) Ag '96
BOSTON, MASSACHUSETTS
Sports Illus 78:68 (c,1) F 15 '93
Trav&Leisure 23:86–7 (c,1) My '93
Nat Geog 186:2–33 (map,c,1) Jl '94
Trav/Holiday 178:21 (c,4) Je '95
Trav&Leisure 25:74 (c,4) N '95
— 1780s map
Am Heritage 43:67 (c,3) D '92
— 1890s Tremont Hotel
Am Heritage 45:52–3 (4) Ap '94
— Arnold Arboretum (1900)
Natur Hist 104:68 (4) Jl '95
— Berklee College of Music
Smithsonian 27:44–6 (c,2) Ag '96
— Boston Common (1893)
Am Heritage 43:56–7 (painting,c,1) F '92
— Bull & Finch "Cheers" pub
Trav&Leisure 23:42 (c,4) My '93
— Boston "T" subway
Sports Illus 78:30 (c,2) Ap 26 '93
— Freedom Trail sites
Trav/Holiday 179:26 (c,4) D '96
— Isabella Stewart Gardner Museum
Trav/Holiday 177:70 (c,4) S '94
— Map of Blue Hills
Natur Hist 101:24 (2) N '92
— Museum of Science static electricity exhibit
Nat Geog 184:86–7 (c,1) Jl '93
— Old State House
Nat Geog 186:28 (c,4) O '94
— Ritz Hotel history
Trav&Leisure 25:58–60 (c,4) My '95
— South Street
Trav&Leisure 23:E10 (c,3) Ja '93
— Trinity Church interior
Am Heritage 43:4 (c,2) D '92
BOSTON MARATHON
Sports Illus 84:16 (4) Ap 15 '96
— 1993

Sports Illus 78:28–30 (c,1) Ap 26 '93
— 1993
Nat Geog 186:29 (c,1) Jl '94
BOTSWANA
— Okavango Swamp
Natur Hist 102:52 (c,2) Ja '93
Life 16:62–72 (c,1) Jl '93
— Wildlife
Life 16:62–72 (c,1) Jl '93
BOTTICELLI, SANDRO
— "The Birth of Venus"
Natur Hist 102:60–1 (painting,c,1) N '93
— "Madonna of the Eucharist"
Trav/Holiday 177:70 (painting,c,4) S '94
— "La Primavera" (1478)
Trav/Holiday 178:79 (painting,c,2) Mr '95
BOTTLES
— 1787 French wine bottle belonging to Thomas Jefferson
Am Heritage 47:114 (c,4) D '96
— Beer bottles
Gourmet 53:121 (c,1) O '93
— Soda bottles recycled into fabric
Life 17:138–40 (c,4) N '94
— Wine bottles
Gourmet 52:26 (painting,c,2) Ja '92
BOUGAINVILLEA PLANTS
Trav&Leisure 25:113 (c,4) My '95
BOURKE-WHITE, MARGARET
Life 15:78 (4) F '92
— Self-portrait
Life 17:30 (4) S '94
BOW, CLARA
Am Heritage 46:102 (3) Jl '95
BOWLING
Sports Illus 82:64–5 (c,1) Ja 30 '95
— Belgian featherbowling (Michigan)
Sports Illus 81:5 (c,4) S 19 '94
— National Bowling Stadium, Reno, Nevada
Sports Illus 84:7 (c,4) My 27 '96
— Open-air resort bowling lanes (New York)
Trav&Leisure 26:88 (c,1) Je '96
— Retirees playing lawn bowling (Florida)
Nat Geog 182:34–5 (c,1) Jl '92
BOWLING—PROFESSIONAL
Sports Illus 78:58 (c,2) My 3 '93
— Tournament of Champions (Fairlawn,Ohio)
Sports Illus 80:62 (c,2) My 2 '94
BOXERS
— Early 19th cent. boxer Dan Donnelly (Ireland)
Sports Illus 82:164–73 (c,1) F 20 '95
— Joe Frazier
Sports Illus 85:cov.,54–67 (c,1) S 30 '96
— Sonny Liston

Sports Illus 77:74 (c,1) Fall '92
Sports Illus 80:152–64 (c,1) F 14 '94
— Kid McCoy
Sports Illus 82:77–9 (4) F 6 '95
— Jersey Joe Walcott
Life 18:106–7 (1) Ja '95
— Harry Wills
Am Heritage 45:132 (4) Ap '94
— See also
ALI, MUHAMMAD
CORBETT, "GENTLEMAN JIM"
DEMPSEY, JACK
LOUIS, JOE
MARCIANO, ROCKY
ROBINSON, SUGAR RAY
TUNNEY, GENE
BOXES
— Early 20th cent. hatboxes
Smithsonian 23:63 (c,4) S '92
BOXING
— 1909 Bellows painting
Smithsonian 23:58–9 (c,1) Je '92
— 1952 Olympics (Helsinki)
Sports Illus 76:51 (4) My 11 '92
— 1960 Olympics (Rome)
Sports Illus 76:49 (4) My 11 '92
— 1964 Olympics (Tokyo)
Sports Illus 76:51 (4) My 11 '92
— 1968 Olympics (Mexico City)
Sports Illus 76:47 (c,2) My 11 '92
— 1988 Olympics (Seoul)
Sports Illus 78:42 (c,4) F 1 '93
— 1992 Olympics (Barcelona)
Sports Illus 77:56 (c,3) Ag 17 '92
— 1996 Olympics (Atlanta)
Sports Illus 85:62–5 (c,1) Ag 12 '96
— Ancient fresco of boxers (Thera, Greece)
Natur Hist 101:52 (c,2) Jl '92
— Boxercise class
Gourmet 56:88,108 (c,4) My '96
— Training child to box (Nevada)
Nat Geog 190:73 (c,3) D '96
BOXING—AMATEUR
Sports Illus 76:154–60 (c,2) Mr 9 '92
Sports Illus 76:34–5 (c,3) Jl 6 '92
Sports Illus 85:164 (c,2) Jl 22 '96
— Australia
Nat Geog 181:68–9 (c,1) Ap '92
BOXING—PROFESSIONAL
Sports Illus 77:28–9 (c,2) S 21 '92
Sports Illus 78:16–17 (c,1) F 15 '93
Sports Illus 78:48–50 (c,1) Je 28 '93
Sports Illus 79:18–19 (c,2) Jl 5 '93
Sports Illus 79:34–8 (c,1) Ag 9 '93
Sports Illus 79:cov.,14–19 (c,1) S 20 '93

Sports Illus 79:36–8 (c,1) O 11 '93
Sports Illus 79:42–5 (c,2) D 13 '93
Sports Illus 80:2–3,54–6 (c,1) My 16 '94
Sports Illus 81:36–8 (c,1) S 26 '94
Sports Illus 81:30–43 (c,1) O 3 '94
Sports Illus 81:cov.,18–22 (c,1) O 10 '94
Sports Illus 82:40–2 (c,1) My 1 '95
Sports Illus 83:32–5 (c,1) Ag 28 '95
Sports Illus 83:28–9 (c,1) S 11 '95
Sports Illus 84:32–5 (c,1) Mr 25 '96
Sports Illus 85:76–80 (c,1) D 23 '96
— 1815 fight (Ireland)
Sports Illus 82:166 (drawing,4) F 20 '95
— Ali-Liston fight (1965)
Sports Illus 77:72–4,80–1 (c,1) Fall '92
Sports Illus 80:156 (c,4) F 14 '94
Sports Illus 81:66–7 (c,1) N 14 '94
Life 18:36 (c,4) My '95
— Ali-Frazier fight (1975)
Sports Illus 81:30–4 (c,1) O 3 '94
Sports Illus 85:56–9 (1) S 30 '96
— Benvenuto-Fullmer fight (1966)
Sports Illus 77:76–7 (c,1) Fall '92
— Blue Horizon (Philadelphia, Pennsylvania)
Sports Illus 85:2–3,70–86 (1) D 9 '96
— Bowe-Holyfield fight (1992)
Sports Illus 77:16–24,29 (c,1) N 23 '92
— Bowe-Holyfield fight (1995)
Sports Illus 83:20–7 (c,1) N 13 '95
— Boxer's body being stretched out
Life 16:21 (c,4) Jl '93
— Carter-Bettini fight (1965)
Sports Illus 76:82 (4) Ap 13 '92
— Corbett-Sullivan fight (1892)
Am Heritage 43:38 (drawing,4) S '92
Sports Illus 77:7 (drawing,4) Fall '92
Sports Illus 83:7 (drawing,4) O 30 '95
— Dempsey-Tunney fight (1926)
Sports Illus 82:68 (4) Ap 17 '95
— Foreman-Moorer fight (1994)
Sports Illus 81:cov.,18–23 (c,1) N 14 '94
Life 18:69 (c,4) Ja '95
— Foreman-Stewart fight (1992)
Sports Illus 77:46–7 (c,1) D 28 '92
— Holyfield-Bowe fight (1993)
Sports Illus 79:cov.,20–7 (c,1) N 15 '93
— Holyfield-Holmes fight (1992)
Sports Illus 76:22–4 (c,1) Je 29 '92
— Holyfield-Tyson fight (1996)
Sports Illus 85:cov.,28–34 (c,1) N 18 '96
Sports Illus 85:90–1 (c,1) D 30 '96
— Liston-Patterson fight (1962)
Sports Illus 76:74 (c,4) Je 1 '92
Sports Illus 80:152–62 (c,1) F 14 '94
— Louis-Walcott fight (1947)

Life 19:79 (2) F '96
— Marciano-Charles fight (1954)
 Sports Illus 81:2–3 (1) Ag 15 '94
— Marciano-Louis fight (1951)
 Sports Illus 79:58 (4) Ag 23 '93
— Marciano-Walcott fight (1952)
 Sports Illus 76:64 (4) Je 1 '92
 Sports Illus 79:60 (4) Ag 23 '93
— McCoy-Corbett fight (1904)
 Sports Illus 82:78 (4) F 6 '95
— Moorer vs. Holyfield (1994)
 Sports Illus 80:12–15 (c,1) My 2 '94
— Paraglider landing in boxing ring (Las
 Vegas, Nevada)
 Sports Illus 79:23 (c,2) N 15 '93
 Life 17:56 (c,4) Ja '94
— Patterson-Johansson fight (1961)
 Sports Illus 77:70–1 (c,1) Fall '92
— Punching bag
 Sports Illus 82:52 (c,2) F 6 '95
— Ticket from 1892 Sullivan-Corbett fight
 Am Heritage 43:12 (4) F '92
— Tiger-Rouse fight (1967)
 Sports Illus 77:78–9 (c,1) Fall '92
— Training
 Sports Illus 76:78–9 (c,2) Je 8 '92
— Tunney-Dempsey fight (1927)
 Sports Illus 83:4 (4) O 2 '95
— Tyson-Holmes fight (1988)
 Sports Illus 76:86 (c,3) Je 8 '92
— Women
 Sports Illus 84:2–3 (c,1) Mr 25 '96
 Sports Illus 84:cov.,56–8 (c,1) Ap 15 '96
— Women's kick boxing
 Sports Illus 76:9 (c,4) Je 15 '92
BOY SCOUTS
— Recruitment poster
 Smithsonian 27:82 (c,3) Jl '96
BRADLEY, OMAR
 Life 18:132 (2) Je 5 '95
BRADY, JAMES (DIAMOND JIM)
 Gourmet 52:108 (painting,c,4) S '92
BRADY, MATHEW
— Photos of Civil War personalities
 Trav/Holiday 175:91,113 (4) O '92
**BRAHMAPUTRA RIVER, BANGLA-
DESH**
 Nat Geog 183:120–1 (c,1) Je '93
BRAINS
 Life 17:cov.,62–9 (c,1) Jl '94
 Nat Geog 187:cov.,2–3,14–19,28–9,36–7
 (c,1) Je '95
— 1848 skull pierced by iron bar
 Natur Hist 104:70 (3) F '95
— Preserved 19th cent. man's brain
 Nat Geog 185:115 (c,1) Ap '94
— Veins in human brain
 Natur Hist 102:65 (drawing,c,4) Ag '93
BRANDO, MARLON
 Life 16:34 (4) N '93
 Life 18:63 (c,3) Ja '95
 Life 19:31 (4) S '96
BRANDT, WILLY
 Life 16:90 (1) Ja '93
BRANTS (GEESE)
— Black brants
 Nat Wildlife 33:39,41 (c,1) Je '95
BRAQUES, GEORGES
— Depicted in 1917 drawing by Vassilieff
 Smithsonian 27:46–7 (2) Jl '96
—"Still Life with Pears, Lemons and
 Almonds" (1927)
 Smithsonian 27:51 (painting,c,2) Jl '96
BRAZIL
 Nat Geog 187:2–27 (map,c,1) F '95
— Amazon area
 Life 15:64–73 (c,1) Jl '92
— See also
 AMAZON RIVER
 BELEM
 IGUACU FALLS
 RAIN FORESTS
 RIO DE JANEIRO
 RIO NEGRO
 SALVADOR
BRAZIL—COSTUME
 Nat Geog 187:4–25 (c,1) F '95
— Amazonian Indians
 Natur Hist 101:36–43 (c,1) Mr '92
— Rio de Janeiro
 Trav&Leisure 23:cov.,132–43 (c,1) N '93
— Salvador, Bahia
 Trav/Holiday 175:57–65 (c,1) Je '92
 Nat Geog 182:80–3 (c,1) S '92
 Life 16:14 (c,2) O '93
— Suya Indians
 Smithsonian 27:25,62–75 (c,1) My '96
— Urueu-Wau-Wau Indians
 Natur Hist 101:38–43 (c,1) Mr '92
BRAZIL—MAPS
— Views from space
 Nat Geog 190:22–3 (c,1) N '96
BRAZIL—RITES AND FESTIVALS
— Carnival (Rio de Janeiro)
 Trav/Holiday 179:13 (c,4) D '96
**BRAZIL—SOCIAL LIFE AND CUS-
TOMS**
— Beating accused murderer
 Life 19:22 (c,2) My '96

BREAD
— Bagels (China)
 Nat Geog 189:37 (c,1) Mr '96
— Breadsticks
 Gourmet 55:129 (c,1) O '95
— France
 Gourmet 53:120–3 (c,1) D '93
 Smithsonian 25:cov.,50–60 (c,1) Ja '95
— Home-baked breads
 Gourmet 53:22,154–5 (c,1) Ap '93
 Gourmet 55:119 (painting,c,4) Ja '95
— Muffins and rolls
 Gourmet 52:148–9 (c,1) N '92
— See also
 BAKERIES
 BAKING
BREAKFAST
— Hotel breakfast tray (France)
 Trav&Leisure 23:107 (c,2) Ja '93
— Set breakfast table (France)
 Trav&Leisure 26:204 (c,1) S '96
BREMEN, GERMANY
 Trav/Holiday 176:50–1,58–9 (c,1) Jl '93
BREUGHEL, PIETER THE ELDER
— "Calvary"
 Trav/Holiday 178:80 (painting,c,4) Mr '95
— "Hunters in the Snow" (1565)
 Natur Hist 101:7 (painting,c,3) Ap '92
— "Return of the Hunters"
 Am Heritage 45:12 (painting,c,4) Ap '94
BRICE, FANNY
— Caricature
 Smithsonian 27:51 (4) N '96
BRICK INDUSTRY
— Firing bricks in kiln (Afghanistan)
 Nat Geog 184:68–9 (c,1) O '93
BRIDGES
— 1415 bridge (St. Ives, England)
 Smithsonian 24:125 (c,4) S '93
— 19th cent. (St. Paul, Minnesota)
 Smithsonian 27:86–7 (3) S '96
— 1930s model for Hamburg bridge, Germany
 Am Heritage 46:66 (4) My '95
— Avignon's unfinished bridge, France
 Gourmet 53:92–3 (c,1) F '93
— Bamboo bridge (Vietnam)
 Nat Geog 183:30–1 (c,1) F '93
— Bixby Creek Bridge, Carmel, California
 Gourmet 53:101 (c,2) O '93
 Trav/Holiday 179:87 (c,2) D '96
— Central Park, New York City
 Nat Geog 183:18–19 (c,1) My '93
— Chain Bridge, Budapest, Hungary
 Trav&Leisure 26:73 (c,4) N '96
— Charles Bridge, Prague, Czechoslovakia

 Trav&Leisure 22:73 (c,1) Ag '92
 Trav&Leisure 24:65 (c,4) N '94
— Concrete bridge (Tennessee)
 Smithsonian 24:28–9 (c,3) Ja '94
— Covered bridge (Indiana)
 Trav/Holiday 178:11 (c,4) My '95
— Covered bridge (Iowa)
 Life 18:46–7 (c,1) Je '95
— Covered bridge (Maine)
 Trav&Leisure 22:E9 (c,3) F '92
— Covered bridge (Pennsylvania)
 Gourmet 55:117 (c,1) O '95
— Covered bridge (Vermont)
 Trav&Leisure 22:NE1 (c,1) My '92
 Gourmet 52:60 (c,4) Ag '92
 Trav&Leisure 25:E1 (c,4) Ag '95
— Crossville bridge, Tennessee
 Smithsonian 25:78 (c,2) D '94
— Curving footbridge (Germany)
 Nat Geog 182:17 (c,4) Ag '92
— Designs for new bridge (St. Paul, Minnesota)
 Smithsonian 27:84–5,90 (c,2) S '96
— Diving off remains of Mostar Bridge, Bosnia
 Sports Illus 83:18 (c,4) S 18 '95
 Nat Geog 189:140 (c,4) Je '96
— Edmund Pettus Bridge, Selma, Alabama
 Am Heritage 43:91 (c,4) Ap '92
— Elizabeth Bridge, Budapest, Hungary
 Trav&Leisure 24:90–1 (c,1) O '94
— Flimsy bridge made of branches (Pakistan)
 Nat Geog 185:118–19 (c,1) Mr '94
— Florida Keys
 Trav/Holiday 176:82–3 (c,1) N '93
 Trav&Leisure 24:110–11 (c,2) D '94
— Footbridge covered with snow (Sweden)
 Nat Geog 184:4–5 (c,1) Ag '93
— Footbridge to temple (Fengdu, China)
 Trav/Holiday 176:66 (c,1) F '93
— Forest canopy walkway (Ghana)
 Natur Hist 105:45 (c,4) F '96
— Glass-covered bridge between buildings (Monterrey, Mexico)
 Nat Geog 190:56–7 (c,2) Ag '96
— Lions Gate Bridge, Vancouver, British Columbia
 Trav&Leisure 26:162 (c,3) Mr '96
— Man walking on California bridge span (1956)
 Trav/Holiday 176:126 (2) F '93
— Manhattan Bridge, New York City, New York
 Life 18:24 (3) My '95
— Montana

Trav/Holiday 177:70 (c,4) Je '94
— Mostar bridge, Bosnia
 Life 16:14–15 (c,1) Mr '93
 Trav/Holiday 178:69 (c,4) S '95
 Smithsonian 27:92 (c,3) S '96
— Mostar bridge, Bosnia (1928)
 Nat Geog 189:140 (c,3) Je '96
— Over canals (Netherlands)
 Trav/Holiday 176:62–4 (c,1) Jl '93
— Pedestrian suspension bridge (Vancouver,
 British Columbia)
 Trav/Holiday 179:69 (c,3) Je '96
— Ponte Vecchio, Florence, Italy
 Trav&Leisure 22:78–9 (c,1) Jl '92
— Puente la Reina, Pamplona, Spain
 Smithsonian 24:66–7 (c,2) F '94
— Railroad bridge at Victoria Falls,
 Zimbabwe
 Life 18:98–9 (c,1) N '95
— San Sebastian, Spain
 Gourmet 54:131 (c,4) N '94
— Seville, Spain
 Trav/Holiday 175:18 (c,4) Mr '92
 Smithsonian 27:78 (c,2) N '96
— Stone footbridge (Giornico, Italy)
 Trav/Holiday 176:74 (c,4) Ap '93
— Suspension footbridge (Great Britain)
 Trav&Leisure 23:67 (c,4) Ag '93
— Sydney, Australia
 Trav/Holiday 176:50–1 (c,1) Je '93
— Tacoma Narrows Bridge, Washington
 Trav&Leisure 26:107 (c,4) S '96
— Tampa, Florida
 Smithsonian 27:94 (c,4) S '96
— Triborough Bridge, New York City, New
 York
 Smithsonian 26:22 (4) Ja '96
— Verrazano Narrows Bridge, New York
 City, New York
 Sports Illus 77:2–3 (c,1) N 9 '92
 Sports Illus 79:2–3 (c,1) N 22 '93
— Wooden suspension bridge (Idaho)
 Smithsonian 23:38–9 (c,2) S '92
— See also
 BROOKLYN BRIDGE
 GEORGE WASHINGTON BRIDGE
 GOLDEN GATE BRIDGE
 SAN FRANCISCO-OAKLAND BAY
 BRIDGE
BRIDGES—CONSTRUCTION
— Pont de Normandie, France
 Life 18:18 (c,2) Mr '95
— Shanghai, China
 Nat Geog 185:14–15 (c,1) Mr '94

BRISTLECONE PINE TREES
 Natur Hist 105:75 (c,4) F '96
 Trav/Holiday 179:50–1 (c,1) Je '96
— Bark
 Natur Hist 101:14 (c,1) Mr '92
BRITISH COLUMBIA
— Alaska Highway marker, Dawson Creek
 Smithsonian 23:104 (c,4) Jl '92
— Alsek River
 Nat Geog 185:122–5 (map,c,1) F '94
— Cariboo area
 Gourmet 53:108–13,166 (map,c,1) O '93
— Chemainus, Vancouver Island
 Smithsonian 25:54–64 (c,2) My '94
— Echo Lake
 Gourmet 53:110–11 (c,1) O '93
— Horseshoe Bay
 Trav&Leisure 23:123 (c,3) Jl '93
— Liard River Hot Springs
 Smithsonian 23:109 (c,4) Jl '92
— MacMillan Park
 Natur Hist 101:72–6 (map,c,1) Ja '92
— Quadra Island, Discovery Passage
 Gourmet 54:94–7,150 (map,c,1) Ap '94
— Tatshenshini River
 Nat Geog 185:122–7 (map,c,1) F '94
— Tatshenshini-Alsek Wilderness Park
 Nat Geog 185:122–34 (c,1) F '94
— See also
 ALASKA HIGHWAY
 ROCKY MOUNTAINS
 VANCOUVER
BRITISH COLUMBIA—MAPS
— Vancouver Island area
 Trav&Leisure 23:126 (c,3) Jl '93
**BRITISH COLUMBIA—RITES AND
 FESTIVALS**
— Christmas harbor festival (Vancouver)
 Nat Geog 181:108–9 (c,1) Ap '92
BRNO, CZECHOSLOVAKIA
— Flower market
 Natur Hist 102:63 (3) F '93
BRONTE FAMILY
— Haworth Parsonage home, Yorkshire,
 England
 Trav&Leisure 24:64–5 (c,1) Ja '94
— Yorkshire sites associated with the
 Brontes, England
 Trav&Leisure 24:64–71,117 (map,c,1) Ja
 '94
**BRONX, NEW YORK CITY, NEW
 YORK**
— 1842 Bartow-Pell mansion
 Trav&Leisure 25:E1 (c,4) Ja '95

— Rubble-strewn lot
 Life 15:26 (c,4) Jl '92
— Slum life
 Life 18:50–8 (1) S '95
— Urban renewal efforts
 Smithsonian 26:100–11 (c,1) Ap '95
BROOKLYN, NEW YORK CITY, NEW YORK
— 1870s Italianate row house
 Trav&Leisure 24:60 (4) N '94
— Brooklyn Botanical Garden
 Gourmet 54:46–8 (map,c,2) Mr '94
— See also
 BROOKLYN BRIDGE
 CONEY ISLAND
BROOKLYN BRIDGE, NEW YORK CITY, NEW YORK
 Life 17:44 (c,4) My '94
 Gourmet 55:142–3 (c,1) My '95
— 1905
 Natur Hist 104:72–3 (2) Jl '95
BROWN, EDMUND "PAT"
— 1966 Brown vs. Reagan California
 governor's race
 Am Heritage 47:39–60 (c,2) O '96
BROWN, JIM (FOOTBALL PLAYER)
 Sports Illus 81:56–8 (c,1) S 19 '94
— Caricature
 Sports Illus 85:94–5 (c,1) Jl 15 '96
BROWN, JOHN
 Am Heritage 46:14 (painting,c,4) S '95
 Smithsonian 27:28 (painting,c,4) Ag '96
— John Brown going to his hanging
 Smithsonian 25:54 (painting,c,2) Je '94
BRUNELLESCHI, FILIPPO
— 1436 design for Florence Cathedral dome,
 Italy
 Natur Hist 101:26 (drawing,1) Ja '92
— Foundling Hospital, Florence, Italy
 Trav/Holiday 176:65–7 (painting,c,1) S
 '93
BRUSSELS, BELGIUM
 Trav/Holiday 178:25 (c,4) O '95
 Trav/Holiday 179:76–81 (c,1) N '96
BRYAN, WILLIAM JENNINGS
 Am Heritage 45:110 (4) N '94
 Am Heritage 47:16 (4) O '96
— 1908 campaign novelty
 Smithsonian 27:40 (c,4) N '96
BRYCE CANYON NATIONAL PARK, UTAH
 Trav&Leisure 22:88–97 (c,1) Jl '92
 Am Heritage 47:78 (c,4) Ap '96
BUCHANAN, JAMES
 Am Heritage 43:120 (4) S '92

— 1861 cartoon
 Am Heritage 43:57 (drawing,4) N '92
BUCKINGHAM PALACE, LONDON, ENGLAND
 Trav/Holiday 177:74–9 (painting,c,1) Ap
 '94
BUDAPEST, HUNGARY
 Trav/Holiday 175:cov.,54–63 (map,1) My
 '92
 Trav&Leisure 24:86–95,142 (c,1) O '94
 Trav/Holiday 179:31 (c,4) F '96
 Trav&Leisure 26:73–6 (c,4) N '96
— Chain Bridge
 Trav&Leisure 26:73 (c,4) N '96
— Doheny Synagogue
 Trav&Leisure 25:128 (c,4) N '95
— Matthias Church
 Trav/Holiday 179:12 (c,4) D '96
BUDDHA
— Cave paintings of Buddha (China)
 Nat Geog 189:52–63 (c,1) Ap '96
— Death of Buddha (Tibet)
 Life 15:68 (painting,c,2) Mr '92
— Sculpture (Thailand)
 Trav&Leisure 26:167 (c,4) S '96
BUDDHISM—ART
— 14th cent. bodhisattva statue (Tibet)
 Smithsonian 27:26 (c,4) Ag '96
— Cave paintings (China)
 Nat Geog 189:52–63 (c,1) Ap '96
BUDDHISM—COSTUME
— Child monks (Bhutan)
 Trav&Leisure 26:122–4 (c,1) Je '96
— Children at monastery (Tibet)
 Life 15:43 (c,1) Jl '92
— Dalai Lama
 Life 17:86–7 (c,1) F '94
 Life 17:72 (4) S '94
— Lama (Nepal)
 Nat Geog 182:86 (c,4) D '92
— Monk novitiates (Siberia)
 Nat Geog 181:28–9 (c,2) Je '92
— Monks (Bhutan)
 Gourmet 54:86 (c,3) Je '94
— Monks (Burma)
 Nat Geog 188:82–3 (c,1) Jl '95
— Monks (Cambodia)
 Trav&Leisure 22:88–9 (1) O '92
— Monks (Nepal)
 Trav&Leisure 24:94 (c,4) Je '94
— Monks (South Korea)
 Trav/Holiday 178:70 (c,3) O '95
— Monks (Thailand)
 Trav/Holiday 177:58 (c,4) D '94
 Trav/Holiday 178:76 (c,4) O '95

Nat Geog 189:82–3 (c,1) F '96
— Monks (Tibet)
 Trav&Leisure 23:87,89 (c,4) Jl '93
 Life 17:16 (c,2) Ag '94
 Life 17:66–73 (1) S '94
— Nun (Vietnam)
 Nat Geog 187:82-3 (c,2) Ap '95
BUDDHISM—RITES AND FESTIVALS
— Dumje festival (Nepal)
 Nat Geog 182:80–1 (c,1) D '92
— Exorcism of demons (Nepal)
 Nat Geog 184:18–19 (c,2) D '93
— Lighting joss stick (Singapore)
 Trav/Holiday 178:54 (c,1) O '95
— Monks praying (India)
 Life 19:78–9 (c,1) Jl '96
— Pilgrims bowing in road (Taiwan)
 Nat Geog 184:30–1 (c,2) N '93
— Robotic priest praying over dead (Japan)
 Life 16:25 (c,4) Je '93
— Zen Buddhist priest trainees meditating
 (Japan)
 Nat Geog 186:84–5 (c,2) S '94
**BUDDHISM—SHRINES AND
SYMBOLS**
— Buddhist caves along Silk Road (China)
 Nat Geog 189:52–63 (c,1) Ap '96
— Chortens (Nepal)
 Trav&Leisure 24:90–3 (c,2) Je '94
— Golden Rock, Burma
 Nat Geog 188:70–1 (c,1) Jl '95
— Green Gulch Farm, California
 Trav&Leisure 25:58,62 (c,4) Ap '95
— Mount Popa, Burma
 Nat Geog 188:80–1 (c,1) Jl '95
— Prayer flags (Bhutan)
 Trav/Holiday 177:78–9 (c,1) O '94
 Smithsonian 25:137 (c,4) O '94
 Trav&Leisure 26:124 (c,4) Je '96
— Prayer flags (Lo)
 Life 16:83 (c,4) F '93
— Prayer wheel (Tibet)
 Trav&Leisure 23:85 (c,4) Jl '93
— Rosary (Tibet)
 Trav&Leisure 23:85 (c,2) Jl '93
— Stupas containing Buddhist relics (China)
 Trav&Leisure 24:86–7 (c,1) Mr '94
— Thuy Son, Da Nang, Vietnam
 Trav/Holiday 177:60–1 (c,1) Jl '94
— Tigers Nest flame, Bhutan
 Trav/Holiday 177:82 (c,4) O '94
— See also
 BUDDHA
BUDGE, DON
 Sports Illus 79:57 (1) Jl 5 '93

BUENOS AIRES, ARGENTINA
 Gourmet 53:138–43,254 (map,c,1) N '93
 Nat Geog 186:84–105 (map,c,1) D '94
 Trav/Holiday 179:24 (c,4) Mr '96
 Trav&Leisure 26:151–61,187–8 (map,c,1)
 D '96
— Calle Caminito tenements
 Smithsonian 24:154–5 (c,2) N '93
— Singer Carlos Gardel's grave
 Trav&Leisure 26:159 (c,4) D '96
BUFFALOES
 Natur Hist 101:59 (c,4) Mr '92
BUGLE PLAYING
— At Saratoga race track, New York
 Trav/Holiday 178:82 (c,4) Je '95
BUILDINGS—CONSTRUCTION
— 1280 cathedral
 Smithsonian 23:72 (drawing,3) My '92
— 1857 construction of U.S. Capitol,
 Washington, D.C.
 Smithsonian 26:26 (4) Ja '96
— Reinforcing building against earthquakes
 (Oakland, California)
 Nat Geog 187:28 (c,4) Ap '95
BUILDINGS—DEMOLITION
— Building that slipped off its foundation
 (Thailand)
 Life 15:28 (c,4) My '92
Bulgaria. See
 SOFIA
BULLDOGS
 Trav/Holiday 179:74 (c,4) My '96
BULLFIGHTING
— Bull goring matador (Spain)
 Sports Illus 76:126 (4) Mr 9 '92
— California
 Sports Illus 77:6–8 (c,4) D 14 '92
— Colombia
 Sports Illus 76:125 (4) Mr 9 '92
— France
 Nat Geog 188:56–7,68–9 (c,1) S '95
 Trav/Holiday 179:80 (c,4) Mr '96
 Trav/Holiday 179:52–61 (c,1) N '96
— Nevada
 Sports Illus 79:2–3 (c,1) D 20 '93
— Practice (Spain)
 Sports Illus 76:124,132 (c,3) Mr 9 '92
— Running of the bulls (Pamplona, Spain)
 Nat Geog 188:92–7 (c,1) N '95
— Spain
 Sports Illus 76:125–8 (c,3) Mr 9 '92
 Nat Geog 181:24–5 (c,2) Ap '92
 Trav/Holiday 178:75 (c,1) Ap '95
 Life 19:50–1 (c,1) Ag '96
— See also

MATADORS

BULLFINCHES
Natur Hist 105:34 (c,4) D '96

BULLFROGS
Smithsonian 24:94 (c,4) Jl '93
Natur Hist 104:86–7 (c,1) O '95
Nat Wildlife 34:64 (c,1) Je '96

BUMBLEBEES
Nat Wildlife 34:58 (c,4) Ap '96

BUNCHBERRIES
Natur Hist 103:22 (C,4) Ap '94

BUNKER HILL, BATTLE OF
Smithsonian 25:90–1 (painting,c,2) Jl '94

BUNTINGS
Nat Wildlife 33:54 (c,4) F '95
— Indigo buntings
Nat Wildlife 31:22 (c,4) Ap '93
Nat Wildlife 34:44–5 (c,1) Ag '96
— Painted buntings
Nat Geog 183:91 (c,1) Je '93

BURDOCK PLANTS
Natur Hist 102:80–1 (c,1) S '93

BURGER, WARREN
Life 18:94 (c,4) O '95
Life 19:98 (4) Ja '96

BURKINA FASO—SOCIAL LIFE AND CUSTOMS
— Dancing
Sports Illus 85:106–7 (c,1) Ag 5 '96

BURMA
Nat Geog 188:70–96 (map,c,1) Jl '95
— Mount Popa
Nat Geog 188:80–1 (c,1) Jl '95
— See also
RANGOON

BURMA—COSTUME
Trav/Holiday 178:28 (c,4) Ap '95
Nat Geog 188:70–96 (c,1) Jl '95
— Padaung women with brass neck rings
Nat Geog 188:96 (c,1) Jl '95
Nat Geog 189:98–9 (c,1) F '96

BURNS, GEORGE
Life 17:80–1 (c,1) O '94
Life 19:126 (2) My '96

BURNS, ROBERT
Gourmet 54:72 (painting,c,4) Ja '94

BUSES
— 1926 double-decker buses (New York City, New York)
Am Heritage 43:84 (1) N '92
— Burma
Nat Geog 188:88–9 (c,2) Jl '95
— Crowded bus (Albania)
Nat Geog 182:66–7 (c,1) Jl '92

— Electric bus (Chattanooga, Tennessee)
Nat Wildlife 34:45 (c,4) F '96
— School bus (Nebraska)
Nat Geog 183:90–1 (c,2) Mr '93
— Sightseeing jitney in national park (Spain)
Trav/Holiday 175:68–9 (c,1) Ap '92

BUSH, GEORGE
Life 15:25 (c,4) Ja '92
Life 15:24–5 (c,2) O 30 '92
Life 16:111 (c,1) Ja '93
Life 16:10–11,34–5 (c,1) Mr '93
Smithsonian 25:104 (4) O '94
Smithsonian 25:141 (c,4) D '94
Am Heritage 47:69 (painting,c,4) F '96
Life 19:26 (4) Mr '96
— 1988 Bush campaign button
Am Heritage 43:59 (c,4) S '92
— Barbara Bush
Smithsonian 23:158 (c,2) O '92
— Bush in bed with grandchildren
Life 19:82 (c,3) S '96
— George Bush's desk
Life 17:112 (c,2) Ja '94
— Playing golf
Sports Illus 82:2 (c,4) F 27 '95
— Throwing out first baseball of season
Sports Illus 78:87 (c,4) Ap 12 '93

BUSINESSMEN
— 1936 (Pennsylvania)
Life 19:31 (4) O '96
— Sewell Avery
Am Heritage 45:20 (4) My '94
— Clarence Birdseye
Life 19:39 (4) D '96
— Elderly businessman with briefcase (Italy)
Trav&Leisure 26:77 (1) Jl '96
— Charles Lang Freer
Smithsonian 24:20 (4) My '93
— Henry Clay Frick's home (Pittsburgh, Pennsylvania)
Gourmet 53:134 (c,4) O '93
— Stephen Girard
Am Heritage 47:16 (painting,c,4) S '96
— Benjamin Graham
Am Heritage 47:24 (4) Ap '96
— Armand Hammer
Life 17:3 (c,4) Ja '94
— William Harley
Smithsonian 24:90 (4) N '93
— Henry Huntington
Trav/Holiday 177:74 (painting,c,4) S '94
— William J. Levitt
Life 18:100 (4) Ja '95
— Bernarr McFadden
Smithsonian 24:78 (4) O '93

— Orville Redenbacher
 Nat Geog 183:107 (c,4) Je '93
— Joseph Robidoux
 Smithsonian 25:48 (4) My '94
— Alvah C. Roebuck
 Am Heritage 44:14 (drawing,4) S '93
— Richard W. Sears
 Am Heritage 44:14 (drawing,4) S '93
— Adolph Sutro
 Smithsonian 23:122 (4) F '93
— Theodore Vail
 Am Heritage 46:16 (4) O '95
— Sam Walton
 Life 16:64 (c,1) Ja '93
— Thomas Watson, Jr.
 Smithsonian 25:68 (2) S '94
 Life 18:100 (4) Ja '95
— William Wrigley, Jr.'s home (Catalina
 Island, California)
 Trav&Leisure 22:E6 (c,3) D '92
— See also
 BRADY, JAMES (DIAMOND JIM)
 CHRYSLER, WALTER P.
 COOPER, PETER
 FISK, JAMES, JR.
 FLAGLER, HENRY
 FORD, HENRY
 GETTY J. PAUL
 HEARST, WILLIAM RANDOLPH
 HEFNER, HUGH
 HUGHES, HOWARD
 KAISER, HENRY
 ROCKEFELLER, JOHN D.
 ROTHSCHILD FAMILY
 SIKORSKY, IGOR
 SLOAN, ALFRED P., JR.
 WOODHULL, VICTORIA
BUTCHERS
— 1920s
 Am Heritage 47:62 (3) S '96
— Butcher shop sign (Switzerland)
 Gourmet 56:67 (c,4) Jl '96
— Pig slaughterhouse (Peru)
 Nat Geog 189:20–1 (c,2) My '96
BUTLERS
— Butler school (Great Britain)
 Life 17:92 (c,4) F '94
BUTTE, MONTANA
 Nat Wildlife 30:40–1 (c,1) Ag '92
 Smithsonian 23:46–57 (c,1) N '92
— Abandoned mines
 Smithsonian 23:46-57 (c,1) N '92
 Nat Wildlife 32:10–11 (c,1) Ap '94
BUTTERCUPS
— Red buttercups

Natur Hist 103:54,58 (c,4) My '94
— Snow buttercups
 Natur Hist 102:54 (c,1) F '93
BUTTERFLIES
 Natur Hist 101:cov.,54–61 (c,1) Ja '92
 Nat Wildlife 31:20 (c,4) Ap '93
 Natur Hist 102:cov.,3,30–9 (c,1) Je '93
 Nat Geog 184:122–35 (c,1) D '93
 Natur Hist 103:26,30–3 (c,1) Ja '94
 Smithsonian 24:18 (c,4) F '94
 Trav&Leisure 24:104 (drawing,c,4) Ap
 '94
 Nat Wildlife 32:14–21 (c,1) Ag '94
 Natur Hist 104:41–3 (c,1) My '95
 Smithsonian 26:114–25 (c,1) Je '95
 Nat Wildlife 33:52 (c,1) Je '95
 Trav/Holiday 179:78 (c,4) O '96
— Chrysalis
 Natur Hist 103:29 (c,4) Ja '94
— Karner blue butterflies
 Natur Hist 104:62 (3) Jl '95
— Life cycle of butterfly
 Life 16:54 (c,4) Ag '93
 Nat Geog 184:128–33 (c,1) D '93
— Mission blues
 Nat Wildlife 30:8 (painting,c,4) Ap '92
— Monarchs
 Natur Hist 102:32–3,38–9 (c,1) Je '93
 Life 16:50–6 (c,1) Ag '93
 Natur Hist 102:3 (c,4) S '93
 Nat Wildlife 32:14–15 (c,1) Ag '94
 Smithsonian 26:125 (c,1) Je '95
 Trav/Holiday 179:44–7 (c,1) N '96
— Pacific Grove, home to monarchs
 (California)
 Trav/Holiday 179:44–7 (map,c,1) N '96
— Pieridine butterflies
 Natur Hist 104:88–9 (c,1) Ap '95
— Pupa
 Nat Geog 190:57 (c,4) N '96
— El Segundo blue
 Nat Geog 187:38 (c,1) Mr '95
— Shoumatoff's hairstreak
 Natur Hist 105:12 (c,4) Mr '96
— Swallowtails
 Nat Wildlife 32:16,18,20 (c,4) Ag '94
 Nat Wildlife 34:64 (c,1) Ap '96
 Natur Hist 105:76 (painting,c,4) My '96
— Zebra butterflies
 Trav/Holiday 177:87 (c,4) O '94
BUTTERFLYFISH
 Natur Hist 101:36 (painting,c,4) O '92
 Nat Geog 184:78–9 (c,4) N '93
 Natur Hist 103:58 (c,3) F '94
 Natur Hist 105:48–9,62 (c,1) N '96

BUZZARDS
Natur Hist 105:45 (c,4) O '96
— Augur buzzard
Sports Illus 78:92–3 (c,2) My 3 '93
BYRON, LORD
Smithsonian 23:140 (painting,c,4) D '92
BYZANTINE EMPIRE—ARTIFACTS
— Silver vase
Trav&Leisure 22:21 (c,4) N '92

–C–

CABINS
— 1930s miner's cabin (Alaska)
Nat Geog 185:90–1 (c,3) My '94
— Slave cabin (Georgia)
Am Heritage 43:96 (c,4) Ap '92
— Summer camp (New York)
Trav/Holiday 175:62 (c,4) Ap '92
— Wilderness lodge inn (Alaska)
Trav&Leisure 22:73 (c,3) Ja '92
— Wooden shack (Florida)
Nat Geog 181:40–1 (c,1) Ap '92
— See also
LOG CABINS
CABLE CARS
— San Francisco, California
Gourmet 55:160 (c,2) My '95
— Seville, Spain
Trav&Leisure 22:91 (c,4) Ja '92
CABLE CARS (GONDOLAS)
— Cortina, Italy
Trav&Leisure 26:210 (c,4) N '96
— Funicular (Bergen, Norway)
Trav/Holiday 178:46 (c,3) Jl '95
— Vancouver ski resort, British Columbia
Nat Geog 181:110–11 (c,1) Ap '92
— Zurs, Austria
Trav&Leisure 24:102 (c,1) N '94
CACTUS
Natur Hist 105:58–61 (c,2) Ap '96
— Barrel cactus
Trav&Leisure 24:E1 (c,4) Ja '94
Trav&Leisure 24:108 (c,4) O '94
Trav/Holiday 178:35 (c,4) Mr '95
— Cardon cactus
Natur Hist 103:58–65 (c,1) O '94
— Cholla
Natur Hist 105:64 (c,4) My '96
— Claret-cup cactus
Nat Wildlife 32:38–9 (c,1) Je '94
— Columnar cactus
Natur Hist 105:64–6 (c,1) F '96
— Cushion cactus

Natur Hist 104:71 (c,4) S '95
— Damaged saguaros
Smithsonian 26:76–83 (c,1) Ja '96
— Hedgehog cactus
Natur Hist 102:16 (c,4) Ag '93
Nat Wildlife 35:31 (c,4) D '96
— Knowlton cactus
Nat Wildlife 30:55 (c,4) Ap '92
— Saguaro
Natur Hist 101:cov. (c,1) S '92
Nat Wildlife 31:54 (c,4) D '92
Trav/Holiday 176:34 (c,4) Mr '93
Gourmet 53:90 (c,4) O '93
Nat Geog 186:36–7,48–9 (c,1) S '94
Smithsonian 25:90 (c,4) Mr '95
Smithsonian 26:76–83 (c,1) Ja '96
— See also
PRICKLY PEARS
SAGUARO NATIONAL PARK
Cafes. See
COFFEEHOUSES
RESTAURANTS
CAGE, JOHN
Life 16:70 (1) Ja '93
CAIRO, EGYPT
Trav/Holiday 175:53–7 (c,1) S '92
Trav&Leisure 22:65–6 (c,4) S '92
Gourmet 52:91–5 (c,1) S '92
Nat Geog 183:38–69 (map,c,1) Ap '93
Nat Geog 187:18–20 (c,1) Ja '95
— 16th cent.
Smithsonian 26:38 (painting,c,4) D '95
— 1992 earthquake damage
Nat Geog 183:68–9 (c,1) Ap '93
— Muhammad Ali mosque
Nat Geog 183:66–7 (c,2) Ap '93
— Mustafa Mahmoud mosque
Nat Geog 183:57 (c,1) Ap '93
CALAMITY JANE
Trav/Holiday 176:69 (4) Je '93
CALCULATORS
— 1853 mechanical calculator
Smithsonian 26:21 (c,4) F '96
CALDER, ALEXANDER
— 1950s wallpaper designed by him
Smithsonian 26:20 (c,4) Ag '95
— "Flamingo"
Gourmet 53:101 (sculpture,c,2) Mr '93
— Outdoor sculpture (Israel)
Trav/Holiday 176:64 (c,2) D '93
CALENDARS
— 1938
Trav&Leisure 25:161 (c,2) O '95
— 1952 nude Marilyn Monroe calendar
Am Heritage 44:49 (c,4) My '93

CALENDULAS
Nat Wildlife 30:50–1 (c,1) Je '92
CALHOUN, JOHN C.
Smithsonian 23:87 (painting,c,4) My '92
CALIFORNIA
Life 19:62–72 (c,1) Ag '96
— 1846 Donner Party disaster site
Am Heritage 44:74 (4) My '93
— 1964 Berkeley student protest
Am Heritage 47:44 (2) O '96
— 1965 burning of Watts
Am Heritage 47:48 (2) O '96
— 1966 Brown vs. Reagan governor's race
Am Heritage 47:39–50 (c,2) O '96
— Ancient scene at La Brea Tar Pits
Natur Hist 103:84–5 (painting,c,1) Ap '94
— Anza-Borrego Desert
Trav&Leisure 24:E1–E4 (map,c,4) Ja '94
— Big Sur
Trav&Leisure 23:115,118 (c,1) N '93
Life 17:98–9 (c,1) O '94
— Boat gridlock on Lake Havasu
Life 15:20–1 (c,3) S '92
— Bodie
Trav&Leisure 23:195 (c,4) Mr '93
— Bottle house replica (Calico)
Trav&Leisure 24:109 (c,2) O '94
— Cambria
Trav&Leisure 26:E9 (c,4) Je '96
— Central coast area
Gourmet 53:98–103,182–4 (map,c,1) O '93
— Channel Islands
Trav&Leisure 26:78–83 (c,4) Ap '96
— Coastal scenes
Trav&Leisure 23:114–23 (map,c,1) N '93
Trav/Holiday 178:68–9 (c,1) N '95
— Cushenbury Canyon
Natur Hist 102:58–60 (map,c,1) F '93
— Deserts
Trav&Leisure 24:106–11,152 (map,c,1) O '94
Nat Geog 189:54–79 (map,c,1) My '96
— Earthquake effects on California land formation
Nat Geog 187:4–33 (map,c,1) Ap '95
— Edna Valley
Gourmet 53:30 (painting,c,2) Jl '93
— Ferndale
Nat Geog 184:54 (c,4) Jl '93
— J. Paul Getty Museum, Malibu
Trav&Leisure 25:136 (c,2) My '95
— Gilroy
Smithsonian 26:72–5 (c,3) D '95
— Hearst Castle

Gourmet 53:98,103 (c,1) O '93
Sports Illus 80:55 (c,4) F 14 '94
— Hess Collection, Napa
Trav/Holiday 179:27 (c,4) My '96
— Highway 1 scenes
Trav/Holiday 179:86–95 (c,1) D '96
— Huntington Museum
Trav/Holiday 177:74 (c,4) S '94
— La Jolla
Trav&Leisure 26:120–1 (c,1) Je '96
— Laguna Beach
Gourmet 52:48 (c,4) Ag '92
— Lake Tahoe area
Nat Geog 181:112–32 (map,c,1) Mr '92
— Marin County
Trav/Holiday 176:50–3 (c,1) Ap '93
Smithsonian 26:102,105 (c,1) D '95
— Mendocino coast
Sports Illus 82:54–5 (1) F 13 '95
— Mono Lake
Trav&Leisure 23:189 (c,4) Mr '93
Nat Wildlife 31:10–11 (c,1) Je '93
Nat Geog 184:57 (c,3) N 15 '93
Nat Wildlife 33:36 (c,1) Je '95
Smithsonian 26:75 (c,3) Ag '95
Natur Hist 105:62 (c,4) S '96
— Napa Valley
Trav&Leisure 22:71–2 (c,4) O '92
Gourmet 54:86–91,152 (map,c,1) Mr '94
— Nevada City
Trav&Leisure 23:E1 (c,4) Ap '93
— New River
Smithsonian 27:92–7 (map,c,1) Je '96
— Nipomo Dunes
Life 16:34–5 (c,1) O '93
— Northern California
Nat Geog 184:48–79 (map,c,1) Jl '93
Trav/Holiday 179:68–75 (map,c,1) Jl '96
— Ojai
Gourmet 54:44 (c,4) Ja '94
— Owens River
Natur Hist 105:39 (c,1) S '96
— Pacific Grove home of monarch butterflies
Trav/Holiday 179:44–7 (map,c,1) N '96
— Palm Springs resort
Gourmet 56:102–4 (c,4) My '96
— Pebble Beach golf course
Sports Illus 76:68–86 (c,1) Je 22 '92
— Phoenix Park, Fair Oaks
Natur Hist 103:22–4 (map,c,1) D '94
— Point Reyes
Life 19:62–3 (c,1) Ag '96
— Riverside's Mission Inn
Trav/Holiday 176:98 (c,4) Ap '93
Trav&Leisure 23:115–21 (c,1) D '93

— Saline Valley
Nat Geog 189:74–5 (c,1) My '96
— San Andreas Fault
Nat Geog 187:16–19,26–7 (map,c,2) Ap
'95
— San Bernadino National Forest
Natur Hist 102:14–16 (map,c,1) Ag '93
— San Fernando Valley housing development
Sports Illus 80:54–5 (c,3) F 14 '94
— San Juan Capistrano mission
Gourmet 55:119 (c,1) F '95
— Santa Monica
Trav&Leisure 26:E1–E2 (c,4) D '96
Trav/Holiday 179:90–1 (c,1) D '96
— Shasta Lake
Nat Geog 184:9 (c,1) N 15 '93
— Skylonda Spa, Woodside
Trav&Leisure 24:94–9 (c,1) Ja '94
— Smith River
Nat Geog 184:68–9 (c,1) Jl '93
— Sonoma region
Gourmet 55:80–3,128 (map,c,1) S '95
— State parks containing redwoods
Trav/Holiday 177:80–9 (map,1) Ap '94
— Stylized depiction of vineyard
Gourmet 53:38 (painting,c,2) Je '93
— Traverse Creek
Natur Hist 103:70 (map,c,2) F '94
— Trinity Alps area
Trav&Leisure 22:94–106 (map,c,1) Ja '92
— 29 Palms area
Trav&Leisure 23:cov.,109–13,152
(map,c,1) D '93
— Venice
Trav/Holiday 179:90,94–5 (c,1) D '96
— Water problems
Nat Geog 184:9,39–53 (map,c,1) N 15 '93
— See also
ALCATRAZ
BERKELEY
BEVERLY HILLS
BROWN, EDMUND "PAT"
CARMEL
CATALINA ISLAND
DEATH VALLEY
FREMONT, JOHN C.
GOLDEN GATE BRIDGE
GREAT SAND DUNES NATIONAL
MONUMENT
HOLLYWOOD
JOSHUA TREE NATIONAL PARK
LAKE TAHOE
LASSEN VOLCANIC NATIONAL
PARK
LAVA BEDS NATIONAL MONUMENT
LOS ANGELES
MOJAVE DESERT
MONTEREY
MOUNT SHASTA
MOUNT WHITNEY
OAKLAND
PASADENA
REDWOOD NATIONAL PARK
SALTON SEA
SAN DIEGO
SAN FRANCISCO
SAN JOSE
SANTA BARBARA
SEQUOIA AND KINGS CANYON NA-
TIONAL PARK
SIERRA NEVADA
YOSEMITE NATIONAL PARK
CALIFORNIA—ARCHITECTURE
— Missions
Gourmet 55:118–23,152 (c,1) F '95
CALIFORNIA—MAPS
— 1852 map of ranch
Am Heritage 44:130 (c,4) Ap '93
— Highway 1 north of Morro Bay
Trav/Holiday 178:86 (c,4) F '95
— Livermore Valley
Gourmet 52:38 (c,2) Ag '92
— Marin County
Trav&Leisure 23:E2 (c,4) F '93
— Napa Valley
Trav/Holiday 179:28 (c,4) My '96
— Russian River Valley
Gourmet 56:64 (c,2) Je '96
CALISTHENICS
— Aquatic aerobics class (Mexico)
Gourmet 56:176 (c,4) My '96
— Baseball players stretching
Sports Illus 80:38–9 (c,2) Mr 14 '94
Sports Illus 80:66–7 (c,1) My 2 '94
— Boxer's body being stretched out
Life 16:21 (c,4) Jl '93
— Elderly dancer doing headstand (Arizona)
Nat Geog 186:38–9 (c,1) S '94
— Group on beach (Spain)
Trav/Holiday 175:18 (c,4) N '92
— Handstand in New York park
Life 19:26 (c,3) N '96
— Women basketball players stretching
Sports Illus 82:2–3,64–5 (c,1) My 29 '95
— See also
EXERCISING
GYMNASTICS
CALLA LILIES
Trav/Holiday 178:81 (c,4) N '95

CAMBODIA
— See also
ANGKOR
MEKONG RIVER
CAMBODIA—COSTUME
Trav&Leisure 22:88,92–3 (1) O '92
CAMBODIA—HOUSING
— Stilt house
Nat Geog 183:25 (c,3) F '93
CAMBODIA—POLITICS AND GOV-ERNMENT
— Election Day chaos
Life 16:14–15 (c,1) Ag '93
CAMBODIA—SOCIAL LIFE AND CUSTOMS
— Amputees playing cards
Nat Geog 183:20–1 (c,1) F '93
CAMBRIDGE, ENGLAND
— Eagle Pub
Nat Geog 185:109 (c,1) Mr '94
CAMBRIDGE, MASSACHUSETTS
Trav&Leisure 24:E1–E6 (map,c,4) Mr '94
CAMELS
Trav&Leisure 22:17 (c,4) N '92
Nat Geog 183:126–31 (c,1) My '93
Natur Hist 102:31–2 (c,1) Ag '93
Nat Geog 184:cov.,66–93 (c,1) S '93
Natur Hist 102:50–6 (c,1) S '93
Trav/Holiday 177:72 (c,2) N '94
Natur Hist 104:54–61 (c,1) Mr '95
— Bactrian camels
Nat Geog 190:20–1 (c,1) D '96
— Camel driver and herd (Egypt)
Nat Geog 183:38–9 (c,1) Ap '93
— Camel race (Oman)
Nat Geog 187:118–19 (c,1) My '95
— Tourist on camel
Trav/Holiday 175:39 (c,4) My '92
— See also
VICUNAS
CAMERAS
— 1850 daguerreotype camera
Smithsonian 26:44 (4) O '95
— 1910 slide projector
Nat Geog 188:138 (3) O '95
— 1949 wristwatch spy camera
Am Heritage 45:102 (4) Jl '94
— Camera-covered van
Smithsonian 26:20 (c,4) O '95
— Photographer transporting gear in boat (Alaska)
Nat Geog 188:65 (c,1) Ag '95
— See also
EASTMAN, GEORGE

CAMPANELLA, ROY
Life 17:98–9 (1) Ja '94
CAMPFIRES
— Montana
Trav&Leisure 22:77 (c,4) Mr '92
Gourmet 54:148 (c,3) My '94
Trav/Holiday 178:44 (c,4) My '95
CAMPING
— Annual family campground reunion (Georgia)
Smithsonian 27:66–75 (c,1) Ag '96
— California beach
Smithsonian 24:05 (c,3) O '93
— Camping under mosquito net (Florida)
Nat Geog 185:27 (c,4) Ap '94
— Children at summer camp (New York)
Life 16:39–42 (c,1) S '93
— Cooking at campsite (Wyoming)
Trav&Leisure 22:112 (4) My '92
— Eating at campsite (Alaska)
Smithsonian 26:36 (c,3) Mr '96
— Sitting around campfire (California)
Nat Geog 189:61 (c,3) My '96
— See also
TENTS
CANADA
Gourmet 53:65–79 (c,1) Ap '93
Smithsonian 24:77–91 (c,1) Ap '93
Trav&Leisure 23:51–65 (map,c,1) Ap '93
Trav&Leisure 25:1–26 (map,c,1) Mr '95 supp.
— Bowie Seamount
Nat Geog 190:74–5 (map,c,2) N '96
— Canadian Pacific Rail System
Nat Geog 186:36–65 (map,c,1) D '94
— Cross-country train trip views
Trav&Leisure 22:100–9 (map,c,1) S '92
— Prairie provinces
Nat Geog 186:36–65 (map,c,1) D '94
— See also
ALBERTA
BAFFIN ISLAND
BAY OF FUNDY
BRITISH COLUMBIA
LABRADOR
NEW BRUNSWICK
NEWFOUNDLAND
NORTHWEST TERRITORIES
NOVA SCOTIA
ONTARIO
PRINCE EDWARD ISLAND
QUEBEC
ST. LAWRENCE RIVER
SASKATCHEWAN
YUKON

CANADA—COSTUME
— Labrador, Newfoundland
 Nat Geog 184:cov.,4–35 (c,1) O '93
CANADA—HISTORY
— Early 19th cent. expeditions of David
 Thompson
 Nat Geog 189:112–37 (c,1) My '96
— Dionne Quintuplets
 Smithsonian 27:38 (4) S '96
CANADA—MAPS
 Nat Geog 189:118–19 (c,1) My '96
— U.S. border areas
 Trav/Holiday 177:100–5 (c,2) Ap '94
CANADA—RITES AND FESTIVALS
— Christmas harbor festival (Vancouver,
 British Columbia)
 Nat Geog 181:108–9 (c,1) Ap '92
CANADA GEESE
 Nat Geog 181:cov.,66–7,82–5 (c,1) F '92
 Nat Wildlife 30:38–9 (c,1) Ag '92
 Nat Wildlife 31:40–3 (c,1) D '92
 Life 16:76–7 (c,1) Ja '93
 Smithsonian 25:70–9 (c,1) Ja '95
 Nat Wildlife 33:23 (c,4) O '95
— Chicks
 Nat Geog 182:2–3 (c,1) O '92
— Geese silhouetted against full moon
 Natur Hist 104:69 (c,2) S '95
 Nat Wildlife 34:cov. (c,1) Ap '96
CANALS
— 1845 canal (Prunn, Germany)
 Nat Geog 182:8–9 (c,2) Ag '92
— Amsterdam, Netherlands
 Gourmet 54:100–2 (c,1) Je '94
 Trav&Leisure 26:82–6,124–5 (c,1) F '96
 Trav/Holiday 179:30–3 (c,4) S '96
— Arizona Canal, Phoenix, Arizona
 Nat Geog 184:2–4 (c,1) N 15 '93
 Natur Hist 105:38 (c,4) S '96
— Burgundy, France
 Trav/Holiday 179:60–7 (map,c,1) Jl '96
— Canal boats (Suzhou, China)
 Trav&Leisure 23:70–1 (c,1) S '93
— Florida
 Nat Geog 185:25 (c,3) Ap '94
— Great Britain
 Trav/Holiday 176:78–85 (map,c,1) My '93
— Hamburg, Germany
 Trav&Leisure 25:116 (c,1) Je '95
— Irrigation canal (California)
 Nat Geog 182:17 (c,3) O '92
— Locks (Scotland)
 Trav&Leisure 23:64–5 (c,1) Jl '93
— Main-Danube Canal, Germany
 Nat Geog 182:2–31 (map,c,1) Ag '92

— Naviglio Grande canal, Milan, Italy
 Nat Geog 182:118–19 (c,1) D '92
— St. Lawrence Seaway lock (Montreal,
 Quebec)
 Nat Geog 186:121 (c,3) O '94
— St. Petersburg, Russia
 Trav&Leisure 23:108–9 (c,1) N '93
— Skating on Rideau Canal, Ottawa, Ontario
 Trav&Leisure 24:54 (c,4) D '94
— Venice, Italy
 Nat Geog 187:70–97 (map,c,1) F '95
 Trav/Holiday 178:cov (c,1) Ap '95
— Vietnam
 Nat Geog 183:2–3,26–7 (c,1) F '93
— Volga-Baltic Waterway, Russia
 Nat Geog 185:120 (c,3) Je '94
— See also
 ERIE CANAL
CANALS—CONSTRUCTION
— Main-Danube Canal, Germany
 Nat Geog 182:12–15 (c,2) Ag '92
— Soo Canal, Michigan
 Am Heritage 43:26 (c,4) S '92
CANARY ISLANDS
 Gourmet 55:120–3,180 (map,c,1) O '95
— Cave
 Trav&Leisure 22:76 (c,4) Mr '92
— Gomera
 Trav/Holiday 175:70–81 (map,c,1) O '92
— Tenerife
 Trav/Holiday 178:13 (c,4) D '95
CANCER
— Cancer patient
 Life 15:71 (c,4) My '92
— Celebrities with breast cancer
 Life 17:cov. (c,1) My '94
— Developing taxol to treat cancer
 Life 15:71–6 (c,2) My '92
— Mammogram showing breast tumor
 Life 17:79 (c,4) My '94
— Skin cancer symptoms
 Life 15:58 (c,4) Ag '92
CANDLES
— 1840s candlestick and mold
 Life 16:66 (c,4) D '93
— Unusual candlesticks
 Gourmet 54:112 (c,4) Je '94
CANES
— Charles Darwin's walking stick
 Natur Hist 105:56 (c,4) Ag '96
— Walking canes
 Smithsonian 26:24,26 (c,4) O '95
CANNONS
— Late 15th cent. Spanish cannonball
 Nat Geog 181:51 (c,4) Ja '92

— 1860s
Am Heritage 43:98–103 (1) N '92
Trav/Holiday 177:81 (c,2) Jl '94
Am Heritage 46:26 (c,4) O '95
— Cannonballs (Monaco)
Trav/Holiday 176:74 (c,3) F '93
— Revolutionary War cannons (Pennsylvania)
Trav/Holiday 179:75–7 (2) F '96
— World War I cannon in Belleau Wood,
France
Life 16:37 (c,3) N '93

CANOEING
Trav&Leisure 22:NY6 (painting,c,2) Ap
'92
Gourmet 52:58–61 (c,1) Ag '92
Am Heritage 45:60–1 (painting,c,1) Ap
'94
Trav/Holiday 178:38–45 (c,1) My '95
Nat Geog 188:64–5 (c,1) Jl '95
— Late 19th cent. (Massachusetts)
Nat Geog 190:66 (4) Jl '96
— 1905 society couple canoeing (Quebec)
Trav&Leisure 25:68 (1) Jl '95
—1992 Olympics (Barcelona)
Sports Illus 77:70–1 (c,1) Ag 10 '92
— Canoe race (Indonesia)
Nat Geog 189:32–3 (c,2) F '96
— Florida
Nat Geog 185:8–9 (c,1) Ap '94
Trav&Leisure 24:8,107 (c,3) Ap '94
— Minnesota
Trav&Leisure 22:124–33 (c,1) My '92
Trav&Leisure 23:46 (c,4) F '93
— Outrigger canoe race (Hawaii)
Sports Illus 78:142–52 (c,1) F 22 '93
— Polynesia
Trav/Holiday 178:42–5,52–3 (c,1) O '95
— Unsafe canoeing behavior
Sports Illus 85:6 (4) Ag 5 '96

CANOES
— Dugout canoes (Papua New Guinea)
Nat Geog 185:40–63 (c,1) F '94
— Maori waka waka (New Zealand)
Nat Geog 190:40–1 (c,2) N '96
— Outrigger canoes (South Pacific)
Nat Geog 182:122–3 (c,1) Jl '92
Trav&Leisure 24:cov. (c,1) Je '94
— Polynesia
Trav/Holiday 178:42–5,52–3 (c,1) O '95
— Sculpting dugout canoe (Papua New
Guinea)
Nat Geog 185:52 (c,1) F '94

CANVASBACKS
Nat Wildlife 34:58 (c,4) O '96

**CANYON DE CHELLY NATIONAL
MONUMENT, ARIZONA**
Life 16:8–9 (1) Ap 5 '93
Trav&Leisure 23:cov.,144 (c,1) Ap '93
Natur Hist 102:58–9 (c,1) Ag '93
Trav&Leisure 24:72 (c,3) Ag '94
Nat Geog 186:44 (c,3) O '94
Trav/Holiday 177:39 (c,4) O '94
Nat Geog 189:106–7 (c,1) Ap '96
Smithsonian 27:118–19 (1) My '96
Nat Geog 190:90–1 (c,1) S '96

**CANYONLANDS NATIONAL PARK,
UTAH**
Nat Geog 185:86–8 (c,1) Ap '94
Trav&Leisure 24:96–105,141 (map,c,1)
My '94
Nat Geog 189:64–5 (c,1) Ja '96

CANYONS
— Chaco Canyon, New Mexico
Trav&Leisure 23:136–7,142–5 (c,2) Ap
'93
Nat Geog 189:94–5 (c,2) Ap '96
— Chitty Canyon, Arizona
Natur Hist 103:19–20 (map,c,1) Ag '94
— Colca Canyon, Peru
Nat Geog 183:124–7,137 (map,c,1) Ja '93
— Corkscrew Canyon, Arizona
Trav/Holiday 178:cov. (c,1) Jl '95
— Havasu Canyon, Arizona
Trav&Leisure 24:E21–E24 (map,c,4) My
'94
— Rinconada Canyon, New Mexico
Nat Geog 187:132–3 (c,1) Ap '95
— See also
BRYCE CANYON NATIONAL PARK
CANYON DE CHELLY NATIONAL
MONUMENT
GRAND CANYON

**CAPE BRETON ISLAND, NOVA SCO-
TIA**
Trav&Leisure 26:49–52 (map,c,2) Ag '96
— Country inn
Trav/Holiday 175:39 (c,2) Je '92

CAPE COD, MASSACHUSETTS
Gourmet 53:8,122–5,196 (map,c,1) Ap '93
Trav&Leisure 24:145–7 (map,c,3) Jl '94
Trav/Holiday 178:31,33 (map,c,4) O '95
Trav&Leisure 26:C1–C4 (map,c,4) O '96
— Lighthouse
Gourmet 53:8 (c,4) Ap '93

**CAPE HATTERAS, NORTH CARO-
LINA**
— Lighthouse
Smithsonian 23:82 (c,4) O '92

CAPE OF GOOD HOPE
Nat Geog 182:70–1 (c,1) N '92
CAPE TOWN, SOUTH AFRICA
Trav&Leisure 22:122,138 (c,2) D '92
Trav/Holiday 177:65 (c,4) O '94
— 1899 Mount Nelson Hotel
Trav&Leisure 24:100 (4) S '94
— Aerial view
Nat Geog 182:70–1 (c,1) N '92
— Ellerman House
Trav&Leisure 26:46 (c,4) S '96
CAPITAL PUNISHMENT
— 1692 Salem witch hangings
Smithsonian 23:120 (engraving,c,4) Ap
'92
— 1847 hanging of U.S. Army traitors
(Mexico)
Am Heritage 46:81 (painting,c,3) N '95
— 1865 hangings of Lincoln assassination
conspirators
Am Heritage 43:108–9 (2) S '92
— 1928 electrocution of Ruth Snyder (New
York)
Am Heritage 45:70 (4) O '94
— 1944 execution of German spy
Life 18:79 (4) Je 5 '95
— Electric chair
Life 17:64 (c,4) O '94
— Gurney used for lethal injection executions
(Louisiana)
Life 16:72 (4) Mr '93
— Onlookers watching firing squad victim
(Liberia)
Life 16:12–13 (c,1) F '93
— See also
LYNCHINGS
**CAPITOL BUILDING, WASHING-
TON, D.C.**
Life 15:36-9 (c,1) Je '92
Smithsonian 23:112–19 (c,2) Mr '93
Life 16:50-9 (c,1) S '93
— 1857 construction of the Capitol
Smithsonian 26:26 (4) Ja '96
— 1941
Smithsonian 23:60 (1) N '92
— Old Capitol columns
Am Heritage 44:91–3 (c,1) Ap '93
— Statuary Hall
Trav/Holiday 175:115 (4) N '92
CAPITOL BUILDINGS—STATE
— Austin, Texas
Trav/Holiday 175:70 (c,1) F '92
Trav&Leisure 25:82 (c,4) F '95
— Baton Rouge, Louisiana
Nat Geog 184:102–3 (c,1) N 15 '93

— Charleston, West Virginia
Gourmet 56:188 (c,4) My '96
— Jackson, Mississippi
Trav&Leisure 26:68 (c,4) Mr '96
— Montpelier, Vermont
Smithsonian 23:106 (c,4) O '92
— Richmond, Virginia
Trav&Leisure 25:E14 (c,4) My '95
— St. Paul, Minnesota
Trav/Holiday 179:42 (c,3) N '96
**CAPITOL REEF NATIONAL PARK,
UTAH**
Trav&Leisure 23:96,100 (c,1) Je '93
CAPONE, AL
Smithsonian 26:87 (4) S '95
— Gravesite (Chicago, Illinois)
Am Heritage 46:88 (c,4) Ap '95
— Robotic Capone
Am Heritage 46:65 (c,4) Ap '95
— Sites related to Al Capone (Chicago,
Illinois)
Am Heritage 46:72,76,88 (c,4) Ap '95
CAPOTE, TRUMAN
Life 18:32 (4) Je '95
Captains. See
SHIP CAPTAINS
CAPUCHIN MONKEYS
Trav/Holiday 176:103 (c,4) O '93
Nat Wildlife 32:9 (c,4) F '94
Natur Hist 103:A4 (c,4) O '94
Trav/Holiday 177:90 (c,4) O '94
Smithsonian 25:124 (c,4) O '94
Life 18:77–9 (c,1) Ag '95
CARACARA BIRDS
Nat Geog 185:122 (c,4) Ap '94
CARAVAGGIO
— Painting of St. John the Baptist
Trav&Leisure 25:60 (c,4) O '95
CARCASSONNE, FRANCE
Gourmet 55:89,92–3 (c,1) Je '95
CARD PLAYING
— Amputees playing cards (Cambodia)
Nat Geog 183:20–1 (c,1) F '93
— At men's club (Argentina)
Nat Geog 186:98–9 (c,2) D '94
— Greece
Trav&Leisure 25:124 (c,4) Je '95
— El Mus (Spain)
Nat Geog 188:80 (c,3) N '95
— Old men in coffeehouse (Spain)
Nat Geog 181:9 (c,3) Ap '92
— Old men playing rummy in cafe
(California)
Nat Geog 184:54–5 (c,1) Jl '93
— Three-card monte

Life 16:115–16 (c,3) O '93
CARDIFF GIANT
Am Heritage 45:12 (4) N '94
CARDIGAN WELSH CORGIS (DOGS)
Smithsonian 23:64 (c,4) Ap '92
CARDINALS (BIRDS)
Sports Illus 76:8 (c,4) Je 15 '92
Nat Wildlife 31:52 (c,4) F '93
Nat Wildlife 33:cov. (c,1) F '95
Nat Wildlife 33:47 (painting,c,2) O '95
Nat Wildlife 34:cov. (c,1) F '96
Nat Wildlife 34:51 (c,4) Je '96
Nat Wildlife 34:50–1 (c,1) Ag '96
CARDS
— Imaginative quilted playing cards
Smithsonian 25:119–21 (c,2) Mr '95
— See also
CARD PLAYING
CREDIT CARDS
TRADING CARDS
Caribbean Sea. See
WEST INDIES
CARMEL, CALIFORNIA
— Point Lobos
Gourmet 55:114 (c,3) My '95
— San Carlos Borromeo mission
Gourmet 55:118,122 (c,2) F '95
CARIBOU
Natur Hist 101:23 (c,3) Je '92
Nat Geog 183:82–3 (painting,c,1) Ap '93
Nat Wildlife 32:14–17 (c,1) F '94
Nat Wildlife 33:14–15 (c,1) Ap '95
Trav/Holiday 178:78–9 (c,1) My '95
Smithsonian 26:38–9 (c,2) Mr '96
Natur Hist 105:32-3 (c,1) My '96
Natur Hist 105:56 (c,4) Je '96
— Aerial view of herd
Nat Wildlife 31:4–5 (c,1) O '93
Nat Geog 184:32–3 (c,1) O '93
— Caribou practicing flying for Santa's
journey
Life 16:102–4 (c,2) D '93
— Silhouetted against ice (Alaska)
Gourmet 54:152 (c,3) My '94
Carnivals. See
FESTIVALS
CARRIAGES AND CARTS
— 19th cent. cart (New Mexico)
Am Heritage 45:96 (c,4) F '94
CARRIAGES AND CARTS—HORSE-DRAWN
— 19th cent. (South Dakota)
Gourmet 55:50 (c,4) Ag '95
— 1801 Hackney carriage
Am Heritage 44:70 (drawing,c,4) S '93

— Camel pulling cart (India)
Natur Hist 104:60 (c,4) Mr '95
— Chile
Trav&Leisure 23:91 (c,4) O '93
— Donkey cart (China)
Smithsonian 24:79 (c,2) N '93
— Egypt
Trav&Leisure 25:168 (c,1) S '95
— New York City, New York
Nat Geog 183:30–1 (c,1) My '93
— Savannah, Georgia
Trav/Holiday 179:76 (c,3) My '96
CARROLL, LEWIS
— *Alice in Wonderland* illustrations
Smithsonian 23:104 (painting,c,4) O '92
Natur Hist 105:31 (drawing,4) N '96
Carrousels. See
MERRY-GO-ROUNDS
CARSON, JOHNNY
Life 15:cov., 38–44 (c,1) My '92
Life 16:98 (c,1) Ja '93
CARSON, RACHEL
Am Heritage 44:43 (4) O '93
Natur Hist 104:66 (c,4) Jl '95
CARTER, JIMMY
Smithsonian 23:156 (4) O '92
Life 18:100–14 (c,1) N '95
— Rosalind Carter
Am Heritage 45:125 (4) D '94
CARTHAGE, TUNISIA
— Ancient Carthage
Smithsonian 25:124–41 (map,c,1) Ap '94
— See also
CATO THE ELDER
DIDO
HANNIBAL
CARTIER-BRESSON, HENRI
Life 17:30 (4) Je '94
— 1949 photo of Beijing, China
Trav&Leisure 25:70 (1) Ja '95
— Photos and sketches by him
Life 17:30-4 (2) Je '94
CARTOONISTS
— Miguel Covarrubias
Am Heritage 46:92 (4) D '95
— Randy Glasbergen
Smithsonian 26:86 (c,4) Je '95
— Hank Ketcham
Smithsonian 26:86 (c,4) Je '95
— Gary Larson
Smithsonian 27:26 (c,4) Ag '96
— Bill Mauldin
Life 18:129 (4) Je 5 '95
— See also
ARNO, PETER

HIRSCHFELD, AL
NAST, THOMAS
CARTOONS
— 1858 cartoon about pollution of the Thames
 River, England
 Natur Hist 103:42–3 (c,1) Je '94
— 1887 cartoon about need for railroad
 regulation
 Am Heritage 47:22 (4) My '96
— 1890 cartoon about occultism
 Smithsonian 26:114 (c,4) My '95
— 1893 cartoon lampooning anti-immigration
 sentiment
 Am Heritage 45:114 (c,4) F '94
— 1898 cartoon of world powers dividing
 China
 Natur Hist 102:61 (c,4) D '93
— 1899 cartoon about monopolies
 Am Heritage 47:16 (c,4) My '96
— 1913 anti-divorce cartoon
 Smithsonian 27:70 (4) Je '96
— 1942 Russian cartoon about Allies striking
 Axis
 Am Heritage 46:48 (c,4) D '95
— 1961 fallout shelter
 Smithsonian 25:56 (4) Ap '94
— 1994 baseball strike cartoons
 Sports Illus 81:20–3 (4) S 26 '94
— Caricatures by Miguel Covarrubias
 Am Heritage 46:93–9 (c,1) D '95
— Cartoon about school violence
 Life 18:44 (4) Ja '95
— Cartoon of threatening storm cloud
 Sports Illus 79:2–3 (c,1) N 15 '93
— Cartoons about husbands and wives at
 breakfast table
 Smithsonian 26:84 (4) Je '95
— Child's mask of Anpanman cartoon figure
 (Japan)
 Smithsonian 25:98 (c,4) D '94
— "Dennis the Menace"
 Smithsonian 26:83,86 (c,4) Je '95
— Disney characters (Florida)
 Life 19:19–21 (c,1) S '96
— Global warning cartoon showing a tropical
 New York City
 Natur Hist 101:18 (4) Ap '92
— Rube Goldberg invention
 Life 17:22 (4) Jl '94
— Edward Lear nonsense cartoon and
 limerick
 Life 17:41 (4) My '94
— Mauldin cartoons about World War II
 Smithsonian 23:cov. (1) N '92
 Am Heritage 45:16 (4) Ap '94

— Remains of forest surrounded by urban life
 Natur Hist 101:6 (c,3) Ag '92
— Statue of Liberty depicted in cartoons
 Smithsonian 27:84–5 (3) Jl '96
— Thurber cartoon about telephone wrong
 numbers
 Life 17:45 (4) D '94
— See also
 CHARACTER SYMBOLS
 COMIC STRIPS
 MICKEY MOUSE
 POLITICAL CARTOONS
CASABLANCA, MOROCCO
— Hassan II Mosque
 Gourmet 56:49 (c,2) Ja '96
CASALS, PABLO
 Life 15:88 (4) O 30 '92
CASCADE RANGE, NORTHWEST
— Washington
 Sports Illus 76:46 (c,3) Je 22 '92
 Life 15:50 (c,2) S '92
— See also
 MOUNT HOOD
 MOUNT SHASTA
CASTLES
— 12th cent. Obidos castle, Portugal
 Trav&Leisure 24:121 (c,4) O '94
— 14th cent. castles on the Rhine, Germany
 Trav/Holiday 177:50–1,56 (c,1) S '94
— Balmoral sitting room, Scotland
 Life 15:60 (c,4) My '92
— Beaumaris Castle, Wales
 Gourmet 56:96 (c,4) Je '96
— Blair castle, Scotland
 Gourmet 52:118 (c,4) Ap '92
— Bouzov castle, Czechoslovakia
 Nat Geog 184:22 (c,4) S '93
— Broughton, England
 Gourmet 52:98 (c,4) Mr '92
— Castle Coole, Northern Ireland
 Trav&Leisure 25:61 (c,4) N '95
— Castle Howard, Yorkshire, England
 Gourmet 55:94 (c,4) Mr '95
— Castelo di Arco, Trentino, Italy
 Gourmet 53:50–1 (c,1) Ag '93
— Castelo dos Mouros, Sintra, Portugal
 Trav&Leisure 24:116 (c,1) O '94
— Cawdor castle, Scotland
 Trav&Leisure 22:78 (c,4) My '92
— Cesky Krumlov, Czechoslovakia
 Trav/Holiday 179:54–6 (c,1) Mr '96
— Conwy castle, Wales
 Trav&Leisure 23:156 (c,4) My '93
— Denmark
 Gourmet 52:52–7,108 (map,c,1) Ag '92

— Dover castle, England
Sports Illus 81:42 (c,3) Jl 18 '94
— Dunguaire castle, Kinvara, Ireland
Trav&Leisure 24:62–3 (c,1) Jl '94
— Edinburgh, Scotland
Smithsonian 25:47 (c,1) D '94
— Eilean Donan castle, Scotland
Trav&Leisure 22:155 (c,3) Ap '92
Nat Geog 190:6–7 (c,1) S '96
— Elmina, Ghana
Natur Hist 105:38 (c,4) F '96
— Euro Disney, France
Natur Hist 103:26 (c,3) D '94
— Falmouth, England
Trav/Holiday 176:62 (c,4) O '93
— Fredensborg castle, Denmark
Gourmet 52:54–5 (c,1) Ag '92
— Frederiksborg castle, Denmark
Gourmet 52:56–7 (c,1) Ag '92
— Herrenchiensee castle, Germany
Trav/Holiday 176:74–5 (c,2) My '93
— Hluboka castle, Czechoslovakia
Nat Geog 184:22–7 (c,1) S '93
— Hohenschwangau castle, Germany
Trav/Holiday 176:70–1 (c,1) My '93
— Ice castle (Quebec)
Trav/Holiday 178:74 (c,4) D '95
— Kasteel de Haar, Netherlands
Trav&Leisure 24:114–15 (c,1) Ap '94
— Kinloch castle, Isle of Rum, Scotland
Trav&Leisure 26:68 (painting,c,3) O '96
— Krak des Chevaliers, Syria
Trav&Leisure 24:73 (c,4) N '94
— Linderhof castle, Germany
Trav/Holiday 176:72–3 (c,2) My '93
Trav&Leisure 23:92–9,143 (map,c,1) D '93
— Macbeth's Castle, Bankfoot, Scotland
Trav/Holiday 179:21 (c,4) S '96
— Neuschwanstein castle, Germany
Trav/Holiday 176:cov.,76 (c,1) My '93
— Penafiel castle, Spain
Trav&Leisure 23:166 (c,4) O '93
— Portugal
Trav&Leisure 23:84–93 (c,1) Ag '93
— Rosenborg castle, Denmark
Gourmet 52:52–3 (c,1) Ag '92
Trav&Leisure 25:99,155 (c,1) Mr '95
— St. John's Castle, Limerick, Ireland
Am Heritage 45:27 (c,2) My '94
— Sand sculpture of Smithsonian Castle, Washington, D.C.
Smithsonian 26:63 (c,3) Ap '95
— Spis castle, Czechoslovakia
Nat Geog 184:34–5 (c,1) S '93

— Tantallon castle, North Berwick, Scotland
Gourmet 52:53 (c,2) Jl '92
— Wawel Castle, Krakow, Poland
Trav&Leisure 25:128 (c,4) N '95
— See also
CHATEAUS
PALACES
WINDSOR CASTLE
CASTRO, FIDEL
Life 17:13 (c,4) Ja '94
Life 19:24 (4) Ag '96
— Playing baseball
Sports Illus 82:62 (2) My 15 '95
CATALINA ISLAND, CALIFORNIA
Trav&Leisure 22:E5–E6 (c,3) D '92
Trav/Holiday 179:26–8 (map,c,3) F '96
CATERPILLARS
Smithsonian 23:52 (c,4) D '92
Natur Hist 102:45 (c,4) D '93
Nat Geog 184:128-37 (c,1) D '93
Natur Hist 103:28–9 (c,1) Ja '94
Natur Hist 103:46–7 (c,1) F '94
Nat Wildlife 32:14–21 (c,4) Ag '94
Nat Wildlife 33:5 (c,4) F '95
Natur Hist 104:30–6 (c,1) Ap '95
Natur Hist 104:40 (c,4) My '95
Natur Hist 104:76 (c,4) S '95
Smithsonian 26:72 (c,4) F '96
— Caterpillars marching in procession
Natur Hist 103:100–1 (c,1) Ap '94
— Poisonous caterpillars
Life 15:66 (c,4) Jl '92
— Stages in life cycle
Nat Geog 184:128–33 (c,1) D '93
CATFISH
Life 15:83 (c,4) S '92
Smithsonian 24:99 (c,4) Ag '93
CATFISH—HUMOR
— Mississippi catfish festival
Nat Wildlife 30:42–5 (painting,c,1) Je '92
Catholic Church. See
CHRISTIANITY
CATLIN, GEORGE
— Painting of Chief Little Bluff (1834)
Natur Hist 102:71 (c,3) O '93
CATO THE ELDER
Smithsonian 25:137 (engraving,4) Ap '94
CATS
Smithsonian 23:61,82 (c,2) Ap '92
Nat Wildlife 30:10–13 (c,1) O '92
Nat Geog 183:32 (c,3) Ap '93
Trav/Holiday 176:136 (2) Ap '93
Life 17:cov.,77–88 (c,1) O '94
Life 18:95 (c,1) Ja '95
Sports Illus 82:90 (c,4) Ap 10 '95

Life 19:55 (c,2) F '96
Trav/Holiday 179:35 (c,4) Jl '96
— Cat leaping through ring of fire (Florida)
Trav/Holiday 176:85 (c,2) N '93
— Kitten
Trav&Leisure 22:126 (c,4) S '92
— Photographing Clinton's cat Socks
Life 16:112 (c,2) Ja '93
— See also
BOBCATS
CHEETAHS
JAGUARS
JAGUARUNDIS
LEOPARDS
LIONS
LYNXES
MARGAYS
MOUNTAIN LIONS
OCELOTS
PANTHERS
SABER-TOOTHED CATS
TIGERS
CATSKILL MOUNTAINS, NEW YORK
Nat Geog 182:110–11,122–5 (c,1) N '92
Gourmet 53:28 (c,4) Ja '93
— Catskill region
Nat Geog 182:108–30 (map,c,1) N '92
CATTLE
Nat Geog 183:102 (c,3) Je '93
Nat Wildlife 32:12–13 (c,1) D '93
Trav&Leisure 25:72 (c,1) Ag '95
— 19th cent. illustration of Angus cattle
Life 18:40 (4) N '95
— Aerial view of dairy cows
Nat Geog 181:59 (c,1) Ap '92
— Aubrac bull
Life 17:34 (c,4) N '94
— Bull
Trav/Holiday 176:66 (c,4) Je '93
— Calf nursing
Smithsonian 24:119 (c,4) Je '93
— Child hugging cow (New York)
Nat Geog 182:130 (c,3) N '92
— Cows grazing
Trav&Leisure 22:122–3 (c,1) N '92
Gourmet 54:98 (c,2) Je '94
— Dairy cows
Life 17:**38,40** (c,4) N '94
— Humped **cattle**
Natur Hist **104**:10,12 (c,3) Jl '95
— Outdoor **cattle** sculptures (Toronto, Ontario)
Nat Geog 189:128–9 (c,2) Je '96
— Running of the bulls (Pamplona, Spain)
Life 16:14–15 (c,1) S '93

— White Park cattle
Smithsonian 25:63 (c,4) S '94
— See also
BISON
BUFFALOES
MUSK OXEN
OXEN
RANCHING
WATER BUFFALOES
YAKS
CATTON, BRUCE
Am Heritage 45:18 (4) D '94
CAVE EXPLORATION
— Antarctica
Life 16:85 (c,2) Mr '93
— Climbing in glacier caves
Nat Geog 189:cov.,70–81 (c,1) F '96
— Huautla cave system, Mexico
Nat Geog 188:78–93 (c,1) S '95
— Romania
Life 15:69 (c,1) N '92
— Water-filled caves (Florida)
Natur Hist 105:44–7 (c,1) N '96
CAVE PAINTINGS
— Ice Age paintings (Lascaux, France)
Natur Hist 102:72 (c,4) Ap '93
— Paleolithic cave paintings of animals (Mediterranean Sea)
Natur Hist 102:64–71 (c,1) Ap '93
— Prehistoric cave drawings (Norway)
Sports Illus 80:2–3 (c,1) F 7 '94
— Prehistoric cave drawings of animals (France)
Natur Hist 104:30–5 (c,1) My '95
— Prehistoric cave paintings
Natur Hist 105:16–18,71 (c,1) Jl '96
CAVES
— Amud Cave, Israel
Nat Geog 189:28–9 (c,2) Ja '96
— Ancient Maya caves (Guatemala)
Nat Geog 183:96,104–5 (c,1) F '93
— Blanchard Springs Caverns, Arkansas
Trav/Holiday 177:86 (c,3) My '94
— Blue Grotto, Malta
Trav/Holiday 177:54 (c,3) D '94
— Canary Islands
Trav&Leisure 22:76 (c,4) Mr '92
— Huautla cave system, Mexico
Nat Geog 188:78–93 (c,1) S '95
— Hubbards Cave, Tennessee
Nat Geog 188:38–9 (c,2) Ag '95
— Ice cave (Antarctica)
Life 16:80–1,85 (c,1) Mr '93
— Ice cave (Iceland)
Nat Geog 182:35 (c,4) D '92

— Ice cave (New Mexico)
 Natur Hist 102:58 (c,4) Ag '93
— Kartchner Cave, Arizona
 Sports Illus 76:73–5 (c,3) Je 1 '92
— Lechuguilla Cave, New Mexico
 Nat Wildlife 34:37–43 (c,1) Ag '96
— Vindija Cave, Croatia
 Nat Geog 189:4–5 (c,1) Ja '96
CAYMAN ISLANDS
 Trav/Holiday 177:46–53 (map,c,1) F '94
CEDAR TREES
— Red cedars
 Smithsonian 27:120 (c,3) O '96
CELLO PLAYING
— Playing in field (Finland)
 Trav/Holiday 178:58 (c,2) Je '95
— See also
 CASALS, PABLO
CELLS
— Fat cells
 Life 18:60,66 (c,4) F '95
CELTIC CIVILIZATION—ARTI-
 FACTS
 Smithsonian 24:118–24 (c,3) My '93
— 5th cent. B.C. stone pillar depicting
 mistletoe leaves
 Natur Hist 105:69 (c,4) F '96
— Horse carved into hilltop by 1st cent. Celts
 (Great Britain)
 Smithsonian 24:125 (c,2) My '93
CEMETERIES
— 19th cent. outlaw cemetery (Arizona)
 Life 16:50–1 (c,1) Ap 5 '93
— American military cemetery (Normandy,
 France)
 Trav/Holiday 177:78–9 (c,1) Je '94
— Bolivia
 Natur Hist 105:38 (c,4) N '96
— Budapest, Hungary
 Trav&Leisure 24:89 (c,4) O '94
— Buenos Aires, Argentina
 Gourmet 53:142 (c,2) N '93
— Burial vault (Corsica)
 Trav&Leisure 25:97 (c,4) Jl '95
— Cairo, Egypt
 Nat Geog 183:62–3 (c,1) Ap '93
— Cambridge, England
 Nat Geog 185:113 (c,1) Mr '94
— Candle-lit cemetery (Mexico)
 Nat Geog 190:22–3 (c,2) Ag '96
— Civil War cemetery (Antietam, Maryland)
 Nat Geog 186:135 (c,4) D '94
— Civil War cemetery (Gettysburg,
 Pennsylvania)
 Gourmet 55:51 (c,4) Jl '95

— Guadeloupe
 Gourmet 53:56 (c,4) Ja '93
— Ireland
 Nat Geog 186:24 (c,3) S '94
— Israel
 Trav&Leisure 24:90–1 (c,1) Ag '94
 Nat Geog 189:24–5 (c,1) Ap '96
— Japan
 Nat Geog 188:123 (c,4) Jl '95
— Japanese (Australia)
 Trav&Leisure 22:126 (c,4) F '92
— Jewish (Caribbean)
 Natur Hist 102:54–8 (c,1) Mr '93
— Jewish (Krakow, Poland)
 Gourmet 54:136 (c,4) N '94
— Jewish (Riga, Latvia)
 Life 15:51 (c,4) D '92
— Little Big Horn troops (Montana)
 Am Heritage 43:84,106 (c,4) Ap '92
— Louisiana
 Am Heritage 47:68–9 (1) O '96
— Mausoleum (Ravenna, Italy)
 Gourmet 56:101 (c,4) F '96
— Mexico
 Sports Illus 78:60 (c,4) F 22 '93
— Muslim cemetery (Kashgar, China)
 Nat Geog 189:34–5 (c,2) Mr '96
— New Orleans, Louisiana
 Smithsonian 24:115 (c,4) F '94
— Pet cemeteries
 Natur Hist 104:44–7 (1) Ag '95
 Trav/Holiday 178:86 (c,4) N '95
— Prehistoric cemetery (Italy)
 Nat Geog 183:64 (c,3) Je '93
— Texas men standing next to their
 tombstones-to-be (1890)
 Am Heritage 47:112 (2) F '96
— Turkey
 Nat Geog 185:32–3 (c,1) My '94
— U.S. military cemetery (Tennessee)
 Life 15:64 (c,4) Ag '92
— Yugoslavia
 Life 15:10–11 (c,1) S '92
— See also
 TOMBS
 TOMBSTONES
CENTIPEDES
 Life 15:66 (c,4) N '92
 Natur Hist 102:46–7 (c,1) Mr '93
 Nat Geog 188:42 (c,4) Ag '95
 Natur Hist 105:76–7 (c,1) Ag '96
— Fossil centipede
 Natur Hist 102:46 (c,1) Mr '93
 Natur Hist 102:61 (c,2) Je '93

CENTRAL PARK, NEW YORK CITY, NEW YORK
Nat Geog 183:2–37 (map,c,1) My '93
Trav/Holiday 177:34 (c,4) O '94
— 1880s
Nat Geog 183:32–5 (1) My '93
— 1903 winter scene by Glackens
Am Heritage 44:cov. (painting,c,1) D '93
— Central Park Zoo
Nat Geog 184:32 (c,1) Jl '93
— Fanciful depiction of Sunday in the park
Trav&Leisure 22:NY1 (painting,c,2) Ap
'92

CENTURY PLANTS
Natur Hist 102:58–9 (c,1) F '93
Life 16:69 (c,3) O '93
Natur Hist 104:70–2 (c,1) S '95
Trav/Holiday 179:71 (c,1) D '96

CERAMICS
— Ceramic tiled steps (San Antonio, Texas)
Gourmet 52:78 (c,4) Je '92

CEZANNE, PAUL
— "Card Players"
Smithsonian 27:88 (painting,c,4) Ap '96
— "Gardanne" (1886)
Smithsonian 23:125 (painting,c,4) D '92
— "Houses along a Road" (1870s)
Smithsonian 25:52 (painting,c,2) Mr '95
— "Leda and the Swan" (1881)
Life 16:83 (painting,c,2) Ap '93
— "Mont Sainte-Victoire" (1902)
Trav&Leisure 23:32 (painting,c,4) My '93
Smithsonian 27:84–5 (painting,c,2) Ap '96
— Paintings by him
Smithsonian 27:cov.,82–91 (c,1) Ap '96
— "La Pendule Noire" (1870)
Smithsonian 25:86 (painting,c,4) N '94
— Self-portrait (1875)
Smithsonian 27:84 (painting,c,4) Ap '96
— Wife Hortense
Smithsonian 27:85 (painting,c,4) Ap '96

CHAIRS
— 1840 Boston rocker
Am Heritage 43:33 (c,1) My '92
— Late 19th cent. wicker pieces
Smithsonian 24:22 (c,4) Jl '93
— Early 20th cent. (Germany)
Smithsonian 25:108 (c,4) F '95
— 1912 backyard rocker-swing (Missouri)
Am Heritage 45:112 (3) Jl '94
— Adirondack chairs (New York)
Gourmet 53:44–5 (c,1) Ag '93
— Adirondack chairs made of skis (Colorado)
Nat Geog 186:110–11 (c,1) Jl '94
— Bentwood rocker (New York)

Gourmet 53:45 (c,4) Ag '93
— Caning chairs (Malaysia)
Trav/Holiday 176:52 (c,4) S '93
— Gaudi chair (Spain)
Gourmet 52:107 (c,4) My '92
— Porch rockers (Southeast)
Trav&Leisure 23:92 (c,1) Jl '93
Trav&Leisure 25:84 (4) Jl '95
— Wicker porch chairs (New York)
Nat Geog 189:84–5 (c,2) Mr '96
— See also
THRONES

CHAMBERLAIN, WILT
Sports Illus 76:50 (3) Mr 23 '92
Sports Illus 79:76 (2) N 8 '93
Sports Illus 81:75 (2) N 14 '94
Am Heritage 46:42 (4) N '95
Sports Illus 85:78,126 (c,4) N 11 '96
— Caricature
Sports Illus 85:96–7 (c,1) Jl 15 '96

CHAMELEONS
Nat Geog 188:32 (c,4) S '95
Natur Hist 105:82 (c,4) Ag '96

CHANDLER, RAYMOND
Am Heritage 44:43 (4) Jl '93

CHANNEL ISLANDS, GREAT BRITAIN
— Lighthouse
Trav&Leisure 22:58 (c,3) S '92

CHAPLIN, CHARLIE
— In "Modern Times" (1936)
Smithsonian 24:154 (2) Ap '93

CHARACTER SYMBOLS
— 1992 Olympic mascot Cobi
Sports Illus 76:82–3 (c,1) Mr 9 '92
— 1996 Olympic mascot Whatizit
Sports Illus 78:172 (c,3) F 22 '93
— Aunt Jemima (1902–1993)
Am Heritage 44:80–2 (c,4) S '93
— Depictions of black "mammy" as
American icon
Am Heritage 44:78–86 (c,1) S '93
— Disney characters (Florida)
Life 19:19–21 (c,1) S '96
— Mr. Peanut
Gourmet 52:14,108 (4) Mr '92
— Sesame Street characters
Life 17:18–22 (c,1) D '94
— Simpsons costumes
Trav/Holiday 179:38 (c,4) S '96
— Snoopy balloon in parade (New York)
Smithsonian 23:130 (c,4) Mr '93
— Tarzan
Nat Geog 181:36 (4) Mr '92
Sports Illus 76:58 (4) Ap 13 '92

— See also
DRACULA
FRANKENSTEIN
MICKEY MOUSE
ROBIN HOOD
SHERLOCK HOLMES
SUPERMAN
CHARIOTS
— Ancient Egypt
Natur Hist 101:50–1 (painting,c,1) Jl '92
CHARLES I (GREAT BRITAIN)
— Portrait by Van Dyck
Smithsonian 24:75 (painting,c,4) Mr '94
CHARLES, RAY
Life 16:94 (c,2) Jl '93
CHARLESTON, SOUTH CAROLINA
Gourmet 54:110–13 (c,1) S '94
Trav/Holiday 179:60–7 (map,c,1) F '96
Am Heritage 47:45–5 (c,4) Ap '96
Am Heritage 47:83 (c,4) O '96
— Antique stores
Trav&Leisure 26:88–90 (c,4) Ap '96
— Drayton Hall
Trav/Holiday 179:61 (c,1) F '96
CHARLESTON, WEST VIRGINIA
— State capitol
Gourmet 56:188 (c,4) My '96
CHARLOTTESVILLE, VIRGINIA
Trav/Holiday 175:32–4 (map,c,4) Ap '92
— Monticello
Gourmet 52:90 (c,4) Mr '92
Gourmet 53:126–9 (c,1) Ap '93
Life 16:30–45 (c,1) My '93
Smithsonian 24:80–93 (c,1) My '93
— University of Virginia
Life 16:40–1 (c,1) My '93
CHATEAUS
— Chateau de Chambord, France
Trav/Holiday 178:cov.,38–43 (c,1) Je '95
— Chateau de Gilly, France
Trav&Leisure 22:16 (c,4) Je '92
— Chateau de Jussy-Champagne, France
Gourmet 54:94 (c,3) Mr '94
— Chateau de la Verrerie, France
Gourmet 54:92 (c,1) Mr '94
— Chateau de Luneville, Lorraine, France
Gourmet 53:106–7 (c,4) O '93
— Chateau d'Haroue, Lorraine, France
Gourmet 53:106–7 (c,1) O '93
— Chateau de Meillant interior, France
Gourmet 54:95 (c,1) Mr '94
— Chateau du Pierrefonds
Gourmet 56:147 (c,1) N '96
— Chateaus along Route Jacques Coeur,Berry
district, France

Gourmet 54:92–5,160 (map,c,1) Mr '94
— Cheverny, France
Trav/Holiday 178:41 (c,3) Je '95
— France
Trav&Leisure 26:208–11 (c,1) S '96
— Normandy, France
Trav&Leisure 23:70–9 (c,1) Je '93
Gourmet 54:99 (c,4) Je '94
— St-Germain-en-Laye, France
Trav&Leisure 25:78 (c,4) F '95
— Vaux-le-Vicomte chateau, Maincy, France
Smithsonian 24:62 (c,3) Je '93
CHATTANOOGA, TENNESSEE
— Riverfront
Smithsonian 25:55,62 (c,2) D '94
CHAUCER, GEOFFREY
— 1430s copy of *Canterbury Tales*
Smithsonian 23:110 (c,4) Ap '92
CHAUFFEURS
— Thailand
Trav&Leisure 24:80 (c,4) Ag '94
CHAVEZ, CESAR
Life 17:72–3 (c,1) Ja '94
CHEERLEADERS
— College basketball
Sports Illus 82:2–3 (c,1) Ap 3 '95
— Dallas Cowboy cheerleaders
Sports Illus 78:2–3 (c,1) F 8 '93
— Football
Sports Illus 80:31 (c,4) F 7 '94
— High school (Virginia)
Nat Geog 183:128–9 (c,1) F '93
— U.S.S.R.
Sports Illus 80:57 (c,4) Ja 10 '94
CHEESE
Gourmet 55:152–3 (c,3) D '95
— France
Trav&Leisure 24:123 (c,2) Je '94
Smithsonian 27:102–8 (c,1) N '96
— Goat cheese
Gourmet 55:105 (c,4) Mr '95
— Handmade Durras cheeses (Ireland)
Gourmet 54:99 (c,2) Mr '94
— Italy
Trav&Leisure 22:120 (c,4) Ja '92
Trav&Leisure 22:72 (c,1) Jl '92
Trav/Holiday 176:95,98 (c,4) Mr '93
— Restaurant cheese carts
Gourmet 52:62 (3) Mr '92
Gourmet 52:64 (c,3) D '92
CHEESE INDUSTRY
— Cheese factory (Wisconsin)
Trav&Leisure 24:114 (c,4) Je '94
— Cheese making (Switzerland)
Nat Geog 184:48–9 (c,2) Ag '93

— Cheese market (Alkmaar, Holland)
Trav/Holiday 175:114 (c,4) Mr '92
— France
Gourmet 54:98–9 (c,4) Je '94
Smithsonian 27:102–11 (c,1) N '96
— French cheese labels
Gourmet 54:97 (c,4) Je '94
— Ireland
Trav&Leisure 24:53 (c,4) Jl '94
CHEETAHS
Trav&Leisure 22:136–7 (c,1) Je '92
Trav/Holiday 175:64 (c,1) N '92
Nat Wildlife 31:13 (c,4) O '93
Nat Wildlife 32:54 (c,4) D '93
Smithsonian 25:17 (c,4) Je '94
Nat Geog 186:28–9 (c,1) D '94
Gourmet 55:78–9 (c,1) Ja '95
Natur Hist 104:78 (c,4) O '95
CHEFS
Gourmet 53:146 (c,4) Ap '93
Gourmet 54:156 (c,4) My '94
Gourmet 55:102,120 (c,4) My '95
Gourmet 56:entire issue (c,1) O '96
— Bermuda
Trav/Holiday 177:73 (c,4) My '94
— Paul Bocuse
Gourmet 52:92,96–7 (c,1) O '92
Trav&Leisure 24:95 (c,1) Jl '94
— California
Gourmet 53:30 (c,3) O '93
Gourmet 53:32 (c,3) D '93
Gourmet 54:78 (c,3) O '94
Gourmet 54:44 (c,4) N '94
— Julia Child
Gourmet 55:70 (c,3) F '95
— Culinary school graduates tossing toques
in air (New York)
Gourmet 56:201 (c,2) O '96
— France
Smithsonian 23:44,53 (c,2) My '92
Gourmet 52:92–7 (c,1) O '92
Trav&Leisure 25:129,134 (c,1) D '95
— Japan
Trav&Leisure 26:145 (c,1) Mr '96
— New York
Gourmet 52:138–9 (c,1) N '92
Gourmet 54:30 (c,3) Je '94
Trav&Leisure 26:37 (c,4) F '96
— Singapore
Trav&Leisure 26:77 (1) Ja '96
— South Africa
Trav&Leisure 26:58 (c,4) Ag '96
— Sushi chef (California)
Gourmet 54:54 (c,4) Je '94
— Sweden

Trav/Holiday 177:53 (c,3) Je '94
— Thailand
Trav/Holiday 179:72–3 (c,1) S '96
— White House, Washington, D.C.
Life 15:72–3 (c,1) O 30 '92
CHEMICALS
— Dioxin hazards
Nat Wildlife 32:4–13 (c,1) Ag '94
— Training for chemical warfare in protective
suits (U.S.S.R.)
Life 18:56–7 (c,1) Jl '95
— See also
PESTICIDES
CHEROKEE INDIANS—COSTUME
Life 17:28 (2) Ag '94
Nat Geog 187:72–97 (c,1) My '95
CHEROKEE INDIANS—HISTORY
— 1838 "Trail of Tears"
Nat Geog 187:86–7 (map,c,1) My '95
**CHEROKEE INDIANS—SOCIAL
LIFE AND CUSTOMS**
— Traditional dance
Smithsonian 23:97 (c,2) F '93
CHERRIES
Gourmet 54:143 (c,4) My '94
Gourmet 56:91 (c,4) Je '96
CHERRY TREES
Nat Geog 183:84–5 (c,1) My '93
**CHESAPEAKE BAY, MARY-
LAND/VIRGINIA**
Nat Geog 183:cov.,2–35 (map,c,1) Je '93
Nat Wildlife 32:4–5 (c,1) O '94
— Delmarva Peninsula seen from space
Nat Geog 190:26–7 (c,1) N '96
— Ecosystem research
Smithsonian 27:100–9 (c,1) Jl '96
CHESS PLAYING
Life 16:26–7 (c,4) S '93
— Blind player
Life 16:94 (c,2) Jl '93
— In thermal spring (Hungary)
Trav/Holiday 175:57 (3) My '92
— Thomas Jefferson's early 19th cent. chess
set (Virginia)
Life 16:43 (c,3) My '93
— Life-size lawn chess (Jamaica)
Trav/Holiday 179:67 (c,1) D '96
— World Championships 1992 (Yugoslavia)
Sports Illus 77:48–50 (c,2) S 14 '92
— World Championships 1995
Sports Illus 83:2–3 (c,1) S 25 '95
— Yugoslavia
Life 16:96 (4) O '93
— See also
FISCHER, BOBBY

CHESTNUT TREES
Smithsonian 27:116 (c,3) O '96
CHESTS
— 1857 sea chest
Life 15:42 (c,3) Mr '92
CHEYENNE, WYOMING
— Railroad station
Am Heritage 45:96 (c,4) Ap '94
CHIANG MAI, THAILAND
— Wat
Trav/Holiday 179:52 (c,4) Ap '96
CHICAGO, ILLINOIS
Trav&Leisure 26:130–41 (map,c,1) Ap '96
— Late 19th cent. Marshall Field's
Am Heritage 43:115 (4) D '92
— 1893
Am Heritage 44:72–3,82–3 (2) Jl '93
— 1893 World Columbian Exposition
Am Heritage 44:111 (2) My '93
Smithsonian 24:38–51 (c,1) Je '93
Am Heritage 44:70–87 (c,1) Jl '93
Smithsonian 24:26–8 (c,4) O '93
— 1930s organized crime sites
Am Heritage 46:65–88 (c,4) Ap '95
— 1934 scenes of black night life
Am Heritage 46:20–1 (painting,c,1) F '95
supp.
— Biograph Theater site of Dillinger's 1934
murder
Am Heritage 46:86 (c,4) Ap '95
— Chicago Stadium
Sports Illus 76:60–72 (c,1) Je 1 '92
— Downtown scenes
Gourmet 53:96–101 (c,2) Mr '93
— J.J. Glessner mansion
Am Heritage 43:108–13 (c,1) D '92
— North Shore suburban sites
Trav&Leisure 25:172–4 (map,c,2) My '95
— Orchestra Hall
Smithsonian 25:94–103 (c,2) S '94
— Palmer House
Am Heritage 45:46–7,52 (c,1) Ap '94
Trav/Holiday 179:60 (c,4) S '96
— Sears Tower
Gourmet 53:96 (c,2) Mr '93
— Sites related to Al Capone
Am Heritage 46:72,76,88 (c,4) Ap '95
— Skyline
Life 17:90–1 (c,1) My '94
Trav&Leisure 26:130 (c,1) Ap '96
Nat Geog 189:118–19 (c,1) Je '96
— Uptown Theater
Smithsonian 27:59 (c,2) S '96
— Whimsical map
Gourmet 54:62 (c,2) Je '94

CHICKADEES
Nat Wildlife 31:20 (c,4) D '92
— Black-capped chickadees
Nat Wildlife 31:43 (c,3) Je '93
Nat Wildlife 33:56–7 (c,1) F '95
Nat Wildlife 33:34 (c,4) Ag '95
Nat Wildlife 34:32–3 (c,1) F '96
CHICKENS
Am Heritage 47:4,52–67 (c,1) S '96
— 1868 chart of poultry breeds
Am Heritage 47:55 (c,1) S '96
— Early 20th cent. postcards featuring
chickens
Am Heritage 47:4 (c,4) S '96
— Chicken embryos
Life 19:40–4 (c,1) N '96
— Chicken farming (Southeast)
Nat Geog 188:76–7 (c,2) D '95
Am Heritage 47:64–5 (c,1) S '96
— Game cock
Am Heritage 47:56 (drawing,4) S '96
— Jubilee Indian Game fowl
Smithsonian 25:64 (c,4) S '94
— Plymouth Rock hens
Am Heritage 47:52–3,66 (c,1) S '96
— See also
ROOSTERS
CHICKS
— Bald eagle chicks
Nat Geog 182:42–50 (c,1) N '92
— Coots
Nat Wildlife 33:4 (c,4) Ap '95
— Cowbirds
Nat Wildlife 32:40–1 (c,1) D '93
— Crows
Smithsonian 23:107 (c,4) Ag '92
— Egrets
Nat Geog 185:22–3 (c,1) Ap '94
— Falcon chick
Nat Wildlife 34:17 (4) D '95
Nat Wildlife 34:39 (c,1) O '96
— Goose chicks
Nat Geog 182:2–3 (c,1) O '92
Nat Geog 189:16 (4) Je '96
— Goshawk chicks
Nat Geog 186:123–7 (c,1) Jl '94
— Goose hatching
Nat Wildlife 33:41 (c,4) Je '95
— Herons
Nat Wildlife 31:54 (c,4) Ap '93
— Kingfisher chicks
Nat Wildlife 34:33 (c,3) Je '96
— Kiwi birds
Natur Hist 102:cov.,56–7 (c,1) D '93
— Macaws

Nat Geog 185:132 (c,4) Ja '94
— Open-mouthed thrush chicks
 Trav&Leisure 22:88 (c,4) Mr '92
— Penguin chicks
 Natur Hist 103:78–9 (c,1) S '94
 Nat Geog 189:cov.,52–3,61–5 (c,1) Mr '96
— Pheasant chicks
 Nat Geog 181:23 (c,4) My '92
— Redwinged blackbirds
 Nat Wildlife 31:40 (c,3) Je '93
— Road runner chick
 Nat Wildlife 32:51 (c,1) F '94
— Stilt chick emerging from egg
 Natur Hist 101:46 (c,4) Ap '92
— Tern chicks
 Natur Hist 102:48 (c,4) Ag '93
 Natur Hist 103:48–9 (c,1) Jl '94
— Vireos
 Nat Wildlife 33:42–3 (c,1) Ag '95
— Warbler chicks
 Nat Wildlife 32:19 (c,4) O '94
 Nat Wildlife 34:9 (c,4) Je '96
— Woodpecker chicks
 Nat Wildlife 34:43 (c,4) Ap '96
 Nat Geog 190:138 (c,4) S '96

CHIHUAHUAS
— Dog with broken leg
 Smithsonian 27:45 (c,1) O '96

CHILDBIRTH
 Life 16:76–7 (c,1) D '93
— Beluga giving birth
 Life 18:12–13 (c,1) D '95
— Nyala antelope giving birth
 Life 19:14 (c,2) Mr '96
— Sea horse giving birth
 Life 18:21 (c,2) Jl '95
— Shark giving birth
 Smithsonian 24:40 (c,4) My '93
— Women assisted by midwife (West
 Virginia)
 Life 18:76–82 (1) F '95
— See also
 PREGNANCY

CHILDREN
— 1953 children riding tricycles (Wash-
 ington, D.C.)
 Life 15:36 (1) O 30 '92
— Annual photo of growing boy
 Life 16:119 (4) O '93
— Balloon bursting contest (Minnesota)
 Nat Geog 182:102–3 (c,1) S '92
— Boy grabbing girl's hair
 Life 15:78–9 (1) Ap '92
— Boys in summer camp (Israel)
 Nat Geog 181:112–13 (c,1) Je '92

— Boys playing cowboy (Colorado)
 Life 15:46 (c,3) Jl '92
 Trav/Holiday 176:72–3 (c,2) Jl '93
— Child laborers (Pakistan)
 Life 19:38–48 (c,1) Je '96
— Children playing on beach
 Trav&Leisure 22:102–3 (c,1) Mr '92
 Gourmet 53:89 (c,2) F '93
 Gourmet 53:124 (c,3) Ap '93
— Children playing on boat ropes (Brazil)
 Nat Geog 187:16–17 (c,1) F '95
— Children playing on ice (Alaska)
 Nat Geog 182:86–7 (c,2) Ag '92
— Children playing on tank (Afghanistan)
 Nat Geog 184:86–7 (c,1) O '93
— Children with birth defects
 Life 18:cov.,46–62 (c,1) N '95
— Children's toy-strewn messy bedroom
 (Pennsylvania)
 Life 15:12–13 (1) Jl '92
— Dionne Quintuplets (Canada)
 Smithsonian 27:38 (4) S '96
— Girl trying on mother's wedding gown
 (Great Britain)
 Life 15:90 (2) Ap '92
— Goat pulling children in cart (1890s)
 Life 15:44–5 (4) O '92
— Russian child living in airport
 Life 16:76–82 (1) My '93
— Serbian children making kites out of
 Yugoslav dinar bills (Belanovca)
 Life 16:19 (c,2) N '93
— Shipibo mothers with children (Peru)
 Natur Hist 101:30–7 (c,1) D '92
— Slum life (Bronx, New York)
 Life 18:50–8 (1) S '95
— Supertwins (multiple birth children)
 Smithsonian 27:cov.,30–41 (c,1) S '96
— Treatment at pediatric hospital
 (Pennsylvania)
 Life 18:40–50 (c,1) D '95
— Underdressed kindergartners in snow
 (Japan)
 Life 17:14–15 (c,1) F '94
— Whimsical photographs
 Life 19:199–212 (c,4) O '96
— With spoons on their noses
 Trav&Leisure 22:114–15 (c,1) Mr '92
— Young children starring in day camp play
 Trav&Leisure 23:E2 (c,4) O '93
— See also
 BABIES
 BOY SCOUTS
 FAMILIES
 FAMILY LIFE

GIRL SCOUTS
PLAYGROUNDS
TOYS
CHILDREN—COSTUME
— 1934 children in tenement (New York City)
 Am Heritage 47:168 (4) N '96
— 1954 children in cowboy outfits
 Am Heritage 45:30–1,36-9 (c,1) D '94
— Boys in school uniform (British Columbia)
 Nat Geog 181:104 (c,1) Ap '92
— Children in army uniforms (China)
 Nat Geog 189:16–17 (c,1) Mr '96
— Children in hard hats to protect against
 volcano (Japan)
 Nat Geog 182:12–13 (c,1) D '92
— Girl in traditional dress (India)
 Trav&Leisure 22:64 (c,4) Je '92
— Nursery school children (Paraguay)
 Nat Geog 182:106 (c,3) Ag '92
— School children (Zimbabwe)
 Trav&Leisure 22:93 (c,3) N '92
— School children at lunch (Japan)
 Nat Geog 181:76 (c,3) Mr '92
— Siberia
 Nat Geog 181:cov.,18–19 (c,1) Je '92
— Ten-year-old South Vietnamese soldier
 (1968)
 Life 19:30 (4) N '96
— Thailand
 Trav&Leisure 26:164 (c,1) S '96
CHILE
— Atacama
 Trav&Leisure 23:68 (c,4) Ap '93
 Natur Hist 104:44–7 (c,1) N '95
— Camarones Cave
 Nat Geog 187:70–3,84–5 (c,1) Mr '95
— Central Valley
 Trav&Leisure 23:95 (c,1) O '93
— Cerro Paranal
 Nat Geog 185:25 (c,3) Ja '94
— Collecting water from fog
 Life 16:80–4 (c,1) N '93
— Cordillera Sarmiento Range
 Nat Geog 185:116–30 (map,c,1) Ap '94
— Fray Jorge National Park
 Natur Hist 105:64–5 (c,1) F '96
— Lake District
 Gourmet 54:102–7,156 (map,c,1) F '94
— Litoral
 Trav/Holiday 178:58–67 (map,c,1) D '95
— Patagonia
 Trav/Holiday 179:56–63 (map,c,1) Je '96
— Resort ranch (Chile)
 Trav&Leisure 23:88–95 (map,c,1) O '93
— Seen from space shuttle

Natur Hist 104:52–3 (c,1) F '95
— Torres del Paine National Park
 Trav/Holiday 179:60–1 (c,2) Je '96
— Volcan Osorno
 Gourmet 54:106–7 (c,1) Mr '94
— See also
 ACONCAGUA
 ANDES MOUNTAINS
 SANTIAGO
CHILE, ANCIENT—ARTIFACTS
— Chinchorro mummies
 Nat Geog 187:69–89 (c,1) Mr '95
CHIMNEYS
— Chimney sweeps
 Smithsonian 26:96–107 (c,1) S '95
CHIMPANZEES
 Nat Geog 181:cov.,6–39 (c,1) Mr '92
 Smithsonian 24:120 (c,4) Je '93
 Natur Hist 102:32–3 (c,1) Jl '93
 Trav&Leisure 24:90 (1) N '94
 Nat Geog 186:33 (c,3) D '94
 Natur Hist 104:48–55 (c,1) Ja '95
 Smithsonian 25:71–5 (c,1) Mr '95
 Life 18:76 (c,2) My '95
 Nat Geog 188:12–13 (c,1) Jl '95
 Nat Geog 188:76 (c,1) Ag '95
 Nat Wildlife 33:19 (c,1) O '95
 Nat Geog 188:102–27 (c,1) D '95
— Astronaut chimpanzees
 Am Heritage 45:46 (4) Jl '94
 Life 19:69 (c,4) Ap '96
— Chimpanzee embryo
 Life 19:46–7 (c,1) N '96
— Drinking from baby bottles
 Life 15:6–7 (c,1) Ap '92
— Performing chimps
 Nat Geog 181:8–9,36–9 (c,1) Mr '92
— Pet chimps
 Life 16:cov. (c,1) Je '93
— Pygmy chimps
 Nat Geog 181:46–53 (c,1) Mr '92
— Work of Jane Goodall
 Nat Geog 188:102–29 (c,1) D '95
CHINA
 Trav&Leisure 23:62–75 (map,c,1) S '93
— Buddhist caves along Silk Road
 Nat Geog 189:52–63 (c,1) Ap '96
— Dragon Hill Cave
 Natur Hist 104:50–4 (map,c,2) D '95
— Fengdu
 Trav/Holiday 176:64–6 (c,1) F '93
— Mekong River source, Qinghai province
 Nat Geog 183:11 (c,3) F '93
— Scenes along the "Silk Road"

Trav&Leisure 24:78–89,131 (map,c,1) Mr
'94
— Shuiluo River
Nat Geog 190:116–29 (map,c,1) N '96
— Site of planned Three Gorges Dam,
Yangtze River
Natur Hist 105:cov.,2,28–39 (map,c,1) Jl
'96
— Tarim Basin
Natur Hist 101:30–9 (map,c,1) S '92
— Wushan
Natur Hist 104:54 (c,3) D '95
Natur Hist 105:36 (c,4) Jl '96
— Xinjiang region
Nat Geog 189:2–43 (map,c,1) Mr '96
— Youshui River, Shaanxi Province
Nat Geog 187:107 (c,1) F '95
— See also
 BEIJING
 GOBI DESERT
 GREAT WALL OF CHINA
 HIMALAYA MOUNTAINS
 HUANG HE (YELLOW) RIVER
 MANCHURIA
 SHANGHAI
 YANGTZE RIVER
CHINA—ART
— 2100-year-old clay soldiers (Xian)
Nat Geog 182:114–30 (c,1) Ag '92
Trav&Leisure 23:68–9 (c,1) S '93
Nat Geog 190:68–85 (c,1) O '96
— 18th cent. handscroll painting of boat on
river
Smithsonian 26:34 (c,4) My '95
— Chinese art treasures
Smithsonian 26:44–52 (c,1) Mr '96
— Folded paper art works by illegal Chinese
immigrants in prison (Pennsylvania)
Life 19:68–72 (c,1) Jl '96
— Tang dynasty horse figure
Smithsonian 26:40 (c,4) S '95
— Works by Chang Dai-chien
Smithsonian 22:90–5 (painting,c,1) Ja '92
CHINA—ARTIFACTS
— 11th cent. bronze ritual food vessel
Smithsonian 24:27 (c,4) My '93
— 13th cent. Xi Xia tombs
Nat Geog 190:22–3 (c,2) D '96
— Han Dynasty tombs, Xian
Nat Geog 182:114–30 (map,c,1) Ag '92
— Huge gold pot (Beijing)
Trav/Holiday 178:71 (c,2) O '95
CHINA—COSTUME
Trav/Holiday 176:58–67 (c,1) F '93
Trav&Leisure 23:63–75 (c,1) S '93

Trav&Leisure 24:78–89 (c,1) Mr '94
Natur Hist 105:30–9 (c,1) Jl '96
— 1900 immigrants to America
Am Heritage 45:83 (4) F '94
— Early 20th cent. warrior costume
Smithsonian 24:102 (1) Jl '93
— 1916 (Yunnan Province)
Natur Hist 104:80 (4) O '95
— 1920 child acrobat in balancing act
Nat Geog 190:55 (1) Jl '96
— 1920s Nationalist soldiers
Am Heritage 47:90–1 (2) Jl '96
— Child in traditional dress
Life 15:18 (c,4) N '92
— Chinese People's Armed Police
Life 16:18 (c,2) Mr '93
— Kazaks (Xinjiang province)
Gourmet 55:86 (c,3) Je '95
Nat Geog 189:5–9,25–7 (c,1) Mr '96
— Lanzhou villager rafting on Yellow River
Trav&Leisure 24:82–3 (c,1) Mr '94
— Medieval monk drinking wine
Natur Hist 105:48–9 (painting,c,1) Jl '96
— Minority tribes
Smithsonian 24:79,83 (c,2) N '93
— Shanghai
Trav/Holiday 176:71–7 (c,1) O '93
Nat Geog 185:cov.,2–35 (c,1) Mr '94
— Soldiers
Sports Illus 79:46 (c,3) S 20 '93
— Toddler (Zhejiang)
Nat Geog 185:55 (c,1) My '94
— Uygur people
Natur Hist 101:36–9 (c,1) S '92
— Xinjiang province
Nat Geog 189:5–43 (c,1) Mr '96
CHINA—HISTORY
— 11th cent. Sung emperor
Smithsonian 26:49 (painting,c,4) Mr '96
— 1214 battle between Mongols and China
Natur Hist 103:50–1 (painting,c,1) O '94
— 19th cent. opium trade
Natur Hist 102:74–8 (c,3) N '93
— 1898 cartoon of world powers dividing
China
Natur Hist 102:61 (c,4) D '93
— 1927 Civil War scenes
Am Heritage 47:86–93 (2) Jl '96
— 1936 soldier shooting Communist
Life 19:36 (4) O '96
— 1949 troops after Communist takeover
(Beijing)
Trav&Leisure 25:70 (1) Ja '95
— 1989 cartoon about repression
Smithsonian 27:84 (3) Jl '96

— 1989 tanks riding into Tiananmen Square
(Beijing)
Sports Illus 79:49 (c,4) S 20 '93
— Kuang-hsu
Smithsonian 24:104 (4) Jl '93
— Homer Lea
Smithsonian 24:102,112,115 (1) Jl '93
— Tz'u-hsi
Smithsonian 24:104 (4) Jl '93
— See also
MAO ZEDONG
SUN YAT-SEN
CHINA—MAPS
— 19th cent. map of Yangtze River area
Natur Hist 103:28–9 (c,1) Jl '94
CHINA—RITES AND FESTIVALS
— Chinese New Year celebration (Malaysia)
Trav/Holiday 176:48–9 (c,2) S '93
— Ice festival palace (Harbin)
Life 18:14 (c,2) Mr '95
— New Year's bathing ritual (Yunnan)
Life 16:19 (c,2) D '93
— New Year's celebrations
Natur Hist 103:54–61 (c,1) Jl '94
CHINA—SOCIAL LIFE AND CUS-
TOMS
— Athletes in training
Sports Illus 83:84–94 (c,1) O 16 '95
— Chinese girls dancing
Life 18:12–13 (c,1) N '95
— Family life
Life 17:59 (c,4) Jl '94
— Female athletes
Sports Illus 85:152–8 (c,1) Jl 22 '96
— Feng shui
Smithsonian 24:70–5 (c,2) Ag '93
— Ribbon dance
Natur Hist 101:70 (c,4) Ap '92
— Shuttlecock game
Nat Geog 190:59 (c,4) Jl '96
— Traditional feast (Hangzhou)
Gourmet 53:98,144 (painting,4) F '93
CHINA SEA, ASIA
— South China Sea, Vietnam
Gourmet 55:88–9 (c,1) S '95
CHINATOWN, KUALA LUMPUR, MA-
LAYSIA
Trav/Holiday 176:46–9 (c,1) S '93
CHINATOWN, PHILADELPHIA,
PENNSYLVANIA
— Dragon mural on building
Trav/Holiday 178:66 (c,3) N '95
CHINATOWN, SINGAPORE
Gourmet 53:65 (c,1) Ja '93

CHINATOWN, SYDNEY, AUSTRALIA
Trav/Holiday 176:55 (c,4) Je '93
CHINATOWN, VANCOUVER, BRIT-
ISH COLUMBIA
Trav/Holiday 179:64–9 (c,1) Je '96
CHINAWARE
— Late 16th cent. Chinese porcelain
Nat Geog 186:49–51 (c,1) Jl '94
— Chinese porcelain
Smithsonian 23:142 (c,4) F '93
— Japanese porcelain
Smithsonian 25:22 (c,4) My '94
— Rack of coffee cups (Seattle, Washington)
Gourmet 56:51 (c,1) Ja '96
— Souvenir restaurant plates (Italy)
Gourmet 56:60 (c,4) Ja '96
CHIPMUNKS
— In hibernation
Nat Wildlife 32:9 (c,4) D '93
CHIPPEWA INDIANS
— Couple gathering wild rice (Minnesota)
Nat Geog 182:106–7 (c,2) S '92
CHOCTAW INDIANS
— Lifestyle (Mississippi)
Smithsonian 26:70–81 (1) Mr '96
CHOPIN, FREDERICK
Smithsonian 27:131–2 (painting,c,4) D '96
CHRISTIAN IV (DENMARK)
— Crown and bust of Christian IV
Gourmet 52:52,54 (c,4) Ag '92
CHRISTIANITY
— Bruderhof community life (Pennsylvania)
Life 19:88–94 (c,1) D '96
— See also
AMISH PEOPLE
CHURCH SERVICES
CHURCHES
JESUS CHRIST
MENNONITES
MONASTERIES
MORMONS
RUSSIAN ORTHODOX CHURCH
SHAKERS
CHRISTIANITY—ART
— 15th cent. crucifixion painting detail
(Lubeck, Germany)
Nat Geog 186:73 (c,4) O '94
— Mary depicted in art works
Life 19:cov.,44–60 (c,1) D '96
— Paintings depicting events around birth of
Jesus
Life 15:cov.,32–42 (c,1) D '92
— Worldwide depictions of Jesus
Life 17:cov.,5,66–82 (c,1) D '94

CHRISTIANITY—COSTUME

— 1551 nun (Italy)
 Smithsonian 26:108 (painting,c,4) My '95
— 1956 nuns (Brazil)
 Trav/Holiday 176:112 (2) Je '93
— Artifacts from World War II army chaplain
 Am Heritage 45:40–6 (c,1) My '94
— Catholic priest (Easter Island)
 Nat Geog 183:72–3 (c,2) Mr '93
— Holy Week participant (Spain)
 Nat Geog 181:19 (c,3) Ap '92
— Holy Week penitent (Italy)
 Nat Geog 181:27 (c,3) Ja '92
— Monastery life (New Mexico)
 Life 19:66–73 (1) Je '96
— Monks (Belgium)
 Gourmet 56:30 (c,2) Ag '96
— Monks (Michigan)
 Nat Geog 184:94–5 (c,1) D '93
— Nun (Italy)
 Life 15:82 (4) Ap '92
 Trav/Holiday 177:71 (c,3) F '94
— Nuns (New Jersey)
 Trav/Holiday 176:60 (c,3) D '93
— Nuns (Washington)
 Nat Geog 187:128–9 (c,1) Je '95
— Nuns donating blood (1943)
 Smithsonian 26:12 (4) My '95
— Palm Sunday altar boys (Israel)
 Nat Geog 187:80–1 (c,2) Je '95
— Priest (Israel)
 Nat Geog 189:29 (c,3) Ap '96
— Priest (Italy)
 Trav/Holiday 177:52 (c,2) O '94
— Priests playing soccer (Spain)
 Life 15:45 (3) Jl '92
— See also
 POPES

CHRISTIANITY—HISTORY

— 1475 Christian map
 Smithsonian 23:117 (c,4) F '93
— 1521 Latin text by Henry VIII defending
 Catholicism
 Smithsonian 24:21 (c,4) Ap '93
— 1844 anti-Catholic riot (Philadelphia,
 Pennsylvania)
 Smithsonian 27:152 (painting,c,4) N '96
— Don Vasco de Quiroga (Mexico)
 Trav/Holiday 175:81 (sculpture,c,4) F '92
— Father Damien's grave (Molokai, Hawaii)
 Life 17:84–5 (c,1) Ap '94
— Martin Luther at Diet of Worms (1521)
 Natur Hist 105:20 (painting,c,4) S '96
— Pope's Palace, Avignon, France
 Gourmet 53:93,96–7 (c,1) F '93

— Sites along Mary and Joseph's journey to
 Bethlehem
 Life 15:cov.,7,32–42 (map,c,1) D '92
— See also
 JESUS CHRIST
 LUTHER, MARTIN
 POPES
 SAINTS

CHRISTIANITY—RITES AND FESTI-VALS

— Advent festivities (Salzburg, Austria)
 Trav/Holiday 176:42–51 (c,1) D '93
— Child costumed for Ascension Thursday
 dance (Spain)
 Life 15:81 (c,2) Ag '92
— Christian rites around the world
 Life 18:36–46 (c,1) Ap '95
— Day of the Dead (Mexico)
 Nat Geog 190:22–3 (c,2) Ag '96
— Feast day dance (Mexico)
 Nat Geog 186:52–3 (c,1) S '94
— Festival of the Virgin of Guadalupe
 (Mexico)
 Nat Geog 190:32–3 (c,1) Ag '96
— Flaming bull horn procession (Paraguay)
 Nat Geog 182:111 (c,2) Ag '92
— Good Friday crucifixion (Philippines)
 Life 18:40 (c,3) Ap '95
— Good Friday horn blowing (Spain)
 Life 15:85 (c,3) Ag '92
— Good Friday trek to hilltop (New Mexico)
 Nat Geog 184:51 (c,3) S '93
— Holy Thursday procession (Sicily, Italy)
 Nat Geog 188:8–9 (c,2) Ag '95
— Holy Week observance (Mexico)
 Nat Geog 186:58–9 (c,1) N '94
— Holy Week pageantry (Peru)
 Nat Geog 181:108–9 (c,1) F '92
 Nat Geog 189:24–5 (c,1) My '96
— Holy Week rituals involving Judas
 (Guatemala)
 Natur Hist 103:46–52 (c,1) Mr '94
— Lighting candles in church (Georgia,
 U.S.S.R.)
 Nat Geog 181:90–1 (c,1) My '92
— Pilgrimages to Christian shrines (Spain)
 Nat Geog 181:6–7 (c,1) Ap '92
 Smithsonian 24:64–75 (c,1) F '94
 Gourmet 56:66 (map,4) Ap '96
— Pilgrims on Via Dolorosa, Jerusalem, Israel
 Nat Geog 189:4–5 (c,1) Ap '96
— Pilgrims to Lourdes, France
 Trav/Holiday 178:41–4 (c,1) Ap '95
 Life 19:50 (c,3) D '96
— Procession of the Virgin (El Rocio, Spain)

Life 18:36–7 (c,1) Ap '95
— Riek Sunday pilgrimage (Ireland)
 Life 18:38–9 (c,1) Ap '95
— St. Paul feast day pageantry (Italy)
 Nat Geog 186:34–5 (c,1) N '94
— Sidewalk altar for Feast of Corpus Christi
 (St. Louis, Missouri)
 Trav/Holiday 176:63 (c,4) S '93
— Sunday procession (Seville, Spain)
 Trav/Holiday 178:58–9 (1) Mr '95
— Washing feet of believer (Tennessee)
 Nat Geog 184:26 (c,3) N 15 '93
— See also
 BAPTISMS
 CHRISTMAS
 CHURCH SERVICES
 COMMUNION
 EASTER
 PRAYING

CHRISTIANITY—SHRINES AND SYMBOLS
— Late 16th cent. rosary (Spain)
 Nat Geog 186:41 (c,1) Jl '94
— Catacomb bones of Capuchin monks
 (Rome,Italy)
 Natur Hist 105:36 (4) O '96
— Creating creche figures (Naples, Italy)
 Trav/Holiday 179:78–85 (c,1) D '96
— Creche (France)
 Trav&Leisure 24:105 (c,3) D '94
— Praetorium, Jerusalem, Israel
 Nat Geog 189:30–1 (c,2) Ap '96
— Roadside crucifixion sculpture (Ireland)
 Nat Geog 186:2 (c,4) S '94
— Tiny Japanese icon
 Nat Geog 182:91 (c,4) N '92
— See also
 ANGELS
 BIBLE
 CHRISTMAS TREES
 CRUCIFIXES
 DEVILS
 JESUS CHRIST
 LOURDES, FRANCE
 SAINTS
 SANTA CLAUS

CHRISTMAS
— 1920 Christmas at Boys Town, Omaha,
 Nebraska
 Sports Illus 77:83 (2) D 21 '92
— 1958 child unwrapping gifts (Pennsyl-
 vania)
 Am Heritage 45:6 (c,3) D '94
— Albuquerque decorated with Christ-
 mas lights, New Mexico

 Trav/Holiday 178:18 (c,4) N '95
— Austria
 Trav/Holiday 176:42–51 (c,1) D '93
— Celebrations around the world
 Life 19:27–30 (c,1) D '96
— Christmas church service (Lincoln,
 England)
 Gourmet 52:106–7 (c,1) D '92
— Eastern European tradition
 Natur Hist 105:72 (painting,c,4) D '96
— Gingerbread house (Vermont)
 Gourmet 54:136 (c,4) D '94
— Holiday scenes around the U.S.
 Am Heritage 43:1–34 (c,1) N '92 supp.
— Hot Springs decorations, Arkansas
 Am Heritage 47:78 (c,4) O '96
— House decorated with lights (Wyoming)
 Nat Geog 183:74–5 (c,1) Ja '93
— Kansas City, Missouri, lit up for Christmas
 Trav&Leisure 22:180 (c,4) D '92
— Montreal festivities, Quebec
 Gourmet 55:136–9 (c,2) D '95
— New York City decorations
 Gourmet 53:66 (c,2) D '93
 Trav&Leisure 25:92–102 (c,1) D '95
— Outdoor Christmas markets (Austria)
 Trav/Holiday 176:46–7 (c,2) D '93
— Paris decorated with Christmas lights,
 France
 Gourmet 56:88 (c,3) D '96
— Presents under tree
 Gourmet 52:154 (drawing,4) D '92
— Provence, France
 Trav&Leisure 24:102–9 (c,1) D '94
— Reindeer practicing flying for Santa's
 journey
 Life 16:102–4 (c,2) D '93
— Solemn Christmas procession (Langenfeld,
 Germany)
 Life 19:24–5 (c,1) D '96
— Switzerland
 Gourmet 54:122–7 (c,1) D '94
— Vermont
 Gourmet 54:132–6 (c,1) D '94
— Woman playing St. Lucia (Sweden)
 Nat Geog 184:32–3 (c,1) Ag '93
— Wreath on door (Switzerland)
 Gourmet 54:127 (c,1) D '94
— Wreaths (Delaware)
 Gourmet 53:113 (c,4) D '93
— See also
 CHRISTMAS TREES
 SANTA CLAUS

CHRISTMAS TREES
— 1950 Santa Claus bulb ornament

Am Heritage 46:80 (c,4) D '95
— Austria
Trav/Holiday 176:50 (c,4) D '93
— Carrying tree home by bicycle (China)
Life 19:28 (c,4) D '96
— Christmas tree farm (North Carolina)
Nat Wildlife 34:24–5 (c,2) D '95
— Christmas tree farm (Wisconsin)
Life 17:104–5 (c,2) D '94
— Decorated trees in Longwood Gardens,
Pennsylvania
Gourmet 53:108–12 (c,1) D '93
— Early ornaments
Am Heritage 44:4 (c,4) D '93
— Old-fashioned tree (New Hampshire)
Am Heritage 46:36 (c,4) D '95
— Origami tree (New York City, New York)
Natur Hist 105:84 (c,4) D '96
— Rockefeller Center tree, New York City,
New York
Life 17:55 (c,4) D '94
Trav&Leisure 24:167 (c,2) D '94
— Whale jawbone "tree" (Alaska)
Life 19:26 (c,4) D '96

CHRYSLER, WALTER P.
Life 19:40 (4) Winter '96

CHURCH SERVICES
— Bora Bora
Trav&Leisure 22:120–1 (c,2) N '92
— Drive-in church service (Maine)
Smithsonian 25:112 (c,4) My '94
— Florida
Sports Illus 82:82–3 (c,1) Je 5 '95
— Harlem, New York City, New York
Trav/Holiday 176:61 (c,4) O '93
— Illinois
Life 19:46–7 (c,1) D '96
— Islamic service (Indonesia)
Life 16:59,64–5 (1) Mr '93
— Mass blessing animals (New York)
Smithsonian 23:36–7,45 (c,1) D '92
— Minister giving praise at AME church
(Washington, D.C.)
Smithsonian 22:60 (3) F '92
— Outside church destroyed by hurricane
(Florida)
Nat Geog 183:6–7 (c,1) Ap '93
— Swinging incense holder (Spain)
Smithsonian 24:74–5 (c,1) F '94
Trav&Leisure 26:122 (c,1) Mr '96
— See also
BAPTISMS
COMMUNION

CHURCHES
— 17th cent. church (Cornwall, England)

Trav/Holiday 176:66 (c,2) O '93
— 1830s Spanish church (Golden, New
Mexico)
Am Heritage 44:cov.,62–3 (c,1) Ap '93
— Early 20th cent. (Missouri)
Smithsonian 22:106 (c,4) F '92
— Antigua, Guatemala
Trav/Holiday 178:85,88–9 (c,1) Mr '95
— Arkansas
Gourmet 52:78,82 (c,4) F '92
— Assumption Cathedral interior, Moscow,
Russia
Trav/Holiday 176:92 (c,3) Ap '93
— Barcelona cathedral, Spain
Trav/Holiday 175:61 (c,1) Mr '92
— Basilica of San Marco, Venice, Italy
Nat Geog 187:78–9 (c,1) F '95
— Canary Islands
Trav/Holiday 175:78–9 (c,2) O '92
— Cathedral of St. Sophia, Novgorod, Russia
Trav&Leisure 25:74–6 (c,3) D '95
— Chapel in salt mine (Poland)
Smithsonian 24:100–1 (c,2) Mr '94
— Chapel in U.S. Capitol, Washington, D.C.
Life 16:58 (c,4) S '93
— Chapel interior (Iowa)
Smithsonian 24:44 (2) Mr '94
— Church of the Holy Sepulchre, Jerusalem,
Israel
Trav&Leisure 24:86,88 (c,1) Ag '94
Trav/Holiday 178:68 (c,2) S '95
— Cologne Cathedral, Germany
Trav/Holiday 177:55 (c,2) S '94
— Corsica
Trav&Leisure 25:76–7,81 (c,1) Jl '95
— Country church (France)
Trav&Leisure 24:90 (c,1) S '94
— Crete
Gourmet 52:76 (c,2) F '92
— Crimea
Nat Geog 186:102–3 (c,1) S '94
— Devonshire, England
Smithsonian 24:75 (c,4) Jl '93
— Dexter Avenue Baptist Church,
Montgomery, Alabama
Am Heritage 46:35 (c,4) F '95 supp.
— Ebenezer Baptist Church, Atlanta, Georgia
Am Heritage 43:98 (c,4) Ap '92
Gourmet 56:75 (c,4) Jl '96
— Florence, Italy
Natur Hist 101:26–9 (painting,c,1) Ja '92
Gourmet 53:99 (c,2) S '93
Trav/Holiday 178:cov.,43 (c,1) D '95
— Frauenkirche, Munich, Germany
Trav&Leisure 24:8 (c,3) My '94

— Hawaii
Life 15:31 (c,4) My '92
Trav&Leisure 26:52 (c,4) Ap '96
— High Hill, Texas
Am Heritage 44:102–5 (c,1) S '93
— Italy
Trav&Leisure 24:111 (2) S '94
Trav/Holiday 179:78–80 (c,1) My '96
Trav&Leisure 26:76 (c,1) Jl '96
Trav&Leisure 26:161 (c,1) N '96
— Kizhi Island, U.S.S.R.
Nat Geog 185:114–15 (c,1) Je '94
— Lalibela, Ethiopia
Trav&Leisure 23:107–8 (c,1) O '93
— Leon, Spain
Smithsonian 24:67 (c,4) F '94
— Lincoln cathedral, England
Gourmet 52:10,104–9 (c,1) D '92
— London, England
Gourmet 55:56 (drawing,c,4) N '95
— Magdalen College Chapel, Oxford,
England
Nat Geog 188:133 (c,1) N '95
— Maine
Trav/Holiday 175:84 (c,1) S '92
— Matisse Chapel, Vence, France
Gourmet 54:100 (c,2) S '94
— Matthias Church, Budapest, Hungary
Trav/Holiday 179:12 (c,4) D '96
— Mexico
Gourmet 55:80–1 (c,1) Ja '95
Nat Geog 190:70–1 (c,1) Ag '96
— Milan, Italy
Nat Geog 182:95–7 (c,1) D '92
Gourmet 55:124 (c,2) O '95
Trav&Leisure 26:162,172 (c,4) O '96
— Montserrat
Trav/Holiday 179:49 (c,4) Mr '96
— Nevski Cathedral, Sofia, Bulgaria
Trav/Holiday 176:43 (c,4) My '93
— New Mexico
Trav&Leisure 22:86–7 (c,1) F '92
Gourmet 53:133 (c,1) N '93
Trav/Holiday 178:46 (c,3) F '95
Smithsonian 27:58 (c,3) S '96
— Newfoundland
Trav/Holiday 177:95 (c,2) My '94
Trav/Holiday 178:48 (c,3) Jl '95
— Norway
Trav/Holiday 175:80–1 (c,2) D '92
Gourmet 54:cov.,65 (c,1) Ja '94
Trav/Holiday 179:98,101 (c,1) D '96
— Notre Dame Basilica, Montreal, Quebec
Gourmet 55:136 (c,2) D '95
— Puerto Rico

Trav/Holiday 177:79 (2) D '94
— Quebec
Gourmet 53:105 (c,4) S '93
— Quito church interior, Ecuador
Trav&Leisure 23:126 (c,4) Ja '93
— Ravenna, Italy
Trav&Leisure 23:80–2 (c,4) N '93
Gourmet 56:98–101 (c,4) F '96
— Red Deer, Alberta
Smithsonian 27:79 (c,3) My '96
— Reims Cathedral, France
Trav/Holiday 178:72 (c,3) S '95
— Rural church (Sprott, Alabama)
Am Heritage 45:75 (c,4) Jl '94
— Russian Orthodox church (Alaska)
Gourmet 54:150 (c,4) My '94
— Russian Orthodox church (Denmark)
Trav&Leisure 25:93 (c,2) Mr '95
— Saba, West Indies
Trav&Leisure 26:116 (1) Mr '96
— Sagrada Familia Church, Barcelona, Spain
Gourmet 52:104–5,109 (c,1) My '92
— St. John the Divine, New York City, New
York
Smithsonian 23:32–45 (c,1) D '92
Trav&Leisure 23:NY1 (c,4) Ja '93
— St. Louis Cathedral, New Orleans,
Louisiana
Life 18:100 (c,4) Ap '95
— Sainte-Mere-Eglise, France
Trav/Holiday 177:81 (c,1) Je '94
— St. Peter's Abbey interior, Salzburg,
Austria
Trav/Holiday 176:42 (c,1) D '93
— St. Petersburg, Russia
Trav&Leisure 23:106–7 (c,4) N '93
Nat Geog 184:100–1,118 (c,1) D '93
— Salvador, Brazil
Trav/Holiday 175:60 (c,2) Je '92
— San Paolo Maggiore, Naples, Italy
Trav/Holiday 179:85 (c,1) D '96
— Santiago de Compostela church, Spain
Trav/Holiday 178:83 (c,1) Ap '95
Trav&Leisure 26:122,127–8 (c,1) Mr '96
— Sao Paulo facade, Macau
Trav/Holiday 175:89 (c,2) Ap '92
— Sardinia, Italy
Gourmet 52:51 (c,4) Jl '92
— Scotland
Trav&Leisure 26:124 (c,4) D '96
— Siberia
Trav&Leisure 23:123 (c,1) Ap '93
— Slavic Orthodox church interior
(Macedonia)
Nat Geog 189:138–9 (c,1) Mr '96

— Soda can replica of church (Padua, Italy)
 Life 16:22 (c,4) Ap '93
— Southern churches destroyed in arson fires
 Life 19:10–11 (c,1) Jl '96
 Smithsonian 27:56–7 (c,4) S '96
— Spirit houses (Papua New Guinea)
 Trav/Holiday 176:65–6 (c,1) Ap '93
— Thingvellir, Iceland
 Natur Hist 105:53 (c,4) Je '96
—Thorncrown Chapel, Eureka Springs,
 Arkansas
 Trav&Leisure 22:162 (c,4) My '92
— Trinity Church interior, Boston,
 Massachusetts
 Am Heritage 43:4 (c,2) D '92
— Tucson, Arizona
 Am Heritage 44:52–3 (c,1) Ap '93
— Turkey
 Gourmet 54:122 (c,4) O '94
 Trav/Holiday 178:48–53 (c,1) S '95
— Uglich, Russia
 Trav/Holiday 176:90 (c,4) Ap '93
— Ukranian church (Pittsburgh, Pennsyl-
 vania)
 Trav&Leisure 22:E1 (c,3) Je '92
— Vermont
 Am Heritage 43:cov. (c,4) Ap '92
 Gourmet 54:133 (c,2) D '94
— Virginia
 Gourmet 54:136 (c,3) My '94
— Voskresenskiy chapel interior, Russia
 Nat Geog 185:126–7 (c,1) Je '94
— Wauwatosa, Wisconsin
 Smithsonian 24:58 (c,3) F '94
— Western Samoa
 Trav/Holiday 179:51 (c,3) My '96
— Wooden church (Kerumaki, Finland)
 Trav/Holiday 178:59 (c,3) Je '95
— Frank Lloyd Wright's Unity Temple, Oak
 Park, Illinois
 Trav&Leisure 24:138 (c,4) Mr '94
— York Minster, England
 Trav&Leisure 25:136 (c,4) Je '95
— See also
 MISSIONS
 MONASTERIES
 MOSQUES
 ST. SOPHIA CATHEDRAL
 SYNAGOGUES
 TEMPLES
CHURCHES—CONSTRUCTION
— 1280 cathedral
 Smithsonian 23:72 (drawing,3) My '92
CHURCHILL, WINSTON
 Life 15:88 (3) O 30 '92

Am Heritage 45:92 (2) My '94
Trav/Holiday 178:88 (3) Ap '95
Nat Geog 187:57 (painting,c,2) My '95
Life 18:107 (c,2) Je 5 '95
Am Heritage 46:54 (4) O '95
Am Heritage 46:62 (4) D '95
Life 19:55 (3) O '96
— Blenheim birthplace, Oxfordshire, England
 Trav&Leisure 23:71 (c,1) Ag '93
 Am Heritage 47:97 (c,4) Jl '96
— Chartwell home, England
 Trav/Holiday 178:88 (4) Ap '95
— Churchill in V-E Day crowd (London,
 England)
 Life 18:54 (2) Je 5 '95
CICADAS
 Natur Hist 102:39 (c,1) Ag '93
 Life 17:60 (c,4) Je '94
CIGAR SMOKING
 Sports Illus 77:70–1 (c,1) Ag 3 '92
 Sports Illus 77:54 (c,4) N 16 '92
 Sports Illus 78:43,46 (c,4) Ja 18 '93
— George Burns smoking cigar
 Life 17:80–1 (c,1) O '94
— Cuba
 Smithsonian 26:139 (c,1) O '95
— Women smoking
 Trav&Leisure 22:113 (4) My '92
 Sports Illus 84:72–3 (c,1) Mr 18 '96
CIGARETTE INDUSTRY
— Early 20th cent. cigarette ads
 Am Heritage 43:72–8 (c,1) D '92
— 1940s cigarette ad featuring baseball
 players
 Sports Illus 78:16 (c,3) My 3 '93
— 1940s line for cigarettes
 Life 18:22–3 (1) Je 5 '95
— Cigarette billboard (Shanghai, China)
 Trav/Holiday 176:74 (c,1) O '93
CIGARETTE SMOKING
 Sports Illus 84:cov. (c,1) My 20 '96
— Early 20th cent. Faberge cigarette cases
 Smithsonian 26:84–7 (c,1) Mr '96
— Lighting up in factory (North Carolina)
 Nat Geog 187:134–5 (c,1) Mr '95
— Mennonite girls smoking (Mexico)
 Life 17:94 (2) O '94
— Nurse handing out cigarettes to soldiers
 (1918)
 Am Heritage 43:72–3 (1) D '92
— Russian child smoking
 Life 16:76–7 (1) My '93
— See also
 ASHTRAYS
 PIPES, TOBACCO

CINCINNATI, OHIO
— Museum Center at Cincinnati Union
 Terminal
 Smithsonian 23:102–11 (c,1) Je '92
CINQUEFOIL PLANTS
 Nat Wildlife 31:56 (c,1) F '93
 Nat Wildlife 32:55 (c,2) D '93
CIRCUS ACTS
 Life 18:82–4 (c,1) S '95
— 1900 "Diving Dog" (Colorado)
 Am Heritage 43:97 (1) F '92
— Cat leaping through ring of fire (Florida)
 Trav/Holiday 176:85 (c,2) N '93
— Equestrian stunt
 Trav&Leisure 25:E1 (c,4) My '95
— Human cannonball
 Life 18:40 (4) O '95
— Man on horseback
 Life 19:30 (c,4) S '96
— Sideshow acts (Coney Island, New York)
 Smithsonian 27:109 (c,1) D '96
— Snake charmer (Morocco)
 Natur Hist 105:40 (c,4) My '96
— Sword swallower (Washington)
 Nat Geog 187:11 (c,2) Je '95
— Tightrope walking across New York City
 street (1982)
 Smithsonian 23:44 (4) D '92
— Tightrope walk in sunset (Florida)
 Trav&Leisure 24:115 (c,4) D '94
— Woman with snake's body (Egypt)
 Nat Geog 183:60–1 (c,2) Ap '93
— See also
 ACROBATIC STUNTS
 ACROBATS
 ANIMAL TRAINERS
 CLOWNS
 JUGGLING
 MAGIC ACTS
CIRCUSES
 Am Heritage 47:78–89,114 (c,1) S '96
— Cirque de Soleil
 Trav&Leisure 24:34 (c,4) Je '94
— Taking down tents (1956)
 Am Heritage 47:78–9 (1) S '96
— See also
 RINGLING, JOHN
CITY HALLS
— Ghent, Belgium
 Smithsonian 25:120 (c,4) N '94
— Munich, Germany
 Trav&Leisure 26:54 (c,4) Ja '96
— Pamplona, Spain
 Nat Geog 188:97 (c,1) N '95
— Philadelphia, Pennsylvania

Smithsonian 26:83 (c,2) Ag '95
— Stockholm, Sweden
 Trav/Holiday 177:49 (c,3) Je '94
— Toronto, Ontario
 Trav&Leisure 22:62 (c,4) Je '92
— Wedding room at Menton City Hall, France
 Trav&Leisure 24:164 (c,2) F '94
CIVIL RIGHTS
— 1896 Plessy v. Ferguson case that upheld
 "separate but equal" policy
 Smithsonian 24:104–115 (c,1) F '94
— 1939 segregated drinking fountain
 (Oklahoma)
 Am Heritage 47:95 (4) F '96
— 1955 order to desegregate Kansas schools
 Am Heritage 47:114 (c,2) F '96
— 1960s activists training to tolerate cigarette
 smoke blown in the face
 Life 18:86–7 (1) O '95
— 1961 desegregation of the University of
 Georgia
 Life 18:32 (4) F '95
— 1964 murderers of civil rights workers at
 trial (Mississippi)
 Life 19:118 (4) O '96
— 1965 burning of Watts, California
 Am Heritage 47:48 (2) O '96
— 1965 lie-in outside White House,
 Washington, D.C.
 Life 15:101 (4) O 30 '92
— 1969 black student protest at Cornell
 University, New York
 Life 18:42 (4) My '95
— 1976 flag-bearing protester beating black
 man (Boston, Massachusetts)
 Life 18:40 (4) My '95
— Black Power salute at 1968 Olympics
 (Mexico City)
 Sports Illus 79:14 (c,4) O 25 '93
— Central High School, Little Rock, Arkansas
 Smithsonian 27:54 (c,4) S '96
— Civil Rights memorial, Montgomery,
 Alabama
 Am Heritage 43:90 (c,4) Ap '92
— Malcolm X speech (New York)
 Life 15:90 (2) D '92
— National Civil Rights Museum, Memphis,
 Tennessee
 Trav&Leisure 22:E26–E28 (c,3) N '92
— Rosa Parks on bus (1956)
 Life 19:27 (4) F '96
— Southern landmarks of black history
 Am Heritage 43:89–99 (c,2) Ap '92
— See also
 BLACK HISTORY

EVERS, MEDGAR
KING, MARTIN LUTHER, JR.
KU KLUX KLAN
MALCOLM X
PARKS, ROSA
list under BLACKS IN AMERICAN HIS-
 TORY
CIVIL RIGHTS MARCHES
— 1963 (Washington, D.C.)
 Life 16:34–5 (1) Je '93
— 1964 hosing of civil rights marchers
 (Birmingham, Alabama)
 Life 19:118–19 (1) O '96
— 1965 (Selma, Alabama)
 Am Heritage 43:91 (c,4) Ap '92
 Life 16:61 (c,3) Ap '93
 Life 18:56 (3) Je 5 '95
 Am Heritage 47:97 (4) F '96
— 1968 (Memphis, Tennessee)
 Am Heritage 47:99 (4) F '96
CIVIL WAR
— 1863 raid on Lawrence, Kansas
 Am Heritage 46:53 (drawing,3) Jl '95
— Antietam cemetery, Maryland
 Nat Geog 186:135 (c,4) D '94
— Appomattox site of Lee's surrender
 Trav/Holiday 175:88–93 (c,2) O '92
 Trav&Leisure 24:E14 (c,4) Mr '94
— Artillery shell exploding
 Am Heritage 43:32 (drawing,4) Jl '92
— Bathing soldiers caught in surprise attack
 Am Heritage 44:88–9 (painting,c,2) D '93
— Battle of Atlanta
 Am Heritage 47:84–5 (painting,c,3) Ap
 '96
— Battle of Chancellorsville (1863)
 Am Heritage 44:99 (4) O '93
— Civil War battle sites (Virginia)
 Trav&Leisure 25:187–9 (map,c,2) Ap '95
— Civil War comic book
 Am Heritage 44:114 (c,3) My '93
— Civil War soldiers
 Trav&Leisure 22:77 (4) Ja '92
— Confederate flags
 Am Heritage 47:6 (drawing,c,4) Jl '96
— Confederate heroes monument (Stone
 Mountain, Georgia)
 Life 15:15 (c,1) Jl '92
— Confederate raider William Clarke
 Quantrill
 Am Heritage 46:53–61 (c,3) Jl '95
— Family home after 1862 Battle of
 Fredericksburg, Virginia
 Am Heritage 47:6 (painting,c,3) O '96
— Female Civil War soldiers

 Smithsonian 24:97–103 (c,2) Ja '94
— Fredericksburg battlefield, Virginia
 Trav&Leisure 25:188 (c,4) Ap '95
— Gettysburg battlefield, Pennsylvania
 Am Heritage 45:104–13 (c,1) Ap '94
 Trav/Holiday 177:74–81 (map,c,1) Jl '94
 Gourmet 55:50–3,86 (map,c,1) Jl '95
— Libby Prison, Richmond, Virginia
 Am Heritage 45:114–18,130 (1) N '94
— Manassas battle reenactment, Virginia
 Nat Geog 186:36–7 (c,1) O '94
— Manassas battlefield, Virginia
 Trav&Leisure 25:189 (c,4) Ap '95
 Am Heritage 47:68–9 (c,1) D '96
— Monument to Terry's Texas Rangers
 (Austin, Texas)
 Trav/Holiday 175:73 (c,3) F '92
— New Market battle reenactment, Virginia
 Nat Geog 190:56–7 (c,2) D '96
— Pea Ridge battle site, Arkansas
 Gourmet 52:78 (c,4) F '92
— Petersburg Civil War sites, Virginia
 Am Heritage 46:26–8 (c,4) O '95
— Prisoners playing baseball (North Carolina)
 Sports Illus 80:90 (painting,c,3) Je 27 '94
— Role of First Kansas Colored Infantry
 Am Heritage 43:78–9,87–91 (paint-
 ing,c,1) F '92
— Scenes along route of Lee's 1865 retreat
 (Virginia)
 Life 18:77–82 (c,1) Ap '95
— Shiloh National Military Park, Tennessee
 Nat Geog 185:94–5 (c,2) Ap '94
— Signal station in tree (Maryland)
 Am Heritage 43:57 (painting,c,4) F '92
— Story of Confederate raider ship
 "Alabama"
 Nat Geog 186:66–83 (c,1) D '94
— See also
 ABOLITIONISTS
 BRADY, MATHEW
 DAVIS, JEFFERSON
 GRANT, ULYSSES S.
 HOOKER, JOSEPH
 JACKSON, STONEWALL
 LEE, ROBERT E.
 LINCOLN, ABRAHAM
 SHERIDAN, PHILIP
 SLAVERY
Civilizations. See
 ANCIENT CIVILIZATIONS
 list under PEOPLE AND CIVILIZA-
 TIONS
CLAM DIGGING
— Vietnam

Smithsonian 26:43 (c,1) Ja '96
CLAMS
— Giant clams
Nat Geog 181:82 (c,1) Je '92
Smithsonian 24:111 (c,3) O '93
Nat Wildlife 32:20 (c,4) O '94
Nat Geog 190:44 (c,4) N '96
— Great clams
Natur Hist 101:42–3 (c,1) F '92
CLARINETS
— Clarinet repair shop (Louisiana)
Life 18:96 (c,3) Ap '95
CLASSROOMS
— Early 20th cent. (Indiana)
Am Heritage 43:45 (3) F '92
— 1901 (Pennsylvania)
Life 17:40 (4) O '94
— 1934 (Amsterdam, Holland)
Life 16:68–9 (1) Je '93
— 1949 crowded classroom of black students
(Arkansas)
Life 19:62 (2) O '96
— Belize
Smithsonian 25:84–5 (c,2) My '94
— Iraq
Natur Hist 105:15 (c,4) S '96
— Mississippi
Smithsonian 26:73 (3) Mr '96
— One-room schoolhouse (Massachusetts)
Nat Geog 181:128–9 (c,1) Je '92
— Outdoor (China)
Nat Geog 189:25 (c,1) Mr '96
— Pakistan
Nat Geog 185:132 (c,4) Mr '94
— Siberia
Nat Geog 181:18–19 (c,1) Je '92
— Sikh school (British Columbia)
Nat Geog 181:118–19 (c,1) Ap '92
— Sudan
Life 15:54–5 (c,1) Je '92
— Syria
Nat Geog 190:120 (c,3) Jl '96
CLAY, HENRY
Am Heritage 46:22 (4) Jl '95
CLAY, LUCIUS
Am Heritage 43:20 (etching,4) F '92
CLEMATIS
Gourmet 53:145 (c,4) N '93
Clemens, Samuel. See
TWAIN, MARK
CLEMENTE, ROBERTO
Sports Illus 77:114–20 (c,1) D 28 '92
Smithsonian 24:128–42 (c,1) S '93
Sports Illus 81:110–12 (c,1) S 19 '94
Sports Illus 82:47 (4) Ja 16 '95

CLEOPATRA
— 1876 sculpture of Cleopatra's death
Smithsonian 27:16,20 (c,4) S '96
CLEVELAND, GROVER
— 1884 campaign poster
Am Heritage 43:46 (c,4) S '92
— 1886 wedding
Life 15:30 (painting,c,4) O 30 '92
Life 17:38 (4) Je '94
— Frances Cleveland
Smithsonian 23:140 (4) O '92
CLEVELAND, OHIO
Gourmet 55:148–9 (c,2) My '95
— 1930–1950 scenes of black life
Am Heritage 46:40–5 (1) F '95 supp.
— "Free Stamp" outdoor sculpture
Smithsonian 26:80 (c,2) Ag '95
— Jacobs Field
Sports Illus 80:42–4 (c,1) Ap 11 '94
— Rock and Roll Hall of Fame treasures
Life 18:13–17 (c,1) S '95
CLIFF DWELLINGS
— 13th cent. Anasazi village (Southwest)
Natur Hist 102:56–7 (c,1) Ag '93
Trav/Holiday 178:40–1 (c,2) Jl '95
Nat Geog 189:86–107 (c,1) Ap '96
— Anasazi dwellings (Utah)
Trav&Leisure 26:E12 (c,4) My '96
Trav/Holiday 179:55 (c,1) Je '96
— Mesa Verde, Colorado
Trav&Leisure 23:141 (c,1) Ap '93
— Mogollon dwellings (New Mexico)
Smithsonian 27:64 (c,3) N '96
— Puye dwellings (New Mexico)
Trav&Leisure 26:220 (c,4) S '96
— Sinagua cliff dwelling (Sedona, Arizona)
Gourmet 53:138–9 (c,3) Ap '93
CLIFFS
— Cliffs of Moher, Ireland
Trav/Holiday 179:21 (c,4) My '96
— Cornwall, England
Gourmet 55:14,85 (c,1) S '95
— Dangling from cliff (Switzerland)
Life 19:16–17 (c,1) My '96
— Echo Cliffs, Arizona
Nat Geog 190:92 (c,4) S '96
— Gay Head, Martha's Vineyard,
Massachusetts
Trav&Leisure 22:E1 (c,3) S '92
Sports Illus 78:93 (c,2) F 22 '93
— Limestone bluffs (Aran Islands, Ireland)
Nat Geog 189:122–3 (c,1) Ap '96
— Lyme, England
Natur Hist 104:66 (2) O '95
— Na Pali coast, Kauai, Hawaii

Life 15:34–5 (c,1) My '92
Trav/Holiday 175:18 (c,4) My '92
Trav&Leisure 23:88 (c,4) N '93
— Old Harry Rocks, Dorset
Nat Geog 188:38–9 (c,1) O '95
— Quebec
Gourmet 53:106 (c,3) S '93
— Quercy, France
Trav&Leisure 24:81 (c,4) My '94
— Rocky Dingle coast, Ireland
Nat Geog 186:25 (c,1) S '94

CLIMATE
— Animal strategies for dealing with heat
Natur Hist 102:cov.,26–67 (c,1) Ag '93
— Infrared reading of building heat (British
Columbia)
Smithsonian 26:111 (c,2) D '95
— Impact of El Nino
Trav/Holiday 178:33 (painting,c,3) D '95
— Microclimates
Smithsonian 26:102–11 (c,1) D '95
— See also
COLD
TIDAL WAVES

CLINTON, BILL
Life 15:10–15 (c,1) D '92
Life 16:10–11,54–5 (c,1) Ja '93
Trav&Leisure 23:99 (painting,c,2) Ja '93
Life 16:74 (c,2) Ap '93
Sports Illus 78:59 (c,4) Je 14 '93
Am Heritage 44:cov.,64 (c,4) S '93
Life 16:12 (1) D '93
Life 17:20 (c,1) Ja '94
Sports Illus 80:cov.,2–3,24–31 (c,1) Mr
21 '94
Smithsonian 25:105 (2) O '94
Smithsonian 25:142 (c,4) D '94
Am Heritage 45:120,123 (c,4) D '94
Life 18:14–15 (1) N '95
Life 19:73 (4) F '96
Smithsonian 27:23 (c,4) Ag '96
— Chelsea Clinton
Life 18:12 (c,2) Je '95
— Clinton playing golf
Sports Illus 77:112–13 (c,1) D 28 '92
Sports Illus 82:2 (c,2) F 27 '95
Sports Illus 82:2–3,50–4 (c,1) Je 12 '95
— Clinton with marching band
Life 16:8–9 (c,1) F '93
— Hillary Rodham Clinton
Life 16:5,11 (c,1) Ja '93
Life 16:38–43 (c,1) Mr '93
Life 17:30 (c,1) Ja '94
Smithsonian 25:105 (2) O '94
Am Heritage 45:120,125 (c,4) D '94

Life 19:73 (4) F '96
— Inauguration Day 1993
Life 16:32–43 (c,1) Mr '93
— Mother Virginia Kelley
Sports Illus 78:44–5 (c,1) Ap 26 '93
Life 18:110 (4) Ja '95
— Photographing Clinton's cat Socks
Life 16:112 (c,2) Ja '93
— Throwing out first baseball of season
(1993)
Sports Illus 78:84–5 (c,1) Ap 12 '93
— Wax replica (Paris, France)
Life 16:26 (c,4) Je '93

CLIPPER SHIPS
— 1830s
Natur Hist 102:74 (painting,c,4) N '93

CLOCKS
Gourmet 55:164,240 (c,3) D '95
— 1780 porcelain clock (France)
Gourmet 53:106 (c,4) O '93
— Late 19th cent. mantel clock (Louisiana)
Trav&Leisure 26:112 (c,1) Ap '96
— Astronomical clock on building (Prague,
Czechoslovakia)
Gourmet 52:113 (c,2) My '92
— Outdoor steam clock (Vancouver)
Trav&Leisure 26:133 (c,4) Mr '96
— Seychelles Islands clock tower
Trav&Leisure 26:145 (c,4) D '96
— See also
SUNDIALS
WATCHES

CLOTHING
— 1843 woman's dress
Life 16:68 (c,4) D '93
— 1896 grebe-skin cape
Smithsonian 25:103 (c,4) Jl '94
— 1900 beaded Lakota Indian vest
Am Heritage 44:88 (c,4) D '93
— Early 20th cent. stockings ads
Am Heritage 47:56 (4) My '96
— 1920s raccoon coat
Nat Geog 181:59 (4) Mr '92
— 1950s women's lollipop dresses
Life 18:116–17 (c,1) N '95
— 1960s women's clothing
Life 18:118–19 (c,1) N '95
— 1965 Saint Laurent dresses inspired by
Mondrian
Smithsonian 26:104–5 (c,2) Je '95
— 1969 fashion show
Life 16:24 (c,3) Jl '93
— 1996 convention of 1970s leisure suits
(Iowa)
Life 19:18–22 (c,2) F '96

— Aprons through history
Gourmet 52:166 (c,4) N '92
— Auctioning 1950s denim outfit (France)
Nat Geog 185:64–5 (c,1) Je '94
— Chadri (Afghanistan)
Nat Geog 184:60–1 (c,1) O '93
— Clothing of Rock and Roll Hall of Famers
Life 18:13–17 (c,1) S '95
— Dog-hair sweater (France)
Life 15:23 (c,4) Mr '92
— Grass skirts (Easter Island)
Nat Geog 183:56–7 (c,2) Mr '93
— History of Brooks Brothers store
Am Heritage 44:40–5 (c,3) N '93
— Kubota's handcrafted kimonos (Japan)
Smithsonian 26:64–7 (c,1) D '95
— Men in formal wear performing toast
Sports Illus 80:70–1 (c,1) Je 27 '94
— Protective suits for fire fighters
Smithsonian 23:34 (c,4) My '92
— Sioux dress
Nat Geog 183:116 (c,4) Ja '93
— T-shirts as fashion items
Smithsonian 23:96–102 (c,2) Ap '92
— Training for chemical warfare in protective
suits (U.S.S.R.)
Life 18:56–7 (c,1) Jl '95
— Women's fashions (1930s–1990)
Life 18:116–24 (c,1) N '95
— See also
BATHING SUITS
FOOTWEAR
GLOVES
HATS
HEADGEAR
MASKS
MILITARY COSTUME
RAINWEAR
U.S.—COSTUME
individual countries—COSTUME
list under OCCUPATIONS
CLOUDS
Smithsonian 25:cov.,36–43 (c,1) Ap '94
Trav/Holiday 177:57 (c,3) Jl '94
— Cartoon of threatening storm cloud
Sports Illus 79:2–3 (c,1) N 15 '93
— Lenticular clouds
Smithsonian 25:12 (c,4) Je '94
— Mammatus clouds
Smithsonian 25:60 (c,4) O '94
— Nylon net generating water from clouds
(Chile)
Natur Hist 104:44–7 (c,1) N '95
— Over mountains (Washington)
Sports Illus 76:46 (c,3) Je 22 '92

Life 15:50 (c,2) S '92
— Over Pacific lagoon
Trav/Holiday 178:48–9 (c,2) O '95
— Sky after storm (North Dakota)
Trav/Holiday 176:54 (c,4) D '93
— Storm clouds
Life 16:32–3 (c,1) S '93
Smithsonian 25:61 (c,3) O '94
CLOVER
Nat Wildlife 30:9 (painting,c,4) Ap '92
CLOWNS
Sports Illus 79:60–1 (c,1) S 20 '93
Smithsonian 26:42 (4) Ag '95
— Mid 19th cent. mime Charles Deburau
Smithsonian 26:72–3 (4) My '95
— Lou Jacobs
Life 16:62 (c,1) Ja '93
— Pinky Lee
Life 17:66 (1) Ja '94
— Rodeo clown school (Louisiana)
Sports Illus 81:2–3,56–70 (c,1) O 3 '94
CLUBS
— 18th cent. men's club initiation (France)
Am Heritage 44:38 (etching,3) S '93
— 1850s Mason
Am Heritage 44:37 (4) S '93
— 1880s Masonic temple
Am Heritage 44:41 (painting,c,4) S '93
— 1939 German singing society (Wisconsin)
Am Heritage 45:81 (4) F '94
— American Academy and Institute of Arts
and Letters
Smithsonian 23:136–47 (c,2) N '92
— American Legion meeting (Philippines)
Nat Geog 181:67 (c,3) Mr '92
— Warren G. Harding in Shriner's hat
Am Heritage 44:42 (4) S '93
— Male bonding groups (18th-20th cents.)
Am Heritage 44:37–45 (c,3) S '93
— Volunteers of America history
Am Heritage 47:85–92 (c,2) F '96
— See also
BOY SCOUTS
GIRL SCOUTS
KU KLUX KLAN
NIGHT CLUBS
CLUBS—HUMOR
— Oddball clubs
Smithsonian 26:128–39 (painting,c,1) Ap
'95
**COAL INDUSTRY—TRANSPORTA-
TION**
— Coal barge on canal (Germany)
Nat Geog 182:20–3 (c,1) Ag '92

COAL MINING
— 1938 (West Virginia)
 Life 15:80–1 (1) My '92
Coats of arms. See
 SEALS AND EMBLEMS
COBB, TY
 Sports Illus 77:60–2 (painting,c,1) Fall '92
 Smithsonian 25:41 (4) Jl '94
 Am Heritage 45:121 (4) N '94
— Artifacts belonging to him
 Sports Illus 82:72 (c,4) My 22 '95
COCKATOOS
 Nat Wildlife 34:24 (painting,c,4) O '96
COCKROACHES
 Nat Wildlife 31:34–9 (c,1) D '92
— Cockroach fossil
 Life 16:112 (c,4) O '93
COCONUT PALM TREES
 Trav&Leisure 23:100–1 (c,1) My '93
 Trav/Holiday 179:77 (c,2) O '96
 Nat Geog 190:48 (c,1) N '96
COCTEAU, JEAN
— Murals of lovers by Cocteau in Menton
 City Hall, France
 Trav&Leisure 24:164 (painting,c,2) F '94
CODY, WILLIAM (BUFFALO BILL)
 Life 16:88 (2) Ap 5 '93
— Home (North Platte, Nebraska)
 Trav&Leisure 25:45 (c,4) Jl '95
COELENTERATES
— Hydroids
 Nat Geog 182:101 (c,3) Jl '92
— See also
 CORALS
 JELLYFISH
 SEA ANEMONES
COFFEE INDUSTRY
— Coffee fields (El Salvador)
 Nat Geog 188:115 (c,3) S '95
— Coffee plants
 Trav&Leisure 26:40 (c,1) Ja '96
— Mexico
 Smithsonian 25:24 (3) N '94
COFFEEHOUSES
 Smithsonian 27:104–13 (c,1) S '96
— Early 20th cent. (Vienna, Austria)
 Smithsonian 27:110 (painting,c,4) S '96
— Coffee bar
 Trav/Holiday 177:39 (c,4) F '94
— Miami, Florida
 Trav/Holiday 179:52–6 (c,3) D '96
— Old men playing cards (Spain)
 Nat Geog 181:9 (c,3) Ap '92
— Paris, France
 Smithsonian 27:111 (4) S '96

— Vienna, Austria
 Gourmet 56:124–7,192 (c,1) D '96
COFFEEPOTS
— Early 10th cent. Rumford coffeepot
 Am Heritage 44:72 (drawing,4) S '93
COFFINS
 Sports Illus 79:20–1 (c,1) Ag 9 '93
— Coffin of murdered infant (Yugoslavia)
 Life 19:12–13 (c,1) D '96
— Fishing coffin out of flood water (Missouri)
 Nat Geog 185:68 (c,3) Ja '94
— Georgia, U.S.S.R.
 Nat Geog 181:94–5 (c,1) My '92
— Infant in coffin (U.S.S.R.)
 Nat Geog 185:61 (c,4) Ap '94
— Ornate fantasy coffins (Ghana)
 Nat Geog 186:120–30 (c,1) S '94
COHAN, GEORGE M.
 Smithsonian 27:48 (4) N '96
COINS
— 15th cent. Medici coin (Italy)
 Trav&Leisure 22:22 (c,4) Ja '92
— Late 16th cent. Spanish coin
 Nat Geog 186:42 (4) Jl '94
— 1838 British coins
 Smithsonian 27:34 (c,4) My '96
— 1838 U.S. ten dollar eagle coins
 Smithsonian 27:34 (c,4) My '96
— 1860s (Brazil)
 Nat Geog 186:79 (c,4) D '94
— 1907 twenty-dollar gold piece
 Gourmet 54:126 (c,4) O '94
— International coins
 Nat Geog 183:80–107 (c,1) Ja '93
COLD
— Frostbitten fingers
 Nat Geog 182:89 (c,4) D '92
 Nat Geog 183:92 (c,4) Ap '93
— Man with frostbite
 Life 19:46 (c,4) Ag '96
— Storing frozen goods outside windows
 (Siberia)
 Nat Geog 182:88–9 (c,1) O '92
— Stacks of frozen milk chunks (Siberia)
 Life 15:26 (c,4) My '92
— Visible frost in the air
 Sports Illus 81:2–3 (c,1) D 19 '94
COLE, THOMAS
 Smithsonian 25:100 (4) My '94
— Paintings by him
 Smithsonian 25:98–107 (c,1) My '94
COLETTE
 Trav&Leisure 26:30 (4) Jl '96
COLLAGES
— Matisse's "Polynesia, The Sea" (1946)

Trav&Leisure 22:92–3 (c,1) S '92
COLLEGE LIFE
— 1866 college women's baseball team
 Am Heritage 45:111 (2) Jl '94
— 1945 coeds (Colorado)
 Life 18:102–3 (1) Je 5 '95
— 1946 students crowding into phone booth
 (California)
 Life 19:126 (4) O '96
— 1950s (Wisconsin)
 Am Heritage 45:110–16 (c,4) D '94
— 1964 Berkeley student protest, California
 Am Heritage 47:44 (2) O '96
— Dorm room (California)
 Smithsonian 26:118 (c,3) Ap '95
— Life of college basketball player (Kansas)
 Sports Illus 82:70–4 (c,1) F 13 '95
— Oxford University, England
 Nat Geog 188:114–27 (c,1) N '95
— Student antics (Indiana)
 Sports Illus 79:30–1 (c,4) N 22 '93
— Students drinking beer (Florida)
 Nat Geog 181:34–5 (c,1) F '92
— Welfare mother studying at college
 (Massachusetts)
 Life 15:60–6 (c,1) Ap '92
COLLEGES AND UNIVERSITIES
— 1940s veterans at Indiana University
 Smithsonian 25:128–39 (1) N '94
— 1968 student sit-in at Columbia University,
 New York City
 Am Heritage 44:50 (4) Ap '93
 Life 19:72 (4) O '96
— 1969 black student protest at Cornell, New
 York
 Life 18:42 (4) My '95
— 1970 student shooting at Kent State, Ohio
 Life 18:39 (4) My '95
— Berklee College of Music, Boston,
 Massachusetts
 Smithsonian 27:43–9 (c,2) Ag '96
— Bryn Mawr, Pennsylvania
 Trav&Leisure 25:212 (c,4) N '95
— University of California, Berkeley carillon
 Smithsonian 25:112–13 (c,1) N '94
— Clemson, South Carolina
 Sports Illus 83:58 (c,1) D 18 '95
— Deep Springs, California
 Smithsonian 26:114–25 (c,1) Ap '95
— Eleutherian College, Lancaster, Indiana
 Smithsonian 24:136–7 (c,1) Ap '93
— Gallaudet students
 Smithsonian 23:34–5,41 (2) Jl '92
— History of Berea College, Kentucky
 Smithsonian 24:92–104 (c,2) D '93

— University of Michigan's Angell Hall
 Smithsonian 25:54 (c,4) S '94
— University of Mississippi Lyceum, Oxford,
 Mississippi
 Smithsonian 26:56–7 (c,1) N '95
— University of Nevada's outdoor flashlight
 sculpture
 Smithsonian 26:79 (c,3) Ag '95
— University of North Carolina at Chapel Hill
 Trav&Leisure 26:56 (c,4) D '96
— Northwestern University library, Evanston,
 Illinois
 Trav&Leisure 25:173 (c,4) My '95
— Tuskegee University, Alabama (1902)
 Am Heritage 46:34 (c,3) F '95 supp.
— University of Virginia, Charlottesville,
 Virginia
 Life 16:40–1 (c,1) My '93
— Wake Forest College, Winston-Salem,
 North Carolina
 Nat Geog 187:120 (c,3) Mr '95
— Williams College, Williamstown,
 Massachusetts (1945)
 Life 18:60 (3) Je 5 '95
— University of Wisconsin
 Am Heritage 45:110–14 (c,4) D '94
— See also
 COLLEGE LIFE
 COMMENCEMENT
 OXFORD UNIVERSITY
 PRINCETON UNIVERSITY
COLLIES
— Border collies
 Smithsonian 27:127–37 (c,1) N '96
— Grooming Lassie
 Life 17:84 (c,2) Ag '94
COLOBUS MONKEYS
 Natur Hist 102:42–7 (c,1) Ap '93
 Natur Hist 102:44–9 (c,1) O '93
 Natur Hist 104:52–3 (c,2) Ja '95
COLOGNE, GERMANY
 Life 19:28 (c,3) D '96
— 1945 ruins
 Life 18:26–7 (1) Je 5 '95
— Cologne Cathedral
 Trav/Holiday 177:55 (c,2) S '94
COLOMBIA
— 1985 volcano damage (Armero)
 Smithsonian 27:35 (c,2) Jl '96
— Simon Bolivar's home (Santa Marta)
 Nat Geog 185:65 (c,3) Mr '94
— Isla del Gallo
 Nat Geog 181:100–1 (c,1) F '92
— Manaitara Island area
 Natur Hist 101:48–53 (map,c,1) Ja '92

— Rain forest
Smithsonian 24:118–19 (c,2) S '93
Nat Geog 184:124 (c,4) D '93
COLOMBIA—COSTUME
— Embera Indians
Nat Geog 185:48–9 (c,1) Mr '94
— Guards
Nat Geog 185:36–7 (c,1) Mr '94
— Makuna Indians
Natur Hist 101:46–53 (c,1) Ja '92
— Yagua children
Nat Geog 187:6–7 (c,1) F '95
— See also
BOLIVAR, SIMON
COLOMBIA—RITES AND FESTI-
VALS
— Independence Day celebration
Nat Geog 185:56–7 (c,1) Mr '94
COLORADO
Trav&Leisure 26:C1–C22 (c,1) Ap '96
— Late 19th cent.
Am Heritage 43:92–9 (1) F '92
— Animas Canyon (early 20th cent.)
Am Heritage 47:132 (1) Ap '96
— Beaver Creek
Trav&Leisure 23:E1–E2 (map,c,3) Ja '93
— Boulder
Nat Geog 190:80–2 (c,1) N '96
— Chimney Rock
Trav/Holiday 177:54–5 (painting,c,1) Je
'94
— Clear Creek (1873)
Natur Hist 102:42 (3) N '93
— Clear Creek Reservoir
Natur Hist 102:43 (3) N '93
— Creede mine
Trav&Leisure 23:125 (c,1) Mr '93
— Crested Butte
Trav/Holiday 177:cov.,78–85 (map,c,1) F
'94
— Cripple Creek (late 19th cent.)
Am Heritage 43:94–5 (1) F '92
— Echo Park
Nat Geog 185:99 (c,1) Ap '94
— Elk Park
Natur Hist 102:66–8 (map,c,1) N '93
— Four Corners countryside
Trav&Leisure 24:68–75,106–7 (map,c,1)
Ag '94
Nat Geog 190:cov.,80–97 (map,c,1) S '96
— Front Range
Nat Geog 190:80–103 (map,c,1) N '96
— Georgetown
Am Heritage 46:32–6 (c,4) N '95

— Glenwood Canyon Highway
Trav&Leisure 23:40 (c,4) Mr '93
— Gunnison River
Nat Wildlife 31:7 (c,4) Ag '93
— High Creek Fen
Natur Hist 104:16–18 (map,c,1) Je '95
— Hoosier Ridge
Natur Hist 103:70–2 (map,c,1) S '94
— Long Lake area
Natur Hist 101:18–21 (map,c,1) Ag '92
— San Juan Mountains
Trav&Leisure 22:E1 (c,3) Ag '92
— San Juan River
Nat Geog 184:110–11 (c,1) N 15 '93
— Steamboat Springs area
Trav&Leisure 22:102–9 (map,c,1) F '92
Trav/Holiday 177:33 (c,4) D '94
— Summitville Mine
Sports Illus 85:84–6 (c,3) O 14 '96
— Telluride area
Nat Geog 181:52–3 (c,1) My '92
Trav&Leisure 22:E1–4 (map,c,3) Ag '92
Trav&Leisure 22:17 (c,4) S '92
Natur Hist 105:34–5 (map,c,1) Ap '96
— Telluride Mushroom Festival
Natur Hist 105:32–5 (c,1) Ap '96
— Trinidad
Am Heritage 45:90–3 (map,c,4) Ap '94
— Uncompaghre National Forest
Nat Wildlife 34:35 (c,1) O '96
— Yampa River
Trav/Holiday 179:72–9 (c,1) Ap '96
— See also
ASPEN
COLORADO RIVER
DENVER
FLORISSANT FOSSIL BEDS
NATIONAL MONUMENT
GREAT SAND DUNES NATIONAL
MONUMENT
MESA VERDE NATIONAL PARK
ROCKY MOUNTAINS
COLORADO RIVER, SOUTHWEST
— Colorado
Gourmet 55:156 (c,2) My '95
— Horseshoe Bend, Arizona
Nat Wildlife 32:54 (c,3) D '93
— See also
HOOVER DAM
COLOSSEUM, ROME, ITALY
Trav/Holiday 175:17 (c,4) Mr '92
COLUMBIA, SOUTH CAROLINA
— 1904
Natur Hist 105:78-9 (1) Ag '96

COLUMBIA RIVER, OREGON/WASH-INGTON
Nat Wildlife 34:37–9,45 (map,c,2) D '95
— Columbia River Gorge
Gourmet 53:6, 142–5 (c,1) Ap '93
Am Heritage 44:75 (c,2) My '93
Life 16:72 (c,2) D '93
— See also
GRAND COULEE DAM
COLUMBINES (FLOWERS)
Trav&Leisure 24:47 (c,4) Jl '94
Smithsonian 25:87 (c,4) Ag '94
Nat Wildlife 33:52 (c,1) Ag '95
COLUMBUS, CHRISTOPHER
Nat Geog 181:16–17,53 (painting,c,1) Ja '92
Trav/Holiday 175:26 (painting,c,4) S '92
Natur Hist 101:4 (painting,c,3) O '92
Life 19:60 (drawing,4) F '96
— 1493 Columbus settlement La Isabela, Hispaniola
Nat Geog 181:40–53 (map,c,1) Ja '92
— Columbus landing spot at Salt River, St. Croix
Am Heritage 45:6 (c,3) Ap '94
— Columbus performing the "egg trick"
Natur Hist 102:2 (painting,c,4) Mr '93
— Depicted on 1893 World's Fair souvenir
Smithsonian 24:26 (c,4) O '93
— Home (Genoa, Italy)
Nat Geog 181:8–9 (c,2) Ja '92
— Markers at reputed landing sites (San Salvador)
Natur Hist 105:24 (c,4) O '96
— Reproduction of Columbus ships
Nat Geog 181:cov.,2–5,18–19,38–9 (c,1) Ja '92
— Sites associated with Columbus' life
Nat Geog 181:2–53 (map,c,1) Ja '92
— Statue (Nassau, Bahamas)
Gourmet 52:57 (c,1) Ja '92
COLUMBUS, OHIO
— Deaf School Park topiary
Trav/Holiday 175:84 (c,4) Jl '92
COMANCHE INDIANS—SOCIAL LIFE AND CUSTOMS
— Traditional dance
Smithsonian 23:90 (c,2) F '93
Comb jellies. See
CTENOPHORES
COMBINES
Nat Geog 185:66–7 (c,2) My '94
COMBS
— 4th cent. Scythian comb (U.S.S.R.)
Smithsonian 25:54 (c,4) Mr '95

Comedians. See
ENTERTAINERS
COMETS
Smithsonian 23:75,83 (c,1) Je '92
— 1976 Comet West
Natur Hist 104:73 (4) S '95
— Comet hunting
Smithsonian 23:74–83 (c,1) Je '92
— Hale-Bopp
Natur Hist 105:55 (c,4) Mr '96
Natur Hist 105:68–9 (c,4) D '96
— Hyakutake
Life 19:20 (c,2) Je '96
— Shoemaker-Levy
Natur Hist 102:40 (c,4) O '93
— Shoemaker-Levy 9
Smithsonian 25:62–71 (c,2) Je '94
— Shoemaker-Levy 9 colliding with Jupiter
Natur Hist 103:70 (painting,c,4) Jl '94
Smithsonian 25:14 (c,4) Ja '95
— Swift-Tuttle comet
Smithsonian 23:24 (c,4) Mr '93
COMIC BOOKS
— Civil War comic book
Am Heritage 44:114 (c,3) My '93
— *Classic Comics* Jekyll and Hyde covers (1943-1953)
Am Heritage 44:8 (4) D '93
— *Classics Illustrated* comics
Am Heritage 44:78–85 (c,4) My '93
— "Teenage Mutant Ninja Turtles" fad
Smithsonian 23:98–107 (c,2) D '92
— See also
SUPERMAN
COMIC STRIPS
— "Blondie"
Life 15:80 (c,4) Ja '92
— "Doonesbury"
Smithsonian 24:108–9 (2) Mr '94
Life 18:41 (4) O '95
— "Peanuts"
Life 16:28 (4) O '93
— "Peanuts'" first strip (1950)
Life 16:28 (4) O '93
— Pogo's "We have met the enemy" strip (1971)
Smithsonian 23:12 (4) Jl '92
— Ripley's "Believe it or Not" subjects
Smithsonian 25:90–9 (c,1) Ja '95
— "Superman's" death
Life 16:108 (c,1) Ja '93
COMMENCEMENT
— Culinary school graduates tossing toques in air (New York)
Gourmet 56:201 (c,2) O '96

— Graduating naval cadets tossing caps in air
(Maryland)
Life 19:12–13 (1) Jl '96
— Graduation at school for deaf
(Pennsylvania)
Life 18:24–6 (1) Je '95
— Harvard graduates celebrating (Massachusetts)
Nat Geog 186:5–6 (c,1) Jl '94
— Oxford, England
Nat Geog 188:134–5 (c,1) N '95
— University of North Carolina
Nat Geog 187:124–5 (c,1) Mr '95

COMMENCEMENT—COSTUME
— College graduates
Sports Illus 79:28–9 (c,1) D 27 '93
Sports Illus 84:2–3,73 (c,1) My 13 '96
— Posing for college yearbook picture
Sports Illus 85:59 (c,4) S 23 '96
— Prep school graduate (Connecticut)
Nat Geog 185:91 (c,4) F '94

COMMUNION
— Greek Orthodox ceremony (Israel)
Nat Geog 181:92–3 (c,1) Je '92
— Ireland
Nat Geog 186:21 (c,1) S '94
Gourmet 55:86–7 (c,2) Je '95
— Italy
Nat Geog 182:92–3 (c,1) D '92
— Massachusetts
Life 17:89 (c,4) N '94
— Mexico
Nat Geog 190:122–3 (c,2) Ag '96

COMMUNISM
— Late 1980s posters promoting Eastern
European revolutions
Smithsonian 24:118–23 (c,2) Ap '93
— Russian vs. American system cartoon
(1959)
Am Heritage 43:72 (4) F '92
— Statue representing hammer and sickle
symbol
Nat Geog 182:113 (c,1) O '92
— See also
HISS, ALGER
LENIN, VLADIMIR
MAO ZEDONG
McCARTHY, JOSEPH
STALIN, JOSEF
TROTSKY, LEON

COMMUTERS
— Commuters bicycling in the rain
(Shanghai, China)
Nat Geog 185:cov.,8–9 (c,1) Mr '94
— Crowded commuter train (Bombay, India)

Nat Geog 187:54–5 (c,1) Mr '95
— Elderly businessman with briefcase (Italy)
Trav&Leisure 26:77 (1) Jl '96
— New York City commuters on subway
Smithsonian 24:60–1 (painting,c,2) Ag '93
— Taiwan commuter traffic
Nat Geog 184:6–7 (c,1) N '93
— Waiting on train platform (Connecticut)
Nat Geog 185:77 (c,3) F '94

COMPASSES
— Early 19th cent. compass used by Lewis &
Clark
Smithsonian 27:23 (c,4) Ag '96
— 1860s compass of John Wilkes Booth
Am Heritage 43:114 (c,4) S '92
— Hiker checking compass (New Hampshire)
Trav&Leisure 22:106 (c,4) My '92

COMPOSERS
— 1930s American popular composers
Am Heritage 44:82–4 (painting,c,1) O '93
— Sammy Cahn
Life 17:88 (3) Ja '94
— Henry Mancini
Life 18:105 (3) Ja '95
— Sites related to famous composers (Austria)
Trav&Leisure 25:133–6 (map,c,4) O '95
— See also
BERLIN, IRVING
BERNSTEIN, LEONARD
BLAKE, EUBIE
CAGE, JOHN
CHOPIN, FREDERICK
DVORAK, ANTONIN
GERSHWIN, GEORGE AND IRA
HAMMERSTEIN, OSCAR II
HART, LORENZ
HAYDN, FRANZ JOSEPH
JOPLIN, SCOTT
KERN, JEROME
LEHAR, FRANZ
LISZT, FRANZ
MacDOWELL, EDMUND
MAHLER, GUSTAV
PORTER, COLE
PUCCINI, GIACOMO
RODGERS, RICHARD
ROSSINI, GIOACCHINO
SIBELIUS, JEAN
VERDI, GIUSEPPE

COMPUTERS
— 1945 MIT "electromechanical brain"
Life 19:86 (1) N '96
— 1976 prototype of Apple computer
Life 19:87 (4) N '96
— Computer art

Smithsonian 25:cov.,56–64 (c,1) F '95
— Computer-generated composite of recent
 presidents
 Am Heritage 46:86 (4) Jl '95
— Future of information technology
 Nat Geog 188:2–37 (c,1) O '95
— History of computers
 Life 19:84–90 (c,1) N '96
— Sitting at terminal
 Smithsonian 25:91,96 (4) Je '94
 Sports Illus 84:82–3 (c,1) Ja 15 '96
— Trader sitting at multiple computers
 (California)
 Nat Geog 183:84 (c,3) Ja '93
— See also
 GATES, WILLIAM
COMPUTERS—HUMOR
— Future "Ubiquitous Computing"
 Smithsonian 25:83–93 (drawing,c,1) S '94
CONCENTRATION CAMPS
— 1940s drawing by child at Theresienstadt
 Trav&Leisure 23:30 (c,4) Ap '93
— 1945 dead bodies at Bergen-Belsen
 Life 19:114–15 (1) O '96
— Auschwitz, Poland
 Trav/Holiday 178:54–61 (1) F '95
— Barbed wire fence at Buchenwald,
 Germany
 Trav&Leisure 24:120 (2) F '94
— Buchenwald inmates
 Life 18:30–1 (1) Je 5 '95
 Life 19:74–5 (1) Ag '96
 Smithsonian 27:124–6 (2) O '96
— Gas chamber door (Poland)
 Smithsonian 24:63 (c,1) Ap '93
— Nazi camps
 Smithsonian 24:49,58–60 (painting,c,2) S
 '93
— Plaszow camp, Austria
 Life 17:30–4 (2) Ap '94
— Zyklon B gas canisters
 Smithsonian 24:58 (c,4) Ap '93
CONCERTS
— 1994 Woodstock II (New York)
 Life 17:12–13 (c,1) O '94
 Life 17:90–1,102 (c,1) N '94
 Life 18:48–9 (c,1) Ja '95
— Classical (Germany)
 Trav&Leisure 25:88 (c,4) Ap '95
— Country music band
 Am Heritage 45:cov.,38–9 (c,1) N '94
— Outdoor chamber music performance
 (Switzerland)
 Trav/Holiday 178:117 (painting,c,3) Mr
 '95

— Outdoor classical concert (Italy)
 Trav/Holiday 177:65 (c,4) Je '94
— Outdoor classical concert (Tanglewood,
 Massachusetts)
 Am Heritage 46:41 (c,4) N '95
— Outdoor Independence Day concert
 (Boston, Massachusetts)
 Nat Geog 186:26–7 (c,1) Jl '94
— Outdoor orchestra (Monaco)
 Nat Geog 189:80–1 (c,1) My '96
— Outdoor rave (California)
 Life 17:86 (c,2) N '94
— Outdoor symphony concert (Turkey)
 Nat Geog 185:22–3 (c,1) My '94
— Rock concert (Ireland)
 Nat Geog 186:5–7 (c,1) S '94
— Rock concerts
 Nat Geog 181:57 (c,1) Je '92
 Life 15:14–15,41,49,106–9 (c,1) D 1 '92
— See also
 AUDIENCES
 BANDS
 CONDUCTORS, MUSIC
 MUSICIANS
 SINGERS
CONCHES
 Trav/Holiday 179:48–9 (c,2) F '96
CONCRETE
— Research on strength and durability of
 concrete
 Smithsonian 24:22–31 (c,1) Ja '94
CONDORS
 Nat Wildlife 30:16 (c,4) Ap '92
 Nat Geog 184:20 (c,3) Jl '93
 Nat Wildlife 34:11 (1) D '95
— California condor
 Life 17:62 (1) S '94
 Nat Geog 190:28–9 (c,2) O '96
— Condor freeing itself from bull in Inca
 festival (Peru)
 Nat Geog 181:104–5 (c,1) Mr '92
CONDUCTORS, MUSIC
 Life 16:92–3 (c,4) Jl '93
 Smithsonian 25:98 (4) S '94
— Pakistan
 Trav&Leisure 24:122 (c,1) S '94
— See also
 BERNSTEIN, LEONARD
 TOSCANINI, ARTURO
**CONEY ISLAND, BROOKLYN, NEW
YORK**
 Trav/Holiday 178:60–8 (c,2) Jl '95
 Life 19:82–6 (1) Ag '96
— Early 20th cent. Luna Park
 Am Heritage 45:106 (4) Jl '94

Smithsonian 27:101–5 (2) D '96
— 1947
Trav&Leisure 26:32 (4) Jl '96
— History of Coney Island
Smithsonian 27:100–9 (c,1) D '96
Confederacy. See
CIVIL WAR
CONGO
— Nouabale-Ndoki National Park
Nat Geog 188:4–45 (map,c,1) Jl '95
— See also
PYGMIES
CONNECTICUT
Nat Geog 185:64–93 (map,c,1) F '94
— Coast
Smithsonian 22:87 (c,3) Mr '92
— Farmington
Trav&Leisure 25:E1–E2 (c,4) O '95
— Litchfield Hills antique shops
Trav&Leisure 24:114–17, 148 (map,c,2) S
'94
— Litchfield museum
Am Heritage 46:37 (c,2) N '95
— North Dumpling Island
Smithsonian 25:108 (c,2) N '94
— Stonington
Am Heritage 44:22 (c,4) O '93
— See also
CONNECTICUT RIVER
HARTFORD
MYSTIC
WATERBURY
**CONNECTICUT RIVER, NEW
ENGLAND**
Am Heritage 47:130–1 (c,2) Ap '96
— Vermont/New Hampshire border
Am Heritage 43:47 (c,4) Ap '92
CONSTELLATIONS
— Orion
Nat Geog 188:92–3 (c,1) D '95
Natur Hist 105:57 (drawing,4) Ja '96
— Southern Cross constellation
Nat Geog 185:28–9 (c,1) Ja '94
CONSTRUCTION
— Flooded town rebuilding on new site
(Valmeyer, Illinois)
Smithsonian 27:110–20 (c,1) Je '96
— Moving Idaho church (1925)
Natur Hist 102:46 (4) N '93
— Research on strength and durability of
concrete
Smithsonian 24:22–31 (c,1) Ja '94
— White House covered in tarp during
renovation (1989)
Life 15:2–3 (1) O '92

— See also
following entries—CONSTRUCTION:
AQUEDUCTS
BARNS
BOATS
BRIDGES
BUILDINGS
CANALS
CHURCHES
DAMS
HOUSES
PYRAMIDS
ROADS
STADIUMS
TUNNELS
CONSUMER PROTECTION
— Product testing by Consumers Union (New
York)
Smithsonian 24:34–43 (c,1) S '93
CONTAINERS
— 11th cent. bronze food vessel (China)
Smithsonian 24:27 (c,4) My '93
— Bringing cans to recycling center (New
York)
Life 16:22 (4) My '93
— See also
BOTTLES
CONTESTS
— Early 20th cent. tug-of-war (Philippines)
Nat Geog 190:58 (4) Jl '96
— Balloon bursting contest (Minnesota)
Nat Geog 182:102–3 (c,1) S '92
— Crawfish eating contest (Breaux Bridge,
Louisiana)
Nat Geog 184:101 (c,3) N 15 '93
— Ice climbing competition (France)
Nat Geog 190:95 (c,2) D '96
— Lifting pumpkin by the teeth (Ohio)
Smithsonian 27:66 (c,4) O '96
— Log-rolling championships 1995
(Wisconsin)
Sports Illus 83:4 (c,4) N 27 '95
— "Odyssey of the Mind" competition for
students
Smithsonian 26:86–93 (c,1) Jl '95
— Oreo-stacking contest winner
Sports Illus 85:22 (c,4) D 9 '96
— Oxen pull (Maine)
Smithsonian 24:86 (c,3) S '93
— Pillsbury Bake-Off (1949)
Life 19:31 (4) F '96
— Robotic gladiator competition (New
Hampshire)
Smithsonian 25:100–1 (c,3) N '94

— Tom Sawyer fence-painting contest
(Hannibal, Missouri)
Life 18:87 (c,2) Ap '95
— Tug-of-war (Scotland)
Nat Geog 190:4 (c,1) S '96
— Watermelon contest (Hope, Arkansas)
Am Heritage 47:64 (c,4) Ap '96
— See also
BEAUTY CONTESTS
RACES
SPORTS
CONVICTS
— 1882 (Vermont)
Am Heritage 47:101 (1) My '96
— Chain gangs (Alabama)
Life 18:64–71 (1) O '95
— Convict having head shaved (Oregon)
Life 17:18 (c,2) N '94
— Convict meditating
Nat Geog 187:32 (c,3) Je '95
— Convicts in cages (U.S.S.R.)
Life 18:60 (c,4) Jl '95
— Convicts working at sewing machines
(China)
Nat Geog 185:28 (c,4) Mr '94
— Famous Alcatraz inmates, California
Smithsonian 26:84–95 (c,1) S '95
— Folded paper art works by illegal Chinese
immigrants in prison (Pennsylvania)
Life 19:68–72 (c,1) Jl '96
— Louisiana
Life 16:68–77 (1) Mr '93
— Prison inmates eating (U.S.S.R.)
Nat Geog 182:122–3 (c,1) O '92
— Spy Aldrich Ames in prison (Pennsyl-
vania)
Life 18:26 (c,2) F '95
— Tattoos on Russian convicts
Natur Hist 102:50–9 (1) N '93
— See also
PRISON LIFE
COOK, JAMES
— Birthplace cottage (relocated in Mel-
bourne, Australia)
Gourmet 52:102 (c,4) Ap '92
— Cook's ship "Endeavor"
Natur Hist 102:68 (engraving,4) My '93
— Replica of his 1770s ship "Endeavor"
Nat Geog 190:36–45 (c,2) N '96
— Treasures from his travels
Nat Geog 190:29–53 (c,1) N '96
COOK ISLANDS
Trav/Holiday 178:cov. (c,1) O '95
COOKING
Gourmet 53:92 (painting,c,4) O '93

— 18th cent. fireplace cooking
Gourmet 52:194 (drawing,4) O '92
— Ancient bread made from maize (Mexico)
Natur Hist 103:76 (engraving,4) My '94
— Baking supplies in cozy kitchen
Gourmet 53:24,46 (painting,c,2) Ja '93
— Barbecue (British Columbia)
Gourmet 53:cov.,110 (c,1) O '93
— Barbecue picnics
Natur Hist 105:68–9 (2) Ag '96
— Barbecue professionals (Kansas City,
Missouri)
Trav/Holiday 179:44–9 (c,1) Je '96
— Barbecue stand (Texas)
Smithsonian 23:109 (c,1) F '93
— Butchering bison (Wyoming)
Nat Geog 186:87 (c,3) N '94
— Chinese restaurant kitchen (California)
Gourmet 56:76 (c,4) D '96
— Cooking breadfruit (Tahiti)
Nat Geog 190:49 (c,4) N '96
— Cooking corn in adobe oven (New Mexico)
Nat Geog 184:44 (c,4) S '93
— Cooking tea over open fire (Nepal)
Nat Geog 184:9,22–3 (c,1) D '93
— Cooking trout in Yellowstone hot spring,
Wyoming (1919)
Nat Geog 189:134 (3) Ap '96
— Country inn (Vermont)
Trav/Holiday 179:37 (c,3) O '96
— Grating cassava roots (Montserrat)
Natur Hist 101:68 (c,4) O '92
— Grilling salmon (Washington)
Gourmet 56:47 (c,2) Ag '96
— Grinding corn for tortillas (Arizona)
Natur Hist 103:72 (c,3) F '94
— Jambalaya for a crowd (New Orleans,
Louisiana)
Trav&Leisure 22:71 (c,4) Ap '92
— Making biscuits in North Carolina (1939)
Life 15:86 (3) My '92
— Making brownies (1950s)
Am Heritage 46:78 (4) N '95
— Making fresh pasta (Italy)
Gourmet 55:55 (c,4) Ag '95
Gourmet 56:91 (c,1) S '96
Gourmet 56:141 (c,1) N '96
Gourmet 56:70 (c,4) D '96
— Making pizza (Italy)
Gourmet 56:142,144 (c,2) N '96
— On beach (Grenada)
Trav&Leisure 24:E10 (c,4) Ja '94
— Over campfire (Montana)
Gourmet 54:10 (c,4) My '94
— Over campfire (Ontario)

Trav/Holiday 178:44 (c,4) My '95
— Over campfire (Wyoming)
Trav&Leisure 22:112 (4) My '92
— Paella at outdoor cafe (Mexico)
Trav/Holiday 178:79 (c,4) S '95
— Pounding millet (Niger)
Natur Hist 101:58 (c,1) N '92
— Preparing sushi (Japan)
Natur Hist 101:74 (c,4) F '92
— Restaurant (California)
Gourmet 52:43 (c,4) My '92
Gourmet 55:62 (c,3) Ap '95
— Restaurant (India)
Trav&Leisure 25:50–4 (c,4) Ap '95
— Restaurant (Japan)
Trav&Leisure 26:145 (c,1) Mr '96
— Restaurant (London, England)
Trav&Leisure 25:40 (c,4) O '95
— Restaurant (New York)
Trav&Leisure 22:NY5 (c,3) Je '92
— Restaurant (Oregon)
Trav&Leisure 24:32 (c,4) D '94
— Roasting caribou heads (Saskatchewan)
Nat Geog 189:129 (c,2) My '96
— Roasting wild boar (Brazil)
Natur Hist 101:40 (c,4) Mr '92
— Rolling dough for Japanese soba noodles
(New York)
Gourmet 52:155 (c,4) F '92
— Skinning snakes at market (Burma)
Nat Geog 188:86 (c,4) Jl '95
— Steaming lobster (Maine)
Trav&Leisure 25:104 (c,4) My '95
— Thailand
Trav/Holiday 179:72–6 (c,1) S '96
— Whale skin hanging to dry (Northwest
Territories)
Nat Geog 185:19 (c,3) Je '94
— See also
BAKING
CHEFS
DINNERS AND DINING
KITCHENS
RESTAURANTS

COOKING—EDUCATION
— Le Cordon Bleu, Paris, France
Gourmet 55:50 (c,2) Ja '95
— Culinary Institute of America, Hyde Park,
New York
Gourmet 56:196–201,258 (c,1) O '96
— France
Gourmet 52:92 (c,4) O '92
Trav&Leisure 26:94 (c,4) N '96
— Italy
Trav&Leisure 26:96 (c,4) N '96

— Napa, California
Trav&Leisure 26:98 (c,4) N '96
— Pastry class (New York)
Gourmet 54:69 (c,4) S '94
— Sommelier school (France)
Nat Geog 181:20 (c,3) F '92
COOKING UTENSILS
— Copper pans (Switzerland)
Gourmet 53:52 (c,2) Jl '93
— Rolling pin
Gourmet 53:136 (c,4) Ap '93
COOLIDGE, CALVIN
Life 15:41 (4) O 30 '92
Smithsonian 25:101 (3) O '94
— Grace Coolidge
Smithsonian 23:144 (4) O '92
Trav/Holiday 175:77 (painting,c,4) N '92
COOPER, GARY
Life 19:48–9 (1) Winter '96
COOPER, PETER
Am Heritage 47:20 (painting,c,4) O '96
COOPERSTOWN, NEW YORK
Trav/Holiday 176:76–85 (c,1) Ap '93
Life 16:80 (c,2) Ag '93
— Farmers' Museum
Am Heritage 45:31 (c,4) My '94
— Glimmerglass Opera
Trav&Leisure 24:67–8 (c,4) Je '94
COOTS (BIRDS)
— Chicks
Nat Wildlife 33:4 (c,4) Ap '95
COPENHAGEN, DENMARK
Trav&Leisure 25:92–9,154–7 (c,1) Mr '95
— Tivoli Gardens
Gourmet 52:56 (c,2) Ag '92
Trav/Holiday 176:18 (c,4) Mr '93
COPPERHEAD SNAKES
Natur Hist 104:cov. (c,1) Ap '95
Nat Wildlife 33:18 (c,1) Ag '95
CORAL REEFS
— Florida Keys, Florida
Life 16:37 (c,4) O '93
— Red Sea
Nat Geog 184:68–9,74–5 (c,1) N '93
— See also
GREAT BARRIER REEF
CORALS
Natur Hist 101:cov. (c,1) F '92
Nat Geog 181:82 (c,1) Je '92
Trav&Leisure 23:48 (c,4) Ja '93
Natur Hist 102:63 (c,2) Mr '93
Nat Geog 184:68–71,82–4 (c,1) N '93
Natur Hist 103:cov. (c,1) F '94
— Corals spawning
Nat Geog 182:130 (c,4) D '92

— Gorgonian coral
Life 15:40 (c,4) Mr '92
— See also
SEA FANS
CORBETT, "GENTLEMAN JIM"
Sports Illus 82:78 (4) F 6 '95
CORDOBA, SPAIN
— Mezquita
Nat Geog 181:28-9 (c,1) Ja '92
CORMORANTS
Nat Geog 181:65 (c,4) Ja '92
— Cormorant deformed from dioxin
poisoning
Nat Wildlife 32:9 (c,3) Ag '94
CORN
Nat Geog 183.92-117 (c,1) Je '93
— Corn varieties
Smithsonian 26:107 (c,1) N '95
— Indian corn
Trav&Leisure 26:222 (c,4) S '96
CORN INDUSTRY
Nat Geog 183:92-117 (c,1) Je '93
CORN INDUSTRY—HARVESTING
— Iowa
Nat Geog 183:104-5 (c,1) Je '93
— New York
Nat Geog 182:118-19 (c,1) N '92
CORNFIELDS
— Illinois
Gourmet 53:134 (c,1) Ap '93
— Iowa
Nat Geog 183:104-5 (c,1) Je '93
Sports Illus 81:112-13 (c,1) Ag 29 '94
CORREGGIO
— "Assumption of the Virgin"
Trav&Leisure 22:120 (painting,c,4) Ja '92
CORSICA
Trav&Leisure 25:75-81,97-8 (map,c,1) Jl
'95
— Bonifacio
Trav&Leisure 23:116-17,126 (c,1) F '93
CORTES, HERNAN
— 1519 conquest of Aztecs (Mexico)
Smithsonian 23:56-69 (painting,c,1) O '92
COSMETICS
— Ballerina applying make-up
Life 16:16-17 (c,1) F '93
— Oddly made up models at beauty show
(New York)
Life 19:24-8 (c,3) Je '96
— Preteen applying lipstick
Life 17:64 (c,2) Ap '94
— Reporter applying lipstick in camera lens
(New York)
Nat Geog 188:36-7 (c,1) O '95

— Woman applying make-up (France)
Trav&Leisure 26:82 (painting,c,2) N '96
— Woman applying make-up in front of
mirror
Life 17:37 (c,3) My '94
COSTA RICA
Trav&Leisure 24:158-61 (map,c,3) F '94
Trav/Holiday 177:84-93 (map,c,1) O '94
Sports Illus 82:130-43 (c,1) F 20 '95
Trav&Leisure 25:159-69,193-8 (map,c,1)
N '95
Trav/Holiday 179:74-81 (map,c,1) O '96
— Arenal Volcano
Trav/Holiday 179:80-1 (c,2) O '96
— Beach
Trav/Holiday 176:42 (c,4) F '93
Trav/Holiday 177:88-95 (c,2) O '94
— Cocos Island
Sports Illus 79:84 (c,4) D 13 '93
— Rain forest
Smithsonian 24:110-11 (c,1) S '93
Trav&Leisure 24:158-9 (c,4) F '94
Trav/Holiday 177:86-7 (c,2) O '94
— Rain forest wildlife
Life 17:58-68 (c,1) Je '94
Trav/Holiday 179:74-81 (c,1) O '96
— See also
SAN JOSE
COSTA RICA—SOCIAL LIFE AND
CUSTOMS
— Harvesting sea turtle eggs
Natur Hist 104:40-2 (c,1) Ag '95
Costume. See
CHILDREN—COSTUME
CLOTHING
COMMENCEMENT—COSTUME
MASKS, CEREMONIAL
MASQUERADE COSTUME
MILITARY COSTUME
THEATER—COSTUME
U.S.—COSTUME
individual countries—COSTUME
individual religions—COSTUME
COTE D'IVOIRE—COSTUME
— Wealthy woman
Nat Geog 190:47 (c,1) O '96
COTTAGES
— Nantucket, Massachusetts
Trav/Holiday 179:34-5 (c,1) Jl '96
— Shepherd's stone cottage
Nat Geog 188:84-5 (c,1) N '95
— Stratford-upon-Avon cottage, England
Trav/Holiday 175:102 (c,3) Mr '92
— Tudor cottage (Lincoln, England)
Gourmet 52:108 (c,3) D '92

COTTON
— Nat Geog 185:60–87 (c,1) Je '94
— Cotton plants
 Nat Geog 185:61–3 (c,1) Je '94
COTTON FIELDS
— Argentina
 Trav&Leisure 25:85 (c,1) Ja '95
— Mississippi
 Trav&Leisure 25:127 (4) S '95
COTTON INDUSTRY
 Nat Geog 185:60–87 (c,1) Je '94
— Laser leveling of field (Arizona)
 Nat Geog 184:32 (c,3) N 15 '93
COTTON INDUSTRY—HARVESTING
— Mississippi
 Am Heritage 43:94–5 (c,2) Ap '92
 Nat Geog 185:67 (c,1) Je '94
Cougars. See
 MOUNTAIN LIONS
Counseling. See
 THERAPY
Country life. See
 RURAL LIFE
COURTHOUSES
— Appomattox courthouse, Virginia
 Trav&Leisure 24:E14 (c,4) Mr '94
— Indiana
 Trav/Holiday 175:75–83 (painting,c,1) Ap
 '92
— Sycamore, Illinois
 Trav/Holiday 175:79 (painting,c,2) Ap '92
COVERED WAGONS
— Mid 19th cent.
 Life 16:14–15 (1) Ap 5 '93
 Am Heritage 44:68,82 (c,3) Ap '93
 Smithsonian 24:89 (engraving,c,4) S '93
 Smithsonian 25:42 (4) My '94
 Smithsonian 27:40,48 (painting,c,2) Ap
 '96
— Pioneer wagon train
 Smithsonian 25:44 (painting,c,4) My '94
COWARD, NOEL
— Home "Firefly" (Jamaica)
 Trav&Leisure 23:30 (c,4) D '93
 Trav&Leisure 24:102 (c,1) F '94
— Tombstone (Jamaica)
 Gourmet 56:97 (c,4) F '96
COWBIRDS
 Nat Wildlife 30:9 (c,2) Ag '92
 Nat Geog 183:78–9 (c,1) Je '93
 Nat Wildlife 32:40–5 (c,1) D '93
 Natur Hist 105:42,45 (c,2) Jl '96
COWBOYS
 Life 16:7,38–47 (c,1) Ap 5 '93
— 1877 painting of vaquero roping cow

Am Heritage 44:61 (c,4) Ap '93
— 1920s black cowboy Bill Pickett
 Am Heritage 46:2 (c,4) F '95 supp.
— 1949
 Life 19:122 (4) O '96
— 1954 children in cowboy outfits
 Am Heritage 45:30–1,36–9 (c,1) D '94
— Argentina
 Trav&Leisure 25:81 (c,1) Ja '95
— At campfire (Arizona)
 Am Heritage 47:31 (c,4) F '96
— Australia
 Nat Geog 181:64–5,76–81 (c,1) Ap '92
— Boys playing cowboy (Colorado)
 Life 15:46 (c,3) Jl '92
 Trav/Holiday 176:72–3 (c,2) Jl '93
— Camargue, France
 Trav/Holiday 179:76–7 (c,1) Mr '96
—Cowboy and horse silhouetted in sunset
 Sports Illus 79:2–3 (c,1) O 4 '93
— Cowboy paraphernalia in gallery display
 Trav&Leisure 23:30 (c,2) Mr '93
— Louisiana
 Natur Hist 104:38–9 (c,2) My '95
— Mexico
 Nat Geog 182:60–1 (c,2) O '92
 Life 16:46 (c,2) Ap 5 '93
 Trav&Leisure 24:114 (4) Ja '94
 Nat Geog 186:60–3 (c,1) S '94
 Nat Geog 190:76–9 (c,2) Ag '96
— Montana
 Trav/Holiday 176:cov. (c,1) Je '93
— Movies depicting frontier life
 Life 16:60–8 (c,1) Ap 5 '93
— New Mexico
 Smithsonian 22:36–7 (c,4) F '92
— Paraguay
 Nat Geog 182:102–3 (c,1) Ag '92
— Swinging a lasso (Wyoming)
 Trav/Holiday 177:40–1 (1) S '94
— Venezuela
 Nat Geog 185:40–1,54–5 (c,1) Mr '94
— See also
 AUTRY, GENE
 MIX, TOM
 RANCHING
 RODEOS
 ROGERS, ROY
 WESTERN FRONTIER LIFE
Cows. See
 CATTLE
COYOTES
 Natur Hist 101:50 (c,2) My '92
 Nat Wildlife 32:11 (c,1) Je '94
 Smithsonian 25:55 (c,4) Ag '94

Nat Wildlife 34:cov.,19–21,26–7 (c,1) D '95

Nat Wildlife 34:2,15–23 (c,1) O '96

Trav/Holiday 179:69 (c,1) N '96

Coypus. See
NUTRIAS

CRAB INDUSTRY
— Baskets of blue crabs (Maryland)
Gourmet 52:98 (c,4) S '92
— Virginia
Nat Wildlife 33:27 (c,4) O '95

CRABS
Natur Hist 101:28–9 (c,1) D '92
Smithsonian 24:113 (c,4) O '93
Smithsonian 24:42 (c,4) F '94
Natur Hist 10␣:34 (c,4) Jl '94
Trav/Holiday 179:82,86 (c,2) F '96
Natur Hist 105:72–3 (c,1) Mr '96
— Boxer crabs
Natur Hist 101:56–7 (c,1) Ap '92
— Land crabs
Natur Hist 105:62–3 (c,4) D '96
— Outdoor crab sculpture (Vancouver,
British Columbia)
Gourmet 53:57 (c,1) Jl '93
— Porcelain crabs
Natur Hist 101:cov.,56 (c,1) Ap '92
Natur Hist 104:26–30 (c,1) Jl '95
— Spider crabs
Nat Geog 182:109 (c,3) Jl '92
Nat Geog 190:91 (c,4) O '96
— See also
BLUE CRABS
FIDDLER CRABS
HERMIT CRABS

CRANBERRY INDUSTRY
— Aerial view of cranberry bog (Massa-
chusetts)
Life 16:76–7 (c,1) N '93

CRANE, STEPHEN
Am Heritage 43:86 (4) O '92
Smithsonian 25:109–18 (2) Ja '95

CRANES
— Black-necked cranes
Trav/Holiday 177:79,82–3 (c,4) O '94
— Common cranes
Natur Hist 105:44,64 (c,4) O '96
— Crowned cranes
Trav/Holiday 175:67 (c,4) N '92
— Eurasian cranes
Nat Geog 186:24–5 (c,2) D '94
— Sandhill cranes
Nat Wildlife 30:52 (c,1) Ag '92
Nat Wildlife 31:54–5 (c,1) F '93
Nat Geog 183:96–7 (c,1) Mr '93

Smithsonian 25:40 (c,4) S '94
Nat Wildlife 33:54–5 (c,1) D '94
— Siberian cranes
Nat Geog 185:124–36 (c,1) My '94
— Silhouette of sandhill cranes flying at
sunset
Nat Wildlife 32:4–5 (c,1) D '93
— See also
WHOOPING CRANES

CRASHES
— 1906 auto race crash
Am Heritage 43:70 (4) My '92
— 1919 auto collision
Life 19:38 (2) Winter '96
— 1931 plane crash wreckage (Kansas)
Smithsonian 24:175 (4) N '93
— 1969 plane crash wreckage (Iowa)
Sports Illus 79:54–5 (2) Ag 23 '93
— 1972 Andes plane wreck survivors
Life 16:48–57 (c,1) F '93
— Apartment building damaged in plane
crash (Amsterdam, Netherlands)
Life 16:50–1 (c,1) Ja '93
— Automobile race crashes
Am Heritage 43:70–1 (c,4) My '92
Sports Illus 76:18–23 (c,1) My 18 '92
Sports Illus 76:9 (c,4) My 25 '92
Sports Illus 76:2–3,16–19 (c,1) Je 1 '92
Sports Illus 79:38–9 (c,2) Ag 2 '93
Sports Illus 80:79 (c,2) Mr 21 '94
Sports Illus 80:60–2 (c,1) My 9 '94
Sports Illus 80:2–3 (c,1) Je 6 '94
Sports Illus 82:26–9 (c,1) Je 5 '95
— Helicopter crash wreckage (Alabama)
Sports Illus 79:51 (c,3) Jl 26 '93
— Remains of small plane after crash
Sports Illus 84:47 (c,4) Ap 29 '96
Sports Illus 85:94 (c,3) D 30 '96
— Russian MiG-29 plane crash
Life 17:22 (c,2) F '94
— School bus destroyed by drunk driver
(Kentucky)
Sports Illus 83:12 (c,4) O 2 '95
— Shoes of 1983 Korean airline disaster
victims
Life 16:22 (c,2) S '93
— Train wrecked by sabotage (Arizona)
Life 18:10–11 (c,1) D '95
— Wrecked car (California)
Sports Illus 79:26–7 (c,2) D 20 '93
— Wrecked truck
Sports Illus 76:36 (c,3) Jl 6 '92
— See also
ACCIDENTS
DISASTERS

SHIPWRECKS
CRATER LAKE, OREGON
Trav&Leisure 25:26 (c,4) Ap '95
Am Heritage 47:50 (c,4) Jl '96
CRATER LAKE NATIONAL PARK, OREGON
Nat Geog 186:16–17 (c,1) O '94
Am Heritage 47:50 (c,4) Jl '96
CRAWFISH
— Mardi Gras crawfish float (New Orleans, Louisiana)
Nat Geog 182:8–9 (c,1) Jl '92
CRAWFORD, JOAN
Life 16:30 (4) N '93
CRAZY HORSE
Natur Hist 101:39 (painting,c,3) Je '92
Gourmet 55:51 (sculpture,c,4) Ag '95
— Construction of Crazy Horse Memorial, South Dakota
Life 16:14 (c,2) D '93
— Shirt belonging to him
Life 17:129 (c,4) N '94
CREDIT CARDS
Nat Geog 183:103 (c,4) Ja '93
CREE INDIANS (QUEBEC)
Nat Geog 184:66–7,72–5 (c,1) N 15 '93
CRETE
Gourmet 52:72–7,112 (map,c,1) F '92
Crew. See
ROWING
CRICKET PLAYING
Natur Hist 104:58–65 (c,1) My '95
— Child playing cricket (South Africa)
Sports Illus 84:122–3 (c,1) Ja 29 '96
— Children playing cricket (Barbados)
Natur Hist 104:58 (c,3) My '95
— Great Britain
Trav&Leisure 24:62–3 (c,1) Ag '94
— Great Britain (1950)
Natur Hist 104:60–1 (3) My '95
— South Africa
Trav&Leisure 26:60 (c,1) Ag '96
— West Indies
Trav/Holiday 177:64 (c,2) Mr '94
Sports Illus 80:60 (c,2) My 2 '94
CRICKETS
Natur Hist 103:49 (c,2) Je '94
Nat Geog 188:43 (c,1) Ag '95
CRIME AND CRIMINALS
— 1812 assassination of Prime Minister Spencer Perceval (Great Britain)
Smithsonian 24:151 (etching,4) Ap '93
— 1865 poster offering reward for Lincoln's assassins
Am Heritage 43:102 (4) Jl '92

— Late 19th cent. train robber Chris Evans
Smithsonian 26:84–94 (painting,c,1) My '95
— Early 20th cent. robberies by the Newton Boys
Smithsonian 24:74–83 (painting,c,1) Ja '94
— 1910 shooting of Mayor Gaynor (New York City, New York)
Am Heritage 45:68 (1) O '94
— 1924 Rondout, Illinois, train robbery by the Newton Boys
Smithsonian 24:74–5 (painting,c,1) Ja '94
— 1930s organized crime sites (Chicago, Illinois)
Am Heritage 46:65–88 (c,4) Ap '95
— 1968 assassination of Robert Kennedy
Sports Illus 82:88 (4) Mr 20 '95
— 1970 black militant with hostage judge (California)
Life 18:30 (4) Ag '95
— 1993 stabbing of tennis pro Monica Seles
Sports Illus 82:46,51 (c,4) Ap 10 '95
— 1994 attack on skater Nancy Kerrigan
Sports Illus 80:cov.,16–17 (c,1) Ja 17 '94
Sports Illus 80:16–20 (c,1) Ja 24 '94
Sports Illus 80:62–4 (c,1) Ja 31 '94
Sports Illus 80:28–41 (painting,c,1) F 14 '94
Sports Illus 80:32–3 (c,1) Mr 28 '94
— Accused murderer kept in cage (California)
Life 15:24 (c,4) D '92
— Beating accused murderer (Brazil)
Life 19:22 (c,2) My '96
— Blood-covered songsheet from 1995 Rabin assassination (Israel)
Life 19:38 (c,2) Ja '96
— Burning confiscated elephant tusks (Kenya)
Natur Hist 104:8 (c,4) N '95
— Chicago police destroying slot machines (1930)
Am Heritage 45:46 (4) S '94
— Dead members of Dalton gang (1892)
Am Heritage 43:38 (4) O '92
— Charles "Pretty Boy" Floyd on deathbed (1934)
Life 17:44 (4) O '94
— Gerald Ford's would-be assassin Squeakie Fromme
Smithsonian 24:123 (4) Mr '94
— Forensic research (Washington, D.C.)
Smithsonian 27:82–90 (c,1) My '96
— Fourteen-year-old killer
Life 18:44 (c,3) Ja '95

— Leo Frank and the 1913 murder of Mary
Phagan (Atlanta, Georgia)
Am Heritage 47:98–113 (1) O '96
— John Gotti
Life 16:102 (c,1) Ja '93
— History of violence in America
Am Heritage 47:cov.,36–51 (c,1) S '96
— Hitler's would-be assassin Karl Goerdeler
Smithsonian 24:113 (4) Mr '94
— George "Machine Gun" Kelly
Smithsonian 26:95 (3) S '95
— Lab researching deaths of endangered
animals (Oregon)
Smithsonian 22:40–9 (c,1) Mr '92
— Lincoln assassination conspirators
Am Heritage 43:cov.,104–19 (1) S '92
— Looting store (Florida)
Nat Geog 183:12 (c,3) Ap '93
— Lee Harvey Oswald
Am Heritage 45:100 (4) F '94
Am Heritage 46:56 (4) N '95
— Reenactment of 1963 Kennedy
assassination
Am Heritage 46:cov.,57 (1) N '95
— Mary Rogers (Early 20th cent. Vermont)
Am Heritage 47:104 (4) My '96
— Arnold Rothstein
Am Heritage 44:49 (4) F '93
— Scientists solving crimes with physical
evidence
Nat Wildlife 30:8–15 (c,1) F '92
— O.J. Simpson
Am Heritage 46:cov. (1) Jl '95
— O.J. Simpson family
Life 18:cov.,36–44 (c,1) Je '95
— O.J. Simpson murder case and trial
Sports Illus 80:16–31 (c,1) Je 27 '94
Life 17:56–63 (c,1) D '94
Life 18:cov.,21,40–1 (c,1) Ja '95
— O.J. Simpson trial court reporter's tape
(1995)
Life 18:86 (c,2) F '95
— Southern churches destroyed in arson fires
Life 19:10–11 (c,1) Jl '96
— Robert Stroud, "Birdman of Alcatraz"
Smithsonian 26:84 (c,2) S '95
— See also
BOOTH, JOHN WILKES
CAPITAL PUNISHMENT
CAPONE, AL
DILLINGER, JOHN
DRUG ABUSE
JAMES, JESSE
JUSTICE, ADMINISTRATION OF
LYNCHINGS

PIRATES
POLICE WORK
PRISONS
PROSTITUTION
SPIES
STARR, BELLE
TERRORISM
Croatia. See
YUGOSLAVIA
CROCKETT, DAVY
Trav/Holiday 175:59 (painting,4) Jl '92
CROCODILES
Nat Geog 181:4–5 (c,1) My '92
Nat Geog 185:14–15 (c,1) Ap '94
Sports Illus 81:99–101 (c,4) D 26 '94
Nat Geog 189:34–47 (c,1) Je '96
— 19th cent. crocodile mask (Torres Strait
Islands)
Smithsonian 25:94–5 (c,2) D '94
— Crocodile farming (Australia)
Nat Geog 189:44–5 (c,2) Je '96
— Crocodiles attacking wildebeests
Nat Geog 183:94–109 (c,1) Ap '93
— Mouth
Nat Wildlife 32:cov. (c,1) Je '94
CRONKITE, WALTER
Am Heritage 45:42–50 (c,4) D '94
CROQUET PLAYING
Smithsonian 23:cov.,102–11 (c,1) O '92
Trav&Leisure 24:50–2 (c,3) S '94
Sports Illus 83:11 (c,4) S 4 '95
— California
Gourmet 54:90 (c,4) Mr '94
— Connecticut
Nat Geog 185:68–9 (c,1) F '94
— Washington
Nat Geog 187:118–19 (c,2) Je '95
CROSS COUNTRY
Sports Illus 79:53 (c,3) D 6 '93
Sports Illus 81:73 (c,2) O 31 '94
— World Championships 1992 (Boston,
Massachusetts)
Sports Illus 76:52–3 (c,2) Mr 30 '92
CROSSBILLS (BIRDS)
Natur Hist 101:38,42 (c,1) D '92
CROW INDIANS—COSTUME
— 19th cent. Crow homosexuals
Am Heritage 43:108 (1) N '92
— Chief Iron Bull
Am Heritage 43:105 (1) N '92
— Crow Indian shield
Life 17:129 (c,4) N '94
CROWDS
— 1940s line for cigarettes
Life 18:22–3 (1) Je 5 '95

— 1945 line for housing permits
 Life 18:76–7 (1) Je 5 '95
— 1994 Woodstock II attendees in the rain
 (New York)
 Life 17:12–13 (c,1) O '94
— Albanian bus
 Nat Geog 182:66–7 (c,1) Jl '92
— Albanian refugees on ship
 Nat Geog 182:71 (c,4) Jl '92
— Bourbon Street, New Orleans, Louisiana
 Nat Geog 187:102–3 (c,1) Ja '95
— Cairo bazaar, Egypt
 Trav/Holiday 175:53 (c,3) S '92
— Ho Chi Minh City street scene, Vietnam
 Nat Geog 187:62–3 (c,1) Ap '95
— St. Petersburg street scene, Russia
 Trav&Leisure 23:105 (c,1) N '93
— Shanghai, China
 Trav/Holiday 176:71–2 (c,1) O '93
 Nat Geog 185:2–4 (c,1) Mr '94
— Taiwan commuter traffic
 Nat Geog 184:6–7 (c,1) N '93
— Tehran, Iran (1980)
 Life 16:60–1 (1) Mr '93
— Wooden boat (Bangladesh)
 Nat Geog 183:134 (c,4) Je '93

CROWNS
— 7th cent. Visigoth crown (France)
 Trav&Leisure 25:70 (c,4) N '95
— Imperial State Crown (Great Britain)
 Nat Geog 184:51 (c,4) O '93
— King Christian IV's crown (Denmark)
 Gourmet 52:54 (c,4) Ag '92
— Royal crown of Bohemia (Czechoslo-
 vakia)
 Nat Geog 184:20 (c,3) S '93
— Yoruba beaded crown (Africa)
 Smithsonian 25:31 (c,4) S '94

CROWS
 Smithsonian 23:101–11 (c,3) Ag '92

CRUCIFIXES
— 15th cent. Spanish crucifix
 Nat Geog 181:52 (c,4) Ja '92
— Celtic cross
 Am Heritage 45:44 (c,4) My '94

CRUISE SHIPS
 Trav&Leisure 22:108–13,154 (c,1) D '92
 Am Heritage 44:93–7 (c,2) N '93
 Trav/Holiday 177:60–1 (c,1) Je '94
 Trav/Holiday 178:68–71 (c,1) N '95
 Trav/Holiday 179:52–3 (c,2) S '96
— Children aboard ship
 Trav&Leisure 24:110–12 (c,4) Ap '94
— Scenes aboard cruise ship

Trav/Holiday 175:66–71 (painting,c,1) S
'92
Trav&Leisure 25:152–7 (painting,c,1) N
'95
Trav&Leisure 26:196–201 (c,1) S '96
— Small ship
 Am Heritage 45:24 (c,4) F '94

CRUSTACEANS
— Amphipods
 Natur Hist 101:52 (c,4) N '92
— Isopods
 Life 15:66–70 (c,1) N '92
 Natur Hist 101:50 (c,4) N '92
— See also
 BARNACLES
 CRABS
 CRAWFISH
 LOBSTERS
 SHRIMPS

CRYING
— Haitian child crying
 Life 17:32–3 (1) Ja '94

CRYSTALS
 Smithsonian 24:24 (c,4) Mr '94
— Designs made by crystals seen through
 microscope
 Smithsonian 24:112–15 (c,3) My '93
— Estrogen crystal
 Nat Wildlife 33:40 (c,4) Ap '95
— Frost crystals on window
 Nat Wildlife 31:57 (c,4) O '93
— Gypsum cave crystals (New Mexico)
 Nat Wildlife 34:43 (c,1) Ag '96
— Quartz crystals
 Nat Wildlife 31:46–51 (c,1) Je '93
 Smithsonian 24:24 (c,4) Mr '94

CTENOPHORES
 Nat Geog 182:110–11 (c,1) Jl '92

CUBA
— Zulueta
 Smithsonian 26:130–9 (c,1) O '95
— See also
 HAVANA

CUBA—COSTUME
 Life 17:70–4 (c,1) My '94
— Cuban refugee child (Florida)
 Life 17:22 (c,2) O '94
— Cuban refugees at sea on flimsy raft
 Life 17:20–1 (c,1) N '94
— Zulueta
 Smithsonian 26:130–9 (c,1) O '95

CUBA—HISTORY
— Cartoon about 1962 Cuban Missile Crisis
 Am Heritage 45:103 (c,4) S '94
— See also

CASTRO, FIDEL

CUBA—RITES AND FESTIVALS
— New Year's festival
Smithsonian 26:130–9 (c,1) O '95
**CUBA—SOCIAL LIFE AND CUS-
TOMS**
— Sports activities
Sports Illus 82:60–78 (c,1) My 15 '95
CUCKOOS
Nat Geog 183:81 (painting,c,4) Je '93
Nat Wildlife 32:25 (painting,c,4) D '93
Nat Wildlife 33:44–5 (c,1) Ag '95
**CUMBERLAND RIVER, KEN-
TUCKY/TENNESSEE**
Nat Geog 184:122–36 (map,c,1) Ag '93
CURACAO
Trav/Holiday 175:108 (c,4) Ap '92
— Willenstad
Am Heritage 47:24–8 (c,4) N '96
CURLEWS
Natur Hist 101:22 (c,3) O '92
Nat Wildlife 34:57–60 (painting,c,4) Je
'96
CURRENCY
— 1917 U.S. dollar bill
Am Heritage 46:114 (c,3) N '95
— 1940s U.S. ration stamps
Life 18:22 (c,4) Je 5 '95
— International currency
Nat Geog 183:80–107 (c,1) Ja '93
— Italian 10,000 lire note
Trav&Leisure 26:42 (c,4) Ag '96
— Loot from 1971 skyjacking
Life 19:34 (4) N '96
— Mollusk dentalium used as currency by
ancient Indians (Northwest)
Nat Geog 183:108–17 (c,1) Ja '93
— Serbian children making kites out of
Yugoslav dinar bills (Belanovca)
Life 16:19 (c,2) N '93
— Shredded bills recycled as stationery
Nat Geog 185:72 (c,4) Je '94
— Stack of one million $1 bills
Life 19:19–22 (c,1) Ap '96
— Swedish fifty kronar note
Natur Hist 102:14 (4) Ap '93
— See also
COINS
CURRY, JOHN STEUART
— Mural painting of John Brown
Am Heritage 46:14 (c,4) S '95
— "Parade to War" (1939)
Am Heritage 43:84–5 (painting,c,1) Jl '92
CUSTER, GEORGE ARMSTRONG
Am Heritage 43:76,78,106 (4) Ap '92

Natur Hist 101:43 (1) Je '92
Trav/Holiday 176:69 (4) Je '93
Am Heritage 44:108 (3) D '93
— Battle of Little Big Horn (1876)
Natur Hist 101:36–41 (painting,c,1) Je '92
— Marker at site where he fell (Montana)
Trav/Holiday 179:95 (c,4) S '96
— Site of Battle of Little Big Horn
Am Heritage 43:76–86 (map,c,1) Ap '92
Am Heritage 43:104 (4) N '92
— Wife Libbie
Am Heritage 44:108 (3) D '93
CUTTLEFISH
Life 18:52 (c,4) Ag '95
Smithsonian 27:133 (c,2) My '96
— Giant cuttlefish
Nat Geog 188:94–107 (c,1) S '95
CUZCO, PERU
Nat Geog 189:26,34–5 (c,2) My '96
— Church of the Compania
Trav&Leisure 25:163 (c,4) Mr '95
CYCLONES—DAMAGE
— 1991 cyclone (Bangladesh)
Nat Geog 183:129 (c,3) Je '93
CYPRESS TREES
Am Heritage 45:108–9 (c,1) My '94
Natur Hist 103:82–3 (c,1) N '94
Nat Wildlife 33:50–1 (c,2) F '95
CYPRUS
Nat Geog 184:104–30 (map,c,1) Jl '93
— See also
NICOSIA
CYPRUS—COSTUME
Nat Geog 184:104–30 (c,1) Jl '93
CZECHOSLOVAKIA
Nat Geog 184:2–37 (map,c,1) S '93
— Bouzov castle
Nat Geog 184:22 (c,4) S '93
— Cesky Krumlov
Nat Geog 184:16–17,25–6 (c,1) S '93
Trav/Holiday 179:52–9 (map,c,1) Mr '96
— Hluboka castle
Nat Geog 184:22–7 (c,1) S '93
— Plzen's Hotel Continental
Trav/Holiday 178:56–65 (1) My '95
— Spis castle
Nat Geog 184:34–5) S '93
— Spisske, Slovakia
Nat Geog 184:34–5 (c,1) S '93
— Troja Castle frescoes
Trav&Leisure 22:67 (c,3) Ag '92
— See also
BRNO
PRAGUE

CZECHOSLOVAKIA—AR - CHITECURE
— Early 20th cent. churches (Texas)
 Am Heritage 44:101–5 (c,1) S '93
CZECHOSLOVAKIA—COSTUME
 Nat Geog 184:2–37 (c,1) S '93
CZECHOSLOVAKIA—HISTORY
— 1618 Defenestration of Prague
 Natur Hist 105:19 (painting,c,1) S '96
— 1980s posters promoting revolution
 Smithsonian 24:118–23 (c,2) Ap '93
— History of Hotel Continental, Plzen
 Trav/Holiday 178:56–65 (1) My '95
— Vaclav Havel
 Life 15:24 (c,4) O '92
 Smithsonian 24:71 (c,4) Je '93
 Trav&Leisure 23:49 (c,4) Jl '93
 Nat Geog 184:8 (c,1) S '93
— Memorial to 1968 victims of Russian
 invasion
 Smithsonian 24:75 (c,2) Je '93
— Russians liberating Czechoslovakia (1945)
 Am Heritage 46:65 (4) D '95
— See also
 DVORAK, ANTONIN
**CZECHOSLOVAKIA—POLITICS
AND GOVERNMENT**
— 1989 demonstration
 Smithsonian 24:70–1 (c,3) Je '93
— Slovaks celebrating independence
 (1993)
 Nat Geog 184:2–3 (c,1) S '93
**CZECHOSLOVAKIA—SHRINES AND
SYMBOLS**
— Royal crown of Bohemia
 Nat Geog 184:20 (c,3) S '93

–D–

DADDY LONGLEGS
 Life 17:65 (c,4) Je '94
DA GAMA, VASCO
— Tomb (Lisbon, Portugal)
 Nat Geog 182:93 (c,2) N '92
DAGGERS
— Copper Age dagger (Italy)
 Nat Geog 183:53 (c,3) Je '93
— Khanjar (Oman)
 Nat Geog 187:138 (c,4) My '95
DAHLIAS
 Natur Hist 102:38–9 (c,1) Je '93
DAIRYING
— Milking cow (California)
 Smithsonian 26:125 (c,4) Ap '95

— Milking sheep (Turkey)
 Nat Geog 182:55 (c,3) Ag '92
DAISIES
 Nat Wildlife 30:48–9 (c,1) Je '92
 Nat Geog 187:86 (c,1) Ja '95
— Field of daisies
 Trav&Leisure 24:100–1 (c,1) S '94
DALI, SALVADOR
 Trav&Leisure 22:66 (c,2) Ap '92
 Life 19:64 (4) O '96
— Dali Museum, Figueras, Spain
 Trav&Leisure 22:66–70 (c,2) Ap '92
DALLAS, TEXAS
— Dallas/Fort Worth Airport
 Smithsonian 24:34–47 (c,1) Ap '93
DALMATIANS
 Life 17:84 (c,4) O '94
 Life 19:73 (c,4) F '96
 Life 19:28 (c,3) N '96
DAMASCUS, SYRIA
 Trav&Leisure 24:70–3 (c,4) N '94
 Nat Geog 190:108–9 (c,1) Jl '96
DAMS
— Ataturk Dam, Turkey
 Nat Geog 183:46–7 (c,1) My '93
— Beaver dams
 Natur Hist 101:52–3 (c,2) My '92
 Natur Hist 103:38–9,43 (c,1) N '94
— Bonneville Dam, Oregon
 Gourmet 53:143 (c,4) Ap '93
— Dalles Dam, Columbia River, Washington
 Natur Hist 104:33 (c,2) S '95
— Glen Canyon, Arizona
 Nat Geog 184:54–5 (c,1) N 15 '93
— Middlesex Dam, Vermont
 Gourmet 52:58 (c,4) Ag '92
— See also
 GRAND COULEE DAM
 HOOVER DAM
DAMS—CONSTRUCTION
— Ethiopia
 Nat Geog 184:114–15 (c,1) Ag '93
— Site of planned Three Gorges Dam,
 Yangtze River, China
 Natur Hist 105:cov.,2,28–39 (map,c,1) Jl
 '96
Damselflies. See
 DRAGONFLIES
DANCERS
— 1890s cancan dancers (Paris, France)
 Life 15:78,80 (c,2) Je '92
— 1930s (Great Britain)
 Smithsonian 25:63 (4) Ap '94
— Aztec Quetzal dancers
 Life 15:52 (c,3) Jl '92

— Child country and western dancers
(Wyoming)
Nat Geog 183:77 (c,3) Ja '93
— Elderly dancer doing headstand (Arizona)
Nat Geog 186:38–9 (c,1) S '94
— Louis Falco
Life 17:80 (1) Ja '94
— Margot Fonteyn
Life 15:94–5 (2) Ja '92
— Hula dancer (Hawaii)
Trav/Holiday 175:75 (c,1) Mr '92
— Java, Indonesia
Trav&Leisure 22:66–7 (c,1) Ja '92
— Las Vegas showgirls
Trav/Holiday 175:33 (drawing,c,4) F '92
Sports Illus 85:38 (c,3) O 14 '96
— Little Egypt (1893)
Smithsonian 24:43 (4) Je '93
— Lola Montez
Smithsonian 26:44 (4) O '95
— Arthur Murray
Life 15:99 (4) Ja '92
— Night club (California)
Smithsonian 23:37 (c,3) Ag '92
— Physical therapy for dancers
Smithsonian 25:97–101 (2) Je '94
— Sally Rand, fan dancer
Am Heritage 43:26 (4) Ap '92
— Square dancers
Smithsonian 26:cov.,92–9 (c,1) F '96
— Underwater photos of dancers
Life 19:114–18 (c,1) N '96
— Whirling Dervishes (Turkey)
Trav&Leisure 22:50,52 (3) Je '92
Nat Geog 185:cov. (c,1) My '94
— See also
ASTAIRE, FRED
BAKER, JOSEPHINE
BALLET DANCERS
DE MILLE, AGNES
DUNCAN, ISADORA
GRAHAM, MARTHA
KELLY, GENE
ROBINSON, BILL "BOJANGLES"
DANCES
— 1954 teens dressed for the prom
Am Heritage 45:38 (c,4) D '94
— High school proms
Nat Geog 183:130–1 (c,1) F '93
Life 17:75,80,102 (c,2) N '94
— Holiday ball (Russia)
Nat Geog 183:6–7 (c,1) Mr '93
— Indian powwows
Nat Geog 185:cov.,88–113 (c,1) Je '94
— Teen moonlight rave (California)

Life 18:20–4 (c,2) Ag '95
— Vienna Opera Ball, Austria
Life 16:12–13 (c,1) Mr '93
DANCING
— 1943 lindy hoppers
Life 19:126 (4) O '96
— 1945 USO show (South Pacific)
Life 18:92–3 (1) Je 5 '95
— 1950s night club scene
Gourmet 54:48 (painting,c,2) Ja '94
— 1954 teenagers dancing at party
Life 17:42 (4) Je '94
— 1963 teens dancing on beach
Life 16:28–9 (1) Je '93
— American Indian dances
Smithsonian 23:cov.,90–7 (c,1) F '93
Nat Geog 185:106–7 (c,1) Je '94
— Apache Indians (Southwest)
Nat Geog 182:48–9 (c,1) O '92
Nat Geog 190:116–17 (c,1) S '96
— Belly dancing (Egypt)
Nat Geog 187:37 (c,3) Ja '95
— Bhutan
Trav&Leisure 26:125–6 (c,1) Je '96
— Cajun dancing (New Orleans, Louisiana)
Nat Geog 187:118–19 (c,1) Ja '95
— Celtic dance (Nova Scotia)
Trav&Leisure 26:50 (c,4) Ag '96
— Chinese girls dancing
Life 18:12–13 (c,1) N '95
— Coast Guard graduation ball (Connecticut)
Nat Geog 185:78–9 (c,1) F '94
— Country-western dancing
Trav/Holiday 177:45 (4) S '94
Gourmet 56:118 (c,4) Ap '96
Gourmet 56:164–6 (c,2) My '96
Nat Geog 190:12–13 (c,1) Ag '96
— Dancing the "Sardana" (Spain)
Sports Illus 77:186–7 (c,2) Jl 22 '92
— Disco (Shanghai, China)
Nat Geog 185:18–19 (c,2) Mr '94
— Foam dancing (New York City, New York)
Life 19:9 (c,4) Ja '96
— Hula (Hawaii)
Trav&Leisure 26:45 (c,4) Ja '96
— Indian powwows
Life 17:125–8 (c,1) N '94
— Kazaks (China)
Nat Geog 189:5–6 (c,1) Mr '96
— Kirumbizi stick dance (Kenya)
Natur Hist 105:56 (c,4) Ja '96
— Lambada (Brazil)
Trav&Leisure 23:140–1 (c,1) N '93
— Limbo (Jamaica)
Trav/Holiday 178:81 (c,4) D '95

— New Yorkers doing "The Big Apple"
(1938)
Life 15:82–3 (1) F '92
— Puerto Rico
Trav&Leisure 22:62 (c,4) Je '92
— Rain dance (Mexico)
Nat Geog 184:99–101 (c,1) N '93
— Ribbon dance (China)
Natur Hist 101:70 (c,4) Ap '92
— Rumba step instructions in sidewalk
(Seattle, Washington)
Trav&Leisure 23:57 (c,4) Ag '93
— Spring festival (Peru)
Nat Geog 189:2–3 (c,1) My '96
— Square dancing
Smithsonian 26:cov.,92–9 (c,1) F '96
— Swing (California)
Trav/Holiday 179:102–6 (c,1) D '96
— Tahiti
Trav/Holiday 179:84 (c,1) N '96
— Tango (Argentina)
Smithsonian 24:cov.,152–61 (c,1) N '93
Gourmet 53:140 (c,4) N '93
Nat Geog 186:87–8 (c,1) D '94
Trav&Leisure 26:151,161 (c,1) D '96
— Tango (New York)
Smithsonian 24:153,158 (c,2) N '93
— Tap dancing (Louisiana)
Trav/Holiday 179:68–9 (c,1) Mr '96
— Turkish belly dancer (Germany)
Nat Geog 183:120–1 (c,1) My '93
— Vietnamese flag dance (California)
Smithsonian 23:36 (c,3) Ag '92
— Vodun dancing (Benin)
Natur Hist 104:43–5 (c,1) O '95
— Whirling Dervishes (Turkey)
Trav&Leisure 22:50,52 (3) Je '92
Nat Geog 185:cov. (c,1) My '94
— Zydecko dancing (Louisiana)
Trav/Holiday 177:59,62–3 (c,2) N '94
— See also
 BALLET DANCING
 ICE DANCING

DANCING—EDUCATION
— Children's dance class (Florida)
Life 17:104 (c,2) My '94
— Class in social graces for privileged
children (Connecticut)
Nat Geog 185:90–1 (c,1) F '94
— Teaching line dance at Catskill resort, New
York
Nat Geog 182:114–15 (c,1) N '92
— Traditional dance (Japan)
Nat Geog 186:86–7 (c,2) S '94
— See also

BALLET DANCING—EDUCATION
DANCING, MODERN
Smithsonian 23:102–9 (c,2) S '92
— Athletes in dance performance
Sports Illus 79:92 (c,3) N 1 '93
— Czechoslovakia
Nat Geog 184:6–7 (c,1) S '93
— Scotland
Smithsonian 25:38–9 (c,1) D '94
DANTE ALIGHIERI
— Tomb (Ravenna, Italy)
Nat Wildlife 34:100 (c,4) F '96
DANUBE RIVER, HUNGARY
— Budapest
Trav&Leisure 24:90–1 (c,1) O '94
DARROW, CLARENCE
Am Heritage 45:110 (4) N '94
DARTERS (FISH)
Nat Wildlife 30:8 (painting,c,4) Ap '92
— Snail darters
Nat Geog 187:26–7 (c,2) Mr '95
DARWIN, CHARLES
Natur Hist 105:22 (2) F '96
— Caricature
Smithsonian 27:149 (4) My '96
— Darwin postage stamp (India)
Natur Hist 105:6 (c,4) My '96
— Down House home, Kent, England
Natur Hist 105:54–7 (c,1) Ag '96
DATE TREES
Life 15:37 (c,2) D '92
DAVID
— 12th cent. depiction of King David (Great
Britain)
Smithsonian 25:114 (c,4) N '94
DAVIS, JEFFERSON
— Stone Mountain carving, Georgia
Life 15:15 (c,1) Jl '92
DAVIS, MILES
Life 15:87 (2) Ja '92
Am Heritage 47:149 (4) Ap '96
DEAD SEA, ISRAEL/JORDAN
Life 15:40–1 (c,2) D '92
DEAD SEA SCROLLS
Trav/Holiday 176:66 (c,4) D '93
DEAFNESS
— Audiologist working with deaf child
Life 16:10–11 (c,1) My '93
— Deaf people signing
Smithsonian 23:30–41 (2) Jl '92
— Signing words at rock concert
Life 18:86–7 (c,2) Mr '95
DEAN, DIZZY
Sports Illus 80:4 (4) Ap 25 '94

DEAN, JAMES
 Life 16:32 (4) N '93
 Life 18:35 (4) Mr '95
 Am Heritage 47:99 (c,4) N '96
DEATH
— 19th cent. photos of dead children
 Am Heritage 43:99–105 (c,2) My '92
— 1942 woman falling off building (Buffalo,
 New York)
 Am Heritage 45:73 (1) O '94
— 1944 Purple Heart and telegram
 announcing death of U.S. sailor
 Life 18:63 (c,2) Je 5 '95
— AIDS patient dying
 Life 16:16 (2) Je '93
— Attempted suicide under metro train (Paris,
 France)
 Life 19:10–11 (1) Je '96
— Bodies in rice sacks (Somalia)
 Life 15:4–5 (1) N '92
— Dead U.S. soldiers on Pacific beach (1942)
 Life 19:52 (1) O '96
— Death of Buddha (Tibet)
 Life 15:68 (painting,c,2) Mr '92
— Deaths and funerals of U.S. presidents
 Life 15:68–9 (c,3) O 30 '92
— Depictions of life after death
 Life 15:cov.,64–72 (c,1) Mr '92
— Head of World War II Japanese soldier
 Life 19:16 (4) O '96
— Man drowning in gorge (Vermont)
 Life 15:8–9 (c,1) Ag '92
— Murder victim on stretcher (Florida)
 Sports Illus 84:38 (c,2) Ap 22 '96
— Onlookers staring at firing squad victim
 (Liberia)
 Life 16:12–13 (c,1) F '93
— Victims of Yugoslavian civil war
 Life 15:12–13 (c,1) O '92
 Life 16:28–9 (1) Ja '93
— See also
 CEMETERIES
 COFFINS
 CRIME AND CRIMINALS
 DEATH MASKS
 FUNERAL RITES AND CEREMONIES
 MUMMIES
 TOMBS
 TOMBSTONES
DEATH MASKS
— James Joyce's death mask
 Smithsonian 23:113 (c,3) Ap '92
— King Tut's funerary mask (Egypt)
 Smithsonian 26:30 (c,4) Ap '95
— Alexander Pushkin's death mask

 Nat Geog 182:61 (c,2) S '92
DEATH VALLEY, CALIFORNIA
 Trav&Leisure 23:190 (c,4) Mr '93
 Gourmet 54:85 (c,3) Je '94
 Nat Geog 186:14–15 (c,1) O '94
— Eureka San Dunes
 Nat Geog 189:57–9 (c,1) My '96
DEBS, EUGENE V.
— 1904 campaign poster
 Am Heritage 43:51 (c,3) S '92
DECLARATION OF INDEPENDENCE
 Life 16:34 (c,2) My '93
DEER
— Black-tailed deer
 Nat Wildlife 31:2–3 (c,2) D '92
— Cutting off antlers (Kazakhstan)
 Nat Geog 183:36 (c,4) Mr '93
— Doe skidding on ice
 Life 17:96 (c,3) Mr '94
— Extinct Irish deer
 Natur Hist 105:16–22 (painting,c,1) Ag
 '96
— Key deer
 Nat Wildlife 30:10 (painting,c,4) Ap '92
 Life 16:37 (c,4) O '93
 Natur Hist 105:75 (4) Mr '96
 Nat Wildlife 34:15 (c,1) Ap '96
 Nat Geog 190:34–5 (c,2) O '96
— Red deer
 Natur Hist 103:61 (c,3) Je '94
— White-tailed deer
 Nat Geog 181:68,70-3 (c,1) F '92
 Natur Hist 101:48–9 (c,4) My '92
 Smithsonian 24:118 (c,4) Je '93
 Nat Wildlife 31:7 (c,4) O '93
 Natur Hist 103:88–9 (c,1) O '94
 Nat Wildlife 32:cov.,34–41 (c,1) O '94
 Nat Wildlife 33:26–7 (painting,c,1) F '95
 Life 18:66 (c,4) S '95
 Nat Wildlife 34:32–3 (painting,c,1) Ag '96
— White-tailed fawns
 Nat Wildlife 32:36–7 (c,1) O '94
 Nat Wildlife 34:56–7 (painting,c,1) D '95
— See also
 ANTLERS
 CARIBOU
 ELKS
 MULE DEER
 MUSK DEER
 REINDEER
DEGAS, EDGAR
— "The Dancer"
 Smithsonian 25:49 (drawing,c,4) Mr '95
— "Dancer with Bouquet" (1893)

Smithsonian 27:cov. (painting,c,1) O '96
— Deem painting done in style of Degas
Smithsonian 24:100–1 (c,4) Jl '93
— Paintings by him
Smithsonian 27:cov.,96–105 (c,1) O '96
— "Place de la Concorde"
Smithsonian 25:49 (painting,c,3) Mr '95
— Self-portrait
Smithsonian 27:99 (painting,c,4) O '96
DE GAULLE, CHARLES
Am Heritage 44:28 (4) S '93
Am Heritage 45:101–2 (c,4) O '94
Trav/Holiday 178:86 (4) Ap '95
DEITIES
— 15th cent. statue of Inca goddess (Chile)
Nat Geog 181:88–9 (c,1) Mr '92
— Hopi god Masau
Smithsonian 22:36 (petroglyph,c,4) Mr '92
— Sekhmet sculpture (Egypt)
Natur Hist 104:82 (3) Ap '95
— Storm god (ancient Mexico)
Nat Geog 188:25 (drawing,4) D '95
— See also
BUDDHA
JESUS CHRIST
MYTHOLOGY
DE KOONING, WILLEM
Smithsonian 25:108 (4) Ap '94
Am Heritage 46:58 (2) S '95
— Elaine de Kooning
Am Heritage 46:58 (2) S '95
— Paintings by him
Smithsonian 25:109–19 (c,1) Ap '94
DELACROIX, EUGENE
— Caricature
Smithsonian 27:132 (painting,c,4) D '96
— Portrait of Chopin
Smithsonian 27:131 (painting,c,4) D '96
DELAWARE
Trav/Holiday 178:38–45 (map,c,1) S '95
— Early 20th cent. Arden Utopian community
Smithsonian 23:124–42 (c,3) My '92
— Winterthur
Gourmet 53:113 (c,2) D '93
Trav&Leisure 26:E1–E2 (c,4) N '96
— See also
WILMINGTON
DELAWARE INDIANS-COSTUME
— Council chief
Smithsonian 25:41 (c,2) O '94
DELFT, NETHERLANDS
— 17th cent. scene by Vermeer
Smithsonian 26:112,119 (painting,c,2) N '95

DE MILLE, AGNES
Life 17:81 (1) Ja '94
Smithsonian 27:cov. (4) N '96
DEMONSTRATIONS
— 1964 Berkeley student protest,California
Am Heritage 47:44 (2) O '96
— 1967 anti-war protesters
Life 18:110 (4) Je 5 '95
Life 18:90 (2) O '95
— 1968 Democratic convention violence
(Chicago, Illinois)
Life 16:27 (4) Ag '93
— 1968 student sit-in at Columbia University,
New York City
Am Heritage 44:50 (4) Ap '93
— 1989 (Czechoslovakia)
Smithsonian 24:70–1 (c,3) Je '93
— Anti abortion demonstrations
Life 15:cov.,32–42 (c,1) Jl '92
— Earth Day 1970
Am Heritage 44:46 (c,4) O '93
Nat Geog 187:124 (c,4) Ap '95
— Kurds (Germany)
Nat Geog 182:47 (c,3) Ag '92
— Muslims protesting Salman Rushdie (Great
Britain)
Life 16:62–3 (2) Mr '93
— Neo-Nazi rally (Germany)
Nat Geog 183:124–5 (c,1) My '93
— Pro choice activists
Life 15:70 (c,3) Ja '92
Life 15:cov.,32–42 (c,1) Jl '92
— Pro job, anti-owl sign (Oregon)
Nat Wildlife 33:10–11 (c,2) Ag '95
— Protest to save koalas (Australia)
Nat Geog 187:52–3 (c,1) Ap '95
— Protesters outside White House (1917–
1992)
Life 15:100–1 (c,3) O 30 '92
— "Save the whales" protest
Nat Wildlife 33:10 (c,4) Ap '95
— Seniors protesting pensions (Italy)
Trav/Holiday 177:56–7 (c,2) My '94
— Sit-in to save tree from loggers (California)
Nat Geog 184:70–1 (c,2) Jl '93
— See also
CIVIL RIGHTS MARCHES
RIOTS
DEMPSEY, JACK
Sports Illus 82:67–8 (4) Ap 17 '95
DENALI NATIONAL PARK, ALASKA
Nat Geog 182:62–87 (map,c,1) Ag '92
Life 17:83–5 (c,2) S '94
Trav/Holiday 178:cov.,74–83 (map,c,1)
My '95

Nat Wildlife 34:30–1 (c,1) Ap '96
Nat Wildlife 34:48–9 (c,1) O '96
— See also
MOUNT McKINLEY
DENMARK
— Castles
Gourmet 52:52–7,108 (map,c,1) Ag '92
— Fredensborg castle
Gourmet 52:54–5 (c,1) Ag '92
— Frederiksborg castle
Gourmet 52:56–7 (c,1) Ag '92
— Funen
Trav/Holiday 176:76–83 (map,c,1) S '93
— Rosenborg castle
Gourmet 52:52–3 (c,1) Ag '92
— Steensgaard castle
Trav&Leisure 25:84 (c,2) N '95
— See also
COPENHAGEN
FAEROE ISLANDS
DENMARK—ART
— 950 amber carving of man
Natur Hist 105:96 (c,1) F '96
Denmark—History. See
CHRISTIAN IV
DENMARK—MAPS
— Copenhagen area
Trav/Holiday 178:102 (c,2) Jl '95
DENMARK—SOCIAL LIFE AND CUS-
TOMS
— Baby adding to "Old Pacifier Tree"
Life 15:26 (c,4) Je '92
DENTISTRY
— 4th cent. Scythian bowl showing tooth
being pulled (U.S.S.R.)
Trav/Holiday 178:80 (c,4) Mr '95
DENTISTS
— Curbside dentist (China)
Nat Geog 189:29 (c,1) Mr '96
— Smile sign outside dentist's office (Taiwan)
Nat Geog 184:26 (c,3) N '93
DENVER, COLORADO
Trav&Leisure 22:112–13,E1–E3
(map,c,3) O '92
Sports Illus 82:27 (c,3) My 8 '95
Trav&Leisure 26:C1–C4 (c,1) Ap '96
Nat Geog 190:86–95,102–3 (c,1) N '96
— Black American West Museum
Am Heritage 46:38 (c,4) F '95 supp.
— Brown Palace Hotel
Trav&Leisure 22:112–13 (c,1) O '92
Trav&Leisure 23:32 (c,4) Ag '93
— Denver Art Museum
Smithsonian 24:96–109 (c,1) S '93
— Lakeside amusement park

Am Heritage 43:74–9,106 (c,1) Jl '92
— Red Rocks outdoor theater
Trav&Leisure 22:E2 (c,3) O '92
DEPRESSION
— 1930s bread lines
Am Heritage 44:58 (4) O '93
Life 19:88–9 (1) O '96
— 1930s hoboes on train
Life 17:37 (2) Mr '94
— 1932 Bonus Army (Washington, D.C.)
Am Heritage 43:69 (2) S '92
— 1936 sharecropper (Mississippi)
Life 19:30 (1) O '96
— Civilian Conservation Corps
Smithsonian 25:66–78 (c,1) D '94
— Depression life photos by Marion Post
. Wolcott
Life 15:80–8 (1) My '92
— Family traveling in old car (1936)
Life 19:60–1 (1) Winter '96
— Man selling apples on street
Am Heritage 44:97 (4) D '93
— Stock market loser selling car
Life 19:46–7 (1) Winter '96
DES MOINES, IOWA
— Great Flood of 1993
Nat Geog 185:82–7 (c,1) Ja '94
DESERTS
— Anza-Borrego Desert, California
Trav&Leisure 24:E1–E4 (map,c,4) Ja '94
— Atacama Desert, Chile
Trav&Leisure 23:68 (c,4) Ap '93
— California
Trav&Leisure 24:106–11,152 (map,c,1) O
'94
Nat Geog 189:54–79 (map,c,1) My '96
— Chihuahuan Desert, Mexico
Trav&Leisure 23:127 (c,1) Mr '93
Nat Geog 188:84–97 (map,c,1) O '95
— Desert flowers
Smithsonian 25:cov.,78–91 (c,1) Mr '95
— Israel
Nat Geog 181:50–1 (c,1) F '92
Life 15:38–9 (c,1) D '92
— Namib Desert, Namibia
Nat Geog 181:56–7,70–3 (c,1) Ja '92
Natur Hist 102:26–32 (c,1) Ag '93
— Richat structure, Sahara, Mauritania
Nat Geog 190:14–15 (c,1) N '96
— Simpson Desert, Australia
Nat Geog 181:66–7,74 (c,1) Ap '92
— Sonoran, Arizona
Nat Geog 184:18–19 (c,1) N 15 '93
Nat Geog 186:36–51 (map,c,1) S '94
Natur Hist 105:58–61 (map,c,2) Ap '96

— Sonoran, Mexico
 Nat Geog 186:45,52–3 (map,c,1) S '94
— Stylized illustration
 Trav&Leisure 26:E1 (painting,c,3) S '96
— Taklimakan Desert, China
 Nat Geog 189:2–4,38–40 (c,1) Mr '96
— Tenere Desert, Niger
 Life 19:76 (c,3) S '96
— See also
 ARABIAN DESERT
 CACTUS
 DEATH VALLEY
 GOBI DESERT
 MOJAVE DESERT
 NEGEV
 SAHARA DESERT
 WHITE SANDS NATIONAL MONU-
 MENT
DESIGN, DECORATIVE
— Late 19th cent. Herter Brothers ornate
 cabinetry
 Am Heritage 46:74–83 (c,1) F '95
— 1920s furnishings inspired by Cubism
 Smithsonian 27:48–9 (c,4) Jl '96
— Art deco buildings (Miami Beach, Florida)
 Trav/Holiday 175:cov.,52–61 (c,1) O '92
 Trav&Leisure 22:cov.,76–87 (c,1) O '92
— Art deco Lakeside amusement park,
 Denver, Colorado
 Am Heritage 43:74–9,106 (c,1) Jl '92
— Baroque palace decor (Rome, Italy)
 Trav&Leisure 25:62 (c,4) O '95
— Designs made by crystals seen through
 microscope
 Smithsonian 24:112–15 (c,3) My '93
— Funky checked house front steps (London,
 England)
 Trav&Leisure 26:68 (c,4) Ag '96
— Geometry in nature
 Life 16:69–76 (c,1) O '93
— Islamic motifs from Spanish occupation
 Smithsonian 23:44–53 (c,2) Ag '92
— Native American motifs
 Trav/Holiday 175:91–2 (painting,c,4) Jl
 '92
— Photomicrograph art
 Life 16:93–5 (c,1) D '93
— South Korean motifs
 Gourmet 54:105 (c,1) Ap '94
— Stylized motifs of India
 Trav&Leisure 23:NY1 (painting,c,4) O '93
— Tools as art
 Smithsonian 27:112–15 (c,1) Ap '96
DESKS
— 1779 French desk

Trav&Leisure 24:111 (c,4) Je '94
— George Bush's desk
 Life 17:112 (c,2) Ja '94
— U.S. vice president signatures carved into
 desk
 Life 17:82–7 (c,1) Mr '94
Detectives. See
 SHERLOCK HOLMES
DETROIT, MICHIGAN
— Fisher Building
 Smithsonian 25:54 (c,4) S '94
DE VALERA, EAMON
 Smithsonian 25:170 (4) N '94
DEVILS
— El Tio sculpture in mine (Bolivia)
 Natur Hist 105:41 (c,4) N '96
**DEVIL'S TOWER NATIONAL MONU-
MENT, WYOMING**
 Trav&Leisure 24:101 (4) Je '94
DEWEY, GEORGE
 Smithsonian 22:88,96 (c,4) Mr '92
DEWEY, THOMAS E.
 Am Heritage 46:32 (4) O '95
— 1948 Dewey button
 Am Heritage 43:57 (c,4) S '92
DIAMOND HEAD, OAHU, HAWAII
 Trav&Leisure 24:101 (c,2) O '94
DIAMONDS
— Hope Diamond
 Life 18:74–5 (c,1) Mr '95
 Smithsonian 26:18 (c,4) My '95
— Making diamonds from carbon
 Life 16:54–6 (c,1) Mr '93
DICKENS, CHARLES
— *A Christmas Carol* manuscript (1843)
 Gourmet 53:146 (c,2) D '93
— Dickens' written-in copy of *A Christmas
 Carol*
 Life 16:112 (c,2) D '93
DIDO (CARTHAGE)
 Smithsonian 25:126 (painting,c,4) Ap '94
DIDRIKSON, BABE
 Sports Illus 76:6 (4) Mr 16 '92
 Sports Illus 85:14 (4) Jl 22 '96
DIETRICH, MARLENE
 Smithsonian 23:141 (4) Je '92
 Life 16:5,59 (1) Ja '93
 Trav&Leisure 23:19 (3) Ja '93
 Life 18:126–7 (1) Je 5 '95
 Life 18:105 (4) O '95
 Life 19:117 (1) O '96
DILLINGER, JOHN
— Biograph Theater site of Dillinger's 1934
 murder, Chicago, Illinois

Am Heritage 46:86 (c,4) Ap '95
DIMAGGIO, JOE
Sports Illus 78:cov.,14–15,21 (1) My 3 '93
Sports Illus 79:2–3,66–74 (1) Jl 19 '93
Sports Illus 79:12 (4) O 4 '93
Sports Illus 80:32–3 (2) Mr 21 '94
Smithsonian 25:41 (4) Jl '94
Life 18:6 (4) Ja '95
Sports Illus 82:23 (c,4) My 8 '95
Sports Illus 83:8 (4) S 18 '95
Sports Illus 83:86 (4) D 11 '95
Sports Illus 84:6 (4) My 13 '96
— At age 17
Am Heritage 44:37 (4) N '93
DINGOES
Natur Hist 102:43 (c,4) Je '93
DINING ROOMS
— 17th cent. dining hall (Oxford, England)
Trav&Leisure 26:67 (c,4) My '96
— Biltmore estate, Asheville, North Carolina
Smithsonian 23:63 (c,4) S '92
— Monticello, Charlottesville, Virginia
Smithsonian 24:84 (c,4) My '93
— Windsor Castle, England
Life 15:61 (c,2) My '92
DINNERS AND DINING
— 1930s dinner party (France)
Gourmet 53:120 (c,2) N '93
— Banquet in Tower of London, England
Nat Geog 184:52–3 (c,1) O '93
— Baseball fans eating at stadiums
Sports Illus 85:48–60 (c,1) Jl 8 '96
— Child eating rice (China)
Nat Geog 185:55 (c,1) My '94
— Chinese restaurant (New York)
Gourmet 55:72 (c,3) Je '95
— Cookout (Minnesota)
Nat Geog 182:105 (c,3) S '92
— Crawfish eating contest (Breaux Bridge, Louisiana)
Nat Geog 184:101 (c,3) N 15 '93
— Dim sum at restaurant (Macau)
Trav/Holiday 175:91 (c,1) Ap '92
— Eating a pile of crawfish (Louisiana)
Sports Illus 81:22 (c,4) Jl 18 '94
— Eating at campsite (Alaska)
Smithsonian 26:36 (c,3) Mr '96
— Eating lobster (Maine)
Trav/Holiday 179:78–9 (c,1) S '96
— Family at ice cream stand
Trav&Leisure 26:52 (painting,c,3) S '96
— Family dinner (Georgia, U.S.S.R.)
Nat Geog 181:82–3 (c,1) My '92
— Family dinner (Italy)
Nat Geog 182:99 (c,3) D '92

— Family eating watermelon (Israel)
Nat Geog 181:52 (c,4) F '92
— Funeral banquet (U.S.S.R.)
Nat Geog 190:71 (c,1) S '96
— Humorous look at dieting
Smithsonian 25:146–56 (drawing,c,1) N '94
— Koryak people feasting on reindeer meat (U.S.S.R.)
Nat Geog 185:65–6 (c,1) Ap '94
— Man eating candy
Sports Illus 78:66–7 (c,1) Je 7 '93
— Man eating cotton candy (France)
Trav/Holiday 177:57 (c,3) Jl '94
— Man eating pizza
Sports Illus 79:68 (c,2) S 13 '93
— Nobel Prize banquet (Stockholm, Sweden)
Nat Geog 184:6–7 (c,1) Ag '93
— Outdoor cafe (California)
Gourmet 52:45 (c,4) S '92
Gourmet 53:68,76 (c,3) N '93
— Outdoor family breakfast (Burma)
Nat Geog 188:82–3 (c,1) Jl '95
— Prison inmates eating (U.S.S.R.)
Nat Geog 182:122–3 (c,1) O '92
— Pub lunch (Great Britain)
Trav&Leisure 22:136 (c,4) N '92
— Restaurant (Florence, Italy)
Trav&Leisure 22:74–7,80–1 (c,1) Jl '92
— Restaurant (New York City, New York)
Gourmet 53:50 (c,3) Je '93
Gourmet 54:34 (c,3) Mr '94
Gourmet 54:38,47 (c,3) O '94
— Rooftop terrace dinner (Venice, Italy)
Nat Geog 187:92–3 (c,1) F '95
— Sequential sketches of man dining well
Gourmet 53:66 (c,4) F '93
— Soup kitchen meal (Moscow, Russia)
Nat Geog 183:12–13 (c,1) Mr '93
— Sumo wrestler eating meal (Japan)
Life 18:102 (c,3) My '95
— Teens eating pizza
Sports Illus 82:76–7 (c,2) F 13 '95
— Toddler covered with spaghetti
Life 19:199 (4) O '96
— Traditional feast (Hangzhou, China)
Gourmet 53:98,144 (painting,4) F '93
— Triangle to call people to ranch lunch (British Columbia)
Gourmet 53:112 (c,4) O '93
— White House dinner party, Washington, D.C.
Life 15:24–5 (c,2) O 30 '92
— See also
BREAKFAST

DRINKING CUSTOMS
FOOD
PICNICS
RESTAURANTS
DINOSAURS
Nat Geog 183:cov.,2–54 (c,1) Ja '93
Natur Hist 104:cov.,3,28–71 (c,1) Je '95
— African dinosaurs
Nat Geog 189:106–19 (painting,c,1) Je '96
— Afrovenator skeleton
Natur Hist 104:46–7 (c,1) Ja '95
— Animated models for theme parks
Nat Geog 183:48–51 (c,1) Ja '93
— Apatosaurus skeleton
Trav&Leisure 25:38 (c,4) My '95
Natur Hist 104:82 (c,4) My '95
— Archaeopteryx skeleton
Natur Hist 102:41,43 (c,1) S '93
— Dinosaur eggs
Nat Geog 189:cov.,96–111 (c,1) My '96
Nat Geog 190:76–7 (c,2) Jl '96
— Dinosaur evolution chart
Nat Geog 183:18–20 (c,1) Ja '93
— Dinosaur fossils
Natur Hist 104:69 (c,4) O '95
Nat Geog 190:70–89 (c,1) Jl '96
— Dinosaur images superimposed on modern
cities
Natur Hist 104:24–5 (c,3) O '95
— Dinosaur Provincial Park, Alberta
Nat Geog 183:6–7,12 (c,1) Ja '93
— Dinosaur skulls
Nat Geog 183:9 (c,2) Ja '93
Natur Hist 105:34–5 (c,3) N '96
— Jim Gurney's fantasy "Dinotopia" land
Life 15:54–61 (painting,c,1) O '92
Natur Hist 101:16 (painting,c,3) D '92
Smithsonian 26:cov.,70–9 (painting,c,1) S
'95
— Iguanodons mating
Natur Hist 104:58 (painting,c,1) Je '95
— "Jurassic Park" models (1993)
Nat Geog 183:49 (c,3) Ja '93
— Models of dinosaurs
Nat Geog 189:cov.,105,110–11 (c,2) My
'96
— Mononykus
Natur Hist 102:38–42 (painting,c,1) S '93
— Oviraptor
Nat Geog 190:72 (painting,c,1) Jl '96
— Oviraptorid embryo
Natur Hist 104:56–7,61 (c,3) Je '95
— Renovating museum exhibit (New York
City, New York)
Natur Hist 104:7–10,82 (c,1) My '95
— Sauropods
Natur Hist 104:40–1 (painting,c,1) Ja '95
Natur Hist 104:42–7 (painting,c,1) Je '95
— Tsintaosaurus skeleton
Trav&Leisure 24:E16 (c,4) Ag '94
— Velociraptor skeleton
Natur Hist 102:40–1 (drawing,3) S '93
DISASTERS
— 1846 Donner Party disaster site (California)
Am Heritage 44:74 (4) My '93
— 1937 crash of the Hindenburg (New Jersey)
Am Heritage 43:36 (4) S '92
— 1972 Andes plane wreck survivors
Life 16:48–57 (c,1) F '93
— 1986 Chernobyl nuclear disaster, Ukraine
Nat Geog 186:100–15 (c,1) Ag '94
— 1993 bomb damage to World Trade
Center, New York City, New York
Life 16:14–15 (c,1) Je '93
— Apartment building damaged in plane
crash (Amsterdam, Netherlands)
Life 16:50–1 (c,1) Ja '93
— Carrying victim of 1947 Texas City
explosion, Texas
Am Heritage 47:26 (4) Jl '96
— Coastal homes threatened by beach erosion
Smithsonian 23:74–86 (c,1) O '92
— Damage caused by tsunamis (tidal waves)
Smithsonian 24:28–39 (c,1) Mr '94
— Fatal stampede at soccer match
(Guatemala)
Sports Illus 85:22 (c,4) O 28 '96
— History of volunteer rescue squads
Am Heritage 47:90–8 (c,1) My '96
— Overturned college sports team bus
Sports Illus 78:54–66 (c,1) Ja 25 '93
— Rescuing cliff-side fall victim (California)
Smithsonian 23:41 (c,1) My '92
— Rescuing girl from flood (California)
Life 19:16–17 (c,1) Ap '96
— Rescuing missing skiers (Colorado)
Sports Illus 78:18–22 (c,2) Mr 8 '93
— Watching coal mine explosion rescue
efforts (Turkey)
Life 15:10–11 (c,1) My '92
— See also
ACCIDENTS
BOMBS
CRASHES
CYCLONES
EARTHQUAKES
EXPLOSIONS
FIRES
FLOODS
HURRICANES

OIL SPILLS
SHIPWRECKS
TERRORISM
TORNADOES
VOLCANOES
DISC JOCKEYS
— "Cousin" Bruce Morrow
Life 16:35 (c,4) Je '93
— Wolfman Jack
Life 19:96 (4) Ja '96
DISCUS THROWING
— 1912 Olympics (Stockholm)
Am Heritage 43:97 (4) Jl '92
DISEASES
— 1799 depiction of gout sufferer
Natur Hist 104:16 (etching,c,4) N '95
Natur Hist 105:52–3 (drawing,3) Jl '96
— 1916 polio patient (New York)
Natur Hist 104:22 (4) N '95
— 1940s poster of VD safety tips for soldiers
Am Heritage 45:22 (c,4) N '94
— Anorexia
Sports Illus 81:52–60 (c,1) Ag 8 '94
— Artist with Parkinson's disease
Life 16:76–80 (c,1) Je '93
— Cerebral palsy patient in wheelchair
(Sweden)
Nat Geog 184:12–13 (c,1) Ag '93
— Child with muscular dystrophy
Smithsonian 26:60 (c,4) Mr '96
— Child with spina bifida
Life 16:90 (c,4) D '93
— Children with Fetal Alcohol Syndrome
Nat Geog 181:36–9 (c,2) F '92
— Diagnosing epileptic spot in brain
Nat Geog 187:36–9 (c,1) Je '95
— Ebola virus victims (Zaire)
Life 18:14–15 (c,1) Jl '95
— Eye diseases (Tanzania)
Nat Geog 182:19–21 (c,1) N '92
— Headaches
Life 17:cov.,67–72 (c,1) F '94
— Japanese child deformed by mercury
poisoning (1972)
Life 19:56–7 (1) O '96
— Killing plague-ridden rats (India)
Life 18:54 (c,3) Ja '95
— Lead poisoning through history
Natur Hist 105:48–53 (c,1) Jl '96
— Man with malaria (Congo)
Nat Geog 188:41 (c,3) Jl '95
— Polio patient (Peru)
Nat Geog 186:65 (c,3) Jl '94
— Treatment of tuberculosis through history
Smithsonian 23:180–94 (c,3) N '92

— "Typhoid Mary" Mallon
Am Heritage 45:121 (painting,c,4) My '94
— Woman with Alzheimer's disease
Nat Geog 187:12–13 (c,1) Je '95
— See also
AIDS
ALCOHOLISM
CANCER
DRUG ABUSE
MALNUTRITION
MEDICINE—PRACTICE
MENTAL ILLNESS
VIRUSES
YELLOW FEVER
**DISNEY WORLD, ORLANDO, FLOR-
IDA**
Trav/Holiday 179:46–50 (c,1) D '96
**DISNEYLAND, ANAHEIM, CALIFOR-
NIA**
— 1955
Life 17:24 (c,4) Jl '94
— Toontown
Trav&Leisure 23:NY1 (c,4) N '93
DIVING
Sports Illus 77:22–3 (c,1) Jl 22 '92
Natur Hist 102:36 (c,3) S '93
Life 18:19 (2) Ap '95
Sports Illus 83:58 (c,3) Ag 7 '95
Sports Illus 85:44–9 (c,1) Jl 1 '96
— 5th cent. B.C. Greek diver
Nat Geog 190:50 (painting,c,4) Jl '96
— Late 19th cent. diving exhibition
Nat Geog 190:54 (2) Jl '96
— 1992 Olympics (Barcelona)
Sports Illus 77:2–3 (c,1) Ag 3 '92
Sports Illus 77:98–9 (c,1) Ag 10 '92
— 1996 Olympics (Atlanta)
Sports Illus 85:66–7 (c,1) Ag 12 '96
— Aerial view
Sports Illus 76:45–6 (c,1) Je 22 '92
— Boys jumping into swimming hole
(Louisiana)
Life 16:12–13 (c,1) O '93
— Child practicing dives (China)
Sports Illus 85:118 (c,2) Jl 15 '96
— Diver entering water (1962)
Life 19:80 (4) F '96
— Diving off remains of Mostar Bridge,
Bosnia
Sports Illus 83:18 (c,4) S 18 '95
— Moment where diver is half in and out of
water
Life 19:22 (c,2) Je '96
— Olympics history
Sports Illus 84:51–70 (2) Ap 29 '96

— See also
SKIN DIVING
DJIBOUTI—COSTUME
— Woman and child
Life 19:41 (4) Mr '96
DNA. See
GENETICS
DOCKS
— Florida lake
Sports Illus 79:18–19 (c,1) Jl 12 '93
— Gulls hovering over docks (Wisconsin)
Trav&Leisure 22:53 (c,4) S '92
— See also
PIERS
DOCTORS
— 1842 (New Hampshire)
Am Heritage 43:6 (painting,c,2) My '92
— Cardiac surgery team at hospital
Life 16:15–18 (c,1) D '93
— Doctor skating through hospital (Great
Britain)
Life 15:88 (2) O '92
— Healer (Zimbabwe)
Trav&Leisure 22:92 (c,3) N '92
— Jack Kevorkian
Life 16:12–13 (c,1) Ap '93
— Ophthalmology office (Minnesota)
Smithsonian 24:46 (4) Mr '94
— Psychiatrist's office furnishings
Life 19:62–3 (1) S '96
— Russia
Nat Geog 183:17 (c,1) Mr '93
— Yugoslavia
Life 16:89–98 (1) O '93
— See also
FREUD, SIGMUND
MEDICINE—PRACTICE
SALK, JONAS
SHAMANS
SURGEONS
VETERINARIANS
DODGE CITY, KANSAS
— Stagecoach mural on building
Smithsonian 25:9 (c,4) S '94
DODO BIRDS
Natur Hist 105:23–4,31 (drawing,c,3) N
'96
DOG RACING
— Winning greyhound wearing crown
Sports Illus 80:48 (c,4) Je 13 '94
DOG SHOWS
— 1980 cartoons about dog shows
Sports Illus 81:46–7 (painting,c,1) Ag 8
'94
— Westminster Kennel Club Dog Show

Life 17:15–18 (c,1) My '94
DOG SLEDS
Nat Geog 187:120–1,127–31 (c,1) Ja '95
Nat Geog 189:78–86 (c,1) Ja '96
— 1908 Alaska race team
Natur Hist 105:41 (4) Mr '96
— Colorado
Trav&Leisure 26:138 (c,1) D '96
— Dogs rescuing sled (Arctic)
Nat Geog 189:78–9 (c,1) Ja '96
— Iditarod
Natur Hist 105:37–40 (c,1) Mr '96
— Wyoming
Gourmet 56:120,186 (c,1) D '96
DOGFISH
Nat Geog 190:96–7 (c,1) O '96
DOGS
Life 17:cov.,76–88 (c,1) O '94
Trav&Leisure 24:113 (c,1) O '94
— 1961 astronaut dog (U.S.S.R.)
Life 19:33 (4) Mr '96
— Alaskan huskies
Natur Hist 105:cov.,34–41 (c,1) Mr '96
— Bathing the dog (Connecticut)
Smithsonian 23:68 (c,4) Ap '92
— Blow-drying dog's fur
Life 18:66–7 (c,1) N '95
— Chart of dog varieties
Life 17:15–18 (c,1) My '94
— Chihuahua with broken leg
Smithsonian 27:45 (c,1) O '96
— Dog relaxing in front of fan
Life 19:31 (4) Jl '96
— Dog snarling from truck window (Idaho)
Nat Geog 185:14–15 (c,1) F '94
— Dog walker leading dogs (Argentina)
Nat Geog 186:104–5 (c,2) D '94
— Dogs aboard World War II submarines
Am Heritage 45:96–9 (1) O '94
— Dogs helping the handicapped
Smithsonian 22:81–7 (2) Ja '92
Nat Geog 182:10–11 (c,1) N '92
— Gnarling dog
Nat Geog 187:55 (c,3) Ap '95
— Hairless dogs
Natur Hist 103:39,41 (c,1) F '94
— Hound trailing (Great Britain)
Nat Geog 186:16–17 (c,1) Ag '94
— Hunting dogs
Nat Geog 190:140 (3) S '96
— Inhumane puppy mills (South Dakota)
Life 15:36–40 (c,1) S '92
— Peering at child through glass door
(Ontario)
Nat Geog 184:92–3 (c,1) D '93

— Performing dog walking on rope
Life 16:76–7 (c,1) S '93
— Pets of athletes
Sports Illus 82:82–91 (c,1) Ap 10 '95
— Playing with ball
Nat Geog 186:32–3 (c,2) Jl '94
— Playing with pet dogs (South Africa)
Sports Illus 81:48–9 (c,1) Ag 8 '94
— Franklin Roosevelt's dog Fala
Am Heritage 44:45 (4) Ap '93
Am Heritage 46:16 (4) Ap '95
Life 18:95 (4) Je 5 '95
— Shar-peis
Life 19:107 (c.4) O '96
— Wolf dog
Nat Geog 183:76–9,84–93 (c,1) Ap '93
— See also
AIREDALES
AKITAS
BERNESE MOUNTAIN DOGS
BULLDOGS
CARDIGAN WELSH CORGIS
CHIHUAHUAS
COLLIES
DALMATIANS
DINGOES
GERMAN SHEPHERDS
GOLDEN RETRIEVERS
GREYHOUNDS
HOUNDS
LABRADOR RETRIEVERS
MASTIFFS
NEWFOUNDLAND DOGS
PIT BULLS
POODLES
RETRIEVERS
ROTTWEILERS
SHEEP DOGS
SIBERIAN HUSKIES
TERRIERS
WOLFHOUNDS
DOGWOOD TREES
Gourmet 52:79 (c,1) F '92
Nat Wildlife 31:46–50 (c,1) Ap '93
Gourmet 54:135 (c,1) My '94
— Dogwood blossoms
Life 15:96 (c,1) O 30 '92
— See also
BUNCHBERRIES
DOLLS
— 1847
Am Heritage 44:60 (c,4) My '93
— 1906 doll in carriage
Am Heritage 43:117 (4) D '92
— Barbie

Life 17:32 (c,2) Mr '94
— Barbie and Ken in Air Force uniforms
Smithsonian 26:30 (c,4) Je '95
— Hopi Indian figures
Smithsonian 25:cov. (c,1) O '94
— Russian nesting dolls painted like NBA
players
Sports Illus 80:61 (c,4) Ja 10 '94
— Russian nesting dolls depicting political
leaders
Trav&Leisure 23:107 (c,4) N '93
— Sioux Indian doll
Nat Geog 183:116 (c,4) Ja '93
DOLOMITE MOUNTAINS, ITALY
Trav/Holiday 175:105 (c,4) Mr '92
Trav&Leisure 26:156,210 (c,1) N '96
DOLPHINS
Nat Geog 182:cov.,2–35 (c,1) S '92
Smithsonian 23:58–67 (c,1) Ja '93
Sports Illus 78:66–7 (c,1) F 22 '93
Life 16:46 (c,1) N '93
Nat Wildlife 32:cov.,4–9 (c,1) Ap '94
Trav&Leisure 24:107 (c,4) Ap '94
Nat Geog 186:18–19 (c,1) S '94
Trav&Leisure 24:131 (c,4) D '94
Nat Geog 190:68 (c,3) D '96
— Bottlenose dolphins
Nat Wildlife 31:41 (c,1) Ag '93
Nat Wildlife 32:52 (c,3) D '93
— Caught in fishing nets
Nat Geog 182:5,14–17 (c,1) S '92
— Silhouetted against sunset
Nat Geog 186:22–3 (c,1) D '94
— Varieties of dolphins
Nat Geog 182:10–11 (painting,c,4) S '92
DOMINICAN REPUBLIC
— 1493 Columbus settlement La Isabela
Nat Geog 181:40–53 (map,c,1) Ja '92
DONKEYS
Smithsonian 22:37 (c,4) Ja '92
Smithsonian 23:102 (c,3) N '92
Smithsonian 24:64 (c,1) F '94
Life 17:40 (c,4) N '94
Trav/Holiday 179:50 (c,2) F '96
— Gigantic donkey
Smithsonian 25:60–1 (c,1) S '94
— Kiangs
Nat Geog 184:84–5 (c,1) Ag '93
— See also
MULES
DOOLITTLE, JAMES HAROLD
Smithsonian 23:113,120–6 (4) Je '92
Life 17:100–1 (1) Ja '94
— 1932 National Air Race plane "Gee Bee"
Am Heritage 44:93 (painting,c,4) D '93

DORE, GUSTAVE
— Dante and Beatrice
 Life 15:72 (engraving,2) Mr '92
DOS PASSOS, JOHN
 Am Heritage 43:97 (4) O '92
 Am Heritage 47:63 (4) Jl '96
— Illustrations from *U.S.A.*
 Am Heritage 47:64–72 (drawing,4) Jl '96
DOUGLAS, STEPHEN A.
 Am Heritage 47:61–3 (2) O '96
DOUGLASS, FREDERICK
 Am Heritage 43:48 (4) F '92
 Smithsonian 25:114–27 (1) F '95
— Cedar Hill home, Washington, D.C.
 Smithsonian 25:121–3,127 (c,4) F '95
DOVER, ENGLAND
— Dover Castle
 Sports Illus 81:42 (c,3) Jl 18 '94
DOVES
— Zenaida doves
 Natur Hist 105:34 (c,3) D '96
DRACULA
— Dracula's castle, Transylvania, Romania
 Trav&Leisure 24:82,91 (c,3) D '94
— Transylvania sites related to Dracula
 Life 17:67–71 (c,1) N '94
DRAGONFLIES
 Life 16:62–7 (c,1) F '93
 Nat Wildlife 31:57 (c,4) O '93
 Nat Wildlife 33:60 (c,1) O '95
 Smithsonian 27:cov.,70–81 (c,1) Jl '96
— Dragonfly fossil
 Natur Hist 105:97 (c,4) F '96
 Smithsonian 27:80 (c,4) Jl '96
DRAGONS
— 17th cent. depiction of dragon (Great
 Britain)
 Natur Hist 105:13 (painting,c,3) F '96
— Ancient Babylonian glazed brick dragon
 Natur Hist 105:12 (c,3) F '96
— Dragon ice sculpture
 Life 18:32 (c,4) F '95
— Friendly dragon
 Gourmet 54:36,46–8 (painting,c,2) Jl '94
DREISER, THEODORE
 Am Heritage 44:73–9 (1) F '93
— Family
 Am Heritage 44:75,79 (4) F '93
DRESDEN, GERMANY
— Dresden after 1945 bombing
 Trav/Holiday 178:71 (2) S '95
DRINKING CUSTOMS
— 1880s tea time (France)
 Am Heritage 43:58–9 (painting,c,1) F '92
— Bar scene

Sports Illus 79:58–9 (painting,c,1) O 25
 '93
— Businessmen making toast (Vietnam)
 Nat Geog 187:60–1 (c,1) Ap '95
— Child drinking wine (France)
 Nat Geog 181:18 (c,4) F '92
— College students drinking beer (Florida)
 Nat Geog 181:34–5 (c,1) F '92
— Drinking from water fountain
 Sports Illus 77:31 (c,3) Jl 13 '92
— Dublin pubs, Ireland
 Trav/Holiday 177:78–82 (c,2) S '94
— Fishermen drinking beer (Japan)
 Nat Geog 185:108–9 (c,1) Ja '94
— International problem of alcoholism
 Nat Geog 181:2–36 (c,1) F '92
— Kava ceremony (Fiji)
 Nat Geog 188:134 (c,3) O '95
— Medieval monk drinking wine (China)
 Natur Hist 105:48–9 (painting,c,1) Jl '96
— Men in formal wear performing toast
 Sports Illus 80:70–1 (c,1) Je 27 '94
— Oktoberfest (Munich, Germany)
 Nat Geog 181:10–11 (c,1) F '92
— Opening and pouring wine
 Gourmet 52:96 (c,4) Ja '92
 Gourmet 56:46,48 (drawing,4) O '96
— People drinking wine
 Gourmet 53:28 (c,3) Mr '93
— Pouring coffee
 Gourmet 56:151 (c,1) N '96
— Pulque (Mexico)
 Nat Geog 181:25 (c,4) F '92
— Sitting at outdoor cafe (Spain)
 Nat Geog 181:23 (c,3) Ap '92
— Tea (Great Britain)
 Nat Geog 189:70–1 (c,2) Ap '96
— Tea setting (Scotland)
 Gourmet 52:55 (c,4) Jl '92
— Waiter pouring tea
 Gourmet 56:120 (c,4) O '96
— Wine tasting (Oregon)
 Life 17:91 (c,4) Ap '94
— See also
 ALCOHOLISM
 COFFEEHOUSES
 TAVERNS
DROUGHT
— Destroyed corn crop (South Carolina)
 Life 16:30 (c,2) S '93
— Dried up wetlands (Kansas)
 Nat Geog 182:41 (c,4) O '92
— Painting lawn green during drought
 (California)
 Nat Geog 184:39 (c,1) N 15 '93

— Satellite photos of Missouri during drought
 Nat Wildlife 32:42–3 (c,2) Ap '94
DRUG ABUSE
— 1870 opium smokers (China)
 Natur Hist 102:78 (3) N '93
— Late 19th cent. ads for legal narcotics
 Am Heritage 44:44–5 (c,4) F '93
— Late 19th cent. opium den (Great Britain)
 Natur Hist 102:76 (engraving,4) N '93
— 1880s cocaine jar
 Am Heritage 44:cov. (c,3) F '93
— Early 20th cent. addict shooting up
 Am Heritage 44:47 (4) F '93
— 1937 police burning marijuana (New York)
 Am Heritage 43:120 (3) D '92
— Catching marijuana smuggler (Texas)
 Nat Geog 190:99 (c,3) Ag '96
— Drug-related crime (Connecticut)
 Nat Geog 185:85 (c,3) F '94
— Drug-smuggling apparel (1923)
 Am Heritage 44:56 (4) F '93
— Injecting speedball (Puerto Rico)
 Nat Geog 186:76–7 (c,2) Jl '94
— Junkie shooting up
 Life 19:130 (4) O '96
— Pencils shaped like syringes
 Life 16:26 (c,4) Mr '93
— Police drug searches (Florida)
 Nat Geog 181:102–3 (c,1) Ja '92
— Police burning marijuana (Kentucky)
 Nat Geog 183:122 (c,4) F '93
— "Reefer Madness" movie poster (1936)
 Am Heritage 44:55 (c,3) F '93
— Shooting heroin (Italy)
 Nat Geog 182:108–9 (c,1) D '92
— Smoking marijuana (Ukraine)
 Nat Geog 183:47 (c,4) Mr '93
— See also
 OPIUM
Drug stores. See
 PHARMACIES
DRUGS
— 1950s birth control pills
 Am Heritage 44:45 (4) My '93
— Concocting herbal remedies (Singapore)
 Trav/Holiday 178:57 (c,4) O '95
— Foreign medicine bottles
 Trav&Leisure 24:64 (c,4) Ap '94
— Taxol
 Life 15:71–6 (c,2) My '92
 Natur Hist 101:20 (c,4) S '92
 Life 16:94–5 (c,1) D '93
 Nat Wildlife 33:17 (c,4) Ap '95
— See also
 PHARMACIES

DRUM PLAYING
— At Indian powwow (Virginia)
 Nat Geog 185:111 (c,3) Je '94
— Female rock drummer
 Life 17:52 (2) N '94
— Steel drums (Trinidad)
 Natur Hist 104:34–9 (c,1) F '95
— Street drummer (Memphis, Tennessee)
 Trav&Leisure 26:92 (c,4) N '96
DRUMS
— 1890s Pawnee painted drum
 Am Heritage 43:4 (c,3) O '92
DRY TORTUGAS NATIONAL PARK, FLORIDA
 Life 17:72–6 (map,c,1) Ap '94
DUBAI
— Countryside
 Sports Illus 82:2–3,42–4,53 (c,1) Ja 30 '95
— See also
 ARABIAN DESERT
DUBAI—COSTUME
— Men in burnooses
 Sports Illus 82:2–3 (c,1) Ja 30 '95
DUBLIN, IRELAND
 Nat Geog 186:8–9,17 (c,1) S '94
 Gourmet 55:140–3,208 (map,c,2) D '95
— Dublin after 1916 Easter uprising
 Smithsonian 25:167 (4) N '94
— Dublin pubs
 Trav/Holiday 177:76–83 (map,c,1) S '94
 Gourmet 55:140–3 (c,2) D '95
DU BOIS, W.E.B.
 Am Heritage 45:101 (4) F '94
DUBUFFET, JEAN
 Smithsonian 24:80 (4) Je '93
— "L'Accouchement"
 Trav&Leisure 22:15 (painting,c,4) O '92
— Paintings by him
 Smithsonian 24:78–87 (c,1) Je '93
DUCHAMP, MARCEL
 Smithsonian 24:88 (4) Mr '94
DUCKS
 Natur Hist 101:52–3 (c,2) O '92
— Harlequin ducks
 Nat Geog 184:116–32 (c,1) N '93
 Nat Wildlife 35:35–9 (c,1) D '96
— See also
 CANVASBACKS
 EIDER DUCKS
 GEESE
 MALLARDS
 MERGANSERS
 SWANS
 WOOD DUCKS

DUCKWEED
Nat Wildlife 34:23 (c,1) Je '96
DUELS
— 1837 duel causing Pushkin's death
(U.S.S.R.)
Nat Geog 182:59 (painting,c,4) S '92
DUERO RIVER, SPAIN
Trav&Leisure 23:165,168 (map,c,4) O '93
DUGONGS
— Ancient dugongs
Natur Hist 103:72–3 (painting,c,2) Ap '94
DUKAKIS, MICHAEL
Smithsonian 25:104 (4) O '94
DULLES, JOHN FOSTER
Am Heritage 46:52 (4) N '95
DULUTH, MINNESOTA
Nat Geog 184:76 (c,3) D '93
DUMAS, ALEXANDRE
Smithsonian 27:110–16 (painting,c,3) Jl
'96
— Home (France)
Smithsonian 27:122 (c,4) Jl '96
— Poster for *The Count of Monte Cristo*
Smithsonian 27:111 (c,2) Jl '96
DU MAURIER, GEORGE
Smithsonian 24:111 (4) D '93
— Illustrations from *Trilby* (1894)
Smithsonian 24:118–25 (drawing,4) D '93
DUNCAN, ISADORA
Life 16:25 (4) S '93
DURANT, WILLIAM
Am Heritage 47:18 (4) F '96
DURANTE, JIMMY
Life 15:89 (4) O 30 '92
— Caricature
Am Heritage 46:94 (c,4) D '95
DURER, ALBRECHT
— Painting of St. James (1516)
Smithsonian 24:64 (c,4) F '94
DURHAM, NORTH CAROLINA
Nat Geog 187:136–7 (c,1) Mr '95
— Durham Athletic Park
Sports Illus 79:2–3 (c,1) Ag 16 '93
DUROCHER, LEO
Life 15:94 (4) Ja '92
Sports Illus 77:44 (4) O 5 '92
— Caricature
Smithsonian 27:62 (drawing,c,4) Ag '96
DURYEA BROTHERS
Smithsonian 25:105 (4) S '94
DUST
— Magnified image of dust speck
Life 16:108 (c,2) N '93

DVORAK, ANTONIN
Am Heritage 43:79,85 (2) S '92
DYLAN, BOB
Life 15:cov.,46–7 (c,4) D 1 '92
Life 16:31 (4) Je '93
Life 17:24 (4) Jl '94
Smithsonian 26:131 (2) N '95

–E–

EAGLES
Natur Hist 105:cov.,45–8 (c,1) O '96
— Bald eagles
Nat Wildlife 30:58–9 (c,1) Ap '92
Nat Geog 182:42–55 (c,1) N '92
Nat Geog 185:124 (c,1) F '94
Nat Wildlife 32:23 (c,2) F '94
Trav&Leisure 24:48 (c,4) Ag '94
Nat Wildlife 32:22–3 (c,1) Ag '94
Life 17:50 (c,1) S '94
Nat Geog 187:23 (c,3) Mr '95
Nat Wildlife 33:cov. (c,1) Ap '95
Nat Wildlife 33:43 (painting,c,3) O '95
Nat Wildlife 34:46–9 (c,1) D '95
Nat Wildlife 34:37,50–1 (c,1) F '96
Nat Wildlife 34:20–1 (c,1) Ap '96
Nat Wildlife 34:32 (painting,c,4) Ag '96
— Bald eagles eating salmon
Natur Hist 104:32 (c,4) S '95
— Bald eaglets
Natur Hist 101:55 (c,3) My '92
Nat Geog 182:42–50 (c,1) N '92
Nat Wildlife 31:8 (c,4) Ag '93
— Crowned eagles
Natur Hist 102:42–8 (c,1) Ap '93
Sports Illus 78:93 (c,4) My 3 '93
— Golden eagles
Natur Hist 105:cov. (c,1) O '96
— Harpy eagles
Natur Hist 103:50 (c,4) My '94
Nat Geog 187:40–9 (c,1) F '95
— Hawk eagle
Nat Geog 190:8–9 (c,1) Jl '96
— Martial eagle
Natur Hist 104:78–9 (c,1) N '95
— Steller's eagles
Natur Hist 103:26–33 (c,1) F '94
EAKINS, THOMAS
— "The Biglin Brothers Racing"
Smithsonian 27:90–1 (painting,c,2) Jl '96
— "The Biglin Brothers Turning the Stake"
Sports Illus 85:49 (painting,c,3) Jl 15 '96
EARHART, AMELIA
Life 15:68–70 (1) Ap '92

Life 15:88 (4) O 30 '92
Am Heritage 45:136 (3) My '94
Smithsonian 25:74 (4) Ag '94
EARP, WYATT
— Depicted in movies
Trav&Leisure 24:92–5,145 (4) F '94
— Sites related to Wyatt Earp (Tombstone,
Arizona)
Trav&Leisure 24:92–7,143–5 (c,3) F '94
EARS
— Diagram of ear
Trav/Holiday 179:22 (c,4) Mr '96
EARTH
— Cambrian period fossils
Nat Geog 184:120–36 (c,1) O '93
— Impact of Ice Age Lake Missoula floods
(Northwest)
Smithsonian 26:48–59 (map,c,1) Ap '95
— Kircher's view of Earth's core (1665)
Nat Geog 189:105 (diagram,3) Ja '96
— Ozone hole
Life 15:36–7 (c,4) Ap '92
Natur Hist 103:38 (map,c,4) O '94
— Photos from space
Life 15:cov.,30–7 (c,1) Ap '92
Nat Geog 181:38–9 (c,1) My '92
Nat Wildlife 32:4–9 (c,1) F '94
Nat Geog 190:2–27 (map,c,1) N '96
— Researching Earth's core
Nat Geog 189:100–11 (c,1) Ja '96
— See also
MOON
EARTH—MAPS
— Pacific volcanoes map
Nat Geog 189:111 (c,3) Ja '96
EARTHQUAKES
— Kobe, Japan (1995)
Life 18:40–50 (c,1) Mr '95
Nat Geog 188:112–14 (c,1) Jl '95
— Landers, California (1992)
Nat Geog 187:20–3 (map,c,1) Ap '95
— Los Angles, California (1994)
Nat Geog 187:2–3,8–13 (map,c,1) Ap '95
— Reinforcing building against earthquake
(Oakland, California)
Nat Geog 187:28 (c,4) Ap '95
— San Andreas fault, California
Nat Geog 187:16–19,26–7 (map,c,2) Ap
'95
— Simulated earthquake ride at Universal
Studios, California
Nat Geog 187:6–7 (c,1) Ap '95
EARTHQUAKES—DAMAGE
— 1906 San Francisco earthquake
Life 17:43 (4) Ap '94

— Anaheim Stadium after 1994 earthquake
Sports Illus 80:2–3 (c,1) Ja 24 '94
— Cairo, Egypt (1992)
Nat Geog 183:68–9 (c,1) Ap '93
— Cars crushed in 1994 Los Angeles
earthquake
Life 17:43 (c,4) Ap '94
— Collapsed San Francisco highway (1989)
Am Heritage 43:34 (4) F '92
— Earthquake effects on California land
formation
Nat Geog 187:4–33 (map,c,1) Ap '95
— Earthquake survivor (Russia)
Life 19:20–1 (c,1) Ja '96
— Kobe, Japan (1995)
Life 18:40–50 (c,1) Mr '95
Nat Geog 188:112–33 (map,c,1) Jl '95
— Los Angeles, California (1994)
Life 17:16–22 (c,1) Mr '94
Life 18:22–3 (c,1) Ja '95
Nat Geog 187:8–9 (c,2) Ap '95
— Pagoda split by 1838 earthquake (Burma)
Nat Geog 188:94–5 (c,1) Jl '95
— Ruins of 14th cent. convent (Lisbon,
Portugal)
Trav/Holiday 177:50–1 (c,1) N '94
— San Francisco, California (1989)
Nat Geog 187:31 (c,4) Ap '95
— Site of Yungay, Peru, destroyed by 1970
earthquake
Nat Geog 189:4–5 (c,1) My '96
EARTHWORMS
— Earthworm in robin's mouth
Natur Hist 102:37 (c,1) N '93
EASTER
— Chocolate Easter bilby (Australia)
Natur Hist 105:16 (c,4) Ap '96
— Easter eggs
Nat Wildlife 34:cov.,137 (c,1) Ap '96
EASTER ISLAND
Nat Geog 183:54–79 (map,c,1) Mr '93
EASTER ISLAND—ART
— Stone sculptures
Nat Geog 183:54–5,60 (c,1) Mr '93
EASTER ISLAND—COSTUME
Nat Geog 183:56–78 (c,1) Mr '93
EASTERN U.S.
— Delmarva Peninsula seen from space
Nat Geog 190:26–7 (c,1) N '96
— See also
APPALACHIAN MOUNTAINS
APPALACHIAN TRAIL
CHESAPEAKE BAY
EASTMAN, GEORGE
Natur Hist 102:66 (4) Ja '93

ECHIDNAS
 Nat Wildlife 32:57 (c,4) Ap '94
ECHINODERMS
— Snake star
 Natur Hist 102:64–6 (c,2) Mr '93
— See also
 SAND DOLLARS
 SEA CUCUMBERS
 SEA URCHINS
 STARFISH
ECLIPSES
— Solar eclipses
 Nat Geog 181:30–51 (c,1) My '92
 Trav/Holiday 175:50–5 (c,1) Je '92
 Nat Geog 189:116 (c,4) Ap '96
— Types of eclipses
 Nat Geog 181:40 (c,4) My '92
ECONOMY
— National Debt Sign, New York, New York
 Sports Illus 78:23 (c,4) Mr 1 '93
ECUADOR
 Trav&Leisure 23:116–26 (map,c,1) Ja '93
 Trav/Holiday 176:72–81 (c,1) Je '93
— Chimborazo Volcano
 Nat Geog 185:50–1 (c,1) Mr '94
— Countryside
 Natur Hist 101:72–5 (c,1) Jl '92
— See also
 ANDES MOUNTAINS
 GALAPAGOS ISLANDS
 QUITO
ECUADOR—COSTUME
 Natur Hist 101:74–5 (c,2) Jl '92
 Trav&Leisure 23:116–21 (c,1) Ja '93
 Trav/Holiday 176:72–81 (c,1) Je '93
— Cofan Indians
 Life 16:68–74 (c,1) S '93
Ecuador—History. See
 BOLIVAR, SIMON
ECUADOR—HOUSING
— Hut on stilts
 Nat Wildlife 30:42–3 (c,1) Ap '92
EDDY, MARY BAKER
 Am Heritage 45:102 (4) S '94
EDERLE, GERTRUDE
 Sports Illus 84:64 (c,4) Ap 29 '96
 Smithsonian 27:123 (4) Ap '96
 Nat Geog 190:67 (3) Jl '96
EDINBURGH, SCOTLAND
 Smithsonian 25:44–7 (c,1) D '94
 Gourmet 56:45,54–9 (map,c,1) Ag '96
 Nat Geog 190:9 (c,4) S '96
— Edinburgh Festival
 Smithsonian 25:38–47 (c,1) D '94
 Gourmet 56:56–8 (c,4) S '96

EDISON, THOMAS ALVA
 Smithsonian 26:32 (painting,c,4) D '95
— Edison's lab (Ft. Myers, Florida)
 Trav&Leisure 22:136 (c,4) Mr '92
EDMONTON, ALBERTA
— Edmonton Science and Space Centre
 Smithsonian 27:78 (c,3) My '96
EDUCATION
— Auction school (Missouri)
 Smithsonian 25:40–2 (c,3) Ag '94
— Butler school (Great Britain)
 Life 17:92 (c,4) F '94
— Fishing school (Great Britain)
 Gourmet 55:38–40 (c,2) Jl '95
— Flight attendant training
 Smithsonian 24:88–97 (c,2) F '94
— Fly fishing school (Pennsylvania)
 Nat Geog 189:66–7 (c,1) Ap '96
— French craftsmen apprentice program
 Smithsonian 27:98–109 (c,1) Je '96
— Industrial apprentice training programs
 Smithsonian 23:44–55 (1) Mr '93
— Math education
 Smithsonian 26:114–25 (1) F '96
— Orangutan think tank (Washington, D.C.)
 Smithsonian 27:32–43 (c,1) Je '96
— Rodeo clown school (Louisiana)
 Sports Illus 81:2–3,56–70 (c,1) O 3 '94
— Scuba class (Bonaire)
 Trav&Leisure 26:166–70,202 (c,1) N '96
— Scuba class (Jamaica)
 Trav/Holiday 175:69 (c,4) D '92
 Trav/Holiday 179:64–5 (c,1) D '96
— Teaching man to read
 Nat Geog 184:73 (c,3) Jl '93
 Smithsonian 27:82–3,86 (1) Ag '96
— Training fire fighters
 Life 15:88 (2) Mr '92
 Smithsonian 23:32–5,38 (c,1) My '92
 Nat Geog 182:16–17 (c,1) Jl '92
— Training video game creators
 Smithsonian 27:86–97 (c,1) D '96
— World Championship Wrestling School
 (Atlanta, Georgia)
 Life 18:72–4 (c,1) Ap '95
— See also
 BALLET DANCING—EDUCATION
 CLASSROOMS
 COOKING—EDUCATION
 DANCING—EDUCATION
 MEDICAL EDUCATION
 MILITARY TRAINING
 MUSIC EDUCATION
 SCHOOLS
 SCIENCE EDUCATION

SKIING—EDUCATION
TENNIS—EDUCATION
EDWARD VIII (GREAT BRITAIN)
Life 18:104 (4) Je 5 '95
Life 19:40 (4) O '96
— Caricature
Am Heritage 46:93 (c,2) D '95
EELGRASS
Natur Hist 101:60 (c,4) Ap '92
EELS
Natur Hist 101:88–9 (c,1) O '92
Natur Hist 104:26 (c,4) My '95
Nat Geog 190:93 (c,4) O '96
Natur Hist 105:51 (c,4) N '96
— Electric eels
Smithsonian 24:94,97 (c,1) Ag '93
— Moray eels
Life 15:3 (c,2) S '92
Smithsonian 24:105 (c,2) O '93
Trav/Holiday 177:51 (c,4) F '94
Natur Hist 105:62 (c,4) N '96
Nat Wildlife 35:51 (c,1) D '96
— Wolf eel
Nat Geog 190:76–7 (c,1) N '96
EGGS
— Baby turtle hatching from egg
Smithsonian 24:101 (c,3) Ap '93
— Bird eggs
Natur Hist 101:45–6 (c,4) Ap '92
Nat Geog 183:78,87 (c,4) Je '93
Natur Hist 102:54–5 (c,1) Jl '93
Smithsonian 24:80 (c,4) D '93
Smithsonian 26:102 (c,4) My '95
Natur Hist 104:32–8 (c,1) Jl '95
— Cowbirds
Nat Wildlife 32:40 (c,4) D '93
Natur Hist 105:42 (c,4) Jl '96
— Dinosaur eggs
Nat Geog 189:cov.,96–111 (c,1) My '96
Nat Geog 190:76–7 (c,2) Jl '96
— Duck eggs
Nat Geog 182:36 (c,4) O '92
Nat Wildlife 31:46–7 (c,1) Ag '93
Nat Geog 184:125 (c,4) N '93
— Eagle eggs
Nat Geog 182:44–5 (c,2) N '92
— Easter eggs
Gourmet 56:cov.,137 (c,1) Ap '96
— Fish eggs
Nat Geog 182:106-7 (c,1) Jl '92
Smithsonian 23:60 (c,3) Ag '92
Natur Hist 103:48–9 (c,1) D '94
Nat Geog 188:106–7 (c,1) S '95
— Flea eggs
Smithsonian 26:78 (c,4) Jl '95

— Gavial hatching from egg
Nat Geog 181:19 (c,4) My '92
— Kiwi birds
Natur Hist 102:50–1 (c,1) D '93
— Lilies of the Valley Faberge egg
Am Heritage 47:8 (c,2) F '96
— Lobster eggs
Natur Hist 102:44 (c,4) Jl '93
— Octopus hatchling emerging from egg
Nat Wildlife 30:9 (c,4) Je '92
— Ostrich eggs
Natur Hist 103:84–5 (c,1) Mr '94
— Oviraptorid dinosaur embryo
Natur Hist 104:56–7,61 (c,3) Je '95
— Penguin eggs
Nat Geog 189:56 (c,4) Mr '96
— Salamander eggs
Natur Hist 103:34–5 (c,2) O '94
Nat Wildlife 33:45 (c,4) F '95
— Thrush
Nat Wildlife 32:40 (c,4) D '93
Natur Hist 105:42 (c,4) Jl '96
— Toad eggs
Natur Hist 103:34 (c,4) O '94
— Turtle eggs
Nat Wildlife 30:21 (c,4) Ap '92
Natur Hist 103:40–1 (c,3) D '94
Natur Hist 104:40–1 (c,1) Ag '95
EGRETS
Trav&Leisure 22:134–5 (c,3) Mr '92
Nat Geog 185:16–17,20–3 (c,2) Ap '94
— Cattle egrets
Nat Geog 181:24–5 (c,1) My '92
— Great egrets
Natur Hist 102:76–7 (c,1) Ja '93
Gourmet 55:100–1 (c,1) Ap '95
Nat Wildlife 33:18–19 (c,1) Ap '95
Nat Wildlife 34:63 (c,3) Ap '96
Nat Wildlife 34:2 (c,1) Je '96
— Reddish egret
Natur Hist 101:84–5 (c,1) S '92
— Snowy egret
Nat Wildlife 31:58 (c,4) D '92
Smithsonian 25:96 (painting,c,1) Jl '94
Nat Wildlife 33:58 (c,3) D '94
— White egret
Nat Wildlife 33:47 (painting,c,1) Je '95
EGYPT
Trav/Holiday 175:cov.,50–65 (map,c,1) S
'92
— Abu Simbel Temple figures
Trav/Holiday 175:64 (c,2) S '92
— Fayum badlands
Natur Hist 102:58–9 (c,2) Ap '93
— St. Catherine's Monastery, Mt. Sinai

Trav/Holiday 177:97 (c,3) Ap '94
— Saqqara market
Nat Geog 187:30–1 (c,1) Ja '95
— Temple of Luxor
Trav/Holiday 175:60–1 (c,1) S '92
— See also
ALEXANDRIA
CAIRO
NILE RIVER
SPHINX
EGYPT—COSTUME
Trav/Holiday 175:50–64 (c,1) S '92
— Alexandria
Trav&Leisure 25:169,183–6 (c,1) S '95
— Blind musicians
Natur Hist 104:cov.,34–43 (1) N '95
— Cairo
Nat Geog 183:38–69 (c,1) Ap '93
— Camel driver
Natur Hist 101:56 (c,4) O '92
— Woman
Life 15:14 (c,1) S '92
EGYPT—HISTORY
— Hosni Mubarak
Nat Geog 183:46 (c,4) Ap '93
Life 18:15 (1) N '95
— See also
SADAT, ANWAR
EGYPT—MAPS
— Gold map on Faberge cigarette case
Smithsonian 26:85 (c,4) Mr '96
EGYPT, ANCIENT
— Daily life
Nat Geog 187:2–43 (map,c,1) Ja '95
— Queen Hatshepsut
Natur Hist 101:58–9 (carving,1) Jl '92
— Statues of the Pharaohs
Nat Geog 187:3,6,26–7,43 (c,1) Ja '95
— See also
CLEOPATRA
MUMMIES
RAMSES II
TUTANKHAMUN
EGYPT, ANCIENT—ARCHITECTURE
— Luxor
Trav&Leisure 23:60 (c,4) Je '93
— Pharos of Alexandria
Life 19:72 (drawing,c,4) Ap '96
— Valley of the Kings tomb
Life 19:3 (c,2) Ja '96
— See also
PYRAMIDS
TEMPLES—ANCIENT
EGYPT, ANCIENT—ART
— Depictions of hunting

Natur Hist 101:50–1,56–9 (c,1) Jl '92
— Glass head of Amenhotep II
Nat Geog 184:45 (c,4) D '93
— Mummy portraits
Smithsonian 26:134–9 (c,1) N '95
— Sekhmet sculpture
Natur Hist 104:82 (3) Ap '95
— See also
SPHINX
EGYPT, ANCIENT—ARTIFACTS
Nat Geog 187:2–43 (c,1) Ja '95
— Underwater dig (Alexandria)
Life 19:70–4 (c,1) Ap '96
EIDER DUCKS
Nat Wildlife 33:43 (c,1) Je '95
EIFFEL TOWER, PARIS, FRANCE
Gourmet 54:66 (painting,c,4) Ap '94
Sports Illus 81:38 (c,3) Ag 1 '94
— View from Eiffel Tower restaurant
Gourmet 56:102 (c,2) Ap '96
EINSTEIN, ALBERT
Life 17:67 (4) Jl '94
Trav/Holiday 178:131 (4) Ap '95
Life 19:69 (2) Ap '96
— Original text of Theory of Relativity
Life 18:36 (4) D '95
EISENHOWER, DWIGHT DAVID
Am Heritage 46:112 (3) My '95
Life 18:72–3 (1) Je 5 '95
Am Heritage 47:79 (4) F '96
— At 1952 Republican convention (Chicago, Illinois)
Smithsonian 27:43 (2) N '96
— Eisenhower throwing out first baseball of season (1960)
Sports Illus 78:2–3 (1) Ap 12 '93
— Mamie Eisenhower
Smithsonian 23:148 (4) O '92
Life 15:83,89 (c,4) O 30 '92
Life 19:80 (c,3) S '96
Life 19:32 (c,4) N '96
EISENSTAEDT, ALFRED
Life 15:78 (4) F '92
Life 16:116 (2) D '93
Life 18:106 (2) O '95
Life 19:102 (4) Ja '96
— 1926 photo of tennis player
Sports Illus 83:24 (4) S 4 '95
— 1945 photo of V-J Day Times Square kiss
Life 19:94 (3) O '96
— Photos by him
Life 18:9,100–5 (1) O '95
EL GRECO
— "Adoration of the Shepherds"
Trav&Leisure 23:80 (painting,c,2) Jl '93

EL PASO, TEXAS
Trav/Holiday 176:88–97 (map,c,1) F '93
Nat Geog 189:48 (c,1) F '96
Trav&Leisure 26:58–62 (c,4) N '96
— Seen from Mexican slum
Nat Geog 184:86–7 (c,1) N 15 '93
EL SALVADOR
Nat Geog 188:108–31 (map,c,1) S '95
— See also
SAN SALVADOR
EL SALVADOR—COSTUME
Nat Geog 188:108–31 (c,1) S '95
EL SALVADOR—POLITICS AND GOVERNMENT
— Maimed survivors of war
Nat Geog 188:108–9,130–1 (c,1) S '95
ELECTIONS
— 19th cent. paper ballots
Am Heritage 43:54–7 (c,4) S '92
— Black man voting (South Africa)
Life 18:26–7 (c,1) Ja '95
— Blacks voting in 1860s election (Louisiana)
Smithsonian 24:106 (woodcut,4) F '94
— Cambodia
Life 16:14–15 (c,1) Ag '93
— Small town (Massachusetts)
Nat Geog 181:124–5 (c,2) Je '92
— See also
POLITICAL CAMPAIGNS
ELECTRICITY
— Human antenna
Life 17:134 (c,2) N '94
— Static electricity generator exhibit at museum (Boston, Massachusetts)
Nat Geog 184:86–7 (c,1) Jl '93
— See also
EDISON, THOMAS ALVA
ELECTRONICS
— 1940s amplifier used in inventing transistor
Smithsonian 27:25 (c,4) Ag '96
— "Clean room" clothing (North Carolina)
Nat Geog 187:127 (c,4) Mr '95
— Future of information technology
Nat Geog 188:2–37 (c,1) O '95
— Laying transatlantic cable (1866)
Smithsonian 25:72–3 (painting,c,4) N '94
— Microchip factory (Taiwan)
Nat Geog 184:15 (c,3) N '93
— Silicon chips
Life 19:84–90 (c,1) N '96
— See also
CALCULATORS
COMPUTERS
HEADPHONES

PHONOGRAPHS
ROBOTS
SATELLITE DISHES
ELEPHANTS
Nat Geog 181:68–73 (c,1) Ja '92
Natur Hist 101:26–7 (c,1) F '92
Trav&Leisure 22:132 (c,1) Je '92
Trav/Holiday 175:65 (c,4) N '92
Natur Hist 101:84–5 (c,1) N '92
Trav&Leisure 22:47,50,90–1,140 (c,1) N '92
Smithsonian 23:157 (painting,c,4) D '92
Trav&Leisure 22:128–9 (c,1) D '92
Natur Hist 102:91 (c,4) Mr '93
Natur Hist 102:cov. (c,1) Ag '93
Trav/Holiday 177:92 (c,4) Mr '94
Smithsonian 25:21 (c,4) My '94
Gourmet 55:74–5 (c,1) Ja '95
Smithsonian 26:28 (c,4) Ap '95
Life 18:68–9 (c,1) My '95
Nat Geog 188:cov.,14–15,22–4 (c,1) Jl '95
Natur Hist 104:cov.,52–61 (c,1) Jl '95
Life 18:88 (c,2) S '95
Sports Illus 84:60 (c,1) Ja 29 '96
Smithsonian 27:109 (c,2) My '96
Nat Geog 190:14–19 (c,1) Jl '96
Trav/Holiday 179:40 (c,4) Jl '96
— Attacked by lions
Nat Geog 186:42–3 (c,1) Ag '94
— Calves playing
Nat Geog 186:10–11 (c,1) D '94
— Childlike drawing of elephant
Gourmet 55:58 (c,2) S '95
— Culled elephant hanging upside-down (South Africa)
Nat Geog 190:14–15 (c,1) Jl '96
— Elephant calf
Nat Geog 181:29 (c,1) My '92
— Elephant moving logs (Burma)
Nat Geog 188:92–3 (c,1) Jl '95
— Elephant swimming
Life 18:12–13 (c,1) Ap '95
— Elephant watch tower on farm (Indonesia)
Natur Hist 104:57 (c,4) Jl '95
— Photo safari on elephants (Nepal)
Trav/Holiday 175:20 (c,3) O '92
— Riding on elephants (Botswana)
Trav&Leisure 22:90–1 (c,1) N '92
— Riding on elephants (Thailand)
Trav&Leisure 22:47 (c,3) N '92
— Tourists riding on elephants (India)
Nat Geog 181:26–7 (c,2) My '92
— Tourists riding on elephants (Thailand)
Nat Geog 189:102–3 (c,1) F '96
— Training elephants (Thailand)

Trav/Holiday 179:49 (c,2) Ap '96
— Two elephants nuzzling
Life 15:3 (2) Ap '92
ELIZABETH I (GREAT BRITAIN)
Smithsonian 23:120 (painting,c,4) Ja '93
ELIZABETH II (GREAT BRITAIN)
Life 15:58–67 (c,1) My '92
Trav&Leisure 22:24 (4) Mr '92
Gourmet 52:32 (drawing,c,2) Ag '92
Life 16:3 (c,2) F '93
Life 16:22 (c,4) Jl '93
Trav/Holiday 177:74 (drawing,c,1) Ap '94
— 1953 coronation
Life 17:38 (2) Je '94
ELKS
Trav/Holiday 175:cov. (c,1) Je '92
Nat Wildlife 30:2–3 (c,2) Ag '92
Smithsonian 23:114 (c,4) N '92
Nat Wildlife 31:10–11,54–5 (c,1) O '93
Natur Hist 102:67 (c,4) N '93
Nat Wildlife 32:52–3 (c,1) F '94
Nat Wildlife 32:6–7 (c,1) O '94
Nat Geog 187:130–1 (c,2) F '95
Trav/Holiday 178:24 (c,4) Ap '95
Nat Wildlife 33:52–3 (c,1) O '95
Nat Geog 190:20–1 (c,2) O '96
Nat Wildlife 34:31 (c,1) O '96
Nat Geog 190:100–1 (c,2) N '96
— Aerial view of herd
Life 17:72–3 (c,1) Ag '94
— Ancient Irish elk
Natur Hist 103:68–9 (painting,c,1) Ap '94
— Roosevelt elk
Trav/Holiday 177:87 (4) Ap '94
ELLINGTON, DUKE
Smithsonian 24:62–74 (2) My '93
Smithsonian 24:14 (4) D '93
Am Heritage 46:78–9 (painting,c,1) O '95
Am Heritage 47:77 (4) S '96
ELLISON, RALPH
Life 18:88 (3) Ja '95
Am Heritage 47:75 (c,4) S '96
ELM TREES
Smithsonian 27:110–11 (c,1) O '96
EMERSON, RALPH WALDO
Life 15:25 (4) F '92
Am Heritage 46:133 (4) Ap '95
Am Heritage 46:86 (4) S '95
EMOTIONS
— Face going through many expressions
Sports Illus 76:37 (c,4) F 10 '92
— Gizmo to produce forced smile (Norway)
Life 17:30 (c,4) F '94
— Returning U.S. soldier kissing ground
(1945)

Life 18:74–5 (1) Je 5 '95
— See also
CRYING
GRIEF
ROMANCE
SHOCK
TERROR
**EMPIRE STATE BUILDING, NEW
YORK CITY, NEW YORK**
Am Heritage 47:cov. (c,1) Ap '96
— Putting colored lights on Empire State
Building
Trav&Leisure 24:149 (c,1) Jl '94
— View from Empire State Building
Life 19:20 (c,3) N '96
EMUS
— Emu legs
Nat Geog 187:89 (c,1) Ja '95
ENERGY
— Wind turbines (California)
Life 19:66–7 (c,3) Ag '96
— See also
ELECTRICITY
NUCLEAR ENERGY
NUCLEAR POWER PLANTS
OIL INDUSTRY
POWER PLANTS
WIND
WINDMILLS
ENERGY SHORTAGE
— 1970s "No Gas" sign at gas station
Life 19:100 (c,2) Winter '96
— 1973 line at gas pump (New York)
Life 16:28 (2) D '93
ENGLISH CHANNEL
— History of swimming English Channel
Smithsonian 27:118–29 (c,1) Ap '96
ENTERTAINERS
— Mid 19th cent. mime Charles Deburau
Smithsonian 26:72–3 (4) My '95
— Late 19th cent. showgirl (Kansas)
Life 16:86 (4) Ap 5 '93
— Abbott and Costello
Life 18:34 (c,4) Mr '95
Sports Illus 85:88 (4) O 14 '96
— Edgar Bergen
Smithsonian 24:cov. (c,1) D '93
— Cab Calloway
Life 18:96 (3) Ja '95
— Eddie Cantor
Smithsonian 27:50 (caricature,c,4) N '96
— Caricatures of 1938 radio personalities
Am Heritage 46:96–7 (c,1) D '95
— Dog walking on rope
Life 16:76–7 (c,1) S '93

— Female impersonator Julian Eltinge
Smithsonian 22:84 (4) F '92
— Female impersonators
Trav&Leisure 22:E2 (c,4) Mr '92
— Las Vegas showgirl, Nevada
Life 16:86–7 (c,1) Ap 5 '93
— Gypsy Rose Lee
Smithsonian 23:141 (4) Je '92
— Shari Lewis
Smithsonian 24:64 (c,4) D '93
— Human statue (Spain)
Sports Illus 77:65 (c,4) Ag 17 '92
— Performing chimpanzees
Nat Geog 181:8–9,36–9 (c,1) Mr '92
— Singer being made up for TV appearance
Life 15:56–7 (c,1) Jl '92
— Street performer with dancing bear (India)
Smithsonian 23:116 (c,4) My '92
— Stripper (Louisiana)
Nat Geog 187:113 (c,1) Ja '95
— Transvestite (Thailand)
Nat Geog 189:105 (c,1) F '96
— Ventriloquists and their dummies
Smithsonian 24:cov.,56–67 (c,1) D '93
— Lawrence Welk
Life 16:88 (2) Ja '93
— Jonathan Winters
Life 19:62–3 (c,1) D '96
— See also
BENNY, JACK
BRICE, FANNY
BURNS, GEORGE
CARSON, JOHNNY
CHAPLIN, CHARLIE
CLOWNS
COHAN, GEORGE M.
DURANTE, JIMMY
FIELDS, W.C.
HARDY, OLIVER
HOPE, BOB
HOUDINI, HARRY
KEATON, BUSTER
LAUREL, STAN
MAGICIANS
MARX, GROUCHO
MARX BROTHERS
PUPPETS
ROGERS, WILL
SINGERS
ZIEGFELD, FLORENZ
ENVIRONMENT
— Battle to ban carofuran pesticide
Nat Wildlife 30:38–41 (c,1) Je '92
— Belize environmental awareness efforts
Smithsonian 25:84–92 (c,2) My '94
— Biosphere 2, Arizona
Trav&Leisure 22:21 (c,4) Ap '92
Smithsonian 25:16 (c,4) My '94
Sports Illus 84:195 (c,4) Ja 29 '96
— Earth Day 1970
Am Heritage 44:46 (c,4) O '93
Nat Geog 187:124 (c,4) Ap '95
— Global warming cartoon showing a
tropical New York City
Natur Hist 101:18 (4) Ap '92
— Grass roots environmental efforts
Nat Geog 187:122–38 (c,1) Ap '95
— Remains of forest surrounded by urban life
Natur Hist 101:6 (cartoon,c,3) Ag '92
— See also
DEMONSTRATIONS
OIL SPILLS
OZONE
POLLUTION
RECYCLING
ENVIRONMENT—HUMOR
— Using bacteria to clean up toxic messes
Smithsonian 24:66–76 (painting,c,1) Ap
'93
Environmentalists. See
CARSON, RACHEL
NATURALISTS
EQUESTRIAN EVENTS
— 1936 hurdle race (Australia)
Nat Geog 190:66–7 (1) Jl '96
— 1956 royal horse landing on stomach
(Aintree, England)
Sports Illus 79:108 (4) N 15 '93
— Accident at steeplechase (Aintree, England)
Life 19:12–13 (c,1) Je '96
— Mule training for equestrian events
Sports Illus 78:82–4 (c,4) My 17 '93
ERIE CANAL, NEW YORK
Smithsonian 24:51 (c,1) F '94
Smithsonian 27:58 (c,4) O '96
— Bushnell Basin
Trav&Leisure 25:E12 (c,3) S '95
ERITREA
Nat Geog 184:96–8,116–17 (map,c,1) Ag
'93
Nat Geog 189:82–105 (map,c,1) Je '96
— Asmara
Nat Geog 189:86 (c,3) Je '96
ERITREA—COSTUME
Nat Geog 184:96–7,116 (c,4) Ag '93
Natur Hist 104:76 (4) F '95
Nat Geog 189:82–105 (c,1) Je '96
ERMINES
Natur Hist 102:50 (C,1) F '93

ERVING, JULIUS
Sports Illus 79:78–9 (1) N 8 '93
— Julius Erving mural (Philadelphia, Pennsylvania)
Smithsonian 24:69 (c,4) Jl '93
Eskimos (Alaska)—Artifacts. See
KAYAKS
UMIAKS
ESKIMOS (ALASKA)—COSTUME
Life 19:64–5 (2) S '96
ESKIMOS (ALASKA)—HOUSING
— 1899 Eskimo hut
Natur Hist 104:69 (4) Jl '95
— See also
IGLOOS
ESKIMOS (CANADA)
— 16th cent. Inuits
Smithsonian 23:122 (painting,c,4) Ja '93
ESKIMOS (CANADA)—ARTIFACTS
— Stone figures
Natur Hist 104:56–63 (c,1) Ja '95
Estonia. See
TALLINN
ETHIOPIA
Trav&Leisure 23:104–9,158 (map,c,1) O '93
— Farms
Nat Geog 184:94–5,112–13 (c,1) Ag '93
— Hadar
Nat Geog 189:98–115 (map,c,1) Mr '96
— See also
ADDIS ABABA
ETHIOPIA—COSTUME
Nat Geog 184:94–5,113–15 (c,1) Ag '93
Sports Illus 83:78–95 (1) D 4 '95
— Amhara people fording river
Trav&Leisure 23:109 (c,2) O '93
— Woman with ear spindles
Trav&Leisure 23:105–6 (c,1) O '93
ETHIOPIA—SOCIAL LIFE AND CUS-TOMS
— Family life
Life 17:57 (c,4) Jl '94
ETRUSCAN CIVILIZATION—ART
— 2500-year-old bronze Amazon warrior (Italy)
Natur Hist 101:cov. (c,1) Jl '92
EUCALYPTUS TREES
Trav&Leisure 26:61 (c,1) Jl '96
EUROPE
Trav&Leisure 24:1–18 (c,1) Mr '94 supp.
Trav&Leisure 25:1–28 (c,1) Mr '95 supp.
Trav/Holiday 178:cov.,45–88 (map,c,1) Ap '95

— European landmarks in sand sculpture (Netherlands)
Life 15:24 (c,4) Ag '92
— Flood of immigrants to Western Europe
Nat Geog 183:94–125 (c,1) My '93
— Souvenirs of 1950s European travel
Gourmet 53:108–10 (c,2) F '93
— See also
ALPS
DANUBE RIVER
MEDITERRANEAN SEA
RHINE RIVER
EUROPE—HISTORY
— 18th cent. British travelers doing "The Grand Tour"
Trav/Holiday 178:46–51 (map,c,1) Ap '95
— History of Hanseatic League (14th–17th cents.)
Nat Geog 186:56–79 (map,c,1) O '94
— See also
MIDDLE AGES
WORLD WAR I
WORLD WAR II
EVANS, OLIVER
Am Heritage 43:18 (drawing,4) O '92
EVANS, WALKER
— "Church Organ, Alabama" (1936)
Smithsonian 23:83 (4) Ja '93
— Photo of 1936 roadside stand (Alabama)
Am Heritage 45:126 (4) D '94
EVERGLADES NATIONAL PARK, FLORIDA
Nat Geog 185:cov.,2–35 (map,c,1) Ap '94
Trav&Leisure 24:8,100–9,140 (map,c,1) Ap '94
Sports Illus 83:76–87 (map,c,1) S 18 '95
Life 18:60–6 (c,1) S '95
— Everglades after Hurricane Andrew (1992)
Trav/Holiday 175:20 (c,4) D '92
— Field covered with spider webs
Natur Hist 104:53 (c,1) Mr '95
EVERS, MEDGAR
— Wife Myrlie
Life 18:18 (c,2) Ag '95
EVOLUTION
Natur Hist 103:entire issue (c,1) Je '94
— 1925 anti-evolution drawings
Am Heritage 45:106–7 (4) N '94
— 1925 Scopes trial (Tennessee)
Am Heritage 45:110 (4) N '94
Natur Hist 105:74–5 (2) Ap '96
— Anti-evolutionist George McCready Price
Am Heritage 45:107 (4) N '94
— Dinosaur evolution chart
Nat Geog 183:18–20 (c,1) Ja '93

— See also
DARWIN, CHARLES
EXERCISING
— At spas
Gourmet 56:79–108 (c,4) My '96
— Baseball player squeezing rice
Nat Geog 185:74–5 (c,1) My '94
— Bench pressing
Sports Illus 84:34 (c,2) F 12 '96
— Boxercise class
Gourmet 56:88,108 (c,4) My '96
— Chinese police playing leapfrog
Life 16:18 (c,2) Mr '93
— Exercise class (California)
Trav&Leisure 24:96 (c,4) Ja '94
— Hanging upside-down in doorway
Sports Illus 84:60 (c,3) Je 24 '96
— Pull-ups on bar at beach (Brazil)
Trav&Leisure 23:cov. (c,1) N '93
— Ski machine
Sports Illus 78:44 (c,3) Ja 18 '93
— Stretching in park (Vietnam)
Trav&Leisure 23:103 (c,1) Ap '93
— Trainer stretching athlete's leg
Sports Illus 81:44–5 (c,1) O 3 '94
— See also
CALISTHENICS
WEIGHT LIFTING
YOGA
EXERCISING EQUIPMENT
— Exercise bike
Sports Illus 80:61 (c,4) Ja 31 '94
Sports Illus 82:2–3 (c,1) Ja 23 '95
— Health club (Paris, France)
Trav&Leisure 25:48 (c,4) Mr '95
— Makeshift equipment (Ukraine)
Nat Geog 183:52–3 (c,1) Mr '93
— Treadmill
Trav&Leisure 25:58 (c,4) N '95
— Virtual reality exercise bike
Sports Illus 81:6 (c,4) S 19 '94
EXPLORATION
— 13th cent. travels of Marco Polo
Trav/Holiday 175:64–74 (map,c,1) My '92
— 15th cent. Portuguese expeditions
Nat Geog 182:56–93 (map,c,1) N '92
— 1804 Lewis & Clark route (Western U.S.)
Trav/Holiday 177:39,68–77 (map,c,1) Je '94
— 1909 expedition of Mary Hastings Bradley (Uganda)
Natur Hist 102:78–9 (2) D '93
— Captain Cook's ship "Endeavor" (1768)
Natur Hist 102:68 (engraving,4) My '93

— Southwestern scenes along 1869 route of explorer John Wesley Powell
Nat Geog 185:86–115 (map,c,1) Ap '94
— See also
ANTARCTIC EXPEDITIONS
ARCTIC EXPEDITIONS
EXPLORERS
— Joseph Banks
Nat Geog 190:29 (painting,c,1) N '96
— Dr. Frederick Look
Sports Illus 83:7 (4) N 13 '95
— John Wesley Powell
Nat Geog 185:89–115 (c,1) Ap '94
— See also
COLUMBUS, CHRISTOPHER
COOK, JAMES
CORTES, HERNAN
DA GAMA, VASCO
FREMONT, JOHN C.
FROBISHER, MARTIN
HEYERDAHL, THOR
HILLARY, EDMUND
LEWIS AND CLARK
PIZARRO, FRANCISCO
POLO, MARCO
SACAGAWEA
SCOTT, ROBERT FALCON
EXPLOSIONS
— 1946 atom bomb test (Bikini)
Nat Geog 181:74–5 (2) Je '92
— Civil War artillery shell exploding
Am Heritage 43:32 (drawing,4) Jl '92
EYES
Nat Geog 182:cov.,2–39 (c,1) N '92
— Checking eye for mercury damage (Quebec)
Nat Geog 184:75 (c,3) N 15 '93
— Eye surgery
Nat Geog 182:2–3,6–7,25–7,38–9 (c,1) N '92
— Fake eyes for dolls
Life 16:106 (c,2) D '93
— Human eye
Nat Wildlife 32:10 (c,4) D '93
— Night reflections of alligators' eyes
Life 15:6–7 (c,1) F '92
— Photorefractive keratectomy
Life 16:102 (2) Jl '93
— Red eye of tree frog
Nat Wildlife 33:37 (c,4) Ag '95
— Sight research
Nat Geog 182:cov.,2–39 (c,1) N '92
— See also
BLINDNESS

–F–

FABERGE, CARL
— Early 20th cent. Faberge cigarette cases
Smithsonian 26:84–7 (c,1) Mr '96
— Lilies of the Valley Faberge egg
Am Heritage 47:8 (c,2) F '96
FACTORIES
— 19th cent. textile mill (Yorkshire, England)
Smithsonian 24:147 (drawing,4) Ap '93
— 1855 whale oil refinery (Massachusetts)
Am Heritage 44:100–1 (painting,c,1) F '93
— Early 20th cent. automobile plants
designed by Albert Kahn
Smithsonian 25:48–59 (c,1) S '94
— Aluminum smelting plant (Canada)
Nat Geog 185:26 (c,3) Je '94
— Bauxite processing plant (Australia)
Nat Geog 189:12 (c,4) Je '96
— Cellulose plant (Siberia)
Nat Geog 181:17 (c,3) Je '92
— Knight Foundry, Sutter Creek, California
Smithsonian 27:56 (c,4) S '96
— Petrochemical plant (Louisiana)
Nat Geog 182:14–15 (c,1) Jl '92
Smithsonian 23:48 (c,3) F '93
Nat Geog 184:102–3 (c,1) N 15 '93
— Steel plant (Russia)
Nat Geog 183:9 (c,4) Mr '93
— See also
MANUFACTURING
MILLS
SAWMILLS
FACTORY WORKERS
— 1953 (U.S.S.R.)
Life 15:92–3 (1) Jl '92
— Connecticut
Nat Geog 185:82–3 (c,1) F '94
— Mexico
Nat Geog 189:60–1 (c,3) F '96
— U.S.S.R.
Nat Geog 186:94–5 (c,1) Ag '94
Nat Geog 190:64–5 (c,1) O '96
FADS
— 1940s-style night life (San Francisco,
California)
Trav/Holiday 179:102–7 (c,1) D '96
— 1946 college students crowding into phone
booth (California)
Life 19:126 (4) O '96
— Adults blowing bubbles (1945)
Life 18:102 (4) Je 5 '95
— Basketball fans doing The Wave
Sports Illus 77:18–19 (c,1) D 14 '92

Sports Illus 82:46–7 (c,1) F 27 '95
— Hippopotamus fad in mid-19th cent.
England
Natur Hist 102:34–9 (c,1) F '93
— Humorous look at dieting
Smithsonian 25:146–56 (drawing,c,1) N
'94
— Teenage Mutant Ninja Turtles fad
Smithsonian 23:98–107 (c,2) D '92
FAEROE ISLANDS, DENMARK
Natur Hist 104:26–33,64 (map,c,1) N '95
FAIRBANKS, ALASKA
— Alaskaland amusement park
Natur Hist 102:68–9,62 (c,2) My '93
FAIRS
— 1893 World Columbian Exposition
(Chicago, Illinois)
Am Heritage 44:111 (2) My '93
Smithsonian 24:38–51 (c,1) Je '93
Am Heritage 44:70–87 (c,1) Jl '93
Smithsonian 24:26–8 (c,4) O '93
— 1939 World's Fair map (New York)
Smithsonian 23:114 (c,4) F '93
— 1964 World's Fair panorama model of
New York City
Am Heritage 47:70–8 (c,1) D '96
— County fair ribbons (Pennsylvania)
Life 18:8–9 (1) S '95
— Iowa State Fair
Trav/Holiday 178:48–55 (c,1) Je '95
— Model of 1876 Philadelphia Centennial
Exhibition fairgrounds
Am Heritage 47:74 (3) D '96
— Roswell, New Mexico
Nat Geog 184:60–1 (c,1) S '93
FALCONS
Sports Illus 82:10–11 (c,4) Ja 23 '95
— Chicks
Nat Wildlife 34:17 (4) D '95
Nat Wildlife 34:39 (c,1) O '96
— Gyrfalcons
Natur Hist 105:61 (c,4) Je '96
— Peregrine
Life 15:44 (c,3) Mr '92
Nat Wildlife 30:58 (c,4) Ap '92
Am Heritage 44:114 (c,4) O '93
Nat Wildlife 33:44–5 (c,1) Ap '95
Nat Wildlife 34:36–41 (c,1) O '96
Natur Hist 105:49–50 (c,4) O '96
— Peregrine falcons on New York City
skyscrapers
Life 18:18–19 (1) O '95
— See also
HAWKS

FALKLAND ISLANDS
— Countryside
Natur Hist 102:50 (c,3) Ag '93
FAMILIES
— 1890s affluent black family
Am Heritage 46:cov. (1) F '95 supp.
— Early 20th cent. prominent black family
(North Carolina)
Smithsonian 24:153 (4) O '93
Am Heritage 44:73 (1) O '93
— 1906 family (Pennsylvania)
Am Heritage 43:117 (4) D '92
— 1951 portrait of wealthy family
(Massachusetts)
Life 16:84–5 (1) Je '93
— 1957 family (Rhode Island)
Am Heritage 45:112 (c,3) S '94
— Descendants of Italian immigrant (New
York)
Life 18:84–5 (c,1) O '95
— Family reunions
Nat Geog 183:134–5 (c,1) F '93
Life 17:78–9 (1) N '94
Trav/Holiday 178:66–73 (c,1) My '95
Smithsonian 27:66–75 (c,1) Ag '96
— Four generations (Georgia)
Smithsonian 27:74–5 (c,1) Ag '96
— Georgia, U.S.S.R.
Nat Geog 181:108–9 (c,1) My '92
— History of prominent black family, the
Delanys
Smithsonian 24:145–64 (2) O '93
— Homeless family (California)
Life 18:86–98 (1) My '95
— Portraits of a family over 40 years
Life 17:115 (4) Je '94
— Reunion of Vietnamese family (Indiana)
Life 17:-3644 (c,1) Jl '94
— Suya Indian family (Brazil)
Smithsonian 27:72 (c,3) My '96
FAMILY LIFE
— 1912 backyard scene (Missouri)
Am Heritage 45:112 (3) Jl '94
— 1950s family watching television
Am Heritage 44:114 (sculpture,c,4) D '93
— 1951 family at drive-in movie
Life 19:84–5 (1) Winter '96
— American woman adopting Chinese baby
Life 19:27–34 (c,2) My '96
— Arrest of abusive father
Life 15:4 (4) Ap '92
— Arthur Ashe and his daughter
Life 16:61–8 (2) N '93
— Baby holding gun (California)
Life 17:12–13 (1) Ap '94

— Caring for aging mother (California)
Life 16:cov.,28–36 (1) Ag '93
— Children's messy toy-strewn bedroom
(Pennsylvania)
Life 15:12–13 (1) Jl '92
— Families around the world
Life 17:54–61 (c,1) Jl '94
— Family canoe vacation (Minnesota)
Trav&Leisure 22:124–33 (c,1) My '92
— Family driving on vacation
Trav/Holiday 176:cov.,33 (c,1) Jl '93
— Family vacation at ranch (Colorado)
Trav/Holiday 176:68–76 (c,1) Jl '93
— Father and son asleep on bed
Sports Illus 80:2–3 (c,1) My 2 '94
— Father dancing with daughter in kitchen
Smithsonian 22:62 (3) F '92
— Father "flying" son in air
Life 18:12–13 (c,1) Jl '95
— Father giving piggyback ride (Texas)
Sports Illus 81:53 (c,2) D 12 '94
— Fathers with toddlers
Sports Illus 80:33–5 (c,1) Mr 14 '94
— Grandfather roughhousing with children
(Florida)
Sports Illus 79:60–1 (c,1) Jl 26 '93
— Home with twelve children
Sports Illus 78:32–6 (c,1) Ap 26 '93
— Huge four-generation family living
together (Pennsylvania)
Life 19:52–61 (1) Ag '96
— Mother with headache surrounded by noisy
children
Life 17:68–9 (c,1) F '94
— Urban backyard in summer (New Jersey)
Sports Illus 77:96–7 (c,1) N 23 '92
— Washing the car (1958)
Life 19:95 (3) Winter '96
— Welfare mother studying at college
(Massachusetts)
Life 15:60–6 (c,1) Ap '92
— Woman caring for sick babies
Life 15:49–56 (1) My '92
— See also
BABIES
CHILDREN
LIFESTYLES
FANS
— 1800 (Japan)
Natur Hist 102:61 (painting,c,2) Ag '93
— 1803 (France)
Smithsonian 23:115 (c,4) F '93
— 1805 shoofly fan over diving roomtable
(Louisiana)
Trav&Leisure 26:118 (c,1) Ap '96

— Collection of fanciful fans
 Life 16:16–17 (c,1) My '93
— Dog relaxing in front of electric fan
 Life 19:31 (4) Jl '96
— Sally Rand, fan dancer
 Am Heritage 43:26 (4) Ap '92
Fans, sports. See
 SPECTATORS
FARM LIFE
— 1945 (Kansas)
 Life 18:152 (2) Je 5 '95
— Farm animals
 Life 17:30–40 (c,3) N '94
— Farm auction (Indiana)
 Smithsonian 25:38–47 (c,1) Ag '94
— Feeding chickens (Germany)
 Trav&Leisure 24:116 (1) F '94
— Life of a rural veterinarian (Illinois)
 Life 15:64–70 (c,1) O '92
— Pennsylvania
 Nat Geog 185:54–9 (c,1) Je '94
— Raising chickens (Spain)
 Smithsonian 24:69 (c,3) F '94
— Ukraine
 Smithsonian 23:62–76 (c,2) D '92
— See also
 DAIRYING
FARM MACHINERY
— Fumigating machine
 Smithsonian 27:40–1 (c,1) D '96
— Museum of old farm machinery (Kinzers,
 Pennsylvania)
 Smithsonian 26:90–1 (c,1) Ap '95
— See also
 COMBINES
FARM WORKERS
— 1936 sharecropper (Mississippi)
 Life 19:30 (1) O '96
— Female farm workers napping (Japan)
 Nat Geog 186:68–9 (c,1) S '94
— Fiji
 Nat Geog 188:126–7 (c,1) O '95
— Georgia, U.S.S.R.
 Nat Geog 181:4–5 (c,1) F '92
— Italy
 Nat Geog 183:96–7 (c,1) My '93
— Mexico
 Nat Geog 186:58 (c,3) S '94
— Migrant workers (California)
 Trav/Holiday 179:92 (c,3) D '96
— Picking oranges (California)
 Nat Geog 184:64–5 (c,1) Jl '93
— Spain
 Nat Geog 188:87 (c,3) N '95
— Sugarcane cutters (El Salvador)

Nat Geog 188:124–5 (c,1) S '95
— Terrace farming (Peru)
 Nat Geog 181:113 (c,1) F '92
— Yemen
 Life 16:18 (c,2) S '93
FARMERS
— Bringing pigs to market by motorcycle
 (Vietnam)
 Nat Geog 187:73 (c,3) Ap '95
— Mexico
 Nat Geog 186:39,54 (c,1) N '94
 Trav&Leisure 25:175,178 (1) O '95
FARMHOUSES
— 15th cent. farmhouse (Cornwall, England)
 Trav/Holiday 176:69 (c,3) O '93
FARMING
— 1941 farmers planting corn (Virginia)
 Life 15:82–3 (1) My '92
 Nat Geog 183:20 (c,3) Je '93
— Amish farmer plowing field (Pennsylvania)
 Trav&Leisure 24:E19 (c,4) Mr '94
— Amish farmer spreading manure (Pennsyl-
 vania)
— Bringing ducks to market (Vietnam)
 Nat Geog 183:28 (c,2) F '93
— Chicken farming (Virginia)
 Nat Geog 188:76–7 (c,2) D '95
— Crocodile farming (Australia)
 Nat Geog 189:44–5 (c,2) Je '96
— Felling tree to make farmland (Guatemala)
 Nat Geog 182:94–6 (c,1) N '92
— Gabion barrier to prevent soil erosion
 Nat Wildlife 30:24 (c,4) Je '92
— Grain elevator (Colorado)
 Nat Geog 183:90 (c,3) Mr '93
— Growing sweet potatoes in plastic tubes
 (Japan)
 Nat Geog 185:97 (c,3) Ja '94
— Injecting methyl bromide into strawberry
 fields (California)
 Smithsonian 27:40–51 (c,1) D '96
— Native American crop system
 Smithsonian 26:100–1 (c,4) N '95
— Native American sentries scaring birds
 (1853)
 Smithsonian 26:104 (engraving,3) N '95
— Natural sustainable farming
 Nat Geog 188:60–89 (c,1) D '95
— Nebraska
 Nat Geog 183:80–109 (c,1) Mr '93
— Planting sweet potatoes on hill (Indonesia)
 Nat Geog 189:12–13 (c,1) F '96
— Scorching weeds on farm (Wisconsin)
 Nat Geog 188:74–5 (c,2) D '95
— Strawberries (California)

Smithsonian 27:40–51 (c,1) D '96
— Threshing sorghum crop (Eritrea)
Nat Geog 189:90–1 (c,2) Je '96
— Use of oxen in farming
Smithsonian 24:cov.,82–93 (c,1) S '93
— Utah
Am Heritage 44:66–7 (c,1) Ap '93
— See also
DAIRYING
IRRIGATION
list of farmed products under INDUS-
TRIES
FARMING—PLOWING
— 15th cent. (France)
Smithsonian 24:88 (painting,c,4) S '93
— Great Britain
Nat Geog 184:114–15 (c,1) S '93
— Oxen pulling plow (Cuba)
Trav&Leisure 23:76 (c,4) O '93
— Oxen pulling plow (Mexico)
Nat Geog 186:54 (c,4) N '94
FARMLANDS
— Aerial view of land sculptures (Kansas)
Smithsonian 25:70–7 (c,1) Jl '94
— Along Mississippi River, Southern U.S.
Smithsonian 23:39 (c,3) F '93
— Bhutan
Trav&Leisure 26:128 (c,3) Je '96
— China
Natur Hist 104:50–1 (c,1) D '95
— Colorado
Nat Geog 190:99 (c,1) N '96
— El Salvador
Nat Geog 188:110–11 (c,1) S '95
— Florida
Nat Geog 185:25 (c,3) Ap '94
— Great Britain
Trav&Leisure 22:122–7 (c,1) N '92
Nat Geog 188:52–3 (c,1) O '95
— Illinois
Gourmet 53:134 (c,1) Ap '93
Life 16:10–11 (c,1) Jl '93
Natur Hist 105:40–1 (c,1) Jl '96
— Israel
Nat Geog 187:64–5 (c,1) Je '95
— Italy
Gourmet 53:64 (painting,c,2) My '93
— Mauritius
Nat Geog 183:112–13 (c,1) Ap '93
— Minnesota
Nat Geog 182:36–7 (c,1) O '92
— New York
Nat Geog 189:74–5,92 (c,1) Mr '96
— North Dakota
Natur Hist 105:37 (c,1) My '96

— Nova Scotia
Gourmet 54:50–1 (c,1) Jl '94
— Pennsylvania
Gourmet 55:116,174 (c,4) O '95
— Venezuela
Natur Hist 104:40–1 (c,1) S '95
FARMS
— Albania
Nat Geog 182:91 (c,3) Jl '92
— Amish (Ohio)
Trav/Holiday 179:54–7 (c,1) O '96
— Amish (Pennsylvania)
Nat Geog 185:34–5 (c,1) Je '94
— Barley fields (Ecuador)
Natur Hist 101:72–5 (c,1) Jl '92
— Chicken farm (Delaware)
Am Heritage 47:64–5 (c,1) S '96
— Climbing silos and grain elevators (Illinois)
Sports Illus 85:5–6 (c,3) N 11 '96
— Connecticut
Smithsonian 26:102–6 (c,1) F '96
— Cow pasture (Great Britain)
Nat Geog 184:112–13 (c,1) S '93
— Dairy farm (New York)
Gourmet 55:104–5 (c,1) Mr '95
—Dairy farm (Pennsylvania)
Nat Geog 185:54–5 (c,2) Je '94
— Farm animals
Trav&Leisure 22:80–1 (c,1) S '92
— In suburbs (California)
Nat Geog 188:80–1 (c,2) D '95
— Indonesia
Natur Hist 104:57 (c,4) Jl '95
— Kansas
Trav/Holiday 176:74–5 (c,1) Mr '93
— Maryland
Gourmet 52:100–1 (c,1) S '92
Smithsonian 24:24 (c,4) N '93
— Montana
Trav/Holiday 176:63 (c,1) Je '93
— New York
Nat Geog 182:118–19 (c,1) N '92
— Pennsylvania
Gourmet 55:174 (drawing,4) O '95
— Quebec
Gourmet 53:105 (c,4) S '93
— Silos (Illinois)
Gourmet 53:136 (c,3) Ap '93
— Soybean field (Missouri)
Nat Wildlife 32:40–1 (c,1) Ap '94
— Stone goose hut (France)
Natur Hist 101:78 (c,4) S '92
— Sunrise over Tennessee farm
Gourmet 56:121 (c,2) Ap '96
— Tea fields (Malaysia)

Trav/Holiday 176:45 (c,1) S '93
— Terraced farms (Pakistan)
 Nat Geog 185:128–9 (c,1) Mr '94
— Ukraine
 Smithsonian 23:64–76 (c,2) D '92
— Wisconsin
 Trav&Leisure 24:115 (c,4) Je '94
 Nat Geog 188:64–9 (c,1) D '95
— See also
 BARNS
 CORNFIELDS
 COTTON FIELDS
 FARMHOUSES
 HORSE FARMS
 ORCHARDS
 PLANTATIONS
 RANCHES
 RICE FIELDS
 SCARECROWS
 STABLES
 VINEYARDS
 WHEAT FIELDS
FASHION SHOWS
 Life 16:24–5 (c,3) Jl '93
— Lifestyle of a supermodel
 Sports Illus 80:120–9 (painting,c,1) F 14
 '94
— Model in bridal gown (Mexico)
 Nat Geog 190:58–9 (c,1) Ag '96
— New York
 Life 15:59 (c,2) S '92
— Paris, France
 Life 17:42–53 (c,1) Mr '94
— Spain
 Nat Geog 181:20–1 (c,2) Ap '92
— Turkey
 Nat Geog 185:18–19 (c,2) My '94
FAULKNER, WILLIAM
 Am Heritage 43:92 (4) O '92
 Am Heritage 43:34 (4) N '92
 Sports Illus 80:55 (3) My 9 '94
— Caricatures of him
 Smithsonian 23:97–9 (3) Ag '92
— Rowan Oak home, Oxford, Mississippi
 Am Heritage 45:32 (c,4) Ap '94
**FEDERAL BUREAU OF INVESTIGA-
TION (FBI)**
— FBI Building, Washington, D.C.
 Trav/Holiday 179:42 (c,4) O '96
— See also
 HOOVER, J. EDGAR
FEET
— Bruised feet of ballet dancer
 Life 19:60–1 (c,4) Ap '96

FELLINI, FEDERICO
 Life 17:102–3 (c,1) Ja '94
FENCERS
 Sports Illus 79:54 (c,2) Ag 9 '93
FENCES
— Aerial view of stone walls on farm (Great
 Britain)
 Nat Geog 188:52–3 (c,1) O '95
— Barbed wire fence at concentration camp
 (Germany)
 Trav&Leisure 24:120 (2) F '94
— Barbed wire ranch fence
 Smithsonian 23:22 (c,4) Ag '92
 Nat Geog 183:64–5 (c,1) Ja '93
— Hedgerows (Great Britain)
 Nat Geog 184:94–117 (c,1) S '93
— Horse farm
 Natur Hist 101:44–5 (c,1) F '92
— Old wooden ranch fence (Wyoming)
 Nat Geog 187:125 (c,3) F '95
— Playground fence (New York)
 Nat Wildlife 31:14–16 (c,1) F '93
— Razor wire fence (South Africa)
 Nat Geog 183:84–5 (c,1) F '93
— Rural England
 Gourmet 56:92 (c,4) Je '96
— Sheep netting fence (Wales)
 Nat Geog 184:115 (c,4) S '93
— Small town picket fence (Virginia)
 Gourmet 54:137 (c,1) My '94
— Spite fences through U.S. history
 Am Heritage 47:70–3 (1) F '96
— Stone walls (Great Britain)
 Gourmet 55:90–1 (c,1) Mr '95
 Trav/Holiday 179:36–7 (c,1) Je '96
— Wooden picket fence along shore
 (Nantucket, Massachusetts)
 Trav/Holiday 179:32–3 (c,4) Jl '96
— See also
 GATES
FENCING
 Smithsonian 27:76–85 (c,1) Je '96
— 1896 (France)
 Smithsonian 27:78–9 (drawing,c,3) Je '96
— 1939 tournament (Monaco)
 Nat Geog 190:63 (3) Jl '96
— 1996 Olympics (Atlanta)
 Sports Illus 85:46–8,53 (c,1) Jl 29 '96
FERMI, ENRICO
 Natur Hist 104:45 (2) Jl '95
FERNS
 Trav/Holiday 176:69 (c,4) My '93
 Nat Geog 186:12–13 (c,1) Ag '94
 Nat Geog 189:6–7 (c,1) F '96

FERRETS
— Black-footed ferrets
 Nat Wildlife 30:11 (painting,c,1) Ap '92
 Life 17:52 (1) S '94
 Nat Geog 187:2 (c,4) Mr '95
FERRIS WHEELS
— 1893 Columbian Exposition, Chicago,
 Illinois
 Smithsonian 24:42 (c,4) Je '93
— Child dangling from ferris wheel (South
 Korea)
 Life 16:18 (c,2) Jl '93
— Coney Island, Brooklyn, New York
 Life 15:3,80–5 (c,1) O '92
 Trav/Holiday 178:61,68 (c,3) Jl '95
— Denver, Colorado
 Trav&Leisure 26:C4–C5 (c,1) Ap '96
— Prater ferris wheel, Vienna, Austria
 Trav/Holiday 177:71 (3) Mr '94
FERRY BOATS
— Bayfield, Wisconsin
 Trav&Leisure 26:50 (c,4) F '96
— Belize
 Trav&Leisure 26:50 (c,4) F '96
— Rio Grande River, Texas/Mexico
 Trav&Leisure 23:106–7 (c,2) F '93
— Staten Island ferry, New York City, New
 York
 Gourmet 55:62 (painting,c,2) Mr '95
— Vancouver, British Columbia
 Trav&Leisure 26:133 (4) Mr '96
— Vietnam
 Nat Geog 187:67 (c,3) Ap '95
 Trav&Leisure 25:173 (c,1) O '95
— Washington
 Nat Geog 187:111–13,130 (c,1) Je '95
FESTIVALS
— 1994 Woodstock II
 Life 18:48–9 (c,1) Ja '95
— Annual tomato food fight (Bunol, Spain)
 Life 18:20–1 (c,1) N '95
— Applefest (Bayfield, Wisconsin)
 Trav&Leisure 25:158–9 (c,1) S '95
— Bluegrass festivals
 Smithsonian 23:cov.,68–80 (c,1) Mr '93
— Carnevale (Venice, Italy)
 Nat Geog 187:74–5 (c,1) F '95
— Carnival (Rio de Janeiro, Brazil)
 Life 19:16 (2) Mr '96
 Trav/Holiday 179:13 (c,4) D '96
— Carnival (Trinidad and Tobago)
 Nat Geog 185:66–7,86–7 (c,1) Mr '94
 Natur Hist 104:36–7,40–1 (c,1) F '95
 Trav/Holiday 179:16 (c,4) F '96
— Cattail Fiesta (Spain)

 Life 15:3 (c,2) Ag '92
— Chelsea Flower Show, England
 Trav&Leisure 25:120–7 (c,1) F '95
— Christmas harbor festival (Vancouver,
 British Columbia)
 Nat Geog 181:108–9 (c,1) Ap '92
— "Course du Mardi Gras" on horseback
 (Louisiana)
 Life 18:22 (c,2) F '95
— Easter Island
 Nat Geog 183:64–5 (c,1) Mr '93
— Edinburgh Festival, Scotland
 Smithsonian 25:38–47 (c,1) D '94
 Gourmet 56:56–8 (c,4) Ag '96
— End of winter festivals (U.S.S.R.)
 Natur Hist 102:34–9 (c,1) Je '93
— Key West Fantasy Fest parade, Florida
 Sports Illus 78:81 (c,4) F 22 '93
— Love Parade (Berlin, Germany)
 Nat Geog 190:96–7 (c,1) D '96
— Mardi Gras (Louisiana)
 Nat Geog 182:8–9,32–3 (c,1) Jl '92
 Life 17:76–7 (c,1) N '94
 Nat Geog 187:102–7 (c,1) Ja '95
— Mississippi Shrimp Festival
 Nat Geog 182:32 (c,4) Jl '92
— Oktoberfest (Munich, Germany)
 Nat Geog 181:10–11 (c,1) F '92
— Prelenten carnivals (Spain)
 Life 15:84–5,88–9 (c,1) Ag '92
— Pumpkin show (Barnesville, Ohio)
 Smithsonian 27:66–7 (c,2) O '96
— Spain
 Life 15:3,81–9 (c,1) Ag '92
— Star Snow Festival (Peru)
 Nat Geog 181:96–7 (c,1) Mr '92
— Telluride Mushroom Festival, Colorado
 Natur Hist 105:32–5 (c,1) Ap '96
— Truffle Festival (Alba, Italy)
 Gourmet 52:106 (c,3) O '92
— See also
 BEAUTY CONTESTS
 FAIRS
 FIREWORKS
 HOLIDAYS
 PARADES
 RELIGIOUS RITES AND FESTIVALS
 individual countries—RITES AND FES-
 TIVALS
 individual religions—RITES AND FESTI-
 VALS
FESTIVALS—HUMOR
— Mississippi catfish festival
 Nat Wildlife 30:42–5 (painting,c,1) Je '92

FEZ, MOROCCO
Gourmet 56:46–9 (c,4) Ja '96
FIDDLER CRABS
Natur Hist 102:37 (c,4) Jl '93
FIELDS
— Finland
Gourmet 54:55 (c,3) Jl '94
— Meadow (Switzerland)
Gourmet 53:83 (c,1) F '93
— Yorkshire, England
Trav&Leisure 25:89 (c,2) Je '95
— See also
CORNFIELDS
COTTON FIELDS
WHEAT FIELDS
FIELDS, W.C.
Smithsonian 25:28 (c,4) F '95
FIGHTING
— Brawl at baseball game
Sports Illus 78:22–3 (c,1) Je 14 '93
Sports Illus 81:68–9 (1) N 14 '94
— Fatal fight in hockey game (Italy)
Sports Illus 79:68–70 (c,4) D 6 '93
— Hitting photographer in courtroom (1951)
Am Heritage 45:66 (4) O '94
— Lincoln in 1831 fistfight
Sports Illus 82:12 (drawing,4) F 6 '95
— Referee pulling football player away from fight
Sports Illus 80:2–3,22–3 (c,1) Ja 17 '94
— Young thugs fighting (Moscow, Russia)
Nat Geog 183:18–19 (c,1) Mr '93
FIGUREHEADS
— 18th cent.
Gourmet 52:100 (c,4) O '92
FIJI
Nat Geog 188:114–37 (map,c,1) O '95
Trav&Leisure 26:93–9 (map,c,1) F '96
Trav&Leisure 26:49 (c,4) S '96
— Suva
Nat Geog 188:120–1 (c,1) O '95
FIJI—COSTUME
Nat Geog 188:114–37 (c,1) O '95
FIJI—HOUSING
— Bures
Trav&Leisure 26:96–7 (c,1) F '96
FILLMORE, MILLARD
Smithsonian 27:157 (painting,c,4) N '96
— 1861 cartoon
Am Heritage 43:57 (drawing,4) N '92
FINCHES
Nat Wildlife 33:52–3 (c,1) F '95
— See also
BULLFINCHES
BUNTINGS

CARDINALS
GOLDFINCHES
FINGER LAKES, NEW YORK
— Seneca Lake
Gourmet 54:122 (c,4) N '94
FINLAND
Trav/Holiday 178:56–63 (map,c,1) Je '95
— Sibelius' home (Jarvenpaa)
Gourmet 54:54–5 (c,3) Jl '94
— See also
HELSINKI
FIR TREES
Natur Hist 101:66–7 (c,1) S '92
Natur Hist 104:28–33 (c,1) F '95
— Balsam fir
Natur Hist 105:56 (c,4) F '96
— Covered with ice
Natur Hist 104:28–9 (c,2) F '95
FIRE FIGHTERS
— 1991 fire fighters covered with oil (Kuwait)
Life 19:29–30 (c,1) Jl '96
— California
Nat Geog 190:118 (c,4) S '96
— Training
Life 15:88 (2) Mr '92
Smithsonian 23:32–5,38 (c,1) My '92
Nat Geog 182:16–17 (c,1) Jl '92
— Venice, Italy
Nat Geog 187:86–7 (c,1) F '95
FIRE FIGHTING
Smithsonian 23:32–40 (c,1) My '92
— Dropping fire retardant from helicopter (Washington)
Life 17:24 (c,2) O '94
— Fireboat (California)
Smithsonian 23:36 (c,4) My '92
— Fireboat (Venice, Italy)
Nat Geog 187:86–7 (c,1) F '95
— Fire fighters rescuing man (Ohio)
Life 17:19–20 (c,1) My '94
— Fireman survivor of fall (Indiana)
Life 15:8–9 (c,1) S '92
— Idaho
Nat Wildlife 34:36 (c,4) D '95
— Smoke jumpers parachuting to fire
Sports Illus 83:5–10 (c,4) S 4 '95
— Training on condemned house (Oregon)
Life 19:16 (c,2) F '96
FIRE HYDRANTS
— Hydrant painted Italian flag colors (Missouri)
Gourmet 53:92 (c,4) S '93
FIREPLACES
— Early 19th cent. (Tennessee)
Smithsonian 26:44–5 (c,2) F '96

— Early 19th cent. Rumford fireplace
 Am Heritage 44:73 (drawing,3) S '93
— Cooking corn in adobe oven (New Mexico)
 Nat Geog 184:44 (c,4) S '93
— English pub
 Smithsonian 24:82 (c,4) Jl '93
— Sitting in front of fireplace
 Trav/Holiday 175:99 (painting,c,4) D '92
FIRES
 Nat Geog 190:116–39 (c,1) S '96
— 1929 White House fire, Washington, D.C.
 Trav/Holiday 175:73 (4) N '92
— 1964 Indianapolis 500 car on fire
 Sports Illus 80:44–5 (1) My 30 '94
— 1992 Los Angeles riots, California
 Life 16:20–1 (c,1) Ja '93
— Arkansas
 Life 17:18 (c,2) Jl '94
— Bonfire at political demonstration
 (Georgia, U.S.S.R.)
 Nat Geog 181:97 (c,1) My '92
— Brittany's parliament building in flames,
 France
 Life 17:17 (c,2) Ap '94
— Burning marshlands (Kansas)
 Nat Geog 182:40 (c,4) O '92
— Burning sugar cane leaves (South Africa)
 Nat Geog 183:70–1 (c,1) F '93
— Caused by lightning (Florida)
 Nat Wildlife 32:30–1 (c,1) Ag '94
— Controlled woodland burns (Georgia)
 Nat Geog 181:45 (c,4) Ap '92
— Fire from earthquake (California)
 Life 17:16–17 (c,1) Mr '94
— Florida scrub fire
 Smithsonian 25:42 (c,3) S '94
— Forest fire (Australia)
 Nat Geog 187:82–3 (c,1) Ja '95
 Nat Geog 189:7–9 (c,1) Je '96
— Forest fire (Wyoming)
 Nat Wildlife 32:32–3 (c,1) Ag '94
— History of Smoky Bear
 Smithsonian 24:59–61 (c,2) Ja '94
— House on fire (Georgia)
 Sports Illus 81:68 (c,4) O 24 '94
— Indonesia fire seen from space
 Nat Geog 190:20–1 (c,1) N '96
— Oakland, California
 Life 15:106–7 (c,1) Ja '92
— Orange glow from nearby fires (Sydney,
 Australia)
 Life 17:28 (c,2) Mr '94
— Prairie fire (Oklahoma)
 Nat Geog 184:116–17 (c,2) O '93
— Rain forest (Brazil)

Natur Hist 101:48 (c,4) Ag '92
Nat Wildlife 31:22–3 (c,1) Ap '93
— Setting brush fire (California)
 Nat Geog 181:124 (c,3) Mr '92
 Nat Geog 190:128–9 (c,1) S '96
— Setting controlled fires
 Smithsonian 26:76 (3) Mr '96
 Nat Geog 190:128–35 (c,1) S '96
— Southern California
 Life 17:62–3 (c,1) Ja '94
— See also
 CAMPFIRES
 SMOKE
FIRES—DAMAGE
— 1942 ruins of night club (Boston, Massa-
 chusetts)
 Am Heritage 43:41 (4) N '92
— Aftermath of Yosemite forest fire,
 California
 Natur Hist 104:74–5 (1) D '95
— Burned juniper trees
 Smithsonian 22:43 (c,2) F '92
— Forests after fire
 Nat Geog 190:120–7 (c,1) S '96
— Home destroyed in 1991 fire (Oakland,
 California)
 Life 15:78–9 (c,1) F '92
— House destroyed by fire (Florida)
 Sports Illus 76:71 (c,4) Ap 13 '92
— Infant burn victim
 Life 18:48 (c,2) Jl '95
— Southern churches destroyed in arson fires
 Life 19:10–11 (c,1) Jl '96
 Smithsonian 27:56–7 (c,4) S '96
FIRETRUCKS
— Converting tanks into fire-fighting equip-
 ment (Czechoslovakia)
 Nat Geog 184:29 (c,3) S '93
FIREWEED
 Nat Wildlife 32:35 (c,2) Ag '94
FIREWORKS
 Life 17:78 (c,2) Jl '94
— Chinese New Year's fireworks (Shanghai,
 China)
 Nat Geog 185:34–5 (c,1) Mr '94
— Fans setting off flares at soccer game
 (Turkey)
 Nat Geog 185:14–15 (c,2) My '94
— Over baseball stadium (California)
 Sports Illus 77:29 (c,3) Jl 13 '92
— Pennsylvania
 Life 17:94–5 (c,1) N '94
FISCHER, BOBBY
 Life 16:26 (4) S '93

FISH
— Anemonefish
Life 18:52 (c,4) Ag '95
Nat Wildlife 33:cov. (c,1) O '95
Nat Wildlife 34:54–5 (c,1) F '96
— Anglerfish
Nat Wildlife 30:22–3 (c,1) F '92
Smithsonian 23:57–60 (c,3) Ag '92
Nat Wildlife 32:34–7 (c,1) F '94
— Anthias
Smithsonian 24:106 (c,4) O '93
Natur Hist 105:50–1 (c,1) N '96
— Balloonfish
Nat Wildlife 33:57 (c,1) Ap '95
— Basslet
Natur Hist 103:59 (c,1) F '94
Trav/Holiday 177:48 (c,4) F '94
Nat Geog 190:128–9 (c,1) D '96
— Batfish
Nat Geog 187:91–2 (c,1) Mr '95
— Bathysaurus
Nat Geog 186:125 (c,4) N '94
— Bigeye
Smithsonian 24:112 (c,4) O '93
— Blenny
Nat Geog 182:106–7 (c,1) Jl '92
Smithsonian 23:61 (c,2) Ag '92
Nat Wildlife 32:59 (c,2) D '93
— Blenny fish hatching
Nat Geog 182:106–7 (c,1) Jl '92
— Char
Natur Hist 105:49–54 (painting,c,3) Je '96
— Cichlids
Nat Geog 188:92–3 (c,2) O '95
— Clownfish
Nat Geog 184:72–3 (c,1) N '93
Natur Hist 105:50 (c,4) N '96
— Deep-sea swallower
Nat Wildlife 30:24–5 (c,1) F '92
— Dottyback fish
Life 18:53 (c,4) Ag '95
— Elephant noses
Smithsonian 24:94,105 (c,1) Ag '93
— Fish eggs
Smithsonian 23:60 (c,3) Ag '92
— Garibaldi fish
Nat Wildlife 30:8–9 (c,1) Je '92
Natur Hist 103:46–51 (c,1) D '94
— Glassy sweepers
Nat Geog 184:60–2,86–7 (c,1) N '93
— Goatfish
Nat Geog 187:64 (c,3) Ja '95
— Goby
Life 15:84–5 (c,1) S '92
Nat Geog 184:73,82–3 (c,1) N '93

Life 18:52 (c,4) Ag '95
Nat Wildlife 34:52 (c,1) F '96
Natur Hist 105:cov.,49 (c,1) N '96
— Gulpers
Smithsonian 26:104 (c,4) Ja '96
— Hawkfish
Life 15:86–7 (c,2) S '92
Nat Geog 184:85 (c,3) N '93
Natur Hist 103:cov. (c,1) F '94
Natur Hist 105:50 (c,4) N '96
— Hogfish
Nat Wildlife 31:6–7 (c,1) Ag '93
— Jawfish
Natur Hist 105:53 (c,4) N '96
— Jock steward fish
Natur Hist 102:62–3 (c,2) Mr '93
— Lionfish
Life 18:52 (c,4) Ag '95
— Mauritius area fish
Natur Hist 101:34–9 (painting,c,1) O '92
— Mudskippers
Nat Wildlife 32:12–13 (drawing,c,1) O '94
— Needlefish
Life 18:53 (c,4) Ag '95
— Notothenid
Natur Hist 101:48–9 (c,2) N '92
— Parrotfish
Smithsonian 24:108 (c,4) O '93
Nat Geog 184:65 (c,4) N '93
Nat Wildlife 32:50–1 (c,1) Ap '94
Life 18:52 (c,4) Ag '95
— Pirarucu
Nat Geog 187:29 (c,3) F '95
— Porcupine fish
Smithsonian 23:57 (c,4) Ag '92
— Pupfish
Nat Geog 188:94 (c,3) O '95
— Rockfish
Nat Wildlife 30:6–7 (c,1) Je '92
— Rockskippers
Nat Wildlife 32:14–15 (drawing,c,1) O '94
— Sandfish
Smithsonian 24:104 (c,4) Ag '93
— School of anchovies
Nat Geog 182:132–3 (c,1) D '92
— School of jacks
Natur Hist 104:80–1 (c,1) F '95
— Scorpionfish
Nat Geog 190:126–7 (c,1) D '96
— Sea dragons
Smithsonian 23:cov.,58–9 (c,1) Ag '92
— Sergeant majors
Life 18:56–7 (c,1) D '95
— Soldierfish
Nat Wildlife 34:50–1 (c,1) F '96

— Spade fish
Nat Wildlife 31:8–9 (c,1) Je '93
— Spawning shad bypassing dam by
elevator (Maryland)
Nat Geog 183:28 (c,3) Je '93
— Stargazers
Smithsonian 23:56–7 (c,1) Ag '92
Smithsonian 24:101 (c,4) Ag '93
— "Stealth" fish
Smithsonian 23:cov.,56–61 (c,1) Ag '92
— Surgeonfish
Natur Hist 101:34 (painting,c,4) O '92
Nat Geog 187:102,110 (c,4) Mr '95
— Sweetlips
Nat Geog 187:103–7 (c,1) Mr '95
— Trunkfish
Smithsonian 23:94 (c,4) O '92
— Turkeyfish
Smithsonian 24:113 (c,4) O '93
— Unicornfish
Nat Geog 187:102 (c,3) Mr '95
— Viperfish
Nat Wildlife 30:26–7 (c,1) F '92
— Walleye monument (Minnesota)
Nat Geog 182:111 (c,3) S '92
— See also
ANGELFISH
AQUARIUMS
BARRACUDAS
BASS
BUTTERFLYFISH
CATFISH
DARTERS
DOGFISH
EELS
GROUPERS
GRUNTS
HAGFISH
HAKE
HALIBUT
HERRINGS
PIPEFISH
PIRHANAS
POMPANOS
PUFFER FISH
RAYS
SALMON
SCULPINS
SEA HORSES
SHARKS
SKATES
SMELTS
SNAPPER
STICKLEBACK FISH
STINGRAYS

SUNFISH
TARPONS
TILEFISH
TRIGGERFISH
TROUT
TUNA
WRASSES
YELLOWTAILS
FISHERMEN
— Early 20th cent. (New York)
Smithsonian 24:28–9 (2) Jl '93
— Alaska
Nat Geog 184:37 (c,4) N '93
— Canary Islands
Trav/Holiday 175:74 (c,4) O '92
— India
Trav/Holiday 176:49 (c,1) N '93
Nat Geog 188:3 (c,1) N '95
— Ireland
Trav&Leisure 24:64 (c,4) Jl '94
Nat Geog 189:128–9 (c,1) Ap '96
— Long Island, New York
Smithsonian 24:26–35 (1) Jl '93
— Macedonia
Nat Geog 189:133 (c,2) Mr '96
— Mexico
Nat Geog 190:84–5,108–9 (c,1) Ag '96
— Mississippi
Smithsonian 23:42 (c,4) F '93
— Morocco
Nat Geog 188:6–7 (c,1) N '95
— Newfoundland
Nat Geog 184:10–13 (c,2) O '93
— Siberia
Nat Geog 181:12–15 (c,1) Je '92
— Tanzania
Natur Hist 105:10 (c,4) S '96
— Vietnam
Life 17:19–21 (c,1) O '94
— Windward Islands
Trav&Leisure 23:44 (c,3) F '93
Natur Hist 103:64–71 (c,1) N '94
FISHING
Smithsonian 24:95 (c,2) Jl '93
— Aborigine spearing stingrays (Australia)
Nat Geog 190:46–7 (c,3) N '96
— Alaska
Trav&Leisure 24:105–7 (c,1) Mr '94
— Angling (New York)
Trav&Leisure 22:E1 (c,3) Ap '92
Nat Geog 182:108–9 (c,) N '92
— Argentina
Trav&Leisure 25:88 (c,1) Ja '95
— Arkansas
Trav/Holiday 177:90 (c,3) My '94

— Bahamas
 Trav/Holiday 177:58–9 (c,1) S '94
 Trav&Leisure 26:70 (c,4) O '96
— Bass (Missouri)
 Trav/Holiday 177:60–1 (c,2) F '94
— Catching piranhas with bloody stick
 (Brazil)
 Life 15:72 (c,4) Jl '92
— Child displaying catch (Virginia)
 Nat Geog 183:27 (c,3) Je '93
— Child fishing (Cyprus)
 Nat Geog 184:105–6 (c,1) Jl '93
— Child netting minnows (Arizona)
 Nat Geog 184:114–15 (c,1) N 15 '93
— Clamming
 Gourmet 53:266 (drawing,4) Ap '93
— Clamming (Nova Scotia)
 Gourmet 54:52–3 (c,1) Jl '94
— Clamming (Spain)
 Nat Geog 181:26–7 (c,1) Ap '92
— Clamming (Vietnam)
 Smithsonian 26:43 (c,1) Ja '96
— Cooking trout in Yellowstone hot spring,
 Wyoming (1919)
 Nat Geog 189:134 (3) Ap '96
— Costa Rica
 Sports Illus 82:130–41 (c,1) F 20 '95
— Dipnetting for salmon (Washington)
 Nat Geog 187:34–5 (c,1) Mr '95
— Displaying caught fish (California)
 Sports Illus 85:116 (c,4) Jl 15 '96
— Displaying caught fish (Easter Island)
 Nat Geog 183:77 (c,3) Mr '93
— Displaying caught sharks
 Smithsonian 24:35 (c,3) My '93
— Displaying caught tuna
 Sports Illus 78:6 (c,4) My 3 '93
— Fishing school (Great Britain)
 Gourmet 55:38–40 (c,2) Jl '95
— Florida
 Life 17:72–3 (c,1) Ap '94
 Sports Illus 81:56–7 (c,1) Jl 4 '94
 Life 18:84 (c,2) Mr '95
— Flounder tramping (Scotland)
 Sports Illus 81:5–6 (c,4) S 5 '94
— Fly fishing
 Trav&Leisure 24:66–8 (c,4) Ap '94
— Fly fishing (Idaho)
 Sports Illus 81:74 (c,3) O 10 '94
— Fly fishing (Montana)
 Smithsonian 23:120 (c,1) S '92
 Gourmet 54:149 (c,1) My '94
 Sports Illus 85:87 (c,4) O 14 '96
— Fly fishing school (Pennsylvania)
 Nat Geog 189:66–7 (c,1) Ap '96

— Massachusetts
 Trav/Holiday 179:32–3 (c,2) Jl '96
— Minnesota
 Nat Geog 182:92–5,112–13 (c,1) S '92
— Montana
 Trav&Leisure 25:E1 (c,3) Je '95
— North Carolina lake
 Trav&Leisure 22:112 (c,1) Mr '92
— Off Padre Island pier, Texas
 Trav/Holiday 177:83 (c,1) D '94
— Pennsylvania
 Nat Geog 185:40 (c,3) Je '94
— Readying fish hooks (Washington)
 Trav/Holiday 179:69 (c,4) Mr '96
— Salmon (Alaska)
 Nat Geog 185:96–7 (c,2) My '94
— Salmon (Nova Scotia)
 Trav&Leisure 26:52 (c,4) Ag '96
— Sea turtles (Nicaragua)
 Nat Geog 185:106–7 (c,1) F '94
— Smelts (Illinois)
 Life 17:90–1 (c,1) My '94
— Spear fishing (Brazil)
 Sports Illus 76:39 (c,3) My '92
— Spearing catfish (Papua New Guinea)
 Nat Geog 185:50–1 (c,1) F '94
— Spearing fish (Mexico)
 Smithsonian 24:85 (c,1) N '93
— Spearing salmon (Yukon)
 Nat Geog 185:130 (c,4) F '94
— Sturgeon (Oregon)
 Sports Illus 78:100–1 (c,3) My 31 '93
— Tahiti
 Trav/Holiday 179:89 (c,1) N '96
— Trout (Great Britain)
 Gourmet 55:91 (c,4) Mr '95
 Trav&Leisure 25:66 (c,4) Je '95
 Nat Geog 189:69 (c,1) Ap '96
— Trout (New Zealand)
 Trav/Holiday 176:56–63 (c,1) Mr '93
— Trout (Wyoming)
 Trav&Leisure 22:112–13 (3) My '92
 Trav/Holiday 177:47 (2) S '94
 Nat Geog 186:42–3 (c,1) O '94
 Nat Geog 189:82–3 (c,1) Ap '96
— With bow and arrow (Brazil)
 Natur Hist 101:36–7 (c,1) Mr '92
— See also
 ICE FISHING
FISHING BOATS
— Alaska
 Nat Geog 184:36–7 (c,1) N '93
— British Columbia
 Trav/Holiday 176:70–1 (c,2) S '93
— Delaware

Trav/Holiday 178:43 (c,2) S '95
— Dhows (Kenya)
Trav&Leisure 26:191 (c,4) N '96
— Dhows (Oman)
Trav&Leisure 25:124 (c,4) D '95
— Fishing boat covered with snow and ice
(Maine)
Life 18:88–9 (c,1) F '95
— France
Trav&Leisure 24:120–1,166–7 (c,1) Je '94
— Huge processing trawlers
Nat Geog 188:8,15–17 (c,1) N '95
— India
Life 15:80–1,84 (c,1) Mr '92
— Japan
Nat Geog 182:18–19 (c,1) S '92
— Madeira
Gourmet 53:117 (c,1) D '93
Nat Geog 186:92–5 (c,1) N '94
— Oyster boats (Florida)
Trav/Holiday 178:50 (c,1) Mr '95
— Portugal
Trav/Holiday 175:23 (c,4) Jl '92
— Shrimp boat (Texas)
Nat Geog 182:12–13 (c,1) S '92
— Spain
Nat Geog 181:29 (c,3) Ap '92
— Utase bune vessels (Japan)
Nat Geog 185:106–7 (c,1) Ja '94
FISHING EQUIPMENT
— Ancient Chile
Nat Geog 187:86 (c,4) Mr '95
— Bamboo traps (Vietnam)
Life 17:19–21 (c,1) O '94
— Butterfly nets (Mexico)
Nat Geog 190:84–5 (c,1) Ag '96
— Fishing nets
Nat Geog 188:6–7,20–1 (c,1) N '95
— Fishing nets (Denmark)
Trav&Leisure 25:95 (c,4) Mr '95
— Fishing nets (India)
Nat Geog 182:76–7 (c,1) N '92
— Fishing nets (Siberia)
Nat Geog 181:12–13 (c,1) Je '92
— Ice fishing shelters (Minnesota)
Smithsonian 27:54–63 (c,1) D '96
— Lobster buoys (New England)
Gourmet 52:100 (c,4) My '92
Gourmet 53:125 (c,1) Ap '93
— Lobster buoys (Nova Scotia)
Gourmet 54:53 (c,4) Jl '94
— Making bamboo fishing rods (Japan)
Nat Geog 186:86 (c,3) S '94
— Making flies
Nat Geog 189:75 (c,4) Ap '96

— Making metal fishing basket (Greece)
Trav/Holiday 178:52 (c,2) My '95
— Repairing fishing nets (Morocco)
Nat Geog 188:6–7 (c,1) N '95
FISHING INDUSTRY
— Alaska
Nat Geog 182:78–9 (c,1) O '92
— Bluefin tuna (Japan)
Nat Wildlife 30:48 (c,4) O '92
— Catfish (Mississippi)
Smithsonian 23:42 (c,4) F '93
— Chile
Trav/Holiday 178:60–1 (c,1) D '95
— Cod (Newfoundland)
Smithsonian 23:35,38 (c,2) Je '92
Nat Wildlife 30:50 (c,4) O '92
— Crabs (Southeast)
Nat Geog 183:4–5 (c,2) Je '93
Gourmet 55:99 (c,4) Ap '95
Nat Wildlife 33:27 (c,4) O '95
— Dolphins and porpoises (Japan)
Nat Geog 182:18–19 (c,1) S '92
— Drying cod (Norway)
Nat Geog 186:67 (c,3) O '94
Natur Hist 105:58 (c,2) My '96
— Drying fish (U.S.S.R.)
Nat Geog 182:38–9 (c,1) S '92
Nat Geog 185:38–9 (c,1) Ap '94
— Drying fishing nets (St. Lucia)
Trav/Holiday 175:50–1 (c,2) F '92
— Drying salmon fillets (Northwest)
Natur Hist 104:32 (c,4) S '95
— Drying squid (Japan)
Nat Geog 186:80–1 (c,2) S '94
— Eritrea
Nat Geog 189:92 (c,4) Je '96
— Flounder in net (New England)
Nat Wildlife 30:46–7 (c,1) O '92
— Global fishing industry
Nat Geog 188:3–55 (map,c,1) N '95
— Halibut (Alaska)
Nat Geog 188:34–5 (c,2) N '95
— King crabs (U.S.S.R.)
Nat Geog 185:56–7 (c,2) Ap '94
— Lobsters (Maine)
Trav/Holiday 179:80–1 (c,1) S '96
— Long Island, New York
Smithsonian 24:26–35 (1) Jl '93
— Mexico
Nat Geog 190:84–5,108–9 (c,1) Ag '96
— Mussel farming (Washington)
Nat Geog 187:124 (c,3) Je '95
— Netting mullet (Florida)
Nat Geog 181:60–1 (c,1) Ap '92
— Oysters (Southern U.S.)

Nat Geog 182:24–5 (c,1) Jl '92
Nat Geog 183:16–17 (c,1) Je '93
Trav/Holiday 178:48–50 (c,1) Mr '95
— Peru
Nat Geog 189:8–9 (c,1) My '96
— Pike Place market, Seattle, Washington
Am Heritage 45:76–7 (c,1) Ap '94
— Pollack on conveyor belt (Alaska)
Nat Wildlife 33:36 (c,4) D '94
— Raising catfish (Vietnam)
Nat Geog 183:6–7 (c,1) F '93
— River fishing from rafts (India)
Trav/Holiday 176:49 (c,1) N '93
— Salmon (Alaska)
Nat Geog 184:36–7 (c,1) N '93
Nat Geog 188:4–5,30–3 (c,1) N '95
— Salmon (Oregon)
Nat Wildlife 32:44 (c,4) O '94
— Salmon (U.S.S.R.)
Nat Geog 190:56–7 (c,2) O '96
— Scallop packing plant (Russia)
Nat Geog 190:57 (c,3) O '96
— Sea urchins (California)
Nat Geog 187:57 (c,3) Je '95
— Shark caught in fishing net
Smithsonian 24:36 (c,3) My '93
— Shark fin on ship (Japan)
Smithsonian 24:34 (c,4) My '93
— Sharks (Spain)
Natur Hist 105:44–5 (c,3) S '96
— Shrimp (Texas)
Nat Geog 188:18–19 (c,1) N '95
— Skinning catfish (Brazil)
Natur Hist 102:4 (c,4) Ap '93
— Spain
Nat Geog 181:29 (c,3) Ap '92
Nat Geog 188:9–11 (c,2) N '95
— Tokyo fish market, Japan
Nat Geog 188:38–51 (c,1) N '95
— Trout farming (Colorado)
Nat Geog 189:76 (c,4) Ap '96
— Tuna (Italy)
Life 18:8–9 (c,1) My '95
Nat Geog 188:28–9 (c,2) Ag '95
— Tuna (Oman)
Nat Geog 187:132–3 (c,1) My '95
— Walleye pond (Minnesota)
Nat Geog 182:110 (c,3) S '92
— Wisconsin
Nat Geog 184:88–9 (c,2) D '93
— Yakima Indian catching salmon
(Washington)
Natur Hist 104:33,75 (c,2) S '95
FISK, JAMES, JR.
Am Heritage 43:18 (drawing,4) N '92

FITZGERALD, F. SCOTT
Sports Illus 83:12 (4) Jl 24 '95
FJORDS
— Fjordland National Park, New Zealand
Trav&Leisure 25:116–19,158 (c,1) Ap '95
— Greenland
Life 17:24–5 (c,1) D '94
— New Zealand
Natur Hist 102:60–1 (c,1) Mr '93
— Norway
Gourmet 53:80–1 (c,1) Je '93
Trav&Leisure 24:164 (c,4) S '94
Trav/Holiday 178:44–6,50 (c,1) Jl '95
Gourmet 55:94 (painting,4) Ag '95
FLAGLER, HENRY
Trav/Holiday 175:56,61,63 (c,4) F '92
— Family
Trav/Holiday 175:59–63 (4) F '92
— Home (Palm Beach, Florida)
Trav/Holiday 175:56–63 (c,1) F '92
FLAGS
— Early 19th cent. frigate displaying many
flags
Am Heritage 44:98–9 (painting,c,1) F '93
— 1824 U.S. "Old Glory"
Smithsonian 24:12 (c,4) Jl '93
— 1860s Confederate flag
Smithsonian 25:22 (c,4) Ap '94
Am Heritage 47:6 (drawing,c,4) Jl '96
— 1918 men assembled into living portrait of
U.S. flag
Smithsonian 26:62 (1) Ja '96
— 1994 "Unity" flag at gay rights march
(New York)
Life 17:12 (c,2) Ag '94
Life 18:36 (c,2) Ja '95
— Bahamas
Trav/Holiday 179:18 (c,4) D '96
— Basque flag, Spain
Nat Geog 188:79 (c,3) N '95
— Canadian flag waved by Olympic
champions
Sports Illus 85:4 (c,4) S 9 '96
— Croatia
Sports Illus 77:25 (c,4) Jl 22 '92
— Flag office at U.S. Capitol, Washington,
D.C.
Life 16:55 (c,3) S '93
— Flags of former Soviet republics
Sports Illus 77:26–7 (c,4) Jl 22 '92
— Germany
Sports Illus 77:24 (c,4) Jl 22 '92
— Israel
Gourmet 54:96 (c,2) F '94
— Liberia

Trav/Holiday 179:18 (c,4) D '96
— Lowering flag outside school (Minnesota)
Life 15:70–1 (c,1) S '92
— Northern Ireland
Life 17:28 (c,2) N '94
— Norway
Gourmet 54:63 (c,4) Ja '94
— Palestinian flag
Nat Geog 187:82 (c,1) Je '95
— Replica of first "Star-Spangled Banner"
Smithsonian 25:18 (c,4) Jl '94
— Slovenia
Sports Illus 77:25 (c,4) Jl 22 '92
— South Africa
Sports Illus 77:25 (c,4) Jl 22 '92
— Umbrella with British flag design
Gourmet 55:117 (c,2) D '95
— United States
Trav&Leisure 22:99 (c,1) Ja '92
Life 15:cov. (c,1) N '92
Gourmet 56:72 (c,4) Jl '96
— U.S. flag from sunken World War II ship
Life 17:48–9 (c,1) Je '94
— U.S. flags covering soldiers' caskets
Am Heritage 43:68–9 (1) F '92
— Vietnam
Smithsonian 26:41 (c,4) Ja '96
— Yugoslavia
Sports Illus 77:25 (c,4) Jl 22 '92
FLAMINGOS
Trav/Holiday 175:71 (c,3) Ap '92
Smithsonian 23:27 (c,4) My '92
Nat Wildlife 31:60 (c,1) F '93
Natur Hist 102:35 (c,4) My '93
Nat Wildlife 32:2–3 (c,2) Ap '94
Nat Wildlife 33:32–3 (c,1) Ag '95
— Flock in flight
Life 17:66–7 (c,1) Ag '94
FLASHLIGHTS
— Outdoor flashlight sculpture (Nevada)
Smithsonian 26:79 (c,3) Ag '95
FLAX
Natur Hist 102:34–5 (c,1) Ap '93
FLEA MARKETS
— California
Smithsonian 24:49 (c,3) O '93
— Canton, Texas
Smithsonian 23:100–9 (c,2) F '93
— New York City, New York
Gourmet 52:78 (c,3) Mr '92
FLEAS
Life 17:62 (c,2) My '94
Smithsonian 26:76–85 (c,1) Jl '95
— Flea eggs
Smithsonian 26:78 (c,4) Jl '95

FLIES
Smithsonian 23:51 (c,4) D '92
Natur Hist 102:cov.,1,30–7 (c,1) Ap '93
Natur Hist 103:49–51 (c,1) Je '94
Smithsonian 27:61 (painting,c,4) Je '96
Natur Hist 105:82–3 (c,1) O '96
— Fly larvae
Natur Hist 103:56–8 (c,1) Ja '94
— Fossil whitefly
Life 16:112 (c,4) O '93
— Houseflies
Natur Hist 101:28 (c,3) F '92
— Magnified blackfly
Life 17:63 (c,2) My '94
— Scorpionflies
Natur Hist 102:30–2 (c,1) S '93
— Stonefly
Natur Hist 104:4 (c,2) F '95
— Swarm of brine flies
Natur Hist 101:84–5 (c,1) Mr '92
— See also
FRUIT FLIES
FLOODS
— Australia
Nat Geog 189:4–6 (c,1) Je '96
— Bangladesh
Nat Geog 183:118–34 (c,1) Je '93
— Bombay street, India
Nat Geog 187:59 (c,1) Mr '95
— Chapel in flood (U.S.S.R.)
Nat Geog 185:125 (c,3) Je '94
— Children stepping on water buffaloes
during flood (India)
Life 16:24 (c,4) N '93
— Destroyed town rebuilding on new site
(Valmeyer, Illinois)
Smithsonian 27:110–20 (c,1) Je '96
— Elegant resort whose dam caused the 1889
Johnstown Flood, Pennsylvania
Am Heritage 43:120–7 (1) N '92
— Great Flood of 1993 (Midwest)
Nat Geog 185:42–87 (map,c,1) Ja '94
Life 17:35–8 (c,1) Ja '94
Nat Wildlife 32:38–43 (map,c,1) Ap '94
— Impact of Ice Age Lake Missoula floods,
Northwest
Smithsonian 26:48–59 (map,c,1) Ap '95
— Man swept off by flood (California)
Life 19:34 (c,3) Ja '96
— Missouri
Life 16:31 (c,2) S '93
Nat Wildlife 32:38–43 (map,c,1) Ap '94
— Missouri forest
Natur Hist 102:25 (c,2) Je '93

— Satellite photos of Missouri during flood
and drought
Nat Wildlife 32:42–3 (c,2) Ap '94
— Street flooded after earthquake (California)
Life 17:16–17 (c,1) Mr '94
— Surrounding mansion (Mississippi)
Smithsonian 23:46–7 (c,3) F '93
— TV reporters standing waist deep in flood-
water (Luxembourg)
Life 17:118 (c,2) Ap '94
— Waterproof, Louisiana depot in 1927 flood
Smithsonian 24:14 (4) Ap '93
— World War II jeeps mired in mud(Italy)
Smithsonian 23:62–4 (2) N '92

FLOODS—DAMAGE
— Destroyed trees (Australia)
Trav&Leisure 24:103 (c,1) Jl '94
— Great Flood of 1993 (Midwest)
Nat Geog 185:42–87 (map,c,1) Ja '94

FLORENCE, ITALY
Trav&Leisure 22:72–81,121 (map,c,1) Jl
'92
Trav&Leisure 25:45,49,84,87 (map,c,1)
Ag '95
Trav/Holiday 178:cov.,38–49 (map,c,1) D
'95
Trav/Holiday 179:22–4 (c,1) O '96
— Early 18th cent.
Natur Hist 101:28–9 (painting,c,2) Ja '92
— Boboli Gardens
Trav&Leisure 23:150 (c,4) Ja '93
— Cloisters
Gourmet 55:106 (drawing,c,2) N '95
— Duomo
Gourmet 53:99 (c,2) S '93
— Foundling Hospital
Trav/Holiday 176:65–7 (painting,c,1) S
'93
— Ponte Vecchio
Trav&Leisure 22:78–9 (c,1) Jl '92
— Restaurants
Trav&Leisure 22:74–7,80–1 (c,1) Jl '92
Gourmet 53:98–103 (c,1) S '93
— Santa Maria del Fiore
Natur Hist 101:26–9 (painting,c,1) Ja '92
— See also
MEDICI, LORENZO DE

FLORIDA
— Early 20th cent. Ormond Hotel
Am Heritage 44:cov.,120–1 (c,2) Ap '93
— 1992 Hurricane Andrew damage
Life 16:42–3 (c,1) Ja '93
Nat Geog 183:2–37 (c,1) Ap '93
— Alexander Springs
Natur Hist 101:66–8 (map,c,1) N '92

— Alligators in Florida sinkhole
Natur Hist 102:92–3 (c,1) N '93
— Archbold scrub area, Lake Placid
Smithsonian 25:36–45 (c,1) S '94
— Boca Raton resort
Trav&Leisure 25:139,143–4 (c,1) N '95
— Bok Tower carillon, Lake Wales
Smithsonian 25:125 (c,1) N '94
— The Breakers, Palm Beach
Trav&Leisure 25:146 (c,1) N '95
— Central Florida sights
Trav&Leisure 22:167–70 (map,c,3) F '92
— Cypress Gardens
Trav&Leisure 22:167 (c,4) F '92
Trav&Leisure 26:33 (c,4) Jl '96
— Disney headquarters, Lake Buena Vista
Smithsonian 23:cov.,64–5 (c,1) Jl '92
— Fisher Island
Trav&Leisure 26:114–17 (c,1) Je '96
— Flagler Museum, Palm Beach
Trav/Holiday 175:56–7,63 (c,1) F '92
— Florida Bay
Sports Illus 83:76–87 (map,c,1) S 18 '95
— Fort Gadsden Dome
Natur Hist 103:80–2 (map,c,1) N '94
— Fort Myers
Nat Geog 182:26–7 (c,1) Jl '92
— Fort Pickens
Nat Geog 182:64 (c,4) O '92
— Gold Coast development by Flagler
Trav/Holiday 175:56–63 (c,1) F '92
— Grayton Beach
Life 18:84–5 (c,1) Ap '95
— Gulf Coast scenes
Trav&Leisure 22:134–41,164 (map,c,1)
Mr '92
Nat Geog 182:2–4,12-13,26–7,34–5
(map,c,1) Jl '92
— Little Palm Island
Gourmet 52:47 (c,4) Ja '92
— Ocala National Forest
Natur Hist 101:58–60 (map,c,1) Ap '92
Natur Hist 101:66–8 (map,c,1) N '92
— Ochlockonee River
Natur Hist 102:26–7 (c,1) D '93
— Ochopee post office
Trav&Leisure 24:108 (c,4) Ap '94
— Panhandle
Trav/Holiday 178:cov.,48–57 (map,c,1)
Mr '95
— Pompano Beach
Trav/Holiday 179:26 (c,4) N '96
— St. Marys River
Nat Geog 181:37–9,43 (map,c,1) Ap '92
— Sanibel Island

Smithsonian 26:61–9 (c,1) Ag '95
— Seaside
Trav&Leisure 22:74–9 (c,1) Ag '92
— Southern Florida's gold coast
Trav&Leisure 25:135–46,182–8 (map,c,1)
N '95
— See also
DRY TORTUGAS NATIONAL PARK
EVERGLADES NATIONAL PARK
FLORIDA KEYS
FORT LAUDERDALE
KEY WEST
MIAMI
MIAMI BEACH
OKEFENOKEE SWAMP
ORLANDO
PENSACOLA
ST. AUGUSTINE
ST. PETERSBURG
SARASOTA
TALLAHASSEE
TAMPA
FLORIDA KEYS, FLORIDA
Sports Illus 78:76–82 (c,4) F 22 '93
Am Heritage 46:71–3 (c,1) F '95
Am Heritage 46:29–31 (c,1) Jl '95
Trav&Leisure 26:E1–E3 (c,4) F '96
— Map
Trav/Holiday 178:85 (c,3) D '95
— Seven Mile Bridge
Trav&Leisure 24:110–11 (c,2) D '94
— See also
KEY WEST
**FLORISSANT FOSSIL BEDS
NATIONAL MONUMENT,
COLORADO**
Natur Hist 105:61–3 (map,c,1) Ag '96
FLOWER INDUSTRY
— Iris farm (Oregon)
Smithsonian 25:50–1 (c,1) My '94
FLOWERS
Nat Wildlife 34:46–51 (c,1) Ap '96
— 18th cent. paintings of flowers
Natur Hist 101:cov.,46–59 (c,1) D '92
— Alaska
Trav/Holiday 178:81 (c,4) My '95
— Alpine avens
Trav&Leisure 24:44 (c,4) Jl '94
— Australian plants
Nat Geog 187:66–89 (c,1) Ja '95
— Balsamroot
Nat Wildlife 31:52 (c,1) Je '93
— Brittlebush
Smithsonian 25:86 (c,4) Mr '95
— Bromeliads

Trav/Holiday 179:76 (c,4) O '96
— Catharanthus
Smithsonian 25:cov.,82–3,91 (c,1) Ag '94
— Caribbean varieties
Gourmet 53:54 (c,4) Ja '93
Trav/Holiday 176:cov.,70–86 (c,1) D '93
— Chelsea Flower Show, England
Trav&Leisure 25:120–7 (c,1) F '95
— Cleome
Smithsonian 25:88 (c,4) Ag '94
— Coneflowers
Nat Wildlife 30:52 (c,1) Je '92
Natur Hist 102:24 (c,1) Ap '93
— Cut flower arrangement
Nat Geog 190:53 (c,1) N '96
— Desert flowers
Smithsonian 25:cov.,78–91 (c,1) Mr '95
— Elephant's head
Natur Hist 101:19 (c,4) Ag '92
— Endangered plants
Life 17:51–63 (c,4) S '94
Nat Wildlife 35:26–31 (c,1) D '96
— Epiphytes
Nat Wildlife 30:46–7 (c,1) Ap '92
— Feather flowers
Nat Geog 187:87 (c,4) Ja '95
— Fields of flowers
Nat Wildlife 30:46–51 (c,1) Je '92
Gourmet 53:74–5 (c,1) Jl '93
— Floral centerpiece in restaurant (NewYork)
Gourmet 52:60 (c,3)) S '92
— Florida scrub plants
Smithsonian 25:36–43 (c,1) S '94
— Geometry in nature
Life 16:69–76 (c,1) O '93
— Goldfields
Natur Hist 103:22–3 (c,1) D '94
— Hawaii
Nat Wildlife 31:30–5 (c,1) Ag '93
Smithsonian 27:118–20 (c,4) N '96
— Helianthus
Natur Hist 104:25 (c,1) Ja '95
— Mustard field (Great Britain)
Gourmet 55:94–5 (c,1) Mr '95
— New Zealand
Gourmet 53:144–7 (c,1) N '93
— Phacelia
Smithsonian 25:80,84 (c,4) Mr '95
— Pipsissewa
Natur Hist 103:18 (c,4) Ag '94
— Purple loosestrife
Nat Geog 189:94–5 (c,2) Mr '96
— Resurrection plants
Nat Geog 187:78–9 (c,1) Ja '95
— Rose crown

Natur Hist 101:20 (c,4) Ag '92
— Salad made of edible flowers
Nat Geog 181:68 (c,1) My '92
— Scarlet trumpet
Natur Hist 101:15 (c,4) Mr '92
— Silverswords
Nat Wildlife 30:54–5 (c,1) Ap '92
Life 15:36 (c,4) My '92
Nat Wildlife 31:35 (c,1) Ag '93
Nat Geog 188:5 (c,2) S '95
Natur Hist 105:60 (c,4) Ja '96
— Snakeweed
Nat Geog 186:51 (c,4) S '94
— Texas snowbells
Nat Wildlife 35:28 (c,4) D '96
— Texas sunnybells
Natur Hist 101:62 (c,1) Jl '92
— Torch flowers
Nat Geog 184:92–3 (c,1) O '93
— Turtleback
Smithsonian 25:80 (c,4) Mr '95
— Wild bergamot
Natur Hist 104:23 (c,1) Mr '95
— Wildflowers
Nat Wildlife 31:56 (c,3) D '92
Natur Hist 102:34–5 (c,1) Ap '93
Natur Hist 103:cov.,52–9 (c,1) My '94
Nat Wildlife 32:38–45 (c,1) Je '94
Smithsonian 25:cov.,82–91 (c,1) Ag '94
— See also
ANEMONES
ARNICA
BACHELOR'S-BUTTONS
BIRDS-OF-PARADISE
BITTER ROOT
BLACK-EYED SUSANS
BOUGAINVILLEA
BUNCHBERRIES
BURDOCK
BUTTERCUPS
CALENDULAS
CALLA LILIES
CENTURY PLANTS
CINQUEFOIL
CLEMATIS
CLOVER
COLUMBINES
DAHLIAS
DAISIES
DUCKWEED
FIREWEED
FOXGLOVE
HEATHER
HIBISCUS
HYSSOP

INDIAN PAINTBRUSH
INDIAN PIPES
IRISES
JACK-IN-THE-PULPIT
LADY'S SLIPPERS
LILIES
LOTUS
LUPINES
MAGNOLIAS
MALLOW PLANTS
MARIGOLDS
MILKWEED
MISTLETOE
MONKEY FLOWERS
MORNING-GLORIES
MUSTARD PLANTS
MYRTLE
ORCHIDS
PANSIES
PASQUEFLOWERS
PINKS
PITCHER PLANTS
POPPIES
PRICKLY PEARS
PRIMROSES
RHODODENDRONS
ROSES
SAGE
SAGEBRUSH
SNAKEROOT
SUCCULENTS
SUNDEW
SUNFLOWERS
SWEET PEAS
THISTLES
TRILLIUM
VENUS'S-FLYTRAPS
VERBENAS
VIOLETS
WATER LILIES
WILLOWS
Flowers, carnivorous. See
PITCHER PLANTS
SUNDEW
VENUS'S-FLYTRAPS
FLUTE PLAYING
Smithsonian 27:47 (c,4) Ag '96
— Blind child playing flute (Colombia)
Life 16:10–11 (c,1) O '93
FLYCATCHERS
Natur Hist 102:44 (c,4) My '93
Nat Geog 183:80 (painting,c,4) Je '93
Nat Wildlife 31:44 (c,3) Je '93
Smithsonian 27:58 (painting,c,4) Je '96

FLYING FOXES
Trav&Leisure 26:52 (c,1) Jl '96
Nat Geog 190:46 (c,4) N '96
FLYING SQUIRRELS
Nat Wildlife 30:58 (c,4) O '92
Natur Hist 103:76–7 (c,1) Ja '94
Natur Hist 103:6 (c,3) My '94
Nat Wildlife 33:50–1 (c,1) D '94
Nat Wildlife 33:59 (c,2) O '95
FLYNN, ERROL
Life 15:85 (4) F '92
Sports Illus 77:101 (4) Fall '92
Smithsonian 27:78 (4) Je '96
FOG
Nat Wildlife 32:52–9 (c,1) F '94
— California
Smithsonian 26:102 (c,1) D '95
— Collecting water from fog (Chile)
Life 16:80–4 (c,1) N '93
Natur Hist 104:44–7 (c,1) N '95
— Hudson Valley, New York
Nat Geog 189:74–5 (c,1) Mr '96
— Morning mist in park (Texas)
Nat Wildlife 35:44–5 (c,1) D '96
— Over Appalachian hollows, Virginia
Nat Geog 183:114–15 (c,1) F '93
— Over California river
Nat Geog 184:68–9 (c,1) Jl '93
— Over lake fishermen (Arkansas)
Trav/Holiday 177:90 (c,3) My '94
— Over marsh (Florida)
Nat Geog 185:12–13 (c,2) Ap '94
— Over New Orleans, Louisiana
Life 16:96–7 (c,1) D '93
— Over park (Washington)
Nat Wildlife 32:54–9 (c,1) F '94
— Playing football in fog
Sports Illus 81:124–5 (c,1) N 14 '94
— Puget Sound, Washington
Nat Geog 187:111–13,122–3 (c,1) Je '95
— Taiwan countryside
Nat Geog 184:28–9 (c,1) N '93
FOOD
— 1930s Coca-Cola poster (Germany)
Am Heritage 46:69 (c,4) My '95
— 1946 cake shaped like atomic mushroom
cloud
Smithsonian 25:54 (4) Ap '94
Natur Hist 104:1 (4) Jl '95
— American pies
Natur Hist 104:30–1 (c,4) O '95
— Antipasto bar in restaurant (New York)
Gourmet 53:54 (c,3) Je '93
— Buffalo chicken wings
Trav/Holiday 175:31 (c,4) Je '92

— Chili
Gourmet 52:132–3 (c,1) D '92
— Choucroute (Alsace, France)
Trav/Holiday 175:78 (c,4) My '92
— Creme brulee
Trav&Leisure 25:48 (c,4) N '95
— Cupcakes
Gourmet 52:cov. (c,1) F '92
— Drive-in restaurant fast food (Georgia)
Gourmet 55:108 (c,2) O '95
— Foodstuffs preserved from 1911 Antarctic
expedition
Life 16:82–3 (c,1) Mr '93
— French fries (Belgium)
Trav/Holiday 179:76–81 (c,1) N '96
— Gingerbread house (Vermont)
Gourmet 54:136 (c,4) D '94
— Humorous look at dieting
Smithsonian 25:146–56 (drawing,c,1) N
'94
— Ice cream cone
Gourmet 52:24 (c,4) S '92
— Indonesian rijsttafel (Netherlands)
Gourmet 54:102 (c,3) Je '94
— Japanese platters
Gourmet 54:112 (drawing,4) N '94
— Lobster clambake (New England)
Gourmet 52:cov. (c,1) Ag '92
— Marshmallow model of Dorothy's ruby
slippers
Smithsonian 25:13 (c,4) Jl '94
— Mock-up of sandwich for an ad
Life 17:107–8 (c,2) D '94
— Oriental foods
Gourmet 56:202–5 (c,1) O '96
— Salad made of edible flowers
Nat Geog 181:68 (c,1) My '92
— Southwestern foods
Gourmet 55:72 (c,2) S '95
— Sushi (Japan)
Nat Geog 188:49 (c,4) N '95
— Sushi keychain (Japan)
Trav/Holiday 179:18 (c,4) S '96
— Symbols of America pictured with
American foods
Gourmet 53:34,64 (painting,c,4) Ap '93
— Thanksgiving foods
Gourmet 52:178–82 (c,1) N '92
— 300 pound lard sculpture of pig (Texas)
Life 15:26 (c,4) Je '92
— Tradition of eating "Hopping John" on
New Year's Day
Smithsonian 24:82–8 (painting,c,1) D '93
— Viennese pastries (Austria)
Trav/Holiday 179:68–73 (c,1) O '96

— Wedding cakes
 Natur Hist 102:58–67 (c,1) D '93
— Welfare family's monthly food purchases
 Life 19:65–71 (c,1) Ja '96
— See also
 BREAD
 BREAKFAST
 CHEESE
 COOKING
 DINNERS AND DINING
 DRINKING CUSTOMS
 FOOD PROCESSING
 FRUITS
 GRAIN
 NUTS
 RESTAURANTS
 SPICES
 VEGETABLES

FOOD MARKETS
— 1936 roadside stand (Alabama)
 Am Heritage 45:126 (4) D '94
— Budapest, Hungary
 Trav/Holiday 175:56 (3) My '92
— Caviar stores (London, England)
 Trav&Leisure 24:8,40 (c,4) Je '94
— Cheese market (Alkmaar, Holland)
 Trav/Holiday 175:114 (c,4) Mr '92
— Edible plant market (India)
 Natur Hist 105:6 (c,4) Jl '96
— Farm stand
 Gourmet 53:62–3 (c,1) Jl '93
— Farmers market (Cahors, France)
 Trav&Leisure 24:84 (c,4) My '94
— Fish market (Ecuador)
 Natur Hist 104:84 (c,4) O '95
— Fish market (Istanbul, Turkey)
 Trav&Leisure 26:85 (c,4) Ag '96
— Fish market (Oman)
 Trav/Holiday 177:93 (c,4) Ap '94
— Fish market (Seoul, South Korea)
 Trav/Holiday 175:18 (c,4) D '92
— Fish market (Tokyo, Japan)
 Nat Geog 188:38–51 (c,1) N '95
— Fish market (Tunisia)
 Trav/Holiday 178:44 (c,3) N '95
— Fish store (Paris, France)
 Trav&Leisure 22:121 (c,1) Ap '92
— Food and medicine shop (Hong Kong)
 Natur Hist 105:44–5 (c,3) S '96
— Fruit stand (Florida)
 Natur Hist 105:74 (4) Ag '96
— Fruit stand (Italy)
 Natur Hist 102:67 (3) Jl '93
 Trav&Leisure 24:94 (c,4) My '94
— Fruit store (New York City, New York)

 Life 17:58–9 (c,1) O '94
— Fulton Fish Market, New York City, New
 York
 Trav&Leisure 22:NY1 (c,4) O '92
 Natur Hist 104:72–3 (2) Jl '95
— Harrod's food hall, London, England
 Gourmet 53:24 (drawing,c,2) Ag '93
— Jewish deli (New York)
 Smithsonian 25:80 (1) Ap '94
— Kabul, Afghanistan
 Nat Geog 185:135 (c,4) My '94
— Kenya
 Natur Hist 105:52–3 (c,1) Ja '96
— Lisbon, Portugal
 Trav/Holiday 177:52–3 (c,2) N '94
— Madeira
 Gourmet 53:116 (c,3) D '93
 Natur Hist 104:80 (2) My '95
— Mercato Centrale (Florence, Italy)
 Trav&Leisure 22:72 (c,1) Jl '92
— Monaco
 Trav/Holiday 176:73 (c,4) F '93
— Olive stall (Ireland)
 Trav&Leisure 24:48 (c,4) Jl '94
— Outdoor market (Nice, France)
 Gourmet 54:101 (c,1) S '94
— Paris, France
 Trav&Leisure 25:99,101 (c,1) Je '95
— Pickle shop (New York City, New York)
 Am Heritage 43:73 (4) Ap '92
— Pike Place Market, Seattle, Washington
 Am Heritage 45:76–7 (c,1) Ap '94
— Roadside fruit stands (Midwest)
 Trav&Leisure 25:159,188 (c,4) S '95
 Trav&Leisure 26:74 (c,1) Ag '96
— Rome, Italy
 Trav&Leisure 25:75 (c,4) Ja '95
— St. Martin
 Trav&Leisure 23:82 (c,4) F '93
— Salvador, Brazil
 Trav/Holiday 175:65 (c,1) Je '92
— Sausage store (Munich, Germany)
 Trav&Leisure 24:117 (c,3) My '94
 Trav&Leisure 24:19 (c,4) Ag '94
— Sausage store (Northern Ireland)
 Gourmet 55:104 (c,3) D '95
— Union Square Greenmarket, New York
 City, New York
 Gourmet 55:48,52 (painting,c,2) Je '95
— Vegetable stand (India)
 Natur Hist 105:74 (3) Je '96
— Vegetable market (Israel)
 Natur Hist 104:72 (2) Ag '95
— See also
 BAKERIES

BUTCHERS
STREET VENDORS
SUPERMARKETS
FOOD PROCESSING
— Clarence Birdseye
 Life 19:39 (4) D '96
— Cleaning teff flour (Ethiopia)
 Natur Hist 102:96 (c,4) Mr '93
— Curing prosciutto (Parma, Italy)
 Trav/Holiday 176:96 (c,3) Mr '93
— Cutting up tuna (Japan)
 Nat Geog 188:48–9 (c,2) N '95
— Drying curd balls (Iran)
 Natur Hist 102:8 (c,4) Mr '93
— Fortune cookie factory
 Smithsonian 24:92 (c,4) Ja '94
— Hershey's Kiss inspector (Pennsylvania)
 Life 16:108 (c,2) O '93
— Making Parmesan cheese (Parma, Italy)
 Trav/Holiday 176:95,98–9 (c,3) Mr '93
— Processing muttonbirds (Tasmania)
 Natur Hist 104:34–5 (c,1) Ag '95
— Sausage plant (California)
 Gourmet 54:118 (c,4) My '94
— Scallop packing plant (Russia)
 Nat Geog 190:57 (c,3) O '96
— Winnowing and husking quinoa (Bolivia)
 Natur Hist 101:73–5 (c,1) Je '92
— See also
 CHEESE INDUSTRY
 FISHING INDUSTRY
 MUSHROOM INDUSTRY
 individual food products listed under IN-
 DUSTRIES
FOOTBALL
— Helmeted boys in huddle (Pennsylvania)
 Nat Geog 185:37 (c,1) Je '94
FOOTBALL—COLLEGE
 Sports Illus 77:18–197 (c,1) Ag 31 '92
 Sports Illus 77:40–7 (c,1) S 14 '92
 Sports Illus 77:26–8,33 (c,2) N 30 '92
 Sports Illus 79:cov.,2–3,24–109 (c,1) Ag
 30 '93
 Sports Illus 79:12–32 (c,1) N 22 '93
 Sports Illus 79:cov.,2–3,14–21 (c,1) N 29
 '93
 Sports Illus 81:cov.,2–3,30–97 (c,1) Ag
 29 '94
 Sports Illus 81:18–22 (c,1) S 19 '94
 Sports Illus 81:cov.,14–19 (c,1) S 26 '94
 Sports Illus 81:cov.,20–8 (c,1) O 3 '94
 Sports Illus 82:cov.,2–3,20–30 (c,1) Ja 9
 '95
 Sports Illus 83:2–3,40–114 (c,1) Ag 28 '95
 Sports Illus 83:16–21 (c,1) O 2 '95

Sports Illus 83:42–50 (c,1) O 16 '95
 Sports Illus 83:24–32 (c,1) D 4 '95
 Sports Illus 85:36–118 (c,1) Ag 26 '96
 Sports Illus 85:28–41 (c,1) S 16 '96
 Sports Illus 85:2–3,28–33 (c,1) O 7 '96
— 1906
 Sports Illus 83:4 (4) D 18 '95
— 1920s
 Sports Illus 85:106 (4) Ag 26 '96
 Sports Illus 85:13 (3) N 25 '96
— 1930s
 Sports Illus 77:98,102–3 (2) Fall '92
 Sports Illus 82:7 (4) Je 26 '95
— 1954
 Sports Illus 83:2–3 (1) Ag 28 '95
— 1960s
 Sports Illus 79:64–5,70–1 (1) O 4 '93
— Coaches
 Sports Illus 78:2–3 (c,1) Ja 11 '93
 Sports Illus 79:94–109 (c,1) Ag 30 '93
 Sports Illus 81:56–7 (c,1) D 5 '94
 Sports Illus 82:35 (c,2) My 15 '95
 Sports Illus 83:74–5 (c,1) O 23 '95
— Cotton Bowl 1994 (Notre Dame vs. Texas
 A&M)
 Sports Illus 80:24–5 (c,1) Ja 10 '94
— Fiesta Bowl 1996 (Nebraska vs. Florida
 State)
 Sports Illus 84:66–7 (c,1) Ja 15 '96
— History of the Southwest Conference
 Sports Illus 83:72–8 (c,2) O 30 '95
— Intercepting pass
 Sports Illus 76:35 (c,1) My 4 '92
 Sports Illus 79:2–3,25 (c,1) S 20 '93
 Sports Illus 82:2–3 (c,1) Ja 9 '95
— Kicking ball
 Sports Illus 85:2–3 (c,1) O 14 '96
— Line of scrimmage
 Sports Illus 81:60 (c,1) N 7 '94
— Mascots
 Sports Illus 77:2–3,50–1 (c,1) Ag 31 '92
 Sports Illus 79:82–3 (c,1) Ag 30 '93
 Sports Illus 79:2–3 (c,1) N 1 '93
— Orange Bowl 1942 (Georgia vs. Texas
 Christian)
 Sports Illus 83:72 (4) O 30 '95
— Orange Bowl 1988 (Miami vs. Okla-
 homa)
 Sports Illus 83:72 (c,3) D 25 '95
— Orange Bowl 1994 (Florida State vs.
 Nebraska)
 Sports Illus 80:cov.,16–23 (c,1) Ja 10 '94
 Sports Illus 83:74 (c,3) D 25 '95
— Passing
 Sports Illus 81:36–7 (c,2) O 24 '94

Sports Illus 83:32–3 (c,1) S 18 '95
— Playing in snow
 Sports Illus 77:2–3 (c,1) N 30 '92
— Receiving pass
 Sports Illus 83:34–6 (c,1) S 18 '95
— Receiving touchdown pass
 Sports Illus 83:30–1 (c,1) D 4 '95
 Sports Illus 85:62 (c,3) N 4 '96
 Sports Illus 85:2–3 (c,1) N 18 '96
 Sports Illus 85:36–7 (c,1) D 16 '96
— Rose Bowl 1958 (Ohio vs. Oregon)
 Sports Illus 81:8 (4) D 26 '94
— Rose Bowl 1963 (USC vs. Wisconsin)
 Sports Illus 83:66–7 (1) D 25 '95
— Rose Bowl 1994 (Wisconsin vs. UCLA)
 Sports Illus 80:2–3 (c,1) Ja 10 '94
— Rose Bowl 1996 (USC vs. Northwestern)
 Sports Illus 84:38–40,45 (c,1) Ja 8 '96
— Running
 Sports Illus 77:48–9,90,100 (c,1) Ag 31
 '92
 Sports Illus 81:cov.,38–43 (c,1) O 24 '94
 Sports Illus 83:40–1 (c,1) S 11 '95
 Sports Illus 83:48–9 (c,1) O 30 '95
 Sports Illus 85:cov. (c,1) D 9 '96
— Student riot after college football win
 (Wisconsin)
 Sports Illus 79:60–7 (c,1) N 8 '93
— Sugar Bowl 1993 (Alabama vs. Miami)
 Sports Illus 78:2–3,26–31 (c,1) Ja 11 '93
— Tackling
 Sports Illus 77:12–13 (c,1) O 12 '92
 Sports Illus 77:22–7,62 (c,1) O 19 '92
 Sports Illus 77:38–9 (c,1) D 7 '92
 Sports Illus 77:96–7 (c,1) D 28 '92
 Sports Illus 78:40 (c,2) My 3 '93
 Sports Illus 79:45 (c,1) S 13 '93
 Sports Illus 79:24–6 (c,1) O 11 '93
 Sports Illus 79:42–3 (c,1) O 25 '93
 Sports Illus 81:2–3 (c,1) O 10 '94
 Sports Illus 83:38–9 (c,1) N 6 '95
— Touchdown
 Sports Illus 81:58–9 (c,1) N 7 '94
 Sports Illus 82:24–5 (c,1) Ja 9 '95
— Touchdown pass
 Sports Illus 81:cov.,20–1 (c,2) O 3 '94
 Sports Illus 81:34–5 (c,1) O 24 '94
FOOTBALL—HIGH SCHOOL
 Sports Illus 81:34–44 (c,1) N 14 '94
 Sports Illus 85:78–88 (c,1) D 16 '96
— California
 Sports Illus 77:44–53 (1) O 19 '92
— Texas
 Sports Illus 85:66–80 (1) O 28 '96

FOOTBALL—HUMOR
— Place-kicking
 Sports Illus 77:78–80 (painting,c,1) S 7
 '92
FOOTBALL—PROFESSIONAL
 Sports Illus 76:12–23 (c,1) Ja 20 '92
 Sports Illus 77:cov.,18–95 (c,1) S 7 '92
 Sports Illus 77:cov.,2–3,18–33 (c,) S 14
 '92
 Sports Illus 77:16–27 (c,1) S 21 '92
 Sports Illus 77:cov.,40–4 (c,1) N 16 '92
 Sports Illus 78:cov.,16–27 (c,1) Ja 18 '93
 Sports Illus 78:cov.,12–25 (c,1) Ja 25 '93
 Sports Illus 78:12–27 (c,1) F 1 '93
 Sports Illus 79:cov.,2–3,34–136 (c,1) S 6
 '93
 Sports Illus 79:cov.,20–31 (c,1) S 13 '93
 Sports Illus 79:16–21 (c,3) D 6 '93
 Sports Illus 81:cov.,2–3,26–146 (c,1) S 5
 '94
 Sports Illus 81:cov.,2–3,22–44,54–67
 (c,1) S 12 '94
 Sports Illus 81:24–33 (c,1) S 19 '94
 Sports Illus 81:cov.,16–21,56–67 (c,1) O
 17 '94
 Sports Illus 82:14–23 (c,1) Ja 16 '95
 Sports Illus 82:18–34 (c,1) Ja 23 '95
 Sports Illus 83:cov.,42–140 (c,1) S 4 '95
 Sports Illus 83:19–27 (c,1) S 11 '95
 Sports Illus 83:28–45 (c,1) O 9 '95
 Sports Illus 83:cov.,2–3,20–30 (c,1) N 20
 '95
 Sports Illus 85:cov.,54–144 (c,1) S 2 '96
 Sports Illus 85:28–45 (c,1) N 11 '96
— 1925
 Sports Illus 83:30–1 (1) Fall '95
— 1930s
 Sports Illus 76:64 (4) Je 1 '92
 Sports Illus 81:28,64–5 (2) S 5 '94
 Sports Illus 83:32–3,64 (3) Fall '95
 Sports Illus 84:13 (4) Ja 8 '96
 Sports Illus 85:4 (4) S 30 '96
— 1940s
 Sports Illus 81:26–7 (1) S 5 '94
 Sports Illus 83:34–5,44–7 (1) Fall '95
 Sports Illus 83:58–9,66–8 (1) D 4 '95
— 1950s
 Sports Illus 80:32–5 (1) Ja 31 '94
 Sports Illus 83:8–17,36–7 (1) Fall '95
— 1960s
 Smithsonian 25:20 (4) N '94
 Sports Illus 81:58–9 (1) N 14 '94
 Sports Illus 82:86 (1) Mr 20 '95
 Sports Illus 83:2–3,66–71 (1) Fall '95
 Life 19:76–7 (c,1) F '96

— 1973
 Sports Illus 80:32–6 (c,1) Je 27 '94
— All-time "dream team" members
 Sports Illus 77:22–5 (painting,c,1) Fall '92
— American football in Europe
 Sports Illus 79:18–21,27 (c,2) Ag 16 '93
— Blocking
 Sports Illus 81:56 (c,3) S 5 '94
— Coaches
 Sports Illus 78:36–7 (c,1) Mr 15 '93
 Sports Illus 80:24 (c,1) My 2 '94
 Sports Illus 82:52–3 (c,1) Ja 9 '95
— Dumping Gatorade on coach
 Sports Illus 82:41 (c,3) F 6 '95
— Field goal kick
 Sports Illus 83:69 (c,2) N 6 '95
— Fumble
 Sports Illus 76:15 (c,2) F 3 '92
— Grabbing a player's face mask
 Sports Illus 83:2–3 (c,1) O 30 '95
— History
 Sports Illus 83:entire issue (c,1) Fall '95
— Huddle
 Sports Illus 82:18 (c,1) Ap 24 '95
— Interception
 Sports Illus 81:20–1 (c,1) O 17 '94
 Sports Illus 82:18–19 (c,1) Ja 23 '95
— Kicking ball
 Sports Illus 85:64–5 (c,1) S 2 '96
— Left tackle moves in slow motion
 Sports Illus 81:2–3 (c,1) O '94
— Lifestyle of Dallas Cowboys
 Sports Illus 81:cov.,20–85 (c,1) D 12 '94
— NFL Playoffs 1994
 Sports Illus 80:cov.,22–36 (c,1) Ja 24 '94
 Sports Illus 80:cov.,22–31 (c,1) Ja 31 '94
— NFL Playoffs 1996
 Sports Illus 84:22–9 (c,1) Ja 8 '96
 Sports Illus 84:cov.,34–53 (c,1) Ja 15 '96
 Sports Illus 84:cov.,26–37 (c,1) Ja 22 '96
— Passing
 Sports Illus 77:cov. (c,1) S 14 '92
 Sports Illus 77:50 (c,4) S 21 '92
 Sports Illus 77:14–17 (c,1) O 5 '92
 Sports Illus 79:20–1 (c,1) Ag 23 '93
 Sports Illus 83:62–5 (c,1) Ag 7 '95
 Sports Illus 84:cov.,84 (c,1) Ja 15 '96
 Sports Illus 85:cov. (c,1) D 16 '96
— Player landing on head
 Sports Illus 77:2–3 (c,1) N 23 '92
 Sports Illus 83:2–3 (c,1) Ag 14 '95
 Sports Illus 83:46–7 (c,1) Ag 21 '95
— Playing in fog
 Sports Illus 81:124–5 (c,1) N 14 '94
— Playing in mud

— Practice drills
 Sports Illus 79:42 (c,4) Ag 2 '93
 Sports Illus 83:68 (c,4) S 25 '95
 Sports Illus 85:24 (c,1) Jl 15 '96
— Receiving
 Sports Illus 77:21,31 (c,1) S 7 '92
 Sports Illus 78:12–13 (c,1) Ja 25 '93
 Sports Illus 81:130–1 (c,1) N 14 '94
 Sports Illus 83:83 (c,1) S 4 '95
 Sports Illus 84:34–5 (c,1) Mr 11 '96
 Sports Illus 85:38–9 (c,1) O 21 '96
— Receiving touchdown pass
 Sports Illus 76:20–1 (c,1) F 3 '92
 Sports Illus 81:134–5 (c,1) N 14 '94
 Sports Illus 81:23 (c,1) N 21 '94
 Sports Illus 81:2–3 (c,1) N 28 '94
 Sports Illus 81:27 (c,2) D 5 '94
 Sports Illus 82:84–5 (c,1) Je 5 '95
 Sports Illus 83:26 (c,3) D 11 '95
 Sports Illus 84:22–9 (c,1) Ja 8 '96
— Referee pulling player away from fight
 Sports Illus 80:2–3,22–3 (c,1) Ja 17 '94
— Running
 Sports Illus 81:cov. (c,1) O 17 '94
 Sports Illus 81:36–8,43–6 (c,1) D 5 '94
 Sports Illus 83:104–5 (c,1) S 4 '95
 Sports Illus 83:48–9 (c,1) S 11 '95
 Sports Illus 83:cov. (c,1) S 18 '95
 Sports Illus 83:cov. (c,1) D 25 '95
 Sports Illus 84:24–5 (c,1) Ja 8 '96
 Sports Illus 85:64 (c,1) Jl 1 '96
 Sports Illus 85:28–31 (c,1) D 16 '96
— Super Bowl 1967 (Green Bay vs. Kansas
 City)
 Sports Illus 83:74–81 (c,1) Fall '95
— Super Bowl 1972 (Dallas vs. Miami)
 Sports Illus 78:35 (c,4) Ja 25 '93
— Super Bowl 1973 (Miami vs. Wash-
 ington)
 Sports Illus 77:58–9 (c,1) Fall '92
— Super Bowl 1976 (Pittsburgh vs. Dallas)
 Sports Illus 81:130–1 (c,1) N 14 '94
— Super Bowl 1982 (San Francisco vs.
 Cincinnati)
 Sports Illus 84:16 (c,3) Ja 22 '96
— Super Bowl 1987 (New Jersey vs. Denver)
 Sports Illus 82:39–54 (c,1) Ja 23 '95
— Super Bowl 1989 (San Francisco vs.
 Cincinnati)
 Sports Illus 84:17 (c,3) Ja 22 '96
— Super Bowl 1990 (San Francisco vs.
 Denver)
 Sports Illus 84:18 (c,3) Ja 22 '96

 Sports Illus 78:60–1 (c,3) F 1 '93
 Sports Illus 83:2–3 (1) Fall '95

— Super Bowl 1992 (Washington vs. Buffalo)
 Sports Illus 76:cov.,2–3,12–25 (c,1) F 3
 '92
 Sports Illus 77:18–19 (c,1) D 28 '92
— Super Bowl 1993 (Dallas vs. Buffalo)
 Sports Illus 78:cov.,14–66,74 (c,1) F 8 '93
 Sports Illus 78:50–1,57 (c,4) My 17 '93
 Sports Illus 79:68–9 (c,2) Jl 12 '93
 Sports Illus 80:14–21 (c,1) Ja 31 '94
— Super Bowl 1994 (Dallas vs. Buffalo)
 Sports Illus 80:cov.,26–42 (c,1) F 7 '94
— Super Bowl 1995 (San Francisco vs. San
 Diego)
 Sports Illus 82:cov.,22–41 (c,1) F 6 '95
— Super Bowl 1996 (Dallas vs. Pittsburgh)
 Sports Illus 84:cov.,2–3,20–41 (c,1) F 5
 '96
— Super Bowl rings
 Sports Illus 78:cov. (c,1) Ap 26 '93
— Tackling
 Sports Illus 76:2–3,22–3 (c,1) Ja 13 '92
 Sports Illus 77:2–3 (c,1) S 7 '92
 Sports Illus 77:41 (c,2) N 16 '92
 Sports Illus 79:4—4 (1) O 11 '93
 Sports Illus 81:86–7 (c,1) S 5 '94
 Sports Illus 81:2–3 (c,1) O 24 '94
 Sports Illus 81:cov.,20–2 (c,1) D 5 '94
 Sports Illus 81:28–9 (c,2) D 19 '94
 Sports Illus 82:62–3 (c,1) My 22 '95
 Sports Illus 83:2–3 (c,1) Ag 7 '95
 Sports Illus 85:2–3,26–8 (c,1) D 2 '96
— Touchdown
 Sports Illus 79:32–3 (c,1) S 27 '93
 Sports Illus 85:30 (c,1) D 30 '96
FOOTBALL HELMETS
 Sports Illus 79:cov.,48–9 (c,1) S 6 '93
 Sports Illus 81:2–3 (c,1) D 12 '94
FOOTBALL PLAYERS
 Sports Illus 76:2–3 (c,1) Ja 20 '92
 Sports Illus 76:37 (c,1) Ap 20 '92
 Sports Illus 77:cov.,18–98 (c,1) S 7 '92
 Sports Illus 77:cov. (c,1) S 28 '92
 Life 16:86 (c,1) Ja '93
 Sports Illus 81:42–55 (c,1) S 5 '94
— 1913
 Smithsonian 24:164 (3) N '93
— 1920s
 Sports Illus 77:94–5 (1) Fall '92
 Sports Illus 84:10 (4) Je 17 '96
— 1930
 Smithsonian 24:177 (4) N '93
— 1945
 Life 18:124 (1) Je 5 '95
— Covered with mud
 Sports Illus 79:53 (c,2) N 1 '93

— High school
 Nat Geog 187:83 (c,3) My '95
 Nat Geog 189:55 (c,3) F '96
— Life of a football player
 Sports Illus 83:22–33 (c,1) O 30 '95
— Town rechristened "Joe, Montana"
 Sports Illus 79:2–3 (c,1) Jl 5 '93
— See also
 BROWN, JIM
 GIPP, GEORGE
 GRANGE, "RED" HAROLD
 LOMBARDI, VINCE
 NAMATH, JOE
 ROCKNE, KNUTE
 THORPE, JIM
 TITTLE, Y.A.
 UNITAS, JOHNNY
FOOTBALL TEAMS
— 1888 Yale team
 Sports Illus 85:5 (4) O 14 '96
— Early 20th cent. college team (Kentucky)
 Smithsonian 24:93 (2) D '93
— 1905 college team
 Sports Illus 79:24 (4) N 22 '93
FOOTWEAR
— 15th cent. Inca sandal (Peru)
 Nat Geog 189:81 (c,2) Je '96
— 19th cent. Indian moccasins
 Smithsonian 23:129 (c,4) N '92
— 1930s saddle shoes
 Life 18:121 (4) N '95
— 1940s army boots
 Life 17:46 (c,1) Je '94
— 1946 building shaped like a shoe (Pennsyl-
 vania)
 Am Heritage 46:52 (c,4) Ap '95
— 1960s "jungle boots" worn by U.S.
 soldiers in Vietnam
 Am Heritage 46:6 (c,3) F '95
 Smithsonian 26:54–5 (c,1) My '95
— 1970s platform shoes
 Life 18:121 (c,2) N '95
— History of athletic shoes
 Sports Illus 77:10–11 (c,4) Fall '92
— Indian moccasins
 Life 17:122 (c,4) N '94
— Marshmallow model of Dorothy's ruby
 slippers
 Smithsonian 25:13 (c,4) Jl '94
— Jesse Owens' track shoes (1936)
 Sports Illus 82:9 (c,4) Ja 23 '95
— Ruby slippers from "The Wizard of Oz"
 (1939)
 Smithsonian 26:24 (c,4) F '96

— Shoes belonging to Imelda Marcos
(Philippines)
Life 19:32 (c,3) Ap '96
— Shoes of 1983 Korean airline disaster
victims
Life 16:22 (c,2) S '93
— Snakeskin sneakers
Smithsonian 22:44 (c,4) Mr '92
— See also
SHOEMAKING
SNOWSHOES
FORD, GERALD
Am Heritage 43:120 (4) S '92
Life 15:35,44 (1) O 30 '92
Smithsonian 25:141 (c,4) D '94
Am Heritage 47:52,55 (c,1) D '96
— Betty Ford
Smithsonian 23:154,158 (c,2) O '92
Life 18:32 (4) S '95
— Playing golf
Sports Illus 82:2–3 (c,2) F 27 '95
— Tripping on airplane steps
Smithsonian 25:102 (4) O '94
— Would-be assassin Squeakie Fromme
Smithsonian 24:123 (4) Mr '94
FORD, HENRY
Am Heritage 43:14 (engraving,4) Ap '92
Am Heritage 43:32 (4) S '92
Life 19:40–1 (1) Winter '96
— Home of Edsel Ford
Smithsonian 25:52 (c,2) S '94
FORECASTS
— Future of information technology
Nat Geog 188:2–37 (c,1) O '95
FORESTS
— Adirondack region, New York
Natur Hist 101:24–31,36–7,58–63 (c,1)
My '92
— Aftermath of Yosemite fire, California
Natur Hist 104:74–5 (1) D '95
— Arizona
Natur Hist 101:66–9 (c,1) S '92
— Barbados
Natur Hist 104:72 (c,2) O '95
— Belleau Wood, France
Life 16:37 (c,3) N '93
— Congo
Nat Geog 188:4–45 (c,1) Jl '95
— Forest brook (Tennessee)
Smithsonian 24:cov. (c,1) Ag '93
— Forest fire (Australia)
Nat Geog 189:7–9 (c,1) Je '96
— Forest fire (Wyoming)
Nat Wildlife 32:32–3 (c,1) Ag '94
— Forests after fires

Nat Geog 190:120–7 (c,1) S '96
— History of Smoky Bear
Smithsonian 24:59–61 (c,2) Ja '94
— Indiana
Natur Hist 104:20–1 (c,1) Ag '95
— Michigan
Natur Hist 104:22 (c,4) Mr '95
— Monongahela National Forest, West
Virginia
Nat Wildlife 34:28–9 (c,1) D '95
— Nez Perce National Forest, Idaho
Smithsonian 23:32–45 (map,c,1) S '92
— Ocala National Forest, Florida
Natur Hist 101:66–8 (map,c,1) N '92
— Oregon
Nat Geog 186:18–19 (c,1) O '94
— Poland
Trav&Leisure 24:48 (c,4) Ap '94
— Remains of forest surrounded by urban life
Natur Hist 101:6 (cartoon,c,3) Ag '92
— Ruined by acid rain and fire (U.S.S.R.)
Nat Geog 186:85 (c,3) Ag '94
— Snow scene (Wisconsin)
Nat Wildlife 32:cov. (c,1) O '94
— South Carolina
Natur Hist 104:60–1 (c,1) N '95
— Tanzania
Trav&Leisure 26:60–3 (c,1) Ja '96
— Tongass National Forest, Alaska
Nat Wildlife 34:40–1 (c,2) Ap '96
— Valley of the Giants, Oregon
Smithsonian 24:72–4 (c,3) D '93
— Virginia
Natur Hist 102:23 (c,1) Ja '93
— Wenatchee National Forest, Washington
Nat Wildlife 34:45 (c,2) D '95
— Willamette National Forest, Oregon
Nat Geog 185:10–11 (c,1) F '94
— See also
AUTUMN
NATIONAL PARKS
RAIN FORESTS
TREES
FORILLON NATIONAL PARK,
QUEBEC
Natur Hist 102:74–6 (map,c,1) My '93
FORKLIFTS
Nat Geog 183:84–5 (c,1) My '93
FORRESTAL, JAMES V.
Am Heritage 43:14 (drawing,4) S '92
FORT LAUDERDALE, FLORIDA
Trav&Leisure 25:136–9,142 (c,1) N '95
Trav&Leisure 26:F2–F11 (c,1) D '96
FORT TICONDEROGA, NEW YORK
Trav/Holiday 177:30 (c,4) Je '94

Natur Hist 104:A4 (c,4) Ap '95
— Late 18th cent.
Am Heritage 47:82 (drawing,4) Jl '96
FORT WAYNE, INDIANA
— Courthouse
Trav/Holiday 175:80–1 (painting,c,1) Ap '92
FORT WORTH, TEXAS
— Dallas/Ft. Worth Airport
Smithsonian 24:34–47 (c,1) Ap '93
FORTRESSES
— 1864 Alcatraz fortress, California
Am Heritage 43:98–103 (1) N '92
— Rumeli Hisar fortress, Istanbul, Turkey
Trav&Leisure 22:69 (c,4) My '92
— See also
ALHAMBRA
KREMLIN
MONT ST. MICHEL
FORTS
— Castillo de San Marcos, San Augustine, Florida
Am Heritage 44:56–7 (c,2) Ap '93
— El Morro, Puerto Rico
Trav&Leisure 22:52 (c,3) O '92
Trav/Holiday 179:38–9 (c,1) N '96
— Fort Laramie, Nebraska
Trav&Leisure 25:46 (c,4) Jl '95
— Fort Laramie, Wyoming (1840s)
Smithsonian 27:42 (painting,c,4) Ap '96
— Fort Scott, Kansas
Am Heritage 45:26 (c,4) N '94
— Nakhl, Oman
Nat Geog 187:124–5 (c,1) My '95
— Namutoni, Namibia
Trav/Holiday 177:90–1 (c,2) Mr '94
— Presidio, San Francisco, California
Trav/Holiday 178:85 (c,2) N '95
— Syrian gun emplacement (Israel)
Nat Geog 187:68 (c,3) Je '95
— World War I pillbox bunker (Verdun, France)
Am Heritage 44:70–1 (1) N '93
— See also
ALAMO
FORT TICONDEROGA
FORTRESSES
WEST POINT
FOSSILS
— Algae
Smithsonian 27:25 (c,4) Ag '96
— Ammonite
Natur Hist 104:68 (c,4) O '95
— Cambrian period fossils
Nat Geog 184:120–36 (c,1) O '93

— Dinosaurs
Nat Geog 183:4–47 (c,1) Ja '93
— Dragonfly fossil
Natur Hist 105:97 (c,4) F '96
Smithsonian 27:80 (c,4) Jl '96
— Fossil arthropods
Natur Hist 102:46–51 (c,1) Mr '93
— Fossil footprints from Permian period (New Mexico)
Smithsonian 23:70–6 (c,1) Jl '92
— Fossil spider
Natur Hist 102:50 (c,4) Mr '93
Natur Hist 104:28 (c,2) Mr '95
— Fossils frozen in amber
Smithsonian 23:cov.,30–41 (c,1) Ja '93
Natur Hist 102:58–61 (c,1) Je '93
Life 16:111–12 (c,2) O '93
— Ichthyosaurs
Natur Hist 101:50–1 (1) S '92
— Plesiosaurus
Natur Hist 104:69 (c,4) O '95
— Sea lilies
Natur Hist 101:40 (4) N '92
— Starfish
Natur Hist 101:41 (3) N '92
— Trilobite fossils
Natur Hist 101:36–43 (c,1) N '92
Smithsonian 23:109 (4) Ja '93
Natur Hist 102:36 (c,2) Jl '93
FOUNTAINS
— 1939 segregated drinking fountains (Oklahoma)
Am Heritage 47:95 (4) F '96
— Adelaide, Australia
Trav/Holiday 175:74 (c,3) F '92
— Backyard Italian fountain (Virginia)
Nat Wildlife 31:15 (c,2) Ag '93
— Bernini's Four Rivers, Rome, Italy
Smithsonian 23:94–5 (c,2) S '92
Trav/Holiday 177:60–1 (c,1) My '94
— Herrenchiensee castle, Germany
Trav/Holiday 176:75 (c,4) My '93
— Hyde Park, London, England
Trav&Leisure 24:98 (c,4) Mr '94
— Portland, Oregon
Nat Geog 184:25 (c,3) N 15 '93
— Rome, Italy
Smithsonian 23:cov.,89,92–101 (c,1) S '92
— Savannah, Georgia
Trav/Holiday 179:cov.,73 (c,1) My '96
— Swann Fountain, Philadelphia, Pennsylvania
Gourmet 55:136,141 (c,1) N '95
— Trento, Italy
Gourmet 53:52 (c,3) Ag '93

— Trevi Fountain, Rome, Italy
 Trav&Leisure 22:cov. (c,1) Ap '92
 Smithsonian 23:101 (c,1) S '92
 Trav&Leisure 24:168 (c,1) S '94
— Villa d'Este, Tivoli, Italy
 Gourmet 52:132–3,136 (c,1) N '92
FOURTH OF JULY
— Early 20th cent. postcards celebrating
 Independence Day
 Smithsonian 25:34–7 (c,4) Jl '94
— Outdoor Independence Day concert
 (Boston, Massachusetts)
 Nat Geog 186:26–7 (c,1) Jl '94
FOX HUNTING
— Virginia
 Gourmet 52:127 (c,4) N '92
FOXES
 Sports Illus 76:172 (c,4) Mr 9 '92
 Natur Hist 102:56–7 (c,1) F '93
 Nat Wildlife 32:38–9 (painting,c,1) Ag '94
 Natur Hist 105:84 (c,4) F '96
 Natur Hist 105:6 (c,4) Ag '96
— Arctic foxes
 Life 17:24–5 (c,1) D '94
 Nat Wildlife 34:16–23 (c,1) F '96
— Colored fox
 Natur Hist 101:28–9 (c,1) Ap '92
— Gray foxes
 Natur Hist 101:26–31 (c,1) Ap '92
 Natur Hist 105:78–9 (c,1) Je '96
— Kit foxes
 Nat Wildlife 30:50–1 (c,1) Ap '92
 Nat Wildlife 32:8–9 (c,1) O '94
 Nat Wildlife 34:29 (c,1) Ap '96
 Nat Wildlife 35:52–7 (c,1) D '96
— Red
 Nat Wildlife 30:2–3 (c,1) F '92
 Natur Hist 101:78–9 (C,1) F '92
 Nat Wildlife 31:cov.,57 (c,1) F '93
 Natur Hist 103:42 (c,4) Jl '94
 Nat Geog 186:14–15 (drawing,c,4) D '94
 Nat Wildlife 33:26–7 (painting,c,1) Ap '95
 Nat Wildlife 33:34 (c,4) O '95
 Nat Wildlife 34:2 (c,1) Ap '96
 Nat Wildlife 34:42–3 (c,1) Je '96
 Nat Wildlife 34:63 (c,2) Ag '96
FOXGLOVE
 Gourmet 53:145 (c,4) N '93
FOXX, JIMMIE
 Sports Illus 85:74,80,84 (3) Ag 19 '96
FRANCE
— 1992 Olympics sites
 Sports Illus 76:88–98,108 (c,1) Ja 27 '92
— Aix-en-Provence
 Gourmet 53:92–7,112 (map,c,1) My '93

 Trav&Leisure 26:110–17,146 (map,c,1)
 My '96
— Albertville
 Sports Illus 76:32–3 (c,1) F 17 '92
— Alsace
 Trav/Holiday 175:78–85 (map,c,1) My '92
— Ardeche region
 Trav&Leisure 24:90–7,134–6 (map,c,1) S
 '94
— Argentiere (1850s and today)
 Natur Hist 101:13 (engraving,4) Ap '92
— Argonne Forest
 Am Heritage 44:69 (1) N '93
— Arles
 Trav&Leisure 24:105 (c,3) D '94
 Nat Geog 188:66–7 (c,2) S '95
— Basque region
 Trav&Leisure 24:118–27,165–7 (map,c,1)
 Je '94
 Gourmet 54:62–7,98 (map,c,1) Ag '94
— Les Beaux
 Trav&Leisure 24:102,109 (c,1) D '94
 Nat Geog 188:61 (c,3) S '95
— Beaulieu
 Trav&Leisure 22:cov.,114–15 (c,1) Je '92
— Belle-Ile, Brittany
 Trav/Holiday 175:66–71 (painting,c,1) Je
 '92
— Belleau Wood
 Am Heritage 44:76–7 (1) N '93
 Life 16:37 (c,3) N '93
— Biarritz beach
 Nat Geog 188:91 (c,3) N '95
— Bordeaux street
 Gourmet 53:38,40 (painting,c,2) Mr '93
— Brittany
 Trav/Holiday 176:36–8 (map,c,4) O '93
— Burgundy region
 Trav/Holiday 179:60–7 (map,c,1) Jl '96
— Buzancy (1918)
 Am Heritage 47:107 (4) F '96
— Cahors
 Gourmet 56:60 (drawing,c,3) N '96
— Cap Ferrat, Riviera
 Gourmet 55:112–17,170 (map,c,1) F '95
— Champagne region
 Trav/Holiday 178:50–9 (map,c,1) N '95
— Chateau de Chambord
 Trav/Holiday 178:cov.,38–43 (c,1) Je '95
— Chateau de Gilly
 Trav&Leisure 22:16 (c,4) Je '92
— Chateau de Jussy-Champagne
 Gourmet 54:94 (c,3) Mr '94
— Chateau de la Verrerie
 Gourmet 54:92 (c,1) Mr '94

— Chateaus along Route Jacques Cartier,
Berry district
Gourmet 54:92–5,168 (map,c,1) Mr '94
— Cheverny chateau
Trav/Holiday 178:41 (c,3) Je '95
— Collioure
Gourmet 55:93–5 (c,2) Je '95
Trav&Leisure 26:47 (c,4) My '96
— Colmar
Trav/Holiday 175:79,83 (c,1) My '92
— Compiegne area
Gourmet 56:146–9,210 (map,c,1) N '96
— Countryside
Nat Geog 187:16–17 (c,1) My '95
— Countryside scarred by World War I
Am Heritage 44:69–77 (1) N '93
— English Channel Tunnel
Nat Geog 185:36–47 (c,1) My '94
— Euro Disney
Natur Hist 103:26 (c,3) D '94
— French craftsmen apprentice program
Smithsonian 27:98–109 (c,1) Je '96
— Gascony countryside
Gourmet 52:64 (painting,c,2) Ag '92
— Gordes
Gourmet 52:84–5 (c,1) F '92
Nat Geog 188:54–5 (c,1) S '95
— Lamastre
Trav&Leisure 24:92–3,96–7 (c,1) S '94
— Languedoc-Roussillon region
Gourmet 55:92–5,146–8 (map,c,1) Je '95
— Loire Valley
Trav/Holiday 178:cov.,38–47 (map,c,1) Je
'95
— Lorraine
Gourmet 53:104–7,171 (map,c,1) O '93
— Matisse Chapel, Vence
Gourmet 54:100 (c,2) S '94
— Megeve Alpine region
Trav&Leisure 26:88–97 (map,c,1) Ag '96
— Menton city hall's wedding room
Trav&Leisure 24:164 (c,2) F '94
— Montreuil-sur-Mer
Trav&Leisure 23:195 (c,4) N '93
— Normandy
Trav&Leisure 23:cov.,70–9 (map,c,1) Je
'93
Gourmet 54:96–9,146 (map,c,1) Je '94
— Provence
Gourmet 54:cov.,98–103,168–70
(map,c,1) Ap '94
Trav&Leisure 24:102–9,147 (map,c,1) D
'94
Nat Geog 188:52–77 (map,c,1) S '95
Smithsonian 26:110 (painting,c,2) Mr '96

Trav/Holiday 179:76–83 (map,c,1) Mr '96
— Quercy
Trav&Leisure 24:81–6 (map,c,4) My '94
— Riviera
Trav&Leisure 22:cov.,114–25 (map,c,1)
Je '92
— Roman amphitheater (Arles)
Trav/Holiday 179:54 (c,4) N '96
— St.-Emilion
Gourmet 54:44 (painting,c,2) Je '94
— St-Germain-en-Laye chateau
Trav&Leisure 25:28 (c,4) F '95
— St. Germaine
Gourmet 54:112 (painting,c,2) F '94
— St. Jean-de-Luz
Trav&Leisure 24:26 (c,4) O '94
— Sainte-Mere-Eglise
Trav/Holiday 177:81 (c,1) Je '94
— St. Tropez
Trav&Leisure 22:118–19,122 (c,1) Je '92
Trav&Leisure 24:50,52 (c,4) Ag '94
— Satolas railroad station
Smithsonian 27:76,88 (c,1) N '96
— Savoie
Gourmet 52:cov., 58–61, 74 (map,c,1) Ja
'92
Sports Illus 76:88–98,108 (c,1) Ja 27 '92
— Troyes
Trav/Holiday 178:56 (c,1) N '95
— Turckheim
Trav/Holiday 175:84 (c,2) My '92
— Van Gogh's home (Auvers-sur-Oise)
Trav&Leisure 24:22 (c,4) Ja '94
— Vaucluse area, Provence
Gourmet 52:84–7,126 (map,c,1) F '92
— Vaux-le-Vicomte chateau, Maincy
Smithsonian 24:62 (c,3) Je '93
— See also
ALPS
AVIGNON
CARCASSONNE
CORSICA
ENGLISH CHANNEL
LILLE
LOURDES
LYON
MEDITERRANEAN SEA
MONT ST. MICHEL
NANCY
NICE
NIMES
PARIS
PYRENEES MOUNTAINS
REIMS
RHINE RIVER

SEINE RIVER
STRASBOURG
FRANCE—ARCHITECTURE
— Cottage
Gourmet 52:124 (painting,c,2) My '92
— Provence
Gourmet 54:98–103,170 (c,1) Ap '94
FRANCE—ART
— Early impressionist works
Smithsonian 25:cov.,78–88 (painting,c,1)
N '94
FRANCE—COSTUME
— Late 18th cent. woman
Smithsonian 25:102 (drawing,c,4) Jl '94
— 1861 men's hats
Smithsonian 24:78 (painting,c,4) Mr '94
— 1890s cancan dancers (Paris)
Life 15:78,80 (c,2) Je '92
— Early 20th cent.
Smithsonian 27:75–83 (painting,c,1) D '96
— 1909 society people
Am Heritage 43:80–1 (painting,c,1) Jl '92
— 1963 children
Life 18:102–3 (1) O '95
— French Foreign Legion
Life 18:36–40 (c,1) F '95
Life 19:38–48 (1) Mr '96
— Pilgrims to Lourdes
Life 18:41–4 (c,1) Ap '95
— Provence
Nat Geog 188:56–75 (c,1) S '95
FRANCE—HISTORY
— 7th cent. Visigoth crown
Trav&Leisure 25:70 (c,4) N '95
— 1066 Norman Conquest depicted in
Bayeux Tapestry
Smithsonian 25:68–78 (c,2) My '94
— 1803 depiction of potential English
Channel tunnel threat from France
Nat Geog 185:39 (engraving,3) My '94
— 1944 liberation of Paris
Smithsonian 23:73 (1) N '92
— Current efforts to dispose of live World
War I bombs (Verdun)
Smithsonian 24:26–33 (1) F '94
— D-Day sites (Normandy)
Trav&Leisure 23:78–83 (map,c,1) Ag '93
Trav/Holiday 177:78–85 (c,1) Je '94
— Marie Antoinette's prison chamber (Paris)
Trav&Leisure 25:69 (c,4) N '95
— Francois Mitterand
Life 19:14 (2) F '96
— Napoleon burning Moscow (1812)
Trav/Holiday 178:67 (lithograph,c,4) S '95
— World War I pillbox bunker (Verdun)

Am Heritage 44:70–1 (1) N '93
— See also
DE GAULLE, CHARLES
FRANCOIS I
LAFAYETTE, MARQUIS DE
MARIE ANTOINETTE
NAPOLEON
WORLD WAR I
WORLD WAR II
FRANCE—MAPS
— Alsace
Gourmet 52:31 (c,2) F '92
— Pyrenees region
Gourmet 52:122 (4) Ag '92
FRANCE—POLITICS AND
GOVERNMENT
— Potatoes strewn in street by angry farmers
(Brest)
Life 15:18 (c,4) S '92
— President Chirac celebrating win
Life 18:22 (c,2) Jl '95
FRANCE—SOCIAL LIFE AND
CUSTOMS
— 17th cent. court tennis
Nat Geog 190:48 (drawing,c,4) Jl '96
— Bullfighting
Trav/Holiday 179:52–61 (c,1) N '96
FRANCOIS I (FRANCE)
— Caricature
Smithsonian 27:65 (painting,c,4) Ag '96
FRANK, ANNE
Life 16:66–74 (1) Je '93
FRANKENSTEIN
— Frankenstein's monster depicted in films
(1910–1994)
Life 17:44 (c,2) N '94
FRANKLIN, BENJAMIN
Life 19:56–7 (painting,4) F '96
FREDERICK THE GREAT
(GERMANY)
— Sanssouci Palace, Potsdam, Germany
Trav&Leisure 25:152–4 (c,1) S '95
FREER GALLERY OF ART, WASH-
INGTON, D.C.
— Treasures of the Freer Gallery
Smithsonian 24:27–8 (c,4) My '93
— Whistler's Peacock Room
Trav&Leisure 23:29 (c,4) My '93
FREMONT, JOHN C.
Smithsonian 27:50 (painting,c,4) Ap '96
— 1856 campaign flag
Am Heritage 43:45 (c,4) S '92
FRENCH, DANIEL CHESTER
— Home (Stockbridge, Massachusetts)

Trav&Leisure 25:81,100 (c,1) Ag '95
French Polynesia. See
 SOCIETY ISLANDS
FRESCOES
— Giotto's Bardi Chapel frescoes, Florence,
 Italy
 Trav/Holiday 178:45 (c,1) D '95
— U.S. Capitol dome canopy by Brumidi,
 Washington, D.C.
 Life 16:56-7 (c,1) S '93
FREUD, SIGMUND
 Trav/Holiday 178:86 (4) Ap '95
— Caricature
 Am Heritage 46:95 (c,2) D '95
— Freud's study (London, England)
 Trav/Holiday 178:86 (4) Ap '95
FRIEDAN, BETTY
 Am Heritage 44:57 (4) My '93
 Life 16:30 (c,4) Je '93
 Life 18:59 (c,4) Je 5 '95
FRIGATE BIRDS
 Nat Wildlife 33:16–17 (c,1) F '95
 Trav/Holiday 179:87 (c,4) F '96
FRIGATES
— Early 19th cent. frigate displaying many
 flags
 Am Heritage 44:98–9 (painting,c,1) F '93
FRISBEE PLAYING
— Disc golf
 Sports Illus 78:4–5 (c,4) Je 14 '93
FROBISHER, MARTIN
 Smithsonian 23:119 (painting,c,4) Ja '93
FROGS
 Smithsonian 23:113–20 (c,2) O '92
 Nat Geog 183:140 (c,4) Ap '93
 Nat Geog 185:33 (c,3) Ap '94
 Life 17:62 (c,2) Je '94
 Natur Hist 103:37 (c,4) O '94
— Chorus frogs
 Natur Hist 102:38–41 (c,2) Ap '93
— Different frog species
 Smithsonian 23:116–17 (c,4) O '92
— Frog eating dragonfly
 Life 16:67 (c,2) F '93
— Northern leopard frog
 Nat Wildlife 33:2–3 (c,1) Ap '95
— Poison dart frogs
 Trav/Holiday 177:90 (c,4) O '94
 Smithsonian 25:122 (c,4) O '94
 Nat Geog 187:99–111 (c,1) My '95
 Natur Hist 105:74–5 (c,1) Ja '96
— Rain forest frogs diving from trees
 Natur Hist 102:42–9 (c,1) F '93
— Tadpoles riding on father's back
 Natur Hist 105:74–5 (c,1) Ja '96

— Wood frogs mating
 Nat Geog 182:8 (c,3) O '92
—See also
 BULLFROGS
 TREE FROGS
FROST, ROBERT
 Sports Illus 81:60 (4) Jl 11 '94
 Am Heritage 46:94 (2) N '95
FRUIT FLIES
 Nat Wildlife 33:25 (c,1) F '95
— Apple maggot flies
 Natur Hist 102:4,6 (c,4) S '93
— Magnified photo of fruit fly
 Life 15:35 (c,2) O '92
FRUITS
—Cashew "apples"
 Natur Hist 101:66–9 (c,1) Ag '92
— Display of produce (Great Britain)
 Trav&Leisure 25:124–5 (c,1) F '95
— Durian fruit (Thailand)
 Trav&Leisure 24:100–1 (c,4) D '94
— Melons
 Gourmet 53:96–7,150–2 (c,1) Je '93
— See also
 APPLES
 APRICOTS
 BANANAS
 BERRIES
 BLACKBERRIES
 BLUEBERRIES
 CHERRIES
 CRANBERRIES
 GRAPES
 NUTS
 OLIVES
 ORCHARDS
 PEARS
 PERSIMMONS
 PINEAPPLES
 RASPBERRIES
 STRAWBERRIES
 TOMATOES
 WATERMELONS
FULBRIGHT, J. WILLIAM
 Life 19:93 (c,4) Ja '96
FULMARS (BIRDS)
 Natur Hist 105:78–9 (c,1) Ap '96
FUNCHAL, MADEIRA
 Nat Geog 186:104–5 (c,1) N '94
— Outdoor produce market
 Natur Hist 104:80 (2) My '95
FUNERAL RITES AND CEREMONIES
 Life 16:8–9 (c,1) My '93
— 100 B.C. stone burial mask (Mexico)
 Smithsonian 25:98 (c,4) D '94

— 19th cent. photos of dead children
Am Heritage 43:99–105 (c,2) My '92
— 1945 burial of U.S. soldiers (Okinawa)
Life 18:70–1 (1) Je 5 '95
— 1995 Kobe earthquake victims, Japan
Nat Geog 188:122 (c,1) Jl '95
— Alabama
Sports Illus 79:50–5 (c,1) Jl 26 '93
— Ancient Greek funeral pyre and wreath
Nat Geog 186:10,24–5 (c,2) N '94
— Ancient Scythian king's funeral
Nat Geog 190:68–9 (painting,c,2) S '96
— Aran Islands, Ireland
Nat Geog 189:132–3 (c,1) Ap '96
— Ashes of 1945 atomic bomb victim (Japan)
Nat Geog 188:96–7 (c,2) Ag '95
— Baby's burial (Papua New Guinea)
Nat Geog 185:54–5 (c,1) F '94
— Bomb victims (Northern Ireland)
Nat Geog 186:32–3 (c,1) S '94
— Cardinal (Ukraine)
Nat Geog 183:48–9 (c,1) Mr '93
— Copper Age
Nat Geog 183:64–5 (painting,c,1) Je '93
— Deaths and funerals of U.S. presidents
Life 15:6–9 (c,3) O 30 '92
— Family at gravesite (Alberta)
Sports Illus 77:38 (c,4) Ag 24 '92
— Funeral of slain policewoman (Pennsylvania)
Life 19:10–11 (c,1) Mr '96
— Funeral of U.S. soldier killed in Gulf War
Life 15:36–7 (c,1) Ja '92
— Funeral procession (China)
Natur Hist 105:34 (c,1) Jl '96
— Georgia, U.S.S.R.
Nat Geog 181:99 (c,2) My '92
— Ghana
Nat Geog 185:84–5 (c,1) Je '94
— Infant in coffin (U.S.S.R.)
Nat Geog 185:61 (c,4) Ap '94
— Italy
Sports Illus 79:69 (4) D 6 '93
Nat Geog 187:88–9 (c,2) F '95
— Jazz funeral (New Orleans, Louisiana)
Trav&Leisure 24:80–1 (1) Ja '94
Life 17:89 (4) N '94
Life 18:98 (c,3) Ap '95
— Ayatollah Khomeini's funeral (1989)
Life 18:112 (c,4) Je 5 '95
— Mennonite funeral (Mexico)
Life 17:94 (4) O '94
— Mexican politician
Nat Geog 190:39 (c,2) Ag '96
— Party for the dead (Madagascar)

Life 19:72 (c,4) S '96
— Putting coffin into hearse
Sports Illus 81:48 (c,4) O 17 '94
— Ritual on stilts for the dead (Mali)
Trav&Leisure 25:141 (c,1) F '95
— Robotic Buddhist priest praying over dead
(Japan)
Life 16:25 (c,4) Je '93
— Franklin Roosevelt's funeral (1945)
Am Heritage 46:40 (4) Ap '95
— Russian skater (Moscow)
Sports Illus 83:35,41 (c,1) D 4 '95
— Shaving head in mourning (Trinidad)
Nat Geog 185:77 (c,2) Mr '94
— Tending Japanese graves (Russia)
Nat Geog 190:52–3 (c,2) O '96
— Women wearing mourning beads (Papua
New Guinea)
Trav/Holiday 176:64 (c,4) Ap '93
— Yugoslavia
Trav/Holiday 175:41 (4) Ap '92
— See also
CEMETERIES
COFFINS
DEATH
DEATH MASKS
GRIEF
MUMMIES
TOMBS
TOMBSTONES

FUNGI
Nat Geog 185:61 (c,4) F '94
Life 17:61 (c,4) Je '94
Natur Hist 103:50 (c,4) N '94
— Corn smut
Natur Hist 104:20 (c,4) Ja '95
— Different fungus varieties
Natur Hist 101:cov.,46–53 (c,1) Mr '92
— Fungus growing on caterpillar
Smithsonian 24:22 (c,4) O '93
— Hunting for truffles (Italy)
Trav/Holiday 175:58–9 (2) N '92
— Morels
Gourmet 52:82 (c,4) F '92
— Starfish stinkhorn
Natur Hist 105:82–3 (c,1) O '96
— Truffle Festival (Alba, Italy)
Gourmet 52:106 (c,3) O '92
— Webcap varieties
Nat Wildlife 33:48–9 (painting,c,4) Ap '95
— White truffles
Gourmet 52:104 (c,4) O '92
— See also
MUSHROOMS

FURNITURE
— Late 17th cent. baby cradle
 Am Heritage 43:102 (c,4) S '92
— 18th cent. Gustavian style (Sweden)
 Trav&Leisure 24:64—5 (c,4) Mr '94
— 1850 Victorian house (Rockport, Maine)
 Trav&Leisure 25:102–3 (c,1) My '95
— Late 19th cent. Herter Brothers ornate
 cabinetry
 Am Heritage 46:74–83 (c,1) F '95
— Late 19th cent. wicker pieces
 Smithsonian 24:22 (c,4) Jl '93
— 1920s furnishings inspired by Cubism
 Smithsonian 27:48–9 (c,4) Jl '96
— Reproduction of 17th cent. Connecticut
 chest
 Am Heritage 46:33 (c,1) Jl '95
— White House, Washington, D.C.
 Life 15:57–65 (c,1) O 30 '92
— See also
 BATHTUBS
 BEDS
 BENCHES
 CHAIRS
 CHESTS
 DESKS
 HOME FURNISHINGS
 SOFAS
 TABLES

FURNITURE INDUSTRY
— Caning chairs (Malaysia)
 Trav/Holiday 176:52 (c,4) S '93

FUTURE
— Fantasy view of the future
 Trav&Leisure 26:147 (painting,c,3) S '96
— Future of information technology
 Nat Geog 188:2–37 (c,1) O '95

–G–

GABLE, CLARK
— Caricature
 Am Heritage 46:93 (c,2) D '95

GAINSBOROUGH, THOMAS
— "Blue Boy"
 Trav/Holiday 177:74 (painting,c,4) S '94
— Painting of Benjamin Thompson (1783)
 Am Heritage 44:77 (c,4) S '93
 Smithsonian 25:103 (c,2) D '94

GALAPAGOS ISLANDS, ECUADOR
 Trav/Holiday 176:15 (c,4) D '93
— Fernandina Island
 Natur Hist 104:28–39 (c,1) Ja '95
— Galapagos Islands wildlife

 Trav/Holiday 179:78–87 (c,1) F '96

GALAXIES
 Smithsonian 24:29,33 (c,2) Je '93
 Nat Geog 185:22–3,33 (c,1) Ja '94
 Natur Hist 104:69 (4) D '95
 Natur Hist 105:60–1 (c,1) Jl '96
— M100 galaxy
 Life 17:104 (c,4) Ap '94
— NGC 1275
 Smithsonian 22:99 (c,4) Mr '92
— Seen from Hubble telescope
 Natur Hist 102:30 (c,4) D '93
— See also
 CONSTELLATIONS
 MILKY WAY
 NEBULAE
 QUASARS
 STARS

GALBRAITH, JOHN KENNETH
 Life 18:111 (c,4) Je 5 '95

GALILEE, SEA OF, ISRAEL
 Life 15:34–5 (c,1) D '92
 Nat Geog 183:58 (c,3) My '93
 Gourmet 54:101 (c,1) F '94

GALLINULES
 Natur Hist 105:66 (c,4) D '96
— Pukeko birds
 Natur Hist 102:50–7 (c,1) Jl '93

GALVESTON, TEXAS
 Nat Geog 182:12–13 (c,1) S '92
— Bishop's Palace
 Trav/Holiday 179:90 (c,4) My '96
— Map
 Trav/Holiday 176:32 (c,4) My '93

GAMBIA
— Bathurst (1943)
 Am Heritage 46:50 (4) O '95

GAMBLING
— 18th cent. lottery
 Am Heritage 45:36,38 (painting,c,4) S '94
— 1867 riverboat gambling
 Am Heritage 45:41 (drawing,4) S '94
— Early 20th cent. slot machines
 Am Heritage 45:4,48 (c,2) S '94
— 1917 sailors playing craps
 Am Heritage 45:35 (4) S '94
— 1950s roulette wheel (Nevada)
 Am Heritage 45:12 (4) D '94
— At roulette table
 Sports Illus 80:152–3 (c,1) F 14 '94
— Atlantic City casino, New Jersey
 Trav&Leisure 22:E1 (c,4) Mr '92
— Black jack table (Las Vegas, Nevada)
 Gourmet 56:128 (c,2) D '96
— Casino (California)

Sports Illus 83:60 (c,4) Jl 10 '95
— Casino (Minnesota)
 Sports Illus 83:58 (c,3) Jl 10 '95
— Casino (Mississippi)
 Trav/Holiday 179:96 (c,4) N '96
— Casino scenes
 Trav/Holiday 177:80–7 (c,1) Mr '94
— Chicago police destroying slot machines
 (1930)
 Am Heritage 45:46 (4) S '94
— Foxwoods casino, Connecticut
 Nat Geog 185:74–5 (c,1) F '94
— Gambling chips (Las Vegas, Nevada)
 Trav&Leisure 25:66 (c,4) O '95
— History of gambling in America
 Am Heritage 45:34–51 (c,1) S '94
— Monte Carlo casino, Monaco
 Trav/Holiday 176:68–9 (c,2) F '93
 Trav/Holiday 178:98 (c,4) Je '95
— Monte Carlo casino, Monaco (19th cent.)
 Trav/Holiday 178:55 (4) Ap '95
— Slot machines (Las Vegas, Nevada)
 Nat Geog 183:100 (c,4) Ja '93
 Am Heritage 45:50–1 (c,1) S '94
 Nat Geog 187:115 (c,3) Ja '95
 Sports Illus 83:52–3 (c,1) Jl 10 '95
 Smithsonian 26:56 (c,3) O '95
 Smithsonian 26:78 (2) Mr '96
— Slot machines in supermarket (Las Vegas,
 Nevada)
 Nat Geog 190:62–3 (c,2) D '96
— Three-card monte
 Life 16:115–16 (c,3) O '93
GAME PLAYING
— 1976 boule game (France)
 Life 17:34 (3) Je '94
— Ancient rubber ball (Mexico)
 Nat Geog 184:100–1 (c,4) N '93
— Arcade basketball
 Sports Illus 78:49 (c,4) F 22 '93
— Bingo (New York)
 Nat Geog 182:114 (c,4) N '92
— Boccie ball (California)
 Trav/Holiday 179:88–9 (c,1) D '96
— Checkers (Guatemala)
 Nat Geog 182:103 (c,4) N '92
— Dominoes
 Smithsonian 25:48–9 (painting,c,1) Je '94
— "Go"
 Sports Illus 76:5–6 (c,4) Mr 9 '92
 Sports Illus 79:67 (c,1) S 13 '93
— Knocking down dominoes
 Life 15:74–5 (c,1) N '92
— Monopoly
 Sports Illus 85:151 (c,4) S 2 '96

— Paintball
 Sports Illus 80:136–7 (c,1) F 14 '94
— Playing checkers on Georgia street (1939)
 Life 15:87 (3) My '92
— Scrabble
 Sports Illus 82:114 (c,4) Mr 20 '95
— Scrabble tournament
 Sports Illus 83:106–18 (c,1) D 18 '95
— Story-telling with string (Easter Island)
 Nat Geog 183:70–1 (c,2) Mr '93
— Tiddlywinks
 Sports Illus 83:160 (c,4) N 27 '95
— See also
 BADMINTON
 BILLIARDS
 CARD PLAYING
 CHESS PLAYING
 CROQUET PLAYING
 FRISBEE PLAYING
 GAMBLING
 MARBLES
 PINBALL MACHINES
 PUZZLES
 ROPE JUMPING
 SPORTS
 TENNIS
 TOYS
 VIDEO GAMES
GAMES
— 19th–20th cent. bagatelle games
 Smithsonian 23:100–1 (c,3) Ja '93
— Atlantic City "Monopoly" billboard
 Trav/Holiday 176:30 (c,4) Mr '93
— Keno ball dispenser
 Am Heritage 45:40 (c,4) S '94
GANDHI, MOHANDAS
 Smithsonian 26:114 (4) My '95
 Life 19:58 (4) F '96
 Life 19:76 (2) O '96
GANGES RIVER, INDIA
 Life 15:74–84 (c,1) Mr '92
— Varanasi
 Life 19:80 (c,3) Jl '96
GANNETS (BIRDS)
 Natur Hist 101:30–9 (c,1) Ja '92
 Natur Hist 103:68–9 (c,1) My '94
 Nat Geog 190:30 (c,3) Jl '96
GARAGES
— Family garage
 Life 16:54–6 (c,1) Mr '93
Garbage. See
 TRASH
GARBO, GRETA
 Life 16:50 (1) Ap '93
 Smithsonian 26:103 (1) O '95

GARDENING
Gourmet 52:50 (drawing,c,2) F '92
Nat Geog 181:52–81 (c,1) My '92
— Buckingham Palace, London, England
Life 15:3 (c,2) My '92
— Herb field (Thailand)
Trav&Leisure 24:82–3 (c,3) Ag '94
— Hosing down baseball field
Sports Illus 80:2–3 (c,1) Ap 11 '94
— Mowing golf course
Sports Illus 78:2–3 (c,1) Ap 19 '93
Sports Illus 81:108–9 (c,1) Ag 29 '94
— Mowing lawn (1954)
Am Heritage 45:33 (4) D '94
— Painting lawn green during drought
(California)
Nat Geog 184:39 (c,1) N 15 '93
— Prison inmates gardening
Nat Geog 181:64–5 (c,1) My '92
— Soil aerating fork (France)
Smithsonian 22:75 (c,2) F '92
— Tending golf course (Vietnam)
Nat Geog 187:84–5 (c,1) Ap '95
— See also
LAWN MOWERS
GARDENS
Nat Geog 181:52–81 (c,1) My '92
— 1st cent. garden paintings (Pompeii)
Smithsonian 25:115–17 (c,2) Je '94
— 16th cent. Villa Lante, Italy
Trav/Holiday 178:77 (c,1) Ap '95
— Adelaide Botanical Garden, Australia
Trav/Holiday 175:67 (c,1) F '92
— Arles, France
Life 15:84 (c,4) O '92
— Atlanta Botanical Garden, Georgia
Gourmet 56:72,76 (c,4) Jl '96
— Bellingarth Gardens, Mobile, Alabama
Natur Hist 103:194 (c,4) Ap '94
— Biltmore estate, Asheville, North Carolina
Trav&Leisure 25:83,88–9 (c,1) Jl '95
— Boboli Gardens, Florence, Italy
Trav&Leisure 23:150 (c,4) Ja '93
— Brooklyn Botanical Garden, New York
Gourmet 54:46–8 (map,c,2) Mr '94
— Buckingham Palace, London, England
Life 15:3 (c,2) My '92
— Cypress Gardens, Florida
Trav&Leisure 22:167 (c,4) F '92
— Elegant gardens (Netherlands)
Trav&Leisure 24:114–19 (c,1) Ap '94
— Fallen leaves in circular pattern in zen
garden (Japan)
Trav/Holiday 177:56 (c,2) Jl '94
— French chateau grounds

Trav&Leisure 25:76 (c,3) F '95
— Great Britain
Trav/Holiday 175:42 (c,2) My '92
Trav&Leisure 22:124–5 (c,1) N '92
Gourmet 53:86–91 (c,1) Je '93
Trav&Leisure 26:48 (c,4) D '96
— Great Britain estate
Gourmet 52:115 (c,2) My '92
Trav&Leisure 23:128–9,132–3 (c,1) O '93
Trav&Leisure 24:116,122–4 (c,1) D '94
Gourmet 55:28 (drawing,c,2) Ag '95
— Harlem garden lots, New York City
Nat Wildlife 33:14 (c,3) D '94
— Hedgerows (Great Britain)
Nat Geog 184:94–117 (c,1) S '93
— Herb garden (Ireland)
Trav&Leisure 24:48 (c,4) Jl '94
— Inner-city gardens (New York)
Nat Geog 187:136–8 (c,1) Ap '95
— Inner-city gardens (Philadelphia,
Pennsylvania)
Nat Geog 181:56–7,76–7 (c,1) My '92
— Ireland
Trav&Leisure 25:59 (c,1) Jl '95
— Iris garden (Montclair, New Jersey)
Life 15:3,62–6 (c,1) Je '92
— Longwood Gardens in Christmas lights,
Pennsylvania
Gourmet 53:108–12 (c,1) D '93
— Miami mansion, Florida
Trav&Leisure 25:100 (1) Mr '95
— Middleton Peace gardens, South Carolina
Trav&Leisure 25:E16 (c,4) Mr '95
— Montecito, California
Trav&Leisure 25:34 (c,4) Je '95
— Monticello vegetable garden, Charlottes-
ville, Virginia
Gourmet 53:126–8 (c,1) Ap '93
— Marie Selby Botanical Gardens, Sarasota,
Florida
Gourmet 53:89 (c,2) F '93
— New Zealand
Gourmet 53:144–7 (c,1) N '93
— Rockefeller's Kykuit gardens,
Westchester, New York
Life 18:132–3 (c,1) N '95
— Ryoanji dry garden, Japan
Trav/Holiday 177:70–1 (c,2) Jl '94
— South Africa
Trav&Leisure 24:104–5 (c,1) S '94
— Sweden
Trav&Leisure 26:93 (c,1) My '96
— Topiary
Smithsonian 23:100–9 (c,1) Mr '93
— Topiary (France)

Trav&Leisure 26:116 (c,1) My '96
— Topiary ducks (Austria)
Gourmet 55:98 (c,2) Je '95
— Topiary garden (Ladew, Maryland)
Trav/Holiday 179:80–4 (c,1) Je '96
— Topiary mimicking Seurat painting
(Columbus, Ohio)
Trav/Holiday 175:84 (c,4) Jl '92
Life 18:100–1 (c,1) My '95
— Topiary of Mickey Mouse (Florida)
Trav&Leisure 26:E6 (c,3) N '96
— Topiary of nude pregnant woman
Life 16:24 (c,4) N '93
— Topiary park (Lisbon, Portugal)
Trav/Holiday 175:12 (c,4) Je '92
— Tryon Palace gardens, New Bern, North
Carolina
Trav/Holiday 178:32 (c,4) F '95
— Tuileries, Paris, France
Am Heritage 46:111 (c,2) Ap '95
— Vizcaya Gardens, Miami, Florida
Trav/Holiday 175:82–9 (c,1) D '92
— White House, Washington, D.C.
Life 15:92–9 (c,1) O 30 '92
— Zen rock garden (Washington)
Nat Geog 181:74–5 (c,1) My '92
— See also
FLOWERS
GARDENING
GREENHOUSES
LABYRINTHS
PLANTS
GARDNER, ERLE STANLEY
Am Heritage 44:42 (4) Jl '93
GARLIC
Smithsonian 26:cov.,70–9 (c,1) D '95
GARLIC INDUSTRY—HARVESTING
— California
Smithsonian 26:73 (c,3) D '95
GARMENT INDUSTRY
— 1890s sweatshop (New York City, New
York)
Am Heritage 45:112 (2) O '94
— Preparing linen for kimonos (Japan)
Nat Geog 186:88–9 (c,2) S '94
— Sari production (India)
Nat Geog 185:82–3 (c,1) Je '94
— Sewing sweatshirts (Mexico)
Nat Geog 189:60 (c,3) F '96
— Sweatshirt factory (West Virginia)
Nat Geog 183:125 (c,4) F '93
— See also
CLOTHING
TEXTILE INDUSTRY

GASOLINE STATIONS
— Early 20th cent. (Iowa)
Am Heritage 46:59 (c,4) Ap '95
— 1920s man sitting on tower of tires to
promote gas station (California)
Smithsonian 24:100 (3) O '93
— 1932 (Ohio)
Am Heritage 46:45 (2) F '95 supp.
— 1936 gas station road sign (Iowa)
Am Heritage 44:6 (c,4) Ap '93
— 1939 (Georgia)
Life 15:87 (3) My '92
— 1940 (Texas)
Life 19:66 (2) Winter '96
— 1940s B–17 bomber on display at Oregon
gas station
Am Heritage 46:90–1 (c,1) My '95
— 1946 (New York)
Am Heritage 47:102 (c,4) D '96
— 1947 (Arizona)
Life 19:72 (1) Winter '96
— 1954 scene
Am Heritage 45:82 (drawing,c,2) D '94
— California
Trav&Leisure 24:107 (c,1) O '94
— History of gas stations
Smithsonian 24:97–101 (c,2) O '93
— Man pumping his own gas
Am Heritage 45:82 (drawing,c,2) D '94
— Marine gas pump (Michigan)
Trav&Leisure 26:106 (c,4) Ag '96
— Restored 1920s filling station (Missouri)
Smithsonian 22:109 (c,2) F '92
— World War II bomber used as gas station
(Texas)
Smithsonian 26:58–9 (4) D '95
GATES
— Brandenburg Gate, Berlin, Germany
Trav&Leisure 22:B1 (c,1) My '92
— Camden Yards gate, Baltimore, Maryland
Sports Illus 76:2–3 (c,1) Ap 13) Ja '92
— Castle Howard, Yorkshire, England
Trav&Leisure 25:88 (c,2) Je '95
— Iron works by Samuel Yellin
Am Heritage 46:96–9,114 (1) O '95
— Mycenae's Lion Gate, Greece
Trav/Holiday 175:75 (c,2) Je '92
GATES, HORATIO
— Caricature
Am Heritage 46:85 (c,4) F '95
GATES, WILLIAM
Nat Geog 188:16–17 (c,1) O '95
Smithsonian 27:25 (c,4) Ag '96
— Gates home under construction
(Washington)

Smithsonian 27:52–3 (c,2) Je '96
GATES OF THE ARCTIC NATIONAL PARK, ALASKA
Trav&Leisure 23:72,74 (c,4) My '93
Smithsonian 26:60–7 (map,c,1) Je '95
GAUDI, ANTONIO
— Casa Batllo, Barcelona, Spain
Trav/Holiday 175:57 (c,4) Mr '92
— Gaudi architecture (Barcelona, Spain)
Gourmet 52:104–9 (c,1) My '92
— Home (Barcelona, Spain)
Gourmet 52:108 (c,3) My '92
GAUGUIN, PAUL
— "Agony in the Garden" (1889)
Life 17:78–9 (painting,c,1) D '94
— "Loulou"
Life 16:82 (painting,c,1) Ap '93
GAVIALS
Nat Geog 181:19 (c,3) My '92
— Gavial hatching from egg
Nat Geog 181:19 (c,4) My '92
GAZEBOS
— California coast
Nat Geog 184:50–1 (c,1) Jl '93
— Oregon inn
Gourmet 54:34 (c,4) Jl '94
— Weston, Vermont
Gourmet 52:98 (c,4) D '92
GAZELLES
Trav&Leisure 23:94 (c,4) F '93
Nat Geog 184:86–7 (c,2) Ag '93
Natur Hist 105:12 (c,4) Je '96
GECKOS
Nat Geog 181:81 (c,4) Ja '92
Natur Hist 103:cov.,52–61 (c,1) S '94
GEESE
— Chicks
Nat Geog 189:16 (4) Je '96
— Emperor geese
Nat Wildlife 33:40 (c,4) Je '95
— Ross's geese in flight
Nat Geog 190:14–15 (c,1) O '96
— Snow geese
Nat Geog 184:102–3 (c,2) O '93
Natur Hist 105:20 (c,4) N '96
— Snow geese flying in fog
Nat Wildlife 32:56–7 (c,1) F '94
— See also
BRANTS
CANADA GEESE
GEHRIG, LOU
Sports Illus 76:76 (4) Ja 20 '92
Sports Illus 77:81 (2) D 21 '92
Sports Illus 79:6 (4) Ag 2 '93
Am Heritage 46:12 (4) F '95

Sports Illus 83:4 (4) S 4 '95
Sports Illus 84:6 (4) My 13 '96
Sports Illus 84:62 (4) Je 24 '96
Gems. See
JEWELRY
list under MINERALS
GEMSBOKS
Natur Hist 102:48–9 (c,2) My '93
GENETICS
— Computer image of DNA
Life 15:39 (c,2) O '92
Nat Wildlife 33:16–17 (c,1) O '95
— DNA crystal
Life 16:94 (c,2) D '93
— DNA research
Nat Geog 181:113–24 (c,1) My '92
Geneva, Switzerland. See
LAKE GENEVA
GENGHIS KHAN
Natur Hist 103:57 (painting,c,1) O '94
Nat Geog 190:cov.,5,29 (sculpture,c,1) D '96
— 1227 funeral procession
Nat Geog 190:34 (painting,c,4) D '96
— Sites associated with him
Nat Geog 190:cov.,2–37 (map,c,1) D '96
GENOA, ITALY
Nat Geog 181:8–11 (c,1) Ja '92
Trav&Leisure 24:107–13,142–4 (map,c,1) S '94
GEOLOGICAL PHENOMENA
— Slaughter Sink, Ozarks, Missouri
Natur Hist 102:25 (map,c,2) Je '93
— See also
ANTARCTICA
ARCTIC
BEACHES
CANYONS
CAVES
CLIFFS
DESERTS
EARTHQUAKES
FARMS
FIELDS
FLOODS
FORESTS
GEYSERS
GLACIERS
HOT SPRINGS
ICEBERGS
ISLANDS
MARSHES
MOUNTAINS
PRAIRIE
RAIN FORESTS

ROCKS
SAND DUNES
TUNDRA
VOLCANOES
WATER FORMATIONS
WEATHER
GEORGE VI (GREAT BRITAIN)
Life 19:35 (4) N '96
GEORGE, HENRY
Smithsonian 23:126 (4) My '92
**GEORGE WASHINGTON BRIDGE,
NEW YORK/NEW JERSEY**
Smithsonian 27:88 (c,4) S '96
— Original design for bridge
Smithsonian 27:88 (4) S '96
GEORGIA
— Cumberland Island
Life 18:84 (c,4) Ag '95
Trav&Leisure 26:E1–E2 (c,4) Ap '96
— Governor John M. Slaton (1915)
Am Heritage 47:105 (4) O '96
— Okefenokee National Wildlife Refuge
Nat Geog 181:43–5,48 (map,c,1) Ap '92
— St. Marys River
Nat Geog 181:37–9,43 (map,c,1) Ap '92
— Sea Islands
Gourmet 54:90–5,144 (map,c,1) F '94
— Stone Mountain Confederate heroes
monument
Life 15:15 (c,1) Jl '92
— See also
ATLANTA
JEKYLL ISLAND
OKEFENOKEE SWAMP
SAVANNAH
SAVANNAH RIVER
GEORGIA, U.S.S.R.
Nat Geog 181:82–111 (map,c,1) My '92
— See also
TBILISI
GEORGIA, U.S.S.R.—COSTUME
Nat Geog 181:82–111 (c,1) My '92
**GEORGIA, U.S.S.R.—POLITICS AND
GOVERNMENT**
— Overthrowing dictator
Nat Geog 181:89,97–101 (c,1) My '92
GERMAN SHEPHERDS
Sports Illus 82:82–4 (c,1) Ap 10 '95
Trav/Holiday 178:61 (c,3) Je '95
GERMANY
— 1845 canal (Prunn)
Nat Geog 182:8–9 (c,2) Ag '92
— Bad Karlshafen
Trav/Holiday 176:56 (c,1) Jl '93
— Bamberg

Trav&Leisure 26:78–80 (c,4) My '96
— Bavarian countryside
Nat Geog 182:2–31 (map,c,1) Ag '92
— Berching
Nat Geog 182:14 (c,1) Ag '92
— Bremerhaven
Am Heritage 47:6 (c,3) Ap '96
— East Germany
Trav&Leisure 24:110–23,126–30 (map,1)
F '94
— Fairy Tales Road
Trav/Holiday 176:50–9 (map,c,1) Jl '93
— Herrenchiensee castle, Bavaria
Trav/Holiday 176:75–6 (c,2) My '93
— Hohenschwangau castle, Bavaria
Trav/Holiday 176:70–1 (c,1) My '93
— Linderhof castle, Bavaria
Trav/Holiday 176:72–3 (c,2) My '93
Trav&Leisure 23:92–9,143 (map,c,1) D
'93
— Lubeck
Nat Geog 186:74–7 (c,1) O '94
— Luneberg
Nat Geog 186:56–61,72û3 (c,1) O '94
— Main–Danube Canal
Nat Geog 182:2–31 (map,c,1) Ag '92
— Neuschwanstein castle, Bavaria
Trav/Holiday 176:cov.,76 (c,1) My '93
— Rudesheim
Trav/Holiday 177:52,57 (c,2) S '94
— Sylt
Trav&Leisure 26:144–51,189–91
(map,c,1) O '96
— Vitra Design Museum, Weil am Rhein
Trav/Holiday 178:67 (c,1) Ap '95
— Weimar
Trav/Holiday 177:35 (c,4) Je '94
— Wurzburg
Trav&Leisure 26:74–6 (c,2) My '96
— See also
BADEN-BADEN
BERLIN
BERLIN WALL
BREMEN
COLOGNE
DRESDEN
HAMBURG
LEIPZIG
MANNHEIM
MUNICH
NUREMBERG
POTSDAM
RHINE RIVER
WESER RIVER
WIESBADEN

GERMANY—COSTUME
— Berlin
 Nat Geog 190:96–115 (c,1) D '96
— Border guards
 Nat Geog 183:122–3 (c,1) My '93
— Folk dress (Alsfeld)
 Trav/Holiday 176:55 (sculpture,c,3) Jl '93
— Lederhosen
 Trav&Leisure 26:53 (1) Ja '96
— Sylt
 Trav&Leisure 26:144–51,189 (c,1) O '96

GERMANY—HISTORY
— 14th–17th cent. Hanseatic League
 Nat Geog 186:56–79 (map,c,1) O '94
— 1936 launch of navy training ship
 Smithsonian 26:25 (3) Ag '95
— 1939 Hitler-Stalin pact
 Am Heritage 43:40 (cartoon,4) My '92
— 1945 Nuremberg Trials
 Am Heritage 45:78–87 (c,1) Jl '94
 Smithsonian 27:124–41 (1) O '96
— Late 1980s posters promoting Eastern
 European revolutions
 Smithsonian 24:118–23 (c,2) Ap '93
— 1989 destruction of the Berlin Wall
 Life 17:46 (c,4) N '94
 Life 18:114 (c,2) Je 5 '95
— Goering at Nuremburg Trial (1945)
 Life 18:104–5 (1) Je 5 '95
 Smithsonian 27:124–8,141 (1) O '96
— German World War II POWs in U.S.
 camps
 Smithsonian 26:126–43 (1) Je '95
— Russian flag atop the Reichstag (1945)
 Life 18:52 (2) Je 5 '95
— Karl Theodor (Bavaria)
 Smithsonian 25:112 (painting,c,4) D '94
— See also
 BRANDT, WILLY
 CONCENTRATION CAMPS
 FREDERICK THE GREAT
 GOERING, HERMANN
 HESS, RUDOLF
 HITLER, ADOLPH
 LUDWIG II
 NAZISM
 SPEER, ALBERT
 WORLD WAR I
 WORLD WAR II

GERMANY—HOUSING
— 14th cent. houses (Lubeck)
 Nat Geog 186:74–7 (c,2) O '94
— 15th cent. row houses (Hamburg)
 Trav&Leisure 25:118 (c,4) Je '95
— Sylt
 Trav&Leisure 26:151 (c,4) O '96

GERMANY—MAPS
— Berlin
 Trav&Leisure 23:105 (c,1) Mr '93
— Rheingau region
 Gourmet 55:44 (4) Mr '95
— Thuringia
 Trav/Holiday 177:37 (c,4) Je '94

GERMANY—POLITICS AND GOVERNMENT
— Neo-Nazi demonstration
 Nat Geog 183:124–5 (c,1) My '93

GERMANY—RITES AND FESTIVALS
— Oktoberfest (Munich)
 Nat Geog 181:10–11 (c,1) F '92
— Solemn Christmas procession (Langenfeld)
 Life 19:24–5 (c,1) D '96

GERMANY—SCULPTURE
— Girl in folk dress (Alsfeld)
 Trav/Holiday 176:55 (c,3) Jl '93

GERMANY—SIGNS AND SYMBOLS
— Nazi swastika
 Life 19:28 (1) O '96

GERMANY—SOCIAL LIFE AND CUSTOMS
— Early 20th cent. German views of Ameri-
 can culture
 Am Heritage 46:62–9 (1) My '95

GERONIMO
 Nat Geog 182:47–71 (1) O '92
— Sites related to Geronimo's life
 Nat Geog 182:47–71 (map,c,1) O '92

GERSHWIN, GEORGE AND IRA
— Caricature
 Am Heritage 44:82–4 (c,1) O '93
— George Gershwin
 Smithsonian 27:53 (4) N '96

GETTY, J. PAUL
— Getty Museum, Malibu, California
 Trav&Leisure 25:136 (c,2) My '95

GETTYSBURG, PENNSYLVANIA
— Civil War battlefields
 Am Heritage 45:104–13 (c,1) Ap '94
 Trav/Holiday 177:74–81 (c,1) Jl '94
 Gourmet 55:50–3,86 (map,c,1) Jl '95
— Lincoln Square
 Gourmet 55:52 (c,4) Jl '95

GEYSERS
— Atlantic Ocean deep-sea geysers
 Nat Geog 182:104–9 (c,1) O '92
— Kamchatka, U.S.S.R.
 Nat Geog 185:54–5 (c,1) Ap '94
 Trav&Leisure 25:61 (c,1) Ag '95
— Old Faithful, Yellowstone, Wyoming
 Trav/Holiday 175:44–5 (c,1) Je '92

ROCKS
SAND DUNES
TUNDRA
VOLCANOES
WATER FORMATIONS
WEATHER
GEORGE VI (GREAT BRITAIN)
Life 19:35 (4) N '96
GEORGE, HENRY
Smithsonian 23:126 (4) My '92
**GEORGE WASHINGTON BRIDGE,
NEW YORK/NEW JERSEY**
Smithsonian 27:88 (c,4) S '96
— Original design for bridge
Smithsonian 27:88 (4) S '96
GEORGIA
— Cumberland Island
Life 18:84 (c,4) Ag '95
Trav&Leisure 26:E1–E2 (c,4) Ap '96
— Governor John M. Slaton (1915)
Am Heritage 47:105 (4) O '96
— Okefenokee National Wildlife Refuge
Nat Geog 181:43–5,48 (map,c,1) Ap '92
— St. Marys River
Nat Geog 181:37–9,43 (map,c,1) Ap '92
— Sea Islands
Gourmet 54:90–5,144 (map,c,1) F '94
— Stone Mountain Confederate heroes
monument
Life 15:15 (c,1) Jl '92
— See also
ATLANTA
JEKYLL ISLAND
OKEFENOKEE SWAMP
SAVANNAH
SAVANNAH RIVER
GEORGIA, U.S.S.R.
Nat Geog 181:82–111 (map,c,1) My '92
— See also
TBILISI
GEORGIA, U.S.S.R.—COSTUME
Nat Geog 181:82–111 (c,1) My '92
**GEORGIA, U.S.S.R.—POLITICS AND
GOVERNMENT**
— Overthrowing dictator
Nat Geog 181:89,97–101 (c,1) My '92
GERMAN SHEPHERDS
Sports Illus 82:82–4 (c,1) Ap 10 '95
Trav/Holiday 178:61 (c,3) Je '95
GERMANY
— 1845 canal (Prunn)
Nat Geog 182:8–9 (c,2) Ag '92
— Bad Karlshafen
Trav/Holiday 176:56 (c,1) Jl '93
— Bamberg

Trav&Leisure 26:78–80 (c,4) My '96
— Bavarian countryside
Nat Geog 182:2–31 (map,c,1) Ag '92
— Berching
Nat Geog 182:14 (c,1) Ag '92
— Bremerhaven
Am Heritage 47:6 (c,3) Ap '96
— East Germany
Trav&Leisure 24:110–23,126–30 (map,1)
F '94
— Fairy Tales Road
Trav/Holiday 176:50–9 (map,c,1) Jl '93
— Herrenchiensee castle, Bavaria
Trav/Holiday 176:75–6 (c,2) My '93
— Hohenschwangau castle, Bavaria
Trav/Holiday 176:70–1 (c,1) My '93
— Linderhof castle, Bavaria
Trav/Holiday 176:72–3 (c,2) My '93
Trav&Leisure 23:92–9,143 (map,c,1) D
'93
— Lubeck
Nat Geog 186:74–7 (c,1) O '94
— Luneberg
Nat Geog 186:56–61,72û3 (c,1) O '94
— Main–Danube Canal
Nat Geog 182:2–31 (map,c,1) Ag '92
— Neuschwanstein castle, Bavaria
Trav/Holiday 176:cov.,76 (c,1) My '93
— Rudesheim
Trav/Holiday 177:52,57 (c,2) S '94
— Sylt
Trav&Leisure 26:144–51,189–91
(map,c,1) O '96
— Vitra Design Museum, Weil am Rhein
Trav/Holiday 178:67 (c,1) Ap '95
— Weimar
Trav/Holiday 177:35 (c,4) Je '94
— Wurzburg
Trav&Leisure 26:74–6 (c,2) My '96
— See also
BADEN-BADEN
BERLIN
BERLIN WALL
BREMEN
COLOGNE
DRESDEN
HAMBURG
LEIPZIG
MANNHEIM
MUNICH
NUREMBERG
POTSDAM
RHINE RIVER
WESER RIVER
WIESBADEN

GERMANY—COSTUME
— Berlin
 Nat Geog 190:96–115 (c,1) D '96
— Border guards
 Nat Geog 183:122–3 (c,1) My '93
— Folk dress (Alsfeld)
 Trav/Holiday 176:55 (sculpture,c,3) Jl '93
— Lederhosen
 Trav&Leisure 26:53 (1) Ja '96
— Sylt
 Trav&Leisure 26:144–51,189 (c,1) O '96
GERMANY—HISTORY
— 14th–17th cent. Hanseatic League
 Nat Geog 186:56–79 (map,c,1) O '94
— 1936 launch of navy training ship
 Smithsonian 26:25 (3) Ag '95
— 1939 Hitler-Stalin pact
 Am Heritage 43:40 (cartoon,4) My '92
— 1945 Nuremberg Trials
 Am Heritage 45:78–87 (c,1) Jl '94
 Smithsonian 27:124–41 (1) O '96
— Late 1980s posters promoting Eastern
 European revolutions
 Smithsonian 24:118–23 (c,2) Ap '93
— 1989 destruction of the Berlin Wall
 Life 17:46 (c,4) N '94
 Life 18:114 (c,2) Je 5 '95
— Goering at Nuremburg Trial (1945)
 Life 18:104–5 (1) Je 5 '95
 Smithsonian 27:124–8,141 (1) O '96
— German World War II POWs in U.S.
 camps
 Smithsonian 26:126–43 (1) Je '95
— Russian flag atop the Reichstag (1945)
 Life 18:52 (2) Je 5 '95
— Karl Theodor (Bavaria)
 Smithsonian 25:112 (painting,c,4) D '94
— See also
 BRANDT, WILLY
 CONCENTRATION CAMPS
 FREDERICK THE GREAT
 GOERING, HERMANN
 HESS, RUDOLF
 HITLER, ADOLPH
 LUDWIG II
 NAZISM
 SPEER, ALBERT
 WORLD WAR I
 WORLD WAR II
GERMANY—HOUSING
— 14th cent. houses (Lubeck)
 Nat Geog 186:74–7 (c,2) O '94
— 15th cent. row houses (Hamburg)
 Trav&Leisure 25:118 (c,4) Je '95
— Sylt

Trav&Leisure 26:151 (c,4) O '96
GERMANY—MAPS
— Berlin
 Trav&Leisure 23:105 (c,1) Mr '93
— Rheingau region
 Gourmet 55:44 (4) Mr '95
— Thuringia
 Trav/Holiday 177:37 (c,4) Je '94
GERMANY—POLITICS AND GOVERNMENT
— Neo-Nazi demonstration
 Nat Geog 183:124–5 (c,1) My '93
GERMANY—RITES AND FESTIVALS
— Oktoberfest (Munich)
 Nat Geog 181:10–11 (c,1) F '92
— Solemn Christmas procession (Langenfeld)
 Life 19:24–5 (c,1) D '96
GERMANY—SCULPTURE
— Girl in folk dress (Alsfeld)
 Trav/Holiday 176:55 (c,3) Jl '93
GERMANY—SIGNS AND SYMBOLS
— Nazi swastika
 Life 19:28 (1) O '96
GERMANY—SOCIAL LIFE AND CUSTOMS
— Early 20th cent. German views of American culture
 Am Heritage 46:62–9 (1) My '95
GERONIMO
 Nat Geog 182:47–71 (1) O '92
— Sites related to Geronimo's life
 Nat Geog 182:47–71 (map,c,1) O '92
GERSHWIN, GEORGE AND IRA
— Caricature
 Am Heritage 44:82–4 (c,1) O '93
— George Gershwin
 Smithsonian 27:53 (4) N '96
GETTY, J. PAUL
— Getty Museum, Malibu, California
 Trav&Leisure 25:136 (c,2) My '95
GETTYSBURG, PENNSYLVANIA
— Civil War battlefields
 Am Heritage 45:104–13 (c,1) Ap '94
 Trav/Holiday 177:74–81 (c,1) Jl '94
 Gourmet 55:50–3,86 (map,c,1) Jl '95
— Lincoln Square
 Gourmet 55:52 (c,4) Jl '95
GEYSERS
— Atlantic Ocean deep-sea geysers
 Nat Geog 182:104–9 (c,1) O '92
— Kamchatka, U.S.S.R.
 Nat Geog 185:54–5 (c,1) Ap '94
 Trav&Leisure 25:61 (c,1) Ag '95
— Old Faithful, Yellowstone, Wyoming
 Trav/Holiday 175:44–5 (c,1) Je '92

Nat Geog 186:5–6 (c,2) O '94
GHANA
— Elmina Castle
Nat Geog 182:64–7 (c,1) S '92
Natur Hist 105:38 (c,4) F '96
GHANA—COSTUME
Nat Geog 181:22–5 (c,1) Ja '92
Nat Geog 182:64–77 (c,1) S '92
Natur Hist 105:cov.,38–47 (c,1) F '96
— Asante king Otumfuo Opoku Ware II
Natur Hist 105:38,42 (c,4) F '96
Nat Geog 190:36–8,43 (c,1) O '96
— Asante people
Nat Geog 190:36–46 (c,1) O '96
GHANA—HISTORY
— History of African slave trade
Nat Geog 182:62–91 (c,1) S '92
GHANA—MAPS
— 1547
Natur Hist 105:36–7 (c,1) F '96
GHANA—RITES AND FESTIVALS
— 1685 Akan birth ceremony
Nat Geog 182:69 (painting,c,2) S '92
— Celebrating 25-year reign of Asante king
Natur Hist 105:cov.,38–47 (c,1) F '96
Nat Geog 190:36–46 (c,1) O '96
— Funeral rites
Nat Geog 185:84–5 (c,1) Je '94
— Ornate fantasy coffins
Nat Geog 186:120–30 (c,1) S '94
— Voodoo rites
Nat Geog 188:102–13 (c,1) Ag '95
GHENT, BELGIUM
— City tower
Smithsonian 25:120 (c,4) N '94
GHIRLANDAIO, DOMENICO
— "An Old Man and His Grandson" (1490)
Life 19:84 (painting,c,4) Jl '96
GHOST TOWNS
— Abandoned gold mine (California)
Trav&Leisure 22:94–5 (c,1) Ja '92
— Battle Harbour port, Labrador,
Newfoundland
Nat Geog 184:18–19 (c,2) O '93
— Bodie, California
Trav&Leisure 23:195 (c,4) Mr '93
— Bottle house replica (Calico, California)
Trav&Leisure 24:109 (c,2) O '94
— Nevada City, California
Trav&Leisure 23:E1 (c,4) Ap '93
— Shakespeare, New Mexico
Smithsonian 22:33 (c,3) F '92
GIBBONS
Life 15:44 (c,3) N '92

GIBRALTAR
Nat Geog 190:54–71 (map,c,1) N '96
— Rock of Gibraltar
Nat Geog 190:54–9 (c,1) N '96
GILLESPIE, JOHN BIRKS (DIZZY)
Natur Hist 102:37 (c,1) S '93
Life 17:108 (1) Ja '94
— Dizzy Gillespie's trumpet
Smithsonian 25:18 (c,4) Jl '94
GIORGIONE
— "Judith" (1505)
Trav&Leisure 24:46 (painting,c,4) N '94
Smithsonian 25:42 (painting,c,3) Mr '95
GIOTTO
— Bardi Chapel frescoes, Florence, Italy
Trav/Holiday 178:45 (c,1) D '95
GIPP, GEORGE
Smithsonian 24:166 (4) N '93
GIRAFFES
Trav&Leisure 22:126 (c,1) Je '92
Natur Hist 101:28–33 (c,1) Ag '92
Life 16:88 (2) Mr '93
Nat Geog 184:2–3 (c,1) Jl '93
Trav/Holiday 177:94 (c,2) Mr '94
Gourmet 55:76–7 (c,1) Ja '95
Sports Illus 84:68 (c,3) Ja 29 '96
Smithsonian 27:104–5 (c,1) My '96
— 15th cent. painting (China)
Natur Hist 101:24 (c,3) D '92
— Baby giraffe
Smithsonian 24:18 (c,4) Ag '93
— White giraffe
Life 18:24 (c,4) Ap '95
— See also
OKAPIS
GIRL SCOUTS
— 1923
Sports Illus 83:15 (4) D 25 '95
— Indonesia
Nat Geog 189:24 (c,3) F '96
GISH, LILLIAN
Life 17:110 (1) Ja '94
GLACIER BAY NATIONAL PARK, ALASKA
Trav&Leisure 23:92,94 (c,3) Je '93
Trav/Holiday 179:43 (c,1) D '96
GLACIER NATIONAL PARK, MONTANA
Gourmet 52:94–5 (c,1) Mr '92
Trav/Holiday 176:64–5 (c,2) Je '93
Life 16:80–2 (c,1) S '93
Trav/Holiday 177:cov.,50–9 (map,c,1) Mr '94
Am Heritage 47:20 (c,4) Jl '96

— Many Glacier Hotel
 Smithsonian 27:54–5 (c,2) S '96
GLACIERS
 Nat Geog 189:cov.,70–81 (c,1) F '96
— Alaska
 Sports Illus 78:107–8,115 (c,1) F 22 '93
— Alsek Glacier, Alaska
 Nat Geog 185:132–3 (c,1) F '94
— Argentiere, France
 Natur Hist 101:13 (4) Ap '92
— Climbing in glacier caves
 Nat Geog 189:cov.,70–81 (c,1) F '96
— Kilimanjaro, Tanzania
 Trav&Leisure 26:60–1,64–5 (c,1) Ja '96
— Mendenhall Glacier, Alaska
 Trav/Holiday 179:42–4 (c,4) D '96
— Tana Glacier, Alaska
 Nat Geog 185:94–5 (c,1) My '94
— Tunnel in Kennecott Glacier, Alaska
 Natur Hist 105:28–9 (c,1) My '96
— Tweedsmuir Glacier, British Columbia
 Nat Geog 185:134 (c,3) F '94
GLACKENS, WILLIAM JAMES
— 1903 winter scene of Central Park, New
 York
 Am Heritage 44:cov. (painting,c,1) D '93
GLASGOW, SCOTLAND
 Trav&Leisure 26:114–18 (c,4) N '96
— St. Enoch shopping center
 Nat Geog 190:16 (c,4) S '96
GLASS
 Nat Geog 184:cov.,36–69 (c,1) D '93
GLASS INDUSTRY
 Nat Geog 184:cov.,36–69 (c,1) D '93
— Glass bottle manufacturing (Mexico)
 Nat Geog 190:56 (c,4) Ag '96
GLASS MAKING
— Making crystal (Ireland)
 Trav&Leisure 25:57 (c,4) Jl '95
— Venice, Italy
 Nat Geog 187:95 (c,3) F '95
GLASSBLOWING
— Creating art glass (Washington)
 Smithsonian 22:90–3 (c,2) F '92
— Czechoslovakia
 Nat Geog 184:31 (c,3) S '93
— Sweden
 Nat Geog 184:42–3 (c,1) D '93
GLASSWARE
— 11th cent. B.C. bronze wine vessel (China)
 Smithsonian 26:48 (c,4) Mr '96
— 11th cent. Islamic glass ewer
 Nat Geog 184:63 (c,1) D '93
— 13th cent. vase (China)
 Smithsonian 26:44 (c,4) Mr '96

— Art glass
 Nat Geog 184:62–9 (c,1) D '93
— Art glass of the Pilchuck school
 Smithsonian 22:cov.,90–101 (c,1) F '92
— Beer steins (Germany)
 Trav&Leisure 24:121 (c,2) My '94
— Egg cups
 Gourmet 54:43 (c,4) Ja '94
— Silver Byzantine vase
 Trav&Leisure 22:21 (c,4) N '92
— Tiffany vase
 Nat Geog 184:68–9 (c,1) D '93
— See also
 STAINED GLASS
GLIDERS
— World War II gliders
 Smithsonian 25:118–34 (2) Je '94
GLOVES
— Sioux beaded gloves
 Gourmet 55:48 (c,4) Ag '95
GOATS
 Natur Hist 102:52–3 (c,1) S '93
 Trav&Leisure 24:88 (c,1) Je '94
 Natur Hist 104:32,49 (c,1) D '95
 Life 19:88 (c,3) Ag '96
 Smithsonian 27:111 (c,1) N '96
— Girgentana goat
 Smithsonian 25:63 (c,2) S '94
— Race horse with pet goat
 Sports Illus 80:84–5 (c,2) F 21 '94
— See also
 IBEXES
 MOUNTAIN GOATS
GOBI DESERT, CHINA/MONGOLIA
 Trav&Leisure 24:86–7 (c,1) Mr '94
 Nat Geog 190:70–89 (c,1) Jl '96
Gods. See
 DEITIES
 JESUS CHRIST
 MYTHOLOGY
GOERING, HERMANN
 Am Heritage 45:78,83 (c,1) Jl '94
 Life 18:104–5 (1) Je 5 '95
 Smithsonian 27:124–8,141 (1) O '96
GOLD
— 19th cent. gold bricks
 Life 15:33,38–9 (c,1) Mr '92
— Ancient Scythian gold relics
 Nat Geog 190:55–67,79 (c,1) S '96
— Asante golden pieces (Ghana)
 Nat Geog 190:36–46 (c,1) O '96
— Bars of gold bullion (Switzerland)
 Nat Geog 183:96 (c,4) Ja '93
— Gold nugget that started the 1848 Gold
 Rush

Smithsonian 27:27 (c,4) Ag '96
GOLD MINES
— Abandoned gold mine (California)
Trav&Leisure 22:94–5 (c,1) Ja '92
— Indonesia
Nat Geog 189:20–1 (c,1) F '96
— See also
GOLD RUSH
PROSPECTING
GOLD RUSH
— Gold nugget that started the 1848 Gold
Rush
Smithsonian 27:27 (c,4) Ag '96
— See also
MARSHALL, JAMES
**GOLDEN GATE BRIDGE, SAN FRAN-
CISCO, CALIFORNIA**
Trav/Holiday 176:cov.,50–1 (c,1) Ap '93
Nat Geog 186:33–4 (c,1) O '94
Trav&Leisure 25:104–5 (c,2) F '95
Gourmet 55:89 (c,4) Je '95
Trav/Holiday 178:78–9 (c,1) N '95
— Depicted with forks as supports
Gourmet 54:90 (painting,c,2) O '94
— Painting the bridge orange
Life 18:84–5 (c,1) F '95
Nat Geog 187:32–3 (c,1) Ap '95
GOLDEN RETRIEVERS
Life 17:86 (c,4) O '94
GOLDFINCHES
Nat Wildlife 31:22 (c,4) D '92
Nat Wildlife 32:23 (c,2) Ap '94
Nat Wildlife 34:58 (c,4) F '96
Smithsonian 27:57 (c,4) Ag '96
Nat Wildlife 34:5 (c,4) Ag '96
GOLDING, WILLIAM
Life 17:82 (4) Ja '94
GOLF
— Ball about to be hit
Trav&Leisure 26:66 (c,3) N '96
— Child swinging club
Life 17:10–11 (c,1) Ag '94
— Clinton playing golf
Sports Illus 77:112–13 (c,1) D 28 '92
Sports Illus 82:2û3,50–4 (c,1) Je 12 '95
— Disc golf
Sports Illus 78:4–5 (c,4) Je 14 '93
— Dubai
Sports Illus 82:2–3,42–4,53 (c,1) Ja 30 '95
— Golf swing in slow motion
Sports Illus 76:50 (c,1) Mr 16 '92
— Hitting balls into the ocean for practice
(California)
Life 15:72–3 (c,1) O '92
— Indoor putting practice

Gourmet 55:70 (c,4) My '95
Sports Illus 84:93 (c,3) Ja 8 '96
— Indoor simulated golf
Sports Illus 76:4 (c,4) Ap 6 '92
— Llama golf caddies (North Carolina)
Life 16:23 (c,4) My '93
Smithsonian 25:58 (c,3) Ag '94
— Miniature golf
Sports Illus 81:163–4 (c,4) S 19 '94
— Night golf (New York City, New York)
Trav&Leisure 25:124 (c,4) N '95
— Nixon playing golf
Life 17:24 (4) Je '94
— Slow motion of sinking ball in hole
Sports Illus 78:24–5 (c,4) Je 14 '93
— Snow golf (New York)
Trav&Leisure 25:E8,E10 (c,4) Ja '95
— SWIN golf (Delaware)
Sports Illus 83:5 (c,4) S 18 '95
GOLF—COLLEGE
— NCAA Women's Championship 1992
Sports Illus 76:72–4 (c,4) Je 8 '92
GOLF—HUMOR
Sports Illus 76:44–50 (painting,c,1) Je 15
'92
Smithsonian 24:46–55 (painting,c,1) Ag
'93
Sports Illus 81:2–3 (painting,c,1) Ag 8 '94
— 1965 social golfing (Texas)
Sports Illus 81:52–60 (painting,c,1) Ag 1
'94
— Origin of golf in Scottish sheep pasture
Smithsonian 23:100–1 (painting,c,1) Je '92
GOLF—PROFESSIONAL
Sports Illus 85:cov.,46–50 (c,1) O 28 '96
— 1930 ticker tape parade for Bobby Jones
(New York City)
Sports Illus 80:105 (1) Ap 11 '94
— France
Sports Illus 81:64–6 (c,1) O 17 '94
— Hitting ball out of water
Sports Illus 81:24–5 (c,2) Jl 4 '94
GOLF COURSES
Sports Illus 78:86–96 (c,2) My 31 '93
— Alberta
Nat Geog 188:59 (c,3) Jl '95
— Arizona
Trav/Holiday 179:50–1 (c,4) S '96
— Baja California, Mexico
Trav&Leisure 23:30 (c,3) Je '93
— Baltusrol, New Jersey
Sports Illus 78:90 (c,2) My 31 '93
— California
Sports Illus 76:39 (c,2) Mr 9 '92
Sports Illus 78:56–7,96 (c,2) My 31 '93

— Downtown Chicago, Illinois
 Sports Illus 83:10 (c,4) Ag 21 '95
— Hawaii
 Sports Illus 78:92 (c,2) My 31 '93
— History of Pinehurst resort, North Carolina
 Am Heritage 46:55–62 (4) F '95
— Machrie, Islay, Scotland
 Nat Geog 190:22 (c,1) S '96
— Maui, Hawaii
 Trav&Leisure 22:K3,K8 (c,1) N '92
— Miniature golf course (Virginia)
 Sports Illus 78:80–1 (c,4) My 17 '93
— Mowing golf course
 Sports Illus 78:2–3 (c,1) Ap 19 '93
 Sports Illus 81:108–9 (c,1) Ag 29 '94
— New York
 Sports Illus 78:94 (c,3) My 31 '93
— Oakland Hills, Bloomfield Hills, Michigan
 Sports Illus 84:4–9 (c,1) Je 3 '96
— Pebble Beach, California
 Sports Illus 76:68–85 (c,1) Je 22 '92
 Trav/Holiday 177:31 (c,4) N '94
 Trav&Leisure 26:68 (c,4) N '96
— St. Andrews, Scotland
 Gourmet 52:54–5 (c,1) Jl '92
— Sand trap (Great Britain)
 Sports Illus 79:2–3 (c,1) Jl 26 '93
— Scotland
 Gourmet 52:52–5 (c,1) Jl '92
— Tending golf course (Vietnam)
 Nat Geog 187:84–5 (c,1) Ap '95
— Tour 18, Houston, Texas
 Sports Illus 79:101 (painting,c,4) O 18 '93
 Trav&Leisure 24:50 (c,4) O '94
— Turnberry Isle, Miami, Florida
 Trav/Holiday 179:15 (c,4) Jl '96
GOLF TOURNAMENTS
— 1930 Grand Slam by Bobby Jones
 Sports Illus 80:106–7 (4) Ap 11 '94
— Australian Open 1992
 Sports Illus 77:2–3 (c,1) D 21 '92
— British Open 1975 (Carnoustie)
 Sports Illus 83:60 (c,1) Jl 17 '95
— British Open 1977 (Turnberry, Scotland)
 Sports Illus 81:56–60 (c,1) Jl 18 '94
 Sports Illus 83:65 (c,4) Jl 17 '95
— British Open 1986 (Turnberry, Scotland)
 Sports Illus 81:76 (c,2) N 14 '94
— British Open 1987 (Muirfield, Scotland)
 Sports Illus 82:34 (c,3) F 20 '95
— British Open 1992 (Muirfield, Scotland)
 Sports Illus 77:18–23 (c,1) Jl 27 '92
— British Open 1993 (Sandwich, England)
 Sports Illus 79:cov.,2–3,12–17 (c,1) Jl 26
 '93

— British Open 1994 (Turnberry, Scotland)
 Sports Illus 81:38–44 (c,1) Jl 25 '94
— British Open 1995 (St. Andrews, Scotland)
 Sports Illus 83:cov.,22–7 (c,1) Jl 31 '95
 Sports Illus 83:52–4 (c,1) S 25 '95
— British Open 1996 (Royal Lytham,
 Blackpool, England)
 Sports Illus 85:68–71 (c,1) Jl 29 '96
— California
 Sports Illus 76:22–3 (c,2) F 10 '92
 Sports Illus 76:38–41 (c,2) Mr 9 '92
 Sports Illus 78:40–7 (c,2) F 15 '93
 Sports Illus 80:36–8 (c,1) Ja 17 '94
 Sports Illus 80:42–3 (c,4) F 14 '94
— LPGA 1993 (Bethesda, Maryland)
 Sports Illus 78:54 (c,2) Je 21 '93
— Masters 1975 (Augusta, Georgia)
 Sports Illus 80:28–30,35 (c,1) Ap 18 '94
— Masters 1976 (Augusta, Georgia)
 Sports Illus 76:69 (c,1) Ap 13 '92
— Masters 1992 (Augusta, Georgia)
 Sports Illus 76:cov.,4–5,18–23 (c,1) Ap
 20 '92
— Masters 1993 (Augusta, Georgia)
 Sports Illus 78:14–21 (c,1) Ap 19 '93
— Masters 1994 (Augusta, Georgia)
 Sports Illus 80:18–27 (c,1) Ap 18 '94
— Masters 1995 (Augusta, Georgia)
 Sports Illus 82:cov.,2–3,16–23 (c,1) Ap
 17 '95
— Masters 1996 (Augusta, Georgia)
 Sports Illus 84:cov.,2–3,24–31 (c,1) Ap
 22 '96
 Sports Illus 85:66–7 (c,1) D 30 '96
— Memorial Tournament 1996 (Dublin, Ohio)
 Sports Illus 84:56–8 (c,1) Je 10 '96
— Michigan
 Sports Illus 81:16–19 (c,1) Ag 15 '94
— PGA 1991 (Carmel, Indiana)
 Sports Illus 78:68–9 (c,1) Je 7 '93
— PGA 1992 (St. Louis, Missouri)
 Sports Illus 77:16–19 (c,1) Ag 24 '92
— PGA 1993 (Toledo, Ohio)
 Sports Illus 79:15–16 (c,1) Ag 23 '93
— PGA 1994 (Tulsa, Oklahoma)
 Sports Illus 81:34–6 (c,1) Ag 22 '94
— PGA 1995 (Pacific Palisades, California)
 Sports Illus 83:34–8 (c,1) Ag 21 '95
— PGA 1996 (Louisville, Kentucky)
 Sports Illus 85:44–5 (c,1) Ag 19 '96
— Ryder Cup 1993 (Belfry, England)
 Sports Illus 79:30–3 (c,1) O 4 '93
— Ryder Cup 1995 (Rochester, New York)
 Sports Illus 83:38–41 (c,1) O 2 '95

— Senior PGA 1993 (Palm Beach Gardens, Florida)
Sports Illus 78:54 (c,2) Ap 26 '93
— Senior PGA 1994 (Palm Beach Gardens, Florida)
Sports Illus 80:46–7 (c,1) Ap 25 '94
— Tour Championship 1993 (San Francisco, California)
Sports Illus 79:54–8 (c,1) N 8 '93
— Tour Championship 1994 (San Francisco, California)
Sports Illus 81:77–8 (c,2) N 7 '94
— Tour Championship 1995 (Tulsa, Oklahoma)
Sports Illus 83:70–2 (c,2) N 6 '95
—TPC 1992 (Sawgrass, Florida)
Sports Illus 76:22–4 (c,3) Ap 6 '92
— TPC 1993 (Sawgrass, Florida)
Sports Illus 78:30–1 (c,2) Ap 5 '93
— TPC 1994 (Ponte Vedra, Florida)
Sports Illus 80:46–8 (c,2) Ap 4 '94
— TPC 1995 (Sawgrass, Florida)
Sports Illus 82:50–2 (c,1) Ap 3 '95
— TPC 1996 (Ponte Vedra, Florida)
Sports Illus 84:50–2 (c,1) Ap 8 '96
— U.S. Amateur 1994 (Sawgrass, Florida)
Sports Illus 81:14–16 (c,2) S 5 '94
— U.S. Amateur 1995 (Newport, Rhode Island)
Sports Illus 83:26–8 (c,1) S 4 '95
— U.S. Amateur 1996 (Portland, Oregon)
Sports Illus 85:2–3,22–6 (c,1) S 2 '96
— U.S. Open 1913 (Brookline, Massachusetts)
Sports Illus 82:40 (4) Je 12 '95
— U.S. Open 1930
Sports Illus 82:40 (4) Je 12 '95
— U.S. Open 1939
Sports Illus 82:40 (4) Je 12 '95
— U.S. Open 1950 (Merion, Pennsylvania)
Sports Illus 82:39 (2) Je 12 '95
— U.S. Open 1960 (Denver, Colorado)
Sports Illus 80:50–2 (2) Je 13 '94
Sports Illus 82:40 (3) Je 12 '95
— U.S. Open 1962 (Oakmont, Pennsylvania)
Sports Illus 82:40 (4) Je 12 '95
— U.S. Open 1967 (Baltusrol, New Jersey)
Sports Illus 78:45A–B (c,3) Je 14 '93
— U.S. Open 1980 (Baltusrol, New Jersey)
Sports Illus 78:45C–D (c,4) Je 14 '93
— U.S. Open 1992 (Pebble Beach, California)
Sports Illus 76:cov.,14–21 (c,1) Je 29 '92
Sports Illus 77:58–9 (c,1) D 28 '92
— U.S. Open 1993 (Baltusrol, New Jersey)
Sports Illus 78:2–3,28–35 (c,1) Je 28 '93

— U.S. Open 1994 (Oakmont, Pennsylvania)
Sports Illus 80:38–42 (c,2) Je 27 '94
— U.S. Open 1995 (Southampton, New York)
Sports Illus 82:2–3,22–8 (c,1) Je 26 '95
— U.S. Open 1996 (Oakland Hills, Michigan)
Sports Illus 84:38–40,45 (c,1) Je 24 '96
— U.S. Senior Open 1993 (Englewood, Colorado)
Sports Illus 79:6–9 (c,1) Jl 19 '93
— U.S. Women's Open 1992 (Oakmont, Pennsylvania)
Sports Illus 77:66–7 (c,2) Ag 3 '92
— U.S. Women's Open 1993 (Carmel, Indiana)
Sports Illus 79:24–9 (c,2) Ag 2 '93
— U.S. Women's Open 1994 (Lake Orion, Michigan)
Sports Illus 81:30–1 (c,2) Ag 1 '94
— U.S. Women's Open 1995 (Colorado Springs, Colorado)
Sports Illus 83:86–7 (c,1) Jl 24 '95

GOLFERS
— 1920s golf apparel catalog
Am Heritage 44:43 (3) N '93
— Famous golfers
Sports Illus 76:38–9 (c,2) My 25 '92
— Famous women golfers
Sports Illus 76:47 (c,4) F 3 '92
— See also
DIDRIKSON, BABE
HOGAN, BEN
JONES, BOBBY
NICKLAUS, JACK
PALMER, ARNOLD
SNEAD, SAM

GONDOLAS
— 1890 Americans in gondola (Venice, Italy)
Life 16:88 (2) Ap 5 '93
— Venice, Italy
Nat Geog 187:90–1 (c,1) F '95
Trav/Holiday 178:cov. (c,1) Ap '95
Trav&Leisure 26:101 (c,1) My '96
Trav/Holiday 179:cov.,64–71 (c,1) S '96
Trav&Leisure 26:124 (c,1) O '96

GONZALES, PANCHO
Sports Illus 83:9 (4) Jl 17 '95
Life 19:99 (1) Ja '96

GORBACHEV, MIKHAIL
Life 15:42 (c,3) Ja '92
Life 19:26 (4) Mr '96

GORILLAS
Nat Geog 181:2–33 (c,1) Mr '92
Nat Geog 184:8–9 (c,1) Jl '93
Nat Geog 186:14–16 (c,4) D '94
Nat Geog 188:17–19 (c,1) Jl '95

184 / GOSHAWKS

Life 19:78–84 (c,1) N '96
— Albino gorilla
Life 18:24 (c,4) Ap '95
— Baby gorilla
Smithsonian 24:18 (c,4) Ag '93
— Gorilla in zoo (1950)
Am Heritage 46:6 (2) S '95
— Gorilla rescuing boy at zoo (Illinois)
Life 19:78–84 (c,1) N '96
— Mountain gorillas
Nat Geog 188:cov.,58–67,78–83 (c,1) O
'95
GOSHAWKS
Nat Geog 186:116–28 (c,1) Jl '94
Nat Wildlife 34:41 (c,2) D '95
Nat Wildlife 34:40 (c,4) Ap '96
GOULD, GLENN
Life 19:118 (3) My '96
GOVERNMENT
— Town meeting (Massachusetts)
Nat Geog 181:124–5 (c,2) Je '92
— See also
ELECTIONS
POLITICAL CAMPAIGNS
U.S. PRESIDENTS
individual countries—POLITICS AND
GOVERNMENT
list under STATESMEN
GOVERNMENT—LEGISLATURES
— Admittance tickets to Congress
Am Heritage 43:28 (c,4) N '92
— Massachusetts House of Representatives,
Boston
Nat Geog 186:11 (c,3) Jl '94
— Syria
Nat Geog 190:116–17 (c,2) Jl '96
GOVERNMENT BUILDINGS
— Buenos Aires, Argentina
Gourmet 53:138 (c,4) N '93
— Parliament buildings (Ottawa, Ontario)
Trav&Leisure 22:C4 (c,3) Je '92
— See also
CAPITOL BUILDING
CAPITOL BUILDINGS—STATE
CITY HALLS
COURTHOUSES
PENTAGON BUILDING
POST OFFICES
SUPREME COURT BUILDING
WHITE HOUSE
GOYA, FRANCISCO
— "Les Jeunes ou La Lettre"
Trav&Leisure 26:86 (painting,c,4) O '96
— "La Maja Vestida"
Trav&Leisure 23:76–7 (painting,c,4) Jl '93

— "Third of May, 1808"
Smithsonian 22:65 (painting,c,2) Ja '92
Trav&Leisure 22:22 (painting,c,4) Ja '92
GRABLE, BETTY
Life 18:141 (2) Je 5 '95
GRACKLES
Natur Hist 105:36–7 (c,4) D '96
GRAFFITI
— Carvings in Tower of London prison wall,
England
Nat Geog 184:48 (c,4) O '93
— Graffiti-covered stadium steps
(Massachusetts)
Life 16:3 (c,2) Je '93
— Moscow
Life 18:58–9 (c,1) Jl '95
— New Jersey
Am Heritage 44:41 (4) F '93
— Painting over graffiti (California)
Nat Geog 186:106–7 (c,2) Jl '94
Nat Geog 187:130–1 (c,1) Ap '95
— Philadelphia, Pennsylvania
Smithsonian 24:62–71 (c,1) Jl '93
— Prague, Czechoslovakia
Smithsonian 24:67 (c,3) Je '93
— U.S. vice presidents' signatures carved into
desk
Life 17:92 (c,2) Mr '94
GRAHAM, BILLY
Life 17:105–16 (c,1) N '94
GRAHAM, MARTHA
Life 15:86 (1) Ja '92
GRAHAME, KENNETH
— *A Wind in the Willows* illustration
Smithsonian 24:62 (painting,c,4) Mr '94
GRAIN INDUSTRY
— Winnowing and husking quinoa (Bolivia)
Natur Hist 101:73–5 (c,1) Je '92
— See also
BARLEY
CORN
OATS
RICE
SORGHUM
WHEAT
GRAIN INDUSTRY—HARVESTING
— Gaza, Israel
Nat Geog 190:40–1 (c,1) S '96
GRAINS
Gourmet 56:170 (c,4) N '96
GRANADA, SPAIN
Gourmet 52:80–5,122 (map,c,1) Je '92
Smithsonian 23:42–53 (c,1) Ag '92
Trav/Holiday 177:44–53 (map,c,1) Jl '94
— See also

ALHAMBRA
GRAND CANYON, ARIZONA
Nat Geog 185:92,108–9 (c,1) Ap '94
Nat Geog 186:2–4 (c,1) O '94
Life 17:15–18 (c,1) O '94
Trav&Leisure 25:122 (painting,c,1) My
'95
Gourmet 55:150–3,222 (map,c,1) My '95
Am Heritage 47:136–44,170 (c,3) Ap '96
**GRAND COULEE DAM, COLUMBIA
RIVER, WASHINGTON**
Nat Geog 184:63 (c,3) N 15 '93
**GRAND TETON NATIONAL PARK,
WYOMING**
Natur Hist 102:34–5 (c,1) Ap '93
Trav&Leisure 23:93–4 (c,3) Je '93
Natur Hist 103:A2 (c,4) Ap '94
Nat Geog 187:116–39 (map,c,1) F '95
Gourmet 56:120–3,182 (map,c,1) D '96
— Autumn scene
Nat Wildlife 34:28–9 (c,1) O '96
— Jenny Lake
Gourmet 55:102 (c,4) My '95
— See also
TETON RANGE
GRANGE, "RED" HAROLD
Life 15:93 (4) Ja '92
Sports Illus 83:30–1 (1) Fall '95
GRANT, CARY
Life 16:38–9 (c,1) Ap '93
GRANT, ULYSSES S.
Trav/Holiday 175:88,91 (4) O '92
Smithsonian 25:100 (4) O '94
— Statue (Illinois)
Gourmet 53:137 (c,1) Ap '93
GRAPE INDUSTRY—HARVESTING
— Georgia, U.S.S.R.
Nat Geog 181:4–5 (c,1) F '92
— Italy
Gourmet 56:56 (painting,4) Mr '96
GRAPES
Gourmet 53:42 (painting,c,2) Ap '93
Gourmet 53:70 (drawing,4) My '93
Trav&Leisure 23:cov.,88 (c,1) Ag '93
Gourmet 54:176 (drawing,4) N '94
Gourmet 55:42 (painting,c,4) Mr '95
Gourmet 55:80 (c,4) S '95
Gourmet 55:102 (drawing,4) N '95
Gourmet 56:54 (painting,c,2) My '96
Gourmet 56:60 (drawing,c,4) N '96
Am Heritage 47:84 (c,4) D '96
GRASS
— Asparagus grass
Life 16:34 (c,4) O '93

— Sweetgrass used in basket weaving
(Southeast)
Nat Wildlife 31:39–41 (c,2) Ap '93
— Tallgrass
Nat Geog 190:16–17 (c,2) O '96
— Yellow star grass
Natur Hist 104:22 (c,4) Ag '95
— See also
ALFALFA
HAY
SORGHUM
GRASSHOPPERS
Nat Geog 184:101 (c,4) O '93
Natur Hist 102:43 (c,1) D '93
Life 17:67 (c,1) Je '94
Life 18:63–4 (c,4) S '95
GRAZ, AUSTRIA
— Graz Opera House
Trav/Holiday 176:49 (c,4) D '93
GREAT BARRIER REEF, AUSTRALIA
Trav/Holiday 179:10 (c,4) O '96
Trav&Leisure 26:125 (c,4) O '96
**GREAT BASIN NATIONAL PARK,
NEVADA**
Natur Hist 101:4 (c,3) S '92
Natur Hist 105:72 (map,c,2) F '96
Trav/Holiday 179:50–1 (c,1) Je '96
Trav/Holiday 179:65 (c,1) N '96
GREAT BRITAIN
Trav&Leisure 22:1–16 (map,c,1) S '92
supp.
Trav&Leisure 23:1–21 (map,c,1) Ap '93
supp.
Trav&Leisure 25:1–37 (map,c,1) Ap '95
supp.
Trav&Leisure 26:Q1–Q23 (map,c,1) Ap
'96
— 2nd. cent. "Cerne Giant" carved into
Dorset landscape
Trav&Leisure 25:88 (c,4) D '95
— Antony House, Cornwall
Trav&Leisure 23:128–35 (c,1) O '93
— Archaeological monuments overseen by
English Heritage
Smithsonian 24:120–7 (c,1) S '93
— Berkshire, England
Gourmet 52:98–103,148 (map,c,1) Mr '92
— Blenheim Palace
Gourmet 52:102–3 (c,1) Mr '92
Trav&Leisure 23:71 (c,1) Ag '93
Am Heritage 47:97 (c,4) Jl '96
— Burnley
Nat Geog 185:76 (c,4) Je '94
— Byker

Natur Hist 104:56 (4) O '95
— Cadbury Castle ruins
 Smithsonian 26:32–3 (c,1) F '96
— Canals
 Trav/Holiday 176:78–85 (map,c,1) My '93
— Castlerigg stone circle
 Trav&Leisure 22:129 (c,4) N '92
— Coastal scenes
 Nat Geog 188:38–57 (map,c,1) O '95
— Cornwall
 Trav/Holiday 176:62–9 (map,c,1) O '93
 Trav/Holiday 178:35 (c,4) My '95
 Gourmet 55:14,84–7,120 (map,c,1) S '95
 Nat Geog 188:44–5 (c,1) O '95
 Smithsonian 26:34–5 (c,2) F '96
— Cumbria countryside
 Smithsonian 26:39 (c,2) F '96
— Devil's Dyke
 Trav&Leisure 23:68–9 (c,1) Ag '93
— Devon countryside
 Trav&Leisure 24:E1–E4 (map,c,3) Ap '94
— Dorset
 Gourmet 52:114–15 (c,2) My '92
 Trav&Leisure 23:62,64 (c,1) Ag '93
 Trav&Leisure 25:84–8 (map,c,3) D '95
— Dorset's Old Harry Rocks
 Nat Geog 188:38–9 (c,1) O '95
— Dozmary Pool, Bodmin Moor
 Smithsonian 26:37 (c,2) F '96
— Dunstanburgh Castle ruins
 Nat Geog 188:42–3 (c,1) O '95
— English Channel Tunnel
 Nat Geog 185:36–47 (c,1) My '94
— Farne Islands, Northumberland
 Nat Geog 188:50–1 (c,1) O '95
— Faversham
 Trav&Leisure 23:192 (c,4) N '93
— Glastonbury tor
 Smithsonian 26:40–1 (c,1) F '96
 Trav/Holiday 179:62–3 (2) My '96
— Great Fosters
 Gourmet 52:150 (painting,4) Mr '92
— Hampton Court, England
 Trav&Leisure 23:20 (c,4) Ja '93
 Gourmet 54:28 (painting,c,2) Jl '94
 Trav&Leisure 24:60–1,101 (c,1) Ag '94
— Haunted hotels
 Trav/Holiday 179:46–53 (c,1) O '96
— Hedgerows
 Nat Geog 184:94–117 (c,1) S '93
— Horse carved into hilltop by 1st cent. Celts
 Smithsonian 24:125 (c,2) My '93
— Isles of Scilly, England
 Trav/Holiday 175:cov.,51–9 (map,c,1) Ap '92

— Lacock
 Trav/Holiday 179:66 (3) My '96
— Lake District
 Trav&Leisure 22:188–92 (map,c,4) Je '92
 Trav&Leisure 22:13,122–33 (map,c,1) N '92
 Nat Geog 186:2–31 (map,c,1) Ag '94
— Lincoln
 Gourmet 52:10,104–9,198 (map,c,1) D '92
— Lyme Regis
 Natur Hist 104:66–71 (map,c,2) O '95
— Manor homes
 Gourmet 52:98–103,150 (c,1) Mr '92
 Trav&Leisure 24:116–24 (c,1) D '94
 Trav&Leisure 26:118–30 (map,c,1) My '96
— Moors
 Nat Geog 184:116–17 (c,1) S '93
— Mottisfont Abbey gardens
 Gourmet 53:86–90,130 (map,c,1) Je '93
— Ouse Washes wildlife reserve, Cambridgeshire
 Natur Hist 101:26–9 (c,1) Jl '92
— Oxford area countryside
 Trav/Holiday 176:78–85 (map,c,1) My '93
— Penberth Cove
 Gourmet 55:87 (c,1) S '95
— River Lyd, Devon
 Gourmet 55:38 (c,2) Jl '95
— River Wye
 Trav&Leisure 23:66–7 (c,1) Ag '93
— Rose gardens
 Gourmet 53:86–91 (c,1) Je '93
— Rye
 Gourmet 54:68–71,108–9 (map,c,1) Ag '94
— St. Ives
 Smithsonian 24:125 (c,4) S '93
— Standing stones of Stall Moor, Dartmoor
 Smithsonian 24:83 (c,1) Jl '93
— Surrey, England
 Gourmet 52:98–103,148 (map,c,1) Mr '92
— Uffington chalk horse
 Trav/Holiday 179:64 (3) My '96
— Waddesdon Manor, Buckinghamshire
 Trav&Leisure 24:6,102–11 (c,1) Je '94
— Yorkshire
 Gourmet 55:90–5,136–8 (map,c,1) Mr '95
 Trav&Leisure 25:86–93,136 (map,c,1) Je '95
— Yorkshire sites associated with the Bronte family
 Trav&Leisure 24:64–71,117 (map,c,1) Ja '94
— See also

BATH
CAMBRIDGE
CHANNEL ISLANDS
DOVER
ENGLISH CHANNEL
GIBRALTAR
LONDON
OXFORD
STONEHENGE
STRATFORD-UPON-AVON
THAMES RIVER
TOWER OF LONDON
WIGHT, ISLE OF
WINDSOR CASTLE
YORK

GREAT BRITAIN—COSTUME
— 16th cent.
Smithsonian 22:68–77 (painting,c,1) Ja '92
— 18th cent. men
Trav/Holiday 178:46 (painting,c,3) Ap '95
— 18th cent. tricorner hat
Smithsonian 24:75 (painting,c,4) Mr '94
— 1840s aristocrats at a hunt
Smithsonian 24:76–7 (painting,c,4) Mr '94
— 1857 man
Smithsonian 25:66 (4) N '94
— Late 18th cent. nobleman
Nat Geog 190:29 (painting,c,1) N '96
— 1900 artillery officer
Smithsonian 25:164 (4) N '94
— 1939 chimney sweep
Smithsonian 26:102 (4) S '95
— Beefeaters at Tower of London
Nat Geog 184:36,46–7,56 (c,1) O '93
— Businessman reading newspaper
Trav/Holiday 175:15 (c,4) My '92
— Dummies of Prince Andrew and Fergie
Life 15:46 (c,2) Je '92
— Lake District
Nat Geog 186:2–31 (c,1) Ag '94
— London
Nat Geog 184:36–56 (c,1) O '93
Trav&Leisure 24:59 (c,4) Ag '94
— Prince Charles
Life 15:27–9,32 (c,1) Ag '92
Life 16:cov.,28–39 (c,1) F '93
Life 18:52 (c,4) Ja '95
— Princess Diana
Life 15:15 (c,2) Ap '92
Life 15:cov.,26–32 (c,1) Ag '92
Life 16:104 (c,1) Ja '93
Life 16:cov.,28–39 (c,1) F '93
Life 18:52 (c,4) Ja '95
— Princess Diana rafting (Colorado)
Life 19:12 (c,4) Ja '96

— Princess Sarah Ferguson
Life 16:105 (c,1) Ja '93
— Punk hairstyles
Trav&Leisure 24:103 (c,4) Mr '94
— Soldiers
Life 15:20 (c,4) Ap '92
— Staff of lord's manor home (Hampshire)
Am Heritage 45:19–22 (c,1) S '94
— Veterans at D–Day reunion (1994)
Life 18:34–5 (c,1) Ja '95

GREAT BRITAIN—HISTORY
— 1066 Norman Conquest depicted in
Bayeux Tapestry
Smithsonian 25:68–78 (c,2) My '94
— 1521 Latin text by Henry VIII defending
Catholicism
Smithsonian 24:21 (c,4) Ap '93
— 18th cent. travel to the Continent
Trav/Holiday 178:46–53 (map,c,1) Ap '95
— Early 19th cent. ship "Temeraire"
Natur Hist 104:18 (painting,c,4) O '95
— 1803 depiction of potential English
Channel tunnel threat from France
Nat Geog 185:39 (engraving,3) My '94
— 1810s Luddite war against technology
Smithsonian 24:140–51 (painting,c,3) Ap
'93
— 1812 assassination of Prime Minister
Spencer Perceval
Smithsonian 24:151 (etching,4) Ap '93
— 1852 opening of Lambeth Waterworks
(London)
Natur Hist 103:44 (engraving,4) Je '94
— 1858 cartoon about pollution of the
Thames River
Natur Hist 103:42–3 (c,1) Je '94
— 1940s murals done by U.S. airmen at
British air bases
Am Heritage 44:114–19 (c,1) Ap '93
— 1953 coronation of Elizabeth II
Life 17:38 (2) Je '94
— 1981 wedding of Prince Charles and Diana
Life 15:28–9 (c,1) Ag '92
Life 16:cov.,28–9 (c,1) F '93
— Archaeological monuments overseen by
English Heritage
Smithsonian 24:120–7 (c,1) S '93
— Joseph Banks
Nat Geog 190:29 (painting,c,1) N '96
— Churchill in V–E Day crowd (London)
Life 18:54 (2) Je 5 '95
— Queen Mary (1945)
Life 18:104 (4) Je 5 '95
— Sites associated with Alfred the Great
Trav/Holiday 179:60–7 (1) My '96

— Sites associated with King Arthur
 Smithsonian 26:32–41 (c,1) F '96
— Margaret Thatcher
 Life 19:26 (4) Mr '96
— Tower of London history
 Nat Geog 184:39–41 (c,1) O '93
— See also
 ALFRED THE GREAT
 ARTHUR, KING
 BOER WAR
 BOLEYN, ANNE
 CHARLES I
 CHURCHILL, WINSTON
 COOK, JAMES
 EDWARD VIII
 ELIZABETH I
 ELIZABETH II
 FROBISHER, MARTIN
 GEORGE VI
 HENRY VIII
 LLOYD GEORGE, DAVID
 MARY II
 MONTGOMERY, BERNARD
 RHODES, CECIL
 ROBIN HOOD
 SCOTT, ROBERT FALCON
 VICTORIA
 WILLIAM III, OF ORANGE
 WILSON, HAROLD
GREAT BRITAIN—HOUSING
— 1620 octagon–towered house
 Smithsonian 24:120 (c,2) S '93
— Stratford-upon-Avon cottage
 Trav/Holiday 175:102 (c,3) Mr '92
— Tudor cottage (Lincoln)
 Gourmet 52:108 (c,3) D '92
GREAT BRITAIN—MAPS
 Nat Geog 188:46–7 (c,1) O '95
GREAT BRITAIN—POLITICS AND GOVERNMENT
— Candidate campaigning (Bath)
 Trav/Holiday 175:82–7 (1) O '92
GREAT BRITAIN—SHRINES AND SYMBOLS
— Imperial State Crown
 Nat Geog 184:51 (c,4) O '93
GREAT BRITAIN—SOCIAL LIFE AND CUSTOMS
— Charles and Di memorabilia
 Life 19:67–74 (c,1) My '96
— Chelsea Flower Show
 Trav&Leisure 25:120–7 (c,1) F '95
— Wedding cakes
 Natur Hist 102:58–65 (c,1) D '93
Great Lakes. See

LAKE MICHIGAN
LAKE SUPERIOR
GREAT SALT LAKE, UTAH
 Life 18:91 (c,4) Ap '95
GREAT SAND DUNES NATIONAL MONUMENT, COLORADO
 Nat Geog 186:5–6 (c,2) O '94
GREAT SMOKY MOUNTAINS, NORTH CAROLINA/TENNESSEE
 Trav/Holiday 175:36 (c,4) Mr '92
 Smithsonian 24:31 (c,1) Ag '93
 Nat Geog 187:84–5 (c,1) My '95
GREAT SMOKY MOUNTAINS NATIONAL PARK, NORTH CAROLINA/TENNESSEE
 Smithsonian 24:cov.,20–31 (c,1) Ag '93
 Nat Geog 186:22–5,32 (c,1) O '94
 Natur Hist 104:A8 (c,4) Ap '95
GREAT WALL OF CHINA
 Trav&Leisure 23:66–7 (c,1) S '93
 Life 16:14 (c,2) N '93
 Life 18:18 (c,2) D '95
Greco, El. See
 EL GRECO
GREECE
 Trav/Holiday 179:26–7 (c,1) O '96
— Epidaurus
 Trav/Holiday 175:73,79 (c,1) Je '92
— Hydra
 Trav&Leisure 26:88 (c,1) My '96
 Trav/Holiday 179:28 (c,4) Je '96
— Meteora
 Trav&Leisure 25:122–3 (c,1) Je '95
— Mycenae
 Trav/Holiday 175:74–5 (c,2) Je '92
— Mykonos windmill
 Trav/Holiday 175:22 (c,4) Mr '92
— Patmos
 Trav&Leisure 22:94–103 (map,c,1) Ag '92
— Northern Greece
 Trav&Leisure 25:122–35 (map,c,1) Je '95
— Peloponnese peninsula
 Trav/Holiday 175:73–9 (map,c,1) Je '92
— Santorini
 Trav/Holiday 178:46–5 (map,c,1) My '95
 Trav&Leisure 26:82–90,134 (c,1) My '96
 Trav/Holiday 179:26–7 (c,1) O '96
— See also
 ATHENS
GREECE—COSTUME
— Patmos
 Trav&Leisure 22:98–101 (c,1) Ag '92
— Santorini
 Trav/Holiday 178:46–54 (c,1) My '95
— Traditional dress (1896)

Sports Illus 84:22 (2) F 26 '96
GREECE, ANCIENT
— Site of ancient Troy
Natur Hist 105:42–51 (map,c,1) Ap '96
— See also
MYTHOLOGY—GREEK AND ROMAN
TROY
**GREECE, ANCIENT—ARCHITEC-
TURE**
— Arms positioned in classic Greek column
styles
Life 18:104 (4) Je '95
— Athens Agora, Greece
Smithsonian 24:38–47 (c,1) Jl '93
— Colonies in Sicily and Italy
Nat Geog 186:2–37 (map,c,1) N '94
— Delos ruins
Trav/Holiday 179:29 (c,4) Je '96
— Knossos, Crete
Gourmet 52:73 (c,4) F '92
— Troy
Smithsonian 22:32–3 (painting,c,2) Ja '92
— See also
PARTHENON
TEMPLES—ANCIENT
THEATERS—ANCIENT
GREECE, ANCIENT—ART
— 5th cent. B.C. tomb painting of diver
Nat Geog 190:50 (c,4) Jl '96
— Fresco of boxers (Thera)
Natur Hist 101:52 (c,2) Jl '92
— Fresco of vaulting over a bull (Crete)
Natur Hist 101:54–5 (c,1) Jl '92
— Role of women in ancient Greece as
depicted in art
Life 19:70–3 (c,4) Mr '96
— See also
SCULPTURE—ANCIENT
GREECE, ANCIENT—ARTIFACTS
— 6th cent. B.C. carving of Athenian
democracy
Am Heritage 44:106 (c,4) Jl '93
— 4th cent. B.C. stele of democracy (Athens)
Smithsonian 24:46 (c,4) Jl '93
— Athens
Smithsonian 24:40–1,46 (c,4) Jl '93
— Funeral wreath
Nat Geog 186:24–5 (c,2) N '94
— Parthenon marbles (Great Britain)
Trav/Holiday 178:82 (c,4) Mr '95
GREECE, ANCIENT—COSTUME
Smithsonian 24:38–9 (painting,c,1) Jl '93
GREECE, ANCIENT—HISTORY
— Italian colonies
Nat Geog 186:2–37 (map,c,1) N '94

— Phidippides dying after Marathon run (490
B.C.)
Sports Illus 83:11 (painting,4) N 13 '95
— Trojan Horse depicted on 570 B.C.
amphora
Natur Hist 105:43 (c,4) Ap '96
— Trojan Horse imagery in basketball
recruiting
Sports Illus 85:17 (painting,c,2) N 11 '96
— Trojan War
Smithsonian 22:28, 32–3 (painting,c,1) Ja
'92
**GREECE, ANCIENT—RITES AND
FESTIVALS**
— Funeral pyre
Nat Geog 186:10 (painting,c,2) N '94
GREECE, ANCIENT—RUINS
— Ephesus, Turkey
Trav/Holiday 175:18 (c,4) F '92
— See also
TROY
**GREECE, ANCIENT—SOCIAL LIFE
AND CUSTOMS**
— Role of women in ancient Greece as
depicted in art
Life 19:70–3 (c,4) Mr '96
**GREEK ORTHODOX CHURCH—
COSTUME**
— Priest (Israel)
Nat Geog 181:92–3 (c,1) Je '92
**GREEK ORTHODOX CHURCH—
RITES AND FESTIVALS**
— See also
COMMUNION
GREENE, GRAHAM
Trav&Leisure 26:104 (c,4) N '96
GREENHOUSES
— Jordan
Nat Geog 183:63 (c,3) My '93
GREENLAND
— Giant arch of ice in sea
Life 15:8–9 (c,1) Jl '92
— King Oscar Fjord
Life 17:24–5 (c,1) D '94
Grenada. See
WINDWARD ISLANDS
GRENADINE ISLANDS
— Mustique
Trav&Leisure 23:116–19,124 (map,c,1)
My '93
GREYHOUNDS
Sports Illus 80:6 (c,4) Je 27 '94
— See also
DOG RACING

GRIEF
— Families of terrorist attack victims
 Life 19:52–60 (c,1) My '96
— Family at bomb victim's funeral (Israel)
 Nat Geog 187:76–7 (c,1) Je '95
— Family of Oklahoma City bombing victim
 (1995)
 Life 19:28–9 (c,1) Ja '96
— Fans mourning Kurt Cobain's death
 (Washington)
 Life 18:52–3 (c,1) Jl '95
— Friends of murdered Orthodox Jewish teen
 (New York)
 Life 17:12–13 (c,1) My '94
— Friends of TWA Flight 800 victims
 Life 19:12 (c,2) S '96
— Mother at son's funeral (California)
 Life 17:14–15 (c,1) D '94
— Muslim woman grieving (Bosnia)
 Life 16:27 (c,2) Ja '93
— Vietnamese widow (1969)
 Life 19:78 (c,3) Ag '96
GRIFFITH, ARTHUR
 Smithsonian 25:175,180 (4) N '94
GRIS, JUAN
— "The Painter's Window"
 Smithsonian 27:50 (painting,c,4) Jl '96
— "Still Life with Guitar"
 Trav&Leisure 23:79 (painting,c,2) Jl '93
GRIZZLY BEARS
 Nat Geog 182:76–7 (c,1) Ag '92
 Smithsonian 23:113–21 (c,1) N '92
 Smithsonian 23:157 (painting,c,4) D '92
 Nat Wildlife 32:34–7 (c,1) Ap '94
 Nat Wildlife 32:2–3 (c,2) Ag '94
 Nat Wildlife 33:cov.,21 (painting,c,1) D
 '94
 Nat Geog 186:26–7 (c,1) D '94
 Life 18:63,66–7 (c,1) My '95
 Trav/Holiday 178:80 (c,2) My '95
 Nat Wildlife 33:cov. (c,1) Je '95
 Nat Geog 188:55 (c,4) Jl '95
 Nat Wildlife 33:20–1 (c,1) O '95
 Smithsonian 26:35 (c,3) Mr '96
 Nat Wildlife 34:48–9 (c,1) Je '96
— Covered with oil from spill
 Nat Wildlife 31:6–7 (c,2) Ap '93
— Cub riding on mother's back
 Natur Hist 101:76–7 (c,1) Jl '92
GROSBEAKS
 Nat Geog 183:80 (painting,c,4) Je '93
 Nat Wildlife 32:52 (c,1) Je '94
 Nat Wildlife 33:59 (c,1) F '95
GROSZ, GEORGE
— "Texas" (1915)

 Am Heritage 46:64 (drawing,4) My '95
Groundhogs. See
 WOODCHUCKS
GROUPERS (FISH)
 Trav/Holiday 175:66–7,70 (c,1) D '92
 Nat Geog 184:78 (c,4) N '93
GROUSE
 Nat Wildlife 34:40 (c,4) D '95
— Sage grouse
 Nat Wildlife 32:12–21 (c,1) Je '94
 Nat Wildlife 33:50 (c,3) O '95
GRUNTS (FISH)
 Sports Illus 79:82 (c,4) D 13 '93
 Nat Geog 187:98–9 (c,1) Mr '95
 Nat Wildlife 34:48–9 (c,1) F '96
GUADALAJARA, MEXICO
— Hospicio Cabanas
 Trav&Leisure 23:108 (c,4) Je '93
GUADELOUPE
 Trav&Leisure 22:187–92 (map,c,4) Mr '92
 Gourmet 53:54–9,104 (map,c,1) Ja '93
GUADELOUPE—COSTUME
 Gourmet 53:58–9 (c,2) Ja '93
GUAM, MARIANA ISLANDS
— Remains of World War II planes and ships
 Natur Hist 103:26–35 (c,1) Ag '94
GUANAJUATO, MEXICO
 Trav/Holiday 178:74–9 (c,2) S '95
 Nat Geog 190:14–15 (c,1) Ag '96
GUARDS
— Argentina
 Gourmet 53:138 (c,4) N '93
— Austrian border guards
 Nat Geog 183:100–1 (c,1) My '93
— Beefeaters at Tower of London, England
 Nat Geog 184:36,46–7,56 (c,1) O '93
— Border guards on camels (India)
 Natur Hist 104:58 (c,4) Mr '95
— Colombia
 Nat Geog 185:36–7 (c,1) Mr '94
— German border guards with illegal
 immigrant
 Nat Geog 183:122–3 (c,1) My '93
— Guard at Great Wall of China
 Trav&Leisure 23:66 (c,1) S '93
— India-Pakistan border guards
 Smithsonian 23:120–1 (c,2) My '92
— Israeli on guard duty
 Nat Geog 181:64–5 (c,1) F '92
— Luxor ruins, Egypt
 Trav&Leisure 23:60 (c,4) Je '93
— Mexican presidential guard
 Sports Illus 76:48 (c,4) Je 29 '92
— Peacekeeping in Cyprus
 Nat Geog 184:110–11 (c,1) Jl '93

— Prison guard (California)
 Smithsonian 24:46–7 (c,4) O '93
— Protecting store (El Salvador)
 Nat Geog 188:122–3 (c,2) S '95
— Royal Palace guards (Oslo, Norway)
 Trav/Holiday 175:77 (c,4) D '92
— School crossing guard (Ontario)
 Nat Geog 184:90–1 (c,1) D '93
— Security guard (Brazil)
 Life 16:14 (c,2) O '93
GUATEMALA
 Trav&Leisure 23:84–95 (map,c,1) Mr '93
— Chichicastenango
 Natur Hist 102:68 (c,3) Ag '93
— Dos Pilas ancient Maya site
 Nat Geog 183:94–111 (map,c,1) F '93
— Maya ruins (Tikal)
 Trav&Leisure 23:88–9 (c,1) Mr '93
— Peten region
 Nat Geog 182:94–107 (map,c,1) N '92
— See also
 ANTIGUA
 MAYA CIVILIZATION
GUATEMALA—COSTUME
 Nat Geog 182:94–103 (c,1) N '92
 Trav&Leisure 23:85–91 (c,1) Mr '93
 Nat Geog 183:92–3,112–13 (c,1) Je '93
 Natur Hist 102:68 (c,3) Ag '93
 Life 18:64–70 (1) Mr '95
— Antigua
 Trav/Holiday 178:84–90 (c,1) Mr '95
— Quiche Indians
 Nat Geog 181:22–3 (c,1) F '92
— Village mayor
 Nat Geog 188:77 (c,4) Ag '95
GUATEMALA—SOCIAL LIFE AND CUSTOMS
— Family life
 Life 17:60 (c,3) Jl '94
— Fatal stampede at soccer match
 Sports Illus 85:22 (c,4) O 28 '96
GUGGENHEIM MUSEUM, NEW YORK CITY, NEW YORK
 Trav&Leisure 22:18 (c,4) Je '92
 Smithsonian 24:61 (painting,c,2) F '94
 Trav&Leisure 24:92 (c,4) Mr '94
— 1945 model of museum
 Life 18:143 (3) Je 5 '95
GUILLEMOTS
— Covered in oil from oil spill
 Life 19:16–17 (c,1) Je '96
GUINEA FOWL
 Natur Hist 105:82 (c,3) Ag '96
GUITAR PLAYING
— Arkansas

 Trav/Holiday 177:84 (c,4) My '94
— Country music singers
 Life 15:56 (c,1) Ja '92
 Am Heritage 45:cov.,38–56 (c,1) N '94
— Jimi Hendrix
 Smithsonian 25:138 (4) D '94
— Playing bluegrass music (West Virginia)
 Smithsonian 23:cov.,70–7 (c,1) Mr '93
— Rock stars
 Life 15:74–81 (c,1) D 1 '92
 Sports Illus 79:32 (c,4) Ag 2 '93
GUITARS
 Smithsonian 27:52–60 (c,1) Jl '96
— Jewel–studded acoustic guitar (Tennessee)
 Smithsonian 26:49 (c,4) F '96
— Manufacturing guitars (Nashville, Tennessee)
 Smithsonian 27:52–62 (c,1) Jl '96
— Portable guitar
 Trav/Holiday 179:19 (c,4) S '96
— Bruce Springsteen's guitar
 Life 18:17 (c,3) S '95
GULF OF MEXICO
— Landsat image of Gulf of Mexico
 Nat Wildlife 32:6–7 (c,1) F '94
— U.S. Gulf Coast
 Nat Geog 182:2–37 (map,c,1) Jl '92
GULF WAR
 Life 15:12–13,28–38 (c,1) Ja '92
— 1991 Gulf War victory parade (New York City)
 Life 15:10–11 (c,1) Ja '92
— 1991 oil well fires set by Iraqis (Kuwait)
 Nat Geog 181:122–34 (c,1) F '92
 Nat Wildlife 32:12–13 (c,1) F '94
 Life 19:29–30 (c,1) Jl '96
— Iraqi soldiers
 Life 19:16,20 (c,4) O '96
— Returning U.S. soldiers (New York)
 Life 19:80 (c,2) Ag '96
— Wounded U.S. soldiers
 Life 19:104 (c,3) O '96
— See also
 SCHWARZKOPF, H. NORMAN
GULLS
 Nat Wildlife 31:60 (c,1) D '92
 Nat Wildlife 31:16–17 (c,2) Je '93
 Nat Geog 187:106–7 (c,1) Je '95
— Feeding on swarm of flies
 Natur Hist 101:84–5 (c,1) Mr '92
— Hovering over docks (Wisconsin)
 Trav&Leisure 22:53 (c,4) S '92
— Swallow-tailed gull
 Trav/Holiday 179:81 (c,4) F '96

GUM CHEWING
— Basketball player blowing bubble
 Sports Illus 81:132 (c,3) N 7 '94
— Blowing bubble
 Sports Illus 78:68–9 (c,1) Ap 12 '93
— Sherpa girl (Nepal)
 Nat Geog 182:78 (c,3) D '92
GUN INDUSTRY
— Gun factory (Connecticut)
 Nat Geog 185:80 (c,3) F '94
GUNS
— 1940s OSS pistol
 Sports Illus 76:76–7 (c,4) Mr 23 '92
— 1940s .75mm Japanese gun
 Natur Hist 101:56–7 (c,1) Je '92
— Baby holding gun (California)
 Life 17:12–13 (1) Ap '94
— Gun that killed Lincoln
 Am Heritage 43:cov.,105 (c,4) S '92
— Howitzer
 Nat Wildlife 33:46–7 (c,1) F '95
— Making blowgun (Colombia)
 Nat Geog 187:104–5 (c,1) My '95
— 12-gauge Beretta
 Life 15:18 (c,3) Mr '92
— See also
 RIFLES
 SHOOTING
GUSTAV III (SWEDEN)
 Natur Hist 102:14 (drawing,4) Ap '93
GUYANA—MAPS
 Nat Geog 187:42 (c,4) F '95
GYMNASIUMS
— Home gym
 Life 17:103 (c,4) Je '94
GYMNASTICS
 Sports Illus 77:54–6 (c,1) Jl 22 '92
 Sports Illus 81:52–5 (c,1) Ag 8 '94
 Sports Illus 82:62–3 (c,1) F 6 '95
 Sports Illus 82:40–1 (c,2) Mr 13 '95
 Sports Illus 85:34–7 (c,1) Jl 8 '96
— 1972 Olympics (Munich)
 Sports Illus 76:86–7 (2) F 24 '92
 Sports Illus 81:114–15 (c,1) S 19 '94
— 1976 Olympics (Montreal)
 Life 19:84 (c,4) F '96
— 1992 Olympics (Barcelona)
 Sports Illus 77:76–9 (c,1) Ag 10 '92
— 1996 Olympics (Atlanta)
 Sports Illus 85:58–68,96–7 (c,1) Ag 5 '96
— Balance beam
 Nat Geog 185:48–9 (c,1) Je '94
— Child doing cartwheel (France)
 Life 19:88 (2) S '96
— Children playing on boat ropes (Brazil)

Nat Geog 187:16–17 (c,1) F '95
— Floor routine shown in slow motion
 Nat Geog 187:8–9 (c,2) Je '95
— Great Olympics moments
 Sports Illus 84:55–70 (c,1) Mr 25 '96
— Man on home trampoline
 Sports Illus 83:30–1 (c,1) Ag 7 '95
— Romania
 Sports Illus 85:212–27 (1) Jl 22 '96
— Training (U.S.S.R.)
 Nat Geog 190:56–7 (c,1) Jl '96
— Vault
 Sports Illus 76:2–3 (c,1) Je 22 '92
 Sports Illus 84:58 (c,3) Mr 25 '96
GYPSIES
— France
 Nat Geog 188:70–1 (c,1) S '95
— Macedonia
 Nat Geog 189:135–7 (c,1) Mr '96
— Romania
 Natur Hist 101:54–5 (1) O '92
— Washington
 Life 15:46–53 (c,1) O '92
GYPSIES—RITES AND FESTIVALS
— Gypsy wedding (Macedonia)
 Nat Geog 189:136–7 (c,1) Mr '96
GYPSUM
 Nat Geog 184:94–5 (c,1) N 15 '93

–H–

HADRIAN
— Hadrian's villa, Tivoli, Italy
 Trav/Holiday 178:52–9 (c,1) Jl '95
HAGFISH
 Natur Hist 105:61 (c,4) N '96
HAIDA INDIANS—ART
 Smithsonian 25:38–47 (c,1) Ja '95
HAIDA INDIANS—ARTIFACTS
— Helmet mask (British Columbia)
 Smithsonian 25:98 (c,3) D '94
— Totem poles (British Columbia)
 Trav/Holiday 179:66–7 (c,2) Je '96
HAIRDRESSING—MEN
— 1945 barber shop scene (Texas)
 Life 18:128–9 (1) Je 5 '95
— Barber shop (California)
 Trav/Holiday 176:90–1 (c,3) Mr '93
— Businessman getting trim in office
 (Georgia)
 Sports Illus 84:78 (c,3) Ja 8 '96
— Convict having head shaved (Oregon)
 Life 17:18 (c,2) N '94
— Shaving head of West African man (Italy)

Nat Geog 183:110–11 (c,1) My '93
— Shaving heads of teenage boys (Illinois)
 Life 16:22 (c,4) F '93
— Street barber (New Orleans, Louisiana)
 Nat Geog 187:98 (c,1) Ja '95
— Texas
 Sports Illus 81:26–7 (c,2) D 12 '94
— See also
 BARBER SHOPS
 COMBS
 SHAVING
HAIRDRESSING—WOMEN
— 1936 women under salon dryers
 Life 19:44 (4) O '96
— Department store salon (New York)
 Trav&Leisure 25:71–2 (c,4) S '95
— Salons (California)
 Trav&Leisure 26:94 (c,3) O '96
— Teen styles (Spain)
 Nat Geog 188:81 (c,2) N '95
— See also
 BEAUTY PARLORS
HAIRSTYLES—MEN
— Bald child (Ukraine)
 Nat Geog 186:86–7 (c,1) Ag '94
— Basketball player with colorful dyed hair
 Sports Illus 82:81 (c,4) Ja 9 '95
 Sports Illus 83:cov.,2–3 (c,1) O 23 '95
— Cherokee boys with Mohawk haircuts
 (North Carolina)
 Nat Geog 187:96–7 (c,2) My '95
— Famous bald people
 Life 19:29 (c,4) S '96
— Man with tall bleached-blond Mohawk
 Sports Illus 80:5 (c,4) Ja 24 '94
— Punk hairstyles (Great Britain)
 Trav&Leisure 24:103 (c,4) Mr '94
— Words razored into scalp
 Sports Illus 85:63 (c,4) O 21 '96
— See also
 BEARDS
 MUSTACHES
 WIGS
HAIRSTYLES—WOMEN
— 1910 women with hair down to waist
 (Texas)
 Am Heritage 47:112 (3) S '96
— 1970s women with Farrah Fawcett hairstyle
 Life 18:124 (3) N '95
— Woman with 21-ft. long hair (India)
 Life 16:84 (c,2) My '93
HAITI
— Receiving relief shipment of grain
 Life 15:16–17 (c,1) Mr '92

HAITI—COSTUME
 Life 15:52–9 (c,1) Ap '92
 Life 15:10–11 (c,1) Ag '92
— Early 20th cent.
 Smithsonian 23:44–54 (c,1) Ja '93
— Haitian boat people
 Life 15:52–9 (c,1) Ap '92
 Life 16:12–13 (c,1) Ja '93
 Smithsonian 23:55 (c,3) Ja '93
— Haitian child crying
 Life 17:32–3 (1) Ja '94
HAITI—HISTORY
— U.S. occupation (1915–1934)
 Smithsonian 23:44–54 (c,1) Ja '93
— See also
 TOUSSAINT L'OUVERTURE
**HAITI—POLITICS AND GOVERN-
MENT**
— Killing Aristide supporter
 Life 18:64–5 (c,1) Ja '95
— Rescuing Haitian refugee baby from boat
 Life 17:14 (c,2) Ag '94
— U.S. military presence in Haiti
 Life 17:56–63 (c,1) N '94
 Life 18:18 (c,2) Je '95
HAKE (FISH)
 Nat Geog 190:91 (c,4) O '96
HALEY, ALEX
 Life 16:63 (c,1) Ja '93
HALIBUT
 Nat Geog 190:76 (c,4) N '96
HALIFAX, NOVA SCOTIA
 Am Heritage 45:22 (c,4) S '94
HALLOWEEN
— Children in costumes
 Life 16:26 (c,3) O '93
— Halloween symbols
 Gourmet 52:72–4 (painting,c,2) O '92
— Jack-o'-lanterns (Vermont)
 Trav/Holiday 175:85 (c,4) S '92
— White jack-o'-lantern
 Life 17:45 (c,4) O '94
— See also
 MASQUERADE COSTUME
 PUMPKINS
HALSEY, WILLIAM FREDERICK, JR.
 Life 18:133 (1) Je 5 '95
HAMBURG, GERMANY
 Nat Geog 186:78–9 (c,1) O '94
 Trav&Leisure 25:115–21,145 (map,c,1) Je
 '95
— 1930s model for proposed Hamburg bridge
 Am Heritage 46:66 (4) My '95
— Lake Alster

Trav&Leisure 25:118 (c,4) Je '95
HAMILTON, ALEXANDER
Smithsonian 23:116 (sculpture,c,4) Mr '93
HAMMERSTEIN, OSCAR II
Am Heritage 44:61 (4) F '93
HAMMETT, DASHIELL
Am Heritage 44:42 (4) Jl '93
Smithsonian 25:114–26 (3) My '94
HAMMOCKS
— Child under hammock (Jamaica)
Trav/Holiday 176:16 (c,4) S '93
— Costa Rica
Trav&Leisure 25:105 (c,4) N '95
— Ecuador
Trav/Holiday 176:77 (c,4) Je '93
— Hammock on tropical beach
Gourmet 53:cov. (c,1) My '93
Trav/Holiday 179:46 (c,1) F '96
— Mexican hotel
Trav&Leisure 25:62 (c,1) Ag '95
— New Hampshire
Trav&Leisure 26:90 (1) Jl '96
— Venezuela
Natur Hist 104:58–9,64–5 (c,1) Ap '95
— West Indies
Trav&Leisure 23:116–17 (c,1) O '93
Life 17:89 (c,2) F '94
Trav/Holiday 177:48–9 (c,2) F '94
Trav&Leisure 24:124 (c,1) N '94
Gourmet 56:45 (c,1) Ja '96
HAND, LEARNED
Am Heritage 43:37 (4) F '92
HAND SHAKING
— Baseball players doing high five
Sports Illus 79:61 (c,4) O 4 '93
— Black hands grasped in unity (Washington,
D.C.)
Life 18:28 (2) D '95
Life 19:18–19 (1) Ja '96
— High five
Sports Illus 85:8 (4) S 23 '96
— Hockey players shaking hands
Sports Illus 80:31 (c,4) My 23 '94
HANDBALL PLAYING
Sports Illus 82:9 (c,4) Je 12 '95
HANDICAPPED PEOPLE
— Amputee soccer (El Salvador)
Nat Geog 188:130–1 (c,2) S '95
— Amputees playing cards (Cambodia)
Nat Geog 183:20–1 (c,1) F '93
— Children with birth defects
Life 18:cov.,46–62 (c,1) N '95
— Deformed children (U.S.S.R.)
Nat Geog 183:22–3 (c,1) Mr '93

Nat Geog 186:72–3 (c,1) Ag '94
— Dogs helping the handicapped
Smithsonian 22:81–7 (2) Ja '92
— Female basketball player with amputated
leg
Sports Illus 80:72–3 (c,1) F 21 '94
— Graduation at school for deaf
(Pennsylvania)
Life 18:24–6 (1) Je '95
— Legless child beggar (Egypt)
Nat Geog 183:54–5 (c,2) Ap '93
— Legless track runner
Life 19:10–11 (c,1) N '96
— Man on crutches
Sports Illus 76:cov.,33 (c,1) Jl 6 '92
— Man with amputated leg
Sports Illus 81:156–7,162 (c,1) N 14 '94
— Man with artificial leg strapped to his back
(Cambodia)
Life 15:18 (c,4) N '92
— Man with fingers lost to frostbite (Nepal)
Nat Geog 182:89 (c,4) D '92
— One-legged man in New York Marathon
(1989)
Sports Illus 81:93 (c,4) N 14 '94
— One-legged mountain climber
Sports Illus 82:9–11 (c,4) My 29 '95
— Paralympics 1996 (Atlanta)
Sports Illus 85:11 (c,2) Ag 26 '96
— Physically challenged boy playing lacrosse
Life 17:24 (2) N '94
— Prosthetic limbs
Sports Illus 82:5–7 (c,4) Ap 17 '95
— Quadriplegic man with pet monkey
Life 18:77–9 (c,1) Ag '95
— Teaching child in wheelchair to cross street
Nat Geog 188:29 (c,4) O '95
— Top disabled athletes
Sports Illus 83:64–76 (c,1) Ag 14 '95
— Victims of birth defects (Japan)
Nat Geog 185:112 (c,4) Ja '94
— Vietnam veteran in wheelchair
Life 15:33 (c,2) N '92
— Wheelchair ballet
Life 16:22 (4) Ap '93
— Wheelchair basketball
Sports Illus 76:126 (c,4) Ap 6 '92
— Woman on crutches (Egypt)
Nat Geog 183:45 (c,1) Ap '93
— See also
BLINDNESS
DEAFNESS
INJURED PEOPLE
KELLER, HELEN
WHEELCHAIRS

HANDS
— Deaf people signing
　Smithsonian 23:30–41 (2) Jl '92
— Famous left-handed people
　Smithsonian 25:132–42 (c,4) D '94
— Gymnast's chafed hands
　Sports Illus 85:214–15 (1) Jl 22 '96
— Hands of artists
　Life 19:86–7 (4) F '96
— Left-handed animals
　Natur Hist 102:cov.,3–9 (c,1) Jl '93
— Man with 3 ft. fingernails (India)
　Life 16:87 (c,4) My '93
HANDY, W.C.
　Trav&Leisure 25:128 (4) S '95
HANG GLIDING
— Paraglider landing in boxing match (Las
　Vegas, Nevada)
　Sports Illus 79:23 (c,2) N 15 '93
— Pennsylvania
　Nat Geog 185:42–3 (c,1) Je '94
— Tanzania
　Sports Illus 78:92–3 (c,2) My 3 '93
Hanging. See
　CAPITAL PUNISHMENT
　LYNCHINGS
HANNIBAL
　Smithsonian 25:124–5 (painting,c,1) Ap
　'94
HANNIBAL, MISSOURI
　Life 18:86–90 (c,2) Ap '95
HANOI, VIETNAM
　Trav&Leisure 23:103–7 (c,1) Ap '93
— Hoan Kiem Lake
　Gourmet 55:91 (c,1) S '95
HARBORS
— Baltimore, Maryland
　Am Heritage 44:83 (c,1) Ap '93
　Gourmet 54:138–41 (c,1) N '94
— Copenhagen, Denmark
　Trav&Leisure 25:96–7 (c,1) Mr '95
— Crete
　Gourmet 52:74–5,77 (c,1) F '92
— Helsinki, Finland
　Trav&Leisure 25:74 (c,3) Je '95
— New York Harbor
　Nat Geog 186:108 (c,1) Jl '94
— Ocracoke, North Carolina
　Gourmet 55:100–1 (c,4) Ap '95
— St. Michael's, Maryland
　Am Heritage 45:26 (c,4) O '94
— San Sebastian, Spain
　Nat Geog 188:76–7 (c,1) N '95
— Sardinia, Italy

Gourmet 52:46–7 (c,1) Jl '92
— See also
　DOCKS
　MARINAS
HARDING, WARREN G.
　Smithsonian 23:143 (4) O '92
　Am Heritage 44:42 (4) S '93
　Smithsonian 26:26 (4) O '95
— 1920 Harding campaign decal
　Am Heritage 43:53 (c,4) S '92
HARDWARE
— Whimsical Yellin nailheads
　Am Heritage 46:44 (c,4) O '95
— See also
　KEYS
　TOOLS
HARDY, OLIVER
　Smithsonian 25:28 (c,4) F '95
HARDY, THOMAS
— Home (Dorset, England)
　Trav&Leisure 25:86 (c,4) D '95
Hares. See
　RABBITS
HARLEM, NEW YORK CITY,
　NEW YORK
— Jumel Terrace homes
　Trav/Holiday 176:60 (c,1) O '93
HARLOW, JEAN
　Life 17:38 (4) F '94
— Caricature
　Am Heritage 46:95 (c,2) D '95
HARMONICA PLAYING
　Smithsonian 26:126,130–1 (c,2) N '95
HARMONICAS
　Smithsonian 26:122–31 (c,1) N '95
HARNETT, WILLIAM MICHAEL
　Smithsonian 22:52 (4) Mr '92
— "The Faithful Colt"
　Am Heritage 43:103 (painting,c,4) S '92
— Trompe l'oeil paintings by him
　Smithsonian 22:cov.53–63 (c,1) Mr '92
HARP PLAYING
— First Lady Louisa Adams playing harp
　Smithsonian 22:24 (painting,c,4) Mr '92
— Playing harp with Ping-Pong paddle
　Sports Illus 82:7 (c,4) Ap 3 '95
HARPOONS
　Smithsonian 23:158 (c,4) N '92
HARPS
　Gourmet 54:110 (c,3) S '94
HARRIERS (BIRDS)
　Natur Hist 105:45,49,64 (c,4) O '96
HARRIMAN, W. AVERELL
　Am Heritage 46:59 (4) D '95

HARRISON, WILLIAM HENRY
— 1841 death
Life 15:68 (painting,c,4) O 30 '92
HART, LORENZ
— Caricature
Am Heritage 44:82–4 (c,1) O '93
HARTFORD, CONNECTICUT
Nat Geog 185:77 (c,3) F '94
— Wadsworth Atheneum
Am Heritage 43:100–3 (c,1) S '92
Harvesting. See
individual crops—HARVESTING
HASSAM, CHILDE
Smithsonian 23:145 (painting,c,4) N '92
— "Road to the Land of Nod" (1910)
Smithsonian 26:102–3 (painting,c,1) F '96
HATS
— 18th cent. tricorne hat (Great Britain)
Smithsonian 24:75 (painting,c,4) Mr '94
— 1861 men's hats (France)
Smithsonian 24:78 (painting,c,4) Mr '94
— Late 19th cent. women's hats
Smithsonian 25:97,100 (4) Jl '94
— Early 20th cent. hatboxes
Smithsonian 23:63 (c,4) S '92
— 1905 women's hat shop (Pennsylvania)
Am Heritage 44:100 (painting,c,4) F '93
— 1930s fedoras
Smithsonian 24:108 (painting,c,4) Mr '94
Am Heritage 45:96,105 (1) N '94
— 1930s top hat
Smithsonian 24:62 (2) My '93
— 1945 sailor hats for women
Life 18:102 (4) Je 5 '95
— Baseball caps with restaurant logos
Gourmet 56:152 (c,4) O '96
— Basque cap, Spain
Nat Geog 188:74–5 (c,1) N '95
— Beaver top hats
Trav&Leisure 25:83 (c,4) Ag '95
— Cowboy hats
Life 15:60–1 (c,1) Jl '92
— Fox pelt hat (Alaska)
Trav/Holiday 176:61 (c,4) My '93
— French beret
Natur Hist 105:20 (c,4) Ja '96
— History of men's hats
Smithsonian 24:72–82 (c,1) Mr '94
— Huge feathered hat worn by society woman
Life 17:88 (c,2) Ag '94
— Sombrero
Smithsonian 24:72 (c,1) Mr '94
— Sun hats (Vietnam)
Nat Geog 183:8–9,32–5 (c,1) F '93
— Tall straw hats (Yemen)

Life 16:18 (c,2) S '93
— Top hat (Great Britain)
Nat Geog 183:97 (c,1) Ja '93
— Women's cowboy hats
Sports Illus 78:49 (c,3) F 15 '93
HAVANA, CUBA
Am Heritage 46:97–105 (c,2) N '95
Trav/Holiday 179:85 (c,4) Mr '96
— 1950s
Am Heritage 46:97–104 (2) N '95
— The Malecon
Trav&Leisure 23:74 (c,4) O '93
HAWAII
Life 15:30–7 (c,1) My '92
Trav/Holiday 175:87–108 (c,3) My '92
Trav&Leisure 22:1–22 (c,1) Je '92 supp.
Trav&Leisure 22:1–48 (map,c,1) S '92
supp.
Trav&Leisure 22:160–8 (map,c,1) N '92
Trav/Holiday 176:11–18 (c,2) F '93
Trav/Holiday 176:37–45 (c,1) Mr '93
Trav/Holiday 176:64–9 (c,1) My '93
Trav&Leisure 23:1–36 (map,c,1) S '93
supp.
Trav&Leisure 23:1–32 (c,1) N '93 supp.
Trav&Leisure 24:1–32 (map,c,1) N '94
supp.
Nat Geog 188:2–37 (map,c,1) S '95
Trav&Leisure 25:89–126 (c,1) S '95
Trav&Leisure 26:cov.,40–9,93–6
(map,c,1) Ja '96
Trav/Holiday 179:29–38 (c,4) My '96
Trav/Holiday 179:84–91 (c,1) S '96
Trav&Leisure 26:117–46 (map,c,3) S '96
Trav&Leisure 26:H1–H31 (c,1) N '96
— Early 20th cent. tourists dipping postcards
into lava flows
Nat Geog 188:132 (2) S '95
— 1946 tsunami (Hilo)
Smithsonian 24:28–9 (1) Mr '94
— Countryside
Smithsonian 27:115–17,123 (c,1) N '96
— Haleakala, Maui
Natur Hist 105:5–60 (map,c,1) Ja '96
— Hawaiian motifs, artifacts, and resources
Trav/Holiday 175:67–87 (c,1) Mr '92
— Kalaupapa peninsula, Molokai
Life 15:30–1 (c,1) My '92
— Kapalua, Maui
Trav&Leisure 22:K1–K8 (c,1) N '92
— Kauai
Trav/Holiday 175:18,104 (c,4) My '92
Trav/Holiday 175:91–8 (c,1) S '92
Trav/Holiday 176:22 (c,4) S '93
Trav/Holiday 176:39–44 (c,2) O '93

Natur Hist 104:56–9 (map,c,1) D '95
Trav&Leisure 26:50–7 (c,4) Ap '96
— Maui
Trav/Holiday 175:94,98 (c,3) My '92
Gourmet 55:162–8 (map,c,1) My '95
— Molokai
Life 17:84–7 (map,c,1) Ap '94
— Mount Waialeale, Kauai
Trav/Holiday 175:28 (c,4) O '92
— Na Pali coast, Kauai
Life 15:34–5 (c,1) My '92
Trav/Holiday 175:18 (c,4) My '92
Trav&Leisure 23:88 (c,4) N '93
Natur Hist 105:65–7 (map,c,1) D '96
— Oahu
Trav/Holiday 177:cov.,62–73 (map,c,1)
Ap '94
Trav&Leisure 24:cov.,99–103 (c,1) O '94
— Queen Emma's house, Kauai
Trav/Holiday 176:67 (c,4) My '93
— Stylistic depiction of Hawaii
Trav/Holiday 179:101 (painting,c,4) Ap
'96
— Waimea, Kauai
Trav&Leisure 22:66 (c,4) O '92
Trav&Leisure 25:112–14,169 (map,c,3)
My '95
— See also
DIAMOND HEAD
HAWAII VOLCANOES NATIONAL
PARK
HONOLULU
KILAUEA
HAWAII—ART
— Tiki statues
Life 15:62 (c,3) O '92
HAWAII—COSTUME
Trav/Holiday 175:75,83–7 (c,1) Mr '92
— Hula dancer
Trav/Holiday 175:75 (c,1) Mr '92
— Traditional girl with lei
Trav&Leisure 22:cov. (c,1) Je '92 supp.
HAWAII—HISTORY
— Father Damien's grave (Molokai)
Life 17:84–5 (c,1) Ap '94
HAWAII—MAPS
Trav/Holiday 175:72–3 (c,1) Mr '92
— Good scuba diving sites
Trav/Holiday 175:73 (c,4) D '92
— Hawaii Island
Trav/Holiday 177:41 (c,4) D '94
**HAWAII VOLCANOES NATIONAL
PARK, HAWAII**
Trav&Leisure 22:162 (c,4) N '92
Nat Geog 182:40–1 (c,1) D '92

Natur Hist 105:78–81 (map,c,1) F '96
HAWKS
Nat Geog 184:109 (c,3) O '93
Natur Hist 104:36 (c,4) Ja '95
Natur Hist 105:47,50–1,65 (c,4) O '96
— Falconer's hawk
Nat Geog 188:105 (c,3) N '95
— Red-tailed hawk
Smithsonian 26:22 (c,4) N '95
— See also
FALCONS
GOSHAWKS
HARRIERS
VULTURES
HAWTHORNE, NATHANIEL
Am Heritage 43:85 (4) O '92
Smithsonian 26:105 (drawing,c,4) Jl '95
— House of the Seven Gables, Salem,
Massachusetts
Gourmet 52:100–1 (c,1) O '92
Trav&Leisure 23:E2 (c,4) Je '93
HAY, JOHN MILTON
Smithsonian 23:138 (4) N '92
HAY INDUSTRY
— Bales of hay (Wisconsin)
Trav&Leisure 24:116–17 (c,1) Je '94
Gourmet 55:89 (c,4) Je '95
— Bales wrapped in polyethylene (Sweden)
Nat Geog 184:18–19 (c,2) Ag '93
— Hauling hay on oxcart (Massachusetts)
Smithsonian 24:82 (c,1) S '93
— Hayfield (France)
Trav&Leisure 23:cov.,79 (c,1) Je '93
— Haystacks (Spain)
Gourmet 54:129 (c,4) N '94
— Haystacks (Ukraine)
Smithsonian 23:64–7 (c,2) D '92
— Packing hay (California)
Nat Geog 184:66–7 (c,2) Jl '93
— Rows of new-mown hay (Colorado)
Trav&Leisure 23:122–3 (c,1) Mr '93
HAY INDUSTRY—HARVESTING
— Nebraska
Nat Geog 183:82 (c,1) Mr '93
HAYDN, FRANZ JOSEPH
— Home (Eisenstadt, Austria)
Trav&Leisure 25:135 (c,4) O '95
HAYES, RUTHERFORD B.
Am Heritage 46:81 (4) Jl '95
— Wife Lucy
Am Heritage 46:80–1 (4) Jl '95
HAYWORTH, RITA
Life 18:139 (1) Je 5 '95
Life 19:106 (1) O '96

HEADGEAR
— 1915 Osage Indian feathered hat
Life 17:129 (c,4) N '94
— African headgear varieties
Smithsonian 27:28 (c,4) Je '96
— Cree Indian headdress
Smithsonian 23:42 (c,4) N '92
— Fez (Tunisia)
Trav/Holiday 178:43–5 (c,3) N '95
— Goddess Kali headdress (Fiji)
Nat Geog 188:129 (c,2) O '95
— Plains Indian headdresses
Trav/Holiday 178:69 (c,3) My '95
— Tlingit Indian headdress
Nat Geog 183:117 (c,1) Ja '93
— See also
CROWNS
HATS
HELMETS
MASKS
WIGS

HEADPHONES
Nat Geog 184:47 (c,3) Ag '93

HEALTH
— Humorous look at dieting
Smithsonian 25:146–56 (drawing,c,1) N
'94

HEALTH CLUBS
— College weight rooms
Sports Illus 77:9 (c,4) O 26 '92

HEARST, WILLIAM RANDOLPH
Smithsonian 22:104 (4) Mr '92
Am Heritage 43:46–56 (4) N '92
— Hearst Castle, San Simeon, California
Gourmet 53:98,103 (c,1) O '93
Sports Illus 80:55 (c,4) F 14 '94
— Hearst political campaign buttons
Am Heritage 43:46–56 (4) N '92

HEARTS
— Bay leaves arranged in heart shape
Gourmet 56:87 (c,4) S '96
— Diseased heart
Life 19:86 (c,1) D '96
— Heart of alcoholic
Nat Geog 181:14 (c,4) F '92
— Mechanical heart
Life 19:87 (c,1) D '96

HEATHER
Gourmet 53:103 (c,4) Mr '93

HEDGEHOGS
Smithsonian 23:80 (c,4) Ap '92
Nat Geog 184:110 (c,4) S '93

HEFNER, HUGH
Am Heritage 44:51 (4) My '93

HEIFETZ, JASCHA
Life 17:3 (4) Ja '94

HELICOPTERS
Sports Illus 80:60 (c,4) Ja 24 '94
Smithsonian 25:104 (c,3) N '94
Sports Illus 84:24–5 (c,1) Mr 11 '96
Nat Geog 190:4–9 (c,1) O '96
— 1863 model of helicopter (France)
Smithsonian 26:76 (4) My '95
— 20th cent. Sikorsky helicopters
Am Heritage 43:44–5 (4) Ap '92
— 1920s helicopter plant (New York)
Am Heritage 43:44 (4) Ap '92
— Helicopter crash wreckage (Alabama)
Sports Illus 79:51 (c,3) Jl 26 '93
— Helicopter destroyed by 1972 Olympic
terrorists (Munich, Germany)
Sports Illus 81:60–1 (1) Jl 25 '94
— Vietnam War (1968)
Am Heritage 44:32 (4) Jl '93
— See also
SIKORSKY, IGOR

HELLMAN, LILLIAN
Smithsonian 25:12 (4) My '94

HELMETS
— Ancient Celtic helmet
Smithsonian 24:123 (c,4) My '93
— Bulletproof police helmets (U.S.S.R.)
Life 15:10–11 (c,1) Ap '92
— Children in hard hats to protect against
volcano (Japan)
Nat Geog 182:12–13 (c,1) D '92
— Fire fighter's helmet
Smithsonian 23:40 (c,4) My '92
— Hockey helmet
Sports Illus 85:100–4 (c,3) D 30 '96
— Knight costumes for medieval-style
warfare (Pennsylvania)
Life 18:28–32 (c,1) N '95
— See also
FOOTBALL HELMETS

HELSINKI, FINLAND
Trav&Leisure 25:7–8 (c,3) Je '95
— Outdoor cafe
Trav/Holiday 177:89 (painting,c,3) Jl '94

HEMINGWAY, ERNEST
Gourmet 52:70 (4) Ap '92
Smithsonian 25:18 (4) Ag '94
Trav&Leisure 24:111 (4) D '94
Am Heritage 46:38,98 (c,4) D '95
— At bullfight (Spain)
Sports Illus 84:23 (4) My 20 '96
— Hemingway lookalike contest (Key West,
Florida)

Life 16:26 (4) Jl '93
HEMLOCK TREES
Natur Hist 102:23 (c,1) Ja '93
HENDRIX, JIMI
Life 15:12 (2) D 1 '92
HENIE, SONJA
Sports Illus 76:34–5 (2) F 3 '92
Sports Illus 76:66 (4) Je 1 '92
Sports Illus 79:13–22 (c,2) O 18 '93
Sports Illus 80:134 (4) F 7 '94
Sports Illus 80:18 (4) F 14 '94
Sports Illus 85:14 (4) Jl 22 '96
HENRI, ROBERT
— 1914 painting of sleeping boy
Am Heritage 44:94 (c,4) D '93
HENRY VIII (GREAT BRITAIN)
— 1521 Latin text by Henry VIII defending
Catholicism
Smithsonian 24:21 (c,4) Ap '93
— Armor belonging to Henry VIII
Nat Geog 184:51 (c,4) O '93
— Portrait by Holbein the Younger (1542)
Life 19:86 (painting,c,4) Jl '96
— See also
BOLEYN, ANNE
**HENRY THE NAVIGATOR
(PORTUGAL)**
Nat Geog 182:59 (painting,c,4) N '92
HEPBURN, AUDREY
Life 17:cov.,64–5 (1) Ja '94
HEPBURN, KATHARINE
Life 19:33 (1) O '96
HERBS
— Herb garden (Ireland)
Trav&Leisure 24:48 (c,4) Jl '94
— See also
LAVENDER
HERCULES
— 1632 Rubens painting
Smithsonian 24:61 (c,4) O '93
HERMIT CRABS
Natur Hist 101:50–5 (c,1) Ap '92
Natur Hist 101:17–19 (drawing,4) Je '92
Trav/Holiday 179:82 (c,4) F '96
**HERMITAGE MUSEUM, ST. PETERS-
BURG, RUSSIA**
Smithsonian 25:40–55 (c,1) Mr '95
HERONS
Nat Wildlife 31:52–60 (c,1) Ap '93
Life 16:68-9 (c,1) Jl '93
— Black-crowned night herons
Smithsonian 25:8 (c,4) Ag '94
— Great blue
Nat Wildlife 31:52–60 (c,1) Ap '93

Life 16:36–7 (c,1) O '93
Trav&Leisure 24:102 (drawing,c,1) Ap
'94
Natur Hist 104:84–5 (c,1) Mr '95
Sports Illus 83:87 (c,4) S 18 '95
— Great white
Life 16:37 (c,4) O '93
— Tricolored heron
Natur Hist 103:26 (c,4) O '94
— See also
EGRETS
HERRINGS
Nat Geog 189:90–9 (c,1) Ja '96
HERSCHEL, CAROLINE L.
Smithsonian 23:76 (drawing,4) Je '92
HESS, RUDOLF
Am Heritage 45:78 (c,1) Jl '94
Smithsonian 27:124–5,128 (4) O '96
HESSE, HERMANN
— Tombstone (Switzerland)
Gourmet 56:69 (c,4) Jl '96
HEYERDAHL, THOR
— On raft in South Seas (1947)
Life 18:58–9 (1) D '95
HIBISCUS
Nat Wildlife 31:31–2 (c,1) Ag '93
Trav/Holiday 177:87 (c,4) O '94
Gourmet 54:130 (c,4) D '94
Gourmet 55:17 (c,4) F '95
HICKOCK, WILD BILL
Life 17:22 (4) Ag '94
Am Heritage 45:35 (painting,c,4) S '94
HIEROGLYPHICS
— Ancient Maya hieroglyphics
Nat Geog 183:97–9 (c,4) F '93
— Ancient Olmec glyphs (Mexico)
Nat Geog 184:110–11 (c,1) N '93
HIGH JUMPING
Sports Illus 80:60–1 (c,1) Ap 18 '94
Sports Illus 81:2–3 (c,1) Ag 1 '94
Sports Illus 85:2–3 (c,1) Jl 1 '96
Sports Illus 85:2–3 (c,1) Jl 22 '96
— 1907 (Rwanda)
Nat Geog 190:54 (4) Jl '96
— 1984 Olympics (Los Angeles)
Sports Illus 84:24 (c,3) F 26 '96
— 1992 Olympics (Barcelona)
Sports Illus 77:20–1,29 (c,1) Ag 10 '92
Sports Illus 77:34–5 (c,1) Ag 17 '92
— 1996 Olympics (Atlanta)
Sports Illus 85:53,110 (c,3) Ag 5 '96
Sports Illus 85:45 (c,3) Ag 12 '96
HIGHWAYS
— Alaska
Trav&Leisure 22:60 (c,4) Jl '92

— Blue Ridge Parkway, North Carolina
Trav&Leisure 26:38 (c,1) N '96
— Colorado
Trav&Leisure 23:40 (c,4) Mr '93
Nat Geog 190:89,91–2 (c,3) N '96
— Concrete ramps (California)
Smithsonian 24:cov. (c,1) Ja '94
— Highway 50, Nevada
Trav/Holiday 179:62–9 (map,c,1) N '96
— History of the 1915 transcontinental
Lincoln Highway
Am Heritage 46:48–60 (c,1) Ap '95
— Karakoram Highway, Pakistan
Trav&Leisure 24:124–5 (c,1) S '94
— Los Angeles freeway after 1994
earthquake, California
Life 18:22-3 (c,1) Ja '95
— Map of ancient Roman Appian Way, Italy
Trav/Holiday 177:40 (c,4) N '94
— Mexico
Nat Geog 190:44–5 (c,1) Ag '96
— New Mexico
Trav&Leisure 26:78 (c,4) S '96
— Newly built Pennsylvania Turnpike (1940)
Trav&Leisure 22:E13 (3) Mr '92
— Pacific Coast Highway
Nat Geog 184:63 (c,1) Jl '93
Trav&Leisure 23:114–25 (map,c,1) N '93
— Route 66, Arizona
Trav&Leisure 26:84 (c,4) S '96
— Route 93, Western U.S.
Nat Geog 182:42–68 (map,c,1) D '92
— San Diego, California
Nat Geog 182:23 (c,2) O '92
— Sheep crossing highway (Colorado)
Trav&Leisure 22:74 (c,3) Ja '92
— See also
ALASKA HIGHWAY
ROADS—CONSTRUCTION
HIKING
— Alaska
Smithsonian 26:62–3,70 (c,4) Je '95
— California
Trav&Leisure 26:E1 (c,3) Je '96
— Himayalas
Life 18:54–5 (c,1) D '95
— New Hampshire
Trav&Leisure 22:104–7 (c,1) My '92
— Switzerland
Gourmet 53:81 (c,4) F '93
— Trek across Brooks Range, Alaska (1989)
Nat Geog 183:70–93 (map,c,1) Ap '93
HILLARY, EDMUND
Life 19:40 (4) Ag '96

HIMALAYA MOUNTAINS, ASIA
— Kingdom of Lo Monthang
Life 16:78–85 (c,1) F '93
HIMALAYA MOUNTAINS, CHINA
— Kunlun Mountains
Natur Hist 101:34–5 (c,2) S '92
HIMALAYA MOUNTAINS, NEPAL
Nat Geog 184:2–29 (map,c,1) D '93
— See also
MOUNT EVEREST
HINDUISM—ART
— Domestic prayer paintings (India)
Smithsonian 26:94–9 (c,1) Jl '95
HINDUISM—RITES AND FESTIVALS
— Ganesh Chatorthi Festival (Bombay, India)
Nat Geog 187:50–1,64–5 (c,1) Mr '95
— Holi spring festival dance (India)
Nat Geog 184:90–1 (c,1) S '93
— Immersing Vishnu image in pool (India)
Trav/Holiday 176:54 (c,3) N '93
— Kumbha mela (Allahabad, India)
Life 15:76–7 (c,1) Mr '92
Smithsonian 23:120 (c,4) My '92
— Phagwa festival (Trinidad)
Nat Geog 185:84–5 (c,1) Mr '94
— Pouring rice on bridal couple (India)
Nat Geog 185:60–1 (c,1) My '94
— Ritual bathing in the Ganges River, India
Life 19:80 (c,3) Jl '96
— Teemeethi fire-walking ceremony (Fiji)
Nat Geog 188:129–31 (c,1) O '95
— Wearing sacred cotton thread (India)
Nat Geog 185:81 (c,2) Je '94
— Wedding (Mauritius)
Trav&Leisure 26:139–40 (c,1) O '96
— Wedding (Trinidad)
Nat Geog 185:76 (c,3) Mr '94
HIPPIES
— 1960s woman in miniskirt
Life 18:118–19 (c,1) N '95
— Allegorical view of hippies by Dinnerstein
Am Heritage 47:126 (painting,c,2) O '96
HIPPOPOTAMI
Nat Geog 184:12–13 (c,1) Jl '93
Life 17:21 (c,2) F '94
Life 17:76 (c,4) Mr '94
Natur Hist 104:cov.,46–57 (c,1) My '95
Life 18:112 (c,2) Je '95
Smithsonian 26:cov.,90–102 (c,1) Mr '96
Trav/Holiday 179:40 (c,4) Jl '96
— 19th cent. paintings (Great Britain)
Natur Hist 102:34–9 (c,1) F '93
— Baby pygmy hippo
Smithsonian 24:18 (c,4) Ag '93

— Hippo fad in mid-19th cent. England
　Natur Hist 102:34–9 (c,1) F '93
— Taxidermists stuffing hippo (1930s)
　Smithsonian 27:160 (4) My '96
HIROHITO
　Nat Geog 181:72–3 (2) Mr '92
　Smithsonian 27:148 (4) My '96
　Life 19:29 (4) O '96
HIROSHIMA, JAPAN
　Nat Geog 188:78–101 (map,c,1) Ag '95
— Hiroshima after 1945 bombing
　Nat Geog 188:81–7 (1) Ag '95
HIRSCHFELD, AL
　Gourmet 56:80 (c,3) F '96
— Self-caricature
　Gourmet 56:80 (drawing,4) F '96
HISS, ALGER
　Life 18:145 (2) Je 5 '95
History. See
　individual countries—HISTORY
　list under PEOPLE AND CIVILIZA-
　TIONS
HITLER, ADOLPH
　Sports Illus 79:58 (3) Jl 5 '93
　Sports Illus 79:18 (4) O 18 '93
　Life 18:40 (2) Je 5 '95
— Actor dressed as Hitler (Russia)
　Nat Geog 183:18 (c,4) Mr '93
— Caricature
　Am Heritage 46:99 (c,2) D '95
　Smithsonian 27:64 (c,4) Ag '96
— Hitler puppet
　Smithsonian 25:111 (c,1) F '95
— Hitler making a speech (1936)
　Life 19:28 (1) O '96
— Would-be assassin Karl Goerdeler
　Smithsonian 24:113 (4) Mr '94
HO CHI MINH
— Bust of him
　Nat Geog 187:69 (c,3) Ap '95
— Tomb (Vietnam)
　Smithsonian 26:41 (c,4) Ja '96
HO CHI MINH CITY, VIETNAM
　Life 17:38–9 (c,2) Jl '94
　Trav&Leisure 24:60,63 (c,4) D '94
　Nat Geog 187:62–87 (map,c,1) Ap '95
　Smithsonian 26:32–3 (c,1) Ja '96
Hoaxes. See
　CARDIFF GIANT
HOBBIES
— Collection of baseball memorabilia (New
　Jersey)
　Sports Illus 82:66–76 (c,1) My 22 '95
— Collections of natural history items
　Smithsonian 23:92–9 (c,2) O '92

— Scrapbooks
　Smithsonian 22:78–87 (c,1) F '92
HOBBIES—HUMOR
— Collecting junk
　Smithsonian 24:78–84 (painting,c,1) F '94
HOBOES
— 1930s hoboes on train
　Life 17:37 (2) Mr '94
HOCKEY
— 1960 Olympics (Squaw Valley)
　Sports Illus 79:10–12 (3) D 13 '93
— 1980 Olympics (Lake Placid)
　Sports Illus 79:9,14–18 (c,2) D 13 '93
　Sports Illus 80:36–49 (c,1) F 21 '94
　Sports Illus 81:178 (c,2) N 14 '94
— 1992 Olympics (Albertville)
　Sports Illus 76:28–31 (c,1) F 24 '92
　Sports Illus 76:28–31,78–9 (c,1) Mr 2 '92
— 1994 Olympics (Lillehammer)
　Sports Illus 80:26–8,33 (c,1) Mr 7 '94
— Carving field hockey sticks (India)
　Sports Illus 85:174 (c,3) Jl 22 '96
— Fans celebrating 1992 World Hockey
　Championship win (Sweden)
　Nat Geog 184:2–3,34–5 (c,1) Ag '93
— Field hockey (India)
　Sports Illus 85:170–6 (c,1) Jl 22 '96
— World Championships 1991 (Sweden vs.
　U.S.S.R.)
　Sports Illus 76:23 (c,2) Ja 27 '92
— World Championships 1996 (Montreal)
　Sports Illus 85:22–7 (c,1) S 23 '96
HOCKEY—COLLEGE
— 1905 women's field hockey
　Nat Geog 190:58–9 (1) Jl '96
— NCAA Championships 1993 (Maine vs.
　Lake Superior State)
　Sports Illus 78:78,81 (c,3) Ap 12 '93
— Women's field hockey
　Sports Illus 81:72,75 (c,2) O 31 '94
　Sports Illus 83:34 (c,4) Jl 24 '95
HOCKEY—PROFESSIONAL
　Sports Illus 76:30–1 (c,2) F 3 '92
　Sports Illus 77:34–50 (c,1) O 12 '92
　Sports Illus 77:50–3 (c,1) O 26 '92
　Sports Illus 77:49–52 (c,1) N 16 '92
　Sports Illus 77:52–3,58 (c,1) D 7 '92
　Sports Illus 78:12–17 (c,1) Mr 15 '93
　Sports Illus 78:cov.,44–5 (c,1) Ap 19 '93
　Sports Illus 79:90–111 (c,1) O 11 '93
　Sports Illus 80:64–70 (c,1) F 21 '94
　Sports Illus 80:52–7 (c,1) My 2 '94
　Sports Illus 80:26–32 (c,1) My 9 '94
　Sports Illus 80:56–7 (c,1) My 23 '94
　Sports Illus 80:34–7 (c,1) My 30 '94

Sports Illus 81:142–3 (c,1) N 14 '94
Sports Illus 82:56–65 (c,1) Je 5 '95
Sports Illus 83:72–98 (c,1) O 9 '95
Sports Illus 84:46–50 (c,1) Ja 22 '96
Sports Illus 84:46–9 (c,1) Ja 29 '96
Sports Illus 84:2–3,80–3 (c,1) Mr 18 '96
Sports Illus 85:54–66 (c,1) O 7 '96
Sports Illus 85:46–8 (c,1) N 11 '96
— 1933
 Sports Illus 76:66 (4) Je 1 '92
— 1940s
 Sports Illus 80:40 (4) Ja 17 '94
— 1950s
 Sports Illus 80:41 (4) Ja 17 '94
 Sports Illus 80:32 (4) My 9 '94
 Sports Illus 81:116–17 (c,1) N 14 '94
— 1960
 Sports Illus 80:54–6 (1) Mr 14 '94
— 1970
 Sports Illus 80:32 (4) My 9 '94
— 1970 horizontal move by Bobby Orr
 Sports Illus 84:20 (4) Je 24 '96
— All-time "dream team" members
 Sports Illus 77:30–1 (painting,c,1) Fall '92
— Fatal fight during game (Italy)
 Sports Illus 79:68–70 (c,4) D 6 '93
— Fight
 Sports Illus 82:2–3 (c,1) Ap 24 '95
 Sports Illus 84:24–5 (c,1) Mr 11 '96
— Goal-tending
 Sports Illus 78:30–2 (c,2) My 3 '93
 Sports Illus 78:22–3 (c,1) My 24 '93
 Sports Illus 78:2–3 (c,1) My 31 '93
 Sports Illus 79:40–2 (c,1) N 1 '93
 Sports Illus 80:52–7 (c,1) My 2 '94
 Sports Illus 82:58–66 (c,1) F 20 '95
 Sports Illus 82:42–3 (c,1) My 22 '95
 Sports Illus 84:40–1 (c,1) F 19 '96
— Oilers holding Stanley Cup (1988)
 Sports Illus 76:48 (c,3) Mr 16 '92
— Player sliding into goal
 Sports Illus 76:2–3 (c,1) My 11 '92
— Players falling on ice
 Sports Illus 76:29 (c,2) My 4 '92
— Publicity stunts
 Sports Illus 81:26–33 (c,1) O 17 '94
— Referee training class
 Life 18:108 (c,2) D '95
— Roller hockey
 Sports Illus 79:50–3 (c,2) Ag 16 '93
— Scoring
 Sports Illus 78:44–5 (c,1) Ap 19 '93
 Sports Illus 80:62–6 (c,1) Mr 14 '94
 Sports Illus 82:36–7 (c,1) Je 26 '95

— Stanley Cup Playoffs 1970 (Bruins vs.
 Blues)
 Sports Illus 84:20 (4) Je 24 '96
— Stanley Cup Playoffs 1988 (Oilers vs.
 Bruins)
 Sports Illus 85:56 (c,3) O 7 '96
— Stanley Cup Playoffs 1992 (Penguins vs.
 Black Hawks)
 Sports Illus 76:36–40 (c,1) My 18 '92
 Sports Illus 76:30–8 (c,1) Je 1 '92
 Sports Illus 76:cov.,2–3,14–19 (c,1) Je 8
 '92
— Stanley Cup Playoffs 1993 (Canadiens vs.
 Kings)
 Sports Illus 78:30–8 (c,2) My 3 '93
 Sports Illus 78:32–6 (c,1) My 10 '93
 Sports Illus 78:26–31 (c,1) My 17 '93
 Sports Illus 78:22–4,29 (c,1) My 24 '93
 Sports Illus 78:2–3,42–4 (c,1) My 31 '93
 Sports Illus 78:32–3 (c,1) Je 7 '93
 Sports Illus 78:cov.,16–20 (c,1) Je 14 '93
 Sports Illus 78:26–31 (c,1) Je 21 '93
— Stanley Cup Playoffs 1994 (Rangers vs.
 Canucks)
 Sports Illus 80:cov.,2–3,12–17 (c,1) Je 13
 '94
 Sports Illus 80:cov.,24–9 (c,1) Je 20 '94
 Sports Illus 80:2–3 (c,1) Je 27 '94
— Stanley Cup Playoffs 1995 (Devils vs. Red
 Wings)
 Sports Illus 83:18–23 (c,1) Jl 3 '95
— Stanley Cup Playoffs 1996 (Avalanche vs.
 Panthers)
 Sports Illus 84:26–31 (c,1) My 6 '96
 Sports Illus 84:58–65 (c,1) My 13 '96
 Sports Illus 84:24–35 (c,1) My 20 '96
 Sports Illus 84:52–4 (c,1) My 27 '96
 Sports Illus 84:38–40,45 (c,1) Je 3 '96
 Sports Illus 84:2–3,50–2,57 (c,1) Je 17 '96
— Stanley Cup winners celebrating (1991)
 Sports Illus 77:45 (c,2) O 12 '92
— Ticker tape parade for Rangers (New York)
 Sports Illus 80:–3 (c,1) Je 27 '94
HOCKEY—PROFESSIONAL—HU -
 MOR
— Teams moving south from Canada
 Sports Illus 82:104–10 (drawing,c,1) Mr
 20 '95
HOCKEY EQUIPMENT
— Hockey pucks
 Sports Illus 82:36 (c,2) Ja 23 '95
HOCKEY PLAYERS
 Sports Illus 76:74–5 (c,1) Mr 9 '92
 Sports Illus 76:45 (c,1) Mr 16 '92

— See also
 ORR, BOBBY
HOGAN, BEN
 Sports Illus 76:38 (2) My 25 '92
 Sports Illus 77:42–51 (1) Fall '92
 Sports Illus 80:50 (2) Je 13 '94
 Am Heritage 46:99 (4) My '95
 Sports Illus 82:39 (2) Je 12 '95
 Sports Illus 85:47 (4) Jl 15 '96
HOLBEIN, HANS THE YOUNGER
— Portrait of Henry VIII (1542)
 Life 19:86 (painting,c,4) Jl '96
HOLIDAY, BILLIE
 Smithsonian 24:66 (4) My '93
 Am Heritage 45:14 (drawing,4) D '94
— Depicted on postage stamp
 Life 17:34 (c,4) S '94
HOLIDAYS
— Putting colored lights on Empire State
 Building, New York City
 Trav&Leisure 24:149 (c,1) Jl '94
— See also
 CHRISTMAS
 EASTER
 FOURTH OF JULY
 HALLOWEEN
 LABOR DAY
 MAY DAY
 MEMORIAL DAY
 NEW YEAR'S DAY
 NEW YEAR'S EVE
 THANKSGIVING
 VALENTINE'S DAY
HOLLY
— Holly leaves
 Natur Hist 102:60 (c,4) S '93
HOLLY, BUDDY
 Life 15:cov.,43 (4) D 1 '92
HOLLYWOOD, CALIFORNIA
 Nat Geog 181:40–65 (map,c,1) Je '92
— "Hollywood" sign on hill
 Nat Geog 181:64 (c,1) Je '92
— Mural of movie stars
 Life 16:52 (c,2) Mr '93
Holmes, Sherlock. See
 SHERLOCK HOLMES
Home furnishings. See
 CLOCKS
 FURNITURE
 HOUSEWARES
 QUILTS
 RUGS
 WALLPAPER
HOMELESS
— Family in shelter (Paraguay)

 Nat Geog 182:90–1 (c,1) Ag '92
— Homeless family (California)
 Life 18:86–98 (1) My '95
— Homeless immigrants (Milan, Italy)
 Nat Geog 182:106–7 (c,2) D '92
— Los Angeles, California
 Nat Geog 181:66–7 (c,1) Je '92
— Man living in cardboard box (New York
 City, New York)
 Nat Geog 183:12–13 (c,2) My '93
— Russian child living in airport
 Life 16:76–82 (1) My '93
— Street children sleeping (South Africa)
 Nat Geog 183:87 (c,2) F '93
— Teen runaways (U.S.S.R.)
 Life 18:58–9 (c,1) Jl '95
HOMER, WINSLOW
 Smithsonian 26:118 (4) O '95
— "The Adirondack Guide"
 Natur Hist 101:46–7 (painting,c,1) My '92
— Deem painting in style of Homer
 Smithsonian 24:98 (c,2) Jl '93
— Paintings by him
 Smithsonian 26:116–29 (c,1) O '95
— Prouts Neck studio, Maine
 Trav&Leisure 25:163 (c,4) My '95
— "Snap the Whip" (1872)
 Smithsonian 26:123 (painting,c,3) O '95
HOMES OF FAMOUS PEOPLE
— Birthplace of Ben Thompson, Count of
 Rumford (Woburn, Massachusetts)
 Smithsonian 25:105 (c,3) D '94
— Sabine Baring-Gould home (Devonshire,
 England)
 Smithsonian 24:75–9 (c,2) Jl '93
— Henry Clay Frick mansion (Pittsburgh,
 Pennsylvania)
 Gourmet 53:134 (c,4) O '93
— Steffi Graf's home (Bruhl, Germany)
 Sports Illus 85:78 (c,4) N 18 '96
— Bob Marley Museum, Jamaica
 Natur Hist 104:48–62 (c,1) N '95
— William Wrigley, Jr.'s home (Catalina
 Island, California)
 Trav&Leisure 22:E6 (c,4) D '92
— See also
 ALLEN, ETHAN
 ANDERSEN, HANS CHRISTIAN
 AUDUBON, JOHN JAMES
 BELL, ALEXANDER GRAHAM
 BOLIVAR, SIMON
 BRONTE FAMILY
 CAPONE, AL
 CHURCHILL, WINSTON
 CODY, WILLIAM (BUFFALO BILL)

COLUMBUS, CHRISTOPHER
COOK, JAMES
COWARD, NOEL
DARWIN, CHARLES
DOUGLASS, FREDERICK
DUMAS, ALEXANDRE
FAULKNER, WILLIAM
FLAGLER, HENRY
FORD, HENRY
FREDERICK THE GREAT
FRENCH, DANIEL CHESTER
FREUD, SIGMUND
GATES, WILLIAM
GAUDI, ANTONIO
HADRIAN
HARDY, THOMAS
HAWTHORNE, NATHANIEL
HAYDN, FRANZ JOSEPH
HEARST, WILLIAM RANDOLPH
HOMER, WINSLOW
HOOVER, HERBERT
JACKSON, MICHAEL
JAMES, HENRY
JEFFERSON, THOMAS
JOPLIN, SCOTT
KING, MARTIN LUTHER, JR.
KIPLING, RUDYARD
LEHAR, FRANZ
LEWIS, SINCLAIR
LUDWIG II
MAHLER, GUSTAV
MEDICI, LORENZO DE
MELVILLE, HERMAN
MITCHELL, MARGARET
MOORE, MARIANNE
MORRIS, WILLIAM
POE, EDGAR ALLEN
POTTER, BEATRIX
PUSHKIN, ALEKSANDR
REAGAN, RONALD
RINGLING, JOHN
ROCKEFELLER, JOHN D.
ROCKEFELLER, NELSON
ROCKWELL, NORMAN
ROTHSCHILD FAMILY
SAINT-GAUDENS, AUGUSTUS
SANDBURG, CARL
SIBELIUS, JEAN
STARR, BELLE
STEVENSON, ROBERT LOUIS
TRUMAN, HARRY S.
TWAIN, MARK
VAN GOGH, VINCENT
VANDERBILT FAMILY
WALPOLE, HORACE

WHARTON, EDITH
WHITE, STANFORD
WHITE HOUSE
WILLIAMS, TENNESSEE
WORDSWORTH, WILLIAM
WRIGHT, FRANK LLOYD
YEATS, WILLIAM BUTLER
YOUNG, BRIGHAM

HOMOSEXUALITY
— 19th cent. Crow Indian "berdaches"
 Am Heritage 43:108 (1) N '92
— 1994 "Unity" flag at gay rights march
 (New York)
 Life 17:12 (c,2) Ag '94
 Life 18:36 (c,2) Ja '95
 Natur Hist 105:10–11 (c,1) Ag '96
— Drag queen (Germany)
 Trav&Leisure 23:106–7 (c,1) Mr '93
— Gay couples
 Life 19:92–8 (c,1) N '96
— Gay men making public commitment vows
 (Pennsylvania)
 Life 17:8—9 (4) N '94
— Transvestite (Thailand)
 Nat Geog 189:105 (c,1) F '96
HONDURAS
— Copan
 Natur Hist 105:24–9.66 (c,1) Ap '96
— Maya ruins (Copan)
 Nat Geog 189:113 (c,3) Ap '96
 Natur Hist 105:24–31 (c,1) Ap '96
HONDURAS—HOUSING
— Wattle-and-daub homes
 Natur Hist 105:26–7 (c,1) Ap '96
HONEY INDUSTRY
 Nat Geog 183:72–93 (c,1) My '93
HONG KONG
 Trav&Leisure 22:143–54 (c,1) Mr '92
 Gourmet 52:cov.,104–7 (c,1) Mr '92
 Trav&Leisure 22:1–16 (c,1) Ap '92 supp.
 Trav/Holiday 176:26 (c,4) F '93
 Smithsonian 24:70–5 (c,2) Ag '93
 Trav&Leisure 24:62,64 (c,4) My '94
 Trav&Leisure 25:cov.,132–43,172
 (map,c,1) S '95
 Trav&Leisure 26:64–7 (map,c,3) F '96
 Trav&Leisure 26:A1–A21 (c,3) Je '96
— Food and medicine shop
 Natur Hist 105:44–5 (c,3) S '96
— Kowloon
 Trav&Leisure 24:E1 (c,4) Ag '94
 Trav&Leisure 25:132 (c,1) S '95
— Restaurants
 Trav/Holiday 178:3—6 (c,4) N '95
 Trav&Leisure 25:38–44 (c,3) D '95

HONG KONG—COSTUME
Gourmet 52:105–7 (c,1) Mr '92
HONG KONG—MAPS
— Hong Kong vicinity
Trav/Holiday 178:130 (c,2) F '95
HONOLULU, HAWAII
Trav&Leisure 22:110–17,152 (map,c,1) F
'92
Gourmet 53:88 (c,1) My '93
Trav&Leisure 24:cov.,99–103 (c,1) O '94
— Waikiki beach
Trav&Leisure 22:110–11 (c,1) F '92
HOOKER, JOSEPH
Am Heritage 44:112 (3) S '93
Am Heritage 44:95,101 (3) O '93
— Statue (Boston, Massachusetts)
Am Heritage 44:103 (4) O '93
HOOVER, HERBERT
— Birthplace (West Branch, Iowa)
Am Heritage 45:78 (c,4) O '94
— Caricature
Am Heritage 46:98 (c,4) D '95
— Lou Hoover
Smithsonian 23:145 (4) O '92
HOOVER, J. EDGAR
Sports Illus 77:100 (4) Fall '92
Am Heritage 45:103 (4) N '94
Sports Illus 83:7 (4) S 18 '95
— Caricature
Am Heritage 46:98 (c,4) D '95
HOOVER DAM, ARIZONA/NEVADA
Natur Hist 102:46–7 (c,1) N '93
Trav&Leisure 26:110 (c,4) N '96
HOPE, BOB
Life 18:65 (4) Je '95
HOPI INDIANS—ART
— Dolls
Smithsonian 25:cov. (c,1) O '94
HOPI INDIANS—COSTUME
— 1926 archers hunting
Nat Geog 190:62 (c,3) Jl '96
HOPPER, EDWARD
— Deem painting in style of Hopper
Smithsonian 24:101 (c,4) Jl '93
HOPS PLANTS
Natur Hist 101:80–1 (c,1) Ja '92
HORN BLOWING
— Blowing bocina horns for Good Friday
(Spain)
Life 15:85 (c,3) Ag '92
HORNBILLS
Gourmet 55:74 (c,4) Ja '95
Natur Hist 105:cov.,41–5 (c,1) Ja '96

HORNE, LENA
Am Heritage 46:111 (4) My '95
Life 18:126 (1) Je 5 '95
HORNED LIZARDS
Natur Hist 101:48–9 (c,1) O '92
Smithsonian 25:82–92 (c,2) D '94
Nat Geog 187:7 (c,4) Mr '95
Nat Wildlife 33:33 (c,4) Je '95
Horse events. See
EQUESTRIAN EVENTS
HORSE FARMS
Natur Hist 101:44–5 (c,1) F '92
— Kentucky
Life 18:74–81 (c,1) Jl '95
— Virginia
Gourmet 52:130–1 (c,1) N '92
HORSE RACING
Sports Illus 76:18–19 (c,2) Mr 23 '92
Sports Illus 76:30–1 (c,2) Ap 27 '92
Sports Illus 80:20–2 (c,1) Ap 25 '94
— Accident
Sports Illus 79:76–80 (c,1) N 1 '93
Sports Illus 80:34 (c,4) Je 13 '94
— Australia
Nat Geog 181:92–3 (c,1) Ap '92
— Belmont Stakes 1973
Sports Illus 81:78–9 (c,1) N 14 '94
— Belmont Stakes 1975
Am Heritage 44:127 (3) Ap '93
— Belmont Stakes 1992
Sports Illus 76:30–1 (c,2) Je 15 '92
— Belmont Stakes 1993
Sports Illus 78:34–6 (c,1) Je 14 '93
— Belmont Stakes 1994
Sports Illus 80:60 (c,4) Je 20 '94
— Belmont Stakes 1995
Sports Illus 82:62–3 (c,1) Je 19 '95
— Belmont Stakes 1996
Sports Illus 84:68–9 (c,1) Je 17 '96
— Breeders' Cup 1986 (Santa Anita,
California)
Sports Illus 78:48 (c,4) Je 7 '93
— Breeders' Cup 1992 (Gulfstream Park,
Florida)
Sports Illus 77:50 (c,2) N 9 '92
— Breeders' Cup 1993 (Santa Anita,
California)
Sports Illus 79:34–6 (c,1) N 15 '93
— Breeders' Cup 1995 (Belmont, New York)
Sports Illus 83:52–60 (c,1) N 6 '95
— Breeders' Cup 1996 (Toronto, Ontario)
Sports Illus 85:42–3 (c,1) N 4 '96
— California
Sports Illus 80:78–80 (c,3) Ap 18 '94

Sports Illus 82:69–70 (c,3) Ap 17 '95
Sports Illus 85:64–5 (c,2) Ag 19 '96
— Chuckwagon race (Arkansas)
Sports Illus 81:83 (c,4) O 17 '94
— Dubai
Sports Illus 85:86 (c,3) D 30 '96
— Florida
Sports Illus 78:26–7 (c,2) Mr 29 '93
Sports Illus 84:70–1 (c,1) Mr 4 '96
— Kentucky
Sports Illus 78:66–7 (c,1) Ap 19 '93
Sports Illus 83:54–5 (c,1) Jl 10 '95
— Kentucky Derby 1919
Sports Illus 80:4 (4) Je 27 '94
— Kentucky Derby 1933
Sports Illus 78:6 (3) Ap 5 '93
— Kentucky Derby 1955
Sports Illus 80:55–8 (3) My 9 '94
— Kentucky Derby 1973
Sports Illus 78:43–50 (c,1) My 3 '93
— Kentucky Derby 1978
Sports Illus 76:32 (c,3) Je 15 '92
Sports Illus 80:11–18 (c,1) My 9 '94
— Kentucky Derby 1988
Sports Illus 78:46 (c,4) Je 7 '93
— Kentucky Derby 1992
Sports Illus 76:16–21 (c,1) My 11 '92
Sports Illus 76:60 (c,4) Je 8 '92
Sports Illus 77:50–1 (c,1) D 28 '92
— Kentucky Derby 1993
Sports Illus 78:12–16 (c,1) My 10 '93
— Kentucky Derby 1994
Sports Illus 80:30–5 (c,1) My 16 '94
— Kentucky Derby 1995
Sports Illus 82:2–3,40–2 (c,1) My 15 '95
— Kentucky Derby 1996
Sports Illus 84:30–5 (c,1) My 13 '96
— Massachusetts
Sports Illus 84:2–3 (c,1) Je 10 '96
— New York
Sports Illus 83:36 (c,2) O 16 '95
Life 19:80–1 (c,2) Ja '96
— Palio banner, Siena, Italy
Trav/Holiday 178:69 (c,1) Ap '95
— Paraguay
Nat Geog 182:92–3 (c,1) Ag '92
— Practice workout (Great Britain)
Sports Illus 77:98–9 (c,1) D 28 '92
— Preakness 1985
Sports Illus 78:46 (c,4) Je 7 '93
— Preakness 1992
Sports Illus 76:66,71 (c,3) My 25 '92
— Preakness 1993
Sports Illus 78:34–5 (c,1) My 24 '93
— Preakness 1994

Sports Illus 80:38–9 (c,1) My 30 '94
— Preakness 1995
Sports Illus 82:62–3 (c,1) My 29 '95
— Preakness 1996
Sports Illus 84:56–7 (c,1) My 27 '96
— Race on Irish beach
Nat Geog 186:10–11 (c,1) S '94
— Travers 1994
Sports Illus 81:20–3 (c,2) Ag 29 '94
— Travers 1995
Sports Illus 83:38 (c,2) Ag 28 '95
— Virginia
Gourmet 52:128–9 (c,1) N '92
— Wood Memorial 1995
Sports Illus 82:26–7 (c,1) Ap 24 '95
— Woodward Stakes 1994
Sports Illus 81:26–7 (c,1) S 26 '94
— Woodward Stakes 1996
Sports Illus 85:16 (c,4) S 23 '96
— See also
JOCKEYS
RACE TRACKS

HORSE RACING—HARNESS
Sports Illus 77:80 (c,4) N 2 '92
Sports Illus 79:107 (c,4) O 18 '93
— 19th cent. sulkies (New York)
Sports Illus 76:8 (c,4) My 18 '92

HORSEBACK RIDING
— Alberta
Nat Geog 182:68–9 (c,1) D '92
— Arizona
Gourmet 55:8 (c,4) My '95
— Breaking bronco (Mongolia)
Nat Geog 183:134 (c,4) My '93
— British Columbia
Gourmet 53:108–9 (c,1) O '93
— California
Nat Geog 184:74–5 (c,1) Jl '93
Trav&Leisure 24:58 (c,4) My '94
— Child on horse (Colorado)
Trav/Holiday 176:6–9 (c,1) Jl '93
— Circus act
Life 19:30 (c,4) S '96
— Costa Rica
Trav/Holiday 179:80 (c,4) O '96
— Crow Indians (Montana)
Nat Geog 185:102–3 (c,1) Je '94
— Florida
Sports Illus 79:22 (c,4) Jl 12 '93
— France
Trav/Holiday 178:38–9,44–6 (c,1) Je '95
— Horseback rider in silhouette (Arizona)
Gourmet 56:106 (c,4) My '96
— Ireland
Trav&Leisure 24:65 (c,2) Jl '94

— Jamaica
Trav/Holiday 178:82 (c,3) D '95
— Japan
Nat Geog 185:102–3 (c,1) Ja '94
— Mongolia
Nat Geog 190:2–4,18–19 (c,1) D '96
— Montana
Gourmet 54:146–8 (c,1) My '94
Trav&Leisure 25:E4 (c,4) Je '95
— On beach (Florida)
Gourmet 54:70 (c,4) D '94
— On beach (Mauritius)
Trav&Leisure 26:141 (1) O '96
— Russian soldier on horseback
Nat Geog 186:98–9 (c,2) O '94
— Texas
Life 16:38–9 (c,1) Ap 5 '93
— Woman on horseback (Great Britain)
Trav/Holiday 179:61 (1) My '96
— Wyoming
Trav&Leisure 22:108–11,115 (1) My '92
Smithsonian 23:118–19 (c,2) N '92
Trav&Leisure 25:130–3 (c,2) Ap '95
— See also
COWBOYS
RANCHING
SADDLES
HORSES
Trav&Leisure 22:108–9 (c,1) Mr '92
Nat Geog 181:64–5 (c,1) Ap '92
Life 16:47–9 (c,1) Ap 5 '93
Trav&Leisure 23:92 (c,1) O '93
Nat Geog 190:54–5 (c,1) S '96
— 1945 rescue of Lippizan horses by
Americans (Austria)
Sports Illus 83:6–7 (4) O 16 '95
— Ancient horses
Natur Hist 103:59 (painting,c,2) Ap '94
— Bathing horse
Sports Illus 76:58–9 (c,1) Je 8 '92
Nat Geog 184:134–5 (c,1) Ag '93
— Burning "fallas" horse sculptures
(Valencia, Spain)
Life 15:82–3 (c,1) Ag '92
— Camargue, France
Trav/Holiday 179:82–3 (c,1) Mr '96
— Chincoteague ponies
Trav/Holiday 179:34–43 (1) Ap '96
— Dales pony
Smithsonian 25:62 (c,3) S '94
— Exmoor pony
Nat Geog 188:49 (c,3) O '95
— Giving horse a pedicure (Wyoming)
Trav/Holiday 177:43 (4) S '94
— Grooming horse (New York)

Life 17:80–1 (c,1) Ag '94
— Horse trampling trainer
Sports Illus 80:38 (painting,c,2) Mr 21 '94
— Horses seen in silhouette
Gourmet 53:74 (c,4) F '93
— Horses walking in water
Trav&Leisure 25:68 (c,3) Ag '95
— Icelandic ponies
Trav&Leisure 26:E7,E10 (c,4) Mr '96
— Miniature horses
Trav/Holiday 178:60 (c,4) S '95
— Pet pony (Ireland)
Nat Geog 186:14–15 (c,1) S '94
— Petiso Argentinos
Life 17:38 (c,4) N '94
— Przewalski's horse
Natur Hist 103:54 (c,4) O '94
— Sheridan's horse
Smithsonian 27:28–30 (c,4) N '96
— Slow motion photos of horse galloping
(1870s)
Life 18:28 (4) Ap '95
— Training horse at resort (California)
Trav&Leisure 22:96–7 (c,1) S '92
— Wild horses
Nat Wildlife 30:22–5 (c,2) O '92
— Wild ponies
Natur Hist 103:94 (c,3) Je '94
Trav&Leisure 26:E2 (c,4) Ap '96
— See also
CARRIAGES AND CARTS—HORSE-
DRAWN
EQUESTRIAN EVENTS
HORSE FARMS
HORSE RACING
HORSEBACK RIDING
MUSTANGS
SADDLES
STABLES
HORSES, RACING
Sports Illus 82:42–3 (c,1) My 8 '95
Life 18:74–81 (c,1) Jl '95
Sports Illus 84:84–90 (c,1) Ap 8 '96
— Race horse with pet goat
Sports Illus 80:84–5 (c,2) F 21 '94
— Ruffian
Am Heritage 44:47–56 (c,2) S '93
— Secretariat
Sports Illus 81:92–4 (c,1) S 19 '94
Sports Illus 81:76–88 (painting,c,1) O 24
'94
— Training race horse
Life 18:74–81 (c,1) Jl '95
HORSESHOE CRABS
Natur Hist 101:16–19 (drawing,4) Je '92

Nat Wildlife 31:14–19 (c,1) Je '93
HORSESHOES
Smithsonian 22:cov. (painting,c,1) Mr '92
HOSPITALS
— Bosnian child in hospital
Life 16:12–13 (1) Jl '93
— Cardiac surgery team at hospital
Life 16:15–18 (c,1) D '93
— Hospice (China)
Nat Geog 185:33 (c,4) Mr '94
— Hospital patients (Sweden)
Nat Geog 184:16–17 (c,1) Ag '93
— Sanitorium (Crimea)
Nat Geog 186:110–11 (c,1) S '94
— Sanitorium in salt mine (Poland)
Smithsonian 24:106 (c,2) Mr '94
— Zaire
Life 18:14–15 (c,1) Jl '95
HOT SPRINGS
— Chico Hot Springs resort, Montana
Trav&Leisure 23:E2 (c,4) S '93
— Grand Prismatic, Yellowstone National
Park, Wyoming
Nat Wildlife 31:56–7 (c,1) O '93
— Liard River Hot Springs, British Columbia
Smithsonian 23:109 (c,4) Jl '92
— Mammoth Hot Springs, Wyoming
Natur Hist 104:A6 (c,4) Ap '95
— Yellowstone National Park, Wyoming
Nat Geog 184:52 (c,3) Ag '93
HOT SPRINGS, ARKANSAS
Trav/Holiday 176:17 (c,4) Mr '93
— 1910s hotels
Sports Illus 78:93 (4) Mr 22 '93
— Buckstaff Baths
Gourmet 53:128 (c,4) N '93
— Decorated for Christmas
Am Heritage 47:78 (c,4) O '96
HOTELS
— 1890s Tremont Hotel, Boston,
Massachusetts
Am Heritage 45:52–3 (4) Ap '94
— 1899 Mount Nelson Hotel, Cape Town,
South Africa
Trav&Leisure 24:100 (4) S '94
— Early 20th cent. Ormond Hotel, Florida
Am Heritage 44:cov.,120–1 (c,2) Ap '93
— 1930s bellhop
Am Heritage 45:cov.,46 (painting,c,4) Ap
'94
— 1980s motel (Mississippi)
Am Heritage 45:77 (c,4) Jl '94
— Adirondack Inn, New York
Gourmet 53:48 (c,3) Ag '93
— Amsterdam, Netherlands

Trav/Holiday 179:30–3 (c,3) S '96
— Baden-Baden, Germany
Gourmet 55:135 (c,1) N '95
— Banff Springs Hotel, Alberta
Nat Geog 188:60–1 (c,1) Jl '95
— Bellhop (Singapore)
Trav&Leisure 26:104 (c,4) Ja '96
— Bermuda
Trav&Leisure 26:42–8 (c,3) O '96
— Biarritz, France
Gourmet 54:63 (c,1) Ag '94
— Boca Raton Resort, Florida
Trav&Leisure 25:139,143–4 (c,1) N '95
— The Breakers, Palm Beach, Florida
Trav&Leisure 25:146 (c,1) N '95
— Brown Hotel lobby, Louisville, Kentucky
Trav&Leisure 26:112 (c,4) O '96
— Brown Palace, Denver, Colorado
Trav&Leisure 22:112–13 (c,1) O '92
Trav&Leisure 23:32 (c,4) Ag '93
— Cambridge, Massachusetts
Trav&Leisure 22:19 (c,3) My '92
— Cape Breton Island, Nova Scotia
Trav/Holiday 175:39 (c,2) Je '92
— Caribbean resort hotels
Trav&Leisure 22:84–95,146–9 (c,1) D '92
Trav&Leisure 25:47–59 (c,1) Ja '95
Trav&Leisure 26:6–6 (c,4) O '96
— Cazenovia's Lincklaen House, New York
Am Heritage 45:50,53 (c,4) Ap '94
— Chateau Frontenac, Quebec City, Quebec
Trav/Holiday 178:68–73 (c,1) D '95
— Chateau Marmont, Los Angeles, California
Trav&Leisure 23:72–7 (c,1) Ag '93
— Chelsea Hotel, New York City, New York
Gourmet 53:101 (c,1) My '93
Trav&Leisure 24:34 (c,4) O '94
— Cipriani Hotel, Venice, Italy
Trav&Leisure 22:94–5 (c,1) S '92
— Concierges (Washington, D.C.)
Trav&Leisure 25:56 (c,3) N '95
— Country inns
Gourmet 55:76–114 (c,3) My '95
— Country inns (Italy)
Trav&Leisure 25:45–55 (c,1) Ag '95
— Country inns (Scotland)
Trav&Leisure 23:102–7 (c,1) D '93
— Country inns (Tennessee)
Trav&Leisure 24:E15 (c,3) O '94
— Country inns (Vermont)
Trav/Holiday 179:36–8 (c,3) O '96
— Cozy Alpine inn (France)
Trav&Leisure 26:89–95 (c,1) Ag '96
— Denmark
Trav&Leisure 25:84–6 (c,2) N '95

— Don CeSar resort, St. Petersburg, Florida
Trav&Leisure 22:135 (c,2) Mr '92
— Fairmont Hotel lobby, San Francisco, California
Am Heritage 45:50 (c,4) Ap '94
— Floating bungalows (Bora Bora)
Trav&Leisure 22:112 (c,1) N '92
— France
Trav&Leisure 26:202–11 (c,1) S '96
— Grand American hotels
Trav&Leisure 22:106–13 (c,1) O '92
Am Heritage 45:46–56 (c,1) Ap '94
— Grand hotels around the world
Trav&Leisure 26:122–31 (c,1) O '96
— Grand old hotel (Saratoga Springs, New York)
Trav/Holiday 178:78 (c,1) Je '95
— Haunted hotels (England)
Trav/Holiday 179:46–53 (c,1) O '96
— Hawaii
Trav&Leisure 22:12–22 (c,4) Je '92 supp.
— Homestead, Hot Springs, Virginia
Gourmet 54:136 (c,4) My '94
— Hotel Meurice parlor, Paris, France
Gourmet 52–42 (painting,c,2) Jl '92
— Hotel room key
Gourmet 54:45 (c,3) Ag '94
— Jefferson Hotel, Washington, D.C.
Trav&Leisure 25:58 (c,4) N '95
— Kinnaird resort hotel, Scotland
Trav&Leisure 23:cov.,58–60 (c,1) Jl '93
— Las Vegas, Nevada
Smithsonian 26:50–9 (c,1) O '95
Trav&Leisure 26:108–9 (c,4) N '96
Nat Geog 190:64–71 (c,1) D '96
— Livingston, Montana
Trav&Leisure 24:80 (c,1) Jl '94
— Luxury hotels (Beverly Hills, California)
Trav&Leisure 25:76–81 (c,3) S '95
— Luxury hotels (London, England)
Trav&Leisure 25:40–4,107 (c,1) Ap '95
— Luxury lodges (Alaska)
Trav&Leisure 22:92–7,140 (c,1) My '92
— Mackinac Island, Michigan
Gourmet 54:142 (c,1) My '94
— Maine inns
Trav&Leisure 24:E6 (c,4) Ja '94
Trav&Leisure 25:97–101,162 (c,1) My '95
— Miami Beach, Florida
Trav&Leisure 22:cov.,76–7,80-1 (c,1) O '92
— Mission Inn, Riverside, California
Trav&Leisure 23:115–21 (c,1) D '93
— Motels
Trav&Leisure 26:80 (painting,c,4) N '96

— Motels (California)
Trav/Holiday 176:90–1 (c,3) Mr '93
— Motels (Florida)
Trav&Leisure 26:E10 (c,3) Ap '96
— Mountain inn (Quebec)
Gourmet 52:68 (c,4) F '92
— National Hotel, Moscow
Trav&Leisure 25:28 (c,4) Je '95
— Old inn (Puerto Rico)
Trav/Holiday 175:51 (c,2) Mr '92
— Otesaga, Cooperstown, New York
Trav/Holiday 176:77 (c,1) Ap '93
— Palm Springs resort, California
Gourmet 56:102–4 (c,4) My '96
— Palmer House, Chicago, Illinois
Am Heritage 45:46–7,52 (c,1) Ap '94
Trav/Holiday 179:60 (c,4) S '96
— Peabody Hotel lobby, Memphis, Tennessee
Trav&Leisure 26:90 (c,4) N '96
— Plaza Hotel, New York City, New York
Am Heritage 45:48–9 (c,1) Ap '94
— Plzen, Czechoslovakia
Trav/Holiday 178:56–65 (1) My '95
— Polana Hotel, Mozambique
Trav&Leisure 23:45 (c,4) N '93
— Raffles, Singapore
Gourmet 53:60–1 (c,1) Ja '93
Trav&Leisure 26:83 (c,1) Ja '96
— Resort hotels
Trav&Leisure 22:1–24 (c,1) Ag '92 supp.
— Resort hotels (Arizona)
Gourmet 53:141 (c,4) Ap '93
Trav&Leisure 23:96–7 (c,1) Jl '93
Trav&Leisure 26:72–81,141 (map,c,1) F '96
— Resort hotels (Bahamas)
Trav/Holiday 177:61 (c,2) S '94
— Resort hotels (Bali, Indonesia)
Trav&Leisure 23:131–7 (c,1) Mr '93
— Resort hotels (Bangkok, Thailand)
Trav&Leisure 24:78–83 (c,1) Ag '94
— Resort hotels (Barbados)
Trav&Leisure 22:146–51 (c,2) Je '92
— Resort hotels (Big Sur, California)
Trav&Leisure 22:86–93 (c,1) Ag '92
— Resort hotels (Caribbean)
Trav&Leisure 25:145–56,184 (c,1) O '95
— Resort hotels (Florida)
Trav&Leisure 25:38,40 (c,4) Ja '95
Trav&Leisure 25:162–9 (c,1) O '95
— Resort hotels (Goa, India)
Trav&Leisure 25:50–7,94–6 (map,c,1) Jl '95
— Resort hotels (Vermont)
Trav&Leisure 23:122–7 (c,1) D '93

— Resort ranch (Chile)
 Trav&Leisure 23:88–95 (c,1) O '93
— Ritz Hotel, Paris, France
 Sports Illus 79:2–3 (c,1) D 6 '93
 Trav&Leisure 26:56–8 (c,4) F '96
— Ritz Hotel history, Boston, Massachusetts
 Trav&Leisure 25:58–60 (c,4) My '95
— Room service (New York)
 Trav&Leisure 26:4,40 (c,4) Ap '96
— Room service via bicycle (Arizona)
 Trav&Leisure 26:75 (c,4) F '96
— The Sagamore, New York
 Gourmet 53:46 (c,4) Ag '93
— Savoy Hotel, London, England
 Trav&Leisure 25:107 (c,1) Ap '95
— Sheraton Palace, San Francisco, California
 Am Heritage 45:51,55 (c,1) Ap '94
— Small hotels (New York City, New York)
 Trav&Leisure 24:80–9 (c,1) S '94
 Gourmet 56:150–3 (c,1) N '96
— Small hotels (Paris, France)
 Trav&Leisure 23:100–9,115 (c,1) Ja '93
— Sonoma Inn, California
 Trav&Leisure 24:28 (c,2) S '94
— Southern France
 Trav&Leisure 25:cov.,74–85,118 (c,1) Mr
 '95
— Waldorf-Astoria, New York City, New
 York
 Trav&Leisure 23:22 (c,4) Jl '93
 Am Heritage 45:52–4 (4) Ap '94
— Wentworth by the Sea hotel, New Castle,
 New Hampshire
 Smithsonian 27:56–7 (c,3) S '96
— Willard Hotel, Washington, D.C.
 Am Heritage 45:50–1 (c,3) Ap '94
— See also
 PORTERS
 RESORTS
HOUDINI, HARRY
 Life 16:31 (4) O '93
HOUNDS
— Hound trailing (Great Britain)
 Nat Geog 186:16–17 (c,1) Ag '94
— Hunting dogs
 Life 15:88 (c,2) F '92
HOUSEBOATS
— California
 Trav&Leisure 23:111 (c,1) D '93
— Paris, France
 Trav&Leisure 22:112–15 (c,1) Ap '92
— Washington
 Nat Geog 187:120–1 (c,2) Je '95
HOUSEHOLD ACTIVITIES
— 1942 child pumping water (Maine)

 Smithsonian 23:115 (4) Ag '92
— Boys carrying firewood (Nepal)
 Nat Geog 182:70–1 (c,1) D '92
— Carrying firewood (Zaire)
 Nat Geog 188:60–2 (c,1) O '95
— Carrying water buckets (Cambodia)
 Nat Geog 183:4–5 (c,1) F '93
— Carrying water buckets (Mexico)
 Nat Geog 184:30 (c,4) N 15 '93
— Carrying water on head (Egypt)
 Nat Geog 183:71 (c,1) My '93
— Carrying water on head (India)
 Nat Geog 184:88–9 (c,1) S '93
— Children fetching water from river (New
 Mexico)
 Nat Geog 184:43 (c,3) S '93
— Fetching water from well (Niger)
 Life 17:62 (2) Ag '94
— Filling water cistern from truck (Colorado)
 Nat Geog 190:93 (c,3) N '96
— Horses carrying firewood (Guatemala)
 Nat Geog 182:102–3 (c,1) N '92
— One week's worth of a housewife's work
 (1947)
 Life 19:128–9 (1) O '96
— Power-washing tennis court (Georgia)
 Life 18:100–1 (c,1) N '95
— Waiter ironing tablecloth (Monaco)
 Nat Geog 189:84 (c,1) My '96
— Washing Louvre's glass pyramid, Paris,
 France
 Life 16:12–13 (c,1) N '93
— Washing ski lodge windows (Utah)
 Nat Geog 189:72 (c,3) Ja '96
— Women carrying purchases on heads (West
 Indies)
 Natur Hist 101:72 (4) Ap '92
— Yanomami Indians doing chores
 (Venezuela)
 Natur Hist 104:58–61 (c,1) Ap '95
— Young girls doing chores (Iran)
 Natur Hist 101:34–45 (c,1) Ag '92
— See also
 BAKING
 COOKING
 GARDENING
 LAUNDRY
 SEWING
 SHAVING
 VACUUMING
HOUSES
— 15th cent. row houses (Hamburg,
 Germany)
 Trav&Leisure 25:118 (c,4) Je '95
— 1790s interior (Tennessee)

Smithsonian 26:53 (c,2) F '96
— Early 19th cent. (Gettysburg, Pennsylvania)
Trav/Holiday 177:76–7 (c,2) Jl '94
— 1870s row houses (Richmond, Virginia)
Trav&Leisure 25:E18 (c,4) My '95
— 1946 building shaped like a shoe
(Pennsylvania)
Am Heritage 46:52 (c,4) Ap '95
— Architectural designs of affordable dream
houses
Life 17:cov.,82–98 (c,1) Je '94
Life 19:90–110 (c,1) My '96
— Bungalows on stilts (Tahiti)
Trav/Holiday 179:cov.,4,82–3,88 (c,1) N
'96
— Coastal homes threatened by beach erosion
Smithsonian 23:74–86 (c,1) O '92
— Crowded homes on hillside (Trinidad)
Nat Geog 185:71 (c,2) Mr '94
— Cutler's nature-sensitive homes
(Washington)
Smithsonian 27:46–57 (c,1) Je '96
— Decorated house (Switzerland)
Trav&Leisure 22:126 (c,4) Mr '92
— Decorative tile-covered house (New
Mexico)
Smithsonian 26:143 (c,2) Ap '95
— Gabled houses (Stockholm, Sweden)
Trav&Leisure 26:98 (c,4) My '96
— Georgian row houses (Edinburgh,
Scotland)
Nat Geog 190:16–17 (c,2) S '96
— House of the Seven Gables, Salem,
Massachusetts
Gourmet 52:100–1 (c,1) O '92
Trav&Leisure 23:E2 (c,4) Je '93
— Ice fishing shelters (Minnesota)
Smithsonian 27:54–63 (c,1) D '96
— Imaginative designs for livable houses
Life 18:70–98 (c,1) Je '95
— Lovely house made from garbage
(Maryland)
Smithsonian 25:121–3 (c,1) Ap '94
— Manor house (Scotland)
Gourmet 52:119 (c,4) Ap '92
— Painted with tribal designs (South Africa)
Trav&Leisure 24:140 (c,4) S '94
— Pile houses (France)
Nat Geog 183:67 (c,2) Je '93
— Victorian style (Saratoga Springs, New
York)
Trav/Holiday 178:81 (c,3) Je '95
— See also
ARCHITECTURAL FEATURES
ARCHITECTURE

FURNITURE
HOUSING
HOUSES—CONSTRUCTION
— 16th cent. New England cabin-raising
Smithsonian 22:70–1 (painting,c,3) Mr '92
— Alberta
Nat Geog 188:62 (c,3) Jl '95
— California
Sports Illus 78:58–9 (c,1) Ja 11 '93
— Cartoon about constructing an igloo
Natur Hist 102:10 (4) Ag '93
— Creating "garbage" house (Maryland)
Smithsonian 25:122–3 (painting,c,1) Ap
'94
— Crimea, Ukraine
Nat Geog 186:116–17 (c,1) S '94
— Firing bricks in kiln (Afghanistan)
Nat Geog 184:68–9 (c,1) O '93
— Bill Gates home (Washington)
Smithsonian 27:52–3 (c,2) Je '96
— Israel
Nat Geog 181:99 (c,3) Je '92
— Lake Placid condominiums, New York
Nat Wildlife 33:36 (c,1) O '95
— Nepal
Nat Geog 182:83 (c,1) D '92
— Repairing stucco house (Mexico)
Nat Geog 190:40–1 (c,1) Ag '96
— Restoring 1433 chalet (Switzerland)
Smithsonian 24:49 (c,3) N '93
HOUSEWARES
— 19th cent. corkscrew
Am Heritage 47:92 (drawing,4) D '96
— 19th cent. silver pieces (Mississippi)
Gourmet 53:133 (c,1) Ap '93
— 1950s kitschy salt and pepper shakers
Am Heritage 46:33 (c,1) My '95
— African crafts
Smithsonian 23:140 (c,4) Ap '92
— Ancient Greek nutcracker shaped like
hands
Nat Geog 186:22–3 (c,1) N '94
— Antique French cookware
Gourmet 56:108–9 (c,2) Mr '96
— Cookie jars
Gourmet 55:130 (c,3) F '95
— Corkscrews
Gourmet 54:156 (c,4) D '94
Gourmet 56:68 (drawing,4) Je '96
— Cruets
Gourmet 55:64 (c,2) Ag '95
— Making brooms (Kentucky)
Smithsonian 24:100 (c,4) D '93
— Mousetraps
Am Heritage 47:cov.,90–7 (c,1) O '96

— Napkin rings
 Gourmet 54:56 (c,4) Jl '94
— Pitchers
 Gourmet 55:112 (c,3) Je '95
— Potato masher
 Gourmet 56:110 (drawing,4) Ap '96
— See also
 ASHTRAYS
 BARRELS
 BASKETS
 BENCHES
 CANDLES
 CHINAWARE
 CLOCKS
 COFFEEPOTS
 COMBS
 COOKING UTENSILS
 GLASSWARE
 KEYS
 LIGHTING
 MAILBOXES
 PIPES, TOBACCO
 TEAPOTS
 TOOLS
 WEATHERVANES

HOUSING
— Family hole-in-the-ground home (Tunisia)
 Life 19:72–3 (c,1) S '96
— Manor homes (Great Britain)
 Gourmet 52:98–103,150 (c,1) Mr '92
— Shotgun shacks (Louisiana)
 Smithsonian 23:44–5 (c,4) F '93
— Wattle-and-daub homes (Honduras)
 Natur Hist 105:26–7 (c,1) Ap '96
— See also
 APARTMENT BUILDINGS
 BIRD HOUSES
 BIRD NESTS
 CABINS
 CASTLES
 CHATEAUS
 CLIFF DWELLINGS
 COTTAGES
 FARMHOUSES
 HOUSEBOATS
 HOUSES
 HOUSING DEVELOPMENTS
 HUTS
 IGLOOS
 INDIAN RESERVATIONS
 LOG CABINS
 MANSIONS
 MOBILE HOMES
 PALACES
 PLANTATIONS
 SLUMS
 SOD HOUSES
 STILT HOUSES
 TENTS
 TEPEES
 TREE HOUSES
 YURTS
 country or civilization entries—HOUSING

HOUSING DEVELOPMENTS
— 1940s Levittown houses, Long Island,
 New York
 Am Heritage 44:62–9 (c,2) Jl '93
— 1950s moving day to suburban homes
 (California)
 Life 18:88 (2) Je 5 '95
— Aerial view (New Jersey)
 Natur Hist 102:64 (4) S '93
— Aerial view of trailer park (Great Britain)
 Nat Geog 188:57 (c,1) O '95
— Annapolis, Maryland
 Nat Geog 183:6–7 (c,2) Je '93
— Apartment complex (Israel)
 Nat Geog 189:18–19 (c,1) Ap '96
— Arizona
 Nat Geog 184:34–5 (c,1) N 15 '93
 Nat Geog 186:40–1 (c,2) S '94
— Cary, North Carolina
 Nat Geog 187:116–17 (c,1) Mr '95
— Colorado
 Nat Geog 190:84–5,99 (c,1) N '96
— Connecticut
 Nat Geog 182:14 (c,4) O '92
— Los Angeles area, California
 Sports Illus 80:54–5 (c,3) F 14 '94
 Nat Geog 187:8–9 (c,2) Mr '95
— Sweden
 Nat Geog 184:25 (c,3) Ag '93
— Utah
 Nat Geog 189:6–9 (c,1) Ja '96

HOUSTON, SAM
 Smithsonian 23:91 (painting,c,2) Jl '92
 Trav/Holiday 175:59 (painting,4) Jl '92

HOUSTON, TEXAS
 Trav&Leisure 23:94–5 (c,1) My '93
— Bayou Bend Estate
 Trav&Leisure 24:E14 (c,4) S '94
— Menil Collection
 Trav/Holiday 177:75 (c,4) S '94

HOWE, ELIAS
— Howe demonstrating sewing machine
 (1845)
 Am Heritage 47:102 (etching,4) S '96

HOWE, JULIA WARD
 Smithsonian 23:145 (painting,c,4) N '92

HOWELLS, WILLIAM DEAN
Smithsonian 23:138 (4) N '92
HOWLERS
— Black howler
Gourmet 55:146 (c,4) D '95
— Red howlers
Natur Hist 103:50–1 (c,1) My '94
HOXHA, ENVER
— Tomb (Albania)
Nat Geog 182:76 (c,3) Jl '92
HUANG HE (YELLOW) RIVER, CHINA
Trav&Leisure 24:82–3 (c,1) Mr '94
HUBBLE, EDWIN POWELL
Natur Hist 105:84 (4) N '96
HUDSON RIVER, NEW YORK
Gourmet 53:86 (c,4) Mr '93
Trav&Leisure 23:141 (c,4) S '93
— 1945
Life 18:96–7 (1) Je 5 '95
HUGHES, CHARLES EVANS
— 1906 political poster
Am Heritage 43:56 (4) N '92
HUGHES, HOWARD
Smithsonian 25:22 (4) F '95
HUGHES, LANGSTON
Smithsonian 25:49 (4) Ag '94
HUGO, VICTOR
— *Hunchback of Notre Dame* films
(1923-1996)
Life 19:35 (c,4) Je '96
Human sacrifice. See
ANIMAL SACRIFICE
HUMMINGBIRDS
Sports Illus 76:8 (c,4) Je 15 '92
Natur Hist 101:4–5 (c,1) Jl '92
Smithsonian 24:22 (c,4) My '93
Natur Hist 102:43 (c,4) My '93
Nat Wildlife 31:30–1 (c,1) Je '93
Natur Hist 102:5 (c,4) Jl '93
Natur Hist 102:28 (c,4) O '93
Nat Wildlife 32:52 (c,1) Ag '94
Trav&Leisure 24:46 (c,4) Ag '94
Natur Hist 105:68 (c,4) F '96
Nat Wildlife 34:34 (c,4) F '96
Smithsonian 27:30 (c,4) Ap '96
Nat Wildlife 34:63 (c,2) Je '96
HUMOR
— American tradition of low humor
Am Heritage 44:106–7 (painting,c,1) O
'93
HUNGARY
— See also
BUDAPEST

DANUBE RIVER
HUNGARY—COSTUME
— 1956 Hungarian immigrants (U.S.)
Am Heritage 43:51 (4) F '92
— Budapest
Trav/Holiday 175:54–63 (1) My '92
HUNGARY—HISTORY
— Shooting Communist officials (1956)
Life 19:91 (3) O '96
— 1956 refugees from Soviet takeover
Am Heritage 44:32,108–9 (c,1) F '93
HUNTERS
— Midwest
Sports Illus 80:68–9 (c,1) Ja 10 '94
— Scotland
Nat Geog 190:2–3,12–13 (c,1) S '96
HUNTING
— 17th cent. duck decoy (Great Britain)
Smithsonian 24:127 (c,2) S '93
— 19th cent. seal hunt by kayak
Smithsonian 23:153 (painting,c,2) N '92
— 1840s aristocrats at a hunt (Great Britain)
Smithsonian 24:76–7 (painting,c,4) Mr '94
— 1845 Indian hunting buffalo
Smithsonian 27:43 (painting,c,3) Ap '96
— 1850s (New York)
Natur Hist 101:42–3 (painting,c,1) My '92
— 1870 display of bison heads
Am Heritage 44:34 (3) O '93
— 1884 Indian hunting buffalo
Smithsonian 23:132–3 (painting,c,2) N '92
— 1914 display of killed deer (New York)
Natur Hist 101:44–5 (painting,c,2) My '92
— 1926 Hopi Indian archers
Nat Geog 190:62 (c,3) Jl '96
— 1945 (Georgia)
Life 18:133 (1) Je 5 '95
— 1945 rabbit hunters (Kansas)
Life 18:152 (2) Je 5 '95
— "After the Hunt" by Harnett
Smithsonian 22:63 (painting,c,2) Mr '92
— Ancient Egyptian depictions of hunting
Natur Hist 101:50–1,56–9 (c,1) Jl '92
— Ancient man ambushing horses (China)
Natur Hist 102:54–5,5—9 (painting,c,1)
My '93
— Birds (North Carolina)
Nat Geog 187:128 (c,4) Mr '95
— Bullet-riddled "Deer crossing" sign
(California)
Life 19:72 (c,4) Ag '96
— Chimpanzees (Liberia)
Nat Geog 181:26 (c,3) Mr '92
— Deer (Great Britain)
Trav/Holiday 177:64–5 (c,2) Jl '94

Nat Geog 186:28–9 (c,1) Ag '94
— Deer (Pennsylvania)
Nat Geog 181:73 (c,4) F '92
— Displaying mountain lions (1929)
Smithsonian 22:114 (4) F '92
— Dogs catching cassowary bird (Papua New
Guinea)
Nat Geog 185:56–7 (c,1) F '94
— Dugongs (Australia)
Nat Geog 189:14–15 (c,1) Je '96
— Eskimos (Alaska)
Nat Wildlife 33:42 (c,4) Je '95
— Feral pigs (Hawaii)
Nat Geog 188:24–5 (c,1) S '95
— Goose calling from blind (Maryland)
Sports Illus 80:88 (c,4) F 21 '94
— Goose hunter inside decoy goose (North
Dakota)
Nat Geog 190:8–9 (c,1) O '96
— Grouse (Scotland)
Nat Geog 190:2–3 (c,1) S '96
— Indonesia
Nat Geog 189:42-3 (c,1) F '96
— Matses Indians (Peru)
Natur Hist 103:44–7 (c,1) S '94
— Minnesota
Nat Geog 182:116 (c,3) S '92
— Mole catching (Great Britain)
Smithsonian 24:53 (c,4) Mr '94
— Moose heads on car roofs (Quebec)
Nat Geog 186:117 (c,1) O '94
— Muttonbirds (Tasmania)
Natur Hist 104:cov.,30–1 (c,1) Ag '95
— Neandertals hunting mammals
Nat Geog 189:24–5 (painting,c,1) Ja '96
— Pheasant (Great Britain)
Sports Illus 81:77 (c,1) N 14 '94
— Pile of antelope carcasses (Tibet)
Nat Geog 184:78–9 (c,1) Ag '93
— Puffins (Iceland)
Nat Geog 189:126–7 (c,1) Ja '96
— Reindeer (Siberia)
Nat Geog 182:97–9 (c,1) O '92
Nat Geog 185:62–7 (c,1) Ap '94
— Safari (Tanzania)
Trav&Leisure 24:90–101,139–42 (c,1) N
'94
— Scotland
Trav&Leisure 26:124–6 (c,1) D '96
— Seals (U.S.S.R.)
Nat Geog 185:58–9 (c,1) Ap '94
— Shooting blowgun (Colombia)
Nat Geog 187:98 (c,3) My '95
— Texas
Sports Illus 81:26 (c,4) D 12 '94

— Trapping martens (Alaska)
Nat Geog 182:82–3 (c,1) Ag '92
— Venezuela
Natur Hist 104:56–7,60–1 (c,1) Ap '95
— Walrus (Alaska)
Natur Hist 101:40–7 (c,1) O '92
— Walrus (Siberia)
Nat Geog 182:93 (c,3) O '92
— Yuqui hunter with dead macaw (Bolivia)
Natur Hist 103:6 (c,4) Ja '94
— See also
FOX HUNTING
WHALING
HUNTING EQUIPMENT
— 200 A.D. duck decoys (Nevada)
Smithsonian 25:45 (c,4) O '94
— 1910 shorebird decoy by Joe Lincoln
Am Heritage 45:27 (c,1) S '94
HURDLING
Sports Illus 76:28–9 (c,2) Mr 9 '92
Sports Illus 76:2–3 (c,1) Jl 6 '92
Sports Illus 77:82–3 (c,1) Jl 22 '92
Sports Illus 77:35 (c,4) S 14 '92
Sports Illus 78:76–7 (c,3) Mr 22 '93
Sports Illus 82:2–3 (c,1) Ap 24 '95
Sports Illus 82:42 (c,2) Je 12 '95
Sports Illus 83:34 (c,3) Ag 14 '95
Sports Illus 83:79 (c,3) S 4 '95
Sports Illus 84:2–3 (c,1) My 27 '96
Sports Illus 85:22–3 (c,2) Jl 1 '96
Sports Illus 85:6–7 (c,1) Jl 22 '96
— 1932 Olympics (Los Angeles)
Sports Illus 85:14 (4) Jl 22 '96
— 1992 Olympics (Barcelona)
Sports Illus 77:25,35 (c,1) Ag 17 '92
— 1996 Olympics (Atlanta)
Sports Illus 85:38–9 (c,1) Ag 12 '96
— Czechoslovakia
Nat Geog 184:14 (c,3) S '93
HURLING
— Ireland
Nat Geog 186:26–7 (c,2) S '94
HURRICANES
— 1985 Hurricane Elena seen from space
(Gulf Coast)
Nat Geog 190:2–3 (c,1) N '96
— Massachusetts island
Nat Geog 181:126–7 (c,1) Je '92
— Path of 1992 Hurricane Andrew
(Southeast)
Nat Geog 183:18–19 (c,1) Ap '93
HURRICANES—DAMAGE
— 1989 Hurricane Hugo damage (Montserrat)
Trav/Holiday 176:106 (c,4) Mr '93

— 1989 Hurricane Hugo damage (South
Carolina)
Smithsonian 23:84,86 (c,2) O '92
Nat Wildlife 31:40 (c,4) Ap '93
— 1992 Hurricane Andrew damage (Florida)
Life 16:42–3 (c,1) Ja '93
Nat Geog 183:2–37 (map,c,1) Ap '93
— 1992 Hurricane Andrew damage to
Everglades, Florida
Trav/Holiday 175:20 (c,4) D '92
— 1995 wreckage of home (St. Martin)
Life 19:34 (c,3) Ja '96
HUSTON, JOHN
Trav/Holiday 175:48 (4) D '92
HUTS
— Hut on stilts (Ecuador)
Nat Wildlife 30:42–3 (c,1) Ap '92
— Painted huts (Africa)
Life 15:46 (c,2) Jl '92
— Stone tool huts (Italy)
Trav&Leisure 26:68 (c,1) Jl '96
— Thatched hut (Ethiopia)
Trav&Leisure 23:104–5 (c,1) O '93
HYENAS
Natur Hist 102:42–53 (c,1) Ja '93
Nat Geog 186:50–1 (c,1) Ag '94
HYPNOSIS
— 1845 (Massachusetts)
Am Heritage 44:6 (3) My '93
— Hypnotherapy for fear of spiders
Life 18:28–30 (c,2) Jl '95
— Ukraine
Nat Geog 183:46 (c,1) Mr '93
HYSSOP PLANTS
Natur Hist 102:32 (c,4) Mr '93

–I–

IBEXES
Nat Geog 186:12 (c,3) D '94
IBISES
Trav/Holiday 176:80 (painting,c,2) O '93
Life 17:71 (c,2) Ag '94
— Scarlet ibises
Natur Hist 103:28 (c,4) O '94
ICE
— Dragon ice sculpture
Life 18:32 (c,4) F '95
— Fishing boat covered with snow and ice
(Maine)
Life 18:88–9 (c,1) F '95
— Frost crystals on window
Nat Wildlife 31:57 (c,4) O '93
— Frost on plants

Smithsonian 26:41 (c,1) Mr '96
— Giant arch of ice (Greenland sea)
Life 15:8–9 (c,1) Jl '92
— Ice castle (Quebec)
Trav/Holiday 178:74 (c,4) D '95
— Ice cave (Antarctica)
Life 16:80–1,85 (c,1) Mr '93
— Ice cave (Iceland)
Nat Geog 182:35 (c,4) D '92
— Ice climbing
Nat Geog 190:82–95 (c,1) D '96
— Ice climbing (Alberta)
Nat Geog 188:56–7 (c,1) Jl '95
— Ice climbing competition (France)
Nat Geog 190:95 (c,2) D '96
— Ice floes
Natur Hist 101:40 (c,1) O '92
Nat Wildlife 35:24–5 (c,1) D '96
— Ice House Museum, Cedar Falls, Iowa
Smithsonian 26:92 (c,2) Ap '95
— Ice palace (Harbin, China)
Life 18:14 (c,2) Mr '95
— Ice sculpture (Minnesota)
Trav/Holiday 179:42–3 (c,3) N '96
— Ice spikes on ground (Nepal)
Nat Geog 182:72–3 (c,1) D '92
— Ice tower (Antarctica)
Life 16:78–9 (c,1) Mr '93
— Ice tower over pile of trees (Michigan)
Life 17:23 (c,2) Mr '94
— Icicles
Gourmet 52:94 (c,4) Mr '92
Nat Wildlife 33:58–9 (c,1) Ap '95
— "Pancake ice" (Antarctica)
Trav/Holiday 175:91,96 (c,1) Mr '92
— Researching Antarctic ice
Nat Geog 189:36–53 (c,1) My '96
— See also
GLACIERS
ICE DANCING
— 1992 Olympics (Albertville)
Sports Illus 76:34–5 (c,1) F 24 '92
Life 16:14–15 (c,1) Ja '93
ICE FISHING
— Minnesota
Nat Geog 182:94–5 (c,1) S '92
Smithsonian 27:54–63 (c,1) D '96
— Siberia
Nat Geog 181:15 (c,4) Je '92
Ice skating. See
SKATING
ICEBERGS
Natur Hist 105:34 (c,4) S '96
— Antarctica
Natur Hist 101:cov. (c,1) N '92

— Iceberg Arch, Antarctica
Trav&Leisure 24:cov. (c,1) D '94
— Newfoundland
Nat Geog 184:16–17 (c,1) O '93
— Researchers collecting debris from Antarctic iceberg
Smithsonian 26:14 (c,4) S '95
— South Sandwich Islands
Life 19:12–13 (c,1) Mr '96
ICELAND
Natur Hist 105:48–55 (map,c,1) Je '96
IDAHO
— Coeur d'Alene
Trav&Leisure 22:E1 (c,2) My '92
Trav/Holiday 178:27,29 (map,c,4) Jl '95
— Ketchum
Trav&Leisure 26:37 (c,4) Ja '96
— Nez Perce National Forest
Smithsonian 23:32–45 (map,c,1) S '92
— Red River
Smithsonian 23:32 (c,1) S '92
— Salmon area
Nat Geog 185:14–39 (map,c,1) F '94
— See also
SNAKE RIVER
IGLOOS
— Cartoon about constructing an igloo
Natur Hist 102:10 (4) Ag '93
IGUACU FALLS, SOUTH AMERICA
Gourmet 53:140–1 (c,1) N '93
IGUANAS
Trav/Holiday 175:48 (4) D '92
Smithsonian 23:54 (c,2) F '93
Trav&Leisure 24:161 (c,4) F '94
Trav/Holiday 177:92 (c,4) O '94
Natur Hist 104:cov.,28–39 (c,1) Ja '95
Natur Hist 104:A1 (c,1) N '95
Sports Illus 83:88–9 (c,1) D 25 '95
Trav/Holiday 179:78–9,85 (c,1) F '96
— Marine iguanas
Natur Hist 101:40–3 (c,2) Ja '92
Life 15:83 (c,4) S '92
ILLINOIS
— Flooded Valmeyer rebuilding on new site
Smithsonian 27:110–20 (c,1) Je '96
— Langham Island
Natur Hist 105:56–8 (map,c,1) Mr '96
— Morrison
Gourmet 53:135 (c,3) Ap '93
— Red Bud
Life 15:8,56–62 (1) Mr '92
— Rural countryside
Life 16:10–11 (c,1) Jl '93
— Carl Sandburg's birthplace (Galesburg)
Gourmet 53:136 (c,4) Ap '93

— Shawnee National Forest
Natur Hist 103:22–4 (map,c,1) Jl '94
— Simpson Township Barrens
Natur Hist 102:25–6 (map,c,3) Ap '93
— Frank Lloyd Wright's bedroom, Oak Park
Trav/Holiday 179:17 (c,4) My '96
— See also
CHICAGO
Illnesses. See
DISEASES
IMMIGRANTS
— 1898 view of Hester Street, New York City, New York
Am Heritage 43:56–7 (1) Ap '92
— Early 20th cent. immigrants to the U.S.
Am Heritage 45:7–89 (1) F '94
— Early 20th cent. immigrants arriving at Ellis Island, New York
Am Heritage 47:48 (4) S '96
— 1956 Hungarian immigrants (U.S.)
Am Heritage 43:51 (4) F '92
— Illegal Chinese immigrants on boat (New York)
Life 16:10–11 (c,1) Ag '93
— Illegal Mexican immigrants crossing into Texas
Nat Geog 182:22–3 (c,4) Jl '92
Nat Geog 189:63 (c,4) F '96
— Vietnamese immigrant life (California)
Smithsonian 23:28–39 (c,1) Ag '92
IMMIGRATION
— 1850s anti-immigration cartoon
Smithsonian 27:151 (2) N '96
— 1881 cartoon of Uncle Sam welcoming immigrants
Am Heritage 43:47 (3) F '92
— 1893 cartoon lampooning anti-immigration sentiment
Am Heritage 45:114 (c,4) F '94
— 1926 immigration officers at Texas/Mexico border
Am Heritage 45:84–5 (2) F '94
— 1946 cartoon about U.S. immigration policies
Smithsonian 27:85 (4) Jl '96
— Flood of immigrants to Western Europe
Nat Geog 183:94–125 (c,1) My '93
— Statue of Liberty ordering immigrants to leave
Am Heritage 45:cov. (c,1) F '94
IMPALAS
Natur Hist 101:58–9 (c,1) Mr '92
Trav/Holiday 175:cov.,65 (c,1) N '92
Natur Hist 102:98–9 (c,1) Ap '93
Natur Hist 102:50–1 (c,1) My '93

Life 16:64–5 (c,1) Jl '93
Nat Wildlife 31:12–13 (c,1) O '93
Trav/Holiday 177:90 (c,4) Mr '94
Gourmet 55:72–3 (c,1) Ja '95
Trav/Holiday 179:40 (c,4) Jl '96
— Attacked by lions
Nat Geog 186:42–3 (c,1) Ag '94
INCA CIVILIZATION—ART
— 16th cent. figurines (Peru)
Nat Geog 181:105,116 (c,4) F '92
INCA CIVILIZATION—ARTIFACTS
— 15th cent. crafts (Peru)
Nat Geog 189:76–7 (c,2) Je '96
— 15th cent. statue of goddess (Chile)
Nat Geog 181:88–9 (c,1) Mr '92
— Alpaca-shaped stone container
Natur Hist 104:64 (c,4) Mr '95
— Ancient Tiahuanaco sculpture
Nat Geog 181:108–9 (c,3) Mr '92
— Ceremonial tunic (Peru)
Nat Geog 181:119 (c,4) F '92
— See also
MACHU PICCHU
INCA CIVILIZATION—COSTUME
Nat Geog 181:94–105 (c,1) Mr '92
— 15th cent. Inca sandal (Peru)
Nat Geog 189:81 (c,2) Je '96
— Peru
Nat Geog 181:92–121 (c,1) F '92
Nat Geog 189:73 (painting,c,2) Je '96
INCA CIVILIZATION—HISTORY
— 1530s conquest by Pizarro (Peru)
Nat Geog 181:102–5 (drawing,c,2) F '92
INCA CIVILIZATION—RITES AND
FESTIVALS
— Condor freeing itself from bull
Nat Geog 181:104–5 (c,1) Mr '92
— Human sacrifice (Peru)
Nat Geog 181:100–3 (c,1) Mr '92
— Inca pilgrimages to Andes peaks
Nat Geog 181:84–111 (c,1) Mr '92
— Inca's Inti Raymi sun festival (Peru)
Nat Geog 181:92–3,120–1 (c,1) F '92
— Mummified Inca sacrifice victim (Peru)
Nat Geog 189:62–81 (c,1) Je '96
— Star Snow Festival (Peru)
Nat Geog 181:96–7 (c,1) Mr '92
Independence Day. See
FOURTH OF JULY
INDEPENDENCE HALL, PHILADEL-
PHIA, PENNSYLVANIA
Trav&Leisure 25:P3 (c,4) O '95
INDIA
— Camel market (Pushkar)
Natur Hist 104:54–7 (c,1) Mr '95

— Children stepping on water buffalo during
flood
Life 16:24 (c,4) N '93
— Goa resort hotel
Trav&Leisure 25:60–7,94–6 (map,c,1) Jl
'95
— Grand Trunk Road
Smithsonian 23:cov.,114–21 (c,1) My '92
— Rajasthan
Trav&Leisure 24:120–32 (map,c,1) Ap '94
Trav/Holiday 177:66–75 (map,c,1) N '94
— Southern India
Trav/Holiday 176:cov.,46–57 (map,c,1) N
'93
— Theosophical Society Building, Madras
Smithsonian 26:120 (c,4) My '95
— Udaipur
Gourmet 55:128–31,186 (map,c,1) N '95
— Wildlife
Nat Geog 181:2–29 (c,1) My '92
— See also
ALLAHABAD
BOMBAY
GANGES RIVER
HINDUISM
JAIPUR
MADRAS
TAJ MAHAL
VARANASI
INDIA—ART
— Domestic prayer paintings
Smithsonian 26:94–9 (c,1) Jl '95
INDIA—COSTUME
Natur Hist 101:66 (4) F '92
Smithsonian 23:cov.,114–21 (c,1) My '92
Trav/Holiday 176:46–56 (c,1) N '93
Nat Geog 185:48–9,60–5,78–9 (c,1) My
'94
Smithsonian 26:94–7 (c,1) Jl '95
— 19th cent. Maharaja of Alwar
Nat Geog 181:16 (3) My '92
— Bodybuilders
Life 16:88 (c,2) My '93
— Bombay
Nat Geog 187:42–67 (c,1) Mr '95
— Fisherman
Nat Geog 188:3 (c,1) N '95
— Girl in traditional dress
Trav&Leisure 22:64 (c,4) Je '92
— India-Pakistan border guards
Smithsonian 23:120–1 (c,2) My '92
— Man with 3 ft. fingernails
Life 16:87 (c,4) My '93
— Man with 12 ft. mustache
Life 16:86–7 (c,1) My '93

— Rabari people
Nat Geog 184:cov.,64–93 (c,1) S '93
— Rajasthan
Trav&Leisure 24:122–31 (c,1) Ap '94
Natur Hist 105:74 (3) Je '96
— Sari production (India)
Nat Geog 185:82–3 (c,1) Je '94
— Sikh students (British Columbia)
Nat Geog 181:118–19 (c,1) Ap '92
— Street vendors
Natur Hist 103:71 (4) My '94
— Tourists riding on elephants
Nat Geog 181:26–7 (c,2) My '92
— Udaipur
Gourmet 55:130–1 (c,2) N '95
— Untouchable
Life 15:15 (c,2) Ap '92
— Woman with 21-ft. long hair
Life 16:84 (c,2) My '93
— Woman in sari
Natur Hist 105:6 (c,4) Jl '96
— See also
GANDHI, MOHANDAS

INDIA—HOUSING
Smithsonian 26:96–8 (c,2) Jl '95

INDIA—MAPS
— Parks and sanctuaries
Nat Geog 181:11 (c,2) My '92

INDIA—RITES AND FESTIVALS
— Ganesh Chatorthi Festival (Bombay)
Nat Geog 187:50–1,64–5 (c,1) Mr '95
— Grabbing bull horn at Pongal celebration
Trav/Holiday 176:50 (c,3) N '93
— Immersing Vishnu image in pool
Trav/Holiday 176:54 (c,3) N '93
— Shaving head in mourning ritual (Trinidad)
Nat Geog 185:77 (c,2) Mr '94

INDIA—SHRINES AND SYMBOLS
— Indian motifs
Trav&Leisure 23:NY1 (painting,c,4) O '93

INDIA—SOCIAL LIFE AND CUS-TOMS
— Child bride and groom
Nat Geog 184:68–71 (c,1) S '93
— Field hockey
Sports Illus 85:170–8 (c,1) Jl 22 '96

INDIAN PAINTBRUSH (FLOWERS)
Smithsonian 22:34 (c,4) F '92
Life 16:34 (c,4) O '93
Nat Wildlife 33:60 (c,1) D '94
Nat Wildlife 34:46–7 (c,1) Ap '96
Natur Hist 105:63 (c,4) Ag '96

INDIAN PIPES (FLOWERS)
Natur Hist 103:70 (c,4) My '94

INDIAN RESERVATIONS
— Rocky Boy, Montana
Nat Geog 185:90–7 (c,1) Je '94
— Wind River reservation, Wyoming
Nat Wildlife 30:18–23 (c,1) Je '92

INDIAN WARS
— 19th cent. Buffalo soldier statue (Arizona)
Am Heritage 44:14 (4) My '93
— 1875 Army scout
Am Heritage 43:110 (3) O '92
— 1876 Battle of Little Big Horn
Am Heritage 43:76–86 (map,c,1) Ap '92
Natur Hist 101:36–41 (painting,c,1) Je '92
Am Heritage 43:104 (4) N '92
— Big Hole Battlefield, Montana
Trav/Holiday 179:95 (c,3) S '96
— Custer's Indian scout
Am Heritage 43:111 (1) N '92
— Indian scalping army officer (19th cent.)
Natur Hist 101:38 (painting,c,4) Je '92
— Marker where Custer fell (Montana)
Trav/Holiday 179:95 (c,4) S '96
— Memorial to pioneer killed by Indians (1861)
Nat Geog 182:50–1 (c,2) O '92
— Sites related to Geronimo's life
Nat Geog 182:47–71 (map,c,1) O '92
— See also
CUSTER, GEORGE ARMSTRONG

INDIANA
— Early 20th cent. courthouses
Trav/Holiday 175:75–83 (painting,c,1) Ap '92
— Clover Lick Barrens
Natur Hist 104:20–2 (map,c,1) Ag '95
— Columbus
Trav&Leisure 25:E6–E8 (c,4) F '95
— Eleutherian College, Lancaster
Smithsonian 24:136–7 (c,1) Ap '93
— Indiana Dunes State Park
Trav/Holiday 178:30,33 (map,c,4) Je '95
— Jefferson Proving Ground, Madison
Nat Wildlife 33:46–9 (c,1) F '95
— West Baden Springs Hotel lobby
Smithsonian 24:130–1 (c,1) Ap '93
— See also
FORT WAYNE
INDIANAPOLIS

INDIANAPOLIS, INDIANA
— Canterbury Hotel
Sports Illus 76:48 (c,4) Ja 20 '92

INDIANS OF LATIN AMERICA
— Ancient Olmec civilization (Mexico)
Nat Geog 184:88–115 (c,1) N '93

— Cofan Indians (Ecuador)
 Life 16:68–74 (c,1) S '93
— Embera Indians (Colombia)
 Nat Geog 185:48–9 (c,1) Mr '94
— Kayapo Indian fishing with bow and arrow
 (Brazil)
 Natur Hist 101:36–7 (c,1) Mr '92
— Makuna Indians (Colombia)
 Natur Hist 101:46–53 (c,1) Ja '92
— Matses Indians (Peru)
 Natur Hist 103:44–50 (c,1) S '94
— Shipibo Indians (Peru)
 Natur Hist 101:30–7 (c,1) D '92
— Suya Indians (Brazil)
 Smithsonian 27:25,62–75 (c,1) My '96
— Trique people (Mexico)
 Nat Geog 186:46–7,58–9 (c,1) N '94
— Uros Indians (Peru)
 Trav&Leisure 25:110–11 (c,1) Mr '95
— Yanomami people (Venezuela)
 Natur Hist 104:56–65 (c,1) Ap '95
— See also
 AZTEC CIVILIZATION
 INCA CIVILIZATION
 MAYA CIVILIZATION
 MONTEZUMA
INDIANS OF LATIN AMERICA—AR-
CHITECTURE
— Teotihuacan, Mexico
 Nat Geog 188:2–35 (c,1) D '95
— Totonalas Indian ruins, Veracruz, Mexico
 Natur Hist 105:51 (c,4) O '96
— See also
 PYRAMIDS
INDIANS OF LATIN AMERICA—ART
— Waura Indian drawings (Brazil)
 Natur Hist 103:62 (c,4) Ja '94
INDIANS OF LATIN AMERICA—
ARTIFACTS
— 15th cent. Taino ceramics (Hispaniola)
 Nat Geog 181:44 (c,4) Ja '92
— Ancient Moche artifacts (Peru)
 Natur Hist 103:26–35 (c,1) My '94
— Ancient Olmec civilization (Mexico)
 Nat Geog 184:88–115 (c,1) N '93
— Mogollon people (Mexico)
 Smithsonian 27:60–73 (c,1) N '96
— Replica of Moche tomb (Peru)
 Natur Hist 104:80 (c,4) N '95
— Teotihuacan, Mexico
 Nat Geog 188:2–35 (c,1) D '95
INDIANS OF LATIN AMERICA—
COSTUME
— Ashaninca Indians (Peru)
 Nat Geog 187:34–5 (c,2) F '95

— Chuna Indians (Panama)
 Nat Geog 185:75 (c,1) Je '94
— Mayoruna woman with straw whiskers
 (Peru)
 Natur Hist 103:51 (c,1) S '94
— Quiche Indians (Guatemala)
 Nat Geog 181:22–3 (c,1) F '92
— Representatives from many tribes
 Life 15:14–15 (c,4) Ag '92
— Tarahumara Indians (Mexico)
 Nat Geog 190:44–51 (c,1) Ag '96
— Txukahamei Indians (Brazil)
 Natur Hist 101:40–1 (c,2) Mr '92
— Urueu-Wau-Wau Indians (Brazil)
 Natur Hist 101:38–43 (c,1) Mr '92
— Yagua children (Colombia)
 Nat Geog 187:6–7 (c,1) F '95
INDIANS OF LATIN AMERICA—
HOUSING
— Ancient apartments (Teotihuacan, Mexico)
 Nat Geog 188:20–1 (drawing,c,1) D '95
INDIANS OF LATIN AMERICA—
RITES AND FESTIVALS
— Rain dance (Mexico)
 Nat Geog 184:99–101 (c,1) N '93
— Skeletons of ancient human sacrifice
 victims (Mexico)
 Nat Geog 188:16–17 (c,1) D '95
— Yaqui Indian deer dance (Mexico)
 Nat Geog 186:52–3 (c,1) S '94
INDIANS OF LATIN AMERICA—
SOCIAL LIFE AND CUSTOMS
— Suya body painting (Brazil)
 Smithsonian 27:68 (c,2) My '96
INDIANS OF NORTH AMERICA
— 1840s Indian hunting buffalo
 Smithsonian 27:43 (painting,c,3) Ap '96
— 1910 Indians riding in car
 Life 16:24–5 (1) Ap 5 '93
— 1910 Salish Indians (Montana)
 Trav&Leisure 25:158–9 (1) O '95
— Native American crop system
 Smithsonian 26:100–1 (c,4) N '95
— Native American sites (Southwest)
 Trav&Leisure 23:cov.,134–45 (map,c,1)
 Ap '93
— See also
 APACHE
 ARAPAHO
 ARIKARA
 BLACKFEET
 CHEROKEE
 CHIPPEWA
 CHOCTAW
 COMANCHE

CRAZY HORSE
CREE
CROW
DELAWARE
GERONIMO
HAIDA
HOPI
INDIAN WARS
IROQUOIS
JOSEPH, CHIEF
KIOWA
KWAKIUTL
MANDAN
NAVAJO
NEZ PERCE
OSAGE
PAWNEE
POCAHONTAS
PUEBLO
SACAGAWEA
SEMINOLE
SHAMANS
SHOSHONE-BANNOCK
SIOUX
SITTING BULL
TECUMSEH
TLINGIT
UTES
ZUNI

INDIANS OF NORTH AMERICA—ARCHITECTURE
— Ancient Indian mounds (Ohio)
 Am Heritage 46:118–19,125 (c,1) Ap '95
— Anasazi Indian sites (Southwest)
 Smithsonian 24:28–39 (c,1) D '93
— Grave Creek mound (West Virginia)
 Am Heritage 46:120–3 (c,1) Ap '95
— Pueblo underground kiva (New Mexico)
 Trav/Holiday 176:61 (2) D '93
INDIANS OF NORTH AMERICA—ART
— 14th cent. Anasazi carving of cougar
 (Arizona)
 Nat Geog 182:54 (c,4) Jl '92
— Anasazi crafts (Southwest)
 Nat Geog 189:96–7,102–3,108 (c,1) Ap
 '96
— Anasazi pictograph (Utah)
 Trav&Leisure 26:E14 (c,4) My '96
— Design motifs
 Trav/Holiday 175:91–2 (painting,c,4) Jl
 '92
— Haida works (Northwest)
 Smithsonian 25:38–47 (c,1) Ja '95
— Indian crafts

Smithsonian 23:42 (c,4) N '92
— Indian petroglyphs (New Mexico)
 Nat Geog 187:132 (c,4) Ap '95
— Kwakiutl arts (Northwest)
 Smithsonian 23:53 (c,3) Ap '92
 Smithsonian 24:22 (c,4) F '94
— Navajo pictographs (Arizona)
 Am Heritage 44:59 (c,1) Ap '93
 Trav&Leisure 23:134–5,140 (c,1) Ap '93
— Plains Indians art
 Smithsonian 23:124–33 (c,2) N '92
INDIANS OF NORTH AMERICA—ARTIFACTS
— 13th cent. mask with antlers (Oklahoma)
 Smithsonian 27:28 (c,4) Ag '96
— 18th cent. Yurok purse (California)
 Nat Geog 183:110 (c,4) Ja '93
— 19th cent. klickitat basket (Northwest)
 Gourmet 53:143 (c,4) Ap '93
— 1890s Pawnee painted drum
 Am Heritage 43:4 (c,3) O '92
— Graphic mica pieces from mound people
 (Ohio)
 Am Heritage 46:126–7 (c,4) Ap '95
— Haida helmet mask (British Columbia)
 Smithsonian 25:98 (c,3) D '94
— Indian arrowhead (Wyoming)
 Nat Geog 184:55 (c,4) D '93
— Mound Indians' carved pipe (Midwest)
 Am Heritage 46:154 (c,4) Ap '95
— Native arts from the Heye Center, New
 York City
 Smithsonian 25:cov.,40–9 (c,1) O '94
 Life 17:120–30 (c,1) N '94
— See also
 TOTEM POLES
INDIANS OF NORTH AMERICA—COSTUME
— Mid 19th cent. Arikara medicine man
 Life 16:70 (4) Ap 5 '93
— Late 19th cent.
 Am Heritage 43:104–11 (1) N '92
— 1900 beaded Lakota vest
 Am Heritage 44:88 (c,4) D '93
— 1906 Yup'ik shaman (Alaska)
 Natur Hist 105:12 (4) Ag '96
— 1908 Apsaroke man
 Am Heritage 47:cov. (1) Jl '96
— Baby on cradle board
 Nat Geog 185:99 (c,1) Je '94
— Festival apparel for powwows
 Nat Geog 185:cov.,88–113 (c,1) Je '94
— Lakota medicine man
 Life 16:70–4 (c,1) Ap 5 '93
— Lakota men

Smithsonian 24:84 (c,3) N '93
Nat Geog 186:66–7,86 (c,1) N '94
— Moccasins
Life 17:122 (c,4) N '94
— Oglala Sioux warrior
Life 16:2–3 (1) Ap 5 '93
— Onondaga Indians (New York)
Smithsonian 23:40 (c,4) D '92
— Osage wedding outfit
Smithsonian 25:45 (c,4) O '94
— Plains Indian headdresses
Trav/Holiday 178:69 (c,3) My '95
— Shinnecock Indians (New York)
Life 17:30 (3) Ag '94
— Traditional dress
Smithsonian 23:cov.,90–7 (c,1) F '93

**INDIANS OF NORTH AMERICA—
HISTORY**
— 1704 Deerfield Massacre (Massachusetts)
Am Heritage 44:8–9 (c,1) F '93
— 1838 Cherokee "Trail of Tears"
Nat Geog 187:86–7 (map,c,1) My '95
— Lost Bird, survivor of Wounded Knee
Massacre (early 20th cent.)
Am Heritage 47:38 (4) Ap '96
— Pocahontas saving Captain John Smith
(1607)
Life 18:66 (painting,c,4) Jl '95
— World War II Navajo code talkers in the
Pacific
Smithsonian 24:34–43 (1) Ag '93
— See also
INDIAN WARS

**INDIANS OF NORTH AMERICA—
HOUSING**
— 1871 Pawnee earth lodges (Nebraska)
Natur Hist 103:24 (c,3) N '94
— 1881 Bella Coola Indian house (Northwest)
Natur Hist 104:4 (3) S '95
— Pueblos (New Mexico)
Trav&Leisure 23:136–7,145 (c,4) Ap '93
— Sinagua cliff dwelling (Sedona, Arizona)
Gourmet 53:138–9 (c,3) Ap '93
— Taos Pueblo, New Mexico
Gourmet 53:134–5 (c,1) N '93
Am Heritage 45:98 (c,4) F '94
Trav/Holiday 178:cov. (c,1) F '95
Nat Geog 189:93 (c,4) Ap '96
— See also
CLIFF DWELLINGS
IGLOOS
INDIAN RESERVATIONS
TEPEES

**INDIANS OF NORTH AMERICA—
RITES AND FESTIVALS**
— Apache puberty ceremony
Nat Geog 182:56–7 (c,1) O '92
— Corn festival (New Mexico)
Nat Geog 189:92 (c,1) Ap '96
— Indian powwows
Nat Geog 185:cov.,88–113 (c,1) Je '94
Life 17:125–8 (c,1) N '94
— Tulalip tribe salmon festival (Washington)
Natur Hist 104:34–5 (c,3) S '95

**INDIANS OF NORTH AMERICA—
SOCIAL LIFE AND CUSTOMS**
— 1853 sentries scaring birds away from
crops
Smithsonian 26:104 (engraving,c,3) N '95
— Apache Dance of the Mountain Spirits
Nat Geog 182:48–9 (c,1) O '92
— Traditional dances
Smithsonian 23:cov.,90–7 (c,1) F '93
— Winnebago dance (Wisconsin)
Trav&Leisure 25:E2 (c,4) My '95

INDONESIA
Trav/Holiday 179:95–101 (c,1) O '96
— Anak Krakatau
Natur Hist 105:6 (c,4) Mr '96
— Bali
Trav&Leisure 23:128–42 (map,c,1) Mr '93
— Borobudor
Trav&Leisure 22:64–5 (c,1) Ja '92
— Crowded van tipping over (Java)
Life 19:14–15 (c,1) My '96
— Elephant watch tower on farm (Sumatra)
Natur Hist 104:57 (c,4) Jl '95
— Irian Jaya
Nat Geog 189:2–43 (map,c,1) F '96
— Java
Trav&Leisure 22:7,58–71,112 (map,c,1)
Ja '92
— Mt. Semeru, Java
Nat Geog 182:38–9 (c,1) D '92
— Moyo
Trav&Leisure 23:96–103,158 (map,c,1) N
'93
— Rijsttafel (Netherlands)
Gourmet 54:102 (c,3) Je '94
— Tana Toraja
Trav&Leisure 22:22–3 (c,4) Ap '92

INDONESIA—ART
— 1930s Balinese paintings
Natur Hist 104:63–7 (2) F '95

INDONESIA—COSTUME
Nat Geog 187:34–5 (c,2) My '95

— 1919
 Nat Geog 187:34 (4) My '95
— Asmat people
 Nat Geog 189:2–5,30-3 (c,1) F '96
— Bali
 Nat Geog 182:37 (c,1) D '92
 Trav&Leisure 23:130–9 (c,1) Mr '93
— Children
 Life 16:60 (4) Mr '93
— Dani people
 Nat Geog 189:14–17 (c,1) F '96
— Irian Jaya
 Nat Geog 189:2–43 (c,1) F '96
— Islamic women in veils
 Life 16:64–5 (1) Mr '93
— Java
 Trav&Leisure 22:7,58–69 (c,1) Ja '92
— Javanese dancers
 Trav/Holiday 178:18 (c,4) D '95
— Kombai people
 Nat Geog 189:34–43 (c,1) F '96
— Korowai people
 Nat Geog 189:34–43 (c,1) F '96
— Savu dancer
 Trav&Leisure 23:176 (c,4) Mr '93
— Yali people
 Nat Geog 189:10–15 (c,1) F '96

INDONESIA—RITES AND FESTIVALS
— Asmat warrior ceremony
 Nat Geog 189:2–4 (c,1) F '96
— Dani people bartering pigs for bride (Irian Jaya)
 Nat Geog 183:94–5 (c,1) Ja '93
— Ritual turtle sacrifice (Bali)
 Natur Hist 105:48–51 (c,1) Ja '96

INDONESIA—SOCIAL LIFE AND CUSTOMS
— Badminton
 Sports Illus 85:200–6 (c,1) Jl 22 '96

INDUSTRIAL REVOLUTION
— 1810s Luddite war against technology (Great Britain)
 Smithsonian 24:140–51 (painting,c,3) Ap '93

Industries. See
 ALFALFA
 APPLES
 APPLIANCES
 APRICOTS
 AUTOMOBILES
 AVIATION
 BANANAS
 BARLEY
 BEER
 BELLS
 BRICKS
 CHEESE
 CIGARETTES
 COAL
 COFFEE
 CORN
 COTTON
 CRABS
 CRANBERRIES
 ELECTRONICS
 FISHING
 FLOWERS
 FURNITURE
 GARLIC
 GARMENT
 GLASS
 GRAIN
 GRAPES
 GUNS
 HAY
 HELICOPTERS
 HONEY
 HUNTING
 LEATHER
 LIQUOR
 LUMBERING
 MANUFACTURING
 MARBLE
 MILK
 MINING
 MOTORCYCLES
 MUSHROOMS
 OATS
 OIL
 OLIVES
 OYSTERS
 PAPER
 PEANUTS
 PEPPERS
 PERFUME
 PINEAPPLES
 POTATOES
 PROSPECTING
 RAILROAD
 RANCHING
 RICE
 RUBBER
 SALT
 SHIPPING
 SILK
 SORGHUM
 SOYBEANS
 SPICES
 STEEL

STRAWBERRIES
SUGAR CANE
SULFUR
TEA
TELEPHONES
TEXTILES
TOBACCO
TOMATOES
WATERMELONS
WHALING
WHEAT
WINE

INJURED PEOPLE
— 1945 soldier with arms in casts
 Life 18:20 (2) Je 5 '95
— 1995 Oklahoma City bomb blast survivor
 Life 18:10–11 (1) Je '95
— Athlete's arm in sling
 Sports Illus 80:20 (c,4) My 2 '94
— Auto racer with eyepatch
 Sports Illus 83:46–7 (c,1) O 9 '95
— Baseball player
 Sports Illus 77:48 (c,2) D 28 '92
— Basketball player
 Sports Illus 78:36–40 (c,1) My 24 '93
— Basketball player with leg in cast
 Sports Illus 82:38 (4) F 13 '95
— Beaten riot victim (California)
 Life 15:13 (c,2) Je '92
— Boxer
 Sports Illus 82:24–9 (c,1) Mr 6 '95
 Sports Illus 82:51 (c,4) My 15 '95
— Boxer on stretcher
 Sports Illus 83:100–1 (c,1) O 23 '95
— CAT scan of javelin imbedded in skull
 Sports Illus 80:16 (4) My 23 '94
— Child cleaning own gunshot wound
 (Maryland)
 Life 18:42 (c,1) Jl '95
— Child disfigured by phosphorous bomb
 (Iraq)
 Nat Geog 182:43 (c,1) Ag '92
— Child injured by shrapnel (Bosnia)
 Life 17:54–5 (c,1) Ja '94
— Cyclist on stretcher
 Sports Illus 76:78 (c,4) Jl 6 '92
— Female basketball players with knee
 injuries
 Sports Illus 82:44–53 (c,2) F 13 '95
— Football player putting on knee brace
 Sports Illus 81:22–3 (c,1) D 12 '94
— Football players
 Sports Illus 77:30–9 (c,1) Jl 27 '92
 Sports Illus 77:cov.,20–7 (c,1) D 7 '92

Sports Illus 79:32–4 (c,1) N 1 '93
Sports Illus 84:48–50 (c,2) F 19 '96
— Football players with head injuries
 Sports Illus 81:26–48 (c,1) D 19 '94
— Girl blinded by shells (Sarajevo)
 Life 18:10–11 (c,1) S '95
— Girl burned by napalm in 1972 (Vietnam)
 Life 18:44-5 (c,1) My '95
— Hiker on stretcher (Wyoming)
 Nat Geog 187:129 (c,3) F '95
— Hockey player
 Sports Illus 78:29 (c,3) My 24 '93
— Hockey player on stretcher
 Sports Illus 83:64–5 (1) N 20 '95
— Infant burn victim
 Life 18:48 (c,2) Jl '95
— Injured runner
 Life 16:38 (c,2) Ja '93
— Knifed tennis player
 Sports Illus 78:cov.,18–22 (c,1) My 10 '93
— Legless man
 Nat Geog 181:79 (c,3) Mr '92
— Maimed survivors of war (El Salvador)
 Nat Geog 188:108–9,130–1 (c,1) S '95
— Man with left hand attached to right arm
 Life 18:70–2 (c,1) Jl '95
— Men with missing limbs from war
 (Afghanistan)
 Life 15:36–7 (c,1) Ag '92
— Mountain climber (Alaska)
 Nat Geog 182:70–1 (c,1) Ag '92
— People scarred by jellyfish stings
 (Australia)
 Nat Geog 186:122 (c,4) Ag '94
— People with frostbite
 Nat Geog 183:92 (c,4) Ap '93
 Life 19:46 (c,4) Ag '96
— Putting injured jockey into ambulance
 Sports Illus 77:51 (c,4) N 9 '92
— Race car driver after crash
 Sports Illus 80:36–7 (c,1) My 23 '94
 Sports Illus 81:46 (c,4) O 31 '94
— Repetitive Strain Injuries (RSIs)
 Smithsonian 25:91–101 (2) Je '94
— Rescuing missing skiers (Colorado)
 Sports Illus 78:18–22 (c,2) Mr 8 '93
— Woman with broken ankle
 Sports Illus 80:35 (c,3) Je 13 '94
— World War II veterans
 Life 15:40 (1) O 30 '92
— Wounded veterans (Eritrea)
 Nat Geog 189:94–5 (c,2) Je '96
— See also
 HANDICAPPED PEOPLE
 MEDICINE—PRACTICE

INSECTS
— 18th cent. paintings of insects
 Natur Hist 101:cov.,46–59 (c,1) D '92
— Caught in carnivorous plants
 Smithsonian 23:49–59 (c,3) D '92
— Costa Rican rain forest
 Life 17:58–68 (c,1) Je '94
— Electron microscope enlargements of
 parasitic insects
 Life 17:58–66 (c,1) My '94
— Fossils frozen in amber
 Smithsonian 23:cov.,30–41 (c,1) Ja '93
 Natur Hist 102:58–61 (c,1) Je '93
— Life inside bamboo stalks
 Smithsonian 25:120–9 (c,1) O '94
— Maybugs
 Nat Wildlife 34:41 (c,1) F '96
— Mutant creatures in cave (Romania)
 Life 15:64–70 (c,1) N '92
— Pseudoscorpions
 Natur Hist 103:40–2 (c,1) Mr '94
— Stick insects
 Natur Hist 101:cov.,30–5 (c,1) Je '92
— Thornbugs
 Nat Wildlife 31:57 (c,2) D '92
 Nat Wildlife 33:59 (c,4) Ap '95
— See also
 ANTS
 APHIDS
 BED BUGS
 BEES
 BEETLES
 BUMBLEBEES
 BUTTERFLIES
 CATERPILLARS
 CICADAS
 COCKROACHES
 CRICKETS
 DRAGONFLIES
 FLEAS
 FLIES
 FRUIT FLIES
 GRASSHOPPERS
 KATYDIDS
 LACEWINGS
 LADYBUGS
 LICE
 MANTIDS
 MAYFLIES
 MIDGES
 MITES
 MOSQUITOS
 MOTHS
 STINK BUGS
 TERMITES
 TICKS
 WASPS
 WATER BUGS
 WEEVILS
Instruments. See
 MEDICAL INSTRUMENTS
 MUSICAL INSTRUMENTS
 NAVIGATION INSTRUMENTS
 SCIENTIFIC INSTRUMENTS
 TELESCOPES

INVENTIONS
— Early 19th cent. inventions by Ben
 Thompson, Count Rumford
 Am Heritage 44:72–5 (drawing,3) S '93
 Smithsonian 25:10–8 (c,4) D '94
— 1895 Selden engine patent
 Am Heritage 47:18 (c,4) N '96
— Cartoon of Rube Goldberg invention
 Life 17:22 (4) Jl '94
— Jefferson's polygraph to make copies of
 letters
 Smithsonian 24:86 (c,4) My '93

INVENTORS
— Charles Babbage
 Smithsonian 26:20,22 (c,4) F '96
— Basketball inventor James Naismith
 Nat Geog 190:59 (4) Jl '96
— August and Fred Duesenberg
 Am Heritage 45:91 (4) Jl '94
— Edwin Land
 Life 15:91 (4) Ja '92
— Benjamin Thompson, Count Rumford
 Am Heritage 44:69–77 (painting,c,1) S '93
 Smithsonian 25:103–4,115 (painting,c,2)
 D '94
— See also
 BELL, ALEXANDER GRAHAM
 DURANT, WILLIAM
 DURYEA BROTHERS
 EASTMAN, GEORGE
 EDISON, THOMAS ALVA
 EVANS, OLIVER
 FORD, HENRY
 FRANKLIN, BENJAMIN
 HOWE, ELIAS
 LEONARDO DA VINCI
 SIKORSKY, IGOR
 WRIGHT, WILBUR AND ORVILLE
 ZEPPELIN, FERDINAND VON

IONESCO, EUGENE
 Life 18:89 (1) Ja '95

IOWA
— Covered bridge
 Life 18:46–7 (c,1) Je '95
— Davenport

Trav&Leisure 26:80 (c,4) S '96
— "Field of Dreams" farm
Sports Illus 84:118 (c,4) Ap 1 '96
— Iowa State Fair
Trav/Holiday 178:48–55 (c,1) Je '95
— Spillville (1893)
Am Heritage 43:86 (4) S '92
— See also
DES MOINES

IOWA—MAPS
— Great River Road route
Trav/Holiday 178:93 (c,4) Mr '95

IRAN—COSTUME
— Young girls
Natur Hist 101:34–45 (c,1) Ag '92

IRAN—HISTORY
— Ayatollah Khomeini's funeral (1989)
Life 18:112 (c,4) Je 5 '95

IRAQ
— Ancient cuneiform library, Sippar
Natur Hist 105:16 (4) S '96
— Basra
Nat Geog 183:50–1 (c,1) My '93

IRAQ—COSTUME
Natur Hist 105:14–16 (c,4) S '96
— Kurdish people
Life 15:38 (1) Ja '92
Nat Geog 182:32–61 (c,1) Ag '92
— Kurdish refugee (Sweden)
Nat Geog 184:28–9 (c,1) Ag '93

IRAQ—HISTORY
— 1992 families hiding under rocks during
bombing
Life 19:74–5 (c,1) S '96
— See also
GULF WAR

IRELAND
Am Heritage 45:2–9 (c,2) My '94
Nat Geog 186:cov.,2–28 (map,c,1) S '94
Trav&Leisure 25:50–9,90–2 (map,c,1) Jl
'95
Natur Hist 105:cov.,6,24–35,61 (c,1) Ja
'96
— Aran Islands
Nat Geog 189:118–33 (map,c,1) Ap '96
— Blackwater River
Gourmet 54:100 (c,4) Mr '94
— Cliffs of Moher
Trav/Holiday 179:21 (c,4) My '96
— Cobh
Am Heritage 47:6 (c,4) Ap '96
— Connemara
Trav&Leisure 24:62–75,118 (map,c,1) Jl
'94
Natur Hist 105:6,24–5 (c,1) Ja '96

— County Cork
Gourmet 54:96–101,58 (map,c,1) Mr '94
— County Kerry countryside
Natur Hist 105:26–9 (c,1) Ja '96
— Dingle Peninsula
Nat Geog 186:3–4,18–19,25 (c,1) S '94
Trav&Leisure 26:48 (c,4) My '96
— Drumkeerin, County Leitrim
Natur Hist 101:58–9 (1) O '92
— Dunguaire castle, Kinvara
Trav&Leisure 24:62–3 (c,1) Jl '94
— Glendalough ruins
Sports Illus 85:52 (c,4) N 11 '96
— Old Head of Kinsale lighthouse
Nat Geog 185:77 (c,4) Ap '94
— St. John's Castle, Limerick
Am Heritage 45:27 (c,2) My '94
— Strokestown Park House
Natur Hist 105:61 (c,4) Ja '96
— See also
DUBLIN
NORTHERN IRELAND
SHANNON RIVER

IRELAND—COSTUME
Natur Hist 101:58–9 (1) O '92
Nat Geog 186:6–28 (c,1) S '94
— Aran Islands
Nat Geog 189:118–33 (c,1) Ap '96
— Fishermen
Trav&Leisure 24:64 (c,4) Jl '94

IRELAND—HISTORY
— 1800 union of Britain and Ireland
Natur Hist 105:33 (cartoon,c,4) Ja '96
— Early 19th cent. boxer Dan Donnelly
Sports Illus 82:164–73 (c,1) F 20 '95
— Mid 19th cent. potato famine
Natur Hist 105:24–38,61 (c,1) Ja '96
— Erskine Childers
Smithsonian 25:158–80 (1) N '94
— Dublin after 1916 Easter uprising
Smithsonian 25:167 (4) N '94
— History of the IRA
Smithsonian 25:158–80 (1) N '94
— See also
DE VALERA, EAMON
GRIFFITH, ARTHUR

IRELAND—HOUSING
— 1814 Swiss Cottage, Tipperary
Trav&Leisure 24:74 (c,4) Jl '94

IRELAND—MAPS
— Dublin environs
Trav/Holiday 178:108 (c,2) Je '95
— Stylized map of Ireland
Gourmet 53:112 (c,2) Mr '93

IRELAND—POLITICS AND GOVERNMENT
— President Mary Robinson
Nat Geog 186:13 (c,3) S '94
IRELAND—RITES AND FESTIVALS
— Riek Sunday pilgrimage
Life 18:38–9 (c,1) Ap '95
IRELAND—SHRINES AND SYMBOLS
— Leprechaun as U.S. college mascot
Sports Illus 79:2–3 (c,1) N 1 '93
IRELAND—SOCIAL LIFE AND CUSTOMS
— Celtic dance (Nova Scotia)
Trav&Leisure 26:50 (c,4) Ag '96
IRISES
Life 15:3,62–6 (c,1) Je '92
Nat Wildlife 32:60 (c,1) Ap '94
Nat Wildlife 34:64 (c,1) Ap '96
IROQUOIS INDIANS—COSTUME
— Shinnecock Indians (New York)
Life 17:30 (3) Ag '94
IRRIGATION
— 4th cent. Hohokam irrigation system
(Arizona)
Nat Geog 184:57 (painting,4) N 15 '93
— Irrigation canal (California)
Nat Geog 182:17 (c,3) O '92
— Irrigation hose (Israel)
Nat Geog 183:59 (c,3) My '93
— Irrigation pipe (California)
Smithsonian 26:125 (c,2) Ap '95
— Ogallala Aquifer, Midwest
Nat Geog 183:80–109 (map,c,1) Mr '93
— Prehistoric irrigation system (Peru)
Natur Hist 104:72 (2) D '95
ISABELLA I (SPAIN)
Trav&Leisure 22:20 (painting,c,4) S '92
Islam. See
MUSLIMS
ISLANDS
— Aeolean Islands, Italy
Trav&Leisure 23:76–87,136 (map,c,1) Ja
'93
Nat Geog 186:8–9 (c,1) N '94
— Bora Bora
Trav&Leisure 22:114–15 (c,1) N '92
Trav/Holiday 177:33 (c,4) My '94
— Broken Group, Vancouver, British
Columbia
Trav/Holiday 176:70,74–5 (map,c,3) S '93
— Bucolic island scenes (Massachusetts)
Nat Geog 181:114–25,130–2 (c,1) Je '92
— Clipperton Island, Latin America
Natur Hist 105:60–1,64 (map,c,2) D '96
— Fiji's Mamanucas

Nat Geog 188:124–5 (c,1) O '95
— Funk Island, Newfoundland
Natur Hist 103:8 (c,4) Ag '94
— Isles of Scilly, England
Trav/Holiday 175:cov.,51–9 (map,c,1) Ap
'92
— Isola Tiberina, Rome, Italy
Trav&Leisure 22:87 (c,4) Ap '92
— Rock Islands, Palau
Nat Wildlife 32:20–1 (c,1) O '94
— San Juan Islands, Washington
Gourmet 52:90 (c,4) Ap '92
— Sveti Stefan, Yugloslavia
Sports Illus 77:53 (c,3) S '92
— Tasmania, Australia
Natur Hist 104:26–9 (c,1) Ag '95
ISRAEL
Life 15:7,32–42 (c,1) D '92
Gourmet 54:96–101,148 (map,c,1) F '94
— Akko
Trav&Leisure 22:151,154 (c,4) O '92
— Amud Cave
Nat Geog 189:2–9 (c,2) Ja '96
— Banias Spring
Trav&Leisure 22:156 (c,4) O '92
— Bat Ayin
Natur Hist 105:38–49 (1) D '96
— Elat
Natur Hist 105:46 (map,c,4) O '96
— Galilee
Nat Geog 187:62–105 (map,c,1) Je '95
— Gaza
Nat Geog 190:28–53 (map,c,1) S '96
— Golan Heights
Nat Geog 190:130–1 (c,1) Jl '96
— Judean desert
Nat Geog 181:50–1 (c,1) F '92
Life 15:38–9 (c,1) D '92
— Judean Hills
Natur Hist 105:38–49 (1) D '96
— Meron
Nat Geog 187:70–1 (c,1) Je '95
— Sites along Mary and Joseph's journey to
Bethlehem
Life 15:cov.,7,32–42 (map,c,1) D '92
— Tomb of Absalom, Kidron Valley
Trav&Leisure 24:96 (c,4) Ag '94
— Tomb of the Patriarchs (Hebron)
Nat Geog 181:93 (c,4) Je '92
— West Bank
Nat Geog 181:64–5 (c,1) F '92
Nat Geog 181:86–7 (c,1) Je '92
— See also
DEAD SEA
GALILEE, SEA OF

JERUSALEM
JUDAISM
NEGEV
PALESTINIANS
TEL AVIV
ISRAEL—COSTUME
Nat Geog 187:62–87 (c,1) Je '95
— 1900 (Palestine)
Trav/Holiday 178:56 (4) Ap '95
— Gaza
Nat Geog 190:28–53 (c,1) S '96
— Jerusalem
Trav&Leisure 24:8–95 (c,1) Ag '94
Nat Geog 189:2–31 (c,1) Ap '96
— Soviet Jewish immigrants
Nat Geog 181:40–65 (c,1) F '92
ISRAEL—HISTORY
— 1972 terrorist attack on Israeli Olympic
athletes (Munich, Germany)
Sports Illus 81:60–4,70 (c,1) Jl 25 '94
— Prime Minister Yitzhak Rabin
Life 18:70 (c,4) Ja '95
Life 18:14 (2) N '95
Life 19:38,88 (c,1) Ja '96
— Scenes from Gaza history
Nat Geog 190:34–5 (painting,c,4) S '96
— See also
BEGIN, MENACHEM
DEAD SEA SCROLLS
MEIR, GOLDA
ISRAEL—MAPS
Nat Geog 181:94–5 (c,2) Je '92
— Northern Israel
Trav&Leisure 22:158 (c,3) O '92
— Satellite views of Middle East
Nat Geog 187:88–105 (c,1) Je '95
**ISRAEL—POLITICS AND GOVERN-
MENT**
— 1993 meeting of Prime Minister Rabin and
PLO's Arafat (Washington, D.C.)
Life 16:20 (2) N '93
— Blood-covered songsheet from Rabin
assassination (1995)
Life 19:38 (c,2) Ja '96
— Intifada
Nat Geog 181:101–2 (c,2) Je '92
— Teddy Kollek
Trav/Holiday 176:69 (drawing,c,4) D '93
— Woman taking cover from Arab stones
Life 18:28–9 (c,1) Ja '95
— Wreckage from Palestinian suicide bomber
Nat Geog 190:46 (c,4) Ag '96
ISRAEL—RITES AND FESTIVALS
— Israeli Independence Day celebration
Nat Geog 190:51 (c,1) S '96

**ISRAEL—SOCIAL LIFE AND CUS-
TOMS**
— Family life
Life 17:58–9 (c,1) Jl '94
ISTANBUL, TURKEY
Trav/Holiday 175:62–73 (map,c,1) Jl '92
Nat Geog 185:4-5,10–11 (c,1) My '94
Trav&Leisure 26:82–7,109–112 (map,c,1)
Ag '96
Trav&Leisure 26:42 (c,4) S '96
— Blue Mosque
Trav/Holiday 179:10 (c,3) S '96
— Rumeli Hisar fortress
Trav&Leisure 22:69 (c,4) My '92
— Suleymaniye Mosque
Trav&Leisure 26:84,112 (c,3) Ag '96
— See also
BOSPORUS STRAIT
ST. SOPHIA CATHEDRAL
ITALY
— 16th cent. Villa Lante
Trav/Holiday 178:77 (c,1) Ap '95
— Aeolian Islands
Trav&Leisure 23:76–87,136-8 (map,c,1)
Ja '93
Nat Geog 186:8–9,20–1 (c,1) N '94
— Alba
Gourmet 52:104–7,160 (map,c,1) O '92
Gourmet 53:64 (painting,c,2) My '93
— Alpine countryside
Nat Geog 183:58–9 (c,1) Je '93
— Apulia region
Trav&Leisure 26:68–77,99–103 (map,c,1)
Jl '96
— Arezzo (15th cent.)
Smithsonian 23:124–5 (painting,c,2) D '92
— Arezzo (19th cent.)
Smithsonian 23:125 (painting,c,4) D '92
— Asolo
Gourmet 55:46–9,78 (map,c,1) Jl '95
Trav&Leisure 26:185 (2) S '96
Trav&Leisure 26:152–3,207 (c,1) N '96
— Assisi
Trav/Holiday 179:83 (c,3) My '96
— Barolo
Trav&Leisure 25:150 (c,4) Je '95
— Bay of Naples
Trav/Holiday 175:21 (c,4) Ap '92
— Bellinzona
Trav/Holiday 176:72–3 (c,2) Ap '93
— Carrara
Smithsonian 22:98–9 (c,1) Ja '92
— Castello di Gargonza
Trav/Holiday 179:113 (painting,c,4) Mr
'96

— Chianti region
 Trav&Leisure 24:cov.,90–5,139 (map,c,1)
 My '94
 Gourmet 55:96–101,146 (map,c,1) Mr '95
— Cinque Terre area
 Gourmet 52:84–9,140 (map,c,1) S '92
— Cortina
 Trav&Leisure 26:157–61,210 (c,1) N '96
— Costiglioli d'Asti
 Gourmet 56:90 (c,4) S '96
— Countryside near Rome
 Gourmet 54:94–6 (painting,c,2) D '94
— Curaglia
 Smithsonian 24:58 (c,2) N '93
— Dolomite Mountains
 Trav/Holiday 175:105 (c,4) Mr '92
— Elba
 Trav&Leisure 23:120–1 (c,1) F '93
— Emilia-Romagna region
 Trav&Leisure 22:119–22 (map,c,4) Ja '92
 Trav&Leisure 24:86–91,153 (c,1) F '94
— Fabbriche di Careggine submerged in
 flooded valley
 Life 18:46–8 (c,1) My '95
— Giornico
 Trav/Holiday 176:74 (c,4) Ap '93
— Gubbio
 Trav/Holiday 179:82–3 (c,3) My '96
— Impressionistic views of Italy
 Trav&Leisure 26:182–7,246–50 (1) S '96
— Isola Comacina, Lake Como
 Trav&Leisure 22:105–6 (c,4) Je '92
— Lake Como region
 Gourmet 52:106–11,132 (map,c,1) Ap '92
— La Langhe
 Trav&Leisure 25:149–51 (map,c,3) Je '95
— Lecce
 Trav&Leisure 26:70,99 (c,4) Jl '96
— Ligurian coastal towns
 Trav&Leisure 22:74–80 (map,c,3) D '92
— Lipari Island
 Nat Geog 186:28–9 (c,2) N '94
— Lucca
 Gourmet 56:100–5,148 (map,c,1) Mr '96
— The Marches region
 Gourmet 53:90–5,142 (map,c,1) Mr '93
— Mediterranean ports
 Trav&Leisure 23:116–21 (c,1) F '93
— Montalcino
 Trav/Holiday 175:55,58–9 (2) N '92
 Gourmet 56:46 (painting,c,2) Mr '96
— Montecosaro
 Gourmet 53:90 (c,3) Mr '93
— Northeastern Italy

 Trav&Leisure 26:156–65,207–11
 (map,c,1) N '96
— Orvieto
 Trav/Holiday 179:78–80 (c,1) My '96
— Otranto
 Trav&Leisure 26:74 (c,4) Jl '96
— Panarea, Aeolian Islands
 Trav/Holiday 175:72–7 (map,c,1) S '92
— Piedmont
 Gourmet 56:88–93 (map,c,1) S '96
— Ponza
 Gourmet 54:92–5,138 (map,c,1) Je '94
— Portofino
 Trav&Leisure 22:76 (c,3) D '92
 Trav&Leisure 23:118–19 (c,2) F '93
— Positano
 Trav&Leisure 26:48 (c,4) My '96
— Ravenna
 Trav&Leisure 23:80–2 (c,4) N '93
 Gourmet 56:98–101,142–3 (map,c,1) F '96
— Rocca Malatina
 Trav&Leisure 22:119 (c,4) Ja '92
— Spoleto
 Trav/Holiday 179:84 (c,2) My '96
— Taormina's ancient Greek theater
 Life 18:46 (c,4) O '95
— Ticino region
 Trav/Holiday 176:70–5 (map,c,1) Ap '93
— Tivoli
 Gourmet 52:108–9 (c,1) Ap '92
 Gourmet 52:132–7 (c,1) N '92
— Trani
 Trav&Leisure 26:70,76 (c,1) Jl '96
— Trentino
 Gourmet 53:50–5,102 (map,c,1) Ag '93
— Treviso
 Trav&Leisure 26:164–5,208 (c,1) N '96
— Tuscany countryside
 Trav&Leisure 22:82–7 (painting,c,1) Jl '92
 Trav/Holiday 175:48–59 (1) N '92
 Trav/Holiday 179:10 (c,3) D '96
— Umbria
 Trav/Holiday 179:78–85 (map,c,1) My '96
— Verona
 Trav&Leisure 22:104–11,146 (map,c,1) N
 '92
 Trav&Leisure 25:26 (painting,c,4) Ag '95
— Villa Lante, Bagnaia
 Gourmet 52:134–5 (c,1) N '92
— See also
 ALPS
 BOLOGNA
 DOLOMITES
 FLORENCE
 GENOA

LAKE COMO
LEANING TOWER OF PISA
MILAN
MOUNT ETNA
NAPLES
PALERMO
PARMA
POMPEII
ROMAN EMPIRE
ROME
SARDINIA
SICILY
SIENA
VENICE
VESUVIUS

ITALY—ARCHITECTURE
— 14th cent. villa (Careggi)
 Natur Hist 101:20-1 (c,2) Jl '92
— 15th cent. Foundling Hospital (Florence)
 Trav/Holiday 176:65-7 (painting,c,1) S
 '93
— Ancient Nurachi stone buildings (Sardinia)
 Trav/Holiday 176:43 (c,4) Je '93
— Hadrian's villa, Tivoli
 Trav/Holiday 178:52-9 (c,1) Jl '95
— Paestum temple
 Nat Geog 186:26-7 (c,1) N '94

ITALY—COSTUME
— Bologna
 Trav/Holiday 177:49-59 (c,1) O '94
— Chianti
 Trav&Leisure 24:90-2 (c,1) My '94
— Elderly businessman with briefcase
 Trav&Leisure 26:77 (1) Jl '96
— Milan
 Nat Geog 182:92-117 (c,1) D '92
— Rome
 Trav/Holiday 177:56-65 (c,1) My '94
— Sicily
 Nat Geog 188:5-35 (c,1) Ag '95
— Venice
 Nat Geog 187:70-99 (c,1) F '95

ITALY—HISTORY
— 1944 destruction of Monte Cassino
 Trav/Holiday 178:66 (3) S '95
— Strung up body of Mussolini (1945)
 Life 18:36 (2) Je 5 '95
— See also
 ETRUSCAN CIVILIZATION
 MEDICI, LORENZO DE
 MUSSOLINI, BENITO
 POLO, MARCO
 ROMAN EMPIRE

ITALY—MAPS
— Adige Valley

Gourmet 55:46 (c,2) Ap '95
— Map of ancient Roman Appian Way
 Trav/Holiday 177:40 (c,4) N '94
**ITALY—POLITICS AND GOVERN-
MENT**
— Seniors protesting pensions (Rome)
 Trav/Holiday 177:56-7 (c,2) My '94
ITALY—RITES AND FESTIVALS
— Palio banner, Siena
 Trav/Holiday 178:69 (c,1) Ap '95
— St. Paul feast day pageantry
 Nat Geog 186:34-5 (c,1) N '94
IVORY COAST—COSTUME
— Man's hat
 Smithsonian 27:28 (c,4) Je '96

–J–

JACARANDA TREES
 Nat Geog 186:100-1 (c,1) D '94
JACK RABBITS
 Smithsonian 22:38 (c,4) F '92
 Nat Wildlife 31:55 (c,4) O '93
JACKALS
 Nat Geog 181:62-3 (c,1) Ja '92
 Nat Geog 186:9 (c,3) D '94
JACK-IN-THE-PULPIT PLANTS
 Nat Wildlife 34:12 (c,4) O '96
JACKSON, ANDREW
 Smithsonian 23:86,90-2 (painting,c,3) My
 '92
 Am Heritage 46:84-5 (painting,c,4) Jl '95
— Wife Rachel
 Smithsonian 23:86 (painting,c,4) My '92
JACKSON, MICHAEL
 Life 15:cov.,18,97 (c,1) D 1 '92
 Life 16:14 (c,2) Ap '93
 Life 16:cov.,52-64 (c,1) Je '93
 Life 18:26 (c,3) Jl '95
— As a child
 Smithsonian 25:89 (4) O '94
— Home (California)
 Life 16:52-64 (c,1) Je '93
JACKSON, "SHOELESS JOE"
 Smithsonian 25:40 (4) Jl '94
JACKSON, STONEWALL
 Am Heritage 47:cov.,56-7 (1) D '96
— Statue (Manassas, Virginia)
 Am Heritage 47:68-9 (c,1) D '96
— Stone Mountain Confederate heroes
 monument, Georgia
 Life 15:15 (c,1) Jl '92
JACKSON, WILLIAM HENRY
— Painting of pioneer wagon train

Smithsonian 25:44 (c,4) My '94
JACKSON, MISSISSIPPI
— State capitol
Trav&Leisure 26:68 (c,4) Mr '96
JAGUARS
Sports Illus 76:174 (c,4) Mr 9 '92
Nat Wildlife 33:22–3 (painting,c,1) D '94
Gourmet 55:146 (c,4) D '95
Trav/Holiday 179:76 (c,4) O '96
— Pet jaguars (Paraguay)
Nat Geog 182:93 (c,4) Ag '92
JAGUARUNDIS
Nat Wildlife 34:15 (1) D '95
JAI ALAI
— Jai alai sculpture (Spain)
Gourmet 54:127 (c,4) N '94
— Pelota (France)
Gourmet 54:62 (c,4) Ag '94
— Pelota (Spain)
Nat Geog 190:60–1 (c,1) Jl '96
JAIPUR, INDIA
— Amber Palace
Trav&Leisure 23:47 (c,4) F '93
— Observatories
Natur Hist 102:48–57 (c,1) Je '93
— Palaces
Trav/Holiday 177:69–71 (c,1) N '94
JAMAICA
Trav&Leisure 23:62–70 (map,c,3) Ja '93
Trav/Holiday 176:75–8 (c,2) D '93
Trav&Leisure 24:98–105 (c,1) F '94
Trav/Holiday 178:76–83 (c,1) D '95
Trav/Holiday 179:50–2 (c,2) Jl '96
Trav&Leisure 26:162–70 (map,c,1) D '96
Trav/Holiday 179:64–71 (c,1) D '96
— Countryside
Trav&Leisure 23:120–5 (c,1) My '93
— Noel Coward's home "Firefly"
Trav&Leisure 23:30 (c,4) D '93
Trav&Leisure 24:102 (c,1) F '94
— Harmony Hall
Trav&Leisure 23:68 (c,4) Ja '93
— Bob Marley Museum
Natur Hist 104:48–52 (c,1) N '95
— North coast
Gourmet 56:92–7,132 (map,c,1) F '96
JAMAICA—COSTUME
— Park rangers
Trav/Holiday 176:75 (c,2) D '93
JAMAICA—RITES AND FESTIVALS
— Voodoo practices
Trav/Holiday 179:70–3 (c,1) N '96
JAMES, HARRY
Life 18:141 (2) Je 5 '95

JAMES, HENRY
Smithsonian 24:116 (4) D '93
— Home (Rye, England)
Gourmet 54:68,70 (c,3) Ag '94
JAMES, JESSE
Life 16:10–11 (1) Ap 5 '93
JANITORS
— Israel
Nat Geog 181:52–3 (c,1) F '92
JAPAN
— 1950 hotel garden
Am Heritage 46:71 (c,2) D '95
— 1995 Kobe earthquake
Life 18:40–50 (c,1) Mr '95
Nat Geog 188:112–33 (map,c,1) Jl '95
— Aso-Kuju National Park
Nat Geog 185:102–3 (c,1) Ja '94
— Beppu
Nat Geog 185:98–9 (c,1) Ja '94
— Damage caused by tsunamis
Smithsonian 24:31,39 (c,2) Mr '94
— Fallen leaves in circular pattern in zen
garden
Trav/Holiday 177:56 (c,2) Jl '94
— Kansai International Airport
Trav&Leisure 24:37 (c,4) S '94
— Kyoto
Trav/Holiday 177:66–73 (map,c,1) Jl '94
Trav/Holiday 179:20 (c,4) F '96
— Kyushu
Nat Geog 185:86–117 (map,c,1) Ja '94
— Miniatures of world landmarks
Trav/Holiday 178:80 (c,4) O '95
— Mito art center
Smithsonian 23:66–7 (c,2) Jl '92
— Mt. Sakurajima
Nat Geog 182:12 (c,4) D '92
Nat Geog 184:83–4 (c,1) Jl '93
— Mt. Unzen eruption
Nat Geog 182:14 (c,4) D '92
— Northern Honshu
Nat Geog 186:6–95 (map,c,1) S '94
— Rice-straw rope over Shinto shrine
Nat Geog 185:50–1 (c,1) My '94
— Ryoanji dry garden
Trav/Holiday 177:70–1 (c,2) Jl '94
— Tempozan Market Place, Osaka
Smithsonian 25:50–1 (c,1) D '94
— Theme parks
Trav/Holiday 178:78–85 (c,1) O '95
— See also
HIROSHIMA
NAGASAKI
SHINTOISM
TOKYO

JAPAN—ART
— Early 20th cent. Goyo woodblock prints
 Smithsonian 26:20 (c,4) S '95
— Kubota's handcrafted kimonos
 Smithsonian 26:64–7 (c,1) D '95
— Porcelain
 Smithsonian 25:22 (c,4) My '94
— Restoring precious scrolls
 Smithsonian 27:94–101 (c,1) My '96
— Zen rock garden (Washington)
 Nat Geog 181:74–5 (c,1) My '92
JAPAN—ARTIFACTS
— Child's mask of Anpanman cartoon figure
 Smithsonian 25:98 (c,4) D '94
JAPAN—COSTUME
 Nat Geog 181:75–7 (c,3) Mr '92
 Nat Geog 186:68–95 (c,1) S '94
— Late 18th cent. women
 Natur Hist 102:62 (painting,c,1) Ag '93
— 1850s
 Smithsonian 25:24 (4) Jl '94
— Ainu people
 Smithsonian 24:84 (c,4) N '93
— Bride in traditional dress
 Trav/Holiday 178:74–5 (c,1) O '95
— Children
 Nat Geog 181:76 (c,3) Mr '92
 Life 18:20–1 (c,1) O '95
— Children in hard hats to protect against
 volcano
 Nat Geog 182:12–13 (c,1) D '92
— Courtesan (1800)
 Natur Hist 102:61 (painting,c,2) Ag '93
— Fish market workers
 Nat Geog 188:38–55 (c,1) N '95
— Geishas
 Nat Geog 188:98–112 (c,1) O '95
— Humorous drawing of samurai
 Gourmet 55:92 (c,3) Ja '95
— Kimonos
 Trav/Holiday 176:47 (c,1) My '93
 Smithsonian 26:64–7 (c,1) D '95
— Kobe
 Nat Geog 188:115–35 (c,1) Jl '95
— Kyushu
 Nat Geog 185:88–117 (c,1) Ja '94
— Preparing linen for kimonos
 Nat Geog 186:88–9 (c,2) S '94
— Princess Masako Owada
 Life 16:19 (c,4) Ag '93
— Tattooed mustache on 1922 Ainu girl
 Nat Geog 190:140 (4) O '96
— Theater costume
 Life 19:86–7 (c,1) Ap '96
— Tokyo

 Trav/Holiday 176:45–53 (c,1) My '93
 Trav&Leisure 26:144–58 (c,1) Mr '96
— Underdressed kindergartners in snow
 Life 17:14–15 (c,1) F '94
— Women in traditional dress
 Trav&Leisure 22:19 (c,4) N '92
JAPAN—HISTORY
— 16th cent. depictions of Portuguese traders
 Nat Geog 182:60-1,86–7 (painting,c,1) N
 '92
— 1854 opening of Japan to the West
 Smithsonian 25:cov.,20–33 (painting,c,1)
 Jl '94
— 1945 bombing of Hiroshima
 Nat Geog 188:81–7 (1) Ag '95
— 1945 bombing of Nagasaki
 Life 18:81 (1) Je 5 '95
 Am Heritage 46:10 (4) N '95
— 1945 surrender of Japan on battleship "Mis-
 souri"
 Life 18:84 (2) Je 5 '95
— 1950 scenes
 Am Heritage 46:71–80 (c,2) D '95
— Post World War II Japan
 Nat Geog 181:72–7 (c,2) Mr '92
— Tokyo after 1945 bombing
 Am Heritage 46:78–82,86 (1) My '95
— World War II caves (New Guinea)
 Nat Geog 181:69 (c,4) Mr '92
— See also
 HIROHITO
 TOJO
 WORLD WAR II
 YAMAMOTO, ISOROKU
JAPAN—HOUSING
— Kyoto
 Nat Geog 188:100 (c,2) O '95
JAPAN—MAPS
— 1804 map
 Natur Hist 103:26–7 (c,1) Jl '94
JAPAN—POLITICS AND GOVERN-
MENT
— Politicians sleeping in Parliament
 Life 15:92 (c,2) S '92
JAPAN—RITES AND FESTIVALS
— Kamakura festival (Yokote)
 Nat Geog 186:92–3 (c,1) S '94
— Memorial service for 1945 Nagasaki
 atomic bomb explosion
 Life 18:20–1 (c,1) O '95
— Tending Japanese graves (Russia)
 Nat Geog 190:52–3 (c,2) O '96
JAPAN—SHRINES AND SYMBOLS
— 1850s Japanese gifts to the U.S.
 Smithsonian 25:27 (c,4) Jl '94

JAPAN—SOCIAL LIFE AND CUS-TOMS
— Businessmen at dinner
Nat Geog 188:110 (c,2) O '95
— Drinking at convention
Nat Geog 181:26–7 (c,1) F '92
— Marriage rites
Nat Geog 181:26 (c,4) F '92
— Mounted archery
Nat Geog 190:44–5 (c,1) Jl '96
— Woman doing laundry
Nat Geog 184:53 (c,4) Ag '93
JASPER NATIONAL PARK, ALBERTA
— Athabasca Pass
Nat Geog 189:132–3 (c,1) My '96
— Climbing frozen waterfall
Nat Geog 190:85,90 (c,1) D '96
JAVELIN THROWING
Sports Illus 84:2–3 (c,1) Je 24 '96
— CAT scan of javelin imbedded in skull
Sports Illus 80:16 (4) My 23 '94
JAYS
— Scrub jay
Natur Hist 101:58 (c,4) Ap '92
Smithsonian 25:38,44 (c,4) S '94
Nat Wildlife 33:9 (c,4) Je '95
— See also
BLUE JAYS
JEEPS
— Role of the jeep in World War II
Smithsonian 23:cov.,60–73 (1) N '92
— World War II Jeep
Life 19:68 (4) Winter '96
JEFFERSON, THOMAS
Trav/Holiday 176:48 (etching,4) Mr '93
Am Heritage 44:87,93,99 (painting,c,1)
My '93
Life 16:3,31,38,45 (c,1) My '93
Gourmet 55:68 (painting,c,4) O '95
Life 19:60 (painting,4) F '96
—1801 anti-Jefferson cartoon
Am Heritage 44:91 (4) My '93
— Bust of Jefferson (Virginia)
Gourmet 53:127 (c,4) Ap '93
— Daughter Martha
Smithsonian 24:82 (painting,c,4) My '93
— Jefferson's polygraph to make copies of
letters
Smithsonian 24:86 (c,4) My '93
— Jefferson's second home "Poplar Forest"
(Virginia)
Am Heritage 44:104–13 (c,1) Ap '93
— Monticello, Charlottesville, Virginia
Gourmet 52:90 (c,4) Mr '92
Gourmet 53:126–9 (c,1) Ap '93

Life 16:30–45 (c,1) My '93
Smithsonian 24:80–93 (c,1) My '93
— Paris sites associated with him
Gourmet 55:68,86 (c,3) O '95
— Portrait of Jefferson by Trumbull
Smithsonian 24:80 (painting,c,4) My '93
JEFFERSON MEMORIAL, WASHING-TON, D.C.
Life 16:3 (c,2) My '93
JEKYLL ISLAND, GEORGIA
Trav&Leisure 26:118–19,136 (c,1) Je '96
— Resort
Trav&Leisure 23:92–3 (c,1) Jl '93
JELLYFISH
Nat Wildlife 30:18–24 (c,1) Ag '92
Natur Hist 101:26–9 (c,1) D '92
Life 18:48–9,52 (c,1) Ag '95
Nat Geog 190:79 (c,4) N '96
— Box jellyfish
Nat Geog 186:116–30 (c,1) Ag '94
— People scarred from jellyfish stings
(Australia)
Nat Geog 186:122 (c,4) Ag '94
JERUSALEM, ISRAEL
Life 15:7,40–1 (c,1) D '92
Gourmet 54:98–9,148 (map,c,1) F '94
Trav&Leisure 24:85–98 (map,c,1) Ag '94
Nat Geog 189:2–31 (map,c,1) Ap '96
— Church of the Holy Sepulchre
Trav&Leisure 24:86,88 (c,1) Ag '94
Trav/Holiday 178:68 (c,2) S '95
— Dome of the Rock
Nat Geog 189:3,7,11–13 (c,1) Ap '96
— Israel Museum
Trav/Holiday 176:62–8 (c,1) D '93
Trav&Leisure 24:92–3 (c,4) Ag '94
— Outdoor vegetable market
Natur Hist 104:72 (2) Ag '95
— Western Wall
Trav&Leisure 24:85,93 (c,1) Ag '94
Nat Geog 189:2 (c,4) Ap '96
JESUS CHRIST
— 15th cent. paintings by Piero della
Francesca
Smithsonian 23:126–31 (c,1) D '92
— 17th Dutch painting
Smithsonian 26:34 (c,3) S '95
— Jesus carrying cross in Breughel painting
Trav/Holiday 178:80 (c,4) Mr '95
— Jesus depicted in art around the world
Life 17:cov.,5,66–82 (c,1) D '94
— Jesus depicted in Holy Week procession
(Italy)
Nat Geog 188:8–9 (c,2) Ag '95

— Paintings depicting events around birth of
Jesus
Life 15:cov.,32–42 (c,1) D '92
JEWELRY
— 17th cent. (Spain)
Nat Geog 190:92–3,100 (c,1) Jl '96
— 1940s patriotic charm bracelet
Am Heritage 45:138 (c,4) My '94
— Ancient Moche jewelry (Peru)
Natur Hist 103:30–3 (c,1) My '94
— Ear spindles (Ethiopia)
Trav&Leisure 23:105–6 (c,1) O '93
— Famous jewels at the Smithsonian,
Washington, D.C.
Life 18:72–81 (c,1) Mr '95
— Padaung women with brass neck rings
(Burma)
Nat Geog 188:96 (c,1) Jl '95
— Prehistoric copper disk (Europe)
Nat Geog 183:62 (c,4) Je '93
— Prehistoric ornaments
Natur Hist 102:60–7 (c,1) My '93
— Rabari people (India)
Nat Geog 184:78 (c,4) S '93
— Super Bowl rings
Sports Illus 78:cov. (c,1) Ap 26 '93
Jewels. See
list under MINERALS
Jews. See
JUDAISM
JOCKEYS
Sports Illus 78:70,76–7 (c,2) Ap 19 '93
Sports Illus 80:11,13 (c,1) My 9 '94
— 19th cent.
Sports Illus 84:104–6 (c,4) Ap 29 '96
— Female jockey
Sports Illus 80:32–3,36 (c,1) Je 13 '94
— Jockey getting dressed (1978)
Life 17:38 (4) My '94
Am Heritage 47:110 (3) S '96
JOGGING
— On snowy road (California)
Sports Illus 82:59 (c,3) F 6 '95
JOHANNESBURG, SOUTH AFRICA
— Market Theater
Trav&Leisure 22:126–7 (c,1) D '92
JOHNSON, LYNDON BAINES
Life 15:45,89 (4) O 30 '92
Sports Illus 79:72 (4) O 4 '93
Am Heritage 45:95 (c,4) S '94
Smithsonian 25:103 (2) O '94
Am Heritage 45:50 (4) D '94
Life 18:51–2 (4) Ap '95
— LBJ with grandchild
Life 19:80–1 (2) S '96

— Lady Bird
Life 15:18 (c,2) Mr '92
Smithsonian 23:151 (4) O '92
Life 15:84 (3) O 30 '92
Life 18:6,48–55 (c,1) Ap '95
— Luci and Lynda Bird
Life 15:31,38–9 (c,1) O 30 '92
— Pulling dog's ears
Trav/Holiday 175:101 (4) N '92
JOHNSON, ROBERT
— Mississippi sites related to his life
Natur Hist 105:48–55 (c,1) S '96
— Tombstone (Mississippi)
Natur Hist 105:51 (c,4) S '96
JOLSON, AL
Am Heritage 45:103 (4) N '94
JONES, BOBBY
Sports Illus 80:104–16 (1) Ap 11 '94
Sports Illus 82:40 (4) Je 12 '95
— 1930 golf Grand Slam by Bobby Jones
Sports Illus 80:105–7 (4) Ap 11 '94
JOPLIN, SCOTT
— Home (St. Louis, Missouri)
Trav/Holiday 176:57 (c,1) S '93
JORDAN
— Jerash
Trav&Leisure 23:61 (c,4) Mr '93
— See also
DEAD SEA
JORDAN RIVER
PETRA
JORDAN—COSTUME
— Farmers
Nat Geog 183:42–3 (c,1) My '93
JORDAN—HISTORY
— King Hussein
Life 18:70 (c,4) Ja '95
JORDAN RIVER, JORDAN
Nat Geog 183:42–3 (c,1) My '93
**JOSEPH, CHIEF (NEZ PERCE
INDIANS)**
Am Heritage 43:106 (1) N '92
Trav/Holiday 176:68 (4) Je '93
Trav&Leisure 25:192 (4) O '95
**JOSHUA TREE NATIONAL PARK,
CALIFORNIA**
Gourmet 54:120–1 (c,1) S '94
Trav&Leisure 24:106,109–11 (c,1) O '94
— Headstone Rock
Nat Geog 189:62–3 (C,1) My '96
JOSHUA TREES
Trav&Leisure 23:cov.,110 (1) D '93
Trav&Leisure 24:106,111 (c,1) O '94
Nat Geog 189:54–6,68–9 (c,1) My '96

JOURNALISTS
— Reporter applying lipstick in camera lens
 (New York)
 Nat Geog 188:36–7 (c,1) O '95
— Mark Sullivan
 Am Heritage 47:49 (1) My '96
— Ida Wells
 Smithsonian 25:125 (4) F '95
— See also
 BIERCE, AMBROSE
 HEARST, WILLIAM RANDOLPH
 PYLE, ERNIE
 SPORTS ANNOUNCERS
 TELEVISION NEWSCASTERS

JOYCE, JAMES
 Trav&Leisure 22:16 (4) Ag '92
 Trav/Holiday 178:87 (4) Ap '95
— Death mask
 Smithsonian 23:113 (c,3) Ap '92
— *Ulysses* manuscript
 Smithsonian 23:113 (c,3) Ap '92

JUAREZ, MEXICO
 Trav/Holiday 176:92–5 (c,2) F '93
 Nat Geog 184:86–7 (c,1) N 15 '93
 Nat Geog 189:66–7 (c,3) F '96
 Trav&Leisure 26:58–62 (c,4) N '96

JUDAISM
— Anti-Semitic movement (Latvia)
 Life 15:44–51 (c,1) D '92
— Anti-Semitic propaganda (Latvia)
 Life 15:50 (c,4) D '92
— New York's Lower East Side
 Am Heritage 43:4,56–74 (map,c,1) Ap '92
— Preparation for Passover seder (California)
 Life 16:12 (c,2) My '93
— Rome's Jewish quarter, Italy
 Gourmet 55:52–5,90 (map,c,2) Ag '95
— See also
 SYNAGOGUES

JUDAISM—COSTUME
— 1930 child (Poland)
 Smithsonian 24:cov. (2) Ap '93
— Elderly religious Jew on swing (Miami,
 Florida)
 Trav/Holiday 179:71 (c,2) Mr '96
— First Jewish Miss America (1945)
 Life 18:148 (2) Je 5 '95
— Hasidic Jews (Israel)
 Nat Geog 187:72–3 (c,1) Je '95
 Natur Hist 105:38–49 (1) D '96
— Lower East Side Jewish shopkeepers (New
 York)
 Smithsonian 25:80–91 (1) Ap '94
— Lubavitch sect
 Life 17:12–13 (c,1) My '94

 Life 18:86 (c,2) Ja '95
— Orthodox Jews (Israel)
 Nat Geog 189:2,9,22–3 (c,1) Ap '96
— Prominent American Jews
 Life 19:60–9 (1) S '96
— Rabbis (Israel)
 Nat Geog 181:58–9 (c,1) F '92
— Menachem Schneerson
 Life 18:86 (c,2) Ja '95
— Students in yeshiva (Brooklyn, New York)
 Life 19:76 (2) Jl '96
— Women in religious prayer garb (New
 York)
 Life 19:64–5 (2) S '96

JUDAISM—HISTORY
— 1898 view of Hester Street, New York
 City, New York
 Am Heritage 43:56–7 (1) Ap '92
— Early 20th cent. model kitchen (New York
 City, New York)
 Am Heritage 47:4 (c,2) Jl '96
— Early 20th cent. scenes of Jewish life in
 Berlin, Germany
 Life 18:126–30 (c,1) N '95
— 1919 pageant of Jewish history (Wisconsin)
 Am Heritage 43:6 (2) F '92
— 1939 Jewish refugee ship "St. Louis"
 Smithsonian 26:18 (painting,c,4) Je '95
— Artifacts from the Holocaust
 Smithsonian 24:56–63 (c,1) Ap '93
— Boxcar used to transport Jews to
 concentration camps
 Smithsonian 24:56 (c,4) Ap '93
— Leo Frank and the 1913 murder of Mary
 Phagan
 Am Heritage 47:98–113 (1) O '96
— Holocaust Museum, Washington, D.C.
 Life 16:19 (c,4) Ap '93
 Smithsonian 24:5–63 (c,1) Ap '93
— Nazi-vandalized tombstones reassembled
 on wall (Krakow, Poland)
 Trav&Leisure 24:118 (c,1) Mr '94
— Nuremberg's "Way of Human Rights"
 monument, Germany
 Trav/Holiday 177:91 (c,4) Je '94
— Refugees from Nazism aboard ship
 Am Heritage 45:89 (4) F '94
— Oskar Schindler
 Life 17:28 (3) Ap '94
— Site of 1941 killing ground (Rumbula,
 Latvia)
 Life 15:51 (c,4) D '92
— See also
 ABRAHAM
 CONCENTRATION CAMPS

DAVID
DEAD SEA SCROLLS
FRANK, ANNE
MOSES
NAZISM
ROTHSCHILD FAMILY
JUDAISM—RITES AND FESTIVALS
— Chanukah meal
Gourmet 54:148 (drawing,4) D '94
— Jews praying at Western Wall, Jerusalem,
Israel
Life 16:25 (c,4) Je '93
— Lag b'Omer bonfire (Israel)
Nat Geog 187:73 (c,4) Je '95
— Orthodox Jewish wedding (Michigan)
Life 17:88–9 (c,2) N '94
— Praying over Sabbath candles (Georgia)
Life 17:59 (c,4) Mr '94
— Prison inmates at Passover seder (New
York)
Life 19:62 (4) S '96
— Purim celebration (Israel)
Natur Hist 105:45 (4) D '96
— Traditional Jewish wedding (Florida)
Trav/Holiday 176:55 (c,2) D '93
JUDAISM—SHRINES AND SYMBOLS
— Chanukah menorahs
Life 19:68–9 (1) S '96
— Menorah shop (New York City, New York)
Am Heritage 43:72 (2) Ap '92
— Nazi-vandalized tombstones reassembled
on wall (Krakow, Poland)
Trav&Leisure 24:118 (c,1) Mr '94
— Passover motifs
Gourmet 52:48,124 (painting,c,2) Ap '92
— Tomb of the Patriarchs (Hebron, Israel)
Nat Geog 181:93 (c,4) Je '92
— Torah scribe at work (New York)
Smithsonian 25:84 (1) Ap '94
— Western Wall, Jerusalem, Israel
Trav&Leisure 24:85,93 (c,1) Ag '94
Nat Geog 189:2 (c,4) Ap '96
Judges. See
HAND, LEARNED
SUPREME COURT JUSTICES
JUDO
— 1996 Olympics (Atlanta)
Sports Illus 85:123 (3) Ag 5 '96
— College
Sports Illus 78:91–2 (c,4) Mr 22 '93
— Cuba
Sports Illus 82:65 (c,3) My 15 '95
JUGGLING
Smithsonian 26:cov.,38–47 (c,1) Ag '95

JUMPING
Sports Illus 76:35 (c,3) Je 8 '92
— 1988 Olympics (Seoul)
Sports Illus 81:123 (c,2) N 14 '94
— 1992 Olympics (Barcelona)
Sports Illus 77:22–4,30 (c,1) Ag 17 '92
— Sequential photos of triple jump
Sports Illus 84:88–92 (c,1) My 13 '96
Jumping rope. See
ROPE JUMPING
JUNGFRAU, ALPS, SWITZERLAND
Gourmet 53:80–1 (c,1) F '93
Trav/Holiday 176:77 (4) N '93
JUNIPER TREES
Natur Hist 105:56 (c,1) Mr '96
JUNKS
— Hong Kong
Gourmet 52:154 (painting,4) Mr '92
— Thailand
Trav&Leisure 26:165 (c,3) S '96
JUNKYARDS
— Children living in dump (El Salvador)
Nat Geog 188:116–17 (c,1) S '95
— Mexico
Smithsonian 25:37 (2) My '94
— Rusty old car
Natur Hist 101:48–9 (c,1) Ag '92
— Sorting electronic trash (Taiwan)
Nat Geog 184:14 (c,4) N '93
JUPITER (PLANET)
Natur Hist 104:76 (c,4) Mr '95
Natur Hist 105:57 (c,4) Jl '96
— Effects of comet impact
Smithsonian 25:63–71 (c,2) Je '94
Natur Hist 103:70 (painting,c,4) Jl '94
Smithsonian 25:14 (c,4) Ja '95
— Moon Europa
Natur Hist 105:70–1 (c,2) S '96
JUSTICE, ADMINISTRATION OF
— 1860 trial
Am Heritage 46:42–3 (painting,c,1) Jl '95
— 1921 Fatty Arbuckle trial (California)
Am Heritage 47:107 (4) S '96
— 1925 Scopes Trial (Tennessee)
Am Heritage 45:110 (4) N '94
Natur Hist 105:74–5 (2) Ap '96
— 1945 Nuremberg Trials
Am Heritage 45:78–87 (c,1) Jl '94
Life 18:104–5 (1) Je 5 '95
Smithsonian 27:124–41 (1) O '96
— Court reporter's tape from O.J. Simpson
trial
Life 18:86 (c,2) F '95
— Gagged defendant at trial (California)

Life 18:18 (c,2) N '95
— Kurdish terrorist on trial (Turkey)
 Nat Geog 182:50–1 (c,1) Ag '92
— See also
 CAPITAL PUNISHMENT
 COURTHOUSES
 CRIME AND CRIMINALS
 LAWYERS
 POLICE WORK
 PRISONS
 PUNISHMENT
 SUPREME COURT BUILDING
 SUPREME COURT JUSTICES
JUSTICE, ADMINISTRATION OF—HUMOR
— History of the world's judicial process
 Smithsonian 25:109–17 (painting,c,1) Mr
 '95

–K–

KABUL, AFGHANISTAN
 Nat Geog 184:67 (c,3) O '93
KAHLO, FRIDA
 Smithsonian 23:38 (4) Mr '93
 Smithsonian 26:32 (4) Je '95
— Kahlo studio-museum, Mexico City,
 Mexico
 Trav/Holiday 177:31 (c,4) F '94
— Self-portrait (1940)
 Life 19:86 (painting,c,4) Jl '96
— "The Two Fridas" (1939)
 Trav&Leisure 23:109 (c,1) Je '93
KAISER, HENRY
 Am Heritage 46:59 (4) D '95
KANDINSKY, WASSILY
— "Succession"
 Natur Hist 103:70 (painting,c,2) Je '94
KANGAROOS
 Smithsonian 24:103–12 (c,1) N '93
 Trav&Leisure 24:99 (c,1) Jl '94
 Natur Hist 104:4 (c,4) Je '95
 Natur Hist 105:63 (c,1) N '96
— "Kangaroo crossing" sign (Australia)
 Trav&Leisure 26:30 (c,4) O '96
 Trav/Holiday 179:38 (c,4) D '96
— Red kangaroos
 Natur Hist 104:38–45 (c,1) Ap '95
— Wallabies
 Smithsonian 24:105–12 (c,2) N '93
KANSAS
— Fort Scott
 Am Heritage 45:26 (c,4) N '94
— Monument Rocks

Natur Hist 104:20–2 (map,c,1) Jl '95
— Paradise
 Trav/Holiday 176:74–5,80–1 (c,1) Mr '93
— See also
 DODGE CITY
KANSAS CITY, MISSOURI
— Barbecue restaurants
 Trav/Holiday 179:44–9 (c,1) Je '96
— City decorated for Christmas
 Trav&Leisure 22:180 (c,4) D '92
KARATE
— Cracking bricks with head (California)
 Life 19:88 (c,2) F '96
KATYDIDS
 Life 17:61 (c,4) Je '94
 Nat Wildlife 33:22–3 (c,1) F '95
KAYAKING
 Trav&Leisure 22:122–3 (painting,c,1) My
 '92
 Sports Illus 77:154 (c,1) Jl 22 '92
 Smithsonian 23:150–63 (c,1) N '92
 Sports Illus 83:18 (c,3) Ag 7 '95
— Alaska
 Trav&Leisure 22:55 (c,3) Mr '92
 Trav&Leisure 22:cov.,88-90 (c,1) My '92
 Gourmet 54:150 (c,4) My '94
 Nat Geog 188:126–7 (c,1) Ag '95
— Bahamas
 Trav&Leisure 23:126–31 (c,1) N '93
— Canada
 Nat Geog 190:136–7 (c,2) O '96
— Greenland
 Nat Geog 187:122–6 (c,1) Ja '95
 Nat Geog 190:68–9 (c,1) Jl '96
— Hawaii
 Trav/Holiday 177:69 (c,4) Ap '94
— Kayak race (Northwest)
 Sports Illus 83:9–10 (c,4) O 16 '95
— Kayaking on Los Angeles street, California
 Trav&Leisure 25:61 (2) Ja '95
— New Hampshire
 Sports Illus 78:80 (c,4) Je 14 '93
— Norway
 Sports Illus 80:54–5 (c,1) Ja 24 '94
— Peru
 Nat Geog 183:118–37 (c,1) Ja '93
— Tennessee
 Nat Geog 184:125 (c,1) Ag '93
— Washington
 Nat Wildlife 30:40–1 (c,1) O '92
— Wisconsin
 Nat Geog 184:80–1 (c,1) D '93
KAYAKS
 Smithsonian 23:150–63 (c,1) N '92
— Model of kayak (Alaska)

Life 17:130 (c,4) N '94
KAZAKHSTAN, U.S.S.R.
Nat Geog 183:22–37 (map,c,1) Mr '93
Smithsonian 25:26–35 (c,2) Ag '94
— Almaty
Smithsonian 25:29 (c,2) Ag '94
KEATON, BUSTER
Trav/Holiday 177:109 (4) Ap '94
Smithsonian 26:104 (4) O '95
KELLER, HELEN
Smithsonian 23:144 (4) O '92
Life 15:89 (4) O 30 '92
KELLY, GENE
Smithsonian 27:cov. (4) N '96
KELP
Nat Wildlife 30:4–11 (c,1) Je '92
KENAI FJORDS NATIONAL PARK,
ALASKA
Nat Geog 187:106–7 (c,1) Ap '95
KENNAN, GEORGE F.
Am Heritage 46:44 (4) D '95
KENNEDY, JOHN FITZGERALD
Am Heritage 43:34 (4) My '92
Am Heritage 43:32 (4) O '92
Smithsonian 23:149 (4) O '92
Life 15:10–11 (c,1) O 30 '92
Trav/Holiday 175:76–7 (4) N '92
Life 16:33 (c,3) Je '93
Am Heritage 44:99–100 (3) N '93
Am Heritage 44:96 (4) D '93
Life 16:13 (1) D '93
Smithsonian 25:47 (4) Ap '94
Life 17:50 (4) Ag '94
Smithsonian 25:103 (2) O '94
Life 18:52–3,57–60 (1) Mr '95
Am Heritage 46:77 (4) Jl '95
Life 18:cov.,34–40 (c,2) Ag '95
Life 19:124 (4) O '96
— 1963 assassination
Life 19:138–9 (c,1) O '96
— 1963 assassination reenactment
Am Heritage 46:cov.,51 (1) N '95
— 1963 funeral
Life 15:69 (c,4) O 30 '92
Life 17:51 (2) Jl '94
Am Heritage 45:95 (c,4) S '94
— 1968 wedding of Jackie and Aristotle
Onassis
Am Heritage 44:110 (4) O '93
— JFK with baby Caroline
Life 19:80–1 (4) S '96
— Kennedy family
Life 18:cov.,3,52–63 (c,1) Mr '95
Life 18:38 (c,4) Ag '95
— Rose Kennedy

Life 18:cov.,3,52–63 (c,1) Mr '95
Life 19:86 (1) Ja '96
— Jacqueline Kennedy Onassis
Life 15:69,80–1,88 (c,1) O 30 '92
Life 17:48–52 (1) Jl '94
Am Heritage 45:91,95,101 (1) S '94
Life 18:cov.,4,74–5 (c,1) Ja '95
Life 18:cov.,34–42 (c,2) Ag '95
Am Heritage 47:103 (4) Jl '96
Life 19:124 (4) O '96
— Jackie Kennedy look-alikes (1960s)
Life 18:124 (4) N '95
— Lee Harvey Oswald
Am Heritage 45:100 (4) F '94
Am Heritage 46:56 (4) N '95
— Sunbathers in Jack and Jackie masks (1963)
Life 16:28 (c,4) Je '93
— Ted Kennedy
Am Heritage 44:16 (drawing,4) N '93
— Throwing out first baseball of season
Sports Illus 78:86–7 (2) Ap 12 '93
— Warren Commission investigation of
Kennedy assassination
Am Heritage 46:52 (4) N '95
KENNEDY, ROBERT FRANCIS
Am Heritage 43:34 (4) My '92
Life 16:cov.,57–67 (c,1) Ap '93
Life 17:50 (4) Ag '94
— 1968 assassination
Sports Illus 82:88 (4) Mr 20 '95
Life 19:96 (1) O '96
KENTUCKY
Trav&Leisure 26:112–18 (map,c,4) O '96
— History of Berea College
Smithsonian 24:92–104 (c,2) D '93
— Maker's Mark Distillery, Loretto
Natur Hist 103:A6 (c,4) Ap '94
— McRoberts
Smithsonian 22:67 (2) F '92
— Mint julep
Trav&Leisure 22:NY10 (c,3) My '92
— See also
CUMBERLAND RIVER
BIG SOUTH FORK NATIONAL RIVER
AND RECREATION AREA
LOUISVILLE
KENYA
Trav&Leisure 26:182–91 (map,c,1) N '96
— Countryside
Natur Hist 105:2,20 (painting,c,3) D '96
— Flatlands
Natur Hist 102:67 (c,3) Ag '93
— Turkana Basin
Nat Geog 188:40–1,48–51 (map,c,2) S '95

KENYA—COSTUME
Natur Hist 105:4,46 (c,4) Ag '96
— Gabbra people
Natur Hist 102:50–7 (c,1) S '93
— Lamu Island
Natur Hist 105:52–6 (c,1) Ja '96
— Masai people
Smithsonian 24:78 (c,3) N '93
Trav&Leisure 26:183,189 (c,1) N '96
— Samburu herdsmen
Smithsonian 27:112–13 (c,1) My '96
KENYA—RITES AND FESTIVALS
— Kirumbizi stick dance
Natur Hist 105:56 (c,4) Ja '96
KERN, JEROME
— Caricature
Am Heritage 44:82–5 (painting,c,1) O '93
Am Heritage 46:22 (4) Ap '95
KEROUAC, JACK
— Neal Cassady
Am Heritage 47:62 (4) N '96
— Gravesite
Am Heritage 47:66 (4) Ap '96
KESTRELS
Natur Hist 105:49 (c,4) O '96
KEY WEST, FLORIDA
Gourmet 52:110–15,200–2 (map,c,1) D
'92
Trav/Holiday 176:80–7 (map,c,1) N '93
Trav&Leisure 24:110–15,154–8 (c,2) D
'94
Am Heritage 46:65–7 (c,2) N '95
KEYS
— Hotel room key
Gourmet 54:45 (c,3) Ag '94
— Key to the City (Cairo, Egypt)
Nat Geog 183:44 (c,4) Ap '93
— Keys to the City (Lyons, France)
Gourmet 52:99 (c,4) O '92
— Sushi keychain (Japan)
Trav/Holiday 179:18 (c,4) S '96
KHRUSHCHEV, NIKITA
Life 15:94 (3) Jl '92
Smithsonian 25:47 (4) Ap '94
Life 18:108 (4) Je 5 '95
Am Heritage 47:103 (4) Jl '96
KILAUEA, HAWAII
Trav&Leisure 26:43 (c,3) Ja '96
Nat Geog 189:110–11 (c,2) Ja '96
— Eruption
Nat Geog 182:cov.,5–7 (c,1) D '92
Nat Wildlife 34:30 (c,3) D '95
Nat Geog 189:100 (c,4) Ja '96
Life 19:cov.,52–60 (c,1) Je '96

KILIMANJARO, TANZANIA
Trav&Leisure 26:60–5,84–6 (map,c,1) Ja
'96
KILLER WHALES
Trav/Holiday 175:24 (c,4) Mr '92
Life 16:46–56 (c,1) N '93
Natur Hist 103:98–9 (c,1) Je '94
Smithsonian 25:46–59 (c,1) N '94
Life 19:cov.,52–8 (c,1) Mr '96
— Saving the real-life orca "Willy"
Life 19:cov.,52–8 (c,1) Mr '96
KING, BILLIE JEAN
Sports Illus 81:60–1 (c,1) S 19 '94
KING, MARTIN LUTHER, JR.
Life 16:cov.,56–64 (c,1) Ap '93
Life 17:26 (4) Ag '94
— Atlanta sites related to King
Am Heritage 43:98–9 (c,4) Ap '92
— Birthplace (Atlanta, Georgia)
Am Heritage 43:98 (c,4) Ap '92
— Dexter Avenue Baptist Church,
Montgomery, Alabama
Am Heritage 46:35 (c,4) F '95 supp.
— Ebenezer Baptist Church, Atlanta, Georgia
Gourmet 56:75 (c,4) Jl '96
— King memorial, Atlanta, Georgia
Am Heritage 47:88–9 (c,2) Ap '96
— Motel scene after 1968 assassination
(Memphis, Tennessee)
Life 19:92 (4) O '96
King crabs. See
HORSESHOE CRABS
KINGFISHERS
Nat Wildlife 32:25 (painting,c,4) D '93
Natur Hist 105:76 (painting,c,4) My '96
Nat Wildlife 34:28–35 (c,1) Je '96
— Chicks
Nat Wildlife 34:33 (c,3) Je '96
KINGLETS (BIRDS)
Natur Hist 102:cov.,4 (c,1) F '93
Kings. See
RULERS AND MONARCHS
KIOWA INDIANS
Natur Hist 102:68–76 (c,1) O '93
KIOWA INDIANS—ARTIFACTS
— Buckskin painting of Kiowa camp (1900)
Natur Hist 102:68–9 (c,1) O '93
— Cradleboard
Smithsonian 25:40 (c,4) O '94
KIPLING, RUDYARD
Trav&Leisure 24:34 (4) My '94
— Naulakha home (Brattleboro, Vermont)
Trav&Leisure 24:34 (4) My '94
Trav&Leisure 24:E8 (c,4) Je '94

KISSING
Sports Illus 85:57 (c,4) N 25 '96
— 1945 Eisenstaedt photo of Times Square
V-J Day kiss
Life 19:94 (3) O '96
— Acrobatic couple kissing on swing
Life 18:43 (4) N '95
— Baseball player kissing bat
Sports Illus 81:16–17 (c,1) Ag 8 '94
— Celebrities kissing
Life 19:72–3 (c,4) F '96
— Couple on steps (Venice, Italy)
Nat Geog 187:98–9 (c,1) F '95
— Couple on subway platform (New York)
Life 18:47 (4) F '95
— Couples kissing in street (Rome, Italy)
Trav&Leisure 22:76–7,83 (c,1) Ap '92
— Filming "Romeo and Juliet" (1996)
Life 19:14–15 (c,1) D '96
— Kissing in a kayak (Puerto Rico)
Trav/Holiday 177:78 (4) D '94
— Madonna kissing her reflection
Life 15:16–17 (1) D 1 '92
—Soldier kissing girlfriend (Israel)
Nat Geog 189:16–17 (c,2) Ap '96
KITCHENS
Life 17:94–5 (c,1) D '94
— Early 19th cent. (Taos, New Mexico)
Trav/Holiday 178:50 (c,4) F '95
— Late 19th cent. (Charleston, South
Carolina)
Gourmet 54:112 (c,4) S '94
— Early 20th cent. model kitchen (New York
City, New York)
Am Heritage 47:4 (c,2) Jl '96
— 1939 (North Carolina)
Life 15:86 (3) My '92
— Baking supplies in cozy kitchen
Gourmet 53:24,46 (painting,c,2) Ja '93
— Colonial period
Am Heritage 43:88 (c,4) My '92
— Country kitchen (Italy)
Trav&Leisure 24:87 (c,1) F '94
— Elegant eat-in kitchen
Gourmet 54:cov.,126–7 (c,1) F '94
— Restaurant kitchen (California)
Gourmet 52:49 (c,4) F '92
— Shelf of kitchen wares
Gourmet 54:100 (painting,c,3) D '94
— Welfare family's monthly food purchases
Life 19:65–71 (c,1) Ja '96
— Well-equipped kitchen (California)
Smithsonian 23:111 (c,2) D '92
— See also
COOKING

STOVES
KITE FLYING
— Washington, D.C.
Life 17:40 (c,4) Mr '94
KITES
— Serbian children making kites out of
Yugoslav dinar bills (Belanovca)
Life 16:19 (c,2) N '93
KITES (BIRDS)
Natur Hist 105:50 (c,4) O '96
KIWI BIRDS
Natur Hist 102:cov.,50–7 (c,1) D '93
KNIGHTS
— Knight costumes for medieval-style
warfare
Life 18:28–32 (c,1) N '95
— Statue of Roland (Bremen, Germany)
Trav/Holiday 176:50–1 (c,1) Jl '93
KNIVES
— Forging tuna knife (Japan)
Nat Geog 188:49–50 (c,1) N '95
— Neandertal flint knives
Nat Geog 189:26 (c,4) Ja '96
— Swiss Army Knife
Trav/Holiday 175:94 (c,4) Ap '92
Trav/Holiday 179:16 (c,4) D '96
— See also
DAGGERS
KNOXVILLE, TENNESSEE
Trav/Holiday 175:36–8 (c,4) Mr '92
KOALAS
Nat Geog 187:37–59 (c,1) Ap '95
Trav/Holiday 179:38–9 (c,1) D '96
— Albino koala
Life 18:22 (c,4) Ap '95
— Protest to save koalas (Australia)
Nat Geog 187:52–3 (c,1) Ap '95
KOCH, ROBERT
Smithsonian 23:184 (4) N '92
KOMODO DRAGONS
Smithsonian 23:132 (drawing,4) F '93
Natur Hist 102:44 (c,3) Je '93
Life 17:75 (c,3) Mr '94
— Baby emerging from egg
Smithsonian 24:18 (c,4) Ag '93
KOREA—ART
— 18th cent. paintings
Smithsonian 24:99–103 (c,1) F '94
KOREA—HISTORY
— 1940s Korean miners working for Japanese
Natur Hist 104:58 (4) O '95
— See also
KOREAN WAR

KOREA, NORTH—RITES AND FESTI-VALS
— 1982 stadium tableau celebrating leader
Kim's birthday
Life 17:8–9 (c,1) Ag '94
KOREA, SOUTH
— Inchon harbor
Nat Geog 181:78–9 (c,1) Mr '92
— See also
SEOUL
KOREA, SOUTH—SOCIAL LIFE AND CUSTOMS
— Marriage ceremony
Natur Hist 105:8 (c,3) Jl '96
KOREAN WAR
— 1950 Pentagon press briefing
Am Heritage 43:92 (4) S '92
— 1950 U.S. soldier
Life 19:76 (1) Ag '96
— Tank
Smithsonian 24:79 (4) Ag '93
KOUFAX, SANDY
Life 16:34 (c,4) Je '93
Sports Illus 80:38–9,44 (1) Ap 25 '94
KRAKOW, POLAND
Trav&Leisure 24:112–21,150 (map,c,1)
Mr '94
Gourmet 54:132–7,236 (c,1) N '94
— Wawel Castle
Trav&Leisure 25:128 (c,4) N '95
KREMLIN, MOSCOW, RUSSIA
— Assumption Cathedral interior
Trav/Holiday 176:92 (c,3) Ap '93
— Cathedral
Sports Illus 83:40 (c,2) D 11 '95
KU KLUX KLAN
— 1870 cartoon
Smithsonian 24:109 (c,4) F '94
— 1871
Am Heritage 43:42 (drawing,4) My '92
— Attack on Ku Klux Klan sympathizer
(Michigan)
Life 19:10–11 (c,1) Ag '96
— Imperial Wizard before burning cross
Life 18:31 (c,4) Ap '95
— Klansman
Am Heritage 43:18 (drawing,4) Ap '92
KUALA LUMPUR, MALAYSIA
— Chinatown
Trav/Holiday 176:46–9 (c,1) S '93
KUBLAI KHAN
Trav/Holiday 175:72 (painting,c,4) My '92
KURDISTAN—MAPS
Nat Geog 182:37 (c,2) Ag '92

KUWAIT
— Burning oil fields
Life 15:12–13,28–9 (c,1) Ja '92
Nat Wildlife 32:12–13 (c,1) F '94
— Effects of Gulf War oil fires
Nat Geog 181:122–34 (c,1) F '92
— See also
GULF WAR
KUWAIT—SOCIAL LIFE AND CUSTOMS
— Family life
Life 17:56–7 (c,1) Jl '94
KWAKIUTL INDIANS—ARTIFACTS
— Kwakiutl arts
Smithsonian 23:53 (c,3) Ap '92
— Kwakiutl masks
Smithsonian 24:22 (c,4) F '94
Life 17:124 (c,1) N '94
KWAKIUTL INDIANS—SOCIAL LIFE AND CUSTOMS
— Hamatsa Dance
Smithsonian 23:93 (c,4) F '93

–L–

LABOR DAY
— Boat gridlock on Lake Havasu, Arizona/California
Life 15:20–1 (c,3) S '92
LABOR UNIONS
— 1919 Actors' Equity strike (New York)
Am Heritage 47:92–9 (1) S '96
— 1937 fight for auto union (Michigan)
Life 19:62 (4) Winter '96
— Painting of 1912 strike (Lawrence,
Massachusetts)
Smithsonian 24:64 (c,4) Ag '93
— See also
CHAVEZ, CESAR
REUTHER, WALTER
LABORATORIES
— Edison's lab (Ft. Myers, Florida)
Trav&Leisure 22:136 (c,4) Mr '92
LABORERS
— Early 20th cent. (New York)
Life 16:86 (4) F '93
— Child laborers (Pakistan)
Life 19:38–48 (c,1) Je '96
— Constructing water tunnel (New York)
Smithsonian 25:60–9 (c,1) Jl '94
— Construction workers (China)
Nat Geog 185:14–15 (c,1) Mr '94
Nat Geog 189:40–1 (c,1) Mr '96

— Migrant worker showering (South Africa)
Nat Geog 183:72 (c,3) F '93
— Painting saluting American labor
Smithsonian 24:62–3 (c,1) Ag '93
— Ship-breaker (India)
Nat Geog 187:56–7 (c,2) Mr '95
— See also
FACTORY WORKERS
FARM WORKERS
RAILROAD WORKERS
LABRADOR, NEWFOUNDLAND
Nat Geog 184:2–35 (map,c,1) O '93
— Schooner Cove
Natur Hist 104:72–5 (map,c,1) My '95
LABRADOR, NEWFOUNDLAND
—MAPS
Natur Hist 105:58 (c,4) Je '96
LABRADOR RETRIEVERS
Sports Illus 81:26 (c,4) D 12 '94
LABYRINTHS
— English manor garden
Nat Geog 188:40–1 (c,1) O '95
— Hampton Court maze, London, England
Trav&Leisure 24:101 (c,4) Ag '94
— Topiary park (Lisbon, Portugal)
Trav/Holiday 175:12 (c,4) Je '92
LACEWINGS
Nat Geog 188:74 (c,4) D '95
LACROSSE
— Physically challenged boy playing lacrosse
Life 17:24 (2) N '94
LACROSSE—COLLEGE
Sports Illus 78:54 (c,2) My 24 '93
— Women
Sports Illus 83:32 (c,1) Jl 24 '95
LADDERS
— Indian pueblo (Taos, New Mexico)
Trav/Holiday 178:48 (c,4) F '95
LADYBUGS
Natur Hist 102:74–5 (c,1) Ag '93
Natur Hist 103:32–4 (c,1) Je '94
Nat Wildlife 32:30–3 (c,1) Je '94
Nat Wildlife 34:10 (c,4) Je '96
Smithsonian 27:61 (painting,c,4) Je '96
LADY'S SLIPPERS (FLOWERS)
Natur Hist 102:24 (c,1) Je '93
Natur Hist 103:21 (c,1) Ap '94
Natur Hist 105:46–7 (c,1) My '96
LA FARGE, JOHN
Smithsonian 23:139 (4) N '92
LAFAYETTE, MARQUIS DE
Smithsonian 24:83 (painting,c,4) My '93
— Caricature
Am Heritage 46:86 (c,4) F '95

LA GUARDIA, FIORELLO
Am Heritage 43:45 (4) Jl '92
Am Heritage 44:28 (4) S '93
Life 18:72 (4) Je 5 '95
— La Guardia crusading against pinball
(1930s)
Smithsonian 23:102 (4) Ja '93
LAKE BAIKAL, SIBERIA
Nat Geog 181:cov.,3–39 (map,c,1) Je '92
Trav&Leisure 23:129 (c,1) Ap '93
LAKE CHAMPLAIN, NEW
YORK/VERMONT
Trav/Holiday 177:32 (c,4) Je '94
LAKE COMO, EUROPE
— Italy
Gourmet 52:106–8,132 (map,c,1) Ap '92
Trav&Leisure 22:105–6 (c,4) Je '92
— Switzerland
Trav&Leisure 23:116–17 (c,1) Ap '93
LAKE CONSTANCE, EUROPE
— Switzerland
Trav&Leisure 23:112–13 (c,1) Ap '93
LAKE GENEVA, SWITZERLAND
Trav&Leisure 25:32 (c,4) Je '95
LAKE GEORGE, NEW YORK
— 1790s map
Am Heritage 47:80 (4) Jl '96
LAKE LUGANO, SWITZERLAND
Trav&Leisure 22:114–15 (c,1) S '92
Gourmet 56:66–7 (c,1) Jl '96
LAKE MICHIGAN, MIDWEST
Gourmet 54:143–5 (c,1) My '94
— Sunset over Lake Michigan
Nat Wildlife 33:56–7 (c,1) O '95
LAKE PLACID, NEW YORK
Natur Hist 101:32–3,60 (c,4) My '92
Trav&Leisure 24:30 (c,2) O '94
LAKE SUPERIOR, MIDWEST
— Michigan
Natur Hist 102:38 (c,1) Ap '93
Nat Wildlife 31:4–5 (c,1) Ag '93
Nat Geog 184:70–95 (map,c,1) D '93
— Wisconsin
Nat Wildlife 31:10–11 (c,1) Ag '93
LAKE TAHOE, CALIFORNIA
/NEVADA
Nat Geog 181:112–32 (map,c,1) Mr '92
LAKE TANGANYIKA, TANZANIA
Trav&Leisure 24:93 (c,1) N '94
LAKE TITICACA, BOLIVIA/PERU
Nat Geog 181:107 (map,c,4) Mr '92
Trav&Leisure 26:108,114–15 (c,1) F '96
LAKES
— Adirondack region, New York

Trav&Leisure 26:84–92 (c,1) Je '96
— Anne Marie, Labrador, Newfoundland
Nat Geog 184:2–3 (c,1) O '93
— Artificial lake (Arizona)
Nat Geog 184:34–5 (c,1) N 15 '93
— Athabasca Lake, Saskatchewan
Nat Geog 189:120–1 (c,1) My '96
— Atitlan, Guatemala
Trav&Leisure 23:95 (c,1) Mr '93
— Blue Mountain Lake, New York
Gourmet 53:44–5 (c,1) Ag '93
— Bowman, Montana
Life 16:80–1 (c,1) S '93
— Central Park, New York City
Nat Geog 183:18–19 (c,1) My '93
— Chile
Gourmet 54:102–7 (c,1) F '94
— Echo Lake, British Columbia
Gourmet 53:110–11 (c,1) O '93
— Heart Lake, Alaska
Trav&Leisure 24:111 (c,1) Mr '94
— Jackson Lake, Wyoming
Nat Geog 187:132–3 (c,1) F '95
— Kintla Lake, Montana
Sports Illus 79:76 (c,3) O 4 '93
— Kuril Lake, U.S.S.R.
Natur Hist 103:28–31 (c,1) F '94
— Lac la Croix, Minnesota/Ontario
Nat Geog 189:112–13 (c,1) My '96
— Lake Alster, Hamburg, Germany
Trav&Leisure 25:118 (c,4) Je '95
— Lake District, England
Nat Geog 186:2–31 (map,c,1) Ag '94
— Lake Havasu, Arizona
Sports Illus 84:47 (c,3) Ap 1 '96
— Lake Havasu boat gridlock, Arizona/
California
Life 15:20–1 (c,3) S '92
— Lake of Brienz, Switzerland
Trav/Holiday 176:74 (c,4) N '93
— Lake of Thun, Switzerland
Trav/Holiday 176:73 (4) N '93
— Lake Paittasjarvi, Sweden
Trav/Holiday 177:cov. (c,1) Je '94
— Lake Parmiento, Argentina
Natur Hist 101:29 (c,4) Ap '92
— Lake Powell, Arizona
Natur Hist 102:cov.,40–5 (c,1) N '93
Trav/Holiday 178:34–43 (map,c,1) Jl '95
— Lake Siljan, Sweden
Trav/Holiday 177:44–5 (c,2) Je '94
— Lake Vanern, Sweden
Nat Geog 184:134 (c,1) O '93
— Lake Wakatipu, New Zealand

Gourmet 55:cov. (c,1) Ap '95
— Little Indian Lake, New York
Natur Hist 101:24–5 (c,1) My '92
— Loch Ness, Scotland
Trav&Leisure 23:64–7 (c,1) Jl '93
— Loch Venachar, Scotland
Gourmet 52:118–19 (c,2) Ap '92
— Long Lake, Colorado
Natur Hist 101:18–19 (c,1) Ag '92
— Lost Lake, Oregon
Natur Hist 103:32 (c,4) O '94
— Minnesota
Nat Geog 182:92–119 (map,c,1) S '92
— Mono Lake, California
Trav&Leisure 23:189 (c,4) Mr '93
Nat Wildlife 31:10–11 (c,1) Je '93
Nat Geog 184:57 (c,3) N 15 '93
Nat Wildlife 33:36 (c,1) Je '95
Smithsonian 26:75 (c,3) Ag '95
Natur Hist 105:62 (c,4) S '96
— North Carolina
Trav&Leisure 22:112 (c,1) Mr '92
— Ontario
Nat Geog 189:136–7 (c,1) My '96
— Otsego Lake, Cooperstown, New York
Trav/Holiday 176:77,85 (c,1) Ap '93
— Pyramid Lake, Nevada
Natur Hist 105:cov.,32–6 (map,c,1) S '96
— Scotland
Trav&Leisure 23:62–9 (c,1) Jl '93
— Shasta, California
Nat Geog 184:9 (c,1) N 15 '93
— Spring Lake, New Jersey
Gourmet 52:70 (c,4) Je '92
— Sun Moon Lake, Taiwan
Nat Geog 184:18–19 (c,2) N '93
— See also
CRATER LAKE
FINGER LAKES
GREAT SALT LAKE
LAKE BAIKAL
LAKE COMO
LAKE CONSTANCE
LAKE GENEVA
LAKE GEORGE
LAKE LUGANO
LAKE MICHIGAN
LAKE PLACID
LAKE SUPERIOR
LAKE TAHOE
LAKE TITICACA
Lamps. See
LANTERNS
LIGHTING
LIGHTS

LANGUAGE
— Deaf people signing
 Smithsonian 23:3–41 (2) Jl '92
— Teaching language to chimpanzees
 Nat Geog 181:33–4 (c,2) Mr '92
LANTERNS
— Chinese lanterns (British Columbia)
 Trav/Holiday 179:64–5 (c,1) Je '96
LAOS
 Trav&Leisure 23:72–7 (c,4) N '93
 Trav/Holiday 178:76–85 (map,c,1) F '95
— Plain of Jars
 Natur Hist 104:48–57 (map,c,1) S '95
— See also
 MEKONG RIVER
 VIENTIANE
LAOS—COSTUME
 Trav&Leisure 23:72–7 (c,4) N '93
 Trav/Holiday 178:77–85 (c,1) F '95
 Natur Hist 104:48–57,74 (c,1) S '95
LAOS—HISTORY
— 1960s bomb craters
 Natur Hist 104:50 (c,1) S '95
LAOS—HOUSING
— Stilt houses
 Natur Hist 104:51 (c,4) S '95
LAOS, ANCIENT—ARTIFACTS
— Bronze Age stone urns
 Natur Hist 104:48–55 (c,1) S '95
LAPP PEOPLE (NORWAY)
 Trav/Holiday 179:98–9 (c,1) D '96
LARKS
 Nat Geog 181:79 (c,4) Ja '92
LAS VEGAS, NEVADA
 Nat Geog 182:46–7 (c,1) D '92
 Trav/Holiday 177:68–9 (1) O '94
 Smithsonian 26:50–9 (c,1) O '95
 Trav&Leisure 25:66,77–82 (c,4) O '95
 Trav&Leisure 26:108–12 (map,c,4) N '96
 Nat Geog 190:58–81 (map,c,1) D '96
 Gourmet 56:128–31 (c,1) D '96
— 1947
 Life 16:30–1 (1) Ap 5 '93
— Casinos along "strip"
 Life 17:17–20 (c,1) F '94
— Drive-through wedding chapel
 Life 16:82 (c,2) Ag '93
— Forum Shops at Caesars
 Trav&Leisure 23:17 (c,4) Jl '93
— Las Vegas showgirls
 Trav/Holiday 175:33 (drawing,c,4) F '92
 Life 16:86–7 (c,1) Ap 5 '93
— Liberace Museum
 Smithsonian 26:56 (c,3) O '95
— Motifs evocative of Las Vegas

 Gourmet 52:116 (drawing,c,2) O '92
— Simulated volcano at hotel
 Nat Geog 184:14–15 (c,1) N 15 '93
LASERS
— Aiming beams at stars (New Mexico)
 Nat Geog 185:2–3 (c,1) Ja '94
LASSEN VOLCANIC NATIONAL PARK, CALIFORNIA
 Trav/Holiday 179:72–3 (c,1) Jl '96
LATIN AMERICA—HISTORY
— 16th cent. sites of Pizarro expeditions
 Nat Geog 181:92–121 (map,c,1) F '92
LATVIA—COSTUME
— 1941 Aizsargi
 Life 15:49 (4) D '92
— Military groups
 Life 15:45–50 (c,1) D '92
LATVIA—POLITICS AND GOVERNMENT
— Anti-Semitic movement
 Life 15:44–51 (c,1) D '92
LAUNDRY
— 1950s toy washing machine
 Smithsonian 24:36 (c,4) O '93
— Clothesline (Italy)
 Nat Geog 188:6–7 (c,1) Ag '95
— Football team laundry (Texas)
 Sports Illus 81:43 (c,2) D 12 '94
— Hanging wash on clothesline (Utah)
 Life 19:80 (2) Ap '96
— Hotel washing machines
 Trav/Holiday 179:30 (4) D '96
— Laundromat (Japan)
 Nat Geog 188:135 (c,4) Jl '95
— Laundromats
 Nat Geog 181:54–5 (c,1) Je '92
 Natur Hist 105:52 (c,3) S '96
— Outdoor hand laundries (India)
 Nat Geog 185:78–9 (c,1) Je '94
— Sorting wash
 Sports Illus 82:75 (c,3) Ja 23 '95
— Washing clothes in brook (Iran)
 Natur Hist 101:34–5 (c,1) Ag '92
— Woman doing laundry (Japan)
 Nat Geog 184:53 (c,4) Ag '93
LAUREL, STAN
 Smithsonian 25:28 (c,4) F '95
LAUSANNE, SWITZERLAND
— Olympic Museum
 Sports Illus 82:9 (c,4) Ja 23 '95
Lava. See
 VOLCANOES
LAVA BEDS NATIONAL MONUMENT, CALIFORNIA
 Trav/Holiday 179:74 (c,4) Jl '96

LAVENDER
— Field of lavender (France)
 Gourmet 54:cov. (c,1) Ap '94
LAVOISIER, ANTOINE LAURENT
 Smithsonian 25:114 (painting,c,4) D '94
Law. See
 JUSTICE, ADMINISTRATION OF
LAWN MOWERS
— 1954
 Am Heritage 45:33 (4) D '94
— Lawn mower race (Great Britain)
 Sports Illus 77:106 (c,4) S 7 '92
LAWRENCE, JACOB
 Smithsonian 23:141 (4) Je '92
LAWYERS
— Alan Dershowitz
 Life 16:101 (c,1) Ja '93
— William Kunstler
 Life 19:100 (c,4) Ja '96
— See also
 DARROW, CLARENCE
 JUSTICE, ADMINISTRATION OF
LEAD
— 19th cent. lead mining
 Natur Hist 105:50–1 (painting,c,3) Jl '96
— Lead poisoning through history
 Natur Hist 105:48–53 (c,1) Jl '96
LEANING TOWER OF PISA, ITALY
 Life 18:22 (2) N '95
LEAR, EDWARD
— Nonsense limerick and cartoon
 Life 17:41 (4) My '94
LEATHER INDUSTRY
— 19th cent. tannery (New York)
 Natur Hist 101:37 (4) My '92
LEAVES
— Autumn leaves swirling in lake (Ontario)
 Nat Wildlife 32:2–3 (c,2) O '94
— Black locust leaves
 Natur Hist 102:61 (c,4) S '93
— Dogwood leaf in autumn
 Nat Wildlife 31:cov. (c,1) O '93
— Fallen leaves in circular pattern in zen
 garden (Japan)
 Trav/Holiday 177:56 (c,2) Jl '94
— Holly leaves
 Natur Hist 102:60 (c,4) S '93
— Maple leaves
 Nat Wildlife 32:60 (c,1) D '93
 Am Heritage 47:83 (painting,c,2) Jl '96
— Tulip tree leaves
 Natur Hist 102:60 (c,4) S '93
LEBANON
— See also
 BEIRUT

LEBANON—HISTORY
— 1991 release of Beirut hostage Terry
 Anderson
 Life 15:28–36 (c,1) F '92
**LEBANON—POLITICS AND GOV-
ERNMENT**
— Riot to overthrow government
 Life 15:6–7 (c,1) Jl '92
LE CORBUSIER
 Trav&Leisure 25:40 (4) S '95
— Villa Turque designed by him, La
 Chaux-de-Fonds, Switzerland
 Trav&Leisure 25:40,44 (c,4) S '95
LEE, ROBERT E.
 Am Heritage 43:10 (engraving,4) Ap '92
 Trav/Holiday 175:88,91 (4) O '92
— Lee's daughters
 Am Heritage 47:111 (c,4) Jl '96
— Stone Mountain Confederate heroes
 monument, Georgia
 Life 15:15 (c,1) Jl '92
LEECHES
 Life 15:68 (c,4) N '92
— On man's ankle (Congo)
 Nat Geog 188:6 (c,4) Jl '95
LEEWARD ISLANDS
— Anguilla
 Gourmet 54:128–31,200–2 (map,c,1) D
 '94
— Antigua
 Trav&Leisure 23:110–19,152 (map,c,1) O
 '93
 Trav/Holiday 179:44–5 (c,1) Jl '96
— Montserrat
 Trav/Holiday 176:106 (c,4) Mr '93
 Trav/Holiday 179:42–51 (map,c,1) Mr '96
— Nevis
 Gourmet 56:42–5,80 (map,c,1) Ja '96
— Saba
 Trav&Leisure 26:110–19,180–1 (map,c,1)
 Mr '96
— St. Barthelemy
 Trav&Leisure 22:5–8 (c,4) Ag '92
 Trav&Leisure 22:84–5,92–3,149 (c,1) D
 '92
— St. Kitts
 Trav&Leisure 22:81–4 (map,c,1) Ja '92
 Gourmet 56:42–5,80 (map,c,1) Ja '96
— St. Martin
 Trav&Leisure 22:20–1 (c,3) My '92
 Trav&Leisure 23:15,74–85 (map,c,1) F
 '93
 Natur Hist 105:59–61 (map,c,1) O '96
— See also
 GUADELOUPE

LEGER, FERNAND
— "Two Women" (1922)
 Smithsonian 27:44 (painting,c,2) Jl '96
LEHAR, FRANZ
— Home (Ban Ischl, Austria)
 Trav&Leisure 25:136 (c,4) O '95
LEIGH, VIVIAN
 Life 19:80 (2) Mr '96
LEIPZIG, GERMANY
 Trav&Leisure 24:113,117 (1) F '94
LEMURS
 Trav&Leisure 22:49,52 (c,4) Jl '92
 Life 16:6 (c,3) My '93
 Nat Geog 186:20 (c,1) D '94
— Extinct Notharctus
 Natur Hist 101:54–8 (painting,c,1) Ag '92
— Lemur embryo
 Life 19:41 (c,4) N '96
— Verreaux's sifaka
 Natur Hist 101:cov.,59 (c,1) Ag '92
— See also
 POTTOS
LENIN, VLADIMIR
 Am Heritage 43:67 (4) F '92
 Nat Geog 182:118 (4) O '92
— Fallen statue of Lenin
 Life 15:26 (c,4) Mr '92
 Life 19:34 (c,4) D '96
LENNON, JOHN
— Depicted in graffiti (Czechoslovakia)
 Smithsonian 24:67 (c,3) Je '93
LEONARDO DA VINCI
— 15th cent. sketches of skulls
 Natur Hist 105:2 (4) O '96
— "Codex Leiceste'" sketches
 Natur Hist 105:14 (c,4) N '96
— "Ginevra de'Benci" (1474)
 Trav/Holiday 178:76 (painting,c,1) Mr '95
— "Mona Lisa" made of toast
 Smithsonian 25:98 (c,4) Ja '95
— Sketches of plants
 Natur Hist 101:23 (1) Jl '92
— "The Virgin of the Rocks" (1485)
 Life 19:82–3 (painting,c,2) Jl '96
LEOPARDS
 Natur Hist 102:76–7 (c,1) Je '93
 Nat Wildlife 31:2–3 (c,2) Ag '93
 Natur Hist 103:cov.,55 (c,1) Ag '94
 Natur Hist 103:6 (c,3) D '94
 Nat Geog 186:21 (c,3) D '94
 Gourmet 55:72 (c,4) Ja '95
 Life 18:72 (c,3) My '95
 Nat Geog 188:26–7 (c,1) Jl '95
 Nat Geog 190:cov.,24–9 (c,1) Jl '96
 Trav/Holiday 179:42–3 (c,1) Jl '96

 Life 19:30 (c,4) S '96
 Life 19:70–1 (c,1) O '96
— Seen in silhouette
 Nat Wildlife 33:4 (c,4) Ag '95
— Snow leopard
 Life 16:4 (c,4) Mr '93
LEOPOLD, ALDO
 Am Heritage 45:53–4,59 (4) S '94
LEWIS, SINCLAIR
 Smithsonian 23:144 (drawing,4) N '92
— Home (Woodstock, Vermont)
 Trav&Leisure 23:122–7 (c,1) D '93
LEWIS AND CLARK
— 1804 exploration route through Northwest
 Trav/Holiday 177:39,68–77 (map,c,1) Je
 '94
— Compass used by Lewis & Clark
 Smithsonian 27:23 (c,4) Ag '96
LHASA, TIBET
 Trav&Leisure 23:84,86–7 (c,2) Jl '93
— Ganden Palace
 Trav&Leisure 23:84 (c,3) Jl '93
LIBERIA—COSTUME
— Children
 Life 16:12–13 (c,1) F '93
**LIBERIA—POLITICS AND GOVERN-
MENT**
— Civil War scene
 Life 19:14 (c,2) Je '96
— Onlookers watching firing squad victim
 Life 16:12–13 (c,1) F '93
**LIBERTY, STATUE OF, NEW YORK
CITY, NEW YORK**
 Life 15:7 (c,3) S '92
 Am Heritage 47:67 (painting,c,2) F '96
 Life 19:7 (c,2) Jl '96
— 1880s cracker ad featuring Miss Liberty
 Smithsonian 27:83 (c,2) Jl '96
— 1918 living portrait
 Smithsonian 26:61 (3) Ja '96
— Depicted in political cartoons
 Smithsonian 27:84–5 (3) Jl '96
— Depicted in World War II poster
 Life 18:117 (c,2) Je 5 '93
— Depicted with mixing bowl and spoon
 Gourmet 53:54 (painting,c,2) Ap '93
— Statue of Liberty ordering immigrants to
 leave
 Am Heritage 45:cov. (c,1) F '94
**LIBERTY BELL, PHILADELPHIA,
PENNSYLVANIA**
 Trav&Leisure 25:P1 (c,2) O '95
 Trav&Leisure 26:P1 (c,3) Jl '96
— 1918 living portrait
 Smithsonian 26:60–1 (1) Ja '96

— Liberty Bell balloon in parade
(Pennsylvania)
Trav/Holiday 178:63 (c,4) N '95
LIBRARIES
— 1880s Chicago mansion, Illinois
Am Heritage 43:110–11 (c,1) D '92
— Ancient cuneiform library, Sippar, Iraq
Natur Hist 105:16 (4) S '96
— Argentina ranch house
Trav&Leisure 25:84 (c,1) Ja '95
— Biltmore estate, Asheville, North Carolina
Smithsonian 23:63 (c,4) S '92
Trav&Leisure 25:87 (c,1) Jl '95
— George Peabody Library, Baltimore,
Maryland
Trav/Holiday 179:57 (c,1) Jl '96
— Home library (Philadelphia, Pennsylvania)
Smithsonian 23:106–7 (c,1) Ap '92
— Los Angeles Central Library, California
Trav&Leisure 24:E8–E9 (c,3) Ap '94
— Miniature model of White House library,
Washington, D.C.
Am Heritage 46:105 (c,4) F '95
— National Geographic Society, Washington,
D.C. (1940s)
Nat Geog 187:58 (4) My '95
— Old-fashioned card catalog and book-
shelves
Life 19:62–3 (1) S '96
— Palace libraries (Sweden)
Trav&Leisure 24:64–5 (c,4) Mr '94
— San Lorenzo, Florence, Italy
Trav/Holiday 178:42 (c,1) D '95
— Sledmere House, Yorkshire, England
Trav&Leisure 25:90 (c,1) Je '95
— See also
LIBRARY OF CONGRESS
NEW YORK PUBLIC LIBRARY
**LIBRARY OF CONGRESS, WASHING-
TON, D.C.**
Life 15:52–8 (c,1) D '92
— Magazine shelves
Smithsonian 24:80 (c,3) O '93
LICE
Life 17:58–9,66 (c,1) My '94
LICENSE PLATES
— Victoria, Australia
Trav&Leisure 26:114 (c,4) Jl '96
LICHENS
Natur Hist 102:74–5 (c,1) Ag '93
Natur Hist 104:74 (c,2) My '95
— Caribou moss
Nat Geog 184:25 (c,4) O '93

LIFESTYLES
— 1880s lake resort of Pittsburgh's elite,
Pennsylvania
Am Heritage 43:120–7 (1) N '92
— Early 20th cent. Arden Utopian
community, Delaware
Smithsonian 23:124–42 (c,3) My '92
— 1930–1950 scenes of black life (Cleveland,
Ohio)
Am Heritage 46:40–5 (1) F '95 supp.
— 1930s Depression life (South)
Life 15:80–8 (1) My '92
— 1934 black night life (Chicago, Illinois)
Am Heritage 46:20–1 (painting,c,1) F '95
supp.
— 1940s-style night life (San Francisco,
California)
Trav/Holiday 179:102–7 (c,1) D '96
— 1946 New York City street scenes
Am Heritage 47:100–3 (c,1) D '96
— 1950s luxury hotel scene (Beverly Hills,
California)
Trav&Leisure 25:76 (3) S '95
— 1950s scenes of U.S. life (Virginia)
Life 19:7,96–100 (1) D '96
— 1954 scenes
Am Heritage 45:30–9 (c,1) D '94
— 1984 teens cruising in convertible
(California)
Life 19:102–3 (c,1) Winter '96
— 1996 convention of 1970s leisure suits
(Iowa)
Life 19:18–22 (c,2) F '96
— Appalachian life
Nat Geog 183:112–36 (c,1) F '93
— Author on national book tour circuit
Trav&Leisure 24:122–5 (4) Mr '94
— Bronx slum life, New York
Life 18:50–8 (1) S '95
— Child beauty pageant contestant
Life 17:56–68 (c,1) Ap '94
— Depressed midwestern town (Illinois)
Life 15:8,56–62 (1) Mr '92
— Depressing view of Russian life
Life 18:56–63 (c,1) Jl '95
— Families around the world
Life 17:54–61 (c,1) Jl '94
— Hasidic life in Judean Hills, Israel
Natur Hist 105:38–49 (1) D '96
— Life of college basketball player (Kansas)
Sports Illus 82:70–4 (c,1) F 13 '95
— Lifestyle of Dallas Cowboys
Sports Illus 81:cov.,20–85 (c,1) D 12 '94

— Lifestyle of football player
Sports Illus 83:22–33 (c,1) O 30 '95
— Lifestyle of a supermodel
Sports Illus 80:120–9 (painting,c,1) F 14
'94
— Lifestyle of Vice President Gore's wife
Tipper
Life 17:82–7 (c,1) Mr '94
— Midwestern woman learning to live in
New York City
Life 15:53–9 (c,2) S '92
— Midwife's life (West Virginia)
Life 18:76–82 (1) F '95
— Paris' Bastille area, France
Trav&Leisure 23:106–15 (1) My '93
— Scenes from summer 1963
Life 16:28–35 (c,1) Je '93
— Scenes of country singer Garth Brooks'
daily life
Life 15:55–63 (c,1) Jl '92
— Social night in small town (North Carolina)
Life 18:54–62 (c,1) O '95
— Society women at tea (Florida)
Nat Geog 182:18 (c,4) Jl '92
— Staff of lord's manor home (Great Britain)
Life 17:19–22 (c,1) S '94
— Vietnamese immigrants (California)
Smithsonian 23:28–39 (c,1) Ag '92
— Washington, D.C.
Life 18:55–74 (1) Ag '95
— Welfare family's monthly food purchases
Life 19:65–71 (c,1) Ja '96
— See also
COLLEGE LIFE
FAMILY LIFE
FARM LIFE
MILITARY LIFE
POVERTY
PRISON LIFE
RURAL LIFE
SUBURBAN LIFE
WESTERN FRONTIER LIFE
YOUTH

LIGHTHOUSES
— Alcatraz, San Francisco, California
Smithsonian 26:88 (c,3) S '95
— Bahamas
Gourmet 52:54–5 (c,1) Ja '92
— Bass Harbor Head lighthouse, Maine
Trav/Holiday 178:77 (c,3) Je '95
— Belle-Ile, France
Trav/Holiday 175:69 (painting,c,2) Je '92
— Big Bay Point Lighthouse, Michigan
Trav&Leisure 23:E6 (c,4) Ag '93
— Block Island, Rhode Island

Trav/Holiday 178:15 (c,4) Mr '95
— Cape Cod, Massachusetts
Gourmet 53:8 (c,4) Ap '93
— Cape Florida
Nat Geog 183:14 (c,4) Ap '93
— Cape Hatteras, North Carolina
Smithsonian 23:82 (c,4) O '92
— Channel Islands, Great Britain
Trav&Leisure 22:58 (c,3) S '92
— Crete
Gourmet 52:77 (c,1) F '92
— Dry Tortugas
Life 17:76 (c,4) Ap '94
— Evanston, Illinois
Trav&Leisure 25:173 (c,4) My '95
— Hatteras Light, North Carolina
Gourmet 55:98,103 (c,2) Ap '95
— Kilauea, Kauai, Hawaii
Natur Hist 105:66 (c,4) D '96
— Mackinac Island, Michigan
Sports Illus 78:126–7 (c,1) F 22 '93
— Maine
Gourmet 54:131 (c,1) My '94
— Marshall Point Light, Maine
Gourmet 52:92–3 (c,1) My '92
— Martha's Vineyard, Massachusetts
Trav&Leisure 26:101 (c,4) Ap '96
— Michigan
Nat Wildlife 33:56–7 (c,1) O '95
— Montauk Point, New York
Gourmet 52:82 (c,4) S '92
— Nantucket, Massachusetts
Trav/Holiday 179:cov.,32–3 (c,1) Jl '96
— New London Harbor Light, Connecticut
Nat Geog 185:86–7 (c,1) F '94
— Nobska Light, Woods Hole, Massachusetts
Gourmet 54:74 (c,4) F '94
— North Dumpling Island, Connecticut
Smithsonian 25:108 (c,2) N '94
— Nubble Lighthouse, Maine
Trav/Holiday 175:30 (c,4) O '92
— Old Head of Kinsale lighthouse, Ireland
Nat Geog 185:77 (c,4) Ap '94
— Pharos of Alexandria, Egypt
Life 19:72 (drawing,c,4) Ap '96
— Point Sur, California
Trav/Holiday 179:88 (c,3) D '96
— St. James, Michigan
Smithsonian 26:92 (c,4) Ag '95
— St. Simon, Georgia
Gourmet 54:92–3 (c,1) F '94
— Split Rock Lighthouse, Minnesota
Nat Geog 184:72–3 (c,1) D '93
— Sydney, Australia
Trav/Holiday 176:53 (c,4) Je '93

— Sylt, Germany
Trav&Leisure 26:148 (c,1) O '96
— Tahiti
Trav&Leisure 24:172 (c,4) Ap '94
— Youghal Lighthouse, County Cork, Ireland
Gourmet 54:96 (c,4) Mr '94
LIGHTING
— Early 19th cent. French chandelier
Trav&Leisure 26:117 (c,4) Ap '96
— Photograph of laser beam
Life 19:74 (c,4) O '96
— See also
ELECTRICITY
LANTERNS
LIGHTNING
Nat Geog 183:108–9 (c,2) Mr '93
Nat Geog 184:cov.,80–103 (c,1) Jl '93
Life 16:cov.,34–5 (c,1) S '93
Nat Wildlife 31:58–9 (c,1) O '93
Nat Wildlife 32:54–5 (c,1) D '93
Smithsonian 25:60 (c,4) O '94
— Aymara people purifying room struck by
lightning (Peru)
Natur Hist 102:6 (c,4) N '93
— Fire caused by lightning (Florida)
Nat Wildlife 32:30–1 (c,1) Ag '94
— "The Lightning Field" (New Mexico)
Trav&Leisure 23:E25 (c,4) My '93
— Over Bosporus Strait, Turkey
Nat Geog 185:4–5 (c,1) My '94
— Over prairie (Oklahoma)
Nat Geog 184:96–7 (c,1) O '93
— Over rural countryside (Illinois)
Life 16:10–11 (c,1) Jl '93
— Over Tucson, Arizona
Nat Geog 184:80–1,96,102–3 (c,1) Jl '93
Life 16:34–5 (c,1) S '93
Nat Geog 184:16–17 (c,2) N 15 '93
LIGHTS
— Putting colored lights on the Empire State
Building, New York City
Trav&Leisure 24:149 (c,1) Jl '94
— Stadium lights (Cincinnati, Ohio)
Sports Illus 78:2–3 (c,1) Je 7 '93
— See also
TRAFFIC LIGHTS
LILIES
Trav/Holiday 176:66 (c,4) My '93
— Desert lily
Smithsonian 25:81 (c,4) Mr '95
— Swamp lilies
Nat Wildlife 35:40 (c,3) D '96
— Western lilies
Nat Wildlife 35:26–7 (c,1) D '96
— Wood lilies

Natur Hist 103:22 (c,4) Mr '94
— See also
CALLA LILIES
LILLE, FRANCE
Trav&Leisure 26:85–8 (c,4) O '96
LIMA, PERU
Nat Geog 189:13–15 (c,1) My '96
LIMESTONE
— Limestone bluffs (Aran Islands, Ireland)
Nat Geog 189:122–3 (c,1) Ap '96
— Limestone tufa (Mono Lake, California)
Nat Wildlife 33:36 (c,1) Je '95
LINCOLN, ABRAHAM
Trav/Holiday 175:113 (4) O '92
Am Heritage 44:cov. (1) O '93
Am Heritage 45:38–42 (2) F '94
Am Heritage 45:19 (4) Ap '94
Am Heritage 46:78–9 (4) Jl '95
Am Heritage 47:68 (painting,c,4) F '96
Am Heritage 47:61–3 (2) O '96
— 1865 poster offering reward for Lincoln's
assassins
Am Heritage 43:102 (4) Jl '92
— At Civil War camp
Trav&Leisure 25:189 (4) Ap '95
— Caricature
Smithsonian 27:65 (c,4) Ag '96
— Conspirators in Lincoln assassination
Am Heritage 43:cov.,104,107–9 (1) S '92
— Gun that killed Lincoln
Am Heritage 43:cov.,105 (c,4) S '92
— Life mask of Lincoln
Am Heritage 46:63 (c,4) F '95
— Lincoln in 1831 fistfight
Sports Illus 82:12 (drawing,4) F 6 '95
— Lincoln family
Smithsonian 23:139 (painting,4) O '92
Trav/Holiday 175:72 (4) N '92
— On deathbed
Smithsonian 24:124 (painting,c,4) Mr '94
— Sites related to Booth's flight
Am Heritage 43:104–19 (c,1) S '92
— Statue (New Jersey)
Smithsonian 23:66 (3) Ag '92
— See also
BOOTH, JOHN WILKES
CIVIL WAR
**LINCOLN MEMORIAL, WASHING-
TON, D.C.**
Smithsonian 23:112 (c,3) Mr '93
Am Heritage 46:114 (c,4) F '95
LINDBERGH, CHARLES A.
Life 19:42 (2) O '96
— Lindbergh baby
Life 18:34 (4) Mr '95

LINNAEUS, CAROLUS
 Natur Hist 102:14 (drawing,4) Ap '93
LIONS
 Nat Geog 181:55,59,85 (c,1) Ja '92
 Nat Geog 181:122-36 (c,1) Ap '92
 Trav&Leisure 22:128,138-9 (c,1) Je '92
 Trav/Holiday 175:67 (c,4) N '92
 Natur Hist 101:84-5 (c,1) N '92
 Trav&Leisure 23:94,100-1 (c,1) F '93
 Life 16:62-3,70-2 (c,1) Jl '93
 Nat Wildlife 31:18-19 (c,1) Ag '93
 Trav/Holiday 176:16 (c,4) O '93
 Life 17:72-3 (c,1) Mr '94
 Trav/Holiday 177:92 (c,4) Mr '94
 Natur Hist 103:80-1 (c,1) My '94
 Nat Geog 186:cov.,32-53 (c,1) Ag '94
 Gourmet 55:74 (c,4) Ja '95
 Trav&Leisure 25:149,202 (c,4) N '95
 Sports Illus 84:74 (c,4) Ja 29 '96
 Natur Hist 105:14 (c,4) My '96
 Life 19:76-86 (c,1) My '96
 Nat Geog 190:5-7 (c,1) Jl '96
 — 13th cent. bronze lion (Spain)
 Smithsonian 23:49 (c,4) Ag '92
 — Cubs
 Nat Geog 186:3-4 (c,1) D '94
 Life 18:cov.,72 (c,1) My '95
 — Lion statue in front of New York Public
 Library, New York City
 Smithsonian 24:92 (c,2) Ag '93
 — Lions mating
 Natur Hist 101:76-7 (c,1) Ap '92
 Life 19:81 (c,4) My '96
 — White lion
 Life 18:24 (c,4) Ap '95
 — See also
 MOUNTAIN LIONS
LIPCHITZ, JACQUES
 — Portrait by Modigliani
 Smithsonian 24:68 (painting,c,4) Ja '94
LIPPI, FILIPPINO
 — Painting of Moses
 Smithsonian 26:70 (c,3) Ja '96
LIQUOR
 — The Manhattan cocktail
 Am Heritage 43:63 (painting,c,4) F '92
 — Martini
 Trav&Leisure 25:48 (c,4) S '95
 Life 19:104 (c,2) N '96
 — Mint julep (Kentucky)
 Trav&Leisure 22:NY10 (c,3) My '92
LIQUOR INDUSTRY
 — Alcohol tank on ship
 Nat Geog 181:16-17 (c,1) F '92
 — International problem of alcoholism

 Nat Geog 181:2-36 (c,1) F '92
 — Maker's Mark distillery, Loretto, Kentucky
 Natur Hist 103:A6 (c,4) Ap '94
LISBON, PORTUGAL
 Gourmet 54:112-17 (c,1) O '94
 Trav/Holiday 177:44-55 (map,c,1) N '94
 — Empire Plaza
 Nat Geog 181:30-1 (c,1) Ja '92
 — Jeronimos Monastery
 Trav&Leisure 22:78 (c,4) Mr '92
 Gourmet 54:114 (c,3) O '94
 — Restaurants
 Trav&Leisure 23:56-8 (c,4) O '93
 — Street scene with trolley
 Trav/Holiday 179:61 (c,2) Ap '96
 — Topiary park
 Trav/Holiday 175:12 (c,4) Je '92
 — Tower of Belem
 Gourmet 54:114 (c,4) O '94
 Trav/Holiday 177:55 (c,3) N '94
LISZT, FRANZ
 — Caricature
 Smithsonian 27:132 (painting,c,4) D '96
LITTLE ROCK, ARKANSAS
 — Central High School
 Smithsonian 27:54 (c,4) S '96
LIZARDS
 — 18th cent. paintings of lizards
 Natur Hist 101:52-3 (c,1) D '92
 — Anoles
 Life 17:58-9,61 (c,1) Je '94
 Life 18:64 (c,4) S '95
 — Basilisk walking on water
 Life 19:16 (c,2) Ag '96
 — Blue-tailed
 Natur Hist 103:66-7 (c,4) Ag '94
 — Collared lizard
 Natur Hist 105:61 (c,4) Ap '96
 — Collared lizard losing fight with roadrunner
 Smithsonian 23:60-1 (c,3) Mr '93
 Nat Wildlife 32:10 (c,4) Je '94
 — Frillneck lizard
 Natur Hist 102:112-13 (c,1) O '93
 — Goanna lizard
 Smithsonian 24:82 (c,2) N '93
 — Mountain devil
 Nat Geog 187:82 (c,4) Ja '95
 — Sand lizards
 Natur Hist 102:28-9 (c,1) Ag '93
 — See also
 CHAMELEONS
 GECKOS
 HORNED LIZARDS
 IGUANAS
 KOMODO DRAGONS

MONITORS
SKINKS
SNAKES
LLAMAS
Trav&Leisure 22:118–19 (painting,c,1)
My '92
Nat Geog 184:60–1 (c,2) Jl '93
Smithsonian 25:54–63 (c,1) Ag '94
Smithsonian 25:12 (c,3) O '94
Trav&Leisure 26:122 (c,4) F '96
Life 19:68–9 (c,3) Ag '96
— Llama golf caddies (North Carolina)
Life 16:23 (c,4) My '93
Smithsonian 25:58 (c,3) Ag '94
LLOYD GEORGE, DAVID
Smithsonian 25:173 (4) N '94
LOBSTERS
Natur Hist 102:42–9 (c,1) Jl '93
Natur Hist 103:50–1 (c,1) F '94
— Baby lobsters
Natur Hist 102:42–7 (c,1) Jl '93
— Cooked lobster
Trav/Holiday 179:79 (c,1) S '96
— Spiny lobsters
Natur Hist 105:24–7 (c,2) Jl '96
LOCKER ROOMS
— Baseball
Sports Illus 85:40 (c,4) Ag 19 '96
— College team
Sports Illus 78:52 (c,4) Mr 8 '93
— Football
Sports Illus 79:21 (c,2) O 4 '93
Sports Illus 81:2–3,24,43,74,84 (c,1) D 12
'94
Sports Illus 82:36–7 (c,1) F 6 '95
LOCOMOTIVES
— 1858
Am Heritage 44:36–7 (painting,c,1) O '93
— Late 19th cent.
Life 16:87 (3) F '93
— 1904
Am Heritage 43:98 (1) F '92
— 1930s
Am Heritage 43:8 (4) Ap '92
— 1950s steam locomotives
Smithsonian 26:62–7 (1) O '95
— Steam locomotives
Am Heritage 47:124–35 (c,1) Ap '96
— Steam trains (Africa)
Life 18:92–9 (c,1) N '95
— See also
RAILROADS
TRAINS
LOG CABINS
— 1790s interior (Tennessee)

Smithsonian 26:53 (c,2) F '96
— 19th cent.
Smithsonian 22:70–1 (4) Mr '92
— 1808 (Virginia)
Am Heritage 45:94 (c,4) O '94
— 1850s (Michigan)
Smithsonian 26:87,89 (4) Ag '95
— 1971 (Wyoming)
Life 16:41 (c,4) Ap 5 '93
— At ski resort (Colorado)
Trav&Leisure 22:102–5 (c,1) F '92
— Contemporary log homes
Smithsonian 22:66–75 (c,1) Mr '92
— Idaho
Trav&Leisure 23:95 (c,2) Jl '93
— Montana
Trav&Leisure 25:132 (1) F '95
— Park shelter (Sweden)
Trav/Holiday 177:45 (c,3) Je '94
Logging. See
LUMBERING
LOMBARDI, VINCE
Sports Illus 81:140 (c,4) N 14 '94
LONDON, ENGLAND
Trav&Leisure 22:75,90–103 (map,c,2) Ap
'92
Trav&Leisure 23:84–5 (map,c,1) S '93
Trav&Leisure 25:103–13,152–6 (c,1) Ap
'95
Trav&Leisure 26:66–73 (c,1) Ag '96
— 1850 Crystal Palace
Natur Hist 105:49 (drawing,c,3) F '96
— Blue Plaques on homes of notable people
Gourmet 52:54,60,181–4 (c,4) My '92
— Churches
Gourmet 55:56,62–4 (map,c,4) N '95
— Criterion restaurant
Trav&Leisure 23:84 (c,4) Ap '93
— East End art scene
Trav&Leisure 26:40–4 (c,4) N '96
— Fulham Palace garden
Gourmet 55:28 (drawing,c,2) Ag '95
— Harrod's food hall
Gourmet 53:24 (drawing,c,2) Ag '93
— Hyde Park
Trav&Leisure 24:97–9 (c,1) Mr '94
— Islington
Trav&Leisure 26:42 (map,c,3) My '96
— Kensington Gardens
Trav&Leisure 25:62 (c,4) D '95
— Kew Palace
Trav&Leisure 24:65–6 (c,1) Ag '94
— Leicester Square
Trav/Holiday 179:46 (c,4) S '96
— Lloyd's of London headquarters

Smithsonian 26:36 (c,4) Ap '95
— Luxury hotels
Trav&Leisure 25:40–4,107 (c,1) Ap '95
— Map of Soho
Gourmet 53:44 (c,2) My '93
— Notting Hill area
Trav&Leisure 24:101–3,140 (map,c,4) Mr '94
Gourmet 56:42 (c,4) Ag '96
— Office buildings damaged by IRA bomb
Life 15:24 (c,4) Je '92
Life 17:22–3 (c,1) Ja '94
— Picadilly Circus
Trav&Leisure 26:71 (c,1) Ag '96
— Portobello Road
Trav/Holiday 175:34 (c,4) N '92
— Restaurants
Trav&Leisure 23:76—85 (c,1) S '93
Trav/Holiday 179:48–9 (c,3) N '96
— Richmond countryside
Trav&Leisure 24:56–67,101,103 (map,c,1) Ag '94
— St. Stephen Walbrook church
Trav/Holiday 179:57 (c,2) Ap '96
— Savoy Hotel
Trav&Leisure 25:107 (c,1) Ap '95
— Theaters
Trav&Leisure 24:178 (c,1) O '94
Trav/Holiday 179:46–8 (c,1) S '96
— Trafalgar Square
Gourmet 56:42 (drawing,c,2) F '96
— Waterloo Terminal
Trav/Holiday 178:31 (c,4) Jl '95
— See also
BUCKINGHAM PALACE
THAMES RIVER
TOWER OF LONDON
LONG, HUEY
— Brother Earl Kemp Long
Life 18:31 (4) Ag '95
— Caricature
Am Heritage 46:99 (c,2) D '95
LONG ISLAND, NEW YORK
— 1940s Levittown houses
Am Heritage 44:62–9 (c,2) Jl '93
— Hamptons beach
Gourmet 53:76 (c,4) Je '93
— Montauk lighthouse
Gourmet 52:82 (c,4) S '92
LOONS
Natur Hist 101:56–7 (c,2) My '92
Nat Geog 182:100 (c,4) S '92
Nat Wildlife 31:2–3 (c,2) Je '93
Natur Hist 102:76–7 (c,1) Jl '93
Nat Wildlife 33:46 (painting,c,3) O '95

Natur Hist 105:cov. (c,1) My '96
Nat Wildlife 34:2,12–19 (c,1) Ag '96
LOS ANGELES, CALIFORNIA
— 1992 riots
Sports Illus 76:24–31 (c,2) My 11 '92
Life 15:10–20 (c,1) Je '92
Life 16:20–1 (c,1) Ja '93
Trav&Leisure 23:171 (c,4) My '93
— Bradbury Building
Trav&Leisure 22:23 (c,3) Ap '92
— Cars crushed in 1994 earthquake
Life 17:43 (c,4) Ap '94
— Central Library
Trav&Leisure 24:E8–E9 (c,3) Ap '94
— Chateau Marmont
Trav&Leisure 23:72–7 (c,1) Ag '93
— Freeway after 1994 earthquake
Life 18:22–3 (c,1) Ja '95
— "In" spots
Trav&Leisure 25:127–48 (c,1) My '95
— Japanese American National Museum interior
Trav&Leisure 22:21 (c,3) S '92
— Los Angeles Museum of Contemporary Art
Smithsonian 23:62 (c,4) Jl '92
— Lummis House
Trav&Leisure 24:E13 (c,4) Ag '94
— Night scene
Nat Geog 187:14–15 (c,1) Ap '95
— Office buildings
Am Heritage 44:51 (c,4) O '93
Nat Wildlife 34:41 (c,1) O '96
— Outdoor cafe
Gourmet 55:38 (c,2) O '95
— Street scene
Trav&Leisure 25:61 (2) Ja '95
Trav&Leisure 26:180 (c,1) S '96
— Sunset Boulevard
Nat Geog 181:40–69 (map,c,1) Je '92
Trav&Leisure 23:72–3 (c,1) Ag '93
Trav&Leisure 25:130–1 (c,1) My '95
— Universal City's City Walk
Trav&Leisure 23:NY6 (c,4) O '93
— View from top of Runyon Canyon
Trav&Leisure 24:38 (c,4) Ja '94
— Wilshire Boulevard
Trav&Leisure 25:170–7 (map,c,4) F '95
LOTUS FLOWERS
Trav&Leisure 26:167 (c,4) S '96
LOUIS, JOE
Life 18:135 (3) Je 5 '95
Nat Geog 190:63 (4) Jl '96
LOUISIANA
— Antebellum estates

Trav&Leisure 26:110–21,156–60 (c,1) Ap '96
— Atchafalaya Basin
Trav/Holiday 177:60–1 (c,1) N '94
— Bayou Barataria cemetery
Am Heritage 47:68–9 (1) O '96
— Bayou Sauvage Wildlife Refuge
Nat Geog 187:96 (c,3) Ja '95
— Cajun country
Trav/Holiday 177:56–65 (map,c,1) N '94
— Countryside
Trav&Leisure 24:166–7 (c,4) Mr '94
Natur Hist 104:36–9 (c,1) My '95
Life 18:108–9 (c,1) Je '95
— Gulf Coast
Nat Geog 182:5–15,26–7 (map,c,1) Jl '92
— Marsh
Nat Geog 190:31 (c,3) O '96
— Natchitoches restaurant
Gourmet 56:38,114 (c,4) Ja '96
— Nottoway Plantation
Trav&Leisure 24:167 (c,4) Mr '94
— Waterproof depot in 1927 flood
Smithsonian 24:14 (4) Ap '93
— See also
BATON ROUGE
LONG, HUEY
MISSISSIPPI RIVER
NEW ORLEANS
LOUISIANA—MAPS
Trav&Leisure 24:169 (c,3) Mr '94
— Cajun country
Trav/Holiday 177:37 (c,4) My '94
LOUISVILLE, KENTUCKY
— Brown Hotel lobby
Trav&Leisure 26:112 (c,4) O '96
— Louisville Slugger Museum
Sports Illus 85:6 (c,4) S 16 '96
LOURDES, FRANCE
Life 19:50 (c,3) D '96
— Replica of Lourdes Grotto (Belleville, Illinois)
Life 19:60 (c,3) D '96
LOUVRE, PARIS, FRANCE
Trav/Holiday 176:41 (c,4) N '93
Life 16:12–13 (c,1) N '93
Smithsonian 24:42–52 (map,c,1) D '93
— Hall of the Hens
Trav&Leisure 23:30 (c,4) N '93
Love. See
KISSING
ROMANCE
LOWELL, PERCIVAL
Natur Hist 105:23 (4) D '96

LUDWIG II (GERMANY)
Trav/Holiday 176:72 (painting,c,4) My '93
— Linderhof Castle, Bavaria
Trav&Leisure 23:92–9,143 (map,c,1) D '93
— Ludwig's castles (Bavaria, Germany)
Trav/Holiday 176:cov.,70–7 (map,c,1) My '93
LUGE
Sports Illus 76:2–3,64,68,79 (c,1) Ja 27 '92
Sports Illus 79:54 (c,1) D 13 '93
Sports Illus 80:118–19 (c,1) F 7 '94
— 1992 Olympics (Albertville)
Sports Illus 76:44 (c,3) F 17 '92
Sports Illus 76:72–3 (c,1) Mr 2 '92
Sports Illus 80:48 (c,4) Ja 10 '94
— 1994 Olympics (Lillehammer)
Sports Illus 80:30–3 (c,2) F 21 '94
— Street luge
Sports Illus 83:42–3 (c,1) Jl 3 '95
LUGGAGE
— 1843 pioneer's trunk
Life 16:70 (c,4) D '93
LUMBERING
— 1890s (California)
Am Heritage 44:40–1 (2) O '93
— Alaska
Nat Geog 184:56 (c,1) N '93
— California
Smithsonian 24:52 (c,4) O '93
Trav/Holiday 177:85 (4) Ap '94
Life 19:66–7 (c,3) Ag '96
— Clear-cut land (British Columbia)
Nat Geog 184:84 (c,3) N 15 '93
— Clear-cut land (Idaho)
Nat Geog 185:22–3 (c,2) F '94
— Clear-cut land (Papua New Guinea)
Nat Geog 185:58 (c,3) F '94
— Clear-cut land (Siberia)
Nat Geog 184:42 (c,1) Jl '93
— Congo
Nat Geog 188:31 (c,1) Jl '95
— Felling tree to make farmland (Guatemala)
Nat Geog 182:94–6 (c,1) N '92
— Maine
Nat Wildlife 33:32 (c,4) O '95
— Sit-in to save tree from loggers (California)
Nat Geog 184:70–1 (c,2) Jl '93
— See also
SAWMILLS
LUMBERING—TRANSPORTATION
— Elephant moving logs (Burma)
Nat Geog 188:92–3 (c,1) Jl '95
— Floating logs to mill (California)

Nat Geog 184:72 (c,1) Jl '93
— Hauling hemlock tree (Oregon)
Nat Geog 185:4–5 (c,1) F '94
LUMBERJACKS
— 1890s (California)
Am Heritage 44:40–1 (2) O '93
LUPINES
Life 16:34 (c,4) O '93
Smithsonian 25:80 (c,4) Mr '95
Natur Hist 104:37 (c,3) Jl '95
LUTHER, MARTIN
— Martin Luther at Diet of Worms (1521)
Natur Hist 105:20 (painting,c,4) S '96
LUXEMBOURG
— TV newscasters waist deep in floodwater
Life 17:118 (c,2) Ap '94
LYNCHINGS
— 19th cent. lynching of rapist (Minnesota)
Life 16:20–1 (1) Ap 5 '93
— 1915 lynching of Leo Frank (Georgia)
Am Heritage 47:107 (1) O '96
LYNXES
Trav/Holiday 175:72 (c,4) Ap '92
Nat Wildlife 31:4–5,54–5 (c,1) D '92
Smithsonian 23:157 (painting,c,4) D '92
Nat Geog 184:77 (c,4) Ag '93
Nat Wildlife 31:52 (c,1) Ag '93
Nat Wildlife 32:2–3 (c,2) D '93
Natur Hist 104:6 (c,3) Mr '95
Nat Wildlife 34:40 (c,4) D '95
LYON, FRANCE
Gourmet 52:92–9 (c,1) O '92

–M–

MacARTHUR, DOUGLAS
Nat Geog 181:55–83 (c,1) Mr '92
Am Heritage 46:40 (4) D '95
Am Heritage 47:74–83 (c,1) F '96
— 1951 parade for MacArthur (New York)
Am Heritage 47:82–3 (1) F '96
— Family
Nat Geog 181:59,81,83 (c,1) Mr '92
— MacArthur landing at Leyte, Philippines
(1944)
Nat Geog 181:56–7,66 (c,1) Mr '92
Life 18:16–17 (1) Je 5 '95
Life 19:120 (3) O '96
— Memorial (Norfolk, Virginia)
Am Heritage 47:84 (c,4) F '96
— Statue of MacArthur (Philippines)
Life 17:29 (c,2) D '94
MACAU
Trav/Holiday 175:84–91 (map,c,1) Ap '92

MACAWS
Natur Hist 101:30 (c,1) F '92
Sports Illus 76:172 (c,4) Mr 9 '92
Trav&Leisure 23:cov. (c,1) Ja '93
Nat Geog 185:cov.,118–40 (c,1) Ja '94
Smithsonian 25:61 (c,4) Ap '94
Nat Wildlife 32:52 (c,4) Ap '94
Nat Wildlife 33:40–1 (painting,c,1) O '95
Gourmet 55:146 (c,4) D '95
Trav/Holiday 179:77 (c,4) O '96
MacDOWELL, EDWARD
Smithsonian 23:138 (4) N '92
MACEDONIA
Nat Geog 189:118–39 (map,c,1) Mr '96
— Skopje
Nat Geog 189:120–1,135 (c,1) Mr '96
MACEDONIA—COSTUME
Nat Geog 189:118–39 (c,1) Mr '96
MACHU PICCHU, PERU
Nat Geog 181:111 (c,4) Mr '92
Trav/Holiday 175:54–5 (c,1) Jl '92
Trav&Leisure 23:61 (c,4) My '93
Trav&Leisure 25:116–17 (c,1) Mr '95
MACK, CONNIE
Sports Illus 85:83 (3) Ag 19 '96
MACKINAC ISLAND, MICHIGAN
Sports Illus 78:126–32 (c,1) F 22 '93
Gourmet 54:142–5 (c,1) My '94
MADAGASCAR—COSTUME
Smithsonian 24:82–3 (c,2) N '93
— Farm workers
Nat Geog 185:52–3 (c,1) My '94
MADAGASCAR—MAPS
— Betsiboka River seen from space
Nat Geog 190:4–6 (c,1) N '96
**MADAGASCAR—RITES AND
FESTIVALS**
— Party for the Dead
Life 19:72 (c,4) S '96
MADEIRA
Gourmet 53:114–19,202 (map,c,1) D '93
Nat Geog 186:90–113 (map,c,1) N '94
— See also
FUNCHAL
MADISON, DOLLEY
Smithsonian 23:138 (drawing,4)) O '92
Trav/Holiday 175:72 (painting,c,4) N '92
MADONNA
Life 15:cov.,16–17,95 (c,1) D 1 '92
— Caricature of Madonna
Sports Illus 85:64,70 (c,1) N 4 '96
MADRAS, INDIA
Trav/Holiday 179:22 (c,4) N '96

MADRID, SPAIN
Trav/Holiday 175:20 (c,4) S '92
Trav/Holiday 176:64–73 (map,c,1) Mr '93
Trav&Leisure 23:70–81,117 (map,c,1) Jl
'93
Trav&Leisure 26:62–6 (c,4) D '96
— La Cebellas Fountain
Trav/Holiday 179:10 (c,4) Jl '96
— El Retiro Park
Trav/Holiday 179:39 (c,4) My '96
— Prado Museum
Smithsonian 22:54–65 (c,1) Ja '92
MAGAZINES
— Early 20th cent. *Lost Trails*
Am Heritage 44:69–73 (c,1) D '93
— 1932 magazine covers
Am Heritage 43:90 (1) N '92
— 1945 *Life* magazine covers
Life 18:8–9 (4) Je 5 '95
— 1992 *Sports Illustrated* covers
Sports Illus 77:2–3 (c,1) D 28 '92
— Designing layout of supermarket tabloid
Smithsonian 24:75 (c,3) O '93
— First *Sports Illustrated* cover (1954)
Sports Illus 83:6 (c,4) Ag 7 '95
— History of *Life* magazine
Life 19:entire issue (c,1) O '96
— *Life* magazine covers 1936–1996
Life 19:entire issue (c,1) O '96
— *Mad* magazine parody of Mount Rushmore
Smithsonian 23:70 (c,4) Ag '92
— Bernarr McFadden
Smithsonian 24:78 (4) O '93
— *Sports Illustrated*'s "Sportsperson of the
Year" covers (1954–1993)
Sports Illus 81:102–24 (c,4) D 19 '94
— See also
HEFNER, HUGH
MAGIC ACTS
— Columbus performing the "egg trick"
Natur Hist 102:2 (painting,c,4) Mr '93
— Three-card monte
Life 16:115–16 (c,3) O '93
MAGICIANS
Trav/Holiday 177:71–7 (2) O '94
— See also
HOUDINI, HARRY
MAGNOLIA TREES
Life 15:92–3,98–9 (c,1) O 30 '92
Gourmet 56:97 (c,2) S '96
— Blossom
Natur Hist 102:24 (c,2) D '93
MAGPIES
Nat Geog 182:84–5 (c,1) Ag '92

Natur Hist 103:54–61 (c,1) Mr '94
MAGRITTE, RENE
Smithsonian 23:49 (c,2) S '92
— "Golconda"
Trav&Leisure 22:18 (painting,c,3) S '92
— Paintings by him
Smithsonian 23:49–57 (c,1) S '92
— "The Son of Man"
Smithsonian 23:57 (painting,c,2) S '92
MAHLER, GUSTAV
— Home (Maiernigg, Austria)
Trav&Leisure 25:136 (c,4) O '95
MAILBOXES
— British post box (Hong Kong)
Gourmet 52:104 (c,4) Mr '92
— Mailbox shaped like set of teeth (Florida)
Life 19:33 (c,4) S '96
— Wyoming
Nat Geog 183:54–5 (c,1) Ja '93
MAILER, NORMAN
Am Heritage 43:40 (4) S '92
MAINE
— Autumn scenes
Nat Wildlife 33:2,30–5 (c,1) O '95
— Bar Harbor
Gourmet 54:132 (c,3) My '94
— Bass Harbor Head lighthouse
Trav/Holiday 178:77 (c,3) Je '95
— Bethel's "Artist's Bridge"
Trav&Leisure 22:E9 (c,3) F '92
— Cadillac Mountain
Trav/Holiday 178:69 (c,1) Je '95
— Coastal areas
Gourmet 52:98–103,158 (map,c,1) My '92
Trav&Leisure 25:96–105,161–3 (map,c,1)
My '95
— Deer Isle
Trav&Leisure 24:E28 (c,4) My '94
— Impressionistic view of Maine island after
rain
Trav&Leisure 24:E16 (c,4) Mr '94
— Monhegan Island
Gourmet 52:100–1 (c,1) My '92
— Mount Desert Island
Gourmet 54:130–3,198 (map,c,1) My '94
Natur Hist 103:33 (c,3) Jl '94
Trav/Holiday 178:69–77 (map,c,1) Je '95
— Nubble Lighthouse
Trav/Holiday 175:30 (c,4) O '92
— Pemaquid Point
Life 18:84 (c,4) Ag '95
— Phillips church
Trav/Holiday 175:84 (c,1) S '92
— Round Pond harbor
Trav/Holiday 179:82–3 (c,2) S '96

— See also
ACADIA NATIONAL PARK
PORTLAND
SMITH, MARGARET CHASE
MALAWI
— Refugee camp (1988)
Life 19:94 (c,2) Je '96
MALAYSIA
Trav/Holiday 176:44–53 (map,c,1) S '93
— Collecting rubber from tree
Trav/Holiday 178:68–9 (1) O '95
— See also
KUALA LUMPUR
MALAYSIA—COSTUME
Trav/Holiday 176:44–53 (map,c,1) S '93
— Penan tribesmen
Smithsonian 24:80 (c,3) N '93
— See also
ABORIGINES
MALCOLM X
Life 15:84–94 (1) D '92
Am Heritage 46:36 (c,4) F '95
— Mural of Malcolm X (Philadelphia, Pennsylvania)
Smithsonian 24:71 (c,1) Jl '93
MALI
Trav&Leisure 25:136–51 (map,c,1) F '95
— Djenne mosque
Trav&Leisure 25:147 (c,1) F '95
MALI—COSTUME
Trav&Leisure 25:136–51 (c,1) F '95
— Dogon people
Trav&Leisure 25:141,144 (c,1) F '95
— Tuareg people
Trav&Leisure 25:140,145–6,150 (c,1) F '95
MALI—RITES AND FESTIVALS
— Ritual on stilts for the dead
Trav&Leisure 25:141 (c,1) F '95
MALLARDS
Nat Wildlife 31:9 (c,2) Ag '93
Nat Wildlife 33:12–13 (c,1) Ap '95
Nat Wildlife 34:12–13,16–17 (c,1) Ap '96
Nat Wildlife 34:26 (c,4) Je '96
— Chicks
Nat Wildlife 34:5 (c,4) O '96
MALLOW PLANTS
Nat Wildlife 32:36 (c,4) Ag '94
Natur Hist 103:22–3 (c,1) D '94
Smithsonian 25:81 (c,4) Mr '95
Natur Hist 105:57 (c,4) Mr '96
Natur Hist 105:77 (c,4) N '96
MALNUTRITION
— 1961 malnourished child (Brazil)
Life 19:68 (1) O '96

— Purple fingers of starving baby (Ethiopia)
Life 17:16–17 (c,1) N '94
— Starving people (Somalia)
Life 15:3–13 (c,1) N '92
Life 16:32–5 (c,1) Ja '93
Nat Geog 184:88–121 (c,1) Ag '93
Life 19:98–9 (c,1) O '96
— Sudan
Life 15:50–8 (c,1) Je '92
Life 16:16 (c,2) Ag '93
MALTA
Trav/Holiday 177:48–55 (map,c,1) D '94
Smithsonian 27:62–73 (c,1) S '96
— Hagar Qim megalith
Smithsonian 27:62–8 (c,1) S '96
— See also
VALLETTA
MALTA—SEALS AND EMBLEMS
— Maltese shield
Smithsonian 27:24 (drawing,c,4) N '96
MAMMOTHS
Natur Hist 102:20–1 (painting,c,3) O '93
MAN, PREHISTORIC
— 1873 depiction of Neandertal man
Natur Hist 103:82 (etching,4) Mr '94
— Afarensis man
Nat Geog 189:96–117 (c,1) Mr '96
— Ancient man ambushing horses (China)
Natur Hist 102:54–5,58–9 (painting,c,1) My '93
— Copper Age "Iceman"
Nat Geog 183:36–55 (c,1) Je '93
— Creating models of ancient humans for museum exhibit (New York)
Life 16:48–52 (c,1) My '93
— Cro-Magnon man
Natur Hist 101:62–3 (painting,c,3) Ag '92
— Diorama of australopithecus (New York)
Natur Hist 102:92 (c,4) Ap '93
— Fossils of early hominids
Nat Geog 188:38–47 (c,1) S '95
— Homo habilis skull (Kenya)
Natur Hist 101:68 (4) F '92
— Lucy (Australopithecus)
Nat Geog 189:96 (c,4) Mr '96
— Map of early human sites (China)
Natur Hist 102:56 (c,3) My '93
— Neandertal man
Smithsonian 25:18 (drawing,4) S '94
Nat Geog 189:cov.,2–35 (c,1) Ja '96
— Otavipithecus jaw (Namibia)
Natur Hist 101:64 (c,4) Je '92
— Prehistoric man's skull
Natur Hist 102:53 (c,3) My '93
— Sculpture of prehistoric man

Natur Hist 104:44–7 (c,1) D '95
— Stone Age "Iceman" found in Alps
Natur Hist 102:60–1 (c,2) Ap '93
— See also
ARCHAEOLOGICAL SITES
CARDIFF GIANT
FOSSILS
MAN, PREHISTORIC—ART
— Cave drawing (Norway)
Sports Illus 80:2–3 (c,1) F 7 '94
— Cave paintings
Natur Hist 105:16–18,71 (c,1) Jl '96
— Cave paintings (France)
Natur Hist 102:72 (c,4) Ap '93
Natur Hist 104:30–5 (c,1) My '95
— Cro-Magnon clay bisons (France)
Natur Hist 102:22 (c,4) Mr '93
— Paleolithic cave paintings of animals
(Mediterranean Sea)
Natur Hist 102:64–71 (c,1) Ap '93
— Rock carvings (France)
Nat Geog 183:56 (c,3) Je '93
MAN, PREHISTORIC—ARTIFACTS
— 2400 year old Pazyryk tomb (Siberia)
Nat Geog 186:80–103 (c,1) O '94
— Bronze Age stone urns (Laos)
Natur Hist 104:48–55 (c,1) S '95
— Callandish Standing Stones, Isle of Lewis,
Scotland
Nat Geog 190:14–15 (c,1) S '96
— Carved figures
Natur Hist 102:60–7 (c,1) My '93
— Casa Malpais, Arizona
Smithsonian 22:33,36 (c,4) Mr '92
— Castlerigg stone circle, England
Trav&Leisure 22:129 (c,4) N '92
— Copper Age tools
Nat Geog 183:51–5,63 (c,2) Je '93
— Flint knives
Nat Geog 189:26 (c,4) Ja '96
— Hagar Qim monolith, Malta
Smithsonian 27:62–8 (c,1) S '96
— Japan
Smithsonian 23:146 (c,4) S '92
— Neolithic amber axes
Natur Hist 105:97 (c,4) F '96
— Neolithic burial mounds (Great Britain)
Smithsonian 24:124 (c,3) S '93
— Niya and Loulan, China
Nat Geog 189:45–51 (c,1) Mr '96
— Prehistoric ornaments
Natur Hist 102:60–7 (c,1) My '93
— Standing stones of Stall Moor, Dartmoor,
England
Smithsonian 24:83 (c,1) Jl '93

— Stone Age tools
Natur Hist 102:62–3 (c,4) Ap '93
— Stone kiva (Arizona)
Smithsonian 22:30–1 (c,2) Mr '92
— See also
STONEHENGE
**MAN, PREHISTORIC—RITES AND
FESTIVALS**
— Copper Age funeral
Nat Geog 183:64–5 (painting,c,1) Je '93
MANATEES
Life 15:60 (c,3) Ag '92
Nat Geog 187:10–13 (c,1) Mr '95
Nat Wildlife 34:25 (c,1) Ap '96
MANCHURIA, CHINA
— 1933 Manchukuo
Am Heritage 47:79 (4) N '96
MANDAN INDIANS—COSTUME
— Mandan woman
Trav&Leisure 25:E8 (c,4) Ag '95
MANDOLIN PLAYING
— Playing bluegrass music (West Virginia)
Smithsonian 23:cov.,70 (c,1) Mr '93
MANDOLINS
Smithsonian 27:56 (c,4) Jl '96
MANET, EDOUARD
— "Le Dejeuner sur l'Herbe" (1863)
Smithsonian 25:81 (painting,c,2) N '94
— "La Musique aux Tuileries"
Smithsonian 25:82–3 (painting,c,1) N '94
— "Olympia"
Natur Hist 104:4 (painting,c,4) Je '95
— Painting of Civil War naval battle
Nat Geog 186:68 (c,2) D '94
MANGROVE TREES
Nat Geog 185:20–1 (c,1) Ap '94
Trav&Leisure 24:109 (c,2) Ap '94
Natur Hist 103:26–8 (c,1) O '94
Nat Wildlife 33:18 (c,4) Ap '95
MANNEQUINS
— Crash test dummies
Smithsonian 26:cov.,30–41 (c,1) Jl '95
— Dummies of Prince Andrew and Fergie
Life 15:46 (c,2) Je '92
MANNHEIM, GERMANY
— Mannheim Prison
Sports Illus 85:77 (c,3) N 18 '96
MANSIONS
— 14th cent. villa (Careggi, Italy)
Natur Hist 101:20–1 (c,2) Jl '92
— 15th cent. manor house (Great Britain)
Trav&Leisure 24:80 (c,4) N '94
— 1620 octagon-towered house (Great
Britain)
Smithsonian 24:120 (c,2) S '93

— 1842 Bartow–Pell mansion, The Bronx, New York
 Trav&Leisure 25:E1 (c,4) Ja '95
— Late 19th cent. mansions (San Francisco, California)
 Am Heritage 47:71 (1) F '96
— Antebellum plantation houses (Louisiana)
 Trav&Leisure 26:110–21,156–60 (c,1) Ap '96
— Antebellum plantation houses (Natchez, Mississippi)
 Gourmet 53:130–3 (c,1) Ap '93
— Antony House, Cornwall, England
 Trav&Leisure 23:128–35 (c,1) O '93
— Astor mansion, Newport, Rhode Island
 Trav/Holiday 179:34 (c,4) O '96
— Atlanta, Georgia
 Trav&Leisure 25:67 (c,4) My '95
— Belle Meade, Nashville, Tennessee
 Gourmet 56:120 (c,4) Ap '96
— Biltmore estate, Asheville, North Carolina
 Am Heritage 43:26 (c,4) My '92
 Smithsonian 23:58–71 (c,1) S '92
 Trav&Leisure 25:82–3,87–9 (c,1) Jl '95
— The Breakers, Newport, Rhode Island
 Trav/Holiday 178:97,102 (c,4) Mr '95
 Trav&Leisure 26:62 (c,4) Je '96
— Carter's Grove mansion, Virginia
 Am Heritage 43:82–7 (c,1) My '92
— Charleston, South Carolina
 Gourmet 54:110–11 (c,1) S '94
— Flagler's Whitehall, Palm Beach, Florida
 Trav/Holiday 175:56–63 (c,1) F '92
— J.J. Glessner mansion (Chicago, Illinois)
 Am Heritage 43:108–13 (c,1) D '92
— Kingston Lacy, Dorset, England
 Gourmet 52:114–15 (c,2) My '92
— Longwood, Natchez, Mississippi
 Gourmet 53:132 (c,4) Ap '93
— Lyndhurst estate, Tarrytown, New York
 Nat Geog 189:76–7 (c,1) Mr '96
— Manor homes (Great Britain)
 Trav&Leisure 24:116–24 (c,1) D '94
 Trav&Leisure 26:118–30 (map,c,1) My '96
— Richmond upon Thames, England
 Trav&Leisure 24:60–7,101 (c,1) Ag '94
— St. Louis, Missouri
 Trav/Holiday 176:60 (c,4) S '93
— Shelburne, Vermont
 Trav/Holiday 178:10 (c,4) D '95
— Staff of lord's manor home (Hampshire, England)
 Life 17:19–22 (c,1) S '94
— Stanton Hall, Natchez, Mississippi

 Gourmet 53:130 (c,1) Ap '93
— Vancouver, British Columbia
 Nat Geog 181:106–7 (c,1) Ap '92
— Victorian mansion of William Carson (California)
 Smithsonian 24:48 (c,4) O '93
— Villa d'Este, Tivoli, Italy
 Gourmet 52:108–9 (c,1) Ap '92
 Gourmet 52:132–3,136 (c,1) N '92
— Villa Lante, Bagnaia, Italy
 Gourmet 52:134–5 (c,1) N '92
— Villa Rothschild, Cap Ferrat, France
 Gourmet 55:117 (c,1) F '95
— Villas (Lake Como, Italy)
 Gourmet 52:106–10 (c,1) Ap '92
— Vizcaya gate, Miami, Florida
 Am Heritage 46:99 (1) O '95
— Waddesdon Manor, Buckinghamshire, England
 Trav&Leisure 24:6,102–11 (c,1) Je '94
— Winterthur, Delaware
 Trav&Leisure 26:E1–E2 (c,4) N '96
— See also
 CHATEAUS
 PLANTATIONS

MANTIDS
— Praying mantis
 Natur Hist 102:cov.,1,28–33 (c,1) Ja '93
 Natur Hist 102:63 (c,4) O '93
 Nat Wildlife 32:9 (c,4) Je '94
 Nat Wildlife 33:21 (c,1) F '95
 Nat Wildlife 34:2 (c,1) D '95
 Nat Wildlife 35:72 (c,1) D '96
— Robotic praying mantis
 Trav/Holiday 177:88 (c,4) F '94

MANTLE, MICKEY
 Sports Illus 79:51–72 (1) O 11 '93
 Sports Illus 80:cov.,66–77 (c,1) Ap 18 '94
 Sports Illus 82:104 (c,4) Je 19 '95
 Sports Illus 83:4 (4) Jl 17 '95
 Sports Illus 83:cov.,18–30 (1) Ag 21 '95
 Life 18:16–17 (2) O '95
 Life 19:85 (1) Ja '96
 Sports Illus 85:12 (4) N 25 '96
— Baseball cards
 Sports Illus 84:24 (c,4) Ja 22 '96

MANUFACTURING
— 1890s sweatshop (New York City, New York)
 Am Heritage 45:112 (2) O '94
— 1920s helicopter plant (New York)
 Am Heritage 43:44 (4) Ap '92
— 1930s automobile factory (Indiana)
 Am Heritage 45:92 (3) Jl '94
— 1940s women steelworkers (Indiana)

Life 18:55 (2) Je 5 '95
— Athletic shoes (Indonesia)
 Sports Illus 79:69 (c,3) Ag 16 '93
— Auto wiring assembly plant (Mississippi)
 Smithsonian 26:70,75 (1) Mr '96
— Automobiles (China)
 Nat Geog 185:13 (c,4) Mr '94
— Automobiles (Japan)
 Nat Geog 185:110–11 (c,2) Ja '94
— Child laborers (Pakistan)
 Life 19:38–48 (c,1) Je '96
— Cotton mills (India)
 Nat Geog 185:76–7 (c,1) Je '94
— Designing car on computer (Michigan)
 Nat Geog 188:24–5 (c,1) O '95
— Glass bottle plant (Mexico)
 Nat Geog 190:56 (c,4) Ag '96
— Greeting card plant (Mississippi)
 Smithsonian 26:74–5 (3) Mr '96
— Guitars (Nashville, Tennessee)
 Smithsonian 27:52–62 (c,1) Jl '96
— Gun factory (Connecticut)
 Nat Geog 185:80 (c,3) F '94
— Microchip factory (Taiwan)
 Nat Geog 184:15 (c,3) N '93
— Motorcycle plant (Pennsylvania)
 Smithsonian 24:94 (c,4) N '93
— Overhauling locomotive (Alberta)
 Nat Geog 186:53 (c,3) D '94
— Railroad car wheel factory (Pennsylvania)
 Nat Geog 185:52–3 (c,1) Je '94
— Razor blades
 Smithsonian 25:53 (c,1) F '95
— Refrigerator plant (1945)
 Life 18:85 (2) Je 5 '95
— Shoes (Eritrea)
 Nat Geog 189:93 (c,3) Je '96
— Smelting iron (Ukraine)
 Nat Geog 190:57 (c,1) S '96
— Testing shaving cream (Massachusetts)
 Nat Geog 186:20–1 (c,1) Jl '94
— Textiles (Mauritius)
 Nat Geog 183:124–5 (c,2) Ap '93
— Tractor parts (Albania)
 Nat Geog 182:78–9 (c,1) Jl '92
— Tractors (U.S.S.R.)
 Nat Geog 182:121 (c,3) O '92
— See also
 FACTORIES
 FOOD PROCESSING
 MILLS
 SAWMILLS
 list under INDUSTRIES
MAO ZEDONG
— Mao buttons

Trav&Leisure 22:149 (c,4) Mr '92
— Mao memorabilia (China)
 Nat Geog 185:17 (c,2) Mr '94
— Poster of Mao
 Trav&Leisure 23:75 (c,1) S '93
MAORI PEOPLE
— Canoeing in waka (New Zealand)
 Nat Geog 190:40–1 (c,2) N '96
MAORI PEOPLE—COSTUME
— Late 18th cent. tattooed tribesmen (New
 Zealand)
 Nat Geog 190:40 (drawing,3) N '96
**MAORI PEOPLE—SOCIAL LIFE
AND CUSTOMS**
— "Hong" nose-press greeting (New
 Zealand)
 Life 19:18 (c,2) N '96
MAPLE TREES
— Leaves
 Am Heritage 47:83 (painting,c,2) Jl '96
— Tapping maple syrup (Vermont)
 Trav/Holiday 178:64 (c,4) F '95
MAPS
— 13th cent. world map
 Trav/Holiday 175:65 (c,2) My '92
— 15th cent. Portuguese trade and
 exploration routes
 Nat Geog 182:66–7 (c,1) N '92
— 1475 Christian map
 Smithsonian 23:117 (c,4) F '93
— 1780s U.S. cities
 Am Heritage 43:64–71 (c,1) D '92
— 1852 map of ranch (California)
 Am Heritage 44:130 (c,4) Ap '93
— Driver reading road map
 Smithsonian 25:56 (c,4) O '94
— Early maps of Asia
 Natur Hist 103:26–31 (c,1) Jl '94
— Landsat map of Gulf of Mexico
 Nat Wildlife 32:6–7 (c,1) F '94
— Road map superimposed on man's chest
 Sports Illus 85:cov. (c,1) D 2 '96
— Satellite maps of ocean ridges
 Natur Hist 105:28–33 (c,1) Mr '96
— Satellite views of the Middle East
 Nat Geog 187:88–105 (c,1) Je '95
— U.S. towns named "Paradise"
 Trav/Holiday 176:cov.,74–93 (c,1) Mr '93
— Unusual maps
 Smithsonian 23:113–17 (c,1) F '93
— Use of maps in Allied World War II
 invasion planning
 Nat Geog 187:54–71 (c,1) My '95
— See also
 EARTH—MAPS

individual countries—MAPS
MARATHONS
— 1936 Olympics winners
 Sports Illus 77:4 (4) S 7 '92
— 1972 Olympics (Munich)
 Sports Illus 85:31 (c,4) Ag 5 '96
— Berlin, Germany
 Nat Geog 190:104–5 (c,2) D '96
— New York (1992)
 Sports Illus 81:13 (c,4) O 17 '94
— New York (1993)
 Sports Illus 79:2–3,64 (c,1) N 22 '93
 Life 17:145 (4) N '94
— New York (1996)
 Sports Illus 85:18 (c,4) N 11 '96
— One-legged man in New York Marathon
 (1989)
 Sports Illus 81:93 (c,4) N 14 '94
— Phidippides dying after marathon run (490
 B.C.)
 Sports Illus 83:11 (painting,4) N 13 '95
— See also
 BOSTON MARATHON
MARBLE INDUSTRY
— Carrara, Italy
 Smithsonian 22:98–104 (c,1) Ja '92
— Colorado
 Smithsonian 22:106–7 (c,2) Ja '92
MARBLES
— Shooting marbles (Tennessee)
 Sports Illus 81:151–2 (c,4) S 5 '94
Marching bands. See
 BANDS, MARCHING
MARCIANO, ROCKY
 Sports Illus 79:52–67 (1) Ag 23 '93
 Sports Illus 81:2–3 (1) Ag 15 '94
MARCOS, FERDINAND
— 1993 funeral (Philippines)
 Life 17:46–7 (c,1) Ja '94
— Shoes belonging to Imelda Marcos
 Life 19:32 (c,3) Ap '96
MARGAYS
 Life 16:82 (c,4) Je '93
MARIE ANTOINETTE (FRANCE)
— Marie Antoinette's prison chamber (Paris,
 France)
 Trav&Leisure 25:69 (c,4) N '95
MARIETTA, OHIO
— 19th cent. post office
 Trav/Holiday 178:12 (4) O '95
MARIGOLDS
 Natur Hist 102:62 (c,4) Jl '93
MARINAS
— Lake Powell, Arizona
 Natur Hist 102:44–5 (c,1) N '93

— Monte Carlo, Monaco
 Trav/Holiday 176:72–3 (c,2) F '93
— San Francisco, California
 Trav/Holiday 176:58–9 (c,1) Ap '93
— See also
 HARBORS
MARINE LIFE
— Antarctic area
 Natur Hist 101:46–53 (c,1) N '92
— Bryozoans
 Natur Hist 103:56–9 (c,1) Je '94
— Cayman Islands
 Trav&Leisure 25:116–17 (painting,c,1) F
 '95
— Chesapeake Bay, Virginia
 Nat Geog 182:94–115 (c,1) Jl '92
— Cuatro Cienegas, Chihuahua, Mexico
 Nat Geog 188:84–97 (c,1) O '95
— Deepwater fish
 Nat Wildlife 30:22–7 (c,1) F '92
— Diorama of ancient sea floor
 Smithsonian 24:18 (c,4) D '93
— Forams
 Natur Hist 105:58 (c,4) N '96
— Glowing dinoflagellates
 Trav&Leisure 23:188 (c,4) N '93
— Gulf of Mexico
 Nat Geog 190:86–97 (c,1) O '96
— Indian Ocean
 Nat Geog 187:90–113 (c,1) Mr '95
— Maine tidal pools
 Natur Hist 103:32–9 (c,1) Jl '94
— New Zealand fjords
 Natur Hist 102:62–9 (c,2) Mr '93
— Ocean floor
 Smithsonian 26:96–106 (c,4) Ja '96
— Palau Islands, Pacific
 Life 18:48–53 (c,1) Ag '95
— Reconstruction of Ordovician scene
 Natur Hist 101:42 (c,4) N '92
— Red Sea
 Nat Geog 184:cov.,60–87 (c,1) N '93
 Natur Hist 105:48–51 (c,1) N '96
— Salps
 Nat Geog 190:78–9 (c,1) N '96
— Siphonophores
 Smithsonian 26:105 (c,4) Ja '96
— Tunicates
 Nat Geog 182:108 (c,1) Jl '92
 Natur Hist 105:41 (c,4) S '96
— Volcanic area of Pacific
 Nat Geog 186:114–25 (c,1) N '94
— See also
 CORALS
 CTENOPHORES

FISH
HORSESHOE CRABS
SEA FANS
SEA LILIES
SEA SQUIRTS
MARIS, ROGER
Sports Illus 81:54–64 (1) S 26 '94
Sports Illus 83:22 (4) Ag 21 '95
— 1961 record-breaking hit by Maris
Sports Illus 82:35 (4) Je 5 '95
MARKETS
— 1898 Hester Street, New York City
Am Heritage 43:56–7 (1) Ap '92
— Bazaar (Turkey)
Nat Geog 185:20–1 (c,2) My '94
— Cairo bazaar, Egypt
Trav/Holiday 175:53 (c,3) S '92
Trav&Leisure 24:70 (c,4) O '94
— Camel market (Pushkar, India)
Natur Hist 104:54–7 (c,1) Mr '95
— Chiapas, Mexico
Natur Hist 105:80 (4) O '96
— Damascus, Syria
Trav&Leisure 24:70 (c,4) N '94
— Fabrics (Kazakhstan)
Nat Geog 183:28–9 (c,1) Mr '93
— Floating market (Thailand)
Trav&Leisure 23:84 (c,4) D '93
Trav&Leisure 26:233 (c,4) S '96
— Flower market (Czechoslovakia)
Natur Hist 102:63 (3) F '93
— Flower market (Seattle, Washington)
Trav&Leisure 23:125 (c,1) N '93
— Flower market (Vietnam)
Nat Geog 183:8–9 (c,1) F '93
— Goods sold from truck (Italy)
Natur Hist 101:72 (c,4) N '92
— Istanbul, Turkey
Trav/Holiday 175:70–3 (c,1) Jl '92
— Kuala Lumpur, Malaysia
Trav/Holiday 176:46 (c,1) S '93
— Marrakesh, Morocco
Natur Hist 105:38–45 (c,1) My '96
Nat Geog 190:106–7 (c,1) O '96
— Medicinal herbs (Ghana)
Natur Hist 105:44 (c,1) F '96
— Outdoor Christmas markets (Austria)
Trav/Holiday 176:46–7 (c,2) D '93
— Outdoor market (Florence, Italy)
Trav/Holiday 178:41 (c,1) D '95
— Outdoor market (Guatemala)
Trav/Holiday 178:87 (c,2) Mr '95
— Outdoor market (Salvador, Brazil)
Trav/Holiday 175:63 (c,3) Je '92
— Portobello Road, London, England

Trav/Holiday 175:34 (c,4) N '92
— St. Lucia
Trav/Holiday 175:53 (c,1) F '92
— Saqqara, Egypt
Nat Geog 187:30–1 (c,1) Ja '95
— Spice market (Arles, France)
Nat Geog 188:74 (c,3) S '95
— Spice market (India)
Gourmet 55:88 (c,4) Je '95
— Spice market (Istanbul, Turkey)
Trav&Leisure 26:86 (c,1) Ag '96
— Tinker's market (Turkey)
Natur Hist 105:68 (3) Ja '96
— Tourist bargaining in Morocco market
Trav/Holiday 175:62–3 (painting,c,1) O
'92
— Tunis, Tunisia
Trav/Holiday 178:40–7 (c,2) N '95
— Xi'an, China
Trav&Leisure 23:72 (c,4) S '93
— See also
FLEA MARKETS
FOOD MARKETS
SHOPPING MALLS
STORES
STREET VENDORS
SUPERMARKETS
MARMOTS
Nat Wildlife 31:20 (c,4) Ag '93
Nat Wildlife 33:36,39 (c,2) Ag '95
MARQUESAS ISLANDS
Trav/Holiday 177:cov.,36–43 (map,c,1) Jl
'94
— Nuku Hiva
Natur Hist 104:4–7 (map,c,3) Ap '95
MARRAKESH, MOROCCO
Trav&Leisure 24:cov.,82–91,137
(map,c,1) Jl '94
Natur Hist 105:38–45 (c,1) My '96
Nat Geog 190:104–7 (c,1) O '96
MARRIAGE RITES AND CUSTOMS
— 1886 wedding (Nebraska)
Am Heritage 47:42 (4) S '96
— Early 20th cent. history of Reno divorce
industry, Nevada
Smithsonian 27:64–73 (c,1) Je '96
— Late 1920s (Great Britain)
Natur Hist 102:64–5 (1) D '93
— 1945 wedding of Bogart and Bacall
Life 18:66–7 (1) Je 5 '95
— 1946 couple atop 176 foot mast (Ohio)
Life 19:91 (2) Je '96
— 1960s
Life 15:31 (c,2) O 30 '92
Life 19:92 (3) Je '96

— 1961 wedding at gas station (Florida)
 Smithsonian 24:99 (4) O '93
— 1968 wedding of Jackie Kennedy and
 Aristotle Onassis
 Am Heritage 44:110 (4) O '93
— 1981 wedding of Prince Charles and Diana
 (Great Britain)
 Life 15:28–9 (c,1) Ag '92
 Life 16:cov.,28–9 (c,1) F '93
— 1982 bride jumping into pool (California)
 Life 19:90–1 (c,1) Je '96
— 1982 mass marriage of Moonies
 Life 19:88–9 (c,1) Je '96
— Albania
 Nat Geog 182:91 (c,3) Jl '92
— Americans renewing wedding vows
 (Tahiti)
 Life 17:90 (c,2) S '94
— Bolivia
 Trav&Leisure 26:113 (c,4) F '96
— Bosnia-Herzegovina
 Life 19:10–11 (1) F '96
— Bride with henna-painted arms (Oman)
 Nat Geog 187:112–13 (c,1) My '95
— Child bride and groom (India)
 Nat Geog 184:68–71 (c,1) S '93
— City hall wedding room (Menton, France)
 Trav&Leisure 24:164 (c,2) F '94
— Grover Cleveland's 1886 wedding
 Life 15:30 (painting,c,4) O 30 '92
— Dani people bartering pigs for bride
 (Indonesia)
 Nat Geog 183:94–5 (c,1) Ja '93
— Drive-thru wedding chapel (Las Vegas,
 Nevada)
 Life 16:82 (c,2) Ag '93
— Filipino bridal couple covered with money
 (Alaska)
 Nat Geog 184:53 (c,4) N '93
— Gay men making public commitment vows
 (Pennsylvania)
 Life 17:88–9 (4) N '94
— Golden wedding anniversary (U.S.S.R.)
 Nat Geog 186:118–19 (c,1) S '94
— Groom removing bride's garter (Easter
 Island)
 Nat Geog 183:73 (c,4) Mr '93
— Group wedding in church (U.S.S.R.)
 Nat Geog 184:119 (c,4) D '93
— Gypsy wedding (Macedonia)
 Nat Geog 189:136–7 (c,1) Mr '96
— Henna patterns on bride's hands (Morocco)
 Trav&Leisure 24:82 (c,1) Jl '94
— Hindu wedding (Mauritius)
 Trav&Leisure 26:139–40 (c,1) O '96

— Hindu wedding (Trinidad)
 Nat Geog 185:76 (c,3) Mr '94
— Japan
 Nat Geog 181:26 (c,4) F '92
— Mexico
 Nat Geog 190:74–5 (c,1) Ag '96
— Muslim pre-wedding mendhi celebration
 (Mauritius)
 Nat Geog 183:126–7 (c,1) Ap '93
— Newly divorced woman on motorcycle
 (California)
 Life 16:87 (4) Ag '93
— Newlyweds posing on Lake Baikal, Siberia
 Nat Geog 181:8–9 (c,2) Je '92
— Orthodox Jewish wedding (Michigan)
 Life 17:88–9 (c,2) N '94
— Palestinians (Israel)
 Nat Geog 181:110 (c,1) Je '92
 Nat Geog 190:52–3 (c,1) S '96
— Papua New Guinea
 Nat Geog 185:48 (c,1) F '94
— Pouring rice on bridal couple (India)
 Nat Geog 185:60–1 (c,1) My '94
— Simulated wedding scene outside church
 tower (France)
 Life 19:20 (c,2) Jl '96
— South Korea
 Natur Hist 105:8 (c,3) Jl '96
— Tiny Tim's wedding to Miss Vicki (1969)
 Life 15:42 (c,4) My '92
— Tower of London, England
 Nat Geog 184:45 (c,1) O '93
— Traditional Jewish wedding (Florida)
 Trav/Holiday 176:55 (c,2) D '93
— U.S.S.R.
 Nat Geog 182:126 (c,3) O '92
— Vietnam
 Nat Geog 187:86–7 (c,1) Ap '95
— Virtual reality wedding
 Nat Geog 188:35 (c,2) O '95
— Wartime wedding (Sarajevo, Yugoslavia)
 Life 16:32–7 (c,1) Ap '93
— Wedding cakes
 Natur Hist 102:58–67 (c,1) D '93
— Wedding on beach (Jamaica)
 Trav/Holiday 179:70 (c,4) D '96
— Wedding party in formal pose
 Sports Illus 81:61 (c,3) O 10 '94
— Wedding reception (Italy)
 Nat Geog 188:22,31 (c,1) Ag '95
— Weddings of U.S. presidents' daughters
 Life 15:30–1 (c,2) O 30 '92

MARRIAGE RITES AND CUSTOMS—
COSTUME

— 1871 royal bride (Great Britain)

Natur Hist 102:60 (2) D '93
— 1906
Life 15:30 (2) O 30 '92
— 1913 wedding party
Life 15:30 (4) O 30 '92
— 1950s bride
Am Heritage 45:116 (4) D '94
— Afghanistan
Nat Geog 184:83 (c,4) O '93
— Bride and groom
Sports Illus 77:49 (c,1) D 7 '92
— Bride and groom (Czechoslovakia)
Nat Geog 184:36–7 (c,1) S '93
— Bride in traditional dress (Japan)
Trav/Holiday 178:74–5 (c,1) O '95
— Girl trying on mother's wedding dress
(Great Britain)
Life 15:90 (2) Ap '92
— Italy
Nat Geog 186:26–7 (c,1) N '94
— Lebanon
Life 15:50–1 (c,1) Jl '92
— Mendi bride (Papua New Guinea)
Trav/Holiday 176:67 (c,4) Ap '93
— Model in bridal gown (Mexico)
Nat Geog 190:58–9 (c,1) Ag '96
— Osage Indian wedding outfit
Smithsonian 25:45 (c,4) O '94
— Turkey
Nat Geog 185:31 (c,1) My '94
— Widest bridal gown ever made (Italy)
Life 18:16 (c,2) Mr '95
MARS (PLANET)
Smithsonian 26:70–7 (c,1) Ag '95
Natur Hist 105:23,32 (c,2) D '96
— Map of canals
Natur Hist 105:24 (4) D '96
— Map of Mangala Valles area
Smithsonian 23:112–13 (c,2) F '93
MARSHALL, GEORGE C.
Life 18:132 (4) Je 5 '95
MARSHALL, JAMES
— Statue of the Gold Rush pioneer
(California)
Am Heritage 46:112 (3) F '95
MARSHALL, THURGOOD
Life 15:72 (c,1) Ja '92
Life 17:72 (4) Ja '94
Smithsonian 24:117 (4) F '94
Marshall Islands. See
BIKINI ATOLL
MARSHES
— Early 20th cent. drained wetlands
(Wisconsin)

Am Heritage 45:110–11 (4) My '94
— Atchafalaya Basin, Louisiana
Trav/Holiday 177:60–1 (c,1) N '94
— California
Am Heritage 45:112–15 (c,1) My '94
— Colorado
Natur Hist 101:21 (c,1) Ag '92
— Dried up wetlands (Kansas)
Nat Geog 182:41 (c,4) O '92
— Florida
Am Heritage 45:108–9 (c,1) My '94
— Georgia
Nat Geog 182:21–2 (c,1) O '92
Nat Wildlife 31:40–1 (c,2) Ap '93
Gourmet 54:92–3 (c,1) F '94
— Louisiana
Nat Geog 190:31 (c,3) O '96
— Michigan
Natur Hist 103:20–2 (map,c,1) Mr '94
Natur Hist 103:20–2 (map,c,3) Ap '94
— Missouri
Nat Geog 182:4–5 (c,1) O '92
— Nevada
Am Heritage 45:112 (c,4) My '94
— North Carolina
Natur Hist 104:74–5 (c,1) Ap '95
— North Dakota
Nat Wildlife 34:20–1,27 (c,1) Je '96
— Okavango Swamp, Botswana
Natur Hist 102:52 (c,2) Ja '93
— Onon River floodplain, Mongolia
Nat Geog 190:6–7 (c,1) D '96
— South Carolina
Trav&Leisure 24:128 (c,1) My '94
Trav/Holiday 179:66 (c,3) F '96
— Sweetwater Marsh, San Diego, California
Nat Wildlife 31:14–15 (c,1) D '92
— Trinidad
Natur Hist 102:26–8 (map,c,1) O '93
Natur Hist 103:26–8 (map,c,1) O '94
— U.S. wetlands
Nat Geog 182:2–45 (map,c,1) O '92
Am Heritage 45:108–15 (c,1) My '94
Nat Wildlife 34:20–7 (c,1) Je '96
— Venezuela
Smithsonian 27:45,50 (c,1) S '96
— Virginia
Natur Hist 103:92 (c,2) Je '94
— Yellowstone National Park, Wyoming
Trav/Holiday 175:41 (c,1) Je '92
— Zekiah Swamp, Maryland
Am Heritage 43:115 (c,2) S '92
— See also
EVERGLADES NATIONAL PARK

OKEFENOKEE SWAMP

MARSUPIALS
— Ancient extinct marsupials
Natur Hist 103:44–7 (painting,c,1) Ap '94
— Bilby
Natur Hist 105:17 (drawing,c,3) Ap '96
— Prehistoric Australian animals
Natur Hist 102:40–5 (painting,c,1) Je '93
— Tasmanian pademelon
Nat Wildlife 30:17 (c,2) F '92
— See also
BANDICOOTS
KANGAROOS
KOALAS
OPOSSUMS
POSSUMS
TASMANIAN DEVILS
WOMBATS

MARTENS
Nat Wildlife 30:58 (c,4) O '92
Natur Hist 103:76–7 (c,1) F '94
Nat Wildlife 32:8 (c,4) F '94

MARTHA'S VINEYARD, MASS-CHUETTS
Gourmet 52:88 (c,4) My '92
Trav&Leisure 22:E1–E4 (map,c,2) S '92
Sports Illus 78:92–4 (c,2) F 22 '93
Trav&Leisure 23:N4 (c,4) My '93
Trav&Leisure 26:cov.,95–103,146–8 (map,c,1) Ap '96

MARTIAL ARTS
— Baseball players doing t'ai chi
Sports Illus 84:2–3 (c,1) Mr 4 '96
— Kendo (Japan)
Nat Geog 181:75 (c,4) Mr '92
— Kickboxing
Sports Illus 79:8 (c,3) D 13 '93
— Self-defense training
Life 16:106 (c,2) N '93
— T'ai chi (China)
Sports Illus 83:86–7 (c,1) O 16 '95
— T'ai chi (Hong Kong)
Trav&Leisure 22:146 (c,4) Mr '92
— T'ai chi class
Gourmet 56:94,178 (c,4) My '96
— Taekwondo
Sports Illus 82:18 (c,4) Je 5 '95
— See also
JUDO
KARATE

MARTINIQUE
Gourmet 53:56–9,100,104 (map,c,2) Ja '93
Trav/Holiday 176:cov.,73,78 (map,c,1) D '93

Trav&Leisure 26:153–9,173–80 (map,c,1) O '96

MARTINS
— Purple martins
Nat Wildlife 31:38–9 (c,1) Je '93

MARX, GROUCHO
Life 15:41 (4) My '92
Smithsonian 23:128 (4) Mr '93

MARX BROTHERS
— Harpo playing croquet
Smithsonian 23:105 (4) O '92
— "A Night at the Opera" stateroom scene (1935)
Trav/Holiday 179:13 (4) O '96

MARY II (GREAT BRITAIN)
Smithsonian 24:112 (engraving,4) Mr '94
— See also
WILLIAM III, OF ORANGE

MARYLAND
— Eastern shore
Gourmet 52:96–101,120 (map,c,1) S '92
— Historical sites
Am Heritage 44:83–90 (c,1) Ap '93
— Ladew Gardens
Trav/Holiday 179:80–4 (c,1) Je '96
— St. Mary's City archaeological site
Smithsonian 27:84 (c,3) My '96
— St. Michaels
Gourmet 52:96–101 (c,1) S '92
Am Heritage 45:26 (c,4) O '94
— Smith Island
Natur Hist 105:10 (c,4) Je '96
— Sotterley Plantation
Smithsonian 27:57 (c,4) S '96
— Zekiah Swamp
Am Heritage 43:115 (c,2) S '92
— See also
ANNAPOLIS
BALTIMORE
CHESAPEAKE BAY

MASKS
— Air pollution masks (Taiwan)
Nat Geog 184:6–7,33 (c,1) N '93
— Ancient Greek actors' masks (Syracuse)
Nat Geog 186:2,21 (c,4) N '94
— Gas masks (Israel)
Life 15:30–1 (c,1) Ja '92
— Hedgehog mask for ballet
Life 16:24 (4) F '93
— Life mask of Lincoln
Am Heritage 46:63 (c,4) F '95
— Sunbathers in Jack & Jackie masks (1963)
Life 16:28 (c,4) Je '93

MASKS, CEREMONIAL
— 13th cent. mask with antlers (Oklahoma)

Smithsonian 27:28 (c,4) Ag '96
— Late 19th cent. Kwakiutl potlatch masks
 (British Columbia)
 Smithsonian 24:22 (c,4) F '94
— Ancient Mexico
 Nat Geog 188:4 (c,2) D '95
— Ancient Olmec mask (Mexico)
 Nat Geog 184:115 (c,1) N '93
— Aztec ceremonial mask (Mexico)
 Natur Hist 105:36–7 (c,2) O '96
— Colombia
 Natur Hist 101:46–7 (c,1) Ja '92
— Guatemala
 Trav&Leisure 23:85 (c,2) Mr '93
— India
 Natur Hist 103:71 (4) My '94
— Kwakiutl Indian mask
 Life 17:124 (c,1) N '94
— Masks from all over the world
 Smithsonian 25:cov.,94–9 (c,1) D '94
— Mudman costume (Papua New Guinea)
 Trav/Holiday 176:63 (c,1) Ap '93
— Spirit mask (Papua New Guinea)
 Trav/Holiday 176:66 (c,1) Ap '93
— Yup'ik masks (Alaska)
 Natur Hist 105:12–13 (c,4) Ag '96
— Zaire
 Smithsonian 25:32 (c,4) Ap '94
— See also
 DEATH MASKS
 MASQUERADE COSTUME
MASQUERADE COSTUME
— Carnevale (Venice, Italy)
 Nat Geog 187:74–5 (c,1) F '95
 Gourmet 55:90 (c,4) Je '95
— Carnival (Brazil)
 Life 19:16 (2) Mr '96
— Carnival (Trinidad)
 Natur Hist 104:36–7, 40–1 (c,1) F '95
— Costume parties (U.S.)
 Life 17:76–7 (c,1) N '94
— Girl in pumpkin costume (Ohio)
 Smithsonian 27:67 (c,4) O '96
— Spain
 Life 15:84–5,88–9 (c,1) Ag '92
— See also
 HALLOWEEN
Mass transit. See
 BUSES
 COMMUTERS
 SUBWAYS
 TROLLEY CARS
MASSACHUSETTS
— 1704 Deerfield Massacre
 Am Heritage 44:82–9 (c,1) F '93

— 1733 Ashley house (Deerfield)
 Am Heritage 44:88–9 (c,2) F '93
— 1830s recreation of farm (Old Sturbridge
 Village)
 Smithsonian 24:82 (c,1) S '93
— Berkshires region
 Trav&Leisure 25:76, 83, 98 (map,c,1) Ag
 '95
— Country road in autumn
 Gourmet 52:112 (c,4) N '92
— Cuttyhunk Island
 Nat Geog 181:114–32 (map,c,1) Je '92
— Henry Gardner
 Smithsonian 27:157 (engraving,4) N '96
— Hancock Shaker Village, Pittsfield,
 Massachusetts
 Am Heritage 46:40 (c,3) N '95
— Lenox home of Edith Wharton
 Life 17:78–83 (c,1) Ap '94
— Marblehead
 Trav&Leisure 23:E1 (c,4) Je '93
— Nashua River
 Nat Geog 184:106–7,117–19 (c,1) N 15
 '93
— Northampton (1836)
 Smithsonian 25:106–7 (painting,c,1) My
 '94
— Western Massachusetts
 Am Heritage 46:37–41 (c,2) N '95
— Williamstown
 Trav&Leisure 22:98–103 (c,1) Jl '92
— Woods Hole lighthouse
 Gourmet 54:74 (c,4) F '94
— See also
 BOSTON
 CAMBRIDGE
 CAPE COD
 MARTHA'S VINEYARD
 NANTUCKET
 SALEM
MASSAGES
 Trav&Leisure 23:32 (c,4) N '93
— At spas
 Trav&Leisure 25:144 (drawing,c,2) S '95
 Gourmet 56:79–80,84,100 (c,4) My '96
 Trav&Leisure 26:83 (c,4) D '96
— Cyprus
 Nat Geog 184:128 (c,1) Jl '93
— Sweden
 Nat Geog 184:24–5 (c,2) Ag '93
— Thailand
 Gourmet 56:98 (c,2) My '96
MASTIFFS (DOGS)
 Sports Illus 82:85 (c,4) Ap 10 '95

MATADORS
— Female matadors (Spain)
 Sports Illus 76:122–32 (c,1) Mr 9 '92
 Life 19:49–51 (c,1) Ag '96
 Trav/Holiday 179:52–61 (c,1) N '96
— Mexico
 Nat Geog 190:20–1 (c,1) Ag '96
— Spain
 Trav/Holiday 176:68 (c,4) Mr '93
 Trav/Holiday 178:60–1 (1) Mr '95

MATHER, COTTON
 Smithsonian 23:122 (painting,4) Ap '92

MATISSE, HENRI
 Trav&Leisure 22:83,86 (c,2) S '92
— 1950s wallpaper designed by him
 Smithsonian 26:20 (c,4) Ag '95
— Depicted in 1917 drawing by Vassilieff
 Smithsonian 27:46–7 (2) Jl '96
— "Ballerina" (1927)
 Smithsonian 25:50 (painting,c,4) Mr '95
— "Flowers and Fruits"
 Gourmet 54:99 (c,1) S '94
— "Joy of Life" (1906)
 Life 16:80–1 (painting,c,1) Ap '93
 Smithsonian 24:96–7 (painting,c,1) My '93
— Matisse Chapel, Vence, France
 Gourmet 54:100 (c,2) S '94
— "Music" (1910)
 Smithsonian 25:46 (painting,c,3) Mr '95
— "The Music Lesson"
 Trav/Holiday 176:102 (painting,c,4) Mr '93
— Paintings by him
 Trav&Leisure 22:82–93,134 (c,1) S '92
 Smithsonian 23:48–53 (c,1) O '92
— "The Pink Shrimp"
 Life 16:21 (painting,c,4) F '93
— Self-portrait
 Smithsonian 23:49 (painting,c,2) O '92
— "View of the Sea, Collioure"
 Life 16:3 (painting,c,2) Ap '93

MATTERHORN, SWITZERLAND
 Gourmet 52:116–21 (c,1) D '92

MAURITANIA
— Richat structure, Sahara
 Nat Geog 190:14–15 (c,1) N '96

MAURITIUS
 Nat Geog 183:110–31 (map,c,1) Ap '93
 Trav&Leisure 26:134–43,181–8 (map,c,1) O '96

MAURITIUS—COSTUME
 Nat Geog 183:110–31 (map,c,1) Ap '93
 Trav&Leisure 26:135–43,181–6 (c,1) O '96

MAY DAY
— Dancing around the maypole (Great Britain)
 Life 16:22 (c,4) Jl '93
— May Day riot (Moscow, Russia)
 Life 16:14–15 (c,1) Jl '93

MAYA CIVILIZATION—ARCHITECTURE
— Bonampak ruins, Mexico
 Nat Geog 187:50–69 (c,1) F '95
— Chichen Itza, Mexico
 Trav&Leisure 22:103 (c,1) N '92
 Smithsonian 24:56–7 (c,3) Je '93
— Copan ruins, Honduras
 Nat Geog 189:113 (c,3) Ap '96
 Natur Hist 105:24–31 (c,1) Ap '96
— Lamanai ruins, Belize
 Gourmet 55:146 (c,4) D '95
— Nohoch Mul Pyramid, Coba, Mexico
 Trav&Leisure 24:108 (1) Ja '94
— Tikal ruins, Guatemala
 Trav&Leisure 23:88–9 (c,1) Mr '93
— Tulum ruins, Mexico
 Trav&Leisure 24:104–5, 114 (c,2) Ja '94
 Nat Geog 190:108–9 (c,1) Ag '96
— Uxmal ruins, Mexico
 Trav&Leisure 22:96–7,101 (c,1) N '92
 Trav&Leisure 25:119 (painting,c,4) N '95
— See also
 PYRAMIDS
 TEMPLES—ANCIENT

MAYA CIVILIZATION—ART
— Ancient mural of Maya life (Mexico)
 Nat Geog 187:cov.,50–69 (c,1) F '95
— Sculpture (Guatemala)
 Nat Geog 183:94–101 (c,1) F '93
— Temple mural (Bonampak)
 Natur Hist 105:18 (c,4) N '96

MAYA CIVILIZATION—ARTIFACTS
— Hieroglyphics
 Nat Geog 183:97–9 (c,4) F '93
 Gourmet 55:144 (c,4) D '95
— Small figures (Honduras)
 Natur Hist 101:18,22 (c,4) Mr '92

MAYA CIVILIZATION—HISTORY
— Dos Pilas history, Guatemala
 Nat Geog 183:94–111 (map,c,1) F '93

MAYA CIVILIZATION—MAPS
— Maya sites
 Natur Hist 101:20 (c,2) Mr '92

MAYA CIVILIZATION—RITES AND FESTIVALS
— Body piercing by ancient Maya (Mexico)
 Nat Geog 187:68–9 (painting,c,1) F '95

— Holy Week rituals involving Judas
 (Guatemala)
 Natur Hist 103:46–52 (c,1) Mr '94
MAYA CIVILIZATION—SOCIAL LIFE AND CUSTOMS
— Ancient mural of Maya life (Mexico)
 Nat Geog 187:cov.,50–69 (c,1) F '95
— Maya theater performances (Mexico)
 Smithsonian 23:78–87 (c,1) Ag '92
MAYER, LOUIS B.
 Life 19:82–3 (c,1) Mr '96
MAYFLIES
 Nat Wildlife 32:56 (c,4) D '93
 Nat Wildlife 32:22 (c,4) F '94
MAYS, WILLIE
 Sports Illus 77:cov. (c,1) Fall '92
 Sports Illus 79:90 (4) Jl 19 '93
 Sports Illus 79–66 (4) O 11 '93
 Sports Illus 82:42,44 (2) Ja 16 '95
McCARTHY, JOSEPH
 Smithsonian 23:130 (4) Ap '92
McKINLEY, WILLIAM
 Am Heritage 44:103 (painting,c,4) F '93
MEADE, MARGARET
— Balinese painting of Mead leaving
 Indonesia
 Natur Hist 104:63 (2) F '95
MEDALS
— 1912 Olympics
 Am Heritage 43:100 (c,4) Jl '92
— 1992 Olympics
 Sports Illus 76:43 (c,4) F 17 '92
 Sports Illus 76:18 (c,2) F 24 '92
 Sports Illus 77:70 (c,4) D 14 '92
— 1996 Olympics
 Sports Illus 85:16 (c,4) Ag 5 '96
— U.S. Medal of Freedom
 Sports Illus 76:83 (c,4) Mr 23 '92
MEDICAL EDUCATION
— Bologna medical theater, Italy
 Trav/Holiday 177:58–9 (c,2) O '94
MEDICAL INSTRUMENTS
— 1860s Navy surgical kit
 Trav/Holiday 179:44 (c,4) O '96
— Ambidextrous medical tools
 Smithsonian 25:143 (c,4) D '94
— Army medical evacuation equipment
 Nat Geog 186:60–1 (c,1) Jl '94
— Artificial hip joint diagram
 Sports Illus 78:24 (c,4) Ap 19 '93
— CAT scanner
 Smithsonian 27:40 (c,4) O '96
— Catheter for angioplasty
 Smithsonian 26:28 (c,4) O '95
— Eye prosthesis

 Nat Geog 182:9 (c,4) N '92
— Mechanical heart
 Life 19:87 (c,1) D '96
— Pencils shaped like syringes
 Life 16:26 (c,4) Mr '93
— Prosthetic limbs
 Sports Illus 82:5–7 (c,4) Ap 17 '95
— Radioisotope detection scanner (Ukraine)
 Nat Geog 186:100–1 (c,1) Ag '94
— See also
 X-RAYS
MEDICAL RESEARCH
— Cold virus research (Virginia)
 Nat Geog 186:66–7 (c,1) Jl '94
— Developing taxol to treat cancer
 Life 15:71–6 (c,2) My '92
— Mutant rhino mice studied for medical
 research
 Life 18:80–6 (c,1) D '95
— Research on the aging process
 Life 15:cov.,32–42 (c,1) O '92
— Research using chimpanzees
 Nat Geog 181:30–3 (c,1) Mr '92
— Sight research
 Nat Geog 182:cov.,2–39 (c,1) N '92
— Testing effects of cigarette tar on mice
 Am Heritage 43:80 (2) D '92
— Virus research
 Nat Geog 186:66–73 (c,1) Jl '94
MEDICI, LORENZO DE
— Likeness on 15th cent. coin
 Trav&Leisure 22:22 (c,4) Ja '92
— Medici family villa (Careggi, Italy)
 Natur Hist 101:20–1 (c,2) Jl '92
MEDICINE—PRACTICE
— Albanian hospital
 Nat Geog 182:83 (c,2) Jl '92
— Alternative medicine
 Life 19:cov.,34–47 (c,1) S '96
— Baby receiving oxygen (Mexico)
 Nat Geog 190:35 (c,4) Ag '96
— Buddhism exorcism of demons (Nepal)
 Nat Geog 184:18–19 (c,2) D '93
— CPR diagrams
 Trav/Holiday 178:24 (drawing,c,4) F '95
— "Cupping" therapy for back pain
 Life 19:40 (c,4) S '96
— Doctor examining child (Nepal)
 Nat Geog 182:85 (c,3) D '92
— Donating blood (1945)
 Smithsonian 25:126 (4) Mr '95
— Examining newborn (Mississippi)
 Smithsonian 26:73 (3) Mr '96
— Fetal tissue transplants
 Life 15:50–6 (c,1) F '92

— First aid after bicycle accident (Tennessee)
 Smithsonian 24:24 (c,4) Ag '93
— Folk medicine people lifting curse
 (California)
 Nat Geog 181:60 (c,4) Je '92
— Giving transfusion to injured World War II
 soldier
 Smithsonian 25:124 (2) Mr '95
— Medical care for premature infants
 Life 19:60–8 (c,1) Mr '96
— Organ recipients (Italy)
 Life 18:45 (c,3) O '95
— Reshaping small girl's malformed skull
 Life 15:70–4 (c,1) Je '92
— Role of blood plasma in World War II
 Smithsonian 25:124–38 (2) Mr '95
— Sarajevo hospital, Yugoslavia
 Life 16:89–98 (1) O '93
— Testing child for radiation damage
 (Kazakhstan)
 Nat Geog 183:32–3 (c,1) Mr '93
— Treating wounded soldiers (1940s)
 Am Heritage 45:104 (4) S '94
— Treatment at pediatric hospital
 (Pennsylvania)
 Life 18:40–50 (c,1) D '95
— Tuberculosis treatment through history
 Smithsonian 23:180–94 (c,3) N '92
— Woman undergoing abortion (New York)
 Life 15:32–3 (c,1) Jl '92
— See also
 CHILDBIRTH
 DOCTORS
 HOSPITALS
 HYPNOSIS
 INJURED PEOPLE
 MEDICAL INSTRUMENTS
 SURGERY
 THERAPY
 VACCINATIONS
 VETERINARIANS
Medicine. See
 DRUGS
MEDITATION
 Sports Illus 83:55 (c,4) S 11 '95
 Life 19:56–7 (c,1) F '96
— At Mexican spa
 Gourmet 56:176 (c,4) My '96
— Convict meditating
 Nat Geog 187:32 (c,3) Je '95
— Group meditating with swami (New York)
 Nat Geog 182:116–17 (c,1) N '92
— Zen Buddhist priest trainees meditating
 (Japan)
 Nat Geog 186:84–5 (c,2) S '94

MEDITERRANEAN SEA
— Computer map
 Nat Wildlife 32:10–11 (c,1) F '94
— Riviera coast
 Trav&Leisure 22:114–21 (map,c,1) Je '92
MEDUSA
— Head of Medusa plaque
 Trav&Leisure 25:103 (c,4) Mr '95
MEERKATS
 Nat Geog 181:66,74 (c,4) Ja '92
 Nat Wildlife 31:21 (c,2) Ag '93
 Smithsonian 26:170 (c,2) Ap '95
 Nat Geog 190:21 (c,1) Jl '96
MEIR, GOLDA
— 1919 portrayal of Miss Liberty (Wisconsin)
 Am Heritage 43:6 (2) F '92
MEKONG RIVER, ASIA
 Nat Geog 183:2–35 (map,c,1) F '93
MELBOURNE, AUSTRALIA
 Gourmet 52:100–5,150 (map,c,1) Ap '92
 Trav&Leisure 26:52–63,112–14 (map,c,1)
 Jl '96
MELVILLE, HERMAN
 Smithsonian 26:100 (painting,c,2) Jl '95
— Family
 Smithsonian 26:104,111 (c,4) Jl '95
— Home (Pittsfield, Massachusetts)
 Smithsonian 26:107 (c,4) Jl '95
— Illustrations from Melville's books
 Smithsonian 26:108–12 (c,3) Jl '95
MEMORIAL DAY
— 1890 (Wisconsin)
 Am Heritage 44:55 (4) O '93
Memorials. See
 MONUMENTS
MEMPHIS, TENNESSEE
— Beale Street
 Am Heritage 46:35 (c,4) F '95 supp.
— Blues clubs
 Natur Hist 105:50 (c,1) S '96
— National Civil Rights Museum
 Trav&Leisure 22:E26–E28 (c,3) N '92
— Peabody Hotel lobby
 Trav&Leisure 26:90 (c,4) N '96
— Sun Records headquarters
 Trav/Holiday 177:114 (4) Mr '94
MEN
— 7'5" tall basketball player
 Sports Illus 81:120–9 (c,1) N 7 '94
— 7'6" tall basketball player
 Sports Illus 84:82 (c,1) Mr 25 '96
— 7'7" tall man
 Sports Illus 83:51 (c,1) O 2 '95
— Male bonding groups (18th-20th cents.)
 Am Heritage 44:37–45 (c,3) S '93

— Nude rugby players streaking across field
 (France)
 Life 17:26–7 (c,1) D '94
— Obese man snorkeling (North Carolina)
 Nat Geog 187:126–7 (c,2) Mr '95
— Short basketball player
 Sports Illus 78:53–4 (c,1) Ap 12 '93
— Very tall and very short basketball players
 Life 17:19–22 (c,1) Ap '94
— See also
 SHAVING
MENCKEN, HENRY LOUIS
— Caricature of Mencken
 Am Heritage 45:102 (4) Jl '94
MENNONITES
— Girls playing basketball on trampoline
 (Ohio)
 Life 16:19 (c,4) Ag '93
— Mexico
 Life 17:90–7 (1) O '94
MENTAL ILLNESS
— Afghanistan
 Nat Geog 184:74–5 (c,1) O '93
— Mentally ill patients
 Nat Geog 187:20–5 (c,1) Je '95
— U.S.S.R.
 Nat Geog 186:89 (c,3) Ag '94
MERGANSERS (DUCKS)
 Nat Wildlife 32:12–13 (c,1) Ag '94
 Nat Wildlife 33:2–3 (c,2) Ag '95
MERMAIDS
— Mermaids at Weeki Wachee Spring,
 Florida
 Nat Geog 182:2–4 (c,1) Jl '92
 Life 16:101 (c,2) Jl '93
MERRY-GO-ROUNDS
— Antique carousel (Bridgeport, Connecticut)
 Life 16:52–5 (c,1) Ap '93
— Rhode Island
 Trav/Holiday 179:35 (c,4) O '96
**MESA VERDE NATIONAL PARK,
 COLORADO**
 Trav&Leisure 23:141 (c,1) Ap '93
 Smithsonian 24:28–9 (c,1) D '93
 Trav/Holiday 177:56 (painting,c,4) Je '94
— Cliff Palace
 Nat Geog 189:86–7,105 (c,1) Ap '96
MESSIER, CHARLES
 Smithsonian 23:76 (drawing,4) Je '92
METALWORK
— Copperware (Mexico)
 Trav/Holiday 175:82 (c,3) F '92
— Iron works by Samuel Yellin
 Am Heritage 46:96–9,114 (1) O '95
— Works by modern blacksmiths

 Smithsonian 24:48–59 (c,1) My '93
METALWORKING
— Extracting copper from ore in Copper Age
 Nat Geog 183:50 (painting,c,1) Je '93
— Forging tuna knife (Japan)
 Nat Geog 188:49–50 (c,1) N '95
— Great Britain
 Trav&Leisure 24:118–19 (c,2) D '94
— Knight Foundry, Sutter Creek, California
 Smithsonian 27:56 (c,4) S '96
— Making bell for clock tower (Great Britain)
 Smithsonian 27:14 (c,4) Ag '96
— Making diamonds from carbon
 Life 16:54–6 (c,1) Mr '93
— Skilled French craftsmen
 Smithsonian 27:98–109 (c,1) Je '96
— Smelting iron (Ukraine)
 Nat Geog 190:57 (c,1) S '96
— Samuel Yellin at forge (1927)
 Am Heritage 46:96 (4) O '95
— See also
 BLACKSMITHS
METEORITES
 Natur Hist 102:60 (c,3) Jl '93
 Natur Hist 104:86 (c,4) Ap '95
— Car dented by meteorite (New York)
 Natur Hist 102:61 (c,2) Jl '93
**METROPOLITAN MUSEUM OF ART,
 NEW YORK CITY, NEW YORK**
 Trav&Leisure 22:96–107,152 (c,1) D '92
MEXICAN AMERICANS
— Backyard barbecue
 Smithsonian 26:34 (painting,c,4) D '95
MEXICAN WAR
 Smithsonian 27:44–5 (etching,c,2) Ap '96
— 1847 hanging of U.S. Army traitors
 Am Heritage 46:81 (painting,c,3) N '95
— Battle of Buena Vista
 Am Heritage 46:68–81 (c,1) N '95
— See also
 ALAMO
 TAYLOR, ZACHARY
MEXICO
 Trav&Leisure 23:1–24 (map,c,1) O '93
 supp.
 Trav&Leisure 24:1–24 (map,c,1) D '94
 supp.
 Natur Hist 104:1–24 (map,c,1) Ja '95 supp.
 Nat Geog 190:entire issue (map,c,1) Ag
 '96
 Trav&Leisure 26:M1–M23 (map,c,1) O
 '96
— Baja California
 Trav&Leisure 23:96–105 (map,c,1) My
 '93

Trav&Leisure 23:30 (c,3) Je '93
Gourmet 56:174–9 (c,2) My '96
Trav/Holiday 179:81–3 (map,c,4) Jl '96
— Cabo San Lucas, Baja California
Nat Geog 190:18–19 (c,1) Ag '96
— Cacaxtla
Nat Geog 182:120–36 (map,c,1) S '92
— Cancun
Nat Geog 190:112–13 (c,1) Ag '96
— Chihuahuan Desert
Nat Geog 188:84–97 (map,c,1) O '95
— Coatzacoalcos River
Nat Geog 184:103 (c,4) N '93
— Copper Canyon area
Trav/Holiday 178:50–7 (map,c,1) D '95
— Hermosillo
Nat Geog 186:56–7 (c,2) S '94
— Huatulco resort
Trav/Holiday 176:17 (c,4) N '93
— Huautla cave system
Nat Geog 188:78–93 (map,c,1) S '95
— Maya ruins (Bonampak)
Nat Geog 187:50–69 (c,1) F '95
— Maya ruins (Chichen Itza)
Trav&Leisure 22:103 (c,1) N '92
Smithsonian 24:56–7 (c,3) Je '93
Am Heritage 46:31 (c,4) F '95
— Maya ruins (Uxmal)
Trav&Leisure 22:96–7,101 (c,1) N '92
Trav&Leisure 25:119 (painting,c,4) N '95
— Mexcaltitan
Nat Geog 190:86–7 (c,1) Ag '96
— Patzcuaro, Michoacan
Trav/Holiday 175:78–85 (map,c,1) F '92
— Pollution problems near Texas border
Smithsonian 25:26–37 (1) My '94
— Puerto Vallarta
Trav/Holiday 175:46–53 (map,c,1) D '92
Nat Geog 190:90–1 (c,2) Ag '96
— Quintana Roo, Yucatan Peninsula
Trav&Leisure 24:102–14 (map,c,1) Ja '94
— San Cristobal hotel
Trav&Leisure 26:90–6 (c,4) D '96
— Sierra Giganta, Baja California
Natur Hist 103:59 (c,4) O '94
— Sonora region
Nat Geog 186:45,52–63 (map,c,1) S '94
— Sonoran Desert
Nat Geog 186:45,52–3 (map,c,2) S '94
— Teotihuacan
Nat Geog 188:2–35 (map,c,1) D '95
— Tex-Mex border life
Nat Geog 189:44–69 (map,c,1) F '96
— See also
GUADALAJARA

GUANAJUATO
JUAREZ
MEXICO CITY
MONTERREY
OAXACA
RIO GRANDE RIVER
SIERRA MADRE
TAXCO
TIJUANA
VERACRUZ
YUCATAN PENINSULA
MEXICO—ART
— 20th cent. works
Trav&Leisure 23:106–18 (c,1) Je '93
— Mexican crafts
Gourmet 55:80–3 (c,1) Ja '95
— Mexican pride mural (El Paso, Texas)
Trav/Holiday 176:88–9 (c,1) F '93
— Modern works
Smithsonian 23:86–93 (c,2) Ap '92
— See also
KAHLO, FRIDA
RIVERA, DIEGO
MEXICO—ARTIFACTS
— 100 B.C. stone burial mask
Smithsonian 25:98 (c,4) D '94
— Tiger masks
Smithsonian 25:96–7 (c,3) D '94
MEXICO—COSTUME
Nat Geog 190:entire issue (c,1) Ag '96
— Girl
Nat Geog 184:12,89 (c,1) N 15 '93
— Guanajuato
Trav/Holiday 178:74–9 (c,2) S '95
— Illegal Mexican immigrants crossing into
Texas
Nat Geog 182:22–3 (c,4) Jl '92
Am Heritage 45:90 (c,4) F '94
Nat Geog 189:63 (c,4) F '96
— Indian rebels (Chiapas)
Nat Geog 190:16–17,126–7 (c,2) Ag '96
— Oaxaca
Nat Geog 186:38–63 (c,1) N '94
— Patzcuaro, Michoacan
Trav/Holiday 175:78–85 (c,1) F '92
— President Zedillo
Nat Geog 190:38 (c,4) Ag '96
— Sombrero
Smithsonian 24:72 (c,1) Mr '94
— Tarahumara Indians
Nat Geog 190:44–51 (c,1) Ag '96
— Traditional costume
Nat Geog 189:44-5 (c,1) F '96
MEXICO—HISTORY
— 1519 conquest of Aztecs by Cortes

270 / MEXICO—RITES AND FESTIVALS

Smithsonian 23:56–69 (painting,c,1) O '92
— 1836 San Jacinto battle against Texas
Smithsonian 23:82–91 (painting,c,2) Jl '92
— 1916 capture of Pancho Villa's men (New Mexico)
Am Heritage 47:28 (4) D '96
— Don Vasco de Quiroga
Trav/Holiday 175:81 (sculpture,c,4) F '92
— Scenes along El Camino Real
Smithsonian 26:140–50 (c,1) N '95
— See also
ALAMO
AZTEC CIVILIZATION
MEXICAN WAR
MONTEZUMA
SANTA ANNA
VILLA, PANCHO
ZAPATA, EMILIANO

MEXICO—RITES AND FESTIVALS
— Independence Day
Nat Geog 190:24–5,30–1,130–1 (c,1) Ag '96
— Rain dance
Nat Geog 184:99–101 (c,1) N '93
— Yaqui Indian deer dance
Nat Geog 186:52–3 (c,1) S '94

MEXICO, ANCIENT—ARCHITECTURE
— Teotihuacan
Natur Hist 101:23 (c,4) Mr '92

MEXICO, ANCIENT—ART
— Cacaxtla murals
Nat Geog 182:120–36 (c,1) S '92
— Dog sculptures
Natur Hist 103:34–7 (c,1) F '94

MEXICO CITY, MEXICO
Trav&Leisure 23:106–17,128 (map,c,1) Je '93
Nat Geog 190:2–4,24–43 (c,1) Ag '96
— Floating gardens of Xochimilco
Nat Geog 184:28–9 (c,2) N 15 '93
— Kahlo studio-museum
Trav/Holiday 177:31 (c,4) F '94
— Map
Trav/Holiday 177:32 (c,4) F '94
— Old College of San Ildefonso
Trav&Leisure 23:106–7 (c,1) Je '93

MIAMI, FLORIDA
Nat Geog 181:86–113 (map,c,1) Ja '92
Sports Illus 82:72–84 (map,c,1) Ja 30 '95
— Elderly religious Jew on swing
Trav/Holiday 179:71 (c,2) Mr '96
— Joe's Stone Crab restaurant sign
Trav/Holiday 177:18 (c,4) D '94
— Miami Holocaust Memorial

Trav&Leisure 22:15 (c,4) Ag '92
— Vizcaya Gardens and gate
Trav/Holiday 175:82–9 (c,1) D '92
Am Heritage 46:99 (1) O '95
— Wolfsonian Foundation Collection
Smithsonian 25:102–11 (c,1) F '95
Trav&Leisure 25:34 (c,4) S '95
— See also
MIAMI BEACH

MIAMI BEACH, FLORIDA
Smithsonian 23:78 (c,3) O '92
Trav&Leisure 22:cov.,76–87 (map,c,1) O '92
— Art Deco District
Trav/Holiday 175:cov.,52–61 (map,c,1) O '92
Trav&Leisure 22:cov.,76–87 (c,1) O '92

MICE
Nat Wildlife 30:9 (painting,c,4) Ap '92
Nat Wildlife 33:49 (c,2) O '95
— Eating cheese from mousetrap
Life 19:8–9 (c,1) Jl '96
— Grass mouse
Natur Hist 101:76–7 (c,1) Je '92
— Mousetraps
Am Heritage 47:cov.,90–7 (c,1) O '96
— Mutant rhino mice studied for medical research
Life 18:80–6 (c,1) D '95
— See also
MICKEY MOUSE

MICHELANGELO
— "The Last Judgment" (1541)
Nat Geog 185:102–23 (painting,c,1) My '94
— "Pieta"
Trav&Leisure 23:31 (sculpture,c,4) Ag '93
— Sistine Chapel ceiling, Vatican
Trav/Holiday 179:28 (c,4) D '96

MICHIGAN
— Mid 19th cent. kingdom of James Strang
Smithsonian 26:84–92 (map,c,1) Ag '95
— Big Bay Point Lighthouse
Trav&Leisure 23:E7 (c,4) Ag '93
— Grand Traverse Bay
Nat Geog 189:114–17 (c,1) F '96
— Isle Royale
Natur Hist 102:38 (c,1) Ap '93
— Keweenaw Peninsula
Nat Geog 184:94–5 (c,1) D '93
— Northern Michigan small towns
Trav&Leisure 26:74–81,106–7 (map,c,1) Ag '96
— Petoskey
Smithsonian 27:58 (c,4) S '96

— Plaque marketing site of original Podunk
Smithsonian 25:16 (c,4) N '94
— Shingleton Bog
Natur Hist 103:20–2 (map,c,3) Ap '94
— Soo Canal
Am Heritage 43:26 (c,4) S '92
— Summerby Swamp
Natur Hist 103:20–2 (map,c,1) Mr '94
— See also
DETROIT
LAKE MICHIGAN
LAKE SUPERIOR
MACKINAC ISLAND
MICHIGAN—MAPS
— Upper Peninsula
Trav&Leisure 23:E14 (c,4) Ag '93
MICKEY MOUSE
Sports Illus 79:92 (c,4) O 11 '93
— Mickey figure
Gourmet 52:114 (c,4) N '92
Micronesia. See
PACIFIC ISLANDS
MIDDLE AGES
— 1475 Christian map
Smithsonian 23:117 (c,4) F '93
— Medieval-style battle (Pennsylvania)
Life 18:28–32 (c,1) N '95
— See also
ALFRED THE GREAT
CASTLES
FORTRESSES
KNIGHTS
MIDDLE EAST
Nat Geog 183:38–71 (map,c,1) My '93
— 19th cent. European views of the Mideast
Smithsonian 26:38 (painting,c,4) D '95
— Scenes along Arabian peninsula coast
Trav/Holiday 177:90–7 (map,c,1) Ap '94
— Water problems in the Middle East
Nat Geog 183:38–71 (c,1) My '93
— See also
GULF WAR
PALESTINIANS
MIDDLE EAST—MAPS
— Satellite photos
Nat Geog 187:88–105 (c,1) Je '95
— View from space (1966)
Nat Geog 190:12–13 (c,1) N '96
MIDGES
— Midge fossil
Life 16:111 (c,2) O '93
MIDWEST
— Great Flood of 1993
Nat Geog 185:42–87 (map,c,1) Ja '94
Life 17:35–8 (c,1) Ja '94

— Ogallala Aquifer
Nat Geog 183:80–109 (map,c,1) Mr '93
— Prairie lands
Nat Geog 184:90–119 (c,1) O '93
— See also
LAKE SUPERIOR
MISSISSIPPI RIVER
MILAN, ITALY
Nat Geog 182:90–119 (map,c,1) D '92
Gourmet 55:124–7,190 (map,c,2) O '95
Trav&Leisure 26:160–72 (c,1) O '96
— Casa Verdi
Smithsonian 26:93 (c,4) D '95
— Duomo
Nat Geog 182:95–7 (c,1) D '92
— La Scala interior
Nat Geog 182:104–5 (c,1) D '92
— Naviglio Grande canal
Nat Geog 182:118–19 (c,1) D '92
— Stylized depiction
Gourmet 54:34 (painting,c,3) Ag '94
MILITARY COSTUME
— 13th cent. Mongol cavalryman
Nat Geog 190:14 (drawing,c,1) D '96
— Late 16th cent. Spanish soldiers
Nat Geog 186:34–57 (c,1) Jl '94
— 19th cent. Buffalo soldier statue (Arizona)
Am Heritage 44:14 (4) My '93
— 1847 U.S. Army colonel
Am Heritage 46:74 (4) N '95
— 1860s Navy
Nat Geog 186:72 (2) D '94
Am Heritage 46:88 (4) O '95
— 1900 artillery officer (Great Britain)
Smithsonian 25:164 (4) N '94
— 1910s French army uniform
Am Heritage 46:7 (4) F '95 supp.
— 1910s U.S. soldiers
Am Heritage 43:72–3 (1) D '92
Am Heritage 44:47–66 (1) N '93
— 1920s-1930s U.S. Army
Am Heritage 43:98–106 (1) D '92
— 1920s Chinese Nationalist soldiers
Am Heritage 47:90–1 (2) Jl '96
— 1920s U.S. Navy
Am Heritage 47:87–9 (2) Jl '96
— 1940s black Tuskegee airmen
Am Heritage 46:110 (4) My '95
— 1940s (U.S.S.R.)
Am Heritage 43:70 (c,3) F '92
— 1940s (U.S.)
Am Heritage 43:70 (c,3) F '92
Am Heritage 45:134 (3) Ap '94
Am Heritage 47:76 (4) F '96
— 1940s U.S. Air Force bombers

Am Heritage 45:43 (4) D '94
— 1940s U.S. airmen
Nat Geog 185:94–5,102 (c,1) Mr '94
Am Heritage 46:47 (4) My '95
— 1940s U.S. soldiers in the Pacific
Am Heritage 44:88–99 (c,1) S '93
— 1945 Japanese general
Life 18:84 (2) Je 5 '95
— 1950s (U.S.)
Sports Illus 81:66–7 (2) Jl 11 '94
— 1950 U.S. soldier (Korea)
Life 19:76 (1) Ag '96
— 1955 cadets at football game
Sports Illus 81:110–11 (c,1) N 14 '94
— 1960s "jungle boots" worn by U.S.
soldiers in Vietnam
Am Heritage 46:6 (c,3) F '95
— 1960s U.S. soldiers (Vietnam)
Sports Illus 79:65–7 (c,1) O 4 '93
— 1991 Gulf War veterans
Life 19:80 (c,2) Ag '96
— Afghanistan
Nat Geog 184:62–5 (c,1) O '93
— Azerbaijan
Nat Geog 189:127 (c,1) F '96
— Cadets (Virginia)
Gourmet 54:134 (c,4) My '94
— Children in army uniforms (China)
Nat Geog 189:16–17 (c,1) Mr '96
— China
Sports Illus 79:46 (c,3) S 20 '93
— Chinese People's Armed Police
Life 16:18 (c,2) Mr '93
— Civil War soldiers
Trav&Leisure 22:77 (4) Ja '92
Smithsonian 26:122 (painting,c,3) O '95
— Female Civil War soldiers
Smithsonian 24:97–103 (c,2) Ja '94
— 5-star general insignia
Nat Geog 181:54–5 (c,2) Mr '92
— French legionnaire
Life 18:36–40 (c,1) F '95
— Great Britain
Life 15:20 (c,4) Ap '92
— Latvia
Life 15:45–50 (c,1) D '92
— Paraguay officers
Nat Geog 182:88–9 (c,1) Ag '92
— Possessions of World War II U.S. Army
chaplain
Am Heritage 45:40–6 (c,1) My '94
Life 17:50–1 (c,1) Je '94
— Revolutionary War battle reenactment
clothes
Trav&Leisure 25:80,85 (c,4) My '95

— Russian navy
Nat Geog 185:116 (c,1) Je '94
— Submarine crew (U.S.S.R.)
Nat Geog 184:108–9 (c,1) D '93
— 10-year-old South Vietnamese soldier
(1968)
Life 19:30 (4) N '96
— Turkey
Nat Geog 185:6–7,12 (c,1) My '94
— Ukraine
Nat Geog 183:43 (c,3) Mr '93
— U.S. general
Am Heritage 44:48–9 (c,2) D '93
— U.S. military presence in Bosnia
Life 19:32–7 (c,1) F '96
— U.S. military presence in Haiti
Life 17:56–63 (c,1) N '94
Life 18:18 (c,2) Je '95
— U.S. National Guardsmen
Life 15:18 (c,2) Je '92
— U.S. soldiers in the Gulf
Life 15:12–13,32–3 (c,1) Ja '92
— U.S. soldiers saluting
Sports Illus 77:2–3 (c,1) S 28 '92
— Women soldiers (Bosnia)
Life 15:26 (c,4) D '92

MILITARY LEADERS
— Ancient Roman soldier Scipio Africanus
Smithsonian 25:131 (painting,c,4) Ap '94
— Commanders of Spanish-American War
Smithsonian 22:88–96 (c,4) Mr '92
— Vo Nguyen Giap (Vietnam)
Life 18:61 (1) Je '95
— Colin Powell
Life 16:36–44 (c,1) Jl '93
— *Time* covers of World War II leaders
Smithsonian 22:129 (c,4) Ja '92
— See also
ALLEN, ETHAN
ARNOLD, BENEDICT
BOLIVAR, SIMON
BRADLEY, OMAR
CLAY, LUCIUS
CUSTER, GEORGE ARMSTRONG
DE GAULLE, CHARLES
DEWEY, GEORGE
DOOLITTLE, JAMES HAROLD
EISENHOWER, DWIGHT DAVID
FROBISHER, MARTIN
GATES, HORATIO
GRANT, ULYSSES S.
HALSEY, WILLIAM FREDERICK, JR.
HANNIBAL
HOOKER, JOSEPH
HOUSTON, SAM

JACKSON, STONEWALL
LAFAYETTE, MARQUIS DE
LEE, ROBERT E.
MacARTHUR, DOUGLAS
MARSHALL, GEORGE C.
MONTGOMERY, BERNARD
PATTON, GEORGE S., JR.
PERRY, OLIVER HAZARD
PERRY, MATTHEW
RIDGWAY, MATTHEW
SANTA ANNA
SCHWARZKOPF, H. NORMAN
SHERIDAN, PHILIP
TAYLOR, ZACHARY
TOJO, HIDEKI
VILLA, PANCHO
WAINWRIGHT, JONATHAN
WASHINGTON, GEORGE
WESTMORELAND, WILLIAM
WAYNE, ANTHONY
YAMAMOTO, ISOROKU
ZAPATA, EMILIANO
ZUMWALT, ELMO

MILITARY LIFE
— 1920s-1930s U.S. Army life
 Am Heritage 43:98–106 (1) D '92
— 1931 tank company with mule
 Am Heritage 44:42 (4) D '93
— 1940s U.S. soldiers in the Pacific
 Am Heritage 44:88–99 (c,1) S '93
— 1940s V-mail letters
 Am Heritage 45:63,78 (4) My '94

MILITARY TRAINING
— 1941 maneuvers (U.S.)
 Am Heritage 44:103 (drawing,2) Jl '93
— Burma
 Nat Geog 188:90 (c,3) Jl '95
— California gunnery range
 Nat Geog 186:46–7 (c,2) S '94
— Citadel cadets celebrating female dropout,
 South Carolina
 Life 19:36 (c,3) Ja '96
— Exposing recruits to tear gas (South
 Carolina)
 Nat Geog 182:36–7 (c,2) N '92
— French Foreign Legion training
 Life 19:38–48 (1) Mr '96
— Kurdish guerrillas (Middle East)
 Nat Geog 182:40–1,56–7 (c,1) Ag '92
— Motorcycle running over cadet in
 endurance test (China)
 Nat Geog 185:29 (c,3) Mr '94
— Navy SEAL tortuous training exercise
 (California)
 Life 19:8–9 (c,1) Ag '96

— Right-wing militia group (Michigan)
 Am Heritage 46:44–6 (c,4) S '95
— ROTC students drilling on street
 (California)
 Nat Geog 181:65 (c,3) Je '92
— Training for chemical warfare in protective
 suits (U.S.S.R.)
 Life 18:56–7 (c,1) Jl '95
— U.S. Coast Guard cadet training
 Smithsonian 26:22–33 (c,1) Ag '95
— U.S. Navy drill practice (Florida)
 Nat Geog 182:20–1 (c,1) Jl '92
— West Point cadets, New York
 Nat Geog 189:78–9 (c,2) Mr '96

MILK INDUSTRY
— Stacks of frozen milk chunks (Siberia)
 Life 15:26 (c,4) My '92

MILKWEED
 Natur Hist 102:26 (c,4) Ap '93
 Natur Hist 102:cov. (c,1) O '93
 Smithsonian 25:41 (c,4) S '94
 Life 18:63 (c,4) S '95
— Spiny pod
 Nat Wildlife 35:30 (c,1) D '96

MILKY WAY
 Life 15:64 (c,4) S '92
 Smithsonian 24:26 (c,4) Ap '93
 Nat Geog 185:16–18,30–2 (c,1) Ja '94
 Natur Hist 104:16,18 (4) Ag '95
Millipedes. See
 CENTIPEDES

MILLS
— 19th cent. flour mill (New Mexico)
 Smithsonian 26:52 (c,4) Jl '95
— 19th cent. textile mill (Yorkshire, England)
 Smithsonian 24:147 (drawing,4) Ap '93
— 19th cent. textile mills (New Hampshire)
 Am Heritage 43:49 (c,3) Ap '92
 Smithsonian 25:104 (c,3) N '94
— 1910 silk mill (Great Britain)
 Trav&Leisure 24:118 (4) D '94
— 1930s textile mill (Great Britain)
 Smithsonian 24:140–1 (painting,c,3) Ap
 '93
— Old flour mill (California)
 Trav&Leisure 22:NY4 (c,3) O '92
— Paper mill (Georgia)
 Nat Geog 181:50–1 (c,1) Ap '92
— Pulp mill (Florida)
 Nat Wildlife 32:7 (c,1) Ag '94
— Steel mill (Czechoslovakia)
 Nat Geog 184:30–1 (c,2) S '93
— See also
 FACTORIES
 MANUFACTURING

SAWMILLS
MINERALS AND GEMS
— Bauxite processing plant (Australia)
 Nat Geog 189:12 (c,4) Je '96
— See also
 AMBER
 CRYSTALS
 DIAMONDS
 GOLD
 GYPSUM
 JEWELRY
 LEAD
 LIMESTONE
 MARBLE
 MINING
 OBSIDIAN
 PROSPECTING
 QUARTZ
 RUBIES
 SALT
 SANDSTONE
 SULFUR
MINERS
— 1880s copper miners (Nevada)
 Nat Wildlife 30:43 (4) Ag '92
— 1938 coal miners (West Virginia)
 Life 15:80–1 (1) My '92
— 1940s Korean miners working for Japanese
 Natur Hist 104:58 (4) O '95
— 1950 (South Africa)
 Life 18:35 (4) S '95
— Coal (Ukraine)
 Nat Geog 183:40–1 (c,1) Mr '93
— Gold mine (South Africa)
 Nat Geog 183:83 (c,4) F '93
— Peru
 Nat Geog 181:117 (c,1) F '92
— Sulfur (Indonesia)
 Life 16:10–11 (c,1) Ap '93
MINES
— Abandoned copper mine (Montana)
 Nat Wildlife 30:40–1 (c,1) Ag '92
 Smithsonian 23:46–57 (c,1) N '92
 Nat Wildlife 32:10–11 (c,1) Ap '94
— Iron mine (Newfoundland)
 Nat Geog 184:27 (c,4) O '93
— Marble quarry (Colorado)
 Smithsonian 22:106–7 (c,1) Ja '92
— Mountain leveled by strip mining
 (Appalachia)
 Nat Geog 183:118 (c,3) F '93
— Ocher quarry (France)
 Nat Geog 188:72–3 (c,2) S '95
— Old mine structures (Creede, Colorado)
 Trav&Leisure 23:125 (c,1) Mr '93

— Open-pit coal mine (Wyoming)
 Nat Geog 183:68–9 (c,1) Ja '93
— Summitville Mine, Colorado
 Sports Illus 85:84–6 (c,3) O 14 '96
— Wieliczka salt mine history, Poland
 Smithsonian 24:96–106 (c,2) Mr '94
— See also
 GOLD MINES
 SALT MINES
MINES, EXPLODING
— Rwanda
 Nat Geog 188:67 (c,3) O '95
— Sign warning of minefield (Israel)
 Nat Geog 183:58 (c,2) My '93
MINING
— 18th cent. engraving of salt mining
 (Poland)
 Smithsonian 24:97 (c,2) Mr '94
— 19th cent. lead mining
 Natur Hist 105:50–1 (painting,c,3) Jl '96
— Late 19th cent. (Colorado)
 Am Heritage 43:92–3 (1) F '92
— 1880s drill (Nevada)
 Nat Wildlife 30:43 (4) Ag '92
— Amber (U.S.S.R.)
 Smithsonian 23:36–7 (c,3) Ja '93
— Copper mining residue in rainwater
 (Arizona)
 Nat Geog 185:8–9 (c,1) F '94
— Emeralds (Afghanistan)
 Nat Geog 184:84–5 (c,1) O '93
— Garnets (New York)
 Natur Hist 101:33 (4) My '92
— Gems (Sri Lanka)
 Nat Geog 182:85 (c,3) N '92
— Marble quarrying (Italy)
 Smithsonian 22:98–104 (c,1) Ja '92
— Silver (Peru)
 Nat Geog 181:117 (c,1) F '92
— Stone quarry (Malta)
 Smithsonian 27:70 (c,3) S '96
— Sulfur (Indonesia)
 Life 16:10–11 (c,1) Ap '93
— Titanium plant (U.S.S.R.)
 Nat Geog 183:24–5 (c,1) Mr '93
— See also
 COAL MINING
 PROSPECTING
MINNEAPOLIS, MINNESOTA
— Oldenburg spoon and cherry outdoor
 sculpture
 Trav&Leisure 24:58 (c,3) Jl '94
 Smithsonian 26:78 (c,1) Ag '95
— Phone booth covered by snow
 Life 15:12 (c,1) F '92

MINNESOTA
— Boundary Waters area
 Trav&Leisure 22:124–33 (map,c,1) My '92
— Lac la Croix
 Nat Geog 189:112–13 (c,1) My '96
— Lake country resorts
 Nat Geog 182:92–119 (map,c,1) S '92
— Lake Pepin
 Trav&Leisure 24:112–17,162 (map,c,1) Je '94
— Lakes
 Nat Geog 182:92–119 (map,c,1) S '92
— Mall of America
 Trav&Leisure 24:59 (c,4) Jl '94
 Trav/Holiday 179:82–9 (c,1) O '96
— Minnesota celebrities
 Sports Illus 76:62–70 (c,1) Ja 20 '92
— Red Wing
 Trav&Leisure 24:113–16 (c,4) Je '94
— Split Rock Lighthouse
 Nat Geog 184:72–3 (c,1) D '93
— Walker
 Nat Geog 182:117 (c,3) S '92
— See also
 DULUTH
 LAKE SUPERIOR
 MINNEAPOLIS
 ST. PAUL

MINNESOTA—RITES AND FESTIVALS
— Ice Fishing Extravaganza (Brainerd)
 Nat Geog 182:94–5 (c,1) S '92

MIRO, JOAN
— "Le Chant au Rossigne a Minuit et la Pluie Matinale"
 Natur Hist 103:31 (painting,c,3) Je '94
— Paintings by him
 Smithsonian 24:62–75 (c,1) N '93
— "The Poetess" (1940s)
 Trav&Leisure 23:28 (painting,c,4) O '93
— Self-portrait (1919)
 Smithsonian 24:63 (painting,c,4) N '93
— "Woman and Bird"
 Trav/Holiday 175:56 (sculpture,c,3) Mr '92

MIRRORS
— Mockingbird attacking car mirror
 Nat Wildlife 30:16 (c,4) Je '92

MISSILES
— Smoke trail of test missile launch (Arizona)
 Life 19:20 (c,2) D '96

MISSIONS
— California
 Gourmet 55:118–23 (c,1) F '95

— Carmel, California
 Am Heritage 44:54–5 (c,1) Ap '93
 Gourmet 55:118,122 (c,2) F '95
— Creel, Mexico
 Trav/Holiday 178:52 (c,4) D '95
— Mission San Jose, San Antonio, Texas
 Gourmet 52:79 (c,1) Je '92
— New Mexico
 Trav&Leisure 26:42,222 (c,4) S '96
— San Antonio de Padua mission, California
 Gourmet 53:101 (c,4) O '93
— San Lorenzo mission, New Mexico
 Am Heritage 46:100 (4) My '95
— San Luis Obispo, California
 Gourmet 53:184 (drawing,4) O '93
— San Miguel Mission, Santa Fe, New Mexico
 Trav&Leisure 22:94–5 (c,1) F '92
— San Xavier del Bac, Arizona
 Nat Geog 188:52–9 (c,1) D '95
 Smithsonian 26:66–7 (c,2) Mr '96
— Santa Barbara, California
 Trav/Holiday 175:39 (c,4) S '92
 Gourmet 55:122 (c,2) F '95
— Santa Ynez, California
 Trav/Holiday 178:59 (c,1) S '95

MISSISSIPPI
— Big Sunflower River
 Natur Hist 105:63 (c,4) Ap '96
— Columbus
 Trav&Leisure 24:E10 (c,4) Ap '94
— William Faulkner's home (Oxford)
 Am Heritage 45:32 (c,4) Ap '94
— Pellucid Bayou
 Natur Hist 104:20–2 (map,c,1) F '95
— Ruins of Windsor mansion
 Am Heritage 47:72–3 (1) O '96
— Sites related to blues singers
 Natur Hist 105:48–55 (map,c,1) S '96
 Natur Hist 105:66–70 (c,4) O '96
— See also
 JACKSON
 MISSISSIPPI RIVER
 NATCHEZ

MISSISSIPPI—MAPS
— Natchez Trace Parkway
 Trav/Holiday 178:89 (c,4) My '95
— Northern Mississippi
 Gourmet 55:88 (4) Ap '95

MISSISSIPPI—RITES AND FESTIVALS
— Shrimp Festival
 Nat Geog 182:32 (c,4) Jl '92

MISSISSIPPI RIVER, U.S.
 Smithsonian 23:36–51 (map,c,1) F '93

Nat Geog 184:10–11,90–105 (map,c,1) N 15 '93
— Great Flood of 1993
Nat Geog 185:42–87 (map,c,1) Ja '94
Life 17:35–8 (c,1) Ja '94
— Lake Pepin, Minnesota/Wisconsin
Trav&Leisure 24:112–17,162 (map,c,1) Je '94
MISSISSIPPI RIVER, ILLINOIS
Trav/Holiday 177:85 (c,4) Mr '94
MISSISSIPPI RIVER, IOWA
— Davenport
Trav&Leisure 26:80 (c,4) S '96
MISSISSIPPI RIVER, LOUISIANA
Nat Geog 184:10–11 (c,1) N 15 '93
Am Heritage 47:68–9 (1) O '96
MISSISSIPPI RIVER, MISSISSIPPI
— Natchez
Gourmet 53:131 (c,3) Ap '93
MISSISSIPPI RIVER, MISSOURI
— Hannibal
Life 18:90 (c,3) Ap '95
MISSOURI
— Branson
Trav/Holiday 176:15 (c,4) Jl '93
Trav/Holiday 177:54–63 (map,c,1) F '94
Life 17:88–9 (map,c,1) Ap '94
— Great Flood of 1993
Life 17:35–8 (c,1) Ja '94
Nat Geog 185:58–79 (map,c,1) Ja '94
Nat Wildlife 32:38–43 (map,c,1) Ap '94
— Mingo National Wildlife Refuge
Nat Geog 182:4–5 (c,1) O '92
— Portage des Sioux in flood
Life 16:31 (c,2) S '93
— Red Oak town replica
Smithsonian 22:104–9 (c,2) F '92
— St. Joseph founder Joseph Robidoux
Smithsonian 25:48 (4) My '94
— Satellite photos of Missouri during drought and flood
Nat Wildlife 32:42–3 (c,2) Ap '94
— Senator Thomas Hart Benton
Smithsonian 22:24 (sculpture,4) F '92
— Slaughter Sink, Ozarks
Natur Hist 102:25 (map,c,2) Je '93
— Times Beach (1983)
Nat Wildlife 32:10–11 (c,1) Ag '94
— See also
HANNIBAL
KANSAS CITY
MISSISSIPPI RIVER
ST. JOSEPH
ST. LOUIS

MISSOURI RIVER, MONTANA
Trav/Holiday 176:66–7 (c,1) Je '93
Trav/Holiday 177:70–1 (c,1) Je '94
MISSOURI RIVER, NEBRASKA
— Aerial view
Natur Hist 101:4 (c,3) Ag '92
MISTLETOE
— Depicted on ancient Celtic stone pillar
Natur Hist 105:69 (c,4) F '96
MITCHELL, MARGARET
Am Heritage 43:91 (4) O '92
Am Heritage 47:90 (4) Ap '96
— Home (Atlanta, Georgia)
Am Heritage 47:90 (c,4) Ap '96
MITES
— Dust mite
Nat Wildlife 32:58 (c,4) Ap '94
— Fossil mite
Natur Hist 102:48 (c,3) Mr '93
MIX, TOM
Am Heritage 43:39 (4) My '92
Smithsonian 26:106 (4) O '95
MOBILE, ALABAMA
— Bellingarth Gardens
Natur Hist 103:A4 (c,4) Ap '94
MOBILE HOMES
Sports Illus 78:42–4 (c,2) Ja 18 '93
— Ireland
Nat Geog 186:22–3 (c,2) S '94
MOCKINGBIRDS
Nat Wildlife 30:12–16 (c,1) Je '92
Natur Hist 105:67 (c,4) F '96
Natur Hist 105:76–7 (c,1) Ag '96
Nat Wildlife 34:cov. (c,1) O '96
MODELS
— 1964 Panorama model of New York City
Am Heritage 47:70–8 (c,1) D '96
— Fashion shoot (Italy)
Nat Geog 182:100–3 (c,1) D '92
— Lifestyle of a supermodel
Sports Illus 80:120–9 (painting,c,1) F 14 '94
— Miniature model of White House library, Washington, D.C.
Am Heritage 46:105 (c,4) F '95
— See also
FASHION SHOWS
MODIGLIANI, AMEDEO
Smithsonian 24:64 (4) Ja '94
— Depicted in 1917 drawing by Vassilieff
Smithsonian 27:46–7 (2) Jl '96
— Painting of Jeanne Hebuterne
Life 16:78 (c,3) Ap '93
— Paintings by him

Smithsonian 24:65–73 (c,1) Ja '94
— "Reclining Nude from the Back"
 Smithsonian 24:102–3 (painting,c,3) My
 '93
MOHAWK RIVER, NEW YORK
— Cohoes Falls (Late 18th cent.)
 Am Heritage 47:84 (drawing,3) Jl '96
MOJAVE NATIONAL PRESERVE,
 CALIFORNIA
 Trav&Leisure 23:cov.,110,113,152
 (map,1) D '93
 Trav/Holiday 178:35 (c,4) Mr '95
 Nat Geog 187:4–5 (c,1) Ap '95
 Smithsonian 26:46–7 (c,1) My '95
 Nat Geog 189:54–6,68–71 (c,1) My '96
MOLES
 Smithsonian 24:52–63 (c,2) Mr '94
— Star-nosed mole
 Nat Wildlife 35:32-3 (c,2) D '96
MOLLUSKS
 Natur Hist 103:32-9 (c,1) Jl '94
 Nat Geog 190:78 (c,4) N '96
— Dentalium used as currency by ancient
 Indians (Northwest)
 Nat Geog 183:108–17 (c,1) Ja '93
— See also
 CLAMS
 CONCHES
 CUTTLEFISH
 MUSSELS
 NAUTILUSES
 OCTOPI
 OYSTERS
 PERIWINKLES
 SLUGS
 SNAILS
 SQUID
 WHELKS
MOLOTOV, VYACHESLAV
 Am Heritage 46:59 (4) D '95
MONACO
 Nat Geog 189:80–95 (map,c,1) My '96
— See also
 MONTE CARLO
MONACO—COSTUME
 Nat Geog 189:80–95 (c,1) My '96
MONACO—HISTORY
— Princess Grace as actress Grace Kelly
 Life 18:26 (c,3) Ap '95
Monarchs. See
 RULERS AND MONARCHS
MONASTERIES
— 12th cent. Cistercian abbey (Jerpoint,
 Ireland)
 Trav&Leisure 25:53 (c,4) Jl '95
— 1944 destruction of Monte Cassino, Italy
 Trav/Holiday 178:66 (3) S '95
— Abbey of Sant' Antimo, Italy
 Trav/Holiday 175:52–3 (2) N '92
— Bhutan
 Trav&Leisure 26:122–3,126 (c,1) Je '96
— Eritrea
 Nat Geog 189:98–9 (c,2) Je '96
— Ganden Monastery, Tibet
 Trav&Leisure 23:82–3 (c,4) Jl '93
— Jeronimos Monastery, Lisbon, Portugal
 Trav&Leisure 22:78 (c,4) Mr '92
 Gourmet 54:114 (c,3) O '94
— Monastery life (New Mexico)
 Life 19:66–73 (1) Je '96
— Monastery of St. George, Israel
 Life 15:38–9 (c,1) D '92
— Monastery of St. John, Patmos, Greece
 Trav&Leisure 22:94–5,99 (c,1) Ag '92
— Mottisfont Abbey gardens, England
 Gourmet 53:86–90,130 (map,c,1) Je '93
— Rievaulx Abbey, Yorkshire, England
 Gourmet 55:92–3 (c,1) Mr '95
— St. Catherine's Monastery, Mt. Sinai, Egypt
 Trav/Holiday 177:97 (c,3) Ap '94
— See also
 MONT ST. MICHEL
MONDRIAN, PIET
 Smithsonian 26:98–9,106 (1) Je '95
— 1965 Saint Laurent dresses inspired by
 Mondrian
 Smithsonian 26:104–5 (c,2) Je '95
— Works by him
 Smithsonian 26:98–107 (c,1) Je '95
MONET, CLAUDE
— 1876 painting of Argenteuil garden
 Smithsonian 25:50–1 (c,1) Mr '95
— "The Boat Studio" (1876)
 Life 16:84 (painting,c,2) Ap '93
 Smithsonian 24:109 (painting,c,2) My '93
— "Garden at Sainte-Adresse" (1867)
 Trav/Holiday 178:129 (painting,c,4) Mr
 '95
— "La Grenouillere" (1869)
 Smithsonian 25:84 (painting,c,4) N '94
— "Impression: Sunrise"
 Trav/Holiday 179:6 (painting,c,4) Je '96
— "Women in the Garden" (1867)
 Smithsonian 25:78 (painting,c,2) N '94
Money. See
 COINS
 CURRENCY
MONGOL EMPIRE
— Depictions of Mongolian horsemen
 Natur Hist 103:48–57 (painting,c,1) O '94

— See also
 GENGHIS KHAN
 KUBLAI KHAN
MONGOL EMPIRE—HISTORY
— 1214 battle between Mongols and China
 Natur Hist 103:50–1 (painting,c,1) O '94
— History of Mongol Empire
 Nat Geog 190:cov.,2–37 (map,c,1) D '96
MONGOLIA
 Nat Geog 183:126–38 (c,1) My '93
— Sites associated with Mongol Empire
 Nat Geog 190:cov.,2–37 (map,c,1) D '96
— See also
 GOBI DESERT
MONGOLIA—COSTUME
 Nat Geog 183:126–38 (c,1) My '93
 Nat Geog 190:2–31 (c,1) D '96
**MONGOLIA—RITES AND FESTI-
VALS**
— Naadam Festival, Ulaanbaator
 Nat Geog 190:18–19,25 (c,1) D '96
MONGOOSES
 Nat Geog 188:30–1 (c,1) S '95
MONITORS (LIZARDS)
 Nat Geog 181:71 (c,1) Ap '92
 Natur Hist 104:52–3 (c,2) Ap '95
 Natur Hist 104:4,50–4 (c,1) O '95
— See also
 KOMODO DRAGONS
MONKEY FLOWERS
 Smithsonian 27:41 (c,1) Jl '96
MONKEYS
 Trav&Leisure 23:185 (c,4) Ap '93
 Natur Hist 102:44–9 (c,1) O '93
 Natur Hist 103:44–51 (c,1) My '94
 Natur Hist 104:cov. (painting,c,1) D '95
— Feast for monkeys (Thailand)
 Nat Geog 189:100 (c,1) F '96
— Langurs
 Trav&Leisure 22:64 (c,4) My '92
 Nat Geog 184:17 (c,1) Jl '93
— Macaque embryos
 Life 19:39–49 (c,1) N '96
— Macaques
 Natur Hist 103:10–11 (c,4) Mr '94
 Nat Geog 186:cov.,18–19 (c,1) D '94
 Smithsonian 27:36 (c,4) Je '96
— Owl monkeys
 Natur Hist 103:44–7 (c,1) My '94
— Performing street monkey (China)
 Nat Geog 189:18–19 (c,2) Mr '96
— Quadriplegic man with pet monkey
 Life 18:77–9 (c,1) Ag '95
— Snow monkey
 Life 19:54 (c,1) O '96

— Spider monkeys
 Nat Geog 187:2–3 (c,1) F '95
— Squirrel monkeys
 Natur Hist 101:42–9 (c,1) Jl '92
 Natur Hist 103:49 (c,4) My '94
— Titis
 Natur Hist 103:48 (c,1) My '94
— Vervets
 Trav&Leisure 22:128 (c,4) Je '92
 Natur Hist 103:48–54 (c,1) Ag '94
— Woolly spider monkeys (muriquis)
 Natur Hist 102:cov.,34–43 (c,1) Mr '93
— See also
 BABOONS
 BARBARY APES
 CAPUCHIN MONKEYS
 COLOBUS MONKEYS
 HOWLERS
 LEMURS
Monks. See
 BUDDHISM—COSTUME
Monorails. See
 RAILROADS
MONROE, MARILYN
 Life 15:72–8 (3) Ag '92
 Smithsonian 23:68 (4) N '92
 Sports Illus 79:70–1 (1) Jl 19 '93
 Life 16:30 (3) N '93
 Life 17:46–56 (c,1) My '94
 Life 19:25,116 (4) O '96
— 1952 nude Marilyn Monroe calendar
 Am Heritage 44:49 (c,4) My '93
MONSTERS
— 19th cent. depiction of sea monster
 attacking ship
 Smithsonian 27:126–7 (engraving,c,1) My
 '96
— Sci-Fi Monster Museum, California
 Smithsonian 26:96 (c,2) Ap '95
— See also
 DEVILS
 DRAGONS
 FRANKENSTEIN
MONT ST. MICHEL, FRANCE
 Gourmet 55:88 (c,4) Je '95
 Life 18:17–20 (c,1) Jl '95
MONTANA
 Trav&Leisure 23:114–19 (c,1) Mr '93
 Trav/Holiday 176:cov.,60–71 (map,c,1) Je
 '93
— 19th cent. personalities
 Trav/Holiday 176:68–9 (4) Je '93
— Bannack
 Trav/Holiday 179:95,99 (c,1) S '96
— Bob Marshall Wilderness

Smithsonian 25:93 (c,2) Ag '94
— Bowman Lake
 Life 16:80–1 (c,1) S '93
— Bozeman
 Am Heritage 43:26 (c,4) Jl '92
— Countryside
 Trav/Holiday 176:60–7 (c,1) Je '93
 Gourmet 54:146–9 (c,1) My '94
 Trav/Holiday 177:70–7 (c,1) Je '94
— Great Falls trailer camp (1970)
 Life 19:98–9 (c,1) Winter '96
— Impact of Ice Age Lake Missoula floods
 Smithsonian 26:48–59 (map,c,1) Ap '95
— Ismay
 Smithsonian 26:82–3 (2) S '95
— Kintla Lake
 Sports Illus 79:76 (c,3) O 4 '93
— Livingston
 Trav&Leisure 23:E8 (c,4) S '93
— Miniature of Miles City
 Trav/Holiday 179:97 (c,1) S '96
— Missoula
 Smithsonian 26:52–3 (c,2) Ap '95
— Paradise
 Trav/Holiday 176:82–3 (c,3) Mr '93
— Paradise Valley
 Trav&Leisure 23:E1–E8,E16 (map,c,4) S '93
— Site of 1876 Battle of Little Big Horn
 Am Heritage 43:76–86 (map,c,1) Ap '92
 Am Heritage 43:104 (4) N '92
— Ski areas
 Gourmet 52:94–7,136 (map,c,1) Mr '92
— Square Butte area
 Life 16:34–5 (c,1) Ap 5 '93
— Three Forks
 Trav/Holiday 177:70–1 (c,1) Je '94
— Town rechristened "Joe, Montana"
 Sports Illus 79:2–3 (c,1) Jl 5 '93
— Unusual museums
 Trav/Holiday 179:92–9 (map,c,1) S '96
— Virginia City (1870s)
 Trav/Holiday 176:69 (4) Je '93
— Whitefish
 Trav&Leisure 23:132 (c,4) F '93
— Winter countryside
 Smithsonian 23:22 (c,4) Ag '92
— See also
 BUTTE
 GLACIER NATIONAL PARK
 MISSOURI RIVER
 RANKIN, JEANNETTE
 ROCKY MOUNTAINS
MONTE CARLO, MONACO
 Trav/Holiday 176:68–75 (map,c,1) F '93

Nat Geog 189:80–9 (c,1) My '96
— Monte Carlo casino
 Trav/Holiday 178:98 (c,4) Je '95
— Monte Carlo casino (19th cent.)
 Trav/Holiday 178:55 (4) Ap '95
MONTEREY, CALIFORNIA
— Monterey Bay Aquarium
 Trav/Holiday 176:58–63 (c,1) N '93
MONTERREY, MEXICO
 Nat Geog 190:52–61 (c,1) Ag '96
MONTEZUMA (MEXICO)
 Smithsonian 23:64,66 (painting,c,4) O '92
MONTGOMERY, ALABAMA
— Civil Rights memorial
 Am Heritage 43:90 (c,4) Ap '92
— Dexter Avenue Baptist Church
 Am Heritage 46:35 (c,4) F '95 supp.
MONTPELIER, VERMONT
— Capitol Building
 Smithsonian 23:106 (c,4) O '92
MONTREAL, QUEBEC
 Trav&Leisure 22:E6–7 (c,4) Jl '92
 Nat Geog 186:121 (c,3) O '94
— Christmas scenes
 Gourmet 55:136–9 (c,2) D '95
— Map
 Gourmet 55:192 (4) D '95
— Montreal Forum
 Sports Illus 79:9 (4) Jl 12 '93
— Old Montreal street
 Trav/Holiday 175:62 (2) D '92
MONUMENTS
— 19th cent. Buffalo soldier statue (Arizona)
 Am Heritage 44:14 (4) My '93
— 1948 unveiling of World War II memorial
 (Pennsylvania)
 Am Heritage 45:80–1 (1) My '94
— Bennington Battle monument, Vermont
 Am Heritage 43:52 (c,4) Ap '92
— Blue Plaques on homes of notable people
 (London, England)
 Gourmet 52:54,60,181–4 (c,4) My '92
— Boer War statue (Adelaide, Australia)
 Trav/Holiday 175:72 (c,3) F '92
— Buffalo Soldier Monument to black
 soldiers (Leavenworth, Kansas)
 Am Heritage 44:8 (c,3) F '93
— Civil Rights memorial (Montgomery,
 Alabama)
 Am Heritage 43:90 (c,4) Ap '92
— Civil War (Austin, Texas)
 Trav/Holiday 175:73 (c,3) F '92
— Civil War (Gettysburg, Pennsylvania)
 Trav/Holiday 177:74–81 (c,1) Jl '94

— Construction of Crazy Horse Memorial,
 South Dakota
 Life 16:14 (c,2) D '93
— European landmarks in sand sculpture
 (Netherlands)
 Life 15:24 (c,4) Ag '92
— Gateway Arch, St. Louis, Missouri
 Gourmet 53:cov.,92–3 (c,1) S '93
 Trav/Holiday 176:cov.,54–5 (c,1) S '93
— Martin Luther King, Jr. memorial, Atlanta,
 Georgia
 Am Heritage 47:88–9 (c,2) Ap '96
— Liberation Monument, Budapest, Hungary
 Trav/Holiday 175:60 (2) My '92
— *Lusitania* victims memorial (Cobh, Ireland)
 Nat Geog 185:84 (c,1) Ap '94
— Markers at Columbus landing sites (San
 Salvador)
 Natur Hist 105:24 (c,4) O '96
— Miami Holocaust Memorial, Florida
 Trav&Leisure 22:15 (c,4) Ag '92
— Miniatures of world landmarks (Japan)
 Trav/Holiday 178:80 (c,4) O '95
— Offerings left at Vietnam Veterans
 Memorial, Washington, D.C.
 Am Heritage 46:cov.,6,92–103 (c,1) F '95
— Paratrooper doll hanging from church
 steeple in memory of D-Day (France)
 Trav/Holiday 177:81 (c,1) Je '94
— Pharos of Alexandria, Egypt
 Life 19:72 (drawing,c,4) Ap '96
— Scotts Bluff Monument, Nebraska
 Trav&Leisure 25:46 (c,4) Jl '95
— Sculpture honoring World War I soldier
 (Verdun, France)
 Smithsonian 24:36–7 (2) F '94
— Sculpture of MacArthur's 1944 return to
 the Philippines
 Life 17:29 (c,2) D '94
— Seattle Space Needle, Washington
 Trav/Holiday 178:20 (c,4) My '95
 Gourmet 56:50 (c,2) Ja '96
 Am Heritage 47:50 (c,4) Jl '96
— Shrines to mountain climbing victims
 (Nepal)
 Nat Geog 182:88–9 (c,2) D '92
— Stone Mountain carvings, Atlanta, Georgia
 Life 15:15 (c,1) Jl '92
 Am Heritage 47:83 (c,1) Ap '96
— Stylized depiction of Paris landmarks,
 France
 Gourmet 54:22 (painting,c,2) Ja '94
— Vietnam Veterans Memorial, Washington,
 D.C.

Life 15:cov.,24–36 (c,1) N '92
Am Heritage 46:cov.,93 (c,1) F '95
Life 18:59 (4) Je '95
Trav/Holiday 179:75 (c,4) Mr '96
— See also
 ALAMO
 ARC DE TRIOMPHE
 DEVIL'S TOWER NATIONAL MONU-
 MENT
 EIFFEL TOWER
 GIBRALTAR
 GREAT WALL OF CHINA
 JEFFERSON MEMORIAL
 LEANING TOWER OF PISA
 LIBERTY, STATUE OF
 LINCOLN MEMORIAL
 MOUNT RUSHMORE
 PANTHEON
 SPHINX
 STONEHENGE
 TAJ MAHAL
 TOWER OF LONDON
 WASHINGTON MONUMENT
MOON
 Natur Hist 105:60 (c,4) S '96
— 1851 photograph
 Smithsonian 26:44 (4) O '95
— 1969 moon walk
 Am Heritage 45:6 (c,2) Jl '94
 Life 17:8–9 (c,1) Jl '94
 Life 18:60 (c,4) D '95
— Geese silhouetted against full moon
 Natur Hist 104:69 (c,2) S '95
 Nat Wildlife 34:cov. (c,1) Ap '96
— Lunar-lander Falcon on moon surface
 (1971)
 Natur Hist 103:68 (4) Ja '94
— Winter solstice moon seen from Antarctica
 Nat Geog 189:54–5 (c,1) Mr '96
MOORE, MARIANNE
— Living room (New York City, New York)
 Smithsonian 23:112 (c,4) Ap '92
MOOSE
 Nat Wildlife 33:33 (c,1) O '95
 Natur Hist 105:68–9 (c,3) Jl '96
 Trav&Leisure 26:52 (c,4) Ag '96
 Nat Wildlife 34:46–53 (c,1) O '96
— Ancient Gallic moose
 Natur Hist 103:68 (drawing,4) Ap '94
MORMONS
— 1846 wagon train to Utah
 Smithsonian 27:48 (painting,c,2) Ap '96
— Mormon sites (Utah)
 Am Heritage 44:cov.,65–82 (c,1) Ap '93
— James Strang

Smithsonian 26:85–91 (4) Ag '95
— See also
YOUNG, BRIGHAM
MORMONS—HISTORY
— 1848 temple fire (Nauvoo, Illinois)
Smithsonian 25:16 (painting,c,4) Ag '94
— Sites along the Pioneer Trail (Utah)
Am Heritage 44:65–82 (c,1) Ap '93
MORMONS—SHRINES AND SYM-BOLS
— Sun face carved on column (Nauvoo, Illinois)
Smithsonian 25:14 (c,4) Ag '94
MORNING-GLORIES
Gourmet 54:60 (c,4) Ja '94
MOROCCO
Trav/Holiday 175:62–9 (painting,c,1) O '92
Gourmet 56:46–9,92 (map,c,1) Ja '96
Nat Geog 190:98–125 (map,c,1) O '96
— Essaouira
Nat Geog 190:100–1 (c,1) O '96
— Taroudant
Gourmet 56:46–7 (c,1) Ja '96
— See also
CASABLANCA
FEZ
MARRAKESH
TANGIER
MOROCCO—COSTUME
Trav/Holiday 175:62–7 (painting,c,1) O '92
Trav&Leisure 24:82–91 (c,1) Jl '94
Gourmet 56:46–9 (c,4) Ja '96
Nat Geog 190:98–125 (c,1) O '96
— Fishermen
Nat Geog 188:6–7 (c,1) N '95
— Marrakesh
Natur Hist 105:38–45 (c,1) My '96
— Women
Natur Hist 101:65 (2) Ja '92
MOROCCO—RITES AND FESTIVALS
— Henna patterns on bride's hands
Trav&Leisure 24:82 (c,1) Jl '94
MORRIS, WILLIAM
— Home (Gloucestershire, England)
Trav&Leisure 24:116, 118 (c,1) D '94
MORRISON, TONI
Am Heritage 43:102 (4) O '92
MOSAICS
— 3rd cent. Roman mosaic floor (Carthage)
Smithsonian 25:141 (c,3) Ap '94
— 6th cent. Byzantine church mosaic (Ravenna, Italy)
Trav&Leisure 23:82 (c,4) N '93

— Corn Palace, Mitchell, South Dakota
Nat Geog 183:114–15 (c,1) Je '93
— Monument to the Discoveries, Lisbon, Portugal
Gourmet 54:117 (c,1) O '94
— Ravenna churches, Italy
Gourmet 56:98–101 (c,2) F '96
MOSCOW, RUSSIA
— Napoleon burning Moscow (1812)
Trav/Holiday 178:67 (lithograph,c,4) S '95
— GUM store
Trav/Holiday 176:93 (c,4) Ap '93
Natur Hist 102:110 (4) O '93
— National Hotel
Trav&Leisure 25:28 (c,4) Je '95
— See also
KREMLIN
MOSES
Smithsonian 27:63 (painting,c,4) Ag '96
— 15th cent. painting of Moses dowsing for water
Smithsonian 26:70 (c,3) Ja '96
Moslems. See
MUSLIMS
MOSQUES
— 17th cent. view of mosque in the Parthenon, Athens, Greece
Trav/Holiday 178:100 (drawing,4) S '95
— Akko, Israel
Trav&Leisure 22:154 (c,4) O '92
— Bari Mosque, Bahawalpur, Pakistan
Trav&Leisure 24:126 (c,4) S '94
— Blue Mosque, Istanbul, Turkey
Trav/Holiday 179:10 (c,3) S '96
— Djenne Mosque, Mali
Trav&Leisure 25:147 (c,1) F '95
— Dome of the Rock, Jerusalem, Israel
Nat Geog 189:3,7,11–13 (c,1) Ap '96
— Hassan II Mosque, Casablanca, Morocco
Gourmet 56:49 (c,2) Ja '96
— Ibn Toulun, Cairo, Egypt
Trav&Leisure 22:66 (c,4) S '92
— Istanbul, Turkey
Trav&Leisure 26:84–5 (c,3) Ag '96
— Muhammad Ali Mosque, Cairo, Egypt
Trav/Holiday 175:56–7 (c,1) S '92
Gourmet 52:94 (c,4) S '92
Nat Geog 183:66–7 (c,2) Ap '93
— Mustafa Mahmoud mosque, Cairo, Egypt
Nat Geog 183:57 (c,1) Ap '93
— Salalah, Oman
Trav/Holiday 177:92 (c,4) Ap '94
— Singapore
Trav&Leisure 26:80 (c,4) Ja '96
— Suleymaniye Mosque, Istanbul, Turkey

Trav&Leisure 26:84,112 (c,3) Ag '96
— Tunis, Tunisia
 Trav/Holiday 178:42–3 (c,2) N '95
— Umayyaad, Damascus, Syria
 Trav&Leisure 24:72 (c,4) N '94
MOSQUITOS
 Smithsonian 23:51 (c,4) D '92
 Life 16:74–5 (c,1) Ag '93
 Nat Wildlife 32:34–5 (c,1) Ap '94
 Life 17:60–1 (c,1) My '94
 Trav/Holiday 178:24 (c,4) Mr '95
 Nat Geog 188:10–11 (c,1) S '95
 Sports Illus 84:4–5 (c,4) Je 24 '96
— Cloud of mosquitos
 Nat Geog 182:73 (c,3) Ag '92
— Large mosquito sculpture (Alaska)
 Trav/Holiday 176:58 (c,4) My '93
MOSS
 Nat Wildlife 32:55 (c,2) D '93
 Natur Hist 104:24 (c,2) N '95
MOTHS
 Smithsonian 23:54 (c,4) D '92
 Natur Hist 103:42–9 (c,1) F '94
 Natur Hist 104:82–3 (c,1) Je '95
 Smithsonian 26:68–81 (c,1) F '96
 Natur Hist 105:32–3 (c,1) Ag '96
— Moth larva
 Nat Wildlife 33:34–5 (c,1) Ag '95
— Moth varieties
 Smithsonian 26:68–81 (c,1) F '96
— Silkworm moths mating
 Nat Wildlife 32:56–7 (c,1) Ap '94
— Stages of moth's life
 Smithsonian 26:72 (c,4) F '96
— Tiger moth
 Natur Hist 103:27 (c,4) Ja '94
MOTION PICTURE INDUSTRY
— 1896 ads for Edison's Vitascope
 Am Heritage 44:78–82 (c,1) N '93
— Early ads for movie theaters
 Am Heritage 44:78–92,114 (c,1) N '93
— Early lantern slide about proper movie-
 going behavior
 Am Heritage 44:112 (4) O '93
— Early movie theaters
 Am Heritage 44:78–92,114 (c,1) N '93
— Documentary editing room
 Smithsonian 25:39,42 (c,1) Jl '94
— Film shoot (Toronto, Ontario)
 Nat Geog 189:131 (c,3) Je '96
— Filming "The Bellamy Trial" (1929)
 Smithsonian 26:114 (2) O '95
— Filming "Romeo and Juliet" (1996)
 Life 19:14–15 (c,1) D '96
— Filming "Rush" (1992)

Smithsonian 23:102–5 (c,3) My '92
— Filming "School Ties" (1992)
 Smithsonian 23:100–11 (c,1) My '92
— Filming "Stargate" in Arizona desert
 (1994)
 Nat Geog 186:42–3 (c,1) S '94
— Making of "Unstrung Heroes" (1995)
 Life 18:68–74 (c,1) S '95
— Joseph Mankiewicz
 Life 17:82 (4) Ja '94
— Production designers altering locales for
 period movies
 Smithsonian 23:100–11 (c,1) My '92
— Hal Roach
 Nat Geog 181:53 (c,3) Je '92
— Steven Spielberg
 Life 16:48 (1) D '93
— Stuntmen performing stunts for movies
 Sports Illus 77:76–86 (c,1) O 5 '92
— See also
 FELLINI, FEDERICO
 HUSTON, JOHN
 MAYER, LOUIS B.
 VON STERNBERG, JOSEF
MOTION PICTURES
— 1949 drive-in movie
 Life 19:78 (1) Winter '96
— 1950 "Sunset Boulevard" poster (Poland)
 Trav&Leisure 23:29 (c,4) Je '93
— 1951 family at drive-in movie
 Life 19:84–5 (1) Winter '96
— 1955 movie audience in 3-D glasses
 (California)
 Life 18:28 (3) F '95
— 1956 drive-in (West Virginia)
 Life 19:96–7 (1) D '96
— "The Alamo" (1960)
 Am Heritage 46:10,105–7 (c,2) Ap '95
— "Andersonville" (1996)
 Life 19:30 (c,4) Mr '96
— "Apocalypse Now" (1978)
 Am Heritage 46:82–3 (c,1) S '95
— "The Babe" (1993)
 Life 15:41–50 (c,2) Ap '92
— "Being There" (1979)
 Smithsonian 23:14 (4) N '92
— "The Big Store" (1941)
 Smithsonian 23:128 (4) Mr '93
— "Boys Town" (1938)
 Sports Illus 77:79 (2) D 21 '92
— "Breathless" (1961)
 Trav&Leisure 24:30 (4) Ja '94
— "The Bridges of Madison County" (1995)
 Life 18:46–54 (c,1) Je '95
 Nat Geog 188:58 (c,3) Ag '95

— "Butch Cassidy and the Sundance Kid"
 (1969)
 Life 16:66–7 (c,3) Ap 5 '93
— "Cabaret" (1972)
 Smithsonian 27:56 (c,4) N '96
— "The Callahans and the Murphys" (1920s)
 Natur Hist 103:64 (3) Ag '94
— "The Cameraman" (1928)
 Smithsonian 26:104 (4) O '95
— "Camille" (1937)
 Smithsonian 23:187 (4) N '92
— "Cyrano de Bergerac" (1950)
 Life 16:80 (1) Ja '93
— "Dances with Wolves" (1991)
 Life 16:68 (c,4) Ap 5 '93
— "Daughter of the Dawn" (1917)
 Natur Hist 102:70–1 (1) O '93
— "The Deadly Mantis" poster (1957)
 Nat Wildlife 33:20 (c,4) F '95
— "The Devil's Brother" (1933)
 Smithsonian 23:29 (4) Ap '92
— "Disclosure" (1994)
 Life 17:45 (c,4) D '94
— Disney characters (Florida)
 Life 19:19–21 (c,1) S '96
— "Dr. Jekyll and Mr. Hyde" (1920)
 Smithsonian 26:53 (4) Ag '95
— "Dracula" (1931)
 Life 17:66–71 (1) N '94
— Drive-in movies
 Smithsonian 25:108–13 (c,1) My '94
 Life 17:18 (c,2) Ag '94
— "Easy Rider" (1969)
 Smithsonian 24:96 (4) N '93
— "Far and Away" (1992)
 Trav/Holiday 175:83 (4) Je '92
— "Field of Dreams" farm (Iowa)
 Sports Illus 84:118 (c,4) Ap 1 '96
— Film roles of Winona Ryder
 Life 17:96,98 (c,4) D '94
— Films featuring Ethel Waters
 Am Heritage 45:67 (4) F '94
— "Fire over England" (1936)
 Am Heritage 43:72 (4) S '92
— "Flesh and the Devil" (1927)
 Smithsonian 26:103 (1) O '95
— "The Flintstones" (1994)
 Sports Illus 80:69 (c,4) Je 6 '94
— "Fort Apache" (1948)
 Life 16:64–5 (4) Ap 5 '93
— Frankenstein movies (1910–1994)
 Life 17:44 (c,2) N '94
— "Free Willy" (1993)
 Life 16:56 (c,4) N '93
— "From Here to Eternity" (1953)

 Life 16:40–1 (1) Ap '93
— "The Front Page" (1931)
 Am Heritage 46:76 (4) S '95
— "Funny Face" (1956)
 Trav&Leisure 22:24 (c,3) D '92
— "The General" (1927)
 Am Heritage 46:92 (4) S '95
— "The Gold Rush" (1925)
 Smithsonian 26:106 (4) O '95
— "Gone with the Wind" (1939)
 Am Heritage 44:85 (4) S '93
 Am Heritage 46:77 (c,4) S '95
— "High Noon" (1952)
 Life 16:62–3 (3) Ap 5 '93
— "The Hunchback of Notre Dame" films
 (1923–1996)
 Life 19:35 (c,4) Je '96
— "The Hunt for Red October" (1990)
 Life 19:76–7 (c,1) Mr '96
— "If I Were King" (1938)
 Am Heritage 43:72 (4) S '92
— IMAX movie audience in 3-D goggles
 (New York)
 Life 18:28 (c,3) F '95
 Nat Geog 188:18–19 (c,1) O '95
— "Imitation of Life" (1934)
 Am Heritage 44:85 (4) S '93
— "In the Name of the Father" (1993)
 Trav/Holiday 176:100 (c,4) D '93
— "It Happened in Athens" (1960)
 Sports Illus 85:7 (4) Ag 5 '96
— "JFK" (1991)
 Am Heritage 46:78 (c,4) S '95
— "Jefferson in Paris" (1995)
 Smithsonian 25:94–105 (c,1) Mr '95
 Am Heritage 46:117 (c,2) Ap '95
— "Jim Thorpe: All American" (1951)
 Life 18:79 (3) Ja '95
— "Judgment at Nuremberg" (1961)
 Smithsonian 27:139 (4) O '96
— "Jurassic Park" logo (1993)
 Life 15:62 (c,4) O '92
— "Jurassic Park" models (1993)
 Nat Geog 183:49 (c,3) Ja '93
— King Kong sculpture
 Life 18:32 (c,3) D '95
— "Knute Rockne, All American" (1940)
 Smithsonian 24:173 (4) N '93
— "The Last Emperor" (1987)
 Trav&Leisure 25:64–5,112 (c,1) Ja '95
— "Lawrence of Arabia" (1962)
 Life 16:48–9 (c,1) Ap '93
— "A League of Their Own" (1992)
 Smithsonian 26:42 (c,4) Ap '95
— "Limelight" (1952)

Smithsonian 25:139 (4) D '94
— "The Lion King" (1994)
Life 18:17 (c,4) Ja '95
— "The Little Colonel" (1935)
Smithsonian 24:60 (4) Je '93
— "Lonesome" (1928)
Smithsonian 26:112 (4) O '95
— "The Long Walk Home" (1990)
Am Heritage 46:79 (c,4) S '95
— "The Lost Weekend" poster (1945)
Life 18:77 (c,4) Je 5 '95
— "Love Me Tonight" (1932)
Am Heritage 44:86 (painting,c,2) O '93
— "The Magnificent Seven" (1960)
Life 16:64 (c,3) Ap 5 '93
— "Maisie Goes to Reno" (1944)
Smithsonian 27:68 (4) Je '96
— "The Maltese Falcon" (1941)
Smithsonian 25:115,119 (3) My '94
— Marshmallow model of Dorothy's ruby
 slippers
Smithsonian 25:13 (c,4) Jl '94
— Steve Martin films
Life 15:49,52,54 (c,4) Mr '92
— "The Master of Ballantree" (1953)
Smithsonian 26:53 (4) Ag '95
— "Member of the Wedding" (1952)
Am Heritage 44:85 (4) S '93
— "The Misfits" (1961)
Smithsonian 27:69 (4) Je '96
— Tom Mix film
Smithsonian 26:106 (4) O '95
— "Moby Dick" (1956)
Smithsonian 26:109 (4) Jl '95
— "Modern Times" (1936)
Smithsonian 24:154 (2) Ap '93
— Movie posters (India)
Nat Geog 187:52 (c,3) Mr '95
— Movies depicting Wyatt Earp
Trav&Leisure 24:92–5,145 (4) F '94
— Movies depicting frontier life
Life 16:60–8 (c,1) Ap 5 '93
— "Mrs. Parker and the Vicious Circle"
 (1994)
Life 17:24 (c,4) Ag '94
— "Mutiny on the Bounty" (1962)
Life 17:45 (c,3) Ap '94
— "My Darling Clementine" (1946)
Life 16:62 (4) Ap 5 '93
Trav&Leisure 24:145 (4) F '94
Am Heritage 46:80 (4) S '95
— "A Night at the Opera" stateroom scene
 (1935)
Trav/Holiday 179:13 (4) O '96
— "Night of the Iguana" (1962)

Trav/Holiday 175:52 (4) D '92
— "The Nightmare Before Christmas" (1993)
Life 16:103–4 (c,2) N '93
— "North by Northwest" (1959)
Smithsonian 23:72 (4) Ag '92
— "The Nutcracker" (1993)
Life 16:34–44 (c,1) D '93
— "Old Gringo"
Smithsonian 22:113 (c,4) Mr '92
— "One Million, B.C." (1940)
Smithsonian 27:32 (4) N '96
— "Our Gang's" Spanky McFarland
Life 17:67 (1) Ja '94
— "The Phantom of the Opera" (1925)
Smithsonian 26:110 (4) O '95
— "Planet of the Apes" (1968)
Natur Hist 105:12–13 (c,2) N '96
— "Pocahontas" (1995)
Life 18:64,68–9 (c,1) Jl '95
— "The Professionals" (1966)
Life 16:67 (c,4) Ap 5 '93
— "Quiz Show" (1994)
Life 17:37 (c,4) S '94
— "Ready, Willing, and Able" (1937)
Am Heritage 44:92–3 (painting,c,1) O '93
— "Red Badge of Courage" (1951)
Smithsonian 25:121 (4) Ja '95
— "Reefer Madness" movie poster (1936)
Am Heritage 44:55 (c,3) F '93
— "Return of the Fly" poster (1959)
Nat Wildlife 33:24 (c,4) F '95
— "A River Runs Through It" (1992)
Smithsonian 23:120–31 (c,1) S '92
— "Rocky" statue (Philadelphia,
 Pennsylvania)
Sports Illus 85:14 (c,4) S 9 '96
— Ruby slippers from "The Wizard of Oz"
 (1939)
Smithsonian 26:24 (c,4) F '96
— "Saturday Night Fever" (1977)
Life 15:83 (c,1) D 1 '92
— Saving the real-life orca "Willy"
Life 19:cov.,52–8 (c,1) Mr '96
— "The Scarlet Pimpernel" (1935)
Am Heritage 43:72 (4) S '92
— "Schindler's List" (1993)
Life 16:50–4 (3) D '93
— "Sea Hawk" (1940)
Smithsonian 27:78 (4) Je '96
— "Shane" (1953)
Life 16:65 (4) Ap 5 '93
— "Silverado" (1985)
Life 16:68 (4) Ap 5 '93
— "Simba" (1928)
Trav/Holiday 177:89 (4) Je '94

— "Six Degrees of Separation" (1993)
Trav&Leisure 23:32 (c,4) D '93
— "Stagecoach" (1939)
Life 16:62 (4) Ap 5 '93
— "Stalag 17" (1953)
Smithsonian 26:137 (4) Je '95
— "A Streetcar Named Desire" (1951)
Smithsonian 23:98 (4) Ap '92
— "Sunset Boulevard" (1950)
Smithsonian 24:60 (4) Je '93
— "Svengali" (1931)
Smithsonian 24:110–1 (2) D '93
— "Tarzan"
Nat Geog 181:36 (4) Mr '92
Sports Illus 76:58 (4) Ap 13 '92
— "Teenage Mutant Ninja Turtles III" (1993)
Smithsonian 23:106–7 (c,2) D '92
— "Thelma and Louise" (1991)
Life 15:67 (c,3) Ja '92
— "The Thin Man" (1934)
Smithsonian 25:121 (4) My '94
— "The Three Musketeers" (1948)
Smithsonian 27:118 (3) Jl '96
Smithsonian 27:12 (4) S '96
— "The Three Musketeers" (1974)
Smithsonian 27:119 (3) Jl '96
— "Top Hat" (1935)
Am Heritage 44:88–9 (painting,c,1) O '93
— "Treasure Island" (1934)
Smithsonian 26:52 (4) Ag '95
— "Treasure of the Sierra Madre" (1948)
Trav/Holiday 178:54 (4) D '95
— "Twelve Angry Men" (1957)
Am Heritage 46:46–7 (2) Jl '95
— "Under Two Flags" (1936)
Am Heritage 43:72 (4) S '92
— "Wake Up and Live" (1937)
Am Heritage 45:96 (1) N '94
— "The Wild One" (1954)
Smithsonian 24:96 (4) N '93
— "The Women" (1939)
Smithsonian 27:68–9 (3) Je '96
— "Young Mr. Lincoln" (1939)
Am Heritage 46:74–5 (1) S '95
— "Zorro" (1920)
Smithsonian 27:79 (3) Je '96
MOTMOTS
Natur Hist 101:59 (c,4) Ja '92
Nat Wildlife 32:22–3 (painting,c,1) D '93
MOTORBOATS
— Personal craft
Sports Illus 79:64–5 (c,1) S 6 '93
MOTORCYCLE INDUSTRY
— William Harley
Smithsonian 24:90 (4) N '93

— Motorcycle plant (Pennsylvania)
Smithsonian 24:94 (c,4) N '93
MOTORCYCLE RIDING
Sports Illus 78:30–1 (c,1) F 15 '93
Sports Illus 78:56 (c,3) Je 21 '93
Life 17:108 (c,2) Je '94
Trav&Leisure 25:E14 (c,4) F '95
Sports Illus 82:48–9 (c,1) My 8 '95
Sports Illus 83:52–3 (c,1) O 30 '95
Sports Illus 84:56–7 (c,1) Je 24 '96
— 1922 (New York)
Natur Hist 105:18 (2) Ja '96
— 1961 biker (California)
Trav&Leisure 25:E2 (4) N '95
— Child seat on motorcycle (Taiwan)
Nat Geog 184:33 (c,1) N '93
— Driver's view of road (Greece)
Trav&Leisure 22:96–7 (c,1) Ag '92
— Great Britain
Trav&Leisure 25:112 (c,4) Ap '95
— Harley-Davidson bikers
Smithsonian 24:88–99 (c,1) N '93
— India
Trav&Leisure 25:66 (c,4) Jl '95
— Man sitting on bike
Sports Illus 77:30–1 (c,1) S 28 '92
— Mongolia
Nat Geog 183:138 (c,3) My '93
— Motocross
Sports Illus 81:149–50 (c,4) S 5 '94
— Motorcycle miniatures
Life 17:40–55 (c,4) D '94
— People on motorbikes and scooters (Milan, Italy)
Trav&Leisure 26:169 (c,4) O '96
— Portugal
Trav&Leisure 24:119 (c,1) O '94
— Riding motor scooter
Sports Illus 81:36 (c,2) Ag 29 '94
— Riding motor scooter (Bermuda)
Trav/Holiday 177:70 (c,4) My '94
— Riding motor scooter (India)
Smithsonian 23:120 (c,4) My '92
— Taiwan commuter traffic
Nat Geog 184:6–7 (c,1) N '93
— Vietnam
Gourmet 55:88 (c,4) S '95
MOTORCYCLES
Sports Illus 78:71 (c,1) My 17 '93
Smithsonian 24:88–99 (c,1) N '93
— 1930s
Am Heritage 43:102 (4) D '92
Smithsonian 24:90 (4) N '93
— 1940s
Smithsonian 24:98 (4) N '93

— Huge motorcycle-shaped balloon
Smithsonian 24:95 (c,3) N '93
MOUNT ETNA, SICILY, ITALY
— 1992 eruption
Life 15:7 (c,2) Mr '92
Nat Geog 182:10–11 (c,1) D '92
Life 16:16–17 (c,1) Ja '93
MOUNT EVEREST, NEPAL/TIBET
Life 19:cov.,32–7 (c,1) Ag '96
— View from space
Nat Geog 190:16–17 (c,1) N '96
MOUNT HOOD, OREGON
Trav/Holiday 175:32 (c,4) My '92
Life 16:70–1 (c,1) D '93
MOUNT McKINLEY, ALASKA
Nat Geog 182:62–5 (c,1) Ag '92
Gourmet 54:20,150–1 (c,1) My '94
Life 17:83 (c,2) S '94
MOUNT RAINIER, WASHINGTON
Trav&Leisure 23:NY4 (c,4) My '93
Nat Geog 186:9–11 (c,1) O '94
Smithsonian 25:44 (c,4) N '94
Nat Geog 187:130 (c,3) Je '95
Gourmet 56:52 (c,4) Ja '96
Smithsonian 27:32–41 (c,1) Jl '96
MOUNT RAINIER NATIONAL PARK, WASHINGTON
Nat Geog 186:cov.,9–11 (c,1) O '94
MOUNT RUSHMORE, SOUTH DA-KOTA
Smithsonian 23:64–75 (c,1) Ag '92
Gourmet 55:48 (c,4) Ag '95
— Construction (1930s)
Smithsonian 23:68,74–5 (c,3) Ag '92
Smithsonian 23:9 (4) O '92
— *Mad* magazine parody
Smithsonian 23:70 (c,4) Ag '92
MOUNT ST. HELENS, WASHINGTON
Nat Geog 182:30–1 (c,1) D '92
— 1980 eruption
Life 17:43 (c,4) My '94
Smithsonian 27:34 (c,4) Jl '96
— Lake created by 1980 eruption
Sports Illus 80:92 (c,4) Je 27 '94
— Visitors Center
Trav&Leisure 24:E14 (c,4) Ap '94
MOUNT SHASTA, CALIFORNIA
Nat Geog 184:56–7 (c,2) Jl '93
Trav/Holiday 179:71 (c,4) Jl '96
MOUNT WASHINGTON, NEW HAMP-SHIRE
Trav&Leisure 22:E10 (c,3) O '92
MOUNT WHITNEY, CALIFORNIA
Trav&Leisure 23:195 (c,4) Mr '93

MOUNTAIN CLIMBING
— 1953 Mount Everest expedition team
Trav/Holiday 176:31 (4) D '93
— Alaska
Nat Geog 182:64–73 (c,1) Ag '92
— Alberta
Nat Geog 188:52–3 (c,1) Jl '95
— California
Sports Illus 85:84 (c,4) S 16 '96
— Chile
Nat Geog 181:92–3 (c,1) Mr '92
Nat Geog 185:116–30 (c,1) Ap '94
— Climbing glacier (Alaska)
Nat Geog 185:99 (c,1) My '94
— Climbing in glacier caves
Nat Geog 189:cov.,70–81 (c,1) F '96
— Dangling from cliff (Switzerland)
Life 19:16–17 (c,1) My '96
— Himalayas
Sports Illus 80:94 (c,4) My 30 '94
— Ice climbing
Nat Geog 190:82–95 (c,1) D '96
— Ice climbing (Alberta)
Nat Geog 188:56–7 (c,1) Jl '95
— Ice climbing (Tibet)
Nat Geog 190:82–4 (c,1) D '96
— Man atop Mt. Everest (1963)
Life 18:59 (c,4) D '95
— Mongolia
Sports Illus 80:55 (c,2) Ja 24 '94
— Mt. Everest, Nepal
Nat Geog 182:72–5 (c,1) D '92
Life 19:cov.,32–42 (c,1) Ag '96
— Old man climbing mountain (Antarctica)
Life 18:80–4 (c,1) My '95
— One-legged mountain climber
Sports Illus 82:9–11 (c,4) My 29 '95
— Peru
Nat Geog 189:64–9,74–5 (c,1) Je '96
— Trango Tower, Pakistan
Nat Geog 189:72–5 (c,1) Ap '96
— Wyoming
Nat Geog 187:119,128–9 (c,1) F '95
—See also
HILLARY, EDMUND
MOUNTAIN GOATS
Trav&Leisure 23:117 (c,1) Mr '93
Sports Illus 78:102 (c,4) Ap 5 '93
Nat Geog 185:83 (c,4) My '94
Nat Geog 186:38–9 (c,2) O '94
Nat Geog 186:30–1 (c,1) D '94
Nat Geog 187:102–21 (c,1) Ap '95
Life 18:70 (c,2) My '95
MOUNTAIN LIONS
Smithsonian 22:113–22 (c,3) F '92

Nat Geog 182:cov.,38–65 (c,1) Jl '92
Nat Geog 184:26–7 (c,1) Jl '93
Nat Wildlife 31:15 (c,1) O '93
Sports Illus 80:6–7 (c,4) My 16 '94
Nat Wildlife 32:42–3 (painting,c,1) Ag '94
Natur Hist 103:53–9 (c,1) D '94
Nat Wildlife 33:35 (c,1) Je '95
MOUNTAINS
— Angelmo, Chile
Gourmet 54:104–5 (c,2) F '94
— Brooks Range, Alaska
Nat Geog 183:74–5,80–1 (c,1) Ap '93
Smithsonian 26:60–71 (c,1) Je '95
Smithsonian 26:32–3 (c,1) Mr '96
— Cadillac Mountain, Maine
Trav/Holiday 178:69 (c,1) Je '95
— Cariboo mountains, British Columbia
Gourmet 53:110–11 (c,1) O '93
— Charleston Mountains, Nevada
Natur Hist 101:16 (c,3) Mr '92
— Cordillera Sarmiento Range, Chile
Nat Geog 185:116–30 (map,c,1) Ap '94
— Crimean Mountains, Ukraine
Nat Geog 186:102–3 (c,1) S '94
— Drakensberg Mountains, South Africa
Nat Geog 190:2–4 (c,1) Jl '96
— Half Dome, Yosemite, California
Trav/Holiday 176:76,80 (c,1) F '93
Life 17:26–9 (c,1) Jl '94
— Jhomolhari Peak, Bhutan
Trav&Leisure 26:125 (c,4) Je '96
— Los Pitons, St. Lucia
Trav/Holiday 175:48–9,54 (c,1) F '92
Gourmet 54:58 (c,2) Ja '94
— Mormon Mountains, Nevada
Nat Geog 182:50–1 (c,1) D '92
— Mount Adams, Washington
Trav&Leisure 24:76–7 (c,1) Ja '94
— Mount Ararat, Turkey
Nat Geog 185:16–17 (c,1) My '94
— Mount Baker, Washington
Trav&Leisure 23:124 (c,4) Jl '93
— Mount Baldy, Arizona
Natur Hist 102:62–3 (c,1) Jl '93
— Mount Egmont, North Island, New Zealand
Gourmet 53:144 (c,3) N '93
— Mount Lemmon, Arizona
Natur Hist 101:68 (c,4) S '92
— Mount Merapi, Indonesia
Trav&Leisure 22:60–1,70–1 (c,1) Ja '92
— Mount Pelee, Martinique
Gourmet 53:57,59 (c,2) Ja '93
— Old Man of the Mountain, New Hampshire
Am Heritage 43:53 (c,4) Ap '92
— Organ Mountains, New Mexico

Am Heritage 47:27 (c,4) F '96
— Patagonia, Chile
Trav/Holiday 179:56–7 (c,1) Je '96
— Pyramid Peak, Aspen, Colorado
Trav&Leisure 24:52 (c,4) D '94
— Rocca Malatina
Trav&Leisure 22:119 (c,4) Ja '92
— San Juan Mountains, Colorado
Trav&Leisure 22:E1 (c,3) Ag '92
— Santa Catalina Mountains, Arizona
Natur Hist 101:cov.,68 (c,1) S '92
— Shawangunk Ridge, New York
Smithsonian 27:cov.,30–41 (c,1) Ag '96
— Southern Alps, New Zealand
Gourmet 55:105 (c,1) Ap '95
— Sugarloaf, Rio de Janeiro, Brazil
Trav&Leisure 23:132 (c,1) N '93
— Towers of Paine, Patagonia, Argentina
Smithsonian 25:44 (c,4) N '94
— Trinity Alps, California
Trav&Leisure 22:96–7,100–1 (c,1) Ja '92
— Washakie Needle, Wyoming
Nat Wildlife 30:22–3 (c,1) Je '92
— See also
ADIRONDACKS
ALASKA RANGE
ALLEGHENY
ALPS
ANDES
APPALACHIANS
BLUE RIDGE
CASCADE
CATSKILL
DOLOMITES
GRAND TETON NATIONAL PARK
GREAT SMOKY MOUNTAINS
HIMALAYA MOUNTAINS
JUNGFRAU
KILIMANJARO
MATTERHORN
MOUNT EVEREST
MOUNT HOOD
MOUNT McKINLEY
MOUNT RAINIER
MOUNT ST. HELENS
MOUNT SHASTA
MOUNT WASHINGTON
MOUNT WHITNEY
PYRENEES
ROCKY MOUNTAINS
ST. ELIAS RANGE
SIERRA MADRE
SIERRA NEVADA
TETON RANGE
WASATCH RANGE

WHITE MOUNTAINS
Movies. See
MOTION PICTURES
MOVING VANS
— Moving furniture into New York apartment
Life 15:54–5 (c,2) S '92
— Packing museum exhibit for travel
Smithsonian 27:48–59 (c,1) My '96
MOZAMBIQUE
— Old slave warehouse
Nat Geog 182:72 (c,4) N '92
— Polana Hote, Maputo
Trav&Leisure 23:45 (c,4) N '93
MOZAMBIQUE—COSTUME
— Woman with sun protection cream on face
Nat Geog 182:74–5 (c,1) N '92
MUD
— 1960 football game in mud
Sports Illus 83:2–3 (1) Fall '95
— 1994 Woodstock II concert
Life 17:90–1,102 (c,1) N '94
Life 18:48–9 (c,1) Ja '95
— Teens lying in mud (California)
Life 18:22 (c,4) Ag '95
MULE DEER
Nat Wildlife 31:6–7 (c,1) Je '93
Nat Geog 188:63 (c,3) Jl '95
Nat Wildlife 33:54 (c,2) O '95
MULES
— Early 20th cent. harvest by mule team
(Washington)
Nat Geog 188:130–1 (1) D '95
— Mule training for equestrian events
Sports Illus 78:82–4 (c,4) My 17 '93
MUMMIES
— Ancient Chinchorro mummies (Chile)
Nat Geog 187:69–89 (c,1) Mr '95
— Anga tribe (Papua New Guinea)
Trav/Holiday 176:64 (c,4) Ap '93
— Doctors studying Egyptian mummy
Life 18:22 (c,2) My '95
— Inca sacrifice victim (Peru)
Nat Geog 189:62–81 (c,1) Je '96
— Xinjiang region, China
Nat Geog 189:45–50 (c,1) Mr '96
MUNCH, EDVARD
— Inflatable version of "The Scream"
Smithsonian 26:34 (c,4) Ap '95
— "The Scream"
Smithsonian 26:43 (painting,c,4) S '95
MUNICH, GERMANY
Trav&Leisure 24:8,117–23 (c,3) My '94
Trav&Leisure 26:51–9,190 (map,c,1) Ja '96
— City Hall

Trav&Leisure 26:54 (c,4) Ja '96
— Englischer Garten
Smithsonian 25:110 (c,4) D '94
MURALS
— 1940s murals done by U.S. airmen at
British air bases
Am Heritage 44:114–19 (c,1) Ap '93
— Ancient Cacaxtla, Mexico
Nat Geog 182:120–36 (c,1) S '92
— Ancient tomb of Sennefer (Egypt)
Trav/Holiday 175:60 (c,4) S '92
— Animal murals by Charles Knight (New
York)
Natur Hist 102:20–5 (c,3) O '93
— Building mural of pop singer (India)
Nat Geog 187:46 (c,1) Mr '95
— Dragon mural on Chinatown building
(Philadelphia, Pennsylvania)
Trav/Holiday 178:66 (c,3) N '95
— Key West, Florida
Trav&Leisure 24:114 (c,2) D '94
— Malcolm X mural (Philadelphia,
Pennsylvania)
Smithsonian 24:71 (c,1) Jl '93
— Mexican pride mural (El Paso, Texas)
Trav/Holiday 176:88–9 (c,1) F '93
— Military mural (Burma)
Nat Geog 188:88–9 (c,2) Jl '95
— Mural of Julius Erving (Pennsylvania)
Smithsonian 24:69 (c,4) Jl '93
— Mural of girls jumping rope (New York)
Smithsonian 26:110 (c,4) Ap '95
— Mural of movie stars (Hollywood,
California)
Life 16:52 (c,2) Mr '93
— New York restaurant
Gourmet 54:36 (c,3) D '94
— Orozco murals (Mexico)
Trav&Leisure 23:106–8,113 (c,1) Je '93
— Diego Rivera's murals (Mexico)
Trav&Leisure 23:112–15 (c,3) Je '93
— San Francisco street mural, California
Trav/Holiday 179:66–7 (c,1) Mr '96
— Stagecoach mural on building (Dodge
City, Kansas)
Smithsonian 25:9 (c,4) S '94
— Street mural (Los Angeles, California)
Nat Geog 181:46–7 (c,1) Je '92
— Street mural of shepherdess (Peru)
Nat Geog 189:6–7 (c,1) My '96
— Town covered with murals (Chemainus,
British Columbia)
Smithsonian 25:54–64 (c,2) My '94
Murder. See
CRIME AND CRIMINALS

DEATH
JUSTICE, ADMINISTRATION OF
MURPHY, AUDIE
Life 18:128–9 (1) Je 5 '95
MUSCAT, OMAN
Nat Geog 182:82–3 (c,1) N '92
MUSEUM OF MODERN ART, NEW YORK CITY, NEW YORK
— MOMA photograph collection
Smithsonian 23:83–93 (c,2) Ja '93
MUSEUMS
— 1860s plans for unbuilt museum (New York City)
Natur Hist 103:62–7 (painting,c,1) Jl '94
— American Visionary Art Museum treasures, Baltimore, Maryland
Trav&Leisure 26:65–8 (c,4) Ap '96
— Baseball Hall of Fame, Tokyo, Japan
Sports Illus 78:98–9 (c,4) My 31 '93
— Black American West Museum, Denver, Colorado
Am Heritage 46:38 (c,4) F '95 supp.
— The Cloisters, New York City, New York
Trav&Leisure 22:104 (c,3) D '92
— Dali Museum, Figueras, Spain
Trav&Leisure 22:66–70 (c,2) Ap '92
— Denver Art Museum, Colorado
Smithsonian 24:96–109 (c,1) S '93
— Edmonton Science and Space Centre, Alberta
Smithsonian 27:78 (c,3) My '96
— Farmers' Museum, Cooperstown, New York
Am Heritage 45:31 (c,4) My '94
— Isabella Stewart Gardner Museum, Boston, Massachusetts
Trav/Holiday 177:70 (c,4) S '94
— Getty Museum, Malibu, California
Trav&Leisure 25:136 (c,2) My '95
— Hess Collection, Napa, California
Trav/Holiday 179:27 (c,4) My '96
— Heye Center, New York City, New York
Smithsonian 25:48 (c,4) O '94
Life 17:120–30 (c,1) N '94
— High Museum, Atlanta, Georgia
Gourmet 56:75 (c,4) Jl '96
— Holocaust Museum, Washington, D.C.
Life 16:19 (c,4) Ap '93
Smithsonian 24:50–63 (c,1) Ap '93
— Huntington Museum, California
Trav/Holiday 177:74 (c,4) S '94
— Israel Museum, Jerusalem, Israel
Trav/Holiday 176:62–8 (c,1) D '93
Trav&Leisure 24:92–3 (c,4) Ag '94

— Japanese American National Museum interior, Los Angeles, California
Trav&Leisure 22:21 (c,3) S '92
— KunstHausWien, Vienna, Austria
Trav/Holiday 175:121 (c,4) Mr '92
— Liberace Museum, Las Vegas, Nevada
Smithsonian 26:56 (c,3) O '95
— London art galleries
Trav&Leisure 26:40–4 (c,4) N '96
— Los Angeles Museum of Contemporary Art
Smithsonian 23:62 (c,4) Jl '92
— Louisville Slugger Museum, Kentucky
Sports Illus 85:6 (c,4) S 16 '96
— Marion Koogler McNay art museum, San Antonio, Texas
Trav/Holiday 177:73 (c,4) S '94
— Menil Collection, Houston, Texas
Trav/Holiday 177:75 (c,4) S '94
— Model for National Museum of the American Indian, Washington, D.C.
Smithsonian 27:76–7 (c,2) My '96
— Montana
Trav/Holiday 179:92–9 (c,1) S '96
— Museo Aldrovandi, Bologna, Italy
Trav/Holiday 177:50–1 (c,2) O '94
— Museu d'Art Contemporani, Barcelona, Spain
Trav&Leisure 26:39 (c,4) Mr '96
— Museum Center at Cincinnati Union Terminal, Ohio
Smithsonian 23:102–11 (c,1) Je '92
— Museum of Appalachia, Norris, Tennessee
Smithsonian 26:44–53 (c,1) F '96
— Museum of Contemporary Art, San Diego, California
Trav&Leisure 26:42 (c,4) Je '96
— Museum of Naval Aviation, Pensacola, Florida
Trav&Leisure 22:140 (c,4) Mr '92
— Museum photography storage area (New York)
Smithsonian 23:82–3 (c,2) Ja '93
— Museums of unusual collections
Smithsonian 26:90–7 (c,1) Ap '95
— National Civil Rights Museum, Memphis, Tennessee
Trav&Leisure 22:E26–E28 (c,3) N '92
— National Palace Museum, Taipei, Taiwan
Smithsonian 26:46 (c,4) Mr '96
— National Video Game Museum, St. Louis, Missouri
Sports Illus 81:8 (c,4) N 28 '94
— Newark Museum, New Jersey
Trav&Leisure 22:NY1–2 (c,4) My '92
— Olympic Museum, Lausanne, Switzerland

Sports Illus 82:9 (c,4) Ja 23 '95
— Pergamon Museum, Berlin, Germany
 Trav&Leisure 22:B3 (c,4) My '92
 Trav/Holiday 176:18 (c,4) N '93
— Phillips Collection, Washington, D.C.
 Trav/Holiday 177:72 (c,3) S '94
— Postal Museum, Budapest, Hungary
 Trav&Leisure 24:92 (c,2) O '94
— Prado, Madrid, Spain
 Smithsonian 22:54–65 (c,1) Ja '92
— Ringling Museum of Art, Sarasota, Florida
 Trav/Holiday 175:88 (c,4) F '92
 Trav&Leisure 22:137 (c,4) Mr '92
 Gourmet 53:86–7,90 (c,1) F '93
 Trav/Holiday 177:71 (c,4) S '94
— Ripley Museum, Grand Prairie, Texas
 Smithsonian 25:99 (c,2) Ja '95
— Rock and Roll Hall of Fame treasures,
 Cleveland, Ohio
 Life 18:13–17 (c,1) S '95
— Rockwood Museum, Delaware
 Trav/Holiday 178:42 (c,2) S '95
— San Francisco Museum of Modern Art,
 California
 Trav&Leisure 25:35 (c,4) Ja '95
 Smithsonian 26:60–1,69 (c,1) Jl '95
— San Jose Museum of Art, California
 Gourmet 54:102 (c,4) O '94
— Seattle Art Museum, Washington
 Smithsonian 23:46–7,53,56 (c,1) Ap '92
 Trav&Leisure 23:58–9 (c,1) Ag '93
— Slo-Pitch Softball Hall of Fame,
 Petersburg, Virginia
 Sports Illus 79:78 (c,4) Ag 9 '93
— Strawbery Banke restoration, Portsmouth,
 New Hampshire
 Trav&Leisure 24:E6 (c,4) O '94
— Theater Museum, Vienna, Austria
 Gourmet 52:86–91 (c,1) Je '92
— UBC Museum of Anthropology,
 Vancouver, British Columbia
 Gourmet 53:55 (c,1) Jl '93
— Vancouver Museum crab sculpture, British
 Columbia
 Gourmet 53:57 (c,1) Jl '93
— Vitra Design Museum, Weil am Rhein,
 Germany
 Trav/Holiday 178:67 (c,1) Ap '95
— Wadsworth Atheneum, Hartford,
 Connecticut
 Am Heritage 43:100–3 (c,1) S '92
— Wolfsonian Foundation Collection, Miami,
 Florida
 Smithsonian 25:102–11 (c,1) F '95
 Trav&Leisure 25:34 (c,4) S '95

— See also
 AMERICAN MUSEUM OF NATURAL
 HISTORY
 FREER GALLERY OF ART
 GUGGENHEIM MUSEUM
 HERMITAGE
 LOUVRE
 METROPOLITAN MUSEUM OF ART
 MUSEUM OF MODERN ART
 SMITHSONIAN INSTITUTION
MUSHROOM INDUSTRY
— Oregon
 Smithsonian 24:34–45 (c,1) Ja '94
MUSHROOMS
 Natur Hist 103:46–7 (c,2) Je '94
 Natur Hist 104:80 (painting,c,4) Jl '95
 Gourmet 56:103 (drawing,4) Ja '96
— Mushroom varieties
 Smithsonian 24:34,42–3 (c,1) Ja '94
— Oyster mushrooms
 Natur Hist 101:46–7 (c,1) Mr '92
— Stinkhorn
 Natur Hist 103:46 (c,3) Je '94
 Life 17:61 (c,4) Je '94
— Telluride Mushroom Festival, Colorado
 Natur Hist 105:32–5 (c,1) Ap '96
MUSIAL, STAN
 Am Heritage 43:35 (4) O '92
 Sports Illus 85:20 (4) Jl 29 '96
MUSIC EDUCATION
— Berklee College of Music, Boston,
 Massachusetts
 Smithsonian 27:43–9 (c,2) Ag '96
MUSICAL INSTRUMENTS
— Autoharp
 Nat Geog 181:56 (c,3) Ap '92
— Bolivian wind instrument
 Smithsonian 25:47 (c,3) O '94
— Cigar-box fiddle (Mississippi)
 Am Heritage 45:73 (4) Jl '94
— Miles Musical Museum, Arkansas
 Smithsonian 26:94 (c,2) Ap '95
— Playing fife (Mississippi)
 Natur Hist 105:67 (c,3) O '96
— Playing keyboard
 Life 16:12–13 (c,1) Ap '93
— Playing long horns (Switzerland)
 Trav&Leisure 25:73 (c,1) Ag '95
— Playing rims of glassware (Washington,
 D.C.)
 Nat Geog 184:60 (c,2) D '93
— Qarageb castanets (Morocco)
 Natur Hist 105:38 (c,4) My '96
— Rribab (Morocco)
 Natur Hist 105:40–1 (c,1) My '96

— Sarangis (India)
 Smithsonian 23:116–17 (c,4) My '92
— Triangle to call people to ranch lunch
 (British Columbia)
 Gourmet 53:112 (c,4) O '93
— See also
 ACCORDIONS
 BAGPIPES
 BANJOS
 BUGLES
 CELLOS
 CLARINETS
 DRUMS
 FLUTES
 GUITARS
 HARMONICAS
 HARPS
 HORNS
 MANDOLINS
 ORGANS
 PIANOS
 SAXOPHONES
 TROMBONES
 TRUMPETS
 VIOLINS

MUSICAL SCORES
— 1775 printed version of "Yankee Doodle"
 Smithsonian 23:111 (c,4) Ap '92
— 1850 cover of "Hippopotamus Polka"
 (Great Britain)
 Natur Hist 102:36 (drawing,2) F '93
 Smithsonian 26:100 (4) Mr '96
— Early 20th cent. "Carolina Mammy" cover
 Am Heritage 45:14 (4) Ap '94

MUSICIANS
— 1950s orchestra performing at resort
 (Quebec)
 Trav&Leisure 25:71 (2) Jl '95
— Blind musicians (Egypt)
 Natur Hist 104:cov.,34–43 (1) N '95
— Bluegrass festivals
 Smithsonian 23:cov.,68–80 (c,1) Mr '93
— Chamber music group at museum (New
 York)
 Trav&Leisure 22:107 (c,2) D '92
— Child playing violin in street (Germany)
 Trav&Leisure 24:114 (2) F '94
— Clothing of Rock and Roll Hall of Famers
 Life 18:13–17 (c,1) S '95
— Cortina, Italy
 Trav&Leisure 26:157,159 (c,1) N '96
— Country music industry
 Am Heritage 45:cov.,38–56 (c,1) N '94
— Early jazz greats

Am Heritage 46:70–85 (painting,c,2) O
 '95
— Famous blues musicians
 Trav&Leisure 25:127–8 (4) S '95
— Famous jazz musicians (1996)
 Life 19:23 (c,4) O '96
— Jerry Garcia
 Life 19:84 (1) Ja '96
— History of rock and roll
 Life 15:entire issue (c,1) D 1 '92
— Jazz band (France)
 Nat Geog 188:58–9 (c,2) S '95
— Jazz bands (New Orleans, Louisiana)
 Gourmet 56:10–11,136 (c,1) Mr '96
— Jazz orchestra (Washington, D.C.)
 Smithsonian 27:74–82 (c,1) S '96
— Huddie "Leadbelly" Ledbetter
 Am Heritage 44:10 (drawing,c,4) O '93
 Trav&Leisure 25:38 (4) N '95
— Yo-Yo Ma
 Trav&Leisure 22:B1 (c,3) Ap '92
— Bob Marley Museum, Jamaica
 Natur Hist 104:48–52 (c,1) N '95
— Wynton Marsalis
 Am Heritage 46:66 (c,1) O '95
— Medieval minstrels
 Trav&Leisure 23:140 (painting,c,4) Jl '93
— Jelly Roll Morton
 Am Heritage 46:70 (drawing,4) O '95
— Albert Murray
 Am Heritage 47:68–77 (c,1) S '96
— Sun Ra
 Life 17:86 (c,2) Ja '94
— Carlos Santana
 Sports Illus 85:93 (c,4) Ag 12 '96
— Street mariachis (Mexico)
 Nat Geog 190:36–7 (c,1) Ag '96
— Street musicians (New Orleans, Louisiana)
 Trav&Leisure 22:67 (c,4) Mr '92
 Nat Geog 187:90–1 (c,1) Ja '95
— Street musicians (Czechoslovakia)
 Smithsonian 24:73 (c,4) Je '93
— Street musicians (Mexico)
 Trav/Holiday 175:44 (c,4) O '92
— String quintet
 Gourmet 55:68 (c,4) My '95
— Stylized sketch of musician types
 Trav&Leisure 26:66–71 (c,4) Je '96
— Top jazz musicians
 Life 19:63–71 (c,1) F '96
— Top jazz musicians (1959)
 Life 19:63 (4) F '96
— The Who
 Life 19:114–15 (c,1) My '96
— See also

ARMSTRONG, LOUIS
BANDS
BANDS, MARCHING
BASIE, COUNT
BLAKE, EUBIE
CASALS, PABLO
COMPOSERS
CONCERTS
CONDUCTORS, MUSIC
DAVIS, MILES
ELLINGTON, DUKE
GILLESPIE, JOHN BIRKS (DIZZY)
GOULD, GLENN
HANDY, W.C.
HEIFETZ, JASCHA
JAMES, HARRY
JOHNSON, ROBERT
JOPLIN, SCOTT
MacDOWELL, EDWARD
PARKER, CHARLIE
SINGERS
STERN, ISAAC

MUSK DEER
Nat Geog 181:13 (c,3) My '92

MUSK OXEN
Nat Wildlife 31:6–7 (c,1) O '93
Nat Wildlife 33:60 (c,1) F '95
Natur Hist 105:35 (c,4) My '96
Nat Geog 190:23 (c,3) O '96
— Shedding coat in spring
Nat Wildlife 32:6 (c,4) D '93

Muslims—architecture. See
ALHAMBRA

MUSLIMS—ART
— 13th cent. bronze lion (Spain)
Smithsonian 23:49 (c,4) Ag '92
— Islamic arts from occupation of Spain
Smithsonian 23:44–53 (c,2) Ag '92

MUSLIMS—COSTUME
Life 16:58–66 (1) Mr '93
— Girl (Turkey)
Nat Geog 185:8 (c,1) My '94
— Women in veils (Indonesia)
Life 16:64–5 (1) Mr '93

MUSLIMS—RITES AND FESTIVALS
Life 16:58–66 (1) Mr '93
— Children memorizing the Koran (Indonesia)
Life 16:60 (4) Mr '93
— Men with needles in their chests for
Yamse festival (Mauritius)
Nat Geog 183:114–15 (c,1) Ap '93
— Muslim cleansing ritual (Macedonia)
Nat Geog 189:134 (c,1) Mr '96
— Muslims washing at midday prayer (Syria)
Nat Geog 183:54–5 (c,1) My '93

— Naadam Festival, Ulaanbaator, Mongolia
Nat Geog 190:18–19,25 (c,1) D '96
— Praying (India)
Life 15:84 (c,3) Mr '92
— Praying at Bukhara mosque, U.S.S.R.
Nat Geog 190:28 (c,3) D '96
— Pre-wedding mendhi celebration
(Mauritius)
Nat Geog 183:126–7 (c,1) Ap '93
— Shiite ashura mourning ceremony
(Azerbaijan)
Life 16:63 (4) Mr '93

MUSLIMS—SHRINES AND SYMBOLS
— Tomb of the Patriarchs (Hebron, Israel)
Nat Geog 181:93 (c,4) Je '92
— See also
MOSQUES

MUSSELS
Nat Geog 182:103 (c,4) Jl '92
Nat Wildlife 31:34–9 (c,1) O '93
Smithsonian 24:40–51 (c,1) F '94
Nat Geog 187:32 (c,4) Mr '95
Nat Geog 190:92–3 (c,1) O '96

MUSSOLINI, BENITO
— Strung up body of Mussolini (1945)
Life 18:36 (2) Je 5 '95
— 360-degree profile sculpture of Mussolini
Smithsonian 25:111 (c,1) F '95

MUSTACHES
— Man with 12 ft. mustache (India)
Life 16:86–7 (c,1) My '93
— Tattooed mustache on 1922 Ainu girl
(Japan)
Nat Geog 190:140 (4) O '96

MUSTANGS
Trav&Leisure 24:42,44 (c,3) Ag '94

MUSTARD PLANTS
Gourmet 55:81 (c,1) S '95

Muttonbirds. See
SHEARWATERS

Myanmar. See
BURMA

MYRTLE
Nat Wildlife 31:35 (c,2) Ap '93
Natur Hist 102:33 (c,4) Ap '93

MYSTIC, CONNECTICUT
Gourmet 56:73–4 (map,c,2) Mr '96

MYTHOLOGY
— See also
DEITIES
MERMAIDS

MYTHOLOGY—GREEK AND RO-MAN
— Persephone

Nat Geog 186:17 (sculpture,c,4) N '94
Natur Hist 104:37 (painting,c,2) D '95
— Romulus and Remus with wolf
Trav/Holiday 177:132 (painting,c,2) My
'94
— Scenes from Greek myths
Trav/Holiday 175:76–7 (c,1) Je '92
— Stained glass depiction of muse
Terpsichore (Pennsylvania)
Smithsonian 23:108 (c,4) Ap '92
— Theseus and the Minotaur (Crete)
Natur Hist 101:54–5 (fresco,c,1) Jl '92
— See also
HERCULES
MEDUSA
VENUS
ZEUS

–N–

NAGASAKI, JAPAN
Nat Geog 182:90–1 (c,2) N '92
— Nagasaki after atomic bomb (1945)
Life 18:81 (1) Je 5 '95
NAMATH, JOE
Sports Illus 81:50–7 (4) O 31 '94
Gourmet 55:62 (c,4) My '95
NAMIBIA
— Etosha National Park
Trav/Holiday 177:88–95 (map,c,1) Mr '94
— Namib Desert
Nat Geog 181:56–7,70–3 (c,1) Ja '92
Natur Hist 102:26-32 (c,1) Ag '93
— Skeleton Coast
Nat Geog 181:54–85 (map,c,1) Ja '92
NAMIBIA—COSTUME
— Himba people
Smithsonian 24:81 (c,2) N '93
NANCY, FRANCE
Gourmet 53:104–7 (c,1) O '93
NANTUCKET, MASSACHUSETTS
Gourmet 53:106 (c,4) D '93
Trav&Leisure 24:72 (painting,c,3) Ap '94
Trav/Holiday 179:cov.,30–7 (map,c,1) Jl
'96
Gourmet 56:94 (c,2) S '96
NAPLES, ITALY
Trav/Holiday 179:78–85 (c,1) D '96
— Sao Paolo Maggiore church
Trav/Holiday 179:85 (c,1) D '96
NAPOLEON
— Caricature
Am Heritage 46:99 (c,2) D '95
— George Steinbrenner in Napoleon pose

Sports Illus 78:cov. (c,1) Mr 1 '93
NASHVILLE, TENNESSEE
Gourmet 56:118–21,154 (map,c,2) Ap '96
Smithsonian 27:62 (c,2) Jl '96
— Belle Meade mansion
Gourmet 56:120 (c,4) Ap '96
— The Parthenon
Trav/Holiday 179:27 (c,4) Ap '96
NASSAU, BAHAMAS
Gourmet 52:56–7 (c,1) Ja '92
— Old public market
Am Heritage 44:28 (c,4) F '93
NAST, THOMAS
— 1878 cartoon about taxes
Smithsonian 26:70–1 (2) Jl '95
NATCHEZ, MISSISSIPPI
Gourmet 53:130–3 (c,1) Ap '93
— Longwood Plantation
Gourmet 53:132 (c,4) Ap '93
Natur Hist 103:A8 (c,4) Ap '94
— Stanton Hall
Gourmet 53:130 (c,1) Ap '93
**NATIONAL GEOGRAPHIC SOCIETY,
WASHINGTON, D.C.**
— Library (1940s)
Nat Geog 187:58 (4) My '95
— Research projects
Nat Geog 189:110–17 (c,1) Ap '96
NATIONAL PARKS
Trav&Leisure 23:92–101 (c,1) Je '93
Nat Geog 186:cov.,2–55 (map,c,1) O '94
— Aso-Kuju, Japan
Nat Geog 185:102–3 (c,1) Ja '94
— Bob Marshall Wilderness, Montana
Smithsonian 25:93 (c,2) Ag '94
— Donana, Spain
Trav/Holiday 175:68–74 (map,c,1) Ap '92
— Etosha, Namibia
Trav/Holiday 177:88–95 (map,c,1) Mr '94
— Fjordland, New Zealand
Trav&Leisure 25:116–19,158 (c,1) Ap '95
— Fray Jorge, Chile
Natur Hist 105:64–5 (c,1) F '96
— Hwange, Zimbabwe
Trav/Holiday 175:cov.,60–7 (c,1) N '92
— Kruger, South Africa
Trav/Holiday 179:38–43 (map,c,1) Jl '96
— Lake Manyara, Tanzania
Trav&Leisure 22:11,130–1 (c,1) Je '92
— National park eatery (western U.S.)
Trav&Leisure 25:125 (painting,c,1) My
'95
— National park visitors
Smithsonian 24:21–9 (c,3) Ag '93
— Nouabele-Ndoki, Congo

Nat Geog 188:4–45 (map,c,1) Jl '95
— Serengeti National Park, Tanzania
 Life 19:76–86 (c,1) My '96
— Tatshenshini–Alsek Wilderness Park,
 British Columbia
 Nat Geog 185:122–34 (c,1) F '94
— Torres del Paine National Park, Chile
 Trav/Holiday 179:60–1 (c,2) Je '96
— Tsitsikamma National Park, South Africa
 Trav/Holiday 177:66 (c,3) O '94
— Uluru, Australia
 Trav/Holiday 175:18 (c,4) S '92
— See also
 ACADIA
 APPALACHIAN TRAIL
 ARCHES
 BADLANDS
 BANDELIER NATIONAL MONUMENT
 BANFF
 BIG BEND
 BIG SOUTH FORK NATIONAL RIVER
 AND RECREATION AREA
 BRYCE CANYON
 CANYON DE CHELLY NATIONAL
 MONUMENT
 CANYONLANDS
 CAPITOL REEF
 CRATER LAKE
 DEATH VALLEY
 DENALI
 DEVIL'S TOWER NATIONAL MONU-
 MENT
 DRY TORTUGAS
 EVERGLADES
 FLORISSANT FOSSIL BEDS
 NATIONAL MONUMENT
 FORILLON
 GATES OF THE ARCTIC
 GLACIER
 GLACIER BAY
 GRAND CANYON
 GRAND TETON
 GREAT BASIN
 GREAT SAND DUNES NATIONAL
 MONUMENT
 GREAT SMOKY MOUNTAINS
 HAWAII VOLCANOES
 JASPER
 JOSHUA TREE
 LASSEN VOLCANIC
 LAVA BEDS NATIONAL MONUMENT
 KENAI FJORDS
 MESA VERDE
 MOJAVE NATIONAL PRESERVE
 MOUNT RAINIER

 MOUNT RUSHMORE
 NAVAJO NATIONAL MONUMENT
 OLYMPIC
 OREGON CAVES NATIONAL MONU-
 MENT
 RAINBOW BRIDGE NATIONAL
 MONUMENT
 REDWOOD
 SAGUARO NATIONAL PARK
 SEQUOIA AND KINGS CANYON
 THEODORE ROOSEVELT
 WATERTON LAKES
 WHITE SANDS NATIONAL MONU-
 MENT
 WIND CAVE
 WRANGELL-ST. ELIAS
 YELLOWSTONE
 YOSEMITE
 ZION

NATURALISTS
— William Bartram
 Natur Hist 105:10 (painting,c,4) Ap '96
— George Perkins Marsh
 Am Heritage 44:43 (4) O '93
— Bob Marshall
 Smithsonian 25:92–6 (4) Ag '94
— Olaus Johann Murie
 Nat Wildlife 30:27 (painting,c,1) O '92
— Roger Tory Peterson
 Am Heritage 47:18 (4) D '96
— Alfred Russel Wallace
 Natur Hist 105:23 (4) D '96
— See also
 AGASSIZ, LOUIS
 CARSON, RACHEL
 LEOPOLD, ALDO

NAUTILUSES (MOLLUSKS)
 Life 16:70 (c,1) O '93

NAVAJO INDIANS—ART
— Navajo pictographs (Arizona)
 Am Heritage 44:59 (c,1) Ap '93
 Trav&Leisure 23:134–5,140 (c,1) Ap '93
— Navajo tapestries (Southwest)
 Smithsonian 25:20 (c,4) Ag '94

NAVAJO INDIANS—COSTUME
— 19th cent. shaman
 Life 16:73 (1) Ap 5 '93
— 1885
 Natur Hist 103:26 (4) N '94
— Small girl (Arizona)
 Life 16:98 (c,4) Jl '93

NAVAJO INDIANS—HISTORY
— World War II code talkers in the Pacific
 Smithsonian 24:34–43 (1) Ag '93

NAVAJO NATIONAL MONUMENT,
ARIZONA
Natur Hist 102:56–7 (c,1) Ag '93
NAVIGATION INSTRUMENTS
— Computerized navigation aids for the blind
(California)
Nat Geog 188:28–9 (c,1) O '95
— See also
ASTROLABES
COMPASSES
LIGHTHOUSES
Navy. See
MILITARY COSTUME
SAILORS
U.S. NAVY
NAZISM
— 1930s American Nazi Fritz Kuhn
Am Heritage 46:102 (4) S '95
— 1945 Nuremberg Trials
Am Heritage 45:78–87 (c,1) Jl '94
Smithsonian 27:124–41 (1) O '96
— SS men in restaurant
Life 17:28 (3) Ap '94
— Neo-Nazi rally (Germany)
Nat Geog 183:124–5 (c,1) My '93
— Neo-Nazi skinheads (Sweden)
Nat Geog 184:26–7 (c,1) Ag '93
— Swastika
Life 19:28 (1) O '96
— See also
CONCENTRATION CAMPS
GOERING, HERMANN
HESS, RUDOLF
HITLER, ADOLPH
SPEER, ALBERT
NEBRASKA
— Aerial view of Fontenelle Forest
Natur Hist 101:4 (c,3) Ag '92
— Bailey's railroad yard, North Platte
Smithsonian 26:40 (c,3) Je '95
— Chimney Rock
Am Heritage 44:69 (c,4) My '93
Life 16:64–5 (c,1) D '93
Trav&Leisure 25:45 (c,4) Jl '95
— Fort Laramie
Trav&Leisure 25:46 (c,4) Jl '95
— Farmlands
Nat Geog 183:80–109 (c,1) Mr '93
— Jail Rock
Am Heritage 44:68 (c,4) My '93
— North Platte River
Am Heritage 44:66 (c,4) My '93
— Scenes along Pony Express route
Trav&Leisure 25:44–6 (map,c,3) Jl '95
— Scotts Bluff

Am Heritage 44:69 (c,4) My '93
Trav&Leisure 25:46 (c,4) Jl '95
— Wheat fields (1916)
Life 19:12-13 (1) Winter '96
— See also
MISSOURI RIVER
OMAHA
PLATTE RIVER
NEBULAE
— Eta Carinae Nebula
Nat Geog 185:28–9 (c,1) Ja '94
— Horsehead Nebula
Life 15:cov.,60–1 (c,1) S '92
— Orion Nebula
Smithsonian 22:100 (c,4) Mr '92
Nat Geog 188:90–101 (c,1) D '95
— Spiral nebula NGC4565
Natur Hist 104:66 (4) My '95
— See also
GALAXIES
STARS
NEEDLEWORK
— Knitting
Trav&Leisure 25:E12 (c,4) Ap '95
— See also
SEWING
TAPESTRIES
NEGEV, ISRAEL
Natur Hist 103:58–9 (c,2) Ag '94
NEMATODES
Natur Hist 101:52 (4) Mr '92
Neon signs. See
SIGNS AND SIGNBOARDS
NEPAL
Nat Geog 182:70–89 (map,c,1) D '92
Nat Geog 184:2–35 (map,c,1) D '93
— Mustang area
Trav&Leisure 24:88–95,140–2 (map,c,1)
Je '94
— See also
HIMALAYA MOUNTAINS
MOUNT EVEREST
NEPAL—COSTUME
Nat Geog 184:5–35 (c,1) D '93
— Dolpo people
Nat Geog 184:9–23 (c,1) D '93
— Rong-pa people
Nat Geog 184:5,24–35 (c,1) D '93
— Sherpa people
Nat Geog 182:70–89 (c,1) D '92
NEPAL—HOUSING
Nat Geog 184:10–11,24–5 (c,1) D '93
Nests. See
BIRD NESTS

NETHERLANDS
— Alkmaar cheese market
 Trav/Holiday 175:114 (c,4) Mr '92
— Countryside
 Trav/Holiday 176:60–7 (c,1) Jl '93
— Elegant gardens
 Trav&Leisure 24:114–19 (c,1) Ap '94
— Het Loo Palace
 Trav&Leisure 24:118–19 (c,1) Ap '94
— Kasteel de Haar
 Trav&Leisure 24:114–15 (c,1) Ap '94
— See also
 AMSTERDAM
 DELFT
NETHERLANDS—COSTUME
— 17th cent.
 Smithsonian 25:115 (drawing,c,4) N '94
 Smithsonian 26:111–17 (painting,c,1) N
 '95
NETHERLANDS—MAPS
 Trav&Leisure 24:156 (c,3) Ap '94
NETHERLANDS ANTILLES
— Bonaire
 Trav&Leisure 26:167–71,204–6 (map,c,1)
 N '96
— See also
 ARUBA
 CURACAO
**NETHERLANDS ANTILLES—HOUS-
 ING**
— Bonaire
 Trav/Holiday 177:18 (c,4) My '94
NEVADA
— Charleston Mountains
 Natur Hist 101:14–16 (map,c,1) Mr '92
— Countryside
 Nat Geog 182:42–57 (c,1) D '92
— Eureka
 Trav/Holiday 179:64 (c,4) N '96
— Highway 50
 Trav/Holiday 179:62–9 (map,c,1) N '96
— Humboldt River
 Natur Hist 103:39–41 (map,c,1) N '94
— Lake Mead area
 Trav&Leisure 26:110–12 (map,c,4) N '96
— Lake Tahoe area
 Nat Geog 181:112–32 (map,c,1) Mr '92
— Mormon Mountains
 Nat Geog 182:50–1 (c,1) D '92
— Pyramid Lake
 Natur Hist 105:cov.,32–6 (map,c,1) S '96
— Sand Mountain
 Trav/Holiday 179:66 (c,1) N '96
— Yucca Mountain
 Smithsonian 26:42–3 (c,3) My '95
— See also
 GREAT BASIN NATIONAL PARK
 HOOVER DAM
 LAKE TAHOE
 LAS VEGAS
 RENO
NEW BRUNSWICK
— Grand Manan Island
 Natur Hist 105:57–9 (map,c,1) S '96
— Hopewell Rocks
 Natur Hist 102:56 (c,4) Ap '93
— See also
 BAY OF FUNDY
NEW ENGLAND
 Trav&Leisure 22:NE1–16 (c,1) My '92
 Trav&Leisure 23:N1–N13 (c,4) My '93
 Trav&Leisure 24:N1–N18 (map,c,1) My
 '94
 Trav&Leisure 25:N1–N10 (c,4) My '95
 Trav&Leisure 26:N1–N14 (c,2) My '96
— Bucolic island scenes (Massachusetts)
 Nat Geog 181:114–25,130–2 (c,1) Je '92
— Northern New England in autumn
 Trav/Holiday 175:79–86 (map,c,1) S '92
— See also
 APPALACHIAN TRAIL
 CONNECTICUT RIVER
 WHITE MOUNTAINS
NEW GUINEA
— Countryside
 Nat Geog 181:68–9 (c,1) Mr '92
— Japanese World War II caves
 Nat Geog 181:69 (c,4) Mr '92
— See also
 PAPUA NEW GUINEA
NEW HAMPSHIRE
 Am Heritage 43:47–55 (map,c,3) Ap '92
— 19th cent. textile mills (Manchester)
 Smithsonian 25:104 (c,3) N '94
— Ammonoosuc Falls
 Trav&Leisure 22:100–1 (c,1) My '92
— Contoocook Mills, Hillsboro
 Am Heritage 43:49 (c,3) Ap '92
— Countryside
 Trav&Leisure 22:98–105 (c,1) My '92
 Nat Geog 187:122–3,126–7 (c,1) Ap '95
— Hanover area
 Trav&Leisure 26:86–8 (c,1) Jl '96
— Old Man of the Mountain
 Am Heritage 43:53 (c,4) Ap '92
— Strawbery Banke restored village
 Am Heritage 46:30–6 (c,4) D '95
— Went By the Sea hotel, New Castle
 Smithsonian 27:56–7 (c,3) S '96
— See also

CONNECTICUT RIVER
MOUNT WASHINGTON
PORTSMOUTH
WHITE MOUNTAINS
NEW HAMPSHIRE—MAPS
— Northern New Hampshire
Trav/Holiday 177:31 (c,4) S '94
NEW JERSEY
— Cape May
Smithsonian 24:132 (c,3) Ap '93
— Montclair iris garden
Life 15:3,62–6 (c,1) Je '92
— Spring Lake
Gourmet 52:70 (c,4) Je '92
— See also
ATLANTIC CITY
GEORGE WASHINGTON BRIDGE
HUDSON RIVER
NEWARK
PRINCETON UNIVERSITY
NEW MEXICO
— 1830s Spanish church (Golden)
Am Heritage 44:cov.,62–3 (c,1) Ap '93
— Area settled by Lucien Maxwell
Smithsonian 26:44–57 (map,c,1) Jl '95
— Carlsbad
Nat Geog 184:52 (c,3) S '93
— Chaco Canyon
Trav&Leisure 23:136–7,142–5 (c,2) Ap
'93
Nat Geog 189:94–5 (c,2) Ap '96
— Chihuahuan Desert
Trav&Leisure 23:127 (c,1) Mr '93
— Cibola National Forest
Natur Hist 103:22–4 (map,c,1) Ja '94
— Countryside
Smithsonian 22:30–43 (c,1) F '92
Nat Geog 184:38–55 (map,c,1) S '93
Smithsonian 26:44–5,57 (c,1) Jl '95
Trav&Leisure 26:78,218–19 (c,1) S '96
— Four Corners countryside
Trav&Leisure 24:68–75,106–7 (map,c,1)
Ag '94
Nat Geog 190:cov.,80–97 (map,c,1) S '96
— Gila National Forest
Am Heritage 45:62–3 (c,1) S '94
— Gray Ranch preserve
Smithsonian 22:30–43 (c,1) F '92
— Hernandez (1941)
Trav&Leisure 22:NY6 (2) Ja '92
— Kiowa National Grassland
Natur Hist 105:64–6 (map,c,1) My '96
— Lechuguilla Cave
Nat Wildlife 34:37–43 (c,1) Ag '96
— "Lightning Field"

Trav&Leisure 23:E25 (c,4) My '93
— Lucien Maxwell
Smithsonian 26:46,56 (painting,c,4) Jl '95
— Missions
Trav&Leisure 26:42,222 (c,4) S '96
— Native American sites
Trav&Leisure 23:cov.,134–45 (map,c,1)
Ap '93
— Northern New Mexico
Trav&Leisure 26:212–28 (map,c,1) S '96
— Organ Mountains
Am Heritage 47:27 (c,4) F '96
— Paxton Cone
Natur Hist 103:22–4 (map,c,1) Ja '94
— Pueblo underground kiva
Trav/Holiday 176:61 (2) D '93
— Rinconada Canyon
Nat Geog 187:132–3 (c,1) Ap '95
— San Jose de Gracia church, Las Trampas
Smithsonian 27:58 (c,3) S '96
Trav&Leisure 26:222 (4) S '96
— San Lorenzo mission
Am Heritage 46:100 (4) My '95
— Sandia Cienega
Natur Hist 104:25–6 (map,c,1) Ja '95
— Sangre de Christo Mountains
Natur Hist 104:A2 (c,4) Ap '95
— Scenes along El Camino Real
Smithsonian 26:140–50 (c,1) N '95
— Shakespeare
Smithsonian 22:33 (c,3) F '92
— Ship Rock
Trav/Holiday 177:57 (painting,c,4) Je '94
Nat Geog 190:81–2 (c,1) S '96
— Trinity site of first atomic bomb explosions
Natur Hist 104:42–51 (1) Jl '95
— See also
ALBUQUERQUE
BANDELIER NATIONAL MONUMENT
PECOS RIVER
RIO GRANDE RIVER
SANTA FE
TAOS
WHITE SANDS NATIONAL MONU-
MENT
NEW ORLEANS, LOUISIANA
Life 16:96–8 (c,1) D '93
Trav&Leisure 24:82–93 (map,c,1) Ja '94
Nat Geog 187:90–119 (map,c,1) Ja '95
Life 18:96–100 (c,3) Ap '95
Trav&Leisure 25:E1–E2 (c,4) D '95
Gourmet 56:110–11 (c,1) Mr '96
— Boy playing trumpet on street
Smithsonian 22:61 (2) F '92
— Building in French Quarter

Trav&Leisure 22:43 (c,4) Ag '92
— Christmas scenes
 Am Heritage 43:26,34 (c,4) N '92 supp.
— Commander's Palace restaurant
 Gourmet 56:82,180 (c,2) O '96
— Jazz funeral
 Trav&Leisure 24:80–1 (1) Ja '94
 Life 18:98 (c,3) Ap '95
— Mardi Gras
 Nat Geog 182:8–9,32–3 (c,1) Jl '92
 Nat Geog 187:102–7 (c,1) Ja '95
— St. Louis Cathedral
 Life 18:100 (c,4) Ap '95
— Site of 1814 Battle of New Orleans
 Am Heritage 46:27 (c,2) F '95 supp.
— Street musician
 Trav&Leisure 22:67 (c,4) Mr '92
— Street scene
 Trav/Holiday 175:16 (c,4) Ap '92

NEW YEAR'S DAY
— China
 Natur Hist 103:54–61 (c,1) Jl '94
— Chinese New Year celebration (Malaysia)
 Trav/Holiday 176:48–9 (c,2) S '93
— Chinese New Year fireworks (Shanghai)
 Nat Geog 185:34–5 (c,1) Mr '94
— Chinese New Year parade (Vancouver,
 British Columbia)
 Trav/Holiday 177:29 (c,4) My '94
— New Year's bathing ritual (Yunnan, China)
 Life 16:19 (c,2) D '93
— New Year's water fights (Burma)
 Nat Geog 188:84–5 (c,1) Jl '95
— Tradition of eating "Hopping John" on
 New Year's Day
 Smithsonian 24:82–8 (painting,c,1) D '93
— Vietnamese Tet festival (California)
 Smithsonian 23:28–9,36,38 (c,1) Ag '92

NEW YEAR'S EVE
— 1954 night club festivities (New York)
 Am Heritage 47:14 (4) D '96
— New Year's Eve festival (Cuba)
 Smithsonian 26:130–9 (c,1) O '95
— Scotland
 Trav&Leisure 26:128–9 (c,1) D '96
— Swanky hotel party (New York)
 Life 17:86 (c,3) N '94
— Traditional New Year's celebration
 accessories
 Gourmet 53:122 (painting,c,3) Ja '93

NEW YORK
— Adirondack region
 Natur Hist 101:cov.,24–63 (map,c,1) My
 '92
 Gourmet 53:44–9 (map,c,1) Ag '93

Trav/Holiday 179:70–9 (c,1) Je '96
 Trav&Leisure 26:84–93,139–43 (map,c,1)
 Je '96
— Ausable Chasm
 Gourmet 53:49 (c,1) Ag '93
— Beacon
 Nat Geog 189:88–9 (c,2) Mr '96
— Berkshires region
 Trav&Leisure 25:77,83,98 (map,c,1) Ag
 '95
— Blue Mountain Lake
 Gourmet 53:44–5 (c,1) Ag '93
— Catskill Mountains region
 Nat Geog 182:108–30 (map,c,1) N '92
— Cazenovia's Lincklaen House
 Am Heritage 45:50,53 (c,4) Ap '94
— Chautauqua
 Trav/Holiday 175:60–7 (1) Ap '92
— Dutchess County countryside
 Trav&Leisure 25:54 (painting,c,4) D '95
— Geneva's Ashcroft House
 Smithsonian 24:126 (c,1) Ap '93
— Hudson Valley
 Gourmet 53:86 (c,4) Mr '93
 Nat Geog 189:72–95 (map,c,1) Mr '96
— Jerden Falls (19th cent.)
 Natur Hist 101:37 (4) My '92
— Lyndhurst estate
 Nat Geog 189:76–7 (c,1) Mr '96
— Mohonk Mountain House, New Paltz
 Trav&Leisure 22:E2 (c,4) Ap '92
 Smithsonian 27:38–9 (c,2) Ag '96
— Norwich
 Sports Illus 79:102–5 (c,1) D 27 '93
— Otsego Lake, Cooperstown
 Trav/Holiday 176:77,85 (c,1) Ap '93
— Rockefeller family home (Tarrytown)
 Trav&Leisure 24:31 (c,4) My '94
 Life 18:132–3 (c,1) N '95
— Saratoga Springs Victorian house
 Trav&Leisure 23:144 (c,4) S '93
— Shawangunk Ridge
 Smithsonian 27:cov.,30–41 (c,1) Ag '96
— South Kortright
 Nat Geog 182:125 (c,3) N '92
— Waterford (late 18th cent.)
 Am Heritage 47:79 (woodcut,4) Jl '96
— See also
 ADIRONDACK MOUNTAINS
 CATSKILL MOUNTAINS
 COOPERSTOWN
 ERIE CANAL
 FINGER LAKES
 FORT TICONDEROGA
 GEORGE WASHINGTON BRIDGE

HARRIMAN, W. AVERELL
HUDSON RIVER
LAKE CHAMPLAIN
LAKE GEORGE
LAKE PLACID
LONG ISLAND
MOHAWK RIVER
NEW YORK CITY
NIAGARA FALLS
ST. LAWRENCE RIVER
SARATOGA
SMITH, ALFRED E.
THOUSAND ISLANDS
WEST POINT
NEW YORK—MAPS
— Lake George area (1790s)
 Am Heritage 47:80 (4) Jl '96
— New York City seen from space
 Nat Geog 190:24–5 (c,1) N '96
NEW YORK CITY, NEW YORK
 Trav&Leisure 23:88–9 (c,1) My '93
 Trav/Holiday 176:cov.,50–61 (map,c,1) O
 '93
 Trav&Leisure 24:1–8 (c,1) Jl '94 supp.
 Gourmet 55:141–5,214 (map,c,1) My '95
 Sports Illus 83:2–3 (c,1) S 25 '95
— 1853 wooden house
 Trav&Leisure 24:58 (2) N '94
— 1860s plans for unbuilt museum
 Natur Hist 103:62–7 (painting,c,1) Jl '94
— 1882 townhouses
 Am Heritage 47:72 (4) F '96
— Early 20th cent. scenes
 Smithsonian 26:28 (painting,c,4) F '96
— 1910 shooting of Mayor Gaynor
 Am Heritage 45:68 (1) O '94
— 1920 Wall Street bombing
 Am Heritage 45:40 (4) Ap '94
— 1926 street scene
 Am Heritage 43:84 (1) N '92
— 1930s scenes
 Nat Geog 181:114–15 (1) Ja '92
 Am Heritage 43:83–97 (1) N '92
— 1945
 Life 18:22–3,42–3,96–7 (1) Je 5 '95
 Am Heritage 47:100–3 (c,1) D '96
— 1957 painting
 Smithsonian 24:68–9 (c,2) Ag '93
— 1964 Panorama model of New York City
 Am Heritage 47:70–8 (c,1) D '96
— 1993 bomb damage to World Trade Center
 Life 16:14–15 (c,1) Je '93
— 1996 cartoon about Statue of Liberty
 buried in snow
 Smithsonian 27:85 (4) Jl '96

— Arthur Avenue area of the Bronx
 Gourmet 53:52 (painting,c,2) S '93
— Broadway (1860)
 Am Heritage 44:106–7 (painting,c,2) F '93
— Brooks Brothers building (1918)
 Am Heritage 44:41 (drawing,4) N '93
— Carnegie Hall
 Trav&Leisure 25:98 (c,4) N '95
— Central Park Zoo
 Nat Geog 184:32 (c,1) Jl '93
— Chelsea area
 Gourmet 53:98–102,152 (map,c,1) My '93
— Chelsea Hotel
 Gourmet 53:101 (c,1) My '93
 Trav&Leisure 24:34 (c,4) O '94
— Chelsea Piers
 Trav&Leisure 26:E6–8 (c,4) S '96
— Claremont Stables
 Gourmet 54:54,56 (painting,c,2) S '94
— The Cloisters
 Trav&Leisure 22:104 (c,3) D '92
— Commuters on subway
 Smithsonian 24:60–1 (painting,c,2) Ag '93
— Constructing water tunnel
 Smithsonian 25:60–9 (c,1) Jl '94
— Fifth Avenue mansion
 Gourmet 52:54 (painting,c,2) D '92
— Flatiron Building
 Gourmet 52:112–13,117 (c,1) Ap '92
— Flatiron District
 Gourmet 52:112–17,191–2 (map,c,1) Ap
 '92
— Fulton Fish Market
 Trav&Leisure 22:NY1 (c,4) O '92
 Natur Hist 104:72–3 (2) Jl '95
— Gargoyles on New York City buildings
 Smithsonian 24:86–92 (c,2) Ag '93
— Grand Central Terminal
 Trav&Leisure 23:113 (4) Ja '93
 Trav&Leisure 25:97 (c,4) D '95
— Grand Central Terminal in miniature
 (1913)
 Am Heritage 47:8 (c,4) D '96
— Hester Street (1898)
 Am Heritage 43:56–7 (1) Ap '92
— Heye Center
 Smithsonian 25:48 (c,4) O '94
— Inner city gardens
 Nat Geog 187:136–8 (c,1) Ap '95
— Lower East Side
 Am Heritage 43:4,56–74 (map,c,1) Ap '92
 Smithsonian 25:80–91 (1) Ap '94
— Lower East Side (1910s)
 Smithsonian 23:68 (painting,c,2) Je '92
 Am Heritage 44:4 (2) O '93

— Lower Manhattan
 Trav&Leisure 26:84 (map,c,2) Ap '96
— Manhattan Bridge
 Life 18:24 (3) My '95
— Mayor Rudolph Giuliani
 Life 19:18 (c,3) Mr '96
— Midwestern woman learning to live in
 New York
 Life 15:53–9 (c,1) S '92
— Miniatures of New York City sites
 Am Heritage 47:8,70–81 (c,1) D '96
— Robert Moses projects
 Am Heritage 43:44–5 (c,4) Jl '92
— New York City seen through kaleidoscopic
 lens
 Life 19:94–6 (c,1) Mr '96
— New York Harbor
 Nat Geog 186:108 (c,1) Jl '94
 Gourmet 55:70 (map,4) Mr '95
— Photos taken from taxi
 Life 18:24–6 (3) My '95
— Plaza Hotel
 Am Heritage 45:48–9 (c,1) Ap '94
— Radio City Music Hall
 Trav&Leisure 25:94 (c,4) N '95
— St. John the Divine church
 Smithsonian 23:32–45 (c,1) D '92
 Trav&Leisure 23:NY1 (c,4) Ja '93
— Skyline
 Trav&Leisure 23:50 (c,3) F '93
 Nat Geog 183:4–5 (c,1) My '93
 Smithsonian 24:48–9 (c,1) Ja '94
 Nat Geog 186:124–5 (c,1) D '94
 Life 18:50–1 (c,1) F '95
 Gourmet 56:80 (c,4) Jl '96
— Skyline (1959)
 Trav&Leisure 23:57 (4) F '93
— Small hotels
 Trav&Leisure 24:80–9 (c,1) S '94
 Gourmet 56:150–3 (c,1) N '96
— Soho
 Trav&Leisure 23:80–7 (map,c,1) Je '93
 Trav&Leisure 26:173–81,199 (map,c,1) N
 '96
— South Street Seaport
 Trav/Holiday 176:52–3 (c,2) N '93
— Store windows decorated for Christmas
 Gourmet 53:66 (c,2) D '93
— Street scene
 Nat Geog 182:12–13 (c,2) N '92
 Trav/Holiday 179:74–5 (c,2) Mr '96
— Stuyvesant High School
 Life 17:48–61 (c,1) O '94
— Stylized depiction of landmarks

Gourmet 55:62 (painting,c,3) Mr '95
— Theaters
 Gourmet 56:42 (c,4) Je '96
— Times Square
 Trav&Leisure 22:74–5 (c,4) Ja '92
— Times Square (1938)
 Am Heritage 43:90 (painting,c,2) D '92
— Triborough Bridge
 Smithsonian 26:22 (4) Ja '96
— The "21" Club front gate
 Gourmet 52:68 (c,4) My '92
 Gourmet 55:208 (drawing,4) N '95
— Union Square Greenmarket
 Gourmet 55:48,52 (painting,c,2) Je '95
— Upper East Side
 Trav&Leisure 24:cov.,86 (c,1) S '94
— Verrazano Narrows Bridge
 Sports Illus 77:2–3 (c,1) N 9 '92
 Sports Illus 79:2–3 (c,1) N 22 '93
— View from atop Chrysler Building
 Life 17:48–9 (1) Ap '94
— View from Empire State Building
 Life 19:20 (c,3) N '96
— View from the ferry
 Trav&Leisure 22:118–19 (c,1) Mr '92
— Waldorf-Astoria hotel
 Trav&Leisure 23:22 (c,4) Jl '93
 Am Heritage 45:52–4 (4) Ap '94
— Winter scenes
 Trav&Leisure 25:cov.,92–102 (c,1) D '95
— Women hailing cab on snowy street
 Smithsonian 24:20 (c,4) Mr '94
— Woolworth Building
 Trav&Leisure 23:37 (c,4) Mr '93
— See also
 AMERICAN MUSEUM OF NATURAL
 HISTORY
 BRONX
 BROOKLYN
 BROOKLYN BRIDGE
 CENTRAL PARK
 CONEY ISLAND
 EMPIRE STATE BUILDING
 GUGGENHEIM MUSEUM
 HARLEM
 HUDSON RIVER
 LA GUARDIA, FIORELLO
 LIBERTY, STATUE OF
 METROPOLITAN MUSEUM OF ART
 MUSEUM OF MODERN ART
 NEW YORK PUBLIC LIBRARY
 POWELL, ADAM CLAYTON, JR.
 ROCKEFELLER CENTER
 WORLD TRADE CENTER

NEW YORK PUBLIC LIBRARY, NEW YORK CITY, NEW YORK
— Lion statue in front of library
 Smithsonian 24:92 (c,2) Ag '93
NEW ZEALAND
 Trav&Leisure 22:70–81 (map,c,1) S '92
 Gourmet 55:cov.,104–9,170 (map,c,1) Ap
 '95
— Antipodes Islands
 Natur Hist 104:54–8 (map,c,1) N '95
— Countryside
 Trav/Holiday 176:56–63 (map,c,1) Mr '93
— Fjordland National Park
 Trav&Leisure 25:116–19,158 (c,1) Ap '95
— Fjords
 Natur Hist 102:60–1 (c,1) Mr '93
— Lake Wakatipu
 Gourmet 55:cov. (c,1) Ap '95
 Trav&Leisure 26:106 (c,4) D '96
— Milford Sound
 Trav/Holiday 177:25 (c,4) N '94
— Mount Egmont, North Island
 Gourmet 53:144 (c,3) N '93
— North Island
 Trav/Holiday 178:41,43 (map,c,4) Ap '95
— Queen Charlotte Sound
 Nat Geog 190:36–7 (c,2) N '96
— South Island
 Smithsonian 23:96 (c,2) Jl '92
 Trav&Leisure 25:114–19,158,164
 (map,c,1) Ap '95
— South Island resort
 Trav&Leisure 23:32 (c,4) Ap '93
— Southern Alps
 Gourmet 55:105 (c,1) Ap '95
— See also
 AUCKLAND
 HILLARY, EDMUND
New Zealand—Costume. See
 MAORI PEOPLE
NEW ZEALAND—MAPS
 Gourmet 53:218 (4) N '93
NEWARK, NEW JERSEY
— Ironbound area
 Trav&Leisure 22:NY5 (c,3) D '92
— Newark Museum
 Trav&Leisure 22:NY1–2 (c,4) My '92
NEWFOUNDLAND
 Natur Hist 102:49,53 (c,1) Ap '93
 Trav/Holiday 177:92–9 (map,c,1) My '94
— Avalon Peninsula
 Trav&Leisure 24:83–5 (map,c,3) Je '94
— Funk Island
 Natur Hist 103:8 (c,4) Ag '94
— Waterfall

Natur Hist 101:42–3 (c,1) D '92
— See also
 LABRADOR
 ST. JOHN'S
NEWFOUNDLAND (DOGS)
 Smithsonian 27:127–36 (c,1) N '96
NEWPORT, RHODE ISLAND
— 1780s map
 Am Heritage 43:64–5 (c,1) D '92
— Astor mansion
 Trav/Holiday 179:34 (c,4) O '96
— The Breakers mansion
 Trav/Holiday 178:97,102 (c,4) Mr '95
 Trav&Leisure 26:62 (c,4) Je '96
Newscasters. See
 SPORTS ANNOUNCERS
 TELEVISION NEWSCASTERS
NEWSPAPER INDUSTRY
— 1880s trading cards of newspaper editors
 Am Heritage 45:75 (c,4) O '94
— 1888 newsboy sculpture
 Am Heritage 45:6 (c,3) O '94
— 1938 newsboys (Pennsylvania)
 Am Heritage 47:49 (1) My '96
— Great 20th cent. news photos
 Am Heritage 45:66–73 (1) O '94
— Publishing small rural paper (New Mexico)
 Smithsonian 26:89–99 (1) O '95
— See also
 HEARST, WILLIAM RANDOLPH
 JOURNALISTS
 WINCHELL, WALTER
NEWSPAPERS
— 1898 advice column
 Am Heritage 43:95 (3) My '92
— 1915 headline about *Lusitania* sinking
 Nat Geog 185:72 (c,1) Ap '94
— 1932 newsstand (New York)
 Am Heritage 43:90 (1) N '92
— Humorous history of American newspapers
 Am Heritage 45:cov.,36-64 (drawing,c,1)
 O '94
— See also
 READING
NEZ PERCE INDIANS—COSTUME
— Nez Perce boys
 Am Heritage 43:110 (4) N '92
— See also
 JOSEPH, CHIEF
NIAGARA FALLS, NEW YORK/ON-TARIO
 Trav/Holiday 176:42–9 (c,1) Jl '93
 Nat Geog 184:cov.,5–7 (c,1) N 15 '93
— 1854
 Smithsonian 26:46 (4) O '95

— 1888
 Smithsonian 27:122–3 (1) My '96
NICE, FRANCE
 Gourmet 54:98–103 (c,1) S '94
NICHOLAS II (RUSSIA)
— Family of Czar Nicholas II
 Nat Geog 182:115 (4) O '92
NICKLAUS, JACK
 Sports Illus 76:39 (4) My 25 '92
 Life 16:33 (4) Je '93
 Sports Illus 80:28–30,35 (c,1) Ap 18 '94
 Sports Illus 80:51–2 (2) Je 13 '94
 Sports Illus 81:100–1 (c,1) S 19 '94
NICOSIA, CYPRUS
 Nat Geog 184:115 (c,3) Jl '93
NIGER
— Tenere Desert
 Life 19:76 (c,3) S '96
— See also
 TUAREG PEOPLE
NIGER—COSTUME
— Blind people
 Life 17:60–5 (1) Ag '94
NIGER—RITES AND FESTIVALS
— Tuareg infant's naming ceremony
 Natur Hist 101:54–62 (c,1) N '92
NIGERIA—ART
— Ibo mask
 Smithsonian 25:96 (c,4) D '94
NIGERIA—COSTUME
— Hausa hat
 Smithsonian 27:28 (c,4) Je '96
NIGHT CLUBS
— 1930s strip club entrance (New York)
 Am Heritage 43:95 (4) N '92
— 1950s night club scene
 Gourmet 54:48 (painting,c,2) Ja '94
— 1954 New Year's Eve festivities (New
 York)
 Am Heritage 47:14 (4) D '96
— Blues club (San Francisco, California)
 Trav&Leisure 26:E10,E16 (c,4) S '96
— Dancing in bubbles (Spain)
 Nat Geog 181:4–5 (c,1) Ap '92
— Disco (Shanghai, China)
 Nat Geog 185:18–19 (c,2) Mr '94
— Foam dancing (New York City, New York)
 Life 19:9 (c,4) Ja '96
— Los Angeles, California
 Trav&Leisure 26:46–8 (c,4) Jl '96
— Memphis, Tennessee
 Natur Hist 105:50 (c,1) S '96
— New York City, New York
 Trav&Leisure 25:108–11,158 (c,1) My '95
— Preservation Hall, New Orleans, Louisiana

 Trav&Leisure 24:89 (c,1) Ja '94
— San Francisco, California
 Trav&Leisure 26:36 (c,2) O '96
— Zaire
 Life 19:72 (c,4) S '96
— See also
 DANCING
NILE RIVER, EGYPT
 Nat Geog 183:39–40 (c,1) My '93
— Cairo
 Nat Geog 183:40–1 (c,1) Ap '93
NIMES, FRANCE
 Trav/Holiday 179:82–3 (c,1) Mr '96
— Roman aqueduct
 Nat Geog 188:67 (c,3) S '95
NIXON, RICHARD M.
 Life 15:6–7,31 (c,1) O 30 '92
 Life 16:28 (3) S '93
 Sports Illus 79:22 (4) D 20 '93
 Am Heritage 45:73 (4) F '94
 Am Heritage 45:42 (4) Ap '94
 Am Heritage 45:122 (4) My '94
 Life 17:16–26 (c,1) Je '94
 Smithsonian 25:102 (c,4) O '94
 Smithsonian 25:141 (c,4) D '94
 Life 18:90–1 (1) Ja '95
 Sports Illus 83:8 (4) S 18 '95
— 1974 resignation
 Trav/Holiday 175:77 (c,4) N '92
— Caricature
 Sports Illus 84:86 (painting,c,4) Je 17 '96
— Depicted as hero to 1956 Hungarian
 refugees
 Am Heritage 44:108–9 (painting,c,1) F '93
— Nixon playing piano
 Am Heritage 43:59 (4) Jl '92
— Pat Nixon
 Smithsonian 23:158 (c,2) O '92
 Life 15:83 (c,4) O 30 '92
 Life 17:78–9 (c,1) Ja '94
 Life 19:82 (c,3) S '96
— Pat Nixon's inaugural gown
 Smithsonian 27:50 (c,4) My '96
— Throwing out first baseball of season
 Sports Illus 78:87 (4) Ap 12 '93
— Young Nixon
 Am Heritage 46:77 (4) Jl '95
NOBEL PRIZE
— Nobel Prize banquet (Stockholm, Sweden)
 Nat Geog 184:6–7 (c,1) Ag '93
NOMADS
— Beritan Kurds (Turkey)
 Nat Geog 182:54–5 (c,1) Ag '92
— Gabbra people (Kenya)
 Natur Hist 102:50–7 (c,1) S '93

— Mongolia
 Nat Geog 183:126–38 (c,1) My '93
— Tibet
 Nat Geog 184:62–4,74–5 (c,1) Ag '93
— See also
 BEDOUINS
 BERBER PEOPLE
 GYPSIES
 TUAREG PEOPLE

NORFOLK, VIRGINIA
— MacArthur memorial
 Am Heritage 47:84 (c,4) F '96

NORTH CAROLINA
— 18th cent. Governor's mansion (New Bern)
 Am Heritage 47:22 (c,4) D '96
— Bahama
 Life 18:54–62 (c,1) O '95
— Blue Ridge Parkway
 Trav&Leisure 26:38 (c,1) N '96
— Cedar Point
 Natur Hist 104:74–6 (map,c,1) Ap '95
— Chapel Hill
 Trav&Leisure 26:55–8 (c,4) D '96
— Cherokee
 Nat Geog 187:77 (c,2) My '95
— Coastal area
 Trav&Leisure 24:E1–E2 (map,c,4) Jl '94
— Countryside
 Trav&Leisure 22:108–13 (c,1) Mr '92
— Fearrington Village
 Trav&Leisure 23:NY4 (c,4) Mr '93
— Hatteras Light
 Gourmet 55:98,103 (c,2) Ap '95
— History of Pinehurst resort
 Am Heritage 46:55–62 (4) F '95
— Outer Banks
 Gourmet 55:98–103,124 (map,c,1) Ap '95
— Piedmont
 Nat Geog 187:114–37 (map,c,1) Mr '95
— Somerset Place Plantation
 Am Heritage 43:92–3 (c,2) Ap '92
— Tryon Palace gardens, New Bern
 Trav/Holiday 178:32 (c,4) F '95
— Wilkes County
 Trav/Holiday 179:44–5 (map,c,4) S '96
— See also
 APPALACHIAN MOUNTAINS
 ASHEVILLE
 CAPE HATTERAS
 DURHAM
 GREAT SMOKY MOUNTAINS
 GREAT SMOKY MOUNTAINS
 NATIONAL PARK

NORTH DAKOTA
— Countryside

 Natur Hist 105:37 (c,1) My '96
— Eldridge
 Smithsonian 24:42–3 (1) Mr '94
— Marshlands
 Nat Wildlife 34:20–1,27 (c,1) Je '96
— Prairie
 Nat Geog 184:103,110–11 (c,2) O '93
— See also
 THEODORE ROOSEVELT NATIONAL
 PARK

NORTHERN IRELAND
 Nat Geog 186:32–5 (c,1) S '94
 Trav&Leisure 25:61–4 (map,c,1) N '95
— Castle Coole
 Trav&Leisure 25:61 (c,4) N '95
— Mourne Mountains area
 Trav/Holiday 179:36–43 (map,c,1) Je '96
— See also
 BELFAST

NORTHERN IRELAND—HOUSING
 Life 18:66–7 (c,1) Ja '95

**NORTHERN IRELAND—POLITICS
AND GOVERNMENT**
— London office buildings damaged by IRA
 bomb, England
 Life 15:24 (c,4) Je '92
 Life 17:22–3 (c,1) Ja '94
— Political murals on buildings
 Sports Illus 79:80–4 (c,3) N 29 '93
 Life 18:66–7 (c,1) Ja '95

**NORTHERN IRELAND—SHRINES
AND SYMBOLS**
— Flag
 Life 17:28 (c,2) N '94

NORTHWEST TERRITORIES
— Barren Lands
 Natur Hist 105:2,30–6,68 (map,c,1) My
 '96
— Bathurst Inlet
 Trav&Leisure 22:82–90 (map,c,3) Mr '92
— Wilberforce Falls
 Trav&Leisure 22:82 (c,3) Mr '92

NORTHWESTERN U.S.
— Columbia River Basin
 Nat Wildlife 34:36–45 (c,1) D '95
— Impact of Ice Age Lake Missoula floods
 Smithsonian 26:48–59 (map,c,1) Ap '95
— See also
 COLUMBIA RIVER

NORWAY
 Gourmet 53:80–5,156 (map,c,1) Je '93
 Trav/Holiday 178:44–51 (map,c,1) Jl '95
— 1994 Olympic sites (Lillehammer)
 Sports Illus 78:50–3 (c,2) Mr 29 '93
— Alesund

Trav&Leisure 22:108–9 (c,1) Jl '92
Gourmet 53:82 (c,3) Je '93
— Countryside
Trav&Leisure 24:164–7 (map,c,4) S '94
— Fimreite
Sports Illus 80:143 (c,4) F 7 '94
— Finnmark & Troms
Trav/Holiday 179:96–101,111 (map,c,1)
D '96
— Fjord ferry
Trav&Leisure 26:52 (c,4) F '96
— Lillehammer
Trav/Holiday 175:74–8 (map,c,1) D '92
Gourmet 54:cov.,62–5,100 (map,c,1) Ja
'94
— Prekestolen Rock
Life 16:88 (c,1) Ap '93
— Roros
Trav/Holiday 175:79–81 (c,2) D '92
— Stavanger
Am Heritage 47:6 (c,4) Ap '96
— Tromso
Trav/Holiday 179:100 (c,4) D '96
— 24-hour summer sun
Life 19:16–17 (c,1) Jl '96
— Western coast
Trav&Leisure 22:105–11 (map,c,1) Jl '92
— See also
BERGEN
FJORDS

NORWAY—COSTUME
— Lapp people
Trav/Holiday 179:98–9 (c,1) D '96
— Royal Palace guards (Oslo)
Trav/Holiday 175:77 (c,4) D '92
Norway—History. See
HEYERDAHL, THOR
VIKINGS

NORWAY—HOUSING
— Gabled wood houses (Bergen)
Trav/Holiday 178:47 (c,1) Jl '95

NOVA SCOTIA
— Countryside
Natur Hist 102:54 (c,3) Ap '93
Trav/Holiday 177:98–9 (c,1) Ap '94
— Evangeline Trail
Gourmet 54:48–53,88 (map,c,1) Jl '94
— See also
BAY OF FUNDY
CAPE BRETON ISLAND
HALIFAX

NOVGOROD, RUSSIA
Trav&Leisure 25:74–8 (c,3) D '95

NUCLEAR ENERGY
— 1942 first nuclear chain reaction (Chicago,
Illinois)
Smithsonian 23:22 (painting,c,4) F '93
— Atomic Lake, Kazakhstan
Nat Geog 183:34–5 (c,1) Mr '93
— Nuclear waste disposal sites
Smithsonian 26:40–51 (c,1) My '95
— See also
ATOMIC BOMBS

NUCLEAR POWER PLANTS
Smithsonian 27:34 (c,4) N '96
— 1986 Chernobyl nuclear disaster, Ukraine
Nat Geog 186:100–15 (c,1) Ag '94
— Chernobyl, Ukraine
Nat Geog 186:102–8 (c,1) Ag '94
— Covered with mural (Cruas, France)
Life 15:26 (c,4) Mr '92
— Diablo Canyon, California
Nat Geog 187:25 (c,2) Ap '95
Nudibranchs. See
SLUGS

NUDITY
— Nude beach (Vancouver, British Columbia)
Nat Geog 181:113 (c,3) Ap '92
— Nude rugby players streaking across field
(France)
Life 17:26–7 (c,1) D '94

NUREMBERG, GERMANY
— "Way of Human Rights" monument
Trav/Holiday 177:91 (c,4) Je '94
— See also
GERMANY—HISTORY

NUREYEV, RUDOLF
Life 17:74–5 (1) Ja '94

NURSES
Life 17:67 (c,4) Mr '94
— 1910 visiting nurse climbing over rooftops
(New York City)
Am Heritage 44:4 (2) O '93
— 1918 Red Cross nurse
Am Heritage 43:72–3 (1) D '92
— 1940s Red Cross nurses
Life 17:54 (4) Je '94
— 1944 squirrel in nurse costume
Nat Geog 188:138 (3) N '95

NUTCRACKERS (BIRDS)
Natur Hist 103:84–5 (c,1) D '94

NUTHATCHES
Nat Wildlife 31:59 (c,1) F '93
Nat Wildlife 33:58 (c,4) F '95

NUTRIAS
Nat Geog 182:13 (c,4) Jl '92

NUTS
— Ancient Greek nutcracker shaped like
 hands
 Nat Geog 186:22–3 (c,1) N '94
— Cashew "apples"
 Natur Hist 101:66–9 (c,1) Ag '92
— Cashew nuts in their fruits
 Nat Wildlife 31:36 (c,2) Ap '93

–O–

OAK TREES
 Nat Geog 181:70–1 (c,1) F '92
 Natur Hist 104:37 (c,1) My '95
 Smithsonian 27:112–13,123 (c,1) O '96
— Seedlings sprouting from acorns
 Natur Hist 103:40 (c,3) O '94
— White oak
 Smithsonian 27:123 (c,1) O '96
OAKLAND, CALIFORNIA
— Houses on fire
 Life 15:106–7 (c,1) Ja '92
— Paramount Theater
 Trav&Leisure 25:96 (c,4) N '95
— See also
 SAN FRANCISCO-OAKLAND BAY
 BRIDGE
OAKLEY, ANNIE
 Life 16:76 (4) Ap 5 '93
 Am Heritage 46:60 (4) F '95
 Am Heritage 47:30 (4) S '96
OAT INDUSTRY
— Oat field (Sicily, Italy)
 Nat Geog 186:16–17 (c,2) N '94
OAXACA, MEXICO
 Nat Geog 186:38–63 (map,c,1) N '94
 Trav&Leisure 25:96 (c,4) F '95
OBESITY
— Overweight man in snorkeling therapy
 (North Carolina)
 Nat Geog 187:126–7 (c,2) Mr '95
OBSERVATORIES
— Cerro Tololo Inter-American Observatory,
 Chile
 Nat Geog 185:24 (c,4) Ja '94
— India
 Natur Hist 102:48–57 (c,1) Je '93
— Mauna Kea, Hawaii
 Nat Geog 181:30–2,44,49 (c,1) My '92
 Trav&Leisure 22:64 (c,4) O '92
 Life 17:23–4 (c,1) S '94
— Starfire Optical Range, New Mexico
 Nat Geog 185:2–3 (c,1) Ja '94
— See also

ANTENNAS
TELESCOPES
OBSIDIAN
 Nat Geog 184:54–5 (c,1) D '93
OCCULT
— 1890 cartoon about occultism
 Smithsonian 26:114 (c,4) My '95
— Birth of the Theosophical Society
 Smithsonian 26:110–27 (1) My '95
— Haunted hotels (Great Britain)
 Trav/Holiday 179:46–53 (c,1) O '96
— Henry Steel Olcott
 Smithsonian 26:111,116,123–7 (3) My '95
Occupations. See
 ACROBATS
 AIRPLANE PILOTS
 ANIMAL TRAINERS
 ASTRONAUTS
 AUTOMOBILE MECHANICS
 BEEKEEPING
 BEGGARS
 BLACKSMITHS
 BUSINESSMEN
 BUTCHERS
 BUTLERS
 CHAUFFEURS
 CHEERLEADERS
 CHEFS
 CLOWNS
 CONDUCTORS, MUSIC
 COWBOYS
 DANCERS
 DENTISTS
 DOCTORS
 ENTERTAINERS
 FACTORY WORKERS
 FARM WORKERS
 FARMERS
 FIRE FIGHTERS
 FISHERMEN
 GUARDS
 HOBOES
 HUNTERS
 JANITORS
 JOCKEYS
 JOURNALISTS
 KNIGHTS
 LABORERS
 LAWYERS
 LUMBERJACKS
 MATADORS
 MINERS
 MODELS
 NATURALISTS
 NURSES

PIRATES
POLICEMEN
PORTERS
POSTAL WORKERS
PROSTITUTION
RAILROAD WORKERS
SCHOLARS
SCIENTISTS
SHAMANS
SHEPHERDS
SHIP CAPTAINS
SHOEMAKING
SPIES
SPORTS ANNOUNCERS
STREET VENDORS
SAILORS
SURGEONS
TAILORS
TELEVISION NEWSCASTERS
VETERINARIANS
WAITERS
WAITRESSES
WITCHES

OCEAN CRAFT
— Research submersible
Nat Geog 181:39 (c,1) Je '92
Smithsonian 26:97 (c,1) Ja '96
Nat Geog 190:86–9 (c,1) O '96
— Research vehicles
Nat Geog 181:120–1 (c,1) Mr '92
Nat Geog 186:116–17,126 (c,2) N '94
— Robotic research vessel
Nat Geog 185:78 (c,1) Ap '94

OCEANS
— Bay of Fundy's extreme tides, Canada
Life 17:80 (c,3) Jl '94
— Diorama of ancient sea floor
Smithsonian 24:18 (c,4) D '93
— Satellite maps of ocean ridges
Natur Hist 105:28–33 (c,1) Mr '96
— U.S. beach erosion problems
Smithsonian 23:73–86 (c,1) O '92
— See also
ATLANTIC OCEAN
PACIFIC OCEAN
TIDAL WAVES
WAVES

OCELOTS
Nat Wildlife 32:35–7 (painting,c,1) Je '94
Life 17:60 (c,1) S '94

OCTOPI
Nat Geog 186:124–5 (c,2) N '94
Smithsonian 26:102 (c,4) Ja '96
— Blue-ringed octopus
Life 17:77 (c,1) Mr '94

Nat Wildlife 32:52–3 (c,1) Ap '94
— Hatchling
Nat Wildlife 30:9 (c,4) Je '92
Smithsonian 24:114 (c,4) O '93
— Larval octopus
Nat Geog 188:49 (c,4) D '95
— Octopus on man's head
Sports Illus 80:80 (c,4) My 16 '94

OFFICE BUILDINGS
— Anheuser-Busch headquarters, St. Louis, Missouri
Gourmet 53:95 (c,1) S '93
— AT&T Building, New York City, New York
Am Heritage 47:96 (c,4) Jl '96
— Boston, Massachusetts
Nat Geog 186:2–4,14 (c,1) Jl '94
— Disney headquarters, Lake Buena Vista, Florida
Smithsonian 23:cov.,64–5 (c,1) Jl '92
— Flatiron Building, New York City, New York
Gourmet 52:112–13,117 (c,1) Ap '92
— Infrared reading of building heat (British Columbia)
Smithsonian 26:111 (c,2) D '95
— Lloyd's of London headquarters, England
Smithsonian 26:36 (c,4) Ap '95
— London office building damaged by IRA bomb, England
Life 15:24 (c,4) Je '92
— Los Angeles, California
Am Heritage 44:51 (c,4) O '93
Nat Wildlife 34:41 (c,1) O '96
— Modern Richard Meier building (Paris, France)
Trav&Leisure 23:111 (c,3) Ja '93
— Nike headquarters, Beaverton, Oregon
Sports Illus 79:59–65 (c,4) Ag 16 '93
— PPG headquarters, Pittsburgh, Pennsylvania
Nat Geog 184:40–1 (c,1) D '93
— Sears Tower, Chicago, Illinois
Gourmet 53:96 (c,2) Mr '93
— Toronto, Ontario
Nat Geog 189:24–5,135 (c,1) Je '96
— Transamerica Pyramid, San Francisco, California
Gourmet 53:36 (c,4) D '93
Gourmet 55:161 (c,1) My '95
— Washing skyscraper windows (Texas)
Life 15:8–9 (c,1) My '92
— Woolworth Building, New York City
Trav&Leisure 23:37 (c,4) Mr '93
— See also

EMPIRE STATE BUILDING
ROCKEFELLER CENTER
WORLD TRADE CENTER
OFFICES
— Cluttered desk
Sports Illus 78:35 (c,4) Mr 8 '93
— Cluttered office (Iowa)
Smithsonian 24:47 (4) Mr '94
— Old-fashioned cluttered office (New York)
Smithsonian 25:87 (2) Ap '94
— Securities firm trading room (Tokyo,
Japan)
Nat Geog 183:90 (c,4) Ja '93
O'HARA, JOHN
Am Heritage 47:99 (4) N '96
OHIO
— Amish country
Trav/Holiday 179:54–9 (c,1) O '96
— Ancient Indian mounds
Am Heritage 46:118–19,125 (c,1) Ap '95
— Barnesville Pumpkin Show
Smithsonian 27:66–7 (c,2) O '96
— Cedar Point roller coaster, Sandusky
Trav&Leisure 26:34 (c,4) Jl '96
— Rankin House, Ripley
Am Heritage 46:30–1 (c,4) F '95 supp.
— See also
CINCINNATI
CLEVELAND
COLUMBUS
MARIETTA
OHIO RIVER
YOUNGSTOWN
OHIO RIVER, MIDWEST
Nat Geog 189:110–11 (c,1) F '96
— Ripley, Ohio
Am Heritage 46:,31 (c,4) F '95 supp.
OIL INDUSTRY
— 1855 whale oil refinery (Massachusetts)
Am Heritage 44:100–1 (painting,c,1) F '93
— 1973 line at gas pump (New York)
Life 16:28 (2) D '93
— 1991 Gulf War oil fires (Kuwait)
Life 15:12–13,28–9 (c,1) Ja '92
Nat Geog 181:122–34 (c,1) F '92
— Drilling platform (Scotland)
Nat Geog 190:26–7 (c,2) S '96
— Factories (Louisiana)
Nat Geog 184:102–3 (c,1) N 15 '93
— Offshore drilling platform (Louisiana)
Nat Geog 182:11 (c,1) Jl '92
— Offshore oil rig (Mexico)
Nat Geog 190:8–9 (c,1) Ag '96
— Oil exploration convoy (China)
Nat Geog 189:38–9 (c,1) Mr '96

— Oil tanks (Barbados)
Trav/Holiday 177:64 (c,2) Mr '94
— Oil wells (Oman)
Nat Geog 187:121 (c,3) My '95
— Pipeline (Alaska)
Nat Wildlife 31:10–11 (c,2) Ap '93
— Refinery (Pennsylvania)
Nat Wildlife 34:26 (c,1) Ap '96
— Refinery (Texas)
Smithsonian 25:28–9 (2) My '94
— See also
GETTY, J. PAUL
ROCKEFELLER, JOHN D.
OIL SPILLS
— Aftermath of 1989 Prince William Sound
oil spill
Trav&Leisure 22:55,58,61 (c,3) Mr '92
Nat Wildlife 31:4–11 (c,1) Ap '93
— Bacteria used to clean oil spills
Nat Geog 184:57 (c,4) Ag '93
— Guillemot covered by oil (Wales)
Life 19:16–17 (c,1) Je '96
OKAPIS
Natur Hist 101:28–35 (c,1) N '92
O'KEEFFE, GEORGIA
Smithsonian 23:141 (4) Je '92
Life 18:32 (3) Ap '95
Life 19:100 (3) O '96
— "The Lawrence Tree" (1929)
Am Heritage 43:103 (painting,c,4) S '92
**OKEFENOKEE SWAMP, FLOR-
IDA/GEORGIA**
Nat Geog 181:34–63 (map,c,1) Ap '92
Trav&Leisure 23:E1–E4 (map,c,4) Mr '93
Am Heritage 45:112 (c,4) My '94
OKLAHOMA
— 1934 Dust Bowl crisis
Life 16:26–7 (1) Ap 5 '93
— Countryside
Nat Geog 187:76 (c,4) My '95
— Guthrie
Am Heritage 44:22 (c,4) S '93
— Guthrie (1889)
Life 16:18–19 (1) Ap 5 '93
— Hoot Owl
Smithsonian 26:80–1 (3) S '95
— See also
OKLAHOMA CITY
OKLAHOMA CITY, OKLAHOMA
— 1995 terrorist bombing
Life 19:28–9,42–8 (c,1) Ja '96
OLDENBURG, CLAES
— Outdoor sculptures by him
Smithsonian 26:78–83 (c,1) Ag '95

OLIVE INDUSTRY—HARVESTING
— Cyprus
 Nat Geog 184:126–7 (c,1) Jl '93
— Italy
 Trav&Leisure 24:92 (c,4) My '94
OLIVE TREES
 Trav&Leisure 26:74 (c,4) Jl '96
OLIVIER, LAWRENCE
 Life 19:80 (2) Mr '96
OLYMPIC NATIONAL PARK, WASHINGTON
 Trav&Leisure 23:92,94 (c,3) Je '93
 Nat Geog 186:7–8 (c,2) O '94
OLYMPICS
— Pierre de Coubertin
 Sports Illus 85:250 (4) Jl 22 '96
— History of Olympic baseball
 Sports Illus 84:7–18 (c,1) My 13 '96
— History of Olympic basketball
 Sports Illus 76:39–62 (c,2) Jl 6 '92
 Sports Illus 84:13–28 (c,1) Ja 15 '96
— History of Olympic diving
 Sports Illus 84:51–70 (2) Ap 29 '96
— History of Olympic gymnastics
 Sports Illus 84:55–70 (c,1) Mr 25 '96
— History of Olympic swimming
 Sports Illus 84:51–70 (2) Ap 29 '96
— History of Olympic volleyball
 Sports Illus 84:11–26 (c,2) Je 17 '96
— Lighting the Olympic flame
 Sports Illus 83:54 (c,4) D 25 '95
— Olympic Museum, Lausanne, Switzerland
 Sports Illus 82:9 (c,4) Ja 23 '95
— Olympic torch
 Sports Illus 84:96 (c,4) Je 17 '96
— Paralympics 1996 (Atlanta)
 Sports Illus 85:11 (c,2) Ag 26 '96
— Senior Olympics
 Life 19:26–30 (c,3) Ag '96
— Track and field Olympic history
 Sports Illus 84:9–26 (c,2) F 26 '96
OLYMPICS—1896 SUMMER (ATHENS)
 Am Heritage 47:52–60,114 (c,1) Jl '96
— American team
 Am Heritage 47:52–60 (c,1) Jl '96
OLYMPICS—1912 SUMMER (STOCKHOLM)
 Am Heritage 43:94–7,100 (4) Jl '92
— Poster
 Sports Illus 85:17 (c,4) Jl 22 '96
OLYMPICS—1920 SUMMER (ANTWERP)
— Tennis
 Nat Geog 190:58 (4) Jl '96

OLYMPICS—1928 WINTER (ST. MORITZ)
— Figure skating
 Sports Illus 76:35 (c,2) F 3 '92
OLYMPICS—1932 SUMMER (LOS ANGELES)
— Program and tickets
 Sports Illus 83:4 (c,4) Jl 31 '95
OLYMPICS—1936 SUMMER (BERLIN)
 Sports Illus 85:14–16 (c,4) Jl 22 '96
— Basketball
 Sports Illus 84:15 (2) Ja 15 '96
 Sports Illus 85:15 (4) Jl 22 '96
— Marathon winners
 Sports Illus 77:4 (4) S 7 '92
— Jesse Owens on victory stand
 Life 19:46 (4) O '96
— Jesse Owens' track shoes
 Sports Illus 82:9 (c,4) Ja 23 '95
OLYMPICS—1948 WINTER (ST. MORITZ)
— U.S. heavyset bobsled team
 Life 17:28 (4) F '94
OLYMPICS—1952 SUMMER (HELSINKI)
— Boxing
 Sports Illus 76:51 (4) My 11 '92
OLYMPICS—1952 WINTER (OSLO)
— Slalom winner on stand
 Sports Illus 79:48 (3) N 15 '93
OLYMPICS—1956 WINTER (CORTINA)
— Skiing
 Sports Illus 79:52 (2) N 15 '93
OLYMPICS—1956 SUMMER (MELBOURNE)
— Basketball
 Sports Illus 84:16 (2) Ja 15 '96
— Poster
 Sports Illus 85:17 (c,4) Jl 22 '96
OLYMPICS—1960 SUMMER (ROME)
— Boxing
 Sports Illus 76:49 (4) My 11 '92
— Shot-putting
 Sports Illus 76:54 (4) Ap 13 '92
— Track
 Sports Illus 81:13 (4) N 21 '94
 Life 18:82 (1) Ja '95
OLYMPICS—1960 WINTER (SQUAW VALLEY)
— Hockey
 Sports Illus 79:10–12 (3) D 13 '93
— Skiing

Sports Illus 79:58 (3) N 15 '93
OLYMPICS—1964 SUMMER (TO-KYO)
— Boxing
Sports Illus 76:51 (4) My 11 '92
— Poster
Sports Illus 85:17 (c,4) Jl 22 '96
OLYMPICS—1968 SUMMER (MEX-ICO CITY)
— Black Power salute
Sports Illus 79:14 (c,4) O 25 '93
— Boxing
Sports Illus 76:47 (c,2) My 11 '92
— Marathon winner
Sports Illus 83:82 (c,4) D 4 '95
— Volleyball
Sports Illus 84:14 (3) Je 17 '96
— Wrestling
Sports Illus 76:143 (4) Mr 9 '92
OLYMPICS—1972 SUMMER (MU-NICH)
— Basketball
Sports Illus 76:64–78 (c,1) Je 15 '92
Sports Illus 84:18 (c,2) Ja 15 '96
— Gymnastics
Sports Illus 76:86–7 (2) F 24 '92
Sports Illus 81:114–15 (c,1) S 19 '94
— Marathon
Sports Illus 85:31 (c,4) Ag 5 '96
— Swimming
Sports Illus 76:43 (c,2) Je 8 '92
— Terrorist attack on Israeli athletes
Sports Illus 81:60–4,70 (c,1) Jl 25 '94
Sports Illus 81:70–1 (c,1) N 14 '94
OLYMPICS—1976 SUMMER (MONT-REAL)
— Basketball
Sports Illus 84:20 (2) Ja 15 '96
— Gymnastics
Life 19:84 (c,4) F '96
— Pole vaulting
Sports Illus 76:45 (c,2) Ap 13 '92
— Swimming
Sports Illus 76:50,52 (c,4) Je 8 '92
Sports Illus 77:54–7 (c,1) Jl 13 '92
— Volleyball
Sports Illus 84:18 (c,2) Je 17 '96
OLYMPICS—1976 WINTER (INNSBRUCK)
— Cross-country skiing
Sports Illus 79:47,60 (c,2) N 15 '93
— Figure skating
Sports Illus 80:50 (c,3) Mr 7 '94
— Speed skating
Sports Illus 76:43–6 (c,2) Ja 13 '92

OLYMPICS—1980 WINTER (LAKE PLACID)
— Bobsledding
Sports Illus 76:50 (c,3) Ja 13 '92
— Hockey
Sports Illus 79:9,14–18 (c,2) D 13 '93
Sports Illus 80:36–49 (c,1) F 21 '94
Sports Illus 81:178 (c,2) N 14 '94
OLYMPICS—1984 SUMMER (LOS AN-GELES)
— Track
Sports Illus 81:132–3 (c,1) N 14 '94
— Vault
Sports Illus 84:58 (c,3) Mr 25 '96
OLYMPICS—1988 SUMMER (SEOUL)
— Baseball
Sports Illus 84:12,16 (c,2) My 13 '96
— Basketball
Sports Illus 84:24–8 (c,2) Ja 15 '96
— Boxing ceremony
Sports Illus 78:42 (c,4) F 1 '93
— Long jump
Sports Illus 81:123 (c,2) N 14 '94
— Track
Sports Illus 81:84 (c,4) N 14 '94
— Volleyball
Sports Illus 84:22–4 (c,2) Je 17 '96
OLYMPICS—1988 WINTER (CAL-GARY)
— Bobsledding
Sports Illus 76:52 (c,2) Ja 13 '92
Sports Illus 81:126–7 (c,1) N 14 '94
— Figure skating
Sports Illus 76:48 (c,4) Ja 13 '92
Sports Illus 76:62 (c,4) F 10 '92
OLYMPICS—1992 SUMMER (BAR-CELONA)
Sports Illus 77:cov.,2–61 (c,1) Ag 3 '92
Sports Illus 77:entire issue (c,1) Ag 10 '92
Sports Illus 77:cov.,14–71 (c,1) Ag 17 '92
Sports Illus 77:cov.,16–17,70–93 (c,1) D 28 '92
Life 16:36–8 (c,1) Ja '93
— African Olympic basketball trials (Egypt)
Sports Illus 76:80–95 (c,2) F 17 '92
— Baseball
Sports Illus 84:18 (c,2) My 13 '96
— Basketball
Sports Illus 77:14–19 (c,1) Ag 17 '92
Sports Illus 84:22,26,28 (c,2) Ja 15 '96
— Olympic athletes
Sports Illus 77:entire issue (c,1) Jl 22 '92
Sports Illus 77:entire issue (c,1) Ag 10 '92
— Olympics Stadium, Barcelona, Spain
Trav&Leisure 22:87 (c,4) Ja '92

— Opening ceremonies
 Sports Illus 77:12–19 (c,1) Ag 3 '92
— Sant Jordi Stadium, Barcelona, Spain
 Trav/Holiday 175:55 (c,1) Mr '92
— Shot-put winners ceremony
 Sports Illus 78:44 (c,3) Mr 15 '93
— Swimming
 Sports Illus 77:cov.,34–9 (c,1) Ag 3 '92
 Sports Illus 77:2–3,30–48 (c,1) Ag 10 '92
 Sports Illus 78:60,64 (c,4) Ja 11 '93
— Track and field
 Sports Illus 77:46–7,50 (c,1) Ag 3 '92
 Sports Illus 77:cov.,12–29,92–3 (c,1) Ag
 10 '92
 Sports Illus 77:cov.,20–44 (c,1) Ag 17 '92
 Sports Illus 77:cov.,75–91 (c,1) D 28 '92
 Sports Illus 84:96 (c,2) Je 10 '96
 Sports Illus 84:76 (c,3) Je 17 '96
— U.S. swimming trials
 Sports Illus 76:2–3,36–8,43 (c,1) Mr 16
 '92
— U.S. track and field trials
 Sports Illus 76:2–3,14–21 (c,1) Jl 6 '92
OLYMPICS—1992 WINTER (AL-
 BERTVILLE)
 Sports Illus 76:2–3,32–46 (c,1) F 17 '92
 Sports Illus 76:cov.,2–3,14–49 (c,1) F 24
 '92
 Sports Illus 76:16–39,68–79 (c,1) Mr 2 '92
 Sports Illus 77:20–1,24 (c,1) D 28 '92
— Bobsledding
 Sports Illus 80:46 (c,4) Ja 10 '94
— Cross-country skiing
 Sports Illus 80:56 (c,1) Ja 24 '94
— Figure skating
 Sports Illus 76:16–21 (c,1) Mr 2 '92
— Hockey
 Sports Illus 76:28–31,78–9 (c,1) Mr 2 '92
— Ice dancing
 Life 16:14–15 (c,1) Ja '93
— Luge
 Sports Illus 80:48 (c,4) Ja 10 '94
— Olympic mascot Cobri
 Sports Illus 76:82–3 (c,1) Mr 9 '92
— Olympic sites
 Sports Illus 76:88–98,108 (map,c,1) Ja 27
 '92
— Opening ceremonies
 Sports Illus 76:34–5 (c,2) F 17 '92
— Slalom
 Sports Illus 76:22–7 (c,1) Mr 2 '92
— Speed skating
 Sports Illus 76:34–5 (c,2) Mr 2 '92

OLYMPICS—1994 WINTER (LILLE-
 HAMMER)
 Sports Illus 80:cov.,18–33 (c,1) F 21 '94
 Sports Illus 80:cov.,2–3,18–55 (c,1) F 21
 '94
 Sports Illus 80:2–3,20–44 (c,1) Mr 7 '94
— Bobsledding
 Sports Illus 80:36 (c,3) Mr 7 '94
— Cross country skiing
 Sports Illus 80:41 (c,3) Mr 7 '94
— Figure skating
 Sports Illus 80:20–5 (c,1) Mr 7 '94
 Sports Illus 81:30 (c,4) D 5 '94
 Life 18:24–5 (c,1) Ja '95
— Hockey
 Sports Illus 80:26–8,33 (c,1) Mr 7 '94
— Olympic sites
 Sports Illus 78:50–3 (c,2) Mr 29 '93
— Opening ceremonies
 Sports Illus 80:2–3,18–19 (c,1) F 21 '94
 Life 17:26 (c,2) Ap '94
— Skating arena
 Sports Illus 79:2–3 (c,1) D 27 '93
— Skiing
 Sports Illus 83:94 (c,3) D 18 '95
— Speed skating
 Sports Illus 80:34–5,42–3 (c,1) Mr 7 '94
 Life 17:26 (c,2) Ap '94
 Sports Illus 81:cov.,70–6,84-5,99–100
 (c,1) D 19 '94
OLYMPICS—1996 SUMMER (AT-
 LANTA)
 Sports Illus 85:cov.,32–62,112 (c,1) Jl 29
 '96
 Sports Illus 85:entire issue (c,1) Ag 5 '96
 Sports Illus 85:entire issue (c,1) Ag 12 '96
— Muhammad Ali lighting Olympic flame
 Life 19:16 (c,2) S '96
— Baseball
 Sports Illus 85:82–4 (c,1) Ag 5 '96
— Basketball
 Sports Illus 85:48–61 (c,1) Ag 12 '96
— Beach volleyball
 Sports Illus 85:88–90,95 (c,1) Ag 5 '96
— Bombing at 1996 Olympics
 Sports Illus 85:4,22–8 (c,1) Ag 5 '96
 Sports Illus 85:88–94 (c,1) Ag 12 '96
— Boxing
 Sports Illus 85:62–5 (c,1) Ag 12 '96
— Constructing Olympic stadium
 Sports Illus 84:86 (c,3) Ja 8 '96
— Diving
 Sports Illus 85:66–7 (c,1) Ag 12 '96

— Gymnastics
 Sports Illus 85:58–68,100–1 (c,1) Ag 5 '96
— Nude Olympic athletes
 Life 19:cov.,2,5,50–66 (1) Jl '96
— Olympic athletes
 Sports Illus 85:entire issue (c,1) Jl 22 '96
— Opening ceremonies
 Sports Illus 85:32–9,112 (c,1) Jl 29 '96
 Sports Illus 85:65 (c,2) D 30 '96
— Soccer
 Sports Illus 85:70–6 (c,1) Ag 12 '96
— Swimming
 Sports Illus 85:cov.,40–5 (c,1) Jl 29 '96
 Sports Illus 85:69–80,96–7 (c,1) Ag 5 '96
— Track and field
 Sports Illus 85:34–57 (c,1) Ag 5 '96
 Sports Illus 85:cov.,26–46,100 (c,1) Ag
 12 '96
 Life 19:6–7 (c,1) S '96
 Sports Illus 85:82–3 (c,1) D 30 '96
— U.S. Olympic trials
 Sports Illus 85:2–3,20–5,44–9 (c,1) Jl 1
 '96
 Sports Illus 85:34–7 (c,1) Jl 8 '96
— Weight lifting
 Sports Illus 85:106 (c,4) Ag 12 '96
— Whatizit Olympic mascot
 Sports Illus 78:172 (c,3) F 22 '93
— Wrestling
 Sports Illus 85:78–83 (c,1) Ag 12 '96
OMAHA, NEBRASKA
— 1910s
 Am Heritage 46:60 (painting,c,4) Ap '95
OMAN
 Trav/Holiday 177:90–3 (c,1) Ap '94
 Nat Geog 187:112–38 (map,c,1) My '95
 Trav&Leisure 25:123–5,142,146
 (map,c,2) D '95
— Birkat al Mawz
 Nat Geog 187:136–7 (c,1) My '95
— Matrah
 Nat Geog 187:114–15 (c,1) My '95
— See also
 MUSCAT
OMAN—COSTUME
 Nat Geog 187:112–38 (c,1) My '95
— Sultan Said
 Nat Geog 187:123 (c,4) My '95
— See also
 BEDOUINS
OMAN—RITES AND FESTIVALS
— Bride with henna-painted arms
 Nat Geog 187:112–13 (c,1) My '95
O'NEILL, EUGENE
— Caricature

Am Heritage 46:94 (c,4) D '95
ONTARIO
— Countryside
 Trav/Holiday 178:38–45 (map,c,1) My '95
— Lac la Croix
 Nat Geog 189:112–13 (c,1) My '96
— Langdon Hall
 Trav&Leisure 23:E1 (c,4) Ag '93
— Sunset over lake
 Nat Geog 189:136–7 (c,1) My '96
— See also
 LAKE SUPERIOR
 NIAGARA FALLS
 OTTAWA
 ST. LAWRENCE RIVER
 THOUSAND ISLANDS
 TORONTO
Opera. See
 THEATER
OPIUM
— 19th cent. Chinese opium trade
 Natur Hist 102:74–8 (c,3) N '93
— 1870 opium smokers (China)
 Natur Hist 102:78 (3) N '93
— Late 19th cent. opium den (Great Britain)
 Natur Hist 102:76 (engraving,4) N '93
— Taking opium (Thailand)
 Nat Geog 183:15 (c,3) F '93
OPOSSUMS
 Natur Hist 101:31 (c,3) F '92
 Nat Wildlife 30:48–9 (c,1) Ap '92
 Nat Wildlife 31:12–16 (c,1) Ap '93
 Am Heritage 47:76 (drawing,4) Jl '96
OPPENHEIMER, J. ROBERT
 Life 18:136 (2) Je 5 '95
OPTICAL ILLUSIONS
 Nat Geog 182:14–15 (c,4) N '92
ORANGUTANS
 Nat Geog 181:40–5 (c,1) Mr '92
 Nat Geog 186:2 (c,4) D '94
 Life 18:60–1 (c,1) My '95
 Natur Hist 104:84–5 (c,1) My '95
 Smithsonian 27:cov.,32–43 (c,1) Je '96
— Orangutan educational program
 (Washington, D.C.)
 Smithsonian 27:32–43 (c,1) Je '96
 Natur Hist 105:26–30 (1) Ag '96
ORCHARDS
— Chianti, Italy
 Trav&Leisure 24:cov.,91 (c,1) My '94
ORCHIDS
 Gourmet 52:8—9 (c,3) F '92
 Natur Hist 101:54–7 (c,1) F '92
 Natur Hist 101:76–7 (c,1) Ag '92
 Natur Hist 102:30 (c,1) Mr '93

Trav/Holiday 176:64,69 (c,4) My '93
Nat Wildlife 32:40–1 (c,1) Je '94
Trav/Holiday 177:88 (c,4) O '94
Nat Wildlife 33:10 (c,4) Je '95
Nat Geog 187:31 (c,3) Mr '95
Gourmet 56:134 (painting,4) F '96
Natur Hist 105:58 (c,4) S '96
— Dead bees caught in flowers
Natur Hist 103:74–5 (c,1) Ag '94
— See also
LADY'S SLIPPERS

OREGON
— Ashland's Elizabethan theater
Trav&Leisure 22:E1 (c,2) F '92
— Bonneville Dam
Gourmet 53:143 (c,4) Ap '93
— Coast
Nat Wildlife 30:48–9 (c,2) Ag '92
— Columbia River Gorge
Gourmet 53:6,142–5 (c,1) Ap '93
Am Heritage 44:75 (c,2) My '93
— Countryside
Trav&Leisure 26:108–14 (c,4) S '96
— Eastern Oregon
Trav/Holiday 179:32–3 (map,c,4) Je '96
— Lost Lake
Natur Hist 103:32 (c,4) O '94
— Myers Creek Rock
Trav&Leisure 23:114 (c,1) N '93
— Newport
Trav/Holiday 178:31–2 (map,c,4) S '95
— Valley of the Giants
Smithsonian 24:72–4 (c,3) D '93
— Willamette National Forest
Nat Geog 185:10–11 (c,1) F '94
— Willamette Valley
Life 17:92–3 (c,1) Ap '94
Smithsonian 25:50–1 (c,1) My '94
Trav&Leisure 24:E9-10 (c,4) S '94
— See also
COLUMBIA RIVER
CRATER LAKE
CRATER LAKE NATIONAL PARK
MOUNT HOOD
OREGON CAVES NATIONAL MONU-
MENT
PORTLAND
SNAKE RIVER

OREGON—MAPS
— Columbia-Snake River system
Nat Wildlife 32:46 (c,2) O '94
— Stylized map of Oregon
Gourmet 53:42 (painting,c,3) Ja '93

**OREGON CAVES NATIONAL MONU-
MENT, OREGON**
Nat Geog 186:18–19 (c,1) O '94
ORGANS
— 1896 Mormon tabernacle organ (Salt Lake
City, Utah)
Am Heritage 47:76 (4) Ap '96
— 1900 Limonaire organ
Gourmet 52:96–7 (c,1) O '92
— Bruckner organ, St. Florian, Austria
Trav&Leisure 25:135 (c,4) O '95
ORIOLES
Nat Wildlife 30:10–11 (c,1) Ag '92
— Baltimore orioles
Nat Geog 183:80–1 (painting,c,4) Je '93
Nat Wildlife 34:46–7 (c,2) Ag '96
— Northern orioles
Nat Wildlife 32:cov.,24–5 (c,1) F '94
Nat Wildlife 32:18–19 (c,1) Ap '94
ORLANDO, FLORIDA
— Railroad station
Trav&Leisure 24:E1 (c,4) Je '94
— See also
DISNEY WORLD
OROZCO, JOSE CLEMENTE
— "Modern Migration of the Spirit" (1934)
Life 17:76 (painting,c,3) D '94
— Murals by him (Mexico)
Trav&Leisure 23:106–8,113 (c,1) Je '93
ORR, BOBBY
Sports Illus 81:124–6 (c,1) S 19 '94
OSAGE INDIANS—COSTUME
— 1915 feathered hat
Life 17:129 (c,4) N '94
— Wedding outfit
Smithsonian 25:45 (c,4) O '94
OSBORN, HENRY FAIRFIELD
Natur Hist 103:62 (4) My '94
OSTRICHES
Nat Geog 181:78–9 (c,1) Ja '92
Trav&Leisure 23:95 (c,4) F '93
Nat Geog 184:4 (c,1) Jl '93
Natur Hist 103:84–5 (c,1) Mr '94
Life 17:87 (c,4) Jl '94
Natur Hist 105:54 (c,4) Mr '96
Life 19:104 (c,3) D '96
— Ostrich eggs
Natur Hist 103:84–5 (c,1) Mr '94
OTTAWA, ONTARIO
— Parliament buildings
Trav&Leisure 22:C4 (c,3) Je '92
— Rideau Canal Skateway
Trav&Leisure 24:54 (c,4) D '94

Sports Illus 85:15 (c,4) N 25 '96
OTTERS
— River otters
Nat Wildlife 31:32–5 (c,1) Je '93
Nat Wildlife 32:40–1 (painting,c,1) Ag '94
Natur Hist 103:cov.,36–45 (c,1) N '94
Nat Wildlife 33:42–3 (c,1) Ap '95
— Sea otters
Nat Wildlife 30:11 (c,4) Je '92
Nat Geog 187:42–61 (c,1) Je '95
OTTOMAN EMPIRE
— Map of 1683 Ottoman Empire
Nat Geog 185:13 (c,4) My '94
OVENBIRDS
Nat Wildlife 30:cov. (c,1) Ag '92
Ovens. See
STOVES
OWENS, JESSE
Sports Illus 80:13 (2) Ap 18 '94
Sports Illus 84:14 (4) F 26 '96
Life 19:23 (4) Ag '96
Life 19:46 (4) O '96
— Owens' track shoes
Sports Illus 82:9 (c,4) Ja 23 '95
OWLS
Nat Wildlife 30:cov.,50–9 (c,1) F '92
— Barn
Nat Wildlife 30:52 (c,4) F '92
Life 16:120 (2) O '93
Nat Geog 186:27 (c,3) Ag '94
— Burrowing
Nat Wildlife 30:56 (c,4) F '92
Nat Wildlife 34:32 (c,4) D '95
Nat Wildlife 34:64 (c,1) Ag '96
— Great gray
Nat Wildlife 30:58–9 (c,1) F '92
Nat Wildlife 32:60 (c,1) F '94
— Great horned
Natur Hist 102:76–7 (c,1) F '93
Natur Hist 103:46–7 (c,1) My '94
Nat Wildlife 32:7 (c,1) Je '94
Nat Wildlife 33:44–5 (painting,c,1) O '95
Nat Wildlife 34:47 (c,4) Je '96
— Long-eared
Nat Wildlife 30:53 (c,1) F '92
— Northern spotted
Nat Wildlife 30:54–5 (c,1) F '92
Nat Geog 187:27 (c,3) Mr '95
Nat Wildlife 33:8–13 (c,1) Ag '95
— Pueo owl
Life 15:36–7 (c,1) My '92
— Pygmy
Nat Wildlife 30:52 (c,4) F '92
— Saw-whet
Nat Wildlife 30:56 (c,4) F '92

Nat Wildlife 33:39 (c,1) O '95
Nat Wildlife 34:32–3 (c,1) O '96
— Screech owl
Nat Wildlife 31:53 (c,2) D '92
Nat Wildlife 34:38–9 (c,1) F '96
— Short-eared
Nat Wildlife 30:50–1 (c,1) F '92
Nat Geog 184:112 (c,3) O '93
— Snow impression of owl striking prey
Nat Wildlife 35:48 (c,4) D '96
— Snowy
Nat Wildlife 30:cov.,56 (c,1) F '92
Nat Wildlife 32:60 (c,1) O '94
Smithsonian 26:39 (c,4) Mr '96
Nat Wildlife 34:34–5 (c,1) Ap '96
— Spotted
Nat Wildlife 30:4–5 (c,1) Ap '92
— Whiskered
Nat Wildlife 30:57 (c,1) F '92
OXEN
Smithsonian 24:cov.,82–93 (c,1) S '93
— Use of oxen in farming
Smithsonian 24:cov.,82–93 (c,1) S '93
— See also
BISON
CATTLE
MUSK OXEN
WATER BUFFALOES
YAKS
OXFORD, ENGLAND
Nat Geog 188:114–37 (map,c,1) N '95
OXFORD UNIVERSITY, ENGLAND
Nat Geog 188:114–37 (c,1) N '95
Trav&Leisure 26:62–7 (c,2) My '96
OYSTER INDUSTRY
— Florida
Trav/Holiday 178:48–50 (c,1) Mr '95
— Oregon
Nat Geog 189:121 (c,3) F '96
OYSTERS
Smithsonian 24:42 (c,4) F '94
OZONE
— Earth's ozone hole
Life 15:36–7 (c,4) Ap '92
— Map of thinning ozone layer
Natur Hist 103:38 (c,4) O '94

–P–

PACIFIC ISLANDS
Trav/Holiday 178:cov.,42–53 (map,c,1) O
'95
— Nikumaroro
Life 15:71 (c,2) Ap '92

— Remains of World War II planes and ships
(Micronesia)
Natur Hist 103:26–35 (c,1) Ag '94
— Vanuatu
Trav&Leisure 24:cov.,76–85,134
(map,c,1) F '94
— Western Samoa
Trav/Holiday 179:42–51 (map,c,1) My '96
— See also
BIKINI ATOLL
COOK ISLANDS
EASTER ISLAND
FIJI
GUAM
MARQUESAS ISLANDS
PALAU
SOCIETY ISLANDS
TAHITI

PACIFIC ISLANDS—ARTIFACTS
— 19th cent. crocodile mask (Torres Strait
Islands)
Smithsonian 25:94–5 (c,2) D '94

PACIFIC ISLANDS—COSTUME
— 19th cent. (Samoa)
Trav&Leisure 26:106 (4) N '96
— 1919 Marquesas Islands people
Nat Geog 190:130 (4) N '96
— Asmat people (Indonesia)
Nat Geog 189:2–5,30–3 (c,1) F '96
— Bikinian man
Nat Geog 181:83 (c,2) Je '92
— Dani tribe (Indonesia)
Nat Geog 189:14–17 (c,1) F '96
— Huli tribesmen (Papua New Guinea)
Gourmet 55:91 (c,4) Je '95
— Kombai people (Indonesia)
Nat Geog 189:34–43 (c,1) F '96
— Korowai people (Indonesia)
Nat Geog 189:34–43 (c,1) F '96
— Marquesas
Trav/Holiday 177:38–9 (c,2) Jl '94
— Polynesia
Trav/Holiday 178:42–53 (c,1) O '95
— Vanuatu
Trav&Leisure 24:79–83 (c,1) F '94
— Western Samoa
Trav/Holiday 179:42–8 (c,1) My '96
— Yali tribe (Indonesia)
Nat Geog 189:10–15 (c,1) F '96
— See also
ABORIGINES
MAORI PEOPLE

PACIFIC ISLANDS—MAPS
— Micronesia
Natur Hist 103:31 (c,4) Ag '94

— Polynesia
Trav/Holiday 177:35 (c,4) My '94

**PACIFIC ISLANDS—RITES AND FES-
TIVALS**
— Americans renewing wedding vows
(Tahiti)
Life 17:90 (c,2) S '94
— Dani people bartering pigs for bride (Irian
Jaya, Indonesia)
Nat Geog 183:94–5 (c,1) Ja '93

**PACIFIC ISLANDS—SOCIAL LIFE
AND CUSTOMS**
— 1950s bungee jumping (Melanesia)
Nat Geog 190:51 (1) Jl '96

PACIFIC OCEAN
— Bowie Seamount, Canada
Nat Geog 190:74–5 (map,c,2) N '96
— Hawaii coast
Trav/Holiday 179:90 (c,1) S '96
— Mendocino coast, California
Sports Illus 82:54–5 (1) F 13 '95
— Oregon coast
Nat Wildlife 30:48–9 (c,2) Ag '92
— Solo rowing trip across the Pacific
Life 15:40–6 (c,1) F '92

PACKAGING
— Classic brand packages
Smithsonian 27:54 (c,4) Ap '96
— Cornstarch packing material
Nat Geog 183:108–9 (c,2) Je '93
— Innovative package design
Smithsonian 27:56–66 (c,2) Ap '96

PADRE ISLAND, TEXAS
Trav/Holiday 177:82–9 (map,c,1) D '94

PAGODAS
— 18th cent. (Munich, Germany)
Smithsonian 25:110 (c,4) D '94
— Vietnam
Trav&Leisure 25:180–1 (c,1) O '95

PAINTING
— Artist in park (New York City, New York)
Trav/Holiday 176:55 (c,4) O '93
— Artist on New Jersey rooftop (1903)
Am Heritage 44:93 (3) Jl '93
— Artist painting mountains (Wyoming)
Trav/Holiday 177:cov. (c,1) S '94
— Artist with Parkinson's disease
Life 16:76–80 (c,1) Je '93
— Artist working on rocky shore (Maine)
Gourmet 54:132 (c,4) My '94
— Child painting flowers (New Jersey)
Life 15:3 (c,2) Je '92
— Decorating floor with dried rice flour
(India)
Trav/Holiday 176:56 (c,1) N '93

— Elizabeth II sitting for portrait (Great Britain)
 Life 15:58–9 (c,1) My '92
— Nude artist on beach (Vancouver, British Columbia)
 Nat Geog 181:113 (c,3) Ap '92
— Painting hot air balloons (Minnesota)
 Trav&Leisure 24:172 (c,4) My '94
— Painting lawn green during drought (California)
 Nat Geog 184:39 (c,1) N 15 '93
— Painting masterpieces on sidewalk (Madrid, Spain)
 Trav/Holiday 176:71 (c,4) Mr '93
— Painting the Golden Gate Bridge orange, San Francisco
 Life 18:84–5 (c,1) F '95
 Nat Geog 187:32–3 (c,1) Ap '95
— Jackson Pollock at work (1950s)
 Am Heritage 46:55,65 (2) S '95
— Spain
 Trav&Leisure 25:105,112 (c,1) Je '95

PAINTINGS
— Aboriginal bark painting (Australia)
 Gourmet 52:104 (c,4) Ap '92
— Ashcan school works
 Smithsonian 26:28 (c,4) F '96
— Bird paintings by Ray Harris-Ching
 Nat Wildlife 33:44–51 (c,1) Je '95
— Cubist works
 Smithsonian 27:44–51 (c,2) Jl '96
— Deem paintings done in styles of famous artists
 Smithsonian 24:98–101 (c,1) Jl '93
— Early impressionist works
 Smithsonian 25:cov.,78–88 (painting,c,1) N '94
— Keane painting of waif
 Life 15:28 (c,4) My '92
— Treasures of the Prado, Madrid, Spain
 Smithsonian 22:54–65 (c,1) Ja '92
— Trompe l'oeil works
 Smithsonian 22:cov.,53–63 (c,1) Mr '92
— Works by Chang Dai-chien
 Smithsonian 22:90–5 (c,1) Ja '92
— Works by nursing home residents (Vermont)
 Smithsonian 23:78–87 (c,2) N '92
— See also
 ARTISTS
 ART WORKS

PAKISTAN
 Trav&Leisure 24:118–32 (map,c,1) S '94
— Hunza region
 Nat Geog 185:114–34 (map,c,1) Mr '94

— Karakoram Highway
 Trav&Leisure 24:124–5 (c,1) S '94
 Natur Hist 105:9 (c,4) My '96
— Sadiq Garh Palace, Bahawalpur
 Trav&Leisure 24:126–7 (c,1) S '94
— Trango Tower, Karakoram Range
 Nat Geog 189:cov.,32–51 (map,c,1) Ap '96

PAKISTAN—COSTUME
 Trav&Leisure 24:118–23 (c,1) S '94
 Natur Hist 105:9 (c,4) My '96
— Child laborers
 Life 19:38–48 (c,1) Je '96
— Hunza region
 Nat Geog 185:114–34 (c,1) Mr '94

PALACES
— Amber Palace, Jaipur, India
 Trav&Leisure 23:47 (c,4) F '93
 Trav/Holiday 177:69 (c,1) N '94
— Beijing, China
 Trav&Leisure 25:68–71 (c,1) Ja '95
— Beloselsky-Belozersky Palace, St. Petersburg, Russia
 Nat Geog 184:104–5 (c,1) D '93
— Blenheim, England
 Gourmet 52:102–3 (c,1) Mr '92
 Trav&Leisure 23:71 (c,1) Ag '93
— Catherine Palace, Pushkin, Russia
 Smithsonian 23:34–5 (c,3) Ja '93
 Nat Geog 184:112–13 (c,1) D '93
 Natur Hist 105:98–9 (c,1) F '96
 Gourmet 56:102–5 (c,1) S '96
— Ch'anggyong-gung Palace, Seoul, South Korea
 Gourmet 54:106 (c,2) Ap '94
— Charlottenburg Palace, Berlin, Germany
 Trav&Leisure 25:177 (c,4) S '95
— Charlottenhof Palace, Potsdam, Germany
 Trav&Leisure 25:148–51 (c,1) S '95
— Donna Fugata Palace, Sicily, Italy
 Trav&Leisure 25:125,129 (c,1) Ap '95
— Falkland Palace, Scotland
 Trav&Leisure 26:122 (c,1) D '96
— Hampton Court, England
 Trav&Leisure 23:20 (c,4) Ja '93
 Gourmet 54:28 (painting,c,2) Jl '94
 Trav&Leisure 24:60–1,101 (c,1) Ag '94
— Het Loo Palace, Netherlands
 Trav&Leisure 24:118–19 (c,1) Ap '94
— Hofburg, Vienna, Austria
 Trav/Holiday 177:70 (3) Mr '94
 Trav/Holiday 179:68 (c,4) O '96
— Kew Palace, London, England
 Trav&Leisure 24:65–6 (c,1) Ag '94
— Knossos, Crete

Gourmet 52:73 (c,4) F '92
— La Moneda, Santiago, Chile
Trav&Leisure 23:67 (c,4) Ap '93
— Marble Palace, St. Petersburg, Russia
Gourmet 56:103 (c,2) S '96
— Palace of Winds, Jaipur, India
Trav/Holiday 177:70–1 (c,1) N '94
— Peterhof Palace, St. Petersburg, Russia
Gourmet 56:104 (c,4) S '96
— Pope's Palace, Avignon, France
Gourmet 53:93,96–7 (c,1) F '93
— Potala, Lhasa, Tibet
Trav&Leisure 23:86–7 (4) Jl '93
— Sadiq Garh Palace, Bahawalpur, Pakistan
Trav&Leisure 24:126–7 (c,1) S '94
— Sanssouci Palace, Potsdam, Germany
Trav&Leisure 25:152–4 (c,1) S '95
— Winter Palace, St. Petersburg, Russia
Gourmet 56:22,105 (c,4) S '96
— See also
ALHAMBRA
BUCKINGHAM PALACE
CASTLES
CHATEAUS
LOUVRE
PALAU
Nat Wildlife 32:20–7 (c,1) O '94
Life 18:46–53 (c,1) Ag '95
PALERMO, SICILY, ITALY
Trav&Leisure 25:123–4 (c,1) Ap '95
PALESTINIANS
Nat Geog 181:84–113 (c,1) Je '92
Life 19:34–42 (1) Jl '96
— 1993 meeting of Israel's Rabin and PLO
Chairman Arafat (Washington, D.C.)
Life 16:20 (2) N '93
— Demonstration (Israel)
Nat Geog 187:82–3 (c,1) Je '95
— Gaza, Israel
Nat Geog 190:28–53 (c,1) S '96
— Intifada (Israel)
Nat Geog 181:101–2 (c,2) Je '92
— Refugee camp (Syria)
Nat Geog 190:118 (c,1) Jl '96
— Terrorists (Israel)
Life 19:34–42 (1) Jl '96
— See also
ARAFAT, YASIR
**PALESTINIANS—RITES AND
FESTIVALS**
— Wedding (Israel)
Nat Geog 190:52–3 (c,1) S '96
PALM TREES
Nat Geog 181:106–7 (c,1) Ja '92
Trav&Leisure 22:80 (c,3) Ja '92

Trav&Leisure 22:146–7 (c,2) Je '92
Trav&Leisure 24:99 (c,2) D '94
Trav&Leisure 25:162 (c,1) N '95
— Cabbage palms
Natur Hist 101:66–7 (c,1) N '92
— Palmetto frond
Nat Wildlife 32:34 (c,4) Ag '94
— See also
COCONUT PALM TREES
PALMER, ARNOLD
Sports Illus 76:39 (4) My 25 '92
Sports Illus 80:51–2 (2) Je 13 '94
Sports Illus 81:70–1 (c,1) S 19 '94
PANAMA
— Coastal scenes
Smithsonian 27:112–21 (c,1) D '96
— Wildlife
Smithsonian 27:112–21 (c,1) D '96
PANAMA—COSTUME
— Cuna Indians
Trav&Leisure 23:67 (c,4) D '93
Nat Geog 185:75 (c,1) Je '94
PANAMA—HOUSING
— Cuna huts
Trav&Leisure 23:70 (c,4) D '93
PANDAS
Nat Geog 183:cov.,60–5 (c,1) F '93
Nat Geog 184:29 (c,3) Jl '93
— Giant pandas
Life 15:8 (c,3) O '92
Natur Hist 102:88 (4) Ap '93
Natur Hist 102:64 (c,4) Je '93
Nat Wildlife 31:22 (c,4) Ag '93
— Great pandas
Nat Geog 187:100–15 (c,1) F '95
— Red panda
Nat Wildlife 30:18 (c,4) F '92
PANGOLINS
Natur Hist 104:74–5 (c,1) Ag '95
PANSIES
Natur Hist 101:46–7 (c,1) F '92
PANTHEON, PARIS, FRANCE
Trav&Leisure 25:100 (c,4) Je '95
PANTHERS
— Florida panthers
Nat Geog 181:51 (c,4) Ap '92
Nat Wildlife 30:60 (c,1) Ap '92
Life 15:68 (c,4) Je '92
Nat Geog 182:62–3 (c,1) Jl '92
Trav&Leisure 24:106 (drawing,c,1) Ap
'94
Nat Wildlife 32:30 (c,4) Ag '94
Life 17:cov.,51 (c,1) S '94
Smithsonian 25:40 (c,4) S '94
Nat Wildlife 33:26–7 (painting,c,1) D '94

Nat Wildlife 33:14–15 (c,1) Je '95
Nat Geog 190:4–5 (c,1) O '96
PAPAYA TREES
Trav/Holiday 177:65 (c,1) Ap '94
PAPER INDUSTRY
— Making paper by hand (New Mexico)
Nat Geog 185:73 (c,3) Je '94
PAPUA NEW GUINEA
Trav/Holiday 176:60–9 (map,c,1) Ap '93
Nat Geog 185:40–63 (map,c,1) F '94
— 1994 volcano seen from space
Nat Geog 190:18–19 (c,1) N '96
— Town buried in volcanic ash
Life 18:20 (c,2) My '95
— Trobriand Islands
Nat Geog 182:116–36 (map,c,1) Jl '92
PAPUA NEW GUINEA—COSTUME
Trav/Holiday 176:60–8 (c,1) Ap '93
Nat Geog 185:40–63 (c,1) F '94
— Huli tribesmen
Gourmet 55:91 (c,4) Je '95
— Trobriand Islands
Nat Geog 182:116–36 (c,1) Jl '92
PAPUA NEW GUINEA—RITES AND FESTIVALS
— Baby's burial
Nat Geog 185:54–5 (c,1) F '94
— Mendi bride
Trav/Holiday 176:67 (c,4) Ap '93
— Tribesmen practicing for battle
Life 19:14 (2) S '96
— Wedding
Nat Geog 185:48 (c,1) F '94
— Women wearing mourning beads
Trav/Holiday 176:64 (c,4) Ap '93
PARACHUTING
— France
Gourmet 52:60 (c,4) Ja '92
— French village seen from parachutist's camera
Trav/Holiday 176:28 (c,4) O '93
— Para plane (Pennsylvania)
Sports Illus 78:9–11 (c,1) My 31 '93
— Paraglider landing in boxing match (Las Vegas, Nevada)
Sports Illus 79:23 (c,2) N 15 '93
Life 17:56 (c,4) Ja '94
— Smoke jumpers parachuting to fire
Sports Illus 83:5–10 (c,4) S 4 '95
— Switzerland
Trav&Leisure 22:126 (c,4) Mr '92
PARADES
— 1930 ticker tape parade for golfer Bobby Jones (New York)
Sports Illus 80:105 (1) Ap 11 '94
— 1941 Army Day parade (New York)
Am Heritage 43:106 (4) D '92
— 1951 parade for MacArthur (New York City)
Am Heritage 47:82–3 (1) F '96
— 1991 Gulf War victory parade (New York City)
Life 15:10–11 (c,1) Ja '92
— 1993 Super Bowl victory parade (Dallas, Texas)
Sports Illus 79:69 (c,4) Jl 12 '93
— 1994 "Unity" flag at gay rights march (New York)
Life 17:12 (c,2) Ag '94
Life 18:36 (c,2) Ja '95
Natur Hist 105:10–11 (c,1) Ag '96
— Flaming bull horn procession (Paraguay)
Nat Geog 182:111 (c,2) Ag '92
— Key West Fantasy Fest parade, Florida
Sports Illus 78:81 (c,4) F 22 '93
— Macy's Thanksgiving Day Parade, New York City, New York
Smithsonian 23:130 (c,4) Mr '93
— Milesburg bicentennial parade, Pennsylvania
Nat Geog 185:32–3 (c,1) Je '94
— Military parade (Peru)
Nat Geog 189:13 (c,3) My '96
— Preparing balloons for Macy's Thanksgiving Day Parade (Hoboken, New Jersey)
Life 16:15–18 (c,1) N '93
— Stilt walkers in Chingay Procession (Singapore)
Trav&Leisure 23:47 (c,4) F '93
— Thanksgiving Day parade (Baltimore, Maryland)
Trav/Holiday 179:54–5 (c,1) Jl '96
— Ticker tape parade for N.Y. Rangers
Sports Illus 80:2–3 (c,1) Je 27 '94
— Truffle Festival (Alba, Italy)
Gourmet 52:106 (c,3) O '92
PARAGUAY
Nat Geog 182:88–111 (map,c,1) Ag '92
— See also
ASUNCION
IGUACU FALLS
PARAGUAY—COSTUME
Nat Geog 182:88–111 (c,1) Ag '92
PARAKEETS
Natur Hist 104:58 (c,4) N '95
— Extinct Carolina parakeets
Trav/Holiday 176:79 (painting,c,1) O '93
Smithsonian 25:126 (painting,c,4) O '94
PARAMECIA
Natur Hist 101:36 (c,2) F '92

PARIS, FRANCE

Trav&Leisure 22:13,75,92–3,103,112–23
(map,c,1) Ap '92
Trav&Leisure 23:cov.,99–109 (c,1) S '93
Trav&Leisure 24:cov.,85–99,139
(map,c,1) Ap '94
Am Heritage 46:108–17 (c,1) Ap '95
Trav&Leisure 25:94–103,140–3 (map,c,1)
Je '95
Trav&Leisure 25:126–36 (map,c,1) D '95
— 18th cent. view of Palais Royal Gardens
Gourmet 55:68 (engraving,c,3) O '95
— 18th cent. view of Port Royal
Gourmet 55:86 (engraving,4) O '95
— 19th cent.
Gourmet 55:54 (drawing,3) Ap '95
— 1944 liberation of Paris
Smithsonian 23:73 (1) N '92
— 1950s
Trav/Holiday 175:112 (2) D '92
— 12th arrondissement
Gourmet 56:40–1,44 (c,3) Jl '96
— American Center
Trav&Leisure 24:36 (c,4) O '94
— Bakeries
Gourmet 53:120–3 (c,1) D '93
Trav/Holiday 177:64 (c,4) D '94
— Bastille area
Trav&Leisure 23:106–15,144 (map,1) My
'93
— Bois de Boulogne restaurant (1909)
Am Heritage 43:80–1 (painting,c,1) Jl '92
— Cafe des Deux Magots
Smithsonian 27:111 (4) S '96
— Cafe menu covers
Trav&Leisure 23:34 (c,3) Jl '93
— Cafes
Trav/Holiday 178:73 (c,1) Ap '95
Trav&Leisure 25:59 (c,4) O '95
— Champs-Elysees through history
Gourmet 55:54 (c,3) Ap '95
— Decorated with Christmas lights
Gourmet 56:88 (c,3) D '96
— Department store map
Gourmet 53:48 (c,2) O '93
— Euro Disney amusement park
Trav&Leisure 22:80–5,114–15 (c,1) Ag
'92
— Hotel Meurice parlor
Gourmet 52:42 (painting,c,2) Jl '92
— Ile Saint-Louis
Trav/Holiday 177:62–71 (map,c,1) D '94
Gourmet 55:34 (map,c,2) Jl '95
— Les Invalides
Life 19:12–13 (c,1) N '96

— Map of Louvre area
Smithsonian 24:46–7 (c,1) D '93
— Modern Richard Meier office building
Trav&Leisure 23:111 (c,3) Ja '93
— Montmartre
Trav/Holiday 175:108 (c,3) Mr '92
— Musee Camondo
Trav&Leisure 25:68 (c,3) N '95
Trav/Holiday 179:77 (c,4) Jl '96
— Opera de la Bastille
Trav&Leisure 23:108–9 (1) My '93
— Parc Andre-Citroen
Trav&Leisure 24:32 (c,4) Je '94
— Paris metro station
Trav/Holiday 179:16 (c,4) D '96
— Place des Vosges
Trav/Holiday 179:63 (c,2) Ap '96
— Restaurants
Gourmet 56:192–5 (c,2) O '96
— Ritz Hotel
Sports Illus 79:2–3 (c,1) D 6 '93
Trav&Leisure 26:56–8 (c,4) F '96
— Sites associated with Thomas Jefferson
Gourmet 55:68,86 (c,3) O '95
— Small hotels
Trav&Leisure 23:100–9,115 (c,1) Ja '93
— Stylized depiction of Paris landmarks
Gourmet 54:22 (painting,c,2) Ja '94
— Stylized depiction of romantic Paris
Trav&Leisure 26:70 (painting,c,3) My '96
— Tuileries
Am Heritage 46:111 (c,2) Ap '95
— View from hotel balcony
Trav&Leisure 26:58 (c,4) F '96
— See also
ARC DE TRIOMPHE
EIFFEL TOWER
LOUVRE
PANTHEON
SEINE RIVER

PARKER, CHARLIE
Am Heritage 46:85 (painting,c,3) O '95

PARKER, DOROTHY
Smithsonian 25:124 (4) My '94
Life 17:24 (4) Ag '94
— Depicted in film "Mrs. Parker and the
Vicious Circle" (1994)
Life 17:24 (c,4) Ag '94

PARKING METERS
— Grave between two parking meters
Life 16:105 (4) Jl '93

PARKS
— California state parks containing redwoods
Trav/Holiday 177:80–9 (map,1) Ap '94
— Dinosaur Provincial Park, Alberta

Nat Geog 183:6–7,12 (c,1) Ja '93
— Enjoying city park
 Nat Wildlife 30:12–15 (painting,c,1) Ag
 '92
— Fanciful depiction of Sunday in the park
 Trav&Leisure 22:NY1 (painting,c,2) Ap
 '92
— Hyde Park, London, England
 Trav&Leisure 24:97–9 (c,1) Mr '94
— Michigan
 Gourmet 54:74 (c,4) Ap '94
— Parc Andre-Citroen, Paris, France
 Trav&Leisure 24:32 (c,4) Je '94
— Piedmont Park, Atlanta, Georgia
 Trav/Holiday 177:48 (c,4) Ap '94
— Retiro Park, Madrid, Spain
 Trav/Holiday 176:68 (c,4) Mr '93
— Saratoga Springs, New York
 Trav/Holiday 178:80,83 (c,2) Je '95
— See also
 AMUSEMENT PARKS
 CENTRAL PARK
 GARDENS
 NATIONAL PARKS
 PLAYGROUNDS
 WILDLIFE REFUGES
 list under NATIONAL PARKS

PARKS, ROSA
 Life 19:27 (4) F '96
PARLORS
— 18th cent. (France)
 Trav&Leisure 25:68 (c,3) N '95
— Late 19th cent. Vanderbilt mansion parlor
 (New York)
 Am Heritage 46:75 (c,1) F '95
— Paris hotel salon, France
 Gourmet 52:42 (painting,c,2) Jl '92
PARMA, ITALY
 Trav/Holiday 176:94–9 (map,c,1) Mr '93
PARRISH, MAXFIELD
— "Christmas Eve—Deep Valley" (1946)
 Am Heritage 46:8 (painting,c,2) D '95
PARROTS
 Nat Geog 183:30–1 (c,1) Ap '93
 Nat Wildlife 32:25 (painting,c,4) D '93
 Sports Illus 82:cov. (c,1) My 29 '95
 Nat Geog 189:17 (c,4) Je '96
— African gray parrot
 Natur Hist 102:35 (c,2) Jl '93
— See also
 MACAWS
 PARAKEETS
PARTHENON, ATHENS, GREECE
 Sports Illus 85:18 (c,3) Jl 22 '96

— 17th cent. view of mosque in the Parthenon
 Trav/Holiday 178:100 (drawing,4) S '95
— 1801
 Smithsonian 23:138 (painting,c,4) D '92
— Parthenon frieze
 Smithsonian 23:135 (c,4) D '92
 Trav/Holiday 178:82 (c,4) Mr '95
PARTIES
— American party behavior
 Life 17:75–102 (c,1) N '94
— Preparing for huge banquet (New York)
 Life 17:98–9 (c,1) N '94
— See also
 BIRTHDAY PARTIES
 DANCES
PARTRIDGES
 Natur Hist 101:62 (painting,c,4) Je '92
PASADENA, CALIFORNIA
 Trav&Leisure 25:64–6 (c,4) Ap '95
PASQUEFLOWERS
 Natur Hist 102:56 (c,4) F '93
PASSPORTS
— 1948 U.S. passport
 Am Heritage 44:34 (4) My '93
PATENTS
— 1895 Selden engine patent
 Am Heritage 47:18 (c,4) N '96
PATTON, GEORGE S., JR.
 Smithsonian 23:68 (4) N '92
 Life 17:46 (4) D '94
PAUL, ALICE
 Am Heritage 43:40 (4) O '92
PAULING, LINUS
 Life 18:94–5 (c,1) Ja '95
PAWNEE INDIANS—ARTIFACTS
— 1890s painted drum
 Am Heritage 43:4 (c,3) O '92
PAWNEE INDIANS—HOUSING
— 1871 earth lodges (Nebraska)
 Natur Hist 103:24 (c,3) N '94
PEACOCKS
 Nat Wildlife 31:42–5 (c,1) Ap '93
 Gourmet 54:93 (c,4) Mr '94
PEALE, CHARLES WILLSON
— Portrait of William Bartram
 Natur Hist 105:10 (painting,c,4) Ap '96
— Portrait of Anne Green
 Smithsonian 23:16 (painting,c,4) S '92
— Portrait of Thomas Jefferson
 Life 16:38 (painting,c,4) My '93
— "Staircase Group" (1795)
 Smithsonian 22:56 (painting,c,4) Mr '92
— Works by son Rembrandt
 Smithsonian 23:26 (painting,c,4) Ja '93

PEANUT INDUSTRY
— Mr. Peanut
 Gourmet 52:14,108 (4) Mr '92
PEANUTS
 Gourmet 52:109 (c,1) Mr '92
PEARS
 Gourmet 52:68,71 (painting,c,3) S '92
PEAT
— Okefenokee Swamp, Florida/Georgia
 Nat Geog 181:44,48 (c,1) Ap '92
PECK, GREGORY
 Life 18:131 (2) Je 5 '95
PECOS RIVER, SOUTHWEST
 Nat Geog 184:38–63 (map,c,1) S '93
PELE (SOCCER PLAYER)
 Sports Illus 80:86–90 (c,1) Je 20 '94
 Sports Illus 81:122–3 (c,1) S 19 '94
PELICANS
 Trav&Leisure 24:98 (c,1) Jl '94
— Brown pelicans
 Nat Wildlife 30:36–8 (c,1) Ap '92
 Nat Wildlife 33:8–9 (c,1) Ap '95
— In flight
 Nat Geog 182:5–7 (c,1) Jl '92
— White pelicans
 Nat Geog 182:6–7 (c,1) O '92
PENCIL SHARPENERS
— Early 20th cent.
 Smithsonian 22:107 (c,4) F '92
PENCILS
— Pencils shaped like syringes
 Life 16:26 (c,4) Mr '93
PENGUINS
 Trav&Leisure 22:52 (c,4) Ja '92
 Natur Hist 102:49–50 (c,1) Ag '93
 Natur Hist 104:54 (c,4) N '95
— Adelie penguins
 Nat Wildlife 31:42 (c,2) Je '93
 Natur Hist 105:36–41 (c,1) Ag '96
— Chinstrap penguins
 Life 19:12–13 (c,1) Mr '96
— Emperor penguins
 Life 16:3 (c,2) Mr '93
 Nat Wildlife 31:42–3 (c,1) Ag '93
 Natur Hist 103:78–9 (c,1) S '94
 Life 18:62 (c,4) My '95
 Nat Geog 189:cov.,52–71 (c,1) Mr '96
— Gentoo penguins
 Trav&Leisure 22:56,61 (c,3) D '92
 Natur Hist 102:92–3 (c,1) D '93
— King penguins
 Nat Wildlife 31:52 (c,4) D '92
 Life 17:68–9 (c,1) Ag '94
— Magellanic penguins
 Natur Hist 102:50 (c,3) Ag '93

PENNSYLVANIA
— Berks County
 Gourmet 55:116–19,170-2 (map,c,1) O '95
— Bethlehem's 1762 waterworks
 Am Heritage 43:cov. (c,1) N '92 supp.
— Central Pennsylvania
 Nat Geog 185:32–59 (map,c,1) Je '94
— Countryside
 Am Heritage 44:30 (c,4) Ap '93
 Life 19:88–9 (c,1) D '96
— Easton
 Sports Illus 76:80 (c,4) Je 8 '92
— Stephen Girard
 Am Heritage 47:16 (painting,c,4) S '96
— Hawk Mountain
 Natur Hist 105:48–9 (map,c,4) O '96
— Horseshoe Curve railway, Altoona
 Smithsonian 26:36–7 (c,1) Je '95
— Longwood Gardens in Christmas lights
 Gourmet 53:108–12 (c,1) D '93
— Newly built Pennsylvania Turnpike (1940)
 Trav&Leisure 22:E13 (3) Mr '92
— See also
 AMISH PEOPLE
 ALLEGHENY MOUNTAINS
 ALTOONA
 GETTYSBURG
 PHILADELPHIA
 PITTSBURGH
 VALLEY FORGE
PENNSYLVANIA—MAPS
— Pennsylvania Dutch country
 Trav/Holiday 178:87 (c,4) O '95
PENS
— 1900 Waterman No. 412
 Am Heritage 43:31 (c,1) Jl '92
PENSACOLA, FLORIDA
— Seville Quarter
 Trav&Leisure 22:134,137 (c,3) Mr '92
PENTAGON BUILDING, AR-
 LINGTON, VIRGINIA
 Am Heritage 43:87–98 (c,3) S '92
PEOPLE AND CIVILIZATIONS
— Indigenous people from around the world
 Life 15:14–15 (c,4) Ag '92
 Smithsonian 24:78–85 (c,1) N '93
— "Mudpeople" (Los Angeles, California)
 Nat Geog 181:61 (c,1) Je '92
— See also
 ABORIGINES
 AFFLUENT
 AFRICAN TRIBES
 AGED
 AMISH PEOPLE
 ASIAN TRIBES

AZTEC CIVILIZATION
BABIES
BABYLONIAN CIVILIZATION
BEDOUINS
BERBER PEOPLE
BYZANTINE EMPIRE
CELTIC CIVILIZATION
CHILDREN
COMMUTERS
CONVICTS
CROWDS
GYPSIES
HANDICAPPED
HIPPIES
HOMELESS
HOMOSEXUALITY
IMMIGRANTS
INCA CIVILIZATION
INJURED PEOPLE
JUDAISM
KU KLUX KLAN
LAPP PEOPLE
MAORI PEOPLE
MENNONITES
MEXICAN AMERICANS
MIDDLE AGES
MONGOL EMPIRE
MUSLIMS
NOMADS
OTTOMAN EMPIRE
PALESTINIANS
PHOENICIAN CIVILIZATION
REFUGEES
SHAKERS
TOURISTS
TUAREG
TWINS
VIKINGS
WITCHES
YOUTH
People's Republic of China. See
 CHINA
PEPPER INDUSTRY
— Chile peppers
 Smithsonian 22:cov.,42–51 (c,1) Ja '92
 Trav&Leisure 24:71 (c,4) Ag '94
— Pepper field (Louisiana)
 Gourmet 53:122 (painting,c,2) O '93
PEPPER INDUSTRY—HARVESTING
— 15th cent. (India)
 Trav/Holiday 175:72–3 (painting,c,3) My
 '92
— Mexico
 Nat Geog 186:58 (c,3) S '94
— New Mexico

Smithsonian 22:51 (c,2) Ja '92
PEPPERS
 Trav&Leisure 24:64,66 (c,2) O '94
— Chile peppers
 Smithsonian 22:cov.,43–51 (c,1) Ja '92
 Trav/Holiday 176:35 (c,4) S '93
 Trav/Holiday 179:77 (c,1) S '96
— Dried chile pepper hanging (New Mexico)
 Gourmet 53:132 (c,4) N '93
Performers. See
 ACTORS
 CIRCUS ACTS
 ENTERTAINERS
 SINGERS
 THEATER
PERFUME INDUSTRY
— 1967 ad for Shalimar perfume
 Gourmet 56:82 (c,3) Mr '96
— Gathering jasmine blossoms (Grasse,
 France)
 Nat Geog 188:75 (c,3) S '95
PERIWINKLES
 Natur Hist 103:38–9 (c,1) Jl '94
PERON, JUAN
— Eva Peron
 Trav&Leisure 26:157 (c,2) D '96
PERRY, MATTHEW
 Smithsonian 25:20–3 (c,1) Jl '94
PERRY, OLIVER HAZARD
 Smithsonian 25:27 (painting,c,4) Ja '95
PERSIMMONS
 Gourmet 53:103 (c,1) My '93
PERU
 Nat Geog 181:92–121 (map,c,1) F '92
 Nat Geog 187:12,28–39 (map,c,1) F '95
 Trav&Leisure 25:107–17,160–3 (map,c,1)
 Mr '95
 Nat Geog 189:2–35 (map,c,1) My '96
— Aerial view of Pisco Valley
 Natur Hist 104:70–2 (2) D '95
— Ancient Moche sites
 Natur Hist 103:28–9 (map,c,2) My '94
— Colca Canyon and River
 Nat Geog 183:118–137 (map,c,1) Ja '93
— Inca sites
 Nat Geog 181:96–111 (map,c,1) Mr '92
— Manu River
 Nat Geog 185:126–7 (c,2) Ja '94
— Nevado Ampato
 Nat Geog 189:64–9,74–5 (c,1) Je '96
— Nevado Sabancata Volcano
 Nat Geog 189:64–5 (c,1) Je '96
— Rain forests
 Nat Geog 185:133–5 (c,1) Ja '94

— Site of Yungay, destroyed by 1970
 earthquake
 Nat Geog 189:4–5 (c,1) My '96
— Tambopata River
 Nat Geog 185:124–5 (map,c,1) Ja '94
— Ucayali River
 Nat Geog 187:30–3 (c,2) F '95
— See also
 AMAZON RIVER
 ANDES MOUNTAINS
 CUZCO
 LAKE TITICACA
 LIMA
 MACHU PICCHU

PERU—COSTUME
 Nat Geog 181:92–121 (c,1) F '92
 Trav&Leisure 23:64 (c,4) My '93
 Nat Geog 187:28–37 (c,1) F '95
 Trav&Leisure 25:107–17,160–2 (c,1) Mr
 '95
 Nat Geog 189:2–35 (c,1) My '96
— Ashaninca Indians
 Nat Geog 187:34–5 (c,2) F '95
— Matses Indians
 Natur Hist 103:44–50 (c,1) S '94
— Mayoruna woman with straw whiskers
 Natur Hist 103:51 (c,1) S '94
— President Alberto Fujimori
 Nat Geog 189:11 (c,3) My '96
— Shipibo Indians
 Natur Hist 101:30–7 (c,1) D '92
— Uros Indians
 Trav&Leisure 25:110–11 (c,1) Mr '95
— See also
 INCA CIVILIZATION

PERU—HISTORY
— 16th cent. sites of Pizarro expeditions
 Nat Geog 181:92-121 (map,c,1) F '92
— 1824 Battle of Junin
 Nat Geog 185:58-9 (drawing,1) Mr '94
— See also
 BOLIVAR, SIMON
 INCA CIVILIZATION

PERU—HOUSING
— Huts
 Trav&Leisure 23:64 (c,4) My '93
— Pole and thatch house
 Natur Hist 101:34–5 (c,2) D '92
— Uros reed houses
 Trav&Leisure 25:111 (c,1) Mr '95

**PERU—POLITICS AND GOVERN-
MENT**
— Civil War
 Nat Geog 187:34–5 (c,2) F '95
— Abimael Guzman in prison cage (Lima)

Life 16:46–7 (c,1) Ja '93

PERU—RITES AND FESTIVALS
— Aymara people purifying room struck by
 lightning
 Natur Hist 102:6 (c,4) N '93
— Condor freeing itself from bull
 Nat Geog 181:104–5 (c,1) Mr '92
— Inca's Inti Raymi sun festival
 Nat Geog 181:92–3,120–1 (c,1) F '92
— Star Snow Festival
 Nat Geog 181:96–7 (c,1) Mr '92

PERU, ANCIENT—ARTIFACTS
— Ancient Moche artifacts
 Natur Hist 103:38 (c,2) F '94
 Natur Hist 103:26–35 (c,1) My '94
— Dog sculptures
 Natur Hist 103:38–40 (c,1) F '94
— Replica of Moche tomb
 Natur Hist 104:80 (c,4) N '95

PESTICIDES
— Airplane dropping pesticides (Florida)
 Nat Geog 182:26–7 (c,1) Jl '92
— Battle to ban carofuran
 Nat Wildlife 30:38–41 (c,1) Je '92
— Crop duster plane (Venezuela)
 Natur Hist 104:46 (c,4) S '95
— Injecting methyl bromide into strawberry
 fields (California)
 Smithsonian 27:40–51 (c,1) D '96
— Plane dusting field with pesticides (Belize)
 Nat Geog 184:126 (c,4) S '93
— Scorching weeds on farm (Wisconsin)
 Nat Geog 188:74–5 (c,2) D '95
— Spraying crops (India)
 Nat Geog 185:65 (c,3) My '94
— Spraying DDT from Nevada truck (1941)
 Am Heritage 44:44–5 (2) O '93
— Spraying DDT on New York beach (1945)
 Nat Geog 189:132 (3) F '96
— Spraying river (Guinea)
 Nat Geog 184:58–9 (c,2) Ag '93

PETRA, JORDAN
 Trav&Leisure 23:64 (c,4) Mr '93
 Trav/Holiday 177:94–5 (c,2) Ap '94
Petroglyphs. See
 CAVE PAINTINGS
 ROCK CARVINGS

PETS
— Pet cemeteries
 Natur Hist 104:44–7 (1) Ag '95
— Wolves as pets
 Smithsonian 25:34–44 (c,2) Je '94

PEWEES
 Natur Hist 102:42 (c,4) My '93

PHALAROPES (BIRDS)
Nat Wildlife 34:45 (c,1) Je '96
Pharaohs. See
RAMSES II
PHARMACIES
— Food and medicine shop (Hong Kong)
Natur Hist 105:44–5 (c,3) S '96
— Herbal drug shop (California)
Smithsonian 23:34 (c,4) Ag '92
PHEASANTS
Natur Hist 104:80 (painting,c,4) Ja '95
— Monal chicks
Nat Geog 181:23 (c,4) My '92
— Ring-necked pheasants
Nat Wildlife 30:14–21 (painting,c,1) O '92
Nat Wildlife 31:50–1 (c,1) F '93
— See also
GUINEA FOWL
PHILADELPHIA, PENNSYLVANIA
Trav&Leisure 25:106,P1–P3 (c,2) O '95
Gourmet 55:136–41,204 (map,c,1) N '95
Trav/Holiday 178:cov.,60–7 (map,c,1) N
'95
Trav&Leisure 26:P1–P6 (c,3) Jl '96
— 18th cent. Senate chamber
Life 16:38 (c,2) My '93
— Late 18th cent.
Am Heritage 47:75 (painting,4) Jl '96
— 1840s view of Chestnut Street
Am Heritage 44:4 (painting,c,3) S '93
— 1850s Lippincott's clothing store
Am Heritage 43:57 (painting,c,4) D '92
— Bleachers outside Shibe Stadium (1929)
Sports Illus 85:78–9 (1) Ag 19 '96
— City hall
Smithsonian 26:83 (c,2) Ag '95
— Fence around Shibe Park
Am Heritage 47:73 (3) F '96
— Inner-city gardens
Nat Geog 181:56–7,76–7 (c,1) My '92
— Model of 1876 Philadelphia Centennial
Exhibition fairgrounds
Am Heritage 47:74 (3) D '96
— "Rocky" statue
Sports Illus 85:14 (c,4) S 9 '96
— Scenes along Main Line
Trav&Leisure 25:210–15 (map,c,4) N '95
— Schuylkill River
Trav/Holiday 178:62–3 (c,1) N '95
— Skyline
Trav/Holiday 178:20 (c,4) Ap '95
— 30th Street Station
Trav/Holiday 179:56–7 (c,1) S '96
— See also
INDEPENDENCE HALL

LIBERTY BELL
PHILIPPINES
— Lucban
Natur Hist 102:88 (c,3) D '93
— Mt. Pinatubo eruption (1991)
Nat Geog 182:2–3,20–7 (c,1) D '92
Life 19:58–9 (c,1) Je '96
— Resort areas
Trav&Leisure 25:cov.,134–46 (map,c,1)
Ap '95
— Rice terraces
Nat Geog 185:56–7 (c,2) My '94
PHILIPPINES—COSTUME
Trav&Leisure 25:134–46 (c,1) Ap '95
PHILIPPINES—HISTORY
— MacArthur landing at Leyte (1944)
Nat Geog 181:56–7,66 (c,1) Mr '92
Life 18:16–17 (1) Je 5 '95
Life 19:120 (3) O '96
— Sculpture of MacArthur's 1944 return to
the Philippines
Life 17:29 (c,2) D '94
— See also
MARCOS, FERDINAND
SPANISH-AMERICAN WAR
WORLD WAR II
PHILIPPINES—SOCIAL LIFE AND
CUSTOMS
— Filipino bridal couple covered with money
(Alaska)
Nat Geog 184:53 (c,4) N '93
PHOENICIAN CIVILIZATION—AR-
CHITECTURE
— Temple of Antos, Sardinia, Italy
Trav/Holiday 176:46–7 (c,2) Je '93
PHOENIX, ARIZONA
Sports Illus 84:184–98 (c,1) Ja 29 '96
— Arizona Canal
Nat Geog 184:2–4 (c,1) N 15 '93
— Biosphere II
Sports Illus 84:195 (c,4) Ja 29 '96
PHONOGRAPHS
— Edison's phonograph (1889)
Smithsonian 26:32 (painting,c,4) D '95
PHOTOGRAPHERS
— 1907 photographer perched on skyscraper
construction beam (New York)
Am Heritage 43:134 (4) N '92
— Dmitri Baltermant (U.S.S.R.)
Life 15:94 (4) Jl '92
— Frontier photographer John H. Fouch
Am Heritage 43:107 (4) N '92
— Hitting photographer in courtroom (1951)
Am Heritage 45:66 (4) O '94
— Edwin Land

Life 15:91 (4) Ja '92
— Annie Leibovitz
 Life 17:46–54 (1) Ap '94
— Felix Nadar
 Smithsonian 26:76 (4) My '95
— *National Geographic* photographers on
 assignment
 Nat Geog 188:59–77 (c,1) Ag '95
— Photographer transporting gear in boat
 (Alaska)
 Nat Geog 188:65 (c,1) Ag '95
— Taking goofy pictures at New York
 amusement park (mid 20th cent.)
 Life 18:28 (3) Ag '95
— Marion Post Wolcott
 Life 15:81 (4) My '92
— See also
 ADAMS, ANSEL
 BOURKE-WHITE, MARGARET
 BRADY, MATHEW
 CARTIER-BRESSON, HENRI
 EISENSTAEDT, ALFRED
 EVANS, WALKER

PHOTOGRAPHY
— Mid 19th cent. works by Felix Nadar
 (France)
 Smithsonian 26:72–81 (1) My '95
— 1850s daguerreotypes
 Am Heritage 43:6 (2) S '92
 Smithsonian 26:44–6 (4) O '95
— Late 19th cent. art photography
 Smithsonian 27:28 (4) S '96
— 1895 double images of one man
 Am Heritage 46:112 (4) O '95
— 1918 men assembled into living patriotic
 symbols
 Smithsonian 26:58–63 (1) Ja '96
— 1918 men assembled into living photo of
 Woodrow Wilson
 Life 17:38 (3) O '94
— Award-winning travel photos
 Gourmet 54:84–91 (c,3) Je '94
— Depression photos by Marion Post Wolcott
 Life 15:80–8 (1) My '92
— Great 20th cent. news photos
 Am Heritage 45:66–73 (1) O '94
— High-speed photo of bullet going through
 apple
 Life 17:53 (c,4) N '94
— Impressionistic photographs by Lynn
 Butler
 Life 15:3,80–5 (c,1) O '92
— Movement studies
 Life 18:82–4 (c,1) S '95

— Museum photography storage area (New
 York)
 Smithsonian 23:82–3 (c,2) Ja '93
— New York City seen through kaleidoscopic
 lens
 Life 19:94–6 (c,1) Mr '96
— Photographs belonging to the Museum of
 Modern Art, New York City, New York
 Smithsonian 23:83–93 (c,2) Ja '93
— Photos taken by moonlight
 Life 18:82–4 (c,1) Ag '95
— Portraits by Arnold Newman
 Smithsonian 23:140–1 (3) Je '92
— Self-portrait taken in fun house mirror
 Life 17:30 (2) S '94
— Slow motion photos or horse galloping
 (1870s)
 Life 18:28 (4) Ap '95
— Small aerial photography plane
 Nat Geog 188:44–5 (c,1) Jl '95
— Sports photos (1954–1994)
 Sports Illus 81:2–3,53–143,178 (c,1) N 14
 '94
— Underwater photos of dancers
 Life 19:114–18 (c,1) N '96
— U.S. landscape photography
 Smithsonian 22:125 (c,4) Mr '92
— Whimsical photos
 Life 19:199–212 (c,4) O '96
— Works by Cindy Sherman
 Life 19:120–4 (1) My '96
— See also
 CAMERAS
 EASTMAN, GEORGE
 PHOTOGRAPHERS

**PHOTOGRAPHY—PICTURE-
TAKING**
— 1910 (Colorado)
 Am Heritage 45:91,93 (4) Ap '94
— Fashion shoot (Italy)
 Nat Geog 182:100–3 (c,1) D '92
— News photographer with Speed Graphic
 camera
 Am Heritage 45:67 (1) O '94
— Photographing Clinton's cat Socks
 Life 16:112 (c,2) Ja '93
— Posing for college yearbook picture
 Sports Illus 85:59 (c,4) S 23 '96
— Posing on fake bull (Colorado)
 Nat Geog 190:90–1 (c,2) N '96
— Press photographers shooting the president
 Life 18:87 (c,2) Jl '95
— Press photographers shooting track star
 Sports Illus 81:53 (c,3) N 14 '94

— Sports photographers
Sports Illus 81:144–5 (c,1) N 14 '94
Sports Illus 83:2–3 (c,1) Ag 21 '95
— Tourists photographing gorilla (Zaire)
Nat Geog 181:2–3 (c,1) Mr '92
PIANO PLAYING
Life 17:91 (c,2) Mr '94
— 1945 Russian soldiers playing piano in
bombed cafe (Germany)
Life 18:32 (3) My '95
— Duke Ellington playing (1930)
Smithsonian 24:65 (3) My '93
— Glenn Gould playing piano
Life 19:118 (3) My '96
— Richard Nixon playing piano
Am Heritage 43:59 (4) Jl '92
— See also
BASIE, COUNT
ELLINGTON, DUKE
GOULD, GLENN
PIANOS
— Bing Crosby's piano
Trav&Leisure 22:101 (c,4) Jl '92
— Elvis Presley's gold piano (Tennessee)
Gourmet 56:118 (c,4) Ap '96
PICASSO, PABLO
Trav/Holiday 178:84 (1) Ap '95
— "The Absinthe Drinker" (1901)
Trav&Leisure 24:48 (painting,c,4) N '94
Smithsonian 25:50 (drawing,c,4) Mr '95
— "Acrobat and Young Harlequin" (1905)
Trav&Leisure 23:114 (painting,c,4) Ja '93
Smithsonian 24:101 (painting,c,4) My '93
— "Composition: The Peasants" (1913)
Life 16:78 (painting,c,4) Ap '93
— Depicted in 1917 drawing by Vassilieff
Smithsonian 27:46–7 (2) Jl '96
— "Dora Maar Seated" (1937)
Trav&Leisure 26:34 (painting,c,4) Ap '96
— Flashlight drawing
Life 19:64 (4) O '96
— "The Girl with a Goat" (1906)
Smithsonian 24:cov. (painting,c,1) My '93
— "Guernica"
Smithsonian 22:56 (painting,c,4) Ja '92
— "Guitar and Wine Glass"
Trav/Holiday 177:73 (collage,c,4) S '94
— "Harlequin Musician" (1924)
Smithsonian 27:47 (painting,c,4) Jl '96
— "Woman with Blue Collar"
Smithsonian 26:43 (painting,c,4) S '95
— "Woman with a Cigarette"
Smithsonian 24:103 (painting,c,4) My '93
PICKFORD, MARY
Smithsonian 26:108 (4) O '95

PICNICS
— 1908
Life 19:22–3 (1) Winter '96
— 1930s (Quebec)
Trav&Leisure 25:72 (4) Jl '95
— 1957
Trav/Holiday 176:120 (2) My '93
— Amish picnic (Pennsylvania)
Life 15:88–9 (c,1) Je '92
— Australia
Nat Geog 187:84–5 (c,1) Ja '95
— Backyard picnic (California)
Life 16:32 (c,3) Ag '93
— Israel
Nat Geog 189:20–1 (c,2) Ap '96
— Massachusetts
Gourmet 52:78–9 (c,1) Jl '92
— Rainy parking lot picnic (California)
Sports Illus 77:26 (c,2) Jl 13 '92
— Siberia
Nat Geog 181:34–5 (c,1) Je '92
— Turkish picnic (Germany)
Nat Geog 182:28–9 (c,1) Ag '92
PIERCE, FRANKLIN
— 1861 cartoon
Am Heritage 43:57 (drawing,4) N '92
PIERO DELLA FRANCESCA
— "Madonna with Child"
Trav&Leisure 22:13 (painting,c,4) Jl '92
Smithsonian 23:11 (painting,c,4) F '93
— Paintings by him
Smithsonian 23:cov.,122–31 (c,1) D '92
— "St. Michael"
Trav/Holiday 178:78 (painting,c,4) Mr '95
PIERS
— Antigua
Trav&Leisure 23:119 (c,1) O '93
— Jamaica
Trav&Leisure 23:125 (c,1) My '93
— Walking along pilings (Virginia)
Nat Geog 183:cov.,2–3 (c,1) Je '93
— Whitby, Yorkshire, England
Trav&Leisure 25:89 (c,2) Je '95
— Wooden pier (Massachusetts)
Nat Geog 181:114–15 (c,1) Je '92
— See also
DOCKS
PIGEONS
— Passenger pigeons
Am Heritage 44:42 (painting,c,3) O '93
PIGS
Nat Geog 185:56–7 (c,1) Ja '94
Life 17:30,34,38 (c,3) N '94
Life 18:12 (c,4) Ja '95
Life 19:32 (c,4) Je '96

— Drug-sniffing pigs
 Life 15:26 (c,4) O '92
— Feral pig
 Nat Geog 188:25 (c,4) S '95
— Mangalitza pig
 Smithsonian 25:62 (c,4) S '94
— Middle white pig
 Smithsonian 25:64–5 (c,1) S '94
— Pig embryo
 Life 19:41 (c,4) N '96
— Truffle-hunting pig (France)
 Natur Hist 105:22 (c,4) Ja '96
— See also
 WART HOGS
PILOT WHALES
 Natur Hist 104:26–32 (c,1) N '95
PINBALL MACHINES
 Smithsonian 23:96–103 (c,1) Ja '93
— La Guardia crusading against pinball
 (1930s)
 Smithsonian 23:102 (4) Ja '93
— National Video Game Museum, St. Louis,
 Missouri
 Sports Illus 81:8 (c,4) N 28 '94
— Pachinko parlor (Japan)
 Trav/Holiday 176:50 (c,2) My '93
 Nat Geog 185:105 (c,4) Ja '94
— Playing pinball
 Sports Illus 77:70–2 (c,4) N 16 '92
 Smithsonian 23:97 (c,4) Ja '93
 Sports Illus 78:22 (c,4) F 8 '93
PINCHOT, GIFFORD
 Smithsonian 23:61 (4) S '92
PINE TREES
 Trav/Holiday 175:72–3 (c,2) Ap '92
 Natur Hist 101:63 (c,4) Jl '92
 Nat Geog 185:102 (c,3) Ap '94
 Nat Wildlife 33:56 (c,3) D '94
 Natur Hist 105:64 (c,4) My '96
— Pine cones
 Natur Hist 101:39–42 (c,2) D '92
 Life 16:74 (c,4) O '93
— Pine trees in winter
 Sports Illus 77:24 (c,2) D 28 '92
— See also
 BRISTLECONE PINE TREES
 SPRUCE TREES
PINEAPPLE INDUSTRY
— Pineapple crate labels (Hawaii)
 Trav/Holiday 175:77 (c,2) Mr '92
PINEAPPLES
 Trav/Holiday 175:77 (c,2) Mr '92
Ping-Pong. See
 TABLE TENNIS

PINKS (FLOWERS)
 Natur Hist 103:72 (c,4) S '94
Pioneers. See
 WESTERN FRONTIER LIFE
PIPE SMOKING
 Nat Geog 184:74–5 (c,1) D '93
PIPEFISH
 Nat Geog 190:130 (c,4) D '96
PIPES
— Giant water pipes (Turkey)
 Nat Geog 183:38 (c,4) My '93
— Mound Indians' carved pipes (Midwest)
 Am Heritage 46:154 (c,4) Ap '95
PIPES, TOBACCO
— Long-stemmed pipe (Virgin Islands)
 Trav/Holiday 176:86 (c,3) O '93
PIRANHAS
 Life 17:74–5 (c,1) Mr '94
PIRATES
— Buccaneer
 Smithsonian 25:90 (painting,c,4) Jl '94
Pisa, Italy. See
 LEANING TOWER OF PISA
PIT BULLS
 Smithsonian 23:cov.,61,66–71 (c,1) Ap
 '92
 Sports Illus 81:24 (c,4) D 12 '94
PITCHER PLANTS
 Nat Geog 181:73 (c,4) My '92
 Natur Hist 101:62 (c,1) Jl '92
 Natur Hist 101:60–2 (c,1) D '92
 Smithsonian 23:48–56 (c,2) D '92
 Natur Hist 103:80 (c,4) N '94
PITTSBURGH, PENNSYLVANIA
 Trav&Leisure 22:E1–E4 (map,c,3) Je '92
 Trav&Leisure 23:90–1 (c,1) My '93
 Smithsonian 24:118 (1) O '93
 Trav/Holiday 176:31–2 (map,c,4) O '93
 Am Heritage 47:22 (c,4) S '96
— Courthouse and jail
 Am Heritage 43:114 (c,4) D '92
— Frick mansion
 Gourmet 53:134 (c,4) O '93
— PPG headquarters
 Nat Geog 184:40–1 (c,1) D '93
— Andy Warhol Museum
 Am Heritage 47:24 (c,4) S '96
PIZARRO, FRANCISCO
 Nat Geog 181:94 (sculpture,c,4) F '92
— 16th cent. sites of Pizarro expeditions
 Nat Geog 181:92–121 (map,c,1) F '92
Planets. See
 EARTH
 JUPITER

MARS
SATURN
VENUS
PLANTATIONS
— Antebellum plantation houses (Louisiana)
Trav&Leisure 26:110–21,156–60 (c,1) Ap
'96
— Antebellum plantation houses (Natchez,
Mississippi)
Gourmet 53:130–3 (c,1) Ap '93
— Longwood, Natchez, Mississippi
Gourmet 53:132 (c,4) Ap '93
Natur Hist 103:A8 (c,4) Ap '94
— Nottoway, Louisiana
Trav&Leisure 24:167 (c,4) Mr '94
— Rosedown, Louisiana
Trav&Leisure 26:110 (c,1) Ap '96
— Savannah, Georgia (1864)
Smithsonian 27:120–1 (1) My '96
— Somerset Place plantation, North Carolina
Am Heritage 43:92–3 (c,2) Ap '92
— Sotterley Plantation, Maryland
Smithsonian 27:57 (c,4) S '96
— Stanton Hall, Natchez, Mississippi
Gourmet 53:130 (c,1) Ap '93
PLANTS
— Beach pea vine
Natur Hist 105:59 (c,1) O '96
— Caribbean plants
Trav/Holiday 176:cov.,70–86 (c,1) D '93
— Chart of endangered species
Nat Geog 187:16–21 (c,1) Mr '95
— Climbing pieris vines
Natur Hist 101:59 (c,1) Ap '92
— Endangered Hawaiian species
Nat Geog 188:2–35 (c,1) S '95
— Endangered plants
Life 17:51–63 (c,4) S '94
— Hedgerows (Great Britain)
Nat Geog 184:94–117 (c,1) S '93
— Maguey
Nat Geog 181:24 (c,1) F '92
— Photosynthesis in chloroplasts
Natur Hist 101:46,50–1 (c,1) Ag '92
— Trigger plants
Natur Hist 102:36–7 (c,1) Ag '93
— See also
ALGAE
BAMBOO
COTTON
EELGRASS
FERNS
FLAX
FLOWERS
FUNGI

GARDENS
HOLLY
HOPS
KELP
LICHENS
MILKWEED
MOSS
MUSHROOMS
SAGEBRUSH
SUCCULENTS
SUMAC
TUMBLEWEEDS
VETCHES
VINES
YUCCA
PLATTE RIVER, NEBRASKA
Nat Geog 183:86–7 (c,1) Mr '93
PLATYPUSES
— Ancient platypuses
Natur Hist 103:49 (painting,c,2) Ap '94
PLAYGROUNDS
Smithsonian 25:78–87 (c,1) Jl '94
— 1942 children on jungle gym
Sports Illus 84:18 (4) My 27 '96
— Children on jungle gym (Florida)
Nat Geog 187:12–13 (c,1) Je '95
— Climbing sculpture (Barcelona, Spain)
Trav&Leisure 22:88 (c,4) Ja '92
— New York City, New York
Smithsonian 25:80–3 (c,2) Jl '94
— See also
SWINGS
PLINY THE ELDER
Smithsonian 26:152,162 (engraving,3) N
'95
— Illustrations of works by Pliny the Elder
Smithsonian 26:152–60 (c,1) N '95
PLOVERS
Natur Hist 101:28–9 (c,4) O '92
Natur Hist 102:8 (c,3) My '93
Natur Hist 104:36 (c,2) Jl '95
— Chick and eggs
Natur Hist 104:32–3,37 (c,1) Jl '95
Plowing. See
FARMING—PLOWING
POCAHONTAS
Life 18:64— 9 (painting,c,1) Jl '95
POE, EDGAR ALLEN
— 1893 seashell textbook by Poe
Natur Hist 102:10,14,18 (2) Jl '93
— Miniature of Poe cottage, New York City
Am Heritage 47:8 (c,4) D '96
POLAND
— Auschwitz concentration camp
Trav/Holiday 178:54–61 (1) F '95

— Bialowieza forest
Trav&Leisure 24:48–50 (c,4) Ap '94
— Wieliczka salt mine history
Smithsonian 24:96–106 (c,2) Mr '94
— See also
KRAKOW
WARSAW
POLAND—COSTUME
— 1930 Jewish child
Smithsonian 24:cov. (2) Ap '93
— Krakow
Trav&Leisure 24:112–121 (c,1) Mr '94
POLAR BEARS
Nat Wildlife 31:7 (c,1) D '92
Natur Hist 101:84–5 (c,1) D '92
Nat Geog 184:32 (c,1) Jl '93
Nat Wildlife 31:16–17 (c,1) Ag '93
Life 17:80–5 (c,1) F '94
Nat Geog 186:5–7,34–5 (c,1) D '94
Life 18:92 (c,3) F '95
Nat Wildlife 33:40–1 (painting,c,1) Ag '95
Nat Wildlife 33:8 (c,4) O '95
Nat Wildlife 34:18,63 (c,2) F '96
Nat Wildlife 34:38 (c,4) Ap '96
Nat Wildlife 35:cov.,16–25 (c,1) D '96
POLE VAULTING
Sports Illus 76:34 (c,2) Je 29 '92
Sports Illus 76:14–17 (c,1) Jl 6 '92
Sports Illus 80:63 (c,2) Je 6 '94
Sports Illus 83:42–3 (c,1) Ag 21 '95
— 1893
Am Heritage 43:96 (3) F '92
— 1976 Olympics (Montreal)
Sports Illus 76:45 (c,2) Ap 13 '92
— 1992 Olympics (Barcelona)
Sports Illus 77:36–7,48 (c,1) Ag 17 '92
— Senior Olympics
Life 19:26 (c,3) Ag '96
— Training under water
Sports Illus 82:2–3 (c,1) Ja 16 '95
— Vaulting over canal (Netherlands)
Nat Geog 190:54 (c,4) Jl '96
POLICE WORK
— 1937 police burning marijuana (New York)
Am Heritage 43:120 (3) D '92
— 1991 police attack on Rodney King
(California)
Life 15:67 (3) Ja '92
— Airport anti-terrorist sharpshooter (Texas)
Smithsonian 24:38–9 (c,4) Ap '93
— Arizona sheriff's work
Life 16:50–8 (c,1) Ap 5 '93
— Arrest of abusive father
Life 15:4 (4) Ap '92

— Arrested woman handcuffed to mailbox
(Washington, D.C.)
Life 17:26 (2) Mr '94
— Arresting abusive husband (1988)
Life 19:134 (3) O '96
— Arresting criminal (U.S.S.R.)
Life 15:10–11 (c,1) Ap '92
— Baltimore, Maryland
Life 16:70–6 (1) F '93
— Camouflaged policemen on stakeout
(Dallas, Texas)
Life 15:26 (c,4) D '92
— Catching marijuana smuggler (Texas)
Nat Geog 190:99 (c,3) Ag '96
— Criminologists working on O.J. Simpson
case
Life 17:62–3 (c,1) D '94
— Drug raid (Florida)
Nat Geog 181:102–3 (c,1) Ja '92
Sports Illus 84:73 (3) Ap 8 '96
— Drug-related crime (Connecticut)
Nat Geog 185:86–7 (c,1) F '94
— Drug-sniffing pigs
Life 15:26 (c,4) O '92
— Frisking thief (Mexico)
Nat Geog 190:31 (c,4) Ag '96
— German border guards with illegal
immigrant
Nat Geog 183:122–3 (c,1) My '93
— Investigating Mafia hit (Sicily, Italy)
Nat Geog 188:16 (c,3) Ag '95
— Police burning marijuana (Kentucky)
Nat Geog 183:122 (c,4) F '93
— Police frisking teens (Washington, D.C.)
Life 18:69 (2) Ag '95
— Policeman holding drug suspect
(California)
Nat Geog 181:59 (c,3) Je '92
— Rescue of seven-year-old hostage (Oregon)
Life 19:10–11 (c,1) D '96
— Rounding up criminals (China)
Life 19:14–15 (c,1) Ag '96
— Scientists solving crimes with physical
evidence
Nat Wildlife 30:8–15 (c,1) F '92
— Security training (Japan)
Life 16:20 (c,4) S '93
— Shooting practice (El Salvador)
Nat Geog 188:112–13 (c,1) S '95
— Warren Commission investigation of 1963
Kennedy assassination
Am Heritage 46:cov.,51-8 (1) N '95
— See also
CRIME AND CRIMINALS
DRUG ABUSE

POLICEMEN
— 19th cent. sheriff (Arizona)
 Life 16:50 (4) Ap 5 '93
— Baltimore, Maryland
 Life 16:68–76 (1) F '93
— Denton, Texas
 Life 16:19 (4) Ag '93
— Finland
 Nat Geog 181:14–15 (c,1) F '92
— Funeral of slain policewoman
 (Pennsylvania)
 Life 19:10–11 (c,1) Mr '96
— Israel
 Nat Geog 181:88–9 (c,1) Je '92
— Los Angeles, California
 Life 15:14 (c,2) Je '92
— New Orleans, Louisiana
 Nat Geog 187:109 (c,3) Ja '95
— New York City, New York
 Gourmet 52:115 (c,4) Ap '92
— Policemen on bicycles
 Nat Geog 181:58–9 (c,1) Je '92
 Trav&Leisure 26:80 (c,4) Ag '96
— Taiwan
 Nat Geog 184:11 (c,4) N '93
— U.S.S.R.
 Life 15:10–11 (c,1) Ap '92

POLITICAL CAMPAIGNS
— 19th and 20th cent. campaign paraphernalia
 Am Heritage 43:43–59 (c,3) S '92
— 1848 campaign songbook
 Am Heritage 43:44 (c,4) S '92
— 1876 Tilden ribbon
 Am Heritage 45:134 (c,4) My '94
— 1884 Cleveland campaign poster
 Am Heritage 43:46 (c,4) S '92
— 1896 McKinley campaign office
 Am Heritage 44:57 (4) O '93
— 20th cent. presidential campaign
 photographs
 Smithsonian 25:98–105 (1) O '94
— 1904 Debs campaign poster
 Am Heritage 43:51 (c,3) S '92
— 1908 Bryan campaign novelty
 Smithsonian 27:40 (c,4) N '96
— 1908 Taft campaign ashtray
 Am Heritage 43:52 (c,4) S '92
— 1920 Harding campaign decal
 Am Heritage 43:53 (c,4) S '92
— 1940 Willkie campaign
 Smithsonian 25:98–9 (1) O '94
 Life 18:92 (4) O '95
— 1944 Democratic convention
 Am Heritage 43:112 (2) My '92
 Am Heritage 43:46–64 (1) Jl '92

— 1948 Dewey campaign
 Am Heritage 43:57 (c,4) S '92
 Am Heritage 46:32 (4) O '95
— 1948 Truman campaign button
 Am Heritage 43:10 (c,4) F '92
— 1952 Republican convention, Chicago,
 Illinois
 Smithsonian 27:43 (2) N '96
— 1966 Brown vs. Reagan governor's race
 (California)
 Am Heritage 47:39–60 (c,2) O '96
— 1968 Democratic convention violence
 (Chicago, Illinois)
 Life 16:27 (4) Ag '93
— 1988 Bush campaign button
 Am Heritage 43:59 (c,4) S '92
— 1992 presidential campaign
 Life 16:5,10–11,24,5,30–1,54–5,110–11
 (c,1) Ja '93
— 1996 politicians campaigning
 Life 19:65–74 (c,1) N '96
— Bath, England
 Trav/Holiday 175:82–7 (1) O '92
— Crowd at rally (1968)
 Life 16:58 (1) Ap '93
— William Randolph Hearst's political
 campaign buttons
 Am Heritage 43:46–56 (4) N '92
— Nixon greeting crowds (1950)
 Life 17:17 (1) Je '94
— Politician speaking to crowd (Italy)
 Nat Geog 182:94–5 (c,1) D '92
— Taiwan
 Nat Geog 184:10–11 (c,2) N '93
— See also
 ELECTIONS
 POLITICAL CARTOONS
 U.S.—POLITICS AND GOVERNMENT

POLITICAL CARTOONS
— 1800 union of Britain and Ireland
 Natur Hist 105:33 (c,4) Ja '96
— 1801 anti-Jefferson cartoon
 Am Heritage 44:91 (4) My '93
— 1830s nullification issue
 Am Heritage 46:20 (4) O '95
— 1850s anti-immigration cartoon
 Smithsonian 27:151 (2) N '96
— 1860 cartoon about political speechmaking
 Am Heritage 43:122 (3) S '92
— 1861 cartoon of mid-19th cent. presidents
 Am Heritage 43:57 (4) N '92
— 1895 cartoon about income tax
 Am Heritage 47:122 (c,4) My '96
— 1936 Arno cartoon about society hatred of
 Franklin Roosevelt

Smithsonian 26:90 (4) Je '95
— 1939 Hitler– Stalin pact
Am Heritage 43:40 (4) My '92
— 1962 cartoon about the Cuban Missile
crisis
Am Heritage 45:103 (c,4) S '94
— Cartoon depictions of Uncle Sam through
U.S. history
Smithsonian 26:70–3 (c,2) Jl '95
— Russian vs. American system cartoon
(1959)
Am Heritage 43:72 (4) F '92
Politics. See
DEMONSTRATIONS
ELECTIONS
POLITICAL CAMPAIGNS
POLITICAL CARTOONS
STATESMEN
U.S.—POLITICS AND GOVERNMENT
specific countries—POLITICS AND
GOVERNMENT
POLK, JAMES KNOX
Smithsonian 27:41 (painting,c,4) Ap '96
POLLOCK, JACKSON
— At work on painting (1950s)
Am Heritage 46:55,65 (2) S '95
POLLUTION
— Effects of Gulf War oil fires (Kuwait)
Nat Geog 181:122–34 (c,1) F '92
— U.S.S.R.
Nat Geog 186:70–99 (map,c,1) Ag '94
— Waste treatment plant (South Dakota)
Nat Geog 184:43 (c,4) Ag '93
— See also
AIR POLLUTION
OIL SPILLS
RECYCLING
WATER POLLUTION
POLO PLAYING
Sports Illus 76:53 (c,4) Mr 16 '92
— 1910 Bellows painting
Smithsonian 23:64 (c,4) Je '92
— Boys playing horseless polo (Pakistan)
Nat Geog 185:132–3 (c,1) Mr '94
— Pakistan
Trav&Leisure 24:123 (c,1) S '94
— See also
WATER POLO
POLO, MARCO
Trav/Holiday 175:64–73 (painting,c,1)
My '92
— 13th cent. travels of Marco Polo
Trav/Holiday 175:64–73 (map,c,1) My '92
Polynesia. See
PACIFIC ISLANDS

POMPANOS (FISH)
Natur Hist 105:26–7 (c,1) S '96
POMPEII, ITALY
— Cast of 79 A.D. victim of Mt. Vesuvius
eruption
Nat Geog 182:9 (c,3) D '92
— Garden murals from 1st cent. Pompeii
Smithsonian 25:115–17 (c,2) Je '94
PONCE, PUERTO RICO
Smithsonian 25:64–71 (c,1) Ag '94
Trav&Leisure 25:88–9 (c,4) Mr '95
PONDS
— Early 20th cent. swimming hole (Delaware)
Smithsonian 23:132 (4) My '92
— Autumn scene (Maine)
Nat Wildlife 33:2,30–5 (c,1) O '95
PONY EXPRESS
— Scenes along Pony Express route across
Nebraska
Trav&Leisure 25:44–6 (map,c,3) Jl '95
POODLES
Sports Illus 84:93 (c,4) Ap 8 '96
Trav&Leisure 26:140 (c,4) D '96
Pool playing. See
BILLIARDS
Pools. See
SWIMMING POOLS
POPES
— John Paul II
Life 15:88 (4) O 30 '92
Life 19:32 (c,2) Ja '96
Life 19:42 (c,4) My '96
POPLAR TREES
Trav/Holiday 176:61 (c,4) Mr '93
POPPIES
Life 16:34 (c,4) O '93
Natur Hist 103:cov.,52–9 (c,1) My '94
Nat Wildlife 32:42–3 (c,1) Je '94
Trav&Leisure 26:72 (c,4) Je '96
— Blue Himalayan poppy
Gourmet 53:54 (c,4) Jl '93
Nat Geog 184:68 (c,4) Ag '93
PORCHES
— Bucolic country inn (Connecticut)
Gourmet 54:88 (c,4) S '94
— Key West houses, Florida
Gourmet 52:112–13 (c,1) D '92
— Man on porch swing (Texas)
Nat Geog 184:62–3 (c,2) S '93
— Parlange Plantation, Louisiana
Trav&Leisure 26:113 (c,1) Ap '96
— Queen Anne porch (Arkansas)
Am Heritage 47:24 (c,4) F '96
— Rundown house (Vermont)
Smithsonian 26:60–1 (c,1) My '95

— Washington resort hotel
Trav&Leisure 25:32 (c,4) My '95
PORCUPINES
Smithsonian 23:57–67 (c,2) My '92
Nat Wildlife 31:8 (c,1) D '92
Nat Wildlife 32:cov.,34–9 (c,1) D '93
Natur Hist 103:80–1 (c,1) My '94
Nat Wildlife 34:42 (c,2) D '95
Porpoises. See
DOLPHINS
PORTER, COLE
Life 18:147 (4) Je 5 '95
Smithsonian 27:53 (4) N '96
— Caricature
Am Heritage 44:82–4 (painting,c,1) O '93
PORTERS
— Early 20th cent. steamship porters
Am Heritage 45:115 (4) Ap '94
— 1930s bellhop
Am Heritage 45:cov.,46 (painting,c,4) Ap
'94
— 1940s female hotel bellhop (New York
City)
Am Heritage 45:112 (3) F '94
— Hotel porter with luggage cart (Nevada)
Nat Geog 190:67 (c,3) D '96
— Railroad redcaps
Trav/Holiday 176:18–19 (4) S '93
PORTLAND, MAINE
— Armory
Trav/Holiday 179:16 (c,4) S '96
PORTLAND, OREGON
Trav/Holiday 175:30,32 (c,4) My '92
Nat Geog 184:25 (c,3) N 15 '93
— Skidmore Fountain
Am Heritage 47:146–7 (c,2) Ap '96
— Skidmore Fountain (1888)
Am Heritage 47:146 (2) Ap '96
Ports. See
HARBORS
PORTSMOUTH, NEW HAMPSHIRE
— Strawbery Banke
Am Heritage 43:53 (c,4) Ap '92
Trav&Leisure 24:E6 (c,4) O '94
PORTUGAL
— Cape Espichel
Nat Geog 182:56–7 (c,1) N '92
— Castle region
Trav&Leisure 23:84–93 (map,c,1) Ag '93
— Castles
Trav&Leisure 24:116,121 (c,1) O '94
— Estremadura
Trav&Leisure 24:116–34 (map,c,1) O '94
— Monsanto
Trav&Leisure 23:90–3 (c,1) Ag '93

— Serpa
Trav&Leisure 23:86 (c,1) Ag '93
— Terena
Trav&Leisure 23:84 (c,1) Ag '93
— See also
AZORES
LISBON
MADEIRA
PORTUGAL—ARCHITECTURE
— Country estate (Lisbon)
Trav/Holiday 175:37 (c,3) F '92
PORTUGAL—COSTUME
Trav&Leisure 24:118–19,130,134 (c,1) O
'94
— Madeira
Nat Geog 186:90–113 (c,1) N '94
— Old woman
Trav&Leisure 23:88 (c,1) Ag '93
PORTUGAL—HISTORY
— 15th cent. "Age of Discovery" explorations
Nat Geog 182:56–93 (map,c,1) N '92
— See also
DA GAMA, VASCO
HENRY THE NAVIGATOR
POSSUMS
— Bushtail possums
Smithsonian 23:92–101 (c,1) Jl '92
POST OFFICES
— 19th cent. (Marietta, Ohio)
Trav/Holiday 178:12 (4) O '95
— Cuttyhunk, Massachusetts
Nat Geog 181:124 (c,4) Je '92
— Eldridge, North Dakota
Smithsonian 24:42–3 (1) Mr '94
— Ochopee, Florida
Trav&Leisure 24:108 (c,4) Ap '94
— Paradise, Montana
Trav/Holiday 176:82–3 (c,3) Mr '93
POSTAGE STAMPS
— 1901 misprinted stamp
Smithsonian 24:82 (c,4) Ag '93
— 1918 stamp with upside-down airplane
Smithsonian 27:24 (c,4) Jl '96
— Charles Darwin stamp (India)
Natur Hist 105:6 (c,4) My '96
— "Legends of American Music" series
Life 17:34 (c,4) S '94
POSTAL SERVICE
— 1896 horse-drawn Rural Free Delivery cart
Smithsonian 24:79 (4) Ag '93
— 1940s soldiers' V-mail letters
Am Heritage 45:63,78 (4) My '94
— Early airmail planes
Smithsonian 24:77,79 (c,4) Ag '93
Smithsonian 27:24–5 (4) Jl '96

— History of postal service
 Smithsonian 24:76–85 (c,1) Ag '93
— Patriotic Civil War envelope
 Am Heritage 46:89 (c,4) O '95
— Rescuing mail soaked in flood (Iowa)
 Nat Geog 185:84–5 (c,1) Ja '94
— Undelivered packages to servicemen (1945)
 Life 18:14–15 (1) Je 5 '95
— See also
 MAILBOXES
 PONY EXPRESS
 POST OFFICES
 POSTAGE STAMPS
 POSTAL WORKERS

POSTAL WORKERS
— Early 20th cent. mailman
 Smithsonian 24:76 (1) Ag '93

POSTCARDS
— Early 20th cent. postcards celebrating July
 Fourth
 Smithsonian 25:34–7 (c,4) Jl '94
— Early 20th cent. postcards featuring
 chickens
 Am Heritage 47:4 (c,4) S '96
— Early 20th cent. scenes of Yellowstone
 National Park, Wyoming
 Trav/Holiday 175:42 (c,4) Je '92
— 1920s postcard of Washington, D.C.
 Smithsonian 26:30 (c,4) My '95
— Postcards of early movie theaters
 Am Heritage 44:78–92,114 (c,1) N '93

POSTERS
— 19th cent. ad for book *The Count of
 Monte Cristo* (France)
 Smithsonian 27:111 (c,2) Jl '96
— 1881 travel poster for "The Great West"
 Smithsonian 27:51 (c,1) Ap '96
— 1893 Columbian Exposition, Chicago,
 Illinois
 Smithsonian 24:50 (c,4) Je '93
— 1896 ads for Edison's Vitascope
 Am Heritage 44:78–82 (c,1) N '93
— 1917 women's suffrage poster
 Am Heritage 46:6 (c,2) Jl '95
— 1921 "Progress through Labor" poster
 (U.S.S.R.)
 Nat Wildlife 34:40 (c,3) Je '96
— 1932 Prohibition repeal poster
 Am Heritage 44:52 (c,4) F '93
— 1940s poster of VD safety tips for soldiers
 Am Heritage 45:22 (c,4) N '94
— 1941 USO poster
 Am Heritage 43:122 (c,4) D '92
— 1945 "Carousel" poster
 Life 18:66 (c,4) Je 5 '95

— 1946 five-year plan poster (U.S.S.R.)
 Nat Wildlife 34:39 (c,3) Je '96
— 1950 "Sunset Boulevard" poster (Poland)
 Trav&Leisure 23:29 (c,4) Je '93
— 1956 Democratic convention poster
 Am Heritage 43:58 (c,3) S '92
— Late 1980s posters promoting Eastern
 European revolutions
 Smithsonian 24:118–23 (c,2) Ap '93
— Classic James Montgomery Flagg World
 War I Uncle Sam poster
 Smithsonian 26:70 (c,4) Jl '95
— "The Lost Weekend" poster (1945)
 Life 18:77 (c,4) Je 5 '95
— Movie posters (India)
 Nat Geog 187:52 (c,3) Mr '95
— Olympics posters (1912–1964)
 Sports Illus 85:17 (c,4) Jl 22 '96
— Posters from Broadway musicals
 Smithsonian 27:46–57 (c,4) N '96
— Posters plastered on walls (Poland)
 Gourmet 54:134 (c,3) N '94
— "Reefer Madness" movie poster (1936)
 Am Heritage 44:55 (c,3) F '93
— U.S. World War II posters
 Am Heritage 43:32 (4) D '92
 Smithsonian 24:cov.,66–9 (c,1) Mr '94
 Life 18:19,117–22 (c,2) Je 5 '95

POTATO INDUSTRY—HARVESTING
— Hand harvesting organic potatoes (Maine)
 Nat Geog 188:78–9 (c,1) D '95

POTATOES
— French fries (Belgium)
 Trav/Holiday 179:76–81 (c,1) N '96
—Potatoes strewn in street by angry farmers
 (France)
 Life 15:18 (c,4) S '92

POTOSI, BOLIVIA
 Trav&Leisure 26:107,110 (c,1) F '96
— Cerro Rico mine
 Natur Hist 105:36–43 (c,1) N '96

POTSDAM, GERMANY
— Charlottenhof Palace
 Trav&Leisure 25:148–51 (c,1) S '95
— Sanssouci Palace
 Trav&Leisure 25:152–4 (c,1) S '95

POTTER, BEATRIX
 Nat Geog 186:20 (4) Ag '94
— Home (Near Sawrey, England)
 Trav&Leisure 22:190 (c,4) Je '92

POTTERY
— 14th cent. Alhambra vase (Spain)
 Smithsonian 23:48 (c,4) Ag '92
— 16th cent. Spanish ship storage jars
 Nat Geog 186:34,44–7,56 (c,1) Jl '94

— 19th cent. face jugs made by slaves (South Carolina)
Smithsonian 24:30 (c,4) N '93
— Colorful plate (Portugal)
Trav&Leisure 23:89 (c,1) Ag '93
— Mexico
Gourmet 55:80–3 (c,1) Ja '95
— Thailand
Trav/Holiday 177:58 (c,4) D '94

POTTERY MAKING
Smithsonian 26:122 (c,3) Ap '95
— Ancient Chinese making clay tomb statues
Nat Geog 182:125 (painting,c,1) Ag '92
— Ancient Thailand
Natur Hist 103:63 (painting,c,2) D '94
— Firing pottery in outdoor kiln (Colorado)
Nat Geog 189:108–9 (c,2) Ap '96

POTTOS (ANIMALS)
Nat Geog 188:20 (c,2) Jl '95

POUND, EZRA
Smithsonian 26:112–27 (1) D '95

POVERTY
— 1930 bread line
Am Heritage 44:58 (4) O '93
— 1934 children in tenement (New York City)
Am Heritage 47:168 (4) N '96
— Cairo, Egypt
Nat Geog 183:50–5,62–5 (c,1) Ap '93
— Children living in dump (El Salvador)
Nat Geog 188:116–17 (c,1) S '95
— Food stamps
Nat Geog 183:98 (c,4) Ja '93
— Shotgun shacks (Louisiana)
Smithsonian 23:44–5 (c,4) F '93
— Soup kitchen meal (Moscow, Russia)
Nat Geog 183:12–13 (c,1) Mr '93
— Welfare family's monthly food purchases
Life 19:65–71 (c,1) Ja '96
— See also
BEGGARS
DEPRESSION
HOMELESS
MALNUTRITION
SLUMS

POWELL, ADAM CLAYTON, JR.
Am Heritage 43:43 (4) F '92
Am Heritage 43:14 (drawing,4) Jl '92

POWER PLANTS
— Hydroelectric project (Quebec)
Nat Geog 184:68–71 (map,c,1) N 15 '93
— Ohio
Nat Geog 189:110–11 (c,1) F '96
— See also
NUCLEAR POWER PLANTS

PRAGUE, CZECHOSLOVAKIA
Gourmet 52:110–13 (c,1) My '92
Trav/Holiday 175:11 (c,3) Je '92
Trav&Leisure 22:62–73 (map,c,1) Ag '92
Smithsonian 24:66–75 (c,1) Je '93
Nat Geog 184:4–5 (c,1) S '93
Trav&Leisure 24:65–6 (c,4) N '94
— 1968
Trav&Leisure 23:50 (4) Jl '93
— Synagogues
Trav&Leisure 25:130,132 (c,4) N '95

PRAIRIE
— Illinois
Natur Hist 102:25 (c,3) Ap '93
— Midwest
Nat Geog 184:90–119 (c,1) O '93
— Tallgrass (Iowa)
Nat Geog 190:16–17 (c,2) O '96

PRAIRIE CHICKENS
Life 16:41 (c,4) O '93

PRAIRIE DOGS
Life 15:86 (c,3) Jl '92
Nat Geog 184:23 (c,4) Jl '93
Natur Hist 102:cov. (c,1) Jl '93
Nat Geog 184:104–6 (painting,c,1) O '93
Nat Wildlife 34:cov.,12–19 (c,1) Je '96

PRAYING
Life 17:cov.,55–63 (c,1) Mr '94
— Buddhist monks (India)
Life 19:78–9 (c,1) Jl '96
— Gamblers Anonymous members in prayer circle (Virginia)
Nat Geog 183:100–1 (c,1) Ja '93
— Jain man making offering (India)
Trav/Holiday 178:72–3 (c,2) O '95
— Japan
Nat Geog 188:55 (c,3) N '95
— Jews praying at Western Wall, Jerusalem, Israel
Life 16:25 (c,4) Je '93
— Muslim praying before Coke machine (Cameroon)
Life 19:98 (c,3) Je '96
— Muslims (Afghanistan)
Nat Geog 184:88–9 (c,1) O '93
— Muslims (Colorado)
Sports Illus 79:80 (c,1) N 15 '93
— Muslims (Egypt)
Life 16:66 (2) Mr '93
Nat Geog 183:56–7 (c,1) Ap '93
Life 19:76–7 (2) Jl '96
— Muslims (Eritrea)
Nat Geog 189:101 (c,1) Je '96
— Muslims (India)

Life 15:84 (c,3) Mr '92
— Muslims (Israel)
Nat Geog 189:12–13 (c,1) Ap '96
— Muslims (Michigan)
Sports Illus 85:61 (c,2) S 30 '96
— Muslims (Morocco)
Nat Geog 190:118–19 (c,2) O '96
— Muslims (Texas)
Life 18:88–9,97 (c,1) D '95
— Muslims (Turkey)
Trav/Holiday 175:67 (c,1) Jl '92
— Muslims washing at midday prayer (Syria)
Nat Geog 183:54–5 (c,1) My '93
— Poor family saying grace (1894)
Am Heritage 46:49 (painting,c,4) F '95
supp.
— Prayer circle (Texas)
Sports Illus 78:51 (c,4) Ja 11 '93
— Woman at bedside
Sports Illus 84:72–3 (c,1) My 20 '96
— See also
MEDITATION
PREGNANCY
Life 16:78–9 (c,1) D '93
— Japanese painting
Natur Hist 104:4 (c,3) D '95
— Sculptures of pregnant woman (France)
Life 16:27 (c,4) Mr '93
— Teenage boy with "empathy belly" to
simulate pregnancy (Texas)
Life 16:20–1 (1) Mr '93
— Topiary of nude pregnant woman
Life 16:24 (c,4) N '93
— See also
CHILDBIRTH
REPRODUCTION
Prehistoric man. See
MAN, PREHISTORIC
Presidents. See
U.S. PRESIDENTS
PRESLEY, ELVIS
Life 15:cov.,4,41–2,52–3 (1) D 1 '92
Life 16:38–47 (1) Ag '93
Am Heritage 45:122 (4) My '94
Am Heritage 45:100 (4) O '94
Smithsonian 26:58–9,67 (c,1) N '95
Life 19:31 (4) N '96
— Elvis impersonator
Smithsonian 26:5–8 (c,2) N '95
— Presley's gold piano
Gourmet 56:118 (c,4) Ap '96
— Presley's grave (Memphis, Tennessee)
Smithsonian 26:60 (c,4) N '95
PRESS CONFERENCES
— 1950 Korean War Pentagon press briefing

Am Heritage 43:92 (4) S '92
— Athlete's press conference
Sports Illus 79:28–30 (c,1) O 18 '93
— Press crowding around baseball player
Sports Illus 78:30 (c,4) Ap 19 '93
PRIBILOF ISLANDS, ALASKA
— St. Paul
Nat Geog 182:86–7 (c,2) O '92
PRICE, LEONTYNE
Life 15:24 (4) S '92
PRICKLY PEARS
Smithsonian 22:33 (c,3) F '92
Natur Hist 103:23 (c,1) Jl '94
Natur Hist 104:37 (c,1) My '95
Natur Hist 105:66 (c,4) My '96
Natur Hist 105:62–4 (c,3) Je '96
Primates. See
APES
MONKEYS
PRIMROSES
Natur Hist 103:20 (c,4) Mr '94
Nat Wildlife 32:45 (c,1) Je '94
Smithsonian 25:86 (c,4) Ag '94
PRINCE EDWARD ISLAND, CANADA
Trav/Holiday 175:82–3 (c,2) N '92
Trav&Leisure 23:E1,E4,E8 (map,c,4) My
'93
— Green Gables house, Cavendish
Trav&Leisure 23:E4 (c,4) My '93
**PRINCETON UNIVERSITY, NEW
JERSEY**
Gourmet 54:72 (c,4) Mr '94
— Wu Hall
Am Heritage 47:97 (c,4) Jl '96
PRISON LIFE
— Chain gangs (Alabama)
Life 18:64–71 (1) O '95
— Inmates at Passover seder (New York)
Life 19:62 (4) S '96
— Louisiana
Life 16:68–77 (1) Mr '93
PRISONS
— Carvings in Tower of London wall,
England
Nat Geog 184:48 (c,4) O '93
— Colombia
Nat Geog 185:44–5 (c,1) Mr '94
— Columbus, Indiana
Trav&Leisure 25:E8 (c,4) F '95
— Convicts working at sewing machines
(China)
Nat Geog 185:28 (c,4) Mr '94
— German World War II POWs in U.S.
camps
Smithsonian 26:126–43 (1) Je '95

— History of Windsor Prison, Vermont
Am Heritage 47:100-9 (c,1) My '96
— Libby Civil War prison, Richmond,
Virginia
Am Heritage 45:114–18,130 (1) N '94
— Lima prison cage, Peru
Life 16:46–7 (c,1) Ja '93
— Man behind bars (Italy)
Sports Illus 79:66–7 (c,1) D 6 '93
— Mannheim Prison, Germany
Sports Illus 85:77 (c,3) N 18 '96
— Marie Antoinette's prison chamber (Paris,
France)
Trav&Leisure 25:69 (c,4) N '95
— Prison inmates gardening
Nat Geog 181:64–5 (c,1) My '92
— Yugoslavia
Life 15:18–19 (c,1) O '92
— See also
ALCATRAZ
CONCENTRATION CAMPS
CONVICTS
PRISON LIFE
PROHIBITION
— 1932 Prohibition repeal poster
Am Heritage 44:52 (c,4) F '93
PRONGHORNS
Nat Wildlife 30:4–7 (c,1) F '92
Nat Wildlife 30:cov. (c,1) O '92
Nat Geog 184:78–9 (c,1) Jl '93
Nat Wildlife 32:19 (c,1) D '93
Nat Wildlife 33:50–1 (c,3) O '95
— Ancient pronghorns
Natur Hist 103:90–1 (painting,c,1) Ap '94
PROSPECTING
— 17th cent. slaves panning for gold (Brazil)
Nat Geog 182:84–5 (painting,c,1) S '92
— Alaska
Nat Geog 185:90–1 (c,2) My '94
— California
Trav&Leisure 23:E2 (c,4) Ap '93
— Ghana
Nat Geog 181:24–5 (c,1) Ja '92
— Laos
Trav/Holiday 178:80 (c,3) F '95
PROSTITUTION
— Late 19th cent. madam (Montana)
Life 16:80 (4) Ap 5 '93
— Late 19th cent. member of sultan's harem
(Turkey)
Trav&Leisure 24:30 (4) F '94
— 1890s prostitutes (Paris, France)
Life 15:78–9 (painting,c,2) Je '92
— Bordello (Nevada)
Nat Geog 182:52–3 (c,1) D '92

— India
Nat Geog 186:82–3 (c,1) Jl '94
— Male prostitutes (California)
Nat Geog 181:62–3 (c,1) Je '92
— Oasis Bordello Museum, Wallace, Idaho
Trav/Holiday 179:95 (c,4) S '96
Protests. See
DEMONSTRATIONS
Protozoa. See
PARAMECIA
PROVIDENCE, RHODE ISLAND
— 1780s map
Am Heritage 43:71 (c,3) D '92
PUBLIC SPEAKING
— 1860 cartoon about political speechmaking
Am Heritage 43:122 (3) S '92
— Hitler making speech (1936)
Life 19:28 (1) O '96
— Malcolm X speech (New York)
Life 15:90 (2) D '92
PUBLISHING
— Sylvia Beach
Trav/Holiday 178:87 (4) Ap '95
— See also
MAGAZINES
PUCCINI, GIACOMO
— Statue (Lucca, Italy)
Gourmet 56:100 (c,4) Mr '96
**PUEBLO INDIANS—ARCHITEC-
TURE**
— 12th cent. Cliff Palace, Colorado
Smithsonian 24:28–9 (c,1) D '93
Nat Geog 189:86–7,105 (c,1) Ap '96
— Underground kiva (New Mexico)
Trav/Holiday 176:61 (2) D '93
PUEBLO INDIANS—COSTUME
— Acoma Indians (New Mexico)
Trav&Leisure 23:138–9 (1) Ap '93
PUEBLO INDIANS—HOUSING
— Cliff dwellings (Colorado)
Trav&Leisure 23:141 (c,1) Ap '93
— Pueblos (New Mexico)
Trav&Leisure 23:136–7,145 (c,1) Ap '93
Smithsonian 24:31 (c,4) D '93
Am Heritage 45:98 (c,4) F '94
Trav/Holiday 177:56–8 (painting,c,3) Je
'94
Trav/Holiday 178:cov. (c,1) F '95
Nat Geog 189:93–5 (c,2) Ap '96
PUERTO RICO
Trav&Leisure 22:P1–P12 (c,1) D '92 supp.
Trav&Leisure 25:86–91,149 (map,c,1) Mr
'95
— Culebra
Trav/Holiday 177:73–81 (map,2) D '94

— El Morro fort
Trav&Leisure 22:52 (c,3) O '92
Trav/Holiday 179:38–9 (c,1) N '96
— Mosquito Bay
Trav&Leisure 23:186 (c,4) N '93
— Vega Baja
Sports Illus 78:60–7 (c,1) Ap 5 '93
— Vieques
Trav/Holiday 177:cov.,73–81 (1) D '94
— See also
PONCE
SAN JUAN

PUERTO RICO—COSTUME
Sports Illus 78:60–7 (c,1) Ap 5 '93

PUFFER FISH
Nat Wildlife 30:2–3 (c,1) O '92
Sports Illus 79:88 (c,4) D 13 '93
Nat Wildlife 32:8 (c,1) Je '94

PUFFINS
Trav&Leisure 22:60 (c,3) My '92
Natur Hist 102:52 (c,4) Ap '93
Gourmet 54:152 (c,4) My '94
Nat Wildlife 32:cov.,44–51 (c,1) Ag '94
Nat Geog 189:112–31 (c,1) Ja '96
— See also
AUKS

PUGET SOUND, WASHINGTON
Nat Geog 187:106–30 (map,c,1) Je '95

PUMPKINS
Gourmet 55:83 (c,1) S '95
Am Heritage 47:77 (c,4) O '96
Smithsonian 27:64–70 (c,1) O '96
— Jack-o'-lanterns (Vermont)
Trav/Holiday 175:85 (c,4) S '92
— Pumpkin farm (New York)
Life 16:70–1 (c,1) N '93
— Pumpkin festival (Ohio)
Smithsonian 27:66–7 (c,2) O '96

PUNISHMENT
— Ancient Maya torturing captives (Mexico)
Nat Geog 187:cov.,50–4 (painting,c,1) F
'95
— Beating accused murderer (Brazil)
Life 19:22 (c,2) My '96
— Depiction of 13th cent. Mongolian
atrocities
Nat Geog 190:30 (drawing,c,4) D '96
— See also
CAPITAL PUNISHMENT
LYNCHINGS
PRISONS

PUPPETS
— Hitler puppet
Smithsonian 25:111 (c,1) F '95
— Marionettes (Austria)

Gourmet 52:89 (c,4) Je '92
— Marionettes (Czechoslovakia)
Trav&Leisure 22:64–5 (c,1) Ag '92
— Maya puppet show (Mexico)
Smithsonian 23:84 (c,4) Ag '92
— Charlie McCarthy
Smithsonian 24:cov. (c,1) D '93
— Mr. Rogers' puppets
Life 15:75 (c,4) N '92
— Muppets
Life 19:30 (c,4) F '96
— Sesame Street characters
Life 17:18–22 (c,1) D '94
— Ventriloquists and their dummies
Smithsonian 24:cov.,56–67 (c,1) D '93
Life 17:136 (c,2) N '94

PURSES
— 18th cent. Yurok Indian purse (California)
Nat Geog 183:110 (c,4) Ja '93

PUSHKIN, ALEXANDER
Smithsonian 22:111–12 (painting,c,3) Ja
'92
Nat Geog 182:37,47,58–9 (painting,c,2) S
'92
— Death mask
Nat Geog 182:61 (c,2) S '92
— Home (Pskov, Russia)
Smithsonian 22:114 (c,4) Ja '92
— Wife Natalya
Smithsonian 22:116 (painting,c,4) Ja '92
— Tomb (Pskov, Russia)
Smithsonian 22:120 (c,4) Ja '92
Nat Geog 182:60 (C,4) S '92

PUZZLES
— Golf jigsaw puzzle
Sports Illus 85:5 (c,3) O 28 '96
— Man tattooed with jigsaw puzzle shapes
Nat Geog 187:11 (c,2) Je '95

PYGMIES
— 1930
Natur Hist 102:66 (4) Ja '93
— Congo
Nat Geog 188:4–5,33–45 (c,1) Jl '95

PYLE, ERNIE
Life 18:135 (4) Je 5 '95
Am Heritage 46:90 (4) S '95

PYLE, HOWARD
Smithsonian 25:89 (4) Jl '94
— Paintings by him
Smithsonian 25:90–1,95 (c,1) Jl '94

PYRAMIDS
— Ancient Moche pyramids (Peru)
Natur Hist 103:29 (c,4) My '94
— Chichen Itza, Mexico
Smithsonian 24:56–7 (c,3) Je '93

Am Heritage 46:31 (c,4) F '95
— Egypt
Trav/Holiday 175:cov.,50–1,54 (c,1) S '92
Life 17:24 (c,3) Je '94
Nat Geog 187:2–43 (c,1) Ja '95
— Giza, Egypt
Trav/Holiday 178:52 (2) Ap '95
Nat Geog 187:2–4 (c,1) My '95
— Maya pyramids (Mexico)
Trav&Leisure 22:96–7,103 (c,1) N '92
— Sudan
Smithsonian 24:92–3 (c,3) Je '93
— Teotihuacan, Mexico
Natur Hist 101:23 (c,4) Mr '92
Nat Geog 188:2–7,14–15,30–1 (c,1) D '95
— Uxmal, Mexico
Trav&Leisure 25:119 (painting,c,4) N '95
PYRAMIDS—CONSTRUCTION
— Pharaoh Khafre's pyramid, Giza, Egypt
Nat Geog 187:16–17 (painting,c,1) Ja '95
PYRENEES MOUNTAINS, FRANCE/SPAIN
Gourmet 54:65 (c,1) Ag '94
PYTHONS
Smithsonian 26:22 (c,4) Je '95
Nat Geog 189:17 (c,4) Je '96
— Albino python
Life 16:63 (c,2) Je '93

–Q–

QUAIL
Nat Wildlife 31:40–3 (c,1) O '93
Nat Wildlife 32:23 (painting,c,4) D '93
—Bobwhites
Nat Wildlife 31:40–1 (painting,c,1) O '93
QUARTZ
Nat Wildlife 31:46–51 (c,1) Je '93
—Quartz crystals
Smithsonian 24:24 (c,4) Mr '94
QUASARS
Smithsonian 22:100 (c,4) Mr '92
QUEBEC
—Bonaventure Island
Natur Hist 103:68–70 (map,c,1) My '94
—Cap Gaspe
Natur Hist 102:76 (map,c,4) My '93
—Countryside
Gourmet 53:104–7 (c,1) S '93
Nat Geog 186:104–25 (map,c,1) O '94
—Eastern townships
Trav/Holiday 178:16 (c,4) My '95
—Gaspesie Park
Natur Hist 101:22–4 (map,c,1) Je '92

—History of Charlevoix resort area
Trav&Leisure 25:68–73,101–4 (map,c,1) Jl '95
—James Bay area
Nat Geog 184:66–75 (map,c,1) N 15 '93
—Perce Rock
Natur Hist 103:68 (c,4) My '94
—See also
FORILLON NATIONAL PARK
MONTREAL
QUEBEC CITY
ST. LAWRENCE RIVER
QUEBEC CITY, QUEBEC
Trav/Holiday 175:80,82 (c,1) N '92
Nat Geog 186:108–9 (c,1) O '94
Trav/Holiday 178:68–75 (c,1) D '95
—Chateau Frontenac
Trav/Holiday 178:68–73 (c,1) D '95
QUEEN, ELLERY
—Ellery Queen writers Dannay and Lee
Am Heritage 44:43 (4) Jl '93
QUILTING
—Amish quilters (Ohio)
Trav/Holiday 179:54–8 (c,1) O '96
QUILTS
—1867
Am Heritage 43:61 (c,2) F '92
—1890s Chinese quilt (Montana)
Life 17:48 (c,4) N '94
—AIDS quilt
Life 19:22 (c,2) D '96
—Amish quilts (Ohio)
Trav/Holiday 179:54 (c,4) O '96
—Antebellum quilts
Smithsonian 27:95–7 (c,2) N '96
—Depicting idyllic Kansas scene
Nat Geog 183:89 (c,1) Mr '93
—Imaginative quilted playing cards
Smithsonian 25:119–21 (c,2) Mr '95
—Quilt depicting 1952 events and personalities
Am Heritage 44:102 (c,2) F '93
QUITO, ECUADOR
Trav&Leisure 23:118,126 (c,4) Ja '93

–R–

RABBITS
— Ancient rabbit
Natur Hist 103:57 (drawing,4) Ap '94
— Brown hares
Natur Hist 103:cov.,43–5 (c,1) Jl '94
— Cottontails
Nat Geog 184:113 (c,3) O '93

— Snowshoe hares
 Natur Hist 102:26-33 (c,1) F '93
 Nat Wildlife 32:6-7 (c,1) D '93
 Nat Wildlife 33:17–19 (c,1) Je '95
— Woolly hare
 Nat Geog 184:69 (c,4) Ag '93
— See also
 JACK RABBITS

RACCOONS
 Nat Wildlife 34:34–5 (painting,c,1) Ag '96

RACE TRACKS
— 1910 Bennings betting shed, Washington, D.C.
 Am Heritage 45:42 (4) S '94
— 1939 betting windows (Hialeah, Florida)
 Am Heritage 45:34 (4) S '94
— Flemington, Melbourne, Australia
 Gourmet 52:104–5 (c,2) Ap '92
— Saratoga, New York
 Trav/Holiday 178:82 (c,4) Je '95
— Simulcasting races (Minnesota)
 Sports Illus 83:61 (c,3) Jl 10 '95
— York, England
 Trav&Leisure 25:86–7 (c,1) Je '95

RACES
— 1908 "Great Car Race" from New York to Paris
 Am Heritage 47:64–77 (c,1) N '96
— 1932 National Air Race plane "Gee Bee"
 Am Heritage 44:93 (painting,c,4) D '93
— Camel race (Oman)
 Nat Geog 187:118–19 (c,1) My '95
— Chuckwagon race (Arkansas)
 Sports Illus 81:83 (c,4) O 17 '94
— Easter Island festival
 Nat Geog 183:64–5 (c,1) Mr '93
— Greased codfish relay race (Maine)
 Sports Illus 85:9 (c,4) S 16 '96
— Handcar racing
 Sports Illus 77:5–6 (c,3) S 21 '92
— Iditarod (Alaska)
 Natur Hist 105:37–40 (c,1) Mr '96
— Kinetic challenge race of human-powered amphibious craft (Colorado)
 Life 19:24–7 (c,2) Jl '96
— Lawn mower race (Great Britain)
 Sports Illus 77:106 (c,4) S 7 '92
— Race on Miami street, Florida
 Sports Illus 80:10–11 (c,2) Ja 31 '94
— Relay race
 Sports Illus 78:2–3 (c,1) My 3 '93
 Sports Illus 79:18–19 (c,1) Ag 30 '93
— Sack race (Somalia)
 Sports Illus 78:60–1 (c,1) Ap 12 '93
— Soap box derby (Ohio)

 Life 15:24 (c,4) Ag '92
— Water buffalo race (Thailand)
 Sports Illus 85:95 (c,3) D 9 '96
— Wheelchair races
 Sports Illus 83:68 (c,1) Ag 14 '95
 Sports Illus 85:11 (c,2) Ag 26 '96
— See also
 AUTOMOBILE RACING
 BICYCLE RACES
 BOAT RACES
 MARATHONS
 SAILBOAT RACES
 SKIING COMPETITIONS
 SWIMMING COMPETITIONS
 TRACK

RACQUETBALL PLAYING
 Sports Illus 79:62 (c,3) N 1 '93
 Sports Illus 84:98 (c,3) Je 10 '96

RADIO BROADCASTING
— 1921 opera broadcast (Colorado)
 Am Heritage 43:99 (4) F '92
— 1940s quiz show
 Am Heritage 46:34 (4) S '95
— 1956 Grand Ole Opry broadcast
 Life 18:41 (c,4) N '95
— Boy listening to baseball game on radio
 Sports Illus 79:2–3 (painting,c,1) Ag 23 '93
— Caricatures of 1938 radio personalities
 Am Heritage 46:96–7 (c,1) D '95
— Listening to bedside radio (1940s)
 Smithsonian 27:22 (4) Ap '96
— See also
 DISC JOCKEYS

RAFTING
— Alaska
 Nat Geog 183:78–9 (painting,c,1) Ap '93
 Trav/Holiday 176:33 (c,4) Je '93
 Gourmet 54:153 (c,1) My '94
 Smithsonian 26:62–3 (c,2) Je '95
— Amazon River, Brazil
 Life 15:66–9 (c,2) Jl '92
— Chile
 Nat Geog 185:120–1 (c,1) Ap '94
— Colorado
 Trav/Holiday 179:76,79 (c,1) Ap '96
— Thor Heyerdahl rafting in South Seas (1947)
 Life 18:58–9 (1) D '95
— Idaho
 Smithsonian 23:36–7 (c,4) S '92
 Nat Geog 185:35 (c,3) F '94
— Jamaica
 Gourmet 56:95 (c,4) F '96
— Klamath River, Oregon

Trav&Leisure 23:171 (c,4) Mr '93
— Lanzhou villager rafting on Huang He
 River, China
 Trav&Leisure 24:82–3 (c,1) Mr '94
— Peru
 Nat Geog 183:120–37 (c,1) Ja '93
— Princess Diana rafting (Colorado)
 Life 19:12 (c,4) Ja '96
— Rafters in life vests (Zambia)
 Trav&Leisure 22:86–7 (c,1) N '92
— Shuiluo River, China
 Nat Geog 190:116–29 (c,1) N '96
— Utah
 Trav&Leisure 26:E8 (c,2) My '96
— West Virginia
 Am Heritage 46:34 (c,4) Ap '95
 Gourmet 56:186–9 (c,1) My '96
— Women's rafting team
 Sports Illus 78:4 (c,4) Je 28 '93

RAILROAD INDUSTRY
— 1887 cartoon about need for railroad
 regulation
 Am Heritage 47:22 (4) My '96
— Overhauling locomotive (Alberta)
 Nat Geog 186:53 (c,3) D '94
— Railroad car wheel factory (Pennsylvania)
 Nat Geog 185:52–3 (c,1) Je '94

RAILROAD STATIONS
— 1937 (Baltimore, Maryland)
 Am Heritage 43:62–3 (painting,c,1) F '92
— Budapest, Hungary
 Trav&Leisure 24:89 (c,4) O '94
— Cheyenne, Wyoming
 Am Heritage 45:96 (c,4) Ap '94
— Cincinnati, Ohio
 Smithsonian 23:102–5 (c,1) Je '92
— Commuter station (Massachusetts)
 Am Heritage 43:114 (c,4) D '92
— Grand Central Terminal, New York City,
 New York
 Trav&Leisure 23:113 (4) Ja '93
 Trav&Leisure 25:97 (c,4) D '95
— Grand Central Terminal miniature (1913)
 Am Heritage 47:8 (c,4) D '96
— Lille, France
 Trav&Leisure 26:85 (c,4) O '96
— Orlando, Florida
 Trav&Leisure 24:E1 (c,4) Je '94
— Satolas, France
 Smithsonian 27:76,88 (c,1) N '96
— 30th Street Station, Philadelphia,
 Pennsylvania
 Trav/Holiday 179:56–7 (c,1) S '96
— Union Station, St. Louis, Missouri
 Am Heritage 45:100–1 (c,2) Jl '94

— Waterloo Terminal, London, England
 Trav/Holiday 178:31 (c,4) Jl '95
— Zurich, Switzerland
 Smithsonian 27:82 (c,4) N '96

RAILROAD TRACKS
— Altoona, Pennsylvania
 Nat Geog 185:53 (c,3) Je '94
— California
 Gourmet 55:157 (c,1) My '95
— Canada
 Nat Geog 186:36–7,46–57 (c,1) D '94
— Mexico
 Trav/Holiday 178:50–1,56 (c,1) D '95

RAILROAD WORKERS
 Smithsonian 26:38–47 (c,4) Je '95
— Late 19th cent. (New York)
 Life 16:87 (3) F '93
— 1910s women railroad workers
 Am Heritage 46:106 (4) Jl '95
— 1940s women railroad workers
 Am Heritage 46:62–74 (1) Jl '95
— 1950s (Virginia)
 Smithsonian 26:64–5 (3) O '95
— Redcaps
 Trav/Holiday 176:18–19 (4) S '93
— Siberia
 Trav&Leisure 23:124 (c,4) Ap '93

RAILROADS
— 1869 railroad trestle (Utah)
 Life 16:12–13 (1) Ap 5 '93
— 1920s (Montana)
 Trav&Leisure 25:160 (painting,c,4) O '95
— 1950s steam railway (West Virginia)
 Life 19:96–100 (1) D '96
— Canadian Pacific Rail System
 Nat Geog 186:36–65 (map,c,1) D '94
— Danish Railway insignia
 Trav&Leisure 25:92 (c,2) Mr '95
— Durango & Silverton Narrow-Gauge
 Railroad, Colorado
 Am Heritage 47:124–5,132–3 (c,1) Ap '96
— Freight trains
 Smithsonian 26:36–49 (c,1) Je '95
— Horseshoe Curve railway, Altoona,
 Pennsylvania
 Smithsonian 26:36–7 (c,1) Je '95
— Model trains
 Sports Illus 78:58–9 (c,1) My 10 '93
— Monorail (Sydney, Australia)
 Trav/Holiday 176:48–9 (c,1) Je '93
— Mount Washington's cog railway, New
 Hampshire
 Trav&Leisure 22:E10 (c,4) O '92
— Pennsylvania
 Am Heritage 44:30 (c,4) Ap '93

— Railroad bridge at Victoria Falls,
Zimbabwe
Life 18:98–9 (c,1) N '95
— Steam narrow-gauge railroad
(Pennsylvania)
Smithsonian 27:55 (c,4) S '96
— See also
LOCOMOTIVES
RAILROAD STATIONS
RAILROAD WORKERS
SUBWAYS
TRAINS

RAILS (BIRDS)
— Clapper rails
Nat Wildlife 31:12–13 (c,1) D '92

RAIN
— 1994 Woodstock II attendees in the rain
(New York)
Life 17:12–13 (c,1) O '94
— Commuters bicycling in the rain
(Shanghai, China)
Nat Geog 185:cov.,8–9 (c,1) Mr '94
— Impressionistic view of Maine island after
rain
Trav&Leisure 24:E16 (c,4) Mr '94
— Over Yosemite Valley, California
Nat Geog 186:12–13 (c,1) O '94
— Rain dance (Mexico)
Nat Geog 184:99–101 (c,1) N '93
— Tourists seeking shelter from summer rain
(Massachusetts)
Nat Geog 181:118–19 (c,2) Je '92
— See also
STORMS

RAIN FORESTS
Nat Wildlife 31:19–36 (c,1) Ap '93
Natur Hist 103:52 (c,1) N '94
— Belize
Nat Geog 184:118–30 (c,1) S '93
— Borneo
Nat Geog 189:115 (c,2) Ap '96
— Colombia
Smithsonian 24:118–19 (c,2) S '93
Nat Geog 184:124 (c,4) D '93
— Costa Rica
Smithsonian 24:110–11 (c,1) S '93
Trav&Leisure 24:158–9 (c,4) F '94
Life 17:58–68 (c,1) Je '94
Trav/Holiday 177:86–7 (c,2) O '94
Trav/Holiday 179:74–81 (c,1) O '96
— Ecuador
Nat Wildlife 30:42–3 (c,1) Ap '92
Trav/Holiday 176:72–81 (c,1) Je '93
— El Salvador
Nat Geog 188:126–7 (c,2) S '95

— Fire in Brazil rain forest
Natur Hist 101:48 (c,4) Ag '92
Nat Wildlife 31:22–3 (c,1) Ap '93
— Latin America
Smithsonian 24:110–19 (c,1) S '93
Trav/Holiday 176:65 (painting,c,1) N '93
— Papua New Guinea
Nat Geog 185:40–63 (c,1) F '94
— Peru
Nat Geog 185:133–5 (c,1) Ja '94
— Rain forest wildlife
Nat Wildlife 31:20–8 (c,1) Ap '93
— Tanzania
Trav&Leisure 26:94–100 (painting,c,3) S
'96
— Zaire
Natur Hist 102:47 (c,2) My '93

RAINBOW BRIDGE NATIONAL MONUMENT, UTAH
Trav/Holiday 178:43 (c,3) Jl '95

RAINBOWS
Nat Wildlife 32:54–5 (c,1) D '93
Nat Geog 186:72–3 (c,1) N '94
— Dominican Republic
Nat Geog 181:40–1 (c,1) Ja '92
— Over Dominica
Trav&Leisure 23:148 (c,3) My '93
— Over harbor (Spain)
Nat Geog 181:29 (c,3) Ap '92
— Over Victoria Falls, Zambia/Zimbabwe
Trav&Leisure 22:94–5 (c,1) N '92

RAINWEAR
— Hikers in rain gear (Montana)
Trav/Holiday 177:58 (c,3) Mr '94
— Slickers (Niagara Falls, New York/Ontario)
Trav/Holiday 176:46–7 (c,1) Jl '93

RAMSES II (EGYPT)
Trav/Holiday 175:60–1 (sculpture,c,1) S
'92

RANCHES
— Argentina
Trav&Leisure 25:81–95 (c,1) Ja '95
— Arizona
Trav&Leisure 22:114–24 (c,1) O '92
— Australia
Nat Geog 181:76–83 (c,1) Ap '92
— Colorado
Sports Illus 81:68–9,72–4 (c,1) S 12 '94
Nat Geog 190:96–7 (c,2) N '96
— Dude ranch (British Columbia)
Gourmet 53:108–13 (c,1) O '93
— Dude ranch (Montana)
Gourmet 54:146–9 (c,1) My '94
— Dude ranch (Wyoming)
Trav&Leisure 25:130–3,173 (c,2) Ap '95

— Family vacation at ranch (Colorado)
 Trav/Holiday 176:68–76 (c,1) Jl '93
— Sheep ranch (Wales)
 Nat Geog 184:108–9 (c,1) S '93

RANCHING
— Late 19th cent. cattle branding (Montana)
 Trav/Holiday 176:69 (4) Je '93
— Alaska
 Nat Geog 184:42–3 (c,1) N '93
— Alberta
 Nat Geog 188:66–7 (c,1) Jl '95
— Branding cattle (Australia)
 Nat Geog 181:76–7 (c,1) Ap '92
— Calf roundup (Texas)
 Life 18:24–8 (c,2) S '95
— California
 Smithsonian 26:114–25 (c,1) Ap '95
— Carrying calf (Mexico)
 Nat Geog 190:114–15 (4) Ag '96
— Cattle ranching (Idaho)
 Nat Geog 185:2–3,26–7,36–9 (c,1) F '94
— Cattle ranching (Nevada)
 Life 16:40–1 (c,1) Ap 5 '93
— Cattle ranching (Virgin Islands)
 Trav/Holiday 176:90 (c,3) O '93
— Cut-off lamb tails (Wyoming)
 Nat Geog 185:6–7 (c,1) F '94
— Dipping sheep (France)
 Nat Geog 188:86 (c,1) N '95
— Dogs herding cattle (Australia)
 Nat Geog 181:78–9 (c,1) Ap '92
— Goat ranch (Utah)
 Life 19:78–81 (1) Ap '96
— Herding cattle (Oregon)
 Nat Wildlife 34:77 (c,4) D '95
— Herding sheep (Nevada)
 Nat Geog 182:56–7 (c,1) D '92
— Lassoing cat (Texas)
 Life 15:92 (c,2) My '92
— Mexico
 Nat Geog 186:60–1 (c,1) S '94
— Ranch hands (Australia)
 Nat Geog 189:26–7 (c,1) Je '96
— Shearing sheep (Genoa, Italy)
 Nat Geog 181:14–15 (c,1) Ja '92
— Shearing sheep (Great Britain)
 Nat Geog 186:6–7 (c,1) Ag '94
— Sheep (Idaho)
 Natur Hist 101:50–1,57 (c,1) O '92
— Sheep (Wyoming)
 Nat Geog 183:66–7 (c,1) Ja '93
— Transporting cattle (Louisiana)
 Natur Hist 104:38–9 (c,2) My '95
— Wyoming
 Life 16:78–9 (c,1) Ap 5 '93

 Life 17:88–9 (c,2) Mr '94
— See also
 COWBOYS

RANGOON, BURMA
 Nat Geog 188:87 (c,1) Jl '95

RANKIN, JEANNETTE
 Am Heritage 43:34 (4) Ap '92
 Trav/Holiday 176:69 (4) Je '93

RASPBERRIES
 Gourmet 55:89 (drawing,c,4) Ag '95

RATS
 Natur Hist 105:18–19 (c,1) Je '96
— Killing plague-ridden rats (India)
 Life 18:54 (c,3) Ja '95

RATTLESNAKES
 Smithsonian 22:38 (c,4) F '92
 Nat Geog 182:44–5 (c,1) D '92
 Trav&Leisure 24:E1 (c,4) Ja '94
 Nat Geog 185:2–3 (c,1) Ap '94
 Natur Hist 104:50–1,54 (c,2) Ap '95
 Nat Wildlife 33:14–21 (c,1) Ag '95
— Snake eating a rat
 Natur Hist 104:50–1 (c,2) Ap '95

RAVENS
 Natur Hist 102:50–7 (c,1) O '93

RAYBURN, SAM
 Am Heritage 46:22 (4) Jl '95

RAYS
 Smithsonian 24:94,96 (c,1) Ag '93
— Cow-nose rays
 Life 16:18–19 (c,1) F '93
— Golden rays
 Natur Hist 105:46–7 (c,1) S '96
— Manta rays
 Natur Hist 102:100–1 (c,1) Mr '93
 Sports Illus 78:5–6 (c,2) My 3 '93
 Nat Geog 188:36–51 (c,1) D '95
— Marble rays
 Sports Illus 79:88 (c,4) D 13 '93
— See also
 STINGRAYS

RAZORS
— History of razors and razor blades
 Smithsonian 25:44–53 (c,1) F '95

READING
— Adult reading to children
 Smithsonian 25:83–90 (c,1) F '95
— Businessman reading newspaper (London,
 England)
 Trav/Holiday 175:15 (c,4) My '92
— In park (Seville, Spain)
 Trav&Leisure 22:89 (c,3) Ja '92
— Man reading newspaper in cafe (New
 Mexico)
 Smithsonian 26:89 (2) O '95

— Men reading newspapers (Vietnam)
 Life 18:18 (c,2) Ap '95
— Reading newspaper (Great Britain)
 Trav&Leisure 26:125 (1) My '96
— Reading newspaper at outdoor cafe
 (France)
 Gourmet 53:94 (c,3) My '93
— Reading newspaper at outdoor cafe
 (Seattle, Washington)
 Gourmet 56:52 (c,2) Ja '96
— Reading newspaper in cafe (Budapest,
 Hungary)
 Trav/Holiday 175:61 (3) My '92
— Tutoring illiterate man (Vermont)
 Smithsonian 27:82–3,86 (1) Ag '96

REAGAN, RONALD
 Trav/Holiday 175:110 (4) N '92
 Sports Illus 78:20 (c,4) Je 14 '93
 Am Heritage 44:59 (4) O '93
 Smithsonian 25:141 (c,4) D '94
 Am Heritage 46:77 (4) Jl '95
— 1966 Brown vs. Reagan governor's race
 (California)
 Am Heritage 47:39–60 (c,2) O '96
— As a teenager
 Am Heritage 47:32 (4) D '96
— Boyhood home (Dixon, Illinois)
 Trav&Leisure 26:80 (c,4) S '96
— Nancy Reagan
 Smithsonian 23:158 (c,2) O '92
 Life 16:26 (c,4) F '93
 Sports Illus 78:88–9 (c,2) Ap 12 '93

RECORDING INDUSTRY
— 1985 "We are the World" recording session
 Life 18:94 (c,4) O '95
— Five-year-old rapper recording song
 (France)
 Life 16:20 (c,4) Ap '93
— History of Motown
 Smithsonian 25:82–95 (c,1) O '94
— Recording nature sounds
 Smithsonian 26:151–61 (c,2) Ap '95
— Recording studio (New York)
 Natur Hist 105:24–5 (c,1) Mr '96
— Sun Records headquarters, Memphis,
 Tennessee
 Trav/Holiday 177:114 (4) Mr '94

RECORDS
— 1930 country record sleeve
 Am Heritage 45:6 (2) N '94
— 1940s recorded message from soldier
 Life 18:91 (c,2) Je 5 '95
— 1963 singles
 Life 16:31–4 (c,4) Je '93
— 45 R.P.M record

 Life 15:114 (c,2) D 1 '92
— Innovative CD packages
 Smithsonian 27:66 (c,2) Ap '96
— "Sgt. Pepper" record cover
 Life 19:25 (c,4) Ag '96
— 78 R.P.M. records by Louis Armstrong
 Smithsonian 27:25 (c,4) Ag '96

Recreation. See
 list under AMUSEMENTS
 list under SPORTS

RECREATIONAL VEHICLES
 Smithsonian 25:45 (c,2) Je '94
— Parking lot full of campers (Pennsylvania)
 Nat Geog 185:47 (c,4) Je '94
— See also
 SNOWMOBILES

RECYCLING
 Nat Geog 186:cov.,92–115 (c,1) Jl '94
— Bringing cans to recycling center (New
 York)
 Life 16:22 (4) My '93
— Compacted trash (Antarctica)
 Life 16:83 (c,2) Mr '93
— Soda bottles recycled into fabric
 Life 17:138–40 (c,4) N '94
— Soda can replica of church (Padua, Italy)
 Life 16:22 (c,4) Ap '93
— Turning recycled Nikes into track surface
 Sports Illus 83:8 (c,4) O 16 '95

RED SEA
 Nat Geog 184:60,70 (map,c,1) N '93
— Marine life
 Nat Geog 184:cov.,60–87 (c,1) N '93
— View from space
 Nat Geog 190:12–13 (c,1) N '96

REDPOLLS (BIRDS)
 Nat Wildlife 33:55 (c,1) F '95

REDSTARTS (BIRDS)
 Nat Wildlife 32:20 (c,1) Ap '94
 Nat Wildlife 32:16 (c,2) O '94

REDWINGED BLACKBIRDS
 Nat Wildlife 33:44–5 (c,1) D '94
— Chicks
 Nat Wildlife 31:40 (c,3) Je '93

**REDWOOD NATIONAL PARK, CALI-
FORNIA**
 Smithsonian 24:42–55 (c,1) O '93
 Natur Hist 104:A1 (c,1) Ap '95
— Beach
 Nat Geog 186:50–1 (c,1) O '94

REDWOOD TREES
 Smithsonian 24:44–5,55 (c,3) O '93
 Trav/Holiday 177:80–8 (1) Ap '94
 Smithsonian 26:106 (c,3) D '95

REFUGEE CAMPS
— Malawi (1988)
 Life 19:94 (c,2) Je '96
— Palestinian (Israel)
 Nat Geog 181:100–1 (c,1) Je '92
 Nat Geog 190:32–3,38–9 (c,1) S '96
— Palestinian (Syria)
 Nat Geog 190:118 (c,1) Jl '96
— Somali (Kenya)
 Life 15:7 (c,1) N '92
— Sudan
 Life 15:50–8 (c,1) Je '92
— Tent city for 1992 Hurricane Andrew
 homeless (Florida)
 Nat Geog 183:24–5 (c,1) Ap '93
REFUGEES
— Bosnian refugees
 Nat Geog 183:94–5,112–19 (c,1) My '93
— Croatian Serb refugees on the move
 Nat Geog 189:53 (2) Je '96
— Cuban (Florida)
 Nat Geog 181:96–9 (c,1) Ja '92
 Life 17:22 (c,2) O '94
— Cuban refugees at sea on flimsy raft
 Life 17:20–1 (c,1) N '94
— Eritrean refugees returning
 Nat Geog 189:84–5 (c,1) Je '96
— Haitian boat people
 Life 15:52–9 (c,1) Ap '92
 Life 16:12–13 (c,1) Ja '93
 Smithsonian 23:55 (c,3) Ja '93
— Jewish refugees from Nazism aboard ship
 Am Heritage 45:89 (4) F '94
— Kurdish (Germany)
 Nat Geog 182:47–9 (c,2) Ag '92
— Kurdish (Sweden)
 Nat Geog 184:28–9 (c,1) Ag '93
— Rwandan refugees (Tanzania)
 Life 17:15 (3) Jl '94
— Rwandan refugees (Zaire)
 Life 18:30–1 (1) Ja '95
 Life 18:36–44 (c,1) F '95
 Nat Geog 188:60–2,70–4 (c,1) O '95
 Life 19:78 (c,2) Ja '96
 Life 19:14–15 (c,1) Ap '96
— Soviet Jews (Israel)
 Nat Geog 181:40–65 (c,1) F '92
REIMS, FRANCE
 Trav/Holiday 178:58 (c,3) N '95
— Reims Cathedral
 Trav/Holiday 178:72 (c,3) S '95
REINDEER
 Nat Geog 182:94–6 (c,1) O '92
 Trav/Holiday 179:cov.,96 (c,1) D '96

— Reindeer practicing flying for Santa's
 journey
 Life 16:102–4 (c,2) D '93
RELIGIONS
— Birth of the Theosophical Society
 Smithsonian 26:110–27 (1) My '95
— See also
 BUDDHISM
 CHRISTIANITY
 GREEK ORTHODOX
 HINDUISM
 JUDAISM
 MORMONS
 MUSLIMS
 RUSSIAN ORTHODOX CHURCH
 SHAKERS
 SHINTOISM
 TAOISM
 VOODOO
RELIGIOUS LEADERS
— Branch Davidian cult leader David Koresh
 Life 17:39 (4) Ja '94
— Dalai Lama
 Life 17:86–7 (c,1) Mr '94
— Mormon James Strang
 Smithsonian 26:85 (4) Ag '95
— Menachem Schneerson
 Life 18:86 (c,2) Ja '95
— See also
 EDDY, MARY BAKER
 GRAHAM, BILLY
 JESUS CHRIST
 MOSES
 POPES
 YOUNG, BRIGHAM
RELIGIOUS RITES AND FESTIVALS
— 1925 Xhosa coming of age dance (South
 Africa)
 Nat Geog 190:132 (3) Jl '96
— Ancient Moche human sacrifice ceremony
 (Peru)
 Natur Hist 103:33 (drawing,4) My '94
— Apache puberty ceremony (Southwest)
 Nat Geog 182:56–7 (c,1) O '92
— Body painted for initiation rite (Argentina)
 Natur Hist 104:62 (4) Mr '95
— Body piercing by ancient Maya (Mexico)
 Nat Geog 187:68–9 (painting,c,1) F '95
— End of winter celebrations (U.S.S.R.)
 Natur Hist 102:34–9 (c,1) Ja '93
— Female circumcision ritual (Africa)
 Natur Hist 105:42–53 (c,1) Ag '96
— Human sacrifice by the Incas (Peru)
 Nat Geog 181:100–3 (c,1) Mr '92

— Inca pilgrimages to Andes peaks
Nat Geog 181:84–111 (c,1) Mr '92
— Offerings to gods (Hawaii)
Trav/Holiday 177:68–9 (c,1) Ap '94
— Rituals of various religions
Life 19:76–80 (c,1) Jl '96
— Xhosa manhood ritual (South Africa)
Nat Geog 183:66–7 (c,1) F '93
Nat Geog 190:132 (3) Jl '96
— See also
ANIMAL SACRIFICE
BAPTISMS
COMMUNION
FUNERAL RITES AND CEREMONIES
MARRIAGE RITES AND CUSTOMS
MASKS, CEREMONIAL
MEDITATION
PRAYING
VOODOO

REMBRANDT
— Portrait of wife Saskia (1634)
Smithsonian 25:44 (painting,c,4) Mr '95
— "The Storm on the Sea of Galilee"
Smithsonian 26:34 (painting,c,4) S '95
— Works by Rembrandt
Smithsonian 26:82–91 (painting,c,2) D '95

REMINGTON, FREDERIC
— "Stormy Morning in the Badlands" (1905)
Am Heritage 47:8 (painting,c,2) My '96

RENO, NEVADA
— Early 20th cent. history of Reno divorce
industry
Smithsonian 27:64–73 (c,1) Je '96
— 1940s
Smithsonian 27:66–7 (c,2) Je '96

RENOIR, AUGUSTE
— "Bathers" (1918)
Smithsonian 24:106 (painting,c,4) My '93
— "La Grenouillere" (1869)
Smithsonian 25:84 (painting,c,4) N '94
— Portrait of Jeanne Durand-Ruel
Life 16:83 (painting,c,4) Ap '93
— "Young Boy with Cat" (1869)
Smithsonian 25:80 (painting,c,4) N '94

REPRODUCTION
— Blenny fish hatching
Nat Geog 182:106–7 (c,1) Jl '92
— Butterflies
Nat Geog 184:128–31 (c,1) D '93
— Chicken embryos
Life 19:40–4 (c,1) N '96
— Chimpanzee embryo
Life 19:46–7 (c,1) N '96
— Corals spawning
Nat Geog 182:130 (c,4) D '92

— Dunnock birds copulating
Natur Hist 104:70 (drawing,4) Ap '95
— Fish hatching
Life 19:50 (c,4) N '96
— Gannet birds mating
Natur Hist 101:38–9 (c,1) Ja '92
— Iguanodon dinosaurs mating
Natur Hist 104:58 (painting,c,1) Je '95
— Iguanas mating
Natur Hist 101:42–3 (c,1) Ja '92
— In vitro fertilization
Life 16:84,90 (c,4) D '93
— Lemur embryo
Life 19:41 (c,4) N '96
— Lions mating
Natur Hist 101:76–7 (c,1) Ap '92
Life 19:81 (c,4) My '96
— Macaque embryos
Life 19:39–49 (c,1) N '96
— Octopus hatchling emerging from egg
Nat Wildlife 30:9 (c,4) Je '92
— Pig embryos
Life 19:40–8 (c,1) N '96
— Pukeko birds mating
Natur Hist 102:56–7 (c,1) Jl '93
— Roadrunners copulating
Smithsonian 23:62 (c,4) Mr '93
— Sharks mating
Nat Geog 187:44–53 (c,1) My '95
— Silkworm moths mating
Nat Wildlife 32:56–7 (c,1) Ap '94
— Stick insects mating
Natur Hist 101:30,34–5 (c,1) Je '92
— Terns mating
Natur Hist 102:46–7 (c,1) Je '93
— Toads mating
Life 19:14 (c,2) Jl '96
— Wood frogs mating
Nat Geog 182:8 (c,3) O '92
— See also
BABIES
CHILDBIRTH
PREGNANCY

REPTILES
— Ichthyosaurs
Natur Hist 101:48–53 (painting,c,1) S '92
— See also
ALLIGATORS
CROCODILES
DINOSAURS
GAVIALS
LIZARDS
SNAKES
Research. See
MEDICAL RESEARCH

SCIENTIFIC EXPERIMENTS
RESERVOIRS
— Clear Creek, Colorado
 Natur Hist 102:43 (3) N '93
RESORTS
— 1880s lake resort for Pittsburgh's elite,
 Pennsylvania
 Am Heritage 43:120–7 (1) N '92
— Anguilla, Leeward Islands
 Gourmet 54:128–31,200–2 (map,c,1) D
 '94
— Antigua
 Trav&Leisure 23:110–19 (c,1) O '93
— Banff Springs Hotel, Alberta
 Nat Geog 188:60–1 (c,1) Jl '95
— Beaver Creek, Colorado
 Trav&Leisure 23:E1–E2 (map,c,3) Ja '93
— Bora Bora
 Trav&Leisure 22:cov.,112–21,152 (c,1) N
 '92
 Trav&Leisure 24:cov.,128–39 (map,c,1)
 Je '94
— Cancun, Mexico
 Nat Geog 190:112–13 (c,1) Ag '96
— Caribbean resort hotels
 Trav&Leisure 22:84–95,146–9 (c,1) D '92
— French Riviera
 Trav&Leisure 22:cov.,114–25 (map,c,1)
 Je '92
— History of Charlevoix resort area, Quebec
 Trav&Leisure 25:68–73,101-4 (map,c,1)
 Jl '95
— History of Pinehurst resort, North Carolina
 Am Heritage 46:55–62 (4) F '95
— Home Ranch, California
 Trav&Leisure 22:102–9 (c,1) F '92
— Huatulco, Mexico
 Trav/Holiday 176:17 (c,4) N '93
— Lost City resort, South Africa
 Trav&Leisure 23:48 (c,4) Ap '93
— Mohonk Mountain House, New Paltz,
 New York
 Trav&Leisure 22:E2 (c,4) Ap '92
 Smithsonian 27:38–9 (c,2) Ag '96
— Moyo, Indonesia
 Trav&Leisure 23:96–103,158 (map,c,1) N
 '93
— Nissi Beach, Cyprus
 Nat Geog 184:124–5 (c,2) Jl '93
— Puerto Vallarta, Mexico
 Nat Geog 190:90–1 (c,2) Ag '96
— La Samanna, St. Martin
 Trav&Leisure 23:74–85 (c,1) F '93
— Southern Florida's Gold Coast

Trav&Leisure 25:135–46,182–8 (map,c,1)
 N '95
— Vietnam
 Smithsonian 26:38–9 (c,2) Ja '96
— See also
 BEACHES, BATHING
 HOT SPRINGS, ARKANSAS
 HOTELS
 MACKINAC ISLAND
 MIAMI BEACH
 SKI RESORTS
 SPAS
RESTAURANTS
 Gourmet 56:entire issue (c,1) O '96
— 1909 (Paris, France)
 Am Heritage 43:80–1 (painting,c,1) Jl '92
— 1920s cafe shaped like a coffee pot
 (Pennsylvania)
 Am Heritage 46:52 (c,4) Ap '95
— 1931 restaurant window (New York)
 Am Heritage 43:92–3 (1) N '92
— 1946 diner (Massachusetts)
 Am Heritage 44:35 (c,1) Ap '93
— 1950s style luncheonette (Massachusetts)
 Smithsonian 23:100–11 (c,1) My '92
— Altoona, Pennsylvania
 Nat Geog 185:38–9 (c,1) Je '94
— Blackboard menu (France)
 Gourmet 56:182 (c,4) My '96
— Buckhead Diner, Atlanta, Georgia
 Gourmet 53:96 (c,4) Ap '93
— Budapest patisserie, Hungary
 Trav&Leisure 24:94–5 (c,1) O '94
— Cafe (Germany)
 Trav&Leisure 23:47 (c,4) F '93
 Trav&Leisure 26:51,55–6 (c,1) Ja '96
— Cafe (Italy)
 Trav/Holiday 175:55,58 (4) N '92
— Cafe (Mexico)
 Trav&Leisure 22:98–9 (c,1) N '92
 Trav&Leisure 23:110–11 (c,1) Je '93
— Cafe (Netherlands)
 Trav&Leisure 26:89 (c,1) F '96
— Cafe (Portugal)
 Trav/Holiday 177:48–9 (c,1) N '94
— Cafe (Vienna, Austria)
 Trav/Holiday 179:69 (c,1) O '96
— Cafe menu covers (Paris, France)
 Trav&Leisure 23:34 (c,3) Jl '93
— Cairo, Egypt
 Gourmet 52:94 (c,4) S '92
— Chez Panisse, Berkeley, California
 Gourmet 52:52,54 (c,3) Je '92
— Chinese restaurants in the U.S. (1850s to
 the present)

Smithsonian 24:86–95 (c,2) Ja '94
— Commander's Palace, New Orleans, Louisiana
Gourmet 56:82,180 (c,2) O '96
— Country restaurants (North Carolina)
Gourmet 54:112 (c,2) D '94
— Criterion, London, England
Trav&Leisure 23:84 (c,4) Ap '93
— Dime store lunch counters
Smithsonian 25:106–7,113 (c,1) Je '94
— Diner
Gourmet 54:66 (painting,c,2) F '94
— Diner (New Hampshire)
Trav/Holiday 175:81 (c,4) S '92
— Diner (New York)
Gourmet 53:102 (c,3) My '93
Life 16:78–9 (c,1) Ag '93
— Diner (Texas)
Trav&Leisure 23:140 (c,4) F '93
— Diners (Rhode Island)
Gourmet 56:110–12 (c,4) N '96
— Drive-in restaurant (Illinois)
Life 19:92–3 (c,1) Winter '96
— Floating restaurant (Ho Chi Minh City, Vietnam)
Nat Geog 187:80–1 (c,2) Ap '95
— Florence, Italy
Gourmet 53:98–103 (c,1) S '93
— The Four Seasons, New York City, New York
Gourmet 52:40,44 (c,3) D '92
Gourmet 53:90 (c,4) Ap '93
— France
Smithsonian 23:48–51 (c,3) My '92
— Fresh fish counter at Lisbon restaurant, Portugal
Trav&Leisure 23:56 (c,4) O '93
— Georgia
Life 19:66–7 (c,1) N '96
— German restaurants (Minnesota)
Trav/Holiday 179:26–7 (c,4) Jl '96
— Hong Kong
Trav/Holiday 178:35–6 (c,4) N '95
Trav&Leisure 25:38–44 (c,3) D '95
— Hot U.S. restaurants
Trav&Leisure 23:88–96 (c,1) Ja '93
Gourmet 53:86–116 (c,2) Ap '93
— India
Trav&Leisure 25:50–4 (c,4) Ap '95
— Joe's Stone Crab restaurant sign, Miami, Florida
Trav/Holiday 177:18 (c,4) D '94
— Logos of famous restaurants
Gourmet 53:86 (c,2) Ap '93
— London, England

Trav&Leisure 23:76–85 (c,1) S '93
Trav/Holiday 179:4–9 (c,3) N '96
— Lyons, France
Trav&Leisure 24:93,96 (c,1) Jl '94
— Lyons, France (1957)
Trav/Holiday 176:146 (2) Mr '93
— Maitr'd escorting couple to table
Gourmet 54:124,126 (drawing,c,4) Jl '94
— Milan, Italy
Trav&Leisure 26:162–70 (c,1) O '96
— Miniature of New York City diner
Am Heritage 47:81 (c,4) D '96
— Monte Carlo, Monaco
Gourmet 55:76 (c,3) Mr '95
— Morocco
Gourmet 56:46–9 (c,4) Ja '96
— Nashville lunchroom, Tennessee
Gourmet 54:38 (painting,c,2) Ja '94
— National park cafe (Western U.S.)
Trav&Leisure 25:125 (painting,c,1) My '95
— New Orleans, Louisiana
Trav&Leisure 24:85–93 (c,1) Ja '94
— New York City, New York
Gourmet 52:62–70 (c,3) Mr '92
Gourmet 53:44 (c,4) N '93
— Outdoor cafes (Amsterdam, Holland)
Gourmet 54:103 (c,2) Je '94
— Outdoor cafes (Bern, Switzerland)
Smithsonian 24:46–7 (c,1) N '93
— Outdoor cafes (Helsinki, Finland)
Trav/Holiday 177:89 (painting,c,3) Jl '94
— Outdoor cafes (Italy)
Trav&Leisure 23:82–3 (c,1) Ja '93
Gourmet 56:98 (c,4) F '96
— Outdoor cafes (Krakow, Poland)
Gourmet 54:136 (c,4) N '94
— Outdoor cafes (Los Angeles, California)
Nat Geog 181:42–3 (c,1) Je '92
Gourmet 55:38 (c,2) O '95
— Outdoor cafes (Paris, France)
Trav&Leisure 22:13,119 (c,4) Ap '92
Trav/Holiday 178:73 (c,1) Ap '95
Trav&Leisure 25:59 (c,4) O '95
— Outdoor cafes (Rome, Italy)
Gourmet 56:140 (c,2) N '96
— Outdoor cafes (France)
Gourmet 53:92–9 (c,2) My '93
— Oyster bar (California)
Gourmet 52:16 (c,3) Ja '92
— Oyster Bar Restaurant, New York City
Gourmet 53:90 (c,4) Ap '93
— Pancake house (New Hampshire)
Trav&Leisure 26:91 (c,2) Jl '96
— Paris, France

Trav&Leisure 22:13,93,106–7,119–20 (c,1) Ap '92
Trav&Leisure 23:110–11 (1) My '93
Trav&Leisure 25:95–9 (c,1) Je '95
Trav&Leisure 25:127–35 (c,1) D '95
Gourmet 56:192–5 (c,2) O '96
— Ratner's, New York City, New York
Am Heritage 43:68–9 (c,3) Ap '92
— Restaurant bar (New York)
Gourmet 55:66 (c,2) Ja '95
— Restaurant bar cart (Spain)
Trav&Leisure 22:21 (c,4) D '92
— Restaurant bars
Gourmet 54:62–4 (c,3) My '94
— Restaurant cheese cart (California)
Gourmet 52:64 (c,3) D '92
— Rome, Italy
Trav&Leisure 22:84–5,110–11,140 (c,2) Ap '92
— San Francisco, California
Trav&Leisure 25:107–9 (c,1) F '95
Gourmet 56:112–14,119 (c,4) O '96
— Seoul, South Korea
Gourmet 54:109 (c,1) Ap '94
— Small-town cafe (New York)
Smithsonian 24:48–9 (1) Mr '94
— Sommelier (California)
Gourmet 55:64 (c,3) Ap '95
— Sushi bar (California)
Gourmet 52:64 (c,4) N '92
— Sushi bar (New York)
Gourmet 54:30 (c,3) Ag '94
— Take-out stand at New Jersey shore
Trav/Holiday 176:60 (c,3) D '93
— Tavern on the Green, New York City, New York
Nat Geog 183:10–11 (c,1) My '93
— Threadgill's roadhouse, Austin, Texas
Gourmet 54:74 (painting,c,2) Mr '94
— Tokyo, Japan
Trav&Leisure 26:145–58 (c,1) Mr '96
— The "21" Club front gate, New York City, New York
Gourmet 52:68 (c,4) My '92
Gourmet 55:208 (drawing,4) N '95
— Utah
Nat Geog 189:56 (c,3) Ja '96
— Venice, Italy
Gourmet 54:104–9 (c,2) S '94
— Verona, Italy
Trav&Leisure 22:108–11,146 (c,2) N '92
— Wine cellar (Italy)
Trav&Leisure 22:110–11 (c,2) N '92
— Working class diner (Japan)
Nat Geog 188:53 (c,1) N '95
— Zurich, Switzerland
Trav&Leisure 26:102,109 (c,1) Je '96
— See also
CHEFS
COFFEEHOUSES
COOKING
DINNERS AND DINING
KITCHENS
STREET VENDORS
TAVERNS
WAITERS

RESTORATION OF ART WORKS
— Animal murals by Charles Knight (New York)
Natur Hist 102:20–5 (c,3) O '93
— Louvre treasures, Paris, France
Smithsonian 24:46–7 (c,1) D '93
— Rescuing neglected outdoor sculpture
Smithsonian 26:141–9 (c,1) Ap '95
— Restoring Amber Room in Catherine the Great's palace, Pushkin, Russia
Smithsonian 23:34–5 (c,3) Ja '93
— Restoring mission (Arizona)
Nat Geog 188:52–9 (c,1) D '95
— Restoring precious scrolls (Japan)
Smithsonian 27:94–101 (c,1) My '96
— Sistine Chapel painting, Vatican
Trav/Holiday 178:65 (c,1) Ap '95

RETRIEVERS (DOGS)
Smithsonian 22:81–7 (2) Ja '92
— See also
GOLDEN RETRIEVERS
LABRADOR RETRIEVERS

REUTHER, WALTER
Life 19:62 (4) Winter '96

REVOLUTIONARY WAR
— 1775 printed version of "Yankee Doodle"
Smithsonian 23:111 (c,4) Ap '92
— Bennington Battle monument, Vermont
Am Heritage 43:52 (c,4) Ap '92
— Reenacting army drills (Valley Forge, Pennsylvania)
Trav/Holiday 179:68–9,72–3 (1) F '96
— Reenacting Revolutionary War battle (New Jersey)
Trav&Leisure 25:80,85 (c,4) My '95
— Spanish hero Bernardo de Galvez
Am Heritage 44:58 (c,4) Ap '93
— See also
ARNOLD, BENEDICT
ALLEN, ETHAN
BUNKER HILL, BATTLE OF
DECLARATION OF INDEPENDENCE
FRANKLIN, BENJAMIN
GATES, HORATIO

INDEPENDENCE HALL
JEFFERSON, THOMAS
LAFAYETTE, MARQUIS DE
LIBERTY BELL
VALLEY FORGE
WASHINGTON, GEORGE
WAYNE, ANTHONY
RHINE RIVER, EUROPE
Trav/Holiday 177:50–6 (map,c,1) S '94
RHINOCERI
Trav&Leisure 22:69 (painting,c,4) F '92
Nat Geog 181:24–5 (c,1) My '92
Nat Wildlife 31:10 (c,4) D '92
Sports Illus 84:62 (c,3) Ja 29 '96
— Baby rhino
Smithsonian 27:22–4 (c,4) D '96
— Black rhinos
Natur Hist 101:62–3 (c,1) Mr '92
Trav&Leisure 22:129 (c,3) Je '92
Trav/Holiday 177:90 (c,4) Mr '94
— Saving rhino from poachers (South Africa)
Nat Geog 190:36–7 (c,1) Jl '96
— White rhinos
Smithsonian 23:16 (c,4) Ag '92
Nat Geog 184:36–7 (c,2) Jl '93
Gourmet 55:76 (c,4) Ja '95
Nat Geog 190:34–5 (c,1) Jl '96
RHODE ISLAND
— Block Island
Trav/Holiday 176:59 (2) D '93
Trav/Holiday 178:15 (c,4) Mr '95
— Coastal areas
Trav/Holiday 179:34–5 (map,c,4) O '96
— See also
NEWPORT
PROVIDENCE
RHODE ISLAND—MAPS
Trav/Holiday 178:80 (c,3) S '95
RHODES, CECIL
— Tomb (Zimbabwe)
Trav/Holiday 175:62 (c,2) N '92
Trav&Leisure 22:140 (c,4) N '92
RHODODENDRONS
Natur Hist 101:24–5 (c,1) Je '92
Nat Wildlife 34:51 (c,4) Ap '96
Trav/Holiday 179:54 (c,1) Je '96
RICE
Nat Geog 185:48–79 (c,1) My '94
— Rice-straw rope over Shinto shrine (Japan)
Nat Geog 185:50–1 (c,1) My '94
RICE FIELDS
Nat Geog 185:48–79 (c,1) My '94
— California
Nat Geog 184:49 (c,3) N 15 '93
— Terraced rice fields (Bali)

Trav/Holiday 175:16 (c,3) My '92
RICE INDUSTRY
Nat Geog 185:48–79 (c,1) My '94
— Planting rice (Burma)
Nat Geog 188:74–5 (c,1) Jl '95
RICE INDUSTRY—HARVESTING
— 1890 woman fanning rice (South Carolina)
Natur Hist 102:71 (3) F '93
— California
Nat Geog 185:66–7 (c,2) My '94
— India
Nat Geog 185:48–9 (c,1) My '94
Gourmet 55:89 (c,4) Je '95
— Madagascar
Nat Geog 185:52–3 (c,1) My '94
— Peru
Natur Hist 101:32–3 (c,2) D '92
— Sierra Leone
Nat Geog 182:74–5 (c,1) S '92
— Thailand
Trav/Holiday 179:48 (c,2) Ap '96
— Wild rice (Minnesota)
Nat Geog 182:106–7 (c,2) S '92
RICHARDSON, HENRY HOBSON
Am Heritage 43:110 (4) D '92
— Buildings by him
Am Heritage 43:4,108–15 (c,1) D '92
RICHMOND, VIRGINIA
— Capitol building
Trav&Leisure 25:E14 (c,4) My '95
— Libby Civil War prison
Am Heritage 45:114–18,130 (1) N '94
RIDGWAY, MATTHEW
Life 17:94 (2) Ja '94
RIFLES
— 1770s
Smithsonian 27:24 (c,4) Ag '96
— Homemade rifle (Peru)
Nat Geog 185:60–1 (c,1) Mr '94
RINGLING, JOHN
Trav/Holiday 177:71 (4) S '94
— Ringling home and museum, Sarasota, Florida
Trav/Holiday 175:88 (c,4) F '92
Trav&Leisure 22:137 (c,4) Mr '92
Gourmet 53:86–91 (c,1) F '93
Trav/Holiday 177:71 (c,4) S '94
RIO DE JANEIRO, BRAZIL
Trav&Leisure 23:cov.,132–43,152 (map,c,1) N '93
— Ipanema Beach
Trav&Leisure 23:cov.,137,142–3 (c,1) N '93
— Sugarloaf
Trav&Leisure 23:132 (c,1) N '93

RIO GRANDE RIVER, TEXAS/MEX-ICO
Trav&Leisure 23:104–11 (c,1) F '93
Trav&Leisure 24:68 (c,4) S '94
Nat Geog 189:46–51,58–9 (map,c,1) F '96
— Pollution problems
 Smithsonian 25:26–9 (1) My '94
— See also
 PECOS RIVER

RIO NEGRO, BRAZIL
Nat Geog 187:8–9 (c,1) F '95

RIOTS
— 1844 anti-Catholic riot (Philadelphia, Pennsylvania)
 Smithsonian 27:152 (painting,c,4) N '96
— 1965 burning of Watts, California
 Am Heritage 47:48 (2) O '96
— Attack on Ku Klux Klan sympathizer (Michigan)
 Life 19:10–11 (c,1) Ag '96
— Brittany's parliament building in flames, France
 Life 17:17 (c,2) Ap '94
— Cape Town, South Africa (1985)
 Life 19:96 (c,4) Je '96
— Los Angeles riots, California (1992)
 Sports Illus 76:24–31 (c,2) My 11 '92
 Life 15:10–20 (c,1) Je '92
 Life 16:20–1 (c,1) Ja '93
 Trav&Leisure 23:171 (c,4) My '93
— Marchers fleeing from police (South Africa)
 Nat Geog 183:76–7 (c,1) F '93
— May Day riot (Moscow, Russia)
 Life 16:14–15 (c,1) Jl '93
— Post sports victory rioting
 Sports Illus 79:30–4 (c,2) Jl 5 '93
— Student riot after college football win (Wisconsin)
 Sports Illus 79:60–7 (c,1) N 8 '93

RIPLEY, ROBERT L.
Smithsonian 25:91,94–5 (3) Ja '95
Rites and ceremonies. See
 FUNERAL RITES AND CEREMONIES
 MARRIAGE RITES AND CUSTOMS
 RELIGIOUS RITES AND FESTIVALS
 individual countries—RITES AND FES-TIVALS

RIVERA, DIEGO
Am Heritage 43:38 (4) N '92
— Detail from "History of Medicine" mural
 Natur Hist 105:7 (c,3) Jl '96
— Mural celebrating auto workers (1932)
 Life 19:60 (c,4) Winter '96
— Murals by him (Mexico)

Trav&Leisure 23:112–15 (c,3) Je '93
— "Zapatist Landscape" (1915)
 Smithsonian 23:121 (painting,c,4) Ag '92

RIVERBOATS
— 1878 stern-wheeler "J.M.White"
 Am Heritage 46:6 (4) Ap '95
— Construction of new steamboat (Louisiana)
 Am Heritage 46:6 (c,3) Ap '95
— "Delta Queen"
 Am Heritage 44:26 (c,4) Jl '93
— Huge old wooden vessel "Nenana" (Alaska)
 Trav/Holiday 178:14 (c,4) S '95
— Illinois
 Am Heritage 47:64–5 (1) O '96
— "Mississippi Queen"
 Am Heritage 43:34 (c,4) N '92 supp.
— New Orleans, Louisiana
 Nat Geog 187:116–17 (c,1) Ja '95

RIVERS
— Aerial view of meandering rivers (Alaska)
 Trav&Leisure 24:109 (c,1) Mr '94
— Alaska
 Natur Hist 104:34–5 (c,1) Jl '95
 Smithsonian 26:32–3,36 (c,1) Mr '96
— Alsek River, British Columbia
 Nat Geog 185:122–5 (map,c,1) F '94
— Betsiboka River seen from space, Madagascar
 Nat Geog 190:4–6 (c,1) N '96
— Big Sunflower River, Mississippi
 Natur Hist 105:63 (c,4) Ap '96
— Blackwater River, Ireland
 Gourmet 54:100 (c,4) Mr '94
— Buffalo River, Arkansas
 Gourmet 52:80,83 (c,1) F '92
 Am Heritage 43:24 (c,4) Ap '92
 Trav&Leisure 22:164 (c,4) My '92
— Coatzacoalcos River, Mexico
 Nat Geog 184:103 (c,4) N '93
— Colca River, Peru
 Nat Geog 183:118–37 (c,1) Ja '93
— Forest brook (Tennessee)
 Smithsonian 24:cov. (c,1) Ag '93
— Gila River, Arizona
 Nat Geog 182:53 (c,4) O '92
— Gunnison River, Colorado
 Nat Wildlife 31:7 (c,4) Ag '93
— Huangpu River, Shanghai, China
 Nat Geog 185:14–15 (c,1) Mr '94
— Klickitat River, Washington
 Nat Geog 187:34–5 (c,2) Mr '95
— Lamoille River, Vermont
 Gourmet 52:60–1,114 (map,c,1) Ag '92
— Manu River, Peru

Nat Geog 185:126–7 (c,2) Ja '94
— Nashua River, Massachusetts
Nat Geog 184:106–7,117–19 (c,1) N 15
'93
— New River, California
Smithsonian 27:92–7 (map,c,1) Je '96
— New River, Virginia
Natur Hist 105:58–9 (map,c,4) Mr '96
— North Platte River, Nebraska
Am Heritage 44:66 (c,4) My '93
— Ochlockonee River, Florida
Natur Hist 102:26–7 (c,1) D '93
— Owens River, California
Natur Hist 105:39 (c,1) S '96
— Paseo del Rio, San Antonio, Texas
Gourmet 52:74–5 (c,1) Je '92
— Pinware River, Labrador
Natur Hist 104:73 (c,1) My '95
— Red River, Idaho
Smithsonian 23:32 (c,1) S '92
— River Wye, England
Trav&Leisure 23:66–7 (c,1) Ag '93
— St. Marys, Florida/Georgia
Nat Geog 181:37–9,43 (map,c,1) Ap '92
— Salt River, Australia
Trav&Leisure 22:122–3 (c,1) F '92
— San Juan River, Colorado
Nat Geog 184:110–11 (c,1) N 15 '93
— San Juan River, Utah
Trav&Leisure 26:E8–E14 (c,2) My '96
— San Pedro River, Arizona
Life 16:38–9 (c,1) O '93
— Schuylkill River, Philadelphia,
Pennsylvania
Trav/Holiday 178:62–3 (c,1) N '95
— Shuiluo River, China
Nat Geog 190:116–29 (map,c,1) N '96
— Smith River, California
Nat Geog 184:68–9 (c,1) Jl '93
— Snow scene
Natur Hist 104:6 (c,3) F '95
— Tambopata River, Peru
Nat Geog 185:124–5 (map,c,1) Ja '94
— Tatshenshini River, Alaska/British
Columbia
Trav/Holiday 176:33 (c,4) Je '93
Nat Geog 185:122–7 (map,c,1) F '94
— Ucayali River, Peru
Nat Geog 187:30–3 (c,2) F '95
— White River, Vermont
Trav&Leisure 25:E2 (c,4) Ag '95
— Winooski River, Vermont
Gourmet 52:58–9,114 (map,c,1) Ag '92
— Yampa River, Colorado
Trav/Holiday 179:72–9 (c,1) Ap '96

— See also
AMAZON
BRAHMAPUTRA
COLORADO
COLUMBIA
CONNECTICUT
CUMBERLAND
DANUBE
DUERO
GANGES
HUANG HE (YELLOW)
HUDSON
JORDAN
MEKONG
MISSISSIPPI
MISSOURI
MOHAWK
NILE
OHIO
PECOS
PLATTE
RHINE
RIO GRANDE
RIO NEGRO
ST. LAWRENCE
SAVANNAH
SEINE
SHANNON
SHENANDOAH
SNAKE
TENNESSEE
THAMES
TIBER
TIGRIS
VOLGA
WESER
YANGTZE
ZAMBEZI

ROADRUNNERS (BIRDS)
Smithsonian 23:58–65 (c,1) Mr '93
Nat Wildlife 32:46–51 (c,1) F '94
Nat Wildlife 32:10 (c,4) Je '94
Smithsonian 25:85 (c,4) D '94

ROADS
— Albanian coast
Nat Geog 182:74 (c,4) Jl '92
— Asphalt made of recycled glass (New
York)
Nat Geog 186:114–15 (c,2) Jl '94
— Country road (Cape Cod, Massachusetts)
Trav&Leisure 24:24 (c,4) N '94
— Country road (Louisiana)
Life 18:108–9 (c,1) Je '95
— Country road (Ohio)
Trav/Holiday 179:59 (c,1) O '96

— Country road in autumn (New Hampshire)
 Gourmet 53:78 (c,4) S '93
— Desert road (California)
 Nat Geog 189:71 (c,2) My '96
— Desolate rural road in winter (Wyoming)
 Nat Geog 183:56–7 (c,1) Ja '93
— Dirt plantation road (Hawaii)
 Trav&Leisure 25:114 (c,4) My '95
— Manhole cover (Louisville, Kentucky)
 Am Heritage 45:126 (4) D '94
— Natchez Trace Parkway, Tennessee
 Trav&Leisure 26:E6 (c,4) Je '96
— Pothole (Kansas)
 Nat Geog 184:56 (c,3) Ag '93
— Road through Andes Mountains, Peru
 Nat Geog 189:18–19 (c,1) My '96
— See also
 ALASKA HIGHWAY
 HIGHWAYS

ROADS—CONSTRUCTION
— Alaska Highway (1942)
 Smithsonian 23:103–7 (3) Jl '92
— Bolivia
 Nat Geog 185:62–3 (c,1) Mr '94
— Tucson, Arizona
 Nat Geog 186:44–5 (c,2) S '94

ROBESON, PAUL
 Sports Illus 82:14 (4) Ja 30 '95

ROBIN HOOD
— Book illustration by Howard Pyle
 Smithsonian 25:91 (drawing,4) Jl '94

ROBINS
 Natur Hist 102:36–7 (c,1) N '93

ROBINSON, BILL "BOJANGLES"
 Life 16:42 (4) N '93
 Smithsonian 26:32 (4) Je '95

ROBINSON, JACKIE
 Sports Illus 77:50 (4) O 5 '92
 Sports Illus 81:74 (1) N 14 '94
 Life 18:149 (1) Je 5 '95
 Sports Illus 84:4–5 (3) Ap 1 '96
— Artifacts belonging to him
 Sports Illus 82:74 (c,4) My 22 '95

ROBINSON, SUGAR RAY
 Life 19:82–3 (c,1) Winter '96

ROBOTS
— Robotic Buddhist priest (Japan)
 Life 16:25 (c,4) Je '93
— Robotic gladiator competition
 Smithsonian 25:100–1 (c,3) N '94
— Robotic praying mantis
 Trav/Holiday 177:88 (c,4) F '94
— Tokyo Stock Exchange robot signaling to
 sell (Japan)
 Nat Geog 183:89 (c,1) Ja '93

— Undersea shipwreck explorer robot
 Life 15:32,36–7 (c,1) Mr '92

ROCK CARVINGS
— 14th cent. Anasazi carving of cougar
 (Arizona)
 Nat Geog 182:54 (c,4) Jl '92
— 14th cent. petroglyphs (New Mexico)
 Smithsonian 26:150 (c,2) N '95
— Copper Age carvings (French Alps)
 Nat Geog 183:56 (c,3) Je '93
— Indian carvings (California)
 Nat Geog 189:60 (c,3) My '96
— Petroglyph (Easter Island)
 Nat Geog 183:79 (c,1) Mr '93
— Petroglyph of ancient deity (Arizona)
 Smithsonian 22:36 (c,4) Mr '92
— See also
 CAVE PAINTINGS
 ROCK PAINTINGS

ROCK CLIMBING
 Sports Illus 81:4–5 (c,4) Ag 22 '94
— Arizona
 Gourmet 56:107 (c,4) My '96
— Climbing inside silo (Illinois)
 Sports Illus 85:5–6 (c,3) N 11 '96
— Colorado
 Trav&Leisure 24:60 (c,4) My '94
 Nat Geog 190:80–2 (c,1) N '96
— Florida
 Trav&Leisure 26:E8 (c,4) N '96
— Free climbing cliffs (California)
 Life 17:26–32 (c,1) Jl '94
— Headstone rock (California)
 Nat Geog 189:62–3 (c,1) My '96
— Indoor climbing wall
 Sports Illus 79:5 (c,3) O 4 '93
 Trav&Leisure 24:40 (c,4) Ag '94
— Shawangunk Ridge, New York
 Smithsonian 27:cov.,30–41 (c,1) Ag '96
— Tennessee
 Smithsonian 24:25 (c,4) Ag '93
— Texas
 Trav/Holiday 175:28 (c,4) Jl '92
— Trango Tower, Pakistan
 Nat Geog 189:cov.,32–51 (c,1) Ap '96
Rock music. See
 SINGERS
Rock of Gibraltar. See
 GIBRALTAR

ROCK PAINTINGS
— Anasazi figures (Utah)
 Smithsonian 24:36 (c,4) D '93
 Trav&Leisure 26:E14 (c,4) My '96
— Indian petroglyphs (New Mexico)
 Nat Geog 187:132 (c,4) Ap '95

— Navajo pictographs (Arizona)
Am Heritage 44:59 (c,1) Ap '93
Trav&Leisure 23:134–5,140 (c,1) Ap '93
— See also
CAVE PAINTINGS
ROCK CARVINGS
ROCKEFELLER CENTER, NEW YORK CITY, NEW YORK
— Christmas tree
Life 17:55 (c,4) D '94
Trav&Leisure 24:167 (c,2) D '94
— Decorated for Christmas
Trav&Leisure 25:98–9 (c,1) D '95
ROCKEFELLER FAMILY
— Kykuit home, Tarrytown, New York
Trav&Leisure 24:31 (c,4) My '94
Life 18:132–3 (c,1) N '95
ROCKNE, KNUTE
Smithsonian 24:164–77 (2) N '93
ROCKS
— Aeolian Island rocks, Italy
Trav&Leisure 23:76–9,136 (c,1) Ja '93
— Ayers Rock, Australia
Trav&Leisure 26:30 (c,4) O '96
— Callandish Standing Stones, Isle of Lewis, Scotland
Nat Geog 190:14–15 (c,1) S '96
— Camel's Hump, Vermont
Natur Hist 105:56 (c,4) Jl '96
— Cathedral Rock, Sedona, Arizona
Natur Hist 103:A1 (c,1) Ap '94
— Chimney Rock, Colorado
Trav/Holiday 177:54–5 (painting,c,1) Je '94
— Chimney Rock, Nebraska
Am Heritage 44:69 (c,4) My '93
Life 16:64–5 (c,1) D '93
Trav&Leisure 25:45 (c,4) Jl '95
— "Chocolate Drops," Canyonlands, Utah
Trav&Leisure 24:96–7 (c,1) My '94
— Cliff rock painted by high school seniors (Washington)
Life 17:106–7 (c,1) Je '94
— Cuttyhunk Island shore, Massachusetts
Nat Geog 181:117 (c,1) Je '92
— Golden Rock, Burma
Nat Geog 188:70–1 (c,1) Jl '95
— Granite formations (California)
Trav/Holiday 179:52–3 (c,1) Je '96
— Hagar Qim megalith, Malta
Smithsonian 27:62–8 (c,1) S '96
— Headstone Rock, California
Nat Geog 189:62–3 (c,1) My '96
— Hopewell Rocks, New Brunswick
Natur Hist 102:56 (c,4) Ap '93

— Jail Rock, Nebraska
Am Heritage 44:68 (c,4) My '93
— Kata Tjuta rocks, Australia
Trav/Holiday 176:38 (c,4) D '93
— Monument Rocks, Kansas
Natur Hist 104:20–2 (map,c,1) Jl '95
— Mule Ear, Utah
Nat Geog 190:91 (c,4) S '96
— Myers Creek, Oregon
Trav&Leisure 23:114 (c,1) N '93
— Perce Rock, Quebec
Natur Hist 103:68 (c,4) My '94
— Pinnacle Rocks, Australia
Natur Hist 104:A2 (c,4) N '95
— Plume Rock, Wyoming
Am Heritage 44:61 (c,1) My '93
— "Remarkable Rocks," Australia
Trav&Leisure 24:108–9 (c,1) Jl '94
— Scotts Bluff, Nebraska
Am Heritage 44:69 (c,4) My '93
— Ship Rock, New Mexico
Trav/Holiday 177:57 (painting,c,4) Je '94
Nat Geog 190:81–2 (c,1) S '96
— Unusual stone pinnacle (Arizona)
Smithsonian 22:34 (c,4) Mr '92
— Volcanic rocks in the sea (Italy)
Trav/Holiday 175:76 (c,3) S '92
— See also
STONEHENGE
ROCKWELL, NORMAN
Life 16:84 (4) Jl '93
Smithsonian 25:89 (4) Jl '94
— Home (Stockbridge, Massachusetts)
Am Heritage 46:40 (c,4) N '95
— Paintings by him
Life 16:85–91 (c,1) Jl '93
Smithsonian 25:88,92–3 (c,1) Jl '94
— "War News" (1944)
Am Heritage 45:6 (painting,c,2) My '94
ROCKY MOUNTAINS, ALBERTA
Nat Geog 186:42–3,58–9 (c,1) D '94
Nat Geog 188:46–67 (c,1) Jl '95
Nat Geog 189:132–3 (c,1) My '96
ROCKY MOUNTAINS, BRITISH COLUMBIA
Smithsonian 23:106–7 (c,1) Ja '93
Nat Geog 186:42–3,58–9 (c,1) D '94
ROCKY MOUNTAINS, COLORADO
— Crested Butte
Trav/Holiday 177:80–1 (c,2) F '94
— Telluride area
Trav&Leisure 22:17 (c,4) S '92
ROCKY MOUNTAINS, MONTANA
Gourmet 52:94–7 (c,1) Mr '92

RODENTS
— Viscachas
 Trav&Leisure 24:52 (c,4) N '94
— See also
 BATS
 BEAVERS
 CHIPMUNKS
 MARMOTS
 MICE
 NUTRIAS
 PORCUPINES
 RATS
 SQUIRRELS
 VOLES
 WOODCHUCKS

RODEOS
 Trav&Leisure 24:76–81,131 (c,1) Jl '94
— Alberta
 Nat Geog 186:54–5 (c,2) D '94
— Charreria competition, Mexico
 Nat Geog 190:76–9 (c,1) Ag '96
— Child on sheep (Idaho)
 Nat Geog 185:20 (c,3) F '94
— Child practicing bull riding on a barrel
 (Wyoming)
 Nat Geog 183:62–3 (c,1) Ja '93
— Children on state fair bull ride (New
 Mexico)
 Nat Geog 184:60–1 (c,1) S '93
— Cowboy Girls
 Sports Illus 80:5–6 (c,2) My 16 '94
— Mexico
 Nat Geog 189:64–5 (c,1) F '96
— Nevada
 Trav&Leisure 23:30 (c,4) O '93
 Sports Illus 79:2–3,42–6 (c,1) D 20 '93
— New Mexico
 Life 16:28–9 (1) Ap 5 '93
— Posing on fake bull (Colorado)
 Nat Geog 190:90–1 (c,2) N '96
— Rodeo clown school (Louisiana)
 Sports Illus 81:2–3,56–70 (c,1) O 3 '94
— Rodeo training class (Arizona)
 Sports Illus 85:12 (c,2) N 25 '96
— Roping calf (Texas)
 Smithsonian 22:64 (2) F '92
— Roping steer (California)
 Sports Illus 79:76 (c,4) Ag 9 '93
— Steer wrestling (Nevada)
 Sports Illus 77:2–3 (c,1) D 14 '92
— Wild West show (New York)
 Nat Geog 186:68–9 (c,2) N '94

RODGERS, RICHARD
 Am Heritage 44:61 (4) F '93
— Caricature

 Am Heritage 44:82–4 (c,1) O '93

RODIN, AUGUSTE
— "The Thinker" in packing crate
 Life 16:16 (c,2) Mr '93
— "The Thinker" lifted by crane (France)
 Life 19:12–13 (c,1) N '96

ROGERS, GINGER
 Life 19:91 (1) Ja '96

ROGERS, ROY
 Life 18:32 (4) Jl '95

ROGERS, WILL
— Land sculpture portrait of Rogers
 Smithsonian 25:72–3 (c,1) Jl '94

ROLLER COASTERS
— Blackpool, England
 Trav&Leisure 24:24 (c,4) Ag '94
— Busch Gardens, Tampa, Florida
 Life 16:8,68–72 (c,1) Ag '93
— California
 Sports Illus 79:114 (c,2) S 6 '93
— Cedar Point, Sandusky, Ohio
 Trav&Leisure 26:34 (c,4) Jl '96
— Cyclone, Coney Island, New York (1940s)
 Trav/Holiday 178:67 (c,4) Jl '95
— Georgia
 Sports Illus 85:60–1 (c,1) S 16 '96
— People on roller coaster
 Life 17:98 (c,2) My '94

ROLLER SKATING
— Amy Carter on skates
 Trav/Holiday 175:77 (4) N '92
— Doctor skating through hospital (Great
 Britain)
 Life 15:88 (2) O '92
— Inline skating
 Sports Illus 83:86 (c,3) O 9 '95
— Inline skating (New York City, New York)
 Nat Geog 183:8–9 (c,2) My '93
 Trav&Leisure 24:58 (4) Mr '94
 Smithsonian 26:60–9 (c,1) S '95
 Sports Illus 84:12–13 (c,1) Mr 4 '96
— Roller skating Museum, Lincoln, Nebraska
 Smithsonian 26:97 (c,2) Ap '95

ROLLING STONES
 Life 15:cov.,14–15,65 (1) D 1 '92
 Life 17:40 (c,4) Je '94
— Mick Jagger
 Life 17:14 (c,4) Ja '94
 Life 18:34 (c,4) S '95
 Life 19:118 (c,4) My '96

ROMAN EMPIRE
— Hannibal crossing the Alps (218 B.C.)
 Smithsonian 25:124–5 (painting,c,1) Ap
 '94
— Soldier Scipio Africanus

Smithsonian 25:131 (painting,c,4) Ap '94
— See also
 CATO THE ELDER
 HADRIAN
 MYTHOLOGY—GREEK AND ROMAN
 PLINY THE ELDER
 POMPEII
 TIBERIUS

ROMAN EMPIRE—ARCHITECTURE
— Apamea colonnade, Syria
 Nat Geog 190:114 (c,3) Jl '96
— Aqueduct (Nime, France)
 Nat Geog 188:67 (c,3) S '95
— Aqueducts (Rome, Italy)
 Smithsonian 23:88–91 (c,2) S '92
— Bath, England
 Trav&Leisure 24:108–9,112–13 (c,1) N
 '94
— Hadrian's villa, Tivoli, Italy
 Trav/Holiday 178:52–9 (c,1) Jl '95
— See also
 COLOSSEUM
 ROMAN FORUM
 TEMPLES—ANCIENT
 THEATERS—ANCIENT

ROMAN EMPIRE—ARTIFACTS
— 1st cent. garden murals (Pompeii)
 Smithsonian 25:115–17 (c,2) Je '94
— 1st cent. silver coin
 Nat Geog 183:82 (c,4) Ja '93
— 3rd cent. mosaic floor (Carthage)
 Smithsonian 25:141 (c,3) Ap '94
— Bronze sculptures found in the sea
 (Brindisi, Italy)
 Nat Geog 187:88–101 (c,1) Ap '95
— Burial chamber (Marsala, Sicily)
 Life 18:78–80 (c,1) S '95
— Ceremonial mask
 Smithsonian 25:cov. (c,1) D '94
— Mosaic of acrobats (Sicily)
 Nat Geog 190:47 (c,4) Jl '96
— Mummy portraits (Egypt)
 Smithsonian 26:134–9 (c,1) N '95

ROMAN EMPIRE—COSTUME
— Centurion costume (Nevada)
 Nat Geog 190:60–1 (c,1) D '96

ROMAN EMPIRE—HISTORY
— 79 A.D. eruption of Mt. Vesuvius
 Smithsonian 26:162 (engraving,3) N '95
— 79 A.D. Vesuvius eruption victims
 (Pompeii)
 Life 19:54–5 (1) Je '96
— Romulus and Remus with wolf
 Trav/Holiday 177:132 (painting,c,2) My
 '94

ROMAN EMPIRE—MAPS
— Appian Way
 Trav/Holiday 177:40 (c,4) N '94

ROMAN EMPIRE—RUINS
— Cassino, Italy
 Smithsonian 24:56 (c,4) Je '93
— Ephesus, Turkey
 Trav/Holiday 175:18 (c,4) F '92
— Jerash, Jordan
 Trav&Leisure 23:61 (c,4) Mr '93
— Nora column, Sardinia
 Trav/Holiday 176:40 (c,4) Je '93

**ROMAN EMPIRE—SOCIAL LIFE
AND CUSTOMS**
— Criminals fighting in arena
 Smithsonian 25:109 (painting,c,2) Mr '95

ROMAN FORUM, ROME, ITALY
Trav/Holiday 177:cov. (c,1) My '94

ROMANCE
— Amorous couples
 Life 15:80–6 (1) Ap '92
— Couple hugging
 Sports Illus 80:66–7,78 (c,1) Je 6 '94
— Couple in gondola (Venice, Italy)
 Sports Illus 81:50–1 (c,1) S 26 '94
— Couple on beach
 Life 15:78 (c,3) N '92
— Couple sleeping on train (1975)
 Life 17:30 (3) Je '94
— "Date" in back seat of old car (1964)
 Am Heritage 47:59 (painting,c,4) N '96
— Elephants nuzzling
 Life 15:3 (2) Ap '92
— Simulated wedding scene outside church
 tower (France)
 Life 19:20 (c,2) Jl '96
— Stylized depiction of romantic Paris
 Trav&Leisure 23:cov. (c,1) S '93
 Trav&Leisure 26:70 (painting,c,3) My '96
— Teen boy carrying girlfriend (Idaho)
 Nat Geog 185:18–19 (c,1) F '94
— Video dating relationship between
 American man and Russian woman
 Life 17:55–65 (c,1) F '94
— Young couple embracing (Sweden)
 Nat Geog 184:31 (c,3) Ag '93
— Young couple in small boat (Great Britain)
 Life 16:16 (c,2) S '93
— See also
 KISSING

ROMANIA
— Transylvania
 Trav&Leisure 24:82,86,91 (map,c,3) D '94
— Transylvania sites related to Dracula
 Life 17:67–71 (c,1) N '94

ROMANIA—HISTORY
— Queen Marie (1926)
Am Heritage 45:110 (3) O '94
— See also
DRACULA
ROMANIA—SOCIAL LIFE AND CUS-
TOMS
— Gymnastics
Sports Illus 85:212–27 (1) Jl 22 '96
ROME, ITALY
Trav&Leisure 22:cov.,75–89,102,130,135
map,c,1) Ap '92
Trav/Holiday 176:39,42 (map,c,4) Ap '93
Trav/Holiday 177:cov.,54–65 (map,c,1)
My '94
Trav&Leisure 25:72–9 (c,1) Ja '95
Gourmet 55:52–5 (c,2) Ag '95
Trav/Holiday 179:22 (c,4) O '96
— Ancient Roman aqueducts
Smithsonian 23:88–91 (c,2) S '92
— Campidoglio
Trav&Leisure 25:74,78–9 (c,3) Ja '95
— Capitoline Museums
Trav&Leisure 25:60 (c,4) O '95
— Catacomb bones of Capuchin monks
Natur Hist 105:36 (4) O '96
— Doria Pamphilj Palace interior
Trav&Leisure 25:62 (c,4) O '95
— Fountains
Smithsonian 23:cov.,89,92–101 (c,1) S '92
— Isola Tiberina
Trav&Leisure 22:87 (c,4) Ap '92
— Jewish quarter
Gourmet 55:52–5,90 (map,c,2) Ag '95
— Palazzo Spada
Trav/Holiday 179:67 (c,2) Ap '96
— Piazza Navona
Trav&Leisure 22:75,86–7 (c,1) Ap '92
Smithsonian 23:94–5,100 (c,2) S '92
Trav/Holiday 176:39 (c,4) Ap '93
Trav/Holiday 177:60–1 (c,1) My '94
— Spanish Steps
Smithsonian 24:54 (c,1) Je '93
— Trevi Fountain
Trav&Leisure 22:cov. (c,1) Ap '92
Smithsonian 23:101 (c,1) S '92
Trav&Leisure 24:168 (c,1) S '94
— Via Condotti
Trav&Leisure 24:58 (c,4) Ja '94
— Villa gardens near Rome
Gourmet 52:132–7 (c,1) N '92
— See also
COLOSSEUM
ROMAN FORUM
TIBER RIVER

VATICAN CITY
ROOSEVELT, ELEANOR
Smithsonian 23:135,146 (2) O '92
Life 15:34,82 (1) O 30 '92
Trav/Holiday 175:73 (4) N '92
Life 18:95 (4) Je 5 '95
Life 19:78-\-9 (1) S '96
ROOSEVELT, FRANKLIN DELANO
Smithsonian 23:135 (2) O '92
Smithsonian 23:68 (4) N '92
Trav/Holiday 175:73 (4) N '92
Sports Illus 78:86 (4) Ap 12 '93
Am Heritage 45:82–92 (c,1) My '94
Am Heritage 45:101 (drawing,c,4) O '94
Smithsonian 25:100 (4) O '94
Smithsonian 25:138 (4) N '94
Am Heritage 46:132 (4) Ap '95
Nat Geog 187:57–8 (c,2) My '95
Life 18:28,107 (c,2) Je 5 '95
Am Heritage 46:54,58 (4) O '95
Am Heritage 46:52 (4) D '95
Life 19:78–9 (1) S '96
Life 19:34,58 (2) O '96
— 1936 Arno cartoon about society hatred of
FDR
Smithsonian 26:90 (4) Je '95
— 1945 funeral (Hyde Park, New York)
Am Heritage 46:40 (4) Ap '95
— Dog Fala
Am Heritage 44:45 (4) Ap '93
Am Heritage 46:16 (4) Ap '95
Life 18:95 (4) Je 5 '95
— Family
Life 15:34 (4) O 30 '92
ROOSEVELT, THEODORE
Smithsonian 22:90 (painting,c,4) Mr '92
Trav/Holiday 175:72 (4) N '92
Am Heritage 46:106 (4) N '95
— Caricatures
Am Heritage 47:54 (4) My '96
— Alice Roosevelt Longworth
Life 15:30 (2) O 30 '92
— Roosevelt on 1914 Amazon expedition,
Brazil
Life 15:64–73 (4) Jl '92
— Edith Roosevelt
Smithsonian 23:141 (4) O '92
— Roosevelt family
Smithsonian 25:100–1 (3) O '94
Am Heritage 46:106 (4) N '95
ROOSTERS
Sports Illus 82:78–9 (c,1) Je 26 '95
ROPE JUMPING
— Basketball player jumping rope
Sports Illus 81:130–1 (c,2) N 7 '94

— Boxer jumping rope
 Sports Illus 83:56–7 (c,1) Ag 21 '95
 Sports Illus 85:166 (c,4) Jl 22 '96
— Football player jumping rope
 Sports Illus 85:31 (c,3) Ag 26 '96
— Mural of girls jumping rope (New York)
 Smithsonian 26:110 (c,4) Ap '95

ROPES
— Rice-straw rope over Shinto shrine (Japan)
 Nat Geog 185:50–1 (c,1) My '94

ROSES
 Gourmet 52:80 (c,4) Je '92
 Smithsonian 23:44–55 (c,1) Jl '92
 Gourmet 53:86–91 (c,1) Je '93
 Gourmet 53:145 (c,4) N '93
— Largest rose tree (Tombstone, Arizona)
 Nat Geog 190:50–1 (c,2) N '96

ROSSETTI, DANTE GABRIEL
— Painting of Persephone
 Natur Hist 104:37 (c,2) D '95

ROSSINI, GIOACCHINO
 Trav&Leisure 22:21 (4) My '92

ROTHKO, MARK
 Trav&Leisure 26:104 (4) N '96
— "Light, Earth & Blue"
 Natur Hist 103:55 (painting,c,3) Je '94

ROTHSCHILD FAMILY
— Villa Rothschild, Cap Ferrat, France
 Gourmet 55:117 (c,1) F '95
— Waddesdon Manor home, Buckingham-
 shire, England
 Trav&Leisure 24:6,102–11 (c,1) Je '94

ROTTWEILERS (DOGS)
 Sports Illus 82:86–7 (c,4) Ap 10 '95

ROUSSEAU, HENRI
— "Unpleasant Surprise"
 Life 16:80 (painting,c,4) Ap '93

ROWBOATS
— Finland
 Gourmet 54:55 (c,3) Jl '94
— Great Britain
 Nat Geog 186:18–19 (c,2) Ag '94
— Newfoundland
 Trav/Holiday 177:92–4 (c,1) My '94
— Single sculls
 Smithsonian 27:99 (c,1) Jl '96

ROWING
— Late 19th cent.
 Sports Illus 85:49 (painting,c,3) Jl 15 '96
— 1880s crew practice (Pennsylvania)
 Am Heritage 43:125 (4) N '92
— 1889 college women's team
 Smithsonian 27:90 (4) Jl '96
— College crew
 Sports Illus 76:32–3 (c,4) Je 22 '92

Nat Geog 185:88–9 (c,1) F '94
 Sports Illus 80:6 (c,4) My 2 '94
— College team (Great Britain)
 Nat Geog 188:123 (c,3) N '95
— Coxswain at 1992 Olympics
 Sports Illus 77:52 (c,1) Ag 10 '92
— History of competitive rowing
 Smithsonian 27:88–99 (c,1) Jl '96
— Lake Baikal, Siberia
 Nat Geog 181:3–4 (c,1) Je '92
— Pair with coxswain (Italy)
 Sports Illus 77:168–9 (c,1) Jl 22 '92
— Rowing competition
 Sports Illus 85:124–5,154–5 (c,1) Jl 22 '96
— Rowing competition (Switzerland)
 Smithsonian 27:88–9 (c,1) Jl '96
— Solo rowing trip across the Pacific
 Life 15:40–6 (c,1) F '92
— Winter rowing practice (Massachusetts)
 Smithsonian 27:93 (c,3) Jl '96
— World Rowing Championships 1994
 (Indianapolis, Indiana)
 Sports Illus 81:84 (c,4) O 17 '94

RUBBER INDUSTRY
— Collecting rubber from tree (Malaysia)
 Trav/Holiday 178:68–9 (1) O '95

RUBENS, PETER PAUL
— "Aurora"
 Smithsonian 26:38 (painting,c,4) S '95
— Paintings by him
 Smithsonian 24:cov.,58–69 (c,1) O '93
— Self-portrait
 Smithsonian 24:64,69 (painting,c,2) O '93
— "Venus"
 Trav&Leisure 23:72 (painting,c,2) Jl '93
— "Venus Before a Mirror"
 Life 18:72 (painting,c,4) F '95

RUBIES
— DeLong star ruby
 Natur Hist 102:74 (c,2) F '93

RUDOLPH, WILMA
 Sports Illus 81:13 (4) N 21 '94
 Life 18:82 (1) Ja '95

RUGBY
 Sports Illus 77:104–5 (c,1) D 28 '92
 Sports Illus 78:4–5 (c,4) Ap 19 '93
— 19th cent. boys playing rugby (Great
 Britain)
 Nat Geog 190:49 (painting,c,4) Jl '96
— Great Britain
 Sports Illus 81:62 (c,1) N 14 '94
— Western Samoa
 Trav/Holiday 179:47 (c,3) My '96

RUGBY—COLLEGE
— Women's rugby

Sports Illus 81:70–2 (c,1) O 31 '94
RUGBY—PROFESSIONAL
— World Cup competition 1995
 Sports Illus 83:32–3 (c,1) Jl 3 '95
RUGBY PLAYERS
 Sports Illus 78:6 (c,3) Je 7 '93
RUGS
— 1961 llama-skin rug (New York)
 Sports Illus 81:51 (4) O 31 '94
— Rugmaking (Oman)
 Nat Geog 187:130 (c,3) My '95
RULERS AND MONARCHS
— 11th cent. Sung emperor (China)
 Smithsonian 26:49 (painting,c,4) Mr '96
— Ancient Egyptian pharaohs
 Nat Geog 187:3,6,26–7,43 (sculpture,c,1)
 Ja '95
— Celebrating 25-year reign of Asante king
 (Ghana)
 Natur Hist 105:cov.,38–47 (c,1) F '96
 Nat Geog 190:36–8,43 (c,1) O '96
— Charles and Diana (Great Britain)
 Life 15:cov.,26–32 (c,1) Ag '92
 Life 16:cov.,28–39 (c,1) F '93
— Czar Paul I's throne (U.S.S.R.)
 Trav&Leisure 26:66 (c,4) Mr '96
— Frederik De Klerk (South Africa)
 Trav&Leisure 24:102 (painting,c,4) S '94
— Alberto Fujimori (Peru)
 Nat Geog 189:11 (c,3) My '96
— Juan Carlos I and Queen Sofia (Spain)
 Sports Illus 77:45 (c,4) Ag 17 '92
— King Asantehene (Ghana)
 Natur Hist 105:38,42 (c,4) F '96
— King Carl Gustaf (Sweden)
 Nat Geog 184:9 (c,4) Ag '93
— King Hussein (Jordan)
 Life 18:70 (c,4) Ja '95
— Nelson Mandela (South Africa)
 Nat Geog 183:75 (c,3) F '93
 Trav&Leisure 24:102 (painting,c,4) S '94
 Life 19:95 (c,2) Je '96
— Queen Marie of Romania (1926)
 Am Heritage 45:110 (3) O '94
— Middle Eastern heads of state
 Life 18:14–15 (1) N '95
— Francois Mitterand (France)
 Life 19:14 (2) F '96
— Hosni Mubarak (Egypt)
 Nat Geog 183:46 (c,4) Ap '93
— President Hafez al-Assad (Syria)
 Nat Geog 190:110 (painting,c,4) Jl '96
— President Zedillo (Mexico)
 Nat Geog 190:38 (c,4) Ag '96
— Queen Hatshepsut (Egypt)

Natur Hist 101:58–9 (carving,1) Jl '92
— Yitzak Rabin (Israel)
 Life 18:70 (c,4) Ja '95
— Sultan Said (Oman)
 Nat Geog 187:123 (c,4) My '95
— See also
 ALFRED THE GREAT
 ARAFAT, YASIR
 ARTHUR, KING
 ATATURK, KEMAL
 BEGIN, MENACHEM
 BOLEYN, ANNE
 BRANDT, WILLY
 CASTRO, FIDEL
 CHARLES I
 CHRISTIAN IV
 CHURCHILL, WINSTON
 CLEOPATRA
 CROWNS
 DAVID
 DAVIS, JEFFERSON
 DE GAULLE, CHARLES
 DE VALERA, EAMON
 DIDO
 EDWARD VIII
 ELIZABETH I
 ELIZABETH II
 FRANCOIS I
 FREDERICK THE GREAT
 GANDHI, MOHANDAS
 GENGHIS KHAN
 GEORGE VI
 GORBACHEV, MIKHAIL
 GUSTAV III
 HADRIAN
 HENRY VIII
 HENRY THE NAVIGATOR
 HIROHITO
 HITLER, ADOLPH
 HO CHI MINH
 HOXHA, ENVER
 ISABELLA I
 KHRUSHCHEV, NIKITA
 KUBLAI KHAN
 LENIN, VLADIMIR
 LLOYD GEORGE, DAVID
 LUDWIG II
 MAO ZEDONG
 MARCOS, FERDINAND
 MARY II
 MOLOTOV, VYACHESLAV
 MONTEZUMA
 MUSSOLINI, BENITO
 NAPOLEON
 NICHOLAS II

PERON, JUAN
RAMSES II
SADAT, ANWAR
SANTA ANNA
STALIN, JOSEF
SUN YAT-SEN
THRONES
TIBERIUS
TITO, MARSHAL
TOJO, HIDEKI
TOUSSAINT L'OUVERTURE
TUTANKHAMUN
VICTORIA
WILLIAM III, OF ORANGE
YELTSIN, BORIS

RUNNING
— Mexico
 Sports Illus 76:42–3,49 (c,1) Je 29 '92
— See also
 BOSTON MARATHON
 CROSS COUNTRY
 MARATHONS
 RACES
 TRACK

RURAL LIFE
— 1920s-1930s Appalachia
 Life 17:32–8 (3) D '94
— Central Pennsylvania
 Nat Geog 185:32–59 (c,1) Je '94
— Museum of Appalachia, Norris, Tennessee
 Smithsonian 26:44–53 (c,1) F '96
— Scenes of small-town America
 Smithsonian 24:42–9 (1) Mr '94
— See also
 FARM LIFE

RUSK, DEAN
 Am Heritage 44:60 (4) S '93

RUSSELL, BERTRAND
 Smithsonian 24:128–42 (c,1) My '93
— Family
 Smithsonian 24:132,136 (4) My '93

RUSSELL, LILLIAN
 Smithsonian 27:48 (c,4) N '96
Russia. See
 U.S.S.R.
Russian Revolution. See
 U.S.S.R.—HISTORY

**RUSSIAN ORTHODOX CHURCH—
COSTUME**
— Nun (U.S.S.R.)
 Nat Geog 185:124 (c,1) Je '94
— Reverends (Alaska)

 Nat Geog 184:44 (c,2) N '93

**RUSSIAN ORTHODOX CHURCH—
RITES AND FESTIVALS**
— Collecting holy water for blessing
 (Ukraine)
 Nat Geog 183:50–1 (c,1) Mr '93

RUTH, GEORGE HERMAN (BABE)
 Life 15:40-50 (1) Ap '92
 Sports Illus 77:70 (4) Jl 13 '92
 Sports Illus 77:101 (4) Fall '92
 Sports Illus 77:81 (2) D 21 '92
 Sports Illus 78:92 (4) Mr 22 '93
 Sport Illus 78:69 (4) My 24 '93
 Sports Illus 79:14 (4) Jl 19 '93
 Sports Illus 80:21 (4) Je 6 '94
 Smithsonian 25:44 (4) Jl '94
 Smithsonian 25:66 (4) O '94
 Smithsonian 25:68–79 (c,1) F '95
 Life 18:12 (1) My '95
 Sports Illus 83:36 (4) Jl 24 '95
 Sports Illus 83:4 (4) S 4 '95
 Sports Illus 83:15 (4) D 25 '95
 Sports Illus 84:62 (4) Je 24 '96
 Sports Illus 85:39 (3) Jl 1 '96
 Sports Illus 85:80 (3) Ag 19 '96
 Sports Illus 85:34 (4) Ag 26 '96
 Sports Illus 85:2–3 (c,1) N 25 '96
— Artifacts belonging to him
 Smithsonian 25:68 (c,1) F '95
 Sports Illus 82:70 (c,4) My 22 '95
— Family
 Smithsonian 25:72 (4) F '95
— Film "The Babe" (1993)
 Life 15:41–50 (c,2) Ap '92

RWANDA—COSTUME
 Life 18:10–11,45 (c,1) Ap '95
 Nat Geog 188:60–74 (c,1) O '95
— Civil War victims
 Life 17:74–80 (c,1) S '94
— Rwandan refugees (Tanzania)
 Life 17:15 (3) Jl '94
— Rwandan refugees (Zaire)
 Life 18:30–1 (1) Ja '95
 Life 18:36–44 (c,1) F '95
 Nat Geog 188:60–2,70–4 (c,1) O '95
 Life 19:78 (c,2) Ja '96
 Life 19:14–15 (c,1) Ap '96

**RWANDA—POLITICS AND GOV-
ERNMENT**
— Land ravaged by civil war
 Nat Geog 188:60–77 (map,c,1) O '95
— Scenes of civil war terrors
 Life 17:74–80 (c,1) S '94

–S–

SABER-TOOTHED CATS
Natur Hist 103:cov.,81-5 (painting,c,1)
Ap '94
SABIN, ALBERT
Life 17:88 (3) Ja '94
SACAGAWEA
— Grave (Wyoming)
Trav/Holiday 177:73 (c,4) Je '94
— Sites related to her life (Northwest)
Trav/Holiday 177:68–77 (c,1) Je '94
SADAT, ANWAR
Life 17:24 (c,3) Je '94
SADDLES
— 1862 Gallatin saddle
Am Heritage 43:31 (c,1) S '92
— 1876 saddle
Smithsonian 27:28 (c,4) Ag '96
SAFARIS
— Photo safari on elephants (Nepal)
Trav/Holiday 175:20 (c,3) O '92
SAGE
Nat Wildlife 32:44 (c,3) Je '94
SAGEBRUSH
Nat Geog 182:56–7 (c,1) D '92
Smithsonian 25:86–7 (c,3) Ag '94
Trav&Leisure 26:217 (4) S '96
**SAGUARO NATIONAL PARK, ARI-
ZONA**
Natur Hist 104:A6 (c,4) Ap '95
Smithsonian 26:76–83 (c,1) Ja '96
SAHARA DESERT, AFRICA
Natur Hist 104:43–5 (c,1) Ja '95
— Morocco
Nat Geog 189:108–9 (c,2) Je '96
— Richat structure, Mauritania
Nat Geog 190:14–15 (c,1) N '96
— Tunisia
Trav&Leisure 23:151 (c,3) F '93
SAILBOARDING
Trav/Holiday 179:68–9 (c,1) D '96
— 1992 Olympics (Barcelona)
Sports Illus 77:56–7 (c,1) Ag 10 '92
— Aruba
Trav&Leisure 22:58 (c,3) Je '92
— Oregon
Gourmet 53:144 (c,4) Ap '93
— Switzerland
Gourmet 53:52 (c,4) Jl '93
SAILBOAT RACES
— All female team
Sports Illus 82:40–2,47 (c,1) F 20 '95
— America's Cup contender (1937)

Life 19:78 (1) F '96
— America's Cup contenders
Sports Illus 76:62–73 (c,1) Ap 20 '92
— America's Cup race 1992
Sports Illus 76:2–3,42–5 (c,1) My 4 '92
Sports Illus 76:59–61 (c,2) My 11 '92
Sports Illus 76:2–3,22[4,29 (c,1) My 25
'92
Sports Illus 77:56 (c,2) D 28 '92
— America's Cup 1995
Sports Illus 82:38–41 (c,1) My 22 '95
— Caribbean
Gourmet 53:56–7 (c,2) Ja '93
— Dhow race (Kenya)
Natur Hist 105:54 (c,4) Ja '96
— Maryland
Nat Geog 183:32–3 (c,1) Je '93
— Sunken boat disaster
Sports Illus 82:24–5 (c,3) Mr 13 '95
— World Cup Competition 1995
Sports Illus 82:2–3,78–85 (c,1) Mr 20 '95
Sports Illus 82:73–82 (c,1) Mr 27 '95
— Yachting at 1992 Olympics (Barcelona)
Sports Illus 77:80–2 (c,1) Ag 10 '92
SAILBOATS
Gourmet 52:99–102 (c,1) My '92
— 1871 schooner
Am Heritage 47:28,32 (c,4) My '96
— Late 19th cent. schooner
Smithsonian 26:55 (4) Ag '95
— Dhows (Kenya)
Natur Hist 105:54 (c,4) Ja '96
— Diagram of sailboat parts
Gourmet 55:112 (4) Ja '95
— Feluccas (Egypt)
Trav/Holiday 175:59 (c,2) S '92
Gourmet 52:95 (c,1) S '92
— Racing boat
Sports Illus 77:34–40 (c,1) N 30 '92
— Schooner
Life 15:8–9 (c,1) Jl '92
— See also
JUNKS
YACHTS
SAILING
Trav&Leisure 24:42–4 (c,4) Ja '94
— Caribbean
Gourmet 54:56–60 (c,1) Ja '94
Trav/Holiday 179:44 (c,4) Mr '96
— Italy
Gourmet 52:50–1 (c,1) Jl '92
— Maine
Gourmet 52:99–103 (c,1) My '92
— Raising anchor of tall ship
Sports Illus 77:5 (c,3) O 5 '92

— Round-the-world solo sail
 Smithsonian 25:58–67 (c,1) Mr '95
— Stadium sailing (Michigan)
 Sports Illus 82:9 (c,4) Je 12 '95
— Steering racing yacht
 Sports Illus 80:72–3 (c,1) My 9 '94
— Tall ships
 Life 15:56–63 (c,1) N '92
 Trav&Leisure 23:cov.,112–26 (c,1) F '93
— U.S. Coast Guard cadet training
 Smithsonian 26:22–33 (c,1) Ag '95

SAILORS
— Late 19th cent. practice of shanghaiing
 sailors
 Am Heritage 46:66–72 (drawing,2) S '95
— 1917 sailors playing craps
 Am Heritage 45:35 (4) S '94
— 1946 U.S. sailors preparing for atom bomb
 test (Bikini)
 Nat Geog 181:73 (1) Je '92
— Teens learning to sail (Denmark)
 Life 15:56–63 (c,1) N '92
— U.S.S.R.
 Life 15:14–15 (c,1) Ja '92
 Nat Geog 185:45 (c,4) Ap '94
 Nat Geog 186:104–5 (c,3) S '94
— World War II (U.S.)
 Am Heritage 45:99 (4) O '94
— See also
 SHIP CAPTAINS

ST. AUGUSTINE, FLORIDA
— Castillo de San Marcos
 Am Heritage 44:56–7 (c,2) Ap '93

ST. ELIAS RANGE, ALASKA
 Trav/Holiday 176:62–3 (c,1) My '93

SAINT-GAUDENS, AUGUSTUS
 Smithsonian 23:138 (4) N '92
— Bust of Saint-Gaudens
 Gourmet 54:124 (c,4) O '94
— Home (Cornish, New Hampshire)
 Gourmet 54:124–6 (c,1) O '94

ST. JOHN'S, NEWFOUNDLAND
 Trav&Leisure 24:83 (c,3) Je '94

ST. JOSEPH, MISSOURI
— 1850s
 Smithsonian 25:42–3 (3) My '94
— Founder Joseph Robidoux
 Smithsonian 25:48 (4) My '94

ST. LAWRENCE RIVER, NORTHEAST
 Nat Geog 186:104–25 (map,c,1) O '94

ST. LAWRENCE RIVER, QUEBEC
 Gourmet 53:104–7 (c,1) S '93

ST. LOUIS, MISSOURI
 Nat Geog 183:96–7 (c,1) Je '93
 Gourmet 53:cov.,92–7 (c,1) S '93

 Trav/Holiday 176:cov.,54–64 (c,1) S '93
 Trav/Holiday 179:15 (c,4) My '96
— 1846
 Smithsonian 27:40 (painting,c,2) Ap '96
— Gateway Arch
 Gourmet 53:cov.,92–3 (c,1) S '93
 Trav/Holiday 176:cov.,54–5 (c,1) S '93
— National Video Game Museum
 Sports Illus 81:8 (c,4) N 28 '94
— Night storm scene
 Nat Geog 185:6–6 (c,3) Ja '94
— Union Station
 Am Heritage 45:100–1 (c,2) Jl '94
St. Martin. See
 LEEWARD ISLANDS

ST. PAUL, MINNESOTA
— 19th cent. bridges
 Smithsonian 27:86–7 (3) S '96
— Designs for new bridge
 Smithsonian 27:84–5,90 (c,2) S '96
— State Capitol
 Trav/Holiday 179:42 (c,3) N '96

ST. PETERSBURG, FLORIDA
— Don CeSar resort
 Trav&Leisure 22:135 (c,2) Mr '92

ST. PETERSBURG, RUSSIA
 Trav/Holiday 175:36,38 (c,4) D '92
 Trav/Holiday 176:88–9 (c,3) Ap '93
 Trav&Leisure 23:105–13,182 (map,c,1) N
 '93
 Nat Geog 184:96–121 (map,c,1) D '93
 Gourmet 56:22,102–5 (c,1) S '96
— Catherine Palace
 Gourmet 56:102–5 (c,1) S '96
— Marble Palace
 Gourmet 56:103 (c,2) S '96
— Peterhof Palace
 Gourmet 56:104 (c,4) S '96
— Sites associated with Catherine the Great
 Gourmet 56:22,102–5 (c,1) S '96
— Winter Palace
 Gourmet 56:22,105 (c,4) S '96
— See also
 HERMITAGE MUSEUM

**ST. SOPHIA CATHEDRAL, ISTAN-
 BUL, TURKEY**
 Trav&Leisure 26:42 (c,4) S '96
— Interior
 Trav/Holiday 175:66 (c,4) Jl '92

SAINTS
— 13th cent. icon of St. Nicholas (U.S.S.R.)
 Smithsonian 25:46 (c,4) Mr '95
— Durer painting of Saint James (1516)
 Smithsonian 24:65 (c,4) F '94
— St. John the Baptist by Caravaggio

Trav&Leisure 25:60 (painting,c,4) O '95
— "St. Michael" by Piero della Francesca
 Trav/Holiday 178:78 (painting,c,4) Mr '95

SALAMANDERS
 Natur Hist 102:22 (c,4) Ja '93
 Natur Hist 103:36–7 (c,2) O '94
 Nat Wildlife 33:45 (c,4) F '95
— Salamander eggs
 Natur Hist 103:34–5 (c,2) O '94
 Nat Wildlife 33:45 (c,4) F '95

SALEM, MASSACHUSETTS
 Gourmet 52:100–3,190 (map,c,1) O '92
 Trav&Leisure 23:E2 (c,4) Je '93
— 1692 Salem witch trials
 Trav/Holiday 175:90 (painting,c,4) F '92
 Smithsonian 23:116–28 (engraving,c,2)
 Ap '92
— House of the Seven Gables
 Gourmet 52:100–1 (c,1) O '92
 Trav&Leisure 23:E2 (c,4) Je '93

SALK, JONAS
 Life 19:89 (4) Ja '96

SALMON
 Nat Geog 181:125 (c,4) Mr '92
 Nat Wildlife 32:8–9 (c,1) D '93
 Nat Geog 187:37 (c,3) Mr '95
 Nat Wildlife 33:32 (c,1) Je '95
 Natur Hist 104:cov.,1,26–39 (c,1) S '95
— Atlantic salmon
 Nat Wildlife 30:50–1 (c,1) O '92
— Chinook
 Natur Hist 104:30 (c,2) S '95
— Going up fish ladder to spawn (California)
 Nat Geog 184:45 (c,1) N 15 '93
— Sockeye
 Natur Hist 101:24–5 (c,1) F '92
 Nat Wildlife 30:14–15 (painting,c,1) Ap
 '92
 Nat Wildlife 32:20 (c,2) F '94
 Life 17:70 (c,4) Ag '94
 Nat Wildlife 32:42–9 (c,1) O '94
 Natur Hist 104:cov.,26–7,31 (c,1) S '95
 Nat Wildlife 34:39 (c,1) Ap '96

SALT
— Mono Lake saltrock towers, California
 Nat Wildlife 31:10–11 (c,1) Je '93
— Salt-encrusted field (Iraq)
 Nat Geog 183:48–9 (c,2) My '93
— Salt marshes (Mexico)
 Nat Geog 188:90–1 (c,2) O '95
— Virgin Mary salt sculpture (Poland)
 Smithsonian 24:96 (c,2) Mr '94

SALT INDUSTRY
— 18th cent. engraving of salt mining
 (Poland)

Smithsonian 24:97 (c,2) Mr '94
— Harvesting salt from pond (France)
 Natur Hist 102:38 (c,4) My '93
— Salt desert (Bolivia)
 Life 17:26 (c,2) N '94
— Salt wagon (Vietnam)
 Trav&Leisure 25:175 (c,4) O '95
— See also
 SALT MINES

SALT LAKE CITY, UTAH
 Trav/Holiday 178:29 (c,3) D '95
 Nat Geog 189:48–50 (c,1) Ja '96
— Mormon sites
 Am Heritage 44:cov.,65–82 (c,1) Ap '93
— Mormon temple draped in flag for 1896
 statehood celebration
 Am Heritage 47:75–6 (3) Ap '96
— See also
 GREAT SALT LAKE

SALT MINES
— New Mexico
 Smithsonian 26:40–1 (c,1) My '95
— Wieliczka salt mine history, Poland
 Smithsonian 24:96–106 (c,2) Mr '94

SALTON SEA, CALIFORNIA
 Smithsonian 27:86–97 (map,c,1) Je '96

SALVADOR, BRAZIL
 Trav/Holiday 175:56–65 (map,c,1) Je '92

SALZBURG, AUSTRIA
 Trav/Holiday 176:42–51 (c,1) D '93
 Trav&Leisure 24:116 (c,2) My '94

Sami people. See
 LAPP PEOPLE

SAMPANS
— China
 Trav/Holiday 176:cov.,60 (c,1) F '93

SAN ANTONIO, TEXAS
 Gourmet 52:74–9,136–8 (c,1) Je '92
 Trav/Holiday 179:31 (c,4) Mr '96
— 1977 street scene
 Smithsonian 25:32 (painting,c,2) D '94
— Marion Koogler McNay art museum
 Trav/Holiday 177:73 (c,4) S '94
— Paseo del Rio
 Gourmet 52:74–5 (c,1) Je '92
— River walk at Christmas
 Am Heritage 43:32 (c,4) N '92 supp.
— See also
 ALAMO

SAN DIEGO, CALIFORNIA
 Trav/Holiday 175:24 (c,4) S '92
 Trav/Holiday 176:34–6 (c,4) D '93
— Horton Plaza
 Trav/Holiday 176:34 (c,4) D '93
— Museum of Contemporary Art

Trav&Leisure 26:42 (c,4) Je '96
— Sweetwater Marsh
Nat Wildlife 31:14–15 (c,1) D '92
SAN FRANCISCO, CALIFORNIA
Trav/Holiday 175:18 (c,4) O '92
Trav/Holiday 176:cov.,50–9 (map,c,1) Ap
'93
Trav&Leisure 23:82–3 (c,1) My '93
Trav&Leisure 25:104–5 (c,2) F '95
Gourmet 55:158–61,230 (map,c,1) My '95
— 1851
Am Heritage 46:68–71 (2) S '95
— Late 19th cent. mansion
Am Heritage 47:71 (1) F '96
— 1900 stereoscope of Cliff House
Am Heritage 45:121 (4) N '94
— 1906 earthquake damage
Life 17:43 (4) Ap '94
— Fairmont Hotel lobby
Am Heritage 45:50 (c,4) Ap '94
— Ferry Building (1930s)
Trav&Leisure 22:51 (3) Ag '92
— Map of environs
Trav/Holiday 178:128 (c,2) My '95
— Museum of Modern Art
Trav&Leisure 25:35 (c,4) Ja '95
Smithsonian 26:60–1,69 (c,1) Jl '95
— North Beach
Life 16:102–4 (c,2) O '93
— Presidio
Nat Geog 186:33–4 (c,1) O '94
Nat Wildlife 33:50–1 (c,2) F '95
Trav/Holiday 178:78–85 (c,1) N '95
— Restaurants
Trav&Leisure 25:107–9 (c,1) F '95
— San Francisco Bay pollution problems
Smithsonian 23:88–95 (c,1) Ag '92
— Sheraton Palace hotel
Am Heritage 45:51,55 (c,1) Ap '94
— SoMa area
Smithsonian 26:60–9 (c,1) Jl '95
— Street mural
Trav/Holiday 179:66–7 (c,1) Mr '96
— Sutro Baths
Smithsonian 23:120–31 (c,1) F '93
— Tadich Grill
Gourmet 56:112–14,119 (c,4) O '96
— Transamerica Pyramid
Gourmet 53:36 (c,4) D '93
Gourmet 55:161 (c,1) My '95
— UnderWater World
Trav&Leisure 26:30 (c,4) Jl '96
— Yerba Buena Gardens complex
Trav&Leisure 23:41 (drawing,c,4) O '93
— See also

ALCATRAZ
GOLDEN GATE BRIDGE
SAN FRANCISCO-OAKLAND BAY
BRIDGE
SAN FRANCISCO-OAKLAND BAY BRIDGE, CALIFORNIA
— 1936
Life 15:81 (2) F '92
SAN JOSE, CALIFORNIA
— Museum of Art
Gourmet 54:102 (c,4) O '94
SAN JOSE, COSTA RICA
— National Museum
Trav/Holiday 179:10 (c,4) D '96
SAN JUAN, PUERTO RICO
Trav/Holiday 179:38–40 (c,1) N '96
— La Fortaleza
Trav/Holiday 176:32 (c,4) N '93
SAN JUAN ISLANDS, WASHINGTON
Gourmet 52:90 (c,4) Ap '92
Nat Geog 187:106–30 (map,c,1) Je '95
Trav&Leisure 26:122–9,164 (map,c,1) Ap
'96
SAN SALVADOR, EL SALVADOR
Nat Geog 188:118–19 (c,2) S '95
SAND
— Children playing with pails on beach
Trav&Leisure 22:102–3 (c,1) Mr '92
— European landmarks in sand sculpture
(Netherlands)
Life 15:24 (c,4) Ag '92
— Sand sculpture of Smithsonian Castle,
Washington, D.C.
Smithsonian 26:63 (c,3) Ap '95
SAND, GEORGE
Smithsonian 27:122–33 (painting,c,1) D
'96
— Family and friends of George Sand
Smithsonian 27:124–35 (painting,c,4) D
'96
— Home (Nohant Chateau, France)
Smithsonian 27:123,136 (c,4) D '96
SAND DOLLARS
Nat Wildlife 31:18–19 (c,2) Je '93
SAND DUNES
— Australia
Nat Geog 181:66–7 (c,1) Ap '92
— Cape Cod, Massachusetts
Gourmet 53:122–3 (c,1) Ap '93
— China
Natur Hist 101:32 (c,1) S '92
— Cumberland Island, Georgia
Trav&Leisure 26:E1 (c,4) Ap '96
— Death Valley, California
Trav&Leisure 23:190 (c,4) Mr '93

Gourmet 54:85 (c,3) Je '94
Nat Geog 189:57–9 (c,1) My '96
— Imperial Sand Dunes, California
Nat Geog 186:50 (c,1) S '94
— Los Angeles, California
Nat Wildlife 31:48–9 (c,1) O '93
— Nipomo Dunes, California
Life 16:34–5 (c,1) O '93
— North Carolina
Gourmet 55:102–3 (c,1) Ap '95
— Padre Island, Texas
Trav/Holiday 177:86 (c,1) D '94
— Sand Mountain, Nevada
Trav/Holiday 179:66 (c,1) N '96
— See also
GREAT SAND DUNES NATIONAL
MONUMENT
SANDBURG, CARL
— Birthplace (Galesburg, Illinois)
Gourmet 53:136 (c,4) Ap '93
SANDPIPERS
Nat Geog 182:42–3 (c,1) O '92
Natur Hist 101:27 (c,4) O '92
Natur Hist 104:39–41 (c,1) Jl '95
Natur Hist 104:58–61 (c,4) Ag '95
Nat Wildlife 34:24–5 (c,1) Je '96
SANDSTONE
— Antelope Canyon, Arizona
Nat Wildlife 33:59 (c,2) D '94
— Shawnee National Forest, Illinois
Natur Hist 103:22–4 (map,c,1) Jl '94
SANTA ANNA
Smithsonian 23:90–1 (painting,c,2) Jl '92
Trav/Holiday 175:59 (painting,4) Jl '92
SANTA BARBARA, CALIFORNIA
Trav/Holiday 175:39,41 (c,4) S '92
Trav/Holiday 178:56–63 (map,c,1) S '95
— Aerial view
Nat Geog 188:80–1 (c,2) D '95
— Mission
Trav/Holiday 175:39 (c,4) S '92
Gourmet 55:122 (c,2) F '95
SANTA CLAUS
Trav&Leisure 25:102 (c,1) D '95
— 1923 sidewalk Santa
Am Heritage 47:92 (4) F '96
— On skis (Vermont)
Gourmet 54:133 (c,4) D '94
— Reindeer in flight
Gourmet 55:128 (painting,c,2) D '95
— Santa Claus bungee jumping (California)
Sports Illus 81:106 (c,2) D 26 '94
— N.C. Wyeth painting
Life 18:39 (c,4) D '95

SANTA FE, NEW MEXICO
Trav&Leisure 22:84–97,141–2 (map,c,1)
F '92
Trav&Leisure 24:75 (c,4) Ag '94
— Loretto Chapel's spiral staircase
Smithsonian 24:10 (c,4) Ag '93
— Night skyline
Smithsonian 26:150 (c,2) N '95
— Open-air theater
Trav&Leisure 26:E1 (c,4) Mr '96
— The Plaza
Gourmet 54:90 (painting,c,2) S '94
— San Miguel Mission
Trav&Leisure 22:94–5 (c,1) F '92
SANTIAGO, CHILE
Trav/Holiday 178:64–7 (c,1) D '95
— La Moneda Palace
Trav&Leisure 23:67 (c,4) Ap '93
SARAJEVO, YUGOSLAVIA
Nat Geog 189:48–9 (1) Je '96
— Effect of war on Sarajevo
Life 16:6,32–7 (c,1) Ap '93
Sports Illus 80:44–52 (c,1) F 14 '94
— Remains of bombed bridge
Life 16:14–15 (c,1) Mr '93
SARASOTA, FLORIDA
Gourmet 53:86–91,134 (map,c,1) F '93
— Ringling home and Museum of Art
Trav/Holiday 175:88 (c,4) F '92
Trav&Leisure 22:137 (c,4) Mr '92
Gourmet 53:86–91 (c,1) F '93
Trav/Holiday 177:71 (c,4) S '94
SARATOGA SPRINGS, NEW YORK
Trav/Holiday 178:78–83 (c,1) Je '95
SARDINIA, ITALY
Trav/Holiday 176:38–47 (map,c,2) Je '93
— Costa Smeralda
Gourmet 52:46–51,90-2 (map,c,1) Jl '92
SARGENT, JOHN SINGER
— Deem painting in style of Sargent
Smithsonian 24:100 (c,4) Jl '93
— "Portrait of Dorothy"
Trav/Holiday 176:103 (painting,c,4) N '93
— Portrait of Isabella Stewart Gardner
Trav/Holiday 177:70 (painting,c,4) S '94
— Portrait of Harriet Hemenway
Smithsonian 25:98 (painting,c,3) Jl '94
SASKATCHEWAN
— Athabasca Lake
Nat Geog 189:120–1 (c,1) My '96
— Countryside
Nat Geog 186:39–40,48–51 (c,1) D '94
SATELLITE DISHES
Sports Illus 77:52–3 (c,1) D 21 '92

SATURN (PLANET)
Smithsonian 22:99 (c,2) Mr '92
SAVANNAH, GEORGIA
Trav/Holiday 179:cov.,68–77 (map,c,1)
My '96
Sports Illus 85:44–6 (c,1) Jl 22 '96
— 1864 plantation
Smithsonian 27:120–1 (1) My '96
— Sites associated with *Midnight in the Garden of Good and Evil*
Trav/Holiday 179:cov.,68–77 (map,c,1)
My '96
SAVANNAH RIVER, GEORGIA
Nat Geog 182:21–2 (c,1) O '92
SAWMILLS
— California
Smithsonian 24:42–3 (c,1) O '93
SAXOPHONE PLAYING
Sports Illus 85:40–1 (c,1) D 30 '96
— Child practicing (Tennessee)
Nat Geog 183:136 (c,3) F '93
SCALES
— Antique food scale (France)
Gourmet 56:109 (c,2) Mr '96
— Delicatessen scale (New York)
Smithsonian 25:80 (1) Ap '94
— Produce market scale (Italy)
Natur Hist 101:62 (4) Ap '92
— Weighing fish at market (New York)
Trav&Leisure 22:NY1 (c,4) O '92
— Weighing limestone (Vietnam)
Trav&Leisure 25:171 (1) O '95
Scandinavia. See
specific countries
VIKINGS
SCARECROWS
— Balloon used as scarecrow (North Dakota)
Nat Geog 188:67 (c,1) D '95
— Belize
Nat Geog 184:126–7 (c,2) S '93
— Native American sentries scaring off birds
(1853)
Smithsonian 26:104 (engraving,c,3) N '95
SCHLESINGER, ARTHUR, JR.
Am Heritage 43:46 (c,4) F '92
SCHLIEMANN, HEINRICH
Natur Hist 105:49 (painting,c,4) Ap '96
SCHOLARS
— Poland
Gourmet 54:136 (c,4) N '94
SCHOOLS
— 1920 one-room schoolhouse (Oregon)
Smithsonian 26:28 (2) Mr '96
— Boys Town history (Omaha, Nebraska)

Sports Illus 77:74–88 (c,1) D 21 '92
— Nursery school children (Paraguay)
Nat Geog 182:106 (c,3) Ag '92
— "Odyssey of the Mind" competition for
students
Smithsonian 26:86–93 (c,1) Jl '95
— One-room schoolhouse (Massachusetts)
Nat Geog 181:128–9 (c,1) Je '92
— One-room schoolhouse (Minnesota)
Life 15:70–7 (c,1) S '92
— One-room schoolhouse (Montana)
Trav/Holiday 176:71 (c,1) Je '93
— Restored one-room schoolhouse (Missouri)
Smithsonian 22:106–7 (c,3) F '92
— Stuyvesant High School, New York City
Life 17:48–61 (c,1) O '94
— World Championship Wrestling School
(Atlanta, Georgia)
Life 18:72–4 (c,1) Ap '95
— See also
CLASSROOMS
EDUCATION
SCHWARZKOPF, H. NORMAN
Life 15:18 (c,3) Mr '92
SCIENCE
— Photosynthesis in chloroplasts
Natur Hist 101:46,50–1 (c,1) Ag '92
— Unusually shaped books on science topics
Smithsonian 26:108–11 (c,1) Je '95
— See also
ANATOMY
ASTRONOMY
EVOLUTION
GENETICS
LABORATORIES
MEDICAL RESEARCH
MEDICINE—PRACTICE
OPTICAL ILLUSIONS
SCIENTIFIC EXPERIMENTS
SPACE PROGRAM
SCIENCE EDUCATION
— Student experiments aboard shuttle
"Endeavor" (1993)
Nat Geog 186:54–69 (c,1) Ag '94
— Teaching science to elementary school
students (Chicago, Illinois)
Smithsonian 24:104–15 (c,1) Ap '93
SCIENCE FICTION
— Jim Gurney's fantasy "Dinotopia" land
Life 15:54–61 (painting,c,1) O '92
Natur Hist 101:16 (painting,c,3) D '92
Smithsonian 26:cov.,70–9 (painting,c,1) S
'95
— Man in alien costume
Natur Hist 105:16 (4) F '96

SCIENTIFIC EXPERIMENTS

— Agronomy lab (New York)
 Smithsonian 26:102 (c,3) N '95
— Bacteria research
 Nat Geog 184:36–61 (c,1) Ag '93
— Biosphere 2, Arizona
 Trav&Leisure 22:21 (c,4) Ap '92
 Trav/Holiday 175:74–7 (c,1) My '92
 Smithsonian 25:16 (c,4) My '94
 Sports Illus 84:195 (c,4) Ja 29 '96
— Criminal forensic research (Washington,
 D.C.)
 Smithsonian 27:82–90 (c,1) My '96
— DNA research
 Nat Geog 181:113–24 (c,1) My '92
— Ecosystem research (Chesapeake Bay
 region)
 Smithsonian 27:100–9 (c,1) Jl '96
— Future of information technology
 Nat Geog 188:2–37 (c,1) O '95
— Geologists collecting debris from Antarctic
 iceberg
 Smithsonian 26:14 (c,4) S '95
— Lab researching deaths of endangered
 animals (Oregon)
 Smithsonian 22:40–9 (c,1) Mr '92
— Neutrino interacting with proton
 Natur Hist 105:9 (c,4) Je '96
— Orangutan think tank at zoo (Washington,
 D.C.)
 Natur Hist 105:26–30 (1) Ag '96
— Product testing by Consumers Union (New
 York)
 Smithsonian 24:34–43 (c,1) S '93
— Research on strength and durability of
 concrete
 Smithsonian 24:22–31 (c,1) Ja '94
— Researching Antarctic ice
 Nat Geog 189:36–53 (c,1) My '96
— Scientists solving crimes with physical
 evidence
 Nat Wildlife 30:8–15 (c,1) F '92
— Student experiments aboard shuttle
 "Endeavor" (1993)
 Nat Geog 186:54–69 (c,1) Ag '94
— Study of dark matter in the universe
 Smithsonian 24:26–35 (c,1) Je '93
— Tagging small animals for tracking
 Nat Wildlife 31:24–7 (c,1) F '93
— Teaching language to chimpanzees
 Nat Geog 181:33–4 (c,2) Mr '92
— See also
 LABORATORIES
 MEDICAL RESEARCH

SCIENTIFIC INSTRUMENTS

— Ozone-measuring balloon (Antarctica)
 Life 16:81 (c,3) Mr '93
— Tsunami warning devices
 Smithsonian 24:36,68 (c,4) Mr '94
— See also
 ANTENNAS
 LASERS
 MEDICAL INSTRUMENTS
 NAVIGATION INSTRUMENTS
 SCALES
 SUNDIALS
 TELESCOPES

SCIENTISTS

— Edwin Cohn
 Smithsonian 25:125,138 (4) Mr '95
— James Dwight Dana
 Natur Hist 105:22 (2) F '96
— Alfred Kinsey
 Am Heritage 44:41 (4) My '93
— Paleontologist Charles Walcott
 Smithsonian 23:108 (4) Ja '93
— Paleontologists uncovering fossil (Africa)
 Natur Hist 104:44–5 (c,1) Ja '95
— Scientists solving crimes with physical
 evidence
 Nat Wildlife 30:8–15 (c,1) F '92
— See also
 BARNARD, EDWARD E.
 DARWIN, CHARLES
 EDISON, THOMAS ALVA
 EINSTEIN, ALBERT
 FERMI, ENRICO
 FREUD, SIGMUND
 HERSCHEL, CAROLINE L.
 HUBBLE, EDWIN POWELL
 KOCH, ROBERT
 LAVOISIER, ANTOINE LAURENT
 LINNAEUS, CAROLUS
 LOWELL, PERCIVAL
 MEAD, MARGARET
 MESSIER, CHARLES
 OPPENHEIMER, J. ROBERT
 OSBORN, HENRY FAIRFIELD
 PAULING, LINUS
 SABIN, ALBERT
 SALK, JONAS
 SCHLIEMANN, HEINRICH
 VON BRAUN, WERNHER

SCOREBOARDS

— Baseball
 Smithsonian 25:76 (c,2) O '94
— Baseball (1960)
 Sports Illus 81:138–9 (1) N 14 '94

— Baseball (Japan)
 Sports Illus 81:32 (c,4) O 31 '94
— Golf
 Sports Illus 81:35 (c,4) Ag 22 '94
— Hockey
 Sports Illus 77:48 (c,4) N 16 '92
SCORPIONS
 Smithsonian 27:93–103 (c,1) Ap '96
SCOTLAND
 Nat Geog 190:2–27 (map,c,1) S '96
— Blair castle
 Gourmet 52:118 (c,4) Ap '92
— Callandish Standing Stones, Isle of Lewis
 Nat Geog 190:14–15 (c,1) S '96
— Cawdor castle
 Trav&Leisure 22:78 (c,4) My '92
— Eastern coastal area
 Gourmet 52:52–5,86–8 (map,c,1) Jl '92
— Eilean Donan castle
 Trav&Leisure 22:155 (c,3) Ap '92
 Nat Geog 190:6–7 (c,1) S '96
— Falkland Palace
 Trav&Leisure 26:122 (c,1) D '96
— Highlands
 Trav&Leisure 22:155–60 (map,c,2) Ap '92
 Trav&Leisure 23:cov.,58–69 (map,c,1) Jl '93
 Trav&Leisure 23:100–3 (c,1) D '93
 Trav/Holiday 177:64–5 (c,2) Jl '94
— Inveraray
 Trav&Leisure 23:103 (c,4) D '93
— Isle of Skye
 Trav/Holiday 179:21 (c,4) Ap '96
— Kinloch castle, Isle of Rum
 Trav&Leisure 26:68 (painting,c,3) O '96
— Kinnaird resort hotel
 Trav&Leisure 23:cov.,58–60 (c,1) Jl '93
— Loch Broom
 Gourmet 53:102–4 (c,1) Mr '93
— Loch Ness
 Trav&Leisure 23:64–7 (c,1) Jl '93
— Macbeth's castle, Bankfoot
 Trav/Holiday 179:21 (c,4) S '96
— Perth area
 Gourmet 52:118–19,166 (map,c,2) Ap '92
— Pittenweem
 Trav&Leisure 26:124 (c,4) D '96
— St. Andrews
 Gourmet 52:54–5 (c,1) Jl '92
 Trav&Leisure 26:cov.,122–31,181–3 (map,c,1) D '96
— Saint Kilda
 Natur Hist 103:28–33 (map,c,1) Mr '94
— Tantallon castle, North Berwick
 Gourmet 52:53 (c,2) Jl '92

— Western coast
 Trav/Holiday 175:76–9 (map,c,1) Jl '92
— See also
 BAGPIPES
 EDINBURGH
 GLASGOW
 SHETLAND ISLANDS
SCOTLAND—COSTUME
 Trav&Leisure 23:61 (c,1) Jl '93
 Nat Geog 190:2–27 (c,1) S '96
— 19th cent. shepherd
 Smithsonian 27:132 (painting,c,3) N '96
— Caber tossers in kilts (Texas)
 Sports Illus 83:157–8 (c,4) N 27 '95
— Kilts
 Nat Geog 190:4 (c,1) S '96
— Traditional attire
 Gourmet 52:118 (c,4) Ap '92
 Trav&Leisure 26:114 (c,4) N '96
SCOTLAND—RITES AND FESTIVALS
— Braw Lads Gathering (Galashiels)
 Nat Geog 190:24–5 (c,1) S '96
— Edinburgh Festival
 Smithsonian 25:38–47 (c,1) D '94
 Gourmet 56:56–8 (c,4) S '96
SCOTLAND—SOCIAL LIFE AND CUSTOMS
— Caber tossing (Texas)
 Sports Illus 83:157–8 (c,4) N 27 '95
— Shinty team
 Trav&Leisure 23:106 (c,3) D '93
SCOTT, PAUL
 Smithsonian 23:134 (4) F '93
SCOTT, ROBERT FALCON
 Trav/Holiday 176:58 (4) Je '93
SCOTTISH TERRIERS
— Franklin Roosevelt's dog Fala
 Am Heritage 44:45 (4) Ap '93
 Life 18:95 (4) Je 5 '95
Scuba. See
 SKIN DIVING
SCULPINS
 Nat Geog 181:38 (c,4) Je '92
SCULPTING
— 1890 stone craftsmen (California)
 Am Heritage 46:112 (3) F '95
— Mexico
 Trav/Holiday 175:80 (c,3) F '92
SCULPTURE
— 13th cent. bronze lion (Spain)
 Smithsonian 23:49 (c,4) Ag '92
— 14th cent. Aztec skull sculpture
 Natur Hist 105:34 (c,4) O '96
— 18th cent. Benin sculpture (Africa)
 Smithsonian 23:30,32 (c,4) F '93

— Blind girl feeling sculpture (New York)
 Life 15:20 (1) Mr '92
— Confederate heroes monument (Stone
 Mountain, Georgia)
 Life 15:15 (c,1) Jl '92
— Garden sculpture (Italy)
 Gourmet 52:132–5 (c,3) N '92
— Glass sculpture
 Nat Geog 184:cov.,36,65–9 (c,1) D '93
— Goldsworthy sculptures in landscape
 Natur Hist 105:8–9 (c,2) O '96
— Hebrew version of Robert Indiana's
 "Love" sculpture (Israel)
 Trav/Holiday 176:62–3 (c,1) D '93
— Huge bison statue (North Dakota)
 Nat Geog 186:82–3 (c,1) N '94
— Ice palace (Harbin, China)
 Life 18:14 (c,2) Mr '95
— Ice sculpture
 Life 18:32 (c,4) F '95
 Trav/Holiday 179:42–3 (c,3) N '96
— Jai alai sculpture (Spain)
 Gourmet 54:127 (c,4) N '94
— Kinetic sculpture by Arthur Ganson
 Smithsonian 26:46–55 (c,1) Ja '96
— Land sculpture of bison (Wyoming)
 Nat Geog 186:76–7 (c,1) N '94
— Lion statue in front of New York Public
 Library, New York City
 Smithsonian 24:92 (c,2) Ag '93
— Maya sculpture (Guatemala)
 Nat Geog 183:94–101 (c,1) F '93
— Modern works (Mexico)
 Smithsonian 23:87,90,93 (c,2) Ap '92
— Modern works by Luis Jimenez
 Smithsonian 23:86–95 (c,1) Mr '93
— Outdoor (Florence, Italy)
 Trav&Leisure 22:75 (c,1) Jl '92
— Outdoor cattle sculptures (Toronto,
 Ontario)
 Nat Geog 189:128–9 (c,2) Je '96
— Outdoor figures in Dorset hillside, England
 Life 16:18 (4) O '93
— Outdoor sculpture by Liberman (St. Louis,
 Missouri)
 Gourmet 53:92 (c,4) S '93
— Outdoor sculpture covered by snow
 (Washington, D.C.)
 Life 19:90 (c,2) Ap '96
— "Portlandia" (Portland, Oregon)
 Trav/Holiday 175:30 (c,4) My '92
— Rescuing neglected outdoor sculpture
 Smithsonian 26:141–9 (c,1) Ap '95
— Sculptor Edmonia Lewis
 Smithsonian 27:18 (4) S '96

— Sculpture of half-buried Cadillacs
 (Nebraska)
 Life 19:116 (c,2) Winter '96
— Spoon and cherry outdoor sculpture
 (Minneapolis, Minnesota)
 Trav&Leisure 24:58 (c,3) Jl '94
— Stone heads (Easter Island)
 Nat Geog 183:54–5,60 (c,1) Mr '93
— Tang dynasty horse figure (China)
 Smithsonian 26:40 (c,4) S '95
— 300 pound lard sculpture of pig (Texas)
 Life 15:26 (c,4) Je '92
— 360-degree profile sculpture of Mussolini
 Smithsonian 25:111 (c,1) F '95
— Tiki statues (Hawaii)
 Trav&Leisure 22:62 (c,3) O '92
— Toothpick sculpture of surfer (California)
 Sports Illus 85:30 (c,3) Jl 29 '96
— Virgin Mary sculpture made of salt
 (Poland)
 Smithsonian 24:96 (c,2) Mr '94
— Works by Vadim Sidur
 Smithsonian 25:118–26 (1) D '94
— See also
 BERNINI, GIOVANNI LORENZO
 BORGLUM, GUTZON
 CALDER, ALEXANDER
 FRENCH, DANIEL CHESTER
 LIPCHITZ, JACQUES
 MICHELANGELO
 MOUNT RUSHMORE
 OLDENBURG, CLAES
 RODIN, AUGUSTE
 SAINT-GAUDENS, AUGUSTUS
 SEGAL, GEORGE
 THORVALDSEN, BERTEL

SCULPTURE—ANCIENT

— 2100-year-old clay soldiers (Xian, China)
 Nat Geog 182:114–30 (c,1) Ag '92
 Trav&Leisure 23:68–9 (c,1) S '93
 Nat Geog 190:68–85 (c,1) O '96
— 2500-year-old bronze Amazon warrior
 (Italy)
 Natur Hist 101:cov. (c,1) Jl '92
—5th cent. B.C. "Kritios Boy" (Greece)
 Trav&Leisure 22:21 (c,4) N '92
— 5th cent. B.C. Celtic stone pillar depicting
 mistletoe leaves
 Natur Hist 105:69 (c,4) F '96
— 4th cent. B.C. stele of democracy (Athens)
 Smithsonian 24:46 (c,4) Jl '93
— 19th cent. Kongo Nkisi figures (Africa)
 Smithsonian 24:18 (c,4) D '93
— Ancient Roman bronze works found in the
 sea (Brindisi, Italy)

Nat Geog 187:88–101 (c,1) Ap '95
— Ancient Scythian gold relics
 Nat Geog 190:55–67,79 (c,1) S '96
— Bronze Age stone urns (Laos)
 Natur Hist 104:48–55 (c,1) S '95
— Bronze Celtic warrior
 Smithsonian 24:118 (c,3) My '93
— Copper Age carved stela
 Nat Geog 183:59–61 (c,1) Je '93
— Cro-Magnon clay bison (France)
 Natur Hist 102:22 (c,4) Mr '93
— "The Dying Gaul"
 Smithsonian 24:120–1 (c,3) My '93
— Egypt
 Nat Geog 187:2–43 (c,1) Ja '95
— Glass head of Amenhotep II (Egypt)
 Nat Geog 184:45 (c,4) D '93
— Greek (Italy)
 Nat Geog 186:2–32 (c,1) N '94
— Hairless dogs depicted in ancient sculpture
 (Latin America)
 Natur Hist 103:34–40 (c,1) F '94
— Nubian funerary figures (Sudan)
 Smithsonian 24:cov. (c,1) Je '93
— Olmec sculpture (Mexico)
 Nat Geog 184:88–115 (c,1) N '93
— Parthenon frieze
 Smithsonian 23:135 (c,4) D '92
 Trav/Holiday 178:82 (c,4) Mr '95
— Prehistoric carved figures
 Natur Hist 102:60–7 (c,1) My '93
— Sakkara tomb sculpture, Egypt
 Trav&Leisure 22:65 (c,4) S '92
— Stone Age figures (Jordan)
 Smithsonian 27:108–9 (c,1) O '96
— "Venus de Milo" from rear
 Smithsonian 24:42–3 (c,1) D '93
— See also
 SPHINX

SEA ANEMONES
Natur Hist 101:cov.,50–7 (c,1) Ap '92
Nat Wildlife 30:8 (c,4) Je '92
Nat Geog 182:113 (c,3) Jl '92
Life 15:82,86 (c,1) S '92
Life 15:32 (c,1) O '92
Natur Hist 101:50–1 (c,2) N '92
Smithsonian 24:112–13 (c,3) O '93
Natur Hist 102:66–7 (c,1) O '93
Nat Geog 184:72–3 (c,1) N '93
Nat Geog 187:96 (c,1) Mr '95
Smithsonian 26:96,100 (c,4) Ja '96
Sea cows. See
 MANATEES

SEA CUCUMBERS
Smithsonian 26:98 (c,4) Ja '96

SEA FANS
Life 15:80–1 (c,1) S '92
Trav&Leisure 23:43 (c,3) Ja '93
Nat Wildlife 31:52–3 (c,1) O '93
Nat Geog 184:84 (c,1) N '93
Nat Geog 187:101 (c,4) Mr '95
Nat Wildlife 34:35 (c,1) D '95
Nat Geog 190:122–3 (c,1) D '96

SEA HORSES
Nat Geog 182:97 (c,1) Jl '92
Nat Geog 186:126–39 (c,1) O '94
Life 18:21 (c,2) Jl '95
Nat Wildlife 34:2 (c,1) F '96
Nat Wildlife 34:44 (c,4) Je '96
— Sea horse giving birth
 Life 18:21 (c,2) Jl '95
— Sea horse sculpture (Puerto Vallarta,
 Mexico)
 Trav/Holiday 175:49 (c,4) D '92

SEA LILIES
Smithsonian 24:112 (c,3) O '93
Nat Geog 190:118–31 (c,1) D '96
— Sea lily fossil
 Natur Hist 101:40 (4) N '92

SEA LIONS
Natur Hist 102:59 (c,4) Ja '93
Nat Wildlife 31:2–3 (c,2) Ap '93
Trav&Leisure 24:109 (c,4) Jl '94
Natur Hist 103:26–33 (c,1) S '94
Nat Geog 186:32–3 (c,1) D '94
Trav/Holiday 179:86 (c,2) F '96
— Steller's sea lions
 Nat Geog 182:82 (c,4) O '92
 Natur Hist 103:31–3 (c,1) S '94
 Nat Wildlife 33:34–9 (c,1) D '94
 Nat Geog 187:24–5 (c,1) Mr '95
 Nat Geog 190:72–3 (c,1) N '96
Sea shells. See
 SHELLS

SEA SQUIRTS
Natur Hist 102:68–9 (c,1) Mr '93

SEA URCHINS
Natur Hist 101:84–5 (c,1) Ja '92
Nat Wildlife 30:10 (c,4) Je '92
Life 15:87 (c,4) S '92
Smithsonian 24:111 (c,3) O '93

SEALS
— Elephant seals
 Nat Wildlife 30:18 (c,4) F '92
 Nat Wildlife 31:44–5 (c,1) Ag '93
 Nat Geog 186:40 (c,3) O '94
 Smithsonian 26:44–57 (c,1) S '95
 Natur Hist 104:57 (c,4) N '95
 Natur Hist 105:58–63 (c,1) F '96
 Natur Hist 105:70–1 (c,1) My '96

— Harp seal pups
 Smithsonian 23:157 (painting,c,4) D '92
 Trav/Holiday 176:106 (c,4) N '93
— Leopard seals
 Natur Hist 105:36–41 (c,1) Ag '96
— Monk seals
 Nat Geog 181:128–43 (c,1) Ja '92
 Life 15:36 (c,4) My '92
 Nat Wildlife 31:44–9 (c,1) D '92
 Natur Hist 103:54–5 (c,1) F '94
 Nat Wildlife 32:10 (c,4) F '94
 Nat Wildlife 34:52 (c,4) Je '96
—Nerpa
 Nat Geog 181:24–5 (c,2) Je '92
— Weddell seals
 Trav&Leisure 22:61 (c,4) D '92
 Nat Wildlife 31:40 (c,4) Ag '93
— See also
 SEA LIONS

SEALS AND EMBLEMS
— 15th cent. Hanseatic town seals
 Nat Geog 186:59 (c,4) O '94
— 1918 living portrait of YMCA emblem
 Smithsonian 26:58–63 (1) Ja '96
— Family coat of arms (Poland)
 Trav&Leisure 24:119 (c,1) Mr '94
— 5-star general insignia
 Nat Geog 181:54–5 (c,2) Mr '92
— Heraldic shield (Italy)
 Gourmet 53:51 (c,4) Ag '93
— See also
 MEDALS

Seas. See
 ARAL SEA
 BERING SEA
 CHINA SEA
 DEAD SEA
 GALILEE, SEA OF
 MEDITERRANEAN SEA
 OCEANS
 RED SEA

Seasons. See
 AUTUMN
 SPRING
 SUMMER
 WINTER

SEATTLE, WASHINGTON
 Trav&Leisure 23:84–5 (c,1) My '93
 Trav&Leisure 23:54–61,103 (map,c,1) Ag
 '93
 Am Heritage 45:70–88 (map,c,1) Ap '94
 Trav/Holiday 177:22 (c,4) S '94
 Gourmet 56:50–2 (c,1) Ja '96
— Early 20th cent. scenes
 Am Heritage 45:70–8 (4) Ap '94

— Fifth Avenue Theater
 Trav&Leisure 25:96 (c,4) N '95
— Pike Place Market
 Am Heritage 45:76–7 (c,1) Ap '94
— Pioneer Place
 Am Heritage 45:88 (c,2) Ap '94
— Seattle Art Museum
 Smithsonian 23:46–7,53,56 (c,1) Ap '92
 Trav&Leisure 23:58–9 (c,1) Ag '93
— Space Needle
 Trav/Holiday 178:20 (c,4) My '95
 Gourmet 56:50 (c,2) Ja '96
 Am Heritage 47:50 (c,4) Jl '96

Seaweed. See
 KELP

SEGAL, GEORGE
 Trav&Leisure 22:99 (c,4) D '92

SEINE RIVER, PARIS, FRANCE
 Trav&Leisure 22:103,112–13 (map,c,2)
 Ap '92
 Trav&Leisure 24:89 (1) Ap '94
 Trav/Holiday 177:62–5 (c,1) D '94
 Am Heritage 46:108–9 (c,1) Ap '95

Self-defense. See
 MARTIAL ARTS

SEMINOLE INDIANS—COSTUME
— Early 20th cent. (Florida)
 Natur Hist 105:80–1 (2) Ag '96
— 1930 boy's Big Shirt
 Trav&Leisure 24:40 (c,4) O '94

SENEGAL
— St.-Louis
 Nat Geog 188:23–7 (c,1) N '95

SENEGAL—COSTUME
 Nat Geog 188:23–7 (c,1) N '95

SENEGAL—SOCIAL LIFE AND CUSTOMS
— Mother bathing small child
 Life 15:14 (c,2) Jl '92

SEOUL, SOUTH KOREA
 Gourmet 54:104–9 (c,1) Ap '94
 Trav&Leisure 24:10,78,82 (c,4) Ap '94
— Ch'anggyong-gung Palace
 Gourmet 54:104 (c,2) Ap '94

SEQUOIA AND KINGS CANYON NA-TIONAL PARK, CALIFORNIA
 Trav&Leisure 23:93–4 (c,3) Je '93

SEQUOIA TREES
 Trav&Leisure 22:E1 (c,4) Jl '92
 Trav/Holiday 176:78 (c,3) F '93
 Trav/Holiday 179:54 (c,1) Je '96
— General Sherman tree, California
 Natur Hist 105:48 (c,1) F '96
 Smithsonian 27:118 (c,4) O '96

SEURAT, GEORGES
— "Models"
Life 16:76–7 (painting,c,1) Ap '93
— Topiary mimicking Seurat painting
(Columbus, Ohio)
Trav/Holiday 175:84 (c,4) Jl '92
Life 18:100–1 (c,1) My '95
— "A Sunday on La Grande Jatte" (1884)
Life 18:100 (painting,c,4) My '95

SEVILLE, SPAIN
Trav&Leisure 22:89–91 (c,1) Ja '92
Trav/Holiday 178:58–69 (map,1) Mr '95
— Alamillo Bridge
Smithsonian 27:78 (c,2) N '96
— Barqueta Bridge
Trav/Holiday 175:18 (c,4) Mr '92
— Street scene
Trav&Leisure 26:44 (c,4) D '96

SEWING
— Convicts working at sewing machines
(China)
Nat Geog 185:28 (c,4) Mr '94
— Tailor at work (India)
Nat Geog 184:64–5 (c,1) S '93
— See also
GARMENT INDUSTRY
QUILTING
TAILORS

SEWING MACHINES
— Howe demonstration sewing machine
(1845)
Am Heritage 47:102 (etching,4) S '96
— See also
HOWE, ELIAS

SEYCHELLES ISLANDS
Nat Geog 187:90–113 (map,c,1) Mr '95
Gourmet 56:112–17,150 (map,c,1) Ap '96
Trav&Leisure 26:144–9,184–6 (map,c,1)
D '96

SHAKERS
— Hancock Shaker village, Pittsfield,
Massachusetts
Am Heritage 46:40 (c,3) N '95
— Shaker twin spiral staircases (Kentucky)
Am Heritage 46:26 (c,4) Jl '95

SHAMANS
— 19th cent. Navajo shaman
Life 16:73 (1) Ap 5 '93
— Mid 19th cent. Arikara medicine man
Life 16:70 (4) Ap 5 '93
— 1906 Yup'ik shaman (Alaska)
Natur Hist 105:12 (4) Ag '96
— Aztec healer with medicinal plants
Natur Hist 105:7 (painting,c,3) Jl '96
— Blackfeet Indian medicine man (1938)

Trav&Leisure 25:161 (painting,c,2) O '95
— Lakota medicine man (South Dakota)
Life 16:70–4 (c,1) Ap 5 '93
— Mongolia
Nat Geog 190:13 (c,4) D '96
— Shoshone medicine man (Wyoming)
Nat Wildlife 30:18–19 (c,1) Je '92
— Siberia
Natur Hist 101:34–41 (c,1) Jl '92
— Zulu medicine woman (South Africa)
Nat Geog 190:11 (c,3) Jl '96

SHANGHAI, CHINA
Trav&Leisure 23:64–5 (c,2) S '93
Trav/Holiday 176:71–7 (c,1) O '93
Nat Geog 185:cov.,2–35 (map,c,1) Mr '94
— 1949
Trav/Holiday 176:73 (4) O '93
— 1959
Trav/Holiday 176:73 (4) O '93
— Huangpu River
Nat Geog 185:14–15 (c,1) Mr '94
— Nanjing Road
Trav/Holiday 176:71–5 (c,1) O '93
Nat Geog 185:2–4 (c,1) Mr '94

SHANNON RIVER, IRELAND
Am Heritage 45:27 (c,2) My '94

SHARKS
Nat Geog 181:135 (c,4) Ja '92
Nat Geog 181:80–1 (c,1) Je '92
Smithsonian 23:60 (c,3) Ag '92
Smithsonian 24:32–43 (c,1) My '93
Sports Illus 79:82 (c,4) D 13 '93
Nat Geog 187:109 (c,4) Mr '95
Smithsonian 26:68–71 (1) Ap '95
Natur Hist 105:40 (c,4) S '96
— Basking sharks
Nat Wildlife 32:20–1 (c,1) D '93
— Gray reef sharks
Nat Geog 184:80–1 (c,1) N '93
Nat Geog 187:cov.,44–67 (c,1) Ja '95
— Great white
Natur Hist 103:92 (c,4) Ap '94
Sports Illus 82:5–6 (c,4) My 15 '95
— Hammerheads
Sports Illus 79:2–3,76–80 (c,1) D 13 '93
Natur Hist 104:32–9 (c,1) O '95
— Nurse sharks
Smithsonian 24:43 (c,2) My '93
Nat Geog 187:44–53 (c,1) My '95
Natur Hist 105:4,40–1 (c,1) S '96
— Shark giving birth
Smithsonian 24:40 (c,4) My '93
— Whale sharks
Nat Geog 182:120–39 (c,1) D '92
Smithsonian 24:38–9 (c,3) My '93

Sports Illus 78:7 (c,3) My 3 '93
Smithsonian 25:94–9 (c,1) F '95
Life 19:8–9 (c,1) S '96
Natur Hist 105:55 (c,3) N '96

SHAVING
Smithsonian 25:44 (c,4) F '95
— Early 20th cent. razor ads
Smithsonian 25:48 (c,4) F '95
— History of razors and razor blades
Smithsonian 25:44–53 (c,1) F '95
— Testing shaving cream at factory
(Massachusetts)
Nat Geog 186:20–1 (c,1) Jl '94

SHAW, IRWIN
Life 15:95 (4) Je '92
Shawnee Indians. See
TECUMSEH

SHEARWATERS
Natur Hist 104:cov.,24–35 (c,1) Ag '95

SHEEP
Trav&Leisure 22:9,76–81 (c,1) S '92
Natur Hist 101:50–1,53 (c,1) O '92
Life 16:94 (c,2) My '93
Trav&Leisure 24:96–7 (c,1) S '94
Nat Geog 189:128–9 (c,1) Mr '96
Nat Geog 190:10–11,62–3 (c,1) S '96
— Bighorn
Life 17:34,38 (c,4) N '94
Nat Wildlife 31:2–3 (c,2) F '93
Nat Geog 184:30–1 (c,1) Jl '93
Nat Wildlife 32:42–3 (painting,c,1) Ag '94
Nat Wildlife 33:8–15 (c,1) F '95
— Churro sheep
Smithsonian 26:42 (c,4) Ap '95
— Dall's sheep
Natur Hist 104:78–9 (c,1) Ja '95
Nat Wildlife 34:33 (c,1) Ap '96
— Feral Soay sheep
Natur Hist 103:cov.,28–35 (c,1) Mr '94
— Lambs in diapers (Wyoming)
Nat Geog 183:67 (c,1) Ja '93
— Manx Loghtan ram
Smithsonian 25:cov. (c,1) S '94
— Sheep crossing highway (Colorado)
Trav&Leisure 22:74 (c,3) Ja '92
— Sheep in spandex suits
Trav/Holiday 178:52 (c,2) Je '95
— See also
RANCHING

SHEEP DOGS
— Maremma sheep dogs
Natur Hist 105:59 (c,1) D '96

SHELLS
Trav&Leisure 24:76 (c,4) D '94
Trav&Leisure 25:134 (c,1) Ap '95

Smithsonian 26:60–9 (c,1) Ag '95
— Sea shells
Natur Hist 105:10,28 (c,4) O '96
— Snail shells
Natur Hist 104:10–16 (drawing,3) Ap '95

SHENANDOAH RIVER, VIRGINIA
Nat Geog 190:38–53 (map,c,1) D '96

SHEPARD, ALAN BARTLETT, JR.
Am Heritage 45:41,50,54 (c,1) Jl '94

SHEPHERDS
— 19th cent. (Scotland)
Smithsonian 27:132 (painting,c,3) N '96
— Austria
Nat Geog 183:39–40 (c,1) Je '93
— Canary Islands
Trav/Holiday 175:74–5 (c,4) O '92
— China
Nat Geog 190:22–3 (c,2) D '96
— Duck shepherd (China)
Natur Hist 101:52–3 (c,2) O '92
— France
Trav&Leisure 24:82 (c,4) My '94
— Germany
Nat Geog 182:18–19 (c,1) Ag '92
— Goatherd (Nepal)
Trav&Leisure 24:88 (c,1) Je '94
— Idaho
Natur Hist 101:50–1,57 (c,1) O '92
— Israel
Natur Hist 105:40–1 (1) D '96
— Italy
Natur Hist 105:57,59 (c,1) D '96
— Kenya
Smithsonian 27:112–13 (c,1) My '96
— Llama watching sheep (Virginia)
Smithsonian 25:54 (c,1) Ag '94
— Macedonia
Nat Geog 189:128–9 (c,1) Mr '96
— Madeira, Portugal
Nat Geog 186:98–9 (c,1) N '94
— Mongolia
Nat Geog 183:126–38 (c,1) My '93
— Nepal
Nat Geog 184:2–23,30–1 (c,1) D '93
— Northern Ireland
Trav/Holiday 179:37 (c,4) Je '96
— Rabari people (India)
Nat Geog 184:cov.,64–93 (c,1) S '93
— South Africa
Nat Geog 190:33 (c,3) Jl '96
— Sweden
Nat Geog 184:19 (c,3) Ag '93
— Turkey
Nat Geog 185:16–17 (c,1) My '94

SHERIDAN, PHILIP
 Smithsonian 27:30 (painting,c,4) N '96
— Sheridan's horse
 Smithsonian 27:28–30 (c,4) N '96
SHERLOCK HOLMES
 Gourmet 53:130 (drawing,c,4) N '93
 Sports Illus 83:5 (drawing,c,4) Jl 24 '95
SHETLAND ISLANDS, SCOTLAND
— 1993 tanker grounded on Shetland Island
 Trav&Leisure 24:60 (c,4) F '94
SHINTOISM—RITES AND FESTI-VALS
— Bonfire at winter festival (Japan)
 Nat Geog 186:91 (c,3) S '94
— Kamakura festival (Yokote)
 Nat Geog 186:92–3 (c,1) S '94
SHINTOISM—SHRINES AND SYM-BOLS
— Izumo Shiato Shrine, Japan
 Nat Geog 185:50–1 (c,1) My '94
SHIP CAPTAINS
 Gourmet 55:32 (c,3) Ag '95
— 1915 "Lusitania" captain
 Nat Geog 185:73 (4) Ap '94
— Great Britain
 Trav&Leisure 24:172 (2) Mr '94
SHIPPING INDUSTRY
— Barge shipping on German canal
 Nat Geog 182:20–7 (c,1) Ag '92
SHIPS
— 15th cent. Portuguese square-rigged
 carrack shown in Japanese painting
 Nat Geog 182:60–1 (c,1) N '92
— 19th cent. depiction of sea monster
 attacking ship
 Smithsonian 27:126–7 (engraving,c,1) My
 '96
— Early 19th cent. ship "Temeraire" (Great
 Britain)
 Natur Hist 104:18 (painting,c,4) O '95
— 1840s whaling ship
 Gourmet 56:72 (c,2) Mr '96
— 1850s steamer
 Life 15:32-5 (painting,c,1) Mr '92
— 1857 iron steamship "Great Eastern"
 (Great Britain)
 Smithsonian 25:62–75 (c,1) N '94
— Late 19th cent. practice of shanghaiing
 sailors
 Am Heritage 46:66–72 (drawing,2) S '95
— 1892 ships
 Am Heritage 43:64–5 (painting,c,1) F '92
— 20th cent. transatlantic liners
 Am Heritage 47:96–115 (c,1) Ap '96
— 1911 Antarctic expedition ship

 Trav/Holiday 176:57 (4) Je '93
— 1928 Antarctic expedition ship
 Sports Illus 79:104 (3) O 18 '93
— 1936 launch of German navy training ship
 Smithsonian 26:25 (3) Ag '95
— 1939 Jewish refugee ship "St. Louis"
 Smithsonian 26:18 (painting,c,4) Je '95
— 1941 Nazi "stealth" raider ship
 Life 17:41 (3) Ap '94
— Canadian Coast Guard ice cutter
 Nat Geog 184:86–7 (c,1) D '93
— Captain Cook's ship *Endeavor* (1768)
 Natur Hist 102:68 (engraving,4) My '93
— Coast Guard cutter
 Smithsonian 26:24 (c,4) Ag '95
— "Intrepid"
 Am Heritage 44:6 (c,2) Jl '93
— "Lusitania" (1907)
 Nat Geog 185:70–1 (1) Ap '94
— Models of square-riggers (Maryland)
 Smithsonian 24:104–9 (c,2) Je '93
— 1000 year old Viking ship (Norway)
 Trav/Holiday 175:78 (c,4) D '92
— Preparing yacht for race (Florida)
 Sports Illus 79:48–51 (c,1) Jl '93
— "QE2"
 Am Heritage 47:cov.,114–15 (c,1) Ap '96
 Trav/Holiday 179:34–5 (c,1) N '96
— Rebuilt War of 1812 ship "Niagara"
 Smithsonian 25:18 (c,4) Mr '95
— Replica of Cook's 1770s ship "Endeavor"
 Nat Geog 190:36–45 (c,2) N '96
— Reproduction of Columbus' ships
 Nat Geog 181:cov.,2–5,18–19,38–9 (c,1)
 Ja '92
— Sinking of the " Maine" (1898)
 Smithsonian 22:91 (c,4) Mr '92
— Story of Confederate raider ship
 "Alabama" (1860s)
 Nat Geog 186:66–83 (c,1) D '94
— Tall ships
 Trav&Leisure 22:16 (c,4) Je '92
 Sports Illus 77:5 (c,4) O 5 '92
 Trav&Leisure 23:112–15 (c,1) F '93
 Life 15:56–7,63 (c,1) N '92
— See also
 list under BOATS
SHIPWRECKS
— 1600 Spanish ship (Philippines)
 Nat Geog 186:34–57 (c,1) Jl '94
— 1641 Spanish galleon "Concepcion"
 (Caribbean)
 Nat Geog 190:96–7 (painting,c,1) Jl '96
— 1857 S.S. " Central America" (Carolinas)
 Life 15:34–5 (painting,c,1) Mr '92

— 1902 (St. Mary's, England)
Trav/Holiday 175:56 (4) Ap '92
— 1915 sinking of the "Lusitania"
Nat Geog 185:6—85 (c,1) Ap '94
— 1975 Edmund Fitzgerald (Lake Superior)
Nat Geog 189:36–47 (c,1) Ja '96
— Stained glass depiction of "Titanic" sink-
ing in 1912 (New York)
Smithsonian 23:38 (c,4) D '92
SHIPWRECKS—ARTIFACTS
— 1600 Spanish ship (Philippines)
Nat Geog 186:34–57 (c,1) Jl '94
— 1641 Spanish galleon "Concepcion"
(Caribbean)
Nat Geog 190:90–105 (c,1) Jl '96
— 1857 shipwreck (Carolinas)
Life 15:32–42 (c,1) Mr '92
— 1915 "Lusitania" artifacts
Nat Geog 185:80–5 (c,1) Ap '94
— Civil War ship "Alabama" (France)
Nat Geog 186:66–7,76–83 (c,1) D '94
SHOCK
— Woman learning of Kennedy assassination
(1963)
Life 16:38 (4) N '93
SHOEMAKING
— Italy
Trav&Leisure 23:34 (c,4) Ap '93
Shoes. See
FOOTWEAR
SHOESHINE STANDS
— Cairo, Egypt
Nat Geog 183:60 (c,4) Ap '93
SHOOTING
— 1812 assassination of Prime Minister
Spencer Perceval
Smithsonian 24:151 (etching,4) Ap '93
— Late 19th cent. sharpshooter
Nat Geog 190:62–3 (2) Jl '96
— Child's drawing of shooting (North
Carolina)
Am Heritage 47:36–7 (c,1) S '96
— College competition
Sports Illus 82:7 (c,4) Ap 17 '95
— Georgian shooting Abkhazian sniper
Life 17:42–3 (c,1) Ja '94
— Killing Aristide supporter (Haiti)
Life 18:64–5 (c,1) Ja '95
— Police shooting practice (El Salvador)
Nat Geog 188:112–13 (c,1) S '95
— Schwarzkopf in clay-shooting contest
Life 15:18 (c,3) Mr '92
—Yugoslavian sniper aiming rifle
Life 15:21 (c,4) O '92
— See also

GUNS
HUNTING
SHOPPING
— 1867 women shopping for gown fabrics
Smithsonian 23:124 (drawing,4) Mr '93
— Customers in store
Smithsonian 23:70–9 (painting,c,1) Ja '93
— Woman carrying TV on head (Saudi
Arabia)
Life 15:14 (c,1) S '92
— Women at produce market (Italy)
Natur Hist 101:62 (4) Ap '92
SHOPPING MALLS
— Glasgow, Scotland
Nat Geog 190:16 (c,4) S '96
— Mall of America, Minnesota
Trav&Leisure 24:59 (c,4) Jl '94
Trav/Holiday 179:82–9 (c,1) O '96
— Milan, Italy
Gourmet 55:126 (c,2) O '95
— The Strand arcade, Sydney, Australia
Trav/Holiday 176:56 (c,3) Je '93
— Vietnamese shopping center (California)
Smithsonian 23:31,39 (c,3) Ag '92
SHOSHONE-BANNOCK INDIANS
— Early 20th cent. Shoshone-Bannocks
(Idaho)
Smithsonian 26:86–9 (1) F '96
— Medicine man (Wyoming)
Nat Wildlife 30:18–19 (c,1) Je '92
— Warrior dancer
Am Heritage 47:85 (c,4) O '96
— See also
SACAGAWEA
SHOT-PUTTING
Sports Illus 77:88–93 (c,2) Jl 22 '92
Sports Illus 78:42–6 (c,2) Mr 15 '93
Sports Illus 85:155 (c,3) Jl 22 '96
— 1960 Olympics (Rome)
Sports Illus 76:54 (4) Ap 13 '92
— 1992 Olympics (Barcelona)
Sports Illus 77:22–3 (c,2) Ag 10 '92
Sports Illus 78:44 (c,3) Mr 15 '93
— 1996 Olympics (Atlanta)
Sports Illus 85:46 (c,4) Ag 5 '96
SHRIMPS
Nat Geog 182:101–2 (c,4) Jl '92
Life 15:3 (c,2) S '92
Nat Wildlife 31:56 (c,4) D '92
Nat Geog 184:83 (c,4) N '93
Natur Hist 103:66–8 (c,1) Je '94
Nat Geog 187:105 (c,1) Mr '95
Nat Geog 188:94 (c,4) O '95
Nat Wildlife 34:35 (c,1) D '95
Natur Hist 105:73 (drawing,4) Ja '96

Nat Wildlife 35:51 (c,1) D '96
— Brine shrimp
Natur Hist 102:34–9 (c,1) My '93
— Eyeless shrimp
Nat Geog 182:108–9 (c,1) O '92
— Fairy shrimp
Nat Geog 182:36 (c,4) O '92
SIBELIUS, JEAN
— Ainola home, Jarvenpaa, Finland
Gourmet 54:54–5 (c,3) Jl '94
— Bust of him
Gourmet 54:54 (c,4) Jl '94
SIBERIA, U.S.S.R.
Trav&Leisure 23:122–9 (map,c,1) Ap '93
— 2400 year old Pazyryk tomb
Nat Geog 186:80–103 (c,1) O '94
— Countryside
Nat Geog 184:42 (c,1) Jl '93
— Lake Baikal area
Nat Geog 181:cov.,3–39 (c,1) Je '92
— Stacks of frozen milk chunks
Life 15:26 (c,4) My '92
— See also
LAKE BAIKAL
SIBERIA—COSTUME
Nat Geog 181:cov.,3–37 (c,1) Je '92
Nat Geog 182:88–100 (c,1) O '92
Natur Hist 102:34–41 (c,1) D '93
— Newlyweds
Nat Geog 181:8–9 (c,2) Je '92
— Nganasan people
Natur Hist 101:34–41 (c,1) Jl '92
SIBERIA—RITES AND FESTIVALS
— Bear Fest
Natur Hist 102:34–41 (c,1) D '93
SIBERIAN HUSKIES (DOGS)
Nat Geog 186:5–7 (c,1) D '94
SICILY, ITALY
Trav&Leisure 25:120–9,165–8 (map,c,1)
Ap '95
Nat Geog 188:2–35 (map,c,1) Ag '95
— Ancient Greek temples (Akragas)
Nat Geog 186:12–15 (c,1) N '94
— Donna Fugata Palace
Trav&Leisure 25:125,129 (c,1) Ap '95
— Segesta
Nat Geog 186:2–4,36–7 (c,1) N '94
Trav&Leisure 25:165 (4) Ap '95
— Taormina
Trav&Leisure 22:75 (c,4) Ja '92
— See also
MOUNT ETNA
PALERMO
SIENA, ITALY
Trav/Holiday 177:68–77 (c,1) F '94

Trav&Leisure 26:95–9 (painting,c,1) Je
'96
— Countryside
Trav&Leisure 26:68 (c,4) My '96
— Palio banner
Trav/Holiday 178:69 (c,1) Ap '95
SIERRA LEONE—COSTUME
— Girls
Natur Hist 105:cov.,42–3 (c,1) Ag '96
**SIERRA MADRE MOUNTAINS, MEX-
ICO**
Nat Geog 190:44–51 (c,1) Ag '96
**SIERRA NEVADA MOUNTAINS,
CALIFORNIA**
— Granite formations
Trav/Holiday 179:52–3 (c,1) Je '96
SIGNS AND SIGNBOARDS
— 1920s drug store sign (New Mexico)
Trav&Leisure 26:215 (1) S '96
— 1936 gas station road sign (Iowa)
Am Heritage 44:6 (c,4) Ap '93
— 1940s direction signs (Saipan)
Nat Geog 187:70 (4) My '95
— Albuquerque, New Mexico "strip" (1969)
Life 19:14–15 (c,1) Winter '96
— Anti-poaching sign (Siberia)
Nat Geog 184:43 (c,4) Jl '93
— Bullet-riddled "Deer crossing" sign
(California)
Life 19:72 (c,4) Ag '96
— Bus stop sign (Greece)
Natur Hist 102:12 (c,4) D '93
— Butcher shop sign (Switzerland)
Gourmet 56:67 (c,4) Jl '96
— Cattle road sign (Nevada)
Trav/Holiday 179:68 (c,4) N '96
— Charcuterie sign (France)
Trav/Holiday 175:83 (c,4) My '92
— Contaminated river sign (Colorado)
Sports Illus 85:85 (c,4) O 14 '96
—"Dead End" sign at cemetery (New York)
Life 17:103 (c,4) My '94
— Dioxin warning signs
Nat Wildlife 32:4–5,10–11 (c,1) Ag '94
— Direction sign (Florida)
Trav&Leisure 24:108 (c,4) Ap '94
Trav&Leisure 24:111 (c,4) D '94
— Direction sign (France)
Gourmet 52:58 (c,3) Ja '92
— Direction sign (Ireland)
Gourmet 54:101 (c,2) Mr '94
— Distance marker (India)
Smithsonian 23:117 (c,4) My '92
— European road signs
Trav/Holiday 178:17 (c,4) My '95

— Hand-painted Coke billboards (Vietnam)
 Smithsonian 26:37 (c,4) Ja '96
— "Hollywood" sign on hill (California)
 Nat Geog 181:64 (c,1) Je '92
— Joe's Stone Crab restaurant sign, Miami,
 Florida
 Trav/Holiday 177:18 (c,4) D '94
— "Kangaroo Crossing" sign (Australia)
 Trav&Leisure 26:30 (c,4) O '96
 Trav/Holiday 179:38 (c,4) D '96
—.Las Vegas "strip," Nevada (1947)
 Life 16:30–1 (1) Ap 5 '93
— "Llama crossing" sign (Virginia)
 Smithsonian 25:62 (c,4) Ag '94
— Mississippi highway signs
 Natur Hist 105:48–9 (c,1) S '96
— Neon restaurant sign (New York)
 Gourmet 53:40 (c,4) My '93
— Neon restaurant sign (Washington)
 Gourmet 54:106 (c,4) My '94
— Neon signs (Hong Kong)
 Trav&Leisure 25:132 (c,1) S '95
— Neon signs (Las Vegas, Nevada)
 Smithsonian 26:56 (c,3) O '95
 Sports Illus 84:46–7 (c,1) Ap 15 '96
— Neon signs (Seoul, South Korea)
 Gourmet 54:104 (c,2) Ap '94
 Trav&Leisure 24:78 (c,4) Ap '94
— Neon signs along "strip" (Japan)
 Nat Geog 185:104–5 (c,2) Ja '94
— Restaurant name sign in backwards letters
 (New York)
 Gourmet 52:70 (c,3) Mr '92
— Rustic direction sign (Norfolk,
 Connecticut)
 Gourmet 53:42 (c,4) Jl '93
— Sign warning of minefield (Israel)
 Nat Geog 183:58 (c,2) My '93
— Small town welcome sign (Viroqua,
 Wisconsin)
 Smithsonian 23:47 (c,4) O '92
— Smile sign outside dentist's office (Taiwan)
 Nat Geog 184:26 (c,3) N '93
— Tractor road sign (Pennsylvania)
 Gourmet 55:118 (c,4) O '95
— U.S. National Debt sign (New York City,
 New York)
 Nat Geog 183:86–7 (c,1) Ja '93
— "Unsafe road" sign (Arkansas)
 Gourmet 52:81 (c,4) F '92
— Water pollution warning sign (Florida)
 Nat Geog 184:79 (c,3) N 15 '93
— See also
 LICENSE PLATES
 POSTERS

TRAFFIC LIGHTS
SIGNS AND SYMBOLS
— Baseball players doing high five
 Sports Illus 77:2–3 (c,1) S 21 '92
 Sports Illus 79:61 (c,4) O 4 '93
— Basketball fans doing the Wave
 Sports Illus 77:18–19 (c,1) D 14 '92
 Sports Illus 82:46–7 (c,1) F 27 '95
— Basketball player giving "high five" to
 child
 Life 16:18 (c,2) Je '93
— Clinton giving "high five"
 Life 16:37 (c,4) Mr '93
— Danish Railway insignia
 Trav&Leisure 25:92 (c,2) Mr '95
— Deaf people signing
 Smithsonian 23:30–41 (2) Jl '92
— Football team's "Hook 'em Horns" salute
 (Texas)
 Sports Illus 77:70–1 (c,4) N 16 '92
— Gizmo to produce forced smile (Norway)
 Life 17:30 (c,4) F '94
— International ATM symbol
 Trav/Holiday 176:28 (4) S '93
— Logos of famous restaurants
 Gourmet 53:86 (c,2) Ap '93
— Maori "Hongi" nose press greeting (New
 Zealand)
 Life 19:18 (c,2) N '96
— Rude finger gesture by tennis player
 Sports Illus 83:16 (4) D 11 '95
— Semiotic analysis of modern symbols
 Smithsonian 24:65–72 (c,1) S '93
— U.S. soldiers saluting
 Sports Illus 77:2–3 (c,1) S 28 '92
— Vacuuming ceremonial "red carpet"
 outside White House, D.C.
 Life 15:18 (c,2) O 30 '92
— World War II service star banner
 Life 18:14 (c,4) Je 5 '95
— Worldwide subway logos
 Trav&Leisure 25:192–3 (c,4) Ap '95
— Yin-yang symbol
 Am Heritage 45:42 (c,4) My '94
— See also
 CHRISTMAS TREES
 FLAGS
 HAND SHAKING
 MEDALS
 SEALS AND EMBLEMS
 UNCLE SAM
 U.S—SIGNS AND SYMBOLS
SIKORSKY, IGOR
 Am Heritage 43:40,44–5 (c,4) Ap '92

SILHOUETTES
— Cowboy and horse silhouetted in sunset
 Sports Illus 79:2–3 (c,1) O 4 '93
— Geese silhouetted against full moon
 Natur Hist 104:69 (c,2) S '95
— Horseback rider in silhouette (Arizona)
 Gourmet 56:106 (c,4) My '96

SILK INDUSTRY
— Starching silk (China)
 Nat Geog 189:36 (c,3) Mr '96

SIMENON, GEORGES
 Am Heritage 44:43 (4) Jl '93

SIMON, PAUL
 Life 16:86–94 (c,1) N '93

SINATRA, FRANK
 Life 16:34 (3) N '93
 Life 18:cov.,74–83 (c,1) O '95

SINCLAIR, UPTON
 Smithsonian 23:137 (4) My '92

SINGAPORE
 Gourmet 53:60–5,92 (map,c,1) Ja '93
 Trav/Holiday 178:54–61 (map,c,1) O '95
 Trav&Leisure 26:76–83,102 (map,c,1) Ja '96
— Market street scene
 Trav/Holiday 175:17 (c,4) S '92
— Raffles Hotel lobby
 Trav&Leisure 26:83 (c,1) Ja '96
— See also
 CHINATOWN

SINGAPORE—COSTUME
 Gourmet 53:61–5 (c,1) Ja '93
 Trav/Holiday 178:54–60 (c,1) O '95

SINGAPORE—RITES AND FESTIVALS
— Stilt walkers in Chingay Procession
 Trav&Leisure 23:47 (c,4) F '93

SINGERS
— 1960s Motown recording artists
 Smithsonian 25:82–95 (c,1) O '94
— 1963 popular singers
 Life 16:31–5 (c,4) Je '93
— Chet Atkins
 Smithsonian 27:57 (c,4) Jl '96
— Tony Bennett
 Life 18:50–6 (c,1) F '95
— Cabaret singer (New York)
 Life 18:64–5,75–6 (c,1) N '95
— Caricatures of 1938 radio personalities
 Am Heritage 46:96–7 (c,1) D '95
— Clothing of Rock and Roll Hall of Famers
 Life 18:13–17 (c,1) S '95
— Country music stars
 Am Heritage 45:cov.,38–56 (c,1) N '94
 Life 19:64–5 (c,1) D '96

— Charlie Daniels
 Smithsonian 27:60 (4) Jl '96
— Billy Eckstine
 Life 17:109 (1) Ja '94
— Five-year-old rapper recording song
 (France)
 Life 16:20 (c,4) Ap '93
— Jerry Garcia
 Life 18:17 (2) O '95
 Life 19:84 (1) Ja '96
— Carlos Gardel's grave (Argentina)
 Trav&Leisure 26:159 (c,4) D '96
— Girls in church choir (Georgia)
 Gourmet 56:73 (c,4) Jl '96
— History of rock and roll
 Life 15:entire issue (c,1) D 1 '92
— Buddy Holly
 Life 19:27 (4) S '96
— Burl Ives
 Life 19:96 (4) Ja '96
— Jazzman singing at funeral (Louisiana)
 Life 16:14 (c,2) F '93
— Mario Lanza Museum, Philadelphia,
 Pennsylvania
 Smithsonian 26:95 (c,2) Ap '95
— Huddie "Leadbelly" Ledbetter
 Am Heritage 44:10 (drawing,c,4) O '93
 Trav&Leisure 25:38 (4) N '95
— Little Richard
 Am Heritage 46:54,56 (3) F '95 supp.
— Bob Marley Museum, Jamaica
 Natur Hist 104:48–52 (c,1) N '95
— Musicians from 1969 Woodstock concert
 Life 17:cov.,33–45 (1) Ag '94
— Luciano Pavarotti
 Life 17:9 (c,4) Ja '94
— Rock stars recording "We Are the World"
 (1985)
 Life 18:32 (c,2) Mr '95
— Scenes of country singer Garth Brooks'
 daily life
 Life 15:55–63 (c,1) Jl '92
— Dinah Shore
 Life 18:109 (c,1) Ja '95
— Sonny & Cher
 Life 18:34 (4) F '95
— Barbra Streisand
 Life 19:37 (3) Mr '96
— Tiny Tim's wedding to Miss Vicki (1969)
 Life 15:42 (c,4) My '92
— Sophie Tucker
 Smithsonian 27:49 (3) N '96
— Conway Twitty
 Life 17:106 (3) Ja '94
— See also

ANDERSON, MARIAN
BEATLES
BERRY, CHUCK
CHARLES, RAY
DYLAN, BOB
HENDRIX, JIMI
HOLIDAY, BILLIE
HOLLY, BUDDY
HORNE, LENA
JACKSON, MICHAEL
JOHNSON, ROBERT
JOLSON, AL
LENNON, JOHN
MADONNA
PRESLEY, ELVIS
PRICE, LEONTYNE
ROLLING STONES
RUSSELL, LILLIAN
SIMON, PAUL
SINATRA, FRANK
SMITH, BESSIE
SPRINGSTEEN, BRUCE
WATER, ETHEL
WONDER, STEVIE

SIOUX INDIANS
— Oglala warrior Red Hawk
 Life 16:2–3 (1) Ap 5 '93
— Sioux beaded gloves
 Gourmet 55:48 (c,4) Ag '95
— See also
 CRAZY HORSE
 SITTING BULL

SIOUX INDIANS—ARTIFACTS
— Doll
 Nat Geog 183:116 (c,4) Ja '93

SIOUX INDIANS—COSTUME
 Nat Geog 185:92–3 (c,1) Je '94
— 1908 woman
 Nat Geog 183:110 (3) Ja '93
— Woman's dress
 Nat Geog 183:116 (c,4) Ja '93

SITTING BULL
 Am Heritage 43:76 (4) Ap '92
 Natur Hist 101:39 (painting,c,3) Je '92
 Trav/Holiday 176:69 (4) Je '93
 Am Heritage 44:10 (painting,c,4) S '93

SKATES (FISH)
 Smithsonian 24:103 (c,4) Ag '93

SKATING
— 1932 waiter on ice skates (Switzerland)
 Life 18:9 (2) O '95
— Child on ice skates
 Sports Illus 81:72–4,92 (1) D 19 '94
— Montreal, Quebec
 Gourmet 55:137 (c,2) D '95

— Ottawa, Ontario
 Trav&Leisure 24:54 (c,4) D '94
 Sports Illus 85:15 (c,1) N 25 '96
— Skating practice (Ohio)
 Life 15:3,58–65 (c,1) F '92
— Ski skating (Colorado)
 Trav&Leisure 24:E8 (c,4) D '94
— Toronto park, Ontario
 Nat Geog 189:120–1 (c,1) Je '96

SKATING, FIGURE
 Sports Illus 76:55–6 (c,2) Ja 13 '92
 Sports Illus 76:30–2 (c,2) Ja 20 '92
 Sports Illus 76:29–30 (c,2) Ap 6 '92
 Sports Illus 78:45–6 (c,2) F 1 '93
 Sports Illus 80:16–21 (c,1) Ja 17 '94
 Sports Illus 80:66–7 (c,1) Ja 31 '94
 Sports Illus 80:73–6,80–1,122 (c,1) F 7 '94
 Life 17:72–3,78 (c,1) Je '94
 Sports Illus 81:134–5 (c,1) S 19 '94
 Sports Illus 81:29 (c,1) D 5 '94
 Sports Illus 82:52–9 (c,1) Mr 6 '95
 Sports Illus 83:2–3,34 (c,1) D 4 '95
 Sports Illus 84:49–50 (c,1) F 12 '96
 Sports Illus 85:74–5 (c,1) D 30 '96
— 1920s
 Sports Illus 79:16,20 (4) O 18 '93
— 1928 Olympics (St. Moritz)
 Sports Illus 76:35 (c,2) F 3 '92
— 1954
 Sports Illus 81:122 (c,1) N 14 '94
— 1976 Olympics (Innsbruck)
 Sports Illus 80:50 (c,3) Mr 7 '94
— 1988 Olympics (Calgary)
 Sports Illus 76:48 (c,4) Ja 13 '92
 Sports Illus 76:62 (c,4) F 10 '92
— 1992 Olympics (Albertville)
 Sports Illus 76:14–17 (c,1) F 24 '92
 Sports Illus 76:16–21,70–1 (c,1) Mr 2 '92
— 1994 attack on skater Nancy Kerrigan
 Sports Illus 80:cov.,16–17 (c,1) Ja 17 ' 94
 Sports Illus 80:16–20 (c,1) Ja 24 '94
 Sports Illus 80:62–4 (c,1) Ja 31 '94
 Sports Illus 80:28–41 (painting,c,1) F 14 '94
 Sports Illus 80:32–3 (c,1) Mr 28 '94
— 1994 Olympics (Lillehammer)
 Sports Illus 80:46–9 (c,1) F 28 '94
 Sports Illus 80:20–5 (c,1) Mr 7 '94
 Sports Illus 81:30 (c,4) D 5 '94
— Backflip
 Life 17:90 (c,2) F '94
— Ice Capades
 Sports Illus 80:48–54 (c,1) Mr 7 '94
— Skaters in show costumes
 Sports Illus 85:50–60 (c,2) D 16 '96

— U.S. Championships 1995 (Rhode Island)
 Sports Illus 82:26–8,31 (c,1) F 20 '95
— U.S. Championships 1996 (San Jose,
 California)
 Sports Illus 84:36–8,45 (c,1) Ja 29 '96
— World Championships 1996 (Edmonton,
 Alberta)
 Sports Illus 84:28–30,35 (c,1) Ap 1 '96
— See also
 HENIE, SONJA
 ICE DANCING

SKATING, SPEED
 Sports Illus 76:49 (c,3) Ja 27 '92
 Sports Illus 79:60–1 (c,1) D 20 '93
 Sports Illus 80:39 (c,2) Ja 10 '94
 Sports Illus 80:90–3,104–5,117 (c,1) F 7
 '94
 Sports Illus 82:52–3 (c,1) F 27 '95
— 1976 Olympics (Innsbruck)
 Sports Illus 76:43–6 (c,2) Ja 13 '92
— 1992 Olympics (Albertville)
 Sports Illus 76:38,43 (c,3) F 17 '92
 Sports Illus 76:cov.,18–19,49 (c,1) F 24
 '92
 Sports Illus 76:34–5 (c,2) Mr 2 '92
— 1994 Olympics (Lillehammer)
 Sports Illus 80:28–9 (c,1) F 21 '94
 Sports Illus 80:cov.,18–23 (c,1) F 28 '94
 Sports Illus 80:34–5,42–3 (c,1) Mr 7 '94
 Life 17:26 (c,2) Ap '94
 Sports Illus 81:cov.,70–6,84–5,99–100
 (c,1) D 19 '94
— "Superskate" (Norway)
 Sports Illus 80:40 (c,4) Ja 10 '94

SKELETONS
— 16th cent. drawing (Italy)
 Natur Hist 105:35 (2) O '96
— Ancient giant ground slots
 Smithsonian 25:20 (c,4) O '94
— Ancient lemur Notharctus
 Natur Hist 101:56–7 (c,4) Ag '92
— Ancient Titanotheres
 Natur Hist 103:61 (c,4) Ap '94
— Catacomb bones of Capuchin monks
 (Rome, Italy)
 Natur Hist 105:36 (4) O '96
— Dinosaurs
 Nat Geog 183:4–47 (c,1) Ja '93
— Murder victim
 Smithsonian 27:82 (c,1) My '96
— Stone Age "Iceman" found in Alps
 Natur Hist 102:60–1 (c,2) Ap '93
— See also
 SKULLS

SKI JUMPING
 Sports Illus 80:131 (c,1) F 7 '94
 Life 17:94 (c,1) F '94
— 1992 Olympics (Albertville)
 Sports Illus 76:46 (c,3) F 17 '92
 Sports Illus 76:73,75 (c,2) Mr 2 '92
— 1994 Olympics (Lillehammer)
 Sports Illus 80:55 (c,2) F 28 '94
 Sports Illus 80:2–3 (c,1) Mr 7 '94
— Practicing on grass mats (Norway)
 Sports Illus 80:82–5 (c,1) F 7 '94
— Training by jumping into foam (Germany)
 Life 15:14–15 (c,1) Mr '92

SKI LIFTS
— 1934 first rope tow (Vermont)
 Life 17:51 (4) D '94
— 1937 first chairlift (Sun Valley, Idaho)
 Trav&Leisure 26:36 (4) Ja '96
— Colorado
 Trav&Leisure 26:192 (c,1) S '96
 Trav&Leisure 26:133 (c,1) D '96
— France
 Sports Illus 76:98 (painting,4) Ja 27 '92
— Idaho
 Nat Geog 185:33 (c,3) F '94
— Japan
 Nat Geog 186:78–9 (c,2) S '94
— Skyeship (Vermont)
 Life 17:51 (c,4) D '94
— Taos, New Mexico
 Trav&Leisure 25:111 (1) D '95
— Vancouver cable car, British Columbia
 Nat Geog 181:110–11 (c,1) Ap '92
— Wyoming
 Trav/Holiday 177:46 (2) S '94

SKI RESORTS
— Aspen, Colorado
 Trav&Leisure 26:133–41,174–5 (c,1) D
 '96
— Austria
 Trav&Leisure 24:102–7,156–8 (map,c,1)
 N '94
— Bolivia
 Trav&Leisure 26:107 (c,4) F '96
— British Columbia
 Gourmet 56:78–80 (c,3) N '96
— Making snow (California)
 Nat Geog 184:54–5 (c,1) Ag '93
— Steamboat Springs, Colorado
 Trav/Holiday 177:33 (c,4) D '94
— Sun Valley, Idaho
 Nat Geog 185:33 (c,3) F '94
— Taos, New Mexico
 Trav&Leisure 25:104–11 (c,1) D '95

SKIERS
— Rescuing missing skiers (Colorado)
Sports Illus 78:18–22 (c,2) Mr 8 '93
— Switzerland
Smithsonian 24:46–7 (c,1) N '93
SKIING
Sports Illus 76:52–5 (c,1) F 3 '92
Gourmet 52:138,140 (drawing,4) Mr '92
Trav&Leisure 23:1–22 (c,1) O '93 supp.
Sports Illus 80:47 (c,1) Mr 14 '94
Trav&Leisure 24:1–19 (c,1) O '94 supp.
Sports Illus 82:34–7 (c,1) Ja 16 '95
— Aerial stunt
Sports Illus 82:94 (c,4) Mr 6 '95
— Colorado
Trav/Holiday 175:17 (c,4) N '92
Trav/Holiday 177:78–9 (c,1) F '94
Trav&Leisure 24:E1,E5 (c,4) O '94
Trav&Leisure 26:134–5,180 (c,1) D '96
— Dry slope skiing (Scotland)
Sports Illus 79:111–12 (c,4) D 27 '93
— Falling
Trav&Leisure 24:166 (4) D '94
— France
Gourmet 52:60–1 (c,1) Ja '92
Trav&Leisure 25:E1–E2 (c,4) F '95
— Mogul skiing
Sports Illus 80:50 (c,2) Ja 24 '94
— Ski skating (Colorado)
Trav&Leisure 24:E8 (c,4) D '94
— Slalom
Sports Illus 79:22–3 (c,1) D 6 '93
— Slalom (1992 Olympics)
Sports Illus 76:22–7 (c,1) Mr 2 '92
— Snowboarding
Nat Geog 181:112 (c,1) Ap '92
Sports Illus 82:78–84 (c,1) Ja 23 '95
Trav&Leisure 25:42–4 (c,2) Mr '95
— Summer freestyle skiing into swimming
pool (Utah)
Life 18:92 (c,3) Ap '95
— Switzerland
Gourmet 54:122–7 (c,1) D '94
— Western U.S.
Gourmet 52:94–7 (c,1) Mr '92
Nat Geog 181:130–1 (c,1) Mr '92
Trav&Leisure 23:86–93 (c,1) F '93
Trav&Leisure 24:72–7,123 (c,1) Ja '94
SKIING—CROSS-COUNTRY
— 1976 Olympics (Innsbruck)
Sports Illus 79:47,60 (c,2) N 15 '93
— 1992 Olympics (Albertville)
Sports Illus 80:56 (c,1) Ja 24 '94
— 1994 Olympics (Lillehammer)
Sports Illus 80:52 (c,2) F 28 '94

Sports Illus 80:41 (c,3) Mr 7 '94
— Colorado
Trav&Leisure 22:102–3 (c,1) F '92
— Montana
Trav&Leisure 25:129–33 (c,1) F '95
— Vermont
Trav/Holiday 178:62–3 (c,1) F '95
— Wyoming
Trav&Leisure 23:E1 (c,4) D '93
SKIING—EDUCATION
— Ski jumping lesson (Norway)
Gourmet 54:64 (c,4) Ja '94
SKIING COMPETITIONS
Sports Illus 76:cov.,44–6,50-3,82–3 (c,1)
Ja 27 '92
— 1956 Olympics (Cortina)
Sports Illus 79:52 (2) N 15 '93
— 1960 Olympics (Squaw Valley)
Sports Illus 79:58 (4) N 15 '93
— 1992 Olympics (Albertville)
Sports Illus 76:2–3,32–3,36–7 (c,1) F 17
'92
Sports Illus 76:2–3,20–7 (c,1) F 24 '92
— 1994 Olympics (Lillehammer)
Sports Illus 80:cov.,20–7 (c,1) F 21 '94
Sports Illus 80:24–31,38–9,43 (c,1) F 28
'94
Sports Illus 83:94 (c,3) D 18 '95
— Olympic competitions
Sports Illus 79:47–60 (c,2) N 15 '93
— 24 Hours of Aspen, Colorado
Sports Illus 85:7 (c,4) D 9 '96
— World Alpine Ski Championships 1993
(Japan)
Sports Illus 78:32–5 (c,1) F 22 '93
— World Alpine Ski Championships 1996
(Spain)
Sports Illus 84:2–3,43 (c,1) F 26 '96
— World Cup championships 1994
Sports Illus 81:20–4 (c,1) D 19 '94
Sports Illus 82:40–1 (c,2) Ja 30 '95
— World Cup championships 1995
Sports Illus 83:2–3 (c,1) D 11 '95
SKIMMERS
Natur Hist 101:44–9 (c,1) Je '92
Life 17:76 (c,4) Ap '94
Nat Geog 190:10 (c,4) O '96
SKIN DIVING
Trav/Holiday 175:66–72 (c,1) D '92
Sports Illus 79:76–90 (c,1) D 13 '93
Natur Hist 105:44–60 (c,1) N '96
— Caribbean
Trav/Holiday 177:69 (c,1) My '94
Gourmet 55:72–4 (c,2) Ap '95
Trav/Holiday 179:49 (c,2) F '96

— Child in snorkeling gear
Gourmet 52:54 (c,4) Ja '92
— Egypt
Life 19:70–1 (c,1) Ap '96
— High tech diving suit
Nat Geog 183:108–9 (c,1) Ja '93
— Man in scuba gear
Smithsonian 25:49 (c,4) N '94
— Man in wet suit
Smithsonian 24:46 (c,1) F '94
— Pacific Islands
Nat Geog 187:62 (c,1) Ja '95
Trav&Leisure 26:94 (c,3) F '96
— Scuba lessons (Bonaire)
Trav&Leisure 26:166–70,202 (c,1) N '96
— Scuba lessons (Jamaica)
Trav/Holiday 179:64–5 (c,1) D '96
— Snorkeling (Virgin Islands)
Trav/Holiday 176:84–5 (c,1) O '93

SKINKS (LIZARDS)
Natur Hist 103:34–9 (c,1) Ja '94
Smithsonian 25:40 (c,4) S '94
Natur Hist 105:76 (c,4) Mr '96

SKIS
— Parabolic skis
Trav&Leisure 25:73 (c,2) F '95
Sports Illus 84:4 (c,4) Ja 22 '96

SKUAS (BIRDS)
Natur Hist 102:5–61 (c,1) Ja '93
Trav&Leisure 24:134 (c,4) D '94

SKULLS
Natur Hist 105:2,34–9 (c,2) O '96
— 15th cent. Leonardo da Vinci sketches
Natur Hist 105:2 (4) O '96
— 1848 skull pierced by iron bar
Natur Hist 104:70 (3) F '95
— Afarensis skull
Nat Geog 189:97,100–1,107–9 (c,1) Mr
'96
— Ancient Greece
Nat Geog 186:33 (c,4) N '94
— Bear skull
Nat Geog 185:52 (c,4) Ap '94
— Charnel house full of human bones
(Czechoslovakia)
Nat Geog 184:18–19 (c,2) S '93
— Coyote skull
Natur Hist 103:26 (c,3) Je '94
— Euraptor skull
Nat Geog 183:9 (c,2) Ja '93
— Homo habilis skull (Kenya)
Natur Hist 101:68 (4) F '92
— Mountain of bison skulls (Michigan)
Nat Geog 186:70 (4) N '94
— Neandertal skulls

Nat Geog 189:cov.,2–3,8–9,16–17,31,35
(c,1) Ja '96
— Prehistoric man's skull
Natur Hist 102:53 (c,3) My '93

SKUNKS
Nat Wildlife 30:16 (C,4) F '92
Nat Wildlife 30:34–9 (c,1) Ag '92

SKYDIVING
— Gymnastics in the air
Sports Illus 80:71–2 (c,4) Je 13 '94
— Norway
Sports Illus 80:58 (c,3) Ja 24 '94
— Skysurfing
Sports Illus 83:2–3,48–9 (c,1) Jl 3 '95

SLAVERY
— 19th cent. face jugs made by slaves (South
Carolina)
Smithsonian 24:30 (c,4) N '93
— 1831 scenes of slave revolt (Virginia)
Am Heritage 43:65–2 (c,2) O '92
— 1838 poster offering reward for escaped
slave
Smithsonian 27:49 (c,4) O '96
— Floor plan of slave ship
Nat Geog 182:78–9 (4) S '92
— Georgia slave cabin
Am Heritage 43:96 (c,4) Ap '92
— History of African slave trade
Nat Geog 182:62–91 (c,1) S '92
— Old slave warehouse (Mozambique)
Nat Geog 182:72 (c,4) N '92
— Reconstructed slave quarters
(Williamsburg, Virginia)
Trav&Leisure 23:NY1 (c,3) F '93
— Reenactment of slave life (Virginia)
Am Heritage 43:89 (c,3) Ap '92
— Retracing Underground Railroad escape
route
Smithsonian 27:48–61 (c,1) O '96
— Slave branding iron
Nat Geog 182:72 (c,4) S '92
— Underground Railroad's Rankin House,
Ripley, Ohio
Am Heritage 46:30–1 (c,4) F '95 supp.
— See also
DOUGLASS, FREDERICK
TUBMAN, HARRIET

SLEDS
— Horse-drawn sled (Montana)
Trav&Leisure 25:135 (2) F '95
— Horse-drawn sled used in harvesting
tobacco (Tennessee)
Nat Geog 183:122–3 (c,1) F '93
— Horse-drawn sleigh (Siberia)
Nat Geog 181:14–15 (c,2) Je '92

— See also
 BOBSLEDDING
 DOG SLEDS
 LUGE
SLEEPING
— 1914 painting of sleeping boy
 Am Heritage 44:94 (painting,c,4) D '93
— Baby asleep on bicycle (China)
 Trav/Holiday 177:60 (c,4) Jl '94
— Businessmen asleep on park benches
 (Japan)
 Life 17:104 (c,3) O '94
— Businessman napping in park (New York
 City, New York)
 Nat Geog 183:2–3 (c,1) My '93
— Couple sleeping on train (1975)
 Life 17:30 (3) Je '94
— Depictions of dreams
 Life 18:36–49 (c,1) S '95
— Female farm workers napping (Japan)
 Nat Geog 186:68–9 (c,1) S '94
— Fox yawning
 Natur Hist 101:78–9 (c,1) F '92
— Hiker sleeping on train (Sweden)
 Trav/Holiday 177:50 (c,3) Je '94
— In classroom (Alaska)
 Sports Illus 80:78–9 (c,2) Ja 31 '94
— Man asleep in lawn chair
 Nat Wildlife 32:18 (c,4) F '94
— Men yawning
 Sports Illus 78:36 (c,4) Mr 8 '93
— Politicians sleeping at Parliament meeting
 (Japan)
 Life 15:92 (c,2) S '92
— Rock climber sleeping on cliff (California)
 Life 17:31 (c,1) Jl '94
— Sleepy teenage girl
 Life 16:75,78 (c,3) Jl '93
— Woman asleep in bed
 Life 18:cov. (c,1) S '95
SLOAN, ALFRED P., JR.
 Life 19:40 (4) Winter '96
SLOAN, JOHN
— 1907 painting of motorists
 Am Heritage 47:43 (c,2) N '96
— "Fishing for Lafayettes" (1908)
 Am Heritage 46:4 (painting,c,2) O '95
— "Hairdresser's Window" (1907)
 Am Heritage 43:103 (painting,c,4) S '92
SLOTHS
 Nat Wildlife 31:6 (c,4) D '92
 Nat Wildlife 31:cov. (c,1) Ap '93
— Ancient sloths
 Natur Hist 103:50–4 (painting,c,1) Ap '94
 Smithsonian 25:20,23 (painting,c,4) O '94

— Three-toed sloths
 Nat Wildlife 33:30–1 (c,1) Ag '95
 Trav/Holiday 179:81 (c,4) O '96
— Two-toed sloth
 Smithsonian 23:56 (c,4) F '93
Slovak Republic. See
 CZECHOSLOVAKIA
SLUGS
— Nudibranchs
 Nat Geog 182:101 (c,3) Jl '92
 Natur Hist 102:66–7 (c,1) O '93
 Natur Hist 104:64–5 (c,1) Ja '95
SLUMS
— 1860s tenement life (New York)
 Smithsonian 23:182 (painting,c,4) N '92
— 1913 (New York City, New York)
 Smithsonian 23:68 (painting,c,2) Je '92
— Bombay, India
 Nat Geog 187:60–1 (c,2) Mr '95
— Bronx, New York
 Smithsonian 26:100–11 (c,1) Ap '95
— Buenos Aires, Argentina
 Smithsonian 24:154–5 (c,2) N '93
 Nat Geog 186:96–7 (c,1) D '94
— Burma
 Nat Geog 188:87 (c,1) Jl '95
— Juarez, Mexico
 Nat Geog 184:86–7 (c,1) N 15 '93
— Lima, Peru
 Nat Geog 189:14–15 (c,2) My '96
— Macau
 Trav/Holiday 175:85 (c,1) Ap '92
— Mexico
 Smithsonian 25:30–1 (2) My '94
— Scotland
 Nat Geog 190:20–1 (c,3) S '96
— Soweto, South Africa
 Sports Illus 84:124–5 (c,1) Ja 29 '96
— Squatter camp (South Africa)
 Nat Geog 183:68–9 (c,1) F '93
SMELTS
 Nat Wildlife 34:48 (c,4) D '95
SMITH, BESSIE
 Am Heritage 46:71 (painting,c,3) O '95
— Motel site of her death (Mississippi)
 Natur Hist 105:68 (c,3) O '96
SMITH, ALFRED E.
 Am Heritage 43:45 (4) Jl '92
SMITH, MARGARET CHASE
 Life 19:93 (4) Ja '96
**SMITHSONIAN INSTITUTION,
WASHINGTON, D.C.**
— American craft treasures of the Renwick
 Gallery
 Smithsonian 23:30,32 (c,4) O '92

— Artrain tour of Smithsonian treasures
 Smithsonian 27:76–81 (c,2) Ag '96
— Bird specimen collection
 Nat Geog 183:76–7 (c,2) Je '93
— Model of mall
 Smithsonian 27:76 (c,4) My '96
— Sand sculpture of Smithsonian castle
 Smithsonian 26:63 (c,3) Ap '95
— James Smithson
 Smithsonian 27:34,36 (painting,c,4) My
 '96
SMOG
— Denver, Colorado
 Nat Geog 190:92 (c,3) N '96
— Mexico City, Mexico
 Nat Geog 190:34–5 (c,2) Ag '96
SMOKE
— 1992 Los Angeles riots, California
 Sports Illus 76:31 (c,3) My 11 '92
 Life 15:20 (c,2) Je '92
— Factory smoke (U.S.S.R.)
 Nat Geog 186:74–5 (c,1) Ag '94
— Oil field fire (U.S.S.R.)
 Nat Geog 186:99 (c,1) Ag '94
— See also
 FIRES
Smoking. See
 CIGAR SMOKING
 CIGARETTE SMOKING
 PIPE SMOKING
SNAILS
 Nat Wildlife 30:9 (painting,c,4) Ap '92
 Nat Wildlife 30:8 (c,4) Je '92
 Natur Hist 103:56–61 (c,1) Ag '94
 Nat Geog 188:93 (c,4) O '95
 Natur Hist 105:74 (1) Mr '96
— Loco snails
 Natur Hist 103:14,18 (c,2) O '94
— Snail shells
 Natur Hist 104:10–16 (drawing,3) Ap '95
— Tree snails
 Natur Hist 102:38–9 (c,1) Jl '93
— See also
 SLUGS
SNAKE RIVER, IDAHO
 Life 16:68–9 (c,1) D '93
 Natur Hist 105:56 (c,4) O '96
SNAKE RIVER, OREGON
 Trav/Holiday 179:32 (C,4) Je '96
SNAKE RIVER, WYOMING
 Am Heritage 45:95 (c,2) Ap '94
 Trav/Holiday 177:47 (2) S '94
SNAKEROOT (FLOWER)
 Smithsonian 25:41 (c,4) S '94

SNAKES
 Natur Hist 103:36 (c,4) Ja '94
 Natur Hist 104:cov.,48–55 (c,1) Ap '95
 Natur Hist 105:58 (c,4) Ap '96
— Blacksnakes
 Natur Hist 103:36–7 (c,1) Ja '94
— Bushmasters
 Nat Wildlife 33:19 (c,4) Ag '95
— Rat snakes
 Natur Hist 104:51 (c,4) Ap '95
— Skinning snakes at food market (Burma)
 Nat Geog 188:86 (c,4) Jl '95
— Snake charmer (Morocco)
 Natur Hist 105:40 (c,4) My '96
— Tree snake
 Smithsonian 25:122 (c,4) O '94
— Two-headed snake
 Am Heritage 45:28 (drawing,4) Jl '94
— See also
 ADDERS
 ANACONDAS
 BOA CONSTRICTORS
 COPPERHEADS
 PYTHONS
 RATTLESNAKES
 VIPERS
SNAPPER
 Nat Geog 187:65 (c,1) Ja '95
 Nat Geog 187:98–9 (c,1) Mr '95
— Red snapper
 Nat Wildlife 30:53 (c,1) O '92
SNEAD, SAM
 Sports Illus 76:38 (2) My 25 '92
SNOW SCENES
— 1996 cartoon about Statue of Liberty
 buried in snow
 Smithsonian 27:85 (4) Jl '96
— Baseball field covered with snow
 Life 17:14–15 (c,1) N '94
— Birds at feeder in winter (Nebraska)
 Nat Wildlife 31:21 (c,2) D '92
— Breughel's "Hunters in the Snow" (1565)
 Natur Hist 101:7 (painting,c,3) Ap '92
— Central Park, New York City
 Nat Geog 183:7,26–7,30–5 (c,1) My '93
— Central Park, New York City (1903)
 Am Heritage 44:cov. (c,1) D '93
— Dolomites, Italy
 Trav&Leisure 26:158 (c,4) N '96
— Fishing boat covered with snow and ice
 (Maine)
 Life 18:88–9 (c,1) F '95
— Forest (British Columbia)
 Natur Hist 101:72–3 (c,1) Ja '92

— Forest (Wisconsin)
 Nat Wildlife 32:cov. (c,1) O '94
— Fox in brush (Montana)
 Nat Wildlife 30:2–3 (c,1) F '92
— House nearly buried in snow (Colorado)
 Trav/Holiday 177:84 (c,2) F '94
— Montana countryside
 Smithsonian 23:22 (c,4) Ag '92
— Morocco
 Nat Geog 190:120–1 (c,1) O '96
— Norway
 Trav/Holiday 175:74–81 (c,1) D '92
— Outdoor sculpture covered by snow
 (Washington, D.C.)
 Life 19:90 (c,2) Ap '96
— Phone booth covered by snow (Minnesota)
 Life 15:12 (c,1) F '92
— Pine trees in winter
 Sports Illus 77:24 (c,2) D 28 '92
— Snow impression of owl striking prey
 Nat Wildlife 35:48 (c,4) D '96
— Swedish Arctic
 Nat Geog 184:4–5 (c,1) Ag '93
— Tibet plain
 Nat Geog 184:66–7 (c,1) Ag '93
— Underdressed kindergartners in snow
 (Japan)
 Life 17:14–15 (c,1) F '94
— Vermont
 Gourmet 54:134 (c,2) D '94
— Virginia countryside
 Nat Geog 190:44–5 (c,2) D '96
— Women hailing taxi on snowy street (New
 York City)
 Smithsonian 24:20 (c,4) Mr '94
— Woodstock, Vermont (1940)
 Life 15:83 (4) My '92
— Yellowstone National Park, Wyoming
 Nat Geog 186:cov.,88–9 (c,1) N '94
— See also
 SLEDS
 SNOW STORMS

SNOW STORMS
— Manitoba marsh
 Nat Geog 182:38–9 (c,1) O '92
— See also
 BLIZZARDS

SNOWMOBILING
— Alaska
 Sports Illus 80:75 (c,4) Ja 31 '94
— Colorado
 Trav/Holiday 177:cov. (c,1) F '94
— New York
 Sports Illus 84:68 (c,4) Mr 4 '96
— Newfoundland

 Nat Geog 184:34–5 (c,1) O '93
— Wyoming
 Nat Geog 183:78–9 (c,2) Ja '93

SNOWSHOES
— 1704 (New England)
 Am Heritage 44:86 (4) F '93
— Snowshoeing (Colorado)
 Trav&Leisure 26:60 (c,4) F '96

SOAP BOX DERBIES
— Derby car
 Sports Illus 81:48–9 (c,1) Ag 22 '94

SOCCER
— 1992 Olympics (Barcelona)
 Sports Illus 77:46 (c,2) Ag 17 '92
— 1996 Olympics (Atlanta)
 Sports Illus 85:70–6 (c,1) Ag 12 '96
— Amputee soccer (El Salvador)
 Nat Geog 188:130–1 (c,2) S '95
— Basic soccer moves
 Life 17:11–14 (c,1) Jl '94
— Beach soccer (Trinidad)
 Nat Geog 185:74–5 (c,1) Mr '94
— Children playing soccer (Crete)
 Gourmet 52:76 (c,4) F '92
— Children playing soccer (Florida)
 Life 18:102 (c,3) D '95
— Children playing soccer (Papua New
 Guinea)
 Nat Geog 182:124–5 (c,1) Jl '92
— Mauritius
 Trav&Leisure 26:181 (c,4) O '96
— Priests playing soccer (Spain)
 Life 15:45 (3) Jl '92

SOCCER—COLLEGE
 Sports Illus 77:61 (c,3) D 14 '92
 Sports Illus 79:67 (c,3) D 13 '93
— NCAA Championships 1994
 Sports Illus 81:62–3 (c,2) D 19 '94
— NCAA Championships 1995 (Wisconsin
 vs. Duke)
 Sports Illus 83:54–6 (c,2) D 18 '95
— Women
 Sports Illus 85:14 (c,4) O 14 '96

SOCCER—PROFESSIONAL
 Sports Illus 78:43 (c,3) Mr 8 '93
 Sports Illus 80:64–5 (c,1) My 16 '94
 Sports Illus 80:4–5,78–114 (c,1) Je 20 '94
 Sports Illus 85:2–3,46–51 (c,1) S 16 '96
 Sports Illus 85:50–2 (c,1) N 25 '96
— Championships 1996 (Foxboro,
 Massachusetts)
 Sports Illus 85:2–3,52–3 (c,1) O 28 '96
— Colombia
 Sports Illus 80:60–9 (c,1) My 23 '94
— European Championship 1996 (London)

Sports Illus 85:27–8 (c,2) Jl 8 '96
— Fans setting off flares at soccer game
 (Turkey)
 Nat Geog 185:14–15 (c,2) My '94
— Fatal stampede at soccer match
 (Guatemala)
 Sports Illus 85:22 (c,4) O 28 '96
— Female player
 Sports Illus 82:72–6 (c,1) Je 5 '95
— Great Britain
 Sports Illus 79:80–5 (c,2) N 29 '93
 Sports Illus 82:60–74 (c,1) Je 12 '95
— Ireland
 Sports Illus 80:60–70 (c,1) Je 13 '94
— U.S. Cup 1993
 Sports Illus 78:36–40 (c,1) Je 21 '93
— Women
 Sports Illus 84:19 (c,4) F 12 '96
— World Cup competition 1992
 Sports Illus 76:40–2 (c,2) Je 15 '92
— World Cup competition 1994
 Sports Illus 80:2–3 (c,1) Ja 31 '94
 Sports Illus 80:56–62 (c,1) Je 27 '94
 Sports Illus 81:cov.,12–21 (c,1) Jl 4 '94
 Sports Illus 81:22–7 (c,1) Jl 11 '94
 Sports Illus 81:24–8 (c,1) Jl 18 '94
 Sports Illus 81:cov.,2–3,20–6 (c,1) Jl 25
 '94
 Life 18:38–9 (1) Ja '95
— Zambia
 Sports Illus 79:2–3,88–98 (c,1) O 18 '93
SOCCER PLAYERS
— Great Britain
 Life 16:21 (c,4) Ag '93
— See also
 PELE
SOCCER TEAMS
— Zambia
 Sports Illus 79:88 (c,3) O 18 '93
SOCIETY ISLANDS
— Bora Bora
 Trav&Leisure 22:cov.,112–21,152
 (map,c,1) N '92
 Trav/Holiday 177:33 (c,4) My '94
 Trav&Leisure 24:cov.,128–39 (map,c,1)
 Je '94
— See also
 TAHITI
SOD HOUSES
— Mid 19th cent. (Nebraska)
 Life 16:16–17 (c,1) Ap 5 '93
— Mid 19th cent. (South Dakota)
 Gourmet 55:50 (c,4) Ag '95
— 1900 (Nebraska)
 Am Heritage 47:112 (4) My '96

SOFAS
— 1820 Dolphin sofa (New York)
 Am Heritage 43:32–3 (c,1) F '92
SOFIA, BULGARIA
— Nevski Cathedral
 Trav/Holiday 176:43 (c,4) My '93
SOFTBALL—AMATEUR
 Smithsonian 27:70–9 (c,1) Ap '96
— 1906 world championships
 Smithsonian 27:75 (4) Ap '96
— 1996 Olympics (Atlanta)
 Sports Illus 85:54–7 (c,1) Jl 29 '96
SOFTBALL—PROFESSIONAL
— Slo-Pitch Softball Hall of Fame,
 Petersburg, Virginia
 Sports Illus 79:78 (c,4) Jl '93
Solar eclipses. See
 ECLIPSES
Soldiers. See
 MILITARY COSTUME
SOLZHENITSYN, ALEKSANDR
 Life 19:108–9 (c,1) O '96
SOMALIA
 Nat Geog 184:cov.,88–121 (map,c,1) Ag
 '93
SOMALIA—COSTUME
 Life 16:23 (c,4) Mr '93
 Life 18:18 (c,2) My '95
**SOMALIA—POLITICS AND GOV-
ERNMENT**
— Starving people
 Life 15:3–13 (c,1) N '92
 Life 16:32–5 (c,1) Ja '93
 Nat Geog 184:cov.,88–121 (c,1) Ag '93
 Life 19:98–9 (c,1) O '96
— U.S. marine befriending a child
 Life 16:22 (c,4) F '93
**SORGHUM INDUSTRY—
HARVESTING**
— Mexico
 Nat Geog 190:88–9 (c,1) Ag '96
SOUTH AFRICA
 Trav&Leisure 22:13,118–38 (map,c,1) D
 '92
 Trav&Leisure 24:98–106,140 (map,c,1) S
 '94
 Sports Illus 84:60–139 (c,1) Ja 29 '96
— Cape Province
 Trav/Holiday 177:cov.,61–7 (map,c,1) O
 '94
 Trav&Leisure 26:cov.,56–65 (map,c,1)
 Ag '96
— Countryside
 Nat Geog 190:2–37 (map,c,1) Jl '96
— Drakensberg Mountains

Nat Geog 190:2–4 (c,1) Jl '96
— Kruger National Park
Trav/Holiday 179:38–43 (map,c,1) Jl '96
— Lost City resort
Trav&Leisure 23:48 (c,4) Ap '93
— Soweto slum
Sports Illus 84:124–5 (c,1) Ja 29 '96
— Sun City resort
Sports Illus 83:48–50 (c,1) D 11 '95
— Tsitsikamma National Park
Trav/Holiday 177:66 (c,3) O '94
— Wildlife
Gourmet 55:72–9 (c,1) Ja '95
Nat Geog 190:cov.,5–37 (c,1) Jl '96
Trav/Holiday 179:40–3 (c,1) Jl '96
— See also
CAPE OF GOOD HOPE
CAPE TOWN
JOHANNESBURG
SOUTH AFRICA—COSTUME
Nat Geog 183:66–93 (c,1) F '93
Sports Illus 84:122–39 (c,1) Ja 29 '96
— Miners (1950)
Life 18:35 (4) S '95
— Ndebele women
Trav&Leisure 24:98–9 (c,1) S '94
— San tribesmen
Nat Geog 190:34–41 (c,1) Jl '96
— See also
ZULUS
SOUTH AFRICA—HISTORY
— 1985 Cape Town riot
Life 19:96 (c,4) Je '96
— See also
BOER WAR
SOUTH AFRICA—MAPS
— Eastern region
Gourmet 55:116 (4) Ja '95
— Homelands map
Nat Geog 183:75 (c,4) F '93
SOUTH AFRICA—POLITICS AND
GOVERNMENT
— Anti-apartheid movement
Nat Geog 183:66–93 (c,1) F '93
— Black man voting
Life 18:26–7 (c,1) Ja '95
— Frederik De Klerk
Trav&Leisure 24:102 (painting,c,4) S '94
— Nelson Mandela
Nat Geog 183:75 (c,3) F '93
Trav&Leisure 24:102 (painting,c,4) S '94
Life 19:95 (c,2) Je '96
SOUTH AFRICA—RITES AND FESTI-
VALS
— 1925 Xhosa coming of age dance

Nat Geog 190:132 (3) Jl '96
— Xhosa manhood ritual
Nat Geog 183:66–7 (c,1) F '93
SOUTH AFRICA—SOCIAL LIFE AND
CUSTOMS
— Sports
Sports Illus 84:122–39 (c,1) Ja 29 '96
South America. See
AMAZON RIVER
ANDES MOUNTAINS
IGUACU FALLS
LAKE TITICACA
SOUTH AMERICA—HISTORY
— Bolivar's role in liberating South America
from Spain
Nat Geog 185:42–3,52–3,58–9 (draw-
ing,c,1) Mr '94
— See also
BOLIVAR, SIMON
SOUTH CAROLINA
— Jimmy Byrnes
Am Heritage 47:32 (4) F '96
— Drayton Hall, Ashley River
Trav/Holiday 178:84 (c,4) Jl '95
— Edisto Island hotel
Gourmet 54:72 (c,4) Je '94
— Francis Marion National Forest
Natur Hist 104:59–61 (map,c,1) N '95
— Kiawah Island
Trav&Leisure 23:E1,E7 (map,c,4) Jl '93
— Middleton Peace gardens
Trav&Leisure 25:E16 (c,4) Mr '95
— Myrtle Beach
Trav/Holiday 179:90–5 (map,c,1) N '96
— See also
BEAUFORT
CHARLESTON
SOUTH DAKOTA
Gourmet 55:48–51,78 (map,c,1) Ag '95
— Badlands
Natur Hist 105:cov.,34–41 (map,c,1) Ap
'96
— Construction of Crazy Horse Memorial
Life 16:14 (c,2) D '93
— Corn Palace, Mitchell
Nat Geog 183:114–15 (c,1) Je '93
— Deadwood
Gourmet 55:49 (c,4) Ag '95
— White Rock
Smithsonian 26:82–3 (2) S '95
— See also
BADLANDS NATIONAL PARK
MOUNT RUSHMORE
WIND CAVE NATIONAL PARK

SOUTH DAKOTA—MAPS
— Black Hills area
 Trav/Holiday 178:89 (c,4) Je '95
South Korea. See
 KOREA, SOUTH
South Pacific. See
 PACIFIC ISLANDS
SOUTH POLE
— Navy posting U.S. flag at South Pole
 (1956)
 Life 18:60 (3) D '95
SOUTHERN U.S.
— Appalachian life
 Nat Geog 183:112–36 (c,1) F '93
— Museum of Appalachia, Norris, Tennessee
 Smithsonian 26:44–53 (c,1) F '96
— Southern landmarks of black history
 Am Heritage 43:89–99 (c,2) Ap '92
— U.S. Gulf Coast
 Nat Geog 182:2–37 (map,c,1) Jl '92
— See also
 APPALACHIAN MOUNTAINS
 GULF OF MEXICO
 KU KLUX KLAN
 MISSISSIPPI RIVER
 PLANTATIONS
SOUTHERN U.S.—HUMOR
— Mississippi catfish festival
 Nat Wildlife 30:42–5 (painting,c,1) Je '92
SOUTHWESTERN U.S.
— Four Corners countryside
 Trav&Leisure 24:68–75,106–7 (map,c,1)
 Ag '94
 Nat Geog 189:86–109 (map,c,1) Ap '96
 Nat Geog 190:cov.,80–97 (map,c,1) S '96
— Native American sites
 Trav&Leisure 23:cov.,134–45 (map,c,1)
 Ap '93
— Sonoran Desert
 Nat Geog 186:36–63 (map,c,1) S '94
— See also
 COLORADO RIVER
SOUVENIRS
— 1893 Columbian Exposition, Chicago,
 Illinois
 Smithsonian 24:51 (c,1) Je '93
 Smithsonian 24:26 (c,4) O '93
— Baseball trading cards
 Sports Illus 85:104–8 (c,1) Jl 29 '96
— Charles and Diana memorabilia (Great
 Britain)
 Life 19:67–74 (c,1) My '96
— Collection of baseball memorabilia (New
 Jersey)
 Sports Illus 82:66–76 (c,1) My 22 '95

— Hockey team souvenir shop (California)
 Sports Illus 78:39 (c,4) Mr 8 '93
— Mao memorabilia (China)
 Nat Geog 185:17 (c,2) Mr '94
— Souvenir restaurant plates (Italy)
 Gourmet 56:60 (c,4) Ja '96
— Souvenirs of 1950s European travel
 Gourmet 53:108–10 (c,2) F '93
— T-shirt stand (Antigua)
 Trav&Leisure 23:114–15 (c,1) O '93
SOYBEAN INDUSTRY
— Soybean field
 Nat Wildlife 32:40–1 (c,1) Ap '94
SPACE PROGRAM
— 1961 Mercury Project
 Am Heritage 45:41–54 (c,1) Jl '94
— 1963 blastoff
 Life 16:30–1 (1) Je '93
— 1966 "Gemini 8" crew after splashdown
 Am Heritage 43:26 (4) D '92
— 1969 "Apollo 11" rocket liftoff
 Am Heritage 45:36 (4) Jl '94
— 1969 diagram of space station
 Am Heritage 43:68 (c,4) N '92
— 1969 moon walk
 Am Heritage 45:6 (c,2) Jl '94
 Life 17:8–9 (c,1) Jl '94
 Am Heritage 45:69–71 (c,2) S '94
 Life 18:60 (c,4) D '95
— 1984 astronaut walking in space
 Am Heritage 43:cov.,60–1 (c,1) N '92
— 1986 space shuttle "Challenger" disaster
 Life 19:39–40 (c,4) F '96
— 1991 space shuttle launch
 Am Heritage 43:71 (c,1) N '92
— Astronaut free-floating in space
 Life 17:17 (c,2) D '94
— Chimp on 1961 space mission
 Am Heritage 45:46 (4) Jl '94
— Goddard Space Center, Maryland
 Trav/Holiday 179:42–3 (c,4) O '96
— Practicing to grab satellite in space (Texas)
 Life 16:22–3 (c,1) Ja '93
— Research on supergun to launch spacecraft
 Smithsonian 26:84–91 (c,2) Ja '96
— Rocket factory (China)
 Nat Geog 185:25 (c,3) Mr '94
— Shuttle launch
 Nat Geog 186:57 (c,1) Ag '94
— Student experiments aboard shuttle
 "Endeavor" (1993)
 Nat Geog 186:54–69 (c,1) Ag '94
— See also
 ASTRONAUTS
 SPACECRAFT

SPACECRAFT
— 1969 "Apollo 11" space capsule
Smithsonian 27:26 (c,4) Ag '96
— Apollo's lunar-lander "Falcon" (1971)
Natur Hist 103:68 (4) Ja '94
— "Gemini 8" space capsule (1966)
Am Heritage 43:26 (4) D '92
— Mars rover
Life 19:46 (c,4) F '96
— Replacing exterior tiles of shuttle
"Columbia"
Nat Geog 184:46 (c,3) D '93
— Shuttle "Discovery"
Smithsonian 25:30 (c,4) Je '94
— Space station
Life 19:44–5 (c,1) F '96
SPAIN
Trav&Leisure 22:86–93 (c,1) Ja '92
Nat Geog 181:2–33 (map,c,1) Ap '92
— Andalusian countryside
Trav&Leisure 26:44 (c,4) D '96
— Basque country
Life 15:41 (c,1) S '92
Gourmet 54:126–31,228 (map,c,1) N '94
Nat Geog 188:74–97 (map,c,1) N '95
— Bilbao
Nat Geog 188:88–9 (c,2) N '95
— Casares
Nat Geog 181:10–11 (c,1) Ap '92
— Cirauqui
Smithsonian 24:70 (c,4) F '94
— Dali Museum, Figueras
Trav&Leisure 22:66–70 (c,2) Ap '92
— Donana National Park
Trav/Holiday 175:68–74 (map,c,1) Ap '92
— Galicia
Trav/Holiday 178:35,37 (map,c,4) Je '95
— Hermitage at San Juan de Gaztelugache
Gourmet 54:128 (c,4) N '94
— Nerja beach
Trav&Leisure 26:51 (c,4) My '96
— Northern countryside
Smithsonian 24:64–75 (c,1) F '94
— Pampaneira
Gourmet 52:82–3 (c,2) Je '92
— Pamplona
Nat Geog 188:92–7 (c,1) N '95
— Penafiel castle
Trav&Leisure 23:166 (c,4) O '93
— Pilgrimage Trail
Trav&Leisure 26:121–9,168,171
(map,c,1) Mr '96
— Puente la Reina Bridge, Pamplona
Smithsonian 24:66–7 (c,2) F '94
— San Sebastian

Gourmet 54:131 (c,4) N '94
Nat Geog 188:76–7 (c,1) N '95
— Santiago de Compostela
Trav/Holiday 178:83 (c,1) Ap '95
Trav&Leisure 26:121–8 (c,1) Mr '96
Gourmet 56:62 (painting,c,2) Ap '96
— South Atlantic coast
Trav/Holiday 175:73 (c,3) Ap '92
— Southern Spain
Trav&Leisure 25:105–13,148 (map,c,1) Je
'95
— Vigo
Nat Geog 188:9 (c,4) N '95
— See also
ALHAMBRA
BARCELONA
CORDOBA
DUERO RIVER
GRANADA
MADRID
PYRENEES
SEVILLE
SPAIN—ART
— Islamic arts from occupation of Spain
Smithsonian 23:44–53 (c,2) Ag '92
SPAIN—COSTUME
Trav&Leisure 22:86–93 (c,1) Ja '92
Nat Geog 181:2–33 (c,1) Ap '92
— Basque region
Nat Geog 188:74–97 (c,1) N '95
— Child in Andalusian riding attire
Nat Geog 181:2–3 (c,1) Ap '92
— Festival costumes
Life 15:3,81–9 (c,1) Ag '92
— Seville
Trav/Holiday 178:58–69 (1) Mr '95
SPAIN—HISTORY
— 1519 conquest of Aztecs by Cortes
Smithsonian 23:56–69 (painting,c,1) O '92
— 1936 Spanish Civil War Loyalists
Life 19:36,90 (3) O '96
— Juan Carlos I and Queen Sofia
Sports Illus 77:45 (c,4) Ag 17 '92
— Landmarks remaining from Spanish
presence in the U.S.
Am Heritage 44:52–63,130 (c,1) Ap '93
— See also
CORTES, HERNAN
ISABELLA I
SPANISH-AMERICAN WAR
SPAIN—HOUSING
— Shepherd's stone cottage
Nat Geog 188:84–5 (c,1) N '95
SPAIN—MAPS
— Northern Spain

Gourmet 56:66 (4) Ap '96

SPAIN—RITES AND FESTIVALS
— Annual tomato food fight (Bunol)
Life 18:20–1 (c,1) N '95
— Burning "fallas" horse sculptures
(Valencia)
Life 15:82–3 (c,1) Ag '92
— Cattail Fiesta
Life 15:3 (c,2) Ag '92
— Festival of San Fermin (Pamplona)
Nat Geog 188:92–7 (c,1) N '95
— Procession of the Virgin (El Rocio)
Life 18:36–7 (c,1) Ap '95
— Running of the Bulls (Pamplona)
Life 16:14–15 (c,1) S '93
Nat Geog 188:92–7 (c,1) N '95
— Spanish festivals
Life 15:3,81–9 (c,1) Ag '92

SPAIN—SIGNS AND SYMBOLS
— Basque flag
Nat Geog 188:79 (c,3) N '95

**SPAIN—SOCIAL LIFE AND CUS-
TOMS**
— Dancing the "Sardana" (Barcelona)
Sports Illus 77:186–7 (c,2) Jl 22 '92
— Monks playing pelota
Nat Geog 190:60–1 (c,1) Jl '96

SPANISH-AMERICAN WAR
— Battle of Manila Bay (1898)
Smithsonian 22:88–97 (c,2) Mr '92
— Signing peace treaty
Am Heritage 44:103 (painting,c,4) F '93
— Sinking of the "Maine" (1898)
Smithsonian 22:91 (c,4) Mr '92

SPARROWS
Natur Hist 102:64 (c,4) F '93
Nat Wildlife 34:35 (c,1) F '96

SPAS
— Arizona
Trav&Leisure 26:64 (c,4) Mr '96
— Baja California, Mexico
Gourmet 56:174–9 (c,2) My '96
— Bathing at Iceland spa
Life 15:26 (c,4) O '92
— Canyon Ranch (Tucson, Arizona)
Trav/Holiday 179:30–2 (c,1) N '96
— Enzyme bath at spa (Japan)
Nat Geog 184:61 (c,1) Ag '93
— Luxury spas around the world
Trav&Leisure 23:92–7 (c,1) S '93
Gourmet 56:75–108,174–9 (c,2) My '96
— Mud masks (Quebec)
Nat Geog 186:106–7 (c,1) O '94
— Palm Springs, California
Trav&Leisure 26:104–9 (c,1) Ap '96

Gourmet 56:102–4 (c,4) My '96
— Resort hotel (Bangkok, Thailand)
Trav&Leisure 24:78–83 (c,1) Ag '94
— Skylonda Spa (Woodside, California)
Trav&Leisure 24:94–9 (c,1) Ja '94
— Sukayu Hot Springs (Japan)
Nat Geog 186:74–5 (c,1) S '94
— Thermal water bath (Budapest, Hungary)
Trav&Leisure 24:86–7 (c,1) O '94
— See also
MASSAGES

SPECTATORS
— 1922 baseball fans
Smithsonian 25:44 (4) Jl '94
— 1958 football fans (Maryland)
Sports Illus 85:108 (3) D 23 '96
— 1994 Olympics (Lillehammer)
Sports Illus 80:22 (c,2) F 21 '94
Sports Illus 80:2–3,41 (c,1) F 28 '94
— Baseball
Sports Illus 76:32–3 (1) Ap 6 '92
Sports Illus 78:46–52 (c,1) Je 14 '93
Sports Illus 79:14–15 (c,1) Ag 2 '93
Sports Illus 79:2–3 (c,1) Ag 9 '93
Sports Illus 81:2–3,28–9 (c,1) Jl 4 '94
Sports Illus 83:2–3 (c,1) S 18 '95
— Baseball fan catching home run ball
Sports Illus 77:18 (c,2) O 19 '92
— Baseball fans at fence
Sports Illus 78:2–3 (c,1) Mr 22 '93
— Baseball fans booing player
Sports Illus 85:29 (c,1) O 14 '96
— Baseball fans eating at stadiums
Sports Illus 85:48–60 (c,1) Jl 8 '96
— Baseball fans lunging for ball on field
Sports Illus 82:2–3 (c,1) Je 5 '95
— Baseball player hosing down fans
Sports Illus 83:2–3 (c,1) Jl 24 '95
— Basketball fans doing the Wave
Sports Illus 77:18–19 (c,1) D 14 '92
Sports Illus 82:46–7 (c,1) F 27 '95
— Boy listening to baseball game on radio
Sports Illus 79:2–3 (painting,c,1) Ag 23
'93
— College football
Sports Illus 77:47 (c,2) S 14 '92
Sports Illus 81:30–1 (c,1) N 28 '94
Sports Illus 82:28–9 (c,1) Ja 9 '95
— Fans protesting football team move
Sports Illus 83:28–35 (c,1) N 13 '95
— Fans setting off flares at soccer game
(Turkey)
Nat Geog 185:14–15 (c,2) My '94
— Fatal stampede at soccer match
(Guatemala)

Sports Illus 85:22 (c,4) O 28 '96
— Football
Sports Illus 76:40 (c,3) Je 22 '92
— Golf
Sports Illus 78:2–3 (c,1) F 1 '93
— Hockey
Sports Illus 80:44–7 (c,4) My 16 '94
— Hockey fans with Stanley Cup hats
Sports Illus 84:60–1 (c,1) Je 10 '96
— Hoopla surrounding Super Bowl
Sports Illus 78:cov.,14–49 (c,1) F 8 '93
— Rowdy soccer fans (Milan, Italy)
Nat Geog 182:116–17 (c,1) D '92
— Soccer
Sports Illus 80:80–1 (c,4) Je 20 '94
— Soccer (Great Britain)
Sports Illus 82:62–3,68 (c,1) Je 12 '95
Sports Illus 85:27 (c,2) Jl 8 '96
— Soccer fans (Ireland)
Sports Illus 80:60–70 (c,1) Je 13 '94
— Soccer fans watching game on TV (Italy)
Nat Geog 188:23 (c,3) Ag '95
— Student riot after college football win
(Wisconsin)
Sports Illus 79:60–7 (c,1) N 8 '93
— Tennis (Great Britain)
Sports Illus 85:26 (c,2) Jl 8 '96

SPECTATORS—HUMOR
— Football fan watching TV
Sports Illus 78:32–5 (painting,c,1) Ja 11 '93

SPEER, ALBERT
Smithsonian 27:124–5,128 (4) O '96

SPHINX, EGYPT
Gourmet 52:cov. (c,1) S '92
Trav&Leisure 25:171 (c,2) S '95

SPICE INDUSTRY
— Brazil spices
Trav&Leisure 23:139 (c,3) N '93
— India
Nat Geog 182:80–1 (c,2) N '92
Gourmet 54:112 (c,1) Ap '94
Natur Hist 103:85 (3) O '94
— Spice market (Arles, France)
Nat Geog 188:74 (c,3) S '95
— See also
PEPPERS

SPIDERS
Smithsonian 23:76–7 (c,3) Ap '92
Natur Hist 102:50–1 (c,2) Mr '93
Natur Hist 102:42 (c,4) Ag '93
Natur Hist 104:28–53 (c,1) Mr '95
Life 18:28,30 (c,4) Jl '95
Nat Wildlife 33:38–9 (c,1) Ag '95
Smithsonian 27:146 (c,4) My '96

Natur Hist 105:74–5 (painting,c,4) Jl '96
— Childlike drawing of spider and web
Gourmet 55:163 (4) O '95
— Crab spiders
Natur Hist 102:cov.,58–65 (c,1) O '93
— Eyeless spiders
Life 15:64–5,68 (c,1) N '92
— Fossil spider
Natur Hist 102:50 (c,4) Mr '93
Natur Hist 104:28 (c,2) Mr '95
— Hypnotherapy for fear of spiders
Life 18:28–30 (c,2) Jl '95
— Portia spiders
Nat Geog 190:104–15 (c,1) N '96
— Sea spiders
Nat Geog 182:101–3 (c,1) Jl '92
Natur Hist 101:46–7 (c,1) N '92
— Web
Natur Hist 102:44 (c,1) D '93
Natur Hist 104:cov.,32–5,42–3,53 (c,1)
Mr '95
Nat Wildlife 33:38–9 (c,1) Ag '95
Life 18:63 (c,2) S '95
Smithsonian 27:142 (c,4) My '96
— Wolf spiders
Natur Hist 102:46–7 (c,2) D '93
— See also
TARANTULAS

SPIES
— 1944 execution of German spy
Life 18:79 (4) Je 5 '95
— 1949 wristwatch spy camera
Am Heritage 45:102 (4) Jl '94
— Aldrich Ames
Life 18:26 (c,2) F '95
— Kim Philby
Smithsonian 24:116 (4) Mr '94
— See also
HISS, ALGER

SPONGES
Life 15:40 (c,4) Mr '92
Nat Geog 181:38 (c,3) Je '92
Trav/Holiday 175:71 (c,1) D '92
— Elephant ear sponge
Life 15:84–5 (c,1) S '92

SPOONBILLS
Nat Geog 185:7 (c,3) Ap '94
— Roseate spoonbills
Trav/Holiday 176:83 (painting,c,3) O '93
Sporting goods. See
BASEBALL BATS
BASEBALL GLOVES
BASEBALLS
BASKETBALLS
FISHING EQUIPMENT

HOCKEY EQUIPMENT
HUNTING EQUIPMENT

SPORTS

— 1954–1994 events
Sports Illus 81:35–66 (c,1) Ag 15 '94
Sports Illus 81:2–3,53–143,178 (c,1) N 14 '94
— 1950s bungee jumping (Melanesia)
Nat Geog 190:51 (1) Jl '96
— 1992 events
Sports Illus 77:entire issue (c,1) D 28 '92
— Ancient world depictions of sports
Natur Hist 101:cov.,50–61 (c,1) Jl '92
— Athletes in training (China)
Sports Illus 83:84–94 (c,1) O 16 '95
— Bungee jumping (Cyprus)
Nat Geog 184:124–5 (c,2) Jl '93
— Bungee jumping (New Zealand)
Life 18:12–13 (c,1) Ag '95
— Caber tossing (Texas)
Sports Illus 83:157–8 (c,4) N 27 '95
— Collection of baseball memorabilia
Sports Illus 82:66–76 (c,1) My 22 '95
— College football mascots
Sports Illus 77:2–3,50–1 (c,1) Ag 31 '92
Sports Illus 79:82–3 (c,1) Ag 30 '93
— "Corn" mascot of high school team (South Dakota)
Nat Geog 183:107 (c,3) Je '93
— Cuba
Sports Illus 82:60–78 (c,1) My 15 '95
— Extreme sports
Sports Illus 83:2–3,42–9 (c,1) Jl 3 '95
— Hackey sack
Sports Illus 85:14 (c,4) N 25 '96
— History of sports
Nat Geog 190:42–69 (c,1) Jl '96
— Log-rolling championships 1995 (Wisconsin)
Sports Illus 83:4 (c,4) N 27 '95
— Monster truck events
Sports Illus 78:54–64 (c,1) Mr 8 '93
— Orienteering
Smithsonian 23:44–55 (c,1) Je '92
— Paintball
Sports Illus 80:130–7 (c,1) F 14 '94
— Pelota (France)
Gourmet 54:62 (c,4) Ag '94
— Pelota (Spain)
Nat Geog 190:60–1 (c,1) Jl '96
— Post victory riots
Sports Illus 79:30–4 (c,2) Jl 5 '93
— Santa Claus bungee jumping (California)
Sports Illus 81:106 (c,2) D 26 '94
— Shinty team (Scotland)

Trav&Leisure 23:106 (c,3) D '93
— Shuttlecock game (China)
Nat Geog 190:59 (c,4) Jl '96
— South Africa
Sports Illus 84:122–39 (c,1) Ja
— Takraw (kick volleyball)
Sports Illus 81:64 (c,4) Ag 8 '94
— Top disabled athletes
Sports Illus 83:64–76 (c,1) Ag 14 '95
— Top mid-20th cent. sports figures
Sports Illus 81:48–147 (c,1) S 19 '94
— U.S.S.R.
Sports Illus 80:56–61 (c,2) Ja 10 '94
— See also
ACROBATIC STUNTS
ARCHERY
ATHLETES
ATHLETIC STUNTS
AUTOMOBILE RACING
BADMINTON
BALLOONING
BASEBALL
BASKETBALL
BICYCLE TOURS
BICYCLING
BILLIARDS
BOAT RACES
BOATING
BOBSLEDDING
BODYBUILDING
BOSTON MARATHON
BOWLING
BOXING
CALISTHENICS
CAMPING
CAVE EXPLORATION
CHEERLEADERS
CRICKET
CROQUET
CROSS COUNTRY
DISCUS THROWING
DIVING
DOG RACING
EXERCISING EQUIPMENT
FENCING
FIGHTING
FISHING
FOOTBALL
FRISBEE PLAYING
GOLF
GYMNASIUMS
GYMNASTICS
HANDBALL
HANG GLIDING
HIGH JUMPING

HIKING
HOCKEY
HORSE RACING
HORSEBACK RIDING
HUNTING
HURDLING
HURLING
ICE DANCING
ICE FISHING
JAVELIN THROWING
JOGGING
JUDO
JUMPING
KARATE
LACROSSE
LOCKER ROOMS
LUGE
MARATHONS
MARTIAL ARTS
MOUNTAIN CLIMBING
OLYMPICS
PARACHUTING
POLE VAULTING
POLO
RACES
RACQUETBALL
ROCK CLIMBING
RODEOS
ROLLER SKATING
ROWING
RUGBY
RUNNING
SAILBOARDING
SAILBOAT RACES
SAILING
SCOREBOARDS
SHOOTING
SHOT-PUTTING
SKATING
SKATING, FIGURE
SKATING, SPEED
SKI JUMPING
SKIING
SKIING—CROSS-COUNTRY
SKIN DIVING
SKYDIVING
SOAP BOX DERBIES
SOCCER
SOFTBALL
SPECTATORS
SPORTS ANNOUNCERS
SQUASH
STADIUMS
SURFING
SWIMMING

TABLE TENNIS
TENNIS
TRACK
TRACK AND FIELD
TROPHIES
VOLLEYBALL
WALKING
WATER POLO
WATER SKIING
WEIGHT LIFTING
WINDSURFING
WRESTLING
YOGA
SPORTS—HUMOR
— Ancient origins of modern sports
 Smithsonian 23:cov.,96–101 (painting,c,1)
 Je '92
SPORTS ANNOUNCERS
— Red Barber
 Sports Illus 77:13 (4) N 2 '92
 Smithsonian 25:48 (4) Jl '94
— Baseball press box
 Sports Illus 79:32–3 (c,3) Jl '93
Sports fans. See
 SPECTATORS
SPRING
— Hindu spring festival Holi (India)
 Nat Geog 184:90–1 (c,1) S '93
SPRINGSTEEN, BRUCE
 Life 15:cov.,16 (2) D 1 '92
SPRUCE TREES
 Nat Wildlife 31:25–7 (painting,c,2) D '92
 Natur Hist 101:39–41 (c,2) D '92
 Nat Wildlife 32:60 (c,1) F '94
 Natur Hist 105:56–7 (c,1) Je '96
— Black spruce
 Nat Geog 184:25 (c,4) O '93
— Sitka spruce
 Smithsonian 27:114 (c,3) O '96
SQUASH PLAYING
— Playing in Grand Central Terminal, New
 York City
 Sports Illus 83:13 (c,3) O 9 '95
— Tournament (Egypt)
 Life 19:12–13 (c,1) Ag '96
SQUID
 Smithsonian 27:130–7 (c,1) My '96
— 26-foot-long squid
 Smithsonian 27:130 (c,3) My '96
SQUIRRELS
 Natur Hist 101:40–1 (c,2) D '92
 Natur Hist 102:cov.,44–9 (c,1) S '93
 Natur Hist 103:41–5 (c,1) O '94
 Gourmet 54:120 (painting,c,4) N '94
 Natur Hist 105:34 (c,4) My '96

Am Heritage 47:75 (drawing,4) Jl '96
Nat Wildlife 35:47,50 (c,1) D '96
— 1944 squirrel in nurse costume
Nat Geog 188:138 (3) N '95
— Gray squirrels
Nat Geog 188:98–113 (c,1) N '95
— Ground squirrels
Nat Wildlife 30:13 (painting,c,4) Ap '92
Nat Wildlife 33:46 (c,4) F '95
— Red squirrels
Nat Wildlife 30:34–5 (c,1) Ap '92
Natur Hist 102:30–1 (c,1) F '93
Nat Wildlife 32:18 (c,4) O '94
— See also
FLYING SQUIRRELS
MARMOTS

SRI LANKA—COSTUME
— Miners
Nat Geog 182:85 (c,3) N '92

STABLES
— 1837 stable block on estate (England)
Trav&Leisure 25:66 (c,3) S '95
— Claremont Stables, New York City
Gourmet 54:54,56 (painting,c,2) S '94

STADIUMS
— 1929 bleachers outside Shibe Stadium,
Philadelphia, Pennsylvania
Sports Illus 85:78–9 (1) Ag 19 '96
— Anaheim Stadium, California
Sports Illus 81:34 (c,3) N 21 '94
— Anaheim Stadium after 1994 earthquake
Sports Illus 80:2–3 (c,1) Ja '94
— Astroturf problems
Sports Illus 79:32–9 (c,1) N 1 '93
— Baseball field, Puerto Rico
Sports Illus 82:44–5 (c,2) Ja 16 '95
— Baseball field covered with snow
Life 17:14–15 (c,1) N '94
— Baseball stadium seats
Sports Illus 81:20–1 (c,1) S 26 '94
— Baseball supply room
Sports Illus 81:36–7 (c,1) O 10 '94
— Boston College football stadium,
Massachusetts
Sports Illus 85:52–3 (c,1) N 18 '96
— Boston Garden, Massachusetts
Sports Illus 82:58–65 (c,2) Ap 17 '95
— Boston Garden's last game, Massachusetts
Sports Illus 83:2–3 (c,1) O 9 '95
— Camden Yards, Baltimore, Maryland
Sports Illus 76:34–6,41 (c,1) Ap 13 '92
Trav&Leisure 22:17 (c,4) Ag '92
Sports Illus 77:44–5 (c,1) D 28 '92
Sports Illus 78:22–3 (c,1) Je 14 '93
Gourmet 55:146–9 (c,1) My '95

Sports Illus 83:28–9 (c,1) Ag 7 '95
— Candlestick Park, San Francisco, California
Sports Illus 77:31 (c,4) Ag 24 '92
— Carolina, Puerto Rico
Smithsonian 24:138 (c,4) S '93
— Chicago Stadium, Illinois
Sports Illus 76:60–72 (c,1) Je 1 '92
— City of Palms Park, Ft. Myers, Florida
Trav&Leisure 26:103 (4) F '96
— Cleveland Municipal Stadium, Ohio
Sports Illus 83:64–5 (c,2) D 4 '95
— College football
Sports Illus 77:2–3 (c,1) D 7 '92
— Converting baseball field to football
stadium (San Diego, California)
Sports Illus 81:2–3 (c,1) S 26 '94
— Coors Field, Denver, Colorado
Sports Illus 82:62 (c,3) Ap 10 '95
Sports Illus 82:27 (c,3) My 8 '95
Trav&Leisure 26:C5 (c,4) Ap '96
Nat Geog 190:86–7 (c,2) N '96
— Diagram of Lillehammer Olympic arena,
Norway
Sports Illus 78:52–3 (c,2) Mr 29 '93
— Doubleday Field, Cooperstown, New York
Trav/Holiday 176:83 (c,1) Ap '93
— Durham Athletic Park, North Carolina
Sports Illus 79:2–3 (c,1) Ag 16 '93
Sports Illus 79:8 (c,4) S 13 '93
— Empty seats, Pittsburgh, Pennsylvania
Sports Illus 83:32–3 (c,2) Jl 10 '95
— Fence around Shibe Park, Philadelphia,
Pennsylvania
Am Heritage 47:73 (3) F '96
— Fenway Park, Boston, Massachusetts
Nat Geog 186:12–13 (c,1) Jl '94
Smithsonian 25:64–5,73–6 (c,1) O '94
— Florida Suncoast Dome, St. Petersburg
Sports Illus 77:31 (c,4) Ag 24 '92
— Foxboro, Massachusetts
Sports Illus 77:38 (c,3) N 2 '92
— Fukuoka Dome, Japan
Nat Geog 185:86–7 (c,1) Ja '94
— Georgia Dome, Atlanta
Sports Illus 78:166 (c,4) F 22 '93
— Graffiti-covered stadium steps,
Massachusetts
Life 16:3 (c,2) Je '93
— High school football stadium New
Mexico
Nat Geog 184:54–5 (c,1) S '93
— Hiroshima baseball stadium, Japan
Nat Geog 188:90–1 (c,2) Ag '95
— Hosing down baseball field
Sports Illus 80:2–3 (c,1) Ap 11 '94

— Jacobs Field, Cleveland, Ohio
 Sports Illus 80:42–4 (c,1) Ap 11 '94
 Gourmet 55:148–9 (c,2) My '95
 Sports Illus 83:24–5 (c,1) Jl 10 '95
 Trav/Holiday 178:18 (c,4) O '95
— Melbourne Cricket Ground, Australia
 Natur Hist 104:62 (c,1) My '95
— Memorial Stadium, Baltimore, Maryland
 Sports Illus 81:56–7 (c,4) Jl 25 '94
— Mile High Stadium, Denver, Colorado
 Sports Illus 78:46–7 (c,1) Je 14 '93
 Sports Illus 81:63 (c,3) O 17 '94
— Montreal Forum, Quebec
 Sports Illus 79:9 (4) Jl 12 '93
— Night baseball game
 Smithsonian 24:66 (painting,c,2) Ag '93
— Olympic skating dome, Lillehammer,
 Norway
 Sports Illus 79:2–3 (c,1) D 27 '93
— Olympics Stadium, Barcelona, Spain
 Trav&Leisure 22:87 (c,4) Ja '92
— Phoenix, Arizona
 Sports Illus 82:28–9 (c,1) Ja 16 '95
— Polo Grounds, New York City, New York
 Sports Illus 77:17–19 (4) Fall '92
— Pulaski, Virginia
 Life 16:44–5 (c,1) Je '93
— Redland Field, Cincinnati (1912)
 Am Heritage 45:100 (4) O '94
— Joe Robbie Stadium, Florida
 Sports Illus 77:72 (c,4) N 30 '92
— Royals Stadium, Kansas City, Missouri
 Sports Illus 78:98 (c,4) Ap 5 '93
— Sant Jordi Stadium, Barcelona, Spain
 Trav/Holiday 175:55 (c,1) Mr '92
 Smithsonian 23:58–60 (c,2) Jl '92
— Silverdome, Pontiac, Michigan
 Sports Illus 78:42 (c,3) Je 21 '93
— SkyDome, Toronto, Ontario
 Sports Illus 76:2–3,48–57 (c,1) Ap 6 '92
 Sports Illus 77:19 (c,3) N 2 '92
 Trav&Leisure 23:103 (c,2) O '93
— Softball field, Pennsylvania
 Smithsonian 27:72–3 (c,1) Ap '96
— Sports surface dirt industry, New Jersey
 Sports Illus 79:4–5 (c,4) S 20 '93
— Spray-painting batter's box on diamond
 Sports Illus 82:2–3 (c,1) My 1 '95
— Stadium vendor hawking beer
 Nat Geog 185:74 (c,3) My '94
— Three Rivers Stadium, Pittsburgh,
 Pennsylvania
 Sports Illus 82:18–19 (c,1) My 8 '95
— Tokyo Dome, Japan
 Trav/Holiday 176:52 (c,4) My '93
 Sports Illus 78:99 (c,4) My 31 '93
— University of Nebraska
 Sports Illus 79:39 (c,3) D 27 '93
— Weehawken Stadium, New Jersey
 Sports Illus 81:7 (c,4) S 5 '94
— See also
 SCOREBOARDS

STADIUMS—CONSTRUCTION
— Constructing Olympic Stadium, Atlanta,
 Georgia
 Sports Illus 84:86 (c,3) Ja 8 '96
— Nashville, Tennessee
 Sports Illus 83:48–50 (c,1) N 27 '95
— St. Louis, Missouri
 Sports Illus 82:44 (c,3) Mr 13 '95

STAINED GLASS
— Czech church (Texas)
 Am Heritage 44:105 (c,4) S '93
— Depicting muse Terpsichore (Pennsylvania)
 Smithsonian 23:108 (c,4) Ap '92
— Panel by Tiffany
 Nat Geog 184:64 (c,1) D '93
— Reims Cathedral, France
 Trav/Holiday 178:72 (c,3) S '95
— Stained glass depiction of "Titanic"
 sinking in 1912 (New York)
 Smithsonian 23:38 (c,4) D '92
— Vienna church, Austria
 Trav/Holiday 179:65 (c,2) Ap '96
— Wawel Cathedral, Krakow, Poland
 Gourmet 54:135 (c,1) N '94

STAIRCASES
 Smithsonian 24:54–63 (c,1) Je '93
— 1600 Jacobean staircase (Great Britain)
 Trav&Leisure 26:122 (4) My '96
— Castle staircase (Genoa, Italy)
 Trav&Leisure 24:113 (c,1) S '94
— Ceramic tiled steps (San Antonio, Texas)
 Gourmet 52:78 (c,4) Je '92
— English manor house
 Trav&Leisure 24:110 (c,2) Je '94
— Funky checked house front steps (London,
 England)
 Trav&Leisure 26:68 (c,4) Ag '96
— Graffiti-covered stadium steps
 (Massachusetts)
 Life 16:3 (c,2) Je '93
— Hermitage, St. Petersburg, Russia
 Smithsonian 25:55 (c,2) Mr '95
— Iowa house
 Smithsonian 24:47 (4) Mr '94
— Loretto Chapel's spiral staircase, Santa Fe,
 New Mexico
 Smithsonian 24:10 (c,4) Ag '93
— New York City mansion, New York

Gourmet 54:76 (c,3) Ap '94
— Shaker twin spiral staircases (Kentucky)
 Am Heritage 46:26 (c,4) Jl '95
— Spanish Steps, Rome, Italy
 Smithsonian 24:54 (c,1) Je '93
— Stair rail depicting Battle of Napoleon
 (Glasgow, Scotland)
 Trav&Leisure 26:118 (c,4) N '96
— Steps going up mountain (Switzerland)
 Gourmet 52:118 (c,4) D '92
— Winterthur, Delaware
 Gourmet 53:113 (c,2) D '93

STALIN, JOSEF
 Nat Geog 182:123 (4) O '92
 Am Heritage 45:92 (2) My '94
 Life 18:107 (c,2) Je 5 '95
 Am Heritage 46:52,62 (4) D '95
 Life 19:55 (4) F '96
— Blindfolded statue of Stalin (Moscow,
 Russia)
 Nat Geog 183:cov.,3 (c,1) Mr '93
— Shrine to Stalin (Tbilisi, Georgia)
 Life 18:63 (c,2) Jl '95

STARFISH
 Life 15:85 (c,4) S '92
 Natur Hist 101:53 (c,1) N '92
 Natur Hist 102:51 (c,4) Ag '93
 Nat Wildlife 31:55 (c,4) O '93
 Natur Hist 103:37 (c,4) Jl '94
 Smithsonian 26:103 (c,4) Ja '96
 Nat Geog 190:76 (c,4) N '96
— Biscuit star
 Natur Hist 102:68–9 (c,1) Mr '93
— Starfish fossil
 Natur Hist 101:41 (3) N '92

STARLINGS
 Nat Wildlife 34:10 (c,4) F '96

STARR, BELLE
— Home (Missouri)
 Smithsonian 22:108 (c,3) F '92

STARS
 Smithsonian 22:99–101 (c,2) Mr '92
 Nat Geog 185:28–9 (c,1) Ja '94
— Beta Pictoris
 Life 15:68 (c,4) S '92
— Betelgeuse
 Natur Hist 105:72 (c,4) Je '96
— Birth of star
 Life 19:40 (c,2) Ja '96
 Life 19:48 (c,4) F '96
— Eta Carinae
 Life 17:107 (c,4) Ap '94
 Natur Hist 103:70 (c,4) D '94
— Supernova 1987A
 Smithsonian 22:100 (c,4) Mr '92
— Supernova explosion blast wave
 Natur Hist 105:72–3 (c,3) Ag '96
— Time exposure photo of star movement
 Trav/Holiday 176:38 (c,4) S '93
 Life 17:23–4 (c,1) S '94
— See also
 CONSTELLATIONS
 GALAXIES
 NEBULAE

STATESMEN
— Jimmy Byrnes
 Am Heritage 47:32 (4) F '96
— Joseph G. Cannon
 Am Heritage 46:22 (4) Jl '95
— John Connally
 Life 17:90 (2) Ja '94
— Millicent Fenwick
 Life 16:68–9 (1) Ja '93
— First black congressmen (1872)
 Smithsonian 24:108 (painting,c,4) F '94
— Henry Gardner (Massachusetts)
 Smithsonian 27:157 (engraving,4) N '96
— H.R. Haldeman
 Life 17:97 (c,3) Ja '94
— Ted Kennedy
 Am Heritage 44:16 (drawing,4) N '93
— Robert Moses
 Am Heritage 43:40–5 (4) Jl '92
— Tip O'Neill
 Life 18:85 (c,1) Ja '95
— H. Ross Perot
 Life 16:24–5 (c,1) Ja '93
— Dan Quayle
 Life 15:27–34 (c,1) S '92
— Thomas Brackett Reed
 Am Heritage 46:22 (4) Jl '95
— See also
 BRYAN, WILLIAM JENNINGS
 CALHOUN, JOHN C.
 CATO THE ELDER
 CLAY, HENRY
 CROCKETT, DAVY
 DEBS, EUGENE V.
 DEWEY, THOMAS E.
 DOUGLAS, STEPHEN
 DUKAKIS, MICHAEL
 DULLES, JOHN FOSTER
 FORRESTAL, JAMES V.
 FREMONT, JOHN C.
 FULBRIGHT, J. WILLIAM
 HAMILTON, ALEXANDER
 HARRIMAN, W. AVERELL
 HAY, JOHN MILTON
 HOUSTON, SAM
 HUGHES, CHARLES EVANS

KENNAN, GEORGE F.
KENNEDY, ROBERT FRANCIS
LA GUARDIA, FIORELLO
LONG, HUEY
MARSHALL, GEORGE C.
McCARTHY, JOSEPH
MOLOTOV, VYACHESLAV
PINCHOT, GIFFORD
POWELL, ADAM CLAYTON, JR.
RANKIN, JEANNETTE
RAYBURN, SAM
ROCKEFELLER, NELSON
RUSK, DEAN
SMITH, ALFRED E.
SMITH, MARGARET CHASE
STEVENSON, ADLAI
TILDEN, SAMUEL
TOJO, HIDEKI
WALLACE, GEORGE
WALLACE, HENRY
WILLKIE, WENDELL
WILSON, HAROLD
Statues. See
LIBERTY, STATUE OF
MONUMENTS
SCULPTURE
STEAMBOATS
Am Heritage 43:4 (c,3) Jl '92
— 19th cent.
Smithsonian 25:10 (painting,c,4) Ja '95
STEEL INDUSTRY
— 1940s women steelworkers (Indiana)
Life 18:55 (2) Je 5 '95
— Coke plant (China)
Nat Geog 185:12–13 (c,1) Mr '94
— Steel plant (Mexico)
Nat Geog 190:57 (c,4) Ag '96
STENGEL, CASEY
Sports Illus 76:86 (4) Mr 23 '92
Sports Illus 76:82,92 (1) My 25 '92
Sports Illus 78:90 (c,3) Ap 12 '93
Sports Illus 79:63 (4) O 11 '93
Sports Illus 80:66,74 (1) My 30 '94
Smithsonian 25:41 (4) Jl '94
Sports Illus 81:95 (c,1) N 14 '94
STERN, ISAAC
Life 16:26 (c,4) N '93
STEVENSON, ADLAI
Am Heritage 43:32 (4) My '92
STEVENSON, ROBERT LOUIS
Smithsonian 26:50–8 (1) Ag '95
Trav&Leisure 26:106 (4) N '96
— Family
Smithsonian 26:50–6 (1) Ag '95
— Home Vailima (Samoa)

Smithsonian 26:57 (c,4) Ag '95
— Illustration from "Kidnapped"
Smithsonian 26:59 (painting,c,1) Ag '95
— Scenes related to his life
Smithsonian 26:50–7 (c,1) Ag '95
STEWART, JAMES
Life 16:32 (4) N '93
Life 18:134 (1) Je 5 '95
— In World War II
Am Heritage 46:94 (4) Jl '95
STICKLEBACK FISH
— Stickleback fish hatching
Life 19:50 (c,4) N '96
STILT HOUSES
— Cambodia
Nat Geog 183:25 (c,3) F '93
— Indonesia
Nat Geog 189:27 (c,1) F '96
— Laos
Natur Hist 104:51 (c,4) S '95
— Philippines
Trav&Leisure 25:145 (c,1) Ap '95
STILTS (BIRDS)
Natur Hist 101:42–9 (c,1) Ap '92
Nat Wildlife 32:26–7 (painting,c,1) D '93
STINGRAYS
Nat Geog 184:75 (c,4) N '93
Trav/Holiday 177:46–8 (c,1) F '94
Nat Wildlife 33:52 (c,3) D '94
STINK BUGS
Natur Hist 104:76–7 (c,1) S '95
STOCK EXCHANGES
— Bombay, India
Nat Geog 187:48 (c,4) Mr '95
— New York Stock Exchange trading floor
Nat Geog 183:85 (c,1) Ja '93
— Shanghai, China
Trav/Holiday 176:76 (c,4) O '93
— Tokyo Stock Exchange robot signaling to
sell (Japan)
Nat Geog 183:89 (c,1) Ja '93
STOCKHOLM, SWEDEN
Nat Geog 184:8–9 (c,1) Ag '93
Trav/Holiday 177:48–9 (c,2) Je '94
Trav&Leisure 26:98 (c,4) My '96
STONEHENGE, ENGLAND
Nat Geog 181:37 (c,4) My '92
STORES
— 1850s clothing store (Philadelphia,
Pennsylvania)
Am Heritage 43:57 (painting,c,4) D '92
— Late 19th cent. Marshall Field's, Chicago,
Illinois
Am Heritage 43:115 (4) D '92
— 1889 (Oklahoma)

Life 16:18–19 (1) Ap 5 '93
— 1948 department store facade (Los Angeles, California)
Trav&Leisure 24:31 (4) My '94
— 1951 Macy's vs. Gimbels price war
Smithsonian 23:124 (4) Mr '93
— Antique stores (Connecticut)
Trav&Leisure 24:114–17 (c,2) S '94
— Bait and tackle store (Texas)
Trav/Holiday 177:87 (c,4) D '94
— Beijing, China
Trav/Holiday 177:77–83 (c,1) My '94
— Bookstore (Japan)
Trav&Leisure 26:153 (c,3) Mr '96
— Bookstore (Tunisia)
Trav/Holiday 178:40 (c,2) N '95
— Candy store (Genoa, Italy)
Trav&Leisure 24:109–10 (c,1) S '94
— Country store (Arkansas)
Trav/Holiday 177:87 (c,3) My '94
— Country store (Kentucky)
Nat Geog 183:127 (c,4) F '93
— Drive-up liquor store (Texas)
Nat Geog 184:56–7 (c,2) S '93
— General store (California)
Trav&Leisure 23:E16 (c,3) F '93
— General store (Indiana)
Trav/Holiday 176:84–5 (c,3) Mr '93
— General store (North Carolina)
Life 18:54–62 (c,1) O '95
— General store (North Dakota)
Smithsonian 24:42–3 (1) Mr '94
— General store (Vermont)
Trav&Leisure 25:E1 (c,4) Ag '95
— General store (West Virginia)
Trav&Leisure 23:E18 (c,4) N '93
— GUM store (Moscow, Russia)
Trav/Holiday 176:93 (c,4) Ap '93
Natur Hist 102:110 (4) O '93
— Hat store (Bologna, Italy)
Trav/Holiday 177:51 (c,4) O '94
— History of Brooks Brothers store
Am Heritage 44:40–5 (c,3) N '93
— History of department stores
Smithsonian 23:122–33 (c,1) Mr '93
— History of dime stores
Smithsonian 25:104–13 (c,1) Je '94
— Hong Kong
Trav&Leisure 22:144–5,148,154 (c,1) Mr '92
— Housewares store (Pakistan)
Nat Geog 185:123 (c,3) Mr '94
— Jewelry store (Nebraska)
Trav&Leisure 25:54–6 (c,4) My '95
— Lingerie shops around the world

Trav&Leisure 26:54–8 (c,2) My '96
— London's Notting Hill section
Trav&Leisure 24:101–3 (c,4) Mr '94
— Lower East Side, New York City, New York
Am Heritage 43:4,56–74 (map,c,1) Ap '92
Smithsonian 25:80–91 (1) Ap '94
— Milan, Italy
Gourmet 55:124–7 (c,2) O '95
— Paris, France
Trav&Leisure 24:86–99 (c,4) Ap '94
— Paris department store map (France)
Gourmet 53:48 (c,2) O '93
— Prices in drug store window (1970s–1990s)
Life 17:89 (4) S '94
— Restored early 20th cent. general store (Missouri)
Smithsonian 22:104–5 (c,2) F '92
— Rome, Italy
Trav&Leisure 25:74–9 (c,3) Ja '95
— Shopping arcade (Hiroshima, Japan)
Nat Geog 188:92–3 (c,1) Ag '95
— Store windows decorated for Christmas (New York City, New York)
Gourmet 53:66 (c,2) D '93
— Tea shop (Hong Kong)
Trav&Leisure 25:141 (c,1) S '95
— Tokyo, Japan
Trav&Leisure 26:142–58 (c,1) Mr '96
— Trading post (Wyoming)
Trav/Holiday 176:56 (c,2) D '93
— See also
FOOD MARKETS
MARKETS
PHARMACIES
SHOPPING MALLS
STREET VENDORS
SUPERMARKETS

STORKS
Trav/Holiday 175:80 (c,4) My '92
Natur Hist 104:A3 (c,4) N '95
Nat Geog 190:33 (painting,c,4) N '96
— Wood storks
Nat Geog 190:32–3 (c,1) O '96

STORMS
— 1934 Dust Bowl crisis (Oklahoma)
Life 16:26–7 (1) Ap 5 '93
— Sky after storm (North Dakota)
Trav/Holiday 176:54 (c,4) D '93
— Storm clouds
Life 16:32–3 (c,1) S '93
Smithsonian 25:61 (c,3) O '94
— Summer lightning storm (Illinois)
Life 16:10–11 (c,1) Jl '93
— Thunderstorm (Oregon)

Nat Wildlife 35:48–9 (c,1) D '96
— Water breaking through house windows
 (Florida)
 Life 15:108–9 (c,1) Ja '92
— Waves hitting coastal rocks
 Trav/Holiday 175:68–74 (map,c,1) Ap '92
— Winter storm (Massachusetts town)
 Life 16:10–11 (c,1) F '93
— See also
 BLIZZARDS
 HURRICANES
 SNOW STORMS
STOUT, REX
 Am Heritage 44:43 (4) Jl '93
STOVES
— 1789 Rumford stove
 Am Heritage 44:73 (drawing,3) S '93
 Smithsonian 25:106 (c,4) D '94
— 1869 large charcoal kilns (Wyoming)
 Am Heritage 45:32 (c,4) Jl '94
— 19th cent. outdoor round brick ovens (New
 Mexico)
 Am Heritage 45:96 (c,4) F '94
— Cooking corn in adobe oven (New Mexico)
 Nat Geog 184:44 (c,4) S '93
— Potbellied stove in store (Arkansas)
 Trav/Holiday 177:87 (c,3) My '94
— Restaurant wood-fired oven (New York)
 Gourmet 53:64 (c,4) O '93
— Wood-burning stove
 Smithsonian 24:45 (2) Mr '94
STRASBOURG, FRANCE
 Trav/Holiday 175:81 (c,2) My '92
**STRATFORD-UPON-AVON, ENG-
 LAND**
— Mary Arden's cottage
 Trav/Holiday 175:102 (c,3) Mr '92
STRAWBERRIES
 Smithsonian 27:50–1 (c,1) D '96
**STRAWBERRY INDUSTRY—HAR-
 VESTING**
— California
 Trav/Holiday 179:92 (c,3) D '96
Street signs. See
 SIGNS AND SIGNBOARDS
STREET VENDORS
— 1946 hot dog stand (New York)
 Am Heritage 47:100–1 (c,1) D '96
— Chinese duck stand (New York)
 Smithsonian 24:89 (c,4) Ja '94
— Dockside peddlers (Russia)
 Trav/Holiday 176:91 (c,4) Ap '93
— Drink stand (Bolivia)
 Trav&Leisure 26:111 (c,4) F '96
— Drink stand (Key West, Florida)

Trav&Leisure 24:154 (c,4) D '94
— Food cart (Santa Fe, New Mexico)
 Gourmet 54:90 (painting,c,2) S '94
— Food stands (Beijing, China)
 Trav/Holiday 177:82–3 (c,2) My '94
— Hard-boiled egg vendor (Morocco)
 Natur Hist 101:65 (2) Ja '92
— Ice cream cart (New York)
 Natur Hist 103:72 (4) Jl '94
— Istanbul, Turkey
 Trav/Holiday 175:62–3,70–1 (c,1) Jl '92
— Java, Indonesia
 Trav&Leisure 22:68 (c,4) Ja '92
— Jewelry (Santa Fe, New Mexico)
 Trav&Leisure 22:84–5, 95 (c,1) F '92
— Mask sellers (India)
 Natur Hist 103:71 (4) My '94
— Meat and cheese pie stand (Australia)
 Trav&Leisure 24:100 (4) Jl '94
— Medicinal herb vendor (Peru)
 Natur Hist 104:80 (4) Mr '95
— Mexico
 Natur Hist 104:80 (4) Je '95
— Moscow, Russia
 Nat Geog 183:14–15 (c,1) Mr '93
— Paraguay
 Nat Geog 182:108–9 (c,1) Ag '92
— Peru
 Nat Geog 189:27 (c,3) My '96
— Selling coffee to commuters in cars
 (Boston, Massachusetts)
 Nat Geog 186:28 (c,3) Jl '94
— Selling Soviet souvenirs from car trunk
 (Czechoslovakia)
 Nat Geog 184:11 (c,3) S '93
— Selling wax printed fabric (Togo)
 Nat Geog 185:87 (c,1) Je '94
— Serving Filipino food from car (Italy)
 Nat Geog 183:109 (c,2) My '93
— Spice merchant (India)
 Natur Hist 103:85 (3) O '94
— Stadium vendor hawking beer
 Nat Geog 185:74 (c,3) My '94
— Taco stand (Mexico)
 Trav/Holiday 176:93 (c,4) F '93
STUART, GILBERT
— Portrait of John Adams
 Am Heritage 44:86 (painting,c,1) My '93
STYRON, WILLIAM
 Am Heritage 43:65 (c,2) O '92
SUBMARINES
 Nat Geog 185:81 (c,1) F '94
— Dogs aboard World War II submarines
 Am Heritage 45:96–9 (1) O '94
— Interior (U.S.S.R.)

Nat Geog 183:44–5 (c,2) Mr '93
— Mini-submarine
Nat Geog 185:68–9 (c,1) Ap '94
— Sunken U.S. submarine (Bikini)
Nat Geog 181:70–1 (c,1) Je '92

SUBURBAN LIFE
— 1940s Levittown houses, Long Island,
New York
Am Heritage 44:62–9 (c,2) Jl '93
— 1950s moving day (California)
Life 18:88 (2) Je 5 '95

SUBWAYS
— Boston "T" (Massachusetts)
Sports Illus 78:30 (c,2) Ap 26 '93
— Miniature of New York City train
Am Heritage 47:81 (c,4) D '96
— New York City, New York
Am Heritage 46:50–1 (2) Jl '95
— New York City (1960s)
Am Heritage 45:101 (4) F '94
— New York commuters on subway
Smithsonian 24:60–1 (painting,c,2) Ag '93
— Paris metro station, France
Trav&Leisure 23:99 (c,4) S '93
Trav/Holiday 179:16 (c,4) D '96
— Worldwide subway logos
Trav&Leisure 25:192–3 (c,4) Ap '95

SUCCULENT PLANTS
— Lithops
Nat Geog 181:62 (c,4) Ja '92

SUDAN—ARCHITECTURE
— Pyramids
Smithsonian 24:92–3 (c,3) Je '93

SUDAN—COSTUME
Smithsonian 24:92,101 (c,1) Je '93
Life 18:110,114 (c,4) N '95
Life 19:76 (c,3) S '96
— Homeless boys
Life 15:50–8 (c,1) Je '92
— Starving people
Nat Geog 184:92–3,108–11 (c,1) Ag '93

SUDAN—HISTORY
— Artifacts from ancient Nubians
Smithsonian 24:cov.,90–100 (c,1) Je '93

**SUDAN—SOCIAL LIFE AND
CUSTOMS**
— Nuba tribesmen wrestling
Nat Geog 190:64–5 (c,1) Jl '96

SUGAR CANE INDUSTRY
— El Salvador
Nat Geog 188:124–5 (c,1) S '95
— Mauritius
Nat Geog 183:112–13,120–1 (c,1) Ap '93
— Sugar cane fields (Hawaii)
Smithsonian 27:116–17 (c,3) N '96

SULFUR INDUSTRY
— Mining (Indonesia)
Life 16:10–11 (c,1) Ap '93

SUMAC
Natur Hist 101:34–7 (c,1) Ap '92
— Sumac leaves
Nat Wildlife 33:56 (c,4) Ap '95

SUMMER
— Animal strategies for dealing with heat
Natur Hist 102:cov.,26–67 (c,1) Ag '93
— Bucolic island scenes (Massachusetts)
Nat Geog 181:114–25,130–2 (c,1) Je '92

SUN
— Solar flare
Nat Wildlife 33:16 (c,4) Je '95
— 24-hour summer sun (Norway)
Life 19:16–17 (c,1) Jl '96
— See also
ECLIPSES

SUN YAT-SEN
Smithsonian 24:107 (4) Jl '93
Nat Geog 184:4–5 (c,4) N '93

SUNBATHING
Sports Illus 76:48 (c,3) Je 1 '92
— 1934 "sweatbox" (Palm Springs,
California)
Nat Geog 189:138 (2) My '96
— 1945 tanning equipment
Life 18:100 (4) Je 5 '95
— Australia beach
Nat Wildlife 30:30–1 (c,1) Ag '92
— Children standing in ultraviolet light
(Siberia)
Life 15:14–15 (c,1) F '92
— Madeira
Gourmet 53:117 (c,1) D '93
— Man on pool float
Sports Illus 85:cov.,62–3 (c,1) Jl 1 '96
— Palm Springs, California
Nat Geog 184:40–1 (c,1) N 15 '93
— Sunbathers in Jack & Jackie masks (1963)
Life 16:28 (c,4) Je '93

SUNBIRDS
Natur Hist 102:42–3,46 (c,2) My '93
Natur Hist 102:4 (c,3) Jl '93

SUNDEW PLANTS
Natur Hist 101:66–7 (c,4) O '92
Smithsonian 23:50–1 (c,4) D '92

SUNDIALS
— Jaipur, India
Natur Hist 102:48–57 (c,1) Je '93
— Washington, D.C.
Smithsonian 25:10 (c,4) Ag '94

SUNFISH
Natur Hist 103:36–9 (c,1) Ag '94

Nat Wildlife 33:46–51 (c,1) Ag '95

SUNFLOWERS

Trav&Leisure 22:92–3 (c,1) Ja '92

Natur Hist 101:65 (c,1) Jl '92

Gourmet 52:59 (c,4) Ag '92

Trav&Leisure 23:126 (c,1) Mr '93

Gourmet 54:10 (c,3) My '94

Smithsonian 25:cov. (c,1) Mr '95

Life 19:38 (c,4) Ap '96

Smithsonian 27:53–61 (c,1) Ag '96

SUNGLASSES

Sports Illus 79:cov. (c,1) Ag 16 '93

SUNRISES

— Jerusalem, Israel

Gourmet 54:98–9 (c,1) F '94

— Midnight sun (Norway)

Gourmet 53:84 (c,4) Je '93

Life 19:16–17 (c,1) Jl '96

— Over Chesapeake Bay, Virginia

Nat Geog 183:cov.,2–3 (c,1) Je '93

— Over Crater Lake National Park, Oregon

Nat Geog 186:16–17 (c,1) O '94

— Over Grand Canyon, Arizona

Nat Geog 186:2–4 (c,1) O '94

— Over harbor (Maryland)

Am Heritage 45:26 (c,4) O '94

— Over Hawaii

Gourmet 55:162–3 (c,1) My '95

— Over Montana countryside

Trav/Holiday 176:71 (c,1) Je '93

— Over North Carolina beach

Gourmet 55:103 (c,4) Ap '95

— Over Tennessee farm

Gourmet 56:121 (c,2) Ap '96

— Over whales in Pacific Ocean

Nat Geog 188:61 (c,4) N '95

— San Francisco Bay, California

Smithsonian 23:94–5 (c,1) Ag '92

— Shenandoah Valley, Virginia

Nat Geog 190:38–9 (c,1) D '96

— West Mitten Butte, Arizona

Nat Geog 190:83–5 (c,1) S '96

SUNSETS

— Alaska

Natur Hist 104:A2 (c,3) N '95

— Amazon River, Brazil

Sports Illus 76:39 (c,3) Je 22 '92

— California coast

Life 17:98–9 (c,1) O '94

— Canary Islands

Gourmet 55:123 (c,1) O '95

— Canoeing at sunset (Minnesota)

Trav&Leisure 23:46 (c,4) F '93

— Cowboy and horse silhouetted in sunset

Sports Illus 79:2–3 (c,1) O 4 '93

— Hawaii

Trav/Holiday 175:94 (c,4) My '92

— In volcanic haze

Nat Geog 181:48 (c,4) My '92

— Lake Tahoe, Nevada

Nat Geog 181:119 (c,3) Mr '92

— Nebraska farmland

Life 15:112 (c,1) Ja '92

— Oregon lake

Life 19:58 (c,4) Mr '96

— Over desert (Southwest)

Trav/Holiday 177:94 (c,3) O '94

— Over Florida Everglades

Sports Illus 83:76–7 (c,1) S 18 '95

— Over Frederick Sound, Alaska

Nat Wildlife 31:58–9 (c,1) D '92

— Over Istanbul, Turkey

Nat Geog 185:138 (c,3) Je '94

— Over Karakoram Range, Pakistan

Nat Geog 189:50–1 (c,1) Ap '96

— Over lake (Michigan)

Nat Wildlife 31:4–5 (c,1) Ag '93

— Over lake (New Mexico)

Smithsonian 26:48–9 (c,3) Jl '95

— Over lake (Ontario)

Nat Geog 189:136–7 (c,1) My '96

— Over Lake Michigan, Midwest

Nat Wildlife 33:56–7 (c,1) O '95

— Over ship's mast

Smithsonian 26:33 (c,1) Ag '95

— Over Singapore skyline

Gourmet 53:60–1 (c,1) Ja '93

— Over tree (Zimbabwe)

Trav/Holiday 175:60–1 (c,1) N '92

— Over water (Indonesia)

Trav&Leisure 23:100–1 (c,1) N '93

— Over water (Key West, Florida)

Gourmet 52:114–15 (c,1) D '92

— Silhouette of birds in flight

Nat Wildlife 32:4–5 (c,1) D '93

— Silhouetting hammock (West Indies)

Gourmet 56:45 (c,1) Ja '96

— Sweden

Nat Geog 184:14–15 (c,1) Ag '93

— Yellowstone National Park, Wyoming

Trav/Holiday 175:43 (c,3) Je '92

— See also

TWILIGHT

SUPERMAN

— Superman costume

Smithsonian 25:18 (c,4) Jl '94

SUPERMARKETS

— Shoppers at meat counter (Kansas)

Life 16:32–3 (c,1) Ap 5 '93

— Stocking bread on shelf (Pennsylvania)

Smithsonian 24:131 (2) O '93
— U.S.S.R.
Nat Geog 185:48 (c,3) Ap '94

SUPERSTITIONS
— Rubbing stone before college football
game (South Carolina)
Sports Illus 77:44–5 (c,1) Ag 31 '92

**SUPREME COURT BUILDING,
WASHINGTON, D.C.**
Trav/Holiday 177:63 (c,2) Jl '94

SUPREME COURT JUSTICES
— 1955 order to desegregate Kansas schools
Am Heritage 47:114 (c,2) F '96
— Ruth Bader Ginsburg
Life 17:28-9 (c,1) Ja '94
Life 19:65 (4) S '96
— John Marshall Harlan
Smithsonian 24:112 (drawing,c,4) F '94
— Sandra Day O'Connor
Life 18:94 (c,4) O '95
— William Rehnquist
Life 17:28–9 (c,1) Ja '94
— Clarence Thomas
Life 15:62,73 (1) Ja '92
— Clarence Thomas confirmation hearings
(1991)
Life 15:62–3 (c,2) Ja '92
— See also
BURGER, WARREN
HUGHES, CHARLES EVANS
MARSHALL, THURGOOD
WARREN, EARL

SURFING
Sports Illus 79:40–1 (c,1) Ag 16 '93
— 1950 surfer scene (California)
Life 19:76 (4) Winter '96
— Bodyboarding (Texas)
Sports Illus 79:5 (c,2) Ag 23 '93
— California
Sports Illus 83:92 (c,3) S 18 '95
Sports Illus 83:5 (c,4) N 13 '95
Sports Illus 85:5 (c,3) Ag 19 '96
— Fatal wipeout (California)
Sports Illus 82:42–3 (c,2) Ja 9 '95
— Flyaway jump (North Carolina)
Life 16:21 (c,4) Jl '93
— Hawaii
Nat Wildlife 30:50–1 (c,1) Ag '92
Trav/Holiday 177:cov. (c,1) Ap '94
— New York
Nat Geog 186:106–8 (c,1) D '94
— Surfboards
Gourmet 54:87 (c,3) Je '94
— Surfers on beach (Costa Rica)
Trav&Leisure 25:169 (c,1) N '95

— Surfing Museum, Santa Cruz, California
Smithsonian 26:93 (c,2) Ap '95
— Toothpick sculpture of surfer (California)
Sports Illus 85:30 (c,3) Jl 29 '96
— See also
SAILBOARDING
WINDSURFING

SURGEONS
Life 15:28–9 (c,4) Je '92

SURGERY
Life 19:35 (c,4) S '96
— Brain surgery
Nat Geog 187:27–9 (c,1) Je '95
Life 18:40–3 (c,1) D '95
— Breast lift (Russia)
Nat Geog 183:16 (c,4) Mr '93
— Cardiac surgery team at hospital
Life 16:15–18 (c,1) D '93
— Children doing simulated appendectomy
(Oregon)
Life 16:26 (c,4) Je '93
— Eye surgery
Nat Geog 182:2–3,6–7,25–7,38–9 (c,1) N
'92
— Eye surgery on dog (New York)
Smithsonian 27:41 (c,1) O '96
— Heart bypass operation scar
Sports Illus 77:22 (2) D 21 '92
— Heart surgery (Guatemala)
Life 18:64–70 (1) Mr '95
— Israel
Nat Geog 181:57 (c,4) F '92
— Liposuction
Life 18:64 (c,4) F '95
— Performing laparoscopy on lioness
(Washington, D.C.)
Nat Geog 184:18 (c,1) Jl '93
— Photorefractive keratectomy on eye
Life 16:102 (2) Jl '93
— Plastic surgery (California)
Nat Geog 181:66 (c,3) Je '92
— Reshaping small girl's malformed skull
Life 15:70–4 (c,1) Je '92
— Scar on football player's elbow
Sports Illus 77:100 (c,2) D 28 '92
Suricates. See
MEERKATS

SWALLOWS
Nat Wildlife 32:22 (c,4) Ap '94
Nat Wildlife 33:42 (painting,c,2) O '95
— Barn swallows
Natur Hist 102:34–5 (c,1) S '93
Swamps. See
MARSHES
OKEFENOKEE SWAMP

SWANS

Nat Geog 183:8–9 (c,1) Je '93

Nat Wildlife 31:12–13 (c,1) Je '93

Nat Wildlife 32:26 (c,4) F '94

Nat Wildlife 32:52–3 (painting,c,1) O '94

Trav&Leisure 26:107 (c,1) Je '96

Life 19:86–7 (c,1) O '96

— Bewick's swans

Natur Hist 101:26–33 (c,1) Jl '92

— Swans begging for food (Great Britain)

Nat Geog 186:30–1 (c,2) Ag '94

SWEDEN

Nat Geog 184:2–35 (map,c,1) Ag '93

Trav/Holiday 177:cov.,42–53 (map,c,1) Je '94

— Fifty kronar note

Natur Hist 102:14 (4) Ap '93

— Gotland

Nat Geog 184:14–15 (c,1) Ag '93

Trav/Holiday 177:42–3,46–7 (c,1) Je '94

— Hagaparken copper tents

Trav&Leisure 26:96 (c,1) My '96

— Lake Paittasjarvi

Trav/Holiday 177:cov. (c,1) Je '94

— Lake Siljan

Trav/Holiday 177:44–5 (c,2) Je '94

— Lake Vanern

Nat Geog 184:134 (c,1) O '93

— See also

STOCKHOLM

SWEDEN—ARCHITECTURE

— 18th cent. Gustavian style

Trav&Leisure 24:64–5 (c,4) Mr '94

SWEDEN—COSTUME

Nat Geog 184:2–35 (c,1) Ag '93

Trav/Holiday 177:cov.,42–53 (c,1) Je '94

Trav&Leisure 26:92–8 (c,1) My '96

— King Carl Gustaf

Nat Geog 184:9 (c,4) Ag '93

— See also

GUSTAV III

SWEDEN—HOUSING

— Gabled houses (Stockholm)

Trav&Leisure 26:98 (c,4) My '96

SWEDEN—RITES AND FESTIVALS

— Fans celebrating 1992 World Hockey Championship win

Nat Geog 184:2–3,34–5 (c,1) Ag '93

— Nobel Prize banquet (Stockholm)

Nat Geog 184:6–7 (c,1) Ag '93

— Woman playing Saint Lucia for Christmas

Nat Geog 184:32–3 (c,1) Ag '93

SWEET PEAS

Nat Geog 188:60–1 (c,1) D '95

Swimmers. See

EDERLE, GERTRUDE

WILLIAMS, ESTHER

SWIMMING

— Early 20th cent. swimming hole (Delaware)

Smithsonian 23:132 (4) My '92

— Aquatic aerobics class (Mexico)

Gourmet 56:176 (c,4) My '96

— Boys jumping into the ocean (Mauritius)

Nat Geog 183:110–11 (c,1) Ap '93

— Butterfly stroke

Sports Illus 76:70 (c,3) Jl 6 '92

— Child jumping off dock (New York)

Trav&Leisure 26:87 (c,3) Je '96

— Children playing in lake (Michigan)

Trav&Leisure 26:75 (c,1) Ag '96

— Elephant swimming

Life 18:12–13 (c,1) Ap '95

— Floating on back in river (Germany)

Nat Geog 182:30–1 (c,2) Ag '92

— History of Olympic swimming

Sports Illus 84:51–70 (2) Ap 29 '96

— History of swimming the English Channel

Smithsonian 27:118–29 (c,1) Ap '96

— Huge family jumping into pool (Florida)

Sports Illus 78:32–3 (c,1) Ap 26 '93

— Man drowning in gorge (Vermont)

Life 15:8–9 (c,1) Ag '92

— See also

BATHING

BATHING SUITS

BEACHES, BATHING

DIVING

SWIMMING POOLS

SWIMMING—COMPETITIONS

Sports Illus 77:64–5,100–10 (c,1) Jl 22 '92

Sports Illus 85:98–106 (c,1) Jl 22 '96

— 1972 Olympics (Munich)

Sports Illus 76:43 (c,2) Je 8 '92

— 1976 Olympics (Montreal)

Sports Illus 76:50,52 (c,4) Je 8 '92

Sports Illus 77:54–7 (c,1) Jl 13 '92

— 1992 Olympics (Barcelona)

Sports Illus 77:cov.,34–9 (c,1) Ag 3 '92

Sports Illus 77:2–3,30–48 (c,1) Ag 10 '92

— 1992 U.S. Olympic trials

Sports Illus 76:2–3,36-8–43 (c,1) Mr 16 '92

— 1996 Olympics (Atlanta)

Sports Illus 85:cov.,40–5 (c,1) Jl 29 '96

Sports Illus 85:69–80,96–7 (c,1) Ag 5 '96

— 1996 U.S. Olympic trials

Sports Illus 84:20–5 (c,1) Mr 18 '96

— Australia

Sports Illus 85:190–8 (c,1) Jl 22 '96

— NCAA Championships 1995

Sports Illus 82:62–4 (c,2) Ap 3 '95
— World Championships 1994 (Rome, Italy)
 Sports Illus 81:40–2 (c,2) S 19 '94
SWIMMING POOLS
 Sports Illus 80:54–60 (c,1) F 14 '94
— 1888 hotel (Florida)
 Trav/Holiday 175:59 (c,4) F '92
— 1982 bride jumping into pool (California)
 Life 19:90–1 (c,1) Je '96
— Aboard cruise ship
 Trav/Holiday 179:52–3 (c,2) S '96
— Girl jumping into pool (Colorado)
 Trav&Leisure 22:106–7 (c,2) F '92
— Hearst Castle, San Simeon, California
 Gourmet 53:98 (c,2) O '93
— Hotel rooftop pool (Melbourne, Australia)
 Trav&Leisure 26:53 (c,1) Jl '96
— Hotels (Arizona)
 Trav&Leisure 26:73,78 (c,1) F '96
— Hotels (Bali, Indonesia)
 Trav&Leisure 23:131,137 (c,1) Mr '93
— Hotels (California)
 Trav&Leisure 25:78 (c,3) S '95
 Trav&Leisure 25:28 (c,4) O '95
— Hotels (Caribbean)
 Trav&Leisure 24:129 (c,1) N '94
 Trav&Leisure 25:149 (c,1) O '95
— Hotels (French Riviera)
 Trav&Leisure 22:114–15,124–5 (c,1) Je
 '92
 Gourmet 55:115 (c,1) F '95
— Hotels (Las Vegas, Nevada)
 Smithsonian 26:55 (c,3) O '95
— Hotels (Thailand)
 Trav&Leisure 24:94–5,98–9 (c,1) D '94
— Israel
 Nat Geog 183:66 (c,3) My '93
— Public indoor pool (Munich, Germany)
 Trav&Leisure 26:57 (c,1) Ja '96
— Straddling California/Nevada border
 Nat Geog 181:116 (c,3) Mr '92
— Sutro Baths, San Francisco, California
 Smithsonian 23:120–31 (c,1) F '93
Swimsuits. See
 BATHING SUITS
SWINGS
— Acrobatic couple kissing on swing
 Life 18:43 (4) N '95
— Adult in swing
 Sports Illus 78:39 (c,4) Mr 29 '93
— Child on swing (Oman)
 Nat Geog 187:128–9 (c,2) My '95
— Elderly religious Jew on swing (Miami,
 Florida)
 Trav/Holiday 179:71 (c,2) Mr '96

— Father pushing child on swing
 Sports Illus 83:91 (c,4) O 23 '95
— Man in porch swing (Texas)
 Nat Geog 184:62–3 (c,2) S '93
SWITZERLAND
 Trav&Leisure 23:110–21 (map,c,1) Ap '93
— Appenzell region
 Trav&Leisure 25:71–5,95–6 (map,c,1) Ag
 '95
— Bernese Oberland
 Trav/Holiday 176:70–9 (map,c,1) N '93
— Chur
 Gourmet 53:53 (c,1) Jl '93
— Countryside
 Trav&Leisure 24:54 (c,4) O '94
— Engadine Valley
 Trav&Leisure 22:120–7,176–7 (c,1) Mr
 '92
 Gourmet 53:48–52,92 (map,c,1) Jl '93
— Gstaad
 Trav&Leisure 25:172–6 (c,1) N '95
— Interlaken
 Gourmet 53:80–5,152 (map,c,1) F '93
— Klosters
 Gourmet 53:48–9 (c,1) Jl '93
— Lake of Brienz
 Trav/Holiday 176:74 (c,4) N '93
— Lake of Thun
 Trav/Holiday 176:73 (4) N '93
— Lorippo
 Gourmet 56:69 (c,3) Jl '96
— Schilthorn Mountain
 Life 19:16–17 (c,1) My '96
— Simplon Pass (19th cent.)
 Trav/Holiday 178:51 (4) Ap '95
— Ticino
 Trav&Leisure 22:110–20 (map,c,1) S '92
 Gourmet 56:66–71 (map,c,1) Jl '96
— Villa Turque, La Chaux-de-Fonds
 Trav&Leisure 25:40,44 (c,4) S '95
— Winter scenes
 Gourmet 54:122–7 (c,1) D '94
— Zermatt
 Gourmet 52:116–21,205 (map,c,1) D '92
— See also
 ALPS
 BERN
 JUNGFRAU
 LAKE COMO
 LAKE CONSTANCE
 LAKE GENEVA
 LAKE LUGANO
 LAUSANNE
 MATTERHORN
 ZURICH

SWITZERLAND—COSTUME
— Traditional costume
Trav&Leisure 25:71–4,95–6 (c,1) Ag '95
SWITZERLAND—HOUSING
Trav&Leisure 22:112–15 (c,4) S '92
— Painted facades (Cevio)
Trav&Leisure 22:112 (c,4) S '92
SWITZERLAND—MAPS
Trav&Leisure 25:180 (c,4) N '95
SWORDS
— 14th cent. Muslim ruler Boabdil (Spain)
Smithsonian 23:49 (c,4) Ag '92
— 19th cent. sword of Simon Bolivar
Nat Geog 185:39 (c,4) Mr '94
— See also
FENCING
SYDNEY, AUSTRALIA
Trav/Holiday 176:22 (c,4) Ap '93
Trav/Holiday 176:48–56 (map,c,1) Je '93
Trav&Leisure 25:116–21 (map,c,1) D '95
Trav/Holiday 179:38–40 (c,4) D '96
— Orange glow from nearby fires
Life 17:28 (c,2) Mr '94
— Sydney Opera House
Trav/Holiday 179:10 (c,4) O '96
— See also
CHINATOWN
Symbols. See
SIGNS AND SYMBOLS
Countries, civilizations, or religions—
SHRINES AND SYMBOLS
SYNAGOGUES
— 1701 Italian synagogue (Israel)
Trav/Holiday 176:67 (c,2) D '93
— Doheny Synagogue, Budapest, Hungary
Trav&Leisure 25:128 (c,4) N '95
— Eldridge Street Synagogue, New York
City, New York
Am Heritage 43:4,58 (c,2) Ap '92
— Prague, Czechoslovakia
Trav&Leisure 25:130,132 (c,4) N '95
— Rome, Italy
Gourmet 55:52 (c,2) Ag '95
— Ruins of 14th cent. synagogue (Katzrin,
Israel)
Gourmet 54:97 (c,1) F '94
— Ruins of 17th cent. synagogue (Caribbean)
Natur Hist 102:59 (c,1) Mr '93
— Tunisia
Trav&Leisure 23:152 (c,4) F '93
SYRIA
Nat Geog 190:106–31 (map,c,1) Jl '96
— Golan Heights
Nat Geog 190:130–1 (c,1) Jl '96
— Krak des Chevaliers castle

Trav&Leisure 24:73 (c,4) N '94
— See also
DAMASCUS
SYRIA—COSTUME
Nat Geog 190:106–31 (c,1) Jl '96
— President Hafez al-Assad
Nat Geog 190:110 (painting,c,4) Jl '96

–T–

TABLE TENNIS
Sports Illus 84:92 (c,4) Je 3 '96
TABLES
— Early 19th cent. sewing table (Massachu-
setts)
Am Heritage 45:31 (c,1) O '94
TACOMA, WASHINGTON
Smithsonian 27:32 (c,1) Jl '96
— Tacoma Narrows Bridge
Trav&Leisure 26:107 (c,4) S '96
TAFT, WILLIAM HOWARD
Smithsonian 23:142 (4) O '92
Life 15:4–5 (c,1) O 30 '92
Smithsonian 25:101 (4) O '94
— 1908 Taft campaign ashtray
Am Heritage 43:52 (c,4) S '92
— Sitting on water buffalo
Smithsonian 22:97 (3) Mr '92
— Taft in bathing suit
Trav&Leisure 25:71 (2) Jl '95
— Taft's bathtub
Trav/Holiday 175:73 (4) N '92
— Throwing out first baseball
Am Heritage 43:22 (drawing,4) S '92
TAHITI
Trav&Leisure 24:170–5 (map,c,4) Ap '94
Trav/Holiday 179:cov.,4,82–9 (c,1) N '96
TAHITI—COSTUME
Trav/Holiday 176:17 (c,3) My '93
Trav/Holiday 179:84–9 (c,1) N '96
TAILORS
— Lederhosen maker (Germany)
Trav&Leisure 26:53 (1) Ja '96
TAIPEI, TAIWAN
Nat Geog 184:12,21 (c,3) N '93
— National Palace Museum
Smithsonian 26:46 (c,4) Mr '96
TAIWAN
Nat Geog 184:2–33 (map,c,1) N '93
— Kaohsiung
Nat Geog 184:6–7,27 (c,1) N '93
— Sun Moon Lake
Nat Geog 184:18–19 (c,2) N '93
— See also

TAIPEI
TAIWAN—COSTUME
 Nat Geog 184:2–33 (c,1) N '93
TAJ MAHAL, INDIA
 Gourmet 54:86 (c,3) Je '94
 Life 18:12–14 (c,1) F '95
 Nat Geog 187:cov.,24–5 (c,1) My '95
 Trav&Leisure 26:42 (c,4) S '96
— Detail of wall
 Trav/Holiday 177:74 (c,1) N '94
TALLAHASSEE, FLORIDA
— William R. Wilson home
 Trav/Holiday 178:52 (c,2) Mr '95
TALLINN, ESTONIA
 Trav&Leisure 25:88–90 (c,2) O '95
TAMPA, FLORIDA
— 1926 movie palace
 Trav&Leisure 25:E16 (c,3) S '95
— Sunshine Skyway Bridge
 Smithsonian 27:94 (c,4) S '96
TANAGERS
 Nat Wildlife 31:21 (c,4) Ap '93
 Nat Geog 183:81 (painting,c,4) Je '93
— Scarlet tanagers
 Nat Wildlife 30:7 (c,2) Ag '92
 Natur Hist 105:46,58 (c,2) Jl '96
 Nat Wildlife 34:55 (c,4) Ag '96
TANGIER, MOROCCO
 Gourmet 56:110 (painting,c,4) F '96
TANKERS
— Tanker grounded on Shetland Island (1993)
 Trav&Leisure 24:60 (c,4) F '94
TANKS
— Wine tanks (California)
 Nat Geog 181:32–3 (c,1) F '92
TANKS, ARMORED
— 1935
 Am Heritage 43:130 (3) N '92
— 1940s tank factory (Michigan)
 Life 19:69 (1) Winter '96
— 1953 Korean War tanks
 Smithsonian 24:79 (4) Ag '93
— Afghanistan
 Nat Geog 184:62–3,86–7 (c,1) O '93
— China
 Sports Illus 79:49 (c,4) S 20 '93
— Eritrea
 Nat Geog 184:116–17 (c,2) Ag '93
— Upended painted tanks decorating East
 Berlin border, Germany
 Life 16:24–5 (c,4) My '93
TANZANIA
 Trav&Leisure 24:90–101,139–42
 (map,c,1) N '94

 Trav&Leisure 26:60–6,84,86 (map,c,1) Ja
 '96
— Countryside
 Sports Illus 78:92–3 (c,2) My 3 '93
— Lake Manyara National Park
 Trav&Leisure 22:11,130–1 (c,1) Je '92
— Ngorongoro Crater
 Nat Geog 181:124 (map,c,1) Ap '92
 Trav&Leisure 22:130–1 (c,2) Je '92
— Rain forests
 Trav&Leisure 26:94–100 (painting,c,3) S
 '96
— Serengeti National Park
 Life 19:76–86 (c,1) My '96
— Wildlife
 Trav&Leisure 22:126–39 (c,1) Je '92
— See also
 KILIMANJARO
TANZANIA—COSTUME
 Natur Hist 105:12–14 (c,3) Jl '96
— Children with eye diseases
 Nat Geog 182:19–21 (c,1) N '92
— Masai women
 Trav&Leisure 26:67 (c,1) Ja '96
 Natur Hist 105:44–5,48–9 (c,1) Ag '96
TAOISM—COSTUME
— Priests with prayer boards (China)
 Nat Geog 190:34–5 (c,2) D '96
TAOS, NEW MEXICO
 Gourmet 53:132–7,186 (map,c,1) N '93
 Am Heritage 45:98 (c,4) F '94
 Trav/Holiday 178:cov.,44–50 (map,c,1) F
 '95
 Trav&Leisure 25:104–11,152 (map,c,1) D
 '95
— 19th cent. Martinez hacienda
 Am Heritage 45:92–9 (c,1) F '94
— Pueblos
 Nat Geog 189:93 (c,4) Ap '96
TAPESTRIES
— 11th cent. Bayeux Tapestry (France)
 Smithsonian 25:68–78 (c,2) My '94
— D-Day depicted in tapestry
 Smithsonian 25:68–81 (c,2) My '94
TARANTULAS
 Natur Hist 101:40–7 (c,1) S '92
 Nat Geog 187:102 (c,1) My '95
 Nat Geog 190:98–115 (c,1) S '96
TARPONS (FISH)
 Nat Geog 189:90–9 (c,1) Ja '96
TASMANIA, AUSTRALIA
 Sports Illus 81:74–5 (c,1) N 21 '94
 Natur Hist 104:26–32 (map,c,1) Ag '95

TASMANIA, AUSTRALIA—COS-
TUME
— Aborigines
Natur Hist 104:30–5 (c,1) Ag '95
TASMANIAN DEVILS
Natur Hist 102:42 (c,1) Je '93
Sports Illus 81:72–6,84 (c,1) N 21 '94
TATTOOING
— Rabari woman (India)
Nat Geog 184:79 (c,1) S '93
TATTOOS
— 18th cent. Maori tribesman (New Zealand)
Nat Geog 190:40 (drawing,3) N '96
— Dog tattoo
Nat Geog 183:cov.,5 (c,1) Ap '93
Sports Illus 82:88 (c,4) Ap 10 '95
— Eagle tattoo on man's arm
Smithsonian 26:32 (c,4) Ag '95
— Henna patterns on bride's hands (Morocco)
Trav&Leisure 24:82 (c,1) Jl '94
— Man tattooed with jigsaw puzzle shapes
Nat Geog 187:11 (c,2) Je '95
— Man with tattoos
Sports Illus 82:cov. (c,1) My 29 '95
— Tattoo of ship (U.S.S.R.)
Nat Geog 182:40 (c,4) S '92
— Tattooed athletes
Sports Illus 83:90–6 (c,1) N 6 '95
— Tattooed man in sideshow (New York)
Trav/Holiday 178:65 (c,2) Jl '95
— Tattoos on Russian convicts
Natur Hist 102:50–9 (1) N '93
— U.S.S.R.
Nat Geog 186:108–9 (c,2) S '94
— Wild boar tattoo
Nat Geog 188:25 (c,4) S '95
TAVERNS
— 1900 seedy bar (New York)
Am Heritage 47:57 (4) S '96
— Alexandria, Virginia
Trav&Leisure 22:E18 (c,4) N '92
— Bar scene (Wyoming)
Nat Geog 183:77 (c,3) Ja '93
— Belfast, Northern Ireland
Trav&Leisure 25:61 (c,4) N '95
— Boston, Massachusetts
Sports Illus 85:26 (c,4) O 7 '96
— Brussels, Belgium
Trav&Leisure 25:44,50 (c,3) N '95
— Bull & Finch "Cheers" pub, Boston,
Massachusetts
Trav&Leisure 23:42 (c,4) My '93
— Cambridge, England
Nat Geog 185:109 (c,1) Mr '94
— Country-western bar (Shanghai, China)

Nat Geog 185:18 (c,4) Mr '94
— Czechoslovakia
Nat Geog 184:12–13 (c,1) S '93
— Denver, Colorado
Trav&Leisure 23:31 (c,4) Ag '93
— Dublin pubs, Ireland
Trav/Holiday 175:20 (c,4) Ap '92
Trav/Holiday 177:76–83 (map,c,1) S '94
Trav&Leisure 25:53 (c,4) Jl '95
Gourmet 55:140–3 (c,2) D '95
— Hotel bar (Milan, Italy)
Trav&Leisure 26:165 (c,1) O '96
— Hotel bar (New York City, New York)
Trav&Leisure 26:40 (c,4) Ap '96
— Key West, Florida
Trav/Holiday 176:84 (c,3) N '93
— Los Angeles, California
Trav&Leisure 26:48 (c,4) Jl '96
— Montana
Trav/Holiday 176:82–3 (c,3) Mr '93
Life 16:43 (c,2) Ap 5 '93
— Nevada
Nat Geog 182:52–3 (c,1) D '92
Life 16:43 (c,2) Ap 5 '93
— Outback pub (Australia)
Nat Geog 181:88–9 (c,2) Ap '92
— Outdoor resort bar (Indonesia)
Trav&Leisure 23:103 (c,2) N '93
— Prague, Czechoslovakia
Sports Illus 83:134 (c,4) N 13 '95
— Restaurant bar (San Francisco, California)
Gourmet 56:184 (c,3) O '96
— Scotland
Trav&Leisure 26:125 (c,2) D '96
— Texas
Nat Geog 184:58–9 (c,2) S '93
— See also
DRINKING CUSTOMS
TAXATION
— 1895 cartoon about income tax
Am Heritage 47:122 (c,4) My '96
TAXCO, MEXICO
Nat Geog 190:82–3 (c,2) Ag '96
TAXICABS
Life 17:13 (c,4) Ja '94
— 1926 (New York City, New York)
Am Heritage 43:84 (1) N '92
— 1930s-style cabs (Great Britain)
Trav&Leisure 24:40 (c,4) S '94
— 1946 (New York City, New York)
Am Heritage 47:103 (c,4) D '96
— Beijing, China
Trav&Leisure 23:74 (c,1) S '93
— Cyclo (Vietnam)
Life 17:38–9 (c,2) Jl '94

Trav&Leisure 25:198 (4) O '95
— History of New York City taxicabs
Am Heritage 43:cov.,90–7 (painting,c,1)
D '92
— London, England
Trav&Leisure 23:79 (c,4) S '93
— Pedicab (Macau)
Trav/Holiday 175:87 (c,2) Ap '92
— Pedicabs (Vietnam)
Smithsonian 26:34–5 (c,2) Ja '96
— Trishaw (Malaysia)
Trav/Holiday 176:49 (c,4) S '93
— Women hailing taxi on snowy street (New
York)
Smithsonian 24:20 (c,4) Mr '94

TAYLOR, ELIZABETH
Life 15:cov.,66–76 (c,1) F '92
Life 16:14 (c,2) Ap '93
Life 18:35 (4) My '95
Life 18:140 (1) Je 5 '95
Life 19:78–9 (1) Mr '96

TAYLOR, ZACHARY
Smithsonian 27:45 (painting,c,4) Ap '96
— Death (1850)
Life 15:68 (painting,c,3) O 30 '92

TBILISI, GEORGIA, U.S.S.R.
Nat Geog 181:100–1 (c,1) My '92

TEA INDUSTRY—HARVESTING
— Malaysia
Trav/Holiday 176:45 (c,1) S '93

TEAPOTS
— Early 19th cent. (Washington, D.C.)
Am Heritage 43:102 (c,4) S '92
— Large teapot outside cafe (Massachusetts)
Trav/Holiday 179:70 (c,3) Mr '96
— Unusual teapots
Gourmet 53:52–4 (c,4) N '93

TECUMSEH (SHAWNEE LEADER)
Smithsonian 26:20 (sculpture,c,4) Jl '95

TEETH
— Mailbox shaped like set of teeth (Florida)
Life 19:33 (c,4) S '96

TEL AVIV, ISRAEL
— Seafront at night
Gourmet 54:98 (c,4) F '94

TELEGRAMS
— 1944 telegram announcing death of U.S.
sailor
Life 18:63 (c,2) Je 5 '95
— Eisenhower telegram announcing German
surrender (1945)
Am Heritage 46:6 (c,2) My '95

TELEGRAPH
— Telegraph pole (New Mexico)
Trav&Leisure 26:84 (c,4) S '96

TELEPHONE INDUSTRY
— AT&T communications maps
Nat Geog 188:22 (c,1) O '95
— Telecommunications equipment
Smithsonian 22:47–56 (painting,c,2) F '92

TELEPHONES
Smithsonian 22:47 (painting,c,2) F '92
— 1915
Am Heritage 46:16 (4) O '95
— 1937 phone
Am Heritage 45:120 (4) N '94
— 1946 college students crowding into phone
booth (California)
Life 19:126 (4) O '96
— Man on office phone
Sports Illus 80:76 (c,4) Ja 10 '94
— Old-fashioned phone
Trav/Holiday 179:26 (c,4) D '96
— Public phones (Israel)
Nat Geog 189:9 (c,1) Ap '96
— Public street phone (Tokyo, Japan)
Trav&Leisure 26:152 (c,1) Mr '96
— Telephone booth covered by snow
(Minnesota)
Life 15:12 (c,1) F '92
— Telephone booths (Australia)
Smithsonian 24:105 (c,4) N '93
— Telephone booths (Great Britain)
Life 18:8 (c,4) Ja '95
Trav/Holiday 179:22 (c,4) S '96
— Telephone booths (U.S.S.R.)
Nat Geog 185:130–1 (c,2) Je '94
— Thurber cartoon about wrong numbers
Life 17:45 (4) D '94
— See also
BELL, ALEXANDER GRAHAM

TELESCOPES
Smithsonian 23:74,82 (c,1) Je '92
Sports Illus 83:58–9 (c,1) Jl 17 '95
— Arecibo radio telescope (Puerto Rico)
Nat Geog 185:39–41 (c,1) Ja '94
— Constructing mirror for sky telescope
(Arizona)
Nat Geog 185:10–11 (c,1) Ja '94
— Goldstone radio telescope (California)
Life 15:62–3 (c,1) S '92
— Hevelius designing telescope (17th cent.)
Smithsonian 26:109 (engraving,4) Je '95
— Hubble telescope
Smithsonian 22:98 (c,4) Mr '92
Smithsonian 25:30 (c,4) Je '94
— Keck telescope, Hawaii
Nat Geog 185:4–5,36–7 (c,1) Ja '94
— Looking through telescope from mountain-
top (Wyoming)

Smithsonian 23:112–13 (c,2) N '92
— Repairing Hubble telescope in space
 Life 17:100–3 (c,1) Ap '94
TELEVISION BROADCASTING
— 1953 network competition to cover Queen
 Elizabeth's coronation
 Am Heritage 44:74–85 (1) D '93
— Applying makeup to actor on set
 (California)
 Sports Illus 84:74–5 (c,1) My 13 '96
— CNN studio (Atlanta, Georgia)
 Gourmet 56:73 (c,4) Jl '96
— ESPN studios (Bristol, Connecticut)
 Sports Illus 77:52–64 (c,1) D 21 '92
— Room full of video screens
 Nat Geog 188:2–4 (c,1) O '95
TELEVISION NEWSCASTERS
— Reporters standing waist deep in
 floodwater (Luxembourg)
 Life 17:118 (c,2) Ap '94
— Eric Sevareid
 Life 16:79 (1) Ja '93
— See also
 CRONKITE, WALTER
 SPORTS ANNOUNCERS
TELEVISION PROGRAMS
— 1950s sidewalk audience for the "Today"
 show (New York City)
 Trav&Leisure 24:38 (4) Je '94
— "American Bandstand"
 Life 15:8–9 (1) D 1 '92
— "Beulah" (1951)
 Am Heritage 45:71 (4) F '94
— "Beverly Hills 90210"
 Life 15:54 (c,1) Ja '92
— "Bonanza"
 Life 16:33 (4) Je '93
— Caricatures of talk show hosts
 Sports Illus 85:31 (painting,c,2) Ag 19 '96
— "Cheers"
 Life 16:cov.,54–64 (c,1) My '93
 Sports Illus 78:62–70 (c,1) My 24 '93
 Life 17:24–5 (c,1) Ja '94
— "Cheers" Bull & Finch pub, Boston,
 Massachusetts
 Trav&Leisure 23:42 (c,4) My '93
— "The Cosby Show"
 Life 16:106 (c,1) Ja '93
— "Dinosaurs"
 Life 15:62 (c,4) O '92
— "E.R."
 Life 18:24–8 (c,2) O '95
— "Friends"
 Smithsonian 27:112 (c,4) S '96

— "Lassie" being groomed
 Life 17:84 (c,2) Ag '94
— "Masterpiece Theater"
 Life 16:107 (c,1) Ja '93
— "Mr. Rogers' Neighborhood"
 Life 15:72–83 (c,1) N '92
— "The Munsters"
 Life 17:104 (2) Ja '94
— "Murphy Brown"
 Life 16:48 (c,2) Ja '93
— "Seinfeld"
 Life 16:78–86 (c,1) O '93
— "Sesame Street" characters
 Life 17:18–22 (c,1) N '94
— "The Simpsons"
 Sports Illus 76:9 (c,4) Ja 27 '92
 Sports Illus 79:16–17 (c,1) D 27 '93
— "The Simpsons" costumes
 Trav/Holiday 179:38 (c,4) S '96
— "The Simpsons" storyboard
 Life 17:86 (2) S '94
— "Star Trek"
 Smithsonian 25:20 (c,4) Je '94
 Life 19:35 (c,4) Mr '96
— "Star Trek" paraphernalia
 Smithsonian 23:160 (c,4) My '92
— "Star Trek: Voyager"
 Smithsonian 26:44 (c,4) Ap '95
— "The Tonight Show"
 Life 15:cov.,38–44 (c,1) My '92
 Sports Illus 78:24–5 (c,1) F 15 '93
 Life 19:10 (c,4) Ja '96
— "Twenty-One"
 Life 17:37 (4) S '94
TELEVISION WATCHING
— 1950s family watching television
 Am Heritage 44:114 (sculpture,c,4) D '93
— Indonesia
 Sports Illus 85:208 (c,2) Jl 22 '96
— Child watching TV in store
 Life 18:44–5 (c,1) Jl '95
— Soccer fans watching game on TV (Italy)
 Nat Geog 188:23 (c,3) Ag '95
TELEVISIONS
— 1954
 Am Heritage 45:30–1,138 (c,1) D '94
TEMPLE, SHIRLEY
 Smithsonian 24:60 (4) Je '93
 Sports Illus 79:20 (4) O 18 '93
 Life 17:cov.,86 (c,1) My '94
 Life 18:12 (4) O '95
 Sports Illus 84:98 (4) My 13 '96
 Nat Wildlife 34:8 (4) Je '96
— 1945 wedding

Life 18:125 (4) Je 5 '95
TEMPLES
— Angkor Wat, Cambodia
Trav&Leisure 22:88–99,139 (map,1) O '92
Trav/Holiday 178:76–7 (2) O '95
— Baha'i Temple, Wilmette, Illinois
Trav&Leisure 25:174 (c,4) My '95
— Bangkok, Thailand
Trav&Leisure 24:81 (c,4) Ag '94
Trav&Leisure 26:166 (c,4) S '96
— Chiang Mai wat, Thailand
Trav/Holiday 179:52 (c,4) Ap '96
— Java, Indonesia
Trav&Leisure 22:65 (c,4) Ja '92
— Mormon temple draped in flag for 1896 Utah statehood celebration
Am Heritage 47:75–6 (3) Ap '96
— Salt Lake City, Utah
Nat Geog 189:48–50 (c,1) Ja '96
— Shore temple (Mahabalipuram, India)
Trav/Holiday 176:52–5 (c,1) N '93
— Tang temple (Fengdu, China)
Trav/Holiday 176:64–6 (c,1) F '93
— Thailand
Trav&Leisure 26:229 (c,3) S '96
— That Luang temple (Vientiane, Laos)
Trav&Leisure 23:72 (c,4) N '93
— See also
CHURCHES
MOSQUES
SYNAGOGUES
TEMPLES—ANCIENT
— Abu Simbel, Egypt
Trav/Holiday 175:64 (c,2) S '92
— Corinth, Greece
Trav/Holiday 175:113 (c,4) Mr '92
— Greek (Akragas, Sicily)
Nat Geog 186:12–15 (c,1) N '94
— Greek temple of Hera, Selinus, Sicily, Italy
Nat Geog 188:32–3 (c,1) Ag '95
— Hephaisteion, Athens, Greece
Smithsonian 24:47 (c,2) Jl '93
— Jerusalem, Israel
Life 15:41 (c,4) D '92
— Luxor, Egypt
Trav/Holiday 175:60–1 (c,1) S '92
— Segesta, Sicily, Italy
Trav&Leisure 25:165 (4) Ap '95
— Temple of Antos, Sardinia, Italy
Trav/Holiday 176:46–7 (c,2) Je '93
— Temple of Vesta, Tivoli, Italy
Gourmet 52:137 (c,1) N '92
— See also
PARTHENON

TEMPLES—CONSTRUCTION
— Ancient Temple of Zeus, Akragas, Sicily
Nat Geog 186:14–15 (painting,c,2) N '94
TENNESSEE
— Crossville bridge
Smithsonian 25:78 (c,2) D '94
— Dayton (1925)
Natur Hist 105:74–5 (2) Ap '96
— Hubbards Cave
Nat Geog 188:38–9 (c,2) Ag '95
— Museum of Appalachia, Norris
Smithsonian 26:44–53 (c,1) F '96
— Natchez Trace Parkway
Trav&Leisure 26:E6 (c,4) Je '96
— Pigeon Forge
Nat Geog 186:24–5 (c,1) O '94
— Shiloh National Military Park
Nat Geog 185:94–5 (c,2) Ap '94
— See also
BIG SOUTH FORK NATIONAL RIVER AND RECREATION AREA
CHATTANOOGA
CUMBERLAND RIVER
GREAT SMOKY MOUNTAINS
GREAT SMOKY MOUNTAINS NATIONAL PARK
KNOXVILLE
MEMPHIS
NASHVILLE
TENNESSEE RIVER
TENNESSEE RIVER, SOUTHEAST
— Chattanooga
Smithsonian 25:62 (c,2) D '94
TENNIS
— 17th cent. court tennis (France)
Nat Geog 190:48 (drawing,c,4) Jl '96
— 1920 Olympics (Antwerp)
Nat Geog 190:58 (4) Jl '96
— 1992 Olympics (Barcelona)
Sports Illus 77:50–1 (c,2) Ag 17 '92
— Australia
Trav&Leisure 25:121 (c,1) D '95
— Power-washing tennis court (Georgia)
Life 18:100–1 (c,1) N '95
— Practice hitting balls (Florida)
Gourmet 53:88 (c,4) F '93
TENNIS—EDUCATION
— South Carolina
Trav&Leisure 23:E6 (c,4) Jl '93
TENNIS—PROFESSIONAL
Sports Illus 81:19–24 (c,2) S 5 '94
TENNIS PLAYERS
— 1993 stabbing of tennis pro Monica Seles
Sports Illus 82:46,51 (c,4) Ap 10 '95
— Suzanne Lenglen

Nat Geog 190:58 (4) Jl '96
— Kitty McKane
 Sports Illus 76:70 (4) Je 29 '92
— Fred Perry
 Sports Illus 79:62 (4) Jl 5 '93
— Baron Gottfried von Cramm
 Sports Illus 79:57–69 (1) Jl 5 '93
— See also
 ASHE, ARTHUR
 BUDGE, DON
 GONZALES, PANCHO
 KING, BILLIE JEAN

TENNIS TOURNAMENTS
 Trav&Leisure 24:45,48 (c,4) Mr '94
— All England Championships 1935
 (Wimbledon)
 Sports Illus 79:57 (1) Jl 5 '93
— All England Championships 1975
 (Wimbledon)
 Sports Illus 77:20 (c,2) D 21 '92
— All England Championships 1992
 (Wimbledon)
 Sports Illus 77:cov.,12–19 (c,1) Jl 13 '92
 Sports Illus 77:64–5 (c,1) D 28 '92
— All England Championships 1993
 (Wimbledon)
 Sports Illus 79:20–5 (c,1) Jl 5 '93
 Sports Illus 79:2–3,32–7 (c,1) Jl 12 '93
— All England Championships 1994
 (Wimbledon)
 Sports Illus 81:40–3 (c,2) Jl 4 '94
 Sports Illus 81:cov.,2–3,16–21 (c,1) Jl 11
 '94
— All England Championships 1995
 (Wimbledon)
 Sports Illus 83:14–20 (c,1) Jl 17 '95
— All England Championships 1996
 (Wimbledon)
 Sports Illus 85:29 (c,4) Jl 8 '96
 Sports Illus 85:58–62 (c,1) Jl 15 '96
— Australian Open 1994 (Melbourne)
 Sports Illus 80:44–6 (c,2) F 7 '94
— Australian Open 1995
 Sports Illus 82:46–51 (c,1) F 6 '95
— Australian Open 1996 (Melbourne)
 Sports Illus 84:60–2 (c,1) F 5 '96
— Davis Cup match 1932
 Sports Illus 79:60–1 (1) Jl 5 '93
— Davis Cup match 1992 (Fort Worth, Texas)
 Sports Illus 77:2–3,20–1 (c,1) O 5 '92
 Sports Illus 77:29 (c,3) D 14 '92
— Davis Cup match 1995 (Moscow, Russia)
 Sports Illus 83:41–4 (c,3) D 11 '95
— French Open 1991 (Paris, France)
 Sports Illus 76:50–1 (c,1) F 24 '92

Gourmet 53:92–3 (c,3) Je '93
— French Open 1992 (Paris, France)
 Sports Illus 76:24–9 (c,1) Je 15 '92
— French Open 1993 (Paris, France)
 Sports Illus 78:2–3,26–8,33 (c,1) Je 14 '93
— French Open 1994 (Paris, France)
 Sports Illus 80:18–20,25 (c,1) Je 13 '94
— French Open 1995 (Paris, France)
 Sports Illus 82:2–3,44–54 (c,1) Je 19 '95
— French Open 1996 (Paris, France)
 Sports Illus 84:58–60 (c,1) Je 17 '96
— U.S. Open 1956 (Forest Hills, New York)
 Sports Illus 82:10 (4) My 1 '95
— U.S. Open 1970 (Forest Hills, New York)
 Sports Illus 82:10 (4) My 1 '95
— U.S. Open 1992 (Flushing Meadows, New
 York)
 Sports Illus 77:cov.,10–15 (c,1) S 21 '92
— U.S. Open 1993 (Flushing Meadows, New
 York)
 Sports Illus 79:138 (4) S 6 '93
 Sports Illus 79:26–9 (c,1) S 20 '93
— U.S. Open 1994 (Flushing Meadows, New
 York)
 Sports Illus 81:35–9 (c,1) S 19 '94
— U.S. Open 1995 (Flushing Meadows, New
 York)
 Sports Illus 83:2–3 (c,1) S 11 '95
 Sports Illus 83:20–30 (c,1) S 18 '95
— U.S. Open 1996 (Flushing Meadows, New
 York)
 Sports Illus 85:22–7 (c,1) S 16 '96

TENTS
— 1873 camping tent
 Natur Hist 101:43 (1) Je '92
— 1899 Eskimo hut (Alaska)
 Natur Hist 104:69 (4) Jl '95
— Camping tents (Alberta)
 Nat Geog 188:68–9 (c,1) Jl '95
— Camping tents (Tanzania)
 Trav&Leisure 22:180 (c,4) Je '92
 Trav&Leisure 24:91–100 (c,1) N '94
 Trav&Leisure 26:62 (c,4) Ja '96
— Camping tents (Washington)
 Trav&Leisure 24:74 (c,3) Ja '94
— Civil War camp reenactment (Virginia)
 Nat Geog 190:56–7 (c,2) D '96
— Cowboy mess tent (Texas)
 Life 18:28 (c,2) S '95
— Danish army tent (Greenland)
 Life 17:24–5 (c,1) F '94
— Himalaya trekkers (Nepal)
 Nat Geog 182:78–9 (c,2) D '92
— Nomad dismantling tent (Kenya)
 Natur Hist 102:56–7 (c,1) S '93

— Tent city for 1992 Hurricane Andrew
 homeless (Florida)
 Nat Geog 183:24–5 (c,1) Ap '93
— Tibet
 Nat Geog 184:78–9 (c,1) Ag '93
— Tourist tents (Costa Rica)
 Trav&Leisure 25:161 (c,1) N '95
— Turkistan, China
 Trav/Holiday 178:73 (c,4) O '95
— See also
 YURTS

TEPEES
 Nat Geog 185:95,100–1 (c,1) Je '94
— 19th cent. model of Sioux tepee
 Smithsonian 25:49 (c,1) O '94
— 1905 Remington painting
 Am Heritage 47:8 (c,2) My '96
— 1910 (Montana)
 Trav&Leisure 25:158–9 (1) O '95
— Buffalo-hide tepee (Colorado)
 Nat Geog 186:84 (c,3) N '94
— Kiowa tepees
 Natur Hist 102:70–3 (1) O '93
— Modern tepees for campers (Wyoming)
 Trav&Leisure 24:97–101,157 (c,1) Je '94
— New Mexico
 Trav/Holiday 178:50 (c,4) F '95

TERMITES
— Ancient termite preserved in amber
 Natur Hist 102:58 (c,1) Je '93
— Termite mounds
 Nat Geog 189:17,22–3 (c,1) Je '96

TERNS
 Nat Wildlife 32:6 (c,4) F '94
— Common terns
 Natur Hist 101:44–5 (c,1) Je '92
— Fairy terns
 Nat Wildlife 34:115 (c,3) Ap '96
 Trav&Leisure 26:147 (c,1) D '96
— Forster's terns
 Nat Wildlife 33:40–1 (c,1) Ap '95
— Least terns
 Natur Hist 103:40–53 (c,1) Jl '94
 Nat Geog 187:14 (c,3) Mr '95
— Least terns mating
 Natur Hist 102:46–7 (c,1) Je '93
— Tern chick
 Natur Hist 102:48 (c,4) Ag '93
— Tern eggs
 Natur Hist 104:38 (c,4) Jl '95

TERRIERS
 Smithsonian 23:cov.,61–71 (c,1) Ap '92
— Bull terrier
 Life 18:106 (2) Je 5 '95
— Jack Russell terrier

Life 17:8 (c,4) My '94
Life 18:46 (c,4) Ja '95
— Terrier getting vaccination
 Life 15:92 (2) Ag '92
— See also
 AIREDALES
 SCOTTISH TERRIERS

TERROR
— Frightened civilians (Yugoslavia)
 Life 15:14,16 (c,1) O '92

TERRORISM
— 1940 right-wing Christian Front militia
 (New York)
 Am Heritage 46:38–9,42 (1) S '95
— 1972 attack on Israeli athletes at Olympics
 (Munich, Germany)
 Sports Illus 81:70–1 (c,1) N 14 '94
— 1991 release of Beirut hostage Terry
 Anderson
 Life 15:28–36 (c,1) F '92
— 1995 Oklahoma City bombing aftermath
 Life 18:10–11 (1) Je 5 '95
 Life 19:28–9,42–8 (c,1) Ja '96
— Bombing at 1996 Olympics (Atlanta,
 Georgia)
 Sports Illus 85:4,22–8 (c,1) Ag 5 '96
 Sports Illus 85:88–94 (c,1) Ag 12 '96
— Family at bomb victim's funeral (Israel)
 Nat Geog 187:76–7 (c,1) Je '95
— Loot from 1971 skyjacking
 Life 19:34 (4) N '96
— Train wrecked by sabotage (Arizona)
 Life 18:10–11 (c,1) D '95
— Wreckage from Palestinian suicide bomber
 (Israel)
 Nat Geog 190:46 (c,4) S '96
— See also
 BOMBS

TETON RANGE, WYOMING
 Nat Geog 187:116–17,125–39 (c,1) F '95
— See also
 GRAND TETON NATIONAL PARK

TEXAS
— 1836 San Jacinto battle against Mexico
 Smithsonian 23:82–91 (painting,c,2) Jl '92
— Black Branch Barrens
 Natur Hist 102:31–2 (map,c,3) Mr '93
— Boykin Springs Longleaf
 Natur Hist 101:62–5 (map,c,1) Jl '92
— Breckenridge
 Am Heritage 44:95 (c,2) Jl '93
— Breckenridge (1925)
 Am Heritage 44:94 (2) Jl '93
— Carrying victims of 1947 Texas City
 explosion

Am Heritage 47:26 (4) Jl '96
— John Connally
Life 17:90 (2) Ja '94
— Fiesta in traditional costume
Trav/Holiday 179:31 (c,4) Mr '96
— Fredericksburg
Gourmet 54:138–41,208 (map,c,1) My '94
— George Grosz depiction of "Texas" (1915)
Am Heritage 46:64 (drawing,4) My '95
— High Hill church
Am Heritage 44:102–5 (c,1) S '93
— Mexican border area
Trav&Leisure 23:102–11,140–2 (map,c,1)
F '93
Nat Geog 189:44–69 (map,c,1) F '96
— Mill Creek Cove
Natur Hist 101:62–4 (map,c,1) F '92
— Pollution problems near Mexican border
Smithsonian 25:26–37 (1) My '94
— Praha (1895)
Am Heritage 44:101 (4) S '93
— Queen Isabella Causeway
Nat Geog 189:68–9 (c,1) F '96
— Ann Richards
Life 16:100 (c,2) D '93
— Ripley Museum (Grand Prairie)
Smithsonian 25:99 (c,2) Ja '95
— South Padre Island
Nat Geog 182:7 (c,3) Jl '92
Nat Geog 189:68–9 (c,1) F '96
— Terlingua
Trav&Leisure 26:E9–E10 (c,4) O '96
— Zephyr
Sports Illus 85:70–2 (1) O 28 '96
— See also
ALAMO
AUSTIN
BIG BEND NATIONAL PARK
CROCKETT, DAVY
DALLAS
EL PASO
FORTH WORTH
GALVESTON
HOUSTON, SAM
HOUSTON
PADRE ISLAND
PECOS RIVER
RIO GRANDE RIVER
SAN ANTONIO
TEXAS—MAPS
— Hill country
Trav/Holiday 178:95 (c,4) Ap '95
TEXTILE INDUSTRY
— 1810s Luddite war against technology

Smithsonian 24:140–51 (painting,c,3) Ap
'93
— Designing embroidery (Madeira)
Gourmet 53:116 (c,4) D '93
— Late 18th cent. spinning jennies (Great
Britain)
Smithsonian 24:144–5 (drawing,c,4) Ap
'93
— Preparing linen for kimonos (Japan)
Nat Geog 186:88–9 (c,2) S '94
— Soda bottles recycled into fabric
Life 17:138–40 (c,4) N '94
— See also
GARMENT INDUSTRY
SILK INDUSTRY
Textiles. See
COTTON
THAILAND
Nat Geog 189:82–105 (map,c,1) F '96
Trav&Leisure 26:162–71,229–34
(map,c,1) S '96
— Floating market
Trav&Leisure 23:84 (c,4) D '93
— Koh Samui
Trav&Leisure 24:94–101,144 (map,c,1) D
'94
Trav/Holiday 177:56–61 (map,c,1) D '94
— Northern Thailand
Trav/Holiday 179:44–53 (map,c,1) Ap '96
— Phuket
Nat Geog 189:94 (c,3) F '96
— Prehistoric Khok Phanom Di
Natur Hist 103:60–5 (painting,c,1) D '94
— Summer palace, Ayutthaya
Trav&Leisure 26:162 (c,1) S '96
— See also
BANGKOK
CHIANG MAI
MEKONG RIVER
THAILAND—ART
— Thai crafts
Trav&Leisure 25:88–90 (c,3) N '95
THAILAND—COSTUME
Nat Geog 189:82–105 (c,1) F '96
Trav/Holiday 179:72–6 (c,1) S '96
Trav&Leisure 26:163–70 (c,1) S '96
— Traditional costume
Trav/Holiday 179:44–51 (c,1) Ap '96
THAILAND—SOCIAL LIFE AND
CUSTOMS
— Water buffalo race
Sports Illus 85:95 (c,3) D 9 '96
THAMES RIVER, LONDON, ENG-
LAND
Trav&Leisure 22:103 (map,c,2) Ap '92

— 1858 cartoon about pollution of the Thames
 Natur Hist 103:42–3 (c,1) Je '94
— Richmond
 Gourmet 54:28,100 (painting,c,2) Jl '94
 Trav&Leisure 24:56–8 (c,1) Ag '94
THANKSGIVING
— Carving turkey (1954)
 Am Heritage 45:34 (c,4) D '94
— Macy's Thanksgiving Day Parade, New
 York City, New York
 Smithsonian 23:130 (c,4) Mr '93
— Parade (Baltimore, Maryland)
 Trav/Holiday 179:54–5 (c,1) Jl '96
— Preparing balloons for Macy's Parade
 (Hoboken, New Jersey)
 Life 16:15–18 (c,1) N '93
— Franklin Roosevelt at Thanksgiving dinner
 (1938)
 Life 19:78–9 (1) S '96
— Thanksgiving foods
 Gourmet 52:178–82 (c,1) N '92
 Gourmet 56:160–3 (c,1) N '96
THEATER
— 1930s Broadway show rehearsal, New
 York
 Am Heritage 43:94 (1) N '92
— 1945 "Carousel" poster
 Life 18:66 (c,4) Je 5 '95
— George Abbott
 Life 19:87 (4) Ja '96
— E.F. Albee
 Am Heritage 47:94 (4) S '96
— "Angels in America"
 Life 16:40 (c,4) N '93
— "Annie Get Your Gun" (1959)
 Smithsonian 27:54 (c,4) N '96
— "Bedtime Story"
 Life 18:76 (1) Ja '95
— David Belasco
 Am Heritage 47:95 (4) S '96
— Busby Berkeley's "human fountain" of
 girls (1933)
 Smithsonian 27:52 (2) N '96
— George Broadhurst
 Am Heritage 47:95 (4) S '96
— "Camelot" (1960)
 Life 18:34 (c,4) D '95
— Chinese opera (Singapore)
 Gourmet 53:60 (c,4) Ja '93
 Trav/Holiday 178:58–9 (c,1) O '95
— "A Chorus Line" (1975)
 Life 18:35 (c,4) Jl '95
— "The Crucible"
 Smithsonian 23:131 (4) Ap '92
— "Damn Yankees"

Sports Illus 80:12 (c,4) Mr 21 '94
— "The Death of Klinghoffer"
 Trav&Leisure 22:NY1 (c,3) N '92
— "The Fantasticks"
 Trav&Leisure 22:117 (c,4) Mr '92
— "Hamlet" (Alabama)
 Trav/Holiday 178:84 (c,4) My '95
— "Hello Dolly"
 Smithsonian 27:46 (c,2) N '96
— History of American musical theater
 Smithsonian 27:cov.,46–57 (c,2) N '96
— Arthur Hopkins
 Am Heritage 47:95 (4) S '96
— Ice Capades
 Sports Illus 80:48–54 (c,1) Mr 7 '94
— "In Dahomey" (1903)
 Smithsonian 27:48 (3) N '96
— "Jelly's Last Jam" (1992)
 Smithsonian 27:56 (c,2) N '96
— "The King and I" (1956)
 Life 19:48 (c,4) My '96
— "Kiss of the Spider Woman"
 Life 18:15–18 (c,1) F '95
— "La Cage aux Folles" (1983)
 Life 16:40 (c,4) N '93
— London theater scenes
 Trav&Leisure 22:95–101,144 (2) Ap '92
— "Lucio Silla" opera (Austria)
 Trav/Holiday 178:81 (c,1) Ap '95
— "Mame" (1966)
 Life 19:30 (c,4) Je '96
— Maya theater performances (Mexico)
 Smithsonian 23:78–87 (c,1) Ag '92
— "Oklahoma" (1943)
 Am Heritage 44:58–71,114 (c,2) F '93
— O'Neill Center playwrights' workshop
 (Connecticut)
 Smithsonian 22:78–87 (c,2) Mr '92
— Opera "Ghosts of Versailles"
 Smithsonian 23:92,95 (c,1) Je '92
— Performance at Epidaurus, Greece
 Trav/Holiday 175:79 (c,2) Je '92
— Performing "Conehead" skit on street
 (Great Britain)
 Life 15:21 (c,4) N '92
— "Peter Pan"
 Smithsonian 27:54–5 (3) N '96
— Posters from Broadway musicals
 Smithsonian 27:46–57 (c,4) N '96
— "Romeo and Juliet" (Scotland)
 Smithsonian 25:41 (c,4) D '94
— "Show Boat" (1927)
 Life 17:48 (4) D '94
 Smithsonian 27:50–1 (2) N '96
— "Show Boat" (1995)

Life 17:48 (c,4) D '94
— "Sunday in the Park with George" (1984)
 Smithsonian 27:57 (c,2) N '96
— Surreal performance art (Russia)
 Nat Geog 183:21 (c,1) Mr '93
— Theater Museum, Vienna, Austria
 Gourmet 52:86–91 (c,1) Je '92
— "Tosca" performed on location (Rome,
 Italy)
 Life 15:12–13 (c,1) S '92
— "Victor/Victoria" (1995)
 Life 18:35 (c,4) D '95
— "West Side Story" (1957)
 Smithsonian 27:55 (4) N '96
— Works by Julie Taymor
 Smithsonian 23:62–73 (c,2) F '93
— Young children starring day camp play
 Trav&Leisure 23:E2 (c,4) O '93
— See also
 ZIEGFELD, FLORENZ

THEATER—COSTUME
— Ancient Greek actors' masks (Syracuse)
 Nat Geog 186:2,21 (c,4) N '94
— "Beauty and the Beast" (New York)
 Life 17:95–6 (c,2) My '94
— "Brigadoon" (1947)
 Smithsonian 27:55 (drawing,c,4) N '96
— Japanese theater costume
 Life 19:86–7 (c,1) Ap '96
— "Kiss of the Spider Woman"
 Life 18:15–18 (c,1) F '95
— No theater masks (Japan)
 Smithsonian 25:97,99 (c,1) D '94
— "Turandot" (Austria)
 Gourmet 52:88 (c,2) Je '92
— Veiled actress (Italy)
 Nat Geog 188:cov.,5 (c,1) Ag '95

THEATERS
— Early 20th cent. Keith's, Washington, D.C.
 Am Heritage 43:64–5 (c,1) S '92
— 1926 movie palace, Tampa, Florida
 Trav&Leisure 25:E16 (c,3) S '95
— Baja California, Mexico
 Trav&Leisure 23:105 (c,2) My '93
— Branson, Missouri
 Trav/Holiday 177:54–9 (c,1) F '94
— Carnegie Hall, New York City, New York
 Trav&Leisure 25:98 (c,4) N '95
— Concert hall on barge, Brooklyn, New York
 Smithsonian 24:48–54 (c,1) Ja '94
— Drive-in theaters
 Smithsonian 25:108–13 (c,1) My '94
 Life 17:18 (c,2) Ag '94
— Elizabethan theater, Ashland, Oregon
 Trav&Leisure 22:E1 (c,2) F '92

— Fifth Avenue Theater, Seattle, Washington
 Trav&Leisure 25:96 (c,4) N '95
— Glimmerglass Opera, Cooperstown, New
 York
 Trav&Leisure 24:67–8 (c,4) Je '94
— Goodspeed Opera House, East Haddam,
 Connecticut
 Gourmet 55:68 (4) My '95
— Graz Opera House, Austria
 Trav/Holiday 176:49 (c,4) D '93
— La Fenice opera house interior, Venice,
 Italy
 Trav&Leisure 22:15 (c,4) O '92
— La Scala interior, Milan, Italy
 Nat Geog 182:104–5 (c,1) D '92
— London, England
 Trav/Holiday 179:46–8 (c,1) S '96
— Los Angeles Theater, California
 Trav&Leisure 25:128 (c,2) My '95
— Mariinsky Theater, St. Petersburg, Russia
 Nat Geog 184:107 (c,4) D '93
— Mt. Tamalpais amphitheater, California
 Smithsonian 25:68–9 (c,4) D '94
— New York City, New York
 Gourmet 56:42 (c,4) Je '96
— Open-air theater, Santa Fe, New Mexico
 Trav&Leisure 26:E1 (c,4) Mr '96
— Opera de la Bastille, Paris, France
 Trav&Leisure 23:108–9 (1) My '93
— Orchestra Hall, Chicago, Illinois
 Smithsonian 25:94–103 (c,2) S '94
— Outdoor theater (Cornwall, England)
 Gourmet 55:84 (c,4) S '95
— Palau de la Musica Catalana, Barcelona,
 Spain
 Trav&Leisure 24:74 (c,4) Mr '94
— Paramount Theater, Oakland, California
 Trav&Leisure 25:96 (c,4) N '95
— Radio City Music Hall, New York City,
 New York
 Trav&Leisure 25:94 (c,4) N '95
— Red Rocks outdoor theater, Denver,
 Colorado
 Trav&Leisure 22:E2 (c,3) O '92
— Savoy Theater, London, England
 Trav&Leisure 24:178 (c,1) O '94
— Slowacki Theater, Krakow, Poland
 Trav&Leisure 24:112–13 (c,1) Mr '94
— Sydney Opera House, Australia
 Trav/Holiday 179:10 (c,4) O '96
— Teatro Colon, Buenos Aires, Argentina
 Gourmet 53:138–9 (c,1) N '93
— Toronto, Ontario
 Trav&Leisure 26:80–2 (c,4) O '96
— Uptown Theater, Chicago, Illinois

Smithsonian 27:59 (c,2) S '96
THEATERS—ANCIENT
— Epidaurus, Greece
 Trav/Holiday 175:73,79 (c,1) Je '92
— Roman amphitheater (Arles, France)
 Trav/Holiday 179:54 (c,4) N '96
— Roman theater, Aspendos, Turkey
 Nat Geog 185:22–3 (c,1) My '94
— Segesta, Sicily, Italy
 Nat Geog 186:2–4 (c,1) N '94
— Taormina, Italy
 Life 18:46 (c,4) O '95
— Xanthos, Turkey
 Gourmet 54:122–3 (c,1) O '94
**THEODORE ROOSEVELT NA-
TIONAL PARK, NORTH DAKOTA**
 Trav/Holiday 176:54 (c,4) D '93
 Am Heritage 47:64 (4) Ap '96
THERAPY
— Acupuncture
 Life 19:38 (c,1) S '96
— Alcoholics Anonymous meeting (Moscow,
 U.S.S.R.)
 Nat Geog 181:8 (c,4) F '92
— Alternative medicine
 Life 19:cov.,34–47 (c,1) S '96
— Athlete in whirlpool (1951)
 Sports Illus 80:71 (1) Ap 18 '94
— Audiologist working with deaf child
 Life 16:10–11 (c,1) My '93
— Hypnotherapy for fear of spiders
 Life 18:28–30 (c,2) Jl '95
— Masks used in group therapy
 Nat Geog 187:33 (c,3) Je '95
— Overweight man in snorkeling therapy
 (North Carolina)
 Nat Geog 187:126–7 (c,2) Mr '95
— Physical therapy for dancers
 Smithsonian 25:97–101 (2) Je '94
— Physical therapy for stroke patient
 Sports Illus 85:104–5 (c,1) N 25 '96
— Physical therapy in pool (Israel)
 Nat Geog 181:54–5 (c,1) F '92
— Psychotherapy session
 Life 18:107 (4) Ap '95
— Repetitive Strain Injuries (RSIs)
 Smithsonian 25:91–101 (2) Je '94
— Stressed out stock traders listening to
 music (Japan)
 Nat Geog 183:90–1 (c,2) Ja '93
— Wildman retreat (Texas)
 Life 15:70 (c,3) Ja '92
— See also
 HYPNOSIS
 MASSAGES

THISTLES
 Natur Hist 102:65 (c,1) O '93
 Natur Hist 103:93 (c,2) Je '94
— Bull thistle
 Nat Wildlife 35:72 (c,1) D '96
THOMAS, DYLAN
 Sports Illus 82:8 (4) Je 26 '95
THORPE, JIM
 Sports Illus 76:49 (4) Ap 13 '92
 Am Heritage 43:93–100 (3) Jl '92
 Sports Illus 83:63 (4) Fall '95
— Thorpe's tomb (Pennsylvania)
 Am Heritage 43:98 (4) Jl '92
THORVALDSEN, BERTEL
— Sculpture by him
 Trav&Leisure 24:54–5 (c,4) Ja '94
**THOUSAND ISLANDS, NEW
YORK/ONTARIO**
 Nat Geog 186:111 (c,3) O '94
THRONES
— Throne of Czar Paul I (U.S.S.R.)
 Trav&Leisure 26:66 (c,4) Mr '96
THRUSHES
 Trav&Leisure 22:88 (c,4) Mr '92
 Nat Wildlife 31:48 (c,4) Ap '93
— Wood thrushes
 Nat Wildlife 30:6 (c,4) Ag '92
 Nat Geog 183:80–1 (painting,c,4) Je '93
 Natur Hist 105:42–4 (c,2) Jl '96
THURBER, JAMES
— Thurber cartoon about telephone wrong
 numbers
 Life 17:45 (4) D '94
TIBER RIVER, ROME, ITALY
 Trav&Leisure 22:87,102 (map,c,2) Ap '92
TIBERIUS
— Portrait on 1st cent. A.D. coin
 Nat Geog 183:82 (c,4) Ja '93
TIBET
 Trav&Leisure 23:82–9 (c,2) Jl '93
— Chang Tang
 Nat Geog 184:62–87 (map,c,1) Ag '93
— Ganden monastery
 Trav&Leisure 23:82–3 (c,4) Jl '93
— See also
 LHASA
TIBET—ART
— 14th cent. bodhisattva statue
 Smithsonian 27:26 (c,4) Ag '96
TIBET—COSTUME
 Trav&Leisure 23:85–9 (c,4) Jl '93
— Dalai Lama
 Life 19:18 (c,2) N '96
— Nomads

Nat Geog 184:62–4,74–5 (c,1) Ag '93
TIBET—MAPS
— 18th cent. map
Natur Hist 103:31 (c,1) Jl '94
TICKETS
— Admittance tickets to Congress
Am Heritage 43:28 (c,4) N '92
— Japanese World Series tickets
Sports Illus 81:2–3 (c,1) O 31 '94
TICKS
— Deer tick
Life 17:64 (c,3) My '94
TIDAL WAVES
— Damage caused by tsunamis
Smithsonian 24:28–39 (c,1) Mr '94
— Tsunami warning devices
Smithsonian 24:36,38 (c,4) Mr '94
TIEPOLO, GIAMBATTISTA
— "Triumph of Zephyr and Flora"
Trav&Leisure 26:68 (painting,c,4) D '96
TIFFANY, LOUIS COMFORT
— Stained glass panel by Tiffany
Nat Geog 184:64 (c,1) D '93
— Tiffany vase
Nat Geog 184:6—9 (c,1) D '93
TIGERS
Nat Geog 181:cov.,12,14,17 (c,1) My '92
Trav&Leisure 22:62 (c,4) My '92
— Pet tiger
Nat Geog 181:119 (c,4) Mr '92
— Siberian tigers
Nat Geog 184:33,38–47 (c,1) Jl '93
— Tiger roaring
Smithsonian 23:74 (c,2) Ap '92
— Tiger undergoing CAT scan
Life 16:20 (c,2) D '93
— Tiger's face
Nat Wildlife 31:11 (c,1) D '92
— Woman posing on tiger (1946)
Life 15:6 (c,4) Je '92
TIGRIS RIVER, TURKEY
Nat Geog 185:24–5 (c,2) My '94
TIJUANA, MEXICO
Nat Geog 190:94–107 (c,1) Ag '96
TILDEN, SAMUEL
— 1876 presidential campaign ribbon
Am Heritage 45:134 (c,4) My '94
TILEFISH
Natur Hist 105:52 (c,4) N '96
TINTORETTO
— "The Origin of the Milky Way"
Natur Hist 104:42–3 (painting,c,1) D '95
TIRES
— Mountain of old tires (California)
Nat Geog 186:92–4 (c,1) Jl '94

— Tires on display at Texas gas station (1940)
Life 19:66 (2) Winter '96
TITIAN
— "Mary Magdalene in Penitence" (1560s)
Smithsonian 25:44 (painting,c,4) Mr '95
TITMICE
Natur Hist 105:94–5 (c,1) F '96
— Bushtits
Nat Wildlife 34:59 (c,2) D '95
— Great tits
Natur Hist 101:52–3 (c,1) F '92
TITO, MARSHAL
Smithsonian 22:129 (painting,c,4) Ja '92
TITTLE, Y.A.
Life 17:44 (4) O '94
Sports Illus 81:102–3 (1) N 14 '94
TLINGIT INDIANS—COSTUME
— Headdress
Nat Geog 183:117 (c,1) Ja '93
TOADS
Nat Wildlife 32:6 (c,4) Je '94
Natur Hist 103:32–4,37 (c,1) O '94
Nat Wildlife 33:34 (c,4) Je '95
Life 19:14 (c,2) Jl '96
Nat Geog 190:32 (c,4) N '96
— Golden toads
Nat Geog 183:140 (c,4) Ap '93
— Tadpoles
Nat Wildlife 33:42–3 (c,1) F '95
— Toads mating
Life 19:14 (c,2) Jl '96
— Wearing radio transmitter backpacks
Nat Wildlife 31:26 (c,3) F '93
— Western toads
Natur Hist 103:32–4 (c,1) O '94
**TOBACCO INDUSTRY—
 HARVESTING**
— Tennessee
Nat Geog 183:122–3,136 (c,1) F '93
Tobago. See
 TRINIDAD AND TOBAGO
TOGO—RITES AND FESTIVALS
— Voodoo
Nat Geog 188:102–13 (c,1) Ag '95
TOJO, HIDEKI
Life 18:98 (4) Je 5 '95
TOKYO, JAPAN
Trav/Holiday 176:44–55 (map,c,1) My '93
Trav&Leisure 26:142–58 (c,1) Mr '96
— Baseball Hall of Fame
Sports Illus 78:98–9 (c,4) My 31 '93
— Tokyo after 1945 bombing
Am Heritage 46:78–82,86 (1) My '95
— Tokyo Fish Market
Nat Geog 188:38–51 (c,1) N '95

TOMATO INDUSTRY—HARVESTING
— Italy
 Nat Geog 183:96–7 (c,1) My '93
TOMATOES
 Smithsonian 22:70–1 (c,1) F '92
 Gourmet 52:36 (painting,c,2) Ag '92
 Gourmet 55:86 (drawing,4) Mr '95
 Trav&Leisure 26:101 (c,4) Ap '96
— Annual tomato food fight (Bunol, Spain)
 Life 18:20–1 (c,1) N '95
— Italian tomatoes
 Trav&Leisure 22:7,118 (c,4) Jl '92
— Tomato varieties
 Nat Geog 181:78 (c,2) My '92
TOMBS
— 2400 year old Pazyryk tomb (Siberia)
 Nat Geog 186:80–103 (c,1) O '94
— 4th cent. B.C. necropolis (Caunos, Turkey)
 Gourmet 54:120–1 (c,1) O '94
— 13th cent. Xi Xia tombs (China)
 Nat Geog 190:22–3 (c,2) D '96
— Ancient Maya tomb (Guatemala)
 Nat Geog 183:100–1 (c,2) F '93
— Ancient Roman burial chamber (Marsala, Sicily)
 Life 18:76–80 (c,1) S '95
— Ancient Scythian tombs (U.S.S.R.)
 Nat Geog 190:67,74–5 (c,1) S '96
— Ancient Thailand
 Natur Hist 103:65 (painting,c,1) D '94
— Ancient tomb of Sennefer (Egypt)
 Trav/Holiday 175:60 (c,4) S '92
— Ancient Valley of the Kings tomb, Egypt
 Life 19:3 (c,2) Ja '96
— Antarctic explorers
 Trav/Holiday 175:96 (c,4) Mr '92
— Charnel house full of human bones (Czechoslovakia)
 Nat Geog 184:18–19 (c,2) S '93
— Vasco da Gama (Portugal)
 Nat Geog 182:93 (c,2) N '92
— Graves covered by Mississippi River (Louisiana)
 Nat Geog 184:10–11 (c,1) N 15 '93
— Ho Chi Minh's tomb, Vietnam
 Smithsonian 26:41 (c,4) Ja '96
— Enver Hoxha (Albania)
 Nat Geog 182:76 (c,3) Jl '92
— Martin Luther King, Jr. memorial, Atlanta, Georgia
 Am Heritage 47:88–9 (c,2) Ap '96
— Neolithic burial mounds (Great Britain)
 Smithsonian 24:124 (c,3) S '93
— Charlie Patton's grave (Mississippi)
 Natur Hist 105:66 (c,4) O '96

— Pioneer's grave (Wyoming)
 Life 16:66 (c,4) D '93
— Pushkin (Pskov, Russia)
 Smithsonian 22:120 (c,4) Ja '92
 Nat Geog 182:60 (c,4) S '92
— Replica of Moche tomb (Peru)
 Natur Hist 104:80 (c,4) N '95
— Cecil Rhodes' tomb (Zimbabwe)
 Trav/Holiday 175:62 (c,2) N '92
— Jim Thorpe's tomb (Pennsylvania)
 Am Heritage 43:98 (4) Jl '92
— Tomb of Absalom, Kidron Valley, Israel
 Trav&Leisure 24:96 (c,4) Ag '94
— Tomb of Han Dynasty's Jing Di (Xian, China)
 Nat Geog 182:114–30 (c,1) Ag '92
— Tomb of the Patriarchs (Hebron, Israel)
 Nat Geog 181:93 (c,4) Je '92
— Zambia soccer team
 Sports Illus 79:86–8 (c,1) O 18 '93
— See also
 CEMETERIES
 COFFINS
 MUMMIES
 PYRAMIDS
 TAJ MAHAL
 TOMBSTONES
TOMBSTONES
— 1684 Jewish grave (Nevis)
 Natur Hist 102:56 (c,1) Mr '93
— 1826 (Virginia)
 Am Heritage 45:95 (c,4) O '94
— 1915 child "Lusitania" victim (Ireland)
 Nat Geog 185:85 (c,4) Ap '94
— Cemetery sculpture of widower and vacant chair (Kansas)
 Am Heritage 46:106 (4) F '95
— Grave between two parking meters
 Life 16:105 (4) Jl '93
— "Husband" and "Wife" tombstones (Pennsylvania)
 Life 15:86 (4) Ap '92
— Little Big Horn troops (Montana)
 Am Heritage 43:79 (painting,c,3) Ap '92
— Memorial to pioneer killed by Indians (1861)
 Nat Geog 182:50–1 (c,2) O '92
— Mexican War soldier (Mexico)
 Am Heritage 46:76 (4) N '95
— Nazi-vandalized Jewish tombstones reassembled on wall (Krakow, Poland)
 Trav&Leisure 24:118 (c,1) Mr '94
— Elvis Presley's grave (Memphis, Tennessee)
 Smithsonian 26:60 (c,4) N '95

— Sacagawea's grave (Wyoming)
 Trav/Holiday 177:73 (c,4) Je '94
— Nicole Brown Simpson's grave (California)
 Life 18:44 (c,4) Je '95
— Texas
 Trav/Holiday 175:46 (c,4) My '92
— Tombstone tombstones, Arizona
 Am Heritage 47:30 (c,4) F '96
TOOLS
— Chain saw
 Sports Illus 84:88–9 (c,1) Mr 18 '96
— Scythes (Madagascar)
 Nat Geog 185:52–3 (c,1) My '94
— Stone Age tools
 Natur Hist 102:62–3 (c,4) Ap '93
— Tools as art
 Smithsonian 27:112–15 (c,1) Ap '96
— See also
 AXES
 KNIVES
Topiary. See
 GARDENS
TORNADOES
 Smithsonian 25:53,58–9 (c,3) O '94
 Natur Hist 105:64 (c,4) Mr '96
— Kansas
 Nat Geog 188:140 (c,2) N '95
— Kansas (1991)
 Life 15:104–5 (c,1) Ja '92
— North Dakota
 Life 16:36–7 (c,1) S '93
— Waterspout (Manitoba)
 Nat Geog 188:1 (c,2) D '95
TORNADOES—DAMAGE
— Destroyed truck stop (Oklahoma)
 Life 16:36 (c,4) S '93
TORONTO, ONTARIO
 Trav&Leisure 23:96–103,149 (map,c,1) O '93
 Nat Geog 189:120–39 (map,c,1) Je '96
— City Hall
 Trav&Leisure 22:62 (c,4) Je '92
— Map
 Trav/Holiday 176:24 (c,3) Je '93
— Theaters
 Trav&Leisure 26:80–2 (c,4) O '96
TORTOISES
 Nat Geog 183:119 (c,4) Ap '93
 Natur Hist 102:34–5 (c,1) Ag '93
 Trav/Holiday 176:15 (c,4) D '93
 Natur Hist 103:67 (c,4) F '94
 Smithsonian 25:45 (c,1) S '94
— Desert tortoise
 Nat Wildlife 31:18–19 (c,1) O '93
 Nat Wildlife 32:14–15 (c,1) D '93

 Nat Geog 187:8 (c,3) Mr '95
— Galapagos
 Trav/Holiday 179:80,83 (c,1) F '96
— Giant tortoise
 Nat Wildlife 32:19 (c,2) F '94
 Nat Geog 187:110 (c,4) Mr '95
— Gopher tortoise
 Natur Hist 101:8–9 (c,1) Je '92
TOSCANINI, ARTURO
 Life 19:116 (4) My '96
TOTEM POLES
— British Columbia
 Gourmet 54:95 (c,4) Ap '94
 Trav/Holiday 179:66–7 (c,2) Je '96
— Northwest
 Smithsonian 25:46 (c,4) Ja '95
TOUCANS
 Sports Illus 76:173 (c,2) Mr 9 '92
 Nat Wildlife 30:41 (c,4) Ap '92
 Nat Wildlife 31:20–1 (c,1) Ap '93
 Smithsonian 25:cov. (c,1) My '94
 Natur Hist 103:A1 (c,1) O '94
 Gourmet 55:145 (c,1) D '95
TOULOUSE-LAUTREC, HENRI DE
 Life 15:76–8,83 (1) Je '92
— "A Montrouge-Rosa la Rouge" (1886)
 Life 16:79 (painting,c,2) Ap '93
 Smithsonian 24:102 (painting,c,4) My '93
— Paintings by him
 Life 15:76–83 (c,1) Je '92
TOURACOS (BIRDS)
 Nat Geog 188:21 (c,3) Jl '95
TOURISTS
— 18th cent. British Grand Tour of Europe
 Trav/Holiday 178:46–53 (map,c,1) Ap '95
— 1861 American couple (Japan)
 Smithsonian 25:30 (painting,c,4) Jl '94
— Early 20th cent. tourists dipping postcards
 into lava (Hawaii)
 Nat Geog 188:132 (2) S '95
— National park visitors
 Smithsonian 24:21–9 (c,3) Ag '93
— On ferry (China)
 Trav/Holiday 176:58 (c,1) F '93
— Photographing gorilla (Zaire)
 Nat Geog 181:2–3 (c,1) Mr '92
— Seeing Swiss Alpine valley through viewer
 Gourmet 53:49 (c,4) Jl '93
— Sightseeing jitney in national park (Spain)
 Trav/Holiday 175:68–9 (c,1) Ap '92
— Southern landmarks of black history
 Am Heritage 43:89–99 (c,2) Ap '92
— Tourist bargaining in Morocco market
 Trav/Holiday 175:62–3 (painting,c,1) O '92

— Tourist on camel
 Trav/Holiday 175:39 (c,4) My '92
— Tourist tram (Key West, Florida)
 Gourmet 52:112 (c,3) D '92
— Tourists on "Maid of the Mist" at Niagara
 Falls
 Trav/Holiday 176:46–7 (c,1) Jl '93
— Tourists riding on elephants (India)
 Nat Geog 181:26–7 (c,2) My '92
— Tourists riding on elephants (Thailand)
 Nat Geog 189:102–3 (c,1) F '96
— Wildlife sightseeing platform (Zimbabwe)
 Trav/Holiday 175:66 (c,3) N '92
— See also
 SOUVENIRS

TOURISTS—HUMOR
— American tourists (Spain)
 Sports Illus 77:46–9 (painting,c,1) Jl 22
 '92

TOUSSAINT L'OUVERTURE (HAITI)
 Nat Geog 182:88 (painting,c,3) S '92

TOWER OF LONDON, ENGLAND
 Nat Geog 184:36–57 (c,1) O '93

TOYS
— 1950s toy washing machine
 Smithsonian 24:36 (c,4) O '93
— Adults blowing bubbles (1945)
 Life 18:102 (4) Je 5 '95
— Ancient rubber ball (Mexico)
 Nat Geog 184:99–101 (c,4) N '93
— Children bouncing on trampoline (South
 Africa)
 Nat Geog 183:88–9 (c,1) F '93
— Motorcycle miniatures
 Life 17:40–55 (c,4) D '94
— Nerf ball
 Sports Illus 82:12 (c,4) My 1 '95
— Original "Teddy" bear
 Smithsonian 27:44 (c,4) My '96
— Super Soaker water gun
 Sports Illus 76:66 (c,2) F 17 '92
 Sports Illus 81:21 (c,3) Jl 18 '94
— SWIN golf (Delaware)
 Sports Illus 83:5 (c,4) S 18 '95
— Teenage Mutant Ninja Turtles fad
 Smithsonian 23:98–107 (c,2) D '92
— Toddlers driving toy cars
 Life 15:25 (c,4) D '92
— Toy parachutes (Mexico)
 Nat Geog 190:81 (c,1) Ag '96
— See also
 BALLOONS, TOY
 DOLLS
 MARBLES
 PUPPETS

PUZZLES
SWINGS
TRACK
 Sports Illus 77:66–7,73–4,78–87 (c,1) Jl
 22 '92
 Sports Illus 79:44–5 (c,4) Jl 5 '93
 Sports Illus 79:10 (c,4) Jl 19 '93
 Sports Illus 79:32 (c,2) Ag 9 '93
 Sports Illus 79:18–19 (c,2) Ag 23 '93
 Sports Illus 79:21 (c,2) S 27 '93
 Sports Illus 81:30–1 (c,2) Jl 18 '94
 Sports Illus 81:34–6 (c,1) Ag 1 '94
 Sports Illus 82:32,34 (c,2) Je 26 '95
 Sports Illus 83:32–5 (c,1) Ag 14 '95
 Sports Illus 83:40–5 (c,1) Ag 21 '95
 Sports Illus 84:44–6 (c,1) My 27 '96
 Sports Illus 84:94 (c,1) Je 10 '96
 Sports Illus 84:46–8 (c,1) Je 24 '96
 Sports Illus 85:20–1,24–5 (c,1) Jl 1 '96
 Sports Illus 85:73–8,142–53 (c,1) Jl 22 '96
— 1896 Olympics (Athens)
 Am Heritage 47:52–3 (1) Jl '96
— 1912 Olympics (Stockholm)
 Am Heritage 43:96–7 (4) Jl '92
— 1936
 Sports Illus 80:13 (2) Ap 18 '94
— 1950s
 Sports Illus 80:72–8 (1) Je 27 '94
— 1960 Olympics (Rome)
 Sports Illus 81:13 (4) N 21 '94
 Life 18:82 (1) Ja '95
— 1984 Olympics (Los Angeles)
 Sports Illus 81:132–3 (c,1) N 14 '94
— 1988 Olympics (Seoul)
 Sports Illus 81:84 (c,4) N 14 '94
— 1992 Olympic trials
 Sports Illus 76:30–5 (c,1) Je 29 '92
 Sports Illus 76:2–3,14–21 (c,1) Jl 6 '92
— 1992 Olympics (Barcelona)
 Sports Illus 84:96 (c,2) Je 10 '96
 Sports Illus 84:76 (c,3) Je 17 '96
 Sports Illus 77:46–7,50 (c,1) Ag 3 '92
 Sports Illus 77:cov.,12–29,92–3 (c,1) Ag
 10 '92
 Sports Illus 77:cov.,20–44 (c,1) Ag 17 '92
 Sports Illus 77:cov.,75–91 (c,1) D 28 '92
— 1996 Olympics (Atlanta)
 Sports Illus 85:58–62 (c,1) Jl 29 '96
 Sports Illus 85:34–43 (c,1) Ag 5 '96
 Sports Illus 85:cov.,26–46,100 (c,1) Ag
 12 '96
 Life 19:6–7 (c,1) S '96
 Sports Illus 85:82–3 (c,1) D 30 '96
— Roger Bannister breaking four-minute mile
 (1954)

Sports Illus 80:72–3 (1) Je 27 '94
Sports Illus 81:30–3 (1) Ag 15 '94
— Classic Olympic moments
Sports Illus 84:9–26 (c,2) F 26 '96
— Mile record holders
Sports Illus 80:70–86 (c,1) Je 27 '94
— Legless track runner
Life 19:10–11 (c,1) N '96
— Jesse Owens' track shoes
Sports Illus 82:9 (c,4) Ja 23 '95
— Penn Relay Carnival, Pennsylvania
Sports Illus 80:13 (c,2) Ap 18 '94
— Race on Miami street, Florida
Sports Illus 80:10–11 (c,2) Ja 31 '94
— Running on office building roof
(Massachusetts)
Nat Geog 186:14 (c,1) Jl '94
— Switzerland
Sports Illus 81:20–1 (c,1) Ag 29 '94
— Triple exposure of 1956 race
Life 19:82–3 (1) F '96
— Turning recycled Nikes into track surface
Sports Illus 83:8 (c,4) O 16 '95
— See also
BANNISTER, ROGER
OWENS, JESSE
RUDOLPH, WILMA
TRACK—WOMEN
Sports Illus 76:51–2 (c,4) Mr 9 '92
— Woman crossing finish line
Sports Illus 80:48 (c,3) Mr 14 '94
TRACK AND FIELD—MEETS
— Atlanta Grand Prix 1996
Sports Illus 84:2–3,44–6 (c,1) My 27 '96
— Bislett Games 1994, Oslo, Norway
Sports Illus 81:2–3,34–6 (c,1) Ag 1 '94
— Bislett Games 1995, Oslo, Norway
Sports Illus 83:2–3,40–1 (c,1) Jl 31 '95
— Decathlon events
Sports Illus 76:45–56 (c,1) Ap 13 '92
— Hammer throw
Sports Illus 82:32–3 (c,1) Mr 13 '95
— Hammer throw in slow motion (1960)
Life 18:34 (4) Jl '95
— Millrose Games 1956 (New York)
Life 19:82–3 (1) F '96
— Millrose Games 1996 (New York)
Sports Illus 84:2–3 (c,1) F 12 '96
— Pan American Games 1995 (Argentina)
Sports Illus 82:2–3,42–4 (c,1) Mr 27 '95
— Steeplechase
Sports Illus 85:150–1 (c,1) Jl 22 '96
— Steeplechase (Oslo, Norway)
Sports Illus 83:2–3 (c,1) Jl 31 '95

— Steeplechase world championships
(Sweden)
Sports Illus 83:2–3 (c,1) Ag 21 '95
— US/Mobil Track & Field Championships
(Oregon)
Sports Illus 78:36–9 (c,1) Je 28 '93
— U.S. Outdoor Track & Field Champion-
ships 1995 (Sacramento, California)
Sports Illus 82:30–5 (c,1) Je 26 '95
— World Track & Field Championships 1993
(Stuttgart, Germany)
Sports Illus 79:18–19 (c,2) Ag 23 '93
Sports Illus 79:18–19 (c,1) Ag 30 '93
— World Track & Field Championships 1995
(Goteborg, Sweden)
Sports Illus 83:32–5 (c,1) Ag 14 '95
Sports Illus 83:2–3,40–5 (c,1) Ag 21 '95
— See also
HIGH JUMPING
HURDLING
JUMPING
POLE VAULTING
SHOT-PUTTING
TRACK
TRACY, SPENCER
Life 18:146 (1) Je 5 '95
TRADING CARDS
— 1880s trading cards of newspaper editors
Am Heritage 45:75 (c,4) O '94
— Baseball cards
Sports Illus 85:104–8 (c,1) Jl 29 '96
Traffic. See
AUTOMOBILES—TRAFFIC
TRAFFIC LIGHTS
— Salmon, Idaho
Nat Geog 185:16–17 (c,1) F '94
TRAILERS
— 1940s campus housing (Indiana)
Smithsonian 25:139 (2) N '94
— 1950s
Trav/Holiday 175:136 (4) My '92
Life 17:98 (c,3) Ap '94
— 1970 trailer camp (Montana)
Life 19:98–9 (c,1) Winter '96
— Aerial view of trailer park (Great Britain)
Nat Geog 188:57 (c,1) O '95
Train stations. See
RAILROAD STATIONS
TRAINS
— 1924 Rondout, Illinois, train robbery by
the Newton Boys
Smithsonian 24:74–5 (painting,c,1) Ja '94
— Aerial view of passenger train
(Pennsylvania)
Trav/Holiday 175:15 (c,4) Ap '92

— Artrain tour of Smithsonian treasures
Smithsonian 27:76–81 (c,2) Ag '96
— California
Gourmet 55:154–6 (c,1) My '95
— Canada
Trav&Leisure 22:100–9,138 (c,1) S '92
— Chunnel shuttle train
Trav/Holiday 177:41 (c,4) O '94
Trav&Leisure 25:172 (c,4) D '95
Trav/Holiday 179:14 (c,4) O '96
— Couple sleeping on train (1975)
Life 17:30 (3) Je '94
— Crowded commuter train (Bombay, India)
Nat Geog 187:54–5 (c,1) Mr '95
— Dining cars
Trav&Leisure 26:107,110 (c,4) S '96
— Family riding on train (New York)
Nat Geog 189:72–3 (c,1) Mr '96
— Freight trains
Smithsonian 26:36–49 (c,1) Je '95
— High tech "tilt train"
Life 16:84 (c,1) S '93
— Hiker sleeping on train (Sweden)
Trav/Holiday 177:50 (c,3) Je '94
— Marco Polo Express (China)
Trav&Leisure 24:78–81,131 (c,1) Mr '94
— Miniature train set
Life 16:107 (c,2) O '93
— Orient Express
Trav/Holiday 178:89 (c,4) N '95
— Scenes aboard train
Trav/Holiday 179:58–9 (c,1) S '96
— Steam trains (Africa)
Life 18:92–9 (c,1) N '95
— Tearful farewell at train station (U.S.S.R.)
Nat Geog 181:45 (c,3) F '92
— Tourist train (South Africa)
Trav/Holiday 177:64 (c,3) O '94
— Train wrecked by sabotage (Arizona)
Life 18:10–11 (c,1) D '95
— See also
LOCOMOTIVES
RAILROADS
SUBWAYS
TRANSPORTATION
— Airport automated electric cars (Texas)
Smithsonian 24:37 (c,4) Ap '93
— Hand tram across river (Alaska)
Nat Geog 185:92–3 (c,2) My '94
— Monorail (Sydney, Australia)
Trav/Holiday 176:48–9 (c,1) Je '93
— See also
AIRPLANES
AIRSHIPS
AUTOMOBILES
BABY CARRIAGES
BABY STROLLERS
BICYCLES
BUSES
CABLE CARS
CARRIAGES AND CARTS—HORSE-
DRAWN
CHARIOTS
COVERED WAGONS
DOG SLEDS
FIRETRUCKS
HELICOPTERS
HORSEBACK RIDING
JEEPS
LOCOMOTIVES
MOBILE HOMES
MOTORCYCLES
MOVING VANS
RECREATIONAL VEHICLES
SLEDS
SNOWMOBILES
SPACECRAFT
SUBWAYS
TANKS, ARMORED
TAXICABS
TRAILERS
TRAINS
TROLLEY CARS
TRUCKS
WAGONS
WHEELS
Trapping. See
HUNTING
TRASH
— Compacted trash (Antarctica)
Life 16:83 (c,2) Mr '93
— Lovely house made from garbage
(Maryland)
Smithsonian 25:121–3 (c,1) Ap '94
— Refugees scavenging in garbage (Bosnia)
Life 19:10–11 (c,1) S '96
— Treating sewage (Virginia)
Nat Geog 183:21 (c,3) Je '93
— Year's worth of garbage generated by
family (California)
Nat Geog 186:98–9 (c,1) Jl '94
TRAWLERS
Nat Geog 182:72–3,78–9 (c,1) O '92
TREE CLIMBING
— Wildlife watchers (South Africa)
Sports Illus 84:66 (c,3) Ja 29 '96
TREE FROGS
Nat Wildlife 31:52 (c,3) D '92
Nat Wildlife 31:20 (c,4) Ap '93
Nat Wildlife 32:60 (c,1) D '93

Trav&Leisure 24:104 (drawing,c,4) Ap
'94
Natur Hist 103:46–7 (c,2) S '94
Natur Hist 103:cov.,38–9 (c,1) O '94
Gourmet 55:146 (c,4) D '95
— Red eye of tree frog
Nat Wildlife 33:37 (c,4) Ag '95
TREE HOUSES
— Couch in tree (California)
Nat Geog 184:52–3 (c,1) Jl '93
— Indonesia
Nat Geog 189:34–41 (c,1) F '96
TREE PLANTING
— Prince Sadruddin Aga Khan planting tree
in French Alps
Trav&Leisure 23:68 (c,4) O '93
TREES
— Aerial view of autumn trees (Connecticut)
Nat Geog 185:64–6 (c,1) F '94
— Autumn scene
Natur Hist 102:58–9,62–3 (c,1) S '93
— Cashew tree
Natur Hist 101:69 (c,1) Ag '92
— Casuarina tree
Natur Hist 102:46–7 (c,1) Ag '93
— Ceiba tree
Trav/Holiday 177:80 (4) D '94
— Certified national champion trees
Smithsonian 27:110–23 (c,1) O '96
— Decorated with lights (New York City,
New York)
Nat Geog 183:10–11 (c,1) My '93
— Divi-divi trees
Trav/Holiday 178:72–3 (c,3) F '95
— Driftwood on beach (Louisiana)
Natur Hist 104:36 (c,4) My '95
— Hackberry trees
Nat Wildlife 32:10–11 (c,1) D '93
— Madrona
Nat Geog 187:108 (c,4) Je '95
— May hawthorne trees
Smithsonian 27:113 (c,4) O '96
— Melaleuca trees
Nat Geog 185:19 (c,3) Ap '94
— Moringas
Trav/Holiday 177:95 (c,3) Mr '94
— Pandanus trees
Trav&Leisure 22:126–7 (c,1) F '92
— Snow-covered trees (U.S.S.R.)
Nat Geog 184:98–9 (c,1) D '93
— Windblown trees (California)
Trav&Leisure 23:122–3 (c,1) N '93
— Wind-bowed sabina trees
Nat Geog 181:32–3 (c,1) Ja '92
— See also

ACACIAS
ALMOND
APPLE
APRICOT
ASH
ASPEN
BANANAS
BANYAN
BAOBAB
BEECH
BIRCH
BRISTLECONE PINES
CEDAR
CHERRY
CHESTNUT
CHRISTMAS TREES
COCONUT PALM
CYPRESS
DATES
DOGWOOD
ELM
EUCALYPTUS
FIR
FORESTS
HEMLOCKS
HOLLY
JACARANDA
JOSHUA
JUNIPER
LEAVES
MAGNOLIA
MANGROVE
MAPLE
OAK
OLIVE
ORCHARDS
PALM
PAPAYA
PINE
POPLAR
RAIN FORESTS
REDWOOD
SEQUOIA
SPRUCE
TREE PLANTING
TULIP
WILLOW
YEW
YUCCA
Trials. See
JUSTICE, ADMINISTRATION OF
TRIGGERFISH
Natur Hist 101:34–5,38–9 (painting,c,1) O
'92
Nat Geog 184:79 (c,4) N '93

Life 18:56 (c,4) D '95
Nat Geog 190:121 (c,4) D '96

TRILLIUM
Natur Hist 102:24 (c,4) Ja '93
Natur Hist 105:54 (c,4) Jl '96

TRILOBITES
— Trilobite fossils
Natur Hist 101:36-43 (c,1) N '92
Smithsonian 23:109 (4) Ja '93
Natur Hist 102:36 (c,2) Jl '93
Nat Geog 184:135 (c,4) O '93

TRINIDAD AND TOBAGO
Trav&Leisure 22:80-3,117 (map,c,1) Ja
'92
Nat Geog 185:66-89 (map,c,1) Mr '94
— Caroni Swamp, Trinidad
Natur Hist 103:26-8 (map,c,1) O '94
— Nariva Swamp, Trinidad
Natur Hist 102:26-8 (map,c,1) O '93
— Trinidad countryside
Natur Hist 101:64,66 (map,c,4) O '92

**TRINIDAD AND TOBAGO—COS-
TUME**
Nat Geog 185:66-89 (c,1) Mr '94
Natur Hist 104:34-41 (c,1) F '95

**TRINIDAD AND TOBAGO—HOUS-
ING**
— Crowded homes on hillside (Trinidad)
Nat Geog 185:71 (c,2) Mr '94

**TRINIDAD AND TOBAGO—RITES
AND FESTIVALS**
— Carnival
Nat Geog 185:66-7,86-7 (c,1) Mr '94
Natur Hist 104:36-7,40-1 (c,1) F '95

TROLLEY CARS
— 1893 (Chicago, Illinois)
Am Heritage 44:72-3,82-3 (2) Jl '93
— 1929 tram car interior (Adelaide, Australia)
Trav&Leisure 24:105 (c,1) Jl '94
— Leipzig, Germany
Trav&Leisure 24:117 (2) F '94
— Lisbon, Portugal
Trav/Holiday 179:61 (c,2) Ap '96
— Melbourne, Australia
Trav&Leisure 26:57 (c,3) Jl '96
— New Orleans, Louisiana
Nat Geog 187:101 (c,3) Ja '95
Trav/Holiday 179:101 (c,4) S '96
— Texas-Mexico border trolley
Trav&Leisure 26:58 (c,4) N '96

TROLLOPE, ANTHONY
Smithsonian 24:158 (4) Ap '93

TROMBONE PLAYING
Smithsonian 23:46-7 (c,1) O '92
— Marching band (Wisconsin)

Trav&Leisure 25:163 (c,1) S '95
— New Orleans, Louisiana
Gourmet 55:68 (c,4) My '95

TROPHIES
— Early 20th cent. Vanderbilt Cup auto
racing trophy
Am Heritage 43:114 (c,4) My '92
— America's Cup prize
Trav&Leisure 22:27 (c,4) F '92
— Baseball's MVP trophy
Sports Illus 79:28 (c,4) N 1 '93
— Basketball's Carlesimo trophy
Sports Illus 77:37 (c,4) D 7 '92
— Basketball trophy collection
Sports Illus 84:69 (c,2) Je 24 '96
— Boxing championship belt
Sports Illus 79:27 (c,4) N 15 '93
— County fair ribbons (Pennsylvania)
Life 18:8-9 (1) S '95
— French Open tennis cup
Gourmet 53:92 (c,3) Je '93
— Golf
Sports Illus 81:77 (c,4) N 7 '94
Sports Illus 82:33 (c,4) F 20 '95
Sports Illus 82:51 (c,4) Ap 3 '95
Sports Illus 82:2-3,28 (c,1) Je 26 '95
— Ryder Cup
Sports Illus 79:33 (c,4) O 4 '93
— Stanley Cup
Sports Illus 80:24-5 (c,1) Je 20 '94
Sports Illus 81:50-5 (c,4) Jl 25 '94
Sports Illus 83:23 (c,2) Jl 3 '95
Sports Illus 84:2-3 (c,1) Je 3 '96
Sports Illus 84:57 (c,3) Je 17 '96
— Stanley Cup (1940)
Sports Illus 80:69 (4) F 21 '94
— Stanley Cup (1960)
Sports Illus 80:54 (4) Mr 14 '94
— Wimbledon plates
Sports Illus 84:6 (c,2) Je 24 '96
— Wimbledon trophy
Sports Illus 78:46 (c,4) Je 21 '93
Sports Illus 81:63 (c,4) Ag 22 '94
— Women's college basketball
Sports Illus 82:43 (c,4) Ap 10 '95

TROTSKY, LEON
Nat Geog 182:118 (4) O '92

TROUT
Smithsonian 25:55 (c,4) D '94
Nat Geog 189:64-5,70-85 (c,1) Ap '96
Life 19:32-43 (painting,c,4) Ap '96
— Brown trout
Trav/Holiday 176:61 (c,4) Mr '93
Nat Wildlife 33:50-1 (c,3) O '95
— Char

Natur Hist 101:4 (drawing,4) N '92
— Golden trout
 Nat Geog 189:64–5 (c,1) Ap '96
— Rainbow trout
 Nat Wildlife 32:40–1 (painting,c,1) Ag '94
 Nat Geog 189:84–5 (c,2) Ap '96
— Trout varieties
 Nat Geog 189:72–3 (painting,c,1) Ap '96
TROY, TURKEY
— Ancient Troy
 Smithsonian 22:28–38 (c,1) Ja '92
— Site of ancient Troy
 Natur Hist 105:42–51 (map,c,1) Ap '96
— Trojan War
 Smithsonian 22:28, 32–3 (painting,c,1) Ja
 '92
TRUCKS
— Early 20th cent. pickup trucks
 Smithsonian 27:142–7 (c,1) N '96
— 1940s amphibious army truck
 Smithsonian 26:63 (2) D '95
— Decorated trucks (Pakistan)
 Trav&Leisure 24:124–5 (c,1) S '94
— History of the pickup truck
 Am Heritage 47:106–12 (c,1) N '96
— Monster truck events
 Sports Illus 78:54–64 (c,1) Mr 8 '93
— Old pickup truck
 Trav/Holiday 177:48 (3) S '94
— Pickup truck ads (1933-1968)
 Am Heritage 47:106–10 (c,1) N '96
— Trucks carrying many people (Sahara,
 Africa)
 Life 19:23 (c,2) Ap '96
— See also
 FIRETRUCKS
TRUMAN, HARRY S.
 Nat Geog 181:80 (4) Mr '92
 Am Heritage 43:46–64 (1) Jl '92
 Smithsonian 23:147 (4) O '92
 Trav/Holiday 175:71 (2) N '92
 Smithsonian 24:67 (4) My '93
 Am Heritage 45:28,39 (4) Ap '94
 Am Heritage 45:32 (4) O '94
 Smithsonian 25:102 (4) O '94
 Am Heritage 46:14 (drawing,c,4) My '95
 Life 18:64–5 (1) Je 5 '95
 Am Heritage 46:77 (4) Jl '95
 Am Heritage 46:112 (c,3) N '95
 Smithsonian 26:20 (4) N '95
 Am Heritage 46:40,62 (4) D '95
— 1944 vice-presidential campaign
 Am Heritage 43:46–64 (1) Jl '92
— 1948 Truman campaign button
 Am Heritage 43:10 (c,4) F '92
— At daughter Margaret's wedding
 Life 19:80 (4) S '96
— Bowling
 Smithsonian 25:140 (4) D '94
— Home (Independence, Missouri)
 Am Heritage 43:54–5 (4) Jl '92
 Smithsonian 27:56 (c,4) S '96
— Swearing in as President (1945)
 Life 18:44 (4) Je 5 '95
— Margaret Truman
 Life 15:40 (1) O 30 '92
— Wife Bess
 Am Heritage 43:54,61 (3) Jl '92
TRUMBULL, JOHN
— Painting of the Declaration of Inde-
 pendence signers
 Am Heritage 44:93 (c,4) My '93
— Portrait of Jefferson
 Smithsonian 24:80 (painting,c,4) My '93
TRUMPET PLAYING
 Nat Geog 181:52 (c,2) Je '92
 Life 16:58–66 (c,1) Ag '93
 Smithsonian 25:95,99 (1) S '94
— Boy playing on New Orleans street
 Smithsonian 22:61 (2) F '92
— Wynton Marsalis
 Am Heritage 46:66 (c,1) O '95
— See also
 ARMSTRONG, LOUIS
 DAVIS, MILES
 GILLESPIE, JOHN BIRKS (DIZZY)
 JAMES, HARRY
TRUMPETS
— Dizzy Gillespie's trumpet
 Smithsonian 25:18 (c,4) Jl '94
TUAREG PEOPLE (MALI)
 Trav&Leisure 25:140,145–50 (c,1) F '95
TUAREG PEOPLE (NIGER)
 Natur Hist 101:54–62 (c,1) N '92
TUAREG PEOPLE—RITES AND
 CEREMONIES
— Infant's naming ceremony (Niger)
 Natur Hist 101:54–62 (c,1) N '92
TUBMAN, HARRIET
 Life 18:38 (4) Mr '95
TUCSON, ARIZONA
 Nat Geog 184:80–1,96,102–3 (c,1) Jl '93
 Nat Geog 186:44–5 (c,2) S '94
— Biosphere 2
 Trav&Leisure 22:21 (c,4) Ap '92
 Trav/Holiday 175:74–7 (c,1) My '92
 Smithsonian 25:16 (c,4) My '94
— Countryside around Tucson
 Gourmet 53:90 (c,4) O '93
 Trav/Holiday 179:30–1 (c,1) N '96

— Lightning over Tucson
 Nat Geog 184:80–1,96,102–3 (c,1) Jl '93
 Life 16:34–5 (c,1) S '93
— Mission San Xavier del Bac
 Am Heritage 44:52–3 (c,1) Ap '93
 Nat Geog 188:52–9 (c,1) D '95
 Smithsonian 26:66–7 (c,2) Mr '96
TULIP TREES
 Trav&Leisure 25:161 (c,4) D '95
— Leaves
 Natur Hist 102:60 (c,4) S '93
TUMBLEWEEDS
 Nat Geog 183:64–5 (c,1) Ja '93
TUNA
— Bluefin tuna
 Nat Wildlife 30:48–9 (c,4) O '92
TUNDRA
— Newfoundland
 Nat Geog 184:22–3 (c,1) O '93
TUNIS, TUNISIA
 Trav/Holiday 178:40–9 (map,c,2) N '95
TUNISIA
 Trav&Leisure 23:151–4 (map,c,3) F '93
— See also
 CARTHAGE
 TUNIS
TUNISIA—COSTUME
— Tunis
 Trav/Holiday 178:40–8 (c,2) N '95
TUNISIA—HOUSING
— Family hole-in-the-ground home
 Life 19:72–3 (c,1) S '96
TUNNELS
— Chunnel shuttle train, England/France
 Trav/Holiday 177:41 (c,4) O '94
 Trav&Leisure 25:172 (c,4) D '95
 Trav/Holiday 179:14 (c,4) O '96
— English Channel Tunnel
 Nat Geog 185:36–47 (c,1) My '94
— Drinking water tunnel (New York)
 Nat Geog 182:122 (c,4) N '92
— Spiral tunnels through Rocky Mountains
 (Alberta)
 Nat Geog 186:58–61 (c,1) D '94
— Yucca Mountain, Nevada
 Smithsonian 26:42 (c,4) My '95
TUNNELS—CONSTRUCTION
— English Channel Tunnel
 Nat Geog 185:36–47 (c,1) My '94
— New York City, New York
 Nat Geog 184:31 (c,1) N 15 '93
— New York City water tunnel
 Smithsonian 25:60–9 (c,1) Jl '94
TUNNEY, GENE
 Sports Illus 82:68 (4) Ap 17 '95

TURKEY
 Nat Geog 185:cov.,2–35 (map,c,1) My '94
— Ataturk Dam
 Nat Geog 183:46–7 (c,1) My '93
— Cappadocia
 Trav/Holiday 178:46–55 (map,c,1) S '95
— Lycian coast
 Gourmet 54:118–23,174 (map,c,1) O '94
— Mount Ararat
 Nat Geog 185:16–17 (c,1) My '94
— See also
 ANKARA
 BOSPORUS STRAIT
 ISTANBUL
 TIGRIS RIVER
 TROY
TURKEY—COSTUME
 Nat Geog 185:cov.,2–35 (c,1) My '94
— Late 19th cent. member of sultan's harem
 Trav&Leisure 24:30 (4) F '94
— Cappadocia
 Trav/Holiday 178:50,54 (c,1) S '95
— Children
 Smithsonian 22:37 (c,4) Ja '92
 Gourmet 56:91 (c,4) Je '96
— Istanbul
 Trav/Holiday 175:62–73 (c,1) Jl '92
— Kurdish people
 Nat Geog 182:32–61 (c,1) Ag '92
— Soldiers
 Nat Geog 185:6–7,12 (c,1) My '94
— Whirling Dervishes
 Trav&Leisure 22:50,52 (3) Je '92
 Nat Geog 185:cov. (c,1) My '94
— Women
 Life 15:10–11 (c,1) My '92
 Natur Hist 101:37–8,43 (c,4) Ag '92
TURKEY—HISTORY
— Prime Minister Tansu Ciller
 Smithsonian 26:119 (c,4) Mr '96
— Trojan War
 Smithsonian 22:28, 32–3 (painting,c,1) Ja
 '92
— See also
 ATATURK, KEMAL
 BYZANTINE EMPIRE
 OTTOMAN EMPIRE
 TROY
TURKEY—MAPS
— Map of 1683 Ottoman Empire
 Nat Geog 185:13 (c,4) My '94
**TURKEY—POLITICS AND GOVERN-
 MENT**
— Attack on Kurds
 Nat Geog 185:26–9 (c,1) My '94

TURKEY, ANCIENT—RUINS
— Ephesus
Trav/Holiday 175:18 (c,4) F '92
— See also
TROY
TURKEYS
Life 16:72–3 (c,1) N '93
Trav/Holiday 178:50 (c,1) S '95
Nat Wildlife 34:64 (c,1) O '96
— Wild turkeys
Nat Geog 181:68,74–7 (c,1) F '92
Trav&Leisure 25:107 (4) Je '95
Gourmet 56:122 (painting,c,4) N '96
TURKS AND CAICOS ISLANDS
Trav/Holiday 179:cov.,44–53 (map,c,1) F
'96
TURNER, FREDERICK JACKSON
Am Heritage 44:88–91 (3) Jl '93
TURNER, J.M.W.
— Painting of ship "Temeraire" (1838)
Natur Hist 104:18 (c,4) O '95
TURTLES
Sports Illus 80:2–3 (c,1) Ap 18 '94
— Baby turtle hatching from egg
Smithsonian 24:101 (c,3) Ap '93
— Blanding's turtle
Natur Hist 101:32–3 (c,3) F '92
— Box turtles
Natur Hist 101:46–7 (c,1) F '92
Natur Hist 102:34 (c,4) Ag '93
Nat Geog 188:94–5 (c,2) O '95
— Flattened musk turtle
Nat Wildlife 34:16 (1) D '95
— Green turtles
Natur Hist 103:cov.,36–43 (c,1) D '94
Natur Hist 105:46–51 (c,1) Ja '96
— Green sea turtles
Nat Wildlife 33:60 (c,1) Ap '95
— Hatchling
Smithsonian 24:115 (c,2) O '93
Natur Hist 103:41 (c,4) D '94
— Hawksbill
Nat Geog 184:63–4 (c,1) N '93
Nat Wildlife 32:2–3 (c,2) Je '94
Nat Geog 186:130 (c,3) Ag '94
Nat Wildlife 33:2–3 (c,2) D '94
— Leatherbacks
Natur Hist 101:28–35 (c,1) Mr '92
Nat Wildlife 31:38–9 (c,1) Ag '93
— Loggerheads
Nat Wildlife 30:18–25 (c,1) Ap '92
Nat Wildlife 32:10–11 (c,1) O '94
Nat Wildlife 33:18 (c,4) O '95
Nat Wildlife 34:10 (c,4) Ag '96
— Painted turtles

Natur Hist 101:22–3 (c,1) Ja '92
— Ritual turtle sacrific (Bali, Indonesia)
Natur Hist 105:48–51 (c,1) Ja '96
— Sea turtle varieties
Nat Geog 185:102–3 (painting,c,1) F '94
— Sea turtles
Nat Geog 185:cov.,94–121 (c,1) F '94
Natur Hist 104:36–43 (c,1) Ag '95
— Snapping turtles
Smithsonian 24:93–101 (c,2) Ap '93
Natur Hist 105:10–11 (painting,c,2) Ap
'96
— Turtle eggs
Natur Hist 104:40–1 (c,1) Ag '95
— Turtle evolution
Natur Hist 103:64–5 (drawing,4) Je '94
— See also
TORTOISES
TUTANKHAMUN (EGYPT)
— Bronze sculpture
Natur Hist 101:56 (c,4) Jl '92
— King Tut's funerary mask
Smithsonian 26:30 (c,4) Ap '95
TWAIN, MARK
Am Heritage 43:89 (4) O '92
Smithsonian 23:139 (4) N '92
Am Heritage 47:76 (4) O '96
— Home (Hannibal, Missouri)
Life 18:90 (c,4) Ap '95
Nat Wildlife 34:76 (4) O '96
— "Tom Sawyer"-inspired events (Hannibal,
Missouri)
Life 18:86–7 (c,2) Ap '95
TWILIGHT
— Bryce Canyon National Park, Utah
Trav&Leisure 22:90–1 (c,1) Jl '92
— Gomera harbor, Canary Islands
Trav/Holiday 175:80 (c,3) O '92
— Over Seneca Lake, New York
Gourmet 54:122 (c,4) N '94
— Trees in twilight
Nat Wildlife 32:10–11 (c,1) D '93
TWINS
— Dionne quintuplets
Smithsonian 27:38 (4) S '96
— Sets of twins on Little League team
(California)
Sports Illus 83:16 (c,4) Jl 3 '95
— Siamese twins
Life 19:cov.,44–56 (c,1) Ap '96
Life 19:10 (c,4) My '96
Life 19:136 (2) O '96
— "Supertwins" (multiple birth children)
Smithsonian 27:cov.,30–41 (c,1) S '96
— Triplet babies

Smithsonian 27:22 (c,4) N '96
— Twin ladies (France)
Life 17:96 (c,2) F '94
— Twin volleyball players
Sports Illus 78:34–5 (c,1) F 1 '93
— Voodoo wooden twin figures (West Africa)
Natur Hist 104:cov.,40–1 (c,1) O '95

TYLER, JOHN
— 1861 cartoon
Am Heritage 43:57 (drawing,4) N '92

TYPEWRITERS
— 1930s
Smithsonian 25:72 (4) D '94

–U–

UGANDA
Trav&Leisure 25:148–51 (map,c,4) N '95

UKRAINE
— 1986 Chernobyl nuclear disaster
Nat Geog 186:100–15 (c,1) Ag '94
— Crimea
Nat Geog 186:96–119 (map,c,1) S '94
— Crimean Mountains
Nat Geog 186:102–3 (c,1) S '94
— Strychowce
Smithsonian 23:62–76 (c,2) D '92
— See also
YALTA

UKRAINE—COSTUME
Smithsonian 23:62–76 (c,2) D '92
Nat Geog 183:38–53 (c,1) Mr '93
— Crimea
Nat Geog 186:96–119 (c,1) S '94
— Soldiers
Nat Geog 183:43 (c,3) Mr '93
— Traditional dress
Smithsonian 23:62,70 (c,2) D '92

UKRAINE—HOUSING
— 19th cent. thatched houses
Smithsonian 23:72 (c,4) D '92

UMBRELLAS
— Beach umbrella on deserted beach (Florida)
Trav/Holiday 178:cov. (c,1) Mr '95
— Beach umbrellas (France)
Trav&Leisure 22:118–19 (c,1) Je '92
— Sun umbrellas (Ghana)
Life 18:17 (c,2) N '95
— Thatched beach umbrellas (Sardinia, Italy)
Trav/Holiday 176:40–1 (c,2) Je '93
— Umbrella with British flag design
Gourmet 55:117 (c,2) D '95

UMIAKS
Natur Hist 101:40–7 (c,1) O '92

UNCLE SAM
— 1881 cartoon of Uncle Sam welcoming
immigrants
Am Heritage 43:47 (3) F '92
— 1898 depictions
Smithsonian 22:89,94 (painting,c,2) Mr
'92
— 1918 living portrait
Smithsonian 26:63 (4) Ja '96
— Cartoon depictions of Uncle Sam through
U.S. history
Smithsonian 26:70–3 (c,2) Jl '95
— Depicted in early 20th cent. patriotic
postcards
Smithsonian 25:34–7 (c,4) Jl '94
— Uncle Sam cooking at stove
Gourmet 54:96 (painting,c,2) O '94
Underground Railroad. See
BLACK HISTORY

U.S.S.R.
— Bukhara, Uzbekistan
Nat Geog 190:26–7 (c,1) D '96
— Catherine Palace, Pushkin
Smithsonian 23:34–5 (c,3) Ja '93
Nat Geog 184:112–13 (c,1) D '93
Natur Hist 105:98–9 (c,1) F '96
— Caucasus region
Nat Geog 189:126–31 (map,c,1) F '96
— Grozny, Chechnya
Life 18:14–15 (1) Ap '95
— Kamchatka Peninsula
Nat Geog 185:36–67 (map,c,1) Ap '94
Trav&Leisure 25:57–61,88–90 (map,c,1)
Ag '95
— Kuril Islands
Nat Geog 190:48–67 (map,c,1) O '96
— Kuril Lake, Kamchatka Peninsula
Natur Hist 103:28–31 (c,1) F '94
— Petropavlovsk
Nat Geog 185:40–1,44-5 (c,1) Ap '94
— Pollution problems
Nat Geog 186:70–99 (map,c,1) Ag '94
— Russia
Nat Geog 183:3–21 (map,c,1) Mr '93
Nat Geog 185:114–38 (map,c,1) Je '94
— Scenes along the Volga
Trav/Holiday 176:86–93 (map,c,2) Ap '93
Nat Geog 185:114–38 (map,c,1) Je '94
— Steppe countryside in snow
Nat Geog 182:44–5 (c,2) S '92
— See also
ARAL SEA
GEORGIA
HERMITAGE
KAZAKHSTAN

KREMLIN
LAKE BAIKAL
MOSCOW
NOVGOROD
ST. PETERSBURG
SIBERIA
UKRAINE
VOLGA RIVER
YALTA

U.S.S.R.—ART
— 4th cent. Scythian bowl
 Trav/Holiday 178:80 (c,4) Mr '95
— Czarist treasures
 Trav&Leisure 26:65–6 (c,4) Mr '96

U.S.S.R.—ARTIFACTS
— 4th cent. Scythian comb
 Smithsonian 25:54 (c,4) Mr '95

U.S.S.R.—COSTUME
 Nat Geog 182:40–61 (c,1) S '92
— 1945 Russian soldiers playing piano in
 bombed cafe (Germany)
 Life 18:32 (3) My '95
— Bulletproof police helmets
 Life 15:10–11 (c,1) Ap '92
— Chechen rebel soldiers
 Life 18:10–11 (c,1) F '95
— Children born without left forearms
 (Moscow)
 Nat Geog 186:72–3 (c,1) Ag '94
— Georgia
 Nat Geog 181:2–6 (c,1) F '92
— Kamchatka Peninsula
 Nat Geog 185:38–67 (c,1) Ap '94
— Kazakhstan
 Nat Geog 183:22–37 (c,1) Mr '93
 Smithsonian 25:26–34 (c,2) Ag '94
— Koryak people
 Nat Geog 185:62–7 (c,1) Ap '94
— Replicas of Romanov era dress
 Nat Geog 184:106–7 (c,1) D '93
— Russia
 Nat Geog 183:3–21 (c,1) Mr '93
— Russian child living in airport
 Life 16:76–82 (1) My '93
— Russian soldier on horseback
 Nat Geog 186:98–9 (c,2) O '94
— St. Petersburg
 Trav&Leisure 23:105–13 (c,1) N '93
 Nat Geog 184:98–119 (c,1) D '93
— Soviet Jews emigrating to Israel
 Nat Geog 181:40–65 (c,1) F '92
— Submarine crew
 Nat Geog 184:108–9 (c,1) D '93
— Tattoos on Russian convicts
 Natur Hist 102:50–9 (1) N '93

— Traditional (Alaska)
 Nat Geog 184:52 (c,4) N '93
— Traditional (Yaroslavl)
 Trav/Holiday 176:86 (c,4) Ap '93
— Winter festival garb
 Natur Hist 102:34–9 (c,1) Ja '93
— See also
 SIBERIA—COSTUME
 UKRAINE—COSTUME

U.S.S.R.—HISTORY
— 1917 Bolsheviks running from troops
 (Petrograd)
 Nat Geog 182:112 (3) O '92
— 1921 "Progress through Labor" poster
 Nat Wildlife 34:40 (c,3) Je '96
— 1930s skulls of Stalin purge victims
 Life 18:63 (c,4) Jl '95
— 1939 Hitler–Stalin pact
 Am Heritage 43:40 (cartoon,4) My '92
— 1940s U.S. posters about friendship with
 Russia
 Am Heritage 46:56,114 (c,4) D '95
— 1946 five-year plan poster
 Nat Wildlife 34:39 (c,3) Je '96
— Late 1980s posters promoting Eastern
 European revolutions
 Smithsonian 24:118–23 (c,2) Ap '93
— 1991 collapse of Communist regime
 Life 15:40–8 (c,1) Ja '92
— Forest memorial to Stalin's victims (Kiev)
 Nat Geog 182:124–5 (c,1) O '92
— History of Russian-American relations
 Am Heritage 43:64–73 (c,1) F '92
— Napoleon burning Moscow (1812)
 Trav/Holiday 178:67 (lithograph,c,4) S '95
— Kim Philby
 Smithsonian 24:116 (4) Mr '94
— Throne of Czar Paul I
 Trav&Leisure 26:66 (c,4) Mr '96
— World War II scenes
 Life 15:88–93 (1) Jl '92
— See also
 COMMUNISM
 KHRUSHCHEV, NIKITA
 LENIN, VLADIMIR
 MOLOTOV, VYACHESLAV
 PUSHKIN, ALEXANDER
 STALIN, JOSEF
 TROTSKY, LEON
 WORLD WAR II
 YELTSIN, BORIS

U.S.S.R.—POLITICS AND GOVERN-MENT
— 1991 collapse of Communist regime
 Life 15:40–8 (c,1) Ja '92

— 1993 attempted coup by Rutskoi
 Life 17:52 (c,3) Ja '94
— Chechen rebel soldiers
 Life 18:10–11 (c,1) F '95
 Life 19:24–5 (c,1) Ja '96
— Georgian shooting Abkhazian sniper
 Life 17:42–3 (c,1) Ja '94
— See also
 GORBACHEV, MIKHAIL
 YELTSIN, BORIS

U.S.S.R.—RITES AND FESTIVALS
— Bear Fest (Siberia)
 Natur Hist 102:34–41 (c,1) D '93
— End of winter celebrations
 Natur Hist 102:34–9 (c,1) Ja '93
— Group wedding in church (St. Petersburg)
 Nat Geog 184:119 (c,4) D '93
— Shaman ritual (Siberia)
 Natur Hist 101:34–41 (c,1) Jl '92

U.S.S.R.—SHRINES AND SYMBOLS
— Flags of former Soviet republics
 Sports Illus 77:26–7 (c,4) Jl 22 '92
— Russian nesting dolls depicting political
 leaders
 Trav&Leisure 23:107 (c,4) N '93
— Shrine to Stalin (Tbilisi, Georgia)
 Life 18:63 (c,2) Jl '95
— Statue representing hammer and sickle
 symbol
 Nat Geog 182:113 (c,1) O '92

**U.S.S.R.—SOCIAL LIFE AND CUS-
TOMS**
— Depressing view of Russian life
 Life 18:56–63 (c,1) Jl '95
— Sports
 Sports Illus 80:56–61 (c,2) Ja 10 '94
— Wrestling
 Sports Illus 85:180–8 (c,1) Jl 22 '96
Unions. See
 LABOR UNIONS

UNITAS, JOHNNY
 Sports Illus 85:106–7,112,119 (1) D 23 '96

UNITED NATIONS
— U.N. Building, New York City, New York
 Gourmet 55:62 (painting,c,2) S '95

UNITED STATES
— Scenes of small town America
 Smithsonian 24:42–9 (1) Mr '94
— Towns named "Paradise"
 Trav/Holiday 176:cov.,74–93 (map,c,1)
 Mr '93
— Western federal land use
 Nat Geog 185:2–39 (map,c,1) F '94
— See also
 APPALACHIAN MOUNTAINS

CHESAPEAKE BAY
MIDWEST
MISSISSIPPI RIVER
NATIONAL PARKS
NORTHWEST
ROCKY MOUNTAINS
SOUTHERN U.S.
SOUTHWESTERN U.S.
UNCLE SAM
WESTERN U.S.

U.S.—COSTUME—18TH CENT.
— 1792 couple (Connecticut)
 Am Heritage 43:102 (painting,c,4) S '92
— Colonial Williamsburg garb (Virginia)
 Trav/Holiday 179:72–6 (c,1) D '96

U.S.—COSTUME—19TH CENT.
— 1829
 Smithsonian 23:84–97 (painting,c,2) My
 '92
— 1830s farmer apparel (Massachusetts)
 Smithsonian 24:82 (c,1) S '93
— 1840s doctor (New Hampshire)
 Am Heritage 43:6 (painting,c,2) My '92
— 1843 woman's dress
 Life 16:68 (c,4) D '93
— Mid 19th cent. pioneers
 Life 16:14–17 (1) Ap 5 '93
— 1845 (Massachusetts)
 Am Heritage 44:6 (3) My '93
— 1849 (California)
 Am Heritage 47:39 (4) S '96
— 1850 fashionably dressed black men
 (Virginia)
 Life 18:35 (4) F '95
— 1850s Westerner with gun
 Am Heritage 47:50 (4) S '96
— 1853 political club members (Maine)
 Am Heritage 43:6 (2) S '92
— 1860s women's dresses
 Nat Geog 186:36–7 (c,1) O '94
— 1862 family (Virginia)
 Am Heritage 47:6 (painting,c,3) O '96
— 1864 couple
 Am Heritage 44:108 (3) D '93
— 1868 women (Kansas)
 Life 16:22–3 (1) Ap 5 '93
— 1870s man
 Am Heritage 45:110 (3) F '94
— Late 19th cent. (Minnesota)
 Life 16:20–1 (1) Ap 5 '93
— Late 19th cent. (New York)
 Am Heritage 43:54–5 (painting,c,1) F '92
 Nat Geog 183:32–3 (2) My '93
 Life 18:82–4 (1) Jl '95
— Late 19th cent. American tourists

Trav/Holiday 178:46–53 (map,c,1) Ap '95
— Late 19th cent. gentleman (Connecticut)
 Smithsonian 26:108 (4) F '96
— Late 19th cent. railroad workers (New
 York)
 Life 16:87 (3) F '93
— 1878 young women
 Smithsonian 23:cov. (painting,c,1) O '92
— 1880s
 Am Heritage 43:58–9 (painting,c,1) F '92
— 1880s wealthy people at resort
 (Pennsylvania)
 Am Heritage 43:120–7 (1) N '92
— 1886 bride and groom (Nebraska)
 Am Heritage 47:42 (4) S '96
— 1890s affluent black family
 Am Heritage 46:cov. (1) F '95 supp.
— 1890s
 Am Heritage 43:91,93 (2) My '92
 Am Heritage 47:85 (2) F '96
 Sports Illus 84:106 (4) Ap 29 '96
— 1893 (Illinois)
 Am Heritage 44:70–83 (1) Jl '93
— 1893 men (Colorado)
 Smithsonian 24:30 (4) D '93
— 1895 men (Ohio)
 Am Heritage 47:84–5 (1) D '96
— 1900
 Am Heritage 45:108–9 (1) Ap '94

U.S.—COSTUME—20TH CENT.
— Early 20th cent.
 Smithsonian 22:114 (4) Mr '92
 Life 15:4–5 (1) O 30 '92
 Am Heritage 43:cov. (painting,c,1) D '92
 Smithsonian 24:88 (4) Mr '94
 Life 15:8–9 (1) O 30 '92
 Smithsonian 27:116 (1) My '96
— Early 20th cent. laborers (New York)
 Life 16:86 (4) F '93
— Early 20th cent. society people
 Trav/Holiday 175:56–61 (c,1) F '92
 Smithsonian 23:61 (4) S '92
— Early 20th cent. women
 Smithsonian 27:34 (painting,c,4) O '96
— 1904
 Am Heritage 43:98 (1) F '92
— 1906 family (Pennsylvania)
 Am Heritage 43:117 (4) D '92
— 1910 (Colorado)
 Am Heritage 45:91–3 (2) Ap '94
— 1910s (New York)
 Am Heritage 45:68 (1) O '94
 Am Heritage 47:92–9 (1) S '96
— 1910 woman (Maine)
 Am Heritage 43:90–1 (1) Jl '92

— 1912 family (Missouri)
 Am Heritage 45:112 (3) Jl '94
— 1915 women's gowns on display at store
 Smithsonian 23:125 (2) Mr '93
— 1920s-1930s Appalachia
 Life 17:32–8 (1) D '94
— 1920s boy dressed up (New Jersey)
 Life 18:76 (1) O '95
— 1920s fashions inspired by Cubism
 Smithsonian 27:44 (painting,c,4) Jl '96
— 1922 society people (Washington, D.C.)
 Trav/Holiday 177:72 (4) S '94
— 1923 children (Kentucky)
 Am Heritage 47:92 (4) F '96
— 1924 women (Harlem, New York)
 Smithsonian 24:20 (4) Ja '94
— 1925 (Tennessee)
 Natur Hist 105:74–5 (2) Ap '96
— 1928 women (Oklahoma)
 Smithsonian 25:24 (4) F '95
— 1930 (Ohio)
 Am Heritage 46:40–1 (1) F '95 supp.
— 1930s (New York)
 Am Heritage 43:83–95 (1) N '92
 Smithsonian 24:20 (4) Ja '94
— 1930s country woman (Mississippi)
 Am Heritage 45:71 (4) Jl '94
— 1930s Depression photos (South)
 Life 15:80–8 (1) My '92
— 1930s girls in Sunday best (Washington,
 D.C.)
 Smithsonian 27:26 (4) My '96
— 1933 (Illinois)
 Am Heritage 45:44 (1) N '94
— 1934 children in tenement (New York City)
 Am Heritage 47:106–12 (c,1) N '96
— 1938 fashions
 Smithsonian 24:80 (painting,c,4) Mr '94
— 1940s-style apparel (California)
 Trav/Holiday 179:102–7 (c,1) D '96
— 1940 farm families (Pennsylvania)
 Trav&Leisure 22:E13 (3) Mr '92
— 1943 opera-goers (New York)
 Am Heritage 45:71 (2) O '94
— 1945
 Life 18:entire issue (c,1) Je 5 '95
— 1945 coeds (Colorado)
 Life 18:102–3 (1) Je 5 '95
— 1947
 Life 16:30–1 (1) Ap 5 '93
— 1950s women's lollipop dresses
 Life 18:116–17 (c,1) N '95
— 1954
 Am Heritage 45:30–9 (c,1) D '94
— 1957 family (Rhode Island)

Am Heritage 45:112 (c,3) S '94
— 1960s women's clothing
Life 18:118–19 (c,1) N '95
— 1962 society ladies in restaurant (Boston, Massachusetts)
Trav&Leisure 25:58 (4) My '95
— 1964 steamship passengers in formal dress
Trav&Leisure 26:E1 (3) Ag '96
— 1996 convention of 1970s leisure suits (Iowa)
Life 19:18–22 (c,2) F '96
— Women's fashions (1930s–1990)
Life 18:116–24 (c,1) N '95

U.S.—HISTORY
— 1936 to 1996
Life 19:entire issue (c,1) O '96
— Historical sites saved by the National Trust
Smithsonian 27:54–9 (c,2) S '96
— History of automobiles in America
Life 19:entire issue (c,1) Winter '96
— History of Russian–American relations
Am Heritage 43:64–73 (c,1) F '92
— History of violence in America
Am Heritage 47:cov.,36–51 (c,1) S '96
— Landmarks remaining from Spanish presence in the U.S.
Am Heritage 44:52-63,130 (c,1) Ap '93
— See also
SLAVERY
U.S. PRESIDENTS

U.S.—HISTORY—COLONIAL PERIOD
— 1692 Salem witch trials
Trav/Holiday 175:90 (painting,c,4) F '92
Smithsonian 23:116–28 (engraving,2) Ap '92
— 1704 Deerfield Massacre (Massachusetts)
Am Heritage 44:82–9 (c,1) F '93
— 1741 map of the colonies
Am Heritage 43:114 (c,3) F '92
— Strawbery Banke restored village, New Hampshire
Am Heritage 46:30–6 (c,4) D '95
— See also
FRANKLIN, BENJAMIN
MATHER, COTTON
WILLIAMSBURG
U.S.—History—Revolutionary War. See REVOLUTIONARY WAR

U.S.—HISTORY—1783-1861
— 1804 Lewis and Clark expedition route
Trav/Holiday 177:39,68–77 (map,c,1) Je '94
— 1830s nullification cartoon
Am Heritage 46:20 (4) O '95

— 1836 Battle of the Alamo, Texas
Sports Illus 78:9 (painting,c,4) Ap 19 '93
— 1836 San Jacinto battle against Mexico
Smithsonian 23:82–91 (painting,c,2) Jl '92
— 1844 anti-Catholic riot (Philadelphia, Pennsylvania)
Smithsonian 27:152 (painting,c,4) N '96
— 1846 movement west
Smithsonian 27:38–51 (c,1) Ap '96
— 1850s Know-Nothing movement
Smithsonian 27:150–8 (2) N '96
— 1854 opening of Japan to the West
Smithsonian 25:cov.,20–33 (painting,c,1) Jl '94
— 1920s bas-relief of Constitution framers
Am Heritage 47:12 (4) S '96
— Peggy Eaton and the Petticoat War (1829)
Smithsonian 23:84–97 (painting,c,2) My '92
— Scenes along the 1843 Oregon Trail
Am Heritage 44:26,60–76 (map,c,1) My '93
Life 16:63–72 (map,c,1) D '93
— See also
ALAMO
CIVIL WAR
GOLD RUSH
MEXICAN WAR
PONY EXPRESS

U.S.—HISTORY—1865-1898
— 1887 cartoon about need for railroad regulation
Am Heritage 47:22 (4) My '96
— 1895 cartoon about income tax
Am Heritage 47:122 (c,4) My '96
— Centennial celebration (New York)
Am Heritage 43:54–5 (painting,c,1) F '92
— History of the "Wild West"
Life 16:entire issue (c,1) Ap 5 '93
— See also
IMMIGRATION
KU KLUX KLAN
SPANISH–AMERICAN WAR

U.S.—HISTORY—1898-1919
— 1899 cartoon about monopolies
Am Heritage 47:16 (c,4) My '96
— See also
IMMIGRATION
WOMEN'S SUFFRAGE MOVEMENT

U.S.—HISTORY—1919-1933
— 1925 Scopes Trial (Dayton, Tennessee)
Natur Hist 105:74–5 (c,2) Ap '96
— See also
DEPRESSION
PROHIBITION

U.S.—HISTORY—1933-1953

— 1934 Dust Bowl crisis (Oklahoma)
 Life 16:26–7 (1) Ap 5 '93
— 1940 right-wing Christian Front militia
 (New York)
 Am Heritage 46:38–9,42 (1) S '95
— 1940s Levittown houses, Long Island,
 New York
 Am Heritage 44:62–9 (c,2) Jl '93
— 1940s-style night life (San Francisco,
 California)
 Trav/Holiday 179:102–7 (c,1) D '96
— 1942 first nuclear chain reaction (Chicago,
 Illinois)
 Smithsonian 23:22 (painting,c,4) F '93
— 1945 events
 Life 18:entire issue (c,1) Je 5 '95
— 1946 atomic testing (Bikini)
 Nat Geog 181:70–6 (c,1) Je '92
— 1950s scenes of U.S. life (Virginia)
 Life 19:7,96–100 (1) D '96
— Civilian Conservation Corps
 Smithsonian 25:66–78 (c,1) D '94
— Nixon examining "Pumpkin Papers" (1948)
 Life 17:20 (4) Je '94
— Quilt depicting 1952 events and
 personalities
 Am Heritage 44:102 (c,2) F '93
— See also
 DEPRESSION
 KOREAN WAR
 McCARTHY, JOSEPH
 WORLD WAR II

U.S.—HISTORY—1954-1960

— 1954 scenes
 Am Heritage 45:30–9 (c,1) D '94
— History of rock and roll
 Life 15:entire issue (c,1)) D 1 '92

U.S.—HISTORY—1961-

— 1960s fallout shelters
 Smithsonian 25:46–58 (1) Ap '94
— 1962 cartoon about the Cuban Missile
 Crisis
 Am Heritage 45:103 (c,4) S '94
— 1963 summer scenes
 Life 16:28–35 (c,1) Je '93
— 1964 Berkeley student protest, California
 Am Heritage 47:44 (2) O '96
— 1965 burning of Watts, California
 Am Heritage 47:48 (2) O '96
— 1968 events
 Sports Illus 79:30–7 (c,4) Jl 19 '93
— 1970 student shootings at Kent State, Ohio
 Life 18:39 (4) My '95
— 1973 line at gas pump (New York)

Life 16:28 (2) D '93
— 1991 events
 Life 15:entire issue (c,1) Ja '92
— 1991 release of Beirut hostage Terry
 Anderson
 Life 15:28–36 (c,1) F '92
— 1992 events
 Life 16:entire issue (c,1) Ja '93
— 1993 events
 Life 17:entire issue (c,1) Ja '94
— 1994 events
 Life 18:entire issue (c,1) Ja '95
— 1994 Woodstock II (New York)
 Life 17:12–13 (c,1) O '94
 Life 17:90–1,102 (c,1) N '94
 Life 18:48–9 (c,1) Ja '95
— 1995 events
 Life 19:entire issue (c,1) Ja '96
— Allegorical view of hippies by Dinnerstein
 Am Heritage 47:126 (painting,c,2) O '96
— History of rock and roll
 Life 15:entire issue (c,1) D 1 '92
— See also
 GULF WAR
 VIETNAM WAR

U.S.—MAPS

— 1741 map of the colonies
 Am Heritage 43:114 (c,3) F '92
— 1780s maps of cities
 Am Heritage 43:64–71 (c,1) D '92
— 1846
 Smithsonian 27:46 (c,2) Ap '96
— Cross-country route through northern U.S.
 Trav/Holiday 178:70–9 (c,2) Jl '95
— Route of the 1915 transcontinental Lincoln
 Highway
 Am Heritage 46:50 (c,4) Ap '95

U.S.—POLITICS AND GOVERNMENT

— 18th cent. Senate chamber (Philadelphia,
 Pennsylvania)
 Life 16:38 (c,2) My '93
— 1801 anti-Jefferson cartoon
 Am Heritage 44:91 (4) My '93
— 1829 Inaugural
 Smithsonian 23:88 (painting,4) My '92
— 1853 political club members (Maine)
 Am Heritage 43:6 (2) S '92
— 1940 right-wing Christian Front militia
 (New York)
 Am Heritage 46:38–9,42 (1) S '95
— Clinton on Inauguration Day 1993
 Life 16:32–43 (c,1) Mr '93
— History of U.S. political parties
 Am Heritage 43:43–59 (c,3) S '92
— House chamber

Life 19:69 (c,4) Ja '96
— Humorous view of early 19th cent.
 Congressmen's behavior
 Smithsonian 26:71–82 (painting,c,1) N '95
— Right-wing militia group (Michigan)
 Am Heritage 46:45–6 (c,4) S '95
— Scenes in a congresswoman's life
 Life 16:69–74 (c,1) Ap '93
— U.S. National Debt sign (New York City,
 New York)
 Nat Geog 183:86–7 (c,1) Ja '93
 Sports Illus 78:23 (c,4) Mr 1 '93
— See also
 CAPITOL BUILDING
 DECLARATION OF INDEPENDENCE
 ELECTIONS
 GOVERNMENT—LEGISLATURES
 POLITICAL CAMPAIGNS
 POLITICAL CARTOONS
 U.S. CONSTITUTION

U.S.—RITES AND FESTIVALS
— Lowering flag outside school (Minnesota)
 Life 15:70–1 (c,1) S '92
— Lowering U.S. flag (1934)
 Smithsonian 23:54 (4) Ja '93
— Pledging allegiance to flag in school
 (Minnesota)
 Life 15:72–3 (c,1) S '92
— Protocol for visiting dignitaries
 (Washington, D.C.)
 Life 15:18–26 (c,2) O 30 '92

U.S.—SEALS AND EMBLEMS
— U.S. Marine Corps emblem
 Smithsonian 24:43 (1) Ag '93

U.S.—SHRINES AND SYMBOLS
— 1824 U.S. flag "Old Glory"
 Smithsonian 24:12 (c,4) Jl '93
— 1918 men assembled into living patriotic
 symbols
 Smithsonian 26:58–63 (1) Ja '96
— 1944 Purple Heart for dead sailor
 Life 18:63 (c,2) Je 5 '95
— American cultural icons
 Smithsonian 25:18 (c,4) Jl '94
— Semiotic analysis of modern American
 symbols
 Smithsonian 24:65–72 (c,1) S '93
— Symbols of America pictured with
 American foods
 Gourmet 53:34,64 (painting,c,4) Ap '93
— See also
 DECLARATION OF INDEPENDENCE
 INDEPENDENCE HALL
 LIBERTY, STATUE OF
 LIBERTY BELL

 UNCLE SAM

U.S.—SOCIAL LIFE AND CUSTOMS
— Early 20th cent. German views of
 American culture
 Am Heritage 46:6–9 (1) My '95
— Early 20th cent. history of Reno divorce
 industry, Nevada
 Smithsonian 27:64–73 (c,1) Je '96
— 1913 anti-divorce cartoon
 Smithsonian 27:70 (4) Je '96
— American party behavior
 Life 17:75–102 (c,1) N '94
— American tradition of low humor
 Am Heritage 44:106–7 (painting,c,1) O
 '93
— Male bonding groups (18th-20th cents.)
 Am Heritage 44:37–45 (c,3) S '93
— Semiotic analysis of modern American
 symbols
 Smithsonian 24:65–72 (c,1) S '93
— U.S. social problems
 Life 15:4–6 (c,2) Je '92
— See also
 LIFESTYLES

U.S. AIR FORCE
— 1951 pilots
 Am Heritage 44:31 (4) D '93
— Barbie and Ken in Air Force uniforms
 Smithsonian 26:30 (c,4) Je '95

U.S. ARMY
— 1920s-1930s U.S. Army
 Am Heritage 43:98–106 (1) D '92
— Listening to draft lottery (1969)
 Life 17:40 (3) D '94
— Buffalo Soldier Monument to black
 soldiers (Leavenworth, Kansas)
 Am Heritage 44:8 (c,3) F '93
— Post-war disposition of war surplus (1940s)
 Smithsonian 26:52–63 (c,2) D '95
— Franklin Roosevelt reviewing the troops
 (1943)
 Am Heritage 45:90–1 (2) My '94
— Testing "smart gear" for combat use
 Nat Geog 188:26–7 (c,1) O '95
— U.S. military presence in Haiti
 Life 17:56–63 (c,1) N '94
— World War II chaplain's possessions
 Life 17:50–1 (c,1) Je '94
— See also
 MILITARY COSTUME
 PENTAGON BUILDING
 list under MILITARY LEADERS

U.S. COAST GUARD
— Coast Guard cadet training
 Smithsonian 26:22–33 (c,1) Ag '95

— Officers
 Nat Geog 184:54–5 (c,1) D '93
U.S. CONSTITUTION
— 1920s bas-relief of Constitution framers
 Am Heritage 47:12 (4) S '96
U.S. MARINES
— Marine emblem
 Smithsonian 24:43 (1) Ag '93
U.S. NAVY
— 1945 show of Navy ships (New York)
 Life 18:96–7 (1) Je 5 '95
— 1946 sailors preparing for atom bomb test
 (Bikini)
 Nat Geog 181:73 (1) Je '92
— Graduating naval cadets tossing caps in air
 (Maryland)
 Life 19:12–13 (1) Jl '96
— Midshipmen jumping into creek
 (Maryland)
 Life 16:12–13 (c,1) Ag '93
— Museum of Naval Aviation, Pensacola,
 Florida
 Trav&Leisure 22:140 (c,4) Mr '92
— Navy SEAL tortuous training exercise
 (California)
 Life 19:8–9 (c,1) Ag '96
— See also
 PERRY, OLIVER HAZARD
 SAILORS
U.S. PRESIDENTS
— 1861 cartoon of mid-19th cent. presidents
 bickering
 Am Heritage 43:57 (4) N '92
— 20th cent. presidents
 Smithsonian 25:100–5 (2) O '94
— Mid 20th cent. presidents
 Life 17:107 (4) N '94
 Life 18:70 (caricatures,4) Ja '95
— 1945 swearing in of Harry Truman
 Life 18:44 (4) Je 5 '95
— Late 20th cent. presidents
 Life 15:78 (4) Ja '92
— Children of presidents
 Life 15:34–41,44–5 (c,1) O 30 '92
— Computer-generated composite of recent
 presidents
 Am Heritage 46:86 (4) Jl '95
— First Ladies through history
 Smithsonian 23:135–58 (c,2) O '92
 Life 15:80–5 (c,1) O 30 '92
— Lifestyle of Vice President Gore's wife
 Tipper
 Life 17:82–7 (c,1) Mr '94
— Pets of presidents
 Life 15:44–5 (3) O 30 '92

— Presidents throwing out first baseball of
 season
 Sports Illus 78:2–3,84–7 (c,1) Ap 12 '93
— Scenes of presidents at White House
 Trav/Holiday 175:71–7,101,110 (c,4) N
 '92
— Vice presidents' signatures carved into
 desk
 Life 17:92 (c,2) Mr '94
— See also
 WASHINGTON, GEORGE
 ADAMS, JOHN
 JEFFERSON, THOMAS
 ADAMS, JOHN QUINCY
 JACKSON, ANDREW
 VAN BUREN, MARTIN
 HARRISON, WILLIAM HENRY
 TYLER, JOHN
 POLK, JAMES KNOX
 TAYLOR, ZACHARY
 FILLMORE, MILLARD
 PIERCE, FRANKLIN
 BUCHANAN, JAMES
 LINCOLN, ABRAHAM
 GRANT, ULYSSES S.
 HAYES, RUTHERFORD B.
 CLEVELAND, GROVER
 McKINLEY, WILLIAM
 ROOSEVELT, THEODORE
 TAFT, WILLIAM HOWARD
 WILSON, WOODROW
 HARDING, WARREN G.
 COOLIDGE, CALVIN
 HOOVER, HERBERT
 ROOSEVELT, FRANKLIN DELANO
 TRUMAN, HARRY S.
 EISENHOWER, DWIGHT DAVID
 KENNEDY, JOHN FITZGERALD
 JOHNSON, LYNDON BAINES
 NIXON, RICHARD M.
 FORD, GERALD
 CARTER, JIMMY
 REAGAN, RONALD
 BUSH, GEORGE
 CLINTON, BILL
 WHITE HOUSE
UNIVERSE
 Nat Geog 185:2–41 (map,c,1) Ja '94
— Artists' renditions of the cosmos
 Natur Hist 105:32–4 (painting,c,3) F '96
— Brown dwarf
 Natur Hist 105:62–3 (c,4) Mr '96
— Photos taken by Hubble telescope
 Smithsonian 22:99–101 (c,2) Mr '92
 Natur Hist 105:60–1 (c,1) Jl '96

— Study of dark matter
 Smithsonian 24:26–35 (c,1) Je '93
— Time exposure of star movement in night
 sky
 Life 17:23–4 (c,1) S '94
— Types of eclipses
 Nat Geog 181:40 (c,4) My '92
— Views of space
 Life 15:cov.,60–8 (c,1) S '92
— See also
 ASTEROIDS
 ASTRONOMY
 AURORA BOREALIS
 COMETS
 CONSTELLATIONS
 EARTH
 ECLIPSES
 GALAXIES
 JUPITER
 MARS
 METEORITES
 MILKY WAY
 MOON
 NEBULAE
 OBSERVATORIES
 QUASARS
 SATURN
 STARS
 SUN
 TELESCOPES
 VENUS

UPDIKE, JOHN
 Life 15:24 (4) S '92
 Am Heritage 43:105 (4) O '92

UTAH
 Nat Geog 189:48–77 (map,c,1) Ja '96
— 1896 statehood celebration
 Am Heritage 47:75–6 (3) Ap '96
— Anasazi cliff dwellings
 Trav/Holiday 179:55 (c,1) Je '96
— Brigham City
 Nat Geog 189:58–9 (c,1) Ja '96
— Countryside
 Trav&Leisure 24:68–9 (c,1) Ag '94
 Smithsonian 25:85 (c,1) Ag '94
— Dead Horse Point
 Trav/Holiday 179:52 (c,4) Je '96
— Four Corners countryside
 Trav&Leisure 24:68–75,106–7 (map,c,1)
 Ag '94
 Nat Geog 190:cov.,80–97 (map,c,1) S '96
— Grand Gulch
 Nat Geog 189:100–1 (c,1) Ap '96
— Manti
 Am Heritage 44:65–7 (c,1) Ap '93

— Mule Ear Rock
 Nat Geog 190:91 (c,4) S '96
— Paradise
 Trav/Holiday 176:77,86–7 (c,3) Mr '93
— San Juan River
 Trav&Leisure 26:E8–E14 (c,2) My '96
— Scenes along 1869 route of explorer John
 Wesley Powell
 Nat Geog 185:86–115 (map,c,1) Ap '94
— Sites along the Mormon Pioneer Trail
 Am Heritage 44:65–82 (c,1) Ap '93
— Sundance
 Gourmet 54:48 (c,4) Ag '94
— Virgin
 Life 19:77–85 (1) Ap '96
— See also
 ARCHES NATIONAL PARK
 BRYCE CANYON NATIONAL PARK
 CANYONLANDS NATIONAL PARK
 CAPITOL REEF NATIONAL PARK
 GREAT SALT LAKE
 MORMONS
 RAINBOW BRIDGE NATIONAL
 MONUMENT
 SALT LAKE CITY
 WASATCH RANGE
 YOUNG, BRIGHAM
 ZION NATIONAL PARK

UTE INDIANS—COSTUME
— 1868
 Smithsonian 25:20 (4) D '94

–V–

VACCINATIONS
— 1950s polio vaccination
 Life 19:89 (4) Ja '96
— Administering measles vaccine to child
 (1962)
 Am Heritage 45:30 (4) F '94
— Brazil
 Nat Geog 186:58–9 (c,1) Jl '94
— Vaccinating dog
 Natur Hist 105:14–15 (c,2) Je '96

VACUUMING
— Vacuuming ceremonial "red carpet"
 outside White House, D.C.
 Life 15:18 (c,2) O '92
— Vacuuming the White House, Washington,
 D.C.
 Life 18:70–1 (1) Ag '95

VALENTINE'S DAY
— Heart-shaped outdoor ice sculptures
 (Alaska)

Nat Geog 184:39 (c,3) N '93
VALLETTA, MALTA
Smithsonian 27:72–3 (c,1) S '96
VALLEY FORGE, PENNSYLVANIA
Trav/Holiday 179:68–77 (1) F '96
VAMPIRE BATS
Natur Hist 105:12 (c,4) S '96
Natur Hist 105:6 (c,4) N '96
VAN BUREN, MARTIN
— 1848 campaign songbook
Am Heritage 43:44 (c,4) S '92
— 1861 cartoon
Am Heritage 43:57 (drawing,4) N '92
VANCOUVER, BRITISH COLUMBIA
Nat Geog 181:94–121 (map,c,1) Ap '92
Gourmet 53:54–7,108 (map,c,1) Jl '93
Nat Geog 186:65 (c,1) D '94
Trav&Leisure 26:130–7,162–5 (map,c,1)
 Mr '96
Trav/Holiday 179:64–9 (c,1) Je '96
— Broken Islands
Trav/Holiday 176:70,74–5 (map,c,3) S '93
— Chinatown
Trav/Holiday 179:64–9 (c,1) Je '96
— Coastal scenes
Trav/Holiday 176:68–75 (map,c,1) S '93
— Outdoor crab sculpture
Gourmet 53:57 (c,1) Jl '93
— UBC Museum of Anthropology
Gourmet 53:55 (c,1) Jl '93
VANDERBILT FAMILY
— Biltmore estate, Asheville, North Carolina
Am Heritage 43:26 (c,4) My '92
Smithsonian 23:58–71 (c,1) S '92
Trav&Leisure 25:82–3,87–9 (c,1) Jl '95
— The Breakers mansion, Newport, Rhode
 Island
Trav&Leisure 26:62 (c,4) Je '96
— New York City mansion parlor
Am Heritage 46:75 (c,1) F '95
— George Vanderbilt
Smithsonian 23:61 (4) S '92
VAN DYCK, ANTHONY
— Portrait of Charles I
Smithsonian 24:74 (painting,c,4) Mr '94
VAN GOGH, VINCENT
— Home (Auvers-sur-Oise, France)
Trav&Leisure 24:22 (c,4) Ja '94
— "Joseph-Etienne Roulin" (1889)
Smithsonian 24:100 (painting,c,2) My '93
— "Starry Night"
Natur Hist 104:20 (painting,c,4) S '95
— "Sunflowers"
Smithsonian 27:61 (painting,c,2) Ag '96

VARANASI, INDIA
Life 15:74–5,80–1 (c,1) Mr '92
VATICAN CITY
Nat Geog 188:72–3 (c,1) Ag '95
— Gallery of Maps
Trav&Leisure 24:56–8 (c,4) D '94
— Sistine Chapel ceiling
Trav/Holiday 179:28 (c,4) D '96
VEGETABLES
Smithsonian 22:70–3 (c,1) F '92
— American vegetables
Life 16:65 (c,1) My '93
— Autumn vegetables
Nat Geog 181:62–3 (c,1) My '92
— Display of produce (Great Britain)
Trav&Leisure 25:124–5 (c,1) F '95
— Farm stand
Gourmet 53:58–9 (c,1) Ag '93
— Leeks
Gourmet 53:186 (drawing,4) S '93
— Unusual varieties
Smithsonian 22:70–3 (c,1) F '92
— See also
CORN
GARLIC
PEPPERS
POTATOES
PUMPKINS
TOMATOES
VELASQUEZ, DIEGO
— Deem painting done in Velasquez style
Smithsonian 24:101 (c,4) Jl '93
— "Las Meninas" (1656)
Smithsonian 22:54 (painting,c,2) Ja '92
Trav/Holiday 176:71 (painting,c,4) Mr '93
Trav/Holiday 178:82 (painting,c,4) Mr '95
VENEZUELA
— Margarita Island
Trav/Holiday 177:22 (c,4) F '94
— Marshes
Smithsonian 27:45,50 (c,1) S '96
VENEZUELA—COSTUME
— Cowhands
Nat Geog 185:40–1,54–5 (c,1) Mr '94
— Yanomami people
Natur Hist 104:56–65 (c,1) Ap '95
Venezuela—history. See
BOLIVAR, SIMON
VENICE, ITALY
Trav&Leisure 23:130–40,168 (map,c,1) D
 '93
Gourmet 54:104–9,160 (c,2) S '94
Nat Geog 187:70–99 (map,c,1) F '95
Trav/Holiday 178:37 (c,4) F '95

Trav&Leisure 26:101–9,143–5 (map,c,1)
My '96
Trav/Holiday 179:cov.,64–71 (c,1) S '96
Trav&Leisure 26:124 (c,1) O '96
— 15th cent.
Trav/Holiday 175:67 (painting,c,2) My '92
— 1890
Life 16:88 (2) Ap 5 '93
— Basilica of San Marco
Nat Geog 187:78–9 (c,1) F '95
— Cipriani Hotel
Trav&Leisure 22:94–5 (c,1) S '92
— La Fenice opera house interior
Trav&Leisure 22:15 (c,4) O '92
— Grand Canal
Trav/Holiday 178:cov. (c,1) Ap '95
— Impressionistic views of Venice
Trav&Leisure 26:184–6,248–50 (1) S '96
— Piazza San Marco
Gourmet 54:108 (c,3) S '94
— Romantic couple in gondola
Sports Illus 81:50–1 (c,1) S 26 '94
— See also
GONDOLAS

VENUS
— Botticelli's "Birth of Venus"
Natur Hist 102:60–1 (painting,c,1) N '93

VENUS (PLANET)
Nat Geog 183:37–59 (c,1) F '93
Natur Hist 102:62–5 (c,1) N '93
Natur Hist 105:82 (c,4) F '96

VENUS'S-FLYTRAPS
Smithsonian 23:58–9 (c,3) D '92
Life 17:112 (c,3) Ap '94
Nat Wildlife 33:56 (c,4) Ap '95

VERACRUZ, MEXICO
Trav&Leisure 22:98–101,149 (map,c,1) N
'92
Nat Geog 190:62–9 (c,1) Ag '96
— Totonalas Indian ruins
Natur Hist 105:51 (c,4) O '96

VERBENAS
— Sand verbena
Nat Wildlife 35:29 (c,1) D '96

VERDI, GIUSEPPE
Smithsonian 26:98 (painting,c,4) D '95
— Tomb (Milan, Italy)
Smithsonian 26:99 (c,1) D '95

VERMEER, JOHANNES
— "The Concert"
Smithsonian 26:34 (painting,c,4) S '95
— Deem painting in style of Vermeer
Smithsonian 24:100–1 (c,4) Jl '93
— "Girl with a Pearl Earring"
Life 18:39 (painting,c,4) N '95

— Paintings by him
Smithsonian 26:cov.,111–19 (c,1) N '95

VERMONT
Am Heritage 43:47–55 (map,c,3) Ap '92
— Bennington Battle monument
Am Heritage 43:52 (c,4) Ap '92
— Camel's Hump State Park
Natur Hist 105:54–6 (map,c,1) Jl '96
— Country inn
Trav/Holiday 179:36–8 (c,3) O '96
— Countryside
Gourmet 52:58–61 (c,1) Ag '92
Gourmet 56:95–6 (c,2) S '96
— Covered bridge
Trav&Leisure 22:NE1 (c,1) My '92
Gourmet 52:60 (c,4) Ag '92
— History of Windsor Prison
Am Heritage 47:100–9 (c,1) My '96
— Kipling's home (Brattleboro)
Trav&Leisure 24:E8 (c,4) Je '94
— Lamoille River
Gourmet 52:60–1,114 (map,c,1) Ag '92
— Manchester
Gourmet 54:133–4 (c,2) D '94
— Middlebury
Trav/Holiday 179:36–7 (c,4) O '96
— Ottauquechee River
Trav/Holiday 178:65 (c,1) F '95
— Shelburne mansion
Trav/Holiday 178:10 (c,4) D '95
— Tunbridge
Am Heritage 43:48 (c,3) Ap '92
— Victory
Smithsonian 26:80–1 (2) S '95
— White River
Trav&Leisure 25:E2 (c,4) Ag '95
— Winooski River
Gourmet 52:58–9,114 (map,c,1) Ag '92
— Winter scenes
Gourmet 54:132–6 (c,1) D '94
Trav/Holiday 178:62–9 (c,1) F '95
— Woodstock
Gourmet 54:127 (c,1) O '94
Am Heritage 46:28 (c,4) My '95
— Woodstock (1940)
Life 15:83 (4) My '92
— See also
ALLEN, ETHAN
CONNECTICUT RIVER
LAKE CHAMPLAIN
MONTPELIER

VERMONT—MAPS
Gourmet 55:116 (c,2) N '95

VESUVIUS, ITALY
— 1777 painting of Vesuvius erupting

Trav/Holiday 178:53 (c,4) Ap '95
— Cast of 79 A.D. victim of Mt. Vesuvius
 (Pompeii, Italy)
 Nat Geog 182:9 (c,3) D '92
— Victims of 79 A.D. Vesuvius eruption
 Life 19:54–5 (1) Je '96
VETCHES
— Milk vetch
 Natur Hist 102:14 (c,4) Ag '93
VETERINARIANS
— New York
 Smithsonian 27:36–45 (c,1) O '96
— Performing eye surgery on dog (New York)
 Smithsonian 27:41 (c,1) O '96
— Performing laparoscopy on lioness
 (Washington, D.C.)
 Nat Geog 184:18 (c,1) Jl '93
— Tiger undergoing CAT scan
 Life 16:20 (c,2) D '93
— Vaccinating dog
 Life 15:92 (2) Ag '92
 Natur Hist 105:14–15 (c,2) Je '96
— Veterinary medicine (Illinois)
 Life 15:64–70 (c,1) O '92
VICTORIA (GREAT BRITAIN)
— Daughter Louise as bride
 Natur Hist 102:60 (2) D '93
**VICTORIA FALLS, ZAMBIA/ZIM-
 BABWE**
 Trav/Holiday 175:68 (c,4) N '92
 Trav&Leisure 22:94–5 (c,1) N '92
 Life 18:98–9 (c,1) N '95
VICUNAS
 Trav&Leisure 24:50 (c,4) N '94
VIDAL, GORE
— As a child
 Am Heritage 43:66–7 (5) S '92
VIDEO GAMES
— Children playing (Mexico)
 Nat Geog 190:68 (c,3) Ag '96
— Playing at arcade
 Smithsonian 27:97 (c,2) D '96
— Playing at arcade (Japan)
 Trav/Holiday 176:46 (c,4) My '93
— Playing home video game
 Sports Illus 83:61 (c,4) D 11 '95
— Training video game creators
 Smithsonian 27:86–97 (c,1) D '96
— See also
 VIRTUAL REALITY
VIENNA, AUSTRIA
 Trav/Holiday 177:68–79 (map,c,1) Mr '94
 Trav&Leisure 24:88–97,138 (c,1) O '94
— Cafe Griensteidl (early 20th cent.)
 Smithsonian 27:110 (painting,c,4) S '96

— Coffeehouses
 Gourmet 56:124–7,192 (c,1) D '96
— Hofburg
 Trav/Holiday 177:70 (3) Mr '94
 Trav/Holiday 179:68 (c,4) O '96
— KunstHausWien Museum
 Trav/Holiday 175:121 (c,4) Mr '92
— Making sachertortes
 Gourmet 56:94 (c,4) D '96
— Parliament Building
 Trav&Leisure 26:cov. (c,1) Jl '96
— Pastry shops
 Trav/Holiday 179:68–73 (c,1) O '96
 Gourmet 56:124–7,192 (c,1) D '96
— Prater ferris wheel
 Trav/Holiday 177:71 (3) Mr '94
— Theater Museum
 Gourmet 52:86–91 (c,1) Je '92
VIENTIANE, LAOS
— That Luang temple
 Trav&Leisure 23:72 (c,4) N '93
VIETNAM
 Trav&Leisure 23:98–109 (map,c,1) Ap '93
 Smithsonian 26:cov.,32–43 (c,1) Ja '96
— Mekong Delta area
 Nat Geog 183:2–3,13,26–35 (map,c,1) F
 '93
 Trav&Leisure 25:171–81,197–202
 (map,c,1) O '95
— Phung Hiep
 Nat Geog 183:26–7 (c,1) F '93
— Thuy Son sanctuary, Da Nang
 Trav/Holiday 177:60–1 (c,1) Jl '94
— Truon Son Mountains
 Gourmet 55:88–9 (c,1) S '95
— See also
 CHINA SEA
 HANOI
 HO CHI MINH CITY
 MEKONG RIVER
VIETNAM—COSTUME
 Nat Geog 183:2–9,28–35 (c,1) F '93
 Trav&Leisure 23:101–9 (c,1) Ap '93
 Nat Geog 187:60–87 (c,1) Ap '95
 Gourmet 55:88–91 (c,1) S '95
 Trav&Leisure 25:171–9,197–202 (c,1) O
 '95
 Smithsonian 26:cov.,34–43 (c,1) Ja '96
— 1971 family
 Life 17:36 (4) Jl '94
— Ao dai traditional women's dress
 Trav&Leisure 24:60 (c,4) O '94
 Nat Geog 187:64–5 (c,2) Ap '95
— Fishermen
 Life 17:19–21 (c,1) O '94

— Reunion of Vietnamese family (Indiana)
Life 17:36–44 (c,1) Jl '94
— Vietnamese immigrants (California)
Smithsonian 23:28–39 (c,1) Ag '92
VIETNAM—HISTORY
— General Vo Nguyen Giap
Life 18:61 (1) Je '95
— See also
HO CHI MINH
VIETNAM WAR
VIETNAM—HOUSING
— Homes on riverbank
Trav/Holiday 176:36 (c,4) N '93
VIETNAM—MAPS
Trav/Holiday 176:38 (c,4) N '93
VIETNAM—RITES AND FESTIVALS
— Tet festival (California)
Smithsonian 23:28–9,36–8 (c,1) Ag '92
**VIETNAM—SOCIAL LIFE AND CUS-
TOMS**
— Men reading newspapers
Life 18:18 (c,2) Ap '95
VIETNAM WAR
— 1960s bomb craters (Laos)
Natur Hist 104:50 (c,1) S '95
— 1967 anti-war protesters
Life 18:110 (4) Je 5 '95
Life 18:90 (2) O '95
— 1968 My Lai Massacre
Life 17:48 (c,4) N '94
Life 19:114 (c,4) O '96
— Anti-war Berrigan brothers
Life 18:62 (4) Je '95
— Evacuating people by helicopter (1975)
Nat Geog 187:64 (4) Ap '95
— General Vo Nguyen Giap
Life 18:61 (1) Je '95
— Girl burned by napalm in 1972
Life 18:44–5 (c,1) My '95
Life 19:102 (c,3) O '96
— Grieving civilian
Life 19:78 (c,3) Ag '96
— Offerings left at Vietnam Veterans
Memorial
Am Heritage 46:cov.,6,92–103 (c,1) F '95
Smithsonian 26:54–9 (c,1) My '95
— Personalities from the war
Life 18:6,60–9 (1) Je '95
— Photos of one week's dead (1969)
Life 19:80–1 (4) O '96
— 10-year-old South Vietnamese soldier
(1968)
Life 19:30 (4) N '96
— U.S. military advisors celebrating 1958
Christmas (Saigon)

Am Heritage 47:112 (2) D '96
— U.S. soldiers
Sports Illus 79:65–7 (c,1) O 4 '93
Am Heritage 46:132 (4) Ap '95
Life 19:92–3 (c,1) O '96
— Vietcong prisoner (1966)
Am Heritage 46:96 (c,4) Jl '95
— Vietnam Veterans Memorial, Washington,
D.C.
Life 15:cov.,24–36 (c,1) N '92
Am Heritage 46:cov.,93 (c,1) F '95
Life 18:57 (4) Je '95
Trav/Holiday 179:75 (c,4) Mr '96
VIKINGS—ARTIFACTS
— 1000 year old ship (Norway)
Trav/Holiday 175:78 (c,4) D '92
VIKINGS—HUMOR
— Vikings ice skating
Smithsonian 23:96–7 (painting,c,2) Je '92
VILLA, PANCHO
Smithsonian 22:112 (4) Mr '92
Trav/Holiday 178:55 (4) D '95
VILLAGES
— Casares, Spain
Nat Geog 181:10–11 (c,1) Ap '92
— Cirauqui, Spain
Smithsonian 24:70 (c,4) F '94
— Curaglia, Italy
Smithsonian 24:58 (c,2) N '93
— Drumkeerin, Ireland
Natur Hist 101:58–9 (1) O '92
— Gordes, France
Gourmet 52:84–5 (c,1) F '92
— Lipari, Italy
Nat Geog 186:28–9 (c,2) N '94
— Lorippo, Switzerland
Gourmet 56:69 (c,3) Jl '96
— Madeira, Portugal
Nat Geog 186:92–3 (c,1) N '94
— Scenes of small town America
Smithsonian 24:42–9 (1) Mr '94
— South Kortright, New York
Nat Geog 182:125 (c,3) N '92
— Stylized depiction of Austrian village
Gourmet 54:102 (painting,c,2) N '94
— Vernazza, Italy
Gourmet 52:84–5,89 (c,1) S '92
— Yali village (Indonesia)
Nat Geog 189:10–11 (c,2) F '96
VINES
Smithsonian 24:112–16 (c,3) S '93
— See also
HOPS PLANTS
VETCHES

VINEYARDS
— California
 Gourmet 54:74 (painting,c,2) N '94
 Trav&Leisure 25:34 (c,4) Ag '95
 Gourmet 55:80–2 (c,1) S '95
 Smithsonian 26:108 (c,4) D '95
 Trav/Holiday 179:30–1 (c,1) O '96
— France
 Trav/Holiday 175:82 (c,1) My '92
 Gourmet 53:48,52 (painting,c,2) D '93
 Gourmet 54:54–6 (painting,c,2) Mr '94
 Gourmet 55:99 (drawing,4) N '95
 Trav/Holiday 178:50–1 (c,1) N '95
— Georgia, U.S.S.R.
 Nat Geog 181:106–7 (c,1) My '92
— Germany
 Trav/Holiday 177:52 (c,2) S '94
 Gourmet 55:132–3 (c,1) N '95
— Italy
 Gourmet 53:83–4 (c,1) Mr '93
 Trav/Holiday 176:70 (c,1) Ap '93
 Gourmet 53:64 (painting,c,2) My '93
— New Zealand
 Gourmet 55:105–8 (c,1) Ap '95
— Oregon
 Life 17:92–3 (c,1) Ap '94
 Trav&Leisure 24:E9–10 (c,4) S '94
— South Africa
 Trav/Holiday 177:63 (c,4) O '94
 Trav&Leisure 26:57 (c,1) Ag '96
— Stylized depiction of California vineyard
 Gourmet 53:38 (painting,c,2) Je '93
— Vines interspersed with oats (California)
 Nat Geog 188:70–1 (c,1) D '95
VIOLETS
 Natur Hist 105:63 (c,4) Ap '96
VIOLIN PLAYING
 Smithsonian 25:91,94 (4) Je '94
— Child at violin lesson (Pennsylvania)
 Nat Geog 187:7 (c,3) Je '95
— Child playing violin (Germany)
 Trav&Leisure 24:114 (2) F '94
— Children practicing
 Life 15:12–13,21 (c,1) Ag '92
— Fiddling at pub (Ireland)
 Nat Geog 186:28 (c,3) S '94
— In restaurant (Budapest, Hungary)
 Trav/Holiday 175:62 (2) My '92
— New York shopkeeper playing violin
 Smithsonian 25:91 (1) Ap '94
— Playing bluegrass music (West Virginia)
 Smithsonian 23:68,72 (c,2) Mr '93
— String quartet tuning up (Finland)
 Trav/Holiday 178:62 (c,3) Je '95
— See also

 HEIFETZ, JASCHA
 STERN, ISAAC
VIOLINS
 Smithsonian 22:60 (painting,c,4) Mr '92
VIPERS
 Natur Hist 104:48–9 (c,1) Ap '95
VIREOS
 Nat Wildlife 30:8 (painting,c,4) Ap '92
 Nat Wildlife 33:42–3 (c,1) Ag '95
VIRGIN ISLANDS, GREAT BRITAIN
 Trav/Holiday 175:106 (c,4) Ap '92
 Trav/Holiday 179:32–3 (map,c,4) Ap '96
VIRGIN ISLANDS, U.S.
— Buck Island, St. Croix
 Trav/Holiday 175:17 (c,4) O '92
— Columbus landing spot at Salt River, St.
 Croix
 Am Heritage 45:6 (c,3) Ap '94
— Harmony Resort, St. John's
 Trav&Leisure 24:68–72 (c,4) Mr '94
— St. Croix
 Trav/Holiday 176:84–91 (map,c,1) O '93
 Life 17:88–9 (c,1) F '94
 Trav&Leisure 24:S1–S15 (map,c,1) S '94
 supp.
— St. John
 Trav/Holiday 175:101 (c,4) Ap '92
 Gourmet 56:102–5,144 (map,c,1) Je '96
— St. Thomas
 Trav&Leisure 24:E1 (c,3) D '94
VIRGINIA
— Appomattox
 Trav&Leisure 24:E12–E14 (c,4) Mr '94
— Appomattox sites related to Civil War
 Trav/Holiday 175:88–93 (c,2) O '92
— Assateague Island
 Trav/Holiday 179:34–43 (map,1) Ap '96
— Carter's Grove mansion
 Am Heritage 43:82–7 (c,1) My '92
— Chincoteague Refuge
 Natur Hist 103:92–4 (map,c,1) Je '94
— Civil War battle sites
 Trav&Leisure 25:187–9 (map,c,2) Ap '95
— Countryside
 Life 16:44–5 (c,1) My '93
 Life 17:24 (c,4) Jl '94
— The Homestead resort
 Gourmet 54:136 (c,4) My '94
— Hunt country
 Gourmet 52:126–31,194 (map,c,1) N '92
— Jefferson's second home, "Poplar Forest"
 Am Heritage 44:104–13 (c,1) Ap '93
— Manassas battlefield site
 Am Heritage 47:68–9 (c,1) D '96
— New River

Natur Hist 105:58–9 (map,c,4) Mr '96
— Petersburg Civil War sites
　　Am Heritage 46:26–8 (c,4) O '95
— Scenes along route of Lee's 1865 retreat
　　Trav/Holiday 178:72–4 (c,1) Ap '95
— Shenandoah Valley
　　Trav&Leisure 23:193,202–4 (map,c,2) Ap
　　　'93
　　Trav/Holiday 177:123–7 (c,3) Ap '94
　　Gourmet 54:20,134–7,204 (map,c,1) My
　　　'94
　　Nat Geog 190:38–57 (map,c,1) D '96
— Staunton
　　Trav&Leisure 23:202 (c,4) Ap '93
— See also
　　APPALACHIAN MOUNTAINS
　　ARLINGTON
　　BLUE RIDGE MOUNTAINS
　　CHARLOTTESVILLE
　　CHESAPEAKE BAY
　　NORFOLK
　　RICHMOND
　　SHENANDOAH RIVER
　　WILLIAMSBURG
　　YORKTOWN

VIRGINIA—MAPS
— Blue Ridge Highways
　　Trav/Holiday 179:86 (c,4) My '96
— Charlottesville area
　　Trav/Holiday 175:34 (c,4) Ap '92

VIRTUAL REALITY
— Virtual reality game (Japan)
　　Trav/Holiday 178:81 (c,2) O '95
— Virtual reality helmet
　　Life 19:90 (4) N '96
— Virtual reality wedding
　　Nat Geog 188:35 (c,2) O '95

VIRUSES
Nat Geog 186:58–91 (c,1) Jl '94

VOLCANIC ERUPTIONS
— 79 A.D. eruption of Mt. Vesuvius, Italy
　　Trav/Holiday 178:53 (painting,c,4) Ap '95
　　Smithsonian 26:162 (engraving,3) N '95
— Fernandina Island, Galapagos, Ecuador
　　(1978)
　　Natur Hist 104:30–1 (c,1) Ja '95
— Hawaii
　　Nat Geog 188:6–7 (c,1) S '95
— Hotel's simulated volcano (Las Vegas,
　　Nevada)
　　Nat Geog 184:14–15 (c,1) N 15 '93
— Kilauea, Hawaii
　　Nat Geog 182:cov.,5–7 (c,1) D '92
　　Nat Wildlife 34:30 (c,3) D '95
　　Nat Geog 189:100 (c,4) Ja '96

Natur Hist 105:79 (c,4) F '96
　　Life 19:cov.,52–60 (c,1) Je '96
— Klyuchevskaya volcano (Kamchatka,
　　U.S.S.R.)
　　Nat Geog 185:50 (c,3) Ap '94
— Mt. Etna, Sicily (1992)
　　Life 15:7 (c,2) Mr '92
　　Nat Geog 182:10–11 (c,1) D '92
　　Life 16:16–17 (c,1) Ja '93
— Mt. Pinatubo, Philippines (1991)
　　Nat Geog 182:2–3,20–7 (c,1) D '92
— Mt. Sakurajima, Japan
　　Nat Geog 184:83–4 (c,1) Jl '93
— Mt. St. Helens, Washington (1980)
　　Life 17:43 (c,4) My '94
— Redoubt Volcano, Alaska
　　Nat Geog 182:32–3 (c,1) D '92
— Unzen, Japan
　　Nat Geog 182:14–15 (c,1) D '92
— Volcanic eruption seen from space (Papua
　　New Guinea)
　　Nat Geog 190:18–19 (c,1) N '96

VOLCANOES
　　Nat Geog 182:cov.,2–41 (map,c,1) D '92
— Early 20th cent. tourists dipping postcards
　　into lava (Hawaii)
　　Nat Geog 188:132 (2) S '95
— Arenal volcano, Costa Rica
　　Trav/Holiday 179:80–1 (c,2) O '96
— Chimborazo, Ecuador
　　Nat Geog 185:50–1 (c,1) Mr '94
— Fernandina Island, Galapagos, Ecuador
　　Natur Hist 104:28–35 (c,1) Ja '95
— Haleakala, Maui, Hawaii
　　Gourmet 55:165 (c,1) My '95
　　Natur Hist 105:58–60 (map,c,1) Ja '96
— Kamchatka, U.S.S.R.
　　Nat Geog 185:51 (c,1) Ap '94
　　Trav&Leisure 25:57–9,88 (c,3) Ag '95
— Kudryavyy, Iturup, U.S.S.R.
　　Nat Geog 190:66–7 (c,2) O '96
— Mt. Sakurajima, Japan
　　Nat Geog 182:12 (c,4) D '92
— Mt. Semeru, Java, Indonesia
　　Nat Geog 182:38–9 (c,1) D '92
— Nevado Sabancata, Peru
　　Nat Geog 189:64–5 (c,1) Je '96
— Northern California
　　Trav/Holiday 179:68–75 (map,c,1) Jl '96
— Ocean life after undersea eruption
　　Nat Geog 186:114–25 (c,1) N '94
— Pacific volcanoes map
　　Nat Geog 189:111 (c,3) Ja '96
— Pico, Azores
　　Nat Geog 182:64–5 (c,2) N '92

— Los Pitons, St. Lucia
　Trav/Holiday 175:48–9,54 (c,1) F '92
— Stromboli, Italy
　Trav&Leisure 23:86,138 (c,4) Ja '93
— Superplumes
　Nat Geog 189:111 (drawing,c,4) Ja '96
— Tanzania
　Life 17:110–11 (c,1) Ap '94
— Volcan Osorno, Chile
　Gourmet 54:106–7 (c,1) F '94
— See also
　DIAMOND HEAD
　HAWAII VOLCANOES NATIONAL
　　PARK
　KILAUEA
　MOUNT ETNA
　MOUNT ST. HELENS
　VESUVIUS
VOLCANOES—DAMAGE
— 79 A.D. Vesuvius victims, Pompeii, Italy
　Life 19:54–5 (1) Je '96
— Armero, Colombia (1985)
　Smithsonian 27:35 (c,2) Jl '96
— Lake created by 1980 Mount St. Helens
　eruption, Washington
　Sports Illus 80:92 (c,4) Je 27 '94
— Mt. Pinatubo, Philippines (1991)
　Life 15:110–11 (c,1) Ja '92
　Nat Geog 182:26–7 (c,2) D '92
　Life 19:58–9 (c,1) Je '96
— Papua New Guinea town buried in white
　ash
　Life 18:20 (c,2) My '95
— Rainwater patterns in volcanic ash
　(Philippines)
　Life 15:8–9 (c,1) F '92
— Unzen, Japan
　Nat Geog 182:14–15 (c,1) D '92
VOLES
　Natur Hist 102:51-3 (c,2) F '93
　Natur Hist 104:12 (c,4) Ag '95
VOLGA RIVER, RUSSIA
　Trav/Holiday 176:87–91 (c,2) Ap '93
　Nat Geog 185:114–38 (map,c,1) Je '94
VOLLEYBALL
　Sports Illus 76:80 (c,4) My 25 '92
　Sports Illus 78:36–7 (c,1) F 22 '93
— Beach volleyball
　Sports Illus 76:34–5 (c,1) Je 22 '92
　Trav/Holiday 175:43 (c,3) Jl '92
　Sports Illus 79:52–3 (c,1) Jl 5 '93
　Sports Illus 81:128 (c,3) S 5 '94
— Beach volleyball at 1996 Olympics
　(Atlanta)
　Sports Illus 85:88–90,95 (c,1) Ag 5 '96

— History of Olympic volleyball
　Sports Illus 84:11–26 (c,2) Je 17 '96
— Pool volleyball (Texas)
　Nat Geog 189:54 (c,3) F '96
— Takraw (kick volleyball)
　Sports Illus 81:64 (c,4) Ag 8 '94
VOLLEYBALL—COLLEGE
— NCAA Championships 1996 (UCLA vs.
　Hawaii)
　Sports Illus 84:28 (c,4) My 13 '96
— NCAA women's tournament (Nebraska vs.
　Texas)
　Sports Illus 83:2–3,46–8 (c,1) D 25 '95
— Women
　Sports Illus 81:78 (c,3) O 31 '94
VON BRAUN, WERNHER
　Life 18:136 (4) Je 5 '95
VON STERNBERG, JOSEF
　Trav&Leisure 23:19 (3) Ja '93
VOODOO
— Benin
　Natur Hist 104:cov.,40–9 (c,1) O '95
— Voodoo rites (West Africa)
　Nat Geog 188:102–13 (c,1) Ag '95
— West Indies
　Trav/Holiday 179:70–5 (c,1) N '96
VUILLARD, EDOUARD
— "Old Woman near a Mantelpiece" (1895)
　Smithsonian 25:53 (painting,c,2) Mr '95
VULTURES
　Nat Geog 185:109 (c,3) F '94
　Natur Hist 103:34–41 (c,1) S '94
　Sports Illus 84:73 (c,3) Ja 29 '96
— King vulture
　Sports Illus 76:172 (c,4) Mr 9 '92
　Natur Hist 103:34,39–40 (c,1) S '94
— Turkey vulture
　Nat Wildlife 32:27 (c,4) F '94
　Natur Hist 103:36–41 (c,1) S '94

–W–

WAGONS
— Late 19th cent. delivery wagon
　Smithsonian 23:132 (c,4) Mr '93
— Chuckwagon race (Arkansas)
　Sports Illus 81:83 (c,4) O 17 '94
— Farm wagon (Ukraine)
　Smithsonian 23:76 (c,2) D '92
— Salt wagon (Vietnam)
　Trav&Leisure 25:175 (c,4) O '95
— Wagon train wheel
　Trav&Leisure 23:19 (c,4) Ja '93
— See also

COVERED WAGONS
WAINWRIGHT, JONATHAN
Life 18:132 (4) Je 5 '95
WAITERS
Trav/Holiday 179:15 (3) D '96
— 1932 waiter on ice skates (Switzerland)
Life 18:9 (2) O '95
— Chicago, Illinois
Gourmet 56:96 (c,4) O '96
— Egypt
Nat Geog 183:48–9 (c,2) Ap '93
— France
Gourmet 52:cov. (c,1) Ja '92
— Hotel room service (New York)
Trav&Leisure 26:4,40 (c,4) Ap '96
— Hotel room service by bicycle (Arizona)
Trav&Leisure 26:75 (c,4) F '96
— New York
Am Heritage 43:68–9 (c,3) Ap '92
— Waiters wearing trendy masks (Idaho)
Nat Geog 185:30–1 (c,1) F '94
WAITRESSES
— Coffee shop (Florida)
Life 15:13 (c,3) My '92
WALES
Trav&Leisure 23:152,156–9 (map,c,3)
My '93
Gourmet 56:96–101 (map,c,1) Je '96
— Beaumaris Castle
Gourmet 56:96 (c,4) Je '96
— Conwy Castle
Trav&Leisure 23:156 (c,4) My '93
Gourmet 56:98 (c,3) Je '96
— Hay-on-Wye
Trav/Holiday 178:70–5 (map,c,2) Mr '95
— Sheep ranch
Nat Geog 184:108–9 (c,1) S '93
WALKING
— Racewalking
Trav&Leisure 25:82 (c,2) Ap '95
— Racewalking at 1996 Olympics (Atlanta)
Sports Illus 85:98–9 (c,1) Ag 5 '96
WALLACE, GEORGE
Am Heritage 44:108 (4) S '93
Am Heritage 46:104 (4) F '95
Life 18:62 (c,3) Je 5 '95
WALLACE, HENRY
Am Heritage 43:49 (4) Jl '92
WALLPAPER
— 1936 walls covered with newspaper
(Mississippi)
Life 19:30 (1) O '96
— 1950s wallpaper designs
Smithsonian 26:20–1 (c,4) Ag '95

WALPOLE, HORACE
— Strawberry Hill home, Twickenham,
England
Trav&Leisure 24:64 (c,4) Ag '94
WALRUSES
Life 16:16 (c,2) O '93
Life 17:71 (c,4) Ag '94
Nat Wildlife 33:2–3 (c,2) F '95
Nat Geog 190:2–3,26–7 (c,1) O '96
WAR OF 1812
— 1814 Battle of New Orleans
Am Heritage 46:28,72 (engraving,4,) F
'95 supp.
— Battle of Lake Erie
Smithsonian 25:24–35 (painting,c,1) Ja '95
— Rebuilt War of 1812 ship "Niagara"
Smithsonian 25:18 (c,4) Mr '95
— See also
PERRY, OLIVER HAZARD
WARBLERS
Nat Wildlife 30:4–5,9 (c,1) Ag '92
Natur Hist 102:40–1 (c,1) My '93
Nat Geog 183:68–89 (c,1) Je '93
Nat Wildlife 32:40–1 (c,1) D '93
Nat Wildlife 32:26–7 (c,1) F '94
Smithsonian 25:18 (painting,c,4) Ap '94
Natur Hist 103:36–41 (c,1) My '94
Nat Wildlife 32:17,19 (c,2) O '94
Nat Wildlife 33:46 (c,4) F '95
Nat Wildlife 33:13 (c,4) Je '95
Nat Wildlife 33:34 (c,4) O '95
Nat Wildlife 34:9 (c,4) Je '96
Natur Hist 105:43,47 (c,1) Jl '96
Nat Wildlife 34:49 (c,1) Ag '96
— Chicks
Nat Wildlife 32:19 (c,4) O '94
Nat Wildlife 34:9 (c,4) Je '96
— See also
OVENBIRDS
REDSTARTS
WARFARE
— 8th cent. Maya battle (Guatemala)
Nat Geog 183:106–7 (painting,c,1) F '93
— 1066 Battle of Hastings depicted in
Bayeux Tapestry
Smithsonian 25:68–78 (c,2) My '94
— 1214 battle between Mongols and China
Natur Hist 103:50–1 (painting,c,1) O '94
Nat Geog 190:24 (painting,c,3) D '96
— 14th–17th cent. Mongolian battles
Natur Hist 103:48–57 (painting,c,1) O '94
— 1577 British fighting Inuits (Canada)
Smithsonian 23:152 (painting,c,4) N '92
— 1600 sea battle between Spanish and
Dutch (Philippines)

Nat Geog 186:38–9 (painting,c,1) Jl '94
— 1876 Battle of Little Big Horn (Montana)
 Am Heritage 43:79 (painting,c,3) Ap '92
 Natur Hist 101:36–41 (painting,c,1) Je '92
— 1921 Washington Naval Conference
 Am Heritage 44:38 (4) D '93
— Afghan snipers
 Nat Geog 184:64–5 (c,1) O '93
— Ancient Mexico
 Nat Geog 182:120–36 (painting,c,1) S '92
— Ancient Scythians attacking on horseback
 Nat Geog 190:58–9 (painting,c,1) S '96
— Bathing Civil War soldiers caught in
 surprise attack
 Am Heritage 44:88–9 (painting,c,2) D '93
— Hannibal crossing Alps (218 B.C.)
 Smithsonian 25:124–5 (painting,c,1) Ap
 '94
— Indian scalping army officer (19th cent.)
 Natur Hist 101:38 (painting,c,4) Je '92
— Medieval-style battle (Pennsylvania)
 Life 18:28–32 (c,1) N '95
— Papua New Guinea tribesmen practicing
 for battle
 Life 19:14 (2) S '96
— See also
 ARMS
 BUNKER HILL, BATTLE OF
 DUELS
 MILITARY COSTUME
 WARS
WARHOL, ANDY
 Life 19:24 (3) S '96
— Warhol Museum, Pittsburgh, Pennsylvania
 Am Heritage 47:24 (c,4) S '96
WARREN, EARL
 Am Heritage 46:52 (4) N '95
WARREN, ROBERT PENN
 Am Heritage 43:98 (4) O '92
WARS
— Afghan guerrilla war
 Gourmet 52:35–8 (c,1) Ag '92
— See also
 BOER WAR
 CIVIL WAR
 GULF WAR
 INDIAN WARS
 KOREAN WAR
 MEXICAN WAR
 MILITARY COSTUME
 MILITARY LEADERS
 REVOLUTIONARY WAR
 SPANISH-AMERICAN WAR
 VIETNAM WAR
 WAR OF 1812

 WARFARE
 WORLD WAR I
 WORLD WAR II
WARSAW, POLAND
— 1939
 Trav/Holiday 178:70 (4) S '95
WART HOGS
 Natur Hist 101:61 (c,4) Mr '92
 Trav&Leisure 22:139 (c,4) Je '92
 Natur Hist 104:78–9 (c,1) N '95
WASATCH RANGE, UTAH
 Nat Geog 189:58–9 (c,1) Ja '96
WASHINGTON, GEORGE
 Smithsonian 23:136 (painting,c,4) O '92
 Smithsonian 24:83 (painting,c,4) My '93
 Am Heritage 47:110 (painting,4) My '96
— 1800 painting of Washington being deified
 (China)
 Am Heritage 43:53 (c,1) D '92
— 1930 N.C. Wyeth painting of Washington
 Am Heritage 44:6 (c,2) N '93
— Caricature
 Am Heritage 46:85 (c,1) F '95
WASHINGTON
— Coastal scenes
 Trav/Holiday 176:68–75 (map,c,1) S '93
 Gourmet 56:45–51 (map,c,1) Ag '96
— Columbia River Basin
 Nat Wildlife 34:36–45 (c,1) D '95
— Dalles Dam, Columbia River
 Natur Hist 104:33 (c,2) S '95
— Entiat's numerical rock
 Life 17:106–7 (c,1) Je '94
— Grays Harbor
 Trav&Leisure 23:NY6 (c,4) Je '93
— Impact of Ice Age Lake Missoula floods
 Smithsonian 26:48–59 (map,c,1) Ap '95
— Island inns
 Trav&Leisure 26:122–9,164 (map,c,1) Ap
 '96
— Klickitat River
 Nat Geog 187:34–5 (c,2) Mr '95
— Mount Adams
 Trav&Leisure 24:76–7 (c,1) Ja '94
— Mount Baker
 Trav&Leisure 23:124 (c,4) Jl '93
— North Cascades Park
 Nat Wildlife 32:54–5 (c,1) F '94
— Orting
 Smithsonian 27:36–7 (c,3) Jl '96
— Palouse Falls
 Smithsonian 26:59 (c,1) Ap '95
— Paradise
 Trav/Holiday 176:cov.,92–3 (c,1) Mr '93
— Port Townsend

Trav/Holiday 176:71 (c,4) S '93
— Puget Sound Islands
Nat Geog 187:106–30 (map,c,1) Je '95
— Wenatchee National Forest
Nat Wildlife 34:45 (c,2) D '95
— See also
CASCADE RANGE
COLUMBIA RIVER
GRAND COULEE DAM
MOUNT RAINIER
MOUNT RAINIER NATIONAL PARK
MOUNT ST. HELENS
OLYMPIC NATIONAL PARK
PUGET SOUND
SAN JUAN ISLANDS
SEATTLE
TACOMA
WASHINGTON—MAPS
Gourmet 53:82 (painting,c,2) N '93
— Cascade Loop
Trav/Holiday 177:46 (c,4) Mr '94
— Columbia–Snake River system
Nat Wildlife 32:46 (c,2) O '94
WASHINGTON, D.C.
Gourmet 52:78 (c,4) O '92
Gourmet 55:76,80 (map,c,3) Je '95
Life 18:10,55–74 (1) Ag '95
— 1857
Smithsonian 26:26 (4) Ja '96
— 1920s postcard of Washington, D.C.
Smithsonian 26:30 (c,4) My '95
— FBI Building
Trav/Holiday 179:42 (c,4) O '96
— Federal Reserve Board
Trav/Holiday 179:42–3 (c,3) O '96
— Holocaust Museum
Life 16:19 (c,4) Ap '93
Smithsonian 24:50–63 (c,1) Ap '93
— Jefferson Hotel
Trav&Leisure 25:58 (c,4) N '95
— Million Man March (1995)
Life 18:24–30 (1) D '95
Am Heritage 47:cov.,103 (c,2) F '96
— National Zoo
Smithsonian 27:32–43 (c,1) Je '96
— Offerings left at Vietnam Veterans
Memorial
Am Heritage 46:cov.,6,92–103 (c,1) F '95
— Old postal building lobby
Smithsonian 24:85 (c,1) Ag '93
— Outdoor sculpture covered with snow
Life 19:90 (c,2) Ap '96
— Phillips Collection
Trav/Holiday 177:72 (c,3) S '94
— Sixth Street wharf (1863)

Smithsonian 26:38 (painting,c,4) N '95
— Vietnam Veterans Memorial
Life 15:cov.,24–36 (c,1) N '92
Am Heritage 46:cov.,93 (c,1) F '95
Life 18:59 (4) Je '95
Trav/Holiday 179:75 (c,4) Mr '96
— Willard Hotel
Am Heritage 45:50–1 (c,3) Ap '94
— See also
CAPITOL BUILDING
FREER GALLERY OF ART
JEFFERSON MEMORIAL
LIBRARY OF CONGRESS
LINCOLN MEMORIAL
SMITHSONIAN INSTITUTION
SUPREME COURT BUILDING
WASHINGTON MONUMENT
WHITE HOUSE
WASHINGTON, D.C.—MAPS
Trav/Holiday 175:22 (c,4) N '92
Trav&Leisure 24:B1 (c,4) Je '94
**WASHINGTON MONUMENT, WASH-
INGTON, D.C.**
Life 15:28 (c,1) N '92
Smithsonian 23:112 (c,3) Mr '93
Life 16:34–5 (1) Je '93
Life 17:40 (c,4) Mr '94
Trav&Leisure 25:E1 (c,4) S '95
WASPS
Natur Hist 103:36–8 (c,1) Je '94
Life 17:64 (c,1) Je '94
Nat Wildlife 33:56–7 (c,1) D '94
Nat Wildlife 33:18–19 (c,1) F '95
— Wasp cocoons
Nat Wildlife 33:34–5 (c,1) Ag '95
— Yellow jacket nest
Natur Hist 104:4 (c,4) Mr '95
WATCHES
— 1480 first watch (Germany)
Am Heritage 47:36 (c,4) D '96
— 1877 Hampden Rail-Way Watch
Am Heritage 44:35 (c,1) N '93
— 1949 wristwatch spy camera
Am Heritage 45:102 (4) Jl '94
— High tech wristwatches
Trav&Leisure 24:34 (c,4) Ag '94
— History of watches
Am Heritage 47:35–50 (c,4) D '96
WATER
— Birch tree reflected in pool of water (New
Hampshire)
Nat Wildlife 34:31 (c,1) D '95
— Desalination station (Kuwait)
Nat Geog 183:68–9 (c,1) My '93
— Destruction of trout stream

Nat Geog 189:78–9 (painting,c,1) Ap '96
— Dowsing
Nat Geog 184:21 (c,3) N 15 '93
Smithsonian 26:66–75 (c,1) Ja '96
— Filling water cistern from truck (Colorado)
Nat Geog 190:93 (c,3) N '96
— Hydroelectric project (Quebec)
Nat Geog 184:68–71 (map,c,1) N 15 '93
— Nylon net generating water from clouds
(Chile)
Natur Hist 104:44–7 (c,1) N '95
— Ogallala Aquifer, Midwest
Nat Geog 183:80–109 (map,c,1) Mr '93
— U.S. water problems
Nat Geog 184:entire issue (map,c,1) N 15
'93
— Water problems in the Middle East
Nat Geog 183:38–71 (c,1) My '93
— Waterspout (Manitoba)
Nat Geog 188:1 (c,2) D '95
— See also
DAMS
DROUGHT
FLOODS
FOUNTAINS
IRRIGATION
WATER POLLUTION

WATER BUFFALOES
Life 16:24 (c,4) N '93
— Bathing in river (Bangladesh)
Nat Geog 183:132–3 (c,1) Je '93
— Water buffalo race (Thailand)
Sports Illus 85:95 (c,3) D 9 '96

WATER BUGS
Nat Wildlife 34:46 (c,1) Je '96
Water formations. See
AQUEDUCTS
BAYS
BOSPORUS STRAIT
CANALS
ENGLISH CHANNEL
FJORDS
FLOODS
FOUNTAINS
GULF OF MEXICO
HOT SPRINGS
MEDITERRANEAN SEA
OCEANS
PONDS
PUGET SOUND
RED SEA
RESERVOIRS
RIVERS
SEAS
WATERFALLS

WAVES
WELLS

WATER LILIES
Life 16:64 (c,4) Jl '93
Nat Geog 188:86–7 (c,1) O '95
Gourmet 56:76 (c,4) Jl '96
Trav&Leisure 26:138 (c,1) O '96

WATER POLLUTION
Nat Geog 184:12–13,76–106 (c,1) N 15
'93
— 1858 cartoon about pollution of the
Thames River, England
Natur Hist 103:42–3 (c,1) Je '94
— Acid runoff from coal mine (West
Virginia)
Nat Wildlife 33:70 (c,4) Je '95
— Azerbaijan
Nat Geog 186:78–9 (c,1) Ag '94
— Bird victims of toxic drainwater
(California)
Sports Illus 78:62–3,69 (c,1) Mr 22 '93
— Chemical waste ponds (U.S.S.R.)
Nat Geog 185:137 (c,4) Je '94
— Cleaning factory waste water (Texas)
Smithsonian 25:32 (r) My '94
— Contaminated river sign (Colorado)
Sports Illus 85:85 (c,4) O 14 '96
— Copper mining residue in rainwater
(Arizona)
Nat Geog 185:8–9 (c,1) F '94
— Creek colored orange by acid (Montana)
Nat Wildlife 30:42 (c,4) Ag '92
— Dioxin hazards
Nat Wildlife 32:4–13 (c,1) Ag '94
— Fish dead from dinoflagellates
Natur Hist 105:18 (c,4) Mr '96
— Rio Grande River, Texas/Mexico
Smithsonian 25:26–37 (1) My '94
— Runoff problems
Nat Geog 189:106–25 (c,1) F '96
— San Francisco Bay pollution problems
Smithsonian 23:88–95 (c,1) Ag '92
— Spilled animal fat (Texas)
Nat Geog 182:28–9 (c,2) Jl '92
— Treated wastewater in holding ponds
(Kansas)
Nat Geog 183:94–5 (c,2) Mr '93
— Water pollution warning sign (Florida)
Nat Geog 184:79 (c,3) N 15 '93
— See also
OIL SPILLS

WATER POLO
Sports Illus 77:45 (c,3) Jl 27 '92
— 1992 Olympics (Barcelona)
Sports Illus 77:47 (c,2) Ag 17 '92

— 1996 Olympics (Atlanta)
Sports Illus 85:2–3 (c,1) Ag 5 '96
WATER SKIING
Sports Illus 76:84 (c,4) My 18 '92
Sports Illus 80:65 (c,3) My 9 '94
Sports Illus 83:144 (c,3) S 4 '95
— 1956 (Lebanon)
Trav/Holiday 175:34 (4) My '92
— Ontario
Sports Illus 77:2–3 (c,1) Jl 13 '92
WATERBURY, CONNECTICUT
Nat Geog 185:70–1 (c,1) F '94
WATERFALLS
— Akaka Falls, Hawaii
Life 15:32–3 (c,1) My '92
Trav/Holiday 175:100 (c,3) My '92
Trav&Leisure 22:160 (c,3) N '92
— Ammonoosuc Falls, New Hampshire
Trav&Leisure 22:100–1 (c,1) My '92
— Arkansas
Natur Hist 102:22–3 (c,1) S '93
— Bathing in waterfall (Brazil)
Life 15:70 (c,4) Jl '92
— Beaver Meadow Falls, New York
Natur Hist 101:30–1 (c,1) My '92
— Calf Creek Falls, Utah
Am Heritage 47:80 (c,4) Ap '96
— Chile
Gourmet 54:104 (c,2) F '94
— Climbing frozen waterfall (Alberta)
Nat Geog 190:85,90 (c,1) D '96
— Cohoes Falls, New York (late 18th cent.)
Am Heritage 47:84 (drawing,3) Jl '96
— Columbia River Gorge, Oregon
Gourmet 53:145 (c,1) Ap '93
— Copper Canyon, Mexico
Trav/Holiday 178:53 (c,1) D '95
— Dominica, Windward Islands
Trav&Leisure 22:85 (c,1) Ja '92
— Fake waterfall at Las Vegas hotel, Nevada
Trav&Leisure 25:66 (c,4) O '95
— Guadeloupe
Trav&Leisure 22:187 (c,4) Mr '92
— Hawaii
Trav/Holiday 176:64,66 (c,2) My '93
Trav&Leisure 26:41 (c,1) Ja '96
— Indonesia
Trav&Leisure 23:102–3 (c,1) N '93
— Latin America
Nat Wildlife 31:19 (c,1) Ap '93
— Martinique
Trav/Holiday 176:73 (c,1) D '93
— Montserrat
Trav/Holiday 179:47 (c,2) Mr '96
— New Zealand

Natur Hist 102:61 (c,1) Mr '93
— Newfoundland
Natur Hist 101:42–3 (c,1) D '92
— Palouse Falls, Washington
Smithsonian 26:59 (c,1) Ap '95
— Puerto Rico
Trav&Leisure 25:87 (c,1) Mr '95
— Rainbow Falls, Adirondacks, New York
Life 16:33 (c,4) O '93
— Rio de Janeiro, Brazil
Trav&Leisure 23:136 (c,1) N '93
— St. Lucia
Trav&Leisure 23:60 (c,4) N '93
— Tahiti
Trav&Leisure 24:170 (c,4) Ap '94
— Tower Falls, Yellowstone, Wyoming
Trav/Holiday 175:46 (c,1) Je '92
— Wailua Falls, Maui, Hawaii
Nat Geog 188:8–9 (c,1) S '95
— Western Samoa
Trav/Holiday 179:45 (c,2) My '96
— Wilberforce Falls, Northwest Territories
Trav&Leisure 22:82 (c,3) Mr '92
— See also
IGUACU FALLS
NIAGARA FALLS
VICTORIA FALLS
**WATERMELON INDUSTRY—HAR-
VESTING**
— Crimea, Ukraine
Nat Geog 186:115 (c,3) S '94
WATERMELONS
Gourmet 54:cov.,117 (c,1) Jl '94
WATERS, ETHEL
Am Heritage 44:110 (3) D '93
Am Heritage 45:61–73 (1) F '94
**WATERTON LAKES NATIONAL
PARK, ALBERTA**
Trav/Holiday 177:54—7 (map,c,1) Mr '94
WATTEAU, ANTOINE
— Deem painting in style of Watteau
Smithsonian 24:100 (c,4) Jl '93
WAVES
Nat Wildlife 30:44–51 (c,1) Ag '92
Life 17:82 (c,2) Ag '94
— Boater swept into ocean to drown
(Australia)
Life 19:18–19 (c,1) Jl '96
— Waves hitting coastal rocks (Great Britain)
Trav/Holiday 175:59 (c,1) Ap '92
WAXWINGS
— Cedar waxwings
Natur Hist 102:34–5 (c,1) N '93
WAYNE, ANTHONY
Am Heritage 44:34 (painting,c,4) D '93

WEASELS
Nat Wildlife 30:19,42–5 (c,1) F '92
Smithsonian 23:66 (c,4) My '92
— See also
ERMINES
FERRETS
MARTENS
SKUNKS
WOLVERINES
WEATHER
— Impact of El Nino
Trav/Holiday 178:33 (painting,c,3) D '95
— See also
AURORA BOREALIS
CLOUDS
COLD
CYCLONES
DROUGHT
FLOODS
FOG
HURRICANES
ICE
LIGHTNING
RAIN
RAINBOWS
SNOW SCENES
SNOW STORMS
STORMS
TORNADOES
WIND
WEATHERVANES
— Massachusetts
Gourmet 53:123 (c,4) Ap '93
WEAVING
— Guatemala
Trav/Holiday 178:84 (c,4) Mr '95
— Mexico
Trav/Holiday 175:81 (c,3) F '92
— Peru
Nat Geog 181:118–19 (c,1) F '92
— Philippines
Trav&Leisure 25:144 (c,4) Ap '95
— Weaving place mats on hand loom
(Kentucky)
Smithsonian 24:100 (4) D '93
— Weaving rug (Greece)
Trav/Holiday 178:53 (c,4) My '95
— Weaving rug (Oman)
Nat Geog 187:130 (c,3) My '95
— See also
BASKET WEAVING
WEEVILS
— Acorn weevils
Natur Hist 103:42 (c,4) O '94

WEIGHT LIFTING
Sports Illus 76:68 (c,4) Ap 27 '92
Sports Illus 77:130–3 (c,1) Jl 22 '92
Sports Illus 79:52–3 (c,1) Ag 9 '93
Life 16:76 (c,2) Ag '93
Sports Illus 81:76 (c,4) O 10 '94
— 19th cent.
Nat Geog 190:54 (4) Jl '96
— 1996 Olympics (Atlanta)
Sports Illus 85:106 (c,4) Ag 12 '96
— Athlete working out in gym
Sports Illus 80:34 (c,3) Ap 25 '94
— Indian powwow dancer in training
(Montana)
Nat Geog 185:104 (c,3) Je '94
— Stone lifting competition (Spain)
Nat Geog 190:52–3 (c,1) Jl '96
WELLS
— Big Well, Greensburg, Kansas
Nat Geog 183:101 (c,1) Mr '93
— Drawing water from well (Niger)
Life 17:62 (2) Ag '94
— Drilling well (Syria)
Nat Geog 183:44–5 (c,1) My '93
— Israel
Nat Geog 183:67 (c,3) My '93
WESER RIVER, GERMANY
Trav/Holiday 176:56 (c,1) Jl '93
WEST, MAE
Am Heritage 43:34 (4) S '92
WEST INDIES
— 1995 hurricane damage (St. Martin)
Life 19:34 (c,3) Ja '96
— Caribbean Island scenes
Trav&Leisure 22:80–5,116–17 (map,c,1)
Ja '92
Trav&Leisure 22:1–22 (map,c,1) Ap '92
supp.
Trav&Leisure 22:1–34 (c,1) N '92 supp.
Trav&Leisure 23:1–22 (c,1) Ap '93 supp.
Trav&Leisure 23:1–24 (c,1) N '93 supp.
Natur Hist 102:A2–A10 (map,c,3) D '93
Trav/Holiday 176:70–86 (map,c,1) D '93
Trav&Leisure 24:1–30 (c,1) N '94 supp.
Trav&Leisure 25:1–22 (map,c,1) Ap '95
supp.
Trav&Leisure 25:144–56,184 (map,c,1) O
'95
Trav&Leisure 25:C1–C26 (c,3) N '95
Trav&Leisure 26:C1–C22 (map,c,4) Mr
'96
Trav&Leisure 26:121–39 (c,4) N '96
— Caribbean resorts
Trav/Holiday 179:44–53 (map,c,1) Jl '96

Trav&Leisure 26:60–6 (c,4) O '96
— Turks and Caicos
Trav&Leisure 24:120–9,136 (map,c,1) N
'94
— See also
ARUBA
BAHAMAS
BARBADOS
CAYMAN ISLANDS
CURACAO
GRENADINE ISLANDS
GUADELOUPE
JAMAICA
LEEWARD ISLANDS
MARTINIQUE
NETHERLANDS ANTILLES
TRINIDAD AND TOBAGO
TURKS AND CAICOS ISLANDS
VIRGIN ISLANDS
VOODOO
WINDWARD ISLANDS
WEST INDIES—MAPS
Trav&Leisure 25:96 (c,3) Ja '95
Trav&Leisure 25:144 (c,1) O '95
— Good scuba diving sites
Trav/Holiday 175:72–3 (c,1) D '92
WEST POINT, NEW YORK
— Late 18th cent.
Am Heritage 47:77 (drawing,4) Jl '96
WEST VIRGINIA
— 1930s coal mining areas
Life 15:80–1,84 (1) My '92
— Countryside
Nat Geog 181:70–1 (c,1) F '92
Gourmet 56:67–74 (map,c,1) Ap '96
— Filbert
Nat Geog 183:120–1 (c,1) F '93
— Grave Creek ancient Indian mound
Am Heritage 46:120–3 (c,1) Ap '95
— Hawk's Nest State Park
Smithsonian 25:76 (c,4) D '94
— Monongahela National Forest
Nat Wildlife 34:28–9 (c,1) D '95
— See also
CHARLESTON
WEST VIRGINIA—MAPS
Gourmet 56:226 (4) My '96
— Allegheny Mountains loop
Trav/Holiday 177:45 (c,4) O '94
WESTERN FRONTIER LIFE
— 19th cent. sheriff (Arizona)
Life 16:50 (4) Ap 5 '93
— 1804 Lewis and Clark expedition route
Trav/Holiday 177:39,68–77 (map,c,1) Je
'94

— 1846 events in westward movement
Smithsonian 27:38–51 (c,1) Ap '96
— 1870s pioneers heading west
Smithsonian 24:89 (engraving,c,4) S '93
— Late 19th cent. personalities
Trav/Holiday 176:68–9 (4) Je '93
— Late 19th cent. train robber Chris Evans
Smithsonian 26:84–94 (painting,c,1) My
'95
— 1881 travel poster for "The Great West"
Smithsonian 27:51 (c,1) Ap '96
— 1895 homesteaders (Wisconsin)
Am Heritage 44:56 (4) O '93
— Dead members of Dalton gang (1892)
Am Heritage 43:38 (4) O '92
— Fort Union, Montana (1834)
Trav&Leisure 25:191 (painting,c,4) O '95
— History of the "Wild West"
Life 16:entire issue (c,1) Ap 5 '93
— Doc Holliday
Smithsonian 23:183 (4) N '92
— Nat Love
Am Heritage 46:38 (4) F '95 supp.
— Lucien Maxwell (New Mexico)
Smithsonian 26:46,56 (painting,c,4) Jl '95
— Mormon pioneers (Utah)
Am Heritage 44:68,72 (3) Ap '93
— Movies depicting frontier life
Life 16:60–8 (c,1) Ap 5 '93
— Scenes along the 1840s Oregon Trail
Am Heritage 44:26,60–76 (map,c,1) My
'93
Life 16:63–72 (map,c,1) D '93
Smithsonian 25:40–51 (c,1) My '94
Smithsonian 27:38–51 (painting,c,1) Ap
'96
— Site of 1846 Donner Party disaster
(California)
Am Heritage 44:74 (4) My '93
— Sites related to Wyatt Earp and the Old
West (Tombstone, Arizona)
Trav&Leisure 24:92–7,143–5 (c,3) F '94
— Tombstone tombstones, Arizona
Am Heritage 47:30 (c,4) F '96
— Wild West show (New York)
Nat Geog 186:68–9 (c,2) N '94
— See also
CALAMITY JANE
CODY, WILLIAM (BUFFALO BILL)
COVERED WAGONS
COWBOYS
CUSTER, GEORGE ARMSTRONG
EARP, WYATT
FREMONT, JOHN C.
GHOST TOWNS

HICKOCK, WILD BILL
JAMES, JESSE
OAKLEY, ANNIE
PONY EXPRESS
RANCHING
RODEOS
STARR, BELLE
TURNER, FREDERICK JACKSON
WESTERN U.S.
— Pacific Coast Highway
 Trav&Leisure 23:114–25 (map,c,1) N '93
— Scenes along 1869 route of explorer John
 Wesley Powell
 Nat Geog 185:86–115 (map,c,1) Ap '94
— Scenes along Route 93
 Nat Geog 182:42–68 (map,c,1) D '92
— Western federal land use
 Nat Geog 185:2–39 (map,c,1) F '94
— See also
 ROCKY MOUNTAINS
 WESTERN FRONTIER LIFE
WESTMORELAND, WILLIAM
 Life 18:6,60 (1) Je '95
WHALES
 Nat Wildlife 31:4–13 (c,1) F '93
— Ancient Basilosaurus
 Natur Hist 103:72–3,86–8 (painting,c,1)
 Ap '94
— Beached pilot whales
 Life 16:16–17 (1) Ap '93
— Bowhead whales
 Nat Geog 188:114–29 (c,1) Ag '95
— Comparative size chart of whale varieties
 Nat Wildlife 31:9 (c,2) F '93
— Dead blue whale (1903)
 Smithsonian 27:30 (4) O '96
— Freeing whale caught in fishing nets
 (Newfoundland)
 Smithsonian 23:30–41 (c,1) Je '92
— Gray whales
 Nat Wildlife 30:52–3 (c,1) Ap '92
 Nat Geog 187:28–9 (c,1) Mr '95
— Humpback
 Nat Wildlife 30:12 (painting,4) Ap '92
 Smithsonian 23:30–41 (c,1) Je '92
 Nat Wildlife 31:9–11 (c,1) F '93
 Life 16:44 (c,3) Ap '93
 Nat Wildlife 32:46–51 (c,1) Je '94
 Nat Wildlife 33:10–11 (c,1) Ap '95
 Nat Wildlife 33:22,58 (c,1) O '95
 Nat Wildlife 34:43–5 (c,1) O '96
— Minke whales
 Trav&Leisure 25:73,76 (c,4) Ap '95
— Model of blue whale (Washington, D.C.)
 Smithsonian 27:28 (c,3) O '96

— Right whales
 Nat Wildlife 31:4–5,9 (c,1) F '93
 Natur Hist 103:cov.,40–7 (c,1) Ja '94
 Nat Geog 189:110–11 (c,1) Ap '96
— "Save the whales" protest
 Nat Wildlife 33:10 (c,4) Ap '95
— Saving the real-life orca "Willy"
 Life 19:cov.,52–8 (c,1) Mr '96
— Sperm whales
 Nat Wildlife 31:8–9 (c,2) F '93
 Nat Geog 188:56–73 (c,1) N '95
— See also
 BELUGAS
 KILLER WHALES
 PILOT WHALES
WHALING
— Alaska
 Nat Geog 188:118–23 (c,1) Ag '95
— Faeroe Islands, Denmark
 Natur Hist 104:26–33 (c,1) N '95
— Harpooning whale (Alaska)
 Nat Geog 182:85 (c,1) O '92
— Windward Islands
 Natur Hist 103:64–72 (c,1) N '94
WHARTON, EDITH
 Am Heritage 43:88 (4) O '92
 Smithsonian 23:144 (painting,c,4) N '92
— Home (Lenox, Massachusetts)
 Life 17:78–83 (c,1) Ap '94
 Trav&Leisure 25:76–80 (1) Ag '95
WHEAT
 Smithsonian 25:54 (c,4) Ja '95
WHEAT FIELDS
— 1916 (Nebraska)
 Life 19:12–13 (1) Winter '96
— Iraq
 Nat Geog 183:43 (c,4) My '93
— Oregon
 Nat Wildlife 35:48–9 (c,1) D '96
— Saskatchewan
 Nat Geog 186:39–40,51 (c,1) D '94
WHEAT INDUSTRY
— Loading wheat onto ship (British
 Columbia)
 Nat Geog 186:64 (c,3) D '94
WHEAT INDUSTRY—HARVESTING
— Early 20th cent. harvest by mule team
 (Washington)
 Nat Geog 188:130–1 (1) D '95
— Combine threshing wheat (Montana)
 Natur Hist 102:104 (c,4) O '93
— Ethiopia
 Nat Geog 184:94–5 (c,1) Ag '93
WHEELCHAIRS
— Computerized wheelchair (Sweden)

Nat Geog 184:12–13 (c,1) Ag '93
— Man in wheelchair
Nat Geog 181:61 (c,1) My '92
Sports Illus 78:71–3 (c,2) Ap 19 '93
— Wheelchair ballet
Life 16:22 (4) Ap '93
— Wheelchair race
Sports Illus 83:68 (c,1) Ag 14 '95
Sports Illus 85:11 (c,2) Ag 26 '96

WHEELS
— Copper Age wooden wheel
Nat Geog 183:63 (c,4) Je '93
— Wagon train wheel
Trav&Leisure 23:19 (c,4) Ja '93

WHELKS
Natur Hist 103:34–7 (c,2) Jl '94

WHIPPOORWILLS
Smithsonian 23:80 (c,4) Ap '92
Nat Geog 183:81 (painting,c,4) Je '93

WHISTLER, JAMES McNEILL
Smithsonian 24:114 (4) D '93
Smithsonian 26:32 (painting,c,4) My '95
— Caricature of him
Smithsonian 24:122 (4) D '93
— "The Chelsea Girl"
Smithsonian 24:22 (painting,c,4) Je '93
— "Nocturne: Battersea Bridge" (1872)
Smithsonian 26:38 (pastel,c,4) O '95
— Whistler's Peacock Room, Freer Gallery
of Art, Washington, D.C.
Trav&Leisure 23:29 (c,4) My '93

WHITE, STANFORD
— White's carriage house, Rhinebeck, New
York
Trav&Leisure 25:36 (c,4) S '95

WHITE HOUSE, WASHINGTON, D.C.
Life 15:cov. (c,1) Je '92
Life 15:entire issue (c,1) O 30 '92
Trav/Holiday 175:71–7 (c,1) N '92
Nat Geog 186:130–1 (c,1) D '94
Nat Geog 188:112–13 (c,2) N '95
— 1829
Trav/Holiday 175:72 (drawing,4) N '92
— 1929 fire
Trav/Holiday 175:73 (4) N '92
— 1937 scene
Am Heritage 46:104 (2) S '95
— 1940s renovation
Trav/Holiday 175:76 (4) N '92
— Cabinet room
Life 18:32 (4) S '95
— Contemporary crafts shown at the White
House
Smithsonian 26:cov.,52–6 (c,1) Je '95
— Diagram of first floor

Trav/Holiday 175:74–6 (c,1) N '92
— Mamie Eisenhower in White House pantry
Life 19:80 (c,3) S '96
— Miniature model of White House library
Am Heritage 46:105 (c,4) F '95
— President's bedroom
Life 16:10–11,38–9 (c,1) Mr '93
— Vacuuming the Oval Office
Life 18:70–1 (1) Ag '95
— White House covered in tarp during
renovation (1989)
Life 15:2–3 (1) O 30 '92

**WHITE MOUNTAINS, NEW HAMP-
SHIRE**
Trav&Leisure 22:98–105 (c,1) My '92
— North Twin Mountain
Natur Hist 104:26–7 (c,1) F '95
— Old Man of the Mountain
Am Heritage 43:53 (c,4) Ap '92

**WHITE SANDS NATIONAL MONU-
MENT, NEW MEXICO**
Trav/Holiday 177:58 (c,3) Jl '94

WHITMAN, WALT
Nat Geog 186:109–138 (c,1) D '94
Am Heritage 46:88,106 (c,4) S '95
— Birthplace (Long Island, New York)
Nat Geog 186:118–19 (c,4) D '94
— Sites relating to his life and works
Nat Geog 186:106–41 (c,1) D '94

WHOOPING CRANES
Life 16:24 (c,4) Ap '93
Nat Geog 187:2–4,40–1 (c,1) Mr '95
Natur Hist 104:65 (c,3) Jl '95

WIESBADEN, GERMANY
Gourmet 55:132–4,196 (map,c,1) N '95

WIGHT, ISLE OF, ENGLAND
Trav/Holiday 178:71 (c,1) Ap '95

WIGS
— Whitening men's wigs (18th cent.)
Natur Hist 105:53 (etching,4) Jl '96

WILDEBEESTS
Trav&Leisure 22:138 (c,4) Je '92
Natur Hist 102:48 (c,2) My '93
Life 17:70 (c,2) Ag '94
Smithsonian 26:24 (c,4) Ja '96
Life 19:80–1 (c,1) My '96
— Crocodiles attacking wildebeests
Nat Geog 183:94–109 (c,1) Ap '93

WILDLIFE REFUGES
Nat Geog 190:2–35 (map,c,1) O '96
— Arctic National Wildlife Refuge, Alaska
Smithsonian 26:32–41 (c,1) Mr '96
— Bayou Sauvage National Wildlife Refuge,
Louisiana
Nat Geog 187:96 (c,3) Ja '95

— Bombay Hook National Wildlife Refuge,
 Delaware
 Trav/Holiday 178:38–9 (c,1) S '95
— Chang Tang, Tibet
 Nat Geog 184:62–87 (c,1) Ag '93
— Chincoteague Refuge, Virginia
 Natur Hist 103:92–4 (map,c,1) Je '94
— Donana National Park, Spain
 Trav/Holiday 175:68–74 (MAP,C,1,) Ap
 '92
— Menindee Lakes, Kinchega, Australia
 Trav/Holiday 178:64–5 (c,1) O '95
— Mingo National Wildlife Refuge, Missouri
 Nat Geog 182:4–5 (c,1) O '92
— Okefenokee National Wildlife Refuge,
 Florida/Georgia
 Nat Geog 181:43–5,48 (map,c,1) Ap '92
— Ouse Washes, Cambridgeshire, England
 Natur Hist 101:26–9 (c,1) Jl '92
— Paynes Prairie State Preserve, Florida
 Life 15:6–7 (c,1) F '92
— Togiak, Alaska
 Nat Geog 190:2–3,26–7 (c,1) O '96
— Yukon Delta, Alaska
 Nat Wildlife 33:40 (c,1) Je '95
**WILLIAM III, OF ORANGE (GREAT
BRITAIN)**
 Smithsonian 24:112 (engraving,4) Mr '94
— See also
 MARY II
WILLIAMS, ESTHER
 Nat Geog 181:53 (c,3) Je '92
 Trav/Holiday 175:102 (c,4) Jl '92
 Sports Illus 80:54–5 (1) F 14 '94
 Am Heritage 45:100 (4) F '94
WILLIAMS, TED
 Sports Illus 79:25–6 (4) Jl 19 '93
 Smithsonian 25:40 (4) Jl '94
 Sports Illus 81:56–9,62,66 (c,1) Jl 4 '94
 Smithsonian 25:68 (4) O '94
 Sports Illus 81:106–7 (c,1) N 14 '94
 Life 19:80 (3) F '96
 Sports Illus 85:26–7 (1) Jl 1 '96
 Sports Illus 85:13 (4) D 23 '96
WILLIAMS, TENNESSEE
 Trav&Leisure 24:112 (4) D '94
 Life 18:147 (3) Je 5 '95
— Birthplace (Columbus, Mississippi)
 Trav&Leisure 24:E10 (c,4) Ap '94
WILLIAMSBURG, VIRGINIA
 Gourmet 55:108 (c,2) D '95
 Am Heritage 47:84 (c,4) O '96
 Trav/Holiday 179:72–7 (c,1) D '96
— 1780s map
 Am Heritage 43:69 (c,1) D '92

— Reconstructed slave quarters
 Trav&Leisure 23:NY1 (c,3) F '93
— Reenactment of slave life
 Am Heritage 43:89 (c,3) Ap '92
WILLKIE, WENDELL
 Smithsonian 25:98–9 (1) O '94
 Life 18:92 (4) O '95
WILLOW TREES
 Natur Hist 102:66–8 (c,1) N '93
 Natur Hist 104:16,18 (c,3) Je '95
WILMINGTON, DELAWARE
— Rockwood Museum
 Trav/Holiday 178:42 (c,2) S '95
WILSON, AUGUST
 Smithsonian 22:78 (c,2) Mr '92
WILSON, HAROLD
 Life 19:87 (4) Ja '96
WILSON, WOODROW
 Am Heritage 43:66 (4) F '92
 Trav/Holiday 175:73 (4) N '92
— Living photo of him (1918)
 Life 17:38 (3) O '94
 Smithsonian 26:59 (2) Ja '96
WINCHELL, WALTER
 Am Heritage 45:96–105 (1) N '94
WIND
— Man grasping lamppost in wind (France)
 Trav/Holiday 179:36 (painting,c,4) Mr '96
— Wind turbines (California)
 Life 19:66–7 (c,3) Ag '96
**WIND CAVE NATIONAL PARK,
SOUTH DAKOTA**
 Trav&Leisure 23:95 (c,4) Je '93
WINDMILLS
— Denmark
 Trav/Holiday 176:82–3 (c,1) S '93
— Mykonos, Greece
 Trav/Holiday 175:22 (c,4) Mr '92
— Nantucket, Massachusetts
 Trav/Holiday 179:36–7 (c,1) Jl '96
— Netherlands
 Trav/Holiday 176:62 (c,4) Jl '93
 Smithsonian 25:133 (3) Je '94
— Virgin Islands
 Trav/Holiday 176:88–9 (c,3) O '93
WINDOWS
— Washing ski lodge windows (Utah)
 Nat Geog 189:72 (c,3) Ja '96
— Washing skyscraper windows (Texas)
 Life 15:8–9 (c,1) My '92
— See also
 STAINED GLASS
WINDSOR CASTLE, ENGLAND
 Trav&Leisure 23:63 (c,1) Ag '93
— Dining room

Life 15:61 (c,2) My '92

WINDSURFING

Sports Illus 83:44 (c,1) Jl 3 '95
— North Carolina
 Gourmet 55:100 (c,4) Ap '95
— Northwest
 Nat Geog 184:64–5 (c,1) N 15 '93
 Nat Wildlife 34:77 (c,4) D '95

WINDWARD ISLANDS

— Bequia, Grenadines
 Trav&Leisure 22:80–4 (map,c,1) Ja '92
— Dominica
 Trav&Leisure 23:148 (c,3) My '93
 Trav&Leisure 24:70,74 (c,4) D '94
— Grenada
 Trav&Leisure 22:60 (c,4) S '92
 Trav/Holiday 175:42–8 (map,c,1) N '92
 Gourmet 54:59 (c,1) Ja '94
— Dominica
 Trav&Leisure 22:81–5 (map,c,1) Ja '92
— St. Lucia
 Trav/Holiday 175:cov.,48–55 (map,c,1) F '92
 Trav&Leisure 23:59–60 (c,4) N '93
 Gourmet 54:58,61 (c,1) Ja '94
 Trav/Holiday 177:76–80 (c,1) N '94
— See also
 MARTINIQUE

WINDWARD ISLANDS—COSTUME

Natur Hist 103:64–71 (c,1) N '94

WINDWARD ISLANDS—MAPS

Gourmet 54:80 (4) Ja '94

WINE

— 1787 French wine bottle belonging to
 Thomas Jefferson
 Am Heritage 47:114 (c,4) D '96
— 19th cent. corkscrew
 Am Heritage 47:92 (drawing,4) D '96
— 1938 wine tasting
 Am Heritage 47:93 (4) D '96
— Corkscrews
 Gourmet 54:156 (c,4) D '94
 Gourmet 56:68 (drawing,4) Je '96
— Mansion wine cellar (Great Britain)
 Trav&Leisure 24:106 (c,2) Je '94
— Opening wine bottle
 Gourmet 56:46 (drawing,4) O '96
— Pouring wine
 Gourmet 53:18 (painting,c,2) Ag '93
 Gourmet 56:48 (drawing,4) O '96
— Restaurant wine cellar (Italy)
 Trav&Leisure 22:110–11 (c,2) N '92
— Restaurant wine rack (California)
 Gourmet 55:62 (c,3) F '95
— Sommelier (California)

Gourmet 55:64 (c,3) Ap '95
— Sommelier offering wine at restaurant
 (New York)
 Gourmet 54:78 (c,4) Ap '94
— Wine bottles
 Gourmet 52:78 (painting,c,2) My '92
— Wine bottles (Italy)
 Trav/Holiday 175:51 (4) N '92
— Wine glasses and carafe
 Gourmet 52:54,59 (painting,c,2) O '92
— Wine in glass
 Gourmet 56:68 (painting,c,2) F '96
— See also
 DRINKING CUSTOMS

WINE INDUSTRY

— 1922 laborers stomping grapes by foot
 (Mexico)
 Nat Geog 190:132 (3) Ag '96
— Barrels of madeira (Madeira)
 Gourmet 53:116 (c,3) D '93
— History of American winemaking
 Am Heritage 47:84–97 (c,1) D '96
— Madeira, Portugal
 Nat Geog 186:106–7 (c,2) N '94
— Riddling champagne bottles (California)
 Life 17:94 (c,2) Mr '94
— Sommelier school (France)
 Nat Geog 181:20 (c,3) F '92
— Wine barrels (California)
 Trav/Holiday 179:31 (c,4) O '96
— Wine barrels (Italy)
 Gourmet 52:106 (c,4) O '92
 Trav/Holiday 175:56 (4) N '92
— Wine barrels (New Zealand)
 Gourmet 55:106 (c,3) Ap '95
— Wine barrels (Spain)
 Gourmet 54:52–4 (painting,c,2) O '94
— Wine cellars (California)
 Gourmet 56:72 (c,4) D '96
— Wine cellars (France)
 Nat Geog 181:18–19 (c,1) F '92
 Trav/Holiday 178:53 (c,1) N '95
 Trav/Holiday 179:64 (c,1) Jl '96
— Wine tanks (California)
 Nat Geog 181:32–3 (c,1) F '92
— Wine tasting (Oregon)
 Life 17:91 (c,4) Ap '94
— Wineries (California)
 Trav&Leisure 22:71–2 (c,4) O '92
 Gourmet 54:88–91 (c,4) Mr '94
 Gourmet 54:76 (painting,4) N '94
— Wineries (New Zealand)
 Gourmet 55:106–9 (c,1) Ap '95
— Wineries (South Africa)
 Trav&Leisure 26:57,65 (c,1) Ag '96

— See also
VINEYARDS
WINTER
— Desolate rural road in winter (Wyoming)
Nat Geog 183:56–7 (c,1) Ja '93
— Vermont
Gourmet 54:132–6 (c,1) D '94
— Winter wildlife scenes
Nat Wildlife 31:cov.,50–9 (c,1) F '93
— See also
SNOW SCENES
WISCONSIN
— Apostle Islands
Nat Wildlife 31:10–11 (c,1) Ag '93
— Applefest (Bayfield)
Trav&Leisure 25:158–9 (c,1) S '95
— Bayfield
Gourmet 53:42 (c,4) Ag '93
Trav&Leisure 25:158–65,187–8 (map,c,1)
S '95
— Bayfield ferry
Trav&Leisure 26:50 (c,4) F '96
— Black River Falls (1890)
Am Heritage 44:55 (4) O '93
— The Dells
Trav&Leisure 25:E1–E4 (map.c,4) My '95
— Dickeyville Grotto
Trav&Leisure 24:161 (4) O '94
— Door County
Trav&Leisure 22:50–4 (map,c,3) S '92
Gourmet 53:86 (c,4) My '93
— Ephraim
Trav&Leisure 22:52 (c,4) S '92
— Lake Pepin
Trav&Leisure 24:112–17,162 (map,c,1) Je
'94
— Mississippi River area
Trav&Leisure 24:112–15 (c,1) Je '94
— Viroqua
Smithsonian 23:36–47 (c,1) O '92
— See also
LAKE MICHIGAN
LAKE SUPERIOR
WISCONSIN—MAPS
— Door County
Trav/Holiday 177:28 (c,4) Jl '94
WITCHES
— 1692 Salem witch trials, Massachusetts
Trav/Holiday 175:90 (painting,c,4) F '92
Smithsonian 23:116–28 (engraving,c,2)
Ap '92
— Burning witches at the stake
Smithsonian 24:117 (drawing,c,4) Mr '94
— Massachusetts
Trav&Leisure 23:E8 (c,4) Je '93

WOLFHOUNDS
— Borzoi (Russian wolfhounds)
Nat Geog 186:98–9 (c,1) S '94
WOLVERINES
Smithsonian 23:136–48 (c,3) Mr '93
WOLVES
Nat Geog 183:90 (painting,c,1) Ap '93
Life 18:74 (c,2) My '95
Nat Wildlife 34:30–1,54 (painting,c,1) Ag
'96
Natur Hist 105:cov.,50–8 (c,1) D '96
— Gray wolves
Nat Wildlife 30:6–7 (c,1) Ap '92
Life 15:3,76–85 (c,1) Jl '92
Nat Wildlife 31:cov. (c,1) D '92
Nat Wildlife 31:4–5 (c,1) Je '93
Nat Wildlife 32:50–1 (c,1) D '93
Nat Wildlife 32:4–5 (c,1) Je '94
Nat Wildlife 33:4–11,24–5 (c,1) D '94
Nat Geog 186:16–17 (c,2) D '94
Nat Wildlife 33:10–11 (c,1) Je '95
Nat Wildlife 34:8 (c,4) F '96
Smithsonian 26:38 (c,4) Mr '96
Nat Wildlife 34:32 (c,4) Ap '96
Nat Wildlife 34:16–21 (c,1) O '96
— Map of worldwide wolf locations
Natur Hist 105:54–5 (c,1) D '96
— Red wolves
Nat Wildlife 30:56–7 (c,1) Ap '92
Nat Geog 186:38 (c,4) O '94
Nat Geog 187:cov.,5–6 (c,1) Mr '95
— Tundra wolf
Natur Hist 105:36 (c,4) My '96
— Wolves as pets
Smithsonian 25:34–44 (c,2) Je '94
WOMBATS
Natur Hist 104:27–9,55 (c,1) D '95
WOMEN
— 1840s black nanny
Smithsonian 27:120 (4) My '96
— 1866 college women's baseball team
Am Heritage 45:111 (2) Jl '94
— 1940s "Rosie the Riveter" symbol
Smithsonian 24:cov.,67 (painting,c,1) Mr
'94
— 1950s birth control pills
Am Heritage 44:45 (4) My '93
— 1987 sculpture of working mother
Natur Hist 104:38 (c,3) D '95
— Celebrities with breast cancer
Life 17:cov. (c,1) My '94
— Depictions of motherhood in art
Natur Hist 104:31–43 (c,1) D '95
— Geishas (Japan)
Nat Geog 188:98–112 (c,1) O '95

— Mother posing as coffee table
 Life 19:38 (c,4) My '96
— Portraits by Cecilia Beaux
 Smithsonian 26:40 (painting,c,4) N '95
— Role of women in ancient Greece as
 depicted in art
 Life 19:70–3 (c,4) Mr '96
— Tall women
 Sports Illus 79:69 (c,1) N 29 '93
— Welfare mother studying at college
 (Massachusetts)
 Life 15:60–6 (c,1) Ap '92
— See also
 PREGNANCY
 PROSTITUTION

WOMEN IN HISTORY
— 19th cent. prints by women graphic artists
 Smithsonian 26:36 (c,4) My '95
— 1868 pioneer women (Kansas)
 Life 16:22–3 (1) Ap 5 '93
— Late 19th cent. member of sultan's harem
 (Turkey)
 Trav&Leisure 24:30 (4) F '94
— Early 20th cent. women pilots
 Smithsonian 25:72–6 (2) Ag '94
— Early 20th cent. women railroad workers
 Am Heritage 46:62–74,106 (1) Jl '95
— Astronaut Christa McAuliffe
 Life 19:cov.,38–41 (c,1) F '96
— Julia Child
 Gourmet 55:70 (c,3) F '95
— Depictions of black "mammy" as
 American icon
 Am Heritage 44:78–86 (c,1) S '93
— Famous women golfers
 Sports Illus 76:47 (c,4) F 3 '92
— Female Civil War soldiers
 Smithsonian 24:97–103 (c,2) Ja '94
— Millicent Fenwick
 Life 16:68–9 (1) Ja '93
— Ruth Bader Ginsburg
 Life 19:65 (4) S '96
— Journalist Ida Wells
 Smithsonian 25:125 (4) F '95
— Ann Landers and Dear Abby
 Life 19:28 (4) Jl '96
— Gypsy Rose Lee
 Smithsonian 23:141 (4) Je '92
— Suzanne Lenglen
 Nat Geog 190:58 (4) Jl '96
— Shari Lewis
 Smithsonian 24:64 (c,4) D '93
— Lifestyle of Vice President Gore's wife
 Tipper
 Life 17:82–7 (c,1) Mr '94

— Queen Marie of Romania (1926)
 Am Heritage 45:110 (3) O '94
— Elsa Maxwell
 Life 18:144 (1) Je 5 '95
— Lola Montez
 Smithsonian 26:44 (4) O '95
— Mother Hale
 Smithsonian 22:65 (4) F '92
— Eva Peron (Argentina)
 Trav&Leisure 26:157 (c,2) D '96
— "Peyton Place" author Grace Metalious
 Am Heritage 44:54 (4) My '93
— Queen Hatshepsut (Egypt)
 Natur Hist 101:5–9 (carving,1) Jl '92
— Sally Rand, fan dancer
 Am Heritage 43:26 (4) Ap '92
— Rock and roll stars (1952-1992)
 Life 15:entire issue (c,1) D 1 '92
— Sculptor Edmonia Lewis
 Smithsonian 27:18 (4) S '96
— Barbra Streisand
 Life 19:37 (3) Mr '96
— Sophie Tucker
 Smithsonian 27:49 (3) N '96
— U.S. First Ladies through history
 Smithsonian 23:135–58 (c,2) O '92
 Life 15:80–5 (c,1) O 30 '92
— Works by 16th cent. woman Sofonisba
 Anguissola (Italy)
 Smithsonian 26:106–9 (painting,c,1) My
 '95
— See also
 ANDERSON, DAME JUDITH
 ANDERSON, MARIAN
 BACALL, LAUREN
 BAKER, JOSEPHINE
 BALL, LUCILLE
 BERGMAN, INGRID
 BERNHARDT, SARAH
 BOLEYN, ANNE
 BOURKE-WHITE, MARGARET
 BOW, CLARA
 BRICE, FANNY
 BRONTE FAMILY
 CALAMITY JANE
 CARSON, RACHEL
 COLETTE
 CRAWFORD, JOAN
 DE MILLE, AGNES
 DIDO
 DIDRIKSON, BABE
 DIETRICH, MARLENE
 DUNCAN, ISADORA
 EARHART, AMELIA
 EDDY, MARY BAKER

EDERLE, GERTRUDE
ELIZABETH I
ELIZABETH II
FRANK, ANNE
FRIEDAN, BETTY
GARBO, GRETA
GISH, LILLIAN
GRABLE, BETTY
GRAHAM, MARTHA
HARLOW, JEAN
HAYWORTH, RITA
HELLMAN, LILLIAN
HENIE, SONJA
HEPBURN, AUDREY
HEPBURN, KATHARINE
HERSCHEL, CAROLINE L.
HOLIDAY, BILLIE
HORNE, LENA
HOWE, JULIA WARD
ISABELLA I
KAHLO, FRIDA
KELLER, HELEN
KING, BILLIE JEAN
LEIGH, VIVIAN
MADISON, DOLLEY
MADONNA
MARIE ANTOINETTE
MARY II
MEAD, MARGARET
MEIR, GOLDA
MITCHELL, MARGARET
MONROE, MARILYN
MOORE, MARIANNE
MORRISON, TONI
OAKLEY, ANNIE
O'KEEFFE, GEORGIA
PARKER, DOROTHY
PARKS, ROSA
PAUL, ALICE
PICKFORD, MARY
POCAHONTAS
POTTER, BEATRIX
PRICE, LEONTYNE
RANKIN, JEANNETTE
ROGERS, GINGER
ROOSEVELT, ELEANOR
RUDOLPH, WILMA
RUSSELL, LILLIAN
SACAGAWEA
SAND, GEORGE
SMITH, BESSIE
SMITH, MARGARET CHASE
STARR, BELLE
TAYLOR, ELIZABETH
TEMPLE, SHIRLEY

TUBMAN, HARRIET
VICTORIA
WATERS, ETHEL
WEST, MAE
WHARTON, EDITH
WILLIAMS, ESTHER
WOMEN'S LIBERATION MOVEMENT
WOMEN'S SUFFRAGE MOVEMENT
WOODHULL, VICTORIA
WOMEN'S LIBERATION MOVE-MENT
— 1970 march (New York City, New York)
Life 18:58 (3) Je 5 '95
— Gagged women demanding free speech (China)
Life 19:36 (c,3) Ja '96
— See also
FRIEDAN, BETTY
WOMEN'S SUFFRAGE MOVEMENT
— 1915 parade (New York)
Life 18:32–3 (4) Ag '95
— 1917 "Jailed for Freedom" pin
Smithsonian 23:30 (4) Mr '93
— 1917 arrested suffragette
Smithsonian 23:32 (4) Mr '93
— 1917 protester
Life 15:100 (3) O 30 '92
— 1917 women's suffrage poster
Am Heritage 46:6 (c,2) Jl '95
— See also
PAUL, ALICE
WOODHULL, VICTORIA
WONDER, STEVIE
Life 15:63 (4) D 1 '92
Smithsonian 25:89 (4) O '94
WOOD, GRANT
— "Death on the Ridge Road" (1935)
Am Heritage 47:45 (painting,c,3) N '96
WOOD DUCKS
Nat Wildlife 30:60 (c,1) F '92
Nat Wildlife 31:cov.,47–51 (c,1) Ag '93
— Wood duck eggs
Nat Wildlife 31:46–7 (c,1) Ag '93
WOOD WORKING
— Carving field hockey sticks (India)
Sports Illus 85:174 (c,3) Jl 22 '96
WOODCHUCKS
Nat Wildlife 33:36,39 (c,2) Ag '95
WOODHULL, VICTORIA
Am Heritage 46:20 (etching,4) D '95
WOODPECKERS
Nat Wildlife 31:cov. (c,1) Je '93
Nat Wildlife 31:16–17 (c,1) O '93
Nat Wildlife 34:42–5 (c,1) Ap '96
— Chick

Nat Geog 190:138 (c,4) S '96
— Downy
Nat Wildlife 34:8 (c,4) O '96
— Hairy woodpecker
Nat Wildlife 30:60 (c,1) O '92
WOODSON, CARTER
Am Heritage 46:5 (4) F '95 supp.
WORDSWORTH, WILLIAM
— Dove Cottage home, Lake District, England
Trav/Holiday 176:96 (c,4) Ap '93
**WORLD TRADE CENTER, NEW
YORK CITY, NEW YORK**
Gourmet 55:142–3 (c,1) My '95
— 1993 bomb damage
Life 16:14–15 (c,1) Je '93
WORLD WAR I
Am Heritage 44:cov.,47–77 (1) N '93
— 1910s women railroad workers
Am Heritage 46:106 (4) Jl '95
— 1915 sinking of the "Lusitania"
Nat Geog 185:68–85 (c,1) Ap '94
— November 7, 1918 false armistice
celebration (New York)
Am Heritage 44:107 (4) N '93
— 1918 armistice celebration (Washington,
D.C.)
Life 15:8–9 (1) O 30 '92
— Argonne Forest, France
Am Heritage 44:69 (1) N '93
— Belleau Wood, France
Am Heritage 44:76–7 (1) N '93
— Cannon in Belleau Wood, France
Life 16:37 (c,3) N '93
— Classic Flagg poster of Uncle Sam
Smithsonian 26:70 (c,4) Jl '95
— Current efforts to dispose of live World
War I bombs (Verdun, France)
Smithsonian 24:26–33 (1) F '94
— Archduke Francis Ferdinand
Smithsonian 24:110 (4) Mr '94
— Nurse handing out cigarettes to soldiers
Am Heritage 43:72–3 (1) D '92
— Soldiers
Am Heritage 43:82–5 (painting,c,1) Jl '92
— U.S. enlistment poster citing the "Lusi-
tania" sinking (1915)
Nat Geog 185:75 (c,1) Ap '94
WORLD WAR II
— 1939 Jewish refugee ship "St. Louis"
Smithsonian 26:18 (painting,c,4) Je '95
— 1940s U.S. posters about friendship with
Russia
Am Heritage 46:56,114 (c,4) D '95
— 1940s women railroad workers
Am Heritage 46:62–74 (1) Jl '95

— 1941 USO poster
Am Heritage 43:122 (c,4) D '92
— 1942 aerial raid on Japan
Smithsonian 23:112–28 (3) Je '92
— 1942 Russian cartoon about Allies striking
Axis
Am Heritage 46:48 (c,4) D '95
— 1943 Japanese attack on Aleutian Islands,
Alaska
Natur Hist 101:52–9 (map,c,1) Je '92
— 1943 Marine attack on Tarawa
Smithsonian 24:118–32 (c,1) N '93
— 1943 Teheran Conference
Am Heritage 45:92 (2) My '94
— 1944 destruction of Monte Cassino, Italy
Trav/Holiday 178:66 (3) S '95
— 1944 liberation of Paris
Smithsonian 23:73 (1) N '92
— 1944 Mauldin cartoon about shooting
crippled jeep
Smithsonian 23:cov. (1) N '92
— 1944 Purple Heart and telegram
announcing death of U.S. sailor
Life 18:63 (c,2) Je 5 '95
— 1945 Battle for Iwo Jima
Life 18:cov.,24–5 (1) Je 5 '95
— 1945 Eisenstaedt photo of V-J Day kiss in
Times Square
Life 19:94 (3) O '96
— 1945 events
Life 18:entire issue (c,1) Je 5 '95
— 1945 Nuremberg Trials
Am Heritage 45:78–87 (c,1) Jl '94
Life 18:104–5 (1) Je 5 '95
Smithsonian 27:124–41 (1) O '96
— 1945 Potsdam conference
Am Heritage 46:62 (4) D '95
— 1945 rescue of Austrian Lipizzan horses
by Americans
Sports Illus 83:6–7 (4) O 16 '95
— 1945 Russian soldiers playing piano in
bombed cafe (Germany)
Life 18:32 (3) My '95
— 1945 surrender of Japan on battleship
"Missouri"
Life 18:84 (2) Je 5 '95
Nat Geog 181:73 (4) Mr '92
— 1945 U.S. directive to drop bomb on Japan
Am Heritage 46:70 (1) My '95
— Allies meeting at Torgau, Germany (1945)
Am Heritage 46:cov. (2) D '95
— Anti German violence (France)
Smithsonian 24:46–52 (painting,c,1) S '93
— Attacking Japanese caves
Am Heritage 46:34 (4) My '95

Nat Geog 187:68 (4) My '95
— B-17 bombing mission over Germany
 Am Heritage 46:40–1,47 (1) My '95
— British veterans at D-Day reunion (1994)
 Life 18:34–5 (c,1) Ja '95
— Churchill in V-E Day crowd (London)
 Life 18:54 (2) Je 5 '95
— D-Day (1944)
 Am Heritage 45:cov.,6,40–59 (1) My '94
 Life 17:46–54 (c,1) Je '94
— D-Day depicted in tapestry
 Smithsonian 25:68–81 (c,2) My '94
— D-Day sites (Normandy, France)
 Trav&Leisure 23:78–83 (map,c,1) Ag '93
 Gourmet 54:98–9 (c,3) Je '94
 Trav/Holiday 177:78–85 (c,1) Je '94
— Dogs aboard World War II submarines
 Am Heritage 45:96–9 (1) O '94
— Dresden after 1945 bombing, Germany
 Trav/Holiday 178:70 (4) S '95
— Eisenhower telegram announcing German
 surrender (1945)
 Am Heritage 46:6 (c,2) My '95
— Fanciful depiction of balloon bombs over
 California (1942)
 Am Heritage 44:92–3 (painting,c,2) D '93
— Fighter pilots in the Pacific
 Smithsonian 23:85,90–5 (painting,c,2) D
 '92
— German POWs in U.S. camps
 Smithsonian 26:126–43 (1) Je '95
— Giving transfusion to injured soldier
 Smithsonian 25:124 (2) Mr '95
— Hiroshima after 1945 bombing
 Nat Geog 188:81–7 (1) Ag '95
— Japanese tunnels (New Guinea)
 Nat Geog 181:69 (c,4) Mr '92
— Jewish refugees aboard ship
 Am Heritage 45:89 (4) F '94
— Kamikaze raid damage to U.S. ship
 Life 18:68–9 (1) Je 5 '95
— MacArthur landing at Leyte, Philippines
 (1944)
 Nat Geog 181:56–7,66 (c,1) Mr '92
 Life 17:29 (sculpture,c,2) D '94
 Life 18:16–17 (1) Je 5 '95
 Life 19:120 (3) O '96
— Mauldin cartoon
 Am Heritage 45:16 (4) Ap '94
— Military leaders on "Time" covers
 Smithsonian 22:129 (c,4) Ja '92
— Murals done by U.S. airmen at British air
 bases
 Am Heritage 44:114–19 (c,1) Ap '93
— Navajo code talkers in the Pacific

Smithsonian 24:34–43 (1) Ag '93
— Nazi "stealth" raider ship
 Life 17:41 (3) Ap '94
— Paratrooper doll hanging from church
 steeple in honor of D-Day (France)
 Trav/Holiday 177:81 (c,1) Je '94
— Poster of VD safety tips for soldiers
 Am Heritage 45:22 (c,4) N '94
— Post-war disposition of war surplus
 Smithsonian 26:52–62 (c,2) D '95
— Purple Heart and telegram announcing
 death of U.S. sailors
 Life 18:63 (c,2) Je 5 '95
— Remains of war equipment (Micronesia)
 Natur Hist 103:26–35 (c,1) Ag '94
— Returning U.S. soldier kissing ground
 (1945)
 Life 18:74–5 (1) Je 5 '95
— Role of blood plasma in World War II
 Smithsonian 25:124–38 (2) Mr '95
— Role of the jeep in World War II
 Smithsonian 23:cov.,60–73 (1) N '92
— Rosie the Riveter symbol
 Smithsonian 24:cov.,67 (painting,c,1) Mr
 '94
— Russian flag atop the Reichstag, Berlin,
 Germany (1945)
 Life 18:52 (2) Je 5 '95
 Am Heritage 46:42–3 (1) D '95
— Russian front
 Life 15:88–93 (1) Jl '92
— Russians liberating Czechoslovakia (1945)
 Am Heritage 46:65 (4) D '95
— Scenes of war in the Pacific
 Nat Geog 181:55–73 (c,1) Mr '92
 Am Heritage 44:88–99 (drawing,c,1) S '93
 Life 19:16,52 (1) O '96
— Oskar Schindler
 Life 17:28 (3) Ap '94
— Service star banner
 Life 18:14 (c,4) Je 5 '95
— Soldiers on V-J Day (France)
 Am Heritage 46:cov. (c,1) My '95
— Tokyo after 1945 bombing
 Am Heritage 46:78–82,86 (1) My '95
— U.S. Air Force raids over Germany
 Nat Geog 185:90–113 (map,c,1) Mr '94
— U.S. Army chaplain's possessions
 Life 17:50–1 (c,1) Je '94
— U.S. glider warfare
 Smithsonian 25:118–34 (2) Je '94
— U.S. ration stamps
 Life 18:22 (c,4) Je 5 '95
— U.S. soldiers crossing the Roehr, Germany
 Life 18:18–19 (1) Je 5 '95

— U.S. World War II posters
 Am Heritage 43:32 (4) D '92
 Smithsonian 24:cov.,66–9 (c,1) Mr '94
 Life 18:19,117–22 (c,2) Je 5 '95
— Use of maps in Allied invasion planning
 Nat Geog 187:54–71 (c,1) My '95
— V-J Day celebration (1945)
 Trav/Holiday 177:37 (4) D '94
 Life 18:82–3 (1) Je 5 '95
— Warsaw after 1939 bombing, Poland
 Trav/Holiday 178:70 (4) S '95
— World War II battleships
 Nat Geog 181:72–8 (3) Je '92
— Yalta Conference (1945)
 Life 18:107 (c,2) Je 5 '95
— See also
 BRADLEY, OMAR
 CHURCHILL, WINSTON
 CONCENTRATION CAMPS
 EISENHOWER, DWIGHT DAVID
 FRANK, ANNE
 HALSEY, WILLIAM FREDERICK, JR.
 MacARTHUR, DOUGLAS
 MARSHALL, GEORGE C.
 MONTGOMERY, BERNARD
 MURPHY, AUDIE
 PATTON, GEORGE S., JR.
 PYLE, ERNIE
 RIDGWAY, MATTHEW
 TOJO, HIDEKI
 WAINWRIGHT, JONATHAN
WORLD'S FAIRS
— 1939 New York World's Fair
 Am Heritage 46:112 (3) D '95
WORMS
 Smithsonian 24:87–94 (c,3) Jl '93
— Bristleworms
 Smithsonian 24:113 (c,4) O '93
— Rockworms
 Nat Geog 182:103 (c,4) Jl '92
— Tube worms
 Nat Geog 186:114–15,119 (c,1) N '94
 Smithsonian 26:106 (c,4) Ja '96
 Nat Geog 190:95 (c,3) O '96
— See also
 EARTHWORMS
 LEECHES
 NEMATODES
WRANGELL-ST. ELIAS NATIONAL PARK, ALASKA
 Nat Geog 185:80–101 (map,c,1) My '94
WRASSES
 Natur Hist 101:37–9 (painting,c,2) O '92
 Nat Geog 184:76–7 (c,1) N '93
 Nat Geog 187:103 (c,1) Mr '95

WRENS
 Nat Wildlife 31:41 (c,2) Je '93
— House wrens
 Natur Hist 102:32–3 (c,1) N '93
— Superb fairy-wrens
 Natur Hist 103:56–63 (c,1) N '94
WRESTLERS
— Sumo wrestler eating meal (Japan)
 Life 18:102 (c,3) My '95
— Sumo wrestlers
 Sports Illus 76:68–82 (c,1) My 18 '92
 Life 16:88 (c,2) Ag '93
 Sports Illus 79:55 (c,2) D 27 '93
 Nat Geog 185:116–17 (c,1) Ja '94
— Sumo wrestlers performing shiko exercise
 before match (Hawaii)
 Nat Geog 185:76–7 (c,1) My '94
WRESTLING
— 1854 sumo wrestling (Japan)
 Smithsonian 25:32 (drawing,4) Jl '94
— 1920s (Mongolia)
 Nat Geog 190:62 (4) Jl '96
— 1968 Olympics (Mexico City)
 Sports Illus 76:143 (4) Mr 9 '92
— 1992 Olympics (Barcelona)
 Sports Illus 77:58 (c,4) Ag 17 '92
— 1996 Olympics (Atlanta)
 Sports Illus 85:78–83 (c,1) Ag 12 '96
— Arm wrestling
 Sports Illus 78:70–8 (c,1) Je 14 '93
— Boys wrestling sumo champion (France)
 Life 19:12–13 (c,1) F '96
— Nuba tribesmen wrestling (Sudan)
 Nat Geog 190:64–5 (c,1) Jl '96
— Oil wrestling (Turkey)
 Sports Illus 83:6 (c,4) N 13 '95
— Sumo wrestling (Japan)
 Sports Illus 76:68–82 (c,1) My 18 '92
 Sports Illus 81:63 (c,2) N 14 '94
— Tuareg women (Niger)
 Natur Hist 101:60–1 (c,1) N '92
— Turkey
 Nat Geog 185:2–3 (c,1) My '94
— U.S.S.R.
 Sports Illus 85:180–8 (c,1) Jl 22 '96
— World Championship Wrestling School
 (Atlanta, Georgia)
 Life 18:72–4 (c,1) Ap '95
WRESTLING—AMATEUR
 Sports Illus 76:61 (c,4) Je 15 '92
 Sports Illus 84:60 (c,4) Je 3 '96
WRESTLING—COLLEGE
 Sports Illus 76:6 (c,4) F 24 '92
 Sports Illus 80:68–9 (c,1) Mr 28 '94
 Sports Illus 82:150 (c,3) F 20 '95

— NCAA Championships 1992
 Sports Illus 76:2–3,46–7 (c,1) Mr 30 '92
— NCAA Championships 1996
 Sports Illus 84:2–3 (c,1) Ap 1 '96
WRESTLING—HIGH SCHOOL
 Sports Illus 76:128 (c,4) Ap 6 '92
WRESTLING—PROFESSIONAL
 Sports Illus 84:45 (c,3) F 5 '96
— Women's wrestling
 Sports Illus 81:8 (c,2) Ag 8 '94
WRIGHT, FRANK LLOYD
 Smithsonian 23:141 (4) Je '92
 Smithsonian 24:55,61 (2) F '94
 Trav&Leisure 24:91 (4) Mr '94
 Life 18:143 (3) Je 5 '95
— 1936 Fallingwater house designed by
 Wright (Mill Run, Pennsylvania)
 Smithsonian 24:cov.,54 (c,1) F '94
 Trav&Leisure 24:138 (c,4) Mr '94
— Architectural structures by him
 Smithsonian 24:cov.,54–61 (c,1) F '94
 Trav&Leisure 24:90–3,136–8 (c,1) Mr '94
— Hollyhock House, Los Angeles, California
 Trav&Leisure 24:90 (c,1) Mr '94
— Home (Oak Park, Illinois)
 Smithsonian 24:56 (c,4) F '94
 Trav/Holiday 179:17 (c,4) My '96
— Taliesin home, Wisconsin
 Trav&Leisure 24:92 (c,4) Mr '94
— Taliesin West home, Arizona
 Smithsonian 24:58 (c,3) F '94
 Trav&Leisure 24:92 (c,4) Mr '94
— Unity Temple, Oak Park, Illinois
 Trav&Leisure 24:138 (c,4) Mr '94
— Willets House, Highland Park, Illinois
 Trav&Leisure 25:174 (c,4) My '95
WRIGHT, RICHARD
 Life 18:143 (4) Je 5 '95
WRIGHT, WILBUR AND ORVILLE
— 1903 airplane
 Smithsonian 27:44 (c,4) My '96
— Orville Wright
 Am Heritage 44:26 (4) O '93
WRITERS
— 1950s Beat poets
 Trav&Leisure 25:E1 (3) N '95
— American Academy and Institute of Arts
 and Letters
 Smithsonian 23:136–47 (c,2) N '92
— Author on national book tour circuit
 Trav&Leisure 24:122–5 (4) Mr '94
— Author signing books
 Sports Illus 80:80 (c,3) Mr 7 '94
— Karl Baedeker
 Trav/Holiday 179:55 (drawing,4) F '96

— Sabine Baring-Gould
 Smithsonian 24:74–6 (painting,c,2) Jl '93
— *Black Like Me* author John Howard Griffin
 Life 19:32 (4) Je '96
— James T. Farrell
 Am Heritage 46:150 (3) Ap '95
— Famous mystery writers
 Am Heritage 44:42–3,49 (4) Jl '93
— James Herriot
 Life 19:89 (4) Ja '96
— Murray Kempton
 Am Heritage 45:10 (drawing,4) S '94
— Ann Landers and Dear Abby
 Life 19:28 (4) Jl '96
— H.P. Lovecraft
 Am Heritage 46:82,84 (2) D '95
— Norman Maclean
 Smithsonian 23:121,134 (c,3) S '92
— Muslims protesting Salman Rushdie (Great
 Britain)
 Life 16:62–3 (2) Mr '93
— Henry Steel Olcott
 Smithsonian 26:111,116,123–7 (3) My '95
— "Peyton Place" author Grace Metalious
 Am Heritage 44:54 (4) My '93
— Poets reading their works (Illinois)
 Smithsonian 23:77–86 (2) S '92
— Neil Simon
 Life 19:32 (4) Jl '96
— Aleksandr Solzhenitsyn
 Life 18:88–9 (c,1) O '95
— Mark Sullivan
 Am Heritage 47:49 (1) My '96
— Gay Talese
 Life 15:95 (4) Je '92
— See also
 ADAMS, HENRY BROOKS
 ALBEE, EDWARD
 ASIMOV, ISAAC
 BAUDELAIRE, CHARLES
 BELLOW, SAUL
 BIERCE, AMBROSE
 BRONTE FAMILY
 BURNS, ROBERT
 BYRON, LORD
 CAPOTE, TRUMAN
 CARROLL, LEWIS
 CARSON, RACHEL
 CATTON, BRUCE
 CHANDLER, RAYMOND
 CHAUCER, GEOFFREY
 COCTEAU, JEAN
 COLETTE
 COWARD, NOEL
 CRANE, STEPHEN

DANTE ALIGHIERI
DICKENS, CHARLES
DOS PASSOS, JOHN
DREISER, THEODORE
DU MAURIER, GEORGE
DUMAS, ALEXANDRE
ELLISON, RALPH
EMERSON, RALPH WALDO
FAULKNER, WILLIAM
FITZGERALD, F. SCOTT
FROST, ROBERT
GARDNER, ERLE STANLEY
GALBRAITH, JOHN KENNETH
GEORGE, HENRY
GOLDING, WILLIAM
GRAHAME, KENNETH
GREENE, GRAHAM
HALEY, ALEX
HAMMERSTEIN, OSCAR II
HAMMETT, DASHIELL
HARDY, THOMAS
HAWTHORNE, NATHANIEL
HELLMAN, LILLIAN
HEMINGWAY, ERNEST
HESSE, HERMANN
HOWE, JULIA WARD
HOWELLS, WILLIAM DEAN
HUGHES, LANGSTON
HUGO, VICTOR
IONESCO, EUGENE
JAMES, HENRY
JOYCE, JAMES
KENNAN, GEORGE F.
KEROUAC, JACK
KIPLING, RUDYARD
LEAR, EDWARD
LEWIS, SINCLAIR
MAILER, NORMAN
MATHER, COTTON
MELVILLE, HERMAN
MENCKEN, HENRY LOUIS
MITCHELL, MARGARET
MOORE, MARIANNE
MORRISON, TONI
O'HARA, JOHN
O'NEILL, EUGENE
PARKER, DOROTHY
PLINY THE ELDER
POE, EDGAR ALLEN
POTTER, BEATRIX
POUND, EZRA
PUSHKIN, ALEXANDER
QUEEN, ELLERY
RUSSELL, BERTRAND
SAND, GEORGE

SANDBURG, CARL
SCHLESINGER, ARTHUR, JR.
SCOTT, PAUL
SHAW, IRWIN
SIMENON, GEORGES
SINCLAIR, UPTON
SOLZHENITSYN, ALEKSANDR
STEVENSON, ROBERT LOUIS
STOUT, REX
STYRON, WILLIAM
THOMAS, DYLAN
THURBER, JAMES
TROLLOPE, ANTHONY
TURNER, FREDERICK JACKSON
TWAIN, MARK
UPDIKE, JOHN
VIDAL, GORE
WALPOLE, HORACE
WARREN, ROBERT PENN
WHARTON, EDITH
WHITMAN, WALT
WILLIAMS, TENNESSEE
WILSON, AUGUST
WINCHELL, WALTER
WOODSON, CARTER
WORDSWORTH, WILLIAM
WRIGHT, RICHARD
YEATS, WILLIAM BUTLER

WRITING
— 13th cent. Arabic writing
 Smithsonian 23:48 (c,4) Ag '92
— Ancient Egyptian text
 Nat Geog 187:29 (c,3) Ja '95
— Arabic
 Trav/Holiday 175:67 (c,1) Jl '92
 Nat Geog 189:2 (c,3) Mr '96
— Arabic script carved on building
 Trav&Leisure 24:89 (c,1) Jl '94
— Chinese
 Nat Geog 189:2 (c,3) Mr '96
— Inscribing characters on grain of rice
 (India)
 Life 16:88 (c,4) My '93
— See also
 HIEROGLYPHICS
WRITING INSTRUMENTS
— Jefferson's polygraph to make copies of
 letters
 Smithsonian 24:86 (c,4) My '93
— See also
 PENS
WYETH, ANDREW
 Smithsonian 27:24 (4) Ag '96
WYOMING
 Nat Geog 183:54–79 (map,c,1) Ja '93

Am Heritage 45:95–103 (c,2) Ap '94
Trav/Holiday 177:cov.,40–9 (map,c,1) S '94
— Cody
Am Heritage 47:87 (c,4) My '96
— Countryside
Trav&Leisure 22:13,108–15 (1) My '92
— Devil's Gate
Am Heritage 44:70–1 (c,2) My '93
— Fort Laramie (1840s)
Smithsonian 27:42 (painting,c,4) Ap '96
— Jackson Hole
Gourmet 56:120–3,182 (map,c,1) D '96
— Jackson Lake
Nat Geog 187:132–3 (c,1) F '95
— Plume Rock
Am Heritage 44:61 (c,1) My '93
— Shoshoni
Nat Geog 183:66,70–1 (c,1) Ja '93
— Washakie Needle
Nat Wildlife 30:22–3 (c,1) Je '92
— Wind River Indian reservation
Nat Wildlife 30:18–23 (c,1) Je '92
— See also
CHEYENNE
DEVIL'S TOWER NATIONAL MONU-
MENT
GRAND TETON NATIONAL PARK
SNAKE RIVER
TETON RANGE
YELLOWSTONE NATIONAL PARK

–X–

X-RAYS
— 1896 x-raying process (Colorado)
Am Heritage 43:99 (2) F '92
— Early 20th cent. x-ray machine
Life 18:38 (4) D '95
— CAT scan of javelin imbedded in skull
Sports Illus 80:16 (4) My 23 '94
— Tubercular patient's x-ray
Smithsonian 23:180 (4) N '92

–Y–

YACHTING
— South Pacific
Trav&Leisure 24:76–7 (c,1) F '94
YACHTS
Trav&Leisure 25:90–2 (c,4) F '95
— 1937
Life 19:78 (1) F '96
— Bahamas

Gourmet 52:54–5 (c,1) Ja '92
YAKS
Nat Geog 183:128–9,136–7 (c,1) My '93
Nat Geog 184:76 (c,4) Ag '93
YALTA, UKRAINE
Nat Geog 186:96–7,106–9 (c,1) S '94
YAMAMOTO, ISOROKU
Natur Hist 101:52 (4) Je '92
YANGTZE RIVER, CHINA
Trav/Holiday 176:cov.,56–67 (map,c,1) F '93
Natur Hist 105:28–38 (c,1) Jl '96
— 19th cent. map of Yangtze River area
Natur Hist 103:28–9 (c,1) Jl '94
— Site of planned Three Gorges Dam
Natur Hist 105:cov.,2,28–39 (map,c,1) Jl '96
— Wushan
Natur Hist 104:54 (c,3) D '95
YEAGER, CHARLES
Smithsonian 27:28 (c,4) Ag '96
YEATS, WILLIAM BUTLER
— Home (County Galway, Ireland)
Am Heritage 45:29 (c,4) My '94
YELLOW FEVER
— 1893 victim (Pennsylvania)
Am Heritage 44:98 (engraving,4) Jl '93
Yellow River. See
HUANG HE RIVER
YELLOWSTONE NATIONAL PARK,
WYOMING
Trav/Holiday 175:cov.,40–9 (map,c,1) Je '92
Smithsonian 23:112–13,118–19 (c,2) N '92
Trav&Leisure 23:120–2 (c,1) Mr '93
Nat Geog 186:5–8,42–3 (c,1) O '94
— Early 20th cent. scenes of Yellowstone
Trav/Holiday 175:42 (c,4) Je '92
— Aftermath of fire
Nat Wildlife 32:35 (c,2) Ag '94
Nat Geog 190:126–7 (c,1) S '96
— Cooking trout in hot spring (1919)
Nat Geog 189:134 (3) Ap '96
— Firehole River
Life 19:62 (c,4) Je '96
— Forest fire
Nat Wildlife 32:32–3 (c,1) Ag '94
— Grand Prismatic
Nat Wildlife 31:56–7 (c,1) O '93
— Hot springs
Nat Geog 184:52 (c,3) Ag '93
Smithsonian 26:74 (c,4) Ag '95
— Lower Falls
Trav&Leisure 23:122 (c,3) Mr '93

— Mammoth Hot Springs
 Trav/Holiday 175:48–9 (c,1) Je '92
 Trav&Leisure 23:120–1 (c,1) Mr '93
 Natur Hist 104:A6 (c,4) Ap '95
— Old Faithful
 Trav/Holiday 175:44–5 (c,1) Je '92
 Nat Geog 186:5–6 (c,2) O '94
— Tower Falls
 Trav/Holiday 175:46 (c,1) Je '92
YELLOWTAILS (FISH)
 Life 18:56–7 (c,1) D '95
YELTSIN, BORIS
 Life 15:40–5 (c,1) Ja '92
 Life 15:25 (c,4) O 30 '92
— Family
 Life 15:21 (c,4) Ap '92
YEMEN
 Trav/Holiday 177:92–5 (c,3) Ap '94
YEMEN—COSTUME
— Women farm workers
 Life 16:18 (c,2) S '93
YEW TREES
 Life 15:71–6 (c,2) My '92
 Natur Hist 101:20–2 (c,3) S '92
 Nat Wildlife 33:16–17 (c,1) Ap '95
YOGA
 Life 16:84–5 (c,1) F '93
 Sports Illus 80:50–1 (c,1) Je 6 '94
 Trav/Holiday 179:109 (drawing,c,3) Mr
 '96
 Sports Illus 85:12 (4) S 9 '96
YORK, ENGLAND
— York Minster
 Trav&Leisure 25:136 (c,4) Je '95
YORKTOWN, VIRGINIA
— 1780s map
 Am Heritage 43:70 (c,3) D '92
YORUBA PEOPLE
— Yoruba rite of passage (South Carolina)
 Nat Geog 182:90–1 (c,1) S '92
YORUBA PEOPLE—ARTIFACTS
— Beaded crown
 Smithsonian 25:31 (c,4) S '94
YORUBA PEOPLE—COSTUME
— Snail shell costume
 Natur Hist 104:82 (c,4) Mr '95
YOSEMITE NATIONAL PARK, CALI-
 FORNIA
 Trav/Holiday 176:7—81 (map,c,1) F '93
 Nat Geog 186:12–13 (c,1) O '94
— Aftermath of forest fire
 Natur Hist 104:74–5 (1) D '95
— El Capitan
 Gourmet 52:62–3 (c,1) Ja '92
 Nat Wildlife 31:53 (c,1) F '93

 Life 17:26,31 (c,1) Jl '94
— Half Dome
 Gourmet 52:64 (c,3) Ja '92
 Trav/Holiday 176:76,80 (c,1) F '93
 Life 17:26–9 (c,1) Jl '94
— Winter scenes
 Gourmet 52:62–5 (c,1) Ja '92
YOUNG, BRIGHAM
— Lion House home (Salt Lake City, Utah)
 Am Heritage 44:78 (c,4) Ap '93
— Wives mourning him after 1887 death
 Am Heritage 47:14 (cartoon,4) N '96
YOUNGSTOWN, OHIO
— Youngstown Museum
 Am Heritage 47:97 (c,4) Jl '96
YOUTH
— 1949 teens in cars
 Life 19:76–8 (1) Winter '96
— 1954 teenagers dancing at party
 Life 17:42 (4) Je '94
— 1954 teens dressed for prom
 Am Heritage 45:38 (c,4) D '94
— 1957 teens gathered around car
 Life 19:5 (2) Winter '96
— 1963 teens dancing on beach
 Life 16:28–9 (1) Je '93
— 1968 student sit-in at Columbia University,
 New York City
 Am Heritage 44:60 (4) Ap '93
— 1984 teens cruising in convertible
 (California)
 Life 19:102–3 (c,1) Winter '96
— Boys Town history (Omaha, Nebraska)
 Sports Illus 77:74–88 (c,1) D 21 '92
— Cliff rock painted by high school seniors
 (Washington)
 Life 17:106–7 (c,1) Je '94
— Field of teen celibacy pledges
 (Washington, D.C.)
 Life 17:16–17 (c,1) S '94
— Lifestyle of teenage girl (Texas)
 Life 16:74–83 (c,1) Jl '93
— Listening to draft lottery numbers (1969)
 Life 17:40 (3) N '94
— Punk hairstyles (Great Britain)
 Trav&Leisure 24:103 (c,4) Mr '94
— Teen moonlight rave (California)
 Life 18:20–4 (c,2) Ag '95
— Teens at video arcade (Newfoundland)
 Nat Geog 184:26–7 (c,2) O '93
— Teens hanging out at ice cream shop
 (Massachusetts)
 Nat Geog 181:118–19 (c,2) Je '92
— Young thugs fighting (Moscow, Russia)
 Nat Geog 183:18–19 (c,1) Mr '93

YUCATAN PENINSULA, MEXICO
Nat Geog 190:108–12 (c,1) Ag '96
YUCCA PLANTS
Trav/Holiday 175:48–51 (c,2) My '92
Trav&Leisure 23:127 (c,1) Mr '93
Nat Wildlife 33:44–5 (c,1) Ap '95
Smithsonian 27:112–13 (c,4) O '96
Natur Hist 105:75–6 (c,1) N '96
YUGOSLAVIA
— Dalmatian coast
Trav/Holiday 179:13 (c,4) S '96
— Dubrovnik
Trav&Leisure 23:52–4 (c,4) S '93
— Dubrovnik (1991)
Trav/Holiday 178:64–5 (c,1) S '95
— Dubrovnik burn.ing in war
Life 15:16–17 (c,1) Ja '92
— Mostar
Nat Geog 189:60–1,140 (2) Je '96
— Mostar bridge
Trav/Holiday 178:69 (c,4) S '95
Nat Geog 189:140 (c,3) Je '96
Smithsonian 27:92 (c,3) S '96
— Sarajevo hospital
Life 16:89–98 (1) O '93
— Sveti Stefan Island
Sports Illus 77:53 (c,3) S 14 '92
— Vindija Cave, Croatia
Nat Geog 189:4–5 (c,1) Ja '96
— See also
MACEDONIA
SARAJEVO
YUGOSLAVIA—COSTUME
Trav/Holiday 175:41 (c,4) Ap '92
Life 16:25 (c,3) Ag '93
— 1943 peasant women
Life 16:22 (2) Ag '93
— Bosnian refugees
Nat Geog 183:94–5,112–19 (c,1) My '93
— Child injured by shrapnel (Bosnia)
Life 17:54–5 (c,1) Ja '94
— Coffin of murdered infant
Life 19:12–13 (c,1) D '96
— Croatian Serb refugees on the move
Nat Geog 189:53 (2) Je '96
— Injured child in hospital bed (Sarajevo)
Life 16:12–13 (c,1) Jl '93
— Sarajevo
Life 16:32–7 (c,1) Ap '93
— Women soldiers (Bosnia)
Life 15:26 (c,4) D '92
YUGOSLAVIA—HISTORY
— Archduke Francis Ferdinand
Smithsonian 24:110 (4) Mr '94
— History of Yugoslavia's break-up

Nat Geog 189:48–61,140 (map,c,1) Je '96
— See also
TITO, MARSHAL
YUGOSLAVIA—POLITICS AND GOVERNMENT
— Civil war
Life 15:16–17 (c,1) Ja '92
Life 16:27–9 (c,1) Ja '93
Life 19:72–9 (1) Ja '96
Nat Geog 189:48–9,60–1 (1) Je '96
— Civil war victims
Life 15:10–19 (c,1) O '92
— Effect of war on Sarajevo
Life 16:6,32–7 (c,1) Ap '93
Sports Illus 80:44–52 (c,1) F 14 '94
— Girl blinded by shells (Sarajevo)
Life 18:10–11 (c,1) S '95
— Houses destroyed by war
Nat Geog 183:114–15 (c,1) My '93
— U.S. military presence in Bosnia
Life 19:32–7 (c,1) F '96
YUGOSLAVIA—SOCIAL LIFE AND CUSTOMS
— Bosnian family life
Life 17:61 (c,3) Jl '94
— Diving off remains of Mostar Bridge
Sports Illus 83:18 (c,4) S 18 '95
Nat Geog 189:140 (c,4) Je '96
— Serbian children making kites out of dinar bills (Belanovca)
Life 16:19 (c,2) N '93
— Wedding
Life 16:32–7 (c,1) Ap '93
Life 19:10–11 (1) F '96
YUKON
— Countryside
Smithsonian 23:110–11 (c,1) Jl '92
— See also
ALASKA HIGHWAY
YURTS
— China
Nat Geog 189:8–9 (c,1) Mr '96
— Kazakhstan
Nat Geog 183:27 (c,3) Mr '93
— Mongolia
Nat Geog 183:129–33 (c,1) My '93

Z

ZAIRE
— Rain forest
Natur Hist 102:47 (c,2) My '93
ZAIRE—ARTIFACTS
— Ceremonial masks

Smithsonian 25:32 (c,4) Ap '94
— Luba memory board
Smithsonian 23:116 (c,4) F '93
ZAIRE—COSTUME
— Headgear
Smithsonian 27:28 (c,4) Je '96
ZAIRE—MAPS
— Photo from space
Nat Geog 186:60–2 (1) Ag '94
ZAMBEZI RIVER, ZAMBIA/ZIM-BABWE
Trav&Leisure 22:86–7,94–5 (c,1) N '92
— See also
VICTORIA FALLS
ZAMBIA
— Tombs of deceased soccer team members
Sports Illus 79:86–8 (c,1) O 18 '93
— See also
VICTORIA FALLS
ZAMBEZI RIVER
ZAMBIA—COSTUME
Sports Illus 79:88–98 (c,3) O 18 '93
ZAPATA, EMILIANO
Smithsonian 22:112 (4) Mr '92
Life 19:52 (4) F '96
ZEBRAS
Natur Hist 101:56–8 (c,1) Mr '92
Trav/Holiday 175:61 (c,4) N '92
Natur Hist 102:86–7 (c,1) My '93
Nat Wildlife 31:8–9 (c,1) O '93
Trav/Holiday 177:88–9 (c,1) Mr '94
Gourmet 55:78 (c,4) Ja '95
Smithsonian 26:24 (c,4) Ja '96
Natur Hist 105:53 (c,4) Mr '96
Life 19:7–9 (c,1) My '96
Natur Hist 105:90–1 (c,1) N '96
— Grant's zebras
Smithsonian 23:18 (c,4) Ag '92
— Grevy's zebras
Nat Geog 186:17 (c,3) D '94
ZEPPELIN, FERDINAND VON
Life 19:58 (4) F '96
ZEUS
Nat Geog 186:29 (sculpture,c,4) N '94

ZIEGFELD, FLORENZ
Am Heritage 43:98 (1) F '92
ZIMBABWE
Trav/Holiday 175:cov.,60–9 (map,c,1) N '92
— Hwange National Park
Trav/Holiday 175:cov.,60–7 (c,1) N '92
— See also
VICTORIA FALLS
ZAMBEZI RIVER
ZIMBABWE—COSTUME
Trav&Leisure 22:92–3 (c,3) N '92
— Healer
Trav&Leisure 22:92 (c,3) N '92
ZION NATIONAL PARK, UTAH
Trav&Leisure 22:89–96 (c,1) Jl '92
ZOOS
Nat Geog 184:2–37 (c,1) Jl '93
— Belize
Sports Illus 76:170–7 (c,1) Mr 9 '92
— Central Park Zoo, New York City, New York
Nat Geog 184:32 (c,1) Jl '93
— National Zoo, Washington, D.C.
Smithsonian 27:32–43 (c,1) Je '96
— Orangutan think tank at National Zoo, Washington, D.C.
Natur Hist 105:26–30 (1) Ag '96
— See also
AQUARIUMS
ZULUS—COSTUME
— Zulu medicine woman (South Africa)
Nat Geog 190:11 (c,3) Jl '96
— Zulu women (South Africa)
Trav&Leisure 22:118 (c,4) D '92
ZUMWALT, ELMO
Life 18:66 (4) Je '95
ZUNI INDIANS—SOCIAL LIFE AND CUSTOMS
— Traditional dances
Smithsonian 23:91–2 (c,2) F '93
ZURICH, SWITZERLAND
Trav&Leisure 26:100–9,133–5 (map,c,1) Je '96

ABOUT THE AUTHOR

Marsha C. Appel has a B.A. from the State University of New York at Albany, and an MLS from Syracuse University. She is Senior Vice President, Manager of Member Information Service at the American Association of Advertising Agencies in New York City. An active member of the Special Libraries Association, she has served as editor of *What's New in Advertising and Marketing,* and as chair of the association's Advertising & Marketing Division. In addition to this volume, she has produced four previous volumes of the *Illustration Index,* together covering the years 1972–1991.